Framing America

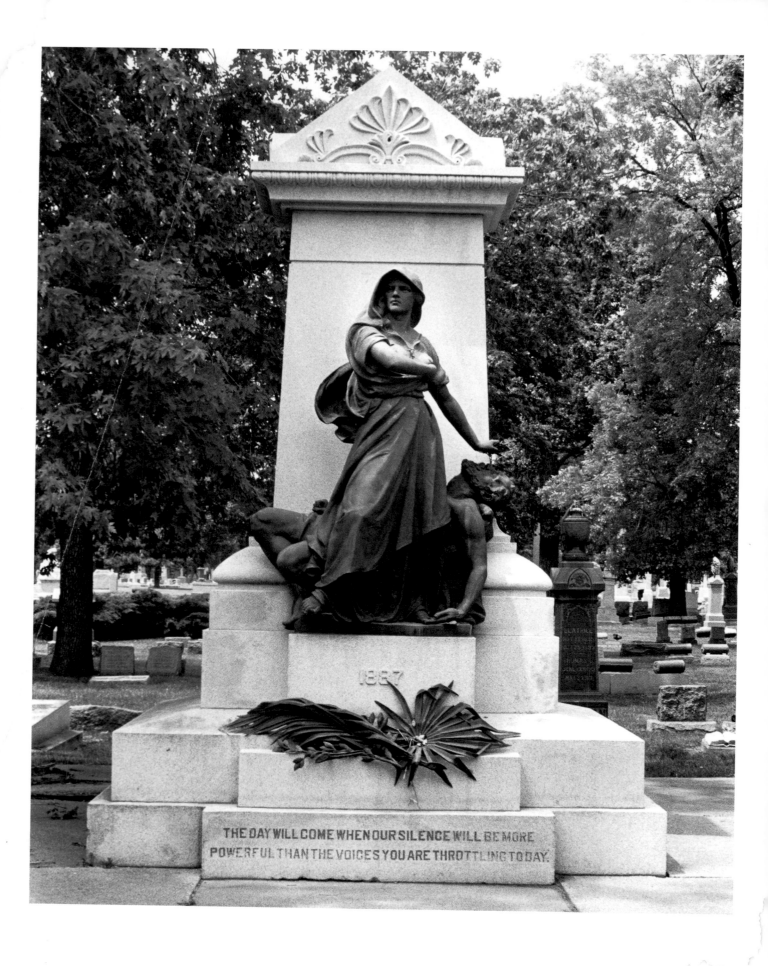

1887

THE DAY WILL COME WHEN OUR SILENCE WILL BE MORE
POWERFUL THAN THE VOICES YOU ARE THROTTLING TODAY.

Frances K. Pohl

Framing America

A Social History of American Art

Third Edition

with 699 illustrations, 360 in color

Thames & Hudson

A Note on the Captions
Dimensions (except in the case of photographs) are given where known;
H = height, L = length, W = width.
Full acknowledgments will be found on pp. 600–03.

On the cover
Front Victor Arnautoff: *City Life* (detail), 1934 (see ill. 7.34). Photo Michael
Halberstadt, Vallejo, California
Back, above left Jeanne Gang: The Aqua Tower, Chicago, 2009 (see ill. 8.140).
Photo © Wilsons Travels Stock/Alamy
Back, above right Cynthia Burr: *Let Virtue be A Guide to Thee*, 1786
(see ill. 2.1). Photo Erik Gould, courtesy the Museum of Art, Rhode Island
School of Design, Providence
Back, below left Anonymous: robe with arrowhead and broken diamond motif,
18th century (see ill. 3.41). Musée de l'Homme, Paris
Back, below right Lilla LoCurto and William Outcault: *thinskinned [b7]*, from
the *thinskinned* series, 2004 (see ill. 8.137). Courtesy the artists

Frontispiece Albert Weinert: The *Haymarket Monument*, 1893
(see pp. 264–65)
Granite and bronze, H 16 ft. (5 m.)
Forest Home (formerly Waldheim) Cemetery, Forest Park, Illinois

First published in 2002 in the United States of America by
Thames & Hudson Inc., 500 Fifth Avenue, New York, New York 10110

thamesandhudsonusa.com

Second edition 2008
Third edition 2012

Library of Congress Catalog Card Number 2011931503
ISBN 978-0-500-28983-9

Printed and bound in China by Toppan Leefung

Acknowledgments

This book emerged out of my years of teaching and research at Pomona
College, and I owe a debt of gratitude to my students and colleagues
for creating a stimulating intellectual environment and to the college
administration for support in the form of research grants and release time.
This book also could not have been written without the many volumes and
articles on American art that have appeared over the past three decades,
in particular those that address the complex intersections of art and politics.
The authors of these studies are too numerous to list here, but I have
attempted to acknowledge as many as possible within the body of the text
and in the bibliography. I am grateful to Nikos Stangos for first expressing
an interest in my work and to Peter Warner for guiding this project over the
several years it took to complete. I would like to thank Geoff Penna for his
design talents, the picture researcher for tracking down elusive images,
John Noble for compiling the index, Carrie Dedon for helping with the
glossary for the third edition, Stefan Helms for help with gathering material
for the website, and, especially, my editor for the first edition, Emily Lane,
for her many careful readings of the text and insightful observations. Peter
Warner, Martin A. Berger, Patricia Hills, Robyn Roslak, and Mary K. Coffey
provided valuable comments on parts or all of the manuscript. Special
appreciation goes to my family and to my good friends Gerald Ackerman,
Leonard Simon, and Kenon Breazeale for providing much-needed emotional
support. Finally, I would like to thank Russell Crowe for his performance
as Maximus in Ridley Scott's *Gladiator*, a film that helped me survive those
difficult final months of writing and revising the original manuscript.
Strength and honor.

For Frances K. Pohl's notes on using the book as a teaching
aid, links to source documents, and images for instructors go to:
www.thamesandhudsonusa.com

Contents

Vol 1

Video Art

31

32

29

30

Spain
France

British

2

4

5

Conquest
New Spain
New France
British/Dutch
Colonies
Am Revolution
Symbols New
Nation

1
2
3
4
5
6

Landscape

Schooling

6

8 Nation/Sacred
9 Occupied Land
10 Domesticated

11 Mex Am War
12 Civil War/Slavery
13 Reconstruction
14 Indian Wars

War, Race
w Honor
8 US Labor

16 Profession
Nature Domestic
Labor

17 Gender
Impressionism 18 End of
Century

VOL 2
Ch 19 Ashcan
Photography
20 Modernism
21 Trends/Manifestos
22-25 Depression/Post WWII

Preface

Writing a survey text on American art at the turn of the 20th and 21st centuries has been both exciting and frustrating, exciting because so much new scholarship has appeared over the past several decades, frustrating because the very breadth and volume of this scholarship has challenged the format of a conventional survey. Not only have the lives and works of artists traditionally included been expanded upon or recontextualized, but scores of individuals previously absent have been uncovered. In addition, new questions have been posed about the very writing of art history. Some have asked whether one should even attempt to create a text that claims to represent the history of American art when, in order to be manageable within the context of a college classroom or a publisher's budget, it necessarily has to leave out so much.

Like other authors of survey texts I must state at the outset that this book in no way purports to be a complete account of the art produced in the United States since the 16th century (and earlier for Native American art). I do believe, however, that survey texts, no matter how selective, are still valuable, for they function as effective vehicles not only for the introduction of a broad range of creative expression, but also for addressing the complexity of historical change. This book is meant to be a starting point, not an end point, for those interested in learning about American art. Its format derives from my own experiences as a scholar and a teacher, while its content is heavily indebted to the scholarship of other historians in the field and to the comments of teachers and students who have used this book. Each new edition contains material shaped by such comments, such as suggestions for alternative interpretations of images or requests for maps, timelines, a glossary, specific artists or media. The writing of art history has been, and always will be, an ongoing process in which many individuals offer sometimes competing arguments. For students of American art, the dis-agreement is often as instructive as any common ground that might be occupied.

I have arranged this book both chronologically and thematically, with an emphasis on developing a critical understanding of how artists, the work they produce, and the critical writings or debates surrounding this work function within specific communities at specific moments in history. Like several earlier surveys of American art, this one includes examples of folk art as well as fine art, of architecture as well as furniture. Unlike many of those surveys, however, I have integrated this material into a single central narrative rather than isolating each medium or category of art into a separate section. I have done this in order to convey the interconnectedness of what have been variously described as fine art, folk art, popular art, and mass culture, and the built environment within which these cultural products circulate. I have also incorporated the work of Native American artists throughout the text as evidence of one of the many ongoing encounters between cultural traditions that have marked the history of this country. Other previously marginalized groups—women, African Americans, Latinos/Latinas, Asian Americans—appear, as well, as active agents in the development of a national culture.

I have also chosen to vary the manner in which I treat the artists included in this text. Some are examined in depth, while others are dealt with briefly as part of a larger movement or historical event. I have done this in an attempt to highlight the different ways in which art historians have approached the study of American art—e.g. through the use of biography, stylistic analysis, the study of patronage and/or the location of artistic production within struggles for political or personal power. I have included many individuals who have been traditionally viewed as major American artists, such as John Singer Sargent and Jackson Pollock; but I have also treated

lesser-known artists, such as the 18th-century needleworker Cynthia Burr, in comparable depth. My intent is not to create a new canon of "great" American artists, but to allow the reader access to the multiplicity of creative processes through which individuals or groups of individuals grapple with ideas and transform them into art forms that speak powerfully to particular groups at particular times. Those individuals who have gained reputations for greatness have done so for a variety of reasons, some having to do with their skills as artists, others with their connections to powerful or influential people or institutions. I hope this book will help students of American art recognize these institutional, as well as personal, factors at work in the creation and promotion of art and artists. The history of art is not simply the inevitable progression of styles and artists towards a predetermined goal in the present, but an accumulation of tensions, crises, accidents, and insights, all embedded in a larger historical process that both forms, and is formed by, the workings and products of artistic activity.

The methodology I have briefly outlined above—the questions I have asked and the places where I have looked for answers—can best be described as a social history of art. In writing this book, I have drawn on, and am greatly indebted to, the work of early practitioners of such a social history. First introduced to a broad public by the German scholar Arnold Hauser in his four-volume *The Social History of Art* (1951), this methodology positions artists and art-making firmly within history. For Hauser, artistic production was an integral part of social relations and was connected to particular social groups. In attempting to trace the connections between specific artistic styles and social groups, Hauser drew on Karl Marx's theory of ideology as the enactment, in the realm of ideas—legal, political, religious, aesthetic, philosophic—of the material conditions of production.

Many art historians have built upon the work of Hauser since the 1960s, often focusing more intensely than he had on the fluidity of the connections between style and social groups, on the social and cultural complexities of artistic production. T. J. Clark, one of the best-known of the second generation of social art historians, wrote in his 1973 book *Image of the People: Gustave Courbet and the 1848 Revolution* that the social history of art needed to cast its net wide, bringing into play "the connecting links between artistic form, the available systems of visual representation, the current theories of art, other ideologies, social classes, and more general historical structures and processes."

The rise of a social history of art was particularly important for historians of American art. In an overview of the field, the art historian Wanda Corn noted that the study of American art began to flourish only in the late 1960s. Prior to this time scholars were primarily "self-trained, motivated by love for the work or curiosity about the development of the field." Many were artists turned historians, freelance writers, or librarians. Support for their work came largely from museums and galleries interested in verifying the provenance of works in their collections. There was little encouragement in graduate schools to work on American topics, in large part because American art was almost always seen as inferior in quality to European art. After World War II, American art appeared as a worthy competitor in the international arena in the form of such Modernist movements as Abstract Expressionism, and many of those who championed this art were interested in earlier work only insofar as it could be interpreted as a precursor to these movements.

The field of American art history was also marked by an emphasis on nationalism. In the years surrounding World War I, concern about "Americanness" resulted in specialized subjects being established in the areas of American history, literature, art, philosophy, etc. This self-conscious examination of the national mind and character led to the formation of American Civilization or American Studies programs in the 1950s and also helped legitimize the serious study of American art in the classroom. In this context, there was no need to apologize for its "quality."

This nationalist emphasis, Corn observed, brought into being most museum collections, wings, and galleries of American art. While these institutions provided the much-needed economic and moral support for scholars, their existence led to the dominance of the documentary monograph in the scholarship of the 1950s and 1960s. Scholars were concerned, above all, with verifying authenticity, tracing ownership or provenance, and fleshing out the biographies of the artists. There was little interest in questions of iconography, patronage (which is different from provenance), and art criticism.

All this began to change when art historians trained in university programs replaced the self-tutored writers of the 1950s and 1960s. Many began engaging with feminist, Marxist, psychoanalytic, and poststructuralist scholarship, as well as the social history of art, often rejecting or supplementing the elite canon that privileged white male artists and "masterpieces." New artists and new media were examined and new attempts made to evaluate the relationship between American and European art. The populist politics of the 1960s and 1970s prompted a renewed interest in the art of the 1930s and a re-examination of the division between "high" and "low" art. Critiques of nationalism led to re-evaluations of such art movements as Abstract Expressionism in light of the Cold War politics of the late 1940s and 1950s.

While I have drawn on sources that exhibit a wide range of methodologies, I have chosen to call my study a "social history of art" because the social history of art, as I have come to understand it, is able to accommodate the many concerns I feel compelled to address. I want to examine how the meaning of a work is a function not only of its content, but also of where it is produced, where it is displayed, the identity of the artist, and how this identity is affected by race, ethnicity, class, gender, and sexuality. I am concerned with the place of art within struggles for power in both the public and private realms, and with rethinking the category "art" itself. The best social history of art combines research on the institutions of art—academies, galleries, museums, journals, community art programs—with attention to the critical discourses surrounding these institutions, in order to achieve an understanding of larger political and aesthetic processes and of the tensions these processes ultimately create as change occurs.

Many practitioners of the social history of art are also concerned, today, with rethinking the processes of conquest and colonization that are such an integral part of American history. While Europeans explored the eastern coastline of North America in the 11th through 15th centuries (e.g. the Vikings, Portuguese cod fishermen), they did not establish permanent settlements until the early 16th century. The land they claimed was inhabited by many different peoples. Some were organized into semi-nomadic chiefdoms, some into sedentary horticultural communities, and others into vast empire states. All had developed complex systems of communication, which drew heavily on images to express their identity, their place in the world, and their political power. The relationships that grew out of these early encounters were complex and are central to an understanding of the history of the United States—political, economic, and artistic. So, too, were those that developed as a result of the importation of vast numbers of slaves from Africa, beginning in the 16th century, in order to facilitate the colonization process.

In his book *Europe and the People Without History*, the anthropologist Eric Wolf argues that "the world of humankind constitutes a manifold, a totality of interconnected processes." Often, however, anthropologists and historians study only fragments of this totality and deny the complexity and interconnectedness and combativeness of human history. Wolf found standard versions of American history particularly problematic in this respect:

the ever-changing boundaries of the United States and the repeated involvement of the polity in internal and external wars, declared and undeclared, are telescoped together

by the teleological understanding that thirteen colonies clinging to the eastern rim of the continent would, in less than a century, plant the American flag on the shores of the Pacific. Yet this final result was itself only the contested outcome of many contradictory relationships.

In other words, the current geographical borders and political organizations that mark this country are the result not of any inevitable historical progression (historicism) but of innumerable struggles, alliances and accidents (historical materialism). The southwestern portion of the United States could have remained part of Mexico; the British could have pressed their interests more aggressively in the northwest and created a border south of the forty-ninth parallel. The United States evolved slowly over time, expanding in territory and, in the process, incorporating areas where artistic practices and cultural traditions were already well established. The Louisiana Purchase of 1803 did not cause the populace of New Orleans immediately to abandon their French ties. Neither did the Treaty of Guadalupe of 1848 erase the Mexican culture that was already firmly in place in what is now the American Southwest. And Native American cultures, while embattled as a result of wars and forced assimilation, did not disappear.

In the following pages I want to trace these ever-changing boundaries, to investigate how the cultural traditions that crossed and re-crossed, or were divided and re-divided by them survived to form a unique mix defined as American culture. In order to do so I will be looking at artistic developments within the United States in part from a continental perspective, i.e. I will be looking at the ways in which the visual culture of this country has been formed not only in relation to cultural practices in Europe, but also in relation to cultural practices that arose within the French and Spanish colonies that flourished along with the British and Dutch colonies on the North American continent beginning with the arrival of the Spaniard Hernán Cortés in central Mexico and the Frenchman Jacques Cartier in the St Lawrence River Valley in the early 16th century. As Caroline Levander and Robert Levine write in the introduction to their 2008 anthology *Hemispheric American Studies*, "moving beyond the nation does not mean abandoning the idea of nation but rather recognizing its dynamic elements and fluid, ever-changing, essentially contingent nature."

Including material previously absent from surveys of American art raises many challenges. Often not only the objects themselves must be analyzed, but also the very processes by which they have been acquired by cultural institutions and come to be considered "art." For example, this country's major

collections of Native American art were put together between 1860 and 1930 by such institutions as the Peabody Museum at Harvard, the American Museum of Natural History in New York, and the Smithsonian Institution in Washington, D.C. As a result of this collecting frenzy, more Northwest Coast Native American material ended up in the city of Washington than in the state of Washington, and the pottery-making traditions of Zuñi and Acoma pueblos were seriously destabilized. In her introduction to *The Early Years of Native American Art History*, Janet Berlo notes that

> for the past one hundred years these bits and pieces, facts and objects, have been arranged and rearranged in a changing mosaic in which we have constructed an image we claim represents Native American art and culture. We now realize that this image tells us at least as much about the collectors as it does about the materials collected.

Any discussion of Native American art created or collected in the late 19th and early 20th centuries must thus acknowledge the historical moment in which it was made and that in which it was collected.

In writing this book, therefore, I am joining many other scholars in calling for a broadening of our understanding of the complex combination of traditions that make up this country's culture. Students in the 21st century need to be able to think both locally and globally, to understand both the separateness and the interconnectedness of nations throughout the world. As a Canadian living in the southwestern portion of the United States, close to the Mexican border, I have experienced the benefits of grappling with these multiple relationships. In *Framing America* I attempt to present a paradigm or framework—hence, the title of this book—for thinking in this broader, more complex and comparative manner. Such a comparative analysis can help provide students in the United States (and beyond) with a sense of this country's shared histories, with an understanding of common patterns of creative expression and cultural consumption, of exploitation and struggles for independence, of divisions and alliances.

At this point I need to say a word about the term "America." Since the 1970s many scholars and activists have taken issue with its use to describe only the United States of America. Some argue we need to speak of "the Americas," others that we need to refer to the country only as "the United States of America" or some other term or phrase that does not double for the continent or hemisphere as a whole. It is helpful to remember that the meaning of "America" has changed over time. In 1507 the German cartographer Martin Waldseemüller published the first map with the name "America" for the New World, after the Italian navigator Amerigo Vespucci. In 1776 rebellious colonists took on the name to describe their own particular part of the continent, the United States of America. Yet even there, "American" was at first used primarily to refer to indigenous peoples; only after 1815 was it adopted as a general term for more recent European arrivals. The anthropologist George Kubler points out that in the late 18th century the term was also "a name of opprobrium in Europe for returning colonials." The Spanish referred to their colonies in America as *las Indias* and the colonists as *indianos*.

For better or for worse, however, "America" has come to be associated today with the United States of America (Canadians traveling abroad are quick to point out that they are Canadians, not Americans). By using the term within a discussion of the political, cultural, and economic processes involved in the production of the art of the United States of America, I hope to indicate the contingency of both the name and that which it describes—that the United States of America was, and is, not a stable entity, and that while the geographical boundaries may not change in the near future, the cultural mix will certainly continue to evolve. As early as 1990, *Time* magazine's culture critic William A. Henry III predicted that by 2056 most Americans will trace their descendants to "Africa, Asia, the Hispanic world, the Pacific Islands, Arabia—almost anywhere but white Europe." We do not have to wait until 2056 to grapple with the implications of this development and to find ways to ensure that the history of American art acknowledges the multiplicity of cultures that constitute this country's creative legacy.

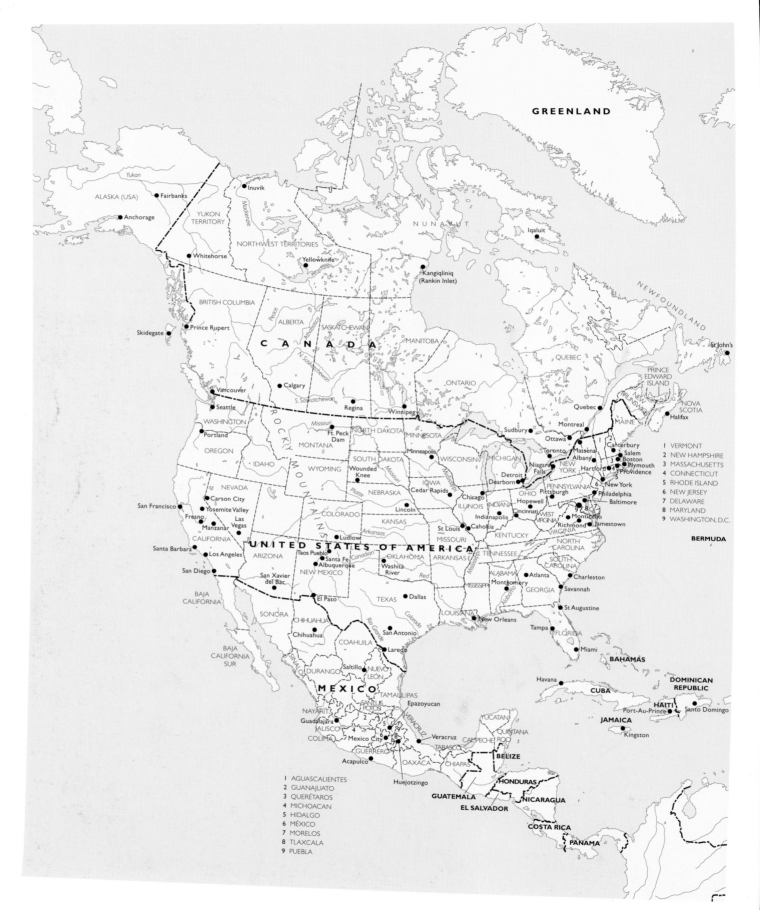

GREENLAND

ALASKA (USA)
Fairbanks
Anchorage
Inuvik

YUKON TERRITORY
Yukon
Mackenzie
Whitehorse

NORTHWEST TERRITORIES
Yellowknife

NUNAVUT
Iqaluit

Kangiqliniq
(Rankin Inlet)

BRITISH COLUMBIA
Peace
Athabasca
Skidegate
Prince Rupert

NEWFOUNDLAND

C A N A D A

ALBERTA
SASKATCHEWAN
MANITOBA
N. Saskatchewan
S. Saskatchewan

ONTARIO
QUEBEC
St John's

PRINCE EDWARD ISLAND
NOVA SCOTIA
Halifax

Calgary
Regina
Winnipeg
Sudbury
Quebec
Montreal
MAINE

Vancouver
Seattle
WASHINGTON
Portland
OREGON

Ft. Peck Dam
Missouri
MONTANA
NORTH DAKOTA
MINNESOTA
WISCONSIN
MICHIGAN
Ottawa
Toronto
Massena
Albany
Canterbury
Salem
Boston
Plymouth
Providence

Niagara Falls
NEW YORK
Hartford

IDAHO
WYOMING
SOUTH DAKOTA
Minneapolis
Cedar Rapids
Chicago
Detroit
Dearborn
OHIO
Pittsburgh
Philadelphia
Baltimore

1 VERMONT
2 NEW HAMPSHIRE
3 MASSACHUSETTS
4 CONNECTICUT
5 RHODE ISLAND
6 NEW JERSEY
7 DELAWARE
8 MARYLAND
9 WASHINGTON, D.C.

ROCKY MOUNTAINS

NEVADA
Carson City
Yosemite Valley
San Francisco
Fresno
Manzanar
Las Vegas
CALIFORNIA

Platte
NEBRASKA
IOWA
Lincoln
Mississippi
ILLINOIS
INDIANA
Indianapolis
Cincinnati
Cahokia
St Louis
KENTUCKY
Hopewell
WEST VIRGINIA
Monticello
Richmond
Jamestown

COLORADO
KANSAS
MISSOURI
Arkansas

NORTH CAROLINA
BERMUDA

Santa Barbara
Los Angeles
San Diego
ARIZONA
Ludlow
Taos Pueblo
Santa Fe
Albuquerque
San Xavier del Bac
NEW MEXICO
Washita River
Canadian
Red
OKLAHOMA
ARKANSAS
TENNESSEE
Atlanta
GEORGIA
Charleston
Savannah

UNITED STATES OF AMERICA
MONTGOMERY
ALABAMA
MISSISSIPPI

SOUTH CAROLINA

BAJA CALIFORNIA
El Paso
TEXAS
Dallas
Colorado
Rio Grande
San Antonio
Laredo
LOUISIANA
New Orleans
St Augustine
Tampa
FLORIDA
Miami

SONORA
CHIHUAHUA
Chihuahua
COAHUILA
Saltillo
NUEVO LEÓN

BAHAMAS
Havana
CUBA
DOMINICAN REPUBLIC

BAJA CALIFORNIA SUR

SINALOA
DURANGO
TAMAULIPAS
Epazoyucan
YUCATÁN
QUINTANA ROO
CAMPECHE
HAITI
Port-Au-Prince
Santo Domingo
JAMAICA
Kingston

M E X I C O
NAYARIT
SAN LUIS POTOSÍ
Guadalajara
JALISCO
COLIMA
Mexico City
GUERRERO
Acapulco
VERACRUZ
Veracruz
TABASCO
OAXACA
CHIAPAS
BELIZE
HONDURAS
GUATEMALA
EL SALVADOR
NICARAGUA
COSTA RICA
PANAMA

Huejotzingo

1 AGUASCALIENTES
2 GUANAJUATO
3 QUERÉTAROS
4 MICHOACAN
5 HIDALGO
6 MÉXICO
7 MORELOS
8 TLAXCALA
9 PUEBLA

Art and Conquest

1.1 Attributed to Frère Luc (Claude François): *France Bringing the Faith
to the Indians of New France, c.* 1675 (see p. 50)
Oil on canvas, 86 × 86 in. (218.4 × 218.4 cm.)
Musée des Ursulines, Quebec

Timeline 900–1790

900–1150 Anasazi culture flourishes in Chaco Canyon [1.16]

1050–1250 Height of Mississippian settlement of Cahokia

c. 1345 Founding of Aztec capital of Tenochtitlan [1.6]

1492 Christopher Columbus makes first of four voyages

1507 Cartographer Martin Waldseemüller publishes the first map with the name "America" for the New World

1519–21 Hernán Cortés arrives on east coast of Mexico; defeats Aztec Empire (1521)

1534–35 Jacques Cartier explores Gulf of St Lawrence for France [1.42]

1535 First Spanish viceroy arrives in Mexico City

1539 Hernan de Soto explores Florida, South Carolina, Tennessee and eastern Oklahoma

1540 Francisco Vásquez de Coronado explores the Rio Grande region

1541 Cartier establishes the first French colony near Quebec City

c. 1550 Formation of the League of the Iroquois

1565 Spanish massacre inhabitants of the French Protestant settlement of Fort Caroline, Florida (founded 1564), establish St Augustine [1.13]

1585 John White accompanies the first short-lived British colony at Roanoke, off the coast of North Carolina, executes watercolors of Algonquian peoples [1.59]

1588 British fleet defeats the Spanish Armada off the coast of Calais

1590 Publication of *A Briefe and True Report* by Theodore de Bry

Puebloan Culture *c.* 700–1600

Mississippian Culture *c.* 800–1600

New Spain 1521–1821

New France 1541–1763

Virginia/New England . . .

1.16 (see p. 29)

1.6 (see p. 21)

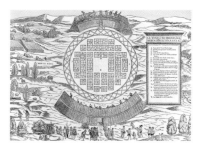

1.42 (see p. 47)

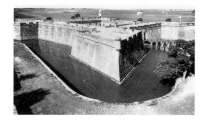

1.13 (see p. 28)

1.59 (see p. 60)

New Spain 1521–1821 ▼
New France 1541–1763 ▼
Virginia/New England 1585–1783 ▼

1598 Establishment of the first Spanish settlement in the northern territory at San Juan Pueblo

1607 John Smith establishes the first successful British colony, Jamestown (Virginia)

1608 Samuel de Champlain founds Quebec, New France [1.44]

1.44 (see p. 48)

1614 Dutch establish colony at Fort Nassau (Albany, New York)

1620 Pilgrims found New Plymouth (Massachusetts)

1620s Arrival of Jesuits in New France [1.45]

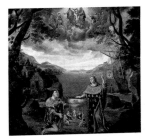

1.45 (see p. 50)

1637 Pequot Massacre

1639 Arrival of Ursulines in New France

1642–49 Civil War in England

1680 Revolt of Pueblo peoples against the Spanish

1681 William Penn founds the colony of Pennsylvania

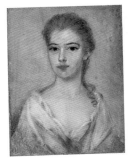

1.80 (see p. 72)

1682 Robert Cavelier, Sieur de La Salle, explores the length of the Mississippi, claiming the entire river basin for France

1708 Henrietta Deering Johnston arrives in South Carolina [1.80]

1710s Ursuline nuns begin producing embroidered birch-bark boxes

1744–48 King George's War between France and Britain

1759–60 British win Battle of Plains of Abraham, ending French and Indian War (begun 1754) [1.84]

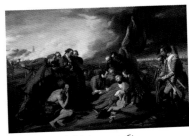

1.84 (see p. 76)

1763 Treaty of Paris cedes French colonies in Canada to Britain

1769–1823 21 missions founded along coast of California [1.39]

1790 Unearthing of statue of Coatlicue in Mexico City

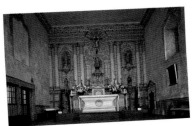

1.39 (see p. 45)

1.2 Overview of Native peoples in the area of the future United States and adjacent parts of Canada and Mexico, c. 1500. Within regions, peoples are listed roughly from north to south ("E" and "W" denote eastern and western parts of a region); those living in areas that span two or more regions are noted in one only.

NORTH · NORTHWEST COAST · Arctic · Sub-arctic · Intermontaine · Northeast · WEST · Great Basin · Plains · EAST · Southeast · California · SOUTHWEST

NORTH
Arctic
Bear Lake
Netsilik Inuit (E)
Arctic Quebec Inuit
Sub-arctic
Tutchone
Kaska
Tahltan
Dogrib
Yellowknife
Slavey
Chipewyan
Naskapi (Innu) (E)
Montagnais (E)
Beothuk (E)
Beaver
Carrier
Sekani
Sarsi
Siksika (Blackfoot)
Chilcotin
Cree
Kaigani
Shuswap
Ojibwa (Chippewa) (E)

NORTHWEST COAST
Tlingit
Gitskan
Tsimshian
Heiltsuk
Haida
Nuxalk
Oowekeeno
Bella Bella
Kwakwaka'wakw
Nuu-chah-nulth
Salish

Makah Puyallup
Nisqually
Chehalis
Chinook
Cowlitz
Tillamook
Klikitat
Molala
Kalapuya
Umpqua
Coos
Takelma

WEST
California
Karok
Yurok
Wiyot
Shasta
Hupa
Maidu
Yana
Mattole
Yuki
Pomo
Wintun
Miwok
Kawaiisu
Costanoan
Mono
S. Paiute
Yokuts
Panamint
Salinan
Chemehuevi
Chumash
Mohave
Serrano
Yavapai

Yuma
Cahuilla
Cochimi
Waicuri
Pericu
Intermontaine
Kutenai
Kalispel
Thompson
Coeur d'Alene
Okanagan
Sanpoil
Colville
Spokane
Yakima
Flathead
Palouse
Nez Perce
Cayuse
Walla Walla
Klamath
Modoc
Chomawi
Tsugewi
Great Basin
Bannock
Shoshone
Washoe
N. Paiute
Gosiute
Ute
Plains
Piegan
Plains Cree
Assiniboin
Atsina
Hidatsa
Mandan
Teton Lakota

Arikara
Crow
Santee Sioux
Yankton Sioux
Ponca
N. Cheyenne
Iowa
Pawnee
Omaha
Oto
Arapaho
Kansa
S. Cheyenne
Osage
Jicarilla Apache

Quapaw
Kiowa
Kiowa Apache
Mescalero Apache
Tawakoni
Wichita
Comanche
Kichai
Waco
Tonkawa

SOUTHWEST
Pueblo
Navaho
Hopi
Zuñi
Kavasupai
Walapai
Pima
Maricopa
Papago
W. Apache
Lipan Apache
Opata
Seri
Concho
Karankawa
Tarahumara
Cahita
Coahuiltec

Yaqui
Acaxee
Tamaulipec
Huichol
Huastec
Totonac

[CENTRAL/SOUTH MEXICO]
Yucatan Maya (E)
Toltec
Tarascan
Otomi
Tlaxcalan
Aztec
Mixtec
Lacandon Maya
Zapotec

EAST
Northeast
Mi'kmaq
Malecite
Passamaquoddy
Abnaki
Penobscot
Pennacook
Mohawk
Ottawa (W)
Huron

Tobacco (W)
Menomini (W)
Oneida
Massachusett
Mahican
Wampanoag
Narragansett
Winnebago (W)
Potawatomie (W)
Sauk (W)
Fox (W)
Neutral (W)
Nipmuc
Pequot
Mohegan
Wappinger
Onondaga
Cayuga
Seneca
Erie
Susquehanna
Delaware
Nanticoke
Powhatan
Pamunkey
Missouri (W)
Wea (W)
Peoria (W)
Illinois (W)
Piankashaw (W)

Shawnee (W)
Southeast
Cherokee
Yuchi
Chickahominy
Mattapony
Tutelo
Pamlico
Nottoway
Tuscarora
Catawba
Tuskegee (W)
Choctaw (W)
Creek (W)
Yamasee
Guale
Alabama (W)
Chickasaw (W)
Timucuan
Hichiti
Caddo (W)
Natchez (W)
Apalachee (W)
Mobile (W)
Biloxi (W)
Tunica (W)
Chitimacha (W)
Alakapa (W)
Seminole
Calusa

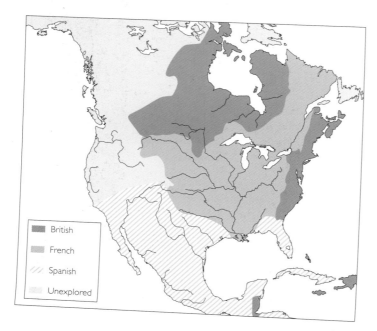

British
French
Spanish
Unexplored

1.3 Colonial North America, c. 1750

A full understanding of the history of the art of the United States of America requires going back in time to the country's origins as one of a series of colonial enterprises undertaken by European powers beginning in the 16th century [1.3]. Those who arrived on the continent of North America encountered many different peoples [1.2], whose languages and customs were unfamiliar and whose architecture, paintings, carvings, textiles, and other decorated objects often prompted awe, if not admiration. While the architecture and art forms produced by the new settlers relied heavily on European prototypes, many also bear evidence of an engagement with local building and artistic practices.

The first to establish a permanent foothold on the North American continent were the Spanish. By the early 1520s Spain had conquered much of what is now central Mexico and had begun both exploiting the natural resources of the region and attempting to convert its peoples to Christianity. The Spanish did not, however, limit their colonizing and missionary ventures to this southernmost region of the North American continent. Instead, they explored almost every part of what is now the southern United States and traveled the full length of the Pacific coast, leaving their imprint in various ways. By 1700 they had established mission churches in the current states of New Mexico, Arizona, California, Texas, and Florida, which marked the northern boundaries of colonial New Spain.

As the Spanish were expanding northward at the end of the 16th century, they were also engaging in a different kind of struggle a continent and an ocean away, one whose outcome would have considerable impact on the nationalities of the colonizers who arrived in the coming century. In 1588, off the coast of Calais, the English fleet defeated the Spanish Armada, sent by Philip II to invade England. This marked the end of Spanish ascendancy and allowed the British, French, and Dutch to step up their efforts to gain a foothold in North America.

Images as well as guns were enlisted in the scramble for control of the Americas. For example, in 1590, two years after the defeat of the Armada, the Franco-Flemish Protestant engraver Theodore de Bry (1528–98) published *A briefe and true report of the new found land of Virginia* [1.4, 1.62], the first of a thirty-volume series of illustrated accounts of European exploration throughout the world. Known collectively as the *Great Voyages* (the Americas, Oceania) and the *Small Voyages* (India, Japan, China, Africa), these were the first widely available illustrated narratives of cross-Atlantic travel (the first volume was published in Latin, German, English, and French; the rest appeared only in German and Latin). While other accounts had been circulated in the first half of the 16th century, they reached a very limited audience. Even fewer people had the opportunity

to see the inhabitants and art works brought back to Europe by Christopher Columbus and other early 16th-century explorers.

De Bry's texts, therefore, were extremely influential in establishing widespread notions of what people in the Americas were like, and the circumstances under which they came into contact with Europeans. Such images and their accompanying texts were not, however, without certain biases. The earlier accounts of voyages of exploration undertaken by the British, Dutch, and French upon which de Bry relied were written by European men concerned not only with understanding what they saw, but also with ensuring that there was enough interest in this New World to fund further voyages. The inhabitants were variously presented as exotic, innocent, savage, mysterious, and almost always less "civilized," indeed "heathen." In addition, de Bry consistently presented the Catholic Spanish, in word and image, as more violent and less "civilized" than their Protestant counterparts; he often heavily edited accounts of their conquest to foreground this violence. In her study of de Bry's texts, Bernadette Bucher notes that they were "completely bound up

1.4 Frontispiece to Theodore de Bry, *A briefe and true report of the new found land of Virginia*, Frankfurt, 1590

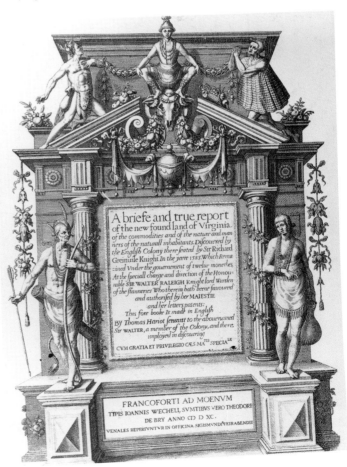

with the emotional, financial, and political interests of the parties engaged in the struggle with the Spanish in America."

The stereotypes of the indigenous peoples of the newly conquered territories found in the work of de Bry persisted in the colonial images produced in New France and New England. Yet an alternative view of both indigenous peoples and Europeans existed as well, one created by the former, who represented themselves, their spiritual world, and Europeans in painted hides, beaded belts, and other carefully crafted objects. Such representations often reveal evidence of the conflicts that inevitably ensued as Europeans attempted either to suppress existing artistic, social, and spiritual traditions or to incorporate them into Christian ones. The study of the art and architecture of the early period of colonization in North America thus provides an opportunity to explore not only how ideas about the New World were constructed and made visible, but also how physical struggles for survival or dominance manifested themselves in the aesthetic realm.

The Spanish and the Aztecs

Shortly after Hernán Cortés landed on the eastern coast of the Aztec empire in 1519 at a site he named Veracruz (the true cross), he advanced inland with an army of approximately five hundred men and twenty horses. At the head of his troops he displayed a

1.5 Anonymous: banner of Cortés, 16th century
National History Museum, Chapultepec Castle, Mexico City

banner bearing the image of the Virgin Mary within a crest and surrounded by the words "This is that which brought Don Fernando Cortes to the conquest of Mexico" [1.5]. Also present was a flag of white and blue flames with a cross in the middle and the Latin motto: "Friends, let us follow the cross and with faith in this symbol we shall conquer." This banner and flag proclaimed the religious justification for the conquest of this new territory in the name of the Spanish monarchs, calling to mind, as well, the recent Spanish expulsion of Muslim forces from the Iberian peninsula. Thus, from the very beginning, images played an important role in the conquest of the Americas. They conveyed not only specific objects or individuals, but also a way of viewing the world.

Cortés was not the first European to set foot in what soon came to be known as the Americas. His most notable predecessor, Christopher Columbus, arrived in the Caribbean in 1492 on the first of four trips between Spain and the Americas, Columbus and his men also saw their exploits as both religious and economic. As they explored various islands, they struggled to describe their impressions of the unfamiliar territory and peoples, filling their notebooks with evaluations of both the wealth and beauty of the land and its inhabitants. Like those who came after them, they tried to fit the objects, peoples, and natural phenomena they encountered into the conceptual framework of late medieval Europe, fabricating an image of this "new world" that would convince the Spanish crown to fund a second journey. Having set out in search of a route to the Far East, Columbus thought he had arrived at the outlying islands of east Asia, in particular Cipango, or Japan. He described the "handsome bodies and faces" of the men who swam out to meet his ships, the clean and well-ordered houses, and wooden statues of female figures. Of these statues he commented: "I do not know whether they regard these as beautiful or for worship." He also described the landscape as a paradise or natural garden and the climate "like Valencia in April," and, believing he was in the Indies, called the inhabitants "Indians" (*Indios*).

Tenochtitlan: Pyramids, Codices, and Monumental Sculpture

Cortés encountered a much more formidable Native presence than had Columbus—the massive Aztec empire under the leadership of Motecuhzoma II or Montezuma, the *tlatoani* or "speaker." The Aztec capital of Tenochtitlan, founded *c.* 1345, was the center of an empire that, by the end of the 15th century, stretched from the central valley to both coasts. When the Spanish arrived, Tenochtitlan was the size of contemporary London (approximately 150,000–200,000 people). It spread over 2,500 acres (just over 1,000 hectares) and was divided into four sections by two causeways. Its main plaza [1.6], surrounded

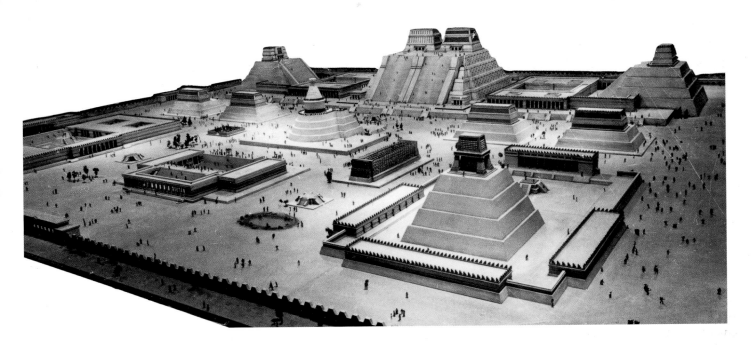

1.6 Reconstruction of the main plaza, Tenochtitlan, Mexico, c. 1500
National Museum of Anthropology, Mexico City

by an enclosing wall, measured 525 x 590 feet (160 x 180 meters) and included 70 to 80 palaces and temples. On the east was the palace compound of Motecuhzoma II, which contained administrative and residential buildings. Also on the east side, perched atop a truncated pyramid platform 200 feet (60 meters) high, were the twin shrines to the warrior god Huitzilopochtli and the rain god Tlaloc. During the rainy season the sun rose behind the blue shrine of Tlaloc; during the dry season, behind the red shrine of Huitzilopochtli. On the two annual equinoxes, it rose between the two and shone on the round temple of Quetzalcóatl, the feathered serpent, in front of the pyramid platform. In form, the twin shrines and their platform echoed the volcanoes surrounding the central valley in which Tenochtitlan was located, in particular Popocateptl (Smoking Mountain) and Itzaccihuatl (White Woman). Lesser temples to the honored gods of subject peoples were also included in the main plaza, as well as a ceremonial ball court. The interiors of the shrines atop the pyramid platforms, which held the statues of the various deities, were modest in size, as the main function of religious architecture was to define an exterior space, a setting for the massive public rituals that characterized Aztec society. The palaces of Motecuhzoma, on the other hand, were described by Cortés as "befitting so great a ruler," with gardens, pools, balconies, patios and "rooms nine feet high and as large as six paces square." The residences of the priests were also "very elegant . . . with very large rooms."

The Spaniards were greatly impressed by the architecture and organization of the city. Bernal Díaz del Castillo, who accompanied Cortés, later wrote: "There were among us soldiers who had been to many parts of the world, to Constantinople, to the whole of Italy and to Rome, and they said they had never seen a market so well organized and orderly, so large, so full of people." Cortés himself wrote that Tenochtitlan "was indeed the most beautiful thing in the world." The historian Stuart B. Schwartz notes that the plan of Tenochtitlan, with its four causeways and its neighborhoods organized in pairs of twenty communal corporate groups and temple-maintenance groups, represented not only the engineering ingenuity of the Aztecs, but also "the Mexica social and religious universe" (the Mexica, after whom Mexico was named, were the dominant group within the Aztec empire). The causeways embodied the four cardinal directions, the neighborhoods the twenty-day cycle of the ritual calendar. After the conquest, the city was razed to make way for the new colonial center of Mexico City.

The Spanish also found a well-developed system of pictographic writing on low-relief and three-dimensional sculpture, murals, and codices—folding paintings usually made of bark paper or deerskin covered with a thin coat of calcium carbonate, such as the *Codex Borgia* [1.7]. The codices recorded genealogies, tribute systems, prophecies, divinations, calendars, religious rites, lists of merchandise, and conquests. The individual pictographs, or glyphs, are composed of a major figure, recognizable as human or animal or a combination of both, and abstract forms, such as dots and bars. The figures are two-dimensional and float in an undefined space, with broad areas of unmodulated colors defining clothing and architectural details. The majority of the preconquest codices were burned by the Spanish immediately after the defeat of the Aztecs. A small number, fewer than twenty,

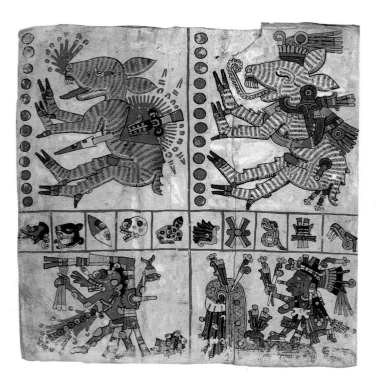

1.7 Anonymous: a leaf from the *Codex Borgia*, pre-16th century
Biblioteca Apostolica Vaticana, Rome

survived as gifts or curiosities sent back to Europe (the *Codex Borgia* [1.7] is now in the Vatican).

The painters of the codices were known as *tlacuilos*, a Nahuatl term that meant both painter and scribe (Nahuatl was the language spoken by the Aztecs). *Tlacuilos* probably came from priestly or noble castes and were trained in special schools. They were powerful people in that they recorded and interpreted myths, rites, and genealogies. They possessed the ability not only to create the painted legends, but also to decipher the meaning of codices through an interpretation of page layout, the scale of the symbols and their groupings, and chromatic variations. The concern was to record not the surface appearance of things or persons existing in a particular place and time, but the essence of a place, person, or object, or, in the words of the historian Serge Gruzinski, to "render certain aspects of the divine world physically present and palpable." The codices produced after the conquest were annotated in Spanish in order to aid the European reader and quickly began to incorporate European artistic conventions, such as three-dimensional rendering.

The Aztecs and those who occupied territories controlled by them produced objects of finely worked gold, silver, jade, feathers, and stone. Peter Martyr of Anghiera, an Italian humanist scholar and teacher at the Spanish court who had been appointed to the Council of the Indies, wrote in 1520 of the gifts sent by Motecuhzoma II to Charles V: "though I little admire gold and precious stones, I am amazed by the skill and effort making the work exceed the material I do not recall ever seeing anything so appealing by its beauty to human eyes." The German artist Albrecht Dürer saw the same objects in Brussels later that year, writing:

> Also I saw the things which were brought to the King from the New Golden Land: a sun entirely of gold, a whole fathom [*c.* 6 feet, or 1.8 meters] broad; likewise, a moon, entirely of silver, just as big I have never seen in all my days that which so rejoiced my heart, as these things. For I saw among them amazing artistic objects, and I marveled over the subtle ingenuity of the men in these distant lands.

Dürer and other Europeans would see few such objects, however, for most were melted down and recast into the coinage and art objects of European nations.

The Aztec pantheon of gods was occupied by a wide array of figures who assumed both animal and human guises. One of the most powerful was Coatlicue. A statue of Coatlicue [1.8], carved out of a massive basalt stone over 8 feet high, was discovered in 1790 during a municipal excavation in the main plaza of Mexico City, which was situated on top of the old Aztec ceremonial center. It appears to have resided either on or near the twin temple pyramid, for Coatlicue was the mother of Huitzilopochtli in Aztec myth. The art historian Mary Ellen Miller summarizes the story of Huitzilopochtli's birth as follows:

> According to legend, Coatlicue kept a temple shrine on a hill near Tula called Coatepec, or "hill of snakes." After tucking a ball of down feathers in her bosom, she became pregnant with Huitzilopochtli. Repelled by her condition, her children, especially her daughter Coyolxauhqui, plotted her death. When Coatlicue's enemies attacked her and sliced off her head, Huitzilopochtli rose from her severed trunk fully grown and armed. He banished the attackers and mutilated his evil sister, severing her extremities, so that she collapsed at the base of the shrine.

This myth was alluded to in the exterior decoration of the twin pyramid, whose base was lined with serpents (serpent is an ideogram for Coatlicue); a large flat round stone with a carving of Coyolxauhqui, limbs severed, was discovered in the late 20th century at the foot of the pyramid.

The statue of Coatlicue is carved in low relief on all sides—there is even a carving of what has been described as an "earth

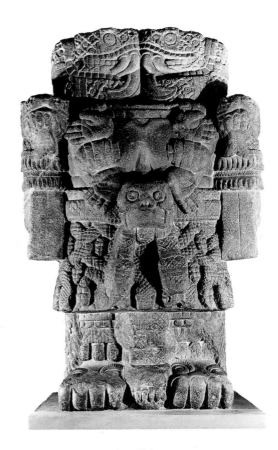

1.8 Anonymous, Aztec: *Coatlicue*, late 15th century
Basalt, H 8 ft. 3¼ in. (2.5 m.)
National Museum of Anthropology, Mexico City

past. The Mexican writer Octavio Paz provides a brief account of Coatlicue's travels. After her discovery in 1790, the goddess was placed among the plaster copies of Greco-Roman statues at the Royal and Pontifical University of Mexico. Meant to represent, in the words of Viceroy Revillagigedo, a "monument of America's ancient past," she proved too disturbing to the professors at the university, who had her reburied in the place where she had been discovered, lest she revive old beliefs. She was also seen as an affront to the very ideal of beauty embodied in the works of the ancient Greeks and Romans.

In 1804, the German naturalist Baron Alexander von Humboldt, on a visit to Mexico City, read of her discovery and requested that she be dug up again. Once his curiosity was satisfied she was reburied, and only permanently unearthed after Mexico won its independence from Spain in 1821. From a corner of a courtyard at the university, she was moved to a hallway behind a screen and then to a more visible place to be studied as an object of historical and scientific interest; finally, she was placed in the National Museum of Anthropology.

Paz tracks the statue's transformation "from goddess into demon, from demon into monster, and from monster into masterpiece," its move from the supernatural to the aesthetic and from the temple to the museum. He suggests that the unearthing of Coatlicue, and perhaps the encounters of modern museum-goers with the statue as well, are repetitions "on a reduced scale, of what the European mind must have experienced when confronted with the discovery of America." Instead of the polished marble and ideal human proportions of a Greek Aphrodite or the modest demeanor of a Virgin Mary there was the massive, aggressive, part-animal goddess of life and death. What Europeans faced was "not another reality but rather the other aspect, the other dimension of reality By contrast to the cases of Persia, Egypt, or Babylonia, American civilizations were not older than that of Europe, they were different. And that difference was radical: it constituted a real 'otherness'."

The historian James Loewen also notes that the encounters with the Native peoples of the Americas created within Europe an increasing self-consciousness:

> In a sense, there was no "Europe" before 1492. People were simply Tuscan, French, and the like. Now Europeans began to see similarities among themselves, at least as contrasted with Native Americans. For that matter, there were no "white" people in Europe before 1492. With the transatlantic slave trade, first Indian, then African, Europeans increasingly saw "white" as a race and race as an important human characteristic.

monster" on its underside. Coatlicue, in addition to being the mother of Huitzilopochtli and of the moon and southern stars, was the goddess of earth and death. Her skirt is made up of intertwined serpents, with a human skull at the waistline; two profile serpent heads create her face. Some have suggested, in keeping with the legend of Huitzilopochtli's birth, that she has been decapitated and the serpents represent blood. Further serpent heads occupy her shoulders and feet, suggesting her limbs have been severed as well; one descends between her legs, perhaps a reference to menstrual blood, and thus birth/life. Finally, Coatlicue wears a necklace of amputated hands and hearts. She was thus a symbol of everything the Spanish would find both fascinating and abhorrent in the New World, an embodiment of the power of the natural world, of the female as creator and destroyer. She was certainly a far cry from the Virgin Mary depicted on Cortés's banner [1.5].

The history of the statue of Coatlicue from its unearthing to its present position of honor in Mexico City's National Museum of Anthropology reveals the complexity of attempts by the Spanish colonizers and their *mestizo* descendants (those of mixed racial background) to come to terms with the indigenous

Paz finds the key to the European conquest of the two American continents in their isolation and lack of substantial contact with significantly different peoples:

> Neither of the two civilizations of America [Incan and Aztec] had an experience that was common and constant among the societies of the Old World, that is, the presence of the *other*, the intrusion of foreign civilizations and peoples. That is why the indigenous peoples of America saw the Spaniards as beings come from another world, as gods or semigods.

The notion that Cortés was the reincarnation of an Aztec deity, in particular Quetzalcoatl, who had been banished from the earlier kingdom of the Toltecs and was predicted to return from the east, appears to have materialized after the conquest. Nahua informants may have created this story in order to explain Motecuhzoma II's vacillation in his dealings with the Spanish. This vacillation initially prevented the Aztec leaders from understanding the motives and tactics of the newcomers.

The anthropologist Tzvetan Todorov adds three other factors that help explain how such a massively outnumbered group of Spaniards was able, by 1521, to defeat the powerful Aztec empire. First, Cortés allied with the Tlaxcalans and with several indigenous groups who had been subdued by the Aztecs, thus building up an army of sufficient size to overcome Motecuhzoma II's successor Cuauhtémoc (Motecuhzoma died in 1520). Once victory was achieved, the Tlaxcalans were rewarded with many of the administrative positions in the new empire (much of the Aztec system of vassalage and taxes was maintained). Second, the Spanish possessed superior weapons: their horses, crossbows, steel swords, and guns, though few in number, initially spread fear among the Aztec armies. Third, the Spanish were able to gather information about the Aztecs through an Aztec woman, whom they called "Doña Marina," who had been sold into slavery to the Maya and ended up with the Spanish as an interpreter (she was later referred to as "La Malinche"). It was she who translated the conversations between Cortés and Motecuhzoma.

Churches, Statues, and Altarpieces

One of the first tasks of the conquerors was to raze the city of Tenochtitlan, destroy the religious images and architecture, and put in their place the symbols and structures of Christianity and the colonial capital of New Spain. A new cathedral was begun close by the site of the twin pyramid, and the palace of the Spanish governors replaced the palace of Motecuhzoma II (the first viceroy, appointed in 1530, arrived in 1535). Objects of gold were melted down. While most of the codices were burned, the priests and friars who arrived after the conquest to convert the indigenous peoples to Christianity recorded their lives and customs in detail and encouraged local painters to produce similar pictographic texts, so that their traditional beliefs could be understood more clearly and thus countered more effectively. We can only wonder how accurate these chronicles are in depicting precolonial life. What they certainly do provide is a description of the process of colonization and its effects on both colonizer and colonized, as can be seen in the *Florentine Codex* [1.9] and *Telleriano-Remensis Codex* (c. 1562–63).

The first century of occupation had a devastating impact on the peoples of the Aztec Empire. Those who survived disease, massacre, or overwork in the mines and fields (the population decreased from approximately 25 million at the time of conquest to less than 1 million by the middle of the 17th century) were incorporated into Spanish society as administrators, manual laborers, merchants, and artisans. Some were able to adapt relatively easily, in part because many of the new political, aesthetic, and commercial structures were similar to those of the Aztecs. Native architects, painters, and carvers constructed and decorated the new religious and secular buildings, while others quickly mastered the languages of Europe, including Latin, and became part of the intelligentsia of New Spain, translating Christian and secular texts into Nahuatl.

The Europeans who took charge of teaching and training Native workers were primarily members of various religious orders who arrived shortly after the Spanish soldiers. The task of converting the peoples of the New World to Christianity had been set by Charles V following the declaration, issued in 1517 after debate at the University of Salamanca, that they were, in fact, rational beings and possessed souls. Four major orders initially assumed this task: the Franciscans, Dominicans, and Augustinians—all mendicant orders who took vows of poverty, renouncing property and relying on begging (mendicancy) and the acceptance of alms to support their missionary endeavors—and the Jesuits. Their monopoly was broken in the 1580s and 1590s, when other orders arrived (e.g. the Benedictines), many of whom focused more on the spiritual needs of the Spanish. While some members of these religious orders participated in the defeat and subjugation of the indigenous inhabitants, others (e.g. Bartolomé de Las Casas) championed their rights against repressive secular governments. In 1810, Father Miguel Hidalgo y Costilla led the first revolution for independence against the Spanish (it failed and he was executed).

For most of the 16th century the church trained artists and supplied commissions. One of the earliest workshops was set up by Fray Pedro de Gante in the Chapel of San José de los

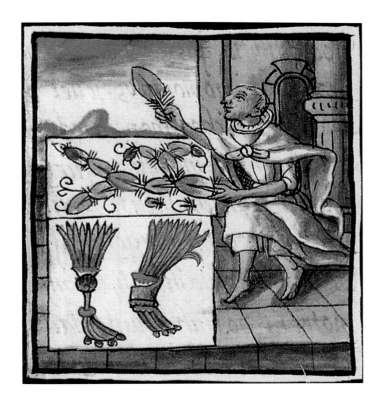

1.9 Anonymous: the art of featherworking, illustrated in the *Florentine Codex*, 1570.
Biblioteca Medicea Laurenziana, Florence

converts in 1570 under the supervision of the Franciscan friar Bernardino de Sahagún, is an excellent example of this new type of imagery. For instance, in one of the scenes of the art of featherworking [1.9], Aztec glyphs, which appear to float in a blank space, coexist with a figure dressed in European clothes, who is firmly grounded in a three-dimensional architectural space achieved through the somewhat awkward use of one-point perspective. The activity depicted—the use of feathers by a Native man in a Christian school to create complex images—itself combined the practices of two cultures. Serge Gruzinski also describes the mixtures of visual traditions that appeared in rural parish churches, which contained "fabrics and chasubles from Rouen, Castile and Holland, chalices and candelabra forged in local silver, crosses, shields and blazons made of tropical bird feathers showing Christ with crucifixion wounds, Michoacán flutes, Italian trumpets, pious images painted on morocco leather."

A sculptural example of *tequitqui* can be found in the stone carving of *La Virgencita del Nuevo Mundo* (*The Virgin of the New World*), created by an unknown Aztec artisan between 1521 and 1540 [1.10]. While much smaller than *Coatlicue* [1.8], it is marked by the same low-relief carving, focus on repetitive, decorative patterns, and bilateral symmetry. Identifiable as the Virgin of

1.10 Anonymous, Aztec: *La Virgencita del Nuevo Mundo* (*The Virgin of the New World*), c. 1521–40.
Cantera stone, 14¾ × 11 × 4½ in.
Private collection

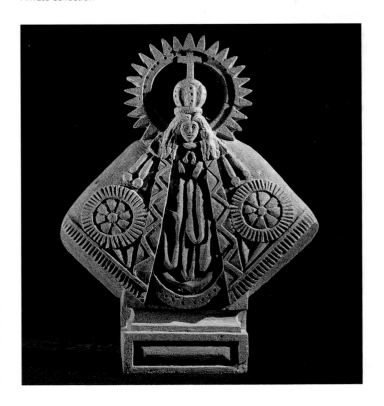

Naturales (St Joseph of the Natives). Many Spanish commented on how quickly Native peoples picked up European tools and skills. Bernal Díaz del Castillo wrote: "According to my judgment, that famous painter of ancient times, the renowned Apelles, or the modern ones named Michelangelo or Berruguete . . . could not with their subtle pencils equal the works which are done by three Mexican artists." Like Europeans, the Native inhabitants of the newly conquered lands recognized the power of images. When the Tlaxcalans attempted to pressure the crown in order to preserve control over their territories, they used images as part of their argument: to guarantee their claim, they produced, between 1550 and 1560, the *Lienzo de Tlaxcala*, a piece of cotton over 23 feet (7 meters) long and 8 feet (2.4 meters) high on which 87 scenes recorded the conquest as a glorious event with the Tlaxcalans as Spain's allies.

The monks distributed countless pious images in the form of illustrated books, prints, paintings, statues, and tapestries that local painters and carvers copied. In the process, these artists assimilated a new iconographic and stylistic repertoire that they combined with earlier artistic forms. This synthetic art produced by Native artists in the service of Christianity was referred to as *tequitqui*, a Nahuatl word meaning "one who pays tribute." The *Florentine Codex*, produced by indigenous

the Immaculate Conception by the crescent moon beneath her feet, she also wears a crown surmounted by a cross, suggesting her role as the Queen of Heaven. According to the historian Linda Hall, the tassels on her cloak that frame her hands may be copied from a European source, or could represent bells, a common motif in indigenous religious images and associated with the female deity Coyolxauqui ("Bells-Her-Face"), sister of Huitzilopochtli. The two large striated circles beneath the bells/tassels, with floral designs inside them, "are characteristic of Tezcatlipoca, the Smoking Mirror, the mysterious Aztec figure associated with the night wind, a trickster who introduced the random and the unexpected into the cosmos"; the feather-like draping of the front of the gown suggests a reference to the Aztec god Quetzalcoatl, or Feathered Serpent.

Quetzalcoatl was paired with Tezcatlipoca in Aztec mythology, functioning as the deity of the dawn, arts, knowledge, and order, in contrast to the darkness and chaos of Tezcatlipoca's realm. The two played major roles in creation myths, at times as collaborators and at times as competitors. In one story, Coatlicue appeared alongside Tezcatlipoca as a key figure in the creation of the fifth Aztec world. The art historian Cecelia Klein summarizes this story as follows: "when the earth was still in darkness, the god Tezcatlipoca created four hundred men and five women 'in order that there be people for the sun to eat.' The four hundred men died four years later, but the five women lived on for another twelve years before dying, according to the text, on 'the day the sun was created.'" Using this story and other colonial documents and pre-colonial sculpture, Klein argues that one of these five women was Coatlicue. She goes on to say that the large statue of this deity found at the base of the main temple of Tenochtitlan in 1790 represented the deity not in her role as the mother of Huitzilopochtli, an interpretation based primarily on a passage from the *Florentine Codex*, but as one of the five women who willingly sacrificed themselves in order to bring about the birth of the fifth sun.

Klein was prompted to question the earlier interpretation of the *Coatlicue* statue in part by the failure of the *Florentine Codex* passage to explain the detail and complexity of her skirt of braided serpents. In accounts of the creation of the fifth world involving Coatlicue, she and her four sisters "left behind only their *mantas*, or large rectangular panels of cloth used to make Mexica skirts, from which they eventually were resurrected." According to Klein, these *mantas* were thought to "contain the essence and powers of their original wearers," an important aspect of Aztec religious beliefs at the time of the conquest. The statue of Coatlicue, or "Snakes-Her-Skirt," therefore, with its elaborate serpent *manta*, represented the resurrection of the deity as creatrix. Similar attention is given to the cloak and

gown of the small stone Virgin; thus, its carver calls up this *manta*/creatrix tradition, and brings together iconographic references to three major Aztec creator deities—Tezcatlipoca, Quetzalcoatl, and Coatlicue.

Another significant aspect of the statue is the Virgin's open mouth, an indication that she is either speaking or singing, something seldom seen in European portrayals of the Virgin. Speaking within Mesoamerican culture was a sign of authority, and powerful leaders were reputed to be eloquent orators. Speaking also implied a connection between the sacred and the human. That the Virgin Mary is shown speaking is quite appropriate, for she played a prominent role in the conquest of New Spain, both for the Spanish and for the indigenous populations. As Hall writes, the Spanish brought the Virgin Mary

> as religious idea, psychological construct, and physical image to their New World The idea and image of the Virgin appealed to indigenous populations as well, especially as a nurturer and a healer. So, in addition to being a comfort and a justification for those engaged in discovery and conquest, Mary became powerful in bringing indigenous peoples, at least in appearance, into the Roman Catholic faith.

At the same time that the Spanish brought the Virgin to the New World, however, they also brought the diseases and disasters that motivated the indigenous populations to appeal to her for relief, creating a certain ambivalence that may well be present in the iconographic complexity of *La Virgencita del Nuevo Mundo*. This small statue can be seen as embodying the tensions between dark and light, chaos and order, found in both the Spanish-dominated present and the Aztec mythological past. With its elaborate *manta*, it also points to the sacrifice—whether of Coatlicue or Christ—needed to bring a new world into being.

The mission churches were the most visible statement of the presence of Christianity in New Spain. By 1536 there were approximately 40 Franciscan monasteries; by 1538, 8 Dominican monasteries; and by 1559, 40 Augustinian monasteries. Some were modest structures; others were built to accommodate massive numbers of converts, often with open chapels or a large courtyard (*atrio*). The historian Elizabeth Wilder Weismann tells of two missionaries at Xochimilco who baptized more than 15,000 people in one day by working in shifts. One monk complained: "It happened many times that they could no longer raise their arms to perform that function, and even though they changed arms, both were worn out."

The Augustinian monastery at Epazoyucan, Hidalgo, north of Mexico City [1.11], has such an outside chapel and courtyard.

Its facade is marked by simple, geometric forms (rectangles, triangle) and classical elements (columns, arches, pediment). The architect may have been familiar with the classical revival sponsored in Spain by Charles V and his successor, Philip II, and have wished to make a statement of allegiance to the king. The reference to a temple front around the entranceway, however, is somewhat idiosyncratic, with the triangular pediment shrunk to less than half its normal size and separated from the columns not only by the suggestion of an architrave and frieze (the two horizontal flat areas outlined by slightly projecting stringcourses or moldings), but also by a rectangular window. The stark simplicity of the building suggests a shortage of funds, although in 1556 the Bishop of New Spain complained that Augustinians were making *retablos* (painted and/or carved altarpieces) that cost more than 6,000 *pesos*.

The elaborate *retablos* in these monasteries were the principal vehicle for the diffusion of style throughout New Spain. One of the earliest recorded examples is by the Flemish painter Simón Pereyns (*c.* 1540–89), whose contract for the *retablo* at Huejotzingo [1.12] is dated 1580. Pereyns arrived in Mexico in 1566 with the Viceroy Gastón de Peralta. One of his first com-

1.11 Church and chapel of the Augustinian monastery, Epazoyucan, Hidalgo, Mexico, 16th century

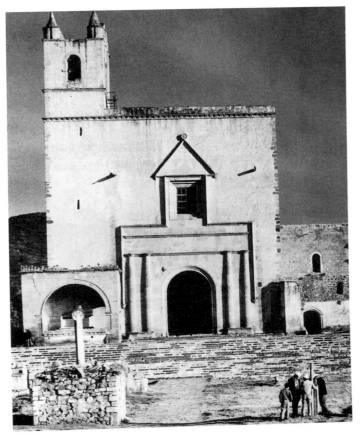

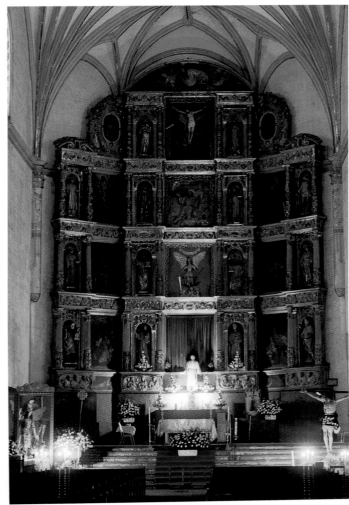

1.12 Simón Pereyns: *retablo*, Franciscan monastery church, Huejotzingo, Puebla, Mexico, 1580

missions was for a series of battle scenes for the viceregal palace. He then gathered around him an army of indigenous woodcarvers, assistant painters, joiners, and gilders and began furnishing *retablos* for the major monasteries. In the process, he introduced a new cadre of artists to the European Renaissance. Some European artists tried to form guilds that would give them exclusive control over major commissions, both civic and religious, but their efforts ultimately failed.

The Northern Territories of New Spain

Once the Spanish had secured control of Tenochtitlan and the surrounding region, they began moving northward. Few had ventured into this territory in the early part of the 16th century. Those who did—Juan Ponce de León (1513, 1521), Alonso de Piñeda (1519), Panfilo de Narváez (1528)—were prompted

primarily by a quest for gold, a quest whose intensity increased after the discovery of the vast treasures of the Aztecs. In 1539, Cortés set sail up the Pacific coast, enticed by stories of towns of great size rich in gold and silver. The following year, 1540, a larger land expedition arrived in the Rio Grande region under the leadership of Francisco Vásquez de Coronado, only to discover that the stories of wealth had been exaggerated and that the villages he encountered in present-day western New Mexico were far from cities of gold. Exploratory parties were sent as far north as the Grand Canyon and east to a Wichita village on the banks of the Arkansas River, but no gold was found.

In addition to these expeditions, a few attempts were made to set up permanent communities. In the summer of 1526, five hundred Spanish with one hundred African slaves led by the lawyer Lucas Vásquez de Ayllón established a short-lived settlement near the mouth of the Pee Dee River in what is now South Carolina. In 1565 a party under the leadership of Pedro Menéndez de Avilés made another attempt to colonize the northern region. Coming upon a settlement of French Protestants that had been established on the east coast of Florida the year before, they massacred the inhabitants and set up their own fort, calling it St Augustine. They also established a second settlement called Santa Elena on Parris Island, South Carolina. Santa Elena succumbed to attacks by the Guale, but St Augustine survived and became an important port, for it was located at the point where the Spanish treasure fleets turned offshore with the north-flowing Gulf Stream. A handful of friars was charged with the task of converting the local Timucuans.

To guard against attack by the British, the Spanish enlisted Native and convict labor to build the Castillo de San Marcos from 1672 to 1687 [1.13]. Designed by Ignacio Daza, it was patterned after the latest fortifications in Europe, with thicker walls and other devices to protect against a relatively new military weapon—the cannon. The walls are *coquina*, or shell-limestone, which absorbs cannon balls rather than shattering like other stone. They are 25 feet (7.6 meters) high and 12 feet (3.7 meters) thick at the base, narrowing to 7 feet (2 meters) at the top. The fort itself is approximately 200 feet (61 meters) across, with triangular bastions at each corner. The enclosed courtyard was ringed by government offices, barracks, and store rooms.

As before, the Spaniards subjugated the resident population, and then set about instituting systems of control through religious conversion, tribute labor, and intermarriage. As the archaeologist Brian Fagan notes, "the Spaniards integrated themselves physically with local populations, while still maintaining detailed, rigid, and highly legalistic classifications of people by race," in contrast to the pattern to be found in British colonies, where interactions were based on trade, warfare, slavery, and servitude, and much less on intermarriage. St Augustine remained the capital of this region, called La Florida by the Spanish, until 1702, when the British attacked the town and forced its residents to flee. La Florida was eventually ceded to England in 1763.

While trade focused on St Augustine, Santa Catalina de Guale, on St Catherine's Island off the coast of Georgia, was the center of missionary activity. By the mid-17th century 38 missions existed throughout La Florida, attended by 70 Franciscans who spread their faith among approximately 25,000 indigenous people. Because the buildings were made primarily of mud, thatch, or thin boards, little remains of this architecture today. Excavations of the 17th-century mission at Santa Catalina revealed a single-nave church with a plaza in front and a friary complex across the plaza. Records show that Guale converts lived there and provided the labor necessary to keep it functioning.

The Pueblo Cultures

Little else was done to populate the northern frontiers of New Spain until the 1580s and 1590s, when the Franciscans moved into what is now New Mexico. In the 1580s they explored the area, noting the types of cultures and planning how they were going to convert the local inhabitants to Christianity. The region was populated by descendants of three main groups who had lived there since approximately 300 BCE [1.14]. They were the Anasazi, in the northern part of Arizona and New Mexico and in Colorado; the Mogollon, in southeastern Arizona, southwestern New Mexico, and sections of northern Mexico; and the Hohokam, in the central region of Arizona to the Mexican border. In addition to hunting, all practiced various forms of agriculture, often utilizing canal-irrigated farmlands. Maize cultivation had arrived from central Mexico around 2000 BCE. All had highly developed ceramic traditions, also thought by some to have originated in central Mexico [3.3, 3.4]. Their

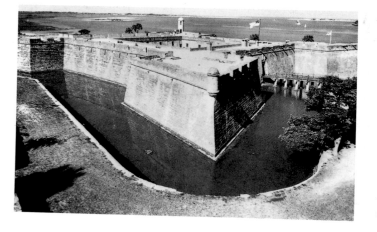

1.13 Castillo de San Marcos, St Augustine, Florida, 1672–87

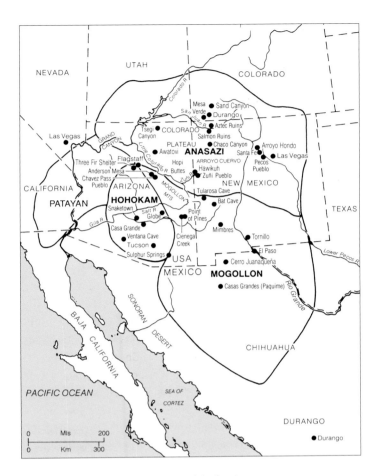

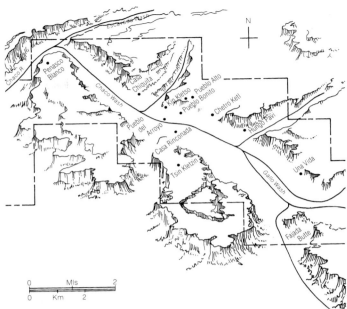

1.14 Sites and major cultural divisions of the Southwest

1.15 Main sites of Chaco Canyon, New Mexico, 900–1150 CE (the stepped lines indicate the boundaries of the National Monument)

1.16 Pueblo Bonito, Chaco Canyon, New Mexico, 900–1150 CE

descendants, named by the Spaniards "Pueblo" peoples (*pueblo* is Spanish for town or village), would continue the development of these ceramic traditions through to the present.

Of these three cultures, the Anasazi left the most impressive architectural remains. They mostly lived in small scattered farming communities, but were associated in some way with larger multihousehold complexes, some of which were built into vast natural indentations in the canyon walls. Chaco Canyon, in northwestern New Mexico, was the most ambitious of these complexes [1.15, 1.16]. Flourishing between 900 and

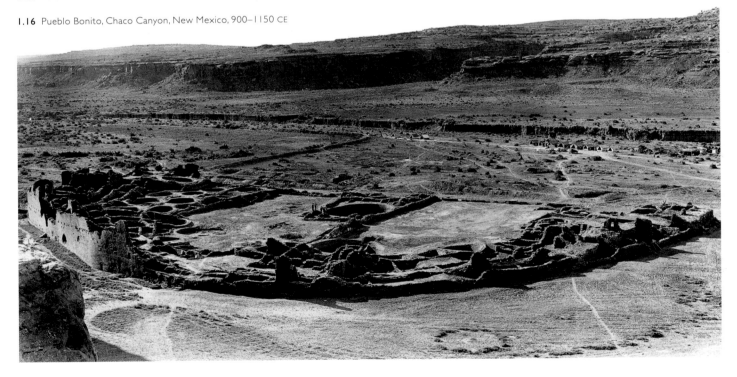

1150 CE, it contained thirteen "towns" and several great *kivas*, or ceremonial buildings. The largest of these "towns" were built on the canyon floor, at the base of the cliffs. Thousands of elaborately carved or decorated items made of turquoise, macaw bones, clay, and copper have been found at the site, suggesting that it functioned as a significant trading center. Another indication of its importance as a focus of either trade or religion or both is the elaborate network of more than 250 miles (400 kilometers) of roads that extend outward in all directions. Fagan argues that the various settlements in the canyon housed fewer people than earlier thought (current estimates for the period 1075–1115 are somewhere between 2,000 and 10,000), and that these "towns" functioned more as ceremonial sites and storage centers for food, where people came together to trade, worship, and participate in the redistribution of resources in times of need. The construction of the buildings and roads would have required the cooperation of large numbers of people, suggesting that a relatively small elite must have possessed the power to orchestrate these projects. It is not clear, however, whether they formed a centralized authority based in Chaco Canyon, or were representatives of various communities who met at Chaco on ceremonial occasions to cement political and economic alliances.

The architectural historian Vincent Scully suggests that influences from the preconquest cultures of central Mexico can be seen at Chaco Canyon and at later Pueblo sites, such as the location of ritual structures on top of cones of earth, imitating temple platforms, and the focus on defining a ritual exterior space. In Pueblo architecture the primary ritual space is the plaza, framed by buildings from whose ledges and roof setbacks ceremonies could be watched [6.68]. In 1540 Pedro de Castañeda, a member of Coronado's expedition, described Pecos Pueblo in north-central New Mexico as "square, situated on a rock, with a large court or yard in the middle, containing the steam rooms. The houses are all alike, four stories high. One can go over the top of the village without there being a street to hinder." The plaza became more important in the Pueblo towns of the 16th century, as the size of the *kiva* diminished.

Around 1200–1250 CE the major Anasazi settlements, such as Chaco Canyon and Mesa Verde (in southwestern Colorado), were systematically abandoned, possibly because of a combination of soil erosion, drought, and political feuds. Many of the inhabitants moved south and west, forming the precursors of the contemporary Pueblo peoples, with their distinctive architecture [1.17]. Archaeological evidence suggests that between 1250 and 1500 the Anasazi moved many times, building and abandoning numerous villages as they searched for fertile land and for a stable social system that would allow for the integration of different lineages. This nomadic exis-

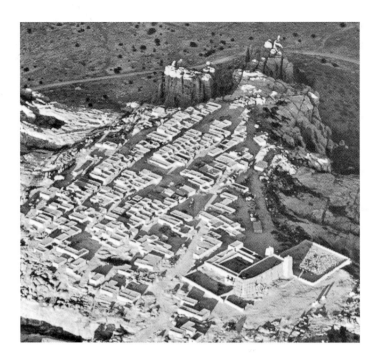

1.17 Acoma Pueblo, New Mexico. The mission church (see 1.20), with its cloister and walled burial ground, is visible lower right

tence is present in Pueblo origin myths, which are marked by people forced to wander in search of water or away from disease and factionalism.

In the 16th century, the population of the region of New Mexico and eastern Arizona was approximately 100,000, with some 150 communities ranging in size from 200 to 3,000 persons. Seven different languages belonging to four families (Tanoan, Keresan, Zuñi, Uto-Aztecan) were spoken. In addition to the various Pueblo peoples, Athapaskan nomads migrated south from Alaska into the region in the second quarter of the century, becoming known later as the Navajo and the Jicarilla Apaches. The competition for game posed by the Athapaskans forced the Pueblo peoples to rely more heavily on agriculture. In times of unrest, particularly after the arrival of the Spanish, groups or clans from certain pueblos would take refuge with the nomadic Navajo and Apaches.

Pueblo society was matrilocal (men moved to the homes of their wives when they married) and matrilineal (property was passed from mother to daughter). Men and women shared in the running of the communities. The main hierarchical division was generational, between the old and the young. In the mythological world of the Pueblo cultures corn was female and rain was male. Both were needed for survival. Men were responsible for hunting, protecting the community, spinning, and weaving. Women were responsible for the home and for building construction (although the men usually put the roof

beams in place); they produced pottery, moccasins, ceremonial apparel, and turkey-down blankets. Sexuality itself was an important force within Pueblo cultures, being equated with fertility, regeneration, and the sacred. Sexual intercourse symbolized cosmic harmony, the balance of the masculine forces of the sky and the feminine forces of the earth.

Men controlled most of the ceremonial life of the pueblos, although the all-female Marau Society conducted ceremonies celebrating female fecundity, sexuality, and reproduction. There were four main male ritual associations, connected with warfare, curing, hunting, and rain-making. While warfare was necessary to protect the pueblos or to acquire goods in times of scarcity, the taking of human life through violence was not held in high esteem. Of greater value was a complex system of gifting, where the offering of food and hospitality to neighbors and travelers assured peace while, at the same time, setting up reciprocal obligations that tied the community together. In addition to the four ritual associations, there was also the primary chief, or "Inside Chief" (members of the warrior association were also referred to as the "Outside Chiefs").

Each of the ritual associations had its own *kiva* [1.18]. The main *kiva* was located in the center of the pueblo and was the preserve of the Inside Chief, who would call together men from the other associations for major ceremonies. *Kivas* in the eastern pueblos were most often circular, while those in the western pueblos were rectangular; most in both regions were set below ground level, with roofs constructed of wooden beams. Entrance was gained through a hole in the roof, which symbolized the place where the Corn Mothers climbed onto the earth's surface, and down a pine ladder. In the center of the floor was a shallow hollow called the *shipapu*, representing the earth's

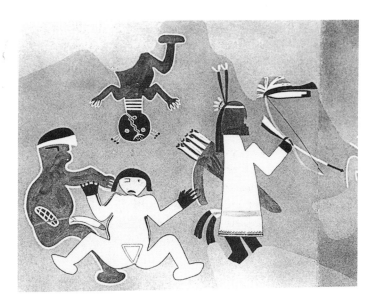

1.19 Anonymous, Hopi: mural of Kokopelli and Kokopell Mana from Room 529, Awatovi Pueblo, Arizona, c. early 15th century (copy by Watson Smith)

navel or the place through which the people emerged from the underworld and through which they would return. The walls, usually made of coursed sandstone blocks covered with plaster, contained stone altars. A low ledge or bench covered with lion and bear skins ran around the room. The central *kiva* was situated not only at the core of the settlement, but also at the core of a spatial scheme that included the four cardinal directions, the four skies above, and the underworld. The ceremonies performed here or in the central plaza, if done correctly and joyfully, ensured cosmic harmony, i.e. the rising and setting of the sun, the coming of rain, the change of seasons.

The *kivas* also contained many ceremonial objects (e.g. prayer sticks, masks) and several show evidence of murals. The latter included elaborate designs painted in a variety of colors [1.19] mostly derived from local minerals mixed with vegetable or animal oil and water. Excavations, most notably at the site of the Hopi pueblo Awatovi, which was abandoned around 1700, have revealed several layers, suggesting that murals were created for specific ceremonies, then plastered over and repainted. The earliest date to 900–1100 CE. Like the paintings of the Aztecs and their contemporaries, the *kiva* murals are two-dimensional in style, with evenly applied colors, an absence of shading, and a tendency toward geometric forms.

Watson Smith, who led the excavations at Awatovi in the 1930s, suggests that the figures in the murals mirror those in the various ceremonies performed in the *kiva* or the plaza, most notably the *katcina* or *kachina*, which represented the forces of nature—clouds, rain, animals, and plants. They were invoked with dances and offerings of prayer sticks and other gifts, lived

1.18 A Hopi *kiva*

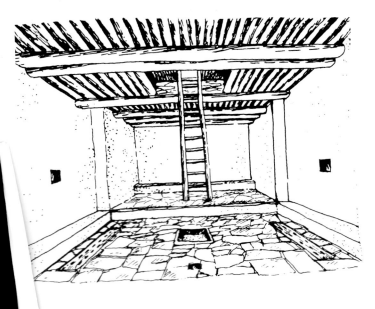

underneath lakes and on mountain tops, and were called with puffs of smoke, representing the clouds it was hoped they would bring. The people believed that they themselves became *katcina* at death—indicating, once again, the reciprocal nature of Pueblo existence: in death there would be life. *Katcina* dancers wore distinctive costumes, which appeared on the numerous carvings or small dolls of the spirits found within Pueblo communities.

Smith lists the most common elements in the *kiva* murals: *katcina*, humans, plants (corn, beans, squash, cactus), animals (badgers, rabbits, deer, snakes, lizards, birds, fish, frogs), head-dresses, prayer sticks, crooks, feathers, animal skins, bows, arrows, shields, clouds, and lightning. One mural from Awatovi [1.19] depicts the spirit-being Kokopelli on the left, characterized by his humped back and extended penis; the upside-down figure of his female companion Kokopell Mana; a young female to whom Kokopelli is bringing the seed of life (he was known as a cosmic seducer of girls and bringer of babies); and a fully outfitted warrior or hunter on the right. Here, warfare and hunting, the domain of men, birthing, the domain of women, and sexuality, the domain of both, are combined in a continuous pictorial space, as in the Pueblo social order.

The Christianization of the Pueblos

The depiction of human sexual organs and the suggestion of sexual activity in the *kiva* murals undoubtedly troubled the celibate Franciscans who arrived in the late 16th century to convert the Pueblo peoples and establish missions (we know from written accounts that they were certainly troubled by the sexually provocative dances). The first permanent Spanish colony was set up in 1598 under the leadership of Juan de Oñate near San Juan Pueblo. Like Cortés, Oñate marched under a banner with an image of the Virgin, was accompanied by a group of Tlaxcalan allies, and brought with him a Pueblo woman captured during an earlier expedition as his translator. And, as was the case with Cortés, written accounts of the journey suggest that the Pueblo peoples thought Oñate might be a deity—in his case, a *katcina*—and thus greeted him, initially, with gifts and a cautious welcome.

The missionaries who accompanied Oñate attempted first to prove that their power to heal the sick, bring rain, and provide material sustenance to the community was greater than that of the Pueblo leaders. While some were suspicious of the friars, many who lived in the pueblos were impressed by their successes. Once established in the area, the Franciscans began to exploit the division between the young and the old to assist their conversion efforts (they were also aided by the presence of Spanish troops close by). They encouraged the young to inform on their parents and attempted to impose a patriarchal order, in large part to control the sexuality of women.

Like their predecessors in central Mexico, the friars systematically confiscated and burned the ceremonial objects of Pueblo life—the *katcina* dolls, ceremonial masks, and prayer sticks. They also destroyed many *kivas* or filled them in with sand. Sometimes they built their mission churches on top of them, at the same time conflating the Christian cult of the saints with the *katcina* cult. Certain formal similarities aided in this conflation: many Pueblo prayer sticks resembled the Christian cross. Other similarities between the practices of Pueblo chiefs and Franciscan friars, such as flagellation and bloodletting, led to a more willing acceptance of certain Christian rituals.

This conflation resulted in a syncretism, or mixing, similar to that which occurred in central Mexico. Unfortunately, few art works produced for the mission churches during the 17th century survived, for reasons that will become clear below, so evidence of the flowering of this combination of aesthetic and religious traditions is not readily available until the 18th century. Also, unlike their counterparts in Mexico City, the friars did not initially have the resources to train many Pueblo peoples in the creation of Christian imagery. Therefore, the majority of the work that adorned the early churches—altarpieces, paintings, chalices, free-standing statues, furniture—came from Mexico City or was made by the friars themselves. As much of the church decoration produced in Mexico City at this time was elaborately carved, polychromed, and gilded, the objects in missions probably evinced such traits. Where we do see the hand of the Pueblo artisan and evidence of the combining of cultural traditions is in the architecture of the buildings.

Like the *kivas*, the mission churches were the physical symbols of the celestial community, containing the sacred objects and providing the focus for sacred ceremonies. The friars adopted the adobe (clay mixed with water and a binder like straw or manure) that was such a distinctive part of Pueblo architecture, while maintaining the general layout established for missions in Mexico City in the middle of the 16th century—a single-nave church, a convent around a patio, and a large walled atrium or churchyard, which might contain an open-air chapel and small corner chapels or *posas* [1.17, 1.21]. The main variation was the inclusion of a transept, or crossing, in front of the high altar in many churches. To assist with the building, the Franciscans were given equipment from Europe. Every friar who set out from Mexico City received the following tools with which to build a church: 10 axes, 3 adzes, 3 spades, 10 hoes, 1 saw, 1 chisel, 2 augers, 1 plane, 1 latch, 2 small locks, 1 dozen hinges, some small latches, and 6,000 nails.

According to Thomas Drain's study of Southwestern churches, by 1660 there were 45 or 50 Franciscan churches in New Mexico; a century later the number had decreased to approximately 30. While some were positioned within the pueblo, most were sited on its edge [1.17], a location determined by mutual distrust between Pueblo peoples and Franciscans, and considerations of defense (many mission churches were conceived of as fortresses) and future expansion. For the most part the buildings were made of sun-dried adobe brick or field stone laid in adobe mortar. In many cases a final coat of clay or adobe was spread thickly over the walls to smooth out the surfaces. The roofs consisted of wooden beams (*vigas*) resting on decorated brackets [1.23], with smaller pieces of wood laid between the beams (*latias*), which were then covered with adobe. The walls were extremely thick (often 3–5 feet/1–1.5 meters) and seldom rose beyond 35 feet (10.7 meters), thus making any kind of external buttressing unnecessary and producing a more intimate, horizontal space, reflective of the tendency of the Pueblo peoples to construct their buildings in horizontal layers. Unlike the churches elsewhere in the Spanish dominions, these adobe churches did not use arches and relied, instead, on post-and-lintel construction. The windows along the nave were few, small, and high. To create a more dramatic lighting over the high altar, the sanctuary roof was sometimes raised to allow for a transverse clerestory window. Often there was a walled courtyard in front [1.21]. The exteriors were largely unadorned, a testament to the simplicity, humility, and poverty that formed the spirit of the Franciscan order.

As noted above, in Pueblo cultures the women were responsible for building (except for the roof beams) and maintaining the house. For their missions, however, the friars tried to enlist Pueblo men in the construction work (women were told they should spin and weave rather than build houses). Fray Alonso de Benavides lamented in 1630: "If we compel any man to work on building a house, the women laugh at him . . . and he runs away." Some took refuge with the Apaches and never returned to their pueblo.

The church of San Estevan at Acoma Pueblo is one of the best examples of 17th-century New Mexican mission architecture [1.20]. Built in 1629–42 at the edge of the pueblo, located on a high rock bluff [see 1.17], it has a rubble core faced with adobe bricks and a smooth layer of adobe applied over the bricks. The two towers speak to the European element in the design, and also had a military function. The massing of the building is characteristic of 17th- and 18th-century missions. The absence of buttresses and the minimal fenestration result in the reduction of the external mass to a block-shaped geometric form. This abstract massing is reinforced by the

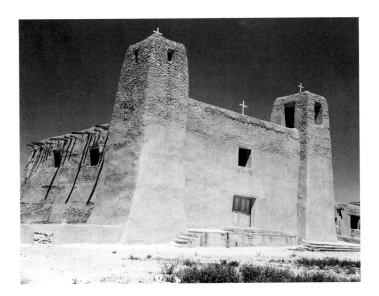

1.20 San Estevan, Acoma Pueblo, New Mexico, 1629–42, seen from the southeast

plain facade, marked only by the doorway, choir-loft window, and towers. With rounded and uneven edges and adobe surfaces, the church appears to grow up out of the ground. While there is evidence that murals existed on the interior walls of the nave, little remains of the 17th-century decoration. (The present decoration, combining European and Pueblo motifs, was probably painted in the 18th or early 19th century.)

The changes wrought by the friars and their mistreatment of the local people did not go unchallenged. In 1680 the Pueblo peoples revolted, killing many of the friars and settlers from New Spain, and reestablishing the old social, religious, and economic order. Their revolt was fueled by a decade of famine and disease and an ongoing rivalry between the clergy and the Spanish civil authorities that often rebounded on them. The Keres Indians at Acoma Pueblo had particular reason to revolt. In 1598 they had been appallingly punished after refusing supplies requested by a passing convoy of Spanish soldiers: all men and women over the age of twelve were sentenced to twenty years of slavery and all men over the age of twenty-five had one of their feet severed. Even a hundred years later they were among the most resistant (along with the Hopi and Zuñi) to Christianization, remaining matrilineal and refusing to abandon their traditional ceremonies.

During the 1680 Pueblo Revolt most of the mission buildings were vandalized or burned, although many survived to be renovated later (the interior of San Estevan at Acoma was burned, but the building remained intact). At one church the statuary and the Holy Communion table were covered with excrement, the crucifix destroyed, and the arms of a statue of

St Francis cut off. At other missions images and altars were burned or paraded as trophies. Just as the Pueblo peoples' sacred objects and deities had been profaned by the Franciscans, so, too, did they profane and destroy Christian images representative of the new order. The revolt, however, was short-lived. By the 1690s the Spanish had reasserted control over the region.

In reconquering New Mexico, both the secular and religious colonial authorities realized that the harsh treatment of the Pueblo peoples had contributed significantly to the unrest that led to the revolt. Under the new governorship of Cuervo y Valdez, Pueblo lands were protected with official royal grants. The Franciscans also became more tolerant of existing traditions, although not to such a degree that the old rituals could be performed in public. By the 18th century local craft practices began to develop to meet the demands of an increasing colonial population, although in 1750 there were fewer than 4,000 Spaniards in New Mexico, with a Native population of just over 10,000, having been decimated by famine and disease. This increase in the Spanish population was due in part to the encroachment of France and England on New Spain's northern borders. While the quest for new territories had lost its appeal for a Spanish crown under duress in Europe, the colonial authorities were not about to lose the buffer zone that protected the valuable mineral resources in the territories just south of New Mexico from incursions by other European powers.

Constant raids on Spanish and Pueblo towns by Comanches and Apaches, continual bickering between the clergy and the secular authorities, minor local rebellions, and isolation from any central authorities prevented ambitious building and decorating projects from being undertaken in the 18th century. Several mission churches were constructed, however, most under the initiative of civil rather than religious authorities, the opposite of what had occurred in the previous century.

One of the first religious structures built after the Spanish reconquest of the region was the church of San José at Old Laguna Pueblo, constructed from 1699 to 1706 of fieldstone mixed with adobe [1.21]. The building exhibits the same geometric massing and uneven lines as San Estevan [1.20], the main difference being the use of a bell-screen rather than towers on the facade. This bell-screen can be seen as an attempt to imitate the more ornate shapes of Spanish facade gables, but its stepped form also corresponds to the Pueblo motif for clouds or the Pueblo universe prominent on pottery and female ceremonial headdresses. Like San Estevan, San José is of post-and-lintel construction, with a roof of beams covered with branches, then adobe. And as at San Estevan, the rectilinearity of this post-and-lintel construction is offset by the uneven lines

and odd angles of the adobe building, which make the church appear more fluid, as if in a state of transition.

The interiors of the 18th-century mission churches were also composites of Pueblo and European architectural and iconographic traditions. The painted and carved *retablo* behind the high altar at Old Laguna Pueblo is thought to have been created some time between 1760 and 1846 [1.22, 1.23]. It includes twisted solomonic columns and biblical figures surrounded by floral frames and scrolls. In the top register the Holy Trinity is represented by three seated male figures: the one in the center holds a staff indicative of his authority to rule over both heaven and earth (God the Father); the one on the left holds a cross, a symbol of Jesus's crucifixion (God the Son); and the one on the right holds a dove (God the Holy Ghost). Below the Trinity is St Joseph, the patron saint of the church, holding the Christ Child. To the right of Joseph is St Barbara, protector against thunder, lighting, firearms, and sudden death; to the left is St John Nepomuk, the patron saint of confession and secrecy. Attached to the ceiling is a painting on animal hide which contains highly abstracted representations of the sun and the moon. Emanating from the former are zigzag lines ending in a triangular head, the mark of an important Pueblo deity, the Horned Water Snake, god of lightning and rain. Thus rain and thunder are represented by both Christian (St Barbara) and Native American (Horned Water Snake) symbols.

A visitor to San José in 1846 described the interior as "painted with curious Indian ornaments, in which they have used the pure red, blue, and yellow." As late as the first half of the 20th century, the walls to the immediate right and left of the altar were covered with floral motifs that replicated the elaborate woven tapestries found in more prosperous churches but out of the financial reach of the northern missions (these

1.21 San José, Old Laguna Pueblo, New Mexico, 1699–1706, looking from the east across the walled courtyard to the facade in 1881

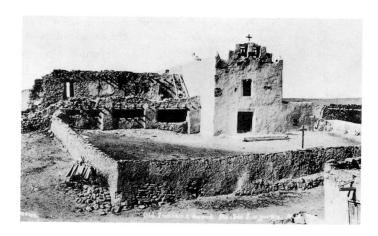

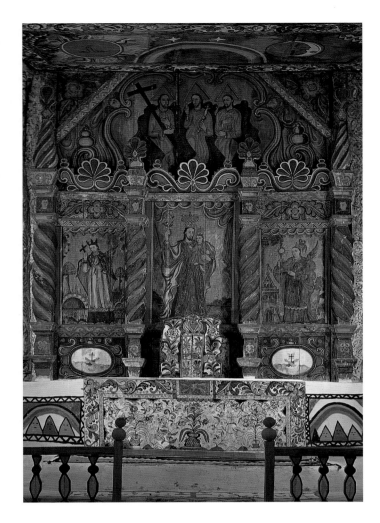

1.22 Anonymous, known as the Laguna *santero*: *retablo*, San José, Old Laguna Pueblo, New Mexico, *c.* 1760–1846

dedicated—flanked by St Teresa of Avila on the left and St Gertrude the Great on the right. Below St Michael in the middle register stands Christ, with St Francis on the left and St Louis IX, King of France and a member of the Third Order of St Francis, on the right. The niche in the lower register contains a statue of St Michael possibly also from central New Spain, with statues on either side made by local *santeros*.

The walls and altars of 18th-century churches were also decorated with paintings on hide, which had the advantage of being both portable and durable. Franciscan friars were often responsible for several missions and had to travel constantly. Perhaps the burning of church interiors in the 1680 revolt also prompted them to favor religious images that could be easily removed in times of unrest. Technically, these paintings drew on the well-established tradition of Spanish leather work, introduced into Spain by the Muslims as early as the 12th century. Iconographically they looked to the paintings of New Spain, which were often copied from book illustrations or prints from Europe. For example, a hide painting, *Christ on the Cross with an angel* [1.25], thought to have been created for the chapel of Captain Sebastián Martinez near San Juan Pueblo, is a traditional depiction of the Crucifixion with the Virgin Mary and the apostle John looking on while Mary Magdalene grasps the bottom of the cross. A cityscape appears on the right in the distance. The figures are convincingly drawn in three dimensions. The composition was probably copied from one of the numerous European woodcuts dating from the 15th and 16th centuries that depict the catching of the blood of the crucified Christ in chalices, a direct reference to the Holy Eucharist, through which humankind is offered heavenly redemption.

Another 18th-century hide painting contains an image of the Virgin Mary, possibly in the guise of Our Lady of the Angels [1.26]. Here the figure is extremely schematic and two-dimensional, and there are Pueblo motifs in the framing architecture, most notably the stepped pattern representing clouds or the Pueblo universe and the two pots perched atop columns that resemble cactus stalks. In addition, two angels on either side of the Virgin hold sticks to which are attached a sun and a moon, motifs that played a significant role in both Christian and Pueblo religions. Christine Mather, writing on the colonial art of New Mexico, suggests that the Pueblo motifs may have been added later, but the fact that other combinations of Christian and Pueblo imagery existed in the 18th century makes it possible that they were painted at the same time (the picture was cropped at some point and also torn in half). Unfortunately, little is known about the individuals who created these hide paintings. The one of Christ on the Cross appears to be the work of a friar who was well versed in the

motifs have since been painted over). Along the nave walls the iconography is primarily Pueblo: cornstalks, sun, rain and thunder symbols, and terraced motifs [1.23]. The birds perched on the stepped or terraced forms are thought to represent the souls of the people buried in the earth floor of the church.

The altar decorations relied on the lessons learned by Spanish and Native artists and artisans who studied in the Mexico City workshops set up by such European artists as Simón Pereyns. They often included a mixture of local and imported work, as in the altarpiece of the Chapel of San Miguel in Santa Fe [1.24]. Erected in 1798, it contains paintings imported from central New Spain set within a frame carved and painted by the same individual who created the altarpiece at Old Laguna Pueblo [1.22], who is known as the Laguna *santero* ("saint maker"). The top register contains an image of St Michael the Archangel—San Miguel, to whom the church is

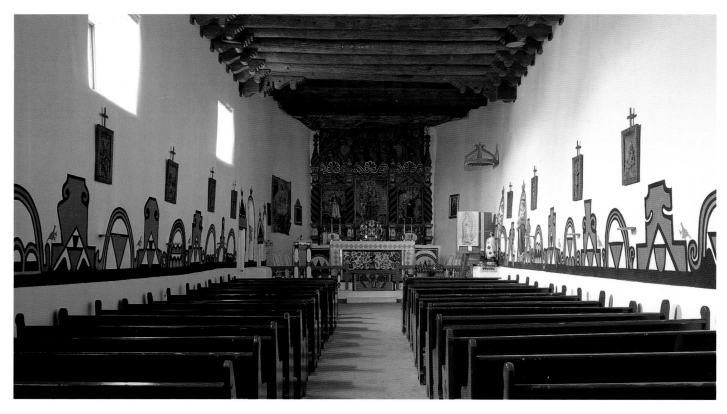

1.23 Nave, San José, Old Laguna Pueblo, New Mexico, c. 1760–1846

1.24 Anonymous: high altar, Chapel of San Miguel, Santa Fe, New Mexico, late 18th century

1.25 Anonymous, probably from New Mexico: *Christ on the Cross with an angel*, 18th century
Painting on hide, 78¾ × 65 in. (200 × 165.1 cm.)
Museum of International Folk Art, Santa Fe, New Mexico

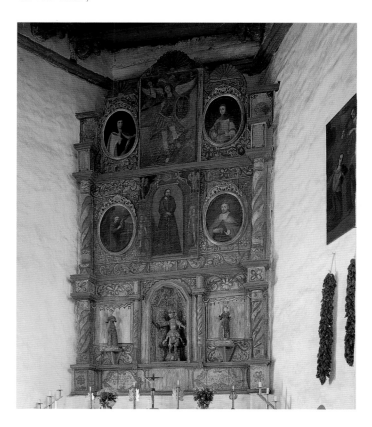

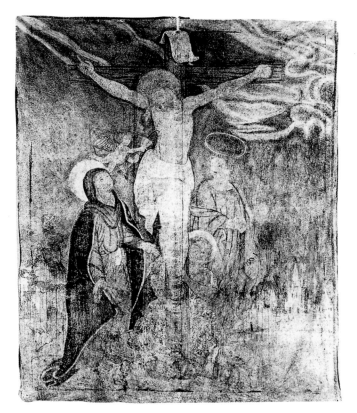

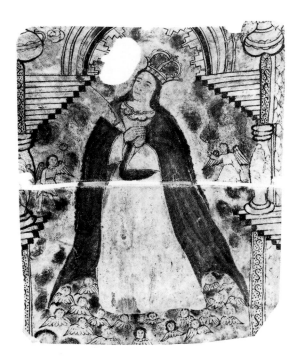

1.26 Anonymous, from New Mexico: *The Virgin* (*Our Lady of the Angels?*),
18th century
Painting on hide, 33½ × 26¹³⁄₁₆ in. (85 × 68 cm.)
Formerly in the L. Bradford Prince Collection

Andrés Garcia (active 1747–79) for the mission church of Santa Cruz de la Cañada, just north of Santa Fe [1.27]. A new church was built in 1732–48, and in 1765 Father Garcia arrived and began decorating the interior.

Over the course of three years Garcia created an altar rail, several carved images, a large *retablo* (probably for the high altar), an ornamented arch at the entrance to the sanctuary, and the *Santo Entierro*. In the latter, a life-size wooden figure of Christ lies in a coffin decorated with flowers. Poles at the base indicate that the carving was carried in the ceremonial processions marking Christ's burial, performed during Holy Week. Two fingers are missing from one hand; Drain notes that "*bultos* were considered to have miraculous powers, and local stories tell of pieces of statues being thrown into rising floodwaters to make them subside, or being burnt into ash for signing the faithful with a cross during an epidemic."

New Mexican *bultos* and *retablos* of the crucified Christ created in the 18th and 19th centuries were often marked by great displays of blood. Garcia's Savior is no exception, with blood streaming from his head, chest, and knees, and from under his loincloth. The historian Ramón Gutiérrez suggests that the blood may have been interpreted by Pueblo viewers "as rain fructifying the earth because blood had always been seen by them as a male nutrient of extraordinary fertilizing power," a meaning paralleled in Christian worship where Christ's blood was seen as a nutrient.

Images of the Virgin Mary rivaled those of Christ in number in New Mexico. One of the most important was a small statue brought to Santa Fe from Mexico City in 1625 by Friar Alonso de Benavides, the newly appointed head of the missions of New

painting conventions of Europe, while the second could well be the product of a converted Puebloan, or of a friar less conversant with European visual conventions but certainly aware of Pueblo imagery.

The 18th century also witnessed the appearance of single-panel paintings and carved wooden statues (*bultos*) of holy figures. While most that remain today are dated to the 19th century, a few survive from the 18th century, most notably the *bulto* of the *Santo Entierro* (Holy Entombment), carved by Father

1.27 Father Andrés Garcia: *Santo Entierro* (Holy Entombment), c. 1765–68
Painted wood
Santa Cruz de la Cañada, New Mexico

1.28 Anonymous: *Virgin of the Rosary* known as *La Conquistadora*, c. 1625
Painted wood, in a setting completed in 1717
Cathedral of St Francis, Santa Fe, New Mexico

The explorations of the French down the Mississippi River to its mouth and their attempts to establish settlements on the Gulf Coast at the end of the 17th century prompted Spanish authorities to send both soldiers and missionaries into the territory to the east of New Mexico, a territory that became known as "Tejas" or "Texas." Alonso de León, governor of the state of Coahuila, just south of Texas, and Fray Damián Massanet led an expedition in 1690 that resulted in the founding of the San Francisco de los Tejas Mission that same year. It was relocated several times before finding a permanent home in 1731 in San Antonio as the Mission of San Francisco de la Espada (St Francis of the Sword). Construction of the church began in 1745 and was completed in 1756 [1.29].

The obvious difference between this church and its New Mexican counterparts [1.20, 1.21] is the material out of

1.29 Church of the San Francisco de la Espada Mission, San Antonio, Texas, 1745–56

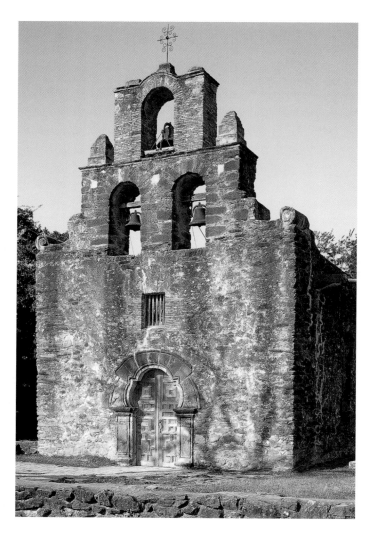

Mexico [1.28]. It was accompanied by its own gilded altarpiece with columns. During the 1680 Pueblo Revolt it was rescued by a Spanish woman, Josefa Sambrano de Grijalva, and taken to El Paso, where it came to be known as *La Conquistadora*, in honor of the Virgin's help in spiritual conquest. The statue was returned to Santa Fe in 1693 and housed in a special chapel, completed in 1717. Like the *Santo Entierro*, *La Conquistadora* is made of wood, which was then painted. Her body, however, rather than being covered in blood as a sign of suffering and ultimate salvation, is clothed in an elaborate gown and jewels, with her head covered by a wig of long black hair. The Virgin Mary was the benevolent face of Christianity, the intercessor who would convey the prayers of rich and poor alike to her son Jesus and God the Father. *La Conquistadora* was attended with devotion, her costume replaced as it showed signs of age. The chapel of *La Conquistadora* is now all that remains of the 18th-century parish church in the present-day Cathedral of St Francis in Santa Fe.

which it is made—stone rather than adobe. The Coahuiltecans, who inhabited the area when the Spanish arrived, were nomadic and had no tradition of permanent building, living primarily in temporary brush shelters. Thus, those who designed the early Texas missions had no competing architectural models as did the designers in New Mexico. Stone was readily available, and was utilized to replicate the churches the missionaries had left in central New Spain or in Spain itself.

Other more subtle differences between Texan and New Mexican churches can be discerned by comparing the facades of San Francisco de la Espada [1.29] and San José at Old Laguna Pueblo [1.21]. Both are strikingly simple, marked primarily by a centrally placed door, a rectangular window above, and a stepped screen with openings for bells (three in the case of San Francisco de la Espada, two at San José). The volutes at the corners of Spanish bell screens, only suggested at San José, are carefully carved in stone at San Francisco, and the bells are placed in arched, rather than rectangular, openings. The pinnacles on either side of the top bell could be the result of Moorish

influence. The door is framed by an unusual trefoil (three-cusped) arch. Drain notes that a number of explanations have been put forward to account for this arch, including the theory that the larger stones at the top should have been on the sides instead; yet the arch also resembles ones found in Moorish architecture and widely adopted by Spanish builders. The combination of arches and rectangles makes for a more complex facade, but the regularity of the stone and the exactitude with which the forms have been defined also results in a more rigid effect than that of the adobe churches.

An even more ambitious church was being built in San Antonio around the same time as the San Francisco de la Espada Mission. In 1740 the foundation was laid for the Mission of Nuestra Señora de la Purísima Concepción (Our Lady of the Immaculate Conception); the church was completed in 1755 [1.30]. The facade is marked by a combination of arches

1.30 Church of the Nuestra Señora de la Purísima Concepción Mission, San Antonio, Texas, 1740–55

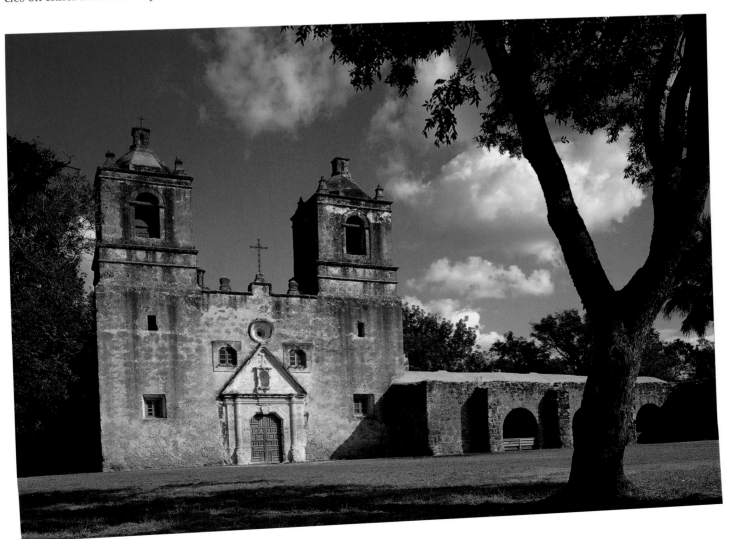

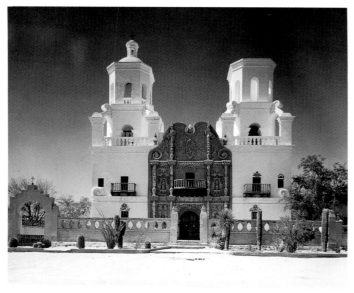

1.31 San Xavier del Bac, Arizona, 1783–97

1.32 Central part of the facade, San Xavier del Bac, Arizona, 1783–97

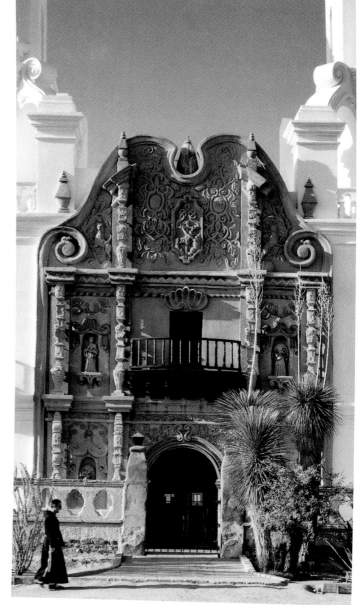

(angular-headed in the case of the doorway and two of the windows, Roman for the bell tower openings), engaged columns, and a pediment that is reminiscent of the 16th-century Augustinian monastery at Epazoyucan [1.11], although somewhat less idiosyncratic in its arrangement. The pediment frames a niche that once held a statue, probably of the Virgin Mary. At the apex is an oculus or round window. The entablature, columns, and area to either side of the door are carved with floral and geometric motifs, as well as a representation of the Five Wounds of Christ, connected by a knotted Franciscan cord to the Franciscan emblem—the crossed arms of Christ and St Francis, both with wounded palms—on the other side of the door. The rather understated look of the facade today is deceptive for, according to Drain, it was originally painted, and each stone in the towers was ornamented with a cross-in-circle design.

Whereas the Franciscans were the key missionary force in New Mexico and Texas, the Jesuits laid claim to Arizona, sending the Italian Father Eusebio Kino into the region at the end of the 17th century. The most impressive of the missions he established is San Xavier del Bac, just south of present-day Tucson [1.31–1.33]. It was founded in 1692 in the center of the Tohono O'Ohdam (Papago) Indian settlement along the banks of the Santa Cruz River. Father Kino had hoped to find an overland trail to California and to set up a series of missions along the way. While the foundation was laid in 1700, the church was not built until the end of the century (1783–97), well after the death of Kino in 1711. By this time the mission was controlled by the Franciscans, the Jesuits having been expelled from Spanish ter-

ritories in 1767 by order of Charles III (Pope Clement XIV suppressed the Jesuit Order in 1773, but it was restored in 1814). The church is composed of fired bricks covered with a lime wash, and incorporates flying buttresses on the bell towers, domes, and round-headed arches, forms missing or very rare in the mission buildings of New Mexico.

The ornate portal, located between the two towers (one was never completed), contains the Franciscan emblem in the center of the top register, accompanied by the monograms of Jesus and Mary on either side and the figures of SS. Barbara, Catherine of Siena, Cecilia, and Lucy in niches below [1.32]. Framing the niches are *estípites*, forms that stand in for the shafts of columns but are so extensively carved that their role as a support device is

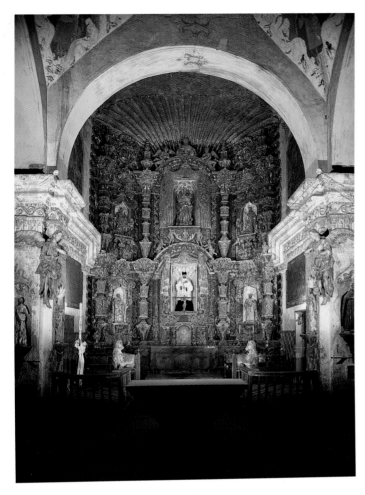

1.33 Looking toward the high altar, San Xavier del Bac, Arizona, late 18th century

dissolved. This use of the *estípite*, along with the decorative volutes and low-relief vegetal carving, connects San Xavier del Bac to the elaborate "ultra-baroque" churches of 17th- and 18th-century New Spain, such as the Sagrario Metropolitano (1768), the parish church of the Cathedral of Mexico City, designed by Lorenzo Rodríguez and located next to the Cathedral. The interior of San Xavier del Bac, particularly the high altar [1.33], also reflects the ornate and crowded interiors of those churches, where, as in the high altar or *Altar de los Reyes* (1737) of the Cathedral of Mexico City designed by Jerónimo de Balbás, almost every square inch of surface is covered with carved and painted figures. The architectural historian Robert J. Mullen notes that this style of architecture arose in New Spain as a result of the rapid accumulation of wealth by the political and religious elite in the 18th century and the escalating competition for power between members of the religious orders (the Franciscans, Dominicans, and Augustinians) on the one hand, who enjoyed considerable independence in the

16th and 17th centuries, and the bishops on the other. The bishops ultimately gained the upper hand, with elaborate cathedrals in urban centers standing as monuments to their religious authority. Yet the "ultra-baroque" style also spread eventually to churches in small towns in central New Spain and to the northern frontier.

Battle Scenes on Hide: Segesser I and II

After the death of Father Kino another Jesuit, Father Philipp von Segesser von Brunegg, oversaw San Xavier del Bac from 1732 to 1735, before being transferred to a mission to the south in the region known as Pimería Baja (San Xavier del Bac was in Pimería Alta). In letters to his family in Switzerland Father Philipp recorded Native uprisings, which involved the local Pimas and their enemies the Apaches, and also the Yaquis and Seris to the south. These attacks grew in frequency in the late 1730s and lasted until the 1760s (Father Philipp died in 1762).

Father Philipp also sent to his family in 1758 a box containing what he termed three "colored skins." Two have survived. Each is made up of three large, rectangular pieces of hide sewn together with sinew. Gottfried Hotz, in a detailed study of the hide paintings, argues that their elaborate scenes represent battles between different groups of Native peoples and between Mexican, French, and Native soldiers. Through a careful analysis of geography, vegetation, costumes, hairstyles, and architecture, he has attempted to identify the subject-matter. In the case of the first, designated Segesser I [1.34], this is only tentative: it may, he suggests, depict an unrecorded battle around 1700 that took place "either on the Sierra Madre Plateau near Sonora . . . against Gila Apaches, traditional enemies of the Sonora Indians and of the Spaniards, or in the southeastern

1.34 Anonymous: Segesser I, c. 1700: detail of battle scene
Painting on hide, overall size c. 19 ft. × 4 ft. 6 in. (6 × 1.5 m.)
Palace of the Governors, Museum of New Mexico, Santa Fe

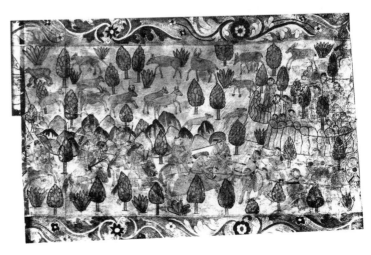

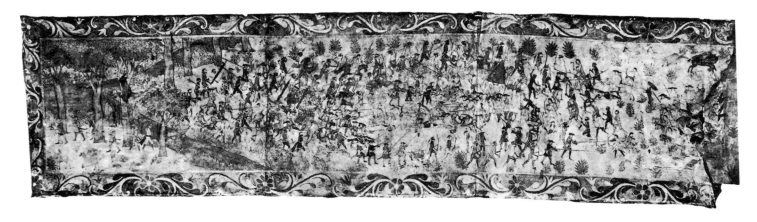

1.35 Anonymous: Segesser II, c. 1720?
Painting on hide, c. 19 ft. x 4 ft. 6 in. (6 x 1.5 m.)
Palace of the Governors, Museum of New Mexico, Santa Fe

part of New Mexico, west of the Pecos River, against Faraon Apaches (later called Mescalero Apaches)." Hotz suggests that the attackers are probably "members of a southern nation—most likely Tarascans or Tarascan half-bloods." Soldiers from indigenous allied groups were used to strengthen the forces sent out during the reconquest of New Mexico; they were often outfitted with Spanish weapons and uniforms, yet maintained distinctive traits, such as hairstyles—a combination seen here, where the short hair and types of headdresses recall those in carved reliefs and codices of central New Spain.

Hotz is more confident of his identification of the participants depicted in Segesser II [1.35]. This hide painting, he

1.36 Anonymous, Mandan: buffalo robe, collected by Lewis and Clark in 1805
Painted hide, L 7 ft. (2 m.)
Peabody Museum, Harvard University, Cambridge, Massachusetts

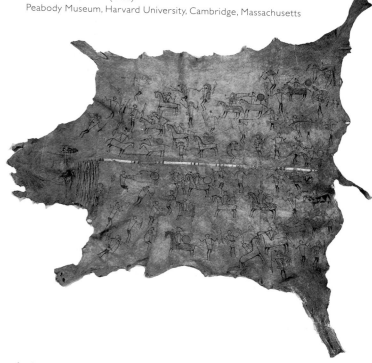

argues, presents the surprise attack and defeat of the Spanish at the conjunction of the Platte and Loup rivers in Nebraska by the Skidi Pawnees and Otos. The Spanish troops numbered 45, with 60 Pueblo soldiers and a Spanish priest, and were led by Pedro de Villasur, who had been sent northeast from Santa Fe in 1720 by Governor Antonio Valverde Cosio to determine the extent of the French presence in the region. Of these, 63 survived the attack. The painter includes several French soldiers with rifles among the attacking forces, perhaps in order to help Governor Valverde explain the defeat to the viceroy of New Spain. There is no hard evidence of French participation in the attack, although rumors to this effect were spread by both the French and the Spanish.

In attempting to determine who painted Segesser I and II, Hotz looked first at the tanning process, paint composition, and method of paint application. He found that all three resembled methods and materials used by Plains Indians. Yet when he looked at the style and iconography of Plains painted hides, he found significant differences. They tended to be marked by profile depictions of both animals and humans, with few facial features; an absence of background or setting; an attention to outline with no highlights or shadows to give the illusion of depth; and geometric body parts (e.g. torsos, thighs). A Mandan buffalo robe from around 1800 contains many of these characteristics [1.36]. While stylistic similarities can be found between these hide paintings and the preconquest codices of the Aztecs and other peoples of central Mexico, there are greater similarities between Segesser I and II and the post-conquest codices of New Spain, such as the *Florentine Codex* [1.9], which contain the same mix of Spanish and indigenous peoples and two- and three-dimensional renderings of figures and landscapes.

Hotz has no doubt that an indigenous person or persons—Tlaxcalan, Tarascan or Pueblo—or someone of mixed heritage painted Segesser I and II, drawing on a tradition of image-making brought north from central New Spain. He also notes

that the Spaniards in Segesser II have much more individuality than the French or Pawnees, suggesting further that the artist was a member of their camp.

The figures in Segesser II are rendered much more convincingly and elegantly than those in Segesser I, with a greater attention to three-dimensionality and accurate bodily proportions and a greater ability to convey movement. Thus, if the same artist painted both works, then Segesser I was painted first, with Segesser II representative of a more mature style. Hotz suggests that Valverde may well have commissioned Segesser II as part of his defense of the Villasur expedition. Perhaps he commissioned Segesser I to commemorate another of his expeditions, for the two paintings appear to have been pendants, being of the same size and having similar borders. The fact that Father Philipp acquired both also suggests that they were in the possession of the same individual. Unfortunately, few such narrative hide paintings from the 18th century have survived, so it is impossible to tell if the general arrangement of Segesser I and II was common to many other works. What is clear, however, is that they provide another example of the combination of traditions and technologies that marked much of the art produced on New Spain's northern frontier.

The Californian Missions

As early as 1533 a small Spanish expedition explored the coast of Baja California, followed by a more ambitious venture by Juan Rodríguez Cabrillo in 1542. Commissioned by the Viceroy of New Spain to seek a water passage linking the Atlantic and Pacific, Cabrillo traveled at least as far north as present-day San Francisco and possibly to Cape Mendocino. He made contact with several groups of Native peoples , noting their physical features, dress, and weapons. In the latter half of the century many galleons passed along the coast on trading expeditions to the Philippines and China, although these were curtailed after 1588 due to attacks by the British under the leadership of Sir Francis Drake. Sebastián Vizcaíno was sent back up the coast in 1602 to produce detailed maps of the area that would ultimately aid in the settling of this territory.

No attempt was made to establish permanent settlements, however, until the last half of the 18th century, with the first mission founded by Franciscans in the south at San Diego in 1769. Two years later another was established slightly north of San Diego at San Gabriel. Douglas Monroy opens his book *Thrown Among Strangers, The Making of Mexican Culture in Frontier California* with a look at the differing views of this second encounter between Native inhabitants and newcomers as related by each side. According to interviews conducted in the early 19th century, the inhabitants of Yang-na (present-day

Los Angeles) and other villages in the surrounding area at first thought the Spaniards were gods because of their ability to create fire. But when they saw a Spaniard kill a bird with a musket, they knew the Spaniards were men, because their own gods were givers, not takers, of life. They refused to eat the corn and beans proffered to them because each world had its own food, and theirs was acorns, deer, coyote, other small animals and birds, and roasted grasshoppers. According to the Franciscans' journals, friars who arrived in 1771 were met by

> a great multitude of savages [who] with frightful yells attempted to prevent the founding of the Mission One of the Fathers produced a canvas picture of Our Lady of Sorrows, [and] at the sight of it they became as if transfixed in wonderment, and all of them threw their bows and arrows on the ground, as "Tomeares" or Chiefs took from around their necks the necklaces they value so highly . . . and placed them at the feet of the Sovereign Queen of the Angels.

Father Junípero Serra, who led the Franciscans in founding the missions of California, provided another account of the transfixing effect of the image of the Virgin:

> As for the Indian women, when the Fathers showed them a beautiful painting of the Most Blessed Mary, artistically executed, . . . they were so taken with it that they could not tear themselves away from it. They went to their homes and came back loaded down with seeds and provisions, which they offered to the holy image The very sight of how intent they were, and how much in earnest, touched one to the heart, and made one feel sure that they would pay even greater homage to the Great Queen when in the light of the faith they would come to know how exalted she was.

Men and women alike, the friars observed, were powerfully impressed by the depiction on canvas of the Virgin Mary. Images thus entered early on into their conversion and colonizing efforts in California, although their evaluation of the power of these images may well have been exaggerated. They would soon have to admit that paintings of the Virgin were not enough to gain the cooperation of the local peoples, and that more aggressive measures would have to be taken.

The great variety of environmental settings in the region encompassed by the current borders of California was matched in the 18th century by an equal variety of Native cultures. The precarious nature of food supplies in the desert areas resulted in small communities that shifted with the seasons. In the

northwest, abundant marine resources allowed for larger, more complex social organizations, including villages with plank houses. In all there were approximately ninety different languages with several hundred dialects spoken. Estimates of the size of the population of California at the time of the arrival of the Franciscans in 1769 range between 100,000 and 300,000.

The southern part of the present state was occupied by people who spoke Shoshonean, part of the Uto-Aztecan family of languages, or derivatives of Hokan stock (Chumash to the north, Yuman to the south) that had much older roots in the region. In contrast to the Pueblo economic and social order, they were patrilineal (inheritance was traced through the male line) and semi-nomadic, engaging in hunting and gathering. Their spiritual world was based on a belief that everything in nature—plants, animals, humans—had an existence or a "spirit" and that a careful balance had to be maintained between all parts of nature in order for humans to flourish. Social balance was also maintained through a system of gift-giving, where the power of a leader depended not only on his ability to amass wealth (stored foods or other consumables), but also on his willingness to give this wealth away. The various tribal groups engaged in warfare with one another and also in trade: the Chumash in the Santa Barbara area would export steatite, wooden vessels, beads, white pigment, and various dried fish, while importing black pigment, antelope and elk skins, obsidian, salt, and piñon nuts.

Villages in the south were composed of a series of round or conical huts of pliable poles supporting reeds, branches, and/or grasses, arranged in rows or clusters. The huts' shape may have been related to the importance of the circle in spiritual life and of a cyclical view of time, determined most obviously by the seasons. The circle was also the distinctive shape of the baskets made by women that were used to gather, store, cook, and eat food and as ritual or everyday headgear. Basketry had a long tradition in the region, dating back to at least 5500–4800 BCE. Baskets are known to have functioned as important gift or trade items and as markers of special initiation rites. As the prized possessions of an individual, they were burned at the person's death or buried with them. They were also valued as prized possessions by the Spanish, as is indicated by the response of those who accompanied Juan Bautista de Anza, charged in 1774 with forging an overland route from Sonora to Monterey. According to Christopher Moser in his book *Native American Basketry of Southern California*, "entire villages were depleted of baskets by the Spanish, who desired them as gifts for people in Mexico and Spain." The design elements on these early baskets were primarily abstract geometrical shapes or highly stylized plant or animal motifs. Their symmetry may be related to the larger belief in the need for balance between humans and nature.

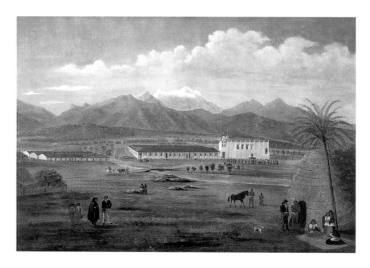

1.37 Ferdinand Deppe: *San Gabriel Mission*, c. 1832
Oil on canvas, 27 × 37 in. (68.6 × 94 cm.)
Santa Barbara Mission Archive Library, Santa Barbara, California

As in New Mexico, the Franciscan friars attempted to alter the social relations and spiritual beliefs of the local populations. In a series of twenty-one missions established along the coast a day's travel apart, an architecture of right angles replaced one of circles. A life of stasis replaced one of movement and freedom. A fully clothed body replaced a naked or partially clothed body. Food produced at the mission supplemented or replaced the meat and plants acquired through hunting and gathering. Metal and porcelain dishes and storage containers joined baskets. People were renamed according to the names of their missions—e.g. Gabrielinos, Fernandeños, Luiseños, Diegueños, Obispeños. These contrasts between architecture and ways of life are captured in a painting of around 1832 by the German naturalist, explorer, and artist Ferdinand Deppe, which contains both the San Gabriel Mission in the background and a Chumash or Gabrielino domical grass house in the foreground [1.37]. Left to the viewer's imagination is the inevitable disruption to indigenous life that this coming together of two worlds entailed.

The friars found the Native peoples of southern California essential not only as converts, but also as labor for the agricultural and commercial activities that turned the missions, by the early 19th century, into highly profitable enterprises. They were employed in construction, adobe brick making, candle making, hide cleaning and tanning, laundry, and cooking, and contributed to the decoration of the mission churches.

In 1792 twenty artisans arrived from Mexico City at the San Gabriel Mission to train the Native converts in masonry, carpentry, tailoring, and leatherworking. The church was constructed in 1800–1806, but suffered extensive damage during an earthquake in December of 1812 and had to be largely rebuilt. The new church was of adobe brick, with walls as much

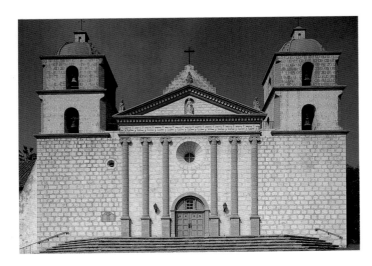

1.38 Church of the Santa Barbara Mission, Santa Barbara, California, 1815–20

mission library. Its facade is dominated by a temple front, with Ionic columns, decorated frieze, and pediment, to which is added a stepped gable. It is dedicated to St Barbara (see p. 34), a Christian Roman virgin beheaded by her pagan father because of her faith. She is represented by the statue in the central niche and is joined by statues of the three theological virtues—Faith, Hope, and Charity—on the pediment above.

St Barbara appears again, in much more colorful form, above the high altar, flanked by the Virgin and St Joseph, with St Francis and St Dominic below [1.39]. The high altar also has four pairs of Ionic columns painted to resemble marble attached to the wall, as well as painted simulations of drapery and niches. This imitation of marble and other expensive materials through *trompe l'oeil* painting is found throughout the Santa Barbara Mission and in other California missions. It can be seen, in part, as an imaginative response by the friars to the shortage of these materials and/or of skilled artisans.

While Native peoples were working on the construction and decoration of mission churches, they also continued to produce items such as baskets for their own use and for trade. During

as 6 feet (1.8 meters) thick and 30 feet (9 meters) high. A much more elaborate church was built further up the coast at the Santa Barbara Mission [1.38]. Erected in 1815–20 by Chumash laborers around the remains of an earlier earthquake-damaged church, it draws heavily on the treatise of the ancient Roman architect Vitruvius, an edition of which was present in the

1.39 Anonymous: high altar, Santa Barbara Mission, Santa Barbara, California

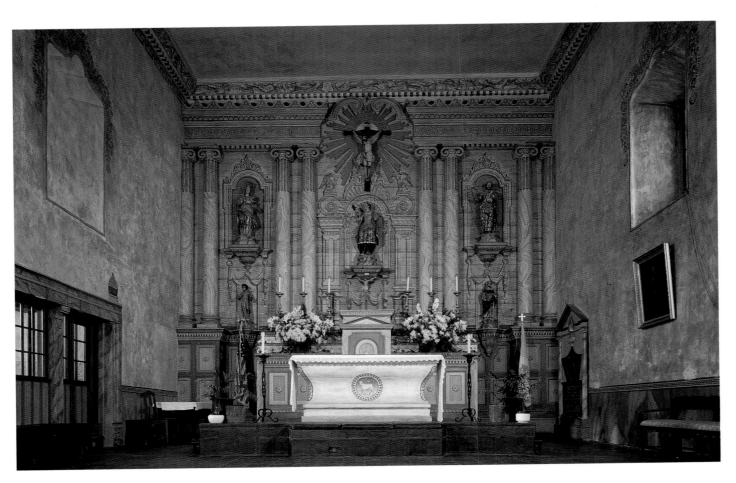

1.40 Anonymous, Chumash: coiled hat, presented to George Vancouver at Santa Barbara, California, in 1793
Juncus reed, D 15¼ in. (38.7 cm.)
British Museum, London

his explorations of the West Coast in the 1790s, the British captain George Vancouver received, among other gifts, a coiled hat made by a Chumash woman that combined traditional geometric Chumash design motifs and the Christian cross [1.40]. Its shape, with a brim, is patterned after the sombreros worn by the friars (the hats of local peoples did not have brims). Special presentation baskets were also commissioned. In the early 19th century Maria Marta (b. *c.* 1766) from the San Buenaventura Mission, whose Native name was Lapulimeu, created such a basket with four repeating motifs derived from a colonial 8 *reales* or *peso* coin, showing the crown and shield of Spain flanked by the Pillars of Hercules [1.41]. On the rim she inscribed, in Spanish: "María Marta neofita de la mision de el Serafico Doctor San Buenaventura me hizo an," which translates: "María Marta, neophyte of the Mission of the Seraphic Doctor San Buenaventura, made me in the yr . . ." (scholars have posited that "an" was the beginning of the word "año" or "year" and that Marta ran out of space to complete the word and add the date). Between the four "coins" are vertical motifs that Moser suggests are some

1.41 Maria Marta (Lapulimeu), Chumash: presentation basket made at the San Buenaventura Mission, California, early 1800s
Juncus reed, D 15½ in. (39.3 cm.)
Phoebe Hearst Museum, University of California at Berkeley

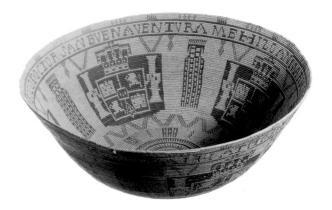

sort of masked figure or possibly clouds with rain descending. Regularly repeating geometrical designs complete the decoration. While a few other surviving baskets from the late 18th and early 19th centuries have inscriptions identifying the artist, the makers of most are unknown.

When the Franciscans arrived in California at the end of the 18th century, they were charged not only with converting the local people, but also with making them citizens of New Spain. "In theory," the architectural historian Stanley Young notes, "each mission was a temporary institution that held all wealth and property in trust for the local Indians. Once the natives were appropriately civilized, the missions were to give up their stewardship of the land to create a pueblo for the Indians." In practice, however, such a transfer never took place. With Mexican independence in 1821, the new government began the secularization of the missions, a process completed in the 1830s. All Spanish-born friars were expelled and the land theoretically became the property of those Native peoples who had converted to Christianity. Mexican settlers who had previously been unable to own land were now able to purchase it from these new owners. Most, however, simply took it, paying little if anything. The "Mission Indians" now worked as blacksmiths, *vaqueros* (cowboys), or servants on the new Mexican *ranchos* for masters who often treated them as poorly as had the friars. They continued to contribute their labor to the creation of buildings and objects that would come to represent Mexican culture in the region in the first half of the 19th century.

France Bringing the Faith: the Northeast

Material Exchange:
The Impact of Trade on Native American Life

When Europeans arrived in the northeastern portion of the North American continent they found no vast empire state with elaborate trade networks, urban centers, and extensive agriculture but, rather, numerous relatively small communities with intricate alliance and trade systems that engaged in a combination of horticulture, fishing, and hunting, and that adapted easily to the trade imperatives introduced by the French, British, and Dutch. These peoples were initially less easily subdued because of the ease with which they were able to disappear into, and survive within, the rich but often harsh northern landscape.

Probably the first Europeans to explore the northeast were Norse sailors, who came via Iceland and Greenland beginning in the 11th century. While their settlements in Greenland lasted approximately five hundred years (982–*c.* 1500), those on the North American continent were short-lived, due, historians

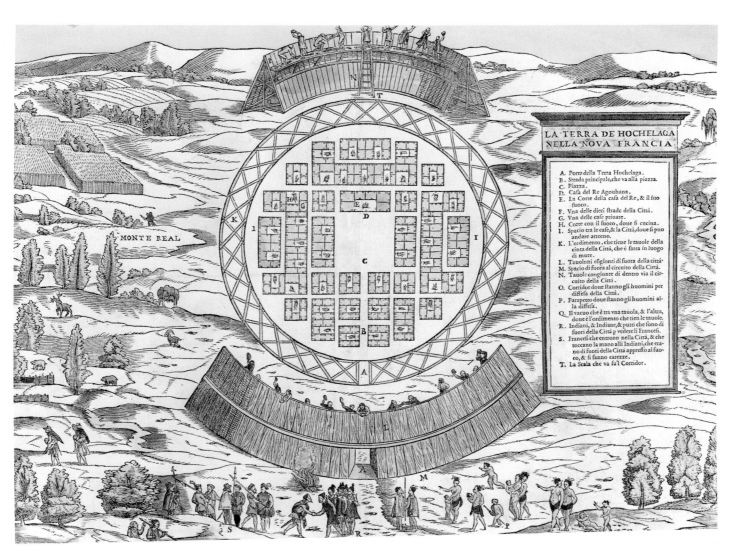

LA TERRA DE HOCHELAGA
NELLA NOVA FRANCIA

A. Porta della Terra Hochelaga.
B. Strada principale, che va alla piazza.
C. Piazza.
D. Casa del Re Agouhana.
E. La Corte della casa del Re, & il suo fuoco.
F. Vna delle dieci strade della Città.
G. Vna delle case priuate.
H. Corte con il fuoco, doue si cucina.
I. Spacio tra le case, & la Città, doue si può andare attorno.
K. L'ordimento, che tiene le tauole della cinta della Città, che è fatta in luogo di mure.
L. Tauoloni còngionti di fuora della città.
M. Spacio di fuora al circuito della Città.
N. Tauole congionte di dentro via il circuito della Città.
O. Corridor doue stanno gli huomini per diffesa della Città.
P. Parapetto doue stanno gli huomini alla diffesa.
Q. Il vacuo che è tra vna tauola, & l'altra, doue è l'ordimento che tien le tauole.
R. Indiani, & Indiane, & putti che sono di fuori della Città p vedere li Francesi.
S. Francesi che entrano nella Città, & che toccano la mano alli Indiani, che erano di fuori della Città appresso al fuoco, & si fanno carezze.
T. La Scala che va su'l Corridor.

MONTE REAL

1.42 The Huron town of Hochelaga, c. 1535; the French appear at the lower left
Engraving from Giovanni Battista Ramusio, *Navigationi et viaggi*, 1556
Public Archives of Canada

speculate, to conflict with the local inhabitants. The first person to explore the coast for France was the Italian Giovanni da Verrazzano, who sailed up from North Carolina to Newfoundland in 1524. Jacques Cartier arrived in 1534 and explored the Gulf of St Lawrence, returning to France with two Huron youths who acted as guides on his second voyage, which took place the following year. On October 2, 1535, Cartier arrived at the Huron town of Hochelaga, the site of present-day Montreal; he was greeted by more than a thousand people with gifts of corn and bread. The town was composed of fifty multi-room houses made of sapling frames covered with sheets of bark (the basic building system in the region) grouped around a central plaza and surrounded by fortifications. Close by were fields of corn. A sketch made shortly after Cartier's visit combines abstracted and illusionistic renderings to convey his understanding of the organization of the town and its relationship to the surrounding landscape [1.42]. A later drawing of the Mohawk town of Caughnawaga on the St Lawrence [1.43] gives a clearer indication of the shape of longhouses in Mohawk and Huron villages—they ranged from 40 to 400 feet (12 to 122 meters) in length and from 20 to 30 feet (6 to 9 meters) in width—and of their arrangement in the 18th century (by this time in many places there were also the more rectilinear buildings of the Jesuit missionaries, shown here to the right).

The peoples of the eastern woodlands belonged to two general language groups, the Algonquians and the Iroquoians. The Huron were one of several Iroquoian groups residing in the 16th century in what is now southeastern Ontario and northern New York State. The northwestern part of this region was occupied by the Huron, Erie, Tobacco and Neutral, the southeastern portion by the League of the Iroquois, or Five Nations, made up of the Seneca, Cayuga, Onondaga, Oneida,

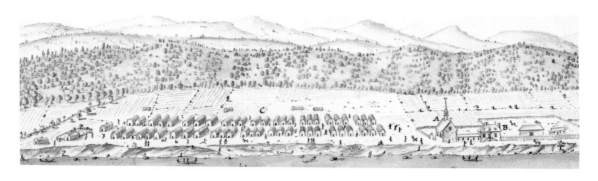

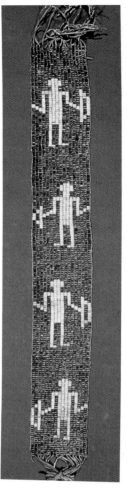

and Mohawk. These two regional groups formed loose confederacies amongst themselves, which sent representatives to ceremonial feasts and conferences to settle disputes, thus limiting blood feuding and warfare. The League of the Iroquois was the strongest confederacy in the region, and was feared by other Iroquoian groups, such as the Huron, as well as by Algonquian-speaking peoples. The Iroquois conceptualized their League as a vast longhouse stretching from west to east. The Seneca were the "Keepers of the Western Door," the Mohawk the "Keepers of the Eastern Door," and the Onondaga both the "Keepers of the Council Fire" and the "Keepers of the Wampum Belts."

Wampum belts were made by both the Iroquoians and the Algonquians ("wampum" is an Algonquian word). They were composed of white and purple or black shells strung in various designs by women. According to the historian Daniel Richter, pre-16th-century belts were made from the shells of whelks or marine snails (white) and quahog clams (dark purple), and while the size and shape of the beads varied, most were disk-shaped. The wampum we are most familiar with—small tubular beads drilled for stringing—was a cross-cultural product made with iron tools obtained from Europeans. It was probably invented by peoples indigenous to the southern New England coast—the Pequot or Narragansetts—in the 16th century and then introduced into Iroquois territory through traditional exchange networks. The designs on the belts functioned as mnemonic devices, reminders of the terms of treaties or trade negotiations. They were carefully prepared for presentation at gatherings of local, or local and European, leaders. As gifts, they were significant symbols of the power of the giver to enter into negotiations as a representative of his people. Traditionally, the recipients often broke them up and distributed the elements to their followers. The beads would then enter into personal or community stores that would be drawn upon to construct more belts as occasion demanded. One of the most famous belts from the 17th century is that commemorating the Four Nations of the Huron, with four highly abstracted human forms, said to have been given to the French explorer Samuel de Champlain in 1611 [**1.44**].

1.43 Anonymous: the Mohawk town of Caughnawaga ("Sault St Louis") on the St Lawrence River, c. 1750.
The key indicates: A church, B house of the missionary, and C "huts or village of the savages"
Drawing on paper (detail)
Bibliothèque Nationale de France, Paris

1.44 Anonymous, Huron: wampum belt commemorating the Four Nations of the Huron, said to have been presented to Samuel de Champlain in 1611
Musée de l'Homme, Paris

In their book *Native Americans: Five Centuries of Changing Images*, Patricia Trenton and Patrick Houlihan discuss the symbolism of the colors white and purple in wampum belts:

> Among the Northeastern Woodland Indians white shell was a metaphor for light and life, and in social rituals, such as treaties, for consensus, harmony, and peace. Purple bead strings and belts connoted death and mourning, and by the mid-18th century other matters of grave importance as well The white field denotes a social context and connotes a peaceful message, while the figurative pictographs of purple beads carry the specific meaning.

There were, however, some exceptions to this use of white for the background and purple or black for the figurative elements, such as the Champlain belt. The use of dark beads for the background may indicate the gravity of the event commemorated.

The Dutch were the first to exploit wampum in their trade with the Iroquois, purchasing it from Algonquians in southern New England and then trading it to the Iroquois for furs. This resulted in the production of unprecedented quantities of the

beads, leading to a drastic decline in their value. Between 1641 and 1658 the value of wampum against specie fell 60 percent; in the 1660s it fell another 200 percent. In addition, the material composition of the belts began to change, as European glass beads replaced the original shell beads.

While feared as warriors, the Iroquois were also known for the quality of their social relationships, which focused on politeness and hospitality to both friends and strangers. They were matrilineal and matrilocal: children lived with their mother's clan, and men moved into their wives' longhouse at marriage. The women tended the children, made clothing and household goods, and took care of the crops (corn, beans, squash, sunflowers), which may have provided up to 80 percent of the diet. The men conducted wars, cleared land, hunted, fished, traded, carved ceremonial objects, and constructed the dwellings.

The arrival of European settlers in the area had a significant impact on this social order. Not only did firearms give certain groups military advantage over their neighbors, but the emphasis on trading in furs and on warfare gave men more power. Acquiring food through trade also reduced the energy devoted to agriculture. The availability of metal pots and dishes created less of a demand for, or interest in making, the watertight baskets used formerly for eating. Conversely, Native peoples also had an impact on the European explorers and settlers. The French learned a great deal from them about the art of trapping, farming techniques, and the use of plants for medicinal purposes.

Initially the exchange between Europeans and Native Americans in the Northeast was on a relatively equal footing, as the superior firepower of the former was offset by the larger numbers of the latter. The Europeans wanted furs, and the Iroquoian and Algonquian peoples wanted iron axes, beads, and guns. Often these were incorporated into existing belief and value systems as yet another category of "exotic" objects with certain powers. Ultimately, however, the pressures brought to bear on Native Americans by the increasing numbers of Europeans eroded the stability of their communities and made it more difficult to maintain their own cultural traditions.

One of the major pressures came in the form of new diseases. As elsewhere on the continent, populations were decimated by European ailments such as smallpox and measles. Iroquois healers brought to bear all of their powers in attempting to cope with these new plagues. Healing in Iroquois communities was carried out primarily by members of the Society of Faces (or False Face Society). Its origin is recounted in a legend involving a contest between the Creator of the World and the first False Face spirit, also known as the Great Defender, over who would ultimately rule the world. Robert Ritzenthaler, in his study of Iroquois masks, relates it as follows:

The False-face shook his giant rattle and commanded a mountain to come to him, but it moved only part of the way. Then the Creator summoned the mountain and it moved in back of False-face, who impatiently turned around and struck his face against it. He broke his nose and twisted his mouth in pain. The Creator then charged False-face with the task of driving disease from the earth. False-face agreed to give the Indians the power to cure by the blowing of hot ashes on a sick person. The Indians, in turn, were to carve masks in his image and make him offerings of respect, such as tobacco and corn mush.

The particular features of the False Face masks were said to appear to a man in a dream or vision (only men wore masks during the curing ceremonies). He then either carved it himself or commissioned another man to carve it for him, out of a soft wood such as basswood, magnolia, poplar, white pine, maple, or willow. The power of the mask was thought to be greater if it was carved from a living tree—the face is roughed out on the tree, then split off from the trunk, with the tree remaining alive.

Although the Society of Faces was unable to prevent the decimation caused by European diseases, its members continued to create masks and perform ceremonies down to the present day. Because of their ongoing religious significance to the Iroquois, and as a result of the passage of the Native American Grave Protection and Repatriation Act of 1990 (NAGPRA) and similar legislation in Canada, most masks in public collections have been repatriated or returned to contemporary Iroquois groups and scholars have subsequently respected Iroquois requests not to reproduce them in their publications.

Religious Instruction and Cultural Exchange: The Jesuits and the Ursulines

The first French colony, established near Quebec City in 1541 by Jacques Cartier, was short-lived. In 1608, when Samuel de Champlain founded Quebec, the emphasis was on the acquisition of fur (French fishermen had been traveling annually to the shoals of Newfoundland for cod-fishing for years). Serious efforts to establish more substantial permanent settlements did not take place until 1663, when Louis XIV decided to invest in New France the institutions of a province—governor, intendant, and sovereign council. French companies had been granted monopolies to process and ship both furs and fish to France, but the borders of their territory were constantly challenged by both the Dutch and the British.

Like the Spanish before them, the French played the various Native nations off against each other. They allied themselves with the Hurons, Montagnais, and Algonquians, who profited

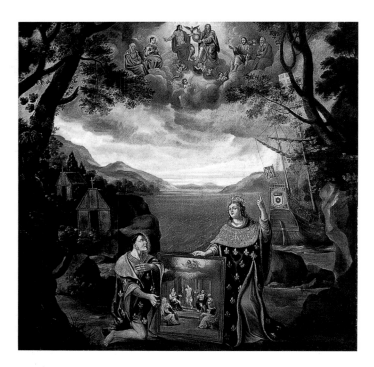

1.45 Attributed to Frère Luc (Claude François): *France Bringing the Faith to the Indians of New France, c.* 1675
Oil on canvas, 86 × 86 in. (218.4 × 218.4 cm.)
Musée des Ursulines, Quebec

France Bringing the Faith hung in the Ursuline convent in Quebec City (and still does today) and shows a scene that pre-figures the one described a century later by Father Junípero Serra (see p. 43). A Native figure, clothed in a robe patterned with the French fleur-de-lis, kneels at the feet of a personification of France, said to have been modeled after a portrait of the Queen Regent Anne of Austria, mother of Louis XIV. Between the two is a painting showing the Trinity—God the Father (in the clouds), Son (seated on the throne), and Holy Ghost (the dove below God the Father)—flanked by the Virgin Mary, John the Baptist, and Anne and Joachim (Mary's parents). The kneeling figure looks in awe at France, indicating acceptance of the lesson presented in the painting by reaching for the canvas with one hand, while touching the heart with the other. The gestures of France indicate ownership and authority: her right hand rests on the painting, while her left hand gestures upward to a scene including the same cast of characters as in the painting. The authority of France comes from God, and is conveyed, in part, through images. In the scene in the clouds, God the Father hands to Christ the orb representing the world; Christ's left hand rests on the globe, while the dove of the Holy Ghost rests on Christ's hand. Religious and secular authority are thus combined into one. Those who sailed up the St Lawrence River, shown in the background, had the political and religious authority to claim the land and convert the peoples who inhabited it. In the process, they built their mission stations, seen on the left, and brought Christianity and European clothes, both of which connoted civilization, to those they encountered.

This depiction of the passive acceptance of Christianity was more wishful thinking, however, than an accurate record of what transpired after the arrival of the French. Many French settlements were attacked and several Jesuits joined the ranks of Christian martyrs. Yet the Jesuits and Ursulines enjoyed some successes, due in part to their willingness to learn local languages and, in the case of the Jesuits, to live in local villages in order to convey more effectively to the inhabitants the value of a Christian life. In the Ursuline convent in Quebec City, Native women were taught to read and write French, as well as sing hymns in French, Huron, and Algonquian. In addition, they were taught European embroidery and painting. Mère Marie de l'Incarnation, one of the founders of the convent, wrote in 1640: "They are so attentive to what they are taught The girls sing with us in the choir, and we teach them what we wish, and they adapt themselves so well to it; I've never seen in French girls the disposition that I remark here," although she later admitted, in 1663, that she had failed to convince a single girl to stay at the convent as a professed Ursuline.

from trading furs, while the Dutch and British allied with the Iroquois League.

Religion arrived with the traders, and in the 1620s the Jesuits began the task of conversion, aided by Ursuline nuns, the first three of whom landed in 1639. Both groups created and commissioned paintings and carvings to adorn their churches and to help teach the ways of the Catholic Christian faith. *France Bringing the Faith to the Indians of New France* [1.1, 1.45] aptly summarizes this use of images. The painting has been attributed to Frère Luc (1614–85), a member of the Recollet Order, a reformed order of Franciscans, and dated around 1675; some now think it was painted in France around 1700 by an unknown Franciscan artist. Frère Luc, born Claude François in Amiens, trained as a painter before joining the Recollets after his mother's death in 1644. He spent only fifteen months in Quebec, in 1670–71, and painted several religious canvases. On his return voyage to France in the company of Bishop Laval, who had been posted to Quebec in 1659, he helped lay out the designs for a proposed new Quebec seminary. He also sent several canvases to the French colony at the request of the Bishop. Around 1668, Laval founded an arts and crafts school at St Joachim, 30 miles (48 kilometers) east of Quebec City along the St Lawrence River, to encourage local production of religious paintings, sculpture, and metalwork.

The nuns, with their assistants, painted, carved, and embroidered most of the items necessary for religious services. One nun mentions in a letter after Mère Marie de l'Incarnation's death that the convent's founder had been aided in her altar painting by a young Native woman. The historian Natalie Zemon Davis suggests that some of the older pupils had probably already learned artistic techniques from their mothers and may have introduced certain Native motifs into the decorative work they did for the church. A painted silk altar cloth dating to before 1682 is a fine early example of the work of the Ursuline convent [1.46]. The simply rendered scene of the Holy Family in the center is surrounded by a proliferation of flowers, birds and fruit, suggesting that belief in Christ is the source of all natural abundance. The ethnologist Marius Barbeau notes that the artist was drawing upon contemporary embroidery design rather than contemporary painting. Indeed, the iconography—the dove from Noah's ark carrying the olive branch, grapes, flowers, vines, and cornucopias—would appear time and again in altar cloths and vestments. It is not surprising that the Ursulines, whose training focused more on needlework than on painting, would turn to what they knew best. The abundance of colorful plants and birds in their work would certainly have been a welcome sight during the long, cold winters in New France. Mère Marie de l'Incarnation wrote to the Ursuline convent in Tours: "Do not suppose that we could live long without returning again and again to the fireplace. Even I, who had never wanted to warm myself, am now reluctant to leave it."

Several of the Ursulines also turned to Native American women for lessons in how to work with local materials, for imported goods were extremely scarce. As early as 1714 a nun from the settlement of Three Rivers had mastered the art of

1.47 Anonymous, probably Quebec convent work: box, late 18th century
Bark embroidered with moose hair, L 7⅞ in. (20 cm.), H 3⁵⁄₁₆ in. (8.5 cm.)
Museum für Völkerkunde, Frankfurt

constructing birch-bark boxes and was showing the nuns of nearby Quebec City how to make them. They and their charges focused their attention on the production of particular types of containers, most often small and decorated with flowers, human figures, and/or animals embroidered in moose hair [1.47]. The general designs and techniques often matched those of the more traditional ecclesiastical objects made of thread and cloth imported from Europe, although the narrative content differed, with biblical figures or scenes often replaced by Native Americans hunting, canoeing, or resting in the landscape.

Birch-bark played an important role in the life of Native peoples in the region, who used it to make items ranging from canoes and dwellings to storage and cooking containers. Some, particularly the Huron, used moose hair to decorate clothing and other articles, but they did not embroider directly on the surfaces of bark containers. Neither did they create boxes with lids, pin cushions, wallets, or any of the many other objects produced by the nuns. "The origin of these wares," writes the art historian Ruth B. Phillips, "was a true contact zone event that fused the technical knowledge of Aboriginal peoples with the entrepreneurship and artistry of Quebec nuns." The objects were often sent back to benefactors as gifts. In addition, their sale to visitors provided much-needed income. Phillips quotes the Ursuline embroiderer Mère Esther de l'Enfant-Jésus, who wrote in a letter of 1761:

Despite all the troubles that have been visited on this country, one doesn't lack for the necessities of life if one has enough money; but we have nothing except what we earn from our little works in bark. As long as they remain in fashion the earnings that we get from them will be an important source of income, for we sell them really dear to Messieurs les Anglais.

1.46 Anonymous: altar cloth with the Holy Family (detail), before 1682
Oil paint on silk
Musée des Ursulines, Quebec

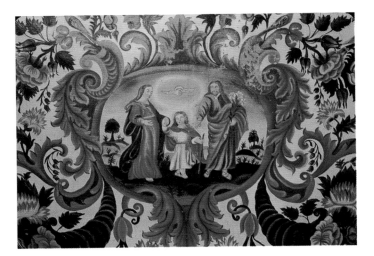

The nuns' birch-bark products were popular with both the French and, after the British defeat of the French in 1759 (see p. 75), "les Anglais." For the former they functioned as "Indian curios," despite the fact that they were often made by French nuns. What made them "Indian" were the materials—birch-bark, moose hair—and the scenes of Native Americans in the wilderness. These objects satisfied the desire of Europeans to see the peoples of the new world as "noble savages." The British also promoted this view of the "noble savage" and were enthusiastic customers. In fact, the English poet and dramatist John Dryden was the first to use the phrase in a 1670 play about the New World entitled *The Conquest of Granada*:

> I am free as nature first made man,
> Ere the base laws of servitude began,
> When wild in the woods the noble savage ran.

"It is impossible, in effect," wrote Mère Esther de l'Enfant-Jésus, "despite our zeal for the work, to furnish this kind of merchandise to all the people who request them." The objects functioned in a second way, too, for the British, as souvenirs of the "colorful" French population they had colonized. "Their purchases of moose hair and bark curios," writes Phillips, "were, thus, doubly romantic and exotic, acting as mementos not only of the Indians of North America, but also of the Catholic world of French Canada."

While the Ursulines had originally been charged with converting Native American girls to Christianity, in 1720 they were officially released from this task and turned, instead, to educating the daughters of the wealthy French families in the region. After the British victory, they also began educating the daughters of the new ruling elite. The embroidery of birch-bark items was among the many lessons the girls received, which fostered a modest vogue for this activity among European women of the upper classes. By the early 19th century, for reasons that are not clear, the nuns ceased production. The activity was subsequently taken over by the Huron, Mi'kmaq, and other Native groups in the region. Their motivation, too, was primarily financial, having had their traditional means of survival—hunting, fishing—severely circumscribed by the arrival of more settlers from both France and England. For many it proved a lucrative activity, as the 19th century saw a surge of travel by members of both the upper and the growing middle classes, who went in search of the primitive and the picturesque and who desired reminders of the Native American settlements lining the more popular tourist routes. Paradoxically, financial success meant replicating the conventions of "Indianness" accepted and promoted by the foreign consumers, an exercise that, according to Phillips, "profoundly destabilized indigenous concepts of identity." More will be said about this in later chapters.

The Influence of Fashion: Painted Caribou-Skin Coats

European features introduced by the French in the 17th and 18th centuries were also incorporated into Native American life in other ways. For example, early descriptions by explorers and priests refer to painted clothing. In 1616 the Jesuit Father Biard wrote of the people of Acadia (present-day Nova Scotia and part of New Brunswick): "They often curry both sides of elk skin, like our buff skin, and then variegate it very prettily with paint put on in a lace-like pattern, and make gowns of it." Father Paul LeJeune observed the costumes worn in Quebec City in 1637–38 during public religious ceremonies: "It was a beautiful sight to see a company of Savages marching behind the French, in their painted and figured robes, two by two, and very modestly."

The museum curator and fashion historian Dorothy Burnham has studied painted caribou-skin coats produced by the Montagnais, Naskapi, and Cree, who inhabited the Quebec–Labrador peninsula (20th-century descendants of these peoples call themselves Innu), and found significant changes over the course of the 18th and 19th centuries. Just as Montagnais women helped embroider the vestments used in the masses celebrated within the Ursuline convents, so too did they translate the dreams of their men into abstract designs painted onto the coats worn during the caribou hunt. In the northern reaches of the peninsula, hunting was the main source of food. It was also viewed as a sacred activity, and Burnham suggests we consider these painted coats "holy vestments, one of the ritual elements that would ensure the success of the hunt." Men killed the caribou; women skinned the animal, prepared its hide, cut and sewed the coat, and painted the designs (it seems the men gave only general directions). The main colors used were yellow, red and brown, with some black, blue and green.

One of the earliest surviving coats, dated to *c*. 1700 [1.48], displays the complexity that marked so many of these garments, with the various motifs organized symmetrically along a central axis. Most of the early coats contain an elaborately decorated triangular inset in the center of the back, which represented the Magical Mountain, home of the caribou. Bilateral symmetry governs not only the overall arrangement of forms, but almost all of the individual patterns. Two basic design types are used: a four-part layout, and a double curve. The collar of the coat illustrated [1.48] shows both: the central lozenge contains a four-part design, and it is flanked by a series of double curves. While some of the elaborate patterns may have been influenced by

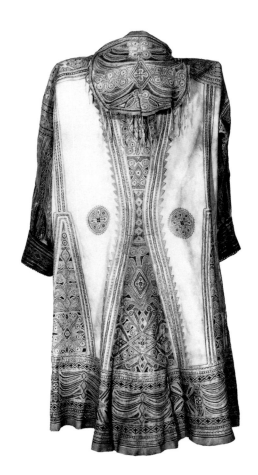

1.48 Anonymous, probably Montagnais, from southwestern Quebec: painted caribou-skin coat, c. 1700
Pitt Rivers Museum, Oxford

French embroidery brought to the area in the 17th century, designs on vestments and altar coverings in New France tended to be much less abstract, more clearly representing vegetal motifs, and also less likely to be segmented into individual units bordered by one or more lines. A comparison makes this difference clear [1.46, 1.48].

Burnham posits an interesting origin for the four-part design on the painted caribou coats, and its "lace-like" quality pointed out by Biard: the rosettes produced by "the widespread and ancient art of biting a design into a thin piece of folded birch-bark" practiced by Native women from Newfoundland to the Plains. Burnham describes the process:

A small piece of bark is peeled down to a thin fine layer, which is folded in half, folded at a right angle in half again, and then folded diagonally from the centre to make eight thicknesses. The woman takes this small folded triangle of bark and moves it around while she bites it. She does not bite through to make a real hole but just squeezes the layers tightly together. When the piece of bark is unfolded, there, like magic, is a pattern of considerable complexity.

More folds might be added, to create complex floral motifs with stems and leaves, butterflies, bugs, or even animals, but most birch-bark bites were rosette designs based on the three basic folds [1.49]. The coat illustrated even contains tiny dots outlining much of the patterning, which suggest bite marks.

Burnham discovered, when making measured diagrams of the coats, that their shape changed from the 17th century onward following the evolution of European fashion. Early descriptions of garments worn by Native Americans along the St Lawrence River note that they often had removable sleeves and that men and women wore the same type of clothing. Yet, by 1700, Native women were producing coats with permanent sleeves worn only by men. Those from the early 18th century have a relatively straight cut, which corresponds to costumes worn by French men along the St Lawrence at that time. By the second half of the 18th century the caribou coats were marked by a distinct flare, also found in European fashion at that time. By the middle of the 19th century the cut had slimmed down once again, just as had European military apparel. This appearance of a special class of clothing worn only by men may have been one effect of the increasing pressure brought to bear on Native communities by the missionaries to adopt patriarchal social arrangements.

These changes in indigenous fashion were undoubtedly the result, in part, of the exchange of clothes as gifts between the French and indigenous male leaders. The son of one such leader returned from France to Quebec in 1639 with six suits of clothes, three of which he gave away to other high-ranking men in his community. All were stored with the Jesuits and worn only

1.49 Angélique Merasty, Cree (1924–96): birch-bark bites, late 20th century
Royal Ontario Museum, Toronto

during important processions honoring the king. The British too exchanged clothes as gifts with the Iroquois and other Native American allies. Local women who saw the foreign coats may have been inspired by their design and symbolic significance in ceremonies marking special occasions. The products of Native women's labor were also appreciated in Europe, whether as painted caribou-hide robes or as unpainted prepared caribou skins transformed into French high fashion.

The Exploration of the Mississippi and Mississippian Culture

Monuments to Death:
Burial Mounds and Effigy Funeral Vessels

While the majority of French settlers remained in the St Lawrence River Valley around the towns of Quebec and Montreal, several explorers pushed on to the Great Lakes and down the Missouri, Ohio, and Mississippi rivers. Robert Cavelier, Sieur de La Salle, worked his way down the length of the Mississippi in 1682 and claimed the entire river basin for France. In 1718 Jean-Baptiste Le Moyne, Sieur de Bienville, founded the city of New Orleans. In the course of their explorations they moved through territory filled not only with indigenous peoples, but also with the impressive archaeological remains of these peoples' ancestors.

The most visible of these remains were large mounds of earth, most of which were used as burial sites. Archaeologists have identified a culture that flourished between *c.* 200 BCE and 400 CE, characterized by enormous earthworks—clusters of mounds and enclosures that sometimes extended over many acres—which they named Hopewell, after a farm in Ohio. The best-known of these earthworks is the Great Serpent Mound in Ohio [1.50], 1,254 feet (382 meters) long. Recent carbon dating has suggested, however, that the mound—which was not a burial site—may have been constructed later, around 1070 CE, making it a part of the Mississippian culture discussed below. While the Ohio River Valley was its center, Hopewell culture spread over much of the Midwest, with another focus in Illinois along the Mississippi; through trade it influenced much of eastern North America. Within the mounds were objects made from a variety of materials, including marine shells, obsidian, shark and alligator teeth, and meteoric iron; there were copper ear spools, representational forms cut out of sheets of mica [1.51], and clay and stone figurines and pipes.

Some burials were much more elaborately decorated than those around them, suggesting Hopewell society was organized into small-scale chiefdoms. A distinctive form of ceremonial pottery found throughout the lower Mississippi, in central Missouri, and in the lower Illinois Valley also suggests, according to Fagan,

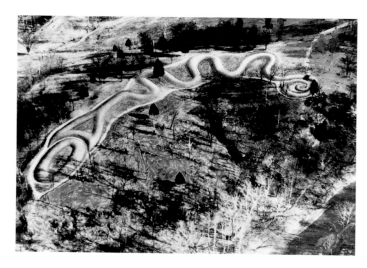

1.50 Hopewell or Mississippian: Great Serpent Mound, Hopewell, Ohio, *c.* 200 BCE–400 CE or *c.* 1070 CE

"a decorative imagery that communicated a broadly similar ritual message in many different, widely separated areas." The pottery took the form of small, squat jars with a thickened vertical rim, decorated with bands of cross-hatched lines and curvilinear, geometric, or bird motifs [1.52]. Such avian motifs are also found on other objects made of stone, bone, copper, and shell.

It is not clear why Hopewell culture declined after 400 CE. What arose in its place, however, was a culture that produced much more impressive mound structures, an even more extensive trade network, and objects of even greater technical and aesthetic complexity. This was the Mississippian culture, which

1.51 Anonymous, Hopewell: cut-out depictions of a human hand and the claw of a bird of prey, from an unknown location in Ohio, *c.* 100–500 CE
Sheet mica, claw L 11 in. (28 cm.)
Field Museum of Natural History, Chicago, Illinois

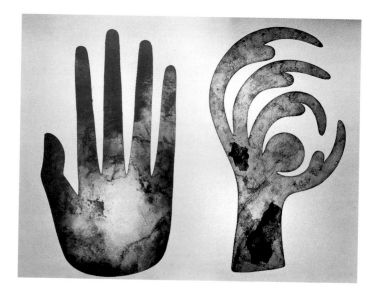

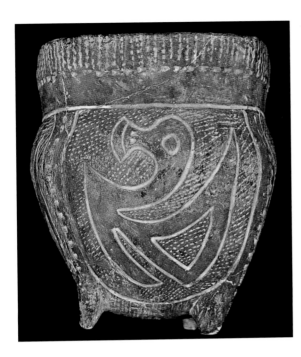

1.52 Anonymous, Hopewell: *ceremonial vessel,* found at at Mound Group City, Ross County, Ohio, 1st century CE
Clay, H 6 in. (15.4 cm.)
Ohio State Museum, Columbus

also described a scene in the village of Talomeco that was to become commonplace within the next few decades. Four of the houses contained hundreds of bodies, stacked and waiting to be either burned or buried. These bodies indicated that epidemics had already begun sweeping through the region, spread by earlier European explorers. De Soto's visit added to these epidemics; he himself died of fever before reaching Cuba.

Monuments to Life:
Cahokia and the Grand Village of the Natchez

Despite the size of many centers of Mississippian culture and the extent of its trade networks, it was not the counterpart of the contemporary state-organized societies of the Toltecs or Aztecs further south. Communities engaged in exchange, but were relatively autonomous. There are, however, a few Mississippian sites that indicate a more complex social, cultural, and political organization, the largest of which is Cahokia in Illinois, across the river from present-day St Louis.

Cahokia was named after the people the French encountered living in the area in the 18th century. At the height of its power between 1050 and 1250 CE, it covered approximately 2,000 acres (about 800 hectares) with perhaps as many as 30,000 people at any one time [1.53]. While the residences were relatively simple pole-and-thatch houses, what marks the site as distinct are the number (over one hundred) and size of the earthen mounds, many of which are located within a central walled precinct. The largest, Monks Mound (Trappist monks owned and farmed it in the 19th century), covers 16 acres (6.5 hectares) and measures 1,037 x 790 feet (316 x 241 meters) at its base; only the pyramids at Cholula and Teotihuacan in Mexico are larger. Constructed in four terraces, rising to a height of 100 feet (30 meters), with a building on the highest terrace, it faced a large plaza, which probably accommodated important civic and religious rituals.

Scholars have suggested that Cahokia was the site of a complex chiefdom, with several tiers of political hierarchy. One way in which leaders may have asserted their legitimacy is by possessing exotic objects obtained through trade, which represented their connection to supernatural powers and which were linked to ceremonial architecture and land through use in rituals. There is little evidence, however, that the leaders were able to exert their control much beyond the outskirts of the site itself. While relationships with other communities appear to have been primarily ones of trade, the existence of what look like warrior figures carved in stone or clay and of walls surrounding the ceremonial precinct suggest that at least limited warfare played a role here, and thus in Mississippian society.

Cahokia's size was undoubtedly due to both its extensive exploitation of agriculture and its location near the confluence of

flourished from 800 to 1500 CE throughout the Midwest and Southeast. Its larger centers were marked by a hierarchical political and social organization. Archaeologists speculate that the leaders of various communities oversaw the collection and redistribution of goods and foodstuffs and that their prestige depended on this activity. Some of these stockpiles reached impressive proportions, as indicated in the accounts of the travels of the Spanish explorer and governor of La Florida and Cuba, Hernando de Soto. In 1539 he took a force of 622 men to the west coast of Florida and then pushed further inland than had previous explorers, marching north into what is now South Carolina, then west through Tennessee and eastern Oklahoma, before turning south to Cuba in 1543. The peoples he encountered were organized into chiefdoms, and their villages were often marked by large earthen burial mounds, many of which were topped by temples. Both mounds and temples were filled with finely crafted objects made of mica, shell, pearls, wood, and many other materials. At Talomeco in South Carolina, the Spanish looted a large temple over 100 feet (30 meters) long and 40 feet (12 meters) wide and situated on top of a large earthen mound. Its steep roof of reeds and split cane was adorned with seashells. Inside they found wooden statues decorated with pearls, bundles of skins and dyed cloth, copper-bladed ceremonial weapons, finely inlaid bows and arrows, and wooden and woven cane shields. Those who chronicled de Soto's expedition

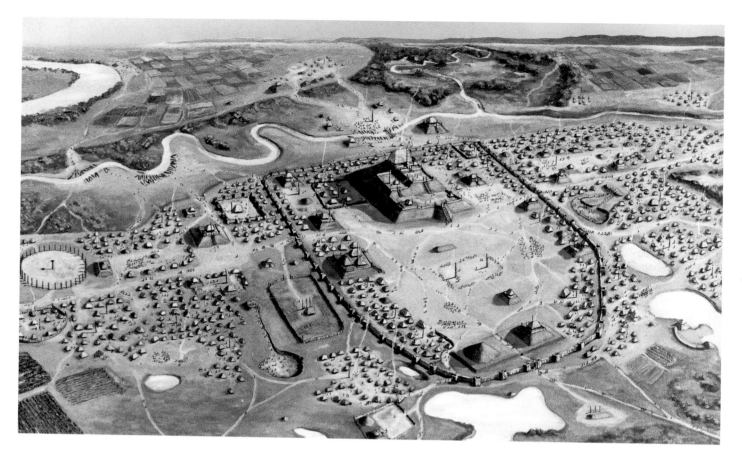

1.53 Mississippian: reconstruction of the mounds at Cahokia, Illinois, c. 1100 CE. Monks Mound is in the center

several major waterways (the Mississippi, Missouri, Illinois, Meramec, and Ohio rivers), which allowed its inhabitants to travel with relative ease as far north as the Great Lakes and as far south as the Caribbean. That they actually made such trips is suggested by the materials found in burial mounds, which include rolled sheets of copper from the Great Lakes, arrowheads of black chert from Oklahoma and Arkansas, mica from North Carolina, and carved shells from the Gulf of Mexico. Cahokia also straddled three major language families, to the south, east, and west. Thus it may have played an important role as a mediator in matters of trade, information, and the regulation of social or political relations.

The shape of Monks Mound and the layout of the central plaza [1.53] immediately bring to mind the Aztec capital of Tenochtitlan [1.6]. Monks Mound, like the pyramid shrines of Tlaloc and Huitzilopochtli, was aligned with the position of the sun at the equinoxes, suggesting that astronomical factors played a role in its design and use. Many have argued that these parallels, plus iconographic and stylistic similarities in carved and painted objects, are strong evidence of contact, chiefly through trade, with cultures in central Mexico. Fagan contends, however, that local

sources can be found for both architectural and sculptural styles, and that they are the result of trade within the Mississippian area.

One of the difficulties facing scholars today who study pre-contact cultures is amassing enough convincing evidence to make substantial claims about social and cultural patterns and influences. Adding to the difficulty in this case is the limited excavation of the Mississippian mounds and the fact that much of the early "excavations" took the form of indiscriminate looting, with little record of the original locations of the objects. As indicated in the Preface, scholars often make generalizations about cultures based on collections whose very existence may be dependent on arbitrary circumstances. Speculation is often the best that can be offered, although technological innovations such as radio-carbon dating have made it possible to piece together more reliable sets of material facts. What always eludes us, however, are the systems of thought of these peoples, whose material worlds we can partially reconstruct but whose reasons for doing or making things remain unknown.

When the French arrived Cahokia had long been abandoned, but they encountered the heirs of Mississippian culture. In 1720 Antoine Le Page du Pratz lived briefly among the Natchez, on the Lower Mississippi. Massive earthen mounds still marked the settlements, the largest of which the French christened the "Grand

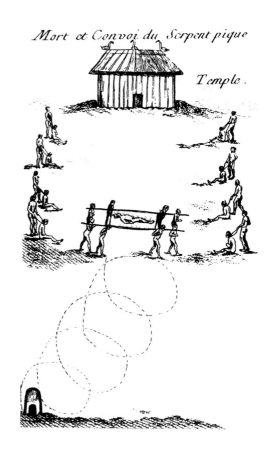

Mort et Convoi du Serpent piqué

Temple.

1.54 Antoine Le Page du Pratz: illustration depicting the funeral rites of the Natchez chief Tattooed Serpent in 1720, from Le Page's *History of Louisiana*, London, 1763

American colonies. By the 1760s they were all gone, lost through war or sold to appease public opinion, which had turned against both the King and his commitments in the New World. When Louis XVI assumed the throne in 1774, however, there was a renewed interest in this world, sparked in part by Enlightenment scholars like Jean-Jacques Rousseau, who promoted the investigation of a human history whose stages of evolution included the "good savage, child of nature."

It was at this time that the Comte d'Artois, Louis XVI's brother, established a "Cabinet," or display, of natural history to aid in the instruction of his children. Included in it, along with seashells, minerals and insects, was "the complete dress of a Canadian savage," arranged on a painter's mannequin [1.55]. Anne Vitart, in an essay on the Royal Cabinets, describes the mannequin as

dressed in a tunic made of animal hide, blue fabric leggings decorated with pearls, and moccasins, with a black feather headdress on his head, a knife in his belt, and an arrow and tomahawk "pipe" in his hands—the latter being a European-made item exchanged in alliance treaties. Above his head stood a sort of canopy with three painted hides, depicting birds, calumet feathers, tree branches, a buffalo, and a hunter.

1.55 The "Canadian Savage" displayed in the Hôtel de Sérent, Versailles Musée de l'Homme, Paris

Village." Its ceremonial center contained three large platform mounds with structures on top. The central mound is thought to have been the residence of the Natchez leader Tattooed Serpent, while the southern mound held a temple. Le Page du Pratz's account of his stay includes a description of the funeral of Tattooed Serpent, accompanied by an illustration that records the various stages of the event [1.54]. The chieftain is carried on a litter to the temple atop the earthen mound, where he is to be buried with his wives and retainers, who are all being strangled. The drawing is highly schematic, emphasizing the procedure undertaken rather than the identity of the individuals. All of the figures are represented unclothed, and Tattooed Serpent stands out from his bearers and retainers only by the slight suggestion of a crown or headdress.

Native America in Europe:
The Comte d'Artois's Cabinet of Natural History

Le Page du Pratz's description of his travels along the Lower Mississippi was published in Paris in 1758, when the French king Louis XV was losing interest in, and control over, his North

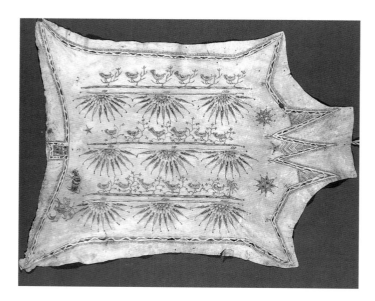

1.56 Anonymous: robe with birds and calumet motif, 18th century
Painted hide, 50¼ × 35½ in. (127.5 × 90.3 cm.)
Musée de l'Homme, Paris

These items had been among a collection purchased by the Count from M. de Fayolle, formerly an official in the American colonies. The costume and canopy probably date to the first half of the 18th century.

The three hides that create the canopy above the "Canadian savage," now in the Musée de l'Homme in Paris, display a combination of geometric and pictographic forms. Vitart notes that the painted hides produced by women in the 18th century, used primarily as robes, were usually different from those produced by men. Women created hides with geometric, abstract designs [1.48]—combinations of parallel lines, diamonds, triangles, etc.—while men utilized a more naturalistic pictographic language, narrating scenes that included recognizable human and animal forms, notably horses and buffalo. Vitart offers two possible explanations for the combination of the styles on the canopy hides. First, they could have been painted by both men and women, with each contributing their own particular form of artistic expression; robes were often used as trade items, and it is conceivable that the pictographic forms could have been added at a later date (an analysis of the paint would help resolve the question). Second, they could be the work of individuals who took on the clothes and duties of the opposite gender and who, according to Vitart, produced an intermediary style.

The majority of written accounts of such gender-mixing individuals, who existed in cultures throughout the North American continent, describe men assuming the roles of women; yet the opposite also occurred. The Pueblo peoples called both "half-men/half-women"; the Spanish referred to the men as *putos* (male whores) or *mujerados* (literally, "made women");

anthropologists later settled on *berdache*, Arabic for male prostitute. In 1711, on a mission in New France, the Jesuit Joseph-François Lafitau noted that they took part in all major religious exercises and were looked upon with great respect. One of these exercises was the ritual of the calumet (a pipe whose stem is decorated with feathers), which began among the Plains Pawnee in the 17th century before spreading east. The art historians Janet Berlo and Ruth Phillips note that in one version of the calumet ceremony the "finely carved stone bowl, usually made of red catlinite, symbolizes the earth with its feminine regenerative powers, while the long stem, decorated with porcupine quills, paint, eagle feathers and other materials, symbolizes the male energizing powers of the sky world." One of the canopy robes [1.56] includes three calumets one above the other, each paired with a pipe stem on which are positioned six birds.

The inclusion of buffalo-hunt scenes on the robe with calumets and on one of the others suggests that they came from the eastern Plains region, just west of the Great Lakes, where the French were beginning their explorations of the Missouri and Mississippi river basins. The birds resemble those in European embroidery, and it is possible that the person who painted the more geometric elements found in the decorative border and the calumets was trained in embroidery technique, perhaps at an Ursuline convent. Another 18th-century painted robe in the Musée de l'Homme provides convincing evidence that this transfer of design elements took place on at least one occasion

1.57 Anonymous: robe with Louis XIV-style motif, 18th century
Painted hide, 41½ × 40 in. (105.6 × 101.9 cm.)
Musée de l'Homme, Paris

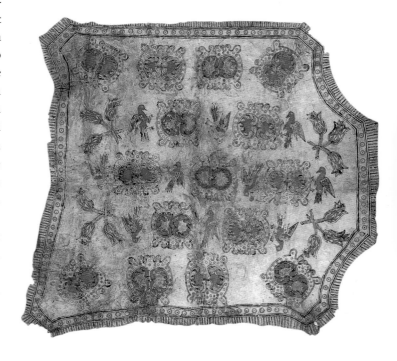

[1.57]. Here the artist has combined tulips and parrots in a motif that is recognizably drawn from the era of Louis XIV. The border of lines and circles is the only reference to the geometric tradition of women's painted robes. Vitart suggests that this hide could have been bought west of the Great Lakes and transported back to the main French settlements on the St Lawrence River, where Native American women trained in European design painted its surface. From there it may have traveled across the ocean as a gift to an official or possibly to the King himself, thus continuing a transatlantic trade in objects and ideas that had begun with the first voyages of Columbus.

A Protestant Presence in America

Picturing the "New World": Jacques Le Moyne de Morgues, John White, and Theodore de Bry

Most French settlements in the north in the 16th and 17th centuries were Catholic and were sited along the St Lawrence, Ohio, Missouri, and Mississippi river basins. In 1562, however, a small group of some 150 settlers led by Jean Ribaut attempted to establish a Protestant, or Huguenot, colony on the east coast of Florida. Landing near the mouth of the St John's River, they erected a column (one of five they had brought with them) establishing France's claim to the area before heading north and settling at a site they named Charlesfort, near present-day Beaufort, South Carolina. Ribaut returned home that year, but France's religious wars prevented his return with supplies, and the settlement was abandoned.

In 1564 René de Laudonnière returned to the area and established Fort Caroline near the mouth of the St John's River. He brought with him the artist Jacques Le Moyne de Morgues (1533–88) to map the territory. Le Moyne executed a series of gouaches of the expedition after he returned to France. The only work that survives is *René de Laudonnière and the Indian Chief Athore visit Ribaut's Column*, of c. 1570 [1.58]. Athore was the leader of the Timucuan people and is shown taking Laudonnière to see Ribaut's column. According to a written account left by the artist, this image describes a scene that took place shortly after Laudonnière's arrival. Le Moyne notes that when the French reached the column, they found the Timucuans worshiping it, having laid out offerings of food, flowers, and weapons.

The column carries the emblem of the Valois kings of France, a shield containing three fleurs-de-lis surmounted by a crown. Festooned with vines and flowers, it is surrounded by various fruits and vegetables, some of which were not native to Florida, along with a bow and arrows. These objects and the people kneeling to the left of the column with their arms raised suggest that the Timucuans are worshiping not only the column, but

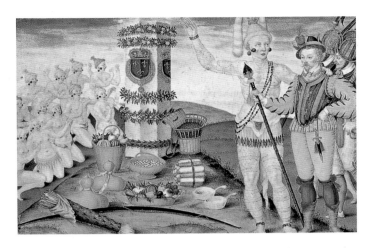

1.58 Jacques Le Moyne de Morgues: *René de Laudonnière and the Indian Chief Athore visit Ribaut's Column*, c. 1570
Gouache and metallic pigments on vellum, 7 × 10¼ in. (17.7 × 26 cm.)
The New York Public Library, New York

also the French themselves. Athore's costume and tattooing are carefully delineated, implying the accuracy of Le Moyne's observations. Yet the artist also utilized the stance and body type of Greek and Roman statues of Apollo. In contrast to the sparsely clothed Timucuans, the Frenchmen are elaborately dressed, as well as armed. Athore places his arm around the shoulders of Laudonnière, indicating his acceptance of the Frenchman. Yet Laudonnière does not return this accepting gesture and, instead, extends his lance across the body of the Timucuan chief. What cannot be gained through diplomacy will be taken by force. Laudonnière's colony was soon destroyed, however, by the Spanish under Pedro Menéndez de Avilés (the column was carried off to Havana).

The territory did not remain under Spanish dominion for long, for the British had already begun making plans to extend their empire across the Atlantic. In addition to the desire to exploit the still unknown resources of this new continent, they wanted to establish a Protestant commonwealth to counterbalance the Hispanic Catholic empire already in place. John Cabot had explored the northern reaches of North America in 1497, but England did not stake claim to this territory, in particular Newfoundland, until 1583. The claim was an attempt to control the cod fishing in the area; no permanent settlements were founded. An effort was made in 1585 under the command of Sir Richard Grenville to establish a settlement on a small island off the northeast coast of North Carolina named by the settlers Roanoke. The larger territory claimed by the expedition, occupied by Algonquian peoples, was designated "Virginia," after the Virgin Queen, Elizabeth I. The initial group of settlers returned to England in 1586 but was followed by another in 1587, which subsequently vanished without a trace.

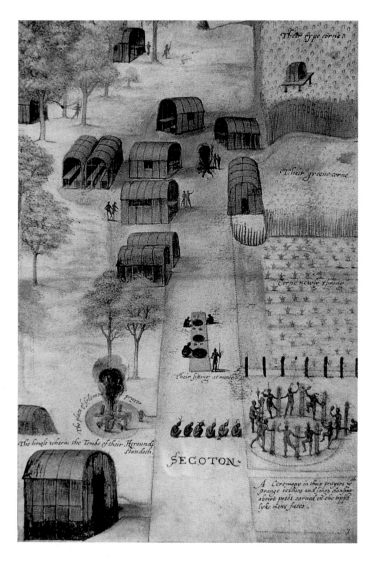

1.59 John White: *The Village of Secoton, c.* 1585
Watercolor on paper, 12¾ × 7¾ in. (32.4 × 19.9 cm.)
British Museum, London

1.60 John White: *Indians Dancing, c.* 1585
Watercolor on paper, 10¾ × 14 in. (27.4 × 35.6 cm.)
British Museum, London

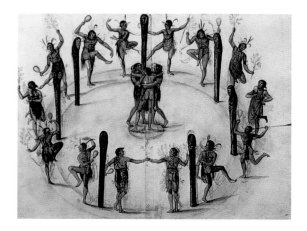

The 1585 Roanoke expedition included an artist, John White (active 1585–93), who executed watercolors of the people, flora, and fauna of the new territory, and who became the leader of the 1587 expedition. White had known Le Moyne, as the latter had left France for England around 1580 and entered the employ of Sir Walter Raleigh, who was responsible for sending the Roanoke expedition across the Atlantic. The scientist Thomas Harriot, another member of the 1585 group, provided an account to accompany the watercolors. Like Le Moyne, White paid close attention to the physical appearance and costumes of the people he encountered, as well as their architecture. His images would provide valuable information for those in England who planned on increasing the number of settlers in Virginia.

One of White's watercolors, an overview of the Algonquian village of Secoton [1.59], located on the Pamlico River in North Carolina, contains a clear indication of the structure of the houses, with their barrel-shaped roofs, wood frames, and mat coverings, and the carefully planted fields. Like the Iroquois longhouse only usually much smaller, such oblong or round dome-shaped huts were known as wigwams and were common among the peoples of the eastern woodlands and as far west as the Mississippi River (in northern New England and southern Canada, however, the term "wigwam" referred to a conical bark-covered structure framed with straight poles). The ceremony depicted in the lower right-hand corner, which White reproduced in a separate drawing entitled *Indians Dancing* [1.60], also gives an indication of the type of artistic activities that took place in the village, for the posts arranged in a circle around which people are dancing are carved at their tops with human faces.

White went back to England shortly after the second expedition arrived on Roanoke in order to obtain more supplies. He was unable to return to Virginia, however, until 1590 because of the threat of the Spanish Armada. When he did manage to make it ashore on Roanoke, no one was to be found. Interest in White's expeditions was kept alive by Theodore de Bry's publication in 1590 of *A briefe and true report of the new found land of Virginia*, Harriot's narrative account, illustrated by engravings after White's watercolors. While the engravings are for the most part faithful, there are certain significant differences. Paul Hulton, in *America 1585: The Complete Drawings of John White*, attributes some of these changes to de Bry's use of Le Moyne's drawings for certain background and costume details (e.g. a Timucuan headdress appears on an Algonquian idol).

In at least one instance, it is obvious that de Bry had a problem with the postures of White's figures. In White's watercolor of a man and woman eating a meal, the two sit on the ground in

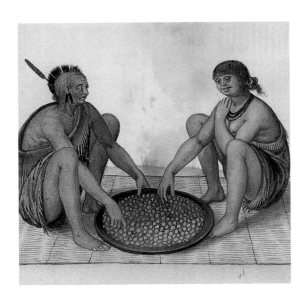

1.61 John White: *Theire Sitting at meate* (detail), c. 1585
Watercolor on paper, whole image 8¼ × 8½ in. (20.9 × 21.4 cm.)
British Museum, London

a squatting position, with their hands reaching out between their knees [1.61]. In the engraved version the legs of both figures are stretched out before them [1.62]. Hulton suggests that de Bry "could not accept" the squatting position because "it was outside his experience." Thus, he engraved the figures "with their legs stretched out before them in European fashion." But certainly much of what de Bry saw—and faithfully copied—in White's watercolors was "outside his experience." It is possible, instead, that his alterations were prompted by formal considerations, which had ideological implications. By stretching the legs outward, de Bry creates a more elongated and elegant

1.62 After John White: "Theire sitting at meate"
Engraving in Theodore de Bry, *A briefe and true report of the new found land of Virginia*, Frankfurt, 1590

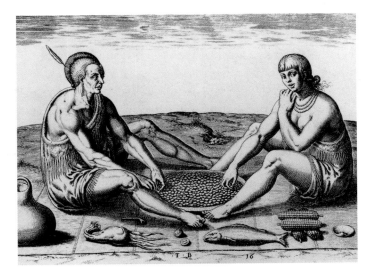

composition. The torsos and the limbs of the figures are more clearly articulated, with the musculature on the male figure highlighted, in the exaggerated style of figuration popular at the time in Europe (de Bry does this in most of his engravings after White's watercolors). He has also changed the features and expression of the female figure. In the watercolor she looks with a smile at the plate of food, anticipating her own pleasure, whereas in the engraving she looks seductively out at us, anticipating our pleasure in looking at her.

White was concerned with recording as accurately as possible the physical characteristics, clothing, and customs of the Algonquians; de Bry was concerned with creating a set of images that would be inviting to look at and that would justify Protestant colonizing ventures (and condemn those of the Spanish) in the Americas (see also pp. 19–20). The female Algonquian, rendered more in keeping with classical ideas of beauty, becomes one of an endless stream of representations of nude or seminude Native women, often intended to symbolize the 'New World' as a whole, who invite male European conquerors to take possession of their bodies and their resources.

Early Settlements: Jamestown and Plymouth

John Smith established the first successful British colony in 1607 at a site he named Jamestown after the King of England. Its funders, the Virginia Company, a joint-stock company set up by British merchants and gentry, intended it as a source of crops for export to England, while Smith viewed it as a stop on the way to the Pacific Ocean (he was still searching for a northwest passage); his men saw it as a source of immediate wealth, preferably gold or other precious minerals. None of these hopes would be realized. Instead, Smith and his men faced the reality of backbreaking labor, disease, and hunger.

The site Smith had chosen for his new settlement was part of the territory controlled by an Algonquian-speaking confederacy of tribes known as the Powhatan, ruled by a patriarchal leader also known as Powhatan. The peoples of this confederacy belonged to the Mississippian culture, so their villages included temples that were closely associated with the treasure houses of ruling families and were filled with various decorated objects made of skins, copper, pearls, and beads. John Smith observed that the leader's treasure house included at its four corners "4 Images as Sentinels, one of a Dragon another of a Beare, the 3rd like a leopard, and the fourth like a giantlike man." These images were probably carved on wooden poles, similar to the ones depicted in John White's watercolor *Indians Dancing* [1.60].

Smith's description has been used to help decipher the meaning of a finely decorated deerskin known as "Powhatan's

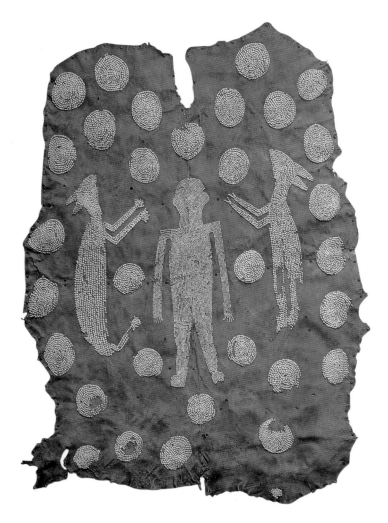

1.63 Anonymous, Powhatan: "Powhatan's Mantle," before 1656
Hide, embroidered with shells, 92½ × 63 in. (234.9 × 160 cm.)
Ashmolean Museum, Oxford, UK

Mantle" [1.63]. Four tanned hides of white-tailed deer have been sewn together and decorated with *Marginella* shell beadwork. The beads form several circles and three figures—a human in the center flanked by two animals. The animal on the right, with cloven hooves, could represent a white-tailed deer; that on the left, with round paws and a long tail, could be a mountain lion of the kind found in eastern Virginia. In the Tradescant Collection in England not long after Smith's time, the mantle was catalogued in 1656 as that of Powhatan. The art historian Christian Feest suggests that the feline and human figures could correspond to two of the four images found at Powhatan's treasure-house, although the connection is still tenuous. Nevertheless, the mantle does represent one type of ceremonial garment created by the Powhatan in the early 17th century.

The historian Gary Nash notes that from the very beginning in Virginia "some Indians lived among the English as day laborers, while a number of settlers fled to Indian villages rather than endure the rigors of life among the autocratic English." Such friendly relations, however, did not last. Food shortages, illness, and internal dissension among the colonists, plus increasing hostility from an indigenous population who had already experienced the treachery of earlier European visitors, led several colonists to initiate attacks on the Powhatan and any colonists who sympathized with them.

Peace was restored in 1614 after the president of the colony had held a young Powhatan girl named Pocahontas captive for two years. During the negotiations for her return, she decided to stay with the English, convert to Christianity, and marry the colonist John Rolfe. Her decision would be commemorated in numerous books, images [1.65] and feature-length films. Ultimately, the colony flourished, due largely to Rolfe's discovery, with the aid of Pocahontas and her people, that tobacco grew well in the Virginia climate. It was planted and harvested primarily by indentured servants, Native Americans, and, later, African slaves (the first Africans were brought to Jamestown in 1619 on a Dutch ship as indentured servants).

Ousted as president of Jamestown, Smith embarked on another voyage of exploration in 1614, this time along the northern Atlantic coast, a territory he named New England. This area would soon see its first permanent settlement at a site also named by Smith, Plymouth. The Puritans who established New Plymouth in 1620—they called themselves Pilgrims—were part of the Protestant Reformation that had spread throughout Europe in the 16th century. While King Henry VIII broke with Rome in 1534 and declared himself head of the Church of England, the church he established steered a middle ground between Roman Catholicism and Protestant reform movements like the Puritans. The latter were critical of what they saw as the extravagance of the Church of England and, as a result, suffered religious and political persecution.

The Pilgrims left England in 1608, traveling first to the Dutch Netherlands before continuing on to North America. The Dutch had flourished with independence from Spain and had become a successful manufacturing and trading Protestant nation. They had founded a colony in 1614 at Fort Nassau (Albany, New York), and certain Dutch businessmen were interested in backing a group to establish a second trading colony on the island of Manhattan. The Pilgrims were not interested, however, in establishing a "New Amsterdam" (that colony would be founded in 1624); instead, they accepted the backing of British merchants and a royal charter from the King of England, and arrived in New England in 1620 along with many non-Pilgrims (according to Loewen, only approximately 35 of the 102 settlers aboard the *Mayflower* were Pilgrims).

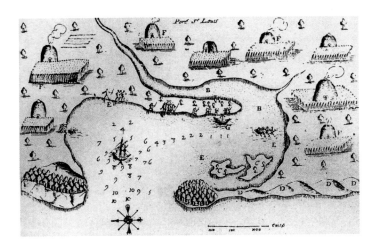

1.64 Samuel de Champlain: map of Patuxet (Plymouth), 1605 From Champlain's *Les Voyages*, 1613

The expedition may have had in its possession a map of the site of Patuxet (Plymouth) drawn by Samuel de Champlain in 1605 [1.64], before the plague of 1617 that wiped out the village. The map shows an orderly arrangement of wigwams and planted fields. Upon their arrival, the Pilgrims found not only a fine harbor and abundant supply of fresh water, but the remains of cleared fields recently planted in corn and local stores of corn and beans, which they raided to use as seed (these discoveries undoubtedly helped reconcile them to the fact that they had been blown off course and arrived not in Virginia, their intended destination, but hundreds of miles to the north). They also had the help of a Wampanoag named Squanto, who had been kidnapped and taken to England in 1614, but managed to make his way back to his village of Patuxet, only to find it decimated by disease. When the first British settlers arrived, he taught them local methods of planting and fishing and how to adapt to the new climate and geography.

Most Puritans who formed the Plymouth Colony, and, in 1629, the Massachusetts Bay Company colony centered in Boston, came from medieval villages and cities, not from large Renaissance urban centers. They came as family units rather than single men as in Jamestown, and were a combination of homemakers, yeomen, middle-class merchants, intellectuals, and ministers. Initially ministers dominated the governing of the settlements, but soon merchants and planters took control, a shift easily justified by a religion that advocated the importance of both individual freedom and material prosperity. A decisive blow to the power of Puritan clergymen came in 1691, when Massachusetts became a royal colony with an appointed governor and voting rights based on property rather than church membership.

The Puritan community itself also began to break up into competing factions, that vied for both civic and religious authority. By the mid-18th century, the colonies were home to several Protestant sects, including Congregationalists, Moravians, Quakers, Methodists, and Presbyterians, as well as Roman Catholics and a small number of Jews. In addition, colonists who were not Puritans seeking religious freedom, but individuals looking only to make their fortune, continued to arrive. By the 1630s several new settlements were being established (e.g. Providence, Newport, New Haven) to accommodate not only the increasing population, but also diverging religious beliefs and economic ambitions. This expansion into lands occupied by the Pequots and Narragansetts resulted in a series of armed conflicts and in one of the most infamous massacres in early American history. In 1637, after declaring war on the Pequots, troops from the Massachusetts and Connecticut colonies, led by Captain John Mason, surrounded the Pequots' coastal village at the mouth of the Mystic River, where some four hundred women, children, and old men had taken refuge, and burned it to the ground, killing all who tried to escape.

The Art and Architecture of the British and Dutch Colonies

Art, Religion, and Politics in 17th-Century New England

The relationship between religion and art in New England was very different from that in New Spain and New France. As Wayne Craven notes in his book *Colonial American Portraiture*, the focus of Protestantism was literary, not visual, expression. The chief means of religious teaching were the sermon and the reading of the Bible. The visual arts were condemned in the context of religious services, particularly images representing God, angels, or other spiritual beings. As the prominent Protestant 16th-century theologian and reformer John Calvin had written, "Only those things are to be sculpted or painted which the eyes are capable of seeing." This rejection of religious imagery was part of the larger Protestant critique of the opulence and corruption of the Roman Catholic Church.

Protestants did not condemn the use of images in secular contexts, and even sometimes found historical biblical scenes acceptable in the home as inspirational aids and as testaments to the truth of the Bible. There was a certain amount of suspicion in England, however, of the art produced for the royal court under the reign of Charles I (r. 1625–49). Charles was an avid patron of the arts and turned increasingly to the Continent for artists to adorn the royal residences, commissioning works from such notables as the Flemish painters Anthony Van Dyck (1599–1641) and Peter Paul Rubens (1577–1640). In 1632 Van

1.65 Simon van de Passe: *Pocahontas*, c. 1616
Engraving, 6⅝ × 4⅝ in. (165.1 × 114.3 cm.)
British Museum, London

Dyck was appointed court portraitist and executed a series of elegant and full-bodied likenesses of the King and Queen. Queen Henrietta Maria was a French Catholic who sponsored extravagant theatrical displays, two facts that increased Puritan distrust of the royal court. According to Craven, many within the gentry and merchant class supported an earlier and more subdued style of portraiture that marked the reigns of Queen Elizabeth I (r. 1558–1603) and King James I (r. 1603–25), with its shallow spaces, minimal shading or other indications of physical depth, and emphasis on detailed decorative patterning.

The engraved portrait of Pocahontas of *c.* 1616 by the Dutch artist Simon van de Passe (*c.* 1595–*c.* 1647) exhibits all of these characteristics [1.65]. Van de Passe spent many years working in England creating both portraits and maps. He executed the engraving of Pocahontas during her visit to London, when John Rolfe introduced her to the court of James I as an example of the success of the new colony of Virginia and of the efforts to convert the peoples of America to Christianity. There is little in her physical appearance, save perhaps the feathered fan in her right hand and the suggestion of dark skin, to indicate her identity as a Native American. Instead, she wears an English costume. The text surrounding the image, however, contains both her Native name, Matoaka (Pocahontas was actually a nickname—her given name was Matoax or Matoaka) and her English name, Rebecca. Pocahontas died of smallpox in 1617 before she was able to return to Virginia.

Displays of Status:
Portraiture and Domestic Spaces in New England

The Puritans who arrived in America in the middle of the 17th century brought with them, therefore, a rejection of art in the context of religious services; many also preferred the Elizabethan-Jacobean style of portraiture. Painting in New England appears to have begun in the 1660s; approximately forty portraits of merchants, ministers, civil officials, and their families remain from the 17th century. Craven points out that these were not the work of amateurish hacks, but of trained artists who came to New England, as did many others, to seek their fortunes. Because of the limited population in the British colonies, artists often had to supplement their income with more utilitarian tasks, such as the painting of signs for businesses.

Two of the best-known and best-studied portraits from this era are of John and Elizabeth Freake and their child Mary [1.66, 1.67]. They were painted around 1671, with Mary added to Elizabeth's portrait in 1674, the year she was born. The complex and layered meanings of these two works are informed by the background of the Freake family and the political situation at the time. John Freake (1635–75) was born in England and came to Boston around 1658. He soon prospered as a merchant and a lawyer, owning two houses, a brewhouse, a mill, land, and part interest in six ships. In 1661 he married Elizabeth Clarke (1642–1713), daughter of the Boston merchant Thomas Clarke.

The paintings [1.66, 1.67] were meant as celebrations of marital domesticity, family lineage, and social position. They also represented the piety of the Freakes and, in the process, the Calvinist doctrine of prosperity. Because of the ban on public religious imagery, one could not reveal one's devotion through the commissioning of altarpieces or other public religious works of art. Images of material prosperity, however, could fill in as signs of piety, for, according to Calvin, God looked with favor on those who worked hard and kept the faith. In addition, as John Freake was among the merchants of Boston who were attempting to break the control of the ministers within the colony, he could use paintings as a way to justify on his own terms his rising prosperity. Displaying one's wealth within a painting in New England was not that simple, however, for while Calvin preached that the devout would prosper, he also condemned lavish or ostentatious displays of this prosperity. There was much argument in the colonies, therefore, over where the line should be drawn between moderation and ostentation. As the wealth of the merchant class grew, its members often got around or ignored the laws set by clergy, in particular those laws governing dress. In his portrait, John

1.66 Artist unknown: *John Freake*, c. 1671 and 1674
Oil on canvas, 42½ × 36¾ in. (108 × 93 cm.)
Worcester Art Museum, Worcester, Massachusetts

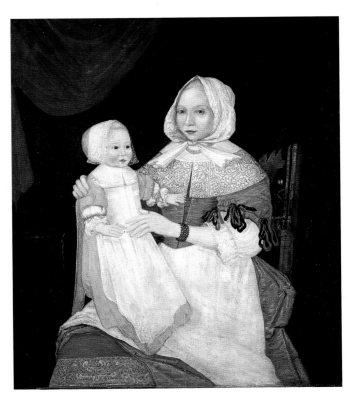

1.67 Artist unknown: *Elizabeth Freake and Baby Mary*, c. 1671 and 1674
Oil on canvas, 42½ × 36¾ in. (108 × 93 cm.)
Worcester Art Museum, Worcester, Massachusetts

Freake is dressed in a refined, but not extravagant, manner [1.66]. His coat is a rich velvet brown, not the black of the Puritan garb. This rich brown sets off the fine lace collar and the white cuffs and gloves, as well as the gold ring, ornate brooch and polished silver buttons. The background is also a rich brown, devoid of objects, so that our attention is drawn first to the bright white of the lace and cuffs, and then to the confident, self-satisfied expression of Freake himself.

Another important detail in this painting is the length of John Freake's hair. Long hair was viewed by the Puritans as a sign of decadence, a mark of royalist sympathies; it was also associated with a suspect sympathy for Native peoples. Men in New England were regularly fined for sporting long hair. Short hair, on the other hand, was a mark of the Puritan clergy, and it was also imposed on the lower classes. Thus hair, like dress, was a sign of class. John Freake's shoulder-length hair is, like his dress, somewhere in between the two extremes.

Elizabeth Freake and baby Mary are much more colorfully and elaborately clothed [1.67]. Elizabeth sports a triple strand of pearls, a four-strand garnet bracelet, and a gold ring. Her satin dress is decorated with fine lace and bows. The materials and jewels were probably imported, the satin from France, the

lace from Spain, Venice, or the Netherlands, the brocade from England, the pearls from the Far East, and the garnets from India. Her costume is thus a catalogue of merchant trade of the late 17th century, and a symbol of resistance to the limits the British crown attempted to impose on its colonial traders.

The inclusion of a chair and drapery allows the artist to indicate the extent of the Freake wealth beyond the costumes of the sitters. Elizabeth sits on a Turkey-work chair, whose upholstery imitates the patterns of Turkish carpeting. This chair was the most expensive type in the region at the time. A swag of drapery appears in the upper left, possibly an allusion to the elegant interiors of more aristocratic households but more likely a reference to Dutch 17th-century paintings of domestic interiors, where the drama of domestic bliss is revealed behind a theatrical curtain. The association between domestic harmony and national harmony was promoted in both New England and the Netherlands.

The first permanent homes built by the settlers of New England were of timber post-and-beam construction with horizontal planks for the exterior. Most were a story and a half, with a loft accessible by steep stairs or a ladder. The main floor contained either a single large room or two separate

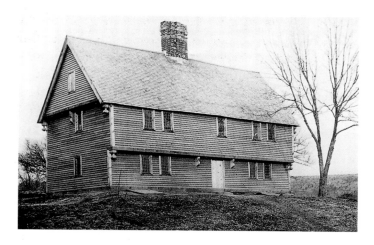

1.68 Parson Capen House, Topsfield, Massachusetts, 1683

rooms, one for general activities and the other doubling as a "parlor" and master bedroom. Visitors would enter directly into one of these rooms from the outside. Smaller rooms were often added at the rear and the slope of the roof extended over them toward the ground, creating what came to be referred to as a "saltbox" house.

An example of a larger two-and-a-half-story structure from the late 17th century is the Parson Capen House of Topsfield, Massachusetts, built in 1683 by the community for the Reverend Joseph Capen [**1.68**]. An imposing, albeit plain, building for its time, it stood on the town common as a statement of the power of the clergy. Such houses were the products of carpenter-craftsmen rather than trained architects and were

1.69 St Luke's, Isle of Wight County, Virginia, 1632

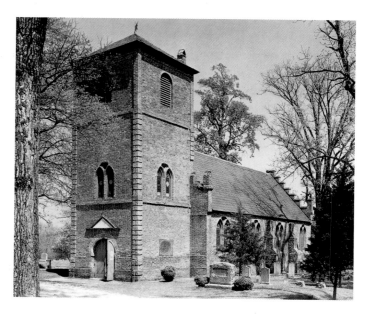

simple in form, with a steeply pitched roof and little exterior decoration—limited here to the deep overhangs of the second story and roof and the pendants beneath them. The design was reminiscent of many medieval merchants' houses in England.

The art historian Michael J. Lewis notes that Puritan towns were often laid out according to the model of the New Jerusalem, "the perfected city that would arise after the second coming of Christ, as described in the Book of Revelation." This city was rectilinear in plan, "recalling other gridded settlements in the Bible where divine order was expressed through right angles." This is not to say that all gridded cities embodied the New Jerusalem; the grid had been used extensively throughout Renaissance Europe and in the Spanish American colonies. "But," according to Lewis, "these Spanish grids lacked the religious theme of the Puritan town plan, which was a diagram of moral order and not merely a convenient system for the equable division of real estate." As such, the Puritan town paralleled the city of Tenochtitlan, whose plan embodied the Aztec social and religious universe (see pp. 20–21).

Because Puritans viewed the entire community as holy, little emphasis was given to the design of the meeting house or place of worship, although it was often placed on high ground, like the Parson Capen House, to indicate the importance of events that took place within. The facades and interiors of these primarily wooden structures were plain, with the pulpit often located in the center of the hall. The situation was different in the South, where the charter of the Virginia Company made the Church of England official, and churches were constructed. Most of the approximately fifty built in the 17th century were simple parish churches made of wood. The only one still standing, St Luke's in Isle of Wight County [**1.69**], built of masonry in 1632, provides an indication of the architectural features that connected these churches to the religious architecture of medieval England—an entrance tower at the west end leading to a single nave, buttresses along the sides of the nave, and windows filled with two pointed arches.

Colonial homes required interior furnishings, which were made locally as well as imported. Almost all designs in New England furniture before 1680 were borrowed from Europe, and in particular from London. By the close of the century, however, with increased prosperity gained largely through international commerce, designs from other parts of the world began to appear, particularly in decorative detailing. They were often transformed by colonial craftspeople, most of whom had been trained in medieval woodworking traditions, into new syncretic forms specific to life and circumstances in the northeastern part of North America. According to the folk-art historians Robert Bishop and Jacqueline M. Atkins, two general

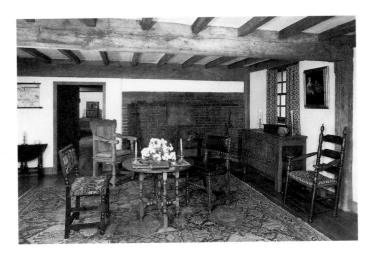

1.70 Oyster Bay Room, 17th century
The Henry Francis du Pont Winterthur Museum, Winterthur, Delaware

schemes existed: "high style (or that most akin to the imported prototypes), to which everyone with pretensions and financial ability aspired, and a popular style, or one that was based on a formal prototype and then simplified and modified by self-taught craftsmen, artists, and artisans."

The main hall of the Freake home may well have resembled the reconstruction of a 17th-century interior by the Winterthur Museum [1.70], with its Turkey-work chair, oak table, carved chest, and portrait on the wall. A fine piece made by a local furniture-maker in Northampton, Massachusetts, is the Esther Lyman Chest (1712–22) [1.71]. Much of its original red

1.71 Erastus Banks (?): the Esther Lyman Chest, 1712–22, from Northampton, Massachusetts
Painted wood, 34 × 45 × 18¾ in. (86.4 × 114.3 × 47.6 cm.)
Private collection

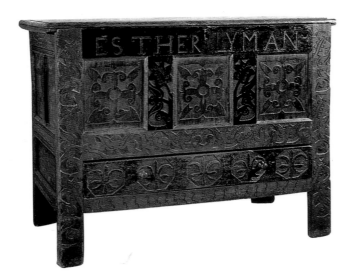

and black paint survives. Painting (often used to cover up inexpensive wood or rough construction) was particularly popular in conjunction with carving for chests in New England. Here the construction is quite simple and the bold decorative floral forms are carved in low relief. The name of the owner—Esther Lyman—is prominently carved across the front, while the name Erastus Banks, possibly the maker, appears on the bottom of the drawer and across the back.

The Esther Lyman Chest was probably meant to hold part of a girl's dowry, perhaps bed furnishings and clothing, to be taken to her new home once she married. It is an example of a type of early 18th-century carved furniture, known as Hadley, found throughout the Connecticut Valley between 1675 and 1740. These items share a decorative motif, a carved tulip-and-leaf pattern on the outer front panels, which may have been drawn from a late Elizabethan-Renaissance style of ornamental carving produced in Massachusetts by an immigrant Englishman named William Searle. The design was then picked up by other craftsmen, who created their own versions, adding scrolls, fleurs-de-lis, and meandering vines. Other chests had painted decoration only, which included buildings and landscapes as well as floral elements. Their legs are often more elegantly shaped and their edges more carefully finished, suggesting that their makers were more concerned with aspiring to the "high style" of furniture than the maker of Esther Lyman's chest.

The Dutch Influence in Architecture and Portraits

Another influence detectable in 17th-century New England portraiture, architecture, and home furnishings comes from the Dutch Netherlands. For example, in the Freake portraits [1.66, 1.67], while the Elizabethan-Jacobean tradition is present in the linear two-dimensionality, the shallow space, and the attention to detail, Dutch painting conventions can be found not only in the swag of drapery mentioned above, but also in the somewhat more naturalistic modeling of the faces. The Dutch influence was not simply the result of the transfer of images from the Netherlands to New England. It was also due to the presence of the Dutch themselves in the New World. The first colony, Fort Nassau (Albany, New York), established in 1614, was followed by a second in 1624, New Amsterdam, which was intended to control the trade between Virginia and Plymouth. Its focus was profit, not religion, and those who prospered constructed homes whose interiors were decorated with numerous prints and paintings.

Few of these early pictures survive today. One of the best-preserved is a portrait of *Governor Peter Stuyvesant*, painted around 1663 and attributed to the Dutch artist Henri Couturier

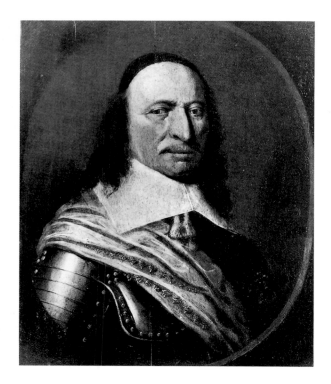

1.72 Attributed to Henri Couturier: *Governor Peter Stuyvesant, c.* 1663
Oil on wood panel, 21½ × 17½ in. (54.6 × 44.4 cm.)
Courtesy The New-York Historical Society, New York City

[1.72], who emigrated to colonial America in 1660, living briefly in New Amstel (New Castle, Delaware) before moving to New Amsterdam. It is certainly very different from the portrait of John Freake [1.66]. The figure is fully modeled, positioned convincingly within a three-dimensional space, and wearing armor whose sheen suggests the hardness of the metal. If Stuyvesant looks somewhat concerned it was no doubt because

1.73 View of the waterfront of New Amsterdam showing the Stadthuys of 1641–42
Lithograph by George Hayward after a sketch by Adrian Danckers of 1679, 19th century
The New York Public Library, New York

of the seemingly impossible task that faced him as he took over the governorship of the colony in 1647.

New Amsterdam was, by all accounts, highly unorganized, with everyone competing for profits and little interest in establishing communal organizations or defenses. The town's architecture was marked by distinctive Dutch brick row houses with crow-stepped gables, seen in a lithograph made from a 1679 sketch by Adrian Danckers [1.73]; the large stone building in the center is the Stadthuys or town hall, built in 1641–42. Alcohol flowed freely and trade with the Iroquois was haphazard. Stuyvesant controlled the sale of alcohol, organized trade with the Iroquois, and negotiated the Treaty of Hartford in 1650 with the British, who were encroaching on Dutch territory and who ultimately declared war in 1652 in an attempt to gain control of trade in the region. Skirmishes with the British to the north and the Swedes to the south continued over the next decade. New Amsterdam finally surrendered to the British in 1664 and the town was renamed New York.

Another portrait from the 17th century attests to this mix of Dutch and British in the New World, the *Self-portrait* painted by Thomas Smith (d. *c.* 1691) in *c.* 1680 [1.74]. The image is much busier than those examined thus far. It includes not only a human figure modeled fully in the round, and evidence of the furnishings within the room, but also a seascape viewed out the

1.74 Thomas Smith: *Self-portrait, c.* 1680
Oil on canvas, 24½ × 23¾ in. (62.9 × 60.4 cm.)
Worcester Art Museum, Worcester, Massachusetts

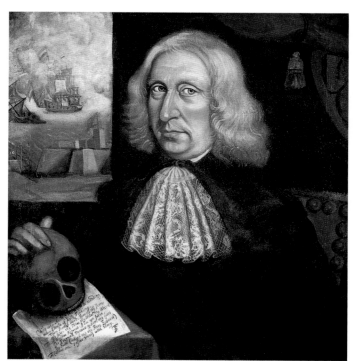

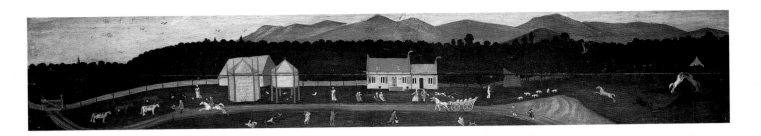

window and a still life composed of a skull and a sheet of paper containing a poem. The art historian Roger Stein notes that despite its relatively small size, it has a commanding presence, due in no small part to the poem resting beneath the skull, which is tipped up so as to be more easily read:

> Why, why should I the World be minding
> therin a World of Evils Finding
> Then Farewell World: Farewell thy Jarres
> thy Joies thy Toies thy Wiles thy Warrs
> Truth Sounds Retreat: I am not Sorye
> The Eternall Drawes to him my heart
> By Faith (which can thy Force Subvert)
> To Crowne me (after Grace) with Glory.

The melancholic tone of the poem, with its focus on aging and past glories, is reinforced by the presence of the skull (which appears to "speak" the words), turning the self-portrait into a *vanitas* or *memento mori* image with the message "remember that thou shalt die," where the conceptual, or the contemplation of death, outweighs the perceptual or worldly appearances.

Thomas Smith was a mariner who came to New England from Bermuda round 1650. A sailor by profession, he also painted and, at his death, was a wealthy man. His wealth did not prevent—and perhaps even encouraged—his philosophical ruminations on his eventual death, ruminations that appear both in the poem and in the painting itself. Smith presents his worldly self—his own full-bodied presence, the fine lace, and the naval exploits in which he took part (the ships in the distance are identifiable as Dutch and English; the fortress flag bearing the three crescents suggests that the scene may represent the joint British/Dutch attack on Cape Spartal on the African coast in 1670). At the same time he denies that self with the poem. Ultimately, he suggests that one can participate fully in worldly events and, in the afterlife, inhabit a spiritual world. The poem allows the religious elements of piety and transformation into the picture without representing saints or Christ himself, thus conforming to the Calvinist admonition not to paint what one cannot see.

Evidence of the Dutch presence in early 18th-century New England can be seen in a large overmantel painting of 1732–33

1.75 Attributed to John Heaten: overmantel from the Marten Van Bergen House, Leeds, Greene County, New York, 1732–33
Oil on wood, 15¼ × 87½ in. (38.7 × 222.2 cm.)
New York State Historical Association, Cooperstown

attributed to John Heaten and found in the Marten Van Bergen homestead in Leeds, Greene County, New York [1.75]. The rich detail of the picture, with the Catskill Mountains in the background, allows us access to both the architecture and the activities of the Van Bergen farm and its inhabitants. Heaten's overmantel documents not only members of the family but also two white servants, four African slaves, and two Native Americans, possibly members of the Catskill or Esopus peoples. Slave-holding was practiced in the Hudson Valley in the 18th century, and it is known that Mrs Van Bergen received a slave as a wedding present from her father. It is not clear whether the Native Americans are also part of the farm's labor force, but the use of indigenous peoples as slaves as early as the 1630s in New England raises the possibility that they are.

The farmhouse is constructed of stone with a tile roof, building materials preferred by Dutch settlers over the wood used by the British (the roof of the kitchen addition is, however, made of wood shingles). The steep-pitched roof with dormer windows and the chimneys in the end walls were also characteristic of Dutch farmhouse architecture. There are a barn and two hay barracks, of a kind distinct to this area, built so that the roof and floors could be lowered or raised to protect the hay (prototypes are known in Europe).

Aristocratic Pretensions in the South

In the 17th century, the southern colonies tended to be royalist and Episcopalian or Church of England, supporting the crown during the Civil War of 1642–51 in England (colonial Puritans backed the successful forces of the Puritan leader Oliver Cromwell). The plantation lifestyle enabled an aristocratic social and political structure, which was reinforced with the large-scale importation of African slave labor. The slave population numbered 15,000 in 1700 and rose to 100,000 in 1750. While initially more expensive, slaves were seen as less troublesome than indentured servants, who often wanted to participate in the political and economic order on an equal footing with the plantation

owners once they had served out their terms. In 1676 Nathaniel Bacon led a rebellion of such "upstarts" against those wealthy Virginians who resisted their participation; the rebellion failed, but not before causing serious distress among the local gentry.

While wary of political revolts carried out by what they perceived as the "lower orders" of society, Virginia aristocrats were not averse to fomenting their own revolution. As Arthur Quinn points out, the generation that came out of the plantations in the middle of the 18th century—which included Patrick Henry, George Washington, Thomas Jefferson, James Madison, John Marshall, and James Monroe—would play a key role in the American Revolution. This elite would build residences patterned not after English village houses, as was the case in New England, but after English country manors.

One example of such a country manor is "Bacon's Castle" in Surrey County, used as a bastion by the followers of Bacon in 1676 [1.76]. The home of Arthur Allen, it was constructed of brick around 1655. There is little exterior decoration, but the placement of the fireplace at the end, rather than in the center as in the Parson Capen House [1.68] (a decision determined in part by climate), allowed for the use of its shape as a decorative

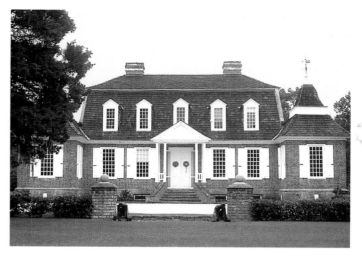

1.77 Mulberry Plantation, Moncks Corner, South Carolina, 1714

element. The mass of the chimney rising through the two-and-a-half stories is topped by three chimneystacks set diagonally, which tower above the roof. Viewed from the end, the receding shapes of chimney, main house and projecting porches, along with the diagonally placed chimneystacks and the shaped gables (imported into England from Holland or Flanders in the late 16th century), create a play of forms that adds to the visual complexity of the building.

Bacon's Castle also included a molded brick pediment over the main doorway (not visible in the illustration), an early version of the classical detail found on the exteriors of most of the grander southern urban mansions and rural plantation houses in the following century (few the size of Bacon's Castle were built in the 17th century). One of the earliest of these 18th-century plantation houses was located on Mulberry Plantation in Moncks Corner, South Carolina. The two-story brick structure was built in 1714 by Thomas Broughton, an English planter and later Royal Governor of South Carolina [1.77]. It is an imaginative architectural design, combining classical pediments over the entrance porch and second-story dormer windows in the central block with tower pavilions on either side and firing slits in the cellar's foundation walls—features that led to the nickname "Mulberry Castle". The building's references to a castle were fitting, as a series of wars broke out in the region from 1711 to 1715 between the colonists and Native peoples over the expansion of English settlements (several people took refuge at Mulberry Plantation during the war between the colonists and the Yemassee in 1715). South Carolina also experienced a major uprising of slaves in 1739, the Stono Rebellion, in which more than twenty white Carolinians and almost twice as many black Carolinians lost their lives.

1.76 Bacon's Castle, Surrey County, Virginia, c. 1655

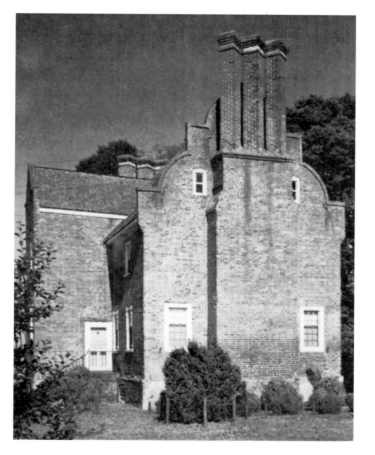

Around 1800, the artist Thomas Coram produced an oil sketch of Mulberry Plantation, part of a projected book of "portraits," or engraved views of southern plantation mansions, that was never competed. It shows a series of small huts with steeply pitched roofs arranged in an orderly fashion along the road leading up to the main entrance of the plantation house. These huts housed the plantation slaves, several of whom are shown on or beside the road. In his study of plantation architecture, John Michael Vlach notes that while slave quarters were often located behind or away from the main house, their presence alongside the major entrance road on some plantations served to reinforce the wealth of the planter and the size of the plantation. This might help explain why the slave quarters dwarf the plantation house in Coram's painting.

Vlach notes not only that the institution of chattel slavery affected the arrangement and types of buildings on southern plantations, but also that the slaves themselves created another, less visible, order on the land, carving out landscapes to fit their own social needs. These included networks of trails through the woods and fields connecting plantations and clandestine meeting places. Large plantations with a hundred or more slaves often contained slave "towns," which were sometimes laid out by the planter in regular rows utilizing a grid plan that embodied, according to Vlach, the order and control that the planters imposed on the life of their slaves. Left to their own devices, slaves preferred irregularly placed buildings a considerable distance from the main house. Vlach quotes one observer of rice plantations in Georgia as commenting that slaves, when allowed to build their own houses, "wanted their cabins in some secluded place, down in the hollow, or amid the trees, with only a path to their abode." The further away from the main house, the less subject the slaves would be to surveillance. Vlach argues that despite the obvious limits placed on slaves' abilities to control their own lives, they were able, in some instances, to claim the spaces "back of the big house"—to create "plantation landscape ensembles" or "black landscapes" out of their own quarters and the various outbuildings (barns, stables, kitchens, storage sheds) that existed between these quarters and the plantation house.

The aristocratic pretensions of southern leaders, their role in the American Revolution notwithstanding, is reflected not only in architecture but also in the portraiture that developed in the southern colonies. *Henry Darnall III as a Child* of c. 1710 [1.78], by Justus Engelhardt Kühn (d. 1717), conveys these pretensions through the elegant costume of the young figure and the elaborate formal gardens and palatial buildings behind him—references to the residences of English or Continental nobility, for none of this magnitude existed in the colonies at this time

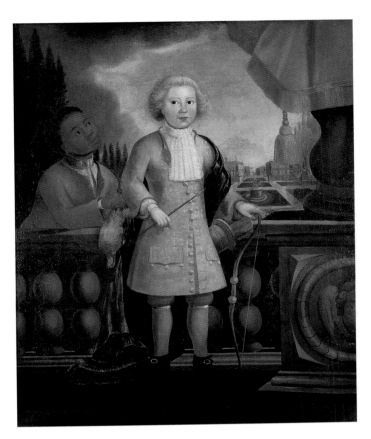

1.78 Justus Engelhardt Kühn: *Henry Darnall III as a Child*, c. 1710
Oil on canvas, 54¼ × 44¼ in. (137.8 × 112.4 cm.)
Maryland Historical Society, Baltimore

(Kühn may have copied them from contemporary engravings). Henry's young black slave is another testament to the wealth and status of his family, one of the richest in the region surrounding Annapolis, Maryland. Wearing a silver collar as an indication of his slave status, he brings young Henry the results of the hunt. Both collar and bird are clear attempts to associate the young boy with a servile dog. His inferior status is further reinforced by his location behind and below Darnall, separated from the white boy by the balustrade and by the color of his skin.

In 1708, the year the German Kühn arrived in Annapolis, another artist stepped ashore in the southern colonies to ply her trade—Henrietta Dering Johnston (c. 1674–1728?). Johnston had traveled to England from France with her Protestant parents in 1687. From there she moved to Dublin, Ireland, before coming to South Carolina as the wife of Gideon Johnston, a clergyman of the Church of England. She may have received some training in Ireland under the tutelage of Simon Digby, Bishop of Elphin, an amateur portraitist. At any rate, she brought with her pastels and paper and immediately began to supplement her husband's income (and pay off his debts) with pastel portraits of the leading citizens of Charleston.

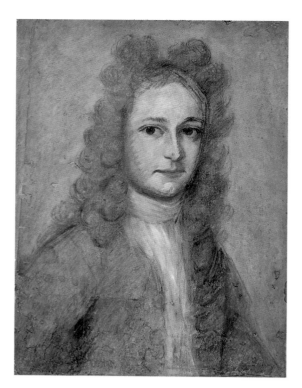

1.79 Henrietta Dering Johnston: *Colonel Samuel Prioleau*, 1715
Pastel on paper, 12 × 9 in. (30.5 × 22.9 cm.)
Museum of Early Southern Decorative Arts, Winston-Salem, North Carolina

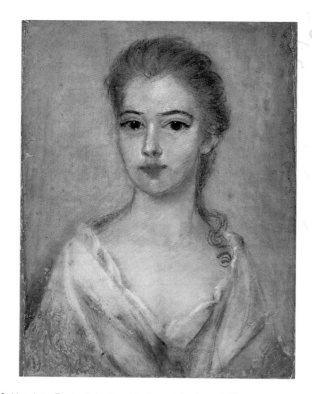

1.80 Henrietta Dering Johnston: *Mrs Samuel Prioleau*, 1715
Pastel on paper, 12 × 9 in. (30.5 × 22.9 cm.)
Museum of Early Southern Decorative Arts, Winston-Salem, North Carolina

It is instructive to compare the portraits Johnston executed of Colonel Samuel and Mary Prioleau in 1715 [1.79, 1.80] with those of John and Elizabeth Freake [1.66, 1.67]. Just as the costumes of John and Elizabeth indicate their social standing as pious but prosperous merchants of Puritan Boston, so the costumes of Samuel and Mary link them to the high society of Charleston and, in particular, to the large Huguenot community of which they were members (like Johnston and her parents, many Huguenots fled from France to Protestant Europe and America in the late 1680s, after Louis XIV revoked their religious and political freedoms in 1685). Samuel wears the long, curled wig and high cravat of French court society, while Mary sports a *décolletage* that would have raised many a Puritan eyebrow, although by the late 17th century wives of successful merchants in New England were looking to the fashions of the European courts. Johnston is not concerned with meticulous, hard-edged detail, as was the painter of the Freake portraits. Instead, she renders Samuel and Mary with loose, painterly strokes and uses firm lines only around the eyes, which give them a particular prominence. And where the Freake portraits have somber backgrounds, the Prioleaus reside within light-filled, indeterminate spaces.

The medium chosen by Johnston is also significant, for pastels were only then being introduced into court society in Europe by another female artist, Rosalba Carriera (1675–1757) (the Freake portraits are done in oil). This medium was particularly popular in the court of Louis XV, for, in the words of the art historian Whitney Chadwick, it was "uniquely suited to the early 18th-century search for an art of surface elegance and sensation." The dry chalk pigments of pastels were also similar to those used in women's and theater make-up; pastel portraits were thus able to capture these enhancers of artifice so prevalent in aristocratic society.

Despite the difficulties of Henrietta Dering Johnston's life—a husband constantly in debt, hurricanes, mosquitoes, illness, the general hardships of colonial life, the antagonism between secular authorities and her husband, and the latter's death in 1716—she managed to produce more than forty portraits, mostly of citizens of Charleston. In 1725 she traveled to New York, where she continued to paint portraits, before returning to Charleston, where she died.

Products of the Needle and the Chisel

Learning Their Stitches and Keeping Warm: Colonial Needlework

Henrietta Dering Johnston may well have been occupied not only with the general upkeep of the home and the painting of portraits, but also with the creation of various kinds of needlework, from quilts to tablecloths to clothing. Because

of the shortage of imported goods, colonial women were often responsible for the production of textiles for the home, from the spinning and weaving of the yarn to the sewing and embroidering of the finished goods. Yet these activities were not seen solely as burdensome tasks. Many women viewed the needle as their brush and the cloth as their canvas.

Young girls began learning their stitches as early as five or six years old. One of the first tasks they were set to was the making of "samplers." Samplers of the 17th and early 18th centuries were much like their English counterparts, long and narrow strips of cloth containing "samples" of needlework stitches. They rarely contained names or dates and the most common motifs were reclining stags, carnations, and fleurs-de-lis. In the mid-18th century, however, their iconography took a new direction, different from that of their European prototypes. Now they began to include embroidered alphabets and numbers, verses, biblical quotations, the maker's name, the community in which she lived, her birth date, and the date on which the needlework was completed. The scenes depicted also expanded to include houses, public buildings, family registers, maps, and biblical subjects. They were used to teach not only stitches, but also spelling, geography, and moral virtue.

During the 17th and 18th centuries the education of young girls outside of the home was limited. If lucky, they were taught reading, writing, and simple arithmetic in public schools after the boys' classes were over, or in the summer, when boys were working on the farms. Wealthy families sometimes sent their daughters to boarding schools, where they were additionally taught the arts of embroidery, music, and dance. Sometimes tutors were hired to conduct lessons in the home. Yet, in almost all cases, the education of girls was intended to give them only enough knowledge to make them effective in carrying out their domestic tasks as wives and mothers—despite the fact that before the Revolution women often played important roles in the running of local industries, either with their husbands or as widows after their husbands' deaths. The creation of samplers, therefore, either reinforced the lessons gained elsewhere or functioned as the primary slate upon which young girls tried out their intellectual and artistic skills.

In 1744 Lydia Hart completed a sampler containing a scene of Adam and Eve in paradise [1.81]. A small work made of silk on linen, it contains an abundance of flora and fauna surrounding the two figures. Bishop and Atkins note that Hart gives an added charm to her work by sewing a small goatee on Adam which, along with his fig leaf and shorter hair, distinguishes him from Eve. They fail to note, however, that she also depicts Adam, as well as Eve, holding an apple, suggesting that the couple's downfall was not the fault of Eve alone (the position of

the snake facing Adam and almost touching the fruit in his hand reinforces Adam's complicity). The sampler also has a border, which was unusual at the time but which suggests the ultimate location of such works—not rolled up and stored away, but framed and hung on the wall within the home, testimony to the skill and learning of its maker.

Women's needlework also decorated what was, along with the hearth, one of the two focal points of colonial domestic life: the bed. Kurt Dewhurst and Betty and Marsha MacDowell point out in *Artists in Aprons* that one of the few pieces of furniture mentioned in early household inventories was the bed. These inventories also included references to embroidered quilts, crewel-worked bed hangings and bed rugs—heavy, woolen rugs, decorated most often with a branching floral bush or flowering vines. Bed rugs are thought to have originated in New England, which is not surprising, considering the extremely cold temperatures of the long winter nights. Perhaps the most elaborate set of bed hangings and coverlet that survives from the colonial period is that made by Mary Bulman

1.81 Lydia Hart: *Adam and Eve*, sampler, Boston, 1744
Silk on linen, 11½ x 9 in. (29.2 x 22.9 cm.)
American Museum of Folk Art, New York

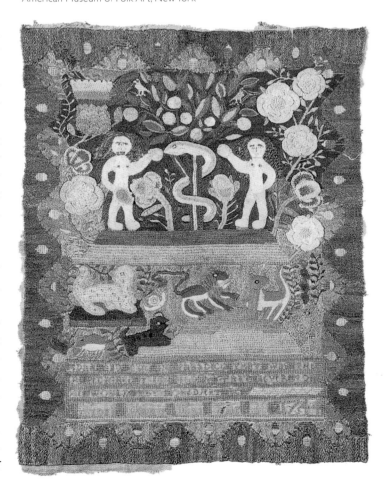

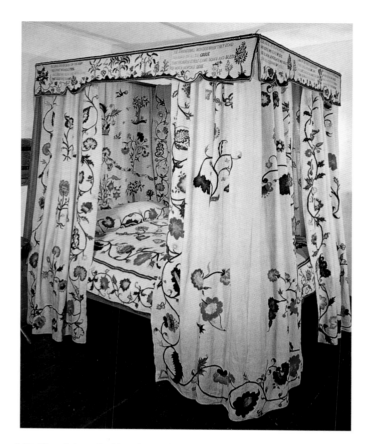

1.82 Mary Bulman: bed hangings and coverlet, c. 1745
Wool and linen, various sizes
Old Gaol Museum, York, Maine

(b. 1715) in York, Maine, around 1745 [1.82]. She began this crewel-embroidered set after the death of her husband at the Battle of Louisburg, Nova Scotia, and included verses on the valances from Isaac Watts's "Meditations in a Grove" (1737) to indicate her sorrowful state. The embroideries are filled with flowering vines, indications of fecundity and abundance. The flowers are in brilliant blues, reds, and yellows, with the open white background allowing the viewer to appreciate fully the precise stitches. The mournful verses, in combination with the lively floral motifs, create a melancholic mood, marking a sad moment in the life of thirty-year-old Mary Bulman.

The cultural historian Neil Harris has written that in the first half of the 18th century in New England "no rigid lines of separation compartmentalized the people's lives, cutting off the fine from the applied arts, high scholarship from folk culture, work from play, or religion from politics." Thus, painted portraits of family members, carved chests, framed needlework samplers, and elaborately decorated bed hangings and rugs would have come together to form an aesthetic environment that both gave pleasure to the inhabitants of a dwelling and confirmed their individual and cultural identities.

Doors to Eternal Peace: Carved Gravestones

Images also marked the final resting places of many colonial Americans. According to Roger Stein, gravestones, often decorated with biblical figures copies from pattern books, were seen as civil memorials of the meaning of human life. As such, they became a kind of portrait rather than a devotional image. The gravestone of William Dickson at Cambridge, Massachusetts, carved in 1692 [1.83], displays common motifs. In the top central register are a winged skull and winged cherubs carrying small coffins. Between the cherubs are the words "memento mori" ("remember you must die") and "fugit hora" ("time flies"), which emphasize human mortality and the passage of time. This theme is further represented by the hourglasses held by the naked long-haired figures in the top corners of the gravestone, who each grasp an arrow. Some have interpreted these figures as demons of the underworld with darts that bring death; for many colonists they may have called to mind deadly encounters with Native peoples.

The seeming gruesomeness of Dickson's gravestone is lightened, however, by the floral and vegetal motifs that fill the spaces below the naked figures and extend along the bottom edge. In addition, in colonial times the skulls and demons conveyed, according to Bishop and Atkins, the announcement of "the entrance of the spirit into a world of eternal peace, far from the daily trials and difficulties of the all-too-human world." Soon gravestone imagery focused more on winged cherub heads or angels and floral motifs.

1.83 Anonymous: gravestone of William Dickson, Cambridge, Massachusetts, 1692
Slate

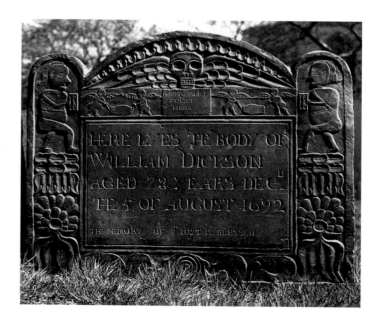

Foreign Wars and Domestic Unrest

Benjamin West's "The Death of General Wolfe" and "Penn's Treaty with the Indians"

Unfortunately, demand for the services of gravestone carvers increased as the 18th century progressed and as relations worsened between French and English colonists, and between these colonists and the various Native peoples with whom they traded. Throughout the 18th century the British systematically attacked the French—off the coasts of Portugal and France, in Africa, the Caribbean, India, and America. Ironically, the battles in the North American colonies could have been avoided. In 1628 the British had blockaded the St Lawrence and in January 1629 they appeared at Quebec. Champlain surrendered, leaving Britain in possession of the French territories. But the two powers subsequently signed a truce, which included the restoration of the colony of New France in 1632.

As indicated earlier, by 1750 France's colonies on the North American continent followed a series of rivers and lakes, beginning with the St Lawrence, on into the Great Lakes, and then down the Missouri and Mississippi rivers. The British were limited to the eastern seaboard by mountains and also by hostile Native peoples, who chose to ally with the French. The one advantage they had was population—while there were only approximately 8,000 French colonists, the British numbered over 1,000,000. Yet less than half were actually of British origin. The rest came from the Dutch Netherlands, Germany, Sweden, and even France. Many, both British and non-British, were not interested in fighting the French. Because of this, the battles that took place were often sporadic and of short duration. Each enlisted their respective Native allies in raids on settlements along the borders. The two sides also encountered each other in 1754–55, when the British launched at least two unsuccessful attacks on the French forts on the Ohio, one of which was led by the young George Washington. These and other attacks initiated the final series of battles known collectively as the French and Indian War, which lasted until the fall of Quebec in 1759–60.

Many different Native peoples were drawn into the conflict on both sides. The French armies, under the leadership of General Louis Joseph de Montcalm, included traditional allies such as the Abenakis and Mi'kmaqs. Occasionally, however, groups not usually in alliance with the French joined with them in particular battles. This happened during the siege of Fort William Henry in 1757. A Jesuit priest who had traveled with a group of Abenakis from Acadia to participate in the siege provided a detailed description of the ornaments worn not only by Abenakis and Mi'kmaqs but also by Iroquois, Sioux and Chippewas. He described an assembly of people

painted with vermilion, white, green, yellow, and black made of soot and the scrapings of pots The head is shaved except at the top, where there is a small tuft, to which are fastened feathers, a few beads of wampum, or some such trinket. Every part of the head has its ornament. Pendants hang from the nose and also from the ears The rest of the equipment answers to this fantastic decoration: a shirt bedaubed with vermilion, wampum collars, silver bracelets, a large knife hanging on the breast, mooseskin moccasins, and a belt of various colors always absurdly combined. The sachems and war-chiefs are distinguished from the rest: the latter by a gorget, and the former by a medal, with the [French] King's portrait on one side, and on the other Mars and Bellona joining hands, with the device, *Virtus et Honor*.

The description reveals a combination of aesthetic traditions that was common by this time, and a fact noticed by many who documented Native cultures—that one of the major spaces for visual artistic expression was the human body. The bringing together of cultures and traditions was utilized by Montcalm on this occasion, as he lifted a large belt of wampum and addressed his Native allies: "Take this sacred pledge of his word. The union of beads of which it is made is the sign of your united strength. By it I bind you all together, so that none of you can separate from the rest till the English are defeated and their fort destroyed."

Ultimately, the French lost the war. The British laid siege to Quebec City and captured it after the battle of the Plains of Abraham outside the city walls on September 13, 1759. It changed hands briefly again in 1760, but was recaptured that fall. The peace terms bringing to an official end the French and Indian War were outlined in the Treaty of Paris of 1763.

The most famous image of the battle of the Plains of Abraham, during which both generals, Montcalm and Wolfe, died, was executed in 1770 by Benjamin West (1738–1820). West, born in Pennsylvania, left in 1759 to study art in Europe, ultimately settling in England, where he participated in the founding of the Royal Academy and succeeded Joshua Reynolds as its president. He became painter to King George III and remained so throughout the American Revolution.

West's *The Death of General Wolfe* [1.84] was exhibited at the Royal Academy in 1771 and was a great success. It was bought by Lord Grosvenor, and the King ordered a second version (the Duke of Westminster, a descendant of Lord Grosvenor, later presented the original version to the Canadian government in recognition of Canada's service to Britain during World War I). It was also distributed to a wider audience in the form of engravings, and the central scene appeared on English ceramic mugs marketed both at home and abroad.

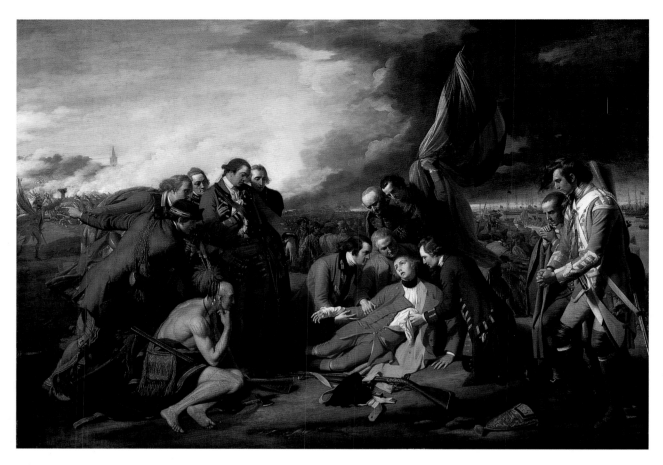

1.84 Benjamin West: *The Death of General Wolfe*, 1770
Oil on canvas, 59½ × 84 in. (151.1 × 213.4 cm.)
National Gallery of Canada, Ottawa

In the late 18th century, history painting—with subjects drawn from the Bible, or classical or modern history—was the culmination of an artist's education at the Academy, revealing the student's skill at rendering the human body and ability to transform the material world into ideal form. In order to suggest that a battle was fought for higher ideals rather than simply material gain, or that the actions of its participants were especially heroic, artists often included allusions to the classical world, through architecture or through clothing. Yet West avoided such obvious allusions, which some claim caused Reynolds to criticize the work for detracting from the universal moral significance of the sacrifice of war by particularizing it. Yet West chose to emphasize the moral significance of Wolfe's death, and the war as a whole, in another way. The General's pose is taken from that of Christ in a print after a painting by Van Dyck, *The Lamentation over the Dead Christ*, of 1634. The posture serves to link the bloody battles for empire with Christ's sacrifice for the salvation of humankind. To heighten the dramatic effect of the painting, West depicts Wolfe dying at the moment when the British secure the defeat of the French— the small figure on the left comes running with the news.

West took artistic license not only in his depiction of Wolfe's dying pose, but also in his selection of those included in the painting. Only one of the onlookers, Lieutenant Henry Browne, who stands directly behind Wolfe holding the flag, was actually present at Wolfe's death. In fact, as far as can be determined, a mere four or five soldiers attended the demise of their general (Wolfe was actually wounded three times, with the third wound fatal). A hint as to how the other figures made it into the painting can be found in a letter written several years later by the daughter of one of the officers who fought at Quebec, General John Hale. She notes that her father, who was not present at Wolfe's death, was not included in the painting because he refused to pay West £100 sterling, suggesting that the others not present at the death, including Brigadier General Robert Monckton standing to the left clutching his chest wound and Wolfe's Adjutant General, Major Isaac Barré, directly above the dying general's head, did pay. (The art historian Susan Rather notes that West was often criticized in England during his life for a particularly "American" obsession with money.)

The group surrounding the dying Wolfe also includes an Iroquois man, seated on the ground in a pensive position. Here

West does allude to the classical past—the figure is modeled after classical prototypes found in Greek and Roman sculpture—and his partial nudity provides West with an opportunity to demonstrate clearly his skill at rendering the human form. He is also the only figure who neither attends to the dying general nor shows distress at the event unfolding before him (West drew on the French painter Charles Le Brun's 1649 publication *Expressions of the Passions of the Soul* in formulating the specific facial expressions of the men surrounding Wolfe). He is present as a reminder of the locale of the battle—the North American colonies—and of the role indigenous peoples played in the wars between the British and the French. With his tattooed skin, sparse but finely decorated clothing, and elaborate hairdo, he is evidence of the difference between these peoples and the British. He is shown passively contemplating an event that would have radical consequences for him and others like him in the near future.

1.85 Benjamin West: *Penn's Treaty with the Indians When He Founded the Province of Pennsylvania in North America*, 1771–72
Oil on canvas, 75½ × 107¾in. (191.8 × 273.7 cm.)
The Pennsylvania Academy of the Fine Arts, Philadelphia

Another figure reminds the viewer of the role of American colonists in the British Army. Directly behind and leaning over the head of the Iroquois is William Johnson, a New Yorker who had distinguished himself in earlier battles at Lake George and Fort Niagara but who was not present at the Battle of the Plains of Abraham. He wears moccasins and beaded breeches and has a beaded bag, similar to the one worn by the Iroquois, slung over his shoulder. As a superintendent of Indian affairs, Johnson had used his knowledge of Native American customs and language (he had married a Mohawk woman) in gaining the cooperation of the Iroquois to ally with the British. He marks a transitional stage between the half-naked Iroquois man and the British officers in their full dress uniforms, just as the American colonies existed somewhere between the "untamed" lands and cultures of Native Americans and the elaborate courts of the British aristocracy.

Shortly after West finished *The Death of General Wolfe* he began another painting that dealt more directly with relations between European settlers and Native Americans—*Penn's Treaty with the Indians When He Founded the Province of Pennsylvania in North America* (1771–72) [1.85]. While ostensibly representing an event that took place in 1682, the year of Penn's

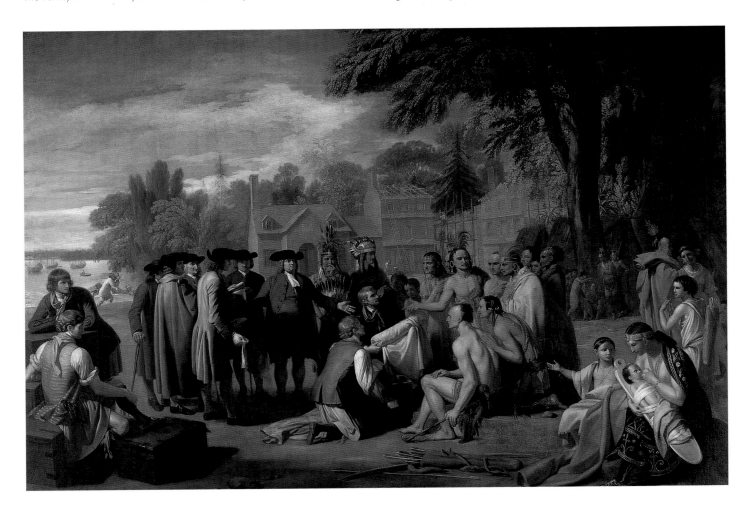

arrival, West's painting also addressed contemporary struggles for power, not only between indigenous peoples and Europeans, but also between different groups of European settlers. Penn was an important member of the Religious Society of Friends, more commonly known as the Quakers, which had been founded in England in the late 1640s. One of its distinctive features was the belief that all members of the religious community were equal. The Quakers did away with the hierarchies that marked not only Catholicism but much of Protestantism as well. They were attacked by Puritans and Anglicans alike and Penn thus sought refuge, as the Puritans had before him, in the New World, hoping to build a community where Quakers could freely practice their religious principles. In 1681 he wrote a memorandum establishing the form of the new settlement of Philadelphia, its name indicating that it was to be the "city of brotherly love."

West's painting records the celebrated meeting between William Penn and the chiefs of the Lenni Lenape or Delaware tribes under an elm tree at Shackamaxon, where papers were signed marking the first legal agreement between Europeans and indigenous peoples and the first time the former paid the latter for land legally granted to them by the British government. Penn believed not only that sharing land and resources was necessary for the survival of the colony, but also that it was morally the right thing to do. Some now argue that the absence of contemporary written accounts of the meeting at Shackamaxon suggest that it never took place and that the painting is, instead, an allegory of colonial America: enlightened man of reason meets noble savage. Even if the meeting did not take place at this location, however, Penn did manage to establish peaceful relations between the Quaker colony of Pennsylvania and the indigenous populations in the region, although they soon eroded as new settlers arrived and more land was needed. By 1737 Thomas Penn, William Penn's son, was appropriating Native lands protected by deeds signed by his father in order to satisfy the demands of these new settlers. Different tensions arose as well. By 1757 prominent Quakers were increasingly questioning both Thomas Penn's tax-exempt status and his desire to arm colonists against the Native peoples. They initiated a "peace offensive" with local tribes, holding gift-exchange ceremonies and recalling William Penn's legacy of peace without guns.

The art historian Ann Uhry Abrams argues that Thomas Penn commissioned West to paint *Penn's Treaty with the Indians* as an attempt to reassert the right of the Penn family to proprietorship of the colony of Pennsylvania. West was a particularly appropriate choice. He had grown up in Pennsylvania, the tenth child of an innkeeper in a Quaker community west of Philadelphia. His introduction to painting, he claimed, came from Native Americans in the area, who showed him how to mix the red and yellow earths with which they painted their faces. Like so many 18th-century artists, West then began copying engravings and portraits that hung in the homes of his family's friends. His talent was soon recognized, and at seventeen he entered Benjamin Franklin's College of Philadelphia as an honorary student. He gained the support of many of the town's leading citizens, among whom was William Smith, an Anglican minister and ally of Penn. When West left Pennsylvania in 1759, fighting had already broken out between Native communities and Quaker settlers. Many of his Quaker relatives were parting ways with Penn and Smith, whose power and fortunes depended on trade. By 1764 pacifist Quakers had lost control of the assembly and Thomas Penn's proprietary party took over. In 1768 Penn signed a series of new treaties that resulted in a temporary lull in the fighting.

West arranges the major historical and contemporary players in Pennsylvania into three overlapping groups—the Quaker political leaders, the merchants, and the Native peoples. The portly figure of William Penn stands slightly to the left of center. To reinforce the connection between the present and the past, West clothes the Quaker men in 18th-century garb and includes his own half-brother and father among them (some think the figure at the far left leaning on a crate is a self-portrait). The Lenni Lenape or Delaware wear a combination of clothing, headgear, and ornaments drawn from the Lenni Lenape, Iroquois, and northern Algonquian peoples and borrowed from the collections of the Penn family and Matthew Clarkson of Philadelphia. The prosperity of the colony is indicated by the bustling harbor—denoting trade—and the large houses being constructed in the background. The Native Americans are placed closest to the forest, confirming their association with a land that has yet to be exploited by the settlers (as in *The Death of General Wolfe*, their bodies are modeled after classical nudes, such as the *Apollo Belvedere*). The calm of the scene was matched at the time West created his work by a momentary lull in the hostilities between Native peoples and Pennsylvanians. This lull was soon broken, however, by a resumption of armed conflict, not only between European colonists and Native peoples, but also between the colonists and the armies of the British King.

Defining America

2.1 Cynthia Burr: *Let Virtue be A Guide to Thee*, 1786 (see p. 90)
Needlework sampler, 16½ × 14½ in. (42 × 37 cm.)
Gift of Mrs. Murray S. Danforth. Museum of Art,
Rhode Island School of Design, Providence

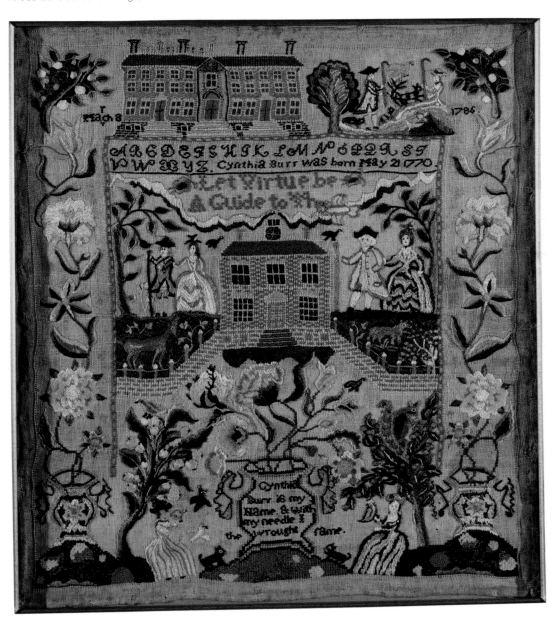

Timeline 1770–1865

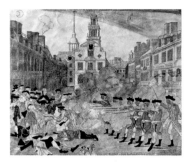

2.3 (see p. 83)

1770 Boston Massacre [2.3]

1773 Pope Clement XIV suppresses Jesuit Order; Boston Tea Party

1774 First Continental Congress in Philadelphia

1775–83 American Revolution

1776 July 4: Declaration of Independence

1776–77 John Singleton Copley paints group portrait after his family join him in London [2.65]

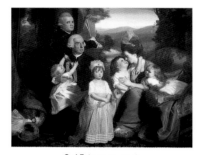

2.65 (see p. 133)

1785–89 Thomas Jefferson designs the Virginia State Capitol [2.25]

1786 Charles Willson Peale opens a museum of fine art and natural history

1787 Founding of the Free African Society

1788 U.S. Constitution ratified

from 1788 Rebuilding of the Vieux Carré in New Orleans

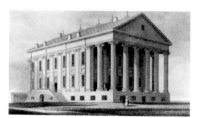

2.25 (see p. 102)

1789 George Washington inaugurated as first president of the United States [2.10]; French Revolution begins

1791 Pierre Charles L'Enfant completes plan of Washington, D.C.

1792 Beginning of construction of the U.S. Capitol Building; Moses Johnson completes Quaker Meeting House, Canterbury, N.H. [2.35]; Benjamin West elected president of the Royal Academy, London

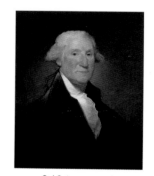

2.10 (see p. 92)

1793 Passage of the Fugitive Slave Act, requiring return between states of escaped slaves

1800 Washington, D.C. replaces Philadelphia as the capital

1801–9 Thomas Jefferson (elected in 1800) serves as president

2.35 (see p. 108)

Federal Style (architecture) 1783–1815

U.S. Capitol Building construction

US Capitol Building construction 1792–1865 ▼

Federal Style 1783–1815 ▼

Second Great Awakening 1800–1830s ▼

1802 Founding of the American Academy of the Fine Arts

1803 Louisiana Purchase

1805 Founding of the Pennsylvania Academy of the Fine Arts

1808 January 1: Importation of slaves prohibited by law

1812–14 War of 1812 between the U.S. and Britain; Capitol burned and subsequently rebuilt [2.28] (completed 1865)

1816 Establishment of congregate prison system, Auburn, New York [2.41]

1817 John Trumbull commissioned by Congress to execute four paintings on the American Revolution for the rebuilt Capitol

1818 Northern boundary of U.S. established at the 49th parallel

1819–21 Florida acquired from Spain

1821 Mexico gains independence from Spain; opening of Santa Fe Trail

1821–42 Charles Bird King completes some 143 portraits of Native Americans

1822 Peale's Museum is incorporated as the Philadelphia Museum [2.55]

1825 Publication of Rufus Porter, *A Select Collection of Valuable and Curious Arts*, with instructions for, among other things, painted walls, floors, and furniture [2.58]

1826 Founding of the National Academy of Design

1827 Cherokee in Georgia draft constitution, declare themselves an independent nation; forcefully removed westward in 1838 (Trail of Tears)

1839 Samuel F. B. Morse introduces the daguerreotype, patented that year in France and England, to the U.S.

1844 Samuel F. B. Morse [2.69] sets up telegraph line between Baltimore and Washington, D.C.

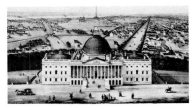

2.28 (see p. 105)

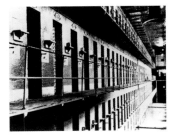

2.41 (see p. 112)

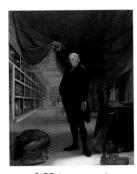

2.55 (see p. 125)

2.58 (see p. 128)

2.69 (see p. 136)

The American Revolution may well have been a godsend for artists, for it created a series of dramatic events and heroic individuals ready to be celebrated in pictorial form. Here was a larger sense of purpose around which artists could rally. The new nation needed a history, and part of that history would be expressed visually. In addition to portraits and history paintings, the United States of America needed new buildings, state seals, stamps, flags, and monumental sculpture. While the creation of a national iconography was relatively easy, the creation of a national style was not. Many debates would ensue during the 19th century over which style would express or embody most effectively the country's values and ideals. Artists and critics would expend a great deal of energy debating the relative merits or patriotic value of history painting, landscape painting, portraiture, and genre painting.

The United States also needed new educational institutions to instill in its citizens the values and skills its leaders deemed essential for success. Among these were academies of art, established not only to train artists but also to invest in the profession a sense of tradition harking back to classical times. While politicians and businessmen alike emphasized the country's newness and the endless opportunities available to all who ventured into its expanding territory, they also were well aware of the need to associate their new state with the political powers of the past, thus endowing their own efforts with a sense of historical legitimacy. Artists struggled to produce images that would satisfy both demands—a celebration of the new and a respect for the old. The latter led, most notably, to a proliferation of classical forms—Greek costumes, temple fronts, columns—on everything from buildings and statues to tableware and needlework. Artists also grappled with the incorporation of Native Americans into their representations of the present and the past, particularly in their accounts of the nation's history located in new government buildings such as the Capitol in Washington, D.C.

Most artists settled in the major urban centers and produced works for wealthy merchants and prominent politicians. Several, however, took to the road, helping both to fill and to encourage a growing demand in rural America for images among those of modest, as well as substantial, means. Some not only created their own works, but also taught others how to make art for themselves, whether it be decorative patterns on walls or floors or human profiles cut out of paper. Thus, while many painters in New York or Boston bemoaned the lack of artistic patronage or taste in America, hundreds, if not thousands, of men and women busied themselves producing their own still lifes or portraits for the decoration of their homes. "Taste" may have been absent in early 19th-century America, but creativity certainly was not.

Representing the Revolution and Its Aftermath

Domestic Production and International Intrigue:
John Singleton Copley's "Governor and Mrs Thomas Mifflin"
and "Watson and the Shark"

As Benjamin West was completing *The Death of General Wolfe* and *Penn's Treaty with the Indians* [1.84, 1.85], another New England painter was recording the features of various notables who would figure prominently in the next military encounter to take place in the British colonies of North America—the American Revolution of 1775–83. John Singleton Copley (1738–1815) was born in Boston in 1738, the same year as West. Unlike West, he received training in the rudiments of art from his stepfather Peter Pelham, a mezzotint artist and dancing teacher. Pelham died when Copley was thirteen, increasing the young man's household responsibilities and prompting him to turn with determination to the practice of painting, copying as many engravings and portraits as possible.

Within a decade Copley had established himself as one of Boston's leading portraitists, known for the exactitude with which he rendered his sitters' features and their liveliness of character. He was also skilled at creating what the art historian Paul Staiti calls "centerpieces in the stagecraft of the eighteenth-century persona," portraits that claimed for their sitters a place "in the hierarchical and circumscribed social theater of colonial Boston." He accomplished this not only through the rendering of material wealth, but also by capturing the gestures, objects, and dress appropriate to the social identity desired by the sitter, be it that of a successful merchant, a pious minister, or a dutiful wife.

The painting that brought Copley to the attention of the London art world was his 1765 portrait of his half-brother Henry Pelham [2.2], submitted to the annual exhibition of the Society of Artists. West wrote to Copley that the work was favorably received, and one can certainly understand why. Copley has managed to capture the qualities of a wide variety of surfaces—skin, mahogany, glass, water, fur, metal, various textiles—with a verisimilitude that impressed those who viewed the painting. He has also created a carefully balanced composition that directs the viewer's gaze from the boy's face to his hand to the squirrel and back through his other hand and collar to his face again, prompting us to wonder what thoughts are occupying the boy's mind and whether the delicate chain attached to the squirrel is not some commentary on the fragile relationship between humans and nature in colonial America (Copley has chosen an American flying squirrel, native to the eastern U.S.).

As a resident of Boston, Copley would have witnessed the eroding of another fragile relationship, that between the colonies and the British crown. Boston, like other flourishing centers in

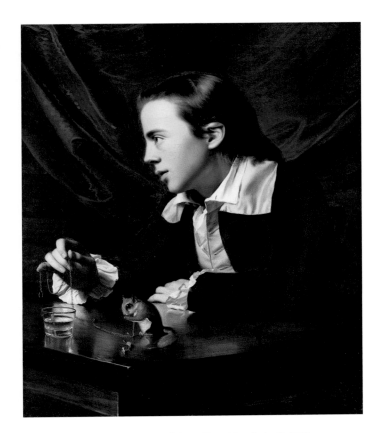

2.2 John Singleton Copley: *Henry Pelham (Boy with a Squirrel)*, 1765
Oil on canvas, 30¼ × 25 in. (76.8 × 63.5 cm.)
Museum of Fine Arts, Boston, Massachusetts

brother (1749–1806) [2.2], who had become an artist himself. *The Bloody Massacre* [2.3] depicts the events of March 5, 1770. A group of Boston residents, mostly laborers, rebelled against these troops, causing them to open fire. Among the five men killed was Crispus Attucks, an African who had escaped slavery twenty years earlier and who was described by many who witnessed the massacre as a leader of the rebellion. Revere's print was issued soon after the fatal shootings. Its depiction of stony-faced soldiers shooting unarmed civilians at close range served to arouse even further resistance to the British, although several among the colonial elite of Boston, fearing the violence of poor blacks and Irish Catholics more than the actions of an army of occupation, defended the behavior of the soldiers as self-defense.

In 1773 Britain attempted to impose a tax on tea, as well as to remove the colonial middlemen in the marketing of tea, which would actually have lowered the final cost of the product. In response, the leaders of Boston refused to let a shipment of tea be unloaded and, instead, dumped it in the harbor, enacting what came to be known as the Boston Tea Party. The British responded by appointing a council to rule the colony in place of elected officials and closed the harbor. Twelve of the thirteen colonies (Georgia did not join in) met in 1774 in Philadelphia in the First Continental Congress and voted to support Massachusetts. They agreed to boycott trade with Great Britain, Ireland, and the British West Indies. Such boycotts were not new, and had been used effectively in the past.

Thomas Mifflin, a wealthy Philadelphia Quaker merchant, was a member of the group that met at the First Continental

2.3 Paul Revere after Henry Pelham: *The Bloody Massacre*, 1770
Hand-colored engraving, 8¹⁵⁄₁₆ × 10³⁄₁₆ in. (22.6 × 26 cm.)
The Metropolitan Museum of Art, New York

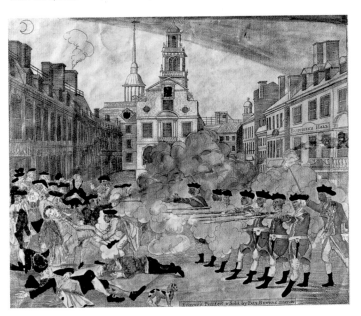

the late 18th century, was chafing under the trade restrictions imposed by British authorities. Such restrictions were an integral part of a mercantilist system, where the health of the colonizing nation takes precedence. Any economic exchange must benefit England. The colonies were thus instructed to trade only in certain goods and with certain trading partners—instructions that were often ignored or subverted through the existence of a black market.

In 1765 the British crown passed the Stamp Act, which authorized a direct tax on all sorts of printed materials to help pay for the French and Indian War. Many of the colonies protested and riots swept Boston, forcing the repeal of the act the following year. Yet other taxes were imposed, along with legislation interfering with the right of the colonies to govern themselves, directed specifically at Massachusetts, the site of much of the most outspoken resistance. By the end of the 1760s British troops and ships of war were a common sight in Boston and its harbor.

From 1765 onward increasing numbers of prints, political cartoons, and broadsides critical of the British circulated throughout the colonies. One such print was a 1770 engraving by the printmaker and silversmith Paul Revere (1735–1818) recording one of the outcomes of the presence of British troops in the city. He copied it from a design by Henry Pelham, Copley's half-

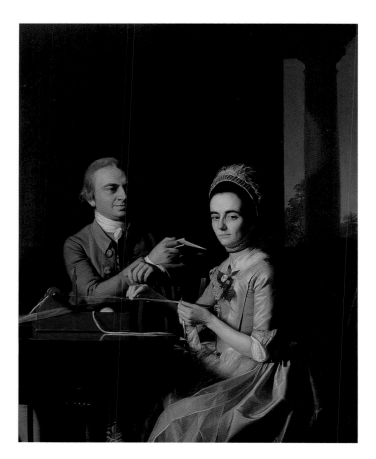

2.4 John Singleton Copley: *Governor and Mrs Thomas Mifflin*, 1773
Oil on bed ticking, 61½ × 48 in. (155 × 122 cm.)
The Historical Society of Pennsylvania, Philadelphia

Congress. In 1773 Copley had created a double portrait of him and his wife Sara [2.4]. This painting, which hung in the Mifflins' imposing Philadelphia home, may well have been witness to many of the conversations during the year before the Congress about the tactics to be used in resisting British interference.

Much about the portrait suggests that it was composed with these tensions in mind. While Thomas was a more important political figure than Sara, Sara seems to be the center of attention. Thomas looks at her and she, in turn, looks out at us with a confident and knowing glance. Dressed in elegant attire, she has paused in the process of working threads of silk on a large wooden frame used to make fringes for carriage whips. Copley thus paints Sara Mifflin engaged in the home production of items that might normally be imported from England, calling to mind earlier boycotts of British goods. The spinning, weaving, and sewing that were expected of women as part of their regular daily routines now took on a patriotic meaning. As the art historian Lois Dinnerstein points out, Copley presents Sara as the industrious housewife, both a model of refinement and domestic virtue and an exemplar of revolutionary zeal.

Copley's own feelings about the impending revolution were ambivalent. By the early 1770s he had become a wealthy man, with three houses and twenty acres on Beacon Hill. In addition, his father-in-law was the principal agent in the colony for the East India Tea Company, owner of the ship whose cargo had been thrown overboard. Copley had friends on both sides of the political fence and had actually attempted to mediate between them before the Boston Tea Party occurred. His attempts failed, however, and he left New England for England on June 10, 1774, and never returned (see p. 133).

The Congress that met in Philadelphia was not initially set on establishing an independent nation. Instead, it demanded that the colonies be allowed to govern themselves through elected officials, while at the same time maintaining certain political and economic ties to England. George III refused these demands, and sent additional forces to defend his interests. The first battle between British and American troops took place on April 19, 1775, at Lexington and Concord, west of Boston. In May, the Second Continental Congress met in Philadelphia and formed a central government under the authority of the people of the colonies, with George Washington as commander in chief of the Continental Army. On June 17, British troops and rebel militiamen clashed at Breed's Hill, near Boston (the battle was mistakenly named after nearby Bunker Hill). While the British won the battle, they sustained heavy casualties. Washington arrived in Cambridge in July and began a siege of Boston that lasted until March 1776, when the British fled the city and set up their headquarters in New York.

On July 4, 1776, the Congress issued the Declaration of Independence. Those loyal to the crown (Loyalists) fled to Britain and Canada. The French entered the conflict on the side of the Americans against France's traditional enemy, Britain, and from 1777 onward supplied much-needed munitions. In August 1781 they sent part of their navy to help in the decisive victory at Yorktown. By September 1783 the fighting was over and the final treaties signed, with the last of the British troops gone by the end of November.

Shortly after his arrival in England, Copley began work on a painting that addressed a key issue in the political debates taking place on both sides of the Atlantic: that many who argued for freedom from oppressive colonial rule also supported the enslavement of Africans. *Watson and the Shark* [2.5], completed in 1778, was commissioned by Brook Watson to commemorate a dramatic incident in which he lost a leg. But the art historian Albert Boime believes the painting is about much more than that. It contains not only a reconstruction of the attack on Watson, but also an indirect reference to the War of Independence.

When the young Watson was attacked by a shark in Havana harbor in 1749, nine men in a boat attempted his rescue. In his painting, Copley has placed a black man in the center of the composition, close to the apex of the pyramid formed by the group of men, a position usually reserved for important figures. He has also placed in the black man's hand the rope that connects Watson to the boat and that symbolizes his impending rescue. Many have read this figure simply as a servant waiting to hand the rope to the other men. Boime suggests a different interpretation, one connected to the debates over slavery.

Watson had traveled to New England in the late 1740s to live with a relative who owned several ships that traded in the West Indies. Vessels regularly left Boston with timber, dried fish, and other goods which were exchanged in Africa for slaves; these were then traded in the West Indies for sugar and molasses, which were brought back to Boston. It was on one such expedition that Watson lost his leg. After his return to England he rose to prominence as a wealthy merchant and Tory leader. When he commissioned his painting from Copley, a heated debate was raging in Parliament over both the Declaration of Independence and the institution of slavery. Watson attacked the Whigs, who supported independence, and pointed out the hypocrisy of the Revolutionary leaders in calling for freedom from the British crown when they themselves were denying freedom to African slaves. While many in New England had begun arguing for an end to slavery, in 1778 it still existed in places—e.g. in Massachusetts. During the Revolution the British used slavery to divide the colonists, promising freedom for every runaway slave who joined the British army (seventeen of Washington's own slaves took the British up on their offer).

2.5 John Singleton Copley: *Watson and the Shark*, 1778
Oil on canvas, 71¾ × 90½ in. (182 × 230 cm.)
Museum of Fine Arts, Boston, Massachusetts

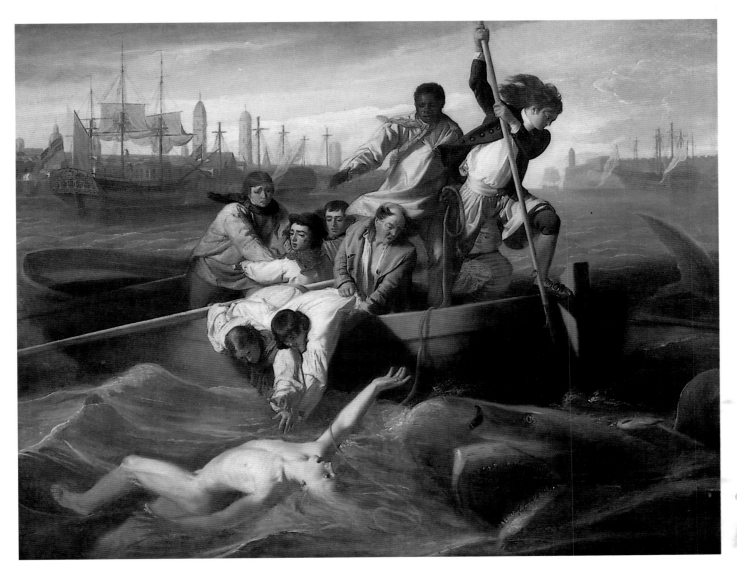

Copley's picture could therefore be read as a demonstration of Tory support for enslaved blacks, in the context of Tory opposition to the American Revolution. The shark-infested waters could also be seen as a metaphor for the colonies themselves, breeding ground of dangerous revolutionary ideas, with the loss of Watson's leg a symbol of the loss of part of the British Empire. That the bodies of African slaves who died on the passage from Africa to the Americas were thrown overboard to the sharks provides a further connection between Watson, slavery, and the American colonies. While the black man might function within this complex set of references to slavery and revolution as a sign of emancipation, Copley still presents him as a servant awaiting orders, not a fully engaged participant in the rescue. Watson, argues Boime, may have realized the political advantage of condemning slavery but, in light of his own profitable involvement in the slave trade, could not wholeheartedly support its abolition.

John Trumbull's Canvases of War

Many artists predicted that the greatest demand after the Revolution would be for portraits and battle scenes. One who moved to meet this demand was John Trumbull (1756–1843). The art historian Alexander Eliot suggests that Trumbull, born in Lebanon, Connecticut, was first attracted to art by the needlework of his sisters. In his autobiography, published in 1841, Trumbull also recalls that his "taste for drawing began to dawn early . . . and for several years the nicely sanded floors . . . were constantly scrawled with my rude attempts at drawing" (in the 19th century floors were often scoured with sand and water, then, when dry, covered with a thin layer of sand carefully swept into curved lines, scrolls, and herringbone patterns). He may also have been familiar with the work of Sibyl Huntington May (1734–?), who lived in the neighboring town of Haddam. Huntington May was well-known for her skill as a painter and for works such as an overmantel of 1756 [2.6], which depicts a hunting scene taken from early Haddam history, as well as the Congregational Church where her husband the Reverend Eleazar May had his pastorate. This overmantel painting could be seen, in fact, as one of the first colonial history paintings.

Eliot writes that Trumbull's father, the governor of Connecticut, found his son's "odd attraction" to art "inappropriate on two counts: first, the boy had lost the use of one eye in a childhood accident, and second, he was a gentleman." While Governor Trumbull accepted picture-making as "a fit diversion for young ladies and a profitable occupation for suitably skilled laborers," it certainly was not a calling for the sons of the elite. John was sent off to Harvard; but there, undoubtedly to his father's dismay, he met Copley, and embarked on an ambitious career as an artist. He served briefly in the Continental Army, where he

2.6 Sibyl Huntington May: *Hunting Scene*, overmantel, 1756
Oil on board, *c.* 24 × 32 in. (61 × 81.3 cm.)
Brainerd Memorial Library, Brainerd, Minnesota

made military maps, then departed for London in 1780, where he became West's student.

Trumbull remained abroad for most of the next thirty-five years, and in 1786 began a series of Revolutionary War scenes. He planned thirteen, but only completed six by the end of the 18th century (two more would be realized in the first decades of the following century). He hoped both to sell the paintings and to have them engraved to sell as prints, thus increasing the financial returns on his artistic investment. Trumbull intended that they would contribute to the creation of a pantheon of national heroes that would help bind together the various factions that were already competing for political and economic power. In 1789 he clarified his reasons for undertaking these first pictorial icons of the new nation in a letter to Thomas Jefferson:

> The greatest motive I had or have for engaging in, or for continuing my pursuit of painting, has been the wish of commemorating the great events of our country's revolution. I am fully sensible that the profession, as it is generally practiced, is frivolous, little useful to society, and unworthy of a man who has talents for more serious pursuits. But, to preserve and diffuse the memory of the noblest series of actions which have ever presented themselves in the history of man; to give the present and the future sons of oppression and misfortune, such glorious lessons of their rights, and of the spirit with which they should assert and support them, and even to transmit to their descendants, the personal resemblance of those who have been the great actors in those illustrious scenes, were objects which gave a dignity to the profession, peculiar to my situation.

With these words Trumbull not only sets out the patriotic nature of his artistic enterprise, but also argues for the political significance of history painting for the new nation.

Trumbull began his series of Revolutionary paintings in 1786 with *The Death of General Warren at the Battle of Bunker's Hill, 17 June 1775* [2.7] and *The Death of General Montgomery in the Attack on Quebec, 31 December 1775* [2.8]. One can see the influence of West in the compositions (Trumbull executed the first of them in West's painting room in London). Yet one can also see the differences. Trumbull's pictures are much more dramatic and colorful than West's *Death of General Wolfe* [1.84]. There is a dynamic diagonal that moves across them, as opposed to the more static equilateral triangle that dominates the center of West's work. While Trumbull undoubtedly relied on some of the same studies of facial expressions as did West, such as those published by Charles Le Brun, the smoke-filled and fiery atmosphere heightens their intensity. Both West and Trumbull focus on the heroic deaths of individual men; Wolfe's death alluded to the impending victory of the British over the French, but Montgomery's (also at Quebec) did not lead to victory, and the results of Warren's were not so clear-cut.

The "Battle of Bunker's Hill" was, in fact, a misnomer for the battle that took place at Breed's Hill, just south of Bunker Hill, on June 17, 1775. Trumbull had observed it from a distance through field glasses. In his painting [2.7] he alludes to its ambiguous end. Neither side is portrayed as totally defeated or totally victorious. Each has its mortally wounded, heroic leader surrounded by loyal comrades, General Joseph Warren—shot in the head with a musket—on the side of the Revolutionaries, Major John Pitcairn on the side of the British. In addition, Trumbull shows the British Major John Small grabbing the bayonet of a grenadier who is about to finish off General Warren. By placing Small's gesture in the center of the composition, the artist shifts the focus of the painting from the outcome of the battle to the enactment of noble deeds by noble men.

Trumbull's presentation can be explained in part by the nature of the battle, which the British won, but at great expense. It can also be explained by his situation when he painted the work. As a resident of England, he could not be too pro-Revolutionary. He had already been arrested for treason in 1780 and forced to return to America upon his release in 1781. The sting of defeat was fresh in British minds when Trumbull arrived back in England in 1784. West himself had had to abandon plans for a

2.7 John Trumbull: *The Death of General Warren at the Battle of Bunker's Hill, 17 June 1775*, 1786
Oil on canvas, 25 × 34 in. (62.5 × 85 cm.)
Yale University Art Gallery, New Haven, Connecticut

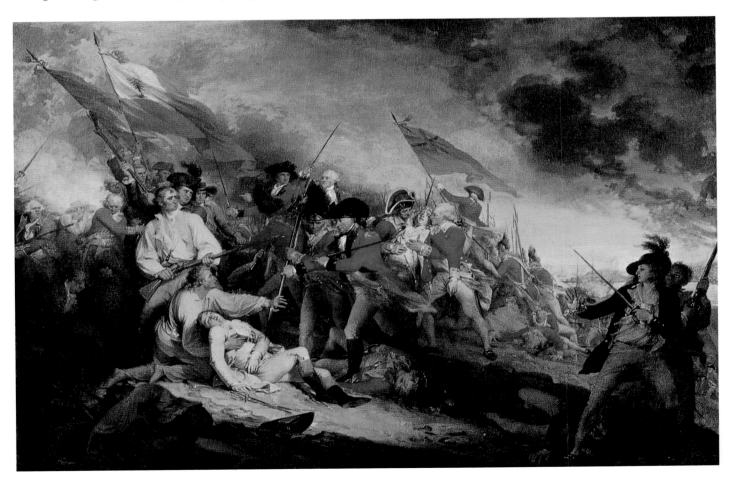

series of paintings on the American Revolution for fear of offending George III, whom he served as court painter. Trumbull hoped to sell the engravings, if not the paintings themselves, in England as well as the United States, so he had to create a series that would appeal to buyers on both sides of the Atlantic.

Just as Copley included a black man in *Watson and the Shark* [2.5], Trumbull includes two black figures among the Revolutionary forces at Breed's Hill. Unlike Copley, however, and more in keeping with West's treatment of the Native American in *The Death of General Wolfe*, Trumbull places them at the edges of the composition. One appears in the lower right-hand corner, accompanied by the white figure of Lieutenant Grosvenor. Trumbull himself described the pair as "a young American, wounded in the sword hand . . . attended by a faithful negro; but seeing his general fall, hesitates whether to save himself, or . . . return and assist in saving a life, more precious to his country than his own." The second black man appears on the opposite side, at the upper left—a mere head above the figure of a British officer and below the upraised arm of a chaplain. Again, as in Copley's painting, these black soldiers raise the issue of slavery and its place in a revolution dedicated to freedom from tyranny. Yet rather than highlight this issue, Trumbull marginalizes it, placing the most visible black man in an obviously subservient position behind Lieutenant Grosvenor.

Trumbull may also have included black soldiers in an attempt to be historically accurate. When the colonists gathered at Lexington and Concord in April 1775, black troops were included in their ranks. Approximately five thousand men of African descent served in the Continental Army (more fought on the side of the British); at least fourteen, known by name, participated in the "Battle of Bunker's Hill." The most famous of these men was Peter Salem. A firsthand account of the battle (recorded in 1787 by the New England historian Dr Jeremy Belknap in his diary) includes the information that "a negro man, belonging to Groton, took aim at Major Pitcairne [sic], as he was rallying the dispersed British troops, and shot him through the head." The same event was described by another early chronicler of the battle, Samuel Swett: "Among the foremost of the leaders was the gallant Maj. Pitcairn, who exultantly cried 'the day is ours', when Salem, a black soldier, and a number of others, shot him through and he died." Some scholars have identified the black man accompanying Grosvenor as Peter Salem. Burnham questions this, noting that Salem, a soldier from Massachusetts, would not have served under Grosvenor, an officer from Connecticut. If the other black man is Salem, he has been so carefully removed from the center of the action and distanced from Major Pitcairn, who has collapsed into the arms of British officers on the far right edge of

the central grouping, that his participation in the death of the latter has been, for all intents and purposes, erased.

Peter Salem fought in battles before the encounter at Breed's Hill and continued to fight after. At the end of the war he returned to Massachusetts, built a cabin near Leicester, and wove cane for a living. He died in 1816 in a poorhouse in Framington. He was among the first of many black men who would fight for their country hoping to improve their economic and political standing, and end up little better off than before. There had been, in fact, a great deal of unrest within black communities in New England before the Revolution. Petitions were gathered demanding access to land and greater freedoms. While many blacks in New England were not slaves as in the South, they did not enjoy the same personal and economic freedoms as Europeans. As John Adams was helping formulate the Declaration of Independence, his wife Abigail wrote to him regarding the protests of blacks: "It always appeared a most iniquitous scheme to me to fight ourselves for what we are daily robbing and plundering from those who have as good a right to freedom as we have." It would have been a very different painting, notes Burnham, had Trumbull "forecast ultimate victory . . . by showcasing Peter Salem killing Pitcairn."

In *The Death of General Montgomery* [2.8], Trumbull followed West's precedent [1.84] and placed a Native American, the Oneida leader "Colonel Joseph Lewis," in the group surrounding the dying general. Unlike West's figure, however, he is more central and actively involved in the drama of the moment, as he turns with tomahawk raised. General Montgomery failed to take Quebec, and was killed by cannon fire; his troops laid siege to the city but were forced back in the spring with the arrival of British reinforcements. Trumbull had accompanied a regiment bound for Fort Ticonderoga in the spring of 1776 and had reported on the condition of the troops retreating from Quebec. "I did not look into tent or hut," he wrote, "in which I did not find either a dead or dying man."

Trumbull has taken the overall composition of his first painting [2.7] and reversed it, with the diagonal now rising from the lower left corner to the upper right. Lord Grosvenor and the black soldier are replaced by three figures—Major Return Jonathan Meigs, Captain Samuel Ward, and Captain William Hendricks—who are similarly shocked at the death of their leader. The art historian Jules Prown suggests that their costumes were based on materials originally sent to West in 1783 by the Philadelphia artist Charles Willson Peale to help him plan his proposed paintings of the war. Peale had obtained from an acquaintance "a hunting shirt & leggens . . . such our of Riflemen usted to wear with Powder horn & shot pouch of the Indian fashion, with Wampum Belts, small Round hats of

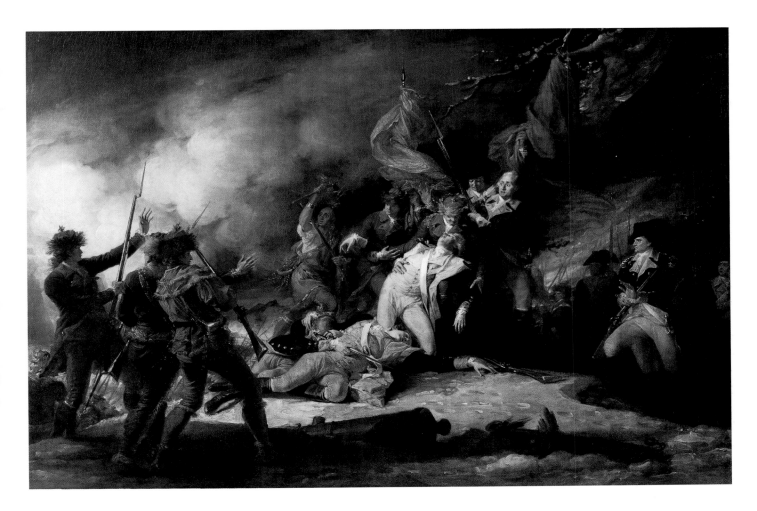

2.8 John Trumbull: *The Death of General Montgomery in the Attack on Quebec, 31 December 1775,* 1786
Oil on canvas, 24⅝ × 37 in. (62.3 × 94 cm.)
Yale University Art Gallery, New Haven, Connecticut

bucks tail and some times Feathers. Very often these shirts were dyed brown—yellow, pink and blue black colour according to the fancy of the companies." Thus while the Oneida leader adopts the white shirt and rifle of European culture, two of the Continental Army officers wear the beaded pouches and moccasins of Native American culture.

Subscriptions for engravings of Trumbull's paintings were offered for sale in the early 1790s, when his talents were being celebrated by at least a few people in the newly independent nation. The Reverend Timothy Dwight, president of Yale College, included a panegyric to Trumbull's works in "The Vision," Part VII of his poem of 1794, *Greenfield Hill*:

> On the bright canvas, see the pencil trace
> Unrivall'd forms of glory, and of grace!
> No strumpet, handed to perpetual fame,
> No scenes of lewdness, and no deeds of shame;
> Scenes, that would Envy of her snakes beguile,
> Deeds where fond Virtue loves to gaze, and smile:
> Such forms, such deeds, on Raphael's tablets shine,
> And such, O Trumbull! glow alike on thine.

Trumbull was the virtuous painter who would celebrate the successes of a nation the Calvinist Reverend Dwight viewed as "the favorite land of heaven; the greatest empire the hand of time ever raised up to view."

Unfortunately for Trumbull, not everyone shared Dwight's high opinion of his paintings. Neither they nor the engravings were the success he had hoped they would be. While in America there might have been some desire for a national art, grandiose history paintings, despite being devoid of "strumpets" or other evidence of "lewdness," were still connected in the minds of many to a corrupt aristocracy and a royal court. Trumbull may also have been seen by some as unpatriotic for preferring residence in England. There, little interest was shown in images that reminded people of recent defeat; in fact, the artist admitted later that his Revolutionary War paintings "had given offence to some extra-patriotic people in England." Trumbull, like so many of his fellow artists, would have to turn to portrait painting to

earn his living. Only later, in 1817, were his talents as a history painter recognized with a commission from Congress for four large canvases for the Capitol Rotunda in Washington (see pp. 113–14).

The Aspirations of Women: Postrevolutionary Samplers

The same year Trumbull finished *The Death of General Montgomery* and *The Battle of Bunker's Hill*, another individual was recording her understanding of the state of the nation, its past and its future. On March 8, 1786, fifteen-year-old Cynthia Burr (1770–?) completed an elaborate needlework sampler [2.1]. The central scene contains a two-story building, with wide steps leading up to a front door above which rises a pediment. Flanking the house are two couples, the one on the right appearing to be older than the one on the left. Each is located beneath a tree, whose branches curve elegantly above them. A line of clouds traverses the area above the couples and house and frames the phrase "Let Virtue be A Guide to Thee." Above this phrase two more lines of text contain an alphabet (minus the "J" and "U") and the statement "Cynthia Burr was born May 21 1770." The lower edge of the central scene is marked by a brick wall, which encloses the two couples and two animals, one beneath each couple. Above the alphabet is a chain-like inner border, which extends down the sides but is open at the bottom, effectively linking the central scene to the subsidiary scene below.

The lower scene is at one and the same time separate and a continuation of the outer border of the sampler itself. It is composed of a large urn containing an elaborate array of flowers flanked by two women who each sit beneath a tree and are accompanied by two small animals, possibly cats. On the surface of the urn are stitched the words "Cynthia Burr is my Name and With my needle I wrought," with the last two words of the sentence —"the same"—located outside the parameters of the urn. Behind the two women are two additional urns, out of which grow the flowers that compose the right and left borders of the entire composition. At the top is another imposing building, this one suggesting a public edifice, possibly a school. To the right of the building is another couple, with crooks, who appear to be herding several animals, although they are quite elegantly dressed for the occasion.

Burr's sampler is similar in content and composition to several others produced at this time, in which the buildings have been identified as the University Hall at Brown University (at top) and the Old State House of Providence, Rhode Island (in the center). She may have attended Polly Balch's school for girls in Providence, for at least one other sampler of this type has been connected with a student there. While girls began with a similar pattern, each made her own additions in order to

personalize her work. Burr's is much less crowded than some, with the various registers clearly separated from each other.

The emphasis on pastoral landscapes and strolling couples in many sampler patterns suggests a debt to British 18th-century landscape painting of country gentry surveying their estates, such as Thomas Gainsborough's *Mr and Mrs Andrews* (c. 1749). Also common to both is the absence of any indication of the hard work involved in tilling the land or tending the animals (the couple in the top right of Burr's sampler seem to be playing at being shepherds). The presence of several couples also indicates one purpose of expertly stitched samplers: to provide evidence of a young woman's readiness for marriage.

Burr locates her name in two places. The line recording her name and birth date in the upper portion is associated with both learning (the alphabet) and virtue ("Let Virtue be A Guide to Thee"). This line is also in close proximity to the two couples below, suggesting she will follow their example in forming a virtuous marriage. By placing her name again on the surface of the urn, she suggests that she is, in fact, the source of fertility, be it as a mother or a needleworker. The abundance of flowers similarly points to the fecundity of both the prospective bride and the land itself. Her decision to place two words outside of the urn's borders may well have been a practical one—they just wouldn't fit. But it also conveys the sense that the conventional frameworks that controlled or allowed for women's creativity were not sufficient to contain the artistic expression of the young Cynthia Burr. Her aspirations are tempered, however, by the misspelling of "March" in the top left-hand corner. Success would obviously require further study and hard work.

Abigail Adams also wrote to her husband John to "remember the ladies" when drafting the Declaration of Independence. He gave this suggestion as little attention as he did her admonition regarding the treatment of blacks. Women in the colonies, like blacks, would have to wage their own battles for political and economic freedom. Both groups realized that the success of their efforts would depend largely on their access to education. They would need the skills necessary to press their demands in the courtroom, the marketplace, and the art world.

Money, Beauty, and Rank: Silver in the New Republic

Both the revolutionary fervor of Trumbull's paintings [2.7, 2.8] and the pastoral iconography of Burr's sampler [2.1] can be found in silver objects created in the colonial era. The former appears in a work by the most politically active, artistically innovative, and successful colonial silversmith, Paul Revere. Just two years before he produced a print of the Boston Massacre of 1770 [2.3], Revere created his Sons of Liberty Bowl to commemorate both the radical Whigs whose names were engraved on

the rim of the bowl and the ninety-two members of the Massachusetts House of Representatives who refused to rescind a letter sent to the legislatures of all the colonies in 1768 protesting the levying of taxes by the British crown. He also added an homage to the radical English Whig and tax critic John Wilkes.

Pastoral iconography appeared primarily on Boston creampots and teapots and narrated, according to the art historian Patricia Kane, "the stories this class of colonial New England consumers told themselves, stories that reflect their concerns and interests," in particular about social status, land ownership, courtship, and sexual pursuit. These stories would have been reflected upon during teatime, a gathering Kane describes as at "the very core of family life, bringing together as it did the whole family once a day." Tea was also a time at which friends, acquaintances, and even strangers were welcomed into the home. At such moments, narratives about sexuality and courtship would have constituted a particularly salient aspect of the conversation, as young women of marriageable age were often responsible for serving at the tea table.

Tea sets were, in fact, among the most sought-after silver objects in the years immediately following the Revolution, one indication of what the curator Jeannine Falino describes as "a trend toward broad ownership of genteel goods." This trend had begun before the emergence of an independent republic, and increased at a rapid pace. A nascent wage-based economy was quickly replacing the subsistence and barter systems of the Middle Ages, enabling people from all walks of life to use their income to purchase goods. "Even in the colonies," writes Falino, "where currency problems were rife until the formation of the new republic, the power of the purse had an enormous impact upon the marketplace, where manufactured products at all price levels soon began to enter everyday life."

Revere's records of his silver commissions, along with other evidence relating to his customers, provide valuable accounts of purchasing patterns for silver in the second half of the 18th century. His customers, many of whom he inherited when his father died in 1754 and he took over the family business, came from a wide range of socio-economic groups—artisans, middling-income merchants, professionals, the business elite, and government appointees. Revere produced more low-end goods—flatware, shoe or knee buckles, buttons, harness fittings—than high-end, for the elite preferred to buy their more elaborate silver goods from England or other European countries. Much of his success after the Revolution, however, lay in his ability to respond to demands for specific kinds of more elaborate silver objects, in particular sugar bowls, creamers, and teapots. Falino notes that after the Revolutionary War, "Revere achieved near dominance of silver teapot production," taking advantage of a return to popularity of a beverage that had earlier symbolized a resistance to English taxes and the consumption of which had thus diminished immediately prior to and during the hostilities.

Before the war, colonists had preferred to purchase silver as single pieces, thus slowly acquiring complete tea sets; after the war the purchase of larger tea services as a complete set became popular. Revere's production of such *en suite* tea services was facilitated by the availability of rolled sheet silver, which was a more economical method of producing silver vessels, in particular fluted teapots like the one at the center of the set he made for a wealthy Boston merchant and his wife, John and Mehitable Templeman, in 1792 [2.9]. The rolled sheet

2.9 Paul Revere: Tea service, 1792
Silver and wood
Minneapolis Institute of Arts

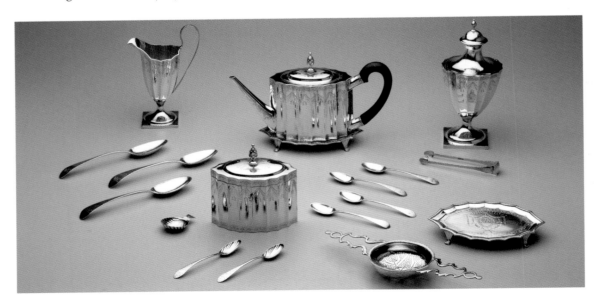

metal also made it easier to achieve the fluting and straight edges that mark these objects. Their clean lines and finely engraved designs of draped fabric and tassels recall the neoclassical forms that were then popular in much of Europe and associated with newly emerging republics on both sides of the Atlantic. These neoclassical attributes, found on all manner of goods and buildings in the immediate post-Revolution or Federal period, were the hallmarks of what came to be known as the Federal Style. Revere also engraved the Templemans' initials—JMT—on the spoon handles, stands, and sugar urn, reinforcing the association between these objects and their owners, and serving as a kind of insurance, making it easier to track down the owner if the item was stolen.

Much of the silver in the homes of the well-to-do in the 18th century took the form of coins that were often melted down and transformed into domestic objects, and sometimes re-melted to pay off debts or to fund revolutionary armies. This transference from craft to currency and back suggests the particular place that silver held in colonial and postrevolutionary America. According to the historian Richard Lyman Bushman, silver was "a powerful material for establishing identity and configuring hierarchical relationships. . . . Everywhere, silver was used to command assent, to assert authority, or to claim respect." Silver's power, notes Bushman, lay in the fact that it could signify three things at once: money, beauty (which was also associated with divinity), and rank. In an era of dramatic fluctuations in paper currency, silver maintained its value and carried with it "the authority of British sterling and . . . the intractable worth of bullion."

Yet the sheen of silver was tarnished by both its origins and its association with thievery and deceit. Much American silver originated in mines in Mexico and Peru and was extracted through a system of forced indigenous labor marked by long hours and appalling conditions, conditions that were remarked upon in political treatises and literary tracts available to American colonists. Many merchants, through their participation in the slave trade, then acquired the coins created from this silver. Once acquired, owners of such silver had to worry about thieves who recognized the wealth and status associated with this valuable metal and who were not averse to counterfeiting as well as stealing. Thus, as Bushman writes, "silver figured in a complex and ambiguous narrative of power." Whether as coinage or as teapots, it represented both elite status and a more democratic consumer revolution, as well as the underbelly of the economic system that made both possible.

Presidential Poses: Images of George Washington

Portraits from Life: Painting and Sculpture

Burr's sampler [2.1] and Revere's tea set [2.9] attest to the presence of cultural traditions, often aristocratic, that originated in England, and Europe in general. As much as leading citizens of the United States might espouse principles of liberty and equality, socio-economic hierarchies still marked the realms of culture and politics. These hierarchies are particularly evident in the portraits created after independence.

While portraits were most often seen as personal commemorations, those of important political or military leaders were also representations of the nation. George Washington was the most important political leader during the first years of American independence. Initially head of the Continental Army, he became the country's first president in 1789. While not an aristocrat by birth, he was a wealthy farmer, as were most of the men who led the colony into rebellion against England and who formed the Federalist Party. They believed that the new leadership must be drawn from the wealthy and well-educated citizenry. This conflict between elite rule and

2.10 Gilbert Stuart: *George Washington* (the Vaughan Portrait), 1795
Oil on canvas, 29 × 23 in. (73.7 × 60.3 cm.)
National Gallery of Art, Washington, D.C.

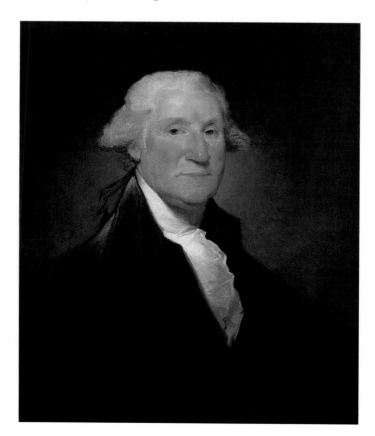

a more radical and leveling republicanism would mark the political debates in the United States throughout its early years of independence.

One artist who devoted much time to the depiction of the country's first president was Gilbert Stuart (1755–1828). Born in Rhode Island, Stuart studied in Scotland, England, and Ireland between 1772 and 1793, becoming a pupil of West's. Upon his return to the United States he met with great success as a portrait painter. One of his earliest paintings of Washington is the Vaughan Portrait of 1795 [2.10], in which the sitter gazes out at the viewer with confidence, a slight smile on his face. Stuart was a Federalist and, like most Federalists, was fearful of runaway populism, looking to strong leadership to keep the country's more "radical" elements in check. Yet he was also aware that lavish pictorial celebrations of the political or economic power of any single individual often met with disapproval in a country having only recently freed itself from British control. While Washington possesses an aristocratic bearing, he appears as a statesman rather than a landowner, a man of republican rather than monarchical aspirations.

In another portrait, commissioned in 1796 by Senator William Bingham of Pennsylvania as a gift to the Marquis of Lansdowne [2.11], Stuart more self-consciously promotes Washington as a republican ruler. His stance, with the upraised arm signaling public address, is that of a Roman republican senator (the stance is found in many Roman statues from the first century BCE). The President is located not on the battlefield or on his estate but in his office. The books under the table, which include a copy of the Constitution and volumes of *The Federalist* and the *Journals of Congress*, indicate the dedication and studiousness of the country's new leader.

The chair and table in the Lansdowne Portrait also display the newly emerging iconography of the young nation—the stars and stripes on the back of the chair, the bald eagle carved on the leg of the table. These appeared on the country's seal, together with an olive branch and a bundle of arrows (representative of the combined strength of the colonies) clutched in the eagle's claws. The eagle and arrows were also symbols of the Iroquois League, an iconographic borrowing that may have represented a much broader, political borrowing. During the debates of the Continental Congress and the Constitutional Convention, speakers referred openly to Iroquois ideas regarding the unification of disparate units (peoples, colonies) into a league or confederation. Congress formulated a speech to the Iroquois in 1775 in which the Six Nations were referred to as a "wise people" who offered valuable counsel. In fact, for the first hundred years of independence, Native Americans were acknowledged as one source of European American democratic

institutions, along with British common law, the Magna Carta, Roman republicanism, and Greek democracy. Thus, the syncretic forms of both art and social organization that appeared shortly after the arrival of European colonists continued to evolve.

George Washington was also commemorated in carved portraits, although they were fewer in number than painted versions. Sculpture did not become a fully developed art form in the U.S. until the early 19th century. Prior to that time it was viewed primarily as a craft, with its practitioners producing low-relief carvings on gravestones and furniture or wooden figures for commercial purposes. Sculpture was also more costly and time-consuming than painting and there were few buildings that required statues or carved decorations. Those who desired training as fine artists had to travel to Europe in order to study

2.11 Gilbert Stuart: *George Washington* (the Lansdowne Portrait), 1796
Oil on canvas, laid to wood, 96 × 60 in. (243 × 152.4 cm.)
The Pennsylvania Academy of the Fine Arts, Philadelphia

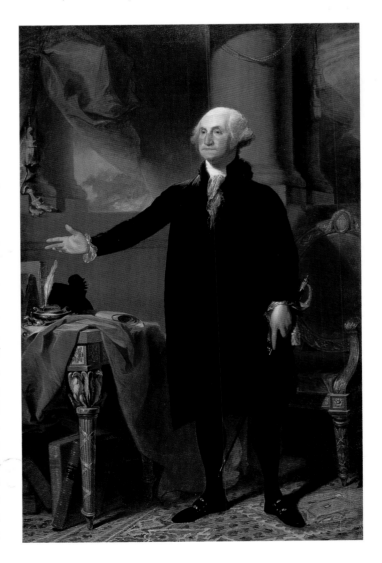

from either classical Greek and Roman statues or plaster copies and to gain access to supplies of marble.

Several skilled woodcarvers from England had set up shop in New England in the late 17th and 18th centuries to service both domestic and commercial needs and to train a new generation born in the colonies. One of the industries most in need of their skills was shipping. Almost every major community on the eastern seaboard had a shipyard, and carvers were enlisted to provide figureheads, sternboards, and other decorations for the ship's interior and exterior. Many successful carvers employed several apprentices. Designs were worked up, often from live models, and submitted to shipbuilders. A lengthy correspondence sometimes followed between the carver and the shipbuilder over the exact features of the figure.

An early example of a wooden figurehead is *Lady with Portrait Medallion*, dated to c. 1795–1805 and attributed to Samuel McIntire (1757–1811), an architect and carver from Salem, Massachusetts [2.12]. McIntire came from a family of carpenters and benefited from the prosperity that Salem

2.12 Attributed to Samuel McIntire: *Lady with Portrait Medallion*, figurehead, c. 1795–1805
Painted wood, H 26 in. (66 cm.)
Peabody Museum, Salem, Massachusetts

2.13 Laban S. Beecher: *Figurehead of Andrew Jackson, from the U.S. frigate "Constitution,"* 1834
Painted wood, H 142 in. (361 cm.)
Museum of the City of New York, New York

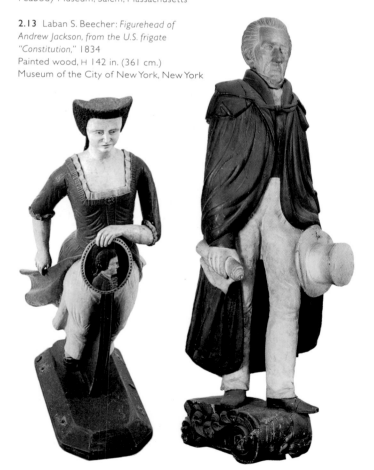

enjoyed after the War of Independence, when shipbuilding and trade flourished. He designed several homes for Salem's wealthy merchants, often providing furniture and carved decorations. He also created the occasional wooden portrait bust. While *Lady with Portrait Medallion* may have been intended for a small sailing vessel or as a study for a larger figure, it was used as a shop sign. The portrait medallion may be of the captain of the vessel and the female figure, with her simple gown and broad shoulders, his wife. Captains of small whaling vessels often commissioned portraits of their wives or daughters who, like the figureheads, constantly surveyed the seas waiting for their husbands and fathers to return home.

Different kinds of ships required different kinds of figureheads, ranging from the small, plain ones of the whalers to the larger, more elaborate women with billowing gowns and striding poses that graced the famous clippers. Not all figureheads, however, were female. Some ships displayed generic male sailors while others bore the likenesses of American politicians. The latter were most likely to be found on military vessels, such as the *Constitution*, which sported the Boston carver Laban S. Beecher's 1834 over-life-size figurehead of President Andrew Jackson [2.13]. Beecher's work was the *Constitution*'s third figurehead, the others having been damaged or worn beyond repair in military battles. While Andrew Jackson may have been the most politically appropriate choice of subject-matter in 1834, this particular rendition was not necessarily the most aesthetically appropriate. Standing stiffly upright in a long dark coat, with a hat in one hand and the rolled-up Constitution in the other, he conveys not movement and dynamism but rigidity and the inability to navigate difficult waters. A more elegant pose or costume may have carried too many elitist associations for this staunchly populist president. One person who objected to the new figurehead and the politics it represented proved his point by sawing off Jackson's head just below the nose shortly after the figure had been mounted on the ship. It was restored the following year.

At least one full-length wooden portrait of Washington was created around 1800 by the carver Joseph Wilson (1779–1857), who was well known for his ship figureheads, for Timothy Dexter, a wealthy merchant who resided in Newbury Port, Massachusetts. It was one of a group of forty-five life-size painted carvings commissioned by Dexter from Wilson between 1799 and 1800, which were set atop the columns, fences, arches, and buildings located on the merchant's estate. The resulting display is recorded in a mezzotint from 1810, four years after Dexter's death [2.14]. The figures included not only Washington, but also Thomas Jefferson, John Adams, Sir William Pitt, Napoleon Bonaparte, Dexter himself, and other

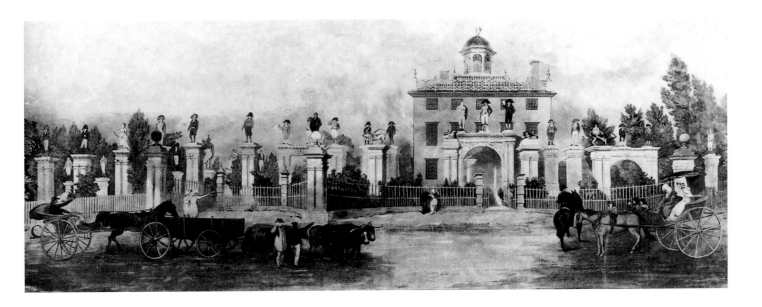

luminaries with whom he wished to be associated (he took on the title of "Lord" as an indication of his own sense of self-importance). Washington can be seen atop the arch, flanked by Adams and Jefferson. Unfortunately, only the figure of Pitt and a few pieces from another carving survive.

Washington also came close to being memorialized in wax by the then well-known sculptor Patience Lovell Wright (1725–86). Born in Bordentown, New Jersey, the daughter of an intensely religious Quaker farmer, Patience Lovell left home at the age of twenty and moved to Philadelphia, where she married the cooper Joseph Wright. She returned to Bordentown and spent the next twenty years raising a family, all the while continuing the modeling in clay that she had begun as a child. After her husband's death Wright, along with her widowed sister Rachel Wells, set up a business modeling portraits in wax. She then moved to New York and became well known for her ability to sculpt accurate likenesses of her sitters, despite the fact that she was mostly self-taught. She created a waxworks show that toured the East Coast and completed portraits of many leading citizens, including Cadwallader Colden, Lieutenant Governor of New York. Her life-size figures were made more life-like by the addition of skin color, eyelashes, glass eyes, and real clothes. After a fire, which damaged many of her works, she left for England with her children in 1772 to make her fortune as an artist.

Once settled in London, Wright set up her waxworks show and began receiving some of the city's leading figures, as well as commissions to produce their portraits in wax. One of her few surviving works is a statue of the Prime Minister, Sir William Pitt [2.15], dressed in his parliamentary robes and holding a scroll in his right hand. Created in 1779, it is a sympathetic

2.14 Anonymous: *A View of the Mansion of the late Lord Timothy Dexter in High Street, Newbury Port,* 1810
Mezzotint, 26½ × 16¼ in. (67.3 × 42.5 cm.)
Henry Ford Museum and Greenfield Village, Dearborn, Michigan

2.15 Patience Lovell Wright: *William Pitt, Earl of Chatham,* 1779
Wax effigy, life-size
Undercroft Museum, Westminster Abbey, London

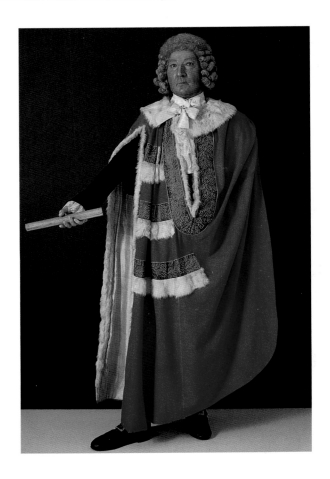

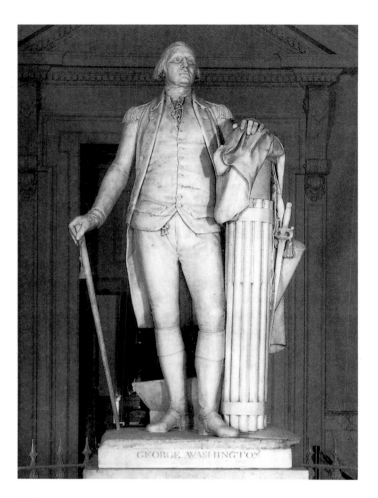

2.16 Jean-Antoine Houdon: *George Washington*, 1788
Marble, life-size
Virginia State Capitol, Richmond

tures. Like her fellow expatriate Trumbull, Wright was inspired by the success of the Revolution and planned to create a series of monuments to the nation's new leaders. She wrote to George Washington, who replied that he would be honored to sit for her. Unfortunately, she died in 1786, before she was able to return to America and execute the portrait.

A year before Wright's death, the French sculptor Jean-Antoine Houdon (1741–1828) was commissioned to create a marble statue of Washington for the Virginia State Capitol at Richmond [2.16]. The piece was completed in 1788, the year before Washington's inauguration as president. It presents him in contemporary dress as a modern Cincinnatus, the Roman general who returned to farming after concluding his military service (the badge of the Society of Cincinnatus, a fraternal order founded in 1783 by several officers of the Continental Army who were returning to civilian life, projects from under Washington's waistcoat). Behind him is the proverbial sword-beaten-into-a-plowshare. Beside him is a bundle of thirteen rods, or fasces. A symbol of Roman political office, they, like the thirteen arrows in the eagle's claw, represent the original thirteen states and the power to be gained through union. Upon these fasces Washington hangs the symbol of his military service, his sword. The battles he would now engage in would take place in the halls of Congress rather than the open countryside.

Posthumous Portraits: The Mourning Picture

After Washington's death in 1799 another type of portrait of the president was produced in great numbers—the mourning picture. Mourning pictures appeared in late 18th-century America first in embroidered form and later as paintings or combinations of embroidery and painting. (They would be replaced by hand-colored lithographs in the middle of the 19th century.) As the death rate declined in the late 18th century, an earlier matter-of-fact approach was replaced by more elaborate and sentimentalized practices. Women played key roles in the rituals of death and mourning, so it is not surprising that they were the main authors of such pictures.

An early work by Prudence Punderson (1758–84) provides a good example of the less sentimental treatment of death. Some time before 1773, the year she married Dr Timothy Wells Rossiter, she created a needlework picture entitled *The First, Second, and Last Scene of Mortality* [2.17]. It depicts the various stages of the life of a white woman of comfortable means, from birth to middle age to death. On the right she comes into the world as a child, taken care of in her early years by a black female servant or slave. At the center she is a mature woman, busying herself with her embroidery (here the child serves a second function as an indication of the mature

portrait of someone Wright described as the "guardian angel" of America for his vocal support of the colonies. The art historian Charlotte Streifer Rubinstein reports that when the sculpture was cleaned in 1935 it was found that "the hands were veined and colored with underslips, and even showed hairs on the surface." She also summarizes Wright's working methods, known from contemporary accounts: "To keep the wax malleable she modeled the bust under her apron, warming it with the heat of her body. At a certain point she would pull the head out from under the apron and put finishing touches on it under the astonished gaze of the sitter." Known for her sharp wit and outspokenness, Wright undoubtedly enjoyed the allusions to childbirth that this working method entailed.

Wright was outspoken in her criticisms of the policies of George III, who had invited her to come to the palace and model his portrait. She advocated independence for the colonies and for women, and was said to have sent messages with political information home to her sister in the wax heads of her sculp-

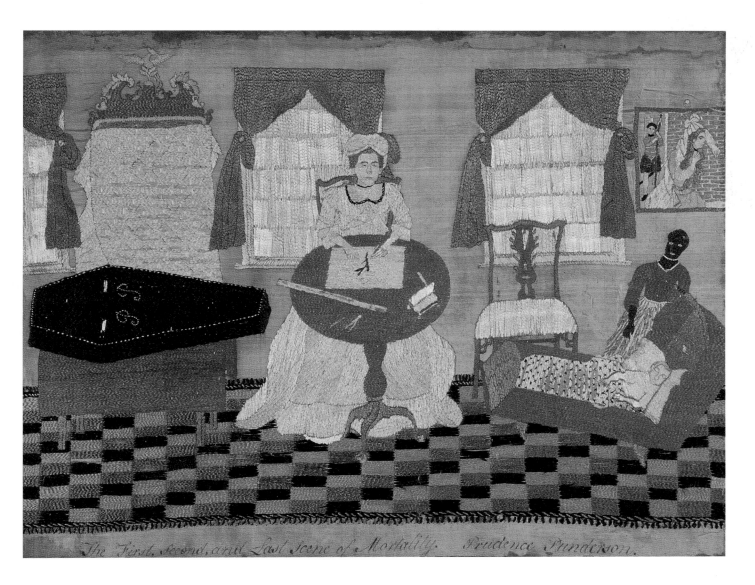

2.17 Prudence Punderson: *The First, Second, and Last Scene of Mortality*,
before 1773
Silk on silk, 13 × 17½ in. (33 × 44.4 cm.)
The Connecticut Historical Society, Hartford

woman's role as a mother). On the left a coffin with the initials
PP (those of the artist) rests on a dropleaf table. The black ser-
vant at the edge of the composition is a common element in
both painted and embroidered scenes by colonial women of
their domestic interiors, indicating the extent of slavery or
other forms of black servitude throughout the northern
colonies in the 18th century. On the wall at the right is a
painting of a woman elegantly attired and attended by a soldier
in what appears to be medieval garb. The mirror behind the
coffin is draped, a sign of mourning.

Early 19th-century mourning pictures were much more
theatrical. They shared certain common features, noted by Kurt
Dewhurst and Betty and Marsha MacDowell: "imaginary land-
scape settings, classical urns mounted on inscribed tomb-
stones, weeping willow trees, and mourning figures, generally
female, bowed in the classical posture of grief." The source of
many of these elements was ancient Greek funerary art, and
their increased use in embroidered and painted images was
part of a larger revival of classical Greek forms in the U.S. at the
end of the 18th century. The American pictures were not drawn
from the original Greek examples, however, but from engrav-
ings of the work of the British architect Robert Adam, the
British ceramic manufacturer Josiah Wedgwood, and the Swiss
painter Angelica Kauffmann, among others. They also con-
tained new elements that set them apart from their European
prototypes—churches, pine trees, villages, ships, angels, birds,
and flowers. Thus the Greek and Roman past was combined
with the American present and infused with Christian symbols.

Mourning Picture for Prudence and Ebenezer Punderson by
Hannah Punderson (1777–1821), the sister-in-law of Prudence

2.18 Hannah Punderson: *Mourning Picture for Prudence and Ebenezer Punderson,* completed *c.* 1822
Pen and ink and watercolor on paper, 16½ × 20⅜ in. (42 × 51.4 cm.)
The Connecticut Historical Society, Hartford

Punderson but a generation younger, is a fine early 19th-century example [2.18]. Painted in watercolor on paper, it commemorates the deaths of her husband's parents with the requisite urns, weeping willow, and mourning female figure (Ebenezer died in 1809; Prudence died in 1822, when the date was filled in on her urn). Punderson has added a church in the background, with its enclosed graveyard, and a curious upside-down angel. Perhaps the latter is descending to crown

2.19 Attributed to Samuel Folwell and an unidentified needleworker:
Memorial to George Washington, Philadelphia, *c.* 1805
Silk embroidery with ink and watercolor on silk, 16⅞ × 20¾ in.
(43 × 52.7 cm.)
Abby Aldrich Rockefeller Folk Art Center, Williamsburg, Virginia

the tombs with laurel, although its rigid form gives little indication of movement. The stitching of the earlier embroidered works is replicated in the short, precise brushstrokes, a practice common in painted mourning pictures and a testament to their needlework origins.

One individual who capitalized on the demand for mourning pictures commemorating George Washington was the artist Samuel Folwell (1764–1813), who developed a stock design, "In Memory of the Illustrious Washington." Folwell would trace the basic composition on silk in grisaille, then give it to a student at the needlework school he and his wife ran in Philadelphia, who would stitch the design under the supervision of his wife, Ann Elizabeth. He then traveled up and down the East Coast selling these needlework patterns, with the background already painted in. *Memorial to George Washington* [2.19] of *c.* 1805 is attributed to Folwell and an unidentified needleworker and closely resembles a memorial painted on silk signed by him five years earlier, except that the figure of a soldier leaning on his rifle has been added. Folwell would have executed the finishing painted touches, such as the portrait of Washington and the sky with an eagle and an angel blowing a trumpet and bearing a laurel wreath, signs of nationality and glory respectively. The mourning figure also holds a rod and cap that symbolize freedom (see p. 116), thus connecting her with representations of Liberty. The soldier speaks to Washington's role as leader of the Continental Army and thus his contribution to the successful struggle for freedom from colonial rule. Such images as this, framed and given a place of honor in the family parlor, helped spread patriotic sentiment and functioned as domestic counterparts to the marble statues and painted canvases that graced the nation's public buildings.

From Painting to Print to Embroidery: The History of an Image
Another image of the President that combines needlework and painting is *George Washington and His Family,* created around 1810 [2.22]. The painted portions include the hands, arms, and heads of the figures and the sky and water in the background. The needleworker and painter, who may have been the same individual, have not been identified, but the work itself is a copy of a 1798 print entitled *The Washington Family* [2.21], created by the American artist Edward Savage (1761–1817), with the assistance of the English engraver David Edwin (1775–1841). Savage made the engraving after his painting of the same name [2.20]. Much can be learned by comparing the different manifestations of this scene.

Savage began his large group portrait in 1789. He took it with him to London in 1791, where he continued to work on

it, and completed it in 1796, two years after he had returned to the United States. The engraved version proved extremely popular; within three weeks of its initial appearance there were over 430 subscribers and Savage estimated that it would earn him $10,000 with a year. Washington ordered four copies and was later presented by Savage with an example printed in color.

The painting shows George and Martha Washington, their two grandchildren Eleanor Parke Custis and George Washington Custis, and a black servant—a sign of wealth and privilege as in earlier paintings—whose identity is not certain. The figures are in a room on the family estate at Mount Vernon, arranged around a table in front of two columns and a swag of drapery, elements often used as framing devices and to suggest both nobility and domestic harmony. On the table is a plan of the city of Washington, possibly the official engraving of Pierre Charles L'Enfant's 1791 design for the new capital [2.27], published in 1792; in the distance is a view of the Potomac River. George Washington wears full military garb. His left hand rests on the table, on top of a set of papers and the plan and next to his sword and hat; Martha Washington points with her fan to one of the main streets of the city. The President's right hand rests on his grandson's shoulder. The grandson in turn rests his right hand, holding a compass, on a globe, and holds a piece of paper in the other. Eleanor Parke Custis also gestures toward the city plan. Thus, Savage has created an image of Washington as a military, civic, and family leader, ensconced in a learned environment and contemplating the future of the nation and its new capital. The artist has modeled the figures fully in the round, reinforcing the three-dimensionality of the setting through the use of a tiled floor pattern, whose diagonal lines (orthogonals) emphasize its recession into the distance.

While the engraved version of Savage's painting [2.21] differs little from its source, the needlework rendition [2.22] contains significant alterations. To begin with, the original format has been altered to produce an almost square picture, thus reducing the relative size of the figures in relation to

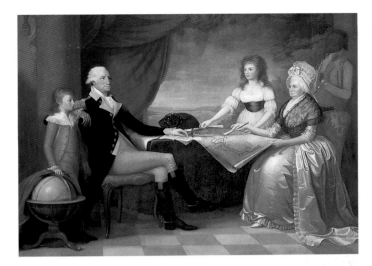

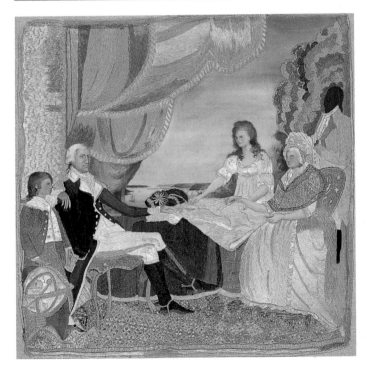

2.20 Edward Savage: *The Washington Family*, 1789–96
Oil on canvas, 84⅜ × 111⅞ in. (213.6 × 284.2 cm.)
National Gallery of Art, Washington, D.C.

2.21 Edward Savage and David Edwin: *The Washington Family*, 1798
Stipple engraving
National Portrait Gallery, Smithsonian Institution, Washington, D.C.

2.22 Anonymous, probably from New England: *George Washington and His Family*, c. 1810
Silk embroidery and watercolor on silk, 20¾ × 20 in. (52.7 × 50.8 cm.)
Abby Aldrich Rockefeller Folk Art Center, Williamsburg, Virginia

the composition as a whole. The column to the right has been omitted and the swag of drapery extended further across. The plain square floor tiles have been replaced by an elaborately embroidered carpet, which is tilted up, sacrificing the illusion of three dimensions for the clear display of the design. In fact, the needleworker seems to have taken the greatest pleasure—and exercised the greatest skill—in replicating the various types of textiles present in the composition, from the carpet and the swag of drapery to Martha's lace shawl and the green suit of the young boy. The trees in the upper right and marble column on the left are less convincing representations of plant matter and stone.

That a needleworker would take great pleasure in representing the qualities of different textiles is not surprising. Needlework played a major role in a woman's sense of herself, of her present and future prospects. Public commentaries reinforced this identification, associating women with the textiles they produced and/or wore. This association was made in an 1802 review of the painting in the *New York Morning Chronicle*. Whereas the author admired Savage's rendition of George Washington for "the serene commanding aspect of a venerable man, whose presence alone calms the tempest," his commentary on Martha Washington focused on her clothing: "it is inexpressibly graceful—the small folds arise by the gentle gradation of an imperceptible curve from the grand and bold parts of the drapery, and are again dissolved in *these* parts with a noble liberty."

Martha Washington (1731–1802) was a skilled needleworker, as evidenced by her pinwheel patchwork quilt of 1785 [2.23]. Indeed, in the needlework version of *George Washington and His Family*, the map on the table could almost be read as an embroidery or a quilt top. Cuesta Benberry, in her study of African American quilts, provides a look into the nature of the textile production carried on at the Washington plantation, and quotes a description by Mrs Edward Carrington in 1799 of the sewing room of Martha Washington:

> on one side sits the chambermaid with her knitting, on the other a little colored pet learning to sew, an old decent woman with her table and shears cutting out the negroes' winter clothes, while the good old lady directs them all, incessantly knitting herself, and pointing out to me several pairs of nice colored stockings and gloves she had just finished.

This intimate scene was not, however, the sum total of textile production at Mount Vernon, for Martha Stewart Wilson relates in another letter that "Mrs. Washington told how it became necessary to make their own domestic cloth, a task at which sixteen spinning wheels were kept constantly busy."

Such ambitious facilities were common on large plantations, and many female slaves were taught needlework skills or bought in part for their sewing abilities. Several were able to use these skills to save enough money to buy freedom for themselves and members of their family and to support themselves once their freedom was gained. The importance of needlework in this regard was recognized by a number of slave-owners. In his will dated July 19, 1697, David Brown of Somerset County, Maryland, directed "that Black Beetee be larned to read the bible and to Sowe with Needle well to have good Cloaths and two Cowes and Calves When set free Which I desire to be at the twenty Second yeare of her Age . . ." The will of Thomas Fluornoy of Powhatan County, probated in 1795, freed all his slaves and directed that the men be apprenticed to some mechanic until twenty-one to learn a trade while the women under eighteen were to be taught to sew, spin, and weave until they became eighteen years of age. Unfortunately, few slave quilts from the 18th century have been preserved or identified.

George Washington stated in his will that all the slaves at Mount Vernon were to be freed after the death of Martha (although this did not stop his nephew, Supreme Court Justice Bushrod Washington, from selling twenty-five slaves to pay taxes on the estate). One of those slaves subsequently freed may have been Savage's model for the black servant. In her essay on the painting, Ellen G. Miles notes that in an early study done before Savage left for London the servant was not present. He was added after Savage arrived in London and, according to one late 19th-century account, was modeled after John Riley, a freeman who was the personal valet of Thomas Pinckney, the American ambassador in London from 1792 to 1796. Another late 19th-century source identifies him as William Lee, a favorite slave of Washington's who had served with him during the Revolution. Lee was given the option, in Washington's will, of either accepting freedom or remaining at Mount Vernon because of accidents that had limited his ability to walk (he was known to have still been at Mount Vernon in 1804). Both men could, in fact, have served as Savage's model, for infrared reflectography has revealed a second, shorter figure underneath the taller one in the finished painting. Savage may have begun with Riley, and ended with Lee.

In the needlework portrait, the black servant has been made even taller and his head and hair are so darkly painted that his features are barely visible (unlike in both the painting and the engraving); in contrast, the faces of the Washington family are shown in exacting detail. The servant's dark profile is reminiscent of another type of portrait popular with women at the beginning of the 19th century: cut paper profiles or silhou-

2.24 Martha Ann Honeywell: *Silhouette of a Woman*, early 19th century
Cut paper on paper background, 4 × 3 in. (10.2 × 7.6 cm.)
Private collection

ettes. These could be traced with mechanical aids, or cut freeform. Perhaps the most famous creator of cut profiles was Martha Ann Honeywell (1787–1848?), born in Lempster, New Hampshire [2.24]. Her fame was due both to her skill and to the fact that she had been born without arms and with only one foot, which required her to cut the profiles by holding the scissors in her mouth. Between 1806 and 1848 she traveled in the United States and in Europe, holding public exhibitions where she cut profile portraits of members of her audience. The twenty-five-cent admission charge included, according to one of her handbills, a "Profile Likeness (cut in a few seconds without hands by Miss Honeywell)."

Honeywell's talents were exploited by her parents, who orchestrated performances that often resembled circus freak shows. Yet she was able to support herself through the production of both silhouettes and other cut, painted, and sewn work. One of her more unusual offerings was the Lord's Prayer written in dime-sized spaces or cut from two-inch (five-centimeter) circles of paper. Her work was often inscribed "cut without hands" or "cut with the mouth by Martha Ann Honeywell." She became one of a growing number of men and women who were able to support themselves with their artistic talents in a country where an increasing demand for images accompanied an unprecedented expansion in population and wealth.

Architectural Symbols of a New Nation

Home for a President: Thomas Jefferson's Monticello

The building in which Houdon's statue of Washington [2.16] was installed was designed by Thomas Jefferson (1743–1826) and built between 1785 and 1789 [2.25]. A minister to the French court in Paris at the time, Jefferson firmly believed that architecture served an important symbolic function. Unlike the Federalists, who felt that England was still the cultural homeland of the new nation, Jefferson thought that the United States of America must not adhere to British colonial architecture but, instead, draw directly on the architecture of the ancient Roman Republic. Republican Rome would function as Jefferson's cultural and political patrimony as he argued against Federalist visions of a land of industry and commerce and in favor of a democratic society of independent farmers. His Virginia State Capitol took classical revivalism a step further than most contemporary designs. Instead of simply adding a pediment or series of columns or applied decoration, Jefferson literally copied the Maison Carrée at Nîmes in southern France, a Roman temple

2.25 Thomas Jefferson: Virginia State Capitol, Richmond, Virginia, 1785–89
This early 19th-century engraving shows the building as designed, before the later addition of wings.
Virginia State Library, Richmond

from the first century BCE. He was helped in the formulation of his design by the French architect Charles-Louis Clérisseau, who was a strong supporter of the French neoclassical movement and the author of a book on the Maison Carrée.

Just as Jefferson's Capitol building confirmed the neoclassical trend in official public architecture, so too did his design for his own home, Monticello [2.26], usher in new thinking in the realm of domestic architecture. The architectural historian Leland Roth observes that Jefferson's political convictions led him to reject not only English designs for government buildings, but also those for country houses. Monticello, located on a large estate outside of Charlottesville, Virginia, was built in two stages, the first from 1770 to 1782, the second from 1796 to 1809. During the first stage Jefferson was involved in the revolution against England and the drafting of the Declaration of Independence; during the second stage he assumed the positions of Vice-President (1796–1800) and President (1800–1808) of the United States.

Jefferson departed from the colonial habit of locating the manor house near the edge of the river and instead placed his home on top of a hill he called Monticello (Italian for "little mountain"), in order to achieve a full view of the nearby Blue Ridge Mountains. The main plan of the complex was a broad 'U' with the house at the center and arms stretching outward. Jefferson looked for inspiration to designs by the 16th-century

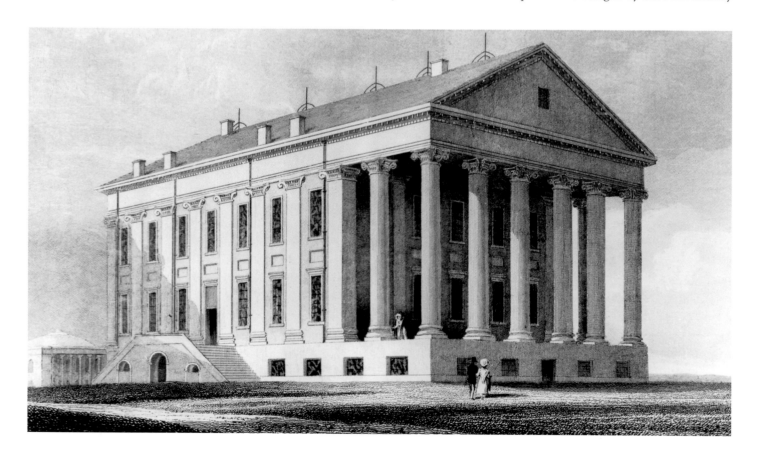

Italian architect Andrea Palladio—revived in Britain in the 18th century—which were inspired by ancient Roman buildings. Roth also notes that Jefferson "pushed the dependencies at Monticello into the earth" (the slave quarters were recessed into the hillside; the kitchen and storerooms were under the house) and, in the second phase of building, changed the proportions of the main pavilion so that its two stories would appear as one, adding a heavy Doric entablature which runs around the house. Jefferson also added a low dome to the garden front of the house, thus creating a third story. The effect of all these changes was, in Roth's words, "to press the house further into the hill," and thus to "preserve the view." But another explanation for these changes is offered by the architectural historian Dell Upton. Upton argues that Jefferson's masking of the actual height of the building, making three stories and a basement appear as one story from the garden front, was part of a larger process of deception at work in Jefferson's life. Jefferson hid not only architectural "stories" but also "stories" or narratives dealing with the actual operations of the estate and the material basis of Jefferson's ideology of the "Republican Man."

Jefferson represented himself as a scientist, a farmer, and a statesman. As President he forbade the use of his image on coins, cut military expenditures, and opened the President's house to any who chose to visit him, wanting to avoid any actions that might be interpreted as in imitation of the British monarch. He also wanted to distinguish himself from the previous Federalist administration of John Adams, which had relished certain lavish ceremonial displays of authority.

Yet Jefferson, the man who coined the words "We hold these truths to be self-evident, that all men are created equal," owned eighty-three slaves who were housed, as mentioned above, away from and lower than the main house (a location that may, in fact, have been preferred by the slaves themselves: see p. 71). Not only were their quarters out of view from his windows, but their bodies were also often out of view within his home through the use of dumb-waiters. This invisibility contributed to the image of Jefferson as the self-sufficient man, the solitary hermit who sat on his hill in his library pondering the monuments of the past and the political tasks of the future. Jefferson rejected the blatant use of slaves as a sign of privilege, as shown in paintings such as Kühn's *Henry Darnall III* [1.78] and Savage's *The Washington Family* [2.20], and in the positioning of the slaves' quarters at Mulberry Plantation (p. 71), but could not give up ownership outright. In his refusal to play the role of the patriarch surrounded by his charges, he recast patriarchal authority as modern individualism. Jefferson's cultivation of his inner self through his study of books—the library was the central room in the private quarters of the house, which were at the opposite end of the building

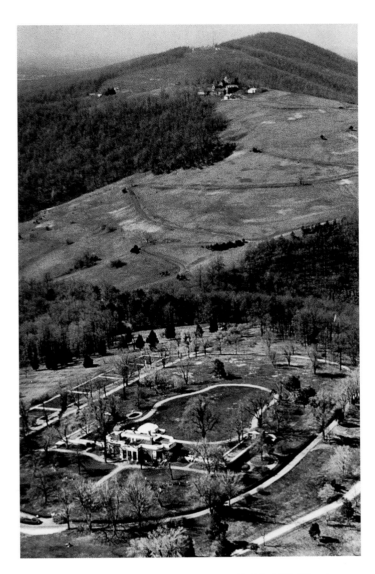

2.26 Thomas Jefferson: Monticello, Charlottesville, Virginia, 1770–82 and 1796–1809

from the public quarters—reconciled the Republican dilemma of how to achieve a balance between Enlightenment concepts of individual liberty and social order. Jefferson could be alone, yet an active citizen; he could be a part of the public, yet not necessarily among the public. Yet this self-sufficient "Republican Man" was a mystification, for the evidence lying beneath the library told another "story," one of reliance on slave labor to facilitate the intellectual and agricultural accomplishments of Jefferson's nation of "independent farmers."

Constructing a Capital: Washington, D.C.

The city where Jefferson took up residence as President was located on a triangular piece of land at the junction of the Potomac and Anacostia rivers (Philadelphia had served as the

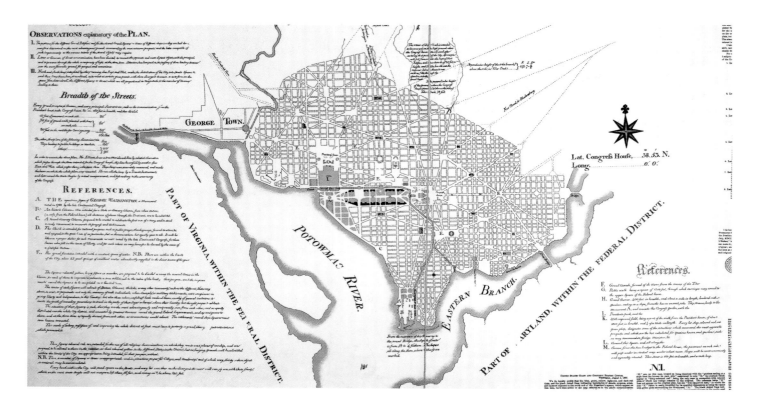

2.27 Pierre Charles L'Enfant: plan for Washington, D.C., 1791
Engraving of 1887 after the original drawing (detail)
Library of Congress, Washington, D.C.

previous capital). In the early stages of its planning Jefferson had proposed a grid format, one he had promoted successfully in 1785, when Congress passed a land ordinance setting up the grid as the standard for all new communities. As a result, four-fifths of the United States, writes the architectural historian Spiro Kostof, were subjected "to a regular system of land survey that answered the needs of an agricultural economy and could speedily be occupied in a democratic fashion." President Washington was not impressed with such a modest proposal and called in Major Pierre Charles L'Enfant (1754–1825), a Frenchman who had been a volunteer with the engineering corps in the American Revolution and whose father was a court painter at Versailles, the French royal palace. L'Enfant produced a grandiose plan in 1791 modeled on the radiating avenues of Versailles, which he superimposed over Jefferson's grid [2.27]. Thus, the pretensions of absolute monarchy and, to a lesser degree, of the Federalists, were placed in tension with the democratic aspirations of Republican Jeffersonians. Just as these two political forces clashed throughout the growing nation, so, too, did the 78-foot (24-meter) wide radiating avenues and fine-meshed grid lead to endless urban complications as residents attempted to maneuver through a city filled with oddly shaped scraps of space.

The settlement of Washington proceeded at a slow pace. Few people wanted to move to the swampy, bug-infested site and so the vast avenues and right-angle streets remained largely unoccupied throughout the early part of the 19th century. In 1842 Charles Dickens visited, and noted that it was often dubbed "the City of Magnificent Distances." He, on the other hand, found "the City of Magnificent Intentions" a more apt appellation: "for it is only on taking a bird's eye view of it from the top of the Capitol [see 2.28], that one can at all comprehend the vast designs of its projector, an aspiring Frenchman. Spacious avenues that begin in nothing, and lead nowhere; streets, mile-long, that only want houses, roads, and inhabitants; public buildings that need but a public to be complete . . ."

The Capitol building from which Dickens was able to achieve his bird's-eye view was not the original structure designed by William Thornton (1759–1828) in 1792 and altered by Benjamin Latrobe (1764–1820), a disciple of Jefferson's. The Thornton/Latrobe building had been gutted by fire when the British attacked the city in 1814, at the end of the War of 1812 (at the time of the fire the central portion was still unfinished). It was rebuilt under the direction of Latrobe, who supervised the repairing of the wings and the construction of a new rotunda and dome. While the building adhered to Jefferson's admonition to turn to classical models for inspiration, there were the occasional nods to local subject-matter, such as the replacement of the acanthus leaves on the capitals of the Corinthian columns

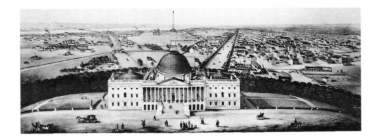

2.28 William Thornton, Benjamin Henry Latrobe, and Charles Bulfinch: United States Capitol, Washington, D.C., 1792–1850
Lithograph by R. P. Smith, 1850
Library of Congress, Washington, D.C.

with corn cobs and tobacco leaves. Latrobe ran afoul, however, of the new commissioner of public buildings, Colonel Samuel Lane, and was relieved of his post as architect of the Capitol in 1817, replaced by Charles Bulfinch (1763–1844) who oversaw the completion of the dome, replacing the original wooden framework with one of cast iron (which was painted gray to blend in with the stone building) [2.28]. In the 1850s Thomas Ustick Walter (1804–87) enlarged the Senate and House wings to accommodate the eighteen new states that had joined the Union by mid-century. He also greatly increased the size of the dome to offset the increased size of the wings [2.29].

2.29 United States Capitol, Washington, D.C., as enlarged by Thomas Ustick Walter, 1851–65

The Louisiana Purchase:
New Orleans and Plantation Architecture

In 1803, while architects and engineers were laying out the streets of the nation's new capital, President Jefferson was finalizing the purchase of the Louisiana Territory from the French leader Napoleon Bonaparte for $15 million. The Louisiana territory extended from the Mississippi west to the Rocky Mountains and from the Gulf of Mexico to British North America, thus effectively doubling the size of the United States [4.6]. It had not always been a French possession. Robert Cavelier, Sieur de La Salle, claimed it for France in 1682, but it remained in French hands only until 1766, when it was ceded to Spain as part of the Treaty of Paris of 1763. France was not too sorry to lose its colony, for Louisiana had been notably unsuccessful in producing any significant export materials and was constantly in need of funds. The Louisiana Territory returned to French control with Napoleon's conquest of Spain in the late 1790s.

Few Europeans were interested in settling in the region in the early 18th century. Some came from Italy, Ireland, the Rhineland, and German-speaking cantons of Switzerland. Another group, French-speaking Catholic farmers known as Acadians, arrived in the late 1760s and 1770s after being expelled from present-day Nova Scotia, New Brunswick, and Prince Edward Island by the British. African slaves were imported into the region early in the century primarily as field hands and composed a large percentage of the population. The indigenous

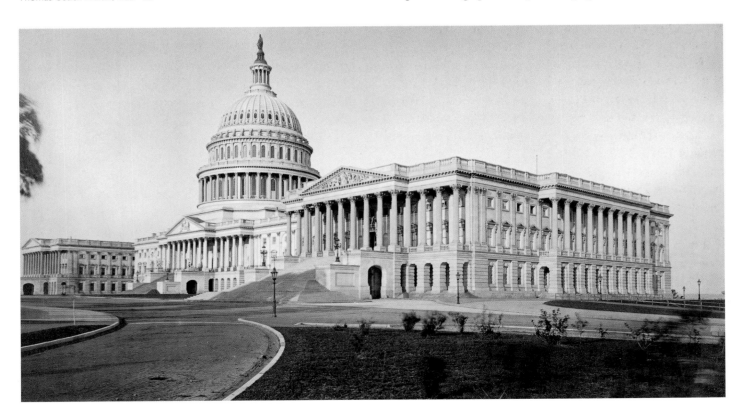

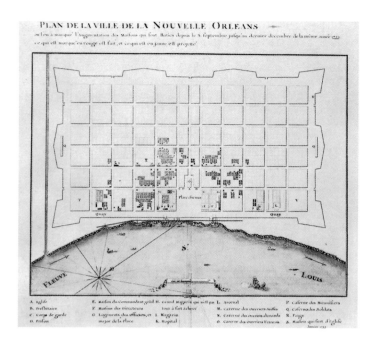

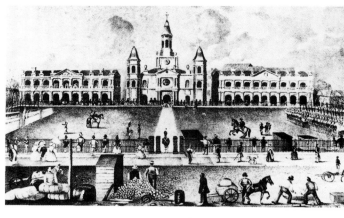

2.30 (left) New Orleans, after the 1721 plan by Pierre Le Blond de La Tour, 1722

2.31 Jackson Square, New Orleans, showing the Cabildo or town hall (1795–99), St Louis Cathedral (1788–94), and the Presbytère or rectory (1788–1813), all by Gilbert Guillemard. The central tower of the Cathedral was added by B. H. Latrobe in 1820. From an early 19th-century lithograph

peoples in the area included the Natchez, Chickasaw, and Cherokee. Envious of the rich farmlands cultivated by the Natchez, the French began attacking their major settlements in the 1720s, culminating in a massacre in 1729. According to the historian Joel Gray Taylor, by 1730, a mere ten years after Le Page du Pratz had recorded the funeral of their leader Tattooed Serpent (see p. 57), the Natchez effectively ceased to exist as a tribe. Those who escaped took refuge with the Chickasaw and Cherokee, who were more effective in resisting French attacks.

Few Spanish actually settled in Louisiana during Spain's control of the territory. French culture—its language, religious practices, food, and entertainment—remained dominant. The Spanish presence was most visible in the architecture of the Vieux Carré in New Orleans, an area rebuilt after fires in 1788 and 1794. The "Old Quarter" had been designed by Pierre Le Blond de La Tour, engineer-in-chief of Louisiana, and laid out in 1721 [2.30]. Its rigid gridiron form and fortifications, patterned after Roman military camps of antiquity, would certainly have appealed to Thomas Jefferson's aesthetic sensibilities. In the center facing the river is the Place d'Armes or military parade ground (later renamed Jackson Square after President Andrew Jackson), a large open area around which are located several important religious and government structures, including the St Louis Cathedral (1788–94) and, flanking that symmetrically, the Presbytère or rectory (1788–1813) and the Cabildo or town hall (1795–99) [2.31]. All three buildings were designed by the French engineer Gilbert Guillemard (1746–1808). The Presbytère and Cabildo were two-story masonry structures with open arcaded ground floors. They were united in design

with the Cathedral (rebuilt in 1849) through the use of classical elements—Roman arches, pediments, and applied columns. Thus, the classical revival in architecture at the end of the 18th century that embodied both the democratic aspirations of the newly founded United States of America and the absolutist dictates of the Spanish monarchs was already in place in Louisiana when it came under American control.

Outside the city, different models were invoked. The plantation house at Parlange, near New Roads [2.32], was built between 1785 and 1795. Its owner, the Marquis Claude Vincent de Ternant, had come from France to set up an indigo plantation. The double gallery surrounding the house, the high ceilings, and numerous large windows and doors were architectural devices utilized on the Caribbean islands to cope with the heat and easily adapted to Louisiana mansions.

2.32 Parlange Plantation, near New Roads, Louisiana, c. 1785–95

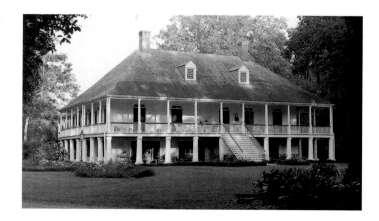

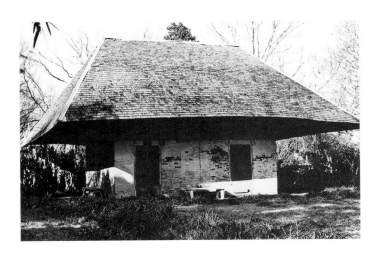

2.33 African House, Melrose Plantation, Natchitoches, Louisiana, late 18th century

Plantation houses and city edifices alike relied on both skilled and unskilled African labor for their construction. Africans were brought into Louisiana, and into British and Spanish colonies in North America, not only to work the fields, but also to function as skilled craftsmen, such as ironsmiths, silversmiths, furniture-makers, and carpenters. African smiths were in particular demand for the production of grillwork and wrought-iron balconies. The art historian David Driskell notes that of the 3,085 skilled laborers registered in Louisiana in 1854, 2,668 were of African ancestry (470 were classified as black, 2,198 as mulatto). While these artisans most often worked from patterns or plans provided by European designers or architects, there is evidence, according to Driskell and others, of memories of African designs in some of their work. In the realm of architecture, this memory appears in several houses, such as a structure known as the African House near Natchitoches, Louisiana [2.33]. Built in the late 18th century by Marie Thérèse Quan Quan, a former slave who married the Frenchman Thomas Metoyer, it closely resembles certain rectangular houses with rammed-earth walls and sloping roofs common to the regions of contemporary Congo and Cameroon.

An Architecture of Discipline

Religious Discipline: The Designing of Shaker Communities

Distinctive architectural styles also developed in certain religious communities in the late 18th century, such as those established by the Shakers. The United Society of Believers in Christ's Second Appearing originated in England in 1747; its members received their familiar name due to the trembling or agitated movement that many of them underwent during intense religious experiences (they were also referred to as the Shaking Quakers). They expanded under the effective leadership of Ann Lee; persecuted because of her claim that she embodied the Christ spirit, she led a group of eight Shakers to America, arriving in New York in 1774 (she died in 1784). By 1826 nineteen Shaker communities were scattered throughout the states of Maine, New Hampshire, Massachusetts, Connecticut, New York, Ohio, Indiana, and Kentucky.

While many utopian religious communities were established in the United States during the early years of its independence, none left as distinctive an aesthetic legacy as the Shakers, a legacy particularly evident in their architecture. The architectural historian Julie Nicoletta writes that "the design, construction, building materials, and function of Shaker structures can be explored as components of a society that struggled to create a kingdom of heaven on earth." Shakers organized their lives around religious devotion and hard work. Ann Lee was said to have advised her followers: "Do all your work as though you had a thousand years to live, and as you would if you knew you must die tomorrow." Shakers practiced celibacy, lived communally, and believed in a deity that manifested both male and female natures. Men and women shared in the leadership of the community, and while the sexes were segregated and assigned particular tasks, neither was viewed as inherently weaker than, or inferior to, the other.

Joseph Meacham, one of Ann Lee's successors, set out clearer formal rules for worship, community property, and social behavior. He believed that spiritual salvation was attainable only through discipline in all aspects of life. He separated individual Shaker communities into "families" reflecting spiritual rather than blood lines. The First Family, known as the Church Family in the East and the Center Family in the Midwest, contained those who had achieved the highest spiritual development. They were the core of each village. Other families were named according to their geographical relationship to the First Family (e.g. North Family) or according to the goods they produced (e.g. the Grist Mill Family).

Meacham also wrote down architectural rules. Nicoletta notes that the Shakers "came out of a long tradition of religious dissent and the Enlightenment belief that by controlling the environment, one could improve oneself and others." The architectural spaces within which they lived and worked were carefully planned. Meacham believed that architecture could help establish hierarchies among members and provide specialized spaces for both temporal and spiritual activities. Shaker communities were meant to be self-sufficient (although they were never entirely so) and included, in addition to the meeting house, dwelling houses, workshops, offices, and barns. Each family had its own set of buildings, but the meeting house was located on the property of the First Family.

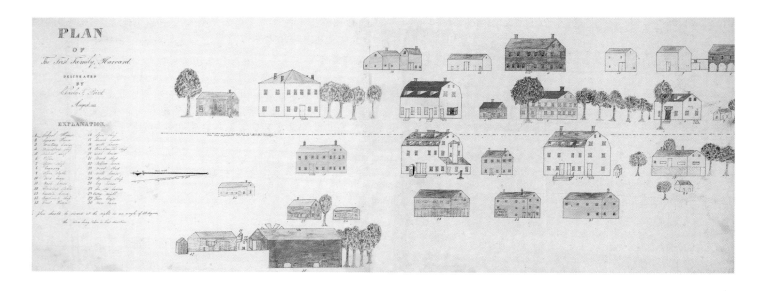

2.34 Charles F. Priest: *Plan of the First Family, Harvard*, 1833. The meeting house, with a dark gambrel roof, is just above the large "First House" in the center. Library of Congress, Washington, D.C.

A plan of the central structures of the Shaker settlement of Harvard, Massachusetts, drawn by Charles F. Priest in 1833, reveals the general outlines of the buildings and their relationship to each other [**2.34**]. Many are multistoried, with the largest being the meeting house and the dwelling houses. While most have gable roofs, the meeting house and two of the dwelling houses have gambrel roofs with dormer windows. Made primarily of wood, with stone foundations, the buildings are marked by extremely plain facades, with window patterns providing the only decoration. Local roads often ran through the center of Shaker towns, allowing travelers to appreciate the well-kept grounds and simple but well-crafted buildings.

While Meacham set out general regulations, there was a certain amount of variation between communities and regions. Reliance on local materials meant that the majority of Eastern Shaker buildings were constructed of wood, while those in the Midwest were more often made of brick or limestone. Eastern and Midwestern designs for particular types of buildings also often differed to a certain degree. The wood meeting house built by Moses Johnson in Canterbury, New Hampshire, in 1792 is marked by a gambrel roof and dormer windows, reflecting local Dutch traditions [**2.35**]. The brick meeting house built at White-water, Ohio, in 1827 has a gable roof, which allows for two full stories and an attic [**2.36**]. Both, however, are simply and symmetrically designed, with two entrances, one for men and one for women. This symmetry and minimal ornamentation around doors and windows were also hallmarks of the Federal Style, a streamlined version of neoclassical architecture that flourished

2.35 Moses Johnson: Meeting House, Canterbury, New Hampshire, 1792

2.36 (right) Meeting House, Whitewater, Ohio, 1827

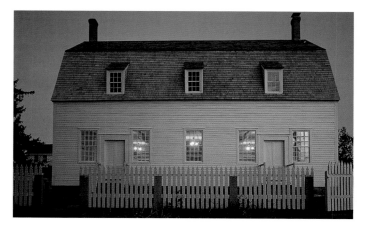

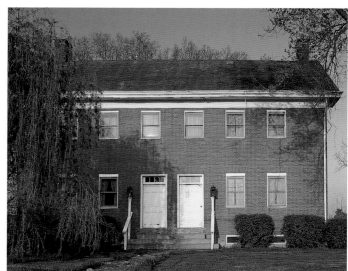

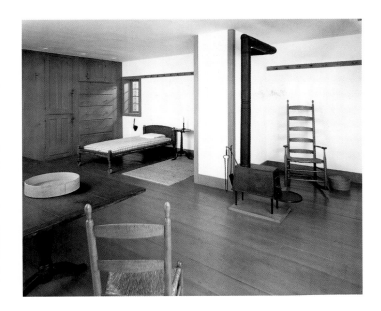

2.37 Shaker retiring room, 1830s
The Henry Francis du Pont Winterthur Museum, Winterthur, Delaware

specified, but much of it was made by the Shakers themselves. It often incorporated ingenious features to make the work of its user easier, such as a yardstick marked off on the front edge of the top of a sewing table. This focus on labor-saving devices made Shaker interior design popular with mid-19th-century writers on domestic reform.

Shakers have also become well known for their sets of nesting boxes [**2.38**], which were made both for community use

2.38 Anonymous, probably from Mount Lebanon, New York:
twelve nesting boxes, first half of the 19th century
Painted wood, various dimensions
Private collection

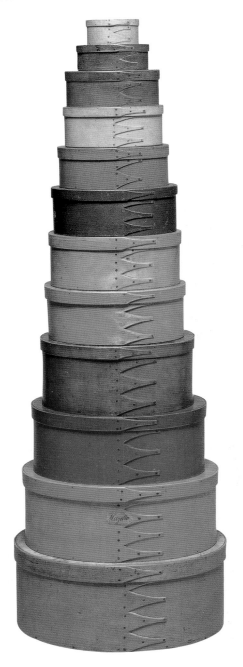

in both the East and Midwest in the late 18th and early 19th centuries. By the mid-century, however, the exterior decoration had become somewhat more elaborate, with the addition of moldings, porches, shutters, and fanlights over the entrances.

The designs for meeting houses were also used for dwelling houses, which were usually larger and were the central structures in the daily lives of the Shakers, where they slept, ate, worked, and worshiped. Codes of behavior were enforced architecturally through separate entrance, sleeping, and working areas for men and women, and limited space for each individual. Excess was to be avoided at all costs and in all areas of one's life—conversation, belongings, dress, food consumption, etc. Work and religion could be included in this list as well, for a balanced life could not be achieved by a focus on one activity alone. As in architecture, however, the rules regarding personal behavior became less rigid as the century progressed and as membership in Shaker communities declined.

Shaker interiors are renowned for their efficient use of space, with built-in cupboards and drawers and pegs along the walls for the hanging of everything from cloaks to chairs [**2.37**]. Regulations regarding the furnishing of sleeping rooms indicated that "bedsteads should be painted green" and that "blankets or comfortables [comforters] for out side [*sic*] spreads, should be blue and white, but not checked or striped." In addition, "no maps, Charts, and no pictures or paintings shall ever be hung up." The proscription against pictures extended to workshops and offices as well (and was also eroded by the last half of the 19th century). The exact type of furniture was not

and for sale to customers on the outside. The American folk art historian Lynette Rhodes describes their construction:

> Oval boxes were made in the Shaker craft shops from thin, one-eighth-inch [3-millimeter] strips of maple that were steamed and wrapped around a mold; the top and bottom were made of pine. The tapered "fingers," fastened with copper rivets, were structural requisites, but also added to the visual appeal of this stark form. Although Shaker boxes were often stained red, yellow, blue, or green, the stylistic emphasis was always on the natural qualities of the wood and the shape of the box itself.

Shakers stressed purity of design, which they saw as enhancing the object's "goodness" and its durability. This purity of design and high quality, evident in all Shaker products—boxes, furniture, architecture, seed packaging, and utensils—reflected a belief that creativity and work were forms of worship and a way of praising God.

Secular Discipline: The Designing of Prisons

One aspect of Shaker architectural and interior design that has received little attention is revealed in a passage of 1842 by Charles Dickens, describing his visit to the Shaker community of Mount Lebanon, New York. After failing to gain entrance to the meeting house, he wrote that "nothing was to be done but walk up and down, and look at it and the other buildings in the village (which were chiefly of wood, painted a dark red like English barns, and composed of many stories like English factories) . . ." Nicoletta notes that the resemblance between Shaker buildings and English factories was no coincidence. Both emphasized efficiency of function as a top design priority. Nicoletta further points out that Shaker buildings also resembled early 19th-century prisons and asylums, institutions concerned not only with efficiency, but also with surveillance.

The American colonies had gained their independence at a time when prison reform was the focus of much debate in England. John Howard's *State of the Prisons*, published in 1777, exposed crowded, unsanitary living conditions, rundown buildings, and an almost total lack of supervision and control over inmates in England, Continental Europe, and Russia. This concern for the health and supervision of prisoners led to the development of a series of circular, polygonal, and radial schemes, the most famous of which is the Panopticon conceived in 1790 by Jeremy Bentham (1748–1832) [2.39].

2.39 Jeremy Bentham: exterior, section, and half-plan of the Panopticon prison, 1791
A cells; B–C annular skylight; D cell galleries; E entrance; F inspection galleries; H inspector's lodge; I dome of the chapel; K skylight of the chapel L store rooms with galleries; M floor of the chapel; N opening in the floor to light the inspector's lodge (open except at church times); O annular wall, for light, air, and separation

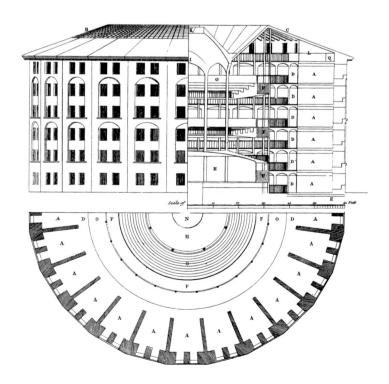

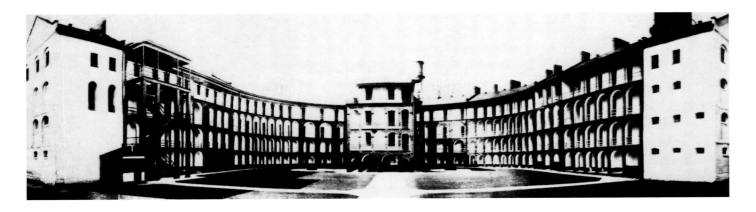

2.40 Thomas Jefferson and Benjamin Latrobe: Virginia Penitentiary, Richmond, 1797–1800, after the removal of the wall linking the ends of the horseshoe

Bentham was a well-known criminal law reformer, social philosopher, and political economist. His design for a circular prison resulted from a trip to Russia, where he witnessed the construction of a circular textile mill, which allowed for easy supervision of the workers. This surveillance, preferably unseen by those being watched, was a central element in Bentham's Panopticon. He believed that the key to disciplining inmates lay in convincing them that they were under constant observation, even if they were not. The architectural historian Norman Johnston describes the building as follows:

> Bentham's scheme, remarkably advanced for the time, consisted of a very large circular building of cast iron and glass containing cells on several tiers around the periphery. The cells were to have barred fronts, and to be heated in winter and artificially cooled in summer by means of air forced over ice and directed through flues into the cells. Speaking tubes would connect each cell with the keeper's tower in the center. By these means the keeper in his louvered tower could carry out continuous, and unseen, surveillance both visual and auditory over the inmates.

The prisoners were not the only ones under surveillance. The keeper would be watched by the superintendents, who would themselves be watched by the public on unexpected visits. Thus, everyone would be disciplined through an atmosphere of constant watchfulness (Bentham also saw his plan as suitable for factories, asylums, hospitals, and schools).

While Bentham's Panopticon was never built, it inspired several circular or semicircular buildings in other countries, including the Virginia Penitentiary in Richmond, built from 1797 to 1800 [2.40]. The penitentiary's plan was laid out by Thomas Jefferson and Benjamin Latrobe. The horseshoe-shaped prison, with cells opening onto covered arcades on four levels, was originally closed by a wall joining the two ends of the horseshoe, with a warden's house in the center. The Roman arcades of the first three levels reaffirm the commitment to Roman architectural precedents revealed by Jefferson in his Virginia State Capitol, also in the city of Richmond [2.25].

The Virginia Penitentiary was one of several new prisons built in the United States in the early 19th century, a time of rapid population growth and changes in the notions of how to treat those who were unwilling or unable to follow the new laws of the land. Prior to the end of the 18th century, few structures existed for the permanent imprisonment of either criminals or the insane. The latter were usually cared for by families or neighbors while the former were fined, whipped, placed in the stocks, banished, or executed. Such punishment was meted out by local authorities. Jails were holding tanks for individuals awaiting trial; imprisonment itself was not seen as a punishment or attempt at reform. Prisoners were placed together, did not have to wear uniforms, and were not supervised.

In America as in Britain, Quaker reformers played a leading role in instituting changes in the treatment of both criminals and the insane in the late 18th century. In 1786 the Pennsylvania state legislature abolished punishment by death, mutilation, or the whip. The following year a number of leading men of the city, including Roberts Vaux, a Quaker penal reformer, established the Philadelphia Society for Alleviating the Miseries of Public Prisons. The core belief of this new society was that criminals could be reformed through imprisonment, when they would be able to reflect on their sins. Their conditions of imprisonment were to be sanitary as well as supervised. Uniforms would be worn to maintain conformity and strict schedules would be followed to ensure discipline and control.

In the ensuing years one of the major debates in the area of prison reform centered around whether or not prisoners should be allowed to associate with one another, or spend most

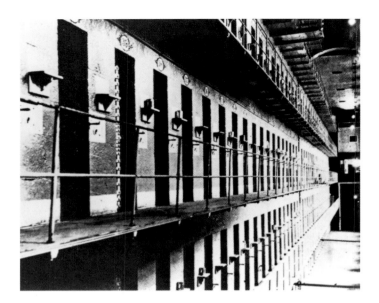

2.41 Auburn State Prison, New York, 1816–35, interior showing cells

process and to the financial stability of the prison) and less to a prisoner's individual cell. The Auburn cells were just over 7 feet long and almost 4 feet wide (about 2 x 1.2 meters), with 7-foot (2.1-meter) high ceilings. They were arranged back to back on five tiers in the center of a long cell building [2.41].

An alternate system, most fully represented by the Eastern State Penitentiary in Philadelphia, designed by John Haviland (1792–1852) and completed in 1829 [2.42], kept prisoners in solitary confinement around the clock. While Haviland had Bentham's Panopticon in mind, there are significant differences. The most important is that constant supervision of all cells in the single-story wings was not possible from the central guard tower. Like the Panopticon, however, each cell in Haviland's building was supplied with running water and a toilet to guarantee complete isolation. The cells were 8 x 12 feet (2.4 x 3.7 meters) with 16-foot (4.9-meter) high ceilings and an exterior yard measuring 8 x 20 feet (2.4 x 6 meters). The cell was used not only for eating and sleeping, but also for working and for spiritual contemplation (each contained a Bible). Haviland's fortress architecture, with its thick walls and crenelated Gothic towers, reaffirmed the function of the complex as a place of incarceration.

if not all of their time in solitary confinement. The congregate system, established at the state prison at Auburn, New York, in 1816 and based in part on the earlier conception of prisons as domestic structures or houses, allowed prisoners to eat and work together in silence, but isolated them at night. Thus, much space was devoted to communal eating, exercise, and work areas (prison labor was seen as integral to the reform

2.42 John Haviland: Eastern State Penitentiary, Philadelphia, Pennsylvania, completed in 1829
From an early 19th-century lithograph

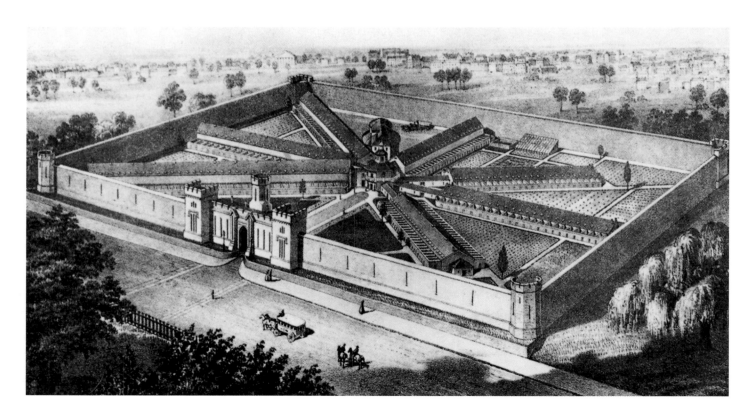

While many praised the Eastern State Penitentiary as an example of effective prison reform—discipline and supervision combined with healthful surroundings—others found the practice of continuous solitary confinement inhuman. Dickens described it in 1842 as "hopeless, . . . cruel and wrong" and added: "I believe that very few men are capable of estimating the immense amount of torture and agony which this dreadful punishment, prolonged for years, inflicts upon the sufferers." Auburn's congregate plan ultimately proved more popular—not, however, for humane reasons, but for financial ones. Each cell in the Eastern State Penitentiary cost ten times as much to construct as a cell in Auburn; the prison shops in the Auburn system were more productive than the isolated cell labor of Eastern State; and isolation prevented inmates from engaging in housekeeping duties in the prison at large, which had to be done by outside labor. Finally, many saw the relative idleness of prisoners in solitary confinement as going against the Protestant ethic of hard work that was so firmly in place by the early 19th century and that was seen as a central component of democratic communities.

In 1825, in order to accommodate New York's growing population of convicted criminals, a second prison was built on the Auburn plan at a nearby site on the Hudson River, the infamous Sing Sing. Just a year earlier, the Shakers at Mount Lebanon, a hundred miles (160 kilometers) up the river from Sing Sing, had finished a new meeting house to accommodate their own growing population. One cannot say whether Shakers influenced the prison system or vice-versa. Both certainly knew about each other, and both shared common concerns. Nicoletta writes,

> Shaker communities incorporated the values of religion, work, and silence introduced into prisons by the Quakers to induce moral improvement. The Shakers ate and worked in silence and according to strict schedules. They sought to enforce conformity through dress, behavior, and environment which stripped members of their individual identity.

The architectural forms adopted by the Shakers were also echoed in many state prisons, with their rows of endlessly repetitive windows and strict classification of interior space. Both prison reformers and Shakers, in their search for order, created an architecture of control that occupied a prominent place in the architectural landscape.

In 2005 only one Shaker community remained, Sabbathday Lake, Maine, with four residents—two men and two women. Many Shaker buildings from other communities have been preserved, however, testaments to the fact that while the Shakers failed to achieve a permanent "kingdom of heaven" on American soil, they did create a striking and distinctive aesthetic that speaks to the power of their belief in an ordered and integrated world.

Nationhood and Native Americans

Native Americans and the Decoration of the Capitol Building

Just as religious and moral commitments could be encoded in the design of a building, so too could a renewed nationalism. Such was the case with the rebuilding and redecorating of the Capitol after the end of the War of 1812 and the departure of the British. The war was a direct result of the outbreak of hostilities between Britain and France in 1803. Both countries began seizing American ships bound for each other's ports as part of an economic offensive intended to prevent the normal operations of trade. After a series of failed attempts at negotiations, the United States declared war on Britain on June 1, 1812. The war lasted until December 1814, with several encounters between British and American troops, including a successful British attack on Washington and the burning of the Capitol.

The resurgence of nationalism and patriotism that surrounded the rebuilding of the Capitol was particularly fortunate for John Trumbull, for it provided him with an opportunity to revive his earlier plan for a series of history paintings documenting the Revolutionary War (see pp. 86–90). After the dismal reception of the first of the series in the early 1790s Trumbull had briefly turned to a career as a diplomat. In 1794 he accompanied Chief Justice John Jay to London as his secretary on the Jay Treaty Commission, intended to settle commercial and border disputes between Britain and the United States, and he continued work on this treaty and its implementation for several years. In 1800 he settled in New York City and began seeking portrait and history painting commissions, the new Capitol being the most likely location for the latter. He was in London at the beginning of the War of 1812 and was unable to return to the United States until 1815, after hostilities had ceased.

In 1817 Trumbull was commissioned by Congress to execute four paintings measuring 12 x 8 feet (3.7 x 2.4 meters) on the American Revolution for the rebuilt Capitol. Two military scenes—*The Surrender of General Burgoyne at Saratoga, 16 October 1777* (1822) and *The Surrender of Lord Cornwallis at Yorktown, 19 October 1781* (1787–1820)—were accompanied by two civic scenes—*The Declaration of Independence, 4 July 1776* (1787–1819) [see **5.4**] and *The Resignation of General Washington,*

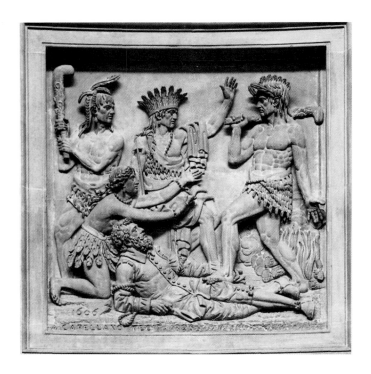

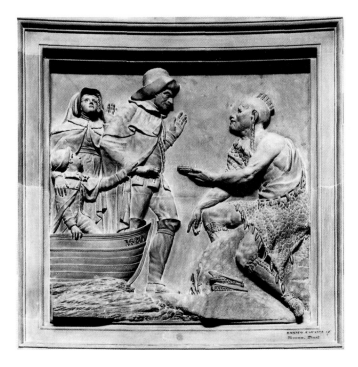

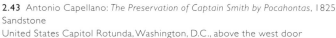

2.43 Antonio Capellano: *The Preservation of Captain Smith by Pocahontas*, 1825
Sandstone
United States Capitol Rotunda, Washington, D.C., above the west door

2.44 Enrico Causici: *The Landing of the Pilgrims*, 1825
Sandstone
United States Capitol Rotunda, Washington, D.C., above the east door

2.45 Nicholas Gevelot: *William Penn's Treaty with the Indians*, 1827
Sandstone
United States Capitol Rotunda, Washington, D.C., above the north door

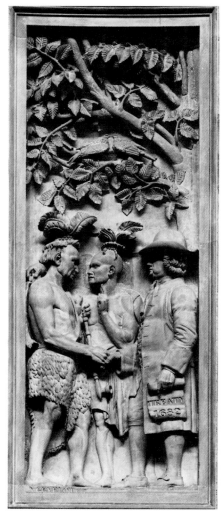

23 December 1783 (1822–24) (*The Surrender of Lord Cornwallis* and *The Declaration of Independence* were part of his earlier series). In his military paintings the high drama of *The Death of General Warren* and *The Death of General Montgomery* [**2.7, 2.8**] is gone, replaced by a much more static representation of reconciliation between the leaders of the opposing forces, which suggested the future establishment of orderly economic, if not political, relations between Great Britain and its former colonies.

The art historian Vivian Green Fryd also notes that nationhood was defined within the Capitol through a series of discoveries and battles in which Native peoples often played a central role and which articulated "a remarkably coherent program of the early course of North American empire." Four relief panels appeared above the doorways of the Rotunda: *The Preservation of Captain Smith by Pocahontas* (1825) by Antonio Capellano (active 1815–) [**2.43**], *The Landing of the Pilgrims* (1825) [**2.44**] and *The Conflict of Daniel Boone and*

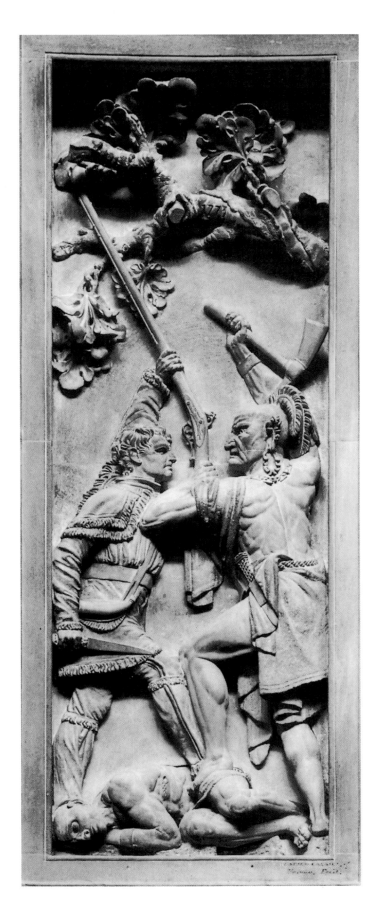

2.46 Enrico Causici: *The Conflict of Daniel Boone and the Indians*, 1826–27
Sandstone
United States Capitol Rotunda, Washington, D.C., above the south door

the Indians (1826–27) [**2.46**] by Enrico Causici (active 1822–32), and *William Penn's Treaty with the Indians* (1827) by Nicholas Gevelot (1791–?) [**2.45**].

These four reliefs encapsulate a vision of European–Native American relations that had already assumed mythicohistorical proportions in the early 19th century through novels, poems, biographies, paintings, and memoirs. Pocahontas saves Smith, foreshadowing her willing assimilation into English culture and conversion to Christianity; the Pilgrims accept the offerings of the Native American, whose crouching position indicates recognition of the superiority of the new arrivals; William Penn negotiates with the Delaware leader as an equal to ensure the peaceful acquisition of land; and Daniel Boone [**2.46**], in facilitating colonial expansion westward, brings out the "true," savage nature of Native Americans, calling into question the civility represented in the other three reliefs. The *Boone* relief was praised by Robert Mills in an 1834 guidebook to the Capitol for effectively conveying "the ferocity and recklessness of the savage," and for having "more of the Indian character and costume represented in these figures than in any of the other sculpted pictures." The Native American as savage thus sat more easily with some visitors to the Capitol than the Native American as noble servant or political equal. Yet in May 1842 *Niles' Weekly Register* recorded the words of Henry Wise, a Whig representative from Virginia, who voiced a particularly astute summary of how Native Americans would undoubtedly read the messages contained in all four reliefs: "We give you corn, you cheat us of our lands: we save your life, you take ours."

These representations would be variously reinforced and challenged throughout the 19th century as territorial expansion and the continued struggle to define a national identity forced Native American and European American alike to rethink their relationships with one another. These relationships were caught up in what the historian Richard Slotkin has described as one of the oldest and most enduring national myths in the United States, the myth of the frontier. Since colonial times, European Americans had defined themselves as peoples engaged in a series of struggles to push the western frontier ever further back, a move justified with the rhetoric of pioneering progress, world mission, and eternal battle against the forces of darkness and subversion.

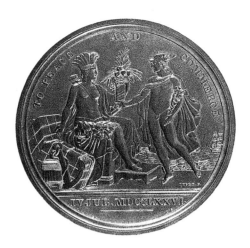

2.47 Augustin Dupré: The *Diplomatic Medal*, 1790
Bronze, D 2⅝ in. (6.7 cm.)
Division of Numismatics, Smithsonian Institution, Washington D.C.

2.48 Anonymous: *America*, from *The Four Continents*, London, 1804
Engraving, 13⅝ × 9⅞ in. (34.6 × 24.6 cm.)
The Henry Francis du Pont Winterthur Museum, Winterthur, Delaware

From Indian Queen to Greek Goddess

During the 17th and 18th centuries Native Americans were often portrayed as the very embodiment of the nation. This geographic personification appeared most often in the guise of the classically rendered, semi-naked "Indian Queen." While this Indian Queen had earlier encompassed the whole of the New World—North, Central, and South America—she was now being claimed as a symbol of the United States alone. For example, she appears in a bronze medal of 1790 designed by the French artist Augustin Dupré (1748–1833) [2.47] and commissioned by President Washington. It was referred to at the time as the *Diplomatic Medal* and was awarded to two individuals, the Marquis de La Luzerne and the Count de Moustier. The obverse of the medal contains the figure of Mercury, the winged messenger representing Europe (the Old World), greeting the female personification of the United States, wearing a feathered headdress and skirt (the New World). She is seated beside packaged objects, toward which she gestures with her right hand; in her left hand she holds a horn filled with fruits which she extends toward Mercury. Thus, in exchange for manufactured goods from Europe, the United States would provide food and raw materials. In order to connect the packages more clearly with Europe, an anchor is placed in the foreground, which alludes to the ship behind Mercury. And finally, in addition to the commemorative date on the lower portion of the medal—July 4, 1776—which marks this female figure as representing the United States rather than the New World as a whole,

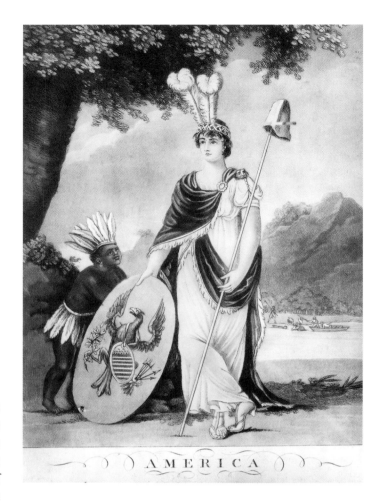

AMERICA

the words "To Peace and Commerce" arch over the scene. On the reverse of the medal is the Great Seal of the United States.

The Indian Queen as a national symbol was soon joined by another female figure, who was more decidedly European than Native American. Such a figure can be found in an anonymous engraving of 1804 entitled *America* [2.48]. The bared breasts and feathered skirt of the figure on the *Diplomatic Medal* [2.47] are replaced by a simple gown reminiscent of the clothing worn by women in ancient Greece. Yet this figure also has a "contemporary" look to her. The Greek world was a major source in the early 19th century not only for sculptors, painters, and architects, but also for dress designers. "America" wears an elaborate cloak elegantly draped across her shoulders, and against her left arm rest the liberty pole and cap that symbolize emancipation, a reference to both the American Revolution, which France entered on the side of the Continental Army, and the French Revolution of 1789.

While the title of the engraving—*America*—might suggest that the figure represents the New World as a whole, the liberty cap and the shield, on which is emblazoned an eagle festooned

with a medallion containing the stars and stripes of the U.S. flag, identify her as a representation of the United States of America. Her association with Native peoples is present in two ways: the ostrich feathers attached to her headband, which function, in the words of the art historian Barbara Groseclose, as "souvenirs of her Indian past," and, more importantly, the dark-skinned, childlike figure of indeterminate gender beside her, who wears the feathered headdress and skirt of the woman in the *Diplomatic Medal*.

Groseclose suggests this shift from a strong central character bearing clear Native American referents to an ancillary childlike indigenous figure parallels the enforced dependency of Native peoples on the federal government during the 19th century. Native physical features or clothing now refer to "condition, not geography—race instead of place." This dependency is borne out in the engraving by the placement of the child behind the shield and by his/her adoring gaze in the direction of America, a position and gaze that replicate those of the young African boy in Kühn's portrait of Henry Darnall III [1.78]. Indeed, the child can be seen as a mix of African American and Native American, for his/her skin is darker than many earlier and contemporary representations of Native peoples. The dependency of African Americans as slaves was already well established; they would continue to be subjected to the rhetoric of infantilization even after the Civil War of the 1860s brought an end to slavery.

The subservience of the Native/black figure in *America* is further evident if we compare the compositions of the *Diplomatic Medal* and the engraving. In the former the relationship between the United States and Europe is presented as an exchange of gifts between equals. The enthroned Indian Queen is both Old World (classicized features) and New World (feathered skirt and headdress). She and Mercury are depicted within a horizontal composition as mutually interdependent. Both are shown with heads in profile and frontal torsos, approximately the same size and on the same level, and "dignified" by classical referents. The New World is gendered female and is associated with the land or nature; the Old World is male and will transform the products of nature offered to it into the products of culture, manufactured goods.

The relationship articulated in the engraving between European Americans and Native Americans/African Americans—domestic relations as opposed to foreign relations—is one of subservience, not equality. The composition itself is hierarchical. The child is located at the base of a triangle whose apex is the head of America. Half the size of the statuesque figure, he/she leans inward and gazes up toward America, while the latter is erect and gazes off into the distance. The child is also more

closely associated with the land in terms of skin color and costume, and is the compositional counterpart of the moose-hunting scene to the right (the place occupied by the ship in the medal—again, domestic production versus foreign trade). The message is that Native peoples/African Americans are children, to be protected by Mother America and by the shield of European American governance.

Narratives of Captivity

A contemporary work, *The Murder of Jane McCrea* by John Vanderlyn (1775–1852) [2.49], draws on recent, as well as ancient, history to create a symbolic narrative of nationhood. It also locates Native Americans as actors along the ever-changing frontier, rather than the very embodiment of the frontier as New World or nation. In Vanderlyn's painting the classicizing elements appear not in references to Liberty figures or Greek architecture or clothing but in the physiques and poses of the two Mohawk warriors, who are about to scalp the young colonist Jane McCrea. Such heavily muscled and dramatically posed men were particularly prevalent in sculpture created during the Hellenistic period in Greece (*c.* 323–30 BCE), and

2.49 John Vanderlyn: *The Murder of Jane McCrea*, 1803–4
Oil on canvas, 32 × 26½ in. (81.3 × 67.3 cm.)
Wadsworth Atheneum Museum of Art, Hartford, Connecticut

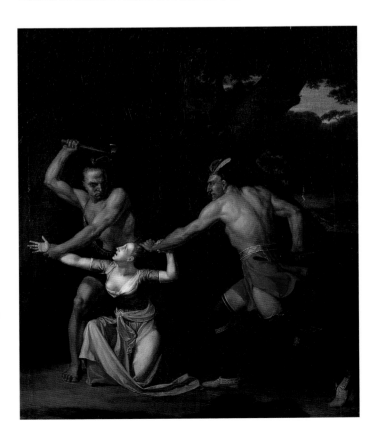

could also be found in abundance on later Roman sarcophagi (Causici also drew on such prototypes for his *Conflict of Daniel Boone and the Indians* [2.46]).

Vanderlyn's painting of Jane McCrea was commissioned by Joel Barlow, President Jefferson's envoy to France, who had commemorated the event in his anti-British epic poem *The Columbiad*. It is meant to illustrate an incident that allegedly occurred in 1777, during the American Revolution. Jane McCrea, the orphaned daughter of a Presbyterian minister who was living with her brother in upper New York State, fell in love with a Loyalist. He left to join the British forces in Canada, but arranged for her to join him so they could marry. Against the wishes of her pro-Revolutionary brother, she left his home, but never arrived at her destination. On the way she was captured, killed, and scalped by Native Americans hired by the British to assist them in the war (the British offered bounties on American scalps). Her death galvanized the residents of the area, who then defeated the British at the Battle of Saratoga, which marked a turning point in the war for the rebels. Thus, in the words of the historian June Namias, "a woman who had run off with a Tory soldier was transformed into a martyred revolutionary heroine." McCrea functioned not only as an individual heroine but also as a symbol of colonial women and of the nation at large, for one justification for the murder of indigenous people, in particular men, was the threat they posed to colonial women and, thus, to the nation's future.

The use of women in this way—as symbols of colonial vulnerability—is particularly evident in narratives documenting the captivity of Europeans among Native Americans, which appeared in written form at the end of the 17th century, and in engravings and paintings in the late 18th century. As the anthropologist Pauline Turner Strong has noted, in the captivity narratives promulgated by colonial clergymen (who often edited or wrote the accounts), the female captive "represents the vulnerability of the English colonies in the New World, where they are preyed upon by the brutish and diabolical forces of the wilderness which destroy domestic and civil order and threaten to seduce or devour them. The opposition between a vulnerable female Captive and a male Captor unrestrained in his savagery is fundamental to this interpretation." Notably absent from tales of captivity were accounts of the experiences of Native peoples, who formed the largest body of captives on the British colonial frontier and who were often treated as cruelly as were those white captives depicted in tales authored by Europeans. The most famous Native captive, Pocahontas, has seldom been represented as such. Instead, she has appeared most often in texts and pictures from colonial times onward as a willing convert to Christianity and to the

ways of the British [1.65] (such is the tenor of the painting *The Baptism of Pocahontas* of 1837–40 by John Gadsby Chapman [1808–89] in the Capitol Rotunda).

Vanderlyn's painting graphically illustrates the opposition described by Strong, and reiterated throughout the 19th century, between the Native American male as diabolical force and the European female as vulnerable captive. Yet it also reveals the complex play between attraction and repulsion that marked so many paintings and that was present in some of the written captivity narratives as well. In the tales of men captured by "Indians" that appeared in the early 19th century (for example, that of Daniel Boone), the experience was presented as having toughened them, made them more manly. The men return to their own people, who appreciate the transformation. Yet not everyone returned. In the Reverend John Williams's earlier account of his own captivity and that of his family in 1704, he records that when they were freed, he was unable to "reclaim" his daughter Eunice, who was seven years old when they were seized. She eventually married a Mohawk who had been converted to Catholicism by the French Jesuits and remained in the community of Caughnawaga. Thus, in the eyes of her father, she was doubly lost—to Catholicism and to a Native American.

Eunice's story was soon buried, however, among the more numerous accounts of female deliverance from diabolical Native forces through divine intervention or, as in Vanderlyn's painting, through death at the hands of these same forces. Vanderlyn's warriors are fearful savages threatening to "seduce or devour" Jane McCrea. The attraction of the Native American man is present in the painting's sexual charge, in the powerful physiques of the men and the almost fully bared breasts of the supplicant Jane McCrea. These elements, in conjunction with the impending blow from the tomahawk, worked simultaneously to enrage and arouse (in a sexual sense) and strike fear into the hearts of European American viewers, both male and female, who attended Vanderlyn's pay-as-you-enter exhibition of this painting and others in New York, Baltimore, New Orleans, and other cities across the nation.

From the beginning of colonization, Europeans viewed Native Americans with an ambivalent attitude of acceptance and rejection, embodied in part by the noble/savage dichotomy. This ambivalence had an erotic element, and captivity narratives, according to Namias, "offer a body of work which depicts Indian–white relations on the sexual frontier as exciting, dangerous, potentially disastrous, sometimes fun, occasionally romantic." In Vanderlyn's painting, this ambivalence is fully conveyed. As if to emphasize the power of the Native men, European manhood is represented by the tiny,

ineffectual figure in the distant right background, possibly McCrea's fiancé, running vainly toward his loved one. The painting was also a warning to women who harbored what many men at the time viewed as a misplaced sense of independence. Had McCrea been an obedient sister, she would have heeded the advice of her brother and stayed home, thus avoiding a violent death.

Portraits and Treaties

European Americans were not the only ones who contemplated the representations of Native Americans being created during the early 19th century, in particular those images residing within the Capitol's Rotunda. Throughout the first decades of the 19th century, Native American delegates traveled to Washington to negotiate and finalize treaties. According to an 1848 guidebook to the Capitol written by William Force, a group of Wisconsin Winnebagos, who visited the building in 1832 after signing a treaty exchanging their land for land in Iowa, responded to Causici's Conflict of Daniel Boone and the Indians [2.46] in the following manner: after "scrutinizing and recognizing every part of the scene . . . they raised their dreadful war cry and ran hurriedly from the hall." Like Father Junípero Serra (see p. 43), Force celebrates the power of European images to convey the authority of the colonizers and emphasizes the cultural superiority of European Americans by relating the ease with which Native Americans can be fooled by mere visual representations. Others, however, were unlikely to have been so easily fooled by Causici's rendering of Daniel Boone. During a set of treaty negotiations in the 1780s the Cherokee leader Old Tassel eloquently expressed his shrewd perception of the situation:

> Much has been said of the want of what you term "civilization" among the Indians. Many proposals have been made to us to adopt your laws, your religions, your manners, and your customs. We do not see the propriety of such a reformation. We should be better pleased with beholding the good effect of these doctrines in your own practices than with hearing you talk about them, or of reading your papers to us on such subjects. You say, "Why do not the Indians till the ground and live as we do?" May we not ask with equal propriety, "Why do not the white people hunt and live as we do?"

Old Tassel thus rejected a policy that dominated official thinking about Native Americans at the end of the 18th century: that they could and must be incorporated into a European way of life, giving up their own hunting, agricultural, and spiritual practices and their claim to vast tracts of land.

Old Tassel was right to question the intentions of federal negotiators. In 1802 the federal government told Georgia state officials that it would end its agreements with the Cherokee allowing them to maintain their land holdings in Georgia in exchange for Georgia ceding its western land claims. When the governor of Georgia attempted to force the Cherokee to relinquish ownership in 1827, they drafted a constitution and declared themselves an independent nation with sovereignty over their lands. This indigenous resistance led federal officials to replace their policy of assimilation with a policy of removal. Ironically, European American animosity toward the Cherokee was fueled, in part, by their very *success* at assimilating. A census taken among the Cherokee in Georgia in 1825 showed that they owned, among other things, thirty-three grist mills, thirteen saw mills, sixty-nine blacksmith shops, 2,486 spinning wheels, and 2,923 plows, sparking the envy of many of their less prosperous European American neighbors. These statistics help give the lie to the governor of Georgia's description of the Cherokee in the 1830s as "ignorant, intractable, and savage people" who needed to cede to "civilized" people what it was their right by the command of the Creator to possess. In the struggles over nationhood, therefore, Native Americans served as more than visual representations of the inevitable conflict between savagery and civilization: they actively questioned these very concepts, writing a constitution modeled after that of the United States and articulating their own demands for citizenship and nationhood. Ultimately, however, they were not strong enough to resist the relocation westward forced upon them by the U.S. government.

While negotiations between Native Americans and federal officials were taking place in Washington, D.C., Wisconsin, and Georgia, several artists were recording the appearance of those Native peoples who traveled to the nation's capital. One such artist was Charles Bird King (1785–1862). King, born in Newport, Rhode Island, studied in London at the Royal Academy and in the studio of West before returning to the United States in 1812. He set up a studio as a portrait painter in Washington in 1819, and between 1821 and 1842 completed approximately 143 portraits of Native Americans, many of which were commissioned by the federal government and included in the Department of War collection (the majority were lost in a fire in the Smithsonian in 1865). These portraits thus became part of a series of documents that recorded the transfer of the ownership of land from Native peoples to the federal government.

One of the earliest of King's portraits is *Young Omawhaw, War Eagle, Little Missouri, and Pawnees*, painted in 1822 to be

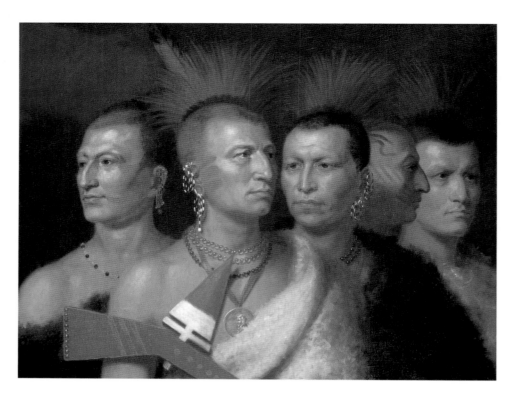

2.50 Charles Bird King: *Young Omawhaw, War Eagle, Little Missouri, and Pawnees*, 1822
Oil on canvas, 36½ × 28 in. (91.7 × 71.1 cm.)
Smithsonian American Art Museum, Washington, D.C.

sold privately [2.50]. The title suggests that it is an image of five different individuals, but they bear a striking resemblance to one another. The art historian Julie Schimmel suggests that all were based on the facial features of two Pawnee leaders, Petalesharro, head of the Pawnee Loups, and Peskelechaco, head of the Republican Pawnees, whom King painted when they visited Washington with a delegation in 1821.

If Schimmel's suggestion is correct, King may have sacrificed the individuality of his sitters in order to create a facial composite that emphasized their nobility and that he hoped would be viewed favorably by a European American audience. At least one writer, the English traveler William Faux, who saw the 1821 delegation in Washington, voiced a similarly positive response to the features of the Pawnees. He noted that the men were "of large stature, very muscular, having fine open countenances, with the real noble Roman nose, dignified in their manners, and peaceful and quiet in their habits." Yet while the "Roman" noses and the peace medal around the neck of War Eagle in King's painting reinforce the nobility and peacefulness of the five men, the face paint, jewelry, hair styles, and war club (its blade pointed ominously at War Eagle's neck) signify their difference and their potential threat to European Americans. Many believed that survival for Native peoples was possible only through the abandoning of such

signs of difference and the subsequent adoption of the signs of civilization—the clothing and habits of European Americans.

While most contemporary viewers of King's multiple portrait would have read the costumes, facial paint, and hairstyles as evidence of a "noble savagery," late 20th-century scholars have begun to read them, instead, as clues to a complex visual language used by many Native American peoples. The art historians Patricia Trenton and Patrick Houlihan have noted in their research that the painted facial designs were related to certain religious rituals and often signified a personal protective medicine. The way in which a person's buffalo robe was positioned also carried a specific message. Nine message-conveying robe positions are currently known, two of which involve baring one shoulder, which was either a courtship sign or a message of admonition. Hairstyles among the Omaha and Pawnee peoples signified group affiliation.

At least two items in the painting attest to the syncretism at work in the formation of Native American cultural expression since the arrival of Europeans. The peace medals distributed by government officials were often prized possessions and signs of status and were worn on all formal occasions. The James Monroe peace medal worn by War Eagle included a profile bust portrait of the President on the obverse and a pair of shaking hands beneath a crossed tomahawk and peace pipe on the reverse. (As was the case in the past, the European hand is indicated by an elaborate cuff, while the Native American wrist is bare.) The knife-blade club held by War Eagle is derived in part

2.51 Anonymous, Northern Plains?: gunstock club, before 1860
Painted oak, L 33½ in. (86 cm.), double-edged blade L 8¼ in. (21 cm.)
The Southwest Museum, Los Angeles, California

from European culture, although in this instance the materials have been refashioned. These clubs were also referred to as "gunstock clubs," due to the rifle-stock shape of the handle, and were recorded as early as the 17th century on the Great Plains [2.51]. The knife blades were often traded to Native Americans, and were subsequently fitted into wooden handles or attached to long sticks to use as spears.

Thus, while some contemporary art historians have questioned whether King's portrait contains accurate likenesses of five specific individuals, others have seen it, nevertheless, as providing valuable pieces of a historical puzzle. This puzzle is now being reconstructed by contemporary scholars in their attempts to understand the dynamics of 19th-century Native American cultures, even if only as filtered through the eyes of 19th- and 20th-century European Americans.

The Schooling of the Nation's Artists: Samuel F. B. Morse and the National Academy of Design

Most of those who assumed the task of interpreting and documenting America's history in the early 19th century were, like Charles Bird King, trained in Europe. Calls soon arose, however, among artists and their supporters for a national academy that could take up this educative role and instill a sense of patriotism along with lessons in anatomy and perspective. One of the most vocal advocates for such a school was Samuel F. B. Morse (1791–1872) [2.69]. Born in Charlestown, Massachusetts, the son of a Calvinist minister, Morse grew up in the midst of a religious upheaval known as the Second Great Awakening, of which his father Jedidiah was a central figure. Paul Staiti, in his study of Morse, describes this movement as "an attempt

to restore the political, moral, and social conventions of the colonial era that Calvinists felt had been undermined by the Revolution and the recently ratified Constitution." Its followers adhered to orthodox notions of human depravity and the divinity of Christ, but attempted to understand, according to Staiti, "how theology was manifest in the social behavior of individuals and even in institutions and governments."

Of particular importance for Morse's artistic and scientific, as well as religious, pursuits was the Second Great Awakening's adherence to millennialism, the belief that the thousand years of peace predicted in the Scriptures was imminent in America. This meant, for Morse, that America would be responsible for bringing peace to the rest of the world. Such an exalted task required not only theologians and politicians, but also artists fully aware of the significance and nature of their mission. Staiti aptly summarizes the parameters of Morse's and his father's often inflammatory evangelical crusade:

they sought the destruction of the Roman Church, which Jedidiah described as the "ecclesiastical whore of Babylon"; they used public education as their primary instrument of persuasion; they made their rhetorical leitmotif the ascent of American culture; they dreaded the influence of foreign artists, ideas, and governments; they believed that only an elite society could guide their country's destiny; and they saw the growth of industrial economy, technology, wealth, and mass communication as agents of freedom and progress and thus as tangible signs of God's favor.

Morse first began to paint while he was studying at Yale College (he graduated in 1810), inspired in part by the Reverend Timothy Dwight's celebrations of the redemptive qualities of painting (see p. 89). The year of his graduation he met the painter Washington Allston (1779–1843) in Boston, with whom he entered into his first directed study of anatomy, drawing, and art theory. Allston had traveled from his home in South Carolina to Harvard and then, in 1801, to England to study at the Royal Academy. From there he traveled to France and Italy and honed his abilities to create elaborate historical or biblical scenes in the "Grand Manner," i.e. in the manner of Renaissance masters such as Michelangelo or Raphael. When he returned briefly to America in 1808, however, what he introduced that was new in the fine arts was not this "Grand Manner," but a more subjective, romantic sensibility, particularly in his depictions of figures in landscapes, inspired by artists such as the 17th-century Italian landscape painter Salvator Rosa. He painted not necessarily what he saw, but, like the creators of many mourning pictures, what he imagined, such as the scene in his *Moonlit*

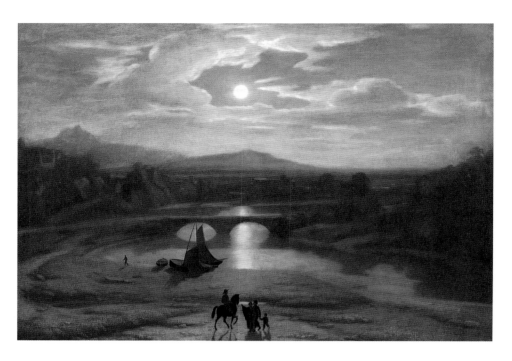

2.52 Washington Allston: *Moonlit Landscape*, 1819
Oil on canvas, 24 × 35 in. (61 × 89 cm.)
Museum of Fine Arts, Boston, Massachusetts

Landscape of 1819 [2.52]. Here, clarity and heroics are sacrificed to gloomy spaces and a subtle foreboding, as dark shapes are chased by their shadows across the landscape.

Soon after commencing his study with Allston, and despite his suspicion of foreign artists and ideas, Morse felt compelled to travel to London with his teacher in order to further his training and career. Arriving in 1811, he was initially impressed by the encouragement artists received in England, as opposed to their relative neglect in America. By 1814, however, his millennialism reasserted itself and he proclaimed his belief that "the palm of painting still rests with America, and is, in all probability destined to remain with us." All that was needed was "a taste in the country and a little more wealth." Morse could not directly affect the latter, but he did feel he could affect the former by introducing "first-rate pictures." He hoped that through the establishment of a national academy, perhaps in Philadelphia, already home to the Pennsylvania Academy of the Fine Arts, "Americans might remain at home and not, as at present, be under the painful necessity of exiling themselves from their country and friends."

Morse, like those academicians with whom he studied in London, believed that the only type of painting truly able to play the part of a national art form was history painting, for only it could "elevate and refine the public feeling by turning their thoughts from sensuality and luxury to intellectual pleasures." Yet Morse's mother's words in a letter of December 19, 1814, proved more prophetic, as she warned her son not to expect "to paint anything in this country, for which you receive any money to support you, but portraits." When Morse returned to Boston in 1815 he was unable to sell the history paintings he had produced in London and was forced to take up portraiture in order to survive. Even his efforts in this field failed until he moved to Charleston, South Carolina, in 1817, where he established a thriving practice painting the likenesses of the city's elite. Two years after his move to Charleston, Morse tried once again to stir interest in his work in Boston, where he put on display a portrait of Sarah Allston. But he fared no better than he had in 1815; the *New England Galaxy and Masonic Magazine*'s reviewer noted that "in ninety-nine instances out of a hundred" the wealthy men and women who attended the exhibition "admired the frame, in preference to the picture . . . and Mr. Doggett, the frame maker, gathered all the laurels at the expense of Mr. Morse the artist."

Morse, still not discouraged, decided to approach the problem in another way. He would paint a large history painting and take it on the road, displaying it for a fee in various halls throughout the country, thus achieving both financial gain and public edification. This entrepreneurial approach to art was not unprecedented. Trumbull's *Declaration of Independence* was shown to paying audiences in New York, Boston, Philadelphia, and Baltimore (at least 21,000 people paid a total of $4,000 to see it) before being installed in the Capitol Rotunda, and several other artists had achieved financial success in the same way. Several had also failed, however, such as John Vanderlyn. His panorama of Versailles, a series of 12-foot (3.7-meter) canvases pieced together to a length of 165 feet (50 meters) and covered with exterior views of the palace's garden facade and the gardens themselves, was

displayed in the circular Rotunda on Chambers Street in New York City in the early 1820s. But the dignity of the classical building and the expansiveness of his canvas failed to draw the crowds that he had anticipated. This was also to be the fate of Morse.

Morse chose as his subject the House of Representatives, which he painted throughout 1822 and put on display in 1823 [2.53]. This was not a traditional history painting, however. Instead of privileging human figures and dramatic action, Morse presents a vast, largely empty, space peopled by eighty-eight figures engaged in, at most, relaxed conversation during a recess in Congressional debate while the candles of the large chandelier are being lit. Thus, despite its great size—over 7 x 10 feet (2 x 3 meters)—and the dramatic lighting created by the massive chandelier in the center of the room, the painting failed to arouse the interest of the general public.

Morse could have added more action and drama to his painting. Contemporary accounts often described sessions of Congress as resembling scenes in local taverns more than the peaceful, churchlike atmosphere depicted here. The inclusion of an increasing number of western states in the Union—Kentucky in 1791, Tennessee in 1796, Indiana in 1816, Illinois in 1818, and Missouri in 1821—brought to Washington individuals less attuned to the refined manners of the Federalist elite. Instead, they were more likely to attend sessions with their hunting dogs and to promote a form of democratic government that caused Federalists to shudder, such as abolishing property ownership as a prerequisite for voting.

As a Federalist, Morse believed that the moral and cultural progress of the nation required a centralized institution like the federal government led by a cultivated, god-fearing, materially prosperous elite. Thus, he wanted to present the House of Representatives in the best possible light. He even passed up the opportunity to record some of the heated debates over the shift from assimilation to removal in Native American federal policy that occurred in 1822, and instead merely included the figure of the Pawnee leader Petalesharro (see p. 120) in the gallery at the far right. Jedidiah Morse had compiled a report, presented to Congress in 1822, arguing for the continuation of the policy of assimilation, in particular through religious instruction, and appears two figures to the left of Petalesharro in the gallery.

2.53 Samuel F. B. Morse: *The House of Representatives*, 1822–23
Oil on canvas, 86 ½ x 130 ¾ in. (220 x 332 cm.)
The Corcoran Gallery of Art, Washington, D.C.

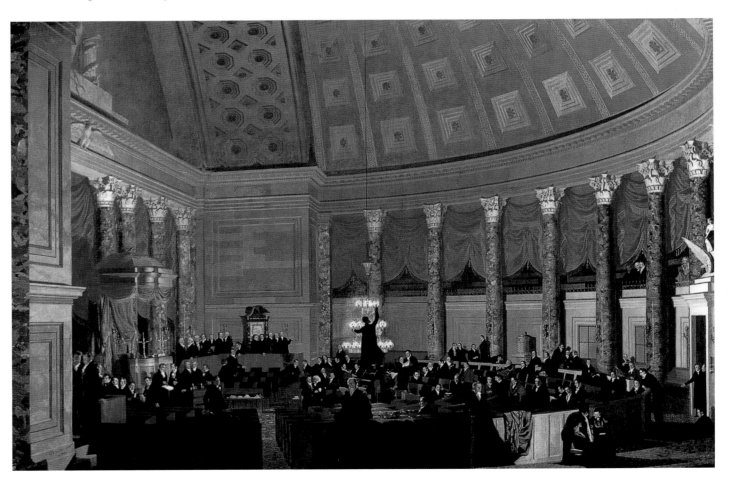

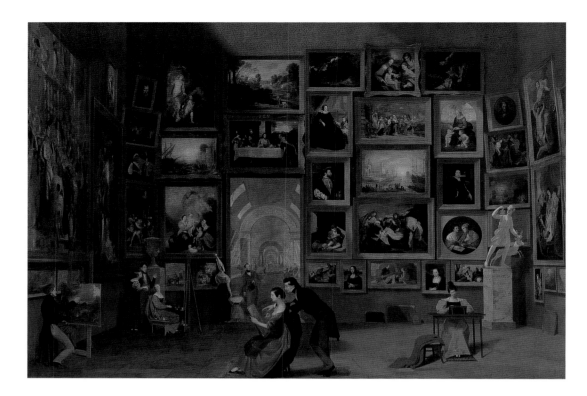

Morse's picture, as a whole, with its peaceable politicians and cavernous architectural space, is, in Staiti's words, "an anti-democratic gloss on the massive and disruptive shifts occurring in national politics." Intending to refine the aesthetic tastes of the populace at large and increase their knowledge of and faith in federal institutions, Morse omitted democratic debates, as well as anecdotal narrative content, and instead created a picture whose symbolic commentary on the importance of centralized government was missed by most of the public, who simply found the painting boring.

Turning away from such public projects, Morse once again took up portrait painting. He was in great demand in New York City by 1826, when he achieved one of his life-long goals, the establishment of the National Academy of Design. The artist's first attempt at setting up a national academy had taken place in Charleston several years earlier. With the help of state senator Joel Poinsett and the artist John Cogdell, he had founded the South Carolina Academy of Fine Arts in 1821. Unfortunately, the local economy took a turn for the worse in the 1820s, as cotton prices dropped and businesses failed. With little private or public support, the Academy closed its doors in 1830. In New York City, Morse's academy was preceded by many smaller teaching institutions, including the Columbian Academy, a private drawing school operated by Alexander and Archibald Robertson from 1792 to 1821. The Columbian Academy, and many others like it, catered to both male and female students, although it was often assumed by the instructors that women were there only to prepare for the genteel life of a refined wife and mother while the men were there to train for professions like engineering and architecture.

The National Academy of Design was also preceded by the more prestigious American Academy of the Fine Arts, founded in 1802 and led in the 1820s by John Trumbull. Yet by this decade many artists in New York found the American Academy wanting on all fronts—it lacked significant exhibitions, collections, and art classes, was controlled by wealthy collectors, and was too expensive for young artists to join. Morse led the call for a teaching academy run by artists, who would share responsibility with wealthy businessmen and politicians in defining the nation's artistic identity. As first president of the National Academy of Design, he drafted the constitution and by-laws of an institution for the training of American artists and the regular exhibition of their work, ensuring their control over their own professional development. He would play a significant role in the National Academy until 1837.

In 1831–33 Morse tried, once again, to capture the public imagination with a large canvas entitled *The Gallery of the Louvre* [2.54], a celebration both of the great masters of Europe and of the talents of the American artist (Morse in particular) who would use these European greats as the foundation for a new and distinctly different national art. It was also a recognition of the growing number of women who were engaging in the study

of art, as three of the four students copying paintings are women. But, again, while appreciated by his colleagues, the painting drew few paying visitors from the general public, confirming Morse's low evaluation of the aesthetic tastes of the latter. This negative reception, combined with his failure to garner a mural commission for the Capitol Rotunda, led Morse to retire from painting and to devote the rest of his life to politics and to the scientific pursuits that had interested him for much of his adult life, in particular his work on the invention of the electromagnetic telegraph and the Morse code.

Some of those who viewed Morse's painting may have felt that the work gave too much emphasis to a European culture from which artists in the United States were trying to distinguish themselves. The same could not be said of another gallery scene, produced by the Philadelphia artist Charles Willson Peale (1741–1827). Peale had been trained as a clocksmith, silversmith, and saddler in Annapolis, Maryland, before taking up the practice of portrait painting in the 1760s. He studied for two years with Benjamin West in London and returned to Maryland to try his skills at rendering likenesses of local notables, transmitting his enthusiasm for art to many members of his family. In 1786 he opened a museum in a building next to his house that combined both fine art and natural history in a display meant to educate the general public in the wonders of both art and nature. It moved subsequently to the American Philosophical Society's Philosophical Hall in 1794 and, finally, to the Philadelphia State House, or Independence Hall, in 1802.

In 1822 Peale's museum was incorporated as the Philadelphia Museum. To honor the occasion, the trustees commissioned a self-portrait from Peale, which resulted in *The Artist in His Museum* [2.55]. The painting presents a very different kind of

2.55 Charles Willson Peale: *The Artist in His Museum*, 1822
Oil on canvas, 103¾ × 79⅞ in. (263.5 × 203 cm.)
The Pennsylvania Academy of the Fine Arts, Philadelphia

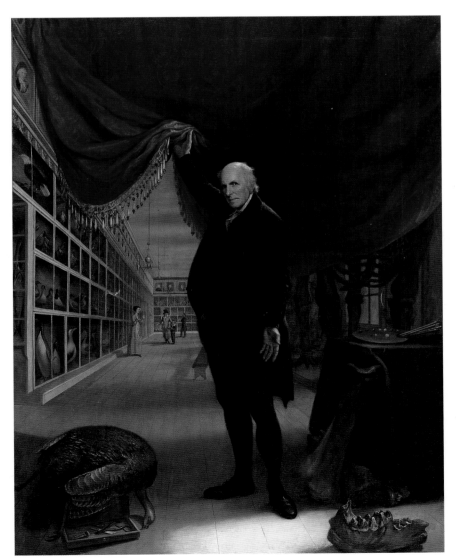

institution from the one in Morse's work [2.54]. Rather than celebrating the masterpieces of European artistic achievement, Peale pulls back the curtain to reveal a mix of portraits of distinguished persons, stuffed specimens of American birds, and mastodon bones that Peale himself had excavated. In the left foreground an American turkey is draped over the tools of taxidermy, signaling its untimely fate, probably at the hands of Peale himself, who had mastered that art. To the right of Peale on a table are his palette and brushes. In the background are visitors, who take advantage of the lessons offered by the artist's museum. Peale takes his inspiration not only from other artists but also from nature, although nature once removed through the process of taxidermy. He thus presents a combination of science and art, imbued with nationalist sentiment, that Morse surely would have appreciated.

The Entrepreneurial Spirit and the Production of American Culture

Rufus Porter and the "Valuable and Curious Arts"

Morse spent much of the last part of his life attacking both Catholicism and capitalism, the one for undermining the spiritual and moral strength of the country, the other for turning the fine arts into bourgeois commodities appealing to the lowest common denominator. He finally came to the conclusion that the nation would lead the world not in culture, but in commerce. But not everyone was so critical of the entrepreneurial spirit of American capitalism or of its effect on the production of American culture. Many artists willingly crafted their images according to the tastes of the average citizen of relatively comfortable means whose enthusiasm for the arts, even if not for the sort of arts Morse preferred, was very real. The art critic John Neal wrote in 1829 that "you can hardly open the door of a best room anywhere, without surprising [sic] or being surprized by the picture of somebody plastered to the wall, and staring at you with both eyes and a bunch of flowers." Thus, there was fortune and fame to be had for those who possessed the willpower and talent to supply a growing demand for cultural commodities, from portraits and landscape paintings to stenciled chairs and clocks.

One such individual was Rufus Porter (1792–1884), who joined the growing ranks of artists traveling the back roads of the North to satisfy the demands of an expanding rural population for pictures [2.56, 2.62]. The Americanist David Jaffee

2.56 Rufus Porter: painted dining room, Holsaert House, Hancock, New Hampshire, c. 1825–30

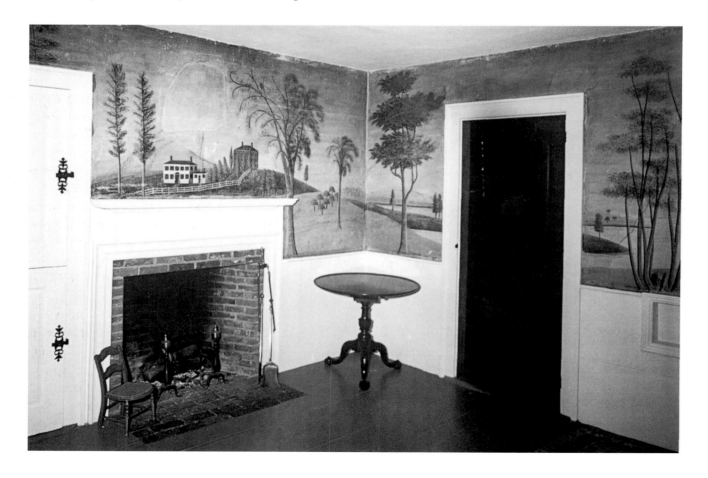

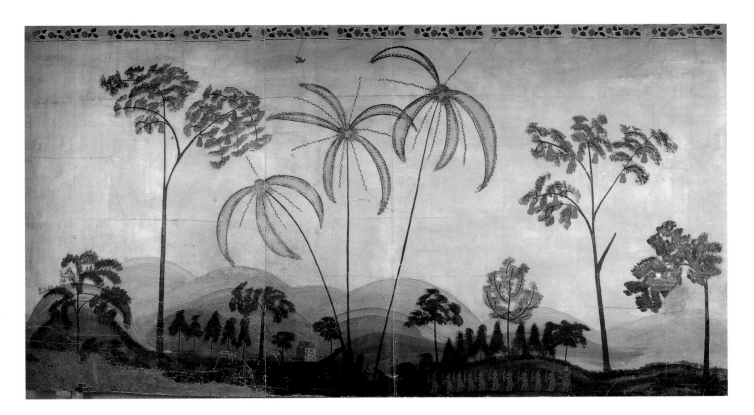

2.57 Attributed to the "Bears and Pears" artist: wallpainting, from Thornton, New Hampshire, 1800–1825. The panel shown, c. 96 in. (244 cm.) high, is one of four that would have decorated the walls above the dado, as in ill. 2.55. Museum of American Folk Art, New York

describes Porter as an "artisan-entrepreneur" who, rather than accept the relatively insular and conservative tastes of such communities, aggressively promoted a more cosmopolitan model of culture and consumption: he thus played an important role in what Jaffee calls the early 19th-century "Village Enlightenment," when rural America was transformed "from a region resistant to change into one eager to embrace it." This transformation was part of a broader economic revolution that engulfed the whole of the country during the first half of the 19th century. A major spur was the growth of the southern cotton economy. As production boomed, aided by Eli Whitney's invention of the cotton gin in 1793, cities in the Northeast began to benefit in a number of ways. Bankers provided southern plantation owners credit, merchant seamen transported the cotton to Europe, and a textile industry emerged to take advantage of the ready supply of raw materials. This increase in wealth promoted a flurry of local projects including new roads, bridges, and canals. Railroads soon followed. The improvement in transportation made access to rural communities much easier for merchants and artists alike. It also made the urban centers of the East Coast more accessible from the country. One no longer needed to live on the coast and rely on the north–south water routes in order to move from place to place.

These improved systems of transportation and communication also brought more people into rural areas looking for land, increasing the pressure on an already short supply. Some moved westward. Those who remained found that they were being pulled out of their close-knit self-supporting communities and into a market economy that provided greater opportunities for both wealth and economic disaster. The influx of new people and new ideas also challenged local traditions of authority, with both sons and daughters now able to envision lives outside of the farm, as traveling merchants or workers in the growing textile industry. Thus, while Jaffee's "Village Enlightenment" opened up new possibilities that were eagerly embraced by many rural inhabitants of the Northeast, it also brought with it increasing anxieties, particularly for the local patriarchal authorities that had governed the old household system. It was into this mix of enthusiasm and anxiety that Rufus Porter and others like him arrived to hawk their artistic wares.

Porter was similar, in many ways, to Morse. While not having had the advantage of academic training or travel to Europe, he too believed that the arts needed to be accessible to, and appreciated by, the nation as a whole. As Morse was putting the final touches on his plans for a National Academy of Design, Porter produced his own pedagogical tool for the dissemination of the arts. In 1825, in Concord, New Hampshire, he published *A Select Collection of Valuable and Curious Arts, and Interesting*

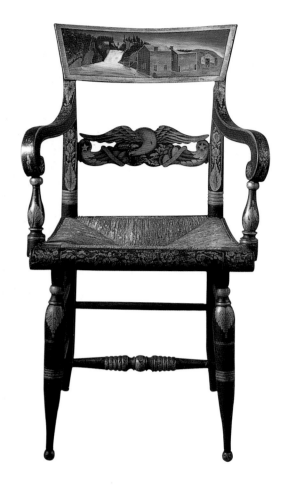

2.58 Anonymous, from New England: Hitchcock-type armchair, c. 1825
Painted and stenciled wood and woven rush seat
Private collection

Experiments Which are Well Explained, and Warranted Genuine, and May be Prepared, Safely and at Little Expense, a text ranging widely over various topics in the arts, manufactures, and science (it went through five reprintings). The book was intended to help those country artisans who wanted to meet more effectively, if not create, the growing demand for the "embellishment" of rural homes. It was filled with practical instruction rather than aesthetic speculation, providing precise measurements and rules for mixing colors, estimating the amounts of materials needed, and plotting out the designs for landscapes to be painted on walls. "In his work—both writing and painting—Porter placed repetition and rule at the very heart of the country vernacular," writes Jaffee. "Porter emphasized color and line, both accessible to precise measurement in careful proportions."

In an advertisement in the *Providence Patriot* in 1822 Porter offered "to paint walls of rooms, in elegant fall colors, landscape scenery, at prices less than the ordinary expence [*sic*] of papering. Those gentlemen who are desirous of spending the gloomy

winter months amidst pleasant groves and verdant fields, are respectfully invited to apply as above, where a specimen of the work may be seen." Porter here identifies one of the central reasons for the popularity of painted walls—that they were less expensive than imported wallpaper. The results of his efforts can be found in the Holsaert House dining room in Hancock, New Hampshire, painted some time between 1825 and 1830 [2.56]. Here Porter provided those "pleasant groves and verdant fields" intended to distract the residents of the house during the long New England winters.

Some artists were more imaginative in their compositions. One is known as the "Bears and Pears" artist for his/her penchant for those subjects. On a wall in a home in Thornton, New Hampshire, between 1800 and 1825, this artist created an array of fantastic foliage, with giant pear and palm trees and a battalion of soldiers with pith helmets and swords [2.57]. Landscapes also decorated pieces of furniture, such as the mill complex depicted on the back of a *c.* 1825 Hitchcock-type armchair [2.58], named after the furniture-maker Lambert Hitchcock. This chair also displays stenciled floral motifs and an eagle flanked by two stars, adding a patriotic element to the scene of industry above.

Porter's book could also have been used as a guide to the painting of floors or floorcloths. One of the few examples from the early 19th century that exist today can be found in the Edward Durant House in Newton, Massachusetts [2.59]. Here a variety of designs have been painted in repetitive patterns using stencils. Several written descriptions also add to our knowledge of this practice. Ruth Henshaw Bascom (1771–1848), who is known to have executed a number of pastel portraits, wrote in her diary in the early 19th century:

> 29 June Tuesday—fair I began to paint my parlor floor in imitation of a striped carpet. 30 June Wednesday
> I painted $^1/_4$ of my striped floor. 3 July Saturday
> I finished painting my floor, at 6 p.m. Striped with red, green, blue, yellow and purple—carpet like.

An 1832 watercolor of the Talcott Family by Deborah Goldsmith (1808–36) [2.60] suggests what such a striped floor might have looked like. As for floorcloths, Dewhurst and the MacDowells quote a revealing passage from *The Autobiography of Lyman Beecher*, where he reminisces of his home in 1800–1801:

> We had no carpets; there was not a carpet from end to end of the town Your mother introduced the first carpet. Uncle Lot gave me some money, and I had an itch to spend it. Went to a vendre [i.e. vendor], and bought a bale of cotton. She spun it, and had it woven; then she laid it down,

sized it, and painted it in oils, with a border all around it, and bunches of roses and other flowers over the centre. The carpet was nailed down to the garret floor, and she used to go up there and paint.

Soon, however, painted floors and floorcloths were replaced by braided, hooked, or woven and embroidered rugs produced in the home or imported from abroad. One of the finest examples of such an embroidered carpet that has survived from the early 19th century was made by Zeruah Higley Guernsey Caswell in

2.59 Anonymous: stenciled wooden floor, in the Edward Durant House, Newton, Massachusetts, c. 1825

2.60 Deborah Goldsmith: *The Talcott Family*, 1832
Watercolor on paper, 18 × 21⁷⁄₁₆ in. (45.7 × 54.6 cm.)
Abby Aldrich Rockefeller Folk Art Center, Williamsburg, Virginia

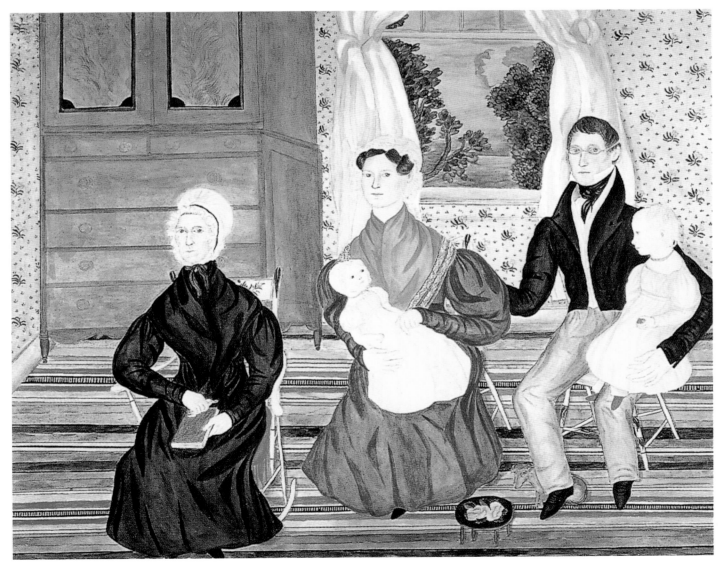

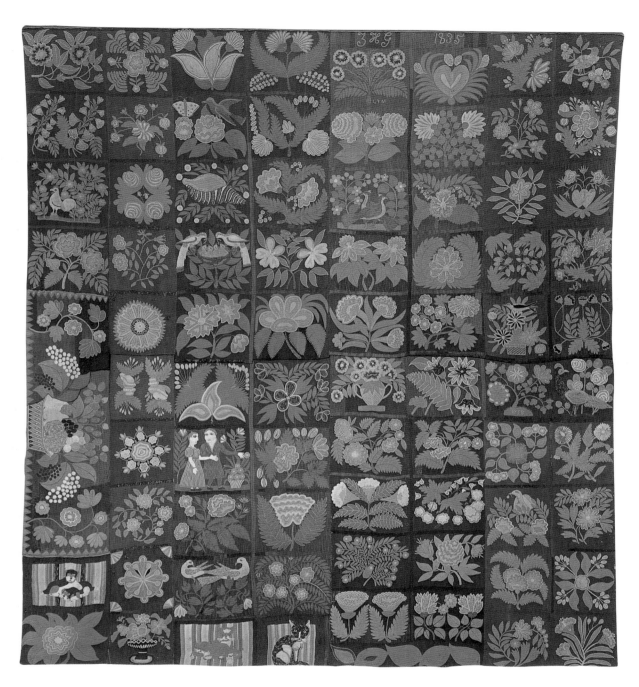

2.61 Zeruah Higley Guernsey Caswell: carpet, from Castleton, Vermont, 1832–35
Wool embroidered on wool, 159 × 147 in. (400 × 373 cm.)
The Metropolitan Museum of Art, New York

1832–35 [**2.61**]. Measuring over 13 x 12 feet and made of wool sheared, spun, and dyed by the maker herself, the carpet is composed of seventy-six embroidered squares. To make it more adaptable to the seasons, Caswell created a removable rectangular section that covered the hearth in the summer months (on the left in illustration). The squares are filled with a wide variety of plants and animals plus a young man and woman, who gesture

toward the main body of the carpet, as if to call our attention to the skill and imagination of its maker (Caswell predicted that this young couple would one day "keep house on her carpet"). The inclusion of a large basket of flowers and fruit on the edge of the removable section might refer to the 18th-century custom of placing a vase of cut flowers or boughs in an unused fireplace.

Like Morse, Porter was an inventor as well as an artist (he founded the journal *Scientific American* in 1845), but unlike Morse he was not averse to combining "art," "experiments," and "expense" in both his book and his daily practice. He produced portraits with the aid of a profile machine and a

2.62 Rufus Porter: *Portrait of a Man*, c. 1820
Watercolor and ink on paper, 4 × 3 in. (10.2 × 7.6 cm.)
Abby Aldrich Rockefeller Folk Art Center, Williamsburg, Virginia

camera obscura or "dark chamber," an artist's device in use since at least the 15th century composed of a light-tight box containing a convex lens at one end and a screen that reflected the image at the other, allowing the artist to trace the image. These devices helped guarantee a "correct likeness" in a short period of time. The price of the portrait depended on the amount of detail (the more detailed the image, the higher the fee). He also made use of a copying machine or pantograph, thus producing a standardized product, giving his patrons, in Jaffee's words, "as much 'art' as they were willing to pay for." This use of mechanical aids, however, may account for certain odd combinations in Porter's portraits, such as profile ears attached to a head in almost full frontal view [2.62].

A Plain Likeness: Itinerant Portrait Painters

Those itinerant, or traveling, portrait painters who joined Porter on the back roads of New England to make their fortunes satisfying the growing demands of a rural population for images now had more opportunities than ever to refine their drawing and painting skills. They could study in New York as well as Paris or London, and could gain advice from manuals and pamphlets or from private tutors. Yet many continued to paint in a style reminiscent of their predecessors, one that emphasized flatness, minute detail, and frontality—"staring at

you with both eyes," as Neal observed in 1824. Such characteristics can be found in the work of Erastus Salisbury Field, Ammi Phillips, and Joshua Johnston, among others. Several scholars have argued that, as with the painter of the Freake portraits at the end of the 17th century [1.66, 1.67], these characteristics cannot be seen as simply the result of ineptitude. Rather, they can be attributed, at least in some instances, to what the artist and folklorist Charles Bergengren calls "a social reticence in the presentation of self in egalitarian communities."

Bergengren, like Jaffee, suggests that we need to evaluate works such as *Joseph B. Moore and His Family* of 1839 by Erastus Salisbury Field (1805–1900) [2.63] as part of a moment of rapid social change in early 19th-century rural America, as an image "poised between forces of modernization at the hands of an upwardly mobile bourgeoisie and forces of a conservative morality drawn from a Puritan egalitarian lineage." While patrons such as Joseph Moore may have desired to be associated through portraiture with a wealthier, often urban class, they were also restrained in their aspirations by earlier ideals based in more egalitarian religious or folk communities. The Reverend Timothy Dwight, who in his 1794 poem *Greenfield Hill* praised Trumbull for banishing from his paintings the "strumpets" and "scenes of lewdness" found in the work of British artists (see p. 89), commended New England's rural people in similar terms. While England was "tinselled outside," a "painted tomb," and "foul harlot," New Englanders were "sunny geniuses," "plain," "frank," and "practical." It was this plainness and frankness that was captured in the portraits of Field and others.

Field was primarily self-taught, encouraged by his parents to explore his artistic talents while growing up in Leverett, Massachusetts. He did spend several months, however, studying with Morse in late 1824 and early 1825 in New York. Certainly he would have learned something of shading and perspective, but for this commission he chose, for the most part, to ignore these lessons. Field was living with his wife's parents in Ware, Massachusetts, and the Moore family lived across the street (he had already painted several portraits of Almira Moore's family, the Gallonds). Joseph Moore was a hatmaker in the winter, a traveling dentist in the summer, and a committed student of religion. Thus, he was a man of considerable means, but also of strong religious conviction.

Field has organized the figures in the foreground of a shallow space, with the floor tipped up at such an angle that it continues the line of the wall, revealing the bright patterns of the carpet or painted floor (see p. 129). The shadows cast by Joseph and the boy beside him do little to break this flatness, which is emphasized also in the equal attention given to foreground and background detail and to the figures themselves,

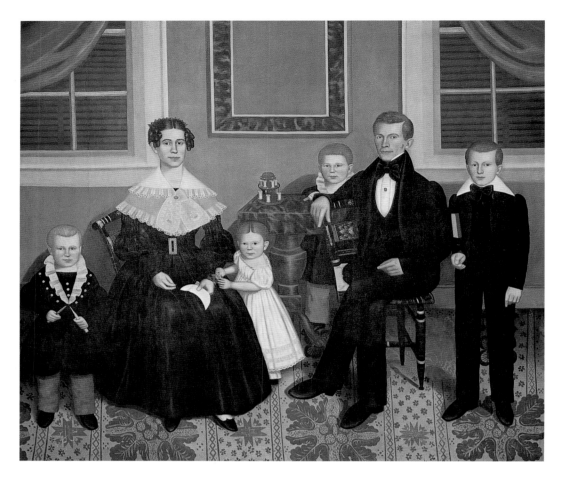

2.63 Erastus Salisbury Field: *Joseph B. Moore and His Family*, 1839
Oil on canvas, 82¾ × 93¼ in. (210.2 × 237 cm.)
Museum of Fine Arts, Boston, Massachusetts

who all stare directly out at the viewer. This evenness of treatment applies to the surface as well, where there is little evidence of brushstrokes. Bergengren comments that such neutral lighting, undifferentiated space, and unmodulated paint surface "all contribute to the conservative effort to erase personality, to downplay aggressive 'presence' and to present instead a stable, permanent, even eternal image for posterity."

Yet personality is not totally absent from Field's portrait [2.63]. The stiff poses are countered by the slight smiles on the faces of the figures, suggesting a certain sense of familiarity and family cohesiveness. Almira Moore is flanked by the two small children of her deceased sister Louisa; she holds a needle in one hand and a needlework form in another; behind her on the table is a small rack filled with spools of thread. The boy at her side holds a knife and a piece of whittled wood while the girl holds a flower. On either side of Joseph Moore are the couple's two sons, the older of whom holds a book under his arm. Industriousness is thus represented through personal objects symbolic of domestic work, creative play, and study. The

dark clothes and shuttered windows suggest a somber mood, perhaps a reference to the death of Almira's sister. This mood is broken, however, by the colorful designs on the floor, chair back, table, and frame on the wall, and by the bright red curtains pulled back from the windows. Then again, the shuttered windows, in denying the viewer access to the world outside of the Moore home, serve to focus attention on the figures, their modest prosperity and their industry.

Perhaps one can best appreciate the significance of Field's formal choices in conveying a certain impression of his sitters by comparing the painting to an earlier family portrait produced for a wealthy merchant in Boston, Joseph Blackburn's 1755 *Isaac Winslow and His Family* [2.64]. Blackburn arrived in the colonies from England in 1752, spending two years in Bermuda painting portraits before traveling to Newport, then to Boston in 1755, the year he painted the Winslow family. He portrayed Isaac and Lucy Winslow and their two daughters Hannah and Lucy in a manner and style common in English portraiture at the time. Whereas Field's portrait is marked by formality and restraint, Blackburn's is filled with informality and excess. Isaac stands in an exaggerated contrapposto (one leg bears the majority of the body's weight, while the other is

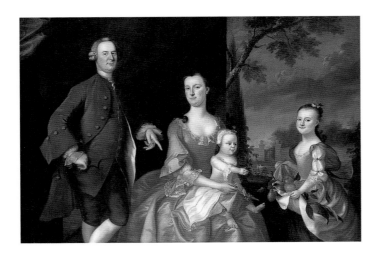

2.64 Joseph Blackburn: *Isaac Winslow and his Family*, 1755
Oil on canvas, 54½ in. × 79½ in. (138 × 202 cm.)
Museum of Fine Arts, Boston, Massachusetts

the single flower in the hand of the child in Field's portrait, the young Lucy Winslow carries an apronful of peaches and pears from the orchard. This is not a spare scene of propriety and industry, but a lushly painted representation of individuals proud of the wealth and status they have achieved.

An even greater contrast can be made between Field's painting and Copley's 1776–77 portrait of himself surrounded by his own family [2.65], which he painted just after they had joined him in London. While Blackburn's figures, like Field's, all (except for the small child) look out at the viewer, thus maintaining a certain degree of formality, many members of Copley's family ignore the viewer altogether, wrapped up as they are in shows of motherly or filial affection or lost in thought. Here the display of materials and textures is even more lavish; the brushstrokes even richer and more visible, particularly in the landscape in the distance; and the personalities of the sitters even more clearly displayed through the objects they hold and/or wear, the expressions on their faces, and their poses. Copley, seated above his father-in-law and holding two sheets of paper in his hand, looks out with confidence and satisfaction at the viewer, a mood undoubtedly caused in part by his recent reunion with his family after an absence of a year and a half.

slightly bent). One of his hands rests on his hip, the other points at his seated wife, thus suggesting a hierarchy of authority. The figures are located in a space on the border between the interior and exterior of the home, with a swag of drapery on the left and lush gardens extending into the background on the right, which increase the sense of depth in the painting. The low-cut bodices of the dresses of the wife and older daughter and their satiny texture add an element of sensuality to the scene. Rather than

2.65 John Singleton Copley: *The Copley Family*, 1776–77
Oil on canvas, 72½ × 90¼ in. (184 × 229.2 cm.)
National Gallery of Art, Washington, D.C.

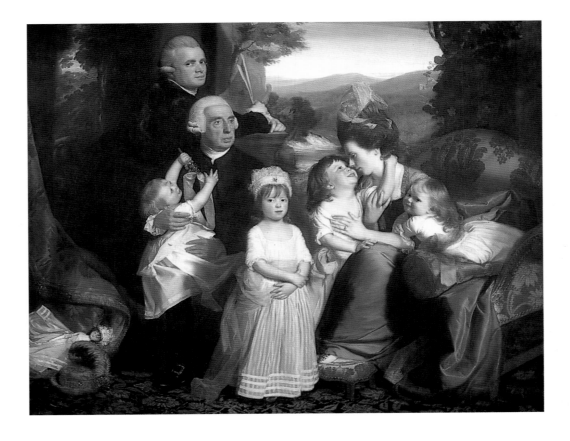

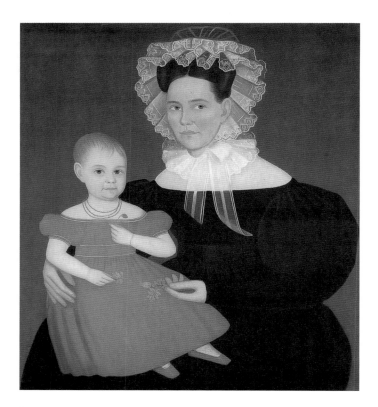

2.66 Ammi Phillips: *Mrs Mayer and Her Daughter*, 1830–40
Oil on canvas, 37⅞ × 34¼ in. (96.2 × 87 cm.)
The Metropolitan Museum of Art, New York

The art historian Margaretta Lovell has noted that the focus on the mother-child relationship in paintings like those of Blackburn and Copley is evidence of a shift in beliefs about the nature of the family and the rearing of children during the 18th century. An authoritarian upbringing was replaced by a "gentler" attitude where mothers attempted to imbue their charges with a sense of self worth and self love rather than simply to control and counter what were seen as deeply rooted natural depravities. As a result, images of children at play and engaging in intimate exchanges with their mothers mark many of the family portraits of the late 18th century.

While many New Englanders, both rural and urban, could well have commissioned family portraits in the manner of Blackburn's or Copley's, many chose not to. This preference for the flat, "plain" portraits of the itinerant painters allowed Ammi Phillips (1788–1865) to support himself for fifty years, from 1810 to 1860, even though his travels extended over only a relatively small area composed of the western parts of Connecticut and Massachusetts and the bordering areas of New York. To date, approximately five hundred works have been attributed to him. Phillips's *Mrs Mayer and Her Daughter* of 1830–40 [2.66] shares with Field's work [2.63] a flattened space, neutral lighting, attention to detail, and contrast between a predominantly

somber mood and a bright flash of color, in this case the young girl's red dress, shoes, and necklace. Phillips has, however, created a much tighter, more integrated composition. He has effectively united the two figures by echoing the necklines of the two dresses; placing the girl to one side of the mother's lap so that the line of the child's shoulder repeats the puffed sleeve of the mother's other shoulder; and bringing the outside arms of both figures in line with each other through the flower in the mother's left hand, from which the child has just pulled a leaf. The intimate relationship between mother and daughter, while certainly more reserved than that between Susanna Copley and her young son as depicted in Copley's family portrait [2.65], is still convincingly conveyed (Mrs Mayer may have only partially adopted the new "gentler" practice of childrearing). In addition, small details—the necklace, the strawberry in the child's other hand, the intricate pattern on the lace cap—are set against broad areas of color or light, adding an element of dramatic contrast to the work.

Such a taste for "plainness" in portraiture was not limited to the states of New England. For example, the likenesses of many of the leading families of the South were captured for posterity in the work of the Baltimore artist Joshua Johnston (1765–1830), who had been born a slave but had gained his freedom by 1796, when he was recorded in the city directory as a portrait painter (he appears in several Baltimore directories between 1796 and 1824, in two specifically listed as a freeman). There is no record of where Johnston received his training, although scholars think he may have studied with the American artist Charles Peale Polk (1767–1822) or at least known of his work. In an advertisement he placed in the December 19, 1798, issue of the *Baltimore Intelligencer* Johnston claimed to be "a self-taught genius deriving from nature and industry his knowledge of the Art" and able "to execute all commands, with an effect, and in a style, which must give satisfaction" [2.67, 2.68].

Johnston was not the only African American painter working in the U.S. at the end of the 18th century. In 1794 and 1795 a large group of French refugees fled the slave insurrection in Santo Domingo (Haiti), bringing with them to the U.S. African slaves, several of whom were known to be silversmiths and painters. Evidence of other free African painters can be found in advertisements such as the one in the January 7, 1775, edition of the *Boston Newsletter*, which offers the services of an African man who "makes portraits at the lowest rates" and who "has worked with the best masters in London." In addition, the poet Phyllis Wheatley, a slave in the Boston household of John Wheatley, mentions the work of an African painter named Scipio Moorhead (active 1770s) in a collection of her poems published in London in 1773. Moorhead may have been a slave

in the household of the Reverend John Moorhead of Boston, and may have learned to draw and paint from the Reverend's wife, Sarah, who was an art teacher.

As Sharon Patton points out in her study of African American artists, Johnston was not an itinerant artist in the same sense as Phillips or Field, for he spent most of his career near his home city of Baltimore. "Itinerancy among black artisans and artists," writes Patton, "was ill-advised because slave-traders were active, and patrols and slave auctions routine." The Fugitive Slave Act of 1793, which provided for the return between states of escaped slaves, "rendered all African Americans potential escapees." This act was particularly important for slave owners after the slave trade was abolished by law in the U.S. on January 1, 1808 (c. 40,000 Africans were brought into the country between 1808 and 1861 via a black market in slaves). Johnston found ample work, however, in Baltimore, home to the Maryland Abolitionist Society as well as to 25,000 free blacks (as compared to 3,000 slaves) in the early 1800s.

All but two of the thirty-odd paintings currently known to be by Johnston are of members of prosperous white families,

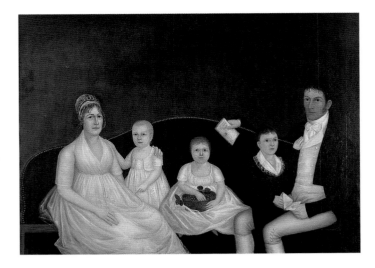

2.68 Joshua Johnston: *The James McCormick Family*, c. 1805
Oil on canvas, 50 ¹³⁄₁₆ × 69 ⁷⁄₁₆ in. (129 × 176.5 cm.)
Maryland Historical Society, Baltimore

2.67 Joshua Johnston: *Portrait of a Cleric*, c. 1805
Oil on canvas, 28 × 22 in. (71 × 55.8 cm.)
Bowdoin College Museum of Art, Brunswick, Maine

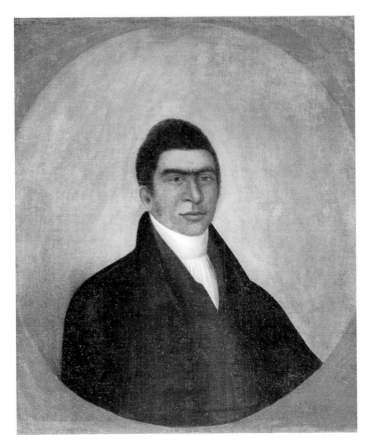

some of whom sympathized with the goals of abolitionism. *Portrait of a Cleric* [**2.67**], of c. 1805, is one of two images of individuals of African descent. The portrait of the James McCormick family, of c. 1805 [**2.68**], is a representative example of the rest of his work. It is obvious from these paintings that Johnston was capable of working in at least two different styles. The head of the cleric is carefully modeled, his distinctive features convincing us that this is, indeed, a portrait. The McCormick family, on the other hand, is depicted in the "plain" style described by Bergengren—neutral lighting, undifferentiated space, formulaic faces, particularly among the children, and a rigid frontality.

While the identity of the cleric is unknown, there is ample information about the McCormick family. James McCormick came to Alexandria, Virginia, from Ireland soon after the Revolution and then moved to Baltimore, where he became a prosperous merchant and married Rachel Ridgely Lux. They had four children, three of whom are shown, William, Sophie, and John. There is little in the painting to indicate the extent of their wealth, except for a general sense of ease and the modest stylishness of the clothing. While certain gestures tie the family together—William's hand on his mother's shoulder, John's on his father's chest—Johnston uses the arching line of brass tacks at the top edge of the Sheraton sofa to literally link four of the figures, with the fifth positioned directly beneath the crest of the arch (his penchant for this element earned him the nickname "the brass-tack artist"). Also, like Ammi Phillips [**2.66**], Johnston uses accents of red, in this instance the slippers of Sophie and the strawberries she holds in her basket, to contrast with the otherwise predominantly white and black/brown color scheme.

A "Scientific" Likeness: The Daguerreotype

The demand for portraits by itinerant painters such as Johnston, Phillips, and Field declined in the 1840s and 1850s with the arrival of the daguerreotype, an early form of photography developed in France in the 1830s by Louis-Jacques-Mandé Daguerre (1789–1851) and introduced in 1839 to the United States by none other than Samuel Morse. While a student at Yale, Morse had experimented with the camera obscura and wanted to capture the reflected image produced by this device on a light-sensitive surface, but was only able to create a negative of the image on paper dipped in a solution of nitrate of silver. Daguerre succeeded where Morse had failed, using light-sensitized metal plates. Morse did not see the daguerreotype as "the ruin of art" but, rather, as an aid for both artists and critics in learning how to look at nature, which could be captured in all its detail.

The extent of the popularity of the daguerreotype is revealed in a quote from T. S. Arthur's temperance tract *Ten Nights in a Barroom*, published in 1850:

> If our children and children's children to the third and fourth generation are not in possession of portraits of their ancestors, it will be no fault of the Daguerreotypists of the present day; for verily, they are limning faces at such a rate that promises to make every man's house a Daguerrean Gallery In our great cities a Daguerreotypist is to be found in almost every square; and there is scarce a county in any state that has not one or more of those industrious individuals busy at work catching "the shadoe" ere the "substance fade." A few years ago it was not every man who could afford a likeness of himself, his wife, or his children; now it is hard to find a man who has not gone through the "operator's" hands from once to a half-a-dozen times Truly the sunbeam art is a most wonderful one, and the public feel it a great benefit.

Thus, the same public that had become accustomed to obtaining increasingly inexpensive likenesses through the efforts of painters like Porter and Phillips, and that preferred the stiffly posed, limited color schemes of these artists, were now drawn to this new black and white medium, which was able to capture an even greater degree of likeness for even less money, with a stiffness of pose guaranteed by the long exposure time. By the early 1850s there were reportedly some 2,000 daguerreotypists plying their trade in the U.S. Some set up shop in cities and towns, while others took to the road in wagons and to the rivers in flatboats. And while they turned their cameras on landscapes and cityscapes, portraits remained the most popular subject-matter among Americans at mid-century.

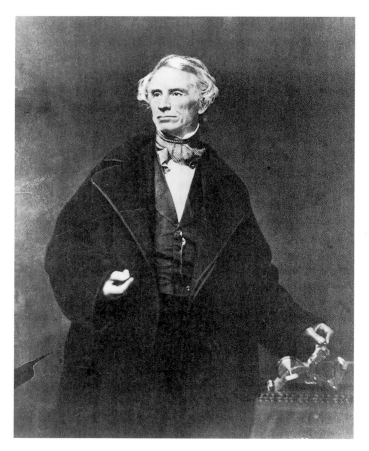

2.69 Mathew B. Brady: *Samuel F. B. Morse, c.* 1845
Daguerreotype
Library of Congress, Washington, D.C.

One of the first to learn the daguerreotype method from Morse was Mathew B. Brady (*c.* 1823–96), who studied art at the National Academy of Design before becoming a daguerreotypist and opening a studio on lower Broadway in New York in 1844. Around 1845 Brady captured his former teacher in a three-quarter-length image, his left hand resting on his newly invented telegraph [2.69]. On May 24 of the previous year Morse had successfully transmitted his first message from Washington to Baltimore. It is fitting that the transmission of sound over wire, appearing magical to many, would be commemorated by an equally magical process. The development of glass negatives in the 1850s, which allowed for sharper and more stable images and the printing of several positive images from the same negative (daguerreotypes were unique objects), marked the demise of the daguerreotype and ensured the further proliferation of photographic reproductions at all levels of American society. The United States was now embarked on an era of vast social and economic transformation fueled by rapid technological change, which artists attempted to record, accommodate, advance, or resist as best they could.

3

Nature and Nation

3.1 Asher B. Durand: *Kindred Spirits*, 1849 (see pp. 151–52)
Oil on canvas, 44 × 36 in. (111.8 × 91.4 cm.)
The New York Public Library, New York

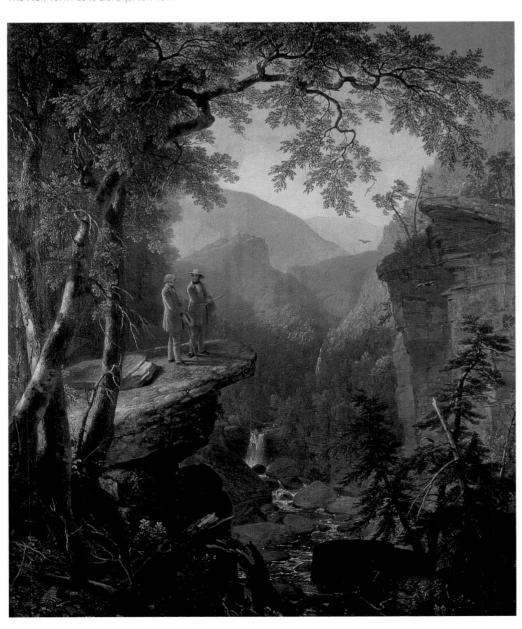

Timeline 1000–1860s

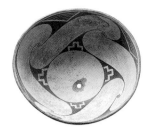

3.3 (see p. 141)

1000–1130	Classic Mimbres pottery [**3.3**]
1770s	Arrival of Russia, England and Spain in the Pacific Northwest
1804–6	Lewis and Clark Expedition map Louisiana Territory
1808–13	Publication of Alexander Wilson's nine-volume *American Ornithology*
1810s	Raphaelle Peale first American to focus on still-life painting [**3.60**]
1820s	Growing division in Quaker communities between Orthodox and Hicksites leads to Separation of 1827
1820s–49	Edward Hicks paints *Peaceable Kingdom*s [**3.23**]
1820s–60s	More than 30,000 miles of railway track laid
1824	Catskill Mountain House opens, becomes favorite retreat for landscape artists
1825	John Trumbull discovers the early landscape paintings of Thomas Cole [**3.11**], beginning the Hudson River School; opening of the Erie Canal
1828	Formation of the Democratic Party, election of Andrew Jackson as first Democratic President of the U.S.; publication of *Metamora: or, The Last of the Wampanoags; An Indian Tragedy in Five Acts*, by John Augustus Stone
1828–38	Publication of John James Audubon's *Birds of America* [**3.69**]
1830	Passage of the Indian Removal Bill
1830–36	George Catlin makes five trips to the territory west of the Mississippi to paint Native peoples
1831	Revolt of African slaves led by Nat Turner, Southampton County, Virginia

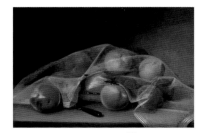

3.60 (see p. 188)

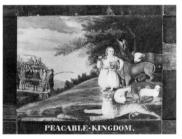

3.23 (see p. 156)

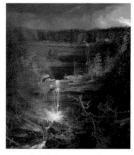

3.11 (see p. 148)

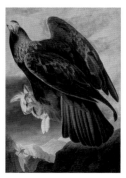

3.69 (see p. 193)

Hudson River School 1825–50s

Height of genre painting

Hudson River School 1825–50s

Height of genre painting 1830s–50s

Luminism 1850s–70s

1832–34 Karl Bodmer accompanies Prince Maximilian of Wied-Neuwied on a journey up the Missouri, makes sketches for the Prince's travel account

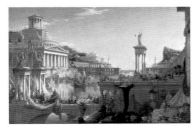

1834–36 Thomas Cole paints the *Course of Empire* series [3.14] for Luman Reed

3.14 (see p. 151)

1835 Thomas Cole publishes "Essay on American Scenery"

1839 Publication of Prince Maximilian of Wied-Neuwied's *Travels in the Interior of North America in the Years 1832 to 1834*, with illustrations by Karl Bodmer; George Catlin leaves for London

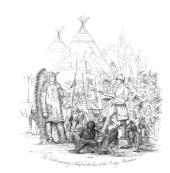

1840s Rise in popularity of flower still-life paintings

1841 George Catlin publishes *Letters and Notes on the Manners, Customs, and Conditions of North American Indians* [3.37]

3.37 (see p. 168)

1842 Founding of the American Art-Union in New York (successor to the Apollo Association, founded 1839), which publishes *Bulletin* and *Transactions*

1852 Publication of Harriet Beecher Stowe's novel *Uncle Tom's Cabin*

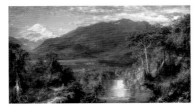

1853 Frederic Edwin Church makes the first of two trips to South America (he makes a second trip in 1857) [3.26]

3.26 (see p. 158)

1854 Founding of Cosmopolitan Art Association, which commissions paintings from artists like Lilly Martin Spencer [3.54] to be reproduced as prints

1856 Henry Row Schoolcraft publishes *Historical and Statistical Information Respecting the History, Condition and Prospects of the Indian Tribes of the United States*

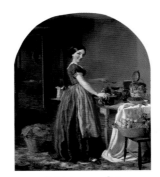

3.54 (see p. 183)

1859 Albert Bierstadt makes the first of several trips out West [3.32]

1869 May 10: Completion of the transcontinental Union Pacific Railway

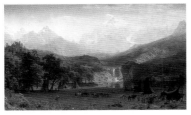

3.32 (see p. 163)

From the moment Europeans first set foot on the North American continent, their attention was drawn to the landscape before them. Many, like Columbus, struggled to describe the strange plants and animals they saw, drawing on mythic tales of monsters and paradises that had circulated in Europe in the 14th and 15th centuries. John White took a more direct approach, attempting to delineate the features of plants and animals, as well as peoples and architecture, without resorting to such myths [1.59–1.61]. Columbus wanted to explain what he saw, White simply to describe it.

3.2 Population density in the United States in 1820 and in 1860

Yet White's mind was not a clean slate; he had been trained as an artist in Europe and brought with him a set of skills and presumptions about how the exterior world appeared to the human eye. His pictures, and those of the numerous European artists who followed him, were very different, stylistically and compositionally, from the pictures produced by many of the peoples who already occupied the North American continent. These differences were due, in part, to different perceptions of the world and of the place of humans within this world. The development of one-point perspective in the 15th century in Europe positioned the human viewer as the center of the world, as the originator of meaning. In much of the narrative art of indigenous peoples, humans and animals and their

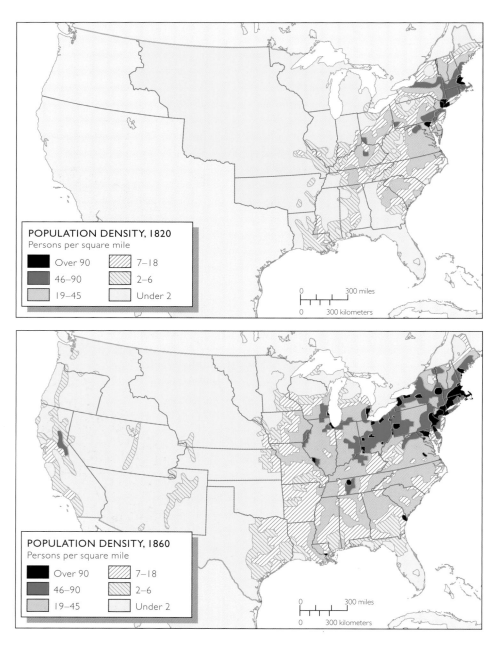

surroundings are viewed as if from above, with no horizon line to locate them within a definable space and no privileging of human over other life forms. As these two world views—humans as organizers and controllers of nature versus humans as one element within a complex and carefully balanced world—collided, each side struggled to maintain and adapt their beliefs and behaviors, using both rhetorical persuasion and force.

The opening up of the continent west of the Mississippi with the Louisiana Purchase in 1803 intensified these struggles and drew artists into a public debate that tested their moral as well as artistic mettle. This westward expansion raised questions not only about the treatment and depiction of Native Americans and European Americans and the land they occupied, but also about relationships between humans and those supernatural beings that helped them understand or come to terms with the joys and hardships they encountered in their daily lives.

These questions came into focus particularly in depictions of the American landscape. Sometimes the landscape was shown devoid of human presence; at other times it was a backdrop for the industrious actions of farmers and merchants. Through displays of the heroic wilderness or the cultivated landscape, American artists attempted to formulate an image of nationhood that accommodated religious, scientific, and commercial concerns, that celebrated God's wonders while at the same time promoting the expropriation and exploitation of the land crucial to the expansionist plans of America's political and industrial elite.

This dual task—the celebration of both the spiritual and the commercial aspects of the American landscape—became more difficult as the population of the country increased dramatically in the first half of the 19th century, from 4 million in 1790 to 31 million in 1860 [3.2]. By the 1860s half lived west of the Atlantic states, many on land previously farmed or hunted on by Native Americans [see 1.3]. This explosive population growth put further pressure on Native Americans and their cultural traditions, significantly diminishing their presence in the physical and cultural landscape of the United States.

Nature and the Sacred in Native American Art

Imagery of Creation and the Vision Quest

In describing two large Mimbres pots from southwestern New Mexico, created around 1000–1130 CE, the artist and architect Rina Swentzell of Tewa-Santa Clara Pueblo wrote:

> Po-wa-ha ("water-wind-breath") is the creative energy of the world, the breath that makes the wind blow and the water flow. Within Mimbres pots, several world levels are usually depicted, showing the human, animal, and plant realms.

Around them are the mountains and surrounding everything is the breath that flows completely around. That's why they're so enormous and all-encompassing—because they suggest the breath that flows around the whole world.

In one bowl [3.3], this integrative, creative breath appears in the swirling cloud forms and the play between light and dark areas. In the other [3.4], the integration is present in the overlapping of human and bear figures, with a diamond-shaped form common to both. This form, writes Swentzell, suggests "the rhythmic motion of the heart that both the man and the bear share. The intertwining of the human and animal is a central theme in Mimbres pottery."

3.3 Anonymous, Mimbres: bowl, c. 1000–1130 CE
Painted clay, D 10½ in. (27 cm.)
National Museum of the American Indian (Smithsonian Institution, Washington, D.C.)

3.4 Anonymous, Mimbres: bowl, c. 1000–1130 CE
Painted clay, D 10½ in. (27 cm.)
National Museum of the American Indian (Smithsonian Institution, Washington, D.C.)

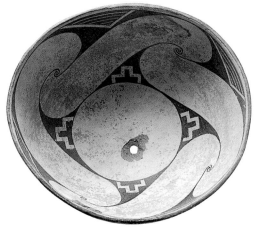

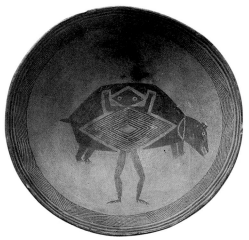

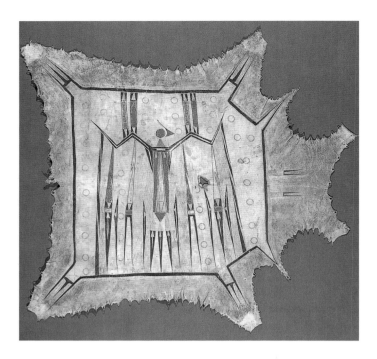

3.5 Anonymous: robe with an abstract thunderbird motif, 18th century
Painted hide, 47¾ × 42⅓ in. (121.3 × 107.6 cm.)
Musée de l'Homme, Paris

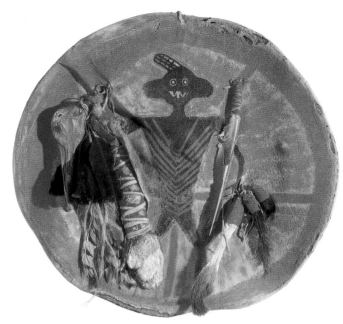

3.6 Sore Belly (Arapoosh), River Crow: decorated hide shield, early 19th century
D 24¼ in. (61.5 cm.)
National Museum of the American Indian (Smithsonian Institution, Washington, D.C.)

Swentzell's words echo earlier accounts by Native Americans of the symbolic meaning of their imagery. Such words reaffirm the strong connection between humans and the natural world and the powerful role of a creative spirit or spirits in bringing order to this world. Creation myths are often the source of Native American iconography and reveal the universe as a layered structure composed of sky, earth, and underworld. In these myths the realms of sky and underworld are personified by supernatural beings, the former often in the shape of a celestial bird or thunderbird, the latter in the form of an underwater panther or water serpent. A highly abstracted thunderbird appears on a painted hide collected by French Jesuits in the Great Lakes region in the 18th century [3.5]. The thunderbird created thunder through the flapping of its wings and lighting through the blinking of its eyes.

Another source of Native American iconography is the vision quest. According to Crow teacher and storyteller Joseph Medicine Crow, these quests are embarked upon by young people in order to obtain *baxbe* or sacred power. This power comes from the First Maker or Creator and is granted through an animal emissary—e.g. an owl, eagle, or butterfly. After a person has spent long periods of fasting and doing without physical comforts, the Creator has mercy and confers some of its power. The individual then creates shields or medicine bundles or other objects containing representations of the sacred animal. Only their owner knows the full story behind these symbols.

One such object, a shield, belonged to Arapoosh or Sore Belly, leader of the River Crow in the early 1800s. It is made up of an outer cover of undecorated buckskin and an elaborately decorated inner cover [3.6]. The central image on the inner cover is thought to represent the moon, which appeared to Sore Belly in a vision and presented him with his shield. The head and body of a stork are attached alongside the figure, together with a deer's tail, partially covered with red flannel, and a single eagle feather. Sore Belly believed his shield possessed magical powers of prophecy, and stories have been handed down over the years containing evidence of these powers. For example, the historian John C. Ewers relates an incident where, "before leading a large war party against the Cheyenne, Sore Belly rolled the shield, promising that if it fell painted side down he would not proceed. It stopped painted side up, and Sore Belly led his people to a great victory on the Arkansas River." It did not, however, guarantee him victory in all instances. Sore Belly was killed in a battle against the Blackfeet in 1834.

The Box that Speaks:
The Integration of Form, Content, and Material

American traders had moved even further west than the Missouri River by the early 19th century, establishing posts on the Pacific coast in the territory now encompassed by Washington state and the Canadian province of British Columbia. The region was rich in fur-bearing animals—seal, sea otter, beaver,

marten and mink, among others—and the Native peoples were expert at both hunting and trading. The Russians were the first outsiders to exploit this natural wealth, having arrived in the 1770s. That same decade also saw the arrival of the Spanish, worried about Russian incursions into Alta California, and the British, under the leadership of Captain Cook. Thus, the area became the hub of an international trading network, with its furs ending up in markets in China, Europe, and the United States.

The social organization of the peoples of the Northwest Coast—the Tlingit, Haida, Tsimshian, Heiltsuk, Nuxalk and Oowekeeno in the northern half, the Kwakwaka'wakw, Nuu-chah-nulth, Makah, Quileute, and Coast and Straits Salish in the south—was dominated by a rigid caste system of nobility, commoners, and slaves, a system facilitated by the abundant natural wealth in the region. That wealth also made possible the development of an elaborate ceremonial life, complete with dances, songs, costumes, and ritual paraphernalia. As with other Native American groups, the ceremonial and spiritual practices of the peoples of the Northwest Coast were dominated by a strong sense of the interconnectedness between the human and animal worlds. In their myths animals often took on human form, and vice versa. The raven was an important figure, known as a trickster or transformer, who put the world and all living things into their present form. He also released the sun from a wooden chest and brought light to the world. Vision quests were part of coming-of-age ceremonies and were marked by the crossing from one world into another and back again. Kinship groupings or clans were identified by specific animals—the raven, the bear—which became the clan's totem and appeared on freestanding poles in front of the large wooden plank houses [3.7], on house posts or door poles, and on personal belongings.

The Northwest Coast peoples are best known for their weaving and woodcarving, the former appearing as hats, blankets and bowls, the latter as boxes, totem poles, and masks. A Haida storage box collected in 1864 [3.8] displays a style common among the majority of two-dimensional carvings and weavings and unique to the Northwest Coast. The surface is filled with interlocking forms, with elbow joints becoming eyes which, in turn, become profile bird heads. Often specific animals can be identified by recognizable characteristics—the teeth of the bear or beaver, the beak of the raven or eagle—but often the identification is left ambiguous, at least to the outside eye. Primary areas are outlined with black lines, which are then filled with secondary forms, usually painted red and blue or blue-green.

3.7 The Haida village of Skidegate, Queen Charlotte Islands, British Columbia, Canada, photographed in 1878
Royal Anthropological Institute of Great Britain and Ireland, London

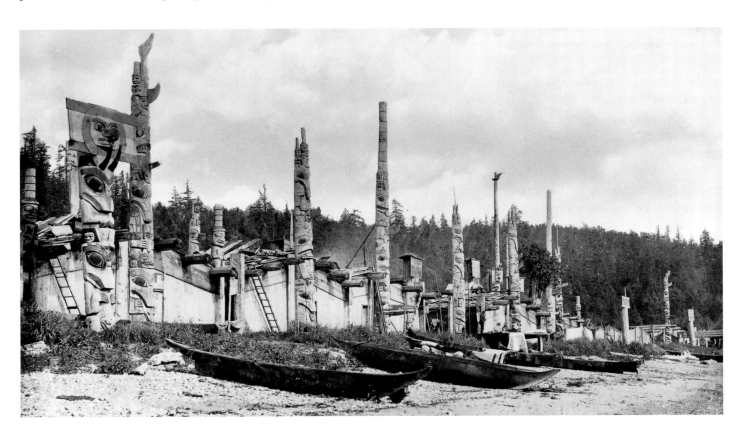

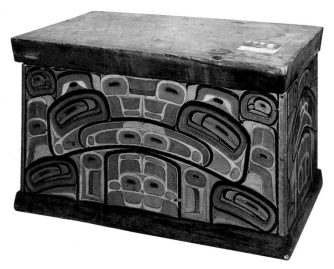

3.8 Anonymous, Haida: storage box, collected in 1864
Engraved and painted wood, W 50⅝ in. (52.5 cm.)
British Museum, London

The most common forms are ovoid shapes, U shapes, split-U shapes, and S shapes. Split representation is also common, with the figure splayed out in a bilateral symmetry that allows the viewer access to the maximum body surface. Such split representation also leads to the double profile, seen earlier in the massive Aztec statue of Coatlicue [1.8]. The overall result is a complex, balanced composition that appears both static and in flux, an effective representation of the transformative powers of nature and the integration of the human and animal worlds.

In the above examples, human and/or animal forms are not placed in an illusionistic landscape. This does not mean, however, that they are separated from the larger natural world. Rather, the objects themselves, the materials out of which they are made, and the ceremonies of which they are a part constitute that natural world, that landscape. The anthropologist Claude Lévi-Strauss discerned this aspect of Native American ceremonial art:

> A vase, a box, a wall are not independent, pre-existing objects which are subsequently decorated. They acquire their definitive existence only through the integration of the decoration with the utilitarian function. Thus, the chests of the Northwest Coast are not merely containers embellished with a painted or carved animal. They are the animal itself keeping an active watch over the ceremonial ornaments which have been entrusted to its care. Structure modifies decoration, but decoration is the final cause of the structure, which must adapt itself to the former. The final product is a whole: utensil-ornament, object-animal, box that speaks.

It is this wholeness, this integration, that appears time and time again in so many of the painted, woven and carved objects produced by Northwest Coast peoples.

God, Nature, and the Rise of Landscape Painting

God's Nature as God in Nature

Like Native Americans, European American artists also articulated a connection between land and spirit in their work, but in a very different way. Depictions of farms and mills and the countryside surrounding small towns had appeared throughout the 18th century in overmantel paintings [1.75, 2.6], wallpaintings [2.56, 2.57], chair backs [2.58], and needlework samplers [2.1] as statements of ownership or cultural traditions. Those containing architecture often drew on the tradition of English country-house portraiture, which celebrated proprietorship. Yet images of the land did not become a major source of interest to American fine art painters until the early 1800s. As political, religious, and cultural leaders struggled to formulate the character of their new nation, many began to turn to one obvious characteristic—its vast, untamed wilderness. At the same time, a "Christianized naturalism" arose in both Europe and America that conflated God and nature in such a way that God's nature became God in nature. America's vast wilderness came to represent both God's original creation, untouched by human hands, and the legendary place where human cultivation of the land began. In 1835 James Brooks wrote in *The Knickerbocker*:

> God has promised us a renowned existence, if we will but deserve it. He speaks of this promise in the sublimity of Nature. It resounds all along the crags of the Alleghanies. It is uttered in the thunder of Niagara. It is heard in the roar of two oceans, from the great Pacific to the rocky ramparts of the Bay of Fundy. His finger has written it in the broad expanse of our Inland Seas, and traced it out by the mighty Father of Waters! The august TEMPLE in which we dwell was built for lofty purposes. Oh! that we may consecrate it to LIBERTY and CONCORD, and be found fit worshippers within its holy wall!

Artists, in interpreting the face of nature/God in their paintings, became spiritual leaders of sorts. The art historian Barbara Novak notes that "painters who took it upon themselves to deal with this 'loaded' subject [landscape painting] were involved not only with art, but with the iconography of nationalism. In painting the face of God in the landscape so that the less gifted might recognize and share in that benevolent spirituality, they were among the spiritual leaders of America's

flock." Nature became a text, like the Bible, to be read and interpreted. Artists, because of their sensitivity to the visual world, thus had the powers of both creation and revelation. Nature and art became routes to spiritual understanding and, through that understanding, to the creation of community, both local and national.

This celebration of God in/as nature was accompanied by the increasing desecration of nature as a result of conquest and settlement. This created a serious conflict among those who concerned themselves with the spiritual, if not material, well-being of the nation. If God resided in nature, then what was to become of this God as increasingly large portions of nature fell to the ax? How could human cultivation be reconciled with God's primordial wilderness? Was not the garden of paradise the place where humans fell from grace? Thus there arose a conflict between piety and ambition, between the desire to remain devout Christians and the desire to exploit God's vast wilderness for material gain. This conflict appeared over and over again in the paintings and writings of American artists.

One of the first actively to promote and to excel in the field of landscape painting was Thomas Cole (1801–48). His awareness of the connection between God, nature, and nation is evident in his 1835 "Essay on American Scenery," in which he argues that America's wilderness is its most distinctive feature

> because in civilized Europe the primitive features of scenery have long since been destroyed or modified And to this cultivated state our western world is fast approaching; but nature is still predominant, and there are those who regret that with the improvements of cultivation the sublimity of the wilderness should pass away; for those scenes of solitude from which the hand of nature has never been lifted, affect the mind with a more deep toned emotion than aught which the hand of man has touched. Amid them the consequent associations are of God the creator—they are his undefiled works, and the mind is cast into the contemplation of eternal things.

The role of the artist was, in Cole's mind, a moral one—to present to the viewer the perfection of God's creation, a perfection often unseen by those of a lesser moral standing.

Landscape Tourism

Yet Cole's reasons for creating landscape paintings were not solely moral. Painting was his chosen profession and, like any working man, he had to support himself and, later, his family. Cole was born in Bolton-le-Moors, a small town in Lancashire, England. His father James, a small-time woolens manufacturer, was a member of the "middling class"—shopkeepers, professionals, and artisans whose numbers grew in the early decades of the 19th century. James was not a very good businessman, however, and he constantly struggled to keep the family out of the poorhouse. Thomas went to work as an engraver at a calico printworks and later, after the family moved to the United States in 1818, he continued to work in this field. The art historian Alan Wallach suggests that Cole's early interest in the arts and his criticism of what many celebrated as industrial or technological progress were prompted in part by a desire to distance himself from the industrial world of his father and the financial insecurity that accompanied it.

In the early 1820s Cole decided to dedicate himself to painting, and methodically went about teaching himself the necessary skills. Rather than attending classes at the Pennsylvania Academy of the Fine Arts or other art schools, Cole did what many before him had done—he traveled as an itinerant portrait painter while copying paintings and prints and reading as many books as he could on the subject of art. One very important book for him was William Oram's *Precepts and Observations on the Art of Colouring in Landscape Painting*, published in London in 1810. With its sections on tonal gradations, aerial perspective, and the setting of palettes for various situations, this book provided him with a firm grounding in the basics of landscape composition and coloring. Once Cole had settled on landscape painting—a decision some claim he made because of his inability to draw human figures—success came relatively quickly. Trumbull noticed his work in 1825, and immediately began introducing him to a circle of people who proved important as future patrons. In 1829 Cole traveled to London and then on to Paris and Florence, studying firsthand the landscapes of the British artists John Martin, John Constable and J. M. W. Turner, and the French artists Claude Lorrain and Nicolas Poussin. While in Florence he produced many Italian landscapes for his American patrons. Thus, Cole was able to explore the full range of landscape traditions available to him through the study of European art and to create his own unique adaptations.

Cole's success was due, in large part, to an already existing taste for landscape, although this taste was still, in the 1820s, the domain of a relatively small group of wealthy individuals who had access to education in aesthetic theory and who not only examined paintings, prints and aesthetic treatises (usually British), but also traveled extensively throughout the north-eastern United States. They engaged in what Wallach calls "landscape tourism." "To put the matter somewhat differently," writes Wallach, "acquiring a taste for landscape in the early 1800s depended upon being part of the genteel subculture in

which landscape was valued as a form of aesthetic experience." This aesthetic experience was framed, in large part, through the conventions of the three major landscape painting traditions: the beautiful, the sublime, and the picturesque (more will be said about these traditions below). Not all landscapes produced aesthetic experiences, however. As is the case today, when national parks are dotted with Kodak signs pointing out particularly "scenic" views for camera-toting tourists, the places visited in the early 19th century were often those that had already been celebrated by Cole and other painters. Thus, a complex reciprocal relationship was set up between the landscape itself and visual representations of it.

Images of Niagara Falls

Perhaps the most dramatic landscape vista that captured the imagination of artists and tourists in the early 19th century was Niagara Falls, located between Lake Ontario and Lake Erie on the border between Canada and the United States. Trumbull had produced a series of early views of the falls in 1807–8. The difference between Cole's work and that of his mentor is apparent when one compares two of their Niagara scenes

[3.9, 3.10]. Also apparent are the similarities, the continuities between what Trumbull attempted and what Cole then developed further, continuities that undoubtedly help explain Trumbull's positive response to Cole's early work.

While Trumbull devoted most of his time to the production of portraits and history paintings, between 1804 and 1808 he executed several paintings of the American landscape, most notably four views of Niagara Falls. Although few in number, these works represent, according to the American Studies scholar Bryan Wolf, "the first sustained effort at landscape painting by an American artist." They also participated in the formulation of an iconography of nationalism, in which natural landmarks such as Niagara Falls gained particular prominence. In his Niagara paintings, especially *Niagara Falls from an Upper Bank on the British Side* [3.9], Trumbull shows a clear reliance on the "picturesque" tradition popular in England in the second half of the 18th century, a tradition that had its roots

3.9 John Trumbull: *Niagara Falls from an Upper Bank on the British Side,* c. 1808
Oil on canvas, 24³/₈ × 36⁹/₁₆ in. (61.9 × 93 cm.)
Wadsworth Atheneum Museum of Art, Hartford, Connecticut

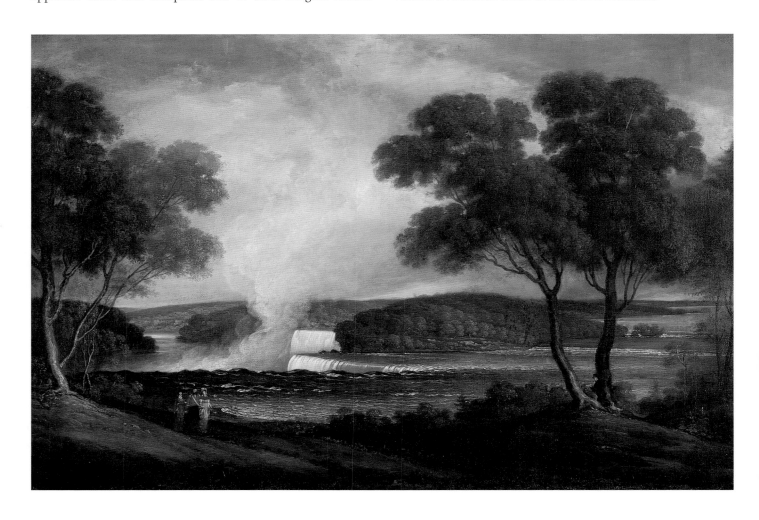

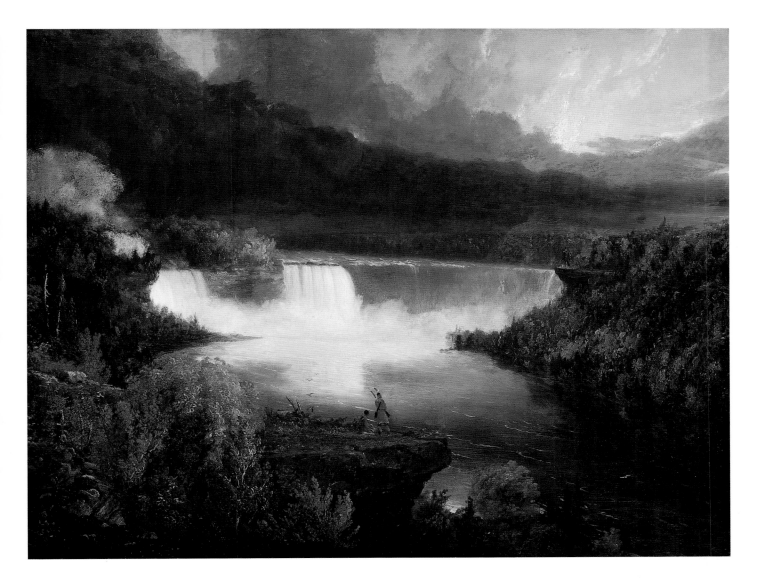

3.10 Thomas Cole: *Distant View of Niagara Falls*, 1830
Oil on panel, 18⅞ × 23⅞ in. (47.9 × 59.3 cm.)
The Art Institute of Chicago, Chicago, Illinois

in the previous century in the work of the French landscape painters Claude Lorrain and Nicolas Poussin. Wolf describes the picturesque as an artistic "middle ground" between the "terror and limitlessness" of the sublime and the "closed perfection" of the beautiful, the sublime and the beautiful being two opposing categories set up by the late 18th-century British writer Edmund Burke in his *Philosophical Inquiry into the Origins of Our Ideas of the Sublime and the Beautiful*. The picturesque, Wolf goes on,

> combines an emphasis on novelty and discontinuous states of being with a celebration of the capacity to frame: to take a random view of nature and compose it according to recognizable aesthetic conventions. The picturesque thus assimilates the strange and uncanny into traditional and familiar form. It employs its conventions in an effort to establish interpretative control over its material.

In Trumbull's view of Niagara, three figures stroll along the river's edge, with a fourth person resting between the trees at the far right sketching the scene (perhaps a self-portrait). The falls, visible in the middle ground, thus become a backdrop to the human activity in the foreground. A balance is achieved in the composition through the placement of the two pairs of trees in the foreground, which frame both the figures and the falls and direct our gaze into the central portion of the painting. They also anchor the horizontal planes into which the composition has been divided. The falls themselves are small in scale; their power is diminished by the calm waters of the Niagara River, which flow on either side, and the vast expanse of sky above. Thus, even the most powerful of natural phenomena is

presented as if tamed by human hands. Trumbull, according to Wolf, "is not interested in the falls *per se*, but in the process of socialization by which natural wealth is translated into *human abundance*, and both then come to be associated with an emerging national destiny."

Trumbull painted the falls from the British—i.e. Canadian —side and included a British soldier as the central one of the three figures. He did so, perhaps, to increase the painting's appeal in England, where he hoped to sell it along with his other three Niagara views (he planned to use two as the basis for a panorama). His hopes were dashed, however, and he had to ship all four back to the United States, where they were later sold. The reasons for the lack of interest in England may well have included the increasing political tensions that led to the War of 1812. In 1807, as Trumbull was sketching at Niagara Falls, the British opened fire on the frigate *Chesapeake* off the coast of Virginia and killed three Americans.

Though he did not explore it fully in his own landscape painting, Trumbull was also interested in another landscape tradition, Burke's "sublime," exemplified by the work of the Italian painter Salvator Rosa. Here the focus is the unrestrained power of nature, expressed in dramatic contrasts rather than pastoral order. This interest may have been what drew Trumbull to the early canvases of Cole when he first saw them in the window of a New York framemaker in 1825. He introduced Cole's work to his artist friends and to the wealthy Baltimore merchant Robert Gilmor, one of Cole's earliest patrons.

Cole painted the falls in *Distant View of Niagara Falls* of 1830 [3.10], a painting that picks up on the tradition of the sublime. Here the viewer, rather than standing on a gentle rise of land as in Trumbull's work, is perched on the edge of a cliff above the falls, thus devoid of easy access to the water's edge. Dark clouds fill most of the horizon and contrast with the small patch of blue in the upper right and the bright white spray. The falls occupy a dominant position in the center of the composition and are painted straight on rather than in profile. The park-like grounds of Trumbull's painting are replaced by untamed wilderness, devoid of any evidence of the numerous tourist facilities that had clustered around the site by the 1830s. The only humans visible are Native Americans, representations of the "wildness" of the territory and its still pristine state. Thus, the viewer is overwhelmed by the vastness and power of the natural world.

In his *Distant View of Niagara Falls* Cole also adopts what Albert Boime has termed "the magisterial gaze," that panoramic view from above that grants access not only to the wonders of God's creation, but also to the future real estate and industrial wealth of the nation. Boime has traced the insistent use of this "view from on high" in both the literature and visual arts of early 19th-century America to rationalize the ongoing expansion of territory and exploitation of natural resources. In some instances the land that artists and writers celebrated was also the land in which they invested financially. It was no coincidence, writes Boime, that Cole, the artist who would gain fame for his views of the Hudson River Valley, first came to the attention of the New York art world in 1825, the same year the Erie Canal was opened. The canal gave the Hudson River increased importance as the main water route between the East Coast and the Midwest, and thus increased profits for those who controlled the territory and businesses along its shores, all the way to New York City. Among Cole's patrons was Philip Hone, Mayor of New York, who purchased two of the artist's Hudson River views.

Cole was particularly fond of the area around the town of Catskill on the Hudson, approximately half way between Albany and New York City. He was not the only one to choose this particular locale, for in 1824 the Catskill Mountain House opened on a high bluff overlooking the river and became the favorite retreat of many of the elite on the East Coast and of a number of landscape artists who, along with Cole, would come to be known as the Hudson River School. In one of his first

3.11 Thomas Cole: *The Falls of Kaaterskill*, 1826
Oil on canvas, 43 × 36 in. (109.2 × 91.4 cm.)
The Warner Collection, Gulf States Paper Corporation, Tuscaloosa, Alabama

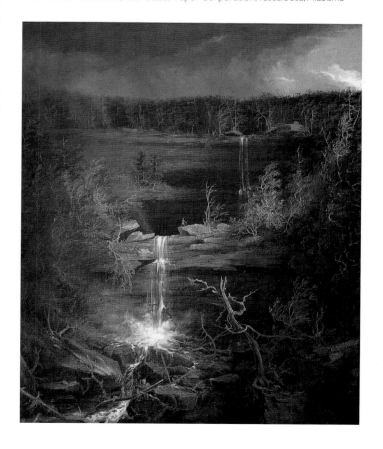

paintings of this region, *The Falls of Kaaterskill* [3.11], Cole locates the viewer not above the waterfalls but below, entangled in the dense undergrowth of the forest. Again, the stormy clouds on the horizon move slowly to reveal a patch of blue sky to the right. And, as in his view of Niagara, a Native American stands on a rock in the center of the image, a further indication of the wildness of the landscape; all evidence of the popularity of the site with tourists that might interfere with the sublime, primordial quality of the scene—a wooden viewing tower, steps, handrails—has been omitted.

Thomas Cole, Federalism, and *The Course of Empire*

Cole's East Coast patrons, while a varied lot, came from two general economic groups: wealthy landowners and business-men who formed the core of the Federalist Party and whose roots in the United States went back to before the Revolution; and a new middle class made up of individuals who were profiting from the nation's phenomenal growth in population, technology, and productivity. The old elite was slowly losing its political clout as first Jefferson and then Andrew Jackson attacked Federalist resistance to the expansion of democratic rights, while the newly rich were gaining political as well as economic influence. Each group made different demands on Cole and the other artists they patronized. The former were more certain of their own aesthetic tastes and thus dictated more closely what they wanted from Cole. The latter attempted to emulate the cultural practices of their "betters," but experienced a certain sense of inferiority. Thus they were more willing to listen to the artist, whose knowledge they viewed with greater respect.

In the late 1820s Cole began to move away from depicting the untamed landscape and to create, instead, what he called "historical landscapes." Certain of his Federalist patrons were willing to support this work. For example, in 1827 Daniel Wadsworth, the son of an important Hartford financier and member of the Connecticut elite, commissioned *Scene from "The Last of the Mohicans": Cora Kneeling at the Feet of Tamenund*, an episode from James Fenimore Cooper's 1826 historical novel *The Last of the Mohicans*. Cole argued that such works, with their incorporation of historical or biblical themes, were "a higher style of landscape," closer to the status accorded history painting. Wadsworth and other of his Federalist patrons were not willing, however, to underwrite his proposals for pairs or series of paintings on a single theme, which would allow him to convey a larger moral message, not limited to any specific locale. When he attempted a pair on his own, *The Garden of Eden* (1828) and *The Expulsion from the Garden of Eden* (1827–28), he was unable to find buyers.

Cole was able, however, to convince at least a few of his bourgeois patrons to support these more ambitious projects, most notably Luman Reed, who commissioned his most complex series of paintings, the five-part *Course of Empire* (completed in 1836). Reed was a self-made man, having risen from a store clerk to a successful merchant in the wholesale grocery business. His success was so great that he was able to retire at the age of forty-eight, yet he was a modest man, unwilling to flaunt his wealth. Art patronage was, for him, a way to gain entrance into a world of culture and attain a greater degree of respectability. He focused his collecting on the work of living American artists and opened his art gallery once a week to a select audience. Cole met Reed in 1833 and, that same year, convinced him to commission *The Course of Empire*.

In *The Course of Empire*, Wallach observes, Cole "set forth in allegorical form his pessimistic philosophy of history and his essentially agrarian-republican critique of Jacksonian democracy." Like Jefferson, Cole worried about the destructive aspects of technological progress. In his 1835 "Essay on American Scenery," he denounced the clearing of the land for roads, railways, and canals: "the ravages of the axe are daily increasing—the most noble scenes are made destitute, and oftentimes with a wantonness and barbarism scarcely credible in a civilized nation." Cole promoted, instead, a form of Jefferson's agrarian ideal where farmers resided in relative harmony within nature, the scene displayed in *The Pastoral or Arcadian State* [3.13]. Yet, like the Federalists and many Jeffersonians, Cole was also concerned about the potentially destructive effects of the spread of democracy and the resulting lawlessness and mob rule that would bring down the republic.

Cole's concerns, and the five paintings, are linked through a cyclical theory of history, based on the view that moral law governs all history, engendering endless cycles of rise and fall caused by the inherent sinfulness of humans. This theory was popular with many Federalists, who hoped that their decline in power was only temporary. Jacksonian democrats may have believed that democracy would halt this historical cycle and prevent the political corruption that ultimately led to downfall. This view was taken by at least one critic, who wrote of the series:

> The climax in the course of man's progress, which Mr. Cole has here represented, is *that which has been* and was founded on the usurpation of the strong over the weak: the perfection which man is hereafter to attain, will be based upon a more stable foundation: political equality; the rights of man; the democratick [*sic*] principle; the *sovereignty of the people.*

3.12 Thomas Cole: installation plan for *The Course of Empire*, 1833
Pen and brown ink over pencil on paper, W 13⅛ in. (33.4 cm.)
The Detroit Institute of Arts, Detroit, Michigan

In 1833 Cole provided Reed with a sketch that showed how the paintings would be displayed [3.12]. *The Savage State* began the series at the upper left, drawing upon the conventions of the sublime landscape tradition to convey the power of nature in its untamed state. Next, below it, came *The Pastoral or Arcadian State* [3.13], a picturesque view suggestive of the benign rule of the Federalist or Jeffersonian landowner, with limited cultivation and a harmony with nature. In the middle, *Consummation* [3.14], while seemingly calm, also suggests, in its crowded streets and the almost total absence of nature, the inevitable chaos conveyed in *Destruction* at the upper right. In the final painting, *Desolation*, the ruins of a once mighty empire give way to nature.

Each scene is shown at a different time of the day, beginning with dawn. To reinforce this passage of time, three small panels above show the rising and setting of the sun. The general locale in all five paintings is kept the same, distinguishable by the mountain in the distance. The civilization presented is a combination of Greek and Roman architectural and cultural motifs. This was to be not one specific empire but empires in general, a universal statement about historical inevitability. Yet some saw a more specific reference to contemporary America. The art historian Angela Miller writes that Cole's series would easily have been understood as a Whig allegory (the Federalists had transformed themselves into the Whig

3.13 Thomas Cole: *The Course of Empire: The Pastoral or Arcadian State*, 1834
Oil on canvas, 39¼ × 63¼ in. (99.7 × 160.6 cm.)
Courtesy The New-York Historical Society, New York City

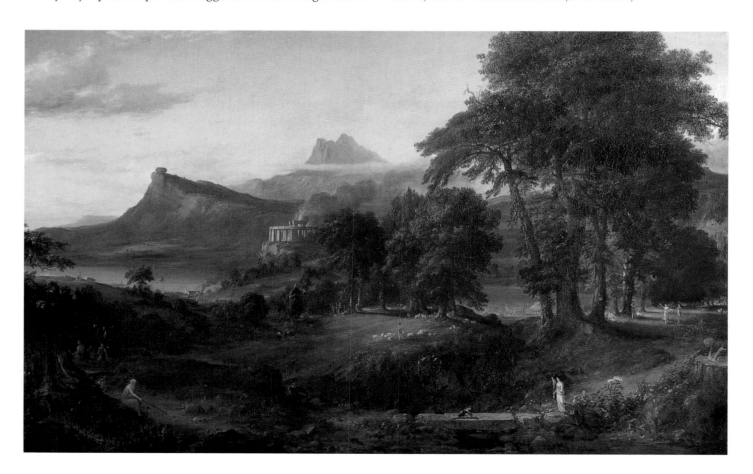

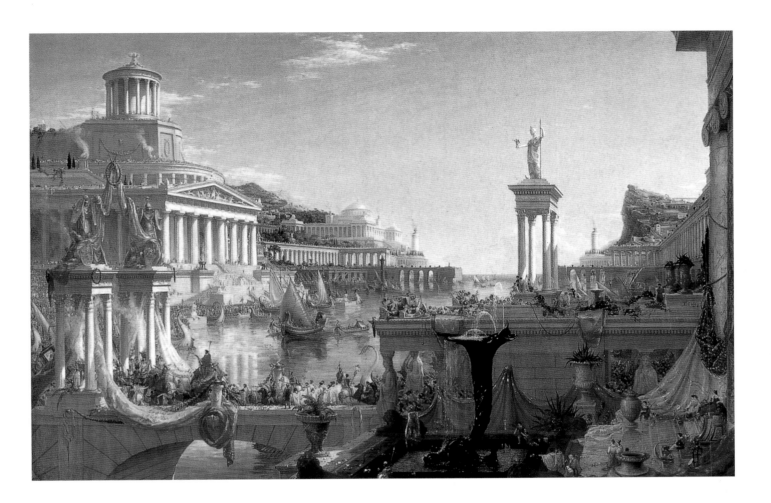

3.14 Thomas Cole: *The Course of Empire: Consummation*, 1835–36
Oil on canvas, 51 1/4 × 76 in. (130.2 × 193 cm.)
Courtesy The New-York Historical Society, New York City

Party in the late 1830s) critical of Andrew Jackson, whose "imperious and arbitrary style of leadership made him a modern-day Caesar, prepared to manipulate the citizens of the republic for his own corrupt and self-serving ends," thus setting the stage for "the triumph of faction, the concentration of power, and the rise of the corrupt imperial state."

Cole's *Course of Empire* met with great success when exhibited in 1836. Those who wanted to see the United States as an exception to this general theory of rise and fall could easily do so, arguing that democracy would prevent, rather than foster, despotism and mob rule. Not surprisingly, the series was also well received by aging Federalists, who saw their era—*The Pastoral or Arcadian State*—celebrated and their demise mourned. Yet there is a certain tragic irony, as Wallach points out, in the fact that "a self-made merchant paid a small fortune [$5,000] to a self-taught artist for paintings that elaborately mourn the passing of an aristocracy to which both merchant

and artist aspired and to which neither could ever belong." While Reed might be able to match the wealth of the Federalist elite, he could never challenge their cultural authority. And while Cole found the occasional sympathetic patron like Reed to support his grander artistic schemes, at the end of his life he issued a lament that could well have come from the pen of Morse or any number of other early 19th-century American artists: "I am not the artist I should have been, had taste been higher. For instead of indulging myself in the production of works such as my feelings and fancy would have chosen—in order to *exist* I have painted to please others."

Successors to Cole

Cole's untimely death in 1848 was met with much mourning and praise of his talent and genius. It also prompted speculation as to who would succeed him as the leader of American landscape painting. Several candidates identified themselves through the production of memorials to Cole. In 1849 Asher B. Durand (1796–1886) exhibited *Kindred Spirits* [3.1], which had been commissioned by Jonathan Sturges, the business partner of Luman Reed. In this work Cole, on the

3.15 Jasper F. Cropsey: *Ideal Landscape: Homage to Thomas Cole*, 1850
Oil on canvas, 8⅛ × 12¼ in. (20.7 × 31 cm.)
Thyssen-Bornemisza Foundation, Lugano, Switzerland

right, surveys the Catskill Mountains with his friend and fellow nature-lover the poet William Cullen Bryant (Sturges presented the painting to Bryant as a gift). Bryant had delivered the eulogy at Cole's funeral and had highlighted the significance of the Catskills in the painter's life and art: "To us who remain, the region of the Catskills, where [Cole] wandered and studied and sketched and wrought his sketches into such glorious creations, is saddened by a certain desolate feeling when we behold it or think of it."

As the president of the National Academy of Design, Durand seemed the logical choice to succeed Cole. Having begun his career as an engraver, he had turned to painting in the mid-1830s and had soon risen to prominence among landscape artists on the East Coast. Yet he was challenged by several younger artists, including Jasper F. Cropsey (1823–1900). Cropsey's *Ideal Landscape: Homage to Thomas Cole* of 1850 [3.15] appeared two years after Cole's death. It presents the landscape as an ideal or holy place, the site of God's glory as captured through the eye and skill of the prophet/painter. This focus on art as a moral force was reiterated in 1851 by the Reverend Samuel Osgood who, in commenting on the virtues of landscape painting, made a toast to "Art, the Interpreter of Nature; Nature, the Interpreter of God."

Cropsey continued to produce moralizing historical landscapes like those of Cole's later years. For example, his *The Millennial Age* of 1854 [3.16], with its luminous cross positioned just below the carved lion on a classical altar, presents the triumph of Christianity over the forces of paganism. Cole's celebrations of Christian progress were praised, yet Cropsey's works did not receive the same positive reviews. Many were troubled by his reliance on the older artist,

evident in *The Millennial Age* in the cross, taken from Cole's last series, *The Cross and the World* (left incomplete at his death), and the allusions to *The Pastoral State* [3.13] from *The Course of Empire* series. In 1852 a critic for the *Literary World* wrote: "Cropsey is commonly considered an imitator of Cole That he willfully imitates Cole we do not think; but that he has been influenced by him to too great a degree is evident, and to a greater extent than is consistent with his own originality." Even Cole's own historical work was coming under attack by the mid-1850s, with one critic noting in 1856 that the "office of painting is with the visible world" and that "the success of [Cole's] allegories, generally, has been as injurious to the ideal of Art, as instrumental to his own success in life." Painters should focus on recording the visible world rather than making art "the servant either of ethics or theology." This view was also being promoted by the contemporary British art critic John Ruskin, whose writings would become influential in the United States in the second half of the 19th century.

Some artists, like Robert Scott Duncanson (1821–72), continued to champion Cole's more fantastic historical landscapes while at the same time attending to the close recording of the American landscape seen in Cole's earlier works. Duncanson was born in New York State into a family of free African Americans whose primary trades were house-painting and carpentry. After moving to Monroe, Michigan, with his family in the late 1820s, he worked briefly as a house- and sign-painter before moving again, around 1840, to Mount Healthy, a small town north of Cincinnati, to embark on a career as an artist (he settled in Cincinnati itself in 1850; see pp. 173–75).

3.16 Jasper F. Cropsey: *The Millennial Age*, 1854
Oil on canvas, 38 × 54 in. (96.5 × 137.2 cm.)
Newington-Cropsey Foundation, Hastings on Hudson, New York

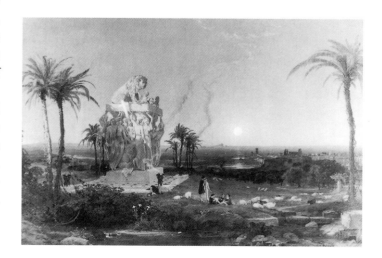

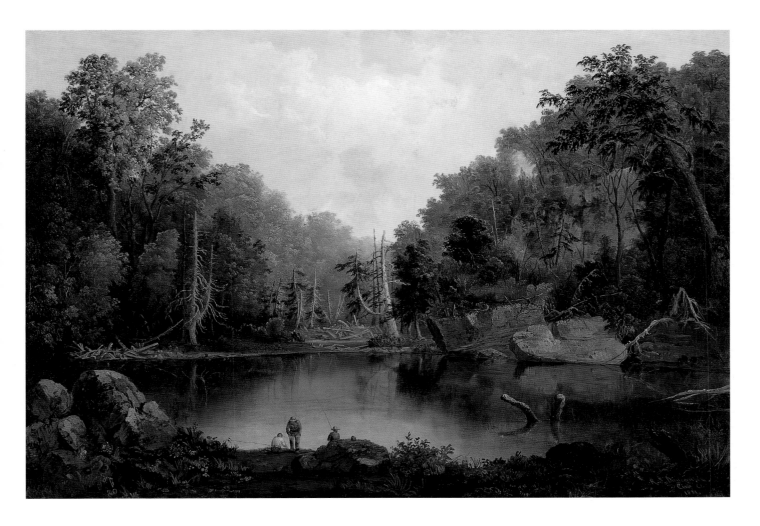

3.17 Robert S. Duncanson: *Blue Hole, Little Miami River*, 1851
Oil on canvas, 29¼ × 42¼ in. (74.3 × 107.3 cm.)
Cincinnati Art Museum, Cincinnati, Ohio

Like others before him, Duncanson began with portraits, executing the likenesses of the members of wealthy families in both Cincinnati and Detroit and of various political notables, including Lewis Cass, Michigan's abolitionist senator, and James G. Birney, editor of the abolitionist newspaper *The Philanthropist*. Nicolas Longsworth, a Cincinnati lawyer, provided Duncanson with his first major landscape commission in 1848: requested to paint a series of eight "wall decorations" for Longsworth's mansion (now the Taft Museum), he produced a series of idealized landscapes heavily indebted to the work of Claude Lorrain. Subsequently, however, he turned to the particularities of the American scene, as in *Blue Hole, Little Miami River* of 1851 [3.17], a painting more in keeping with Cole's wilderness landscapes. Cole's influence on Duncanson in the realm of historical or biblical landscapes is also clearly evident in *The Garden of Eden* of 1852 [3.18], which was based on a print of Cole's own 1828 painting of the same name.

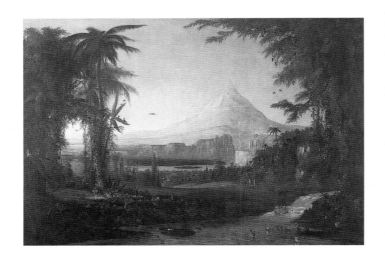

3.18 Robert S. Duncanson: *The Garden of Eden*, 1852
Oil on canvas, 32¾ × 48 in. (83 × 121.9 cm.)
West Foundation, on loan to the High Museum of Art, Atlanta, Georgia

Edward Hicks and *The Peaceable Kingdom*

The artist who most consistently situated a biblical narrative within an American landscape was Edward Hicks (1780–1849), a Quaker minister and sign-painter from Bucks County, Pennsylvania. The Quakers, or Society of Friends, in keeping with many other Protestant sects, did not encourage the arts. Yet, while prohibitions against music, dancing and theater were clearly written down, there seem to have been no written proscriptions against painting or drawing. Thus, while Hicks was visited on at least one occasion by a committee of Quakers who protested his public defense of art, there was no formal attempt to prevent him from painting. The art historian Eleanore Price Mather further observes that Hicks's initial painterly efforts would have been considered craft rather than art, and thus a useful activity. The Quaker respect for craft resulted in the presence of many skilled potters, silversmiths, cabinetmakers, and needleworkers in Quaker communities across America.

Hicks was born to Anglican parents, but his mother died when he was only eighteen months old and he was raised by a Quaker friend of hers. He began work as a coach- and sign-painter, and did not convert to Quakerism until his early twenties, by which time he had tasted the pleasures not only of painting, but also of music, dancing, and theater. In 1812 he was recognized as having a special gift for voicing the Inner Light, or Holy Spirit, and was accorded the title of minister. As such, he joined other ministers in local meetings and traveled to neighboring towns carrying the word of Truth.

Hicks was certainly aware of the potential conflicts between the life of a Quaker minister, with all that meant about plainness and simplicity, and the life of a painter of colorful commercial coaches and signs. He briefly gave up painting in the 1810s in favor of farming, but his agricultural skills left much to be desired, and he soon returned to the painting that he loved. What allowed Hicks to take up his former activity without his earlier pangs of conscience was his discovery of the theme of "the Peaceable Kingdom" in a Bible engraving after the British artist Richard Westall [3.19], which illustrates the sixth verse of the eleventh chapter of Isaiah: "The wolf also shall dwell with the lamb, and the leopard shall lie down with the kid; and the calf and the young lion and the fatling together: and a little child shall lead them." Mather posits that Hicks may have been drawn to this theme by his love of children, animals, and the Scriptures themselves. Or he simply may have "correctly perceived in the biblical engraving a sermon on salvation that would justify the pictorial work he inwardly craved." The appropriateness of his choice of subject-matter is attested to by the fact that many of his paintings were purchased by fellow Quakers.

3.19 Charles Heath after Richard Westall: *The Peaceable Kingdom of the Branch* Engraving in *The Holy Bible* (London, 1815)
Free Library of Philadelphia, Philadelphia, Pennsylvania

In one of his first paintings on this theme, his *c.* 1825–30 *Peaceable Kingdom of the Branch* [3.20], Hicks added to Westall's general grouping of figures a distinctly American setting. At the left is the Natural Bridge of Virginia, taken from a vignette to a popular map designed by Henry S. Tanner in 1822 [3.21]. Below its arch is the central group of figures in Benjamin West's *Penn's Treaty with the Indians* [1.85], with the positions of the Quakers and the Native Americans reversed. Hicks may have seen an engraving of the painting, or perhaps a version of it on a printed linen handkerchief [3.22] manufactured by the Germantown Print Works in 1824. Hicks was thus in agreement with at least

3.20 Edward Hicks: *The Peaceable Kingdom of the Branch, c.* 1825–30
Oil on canvas, 32¼ × 37¾ in. (81.9 × 95.9 cm.)
Abby Aldrich Rockefeller Folk Art Center, Williamsburg, Virginia

3.21 Vignette from *A Map of North America* by Henry S. Tanner, Philadelphia, 1822
Library of Congress, Washington, D.C.

3.22 Germantown Print Works: handkerchief with motif after an engraving by John Hall of Benjamin West's *William Penn's Treaty with the Indians* (detail), 1824
Printed linen, W 14½ in. (36.8 cm.)
Swarthmore College Peace Collection, Swarthmore, Pennsylvania

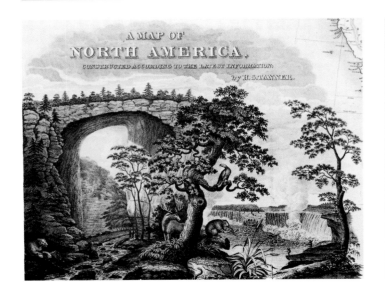

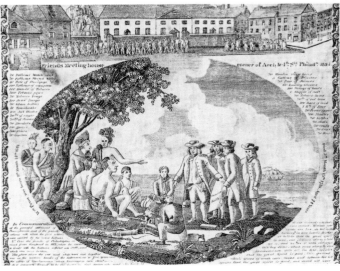

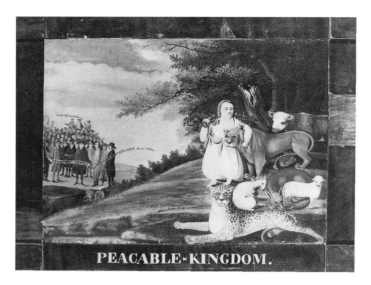

3.23 Edward Hicks: *Peaceable Kingdom with Quakers Bearing Banners*, c. 1827–32
Oil on canvas, 17¾ × 23¾ in. (45.1 × 60.3 cm.)
Holger Cahill Collection, New York; on extended loan to Smith College, Northampton, Massachusetts

one well-known academic artist, Samuel F. B. Morse, in situating the impending millennium on American soil. His inclusion of William Penn is an obvious tribute to the Quaker leader and to his attempts to initiate a more immediate and pragmatic peace on earth in America through treaties with its indigenous peoples. The child in this early *Peaceable Kingdom* carries a grape branch (hence, the title of the work), a symbol of the redemptive blood of Christ. The painting also includes a border containing not only the title of the painting at the top in black, but also the verse from Isaiah rendered in gold lettering. Such narrative borders appear in many of Hicks's paintings and recall his early practice as a sign-painter, where image and text were often combined. They also reinforce his role as a Quaker minister, where the word, rather than the image, carried ultimate authority.

Over the course of some thirty years Hicks painted a large number of *Peaceable Kingdoms*, at least sixty of which have survived. In tracing the changes in these paintings, Mather argues that they address not only "the nature of man and his relation to the Divine," but also Hicks's own inner conflicts and the growing divisions within the ranks of Quakers as a whole. The community suffered a serious split in the 1820s between the Orthodox Quakers, who promoted a greater reliance on a "correct" interpretation of biblical texts and increased attention to the life and death of Christ, and the Hicksites, who resisted such a move in favor of an emphasis on individual revelation, or the Inner Light, as one's primary spiritual guide. One of the most famous leaders of the latter group was Edward's cousin

Elias Hicks, whose name became synonymous with rebellion against the Orthodox. While Edward allied himself with Elias, he also had misgivings about the severity of some of his cousin's pronouncements and regretted the split in the Quaker community, which was finalized on April 21, 1827, at the Philadelphia Yearly Meeting.

Some time between 1827 and 1832 Hicks painted the first of a series of *Peaceable Kingdoms* in which a pyramid of Quakers replaces the scene of Penn and the Indians [3.23]. These works, with their harsh landscapes and worried looks on the faces of the animals, are direct references to the Separation of 1827. The banner weaving through the Quakers includes the Hicksite doctrine—"Mind the LIGHT within"—and the angel song from the Gospel of Luke announcing the birth of Christ—"IT IS GLAD TIDING [sic] of Grate [sic] Joy PEACE ON EARTH GOOD WILL to ALL MEN Everywhere." Elias Hicks is shown hatless in profile at the front of the group, with the banner circling behind him; at the apex are, right to left, George Fox, the founder of Quakerism, William Penn, and Robert Barclay, theological defender of Quakerism.

In subsequent *Peaceable Kingdoms*, Hicks would convey his alliance with the Hicksites in more subtle terms. The pyramid of Quakers disappears, and is replaced once again by William Penn and the Indians, larger than ever and located not beneath the Natural Bridge of Virginia but in front of a view of the Delaware River. Elias Hicks's promotion of the doctrine of the Inner Light is expressed in these paintings not by the presence of Quakers and banner but by the absence of the grape branch, symbol of Christ's death on the cross, that had appeared in the child's right hand in earlier versions of the scene. His original inclusion of the grapes may have been due more to his copying of the Westall engraving than to any particular doctrinal concern. But in the midst of the Quaker controversy, grapes and what they symbolized took on a new meaning. They stood for "the blood of Christ," a phrase that, during the split, had become a badge of Orthodoxy.

Landscape Painting at Mid-Century: Frederic Edwin Church and the Luminists

Frederic Edwin Church: From the Pastoral to the Sublime

In 1848, the year of Thomas Cole's death, another young landscape painter, Frederic Edwin Church (1826–1900), produced a tribute entitled *To the Memory of Cole* [3.24]. While Church, like Cropsey [3.15], presents the landscape as an ideal or holy place, he also includes mountains in the background that are recognizable as the Catskills. Church may well have been the true successor of Thomas Cole. He not only created a series of early works that

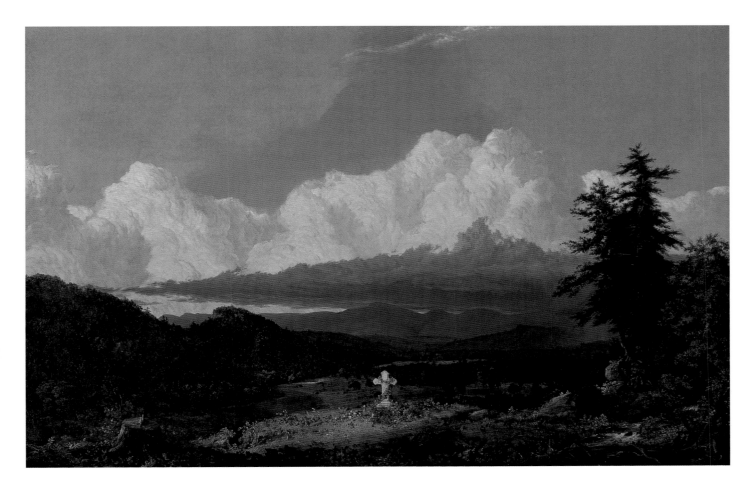

3.24 Frederic Edwin Church: *To the Memory of Cole*, 1848
Oil on canvas, 32 × 49½ in. (81.3 × 125.7 cm.)
Courtesy Sotheby's, London

emulated Cole's historical landscapes, such as *Hooker and Company Journeying through the Wilderness from Plymouth to Hartford, in 1636* (1846), but he also, and more importantly, continued Cole's deliberate attempts, according to the art historian Franklin Kelly, "to infuse realistic landscape with deep and profound content." In so doing, he brought together, in a way Cole was never able to, science and religion, the real and the ideal.

Church came from the kind of background to which Cole aspired. The son of a wealthy and influential family in Hartford, Connecticut, he had access to whatever was needed to achieve his desired goal—to become a great landscape painter. Having overcome his father's initial resistance to his chosen profession, he gained unprecedented access to the master himself, becoming Cole's first and only pupil in 1844, for which his father paid the considerable sum of $600. Church was a quick pupil, exhibiting his first works at the National Academy of Design in 1846.

In his paintings of the late 1840s and early 1850s Church focused on the pastoral vistas of Cole's *Arcadian State* [3.13]. Yet

Church was not depicting the picturesque as a memorial to a past era. While certainly aware of Cole's mixed feelings regarding the effects of human industry on the landscape, he opted for a more celebratory presentation of the picturesque, of nature as altered by civilization. In his *New England Scenery* of 1851 [3.25] he includes the requisite cultivated fields and small town with

3.25 Frederic Edwin Church: *New England Scenery*, 1851
Oil on canvas, 36 × 53 in. (102 × 145 cm.)
George Walter Vincent Smith Art Museum, Springfield, Massachusetts

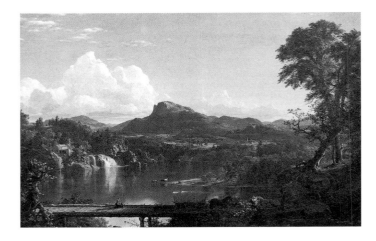

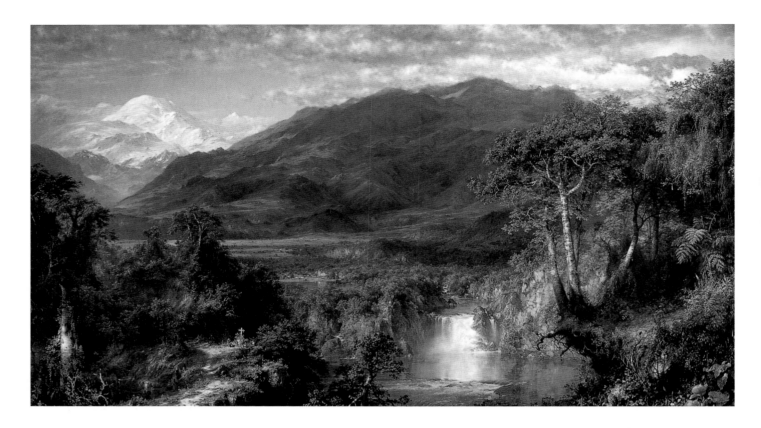

3.26 Frederic Edwin Church: *The Heart of the Andes*, 1859
Oil on canvas, 66⅛ × 119¼ in. (168 × 303 cm.)
The Metropolitan Museum of Art, New York

church spire, but also a saw mill, a sign not only of the clearing of the land but of the utilization of new technology in the process. His inclusion of saw mills rather than the more traditional grist mills in several of his landscapes may well have been due to his own family's financial investments in the products of the forest (his father and uncle owned a paper mill and had interests in other mills). Saw mills also signified a more positive view of the clearing of the land than tree stumps, often included in the foreground of landscape paintings to indicate an ambiguous attitude toward the arrival of civilization [3.48].

New England Scenery was different from Church's earlier topographical landscapes in that it did not record a specific site. Rather, it was a compilation of many different scenes, brought together in order to make a broader statement. It was, in Kelly's words, "an ideal of what New England—and, by extension, the nation—should be." It moved from a mere record of the details of reality to a thoughtful and consciously manipulated image of reality, a manipulation that moved the painting, in the minds of contemporary art critics, into a higher category of art. Its symbolism placed it in the realm of Cole's historical landscapes, except that biblical narratives are replaced by an account of

everyday life in America. The bridge and road indicate the expansion of transportation networks, the mill technology, the cleared fields agriculture, and the church religion. There is a harmonious balance between humans and nature. The Conestoga wagon in the foreground symbolizes the export of these industrious New Englanders and their political, religious, and economic ideals westward across the Great Plains and beyond.

In the middle of the 1850s Church's work began to shift from the pastoral landscape to the dramatic wilderness, from the picturesque to the sublime. This shift was prompted in part by a trip to South America with his friend Cyrus Field. Field was interested in exploring the commercial possibilities of this new territory and welcomed the painter along as both companion and recorder of the landscape. Church's interest in South America had already been piqued by the writings of the German naturalist Alexander von Humboldt, in particular *Cosmos*, available in the United States in the late 1840s. In writing of the different climate zones throughout the world, Humboldt displayed his widespread knowledge of geology, botany, chemistry, archaeology, geography, mathematics, metallurgy, and landscape painting. In a chapter on the latter he praised the art for its ability not only to reveal "the external world in all its rich variety of forms" but also to take these forms and transform them, through an "inward process of mind," into something more than a simple record of facts—into,

instead, "heroic landscape painting." That Church had already engaged in such a transformation with his *New England Scenery* shows the extent to which he empathized with Humboldt's thinking. Now he was to try his hand at a similar synthesis in new territory—South America.

Church spent six months traveling with Field and made extensive sketches and notes. The first canvases he produced upon his return to the United States drew on the same pastoral formula he had used in his New England landscapes, with palm trees replacing elm trees. In the mid-1850s, however, he moved away from pastoral scenes and began a long series of dramatic images that were dominated not by the marks of civilization and progress, but by the features of rugged, vast, and uninhabited lands.

Church was not the only one turning his attention to uninhabited lands. By the mid-1850s many intellectuals on the East Coast were calling for the preservation not of the picturesque but of America's disappearing wilderness. In 1853 the writer Henry David Thoreau issued a call for "national preserves . . . not for our own idle sport or food, but for inspiration and our own true recreation." Two years later Asher B. Durand wrote in the newly founded journal *The Crayon* that aspiring painters should focus not on foreign subject-matter but on "the 'lone and tranquil' lakes embosomed in ancient forests, that abound in our wild districts, the unshorn mountains surrounding them with their richly textured covering, the ocean prairies of the West, and many other forms of Nature yet spared from the pollutions of civilization." In 1858 not only did New York City begin construction of Central Park in recognition of the belief that access to nature was morally uplifting, but Frederick Law Olmsted, the park's designer, also pushed forward with his campaign to create a series of national parks to preserve the most spectacular and sublime of the nation's wilderness areas (see pp. 297–99). Church appears to have shared the concerns of Thoreau and Olmsted and heeded Durand's call for the depiction of nature "spared from the pollutions of civilization."

Church made a second trip to South America in 1857, spending all of his time in Ecuador. Two years later he produced *The Heart of the Andes* [3.26], the sublime equivalent to his picturesque *New England Scenery* [3.25]. Like *New England Scenery*, *The Heart of the Andes* records no single location, but a composite of elements combined to represent the essence of South America, its geography and climate. With this painting Church also entered into a new, more entrepreneurial phase of exhibiting his work. Rather than submitting the 10-foot (3-meter) wide canvas to the National Academy of Design exhibition, as he had previous works, he followed the examples of earlier panorama artists and exhibited it on his own as a paid-entrance attraction. By displaying the painting in a darkened room surrounded by tropical plants, Church was able to heighten its dramatic effect and attract increased public attention.

Perhaps Durand's call to paint national rather than foreign locales also prompted Church to create two of his best-known images of the American wilderness, *Niagara* of 1857 and *Twilight in the Wilderness* of 1860. In his depiction of Niagara Falls [3.27], Church departs from the conventions utilized by both Trumbull and Cole. He provides no stable, cultivated

3.27 Frederic Edwin Church: *Niagara*, 1857
Oil on canvas, 42¼ × 90½ in. (107.3 × 229.9 cm.)
The Corcoran Gallery of Art, Washington, D.C.

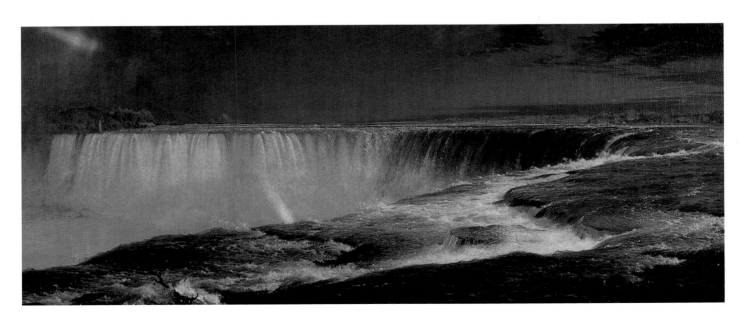

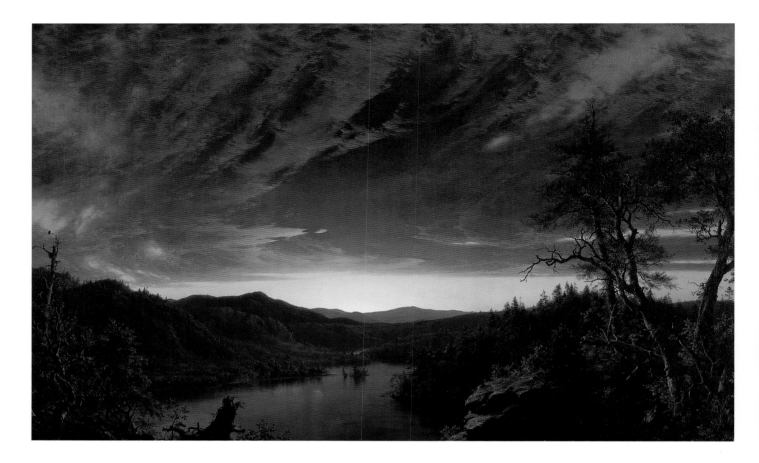

3.28 Frederic Edwin Church: *Twilight in the Wilderness*, 1860
Oil on canvas, 40 × 64 in. (101.6 × 162.6 cm.)
The Cleveland Museum of Art, Cleveland, Ohio

ground upon which to stroll or high cliff from which to gaze upon the falls in the distance. Rather, the viewer appears to be literally standing *in* the falls, or precipitously perched on their edge, the driftwood in the foreground about to be carried over suggesting the fate of anyone who takes a wrong step. Here, certainly, is an image that takes the experience of the sublime to the extreme. The painting was also read, like the works of Trumbull and Cole, as a statement of nationhood and of the unlimited power of American empire. That Church painted the view from just above Table Rock overlooking Horseshoe Falls on the Canadian side did not interfere with such a reading. Church's works had already been consistently interpreted in a nationalistic light, and would continue to be seen this way, even when the landscapes depicted were of foreign locales. *Niagara* toured successfully in both the United States and Britain, gaining the approval of John Ruskin.

In *Twilight in the Wilderness* [3.28], Church has banished all evidence of human habitation. In addition, rather than the bright sunlight of midday, he has portrayed a brilliant autumn sunset. Read symbolically, Kelly suggests, this is not an optimistic vision of the future of the nation, but a more troubled image of uncertain times ahead, particularly in the western regions where the sun is setting. Increased expansion westward had not only pitted East Coast preservationists against western settlers, who saw no need to "preserve" what appeared as an endless wilderness and source of income to them, but had also brought into heightened relief the issue of slavery. Were the new territories, once admitted to the Union, to be free or slave states? Would the Union, itself, survive the factionalism that was increasingly surfacing in state and national assemblies? The outbreak of Civil War the following year would make it more difficult for artists to produce optimistic expressions, via depictions of the American landscape, of inviolable truths about the nation.

Still and Troubled Waters: Luminist Landscapes

In contrast to the large, dramatic vistas of Church, several East Coast artists were producing relatively small, intimate depictions of the American landscape, many of which focused on the Atlantic coastline or the shores of New England's lakes. The distinctive quality of the light in their paintings, which often enveloped the entire scene in a uniform glow, led to their being

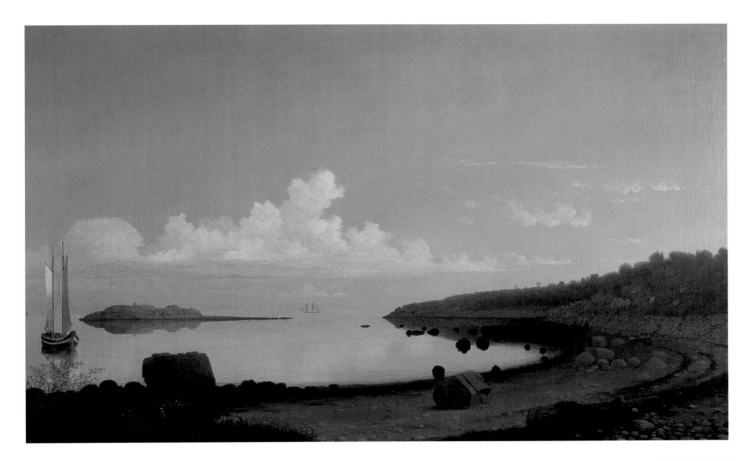

3.29 Fitz Hugh Lane: *The Western Shore with Norman's Woe*, 1862
Oil on canvas, 21½ × 35¼ in. (54.6 × 89.5 cm.)
Cape Ann Historical Association, Gloucester, Massachusetts

3.30 John F. Kensett: *Beacon Rock, Newport Harbor*, 1857
Oil on canvas, 22½ × 36 in. (57.2 × 91.4 cm.)
National Gallery of Art, Washington, D.C.

3.31 Martin Johnson Heade: *Thunder Storm on Narragansett Bay*, 1868
Oil on canvas, 32 × 54 in. (81.3 × 137.2 cm.)
Amon Carter Museum, Fort Worth, Texas

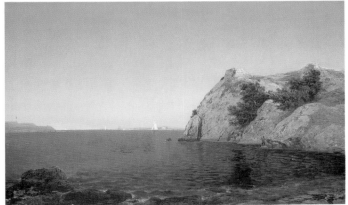

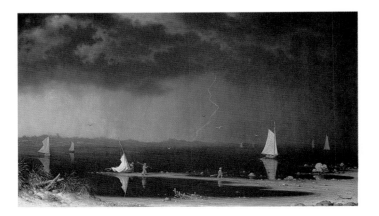

dubbed "Luminists" in 1954 by the art historian John I. H. Baur. Among this group of artists were Fitz Hugh Lane (1804–65), John Frederick Kensett (1816–72), and Martin Johnson Heade (1819–1904). In Lane's *The Western Shore with Norman's Woe* of 1862 [**3.29**], Kensett's *Beacon Rock, Newport Harbor* of 1857 [**3.30**], and Heade's *Thunder Storm on Narragansett Bay* of 1868 [**3.31**] one senses not the bravura of a nation whose future lies to the west, but the reflectiveness of a nation whose past lies to the east and whose future is not yet resolved. Here one finds not paint-laden brushstrokes, reminders of the artist's presence, but smooth surfaces, devoid of any unnecessary evidence of artistic labor to distract the viewer. "The impersonality of many luminist paintings," writes the literary scholar David C. Miller,

also ". . . derives from the simplification and abstraction of forms" and an evenness of treatment over the entire composition that verges on "a democratization of the picture plane." These qualities distinguished Luminist works from the pastoral, allegorical, and sublime landscapes of Church, Cole, and others, in which certain select areas of the canvas are highlighted through, among other things, contrasts of light and dark.

Novak has noted the quiet, spiritual qualities of these paintings (even Heade's *Thunder Storm* is marked by calm waters and a clear golden light in the foreground) and has posited a connection with the American Transcendentalist movement led by figures like Ralph Waldo Emerson and Henry David Thoreau. Transcendence is achieved not through immersion in the awesome sublime, representative of God's terrible power, but through repose within the silence of nature (Emerson's "wise silence" of the Over-Soul). Cole himself noted this alternative experience of nature, which he also equated with a certain kind of sublime. In his 1835 "Essay on American Scenery" he writes that in encountering two lakes in Franconia Notch, he was

> overwhelmed with an emotion of the sublime such as I have rarely felt. It was not that the jagged precipices were lofty, that the encircling woods were of the dimmest shade, or that the waters were profoundly deep; but that over all, rocks, wood and water, brooded the spirit of repose, and the silent energy of nature stirred the soul to its inmost depths.

While Luminist paintings refrained from high drama, they were not always restful. The foregrounds of several, such as Heade's *Thunder Storm*, contain evidence of unease, a silence that suggests emptiness and barrenness as much as oneness with nature. Transcendentalism also had its less optimistic side, a sense of alienation that often appeared in representations of "desert places." The foregrounds of both *Thunder Storm* and Lane's *Western Shore with Norman's Woe* could stand in for those desert places, with their rocky, vacant terrain. These are not plentiful landscapes; even the boats give little evidence of the bounty of the sea. Miller suggests that Luminism is perhaps best understood "as a quality of vision its practitioners unconsciously expressed which bore a profound affinity to the contemporary cultural climate." In this sense, their preoccupation "with the liminal area of the shoreline . . . where values constantly turn into their opposites, where the moment confronts eternity, where flux and stasis endlessly trade places . . . deeply touched people confronting a world whose underlying assumptions were giving way to an unprecedented degree in the years around the Civil War." Perhaps the stasis in these paintings is a symbolic attempt to arrest both land and history, to stop the inevitable escalation of political turmoil and commercial development that was so apparent on the Eastern seaboard and that would soon lead to armed conflict.

Native Americans as Nature

Thrilling Spectacles of Westward Expansion: Albert Bierstadt's "The Rocky Mountains"

Church was joined in his grandiose depictions of the American landscape by another artist who focused not on the East Coast but on the West. Like Church, this artist would rely on his entrepreneurial skills as well as artistic talents to promote his career. The beginnings of Albert Bierstadt (1830–1902) were much more humble than Church's. His family moved in 1832 from Prussia to New Bedford, Massachusetts, the capital of New England's whaling industry, where his father worked as a cooper to support a wife and six children. It is not clear exactly when Bierstadt decided he was going to become a painter, but once he had done so he went about teaching himself the necessary skills, feeling confident enough in his accomplishments by 1850 that he advertised himself as a drawing instructor. Unable to accumulate much income from his lessons, he worked together with fellow artist George Harvey (1801–78) on Harvey's "Dissolving Views" of American scenery, in which landscapes painted on glass were projected in a theater (such projected scenes anticipated the technology of turn-of-the-century motion pictures). The success of this traveling show allowed Bierstadt to go in 1853 to Düsseldorf, where the city's academy had already attracted a number of American artists. Unfortunately, he was not able to enroll, but he was taken in by the American artists Emanuel Leutze (1816–68) and Worthington Whittredge (1820–1910), who provided him with his first sustained lessons in painting. After exploring Germany, Switzerland, and Italy, Bierstadt returned to New Bedford in 1857.

While he drew a certain amount of attention with his European paintings, Bierstadt soon realized that depictions of America's landscapes were in much greater demand. He made his first of many trips out west in the spring of 1859, and upon his return in the fall moved to New York City and began the production of a series of western landscapes that would gain for him a firm footing as perhaps *the* major American landscape painter. *The Rocky Mountains, Lander's Peak* of 1863 [**3.32**] was among the first of his paintings to be exhibited publicly as a paid-entrance piece, with an accompanying pamphlet for sale that described the significance of the work. The success of Bierstadt's western paintings has been attributed by the art

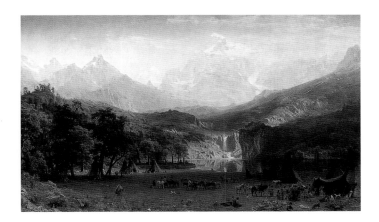

3.32 Albert Bierstadt: *The Rocky Mountains, Lander's Peak*, 1863
Oil on canvas, 73½ × 120¾ in. (186.7 × 306.7 cm.)
The Metropolitan Museum of Art, New York

historian Linda S. Ferber to "public curiosity and excitement about these remote national territories" and to "the powerful idea of Manifest Destiny," a phrase that gained currency in the 1840s and that implied the inevitability of the continued territorial expansion of the U.S. to the west and south, an expansion made more attractive in the early 1860s by anxieties about the future of the Union. The groundwork for their popularity had also already been laid by the panoramas of the early 19th century, many of which were slowly unrolled in theatrical settings to the thrill of the audience. The art critic and collector James Jackson Jarves observed in 1864: "The countryman that mistook the *Rocky Mountains* for a panorama, and after waiting a while asked when the thing was going to move, was a more sagacious critic than he knew himself to be." Like panoramas, Bierstadt's paintings were large and thrilled not only with their size but also with their comprehensiveness and detail. *The Rocky Mountains* toured the U.S. and Europe and was purchased by James McHenry, an Englishman who profited financially from the building of the railroads in the U.S. that helped open the West to further settlement and commercial ventures.

In the pamphlet Bierstadt produced to accompany *The Rocky Mountains, Lander's Peak* he wrote that, in the area mapped in the foreground of the painting, "a city, populated by our descendants, may rise, and in its art-galleries this picture may eventually find a resting-place." Yet this foreground plain is not devoid of humans: it includes a Shoshone camp, with tipis and horses and individuals engaged in the daily activities necessary for survival. Their presence, in combination with Bierstadt's comment, points to the widespread belief that Native peoples were destined to make way for the increasing waves of white settlers moving across the continent in the second half of the 19th century.

Native Borders:
Emanuel Leutze's "Westward the Course of Empire"

Most Europeans who settled in North America believed that the key to prosperity and a new life lay in the acquisition of land. For most of the 19th century, the richest land yet to be exploited by European colonists and their descendants lay west of the Mississippi River. This was the area most commonly conjured up in people's minds when they heard the phrase "the West." The Louisiana Purchase of 1803, and the simultaneous exploration of the northwestern reaches of the continent by Meriweather Lewis (friend and secretary to President Thomas Jefferson) and William Clark quickened the pace of westward expansion and the demand for land by a rapidly growing population. It also stimulated the interest of artists and writers in this new territory, individuals who, knowingly or not, would help formulate justifications for confiscating the land from its current inhabitants while, at the same time, celebrating the humanity of indigenous peoples and the value of their cultural practices.

The Louisiana Purchase was quickly seen as a solution to "the Indian problem." Those who refused to give up claim to their lands would simply be "relocated" west of the Mississippi. In 1830, two years after he was elected president, Andrew Jackson secured the passage of the Indian Removal Bill. By 1838, 70,000 Native Americans had been forcibly removed to the Plains area west of the river, despite treaties guaranteeing them the right to their lands. Thousands died during these forced marches, and many would suffer several subsequent relocations as participants in the ever-westward-moving stream of settlers and entrepreneurs cast covetous eyes on the newly established Indian territories. And in each case, the confiscation of land would be accompanied by pronouncements of the "savagery" of Native peoples and, increasingly, of their inevitable demise. As early as 1824 the U.S. Secretary of War declared that Indians as a race were approaching extinction, despite the fact that their numbers, while greatly diminished, were still significant.

One highly visible image of this seemingly inevitable push by European Americans was Emanuel Leutze's *Westward the Course of Empire Takes Its Way (Westward Ho!)* painted in 1861–62 for the Capitol in Washington, D.C. [4.17]. An oil study of 1861 [3.33] shows the artist's overall conceptualization of the scene. The title of the work is drawn from a poem by the Irish idealist philosopher Bishop George Berkeley entitled "Verses on the Prospect of Planting Arts and Learning in America" (1752), inspired by Berkeley's efforts in 1726 to establish an experimental college in Bermuda to convert America's indigenous peoples to Christianity. Its final stanza reads:

Westward the course of Empire takes its way;
The four first Acts already past,
A fifth shall close the Drama with the day;
Time's noblest offspring is the last.

Housed in the Capitol, along with the images of Native Americans discussed earlier [2.43–2.46], Leutze's painting articulated the belief of Europeans and European Americans since the 16th century that they had a Christian duty and an inalienable right to expand their territory and influence. This belief was codified in the United States in the 19th century in the doctrine of Manifest Destiny. In conquering the West, the final New World frontier, European Americans would bring to culmination the progress of civilization.

The sun-bleached bones and burial scene in the center of the painting [3.33, 4.17] attest to the hardships that the pioneers endured in crossing the vast continent, whose natural power and beauty are evoked by the towering, snow-capped mountains, the broad expanse of plateau land, and Golden Gate Bay, the port of San Francisco, shown in a separate scene at the bottom. Yet Leutze chooses to downplay one of the most written-about hardships encountered during the journey across the continent: attacks by Native peoples. The only possible reference to these attacks in the oil study is the bandaged head of the young man in the center foreground (the final composition [4.17] also includes a small boy clutching a bow and arrows). Instead, Leutze places Native Americans in the decorative margins of the composition, caught up among the tendrils along with wild animals, which, like them and the land itself, must be conquered and subdued. They are literally marginalized, functioning as a framing device for the exploits of the American pioneers.

3.33 Emanuel Leutze: study for *Westward the Course of Empire Takes Its Way (Westward Ho!)*, 1861
Oil on canvas, 33¼ × 43⅜ in. (84.5 × 110.2 cm.)
Smithsonian American Art Museum, Washington, D.C.

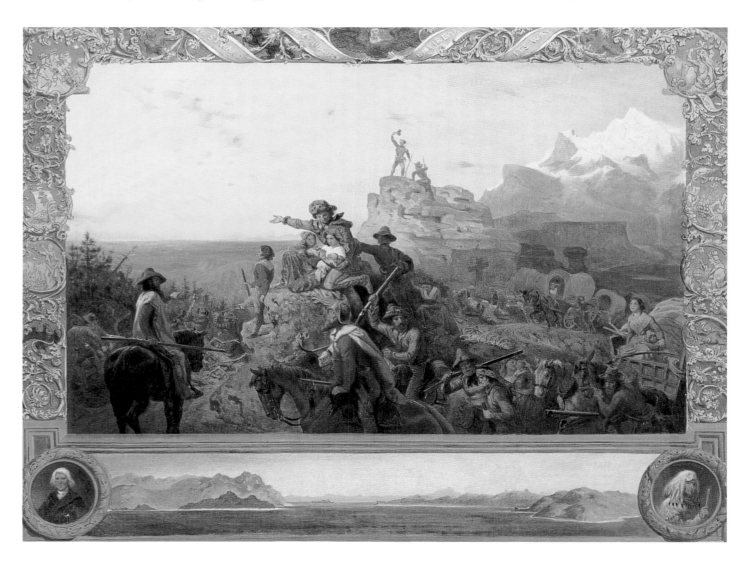

Also included in the painting's border are roundels containing scenes such as Moses leading the Israelites through the desert, the spies of Eshcol bearing the fruits from Canaan, and Hercules dividing Spain from North Africa. Yet these Old World figures are not presented as the equals of the Native figures or even as occupying the same world. Rather, they occupy their own separate worlds contained within the leafy borders of the roundels instead of being caught up among the vines like the animals and Native figures. These Old World men serve to reinforce the sanctity and significance of the main scene and the preordained mission of the United States to expand westward. Like them, the settlers are embarked on a momentous, heroic journey marked by trials and tribulations.

There is one other, more indirect, reference to Native American life in Leutze's painting. It appears in the medallion portrait of the explorer William Clark, in the lower right-hand corner of the oil study [3.33]. Unlike Daniel Boone on the left, who is dressed in recognizably European clothes, Clark wears a buckskin jacket and animal-fur headdress, clothing that would have been immediately associated with the dress of the mountain men and trappers, who were but one step removed from Native Americans. These medallion portraits were transferred to the vertical frame segments in the final composition [4.17]. In their place in the lower border, framing Golden Gate Bay, are symbols of mining, agriculture and hunting, activities that would transform the land from a state of wilderness into one of civilized productivity.

Depicting the "Looks and Modes" of Native American Life

George Catlin and His Indian Gallery

While many European Americans engaged wholeheartedly in the condemnation of Native Americans as savages and heathens, others felt more conflicted about the destruction of these peoples, as well as about the continuing exploitation of the land. One way in which they expressed these views was through dressing up as "Indians." For explorers like Clark, wearing Native American clothes and learning Native American ways was often essential for survival. For white men living in urban centers, dressing up as Native Americans was often a way to express symbolically a dissatisfaction with the material results of the government's expansionist policies—the decimation of Native peoples and of the forests in which they lived—or with the very idea of Progress itself. This form of dissatisfaction was acted out in various plays throughout the 19th century, one of the most popular of which was *Metamora: or, The Last of the Wampanoags; An Indian Tragedy in Five Acts* (1828) by John

Augustus Stone. Native peoples represented a time of innocence and nobility before the development of urban centers and industrialization.

There were certain European American men, however, who were not satisfied with simply donning the clothes of Native Americans; they also wanted to examine Native Americans themselves and to define through pictorial representation what it meant to be or look "Indian." They were encouraged to do so by both government and non-government agencies, which issued calls for artists to capture the "look" of the indigenous peoples before they disappeared from the face of the earth. As the editor of the art magazine *The Crayon* wrote in 1856:

> It seems to us that the Indian has not received justice in American art It should be held in dutiful remembrance that he is fast passing away from the face of the earth Absorbed in his quiet dignity, brave, honest, eminently truthful, and always thoroughly in earnest, he stands grandly apart from all other known savage life. As such let him be, for justice sake, sometimes represented.

Charles Bird King had met this challenge in Washington, painting Native delegations to the nation's capital [2.50, 3.43]. George Catlin (1796–1872), on the other hand, left his position as a successful, largely self-taught, portrait painter in Washington and Philadelphia in 1830 and headed for the frontier city of St Louis. Over the next six years he would make five trips into the territory west of the Mississippi, recording his observations of Native American costumes and practices.

This was not the first time, however, that Catlin had turned his attention to this subject-matter. In the late 1820s he had visited Iroquois reservations in New York State and painted several portraits. But Catlin, like some of his contemporaries, was not satisfied with simply recording the consequences of federal assimilationist policies—Native Americans living in log houses and wearing suits and dresses patterned after European fashions and made out of cloth purchased from local stores. Instead, he wanted to convey an image of indigenous peoples devoid of evidence of contact with European civilization, declaring: "it is for these uncontaminated people that I would be willing to devote the energies of my life." In 1832 he explained his reasons for wanting to paint such Native American life:

> I have, for many years past, contemplated the noble races of red men who are now spread over these trackless forests and boundless prairies, melting away at the approach of civilization. Their rights invaded, their morals corrupted, their lands wrested from them, their customs changed, and

therefore lost to the world; and they at last sunk into the earth, and the ploughshare turning the sod over their graves, and I have flown to their rescue—not of their lives or of their race (for they are "*doomed*" and must perish), but to the rescue of their looks and their modes, at which the acquisitive world may hurl their poison and every besom of destruction, and trample them down and crush them to death; yet, phoenix-like, they may rise from the "stain on a painter's palette," and live again upon canvass [*sic*], and stand forth for centuries yet to come, the living monuments of a noble race.

While Catlin sympathized with the plight of Native Americans, and harshly criticized government policies that had resulted in their degradation if not demise, he also ultimately accepted the proposition that they were "doomed and must perish." He does not attempt to rescue "their lives or . . . their race"—it would be hard to imagine how he could have done so in the face of federal policies and the market imperatives of both real estate and the fur trade—but only "their looks and their modes." Native Americans in their "free" state can survive only as representations constructed through the eyes of a European American artist. Catlin thus engages in what the anthropologist Renato Rosaldo calls "imperialist nostalgia," a yearning for that which one has directly or indirectly participated in destroying, a preservation of "looks and modes" in the face of the "unfortunate but necessary" destruction of a people.

When Catlin arrived in St Louis he met General William Clark of the Lewis and Clark Expedition, who had been made Superintendent of Indian Affairs for the western tribes. Clark was impressed by his portfolio of Iroquois paintings and agreed to help him visit various Native settlements in the West. Catlin subsequently produced over five hundred scenes of Indian life. *The Last Race, Part of Okipa Ceremony* (Mandan) of 1832 [3.34] and *Mah-To-Toh-Pa (Four Bears), Mandan Chief* of 1832–34 [3.35] represent the two general categories within which Catlin's images can be placed: multi-figure scenes set in natural landscapes and studio-type portraits of single individuals. The former are more loosely painted and often have the appearance of field sketches. The latter tend to be much more carefully worked up and utilize poses familiar to portrait painters back East.

Having spent six years in the field, Catlin returned to the East Coast in 1837 and organized his paintings, along with costumes and a collection of Native objects, into an "Indian Gallery," which toured the United States from 1837 to 1840. The year Catlin began his tour the Mandan, a tribe whose "looks and modes" Catlin had "rescued," were nearly completely wiped out by a plague of smallpox. Catlin's father wrote to him and commented that this event would greatly increase the value and importance of his son's works for they would, indeed, be one of the few reminders of a once flourishing tribe.

Catlin also took his "Indian Gallery" to London and Paris in the 1840s. Its success there was due in no small part to the fact that what Catlin presented was an affirmation of an already well-established conception of the Native American as "noble savage" popularized initially by writers such as John Dryden (see p. 52). Dryden's presentation of "noble savagery" in a positive light at the end of the 17th century was taken up again in the 18th century by Rousseau, Voltaire, and other French Enlightenment thinkers in their criticisms of what they viewed as corrupt contemporary French morals and practices. While Catlin's images were more particularized, they still participated in a larger discourse about an innocence and purity that, while desirable in many ways, were part of a past that, ultimately, could not be recreated. The "noble savage," untainted by civilization, was destined to make way for civilization's inevitable arrival.

Catlin's paintings have often been praised for providing a wealth of information about the "manners, customs, and conditions of North American Indians" in the early 19th century—manners and customs that had already been altered by contact with Europeans. Catlin himself went to great pains to verify the accuracy of his depictions. He included in his 1841 *Letters and Notes on the Manners, Customs, and Conditions of North American Indians* written statements attesting to this accuracy by various government officials, traders, and scholars familiar with the peoples he was painting. These statements of authenticity are accompanied in Catlin's book by his constant laments about how others had misrepresented Native Americans, feeding an antagonism toward these peoples that was unfounded or exaggerated. Those searching after truth would be most likely to find it, according to Catlin, in his own text and images.

More recently, several art historians, while admitting that both Catlin's text and images certainly add to our knowledge of Native American life, have gone on to question certain aspects of these representations. Catlin sometimes intentionally left out elements of a scene or individual he was painting or altered the scene itself. Kathryn Hight points out one example of this in the frontispiece to *Letters and Notes* [3.37]. Catlin would like us to believe that he has recorded a scene that actually occurred. Captioned "The Author painting a Chief at the base of the Rocky Mountains," it shows sitter and artist outdoors, surrounded by a crowd chiefly of men, in front of two tipis. In the text of the book, however, Catlin describes painting the individual in question—Mah-To-Toh-Pa (Four Bears), second chief of the

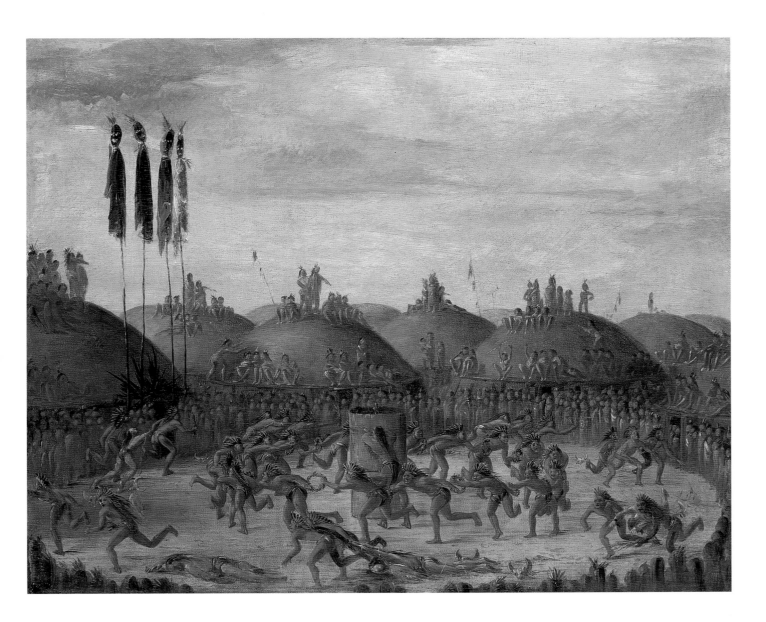

3.34 George Catlin: *The Last Race, Part of Okipa Ceremony* (Mandan), 1832
Oil on canvas, 23⅜ × 28⅛ in. (58.8 × 71.3 cm.)
Smithsonian American Art Museum, Washington, D.C.

Mandan—in the Mandan village of Metutahanke on the upper Missouri River, indoors, surrounded by women and children. He also adds a detailed description of the chief's costume, which included a belt containing a tomahawk and scalping knife, a painted robe, and a bear-claw necklace. In the single-figure painting on which the figure in the frontispiece was based [3.35], these specific items are already not in evidence.

What is the significance of these changes? How do they alter the meaning of the images? In his text, Catlin tells his readers how much time the chief had spent getting ready for his portrait, indicating that the Mandan had a very clear idea how

he wanted to be represented. Catlin then goes on to justify the omissions: "Such was the dress of Mah-To-Toh-Pa when he entered my wigwam to stand for his picture; but such I have not entirely represented it in his portrait; having rejected such trappings and ornaments as interfered with the grace and simplicity of the figure." Removing several symbols of the chief's power as a warrior and spiritual leader—the tomahawk, scalping knife, and bear-claw necklace—may, indeed, simplify the composition, but it also makes Mah-To-Toh-Pa appear less threatening, both to the painter within the image itself and to the reader of Catlin's memoirs. Moving the scene outdoors allows an increase in the size of the audience, and this larger number, which now includes men as well, attests to the importance of the event and the significance of Catlin's artistic achievements. The expressions of fear and wonder on the faces

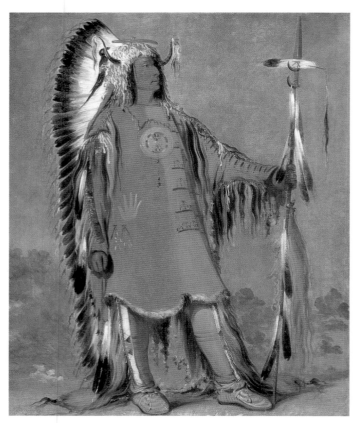

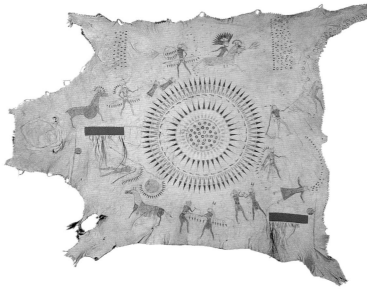

3.35 (left) George Catlin: *Mah-To-Toh-Pa (Four Bears), Mandan Chief*, 1832–34
Oil on canvas, 29 × 24 in. (73.7 × 61 cm.)
Smithsonian American Art Museum, Washington, D.C.

3.36 Anonymous, Mandan: buffalo robe, collected in 1837
Painted hide, w 82¾ in. (210 cm.)
Historisches Museum, Bern, Switzerland

3.37 George Catlin: "The Author painting a Chief at the base of the Rocky Mountains," frontispiece to *Letter and Notes*, 1841
Engraving, 9½ × 6 in. (24.1 × 15.2 cm.)
Henry E. Huntington Library and Art Gallery, San Marino, California

of the spectators attest additionally to the accomplishments of European artistry in general. Catlin depicts his ability to capture the physical likeness of the chief on canvas as an act of magic in the eyes of the Mandan villagers. While the frontispiece is rendered in a reductive graphic style, with little shading or other attempts to create a convincing three-dimensional space, Catlin, Ma-To-Toh-Pa, and the other figures are still much more life-like than the elementary stick figures on the sides of the tipi that represent Mandan artistic expression.

Catlin's familiarity with the pictorial art of the Mandan is recorded in his memoirs. In fact, Mah-To-Toh-Pa gave the artist a replica of his own painted buffalo-skin robe on which he had recorded his military exploits and which he wore to have his portrait painted (and which the artist did not show). While the whereabouts of Catlin's robe are unknown today, another Mandan robe [3.36], collected in 1837, has scenes that closely resemble his written and pictorial descriptions of it, and may in fact have belonged to Mah-To-Toh-Pa. The horses and human figures are certainly two-dimensional and highly schematic. Yet they are much more sophisticated in their rendering and

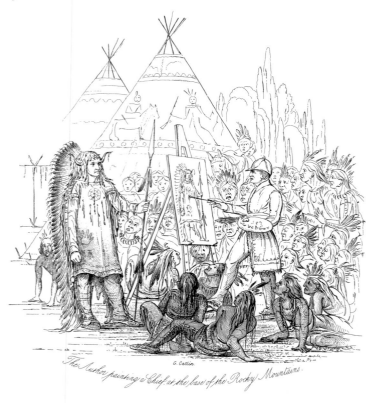

The Author painting a Chief at the base of the Rocky Mountains.

G. Catlin

design than the stick figures on the tipi. These latter figures, with their triangular torsos and frontal heads, more closely resemble the designs on an earlier Mandan buffalo robe sent to President Jefferson by Lewis and Clark in 1805 [1.36]. The later example reveals an increasing sureness in the handling of human and animal bodies and a greater concern with decorative patterning.

The Native peoples of the Plains had already had extensive contact with Spanish, French, and English traders and/or soldiers before the arrival of Catlin (see Chapter 1) and some had undoubtedly been exposed to European images through reproductions or contact with European artists who accompanied these trading expeditions. Native American artists would continue to develop the narrative art forms found in hide paintings throughout the 19th century and use them as a means of pictorial communication, incorporating knowledge they had gained from observing the work of artists like Catlin while maintaining aspects of their own distinctive style and iconography. A major change in materials also occurred in the middle of the century with the widespread introduction through trade of paper and new pigments. Some examples of these new works will be discussed later.

The tipis in Catlin's frontispiece [3.37] may have been included for compositional reasons. The central one not only provides a surface for the display of Native American imagery but also connects the figures of Catlin and Mah-To-Toh-Pa. The lines of its sides link their heads, anchoring them within the pyramidal composition and suggesting a certain equality between them. The easel echoes the shape of the tipi, reinforcing the comparison between the stick figures behind and the mimetic portrait that it supports, between the "childlike" record of gun-toting exploits and the European celebration of noble individuality.

But the inclusion of the tipis in this particular scene is puzzling in view of the fact Catlin knew quite well that the distinctive dwellings of the more sedentary, horticultural Mandan were not portable bison-hide tipis but hemispherical earth structures. These are evident in his painting *The Last Race, Part of Okipa Ceremony* [3.34]. By locating the Mandan in front of tipis, the dwelling type of nomadic Plains tribes, Catlin participates in the creation of a generalized view of

3.38 George Catlin: *Catlin Painting the Portrait of Mah-To-Toh-Pa—Mandan*, 1857–69
Oil on board, 15⅜ × 23⅞ in. (39 × 60.6 cm.)
National Gallery of Art, Washington, D.C.

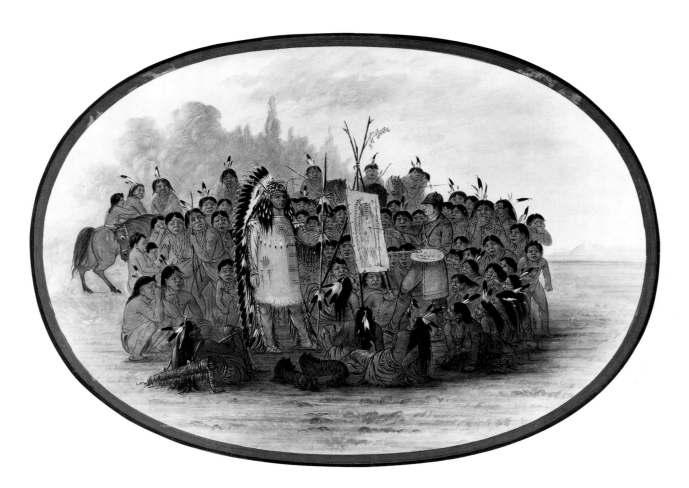

Native Americans, one which erases their differences and particularities (the tipi soon became a sign for "Indian"), even as he claims to be recording these particularities. This generalized view was particularly appropriate for the frontispiece of his book, which included a vast array of Native peoples too complex to be captured in one image, although the numerous illustrations contained in the book allowed the reader access to this complexity.

It is interesting to compare the frontispiece with a later picture based on it, *Catlin Painting the Portrait of Mah-To-Toh-Pa—Mandan* of 1857–69 [3.38]. Catlin has removed the tipis and shifted Mah-To-Toh-Pa closer to the center of the composition, increasing the number of Mandan located behind the chief. He has also replaced the European easel with a makeshift structure of branches tied together like a tipi. In addition, he shows the canvas only roughly attached to this frame, suggesting the loosely attached hide coverings of the tipi. Thus, the tipi and easel of the engraving have been collapsed together in the painting. The effect of these changes is to heighten the presence of the Mandan chief in the composition and the connection between the Mandan and nature, and to locate Catlin the artist more clearly within the Mandan world. Yet Catlin is still very much present as artist and creator as well, and perhaps even more so than in the engraving. In the painting Catlin presents himself as literally repainting the surfaces of the "Indian" tipi/easel, which once held Mandan pictographs, and thus as redefining the significance of the Mandan leader-as-artist and of pictorial representation in general in Mandan culture.

Catlin's account of his painting of the portrait in his *Letters* includes the following passage:

> No tragedian ever trod the stage, nor gladiator ever entered the Roman Forum, with more grace and manly dignity than did Mah-To-Toh-Pa enter the wigwam, where I was in readiness to receive him. He took his attitude before me, and with the sternness of a Brutus and the stillness of a statue, he stood until the darkness of night broke upon the solitary stillness.

This use of Roman references can certainly be seen as a way of praising the nobility and bravery of Native American leaders. Yet, combined with a belief in their inevitable demise, these references functioned to locate Native Americans even more firmly in the past, as noble precursors to a present and future society in which they would have little control over their own destiny.

The effect of Catlin's vision of Mah-To-Toh-Pa as Brutus on his portrait can be seen if we compare it to another painting of

the Mandan leader done at the same time by the Swiss artist Karl Bodmer [3.39]. Bodmer (1809–93) accompanied the German Prince Maximilian of Wied-Neuwied on a two-year journey up the Missouri River through the northern Plains territory. He was commissioned to execute watercolors of Native Americans that would be used to illustrate Maximilian's *Travels in the Interior of North America in the Years 1832 to 1834*, published in 1839. While Bodmer's figure exhibits certain similarities in costume and facial features, the relative sizes of warrior and spear suggest a much smaller man than appears in Catlin's painting [3.35]. Perhaps Bodmer, as illustrator of another man's narrative, had less of an investment in dignifying Mah-To-Toh-Pa through Roman allusions than had Catlin.

Bodmer's paintings are often much more precise in their rendering of costumes and facial features than Catlin's, due probably to his more extensive training as an artist. For example, Bodmer presents a careful depiction of a Teton Sioux

3.39 Karl Bodmer: *Mató-Tópe (Four Bears), Mandan Chief*, 1833–34
Watercolor on paper, 16½ × 11⅝ in. (41.9 × 29.2 cm.)
Joslyn Art Museum, Omaha, Nebraska

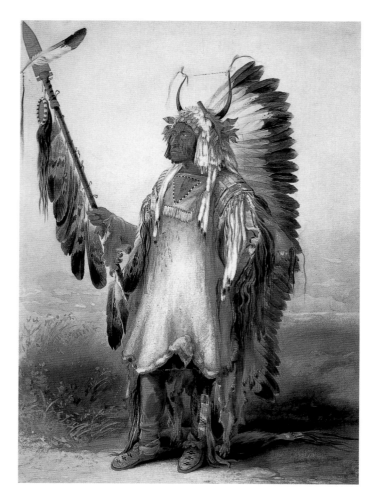

3.40 Styles of painted designs for Plains women's buffalo robes: (a) horizontally striped, (b) bilaterally symmetrical, (c) feathered circle, (d) border-and-box, (e) border-and-hourglass

3.41 Anonymous: robe with arrowhead and broken diamond motif, 18th century
Painted hide, 49¾ × 40¼ in. (126.3 × 102.2 cm.)
Musée de l'Homme, Paris

3.42 Karl Bodmer: *Chan-Chä-Uiá-Teüin, Teton Sioux Woman*, 1833–34
Watercolor and pencil, 17 × 11⅞ in. (43.2 × 30.4 cm.)
Joslyn Art Museum, Omaha, Nebraska

woman's costume in his portrait *Chan-Chä-Uiá-Teüin* of 1833–34 [3.42]. As mentioned earlier (see pp. 58–59), women's robes tended to display abstract, geometric patterns, while men's contained narrative scenes. Of the five generalized geometric patterns used, the one in Bodmer's painting appears to be of the border-and-box variety [3.40d]. An 18th-century Plains robe provides a clearer view of this design [3.41], which is thought to derive from the splayed outline of a skinned-out large animal, such as a buffalo, with the "box" representing the animal's viscera.

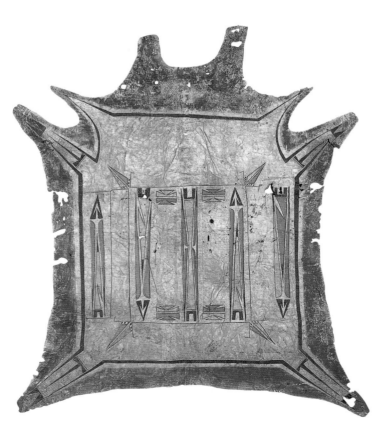

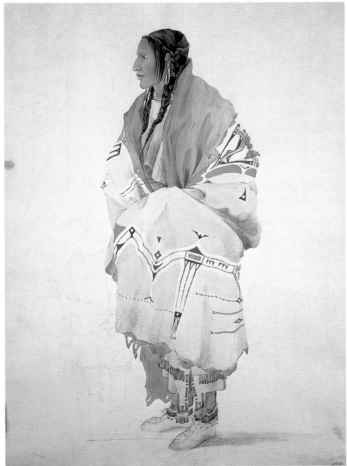

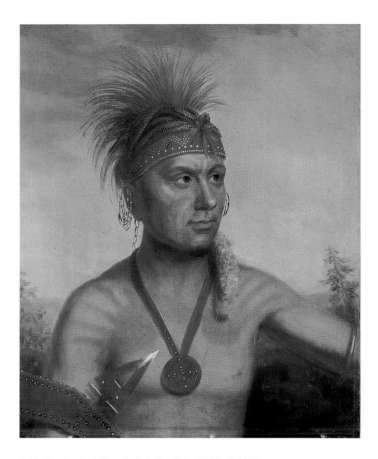

3.43 Charles Bird King: *Keokuk, Sac (Watchful Fox)*, 1827
Oil on panel, 17½ × 13¾ in. (44.4 × 34.9 cm.)
The National Museum of Denmark, Copenhagen

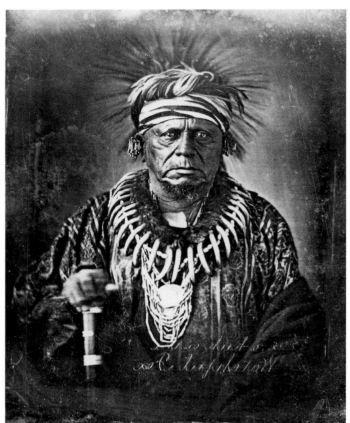

3.44 Thomas Easterly: *Keokuk, or the Watchful Fox*, 1847
Daguerreotype, copied in 1868 (reproduced here with original orientation)
National Anthropological Archives, National Museum of Natural History,
Smithsonian Institution, Washington, D.C.

Photographic Portraits: Another Take on the Real

At the same time that Catlin was drawing on easel painting to construct his images of Native Americans, others were utilizing a different medium, one they claimed was better able to render accurately the faces of the frontier, albeit in black-and-white—photography. In 1847 Thomas Easterly (1809–82) produced a photograph of the Sauk and Fox leader Keokuk, or the Watchful Fox [3.44], who was well known for his diplomacy in negotiating with government officials. In 1837 he succeeded in protecting Sauk and Fox claims to their Iowa land holdings against counterclaims by the Sioux. Easterly presents Keokuk in a stark interior setting, eyes staring straight ahead, impassive and stony-faced, rendered in sharp detail yet emotionally inaccessible. These pictorial qualities had much to do with the mechanics of photography—e.g. the long exposure time that required the subject to sit completely still for several seconds—and the unfamiliarity of the medium, which resulted in an awkwardness or discomfort in front of the camera. Yet photographers would also, like painters, manipulate their images through choice of costume or setting, and invest them with their own understanding of the frontier and the peoples who inhabited it.

The differences between the conventions of painting and mid-19th-century photography can be seen in comparing Easterly's photograph to an earlier image of the same man. In 1824 Keokuk had traveled to Washington with a delegation of Sauk, Fox, Iowa, and Piankashaw leaders. During this visit, he had his portrait painted by King, a copy of which was made by the artist in 1827 [3.43]. Here Keokuk is at ease, a slight smile on his face, his gaze directed beyond the picture frame, allowing the viewer's eye to wander over his body, stopping to examine his costume or facial features. He wears a simple medallion on his bare chest, reminiscent of the peace medals distributed to Native leaders [see **2.50**], and his war club with its knife blade is given a secondary position in the lower left-hand corner. There is a sense of complicity between the viewer/painter and the sitter, a willingness on the part of Keokuk to expose himself to scrutiny. The trees and sky locate the tribal leader in an ill-defined landscape, belying the fact that the portrait was painted in King's studio.

Easterly engages in no such illusionism and his photograph of the massive, fully clothed older man creates little sense of willing complicity. Keokuk sits in front of a black backdrop, directly engaging the viewer with his gaze. His head is partially framed by an imposing bear-claw necklace, a symbol of his physical and spiritual power, which creates a distinctly more threatening image than the boy-like figure in King's painting.

It is difficult to imagine that the painted Keokuk is the same young man that the ethnologist Henry Rowe Schoolcraft met in 1825. Schoolcraft, the author of a six-volume history of Native Americans entitled *Historical and Statistical Information Respecting the History, Condition, and Prospects of the Indian Tribes of the United States* (1856), described him as "like another Coriolanus," "a prince, majestic and frowning. The wild, native pride of man, in the savage state, flushed by success in war, and confident in the strength of his arm, was never so fully depicted to my eyes." The Roman analogies are similar to those used by Catlin in his description of Mah-To-Toh-Pa. Schoolcraft had been an early admirer of the work of Catlin; indeed, a testimony by him is included in *Letters and Notes* verifying the artist's accuracy. Yet he later questioned the truthfulness of some of Catlin's descriptions—a questioning that, according to the painter's granddaughter, prevented the sale of Catlin's collection to the French government.

Nature Transformed: Settling the Landscape

The Iconography of Progress: The City and the Train

Catlin's memoirs included not only descriptions of the "manners, customs, and conditions" of the Native peoples of North America, but also detailed descriptions of the land they inhabited:

> Soul melting scenery that was about me! . . . I mean the prairie . . . whose thousand thousand velvet-covered hills, (surely never formed by chance, but grouped in one of Nature's sportive moods)—tossing and leaping down with steep or graceful declivities to the river's edge, as if to grace its pictured shores, and make it "a thing to look upon."

Just as Catlin participated in defining how the nation would understand the lives and customs of Native peoples, so too did he join in the pictorialization of the American landscape, its transformation, through both written description and painted canvas, into "a thing to look upon." And just as his respect for Native peoples was combined with an acceptance of their inevitable demise, so too was his appreciation of the beauty of the untamed landscape tempered by an acknowledgment of its inevitable transformation through cultivation and settlement

by Europeans. A page after exulting over the wild prairie, Catlin writes:

> I . . . roamed from hill-top to hill-top, and culled wild flowers, and looked into the valley below me, both up the river and down, and contemplated the thousand hills and dales that are now carpeted with green, streaked as they *will* be, with the plough, and yellow with the harvest sheaf; spotted with lowing kine—with houses and fences, and groups of hamlets and villas.

By the mid-19th century several artists were producing images of this transformation of the natural landscape into farms, towns and cities, building on the pastoral vistas of the first half of the century. In 1853, before he issued his call to artists to paint the American wilderness, Durand produced *Progress* [3.45], a clear representation of the inevitable march of Progress, from the wilderness foreground, with its Native Americans looking on, to the bustling city on the banks of the river in the valley below. "The wild Indian," one reviewer wrote, "is seen taking a last look at the land of his fathers, and for the last time treading those mountain glades, so beautiful in their wild scenery, but soon to change and disappear before the white man's resistless march of improvement."

Duncanson also directed his attention to the landscape transformed in his *View of Cincinnati, Ohio, from Covington, Kentucky* of 1858 [3.47]. Here the foreground is occupied not by displaced Native Americans but by African American farmers, whose rural life in Covington is contrasted with the bustling commercial center of Cincinnati. Unlike Durand's *Progress*, which offers a symbolic landscape, Duncanson's work focuses on the specifics of a particular site, from the Mitchel (Mount

3.45 Asher B. Durand: *Progress*, 1853
Oil on canvas, 48 × 72 in. (121.9 × 182.9 cm.)
The Warner Collection, Gulf States Paper Corporation, Tuscaloosa, Alabama

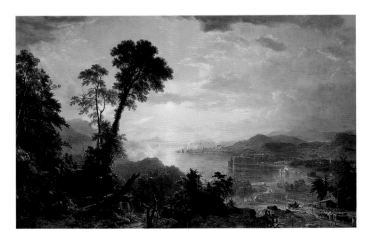

3.46 Anonymous: *View of Cincinnati, Ohio*, 1848
Engraving from *Graham's Magazine*, June 1848

Adams) Observatory on the hill at the far right to the boats moored at the Cincinnati Public Landing. His painting is based on a daguerreotype which appeared in engraved form in *Graham's Magazine* of June 1848 [3.46], although, as Joseph D. Ketner has pointed out in his study of Duncanson, he has changed the

white man in the foreground of the engraving speaking to two white children to a black farmer and the woman hanging out laundry from white to black. This black man and woman might well represent two of the 50 free African Americans who, in addition to 15,000 whites and 100 slaves, made up Covington's population at the time. The theme of freedom is further reinforced by the fact that African Americans in Kentucky often escaped slavery via Covington in the winter when the Ohio River froze over.

The art historian David Lubin also argues that the bodies of water that play a dominant role in Duncanson's landscape paintings—*View of Cincinnati* [3.47], *Blue Hole, Little Miami River* [3.17], and *The Garden of Eden* [3.18] being only three examples—functioned as a "trope of freedom itself." The writings of African Americans often included references to crossing bodies of water to freedom, be it the passage over the Great Lakes to Canada or over the Ohio River to Ohio (Duncanson's residence in both Detroit and Cincinnati would have made him

3.47 Robert S. Duncanson: *View of Cincinnati, Ohio, from Covington, Kentucky*, 1858
Oil on canvas, 25 × 36 in. (63.5 × 91.4 cm.)
The Cincinnati Historical Society, Cincinnati, Ohio

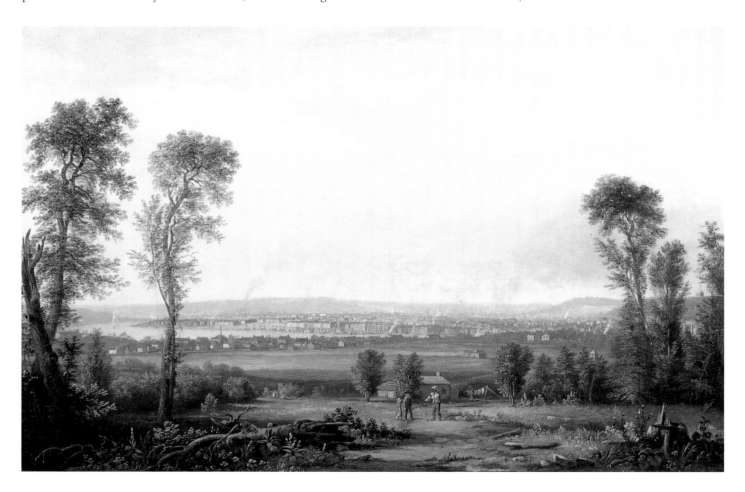

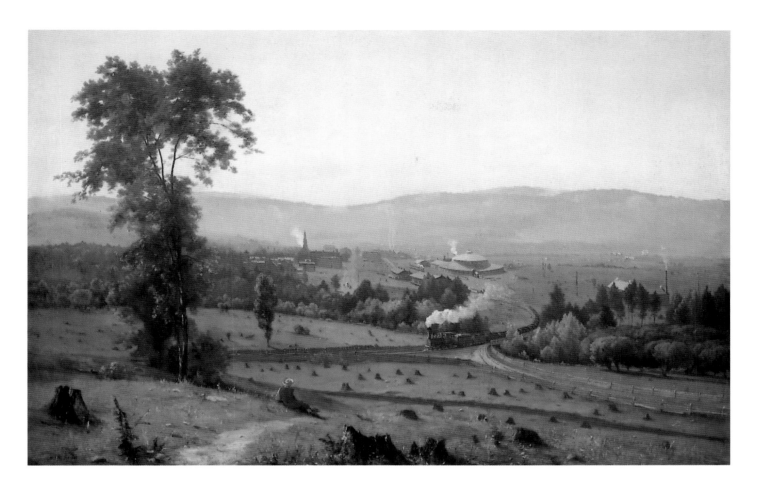

3.48 George Inness: *The Lackawanna Valley, c.* 1855
Oil on canvas, 33⅞ × 50¼ in. (86 × 127.5 cm.)
National Gallery of Art, Washington, D.C.

particularly aware of the symbolic dimensions of these two bodies of water). Probably the most famous mid-19th-century description of such a crossing appeared not in the writings of an African American, however, but in the European American Harriet Beecher Stowe's popular 1852 novel *Uncle Tom's Cabin; or, Life Among the Lowly*, where the Kentucky slave Eliza, faced with the icy Ohio River, "vaulted sheer over the turbid current by the shore, on to the raft of ice beyond," stopping only when, "as in a dream, she saw the Ohio side, and a man helping her up the bank." Stowe lived in Cincinnati in the 1840s and patterned this episode after a news item describing a similar winter crossing of the Ohio by a slave woman with her child in her arms. That Duncanson was aware of Stowe's book is certain, for the year after its publication, he painted two of its characters, Uncle Tom and Little Eva, in a landscape which contained, not surprisingly, a large body of water [4.20].

Another landscape artist concerned with the specific topography of a particular location was George Inness (1825–94).

In 1855 he was commissioned by the first president of the Delaware, Lackawanna, and Western Railroad to depict its new roundhouse complex at Scranton, Pennsylvania, for the princely sum of $75 (Church received $5,500 for *Niagara* in 1857) [3.48]. Some scholars date Inness's painting to the end of the 1850s, noting that the roundhouse complex was not completed until 1856. Others defend the 1855 date, saying he could have included it on the basis of designs to which he undoubtedly had access.

Here, once again, a tiny foreground figure, a young boy, directs our gaze down the gently sloping hill to the train, the roundhouse, and the town of Scranton. Rather than a wilderness foreground, however, Inness presents us with a field of stumps, evidence of the axe's progress in pushing back untamed nature to make way for the technology of civilization most aptly represented by the train, which emerges out of the settled landscape into the intermediate space of the freshly cleared field. The train and the railroad buildings are framed by the church on the left, its spire rising above the town, and the factory on the right, its chimney emitting a stream of smoke. The factory itself is almost totally hidden by trees, thus appearing as if part of nature rather than of the urban landscape.

Inness's privileging of the train and the roundhouse complex could be read as a celebration of this appearance of technology in the American landscape. Indeed, alongside the promotion of the sublime aspects of the American wilderness there had also emerged effusive praise of what Barbara Novak terms the "technological sublime," a sense of awe in the face of the vast power of machines. But the celebratory aspects of the painting are undercut by Inness's use of the tree stumps, which had long since come to represent mixed feelings regarding the destruction of the pristine wilderness. If God-as-nature is destroyed, would God-as-organized-religion, represented by the church, be able to survive? By pairing the church spire and the factory chimney, is Inness suggesting divine sanction of American enterprise, or is he suggesting that both, to survive, must keep their distance?

That Inness places so many tree stumps in such a prominent position in the painting certainly suggests his awareness of the massive destruction of forests necessitated by the construction of the railways. Companies were often given the right to fell a broad section on either side of the railway bed to prevent trees from falling on the track. Between 1820 and 1860 more than 30,000 miles (48,000 kilometers) of track were laid, with the final spike linking the Atlantic and Pacific coast lines driven on May 10, 1869, at Promontory, Utah. Trees were also used for railroad ties, fuel, and in the building of the cars. The existence of railroads facilitated the transportation of lumber which, in turn, led to more trees falling to the ax. How exhaustible these forests actually were would not become clearly apparent for at least another century, although far-thinking individuals at the time predicted their inevitable demise if measures were not taken to limit their destruction. These protests, however, were drowned out by the more insistent declaration of America's boundless opportunities and resources.

Human Actors in the Landscape: Genre Paintings of the Yeoman Farmer

The transformation of the land also appeared in another series of images, ones in which the small figures in the foreground of many earlier landscapes began to take center stage and to form the basis of what came to be known as genre paintings. In her study of American genre paintings, Elizabeth Johns notes that these scenes of "everyday life" were most consistently celebrated by critics during the antebellum period, from 1830 to 1860. Two of the most common scenes were those of the yeoman farmer and the Westerner. Why, Johns asks, were these particular subjects so popular at this time? What are the ideologies that inform these images, the social assumptions that are not necessarily apparent at first glance, but which provide the interpretive framework upon which the figures and settings are hung? Who exactly found them so appealing?

While the genre paintings discussed by Johns were often celebrated as distinctly American, she sees their popularity as the result of their appeal to a particular region of the country—New York City. It was here that the majority of the paintings were either produced or exhibited or both. It was here that the political, economic, and cultural forces of the nation were coalescing, particularly after the opening of the Erie Canal. It was here, also, that the most intense upheavals and challenges to the social cohesion of the nation were felt, upheavals that contributed to the popularity of genre paintings.

The thirty years of genre painting's heyday were years of increased opportunities for a broad segment of the white male population, opportunities that were accompanied by increasing tensions surrounding changes in economic and social status. One response to such tensions was the creation of "types," characters who embodied these changes and upon whom others could project their anxieties. Two issues of particular significance during the 1830s and 1840s were democracy and citizenship—who was a citizen, how were citizens supposed to conduct themselves, what were the implications of the spread of individual sovereignty? Such questions and the anxieties they produced were not new, but they became of increasing concern to the political and financial elite of the East Coast after 1828 when Andrew Jackson, a Westerner and a Democrat, was elected to the presidency.

The yeoman farmer as a type had roots in the British yeoman, an individual loyal to the landowning class as well as aware of his inferior station. In the United States, the farmer who worked the land was seen as the fundamental productive force of the new nation, a nation made up of small landholders who would guarantee the moral and economic wellbeing of the country through their productive labor. But American yeomen did not "know their place." Those large landholders who formed the founding fathers and who dominated the political scene into the early 19th century were constantly complaining of the uncitizen-like actions of many new property owners. These newcomers were often portrayed in literary publications and theatrical venues as lower-class, ignorant, and concerned only with individual gain rather than the betterment of the community at large. New Yorkers further refined this image into the "Yankee" farmer, a reference to New Englanders upon whom New Yorkers could project all of their anxieties about their own drive to amass wealth. Thus while the country's rural origins were celebrated, actual farmers were often mocked and ridiculed.

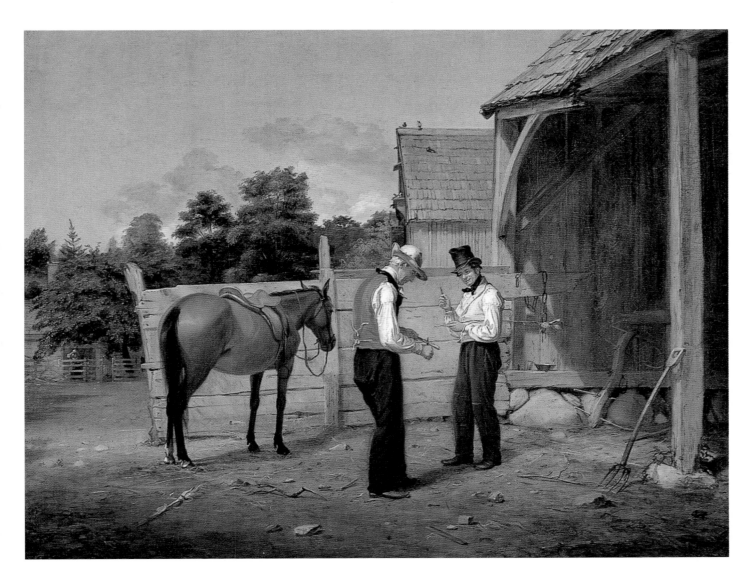

3.49 William Sidney Mount: *Bargaining for a Horse*, 1835
Oil on canvas, 24 × 30 in. (61 × 76.2 cm.)
Courtesy The New-York Historical Society, New York City

One artist who tapped into these mixed emotions was William Sidney Mount (1807–68). Born into a comfortable, landowning family on Long Island, Mount was apprenticed to his brother Henry, a sign-painter, in 1824. After enrolling in lessons at the National Academy of Design, he began his career as a painter at the end of the decade, exhibiting his first history painting in 1828. Meeting with little success with his history canvases, in 1830 he hit on the portrayal of the nation's rural life, creating scenes of dances and general country life. But the proliferation of caricatures of the Yankee farmer after the election of Jackson in 1828 must have struck a chord with Mount, for he began a series of images of this much-maligned character that gained him considerable critical attention.

Mount's first significant work in this vein was his 1835 painting *Bargaining for a Horse* [3.49]. The work was commissioned by Luman Reed, the self-made merchant from a rural background in upper New York State who, two years earlier, had charged Cole with executing his five-part *The Course of Empire* (see pp. 149–51). Interestingly, just as Cole's series recorded a cyclical view of history that captured the anxieties of an elite cultural world of which Reed would never be a part, *Bargaining for a Horse* mocks a general social type—the ambitious, materialistic individual—to which Reed could easily be seen as belonging.

Bargaining for a Horse depicts two men, one considerably older than the other, engaged in a business transaction. One wears a straw hat, identifying him as a farmer, while the other wears a black top hat, suggesting the city—though Mount's original title, *Farmers Bargaining*, identifies both as farmers. The process of negotiation is accompanied by whittling, which adds a certain nonchalance and goodwill to the scene. The open shed in front

of which the figures stand, however, is run-down and empty, suggesting a lack of productivity. "In their devotion to getting a good deal," Johns proposes, "the yeomen have abandoned the productive work of plowing, sowing seed, harvesting, stacking hay, and even maintaining their property." Here are the results of subordinating production to deal making, a message that would undoubtedly have added meaning in 1835, the year in which a frenzy of land speculation and gambling took hold in New York.

Mount also makes use of verbal metaphors in his painting. "Horsetrading" was a term recently applied to the practice of promising material benefits in exchange for votes, a practice identified with the Democratic Party. The whittling also brought to mind two other colloquialisms, "coming to the point" and "shaving" or being duplicitous. In addition, the birds located on the roof of the far shed above and between the two men, probably pigeons (note the loft on the end wall of the shed beneath the peak of the roof), suggest according to Johns "that a 'pigeon'— a term ubiquitous in the anxious vernacular of the period—is about to be plucked." At least one reviewer perceived the intended vernacular wordplays when the work was exhibited in 1835. After noting that the painting was "an image of pure Yankeeism and full of wholesome humor," he added that "both of the yeomen seem to be 'reckoning,' both whittling, both delaying." When the painting was engraved in 1839 for the annual publication *The Gift of 1840*, the title was changed by the publisher Edward L. Carey from *Farmers Bargaining* to *Bargaining for a Horse*, thus making it easier for the engraving's broader audience to perceive the horsetrading metaphor.

Human Actors in the Landscape: Genre Paintings of the Westerner

If the wheeling and dealing of the New England farmer caused certain New Yorkers some anxiety about the demise of the nation's agrarian ideal, the seemingly uncontrollable egalitarianism and entrepreneurship of the Westerner caused them even greater concern. At least the Yankee was a known entity, whereas the Westerner was somewhere "out there," in a landscape that was both intimidating and profitable beyond many Easterners' wildest dreams. Just as the Yankee farmer served as a figure on which New Yorkers could project their anxieties about citizenship and materialism, so the Westerner provided them with a site for the projection of their dreams of classlessness and individualism. As the urban and industrial centers of the East Coast expanded and immigration from Europe increased, creating more glaring class and ethnic divisions, the West appeared refreshingly devoid of these social and economic complications. If the agrarian life of the past provided a nostalgic vision of social balance, the West functioned as a present and future promise.

One of the best-known painters of the West in the antebellum period was George Caleb Bingham (1811–79). Bingham first gained attention as a portrait painter in the 1830s, but soon turned to the landscape and daily activities of the West, and in particular of the Missouri and Mississippi Rivers (he had moved to Missouri at the age of eight). While the majority of his paintings depict the presence of white settlers, Bingham produced a few early images that served to highlight the transitions this landscape was undergoing through the use of the figure of the Native American. In 1845 he painted *The Concealed Enemy* [3.50], in which an Osage warrior (recognizable by his headdress and body paint) crouches behind a rock, rifle in hand. The dark foreground adds to the drama of the scene, made even more sinister by its contrast to the bright sky at the upper right. This Osage is obviously waiting for his prey, some riverboatmen who hoped safely to navigate the waters shown at the base of the cliff below.

By the 1840s the Osage had disappeared from much of the Missouri landscape, having been forced to relocate to territory further west. Bingham's painting most likely refers to a time some twenty years earlier, when they were still numerous in the region. He may have come across some Osage in the 1820s in the town of Arrow Rock where he grew up. He also may have learned about them through talks with his father, who had kept a diary of his travels that contained descriptions of the various Native peoples he had encountered along the way. Or he may have gotten his ideas from the growing number of illustrated books being published about the West, which favored dramatic renditions of dangerous warriors rather than picturesque portraits of noble leaders.

3.50 George Caleb Bingham: *The Concealed Enemy*, 1845
Oil on canvas, 29¼ × 36½ in. (74.3 × 92.7 cm.)
Stark Museum of Art, Orange, Texas

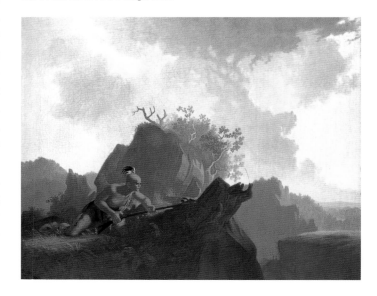

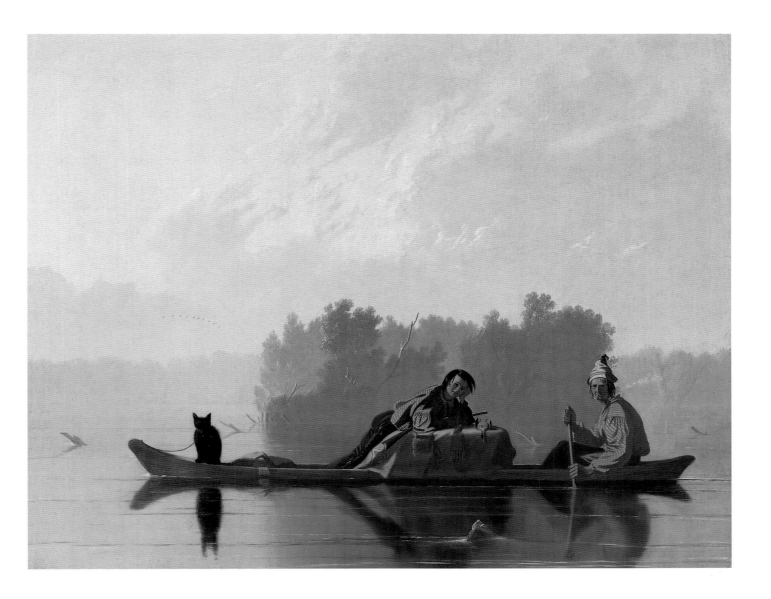

3.51 George Caleb Bingham: *Fur Traders Descending the Missouri*, 1845
Oil on canvas, 29¼ × 36¼ in. (74.3 × 92.1 cm.)
The Metropolitan Museum of Art, New York

Bingham painted another work in 1845 that many consider a companion piece to *The Concealed Enemy*: *Fur Traders Descending the Missouri* [3.51]. Catlin's writings give us an insight into the situation of fur traders in the Missouri region in the 1830s and 1840s. He was accompanied during much of his travel up and down the river and its tributaries by two French Canadian trappers, Ba'tiste and Bogard, who appear to have done most of the paddling while he steered. Catlin describes them as hardy, somewhat comical men who were skilled in the arts of navigating rivers and shooting or trapping game. The men were members of a much larger group of French Canadian *voyageurs* who first opened up the region's fur trade in the late 18th century and who continued to work the area in the early 19th century. But the expansion of American settlements and the arrival of the steamboat and other larger vessels put many of them out of business or forced them even further west. Indeed, Catlin

includes an account in his memoirs of how he rescued Ba'tiste from the difficult conditions of a "free trapper"—constant debt to the fur companies, constant attacks by Native peoples who stole his furs—by offering him a job as boatman, which Ba'tiste quickly and gratefully accepted.

The French Canadian trappers often had as companions Native American women, who bore them children. This situation is referred to in the original title of Bingham's painting, *French Trader and His Half-Breed Son*. Unlike the Osage in *The Concealed Enemy*, the young boy wears pants and a shirt, rather than body paint and feathered headdress. His hair has been cut short rather than shaved off and his rifle lies at rest beneath him

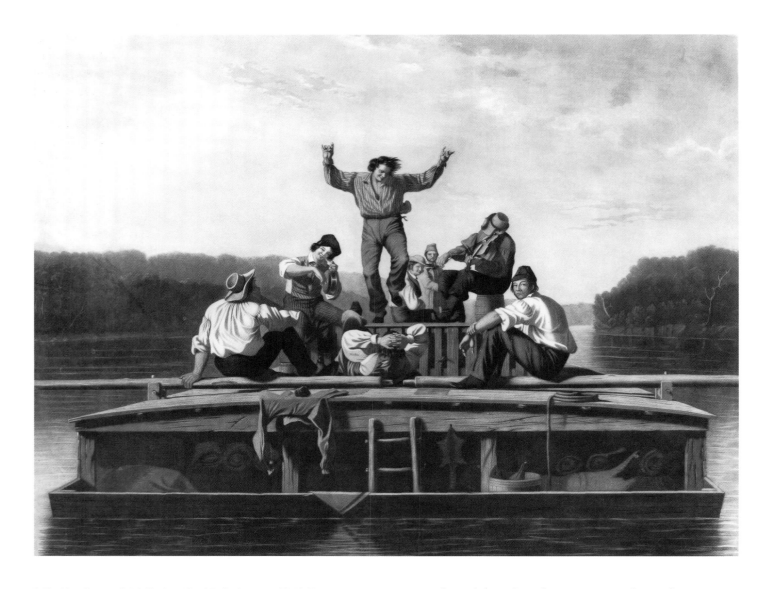

3.52 After George Caleb Bingham: *The Jolly Flatboatmen (1)*, 1847
Line engraving and mezzotint, 21 ¼ × 25 ⅝ in. (54 × 64.8 cm.)
Amon Carter Museum, Fort Worth, Texas

rather than ready for attack. He leans on the pile of furs and looks out at us, as does his father, rather than toward the river. The atmosphere is calm rather than foreboding, with the glassy surface of the river reflecting the figures in the boat.

Thus the two paintings are both parallel and different in their subject-matter. *The Concealed Enemy* suggests the presence, although diminishing, of the threat of Native Americans to westward expansion, while *Fur Traders Descending the Missouri* represents the beginning of European American commerce on the rivers of the Midwest and the resultant taming of both the indigenous peoples and the wildlife that inhabited the region (the species of the furry animal chained to the front of the boat—cat, bear cub—is still the subject of much debate).

Bingham did not limit his activities to those of an artist. In 1839 he became involved in the founding of the Whig Party in Missouri and served as a state representative in the late 1840s. He also produced painted banners for various Whig campaigns, the iconography of which, according to the art historian Nancy Rash, provided inspiration for a later series of riverboat paintings, such as *The Jolly Flatboatmen (1)* of 1846 [see **3.52**]. One of the major Whig goals of the 1840s was to obtain federal funding for the clearing of the Missouri and Mississippi Rivers. The Democratic Party argued, however, for territorial expansion, including the annexation of Texas, rather than internal improvements, and felt that states should pay for river projects. Bingham's paintings of commerce on Missouri's rivers, therefore, were the products of an avid Whig politician, who made several speeches in the 1840s in support of facilitating such commerce. The snags which appear in *Fur Traders* and several of his riverboat paintings are reminders of the dangers that

face traffic, both large and small, along these waterways (a few paintings also include steamboats that have run aground).

Fur Traders and *The Concealed Enemy* were among a group of four of Bingham's paintings purchased in December 1845 by the American Art-Union (the other two were rural scenes, the agricultural counterpart to scenes of commerce on the river). The Art-Union had been founded in 1842 as an outgrowth of New York City's Apollo Association. It was organized as a lottery and was open to anyone who paid the membership fee. The prizes were the paintings it had purchased. All members received an engraving each year made after a popular painting. In its calls for submissions, the organization encouraged landscapes or scenes of daily life in all parts of America. Thus, through the circulation of engravings of works by contemporary American artists, the Art-Union hoped to develop a taste among Americans for American art dealing with American subject-matter, while at the same time providing financial support for artists. It was enormously successful, distributing some 150,000 engravings and 2,400 paintings by more than 250 artists in the ten years that it existed. Its two publications, *Bulletin* and *Transactions*, sent to the members, were among the first journals of art in this country. In a way, its success was its downfall. Other art organizations, such as the National Academy of Design, and artists not favored by the Art-Union helped initiate a legal suit against it, which resulted in a court decision outlawing it as a lottery. After its demise, its role was taken over by its successor, the Cosmopolitan Art Association.

The fact that *Fur Traders* received the highest price of the four paintings undoubtedly encouraged Bingham to continue with his riverboat subject-matter. *The Jolly Flatboatmen* was subsequently purchased and distributed in engraved form by the Art-Union [3.52]. The popularity of these paintings was part of a growing interest in western scenes among audiences in the East, an interest undoubtedly encouraged by Catlin's Indian Gallery. Bingham's paintings differed from Catlin's, however. They celebrated not the nobility of a dying race, but the commercial and agricultural progress of a European-based civilization in the western regions.

Bryan Wolf suggests two additional levels of meaning in Bingham's paintings. *Fur Traders Descending the Missouri* re-affirmed in Missouri viewers their pride in their state and also appealed to the specialized knowledge of some—if the animal is a bear cub, it would refer to the state symbol; the canoe would call to mind the state's name, Missouri, which is a Native American word that means "people who use canoes." This same painting, and the later riverboat paintings, allowed Eastern audiences faced with increasing incidents of labor unrest in their cities—the result of the demise of the independent artisan and the rise of a system of wage labor—to convince themselves that the world of artisan and free laborer, the bulwark of republican values, still existed, in the West if not in their own back yard. Thus, the West provided a solution not only to the "Indian problem" but also to the "labor problem." Unemployed workers could go west to start a new life, rather than remain in the East and foment rebellion against those whose wealth depended on an acquiescent wage-labor force. Yet, as Catlin's description of Ba'tiste's situation indicates, one would have to travel much further west than the Missouri River to retain one's independence in the face of market forces that encouraged the consolidation of industries and the spread of wage labor.

Woman as Nature: The Nude, the Mother, and the Cook

As Elizabeth Johns notes, women seldom appear in the genre paintings of Bingham or Mount or other men who became famous in this category of painting during the antebellum period. When they do appear, they are most often tiny figures in the background, as in Mount's *Bargaining for a Horse* [3.49]. They certainly do not congregate in groups and exhibit the camaraderie of Bingham's boatmen. Instead, in the world of art, as elsewhere, women were conceived of *as* nature, both literally and figuratively. Women were seen as more "natural" because of their supposed inability to engage in sophisticated intellectual activity. They represented the body, the world of the senses and the earth, while men represented the mind, the world of art and science and industry.

Paintings from continental Europe, in particular France and Italy, often included female nudes reclining in lush landscapes, with the fecundity of their bodies depicted as equal to the fecundity of the land. Few such nudes appeared in the United States in the first half of the 19th century, a testament to the ongoing influence of Puritan sentiments and British painting traditions (depictions of nudes were rare in Britain as well) in the art world.

One that did manage to make its way into the public domain was John Vanderlyn's *Ariadne Asleep on the Island of Naxos* of 1809–14 [3.53]. David Lubin posits that the painting met with little critical success not only because of Puritan prudishness, but also because the story depicted—the seduction and abandonment of Ariadne, the daughter of King Minos, on the Isle of Naxos by Theseus, whom she has just saved from the Minotaur—did not provide a suitable metaphor for nationalist propaganda at a time when major art works were

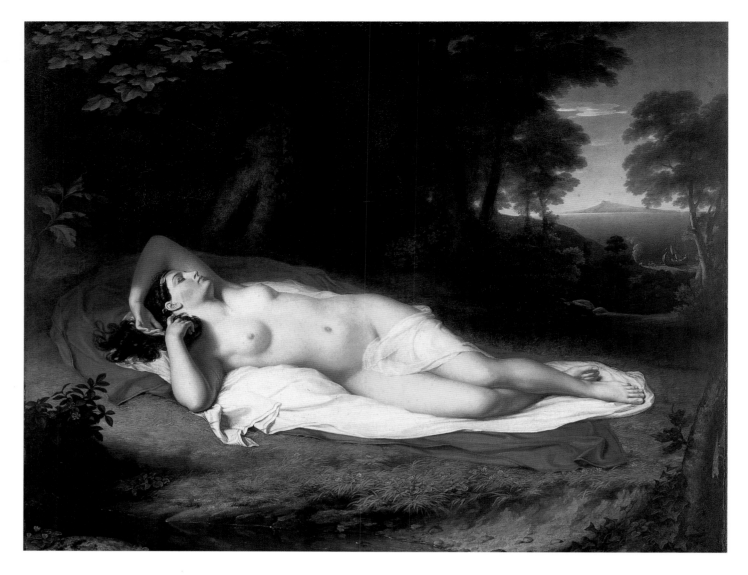

3.53 John Vanderlyn: *Ariadne Asleep on the Island of Naxos*, 1809–14
Oil on canvas, 68½ × 87 in. (174 × 221 cm.)
The Pennsylvania Academy of the Fine Arts, Philadelphia

often expected to embody just that. Neither did it portray the male hero in a very admirable light.

The genre painter who brought together women and nature in the most compelling way in the antebellum period was herself a woman—Lilly Martin Spencer (1822–1902). In her paintings of domestic scenes, the nation's natural resources often appear as fruits and vegetables, freshly picked and awaiting further transformation into the nutritious meals that were to sustain her family, the nation's present and future citizens. Spencer's parents were French socialists, who traveled first to England, then to the United States in 1830, settling near Cincinnati. Their goal had been to form a utopian colony of families, and while they never achieved this goal, they became strong supporters

of women's rights, the temperance movement, and the abolition of slavery. Spencer received encouragement from her parents in her artistic pursuits in Cincinnati (she was largely self-taught) and, after 1848, in New York. Her first year in New York she sold several paintings to the Art-Union—which became her most dependable patron, creating for her a national reputation through the circulation of prints of her works—and then to its successor, the Cosmopolitan Art Association.

This reputation was vital for Spencer, for she had to support not only herself, but also her husband and their seven children (she gave birth to thirteen, but only seven survived to adulthood). During the 1850s she produced several scenes of women in kitchens preparing meals, including *Kiss Me and You'll Kiss the 'Lasses* of 1856 [**3.54**]. Here the young woman smiles suggestively at the viewer, teasing him (anyone examining the painting at the time would most certainly have assumed that she was addressing herself to a man) and, like Mount, only more

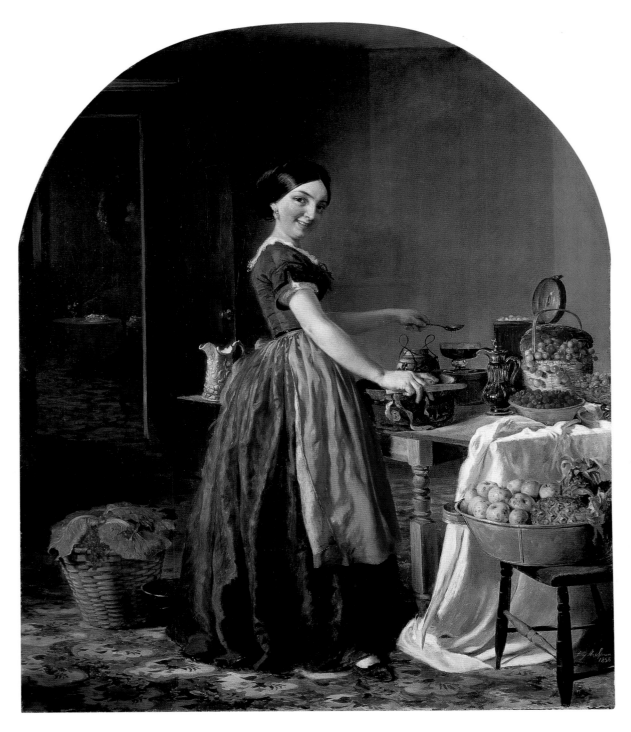

3.54 Lilly Martin Spencer: *Kiss Me and You'll Kiss the 'Lasses*, 1856
Oil on canvas, 30 1/16 x 25 1/16 in. (76.5 x 73.8 cm.)
The Brooklyn Museum of Art, New York

blatantly, making a play on words. Having just tasted the molasses ('lasses) in the pot in front of her, she warns her guest of what is in store for him if he kisses her (the lass). Like Vanderlyn, Spencer connects the fertility of nature, evident in the abundant produce in the baskets on either side of her, with the sexuality of women. Here, however, the woman is standing, not lying down. She is awake, not asleep. And she actively takes pleasure in her awareness of her own sexual attractiveness.

Kiss Me and You'll Kiss the 'Lasses was commissioned by the Cosmopolitan Art Association, which recognized the potential popularity of such an image, where sexuality is playfully suggested, yet safely ensconced in a domestic setting. As more

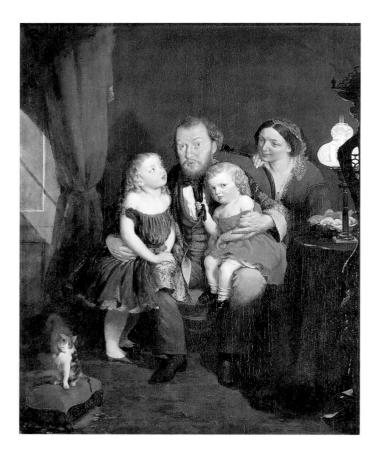

3.55 Lilly Martin Spencer: *Fi! Fo! Fum!*, 1858
Oil on canvas, 35 ⅞ × 28 ⅝ in. (91.4 × 72.4 cm.)
Private collection

herself. Women who worked in textile factories or in other women's homes were not celebrated as guardians of virtue. While Spencer presents her women in the domestic sphere, she also recognizes not only their power as sexual beings, but also the labor involved in maintaining this sphere, its importance and its difficulty. There is a tongue-in-cheek quality to *Kiss Me and You'll Kiss the 'Lasses* that would have spoken particularly to the primarily middle-class women who would have bought her prints, many of whom, like her, would have known from their own experience the pains of domestic labor, as well as the difficulties of living up to the vision of the domestic angel.

While Spencer's husband, unable to find steady employment, stayed home to help with the family and with the book-keeping aspects of her painting career, she still had to rely on her own household skills to ensure the smooth running of her home. She was thus torn between maintaining her responsibilities as a mother and as a professional artist in an art world that assumed that women could not be major painters, and that if they did paint, they must paint appropriate subject-matter, that is, domestic scenes. While she accepted certain assumptions about the proper roles for women, she also subscribed to many of the more radical demands being made by women for greater individual freedom outside of the home and for changes in the social relations within the home itself. Utopian socialists and feminists like Spencer's parents attacked the patriarchal family model, which assumed an unquestioned male authority who meted out punishment and showed little open affection. They advocated instead more communal family arrangements, with fathers as companions, and women as both workers and mothers. Others did not want to get rid of the patriarchal family altogether, but to humanize the father figure, to allow him to dispense both discipline and affection.

It was this middle version, known as the sentimental family, that Spencer celebrated in such paintings as *Fi! Fo! Fum!* of 1858 [**3.55**]. Here the father entertains his children while the mother looks on. While he is the center of attention, he is also presented in a humorous, somewhat vulnerable manner. In telling the story of Jack and the Beanstock he creates considerable anxiety in his two children, the younger of whom grabs hold of his cravat; at the same time, he reassures them with his firm embrace. Lubin suggests that when Spencer created this painting, she may have been thinking of a larger economic anxiety, one that swept the nation in the face of the Panic of 1857. In this context Jack, who exchanges the family cow for magic beans on the chance that he might make it rich, becomes the epitome of the Yankee trader, ever willing to risk his family's well-being in search of an easy fortune.

women began organizing and demanding economic and political rights—the first national meeting around women's rights was held in 1848 at Seneca Falls, New York (see p. 272)—more men, and some women, responded by reinforcing the argument that woman's "natural" place was in the home, that women were the moral center of the nation, and that the preservation of their virtue depended upon their domestic locale. The creation of a safe domestic space presided over by a loving, virtuous woman was seen as an essential antidote to the materialistic and self-interested pursuits of men in the world outside of the home.

While Spencer locates her women in domestic settings, they are often not as virtuous as many viewers might have wanted. They are a little too forward, a little too "lower-class." For the domestic angel, as she evolved throughout the latter half of the 19th century, was conspicuously middle-class. She was a sign of status for the urban man who could afford to maintain a family on his own income in relative comfort. As will become clear in a later chapter, this domestic angel was most often portrayed at rest, and while she might oversee the activities of servants, she would seldom be shown engaging in cooking or housecleaning

Nature Morte: Still Life and the Art of Deception

The Fruits of Art: The Peale Family and Still-Life Painting

Spencer also excelled in another category of painting that commented on nature transformed—the still life, or *nature morte*. As the demand for genre paintings declined in the 1860s, she found a lucrative market in the production of fruit and flower paintings [**3.56**] which, like her genre scenes, were reproduced in lithographic form and sold to a wide audience. They did not increase her reputation as an artist, however, for in the hierarchy of subject-matter determined by academies of art, still life occupied the lowest position. As early as 1669 the critic and theorist André Félibien lectured to students at the French Royal Academy:

> to the degree that painters are concerned with the most difficult and most noble things, they are separated from the lowest and most common and ennoble themselves by more illustrious work. Thus, those that do landscape perfectly are above those who only create fruits, flowers and shells. Those who paint living animals are more worthy than those who represent only dead things without movement; and as the figure of man is the most perfect work of God on earth, it is thus certain that he who acts in imitation of God in painting human figures is much more excellent than all others.

A century later, in 1770, Sir Joshua Reynolds, so prominent a figure in London's Royal Academy and an influential authority in the development of art institutions in the United States, praised still life but affirmed that, no matter how expert one might become in the production of this type of art, it should never be one's *primary* focus of attention:

> Even the painter of still life, whose highest ambition is to give a minute representation of every part of those low objects which he sets before him, deserves praise in proportion to his attainments; because no part of this excellent art, so much the ornament of polished life, is destitute of value and use. These, however, are by no means the views to which the mind of the student ought to be *primarily* directed.

The texts of Reynolds and Félibien clearly indicate why still life was relegated to the bottom rung of the aesthetic ladder: because it dealt with "low objects" and "dead things" and because it neglected the most perfect of God's creations, the human form. Thus, the disparate array of objects included

3.56 Lilly Martin Spencer: *Still Life with Berries and Currants*, c. 1859–60 Oil on panel, 8 × 12 in. (20.3 × 30.5 cm.) Ira Spanierman Gallery, New York

in still-life paintings—fruit, flowers, vegetables, tableware, dead game, cheese, bread, armor, shells, ceramic and glass containers—are brought together as a coherent category by the fact that they are all part of what guardians of high culture viewed as a lower plane of reality. This reality was above all that of the domestic sphere, the locus of the repetitive and mundane activities necessary for the maintenance of daily life, rather than the site of the heroic exploits of a larger History. It is little wonder, therefore, that women found an accepted place as still-life painters, for the home or domestic sphere was their acknowledged realm. Yet in the middle of the 19th century, even in this lowliest of art forms, those who tended to garner the greatest reputations as still-life painters were men, among the best known of whom were Raphaelle and James Peale.

Raphaelle Peale (1774–1825) was the son of Charles Willson Peale (see p. 125) and the nephew of James Peale (1749–1831). While fruit and flowers had appeared as prominent items in the portraits of artists like Copley, West and the elder Peale, Raphaelle Peale was the first fine artist in the U.S. to focus on the category of still-life painting, taking it up in the 1810s. He was followed in the next decade by his uncle James. In both style and composition their work was influenced by 17th- and 18th-century French, Dutch, and Spanish still-life paintings. It also contained the sort of allusions to the abundance of a burgeoning economy or to the transience of life that marked those European paintings.

In the United States fruit and vegetables dominated the still-life paintings of the first half of the 19th century, with flower paintings gaining popularity in the 1840s, paintings of game and fish in the 1860s, and paintings of compilations of manufactured objects at the end of the century. Raphaelle

3.57 Raphaelle Peale: *Still Life*, 1818
Oil on board, 10¼ × 15¼ in. (26 × 38.7 cm.)
Collection of Edith and Robert Graham

3.58 James Peale: *Vegetables with Yellow Blossoms*, 1828
Oil on canvas, 19¹³⁄₁₆ × 25⅜ in. (50.2 × 64.7 cm.)
The Henry Francis du Pont Winterthur Museum, Winterthur, Delaware

self-contained, and contemplative mood, and that reduces associations with the world outside of this carefully constructed pictorial space. James's paintings show a greater abundance of fruits and vegetables—allowing him to display a more wide-ranging virtuosity—and the occasional leaf or branch often extends over the edge of the shelf, providing a small bridge to the space of the viewer. He also tends to reveal blemishes or wormholes, evoking a sense of transience. In addition, James's works tend to be larger than Raphaelle's, ranging upward from 18 x 24 inches (45.7 x 50.8 centimeters), while Raphaelle's were more often approximately 8 x 10 inches (20.3 x 25.4 centimeters).

While the proximity to familiar objects of bodily sustenance in these still lifes might well elicit feelings of comfort and satisfaction, it also has the potential to create feelings of anxiety, if not alienation. The viewer is close to the fruit and vegetables, but the edge of the shelf or table clearly divides her or his space from that of the objects desired. The harsh light, while allowing the viewer to recognize the objects in all their characteristic detail, also creates a feeling of unfamiliarity, for few are used to seeing them in this particular way. In his study of still-life paintings, Norman Bryson notes that many contain a "feeling of impassiveness, of a protocol of distance." The celebration of the mundane, of the food that allows us to live, is simultaneously reassuring and disturbing, countering the sense of conviviality usually associated with food and the table by denying human fellowship, thus prompting reflections on the nature of one's membership in civil society, as well as on one's own mortality.

One of James Peale's daughters, Margaretta Angelica Peale (1795–1882), was also a still-life painter. She produced a type that falls somewhere between the work of her father and her cousin in content and composition. In *Still Life with Watermelon and Peaches* of 1828 [**3.59**] Margaretta creates a certain quietness of mood and humbleness of form that recall Raphaelle's work. The subject-matter, carefully delineated, is limited to a slice of watermelon, a plate of peaches, and a bunch of grapes. Yet Margaretta does not include all of the grapes within the space of the canvas, suggesting an abundance that is more in keeping with the work of her father and inviting viewers to partake in a feast that she clearly indicates shares the space in which they are located. Also, several of the seeds of the watermelon appear to be captured in the act of falling onto the table. Thus the still

Peale's *Still Life* of 1818 [**3.57**] and James Peale's *Vegetables with Yellow Blossoms* of 1828 [**3.58**] are representative of the first phase. Each records a selection of the foods found in the majority of homes on the eastern seaboard—apples, peaches, dried plums, nuts, squashes, eggplants, tomatoes, and beets. In both works the various fruits and vegetables are painted in a meticulous manner, with great attention to detail. They are brightly lit from one side and are located within a shallow space, between the edge of a plain shelf visible in the foreground and a blank wall behind. This meticulous detail, bright light, and shallow space force the viewer to pay attention to objects that would normally not be noticed in daily life. Pushed to the foreground, they are there for us to reach out and take. The pictures reproduce the atmosphere of the table and allude to the process of eating.

While the still lifes of Raphaelle and James Peale have many common characteristics, they also differ in certain important ways. Raphaelle tends to choose fewer objects, organizing them horizontally along the shelf, in a way that creates a restrained,

3.59 Margaretta Angelica Peale: *Still Life with Watermelon and Peaches*, 1828
Oil on canvas, 13 × 19½ in. (33 × 49.5 cm.)
Smith College Museum of Art, Northampton, Massachusetts

life as a whole is not a passive, distanced representation of human sustenance, but a work alive with the potential for conviviality, as seeds drop and hands reach out for the grapes just beyond the edge of the picture.

The sense of calm that marked Raphaelle's still lifes may well have resulted from a trip he made to South and Central America in 1793 in order to collect specimens of birds and mammals for his father's museum [2.55]. While in Mexico he may have come across Spanish still lifes of the *bodegón* type, in which the harsh light, shallow space, and limited number of forms create a sense of monastic discipline involving the contemplation of one's daily bread in an attempt to transcend its function as earthly sustenance. Raphaelle was neither a monk nor an overly religious person, yet he did capture this mood of ascetic contemplation or abstinence, a mood reinforced by the fact that both his works and *bodegón* paintings usually present the prelude, rather than the aftermath, of a meal. The greatest difference between them is that his paintings often include items indicative of the life of Philadelphia's comfortable middle class: China trade porcelain, silver spoons, cut-glass decanters and wine glasses, or pearl-handled knives with silver blades. Yet even when these items are included, they are never present in such abundance that excessive wealth is suggested. Rather, they indicate a restrained display that recalls early Puritan proscriptions against pride in one's material prosperity.

Tricking the Eye: Raphaelle Peale and the Art of Deception

While several scholars have celebrated Raphaelle's work as the first significant body of still-life painting to appear in America, few have attempted to explain exactly why he chose this much-denigrated category of painting, one that had yet to find an audience large enough to support him and his family (in 1817 two of his still lifes were purchased by the Pennsylvania Academy of the Fine Arts for $24). Some argue that it was lack of ambition that led him to fail as a portraitist, others that he succumbed to the overbearing will of a tyrannical father. Raphaelle himself left few records—what we know of him comes primarily from the correspondence of his large extended family—and no explanation.

Recently the historians Daniel C. Ward and Sidney Hart have taken up this question, looking again, more closely, at Raphaelle's relationship with his father. Charles had high hopes for his eldest son as a portrait painter, particularly after retiring from his own career in 1794 to devote himself to his natural history museum and mechanical inventions (he developed a new type of stove and innovative bridge designs). But Raphaelle did not live up to his father's expectations. "He paints in portraits the striking likeness," Charles wrote to Benjamin West in 1815, "but does not give them dignity and pleasing effects."

Although he could never totally break away from his father's world, as he was forced to remain financially dependent, Raphaelle resisted his father's agenda, and also refused to adhere to the staunch Enlightenment principles that informed the elder Peale's scientific and artistic pursuits. Charles was an ardent advocate of the powers of observation and reason. Raphaelle, on the other hand, took pleasure in the powers of deception and illusion. He became an expert ventriloquist and developed a coded language that he used in his correspondence with his brothers. Ventriloquism, or "biloquism," as Ward and Hart point out, was not simply an innocent parlor trick in early 19th-century America. "Rather, it was seen as a subversive action that undermined Enlightenment epistemology concerning the accuracy of the informing senses. In terms of the political culture of the early Republic, ventriloquism was seen as an attack on the notion of an informed and virtuous citizenry capable of making intelligent decisions based on observation." Thus, deception, illusion and coded meaning, hallmarks of both ventriloquism and much of Raphaelle's art, represented a "rejection of his father's world," a world that also represented the mainstream of American art at the time.

Raphaelle Peale's penchant for deception can be seen most clearly in two paintings, *Fruit Piece with Peaches Covered by a Handkerchief* (*Covered Peaches*) of c. 1819 [3.60] and *Venus Rising from the Sea—A Deception* (*After the Bath*) of c. 1822 [3.61]. "Deception" was the word used to describe a category of painting better known today as *trompe l'oeil*. "Deceptions" were paintings that tricked the eye into believing that what one saw was real, not a painting—the equivalent of ventriloquism. One of the earliest references to *trompe l'oeil* painting can be found in ancient

3.60 Raphaelle Peale: *Fruit Piece with Peaches Covered by a Handkerchief (Covered Peaches)*, c. 1819
Oil on panel, 12½ × 18⅛ in. (31.8 × 46 cm.)
Private collection

3.61 Raphaelle Peale: *Venus Rising from the Sea—A Deception (After the Bath)*, c. 1822
Oil on canvas, 29¼ × 24⅛ in. (74.3 × 61.5 cm.)
The Nelson-Atkins Museum of Art, Kansas City, Missouri

Greece, in a competition between two artists recorded by the 1st-century CE Roman author Pliny the Elder in his *Natural History*:

> Parrhasios and Zeuxis entered into competition, Zeuxis exhibiting a picture of some grapes, so true to nature that birds flew up to the wall of the stage. Parrhasios then displayed a picture of a linen curtain realistic to such a degree that Zeuxis, elated by the verdict of the birds, cried out that now at last his rival must draw the curtain and show his picture. On discovering his mistake he surrendered the prize to Parrhasios, admitting candidly that he, Zeuxis, had deceived only the birds, while Parrhasios had deceived himself, a painter.

In his *Covered Peaches* [3.60], Raphaelle paints a wasp crawling onto one of the peaches, thus creating two levels of deception: if the viewer recognizes the peaches as painted, she or he may still mistake the wasp as real. In *Venus Rising* [3.61], he

3.62 Valentine Greene after James Barry: *Venus Rising from the Sea*, 1771
Mezzotint, 24¹⁄₁₆ × 15⅜ in. (61.1 × 39 cm.)
Ackland Art Museum, The University of North Carolina at Chapel Hill

adds to Parrhasios's linen curtain the arm and foot of a woman. In so doing, he gives the viewer an additional, prurient reason for wanting to pull back the curtain and see what is behind. By making the woman Venus, Raphaelle moves the subject from the lascivious to what the academy deemed a higher level of aesthetic contemplation. Yet while apparently embracing this mythological subject, Raphaelle simultaneously rejects the subject, and the academic canon it represents, by not painting Venus. He may also have been commenting wryly on a gradual increase in the number of prints and paintings of naked women in the homes of prosperous Americans, who passed off their presence as a sign of cultivation rather than as an opportunity to indulge in more sensual viewing pleasures. Indeed, Raphaelle's Venus looks back to an engraving by Valentine Greene after James Barry's *Venus Rising from the Sea* of 1771 [3.62], an engraving that is thought to have been the source for a 1774 painting of Venus by Raphaelle's father. Unfortunately Charles's painting, commissioned by his Maryland patron the plantation owner Edward Lloyd, no longer exists.

Thus, Ward and Hart suggest that in *Venus Rising*, Raphaelle negates the academic system upon which his father based his whole career as an artist, as well as the corruptions of an art market his father wanted him willingly to join. Raphaelle's painting is also in stark contrast to his father's *The Artist in His Museum* [2.55], painted around the same time. As Roger Stein points out, while Charles pulls back the curtain to reveal the results of his scientific and artistic endeavors—nature transformed through the tools of painting and taxidermy—Raphaelle leaves it in place, denying the viewer access to woman-as-nature, while at the same time seemingly effacing his own efforts and thus calling into question the feasibility of a successful artistic career. Yet he is also effacing the efforts of his father to define him—literally—for it was recently discovered that beneath this painting of Venus lies Raphaelle's copy of his father's 1822 half-length portrait of him (the barely visible segment of a framed still life at the upper right and a palette and brushes at the lower left are from the original portrait). He initially simply covered the face and shoulders with the cloth, only subsequently backing away from such a direct refusal of his father's image and transforming the painting into *Venus Rising*.

Gender and the Art of Flower Painting

By the 1840s the fruits and vegetables so popular in the canvases of the Peales were being joined by all manner of flowers, artfully arranged in vases or spilling over onto the surfaces on which the vases have been set. Representations of flowers were already present in abundance in American homes in painted fireboards and furniture and in the needlework of women

3.63 Attributed to Mary Heidenroder Simon: album quilt, 1848 Appliquéd cottons, with ink work, 108 × 108 in. (274.3 × 274.3 cm.) Collection of Linda Reuther, Julie Silber/Mary Strickler's Quilt

[1.81, 1.82, 2.1]. One example of this mid-century floral abundance is an album quilt of 1848, made up of several blocks or sections each containing their own "picture," attributed to Mary Heidenroder Simon (1810–?) of Baltimore, Maryland [3.63]. What distinguishes her work from that of earlier quilters is the integration of the world of commerce and technology into its making. Her procedure, the quilt historian Elaine Hedges writes, "of supplying prefabricated blocks for which she received payment (and also of signing those blocks in a standardized script with their donors' names) suggests both the specialization of work of the new industrial world and the commercial methods of the urban merchants who were proliferating in Baltimore at the time." Often blocks purchased from Simon would be combined with blocks made by women in the family, integrating the prefabricated and the homemade. In addition, this combination of the industrial and the preindustrial worlds appeared in the subject-matter of several quilts. While most album quilts were composed of floral wreaths, cornucopias and baskets of fruit and flowers, these items were now supplemented by ships, steam engines, and urban buildings and monuments.

The flower paintings of the 1840s and 1850s were preceded by illustrations in various publications. Since the arrival of John White (see pp. 59–60), European naturalists had been recording the flora and fauna of North America in carefully worked drawings and watercolors. Their American descendants

3.64 George Harvey: *Still Life*, 1865
Watercolor on paper, 15 × 9¼ in. (38.1 × 23.5 cm.)
Private collection

continued this work. In the early 19th century another type of publication appeared: sentimental flower books, usually written by women, that combined illustrations of specific flowers with poetry, such as Sarah Edgerton Mayo's *The Flower Vase: Containing the Language of Flowers* (1848). Several included scientific descriptions and/or histories of each flower, but most were concerned with the symbolic aspects of their subject. For example, the anemone symbolized frailty, the carnation pride, the daisy innocence, and the violet faithfulness. These books were particularly popular from the 1830s through the 1850s and provided a broader access to the combined efforts of science and art.

The art historian William H. Gerdts doubts that many of the flower painters of the mid-19th century were influenced by these flower books. Rather, he argues, they looked to models from France or the Netherlands. One early flower painter, however, who was certainly aware of the books was George Harvey (see p. 162). In 1843 he exhibited five paintings in a one-man show in New York City, two of which were described in the catalogue as "A Complimentary Letter from Flora" and "For Eulogy Conveyed by Flowers." Each entry lists the flowers in the picture and their symbolic references. The first image contained hollyhock

("Aspiring"), mignonette ("Worth and Liveliness"), convolvulus ("Worth Sustained by Affection"), scarlet lily ("High Souled"), white and blue periwinkle ("Pleasures of Memory" and "Early Friendship"), and yellow jasmine ("Grace and Elegance"). Taken together, the message was: "The pleasures of memory of our early friendship, when grace and elegance were to be seen by the side of high souled worth and loveliness, causes [*sic*] me to aspire in all my actions to be worthy of your affections." Harvey's later works, including *Still Life* of 1865 [**3.64**], were seldom accompanied by such clear explications of their symbolic characteristics, but one can assume that he never completely forgot the lessons he learned from his early exposure to sentimental flower books.

One of the most successful flowers painters of the 1850s was Severin Roesen (active 1845–72), about whom very little is known. He is thought to have come to the United States from Germany around 1848, one of many painters who left Europe after the political revolutions of that year. He exhibited two floral still lifes at the American Art-Union in 1848 and another five paintings the following year. He lived in New York City until 1857, and then abandoned his family and moved to Pennsylvania, living in various towns until he finally settled in Williamsport. Nothing is known of him after he left Williamsport in 1872.

Despite this lack of information, three to four hundred works of his are known today, and undoubtedly many more have not yet been unearthed. Unfortunately, only some twenty are dated. All of his known works are still lifes, filled with fruit or flowers or combinations of both. His canvases tend to be large, like *Flowers in a Glass Pitcher with Bird's Nest and Fruit* [**3.65**], and filled with a profusion of items. "While these often gigantic paintings of literally hundreds of objects have been interpreted as standard Victorian *horror vacui*," Gerdts notes, "they are also the ultimate embodiment of mid-century optimism, representing the richness and abundance of the land, the profusion of God's bounty in the New World, his blessing upon the American Eden through this cornucopia of plenitude."

The size of Roesen's paintings may have contributed to their popularity. Rather than adding a subtle highlight to a dining room or parlor, these works dominated the room, providing both a visual and a conversational focus. His New York and Williamsport patrons may have been intrigued by his enlargement of a type of painting traditionally modest in size. In order to facilitate the continuous production of these large canvases it seems Roesen resorted to the use of templates, for individual flowers or pieces of fruit, or even whole arrangements, are often repeated in several paintings.

Templates were essential to the practice of theorem or stencil painting, which was carried out primarily by women for the decoration of their homes. The technique came into fashion in

America soon after its introduction into England from China at the end of the 18th century. (Similar stencils were used to decorate walls and furniture in the early 19th century.) Theorem painters would use several stencils to outline the basic shapes of their compositions, typically still lifes of fruit or flowers, and then add various details. *Fruit in Yellow Bowl* [3.66], painted *c.* 1840 by Mary R. Wilson, is executed in watercolor and gold foil on wove paper, the foil embellishing the dish holding the fruit and simulating the top of a table. Wilson has added a diamond pattern to the dish and has shaded the pears and painted in the spaces between the fruit to add depth. Such pictures provided symbols of nature's abundance and beauty for those who could not afford to purchase an oil painting or watercolor by a professional artist. And even for those who could, many would undoubtedly have continued to produce their theorems, as they did their needlework, for the pleasure and sense of accomplishment such work gave them.

3.66 Mary R. Wilson: *Fruit in Yellow Bowl, c.* 1840
Watercolor and gold-foil collage on paper, 10⅛ × 17½ in. (25.2 × 44.4 cm.)
Abby Aldrich Rockefeller Folk Art Center, Williamsburg, Virginia

3.65 Severin Roesen: *Flowers in a Glass Pitcher with Bird's Nest and Fruit, c.* 1867
Oil on canvas, 50 × 36 in. (127 × 91.4 cm.)
Reynolda House, Museum of American Art, Winston-Salem, North Carolina

Ornithological Paintings as "Nature Morte": Alexander Wilson and John James Audubon

While early 19th-century bird paintings are seldom categorized as still lifes in art history texts, they are included here because they represent, for the most part, *nature morte*, or "dead nature." The "founder of American ornithology," the English gentleman Mark Catesby, who taught himself etching so as to be able to produce his two-volume *Natural History of Carolina, Florida and the Bahama Islands* (1731–43), drew most of the 109 illustrations of birds there from life, but his successors Alexander Wilson and John James Audubon did not. Instead, they relied on lifeless specimens to produce their lifelike representations.

The Scottish poet and artist-naturalist Alexander Wilson (1766–1813) found inspiration not only in nature but also in the natural history museum of Charles Willson Peale, who was also particularly fond of birds. In his study of early American naturalists, Christoph Irmscher notes that there was a marked preoccupation in the 18th century with birds. This preoccupation had one of its roots in the assumption that, although "birds were in their superficial anatomy the animals most different from humans . . . their social habits often had something to teach us." Thus, observing birds could, in some manner, provide lessons for the human observer, if not a mirror image of his or her own basic assumptions about right and wrong actions. A bird building a nest was a model for human industry; a hummingbird tearing a flower or a fellow bird apart a warning of human destructiveness.

Peale's penchant for birds was also due, however, to the fact they were easier to handle than larger mammals and more effectively preserved for museum display. He ultimately gathered together a collection of over 1,600 species, many of them exhibited in the Long Room of his State House museum

quarters [2.55] in identical cases with painted backgrounds of the habitat appropriate to each bird. Wilson used Peale's collection to create drawings for his nine-volume *American Ornithology*, published in 1808–13 (three volumes were later added by Charles-Lucien Bonaparte). His *White-Headed Eagle* of 1811 [3.68], shown here in a hand-colored print engraved by Alexander Lawson (1772–1846), was based on Peale's white-headed or bald eagle, one of the few birds that have survived to this day from the artist's museum [3.67]. The differences between the stuffed specimen and the bird in the print are obvious. In an attempt to bring his subject to life, Wilson has opened its mouth, placed a fish under one of its claws, and given it a more sinister expression. He has also positioned it on a bank with Niagara Falls in the distance, thus connecting two national symbols. Yet while the viewer would undoubtedly accept as accurate the descriptive aspects of Wilson's work, he or she would also recognize the contrived nature of the image, that the eagle was most likely not drawn in this exact location.

While Wilson relied on Peale to be the executioner of the birds he drew for his *American Ornithology*, John James Audubon (1785–1851) did the honors himself. Irmscher notes that the 20th-century poet Robert Penn Warren, in response to an inquiry as to what inspired his *Audubon: A Vision*, stated: "Audubon was the greatest slayer of birds that ever lived He destroyed beauty to create beauty." Audubon was born Jean Rabin in Les Cayes, Haiti, in 1785, the illegitimate son of Captain Jean Audubon, a trader, plantation owner, and slaveholder, and Jeanne Rabin, a chambermaid from Les Touches, France. His mother died shortly after giving birth. His father, troubled by the early signs of slave insurrection on the island, took Jean back to France in 1788, subsequently adopting him. By 1803 the young man had anglicized his name, becoming John James Audubon, and left France for Philadelphia in order to avoid being drafted into Napoleon's army and to manage his father's nearby estate, Mill Grove. His managerial skills left much to be desired, and after engaging in a series of failed business enterprises, which left him bankrupt, he turned to what he called his first love, ornithology.

Audubon claimed to have studied drawing with the French painter Jacques-Louis David, a claim many historians now question. No other evidence of professional training exists, so one might assume that he, like many other American artists, was self-taught. He was obviously an excellent teacher, for his unrivaled masterpiece, *The Birds of America*, issued in 87 parts between 1828 and 1838, was an instant success, bringing him material rewards (full sets sold for more than $1,000), election

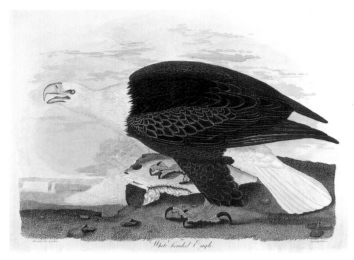

3.67 White-headed or bald eagle, from Peale's Museum, c. 1810
Ernst Mayr Library of the Museum of Comparative Zoology, Harvard University, Cambridge, Massachusetts

3.68 Alexander Lawson after Alexander Wilson: *White-Headed Eagle*, from Wilson's *American Ornithology*, 1811
Hand-colored engraving and etching, 10⅞ × 14½ in. (27.9 × 36.8 cm.)
Academy of Natural Sciences of Philadelphia, Philadelphia, Pennsylvania

3.69 (opposite) John James Audubon: *Golden Eagle Female Adult*, 1833–34
Watercolor, graphite, pastel, and selective glazing on paper, 38 × 25½ in. (96.6 × 64.7 cm.)
Courtesy The New-York Historical Society, New York City

as Fellow of the Royal Society in London, and membership in the American Philosophical Society.

In his essay "My Style of Drawing Birds," Audubon describes how he arrived at his own particular method of acquiring and posing his models:

I continued for months together, simply outlining birds *as I observed them*, either alighted or on the wing, but could finish none of my sketches. I procured many individuals of different species, and laying them on the table or on the ground, tried to place them in such attitudes as I had sketched. But, alas! they were *dead*, to all intents and purposes.

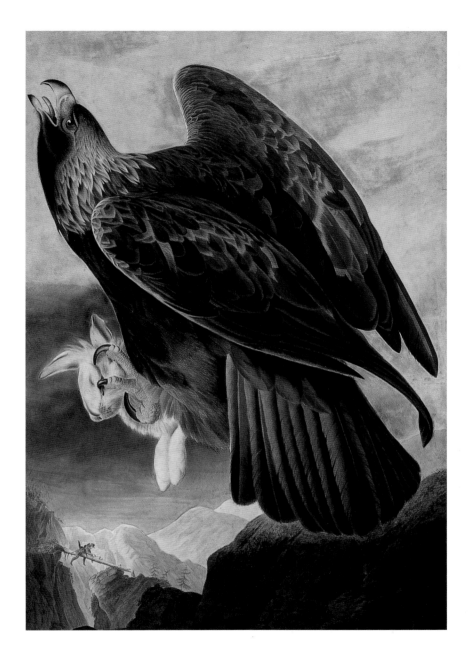

In order to breathe life back into them, he mounted the dead birds on wooden boards with wires so that he could pose them:

> I pierced the body of the fishing bird, and fixed it on the board; another wire passed above his upper mandible held the head in a pretty fair attitude, smaller ones fixed the feet according to my notions, and even common pins came to my assistance. The last wire proved a delightful elevator to the bird's tail, and at last—there stood before me the *real* Kingfisher This was what I shall call my first drawing actually from nature, for even the eye of the Kingfisher was as if full of life whenever I pressed the lids aside with my finger.

As the birds were not preserved, Audubon had to work quickly, before they decomposed. His work was made more arduous by the fact that he insisted on rendering his feathered specimens life-size, using the largest paper available to him at the time (38 x 25½ inches/96.5 x 64.8 centimeters). Those birds too large to fit upright were painted in a variety of ingenious poses. He also included natural backdrops. Audubon completed 435 watercolors containing 1,065 birds representing 489 species, which served as models for the even larger plates executed by the English engraver Robert Havell, Jr (1793–1878), who utilized a complex process of engraving, etching, and aquatint. Each plate was hand-colored in London under Audubon's watchful eye.

In his depictions of birds, Audubon often focused on the more violent aspects of their lives. Many of his works deal with death, meted out by the birds on each other or on their unsuspecting prey, as in his *Golden Eagle Female Adult* of 1833–34 [**3.69**]. Here one can see how Audubon's method far surpassed that of Wilson in presenting the illusion of "realness." The eagle has a fleshiness and flexibility impossible to achieve when working from a stiff museum specimen.

Irmscher suggests that Audubon's watercolor *Golden Eagle Female Adult* includes a portrait of Audubon himself in the lower left-hand corner, as the man making his way across a fallen tree with a dead bird under his arm and a gun strapped to his back (the figure was omitted from the engraving). Yet in an essay in his *Ornithological Biography*, Audubon tells a different story about how he came to possess the eagle depicted: he bought it alive in 1833 from Nathan E. Greenwood, a subscriber to *Birds of America*. Both attracted and irritated by the bird's noble and haughty demeanor, its "bright unflinching eye," Audubon considered letting it go, yet ultimately decided a portrait was in order. Rather than shooting it, he attempted to suffocate it by placing it in a sealed room with a pan of burning charcoal. When the charcoal didn't work, he added sulfur, and when even that failed to kill the bird (although it almost killed Audubon and his son), he pierced its heart with a long piece of steel. He then spent a fortnight, much longer than usual, drawing the bird, claiming that he "worked so constantly at the drawing, that it nearly cost me my life."

In Audubon's painting both human and animal are shown having successfully killed their prey. While the artist identified the bird in an inscription on the painting as female, he transforms it in his written account into a male, "casting the encounter," according to Irmscher, "in the terms of a heroic struggle between males." Yet the bird and the man in the watercolor are certainly not presented as equals. The eagle ascends with her prey, calling out her victory; the man balances precariously as he descends the log, head down, bird corpse under his arm. Both have their prey, but the eagle appears also to have maintained her dignity. The very inclusion of the male figure struggling in the wilderness in the composition may be a reference to the struggles Audubon engaged in to create this work, which, in his own words, "nearly cost [him] his life." Irmscher notes that this watercolor, with its tiny man and life-size bird, is "an ironic counterpoint to Charles Willson Peale's life-sized self-representation at the very center of his famous painting *The Artist in His Museum*" [**2.55**].

In his *Ornithological Biography*, Audubon describes another encounter with a female bird, a broad-winged hawk, only this time he managed to capture her alive. The bird did not resist when taken from her nest, and when brought to Audubon's

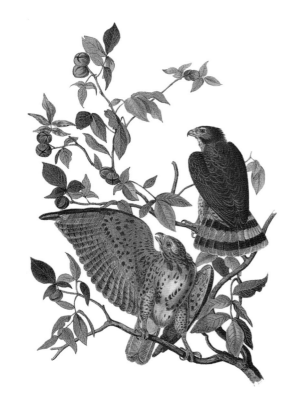

3.70 Robert Havell, Jr, after John James Audubon: *Broad-winged Hawk*, from Audubon's *The Birds of America*, 1828–38
Hand-colored aquatint, 39½ × 29½ in. (100.3 × 74.9 cm.)
British Library, London

studio seems to have willingly assumed the poses desired by the artist, as if he had already killed her and strung her up with wires [**3.70**]. The attitude of the hawk, as perceived by Audubon, was also very different from that of the golden eagle, although it achieved a similar disquieting effect: "Its eye," writes Audubon, "directed toward mine, appeared truly sorrowful, with a degree of pensiveness, which rendered me at that moment quite uneasy." According to Irmscher, the bird, in *"playing her own birdness,* at least the kind of birdness Audubon wants for his lifelike, life-sized paintings," survived her own representation and was finally set free by the artist.

If humans were to learn lessons applicable to their own lives from the actions of birds, then the message for women embedded in these two encounters between man and female bird was grim. Yet one could argue that the women who met at Seneca Falls in 1848 to initiate a movement to expand the rights of women (see p. 272) did, in fact, heed the message. Some would choose to resist male authority openly, risking their reputations, if not their lives. Others would choose to work within the system, to frame their demands within the rhetoric of patriarchy (e.g. women needed more education to be better wives and mothers) in order to ensure their own political survival.

A Nation at War

4.1 Yellow Nose (Hehúwésse), Cheyenne: *Drawing of the Battle of the Little Big Horn*, c. 1885 (see p. 243)
Pencil and colored pencil on paper, 12½ × 7¼ in. (31.7 × 18.4 cm.)
National Anthropological Archives, National Museum of Natural History, Smithsonian Institution, Washington, D.C.

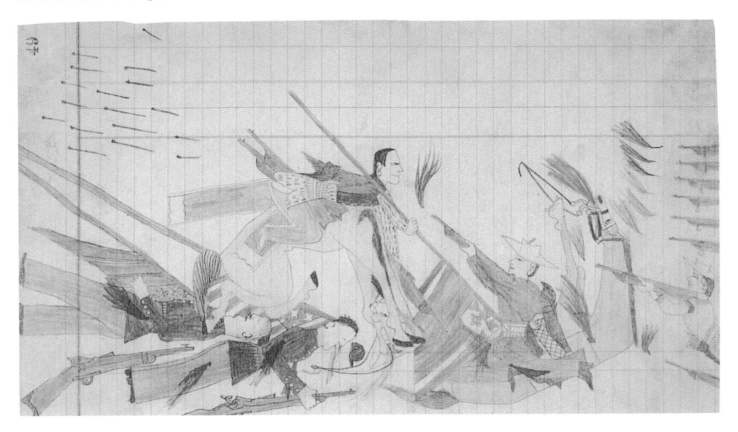

Timeline 1839–1900

1839 Rebellion of African slaves on the ship *La Amistad*, led by Cinque [4.19]

1845 Texas becomes the 28th state

1846 Territory comprising the states of Washington, Oregon and Idaho acquired by treaty with Britain; establishment of the Smithsonian Institution in Washington, D.C.

1846–48 War between the United States and Mexico [4.2]

1848 California Gold Rush; Chinese immigration begins

1850 Compromise allows California to enter the Union as a free state in exchange for strengthening of the Fugitive Slave Act

1851 Arrival of French-American priest Jean-Baptiste Lamy as first Bishop of Santa Fe, who condemns sculptures and paintings by local *santeros* [4.9]

1852 Harriet Hosmer leaves for Rome, founds colony of women artists [4.38]

1857 Supreme Court issues the Dred Scott decision, confirming that a slave's arrival in the North did not automatically result in freedom

1859 John Brown leads a raid on the arsenal at Harper's Ferry, West Virginia, as part of a planned slave revolt; mixed response to John Rogers's *Slave Auction*

1861 Winslow Homer begins work for *Harper's Weekly* as artist-reporter [4.27]; Civil War begins

1862 Publication of Matthew Brady's *Photographic Views of the War*

1863 January 1: President Lincoln issues Emancipation Proclamation; Navajo forced to move to eastern New Mexico in the "Long Walk" (allowed to return to northwestern New Mexico/northeastern Arizona in 1868)

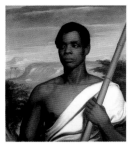

4.19 (see p. 211)

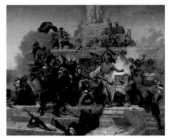

4.2 (see p. 199)

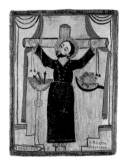

4.9 (see p. 205)

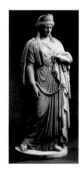

4.38 (see p. 230)

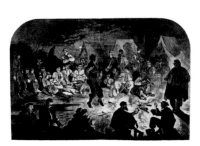

4.27 (see p. 219)

Community of female sculptors in Rome 1852–1900

Reconstruction Period 1865–77

Gilded Age 1877–1900

1865 Thirteenth Amendment to the U.S. Constitution abolishes slavery [**4.39**]; President Abraham Lincoln assassinated; Andrew Johnson becomes President; Civil War ends

1866 Publication of Alexander Gardner's *Photographic Sketch Book of the War* [**4.33**]; founding of the Ku Klux Klan

1867–68 Reconstruction Acts passed dividing the South into five military districts

1868 Massacre of Cheyenne by U.S. Army at Washita River; founding of the Hampton Institute to educate freed blacks

1870 Fifteenth Amendment to the U.S. Constitution grants African American men the vote

1875 Passage of Civil Rights Act outlawing discrimination in use of public facilities

1875–77 Creation of ledger books by Plains Native leaders imprisoned at Fort Marion, Florida [**4.49**]

1876 Defeat of General George A. Custer at the battle of the Little Bighorn

1877 Federal troops withdrawn from the South, ending Reconstruction; Hampton Institute admits Native Americans

1883 U.S. Supreme Court voids the Civil Rights Act of 1875

1889–90 Ghost Dance movement [**4.53**]

1890 December 29: Defeat of Lakota at the Battle of Wounded Knee, South Dakota

1896 U.S. Supreme Court upholds the "separate but equal" doctrine of segregation

1897 Augustus Saint-Gaudens creates memorial to Robert Gould Shaw and the all-black 54th Massachusetts Regiment

1899–1900 Frances Benjamin Johnston produces photographs of the Hampton Institute [**4.57**]

4.39 (see p. 230)

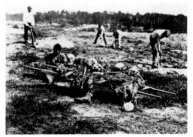

4.33 (see p. 222)

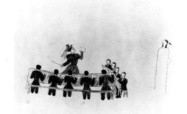

4.49 (see p. 242)

4.53 (see p. 246)

4.57 (see p. 248)

The middle decades of the 19th century in the United States were marked by heightened military conflict. Up until the 1830s, expansion westward meant battles with Native Americans, who were seen as having little legitimate claim to the territories they inhabited. But coveting the land of the newly independent nation of Mexico was another story. Here was a territory occupied not only by indigenous peoples but also by descendants of Spanish settlers. To claim it meant engaging in armed conflict with a sovereign nation. While some in the United States argued against such action, their opinions did not hold sway.

Artists had been celebrating war in their work since the colonial period. They continued to paint and draw the battles on the western frontier. But they were joined now by a new group of image-makers who claimed they were able to bring to the public more "truthful" images than those of the fine artist. These individuals drew on photography and on the development of what came to be known as the penny press to promote their careers and their version of the key events in American military and political life. Many of the works produced in the course of the war with Mexico were as much about the process of recording the war as about battles or military leaders.

It would be a mistake, however, to think that popular or commercial art and fine art occupied completely separate spheres. Often fine artists were drawn into the world of the new mass media—newspapers, popular prints, magazines. Those who worked for popular magazines also often drew upon the conventions of fine art in composing their images, while fine artists, in turn, often looked to popular culture for inspiration. Indeed, many artists who came to prominence in the fine art world in the United States in the second half of the 19th century began their careers as commercial artists and often continued to create illustrations for popular magazines after their reputations had been established. Some did so for financial reasons, others for political reasons, believing that the work of fine artists needed to be made more accessible to a larger, non-art-world audience because it would improve the aesthetic and moral fiber of the nation. In addition, the meaning of a particular image often depended upon where it appeared and by whom it was viewed. For example, a painting may have meant one thing when seen by an art critic in a gallery and quite another when seen by a female textile worker as an engraving in a magazine. Acknowledging the significance of context and audience thus helps us understand the wide-ranging and varied impact of pictorial representations.

The conflicts of the mid-century included battles not only with foreign nations and indigenous peoples but also with fellow-citizens, battles over political and economic independence that led to a bloody and devastating civil war. This created a challenge for artists. How were they to use the conventions of battle painting meant to glorify the victors and humiliate the vanquished when both the victors and the vanquished were citizens of the same nation? Where was the romance in brothers slaughtering brothers? Several artists rose to the occasion, creating images that acknowledged the complexity of internal conflict.

The War between the United States and Mexico

Learning from the Past:
Emanuel Leutze's "The Storming of the Teocalli"

In 1848, thirteen years before his grandiose *Westward the Course of Empire Takes Its Way* [3.33, 4.17], Emanuel Leutze completed a large and dramatic history painting entitled *The Storming of the Teocalli by Cortez and His Troops* [4.2]. The work is marked by an obsession with detail and a tight, naturalistic rendering of both figures and setting that implies an accurate depiction of what actually occurred. While chaos appears to reign over the mass of writhing bodies arranged on the steps of the *teocalli* or sacred pyramid, Leutze has, in fact, divided the figures, with Cortez and his troops massed on the left and the Aztec leader and his followers on the right. While the dead and dying include both Aztec and Spanish, the impending Spanish victory is indicated by their greater numbers (the soldier in the lower right suggests the Aztecs are surrounded) and by the Spaniards waving the flag on the top of the pyramid. The bravery of the Aztec warriors and the sacrifices of the Aztec priest will not be enough to stave off disaster.

Leutze patterned his painting after an episode in William H. Prescott's *History of the Conquest of Mexico*, published in 1843. Prescott was a close friend of Amos Binney, the physician and businessman who commissioned the painting. Leutze's rendition of the scene differs, however, from Prescott's account. As the art historian Ron Tyler has pointed out, Leutze problematizes the "savage Aztec/civilized Spaniard" stereotypes promoted by Prescott. While the Aztecs are shown sacrificing a young child in a religious ritual, they are also portrayed as handsome and heroic. Leutze, a Protestant, continues the pictorial tradition begun by Theodore de Bry, presenting the Spaniards as just as savage in their actions, despite their civilized dress and weaponry, as the Aztecs. A Spaniard atop the pyramid is killing a child, and for that there is no religious justification. Neither is there a reason other than greed for stealing from the dead. A dying Aztec at the extreme left refuses the last rites offered by a friar, inviting us to recognize the hypocrisy of the Catholic faith. The

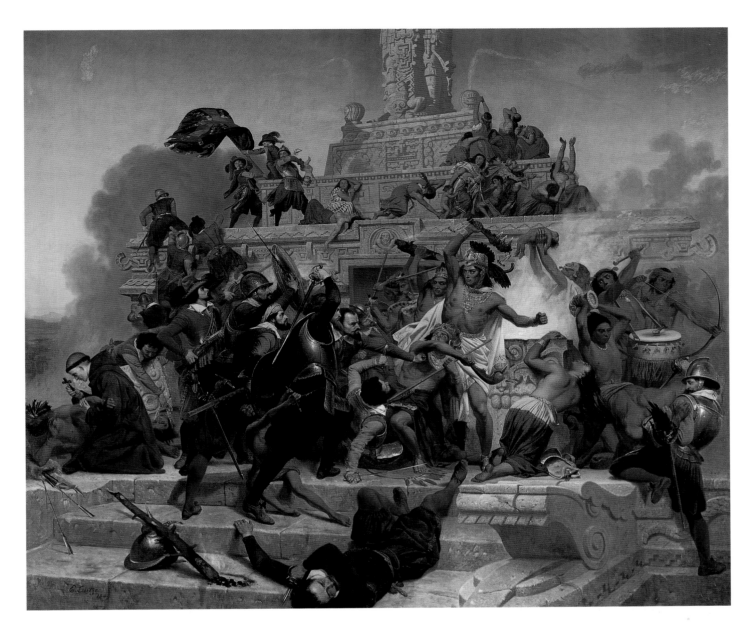

4.2 Emanuel Leutze: *The Storming of the Teocalli by Cortez and His Troops*, 1848
Oil on canvas, 84¾ × 98¾ in. (211.9 × 246.9 cm.)
Wadsworth Atheneum Museum of Art, Hartford, Connecticut

behavior of the victors caused contemporary critics to view the picture as somewhat problematic. If neither side was morally superior, then what would justify the vicious acts being committed by both?

Leutze's painting referred not only to the invasion of the Aztec empire by the Spanish but also to the more recent conflict between the United States and Mexico, begun in 1846 and brought to a close in 1848, the year of the work's completion. It also may have been informed by the revolutions taking place in Europe in 1848, particularly in Germany. Leutze, who was

born in Germany but raised in the U.S., supported these uprisings of peasants, workers, and small businessmen in their quest for a constitutional government and national freedom. He was also a strong proponent of democracy as it had been achieved in the United States. His presentation of the victorious Spaniards engaged in acts of barbarism may have been intended as a reminder to his American audience that victory in the battle with Mexico must be accompanied by democratic institutions and just treatment for those who would now become citizens of the United States.

The annexation of Mexican territory by the United States began prior to the war of 1846–48 [4.6]. New Spain's northern territories—the present states of California, Utah, Nevada, Arizona, New Mexico, parts of Colorado, Texas, and Florida—

were always the most isolated from Mexico City, the center of the colony's political, cultural, and economic life. They became even more isolated after New Spain gained its independence from Spain in 1821 and formed the sovereign nation of Mexico. The decades following 1821 were fraught with political unrest and economic crisis, and the financial support given to the northernmost territories became sporadic at best. General Antonio López de Santa Anna Perez—Santa Anna—was president eleven times between 1833 and 1855 (there were thirty-six presidents during this period). His corruption led the country to near bankruptcy, a crisis complicated by war with France.

The survival of the northern territories was facilitated in part by the Mexican government's removal of the bans on trade with outside nations, leading to the opening of the Santa Fe Trail in 1821, which allowed trade with the United States. In addition, as the residents of New Spain were about to gain independence, the Spanish crown gave permission to Moses Austin, a U.S. citizen, to colonize Texas. The main conditions were that the settlers were to be of good moral character, accept the Roman Catholic faith, and abide by the laws of Mexico. Land was to be sold for ten cents an acre, with each male colonist allowed 640 acres (260 hectares) for himself, 320 for his wife, 160 for each child, and 80 for each slave. It was not long before the immigrant population outnumbered the Spanish missionaries and civilians. With the support of the majority of this new population, and with the help of the United States government, Texas broke away from Mexico in 1836 and became the Lone Star Republic. It was brought into the Union as a state in 1845.

President Polk was not satisfied, however, with simply annexing Texas; he had his sights set on California. A Washington newspaper echoed Polk's ambitions in 1845:

> Let the great measure of annexation be accomplished, and with it the questions of boundary and claims. For who can arrest the torrent that will pour onward to the west? The road to California will be open to us. Who will stay the march of our people?

Shortly after, John O'Sullivan, the editor of the *Democratic Review*, commented: "Our manifest destiny is to overspread the continent allotted by providence for the free development of our yearly multiplying millions." Thus was coined the phrase— "Manifest Destiny"—that would be used time and again over the course of the 19th century to justify with religious fervor what was carried out through diplomacy or force.

With such pronouncements from the White House and media in Washington, it was only a matter of time before war erupted between Mexico and the United States, with the first encounter occurring on April 25, 1846, in the lower Rio Grande Valley in far south Texas. Not everyone in the United States was in favor of war. Abolitionists were concerned that it would provide a means to extend southern slave territory, a concern justified in light of the slaveholding policies of Texas. Many condemned this imperialist adventure as inimical to the legacy of the Revolutionary generation. Others were worried that the addition of large numbers of former Mexican citizens, many of whom were *mestizos* or mixed race and most of whom were Catholics, would "pollute" the purity of the U.S. population. Yet those who ultimately won out saw the war, instead, as an opportunity to extend the blessings of liberty. *The Home Journal* carried the following challenge in July 1848:

> We vanquish in order to elevate It is a divine, rather than a mortal trait, thus to exert superior force—not to appropriate a triumph, but to diffuse a blessing The duty of maintaining uninjured . . . this matchless establishment, which God and our forefathers have given us, is of infinite responsibility.

Life on the Home Front

Ambivalence regarding the war can be found not only in *The Storming of the Teocalli* by Leutze, but also in *Old '76 and Young '48* of 1849 [4.3] by Richard Caton Woodville (1825–55). Here the Revolution of 1776 and the war between the United States and Mexico are brought together in the form of two individuals, the old man seated next to the fireplace, his gaze directed downward in contemplation, and the young wounded soldier, who gestures excitedly as he relates tales of military glory to his parents, sibling, grandfather, and black household servants (the latter, as is so often the case, relegated to the edge of the composition). The old man's connection to the Revolutionary war appears in his oval portrait as a youthful member of the Continental Army, toward which the young soldier gestures, a bust of George Washington, and a framed print of John Trumbull's *Declaration of Independence*. Thus, Woodville summarizes the various ways in which this war and its aftermath had been celebrated artistically. The art historian Gail Husch notes of the the troubled old man that this "link to the glorious Revolutionary past does not, by carriage or expression, affirm victorious American exploits in Mexico." It seems that Woodville hesitated to replicate the pictorial celebrations of the American Revolution in his treatment of a war whose revolutionary goals many had called into question.

Woodville produced another painting that addressed the conflict between the United States and its southern neighbor,

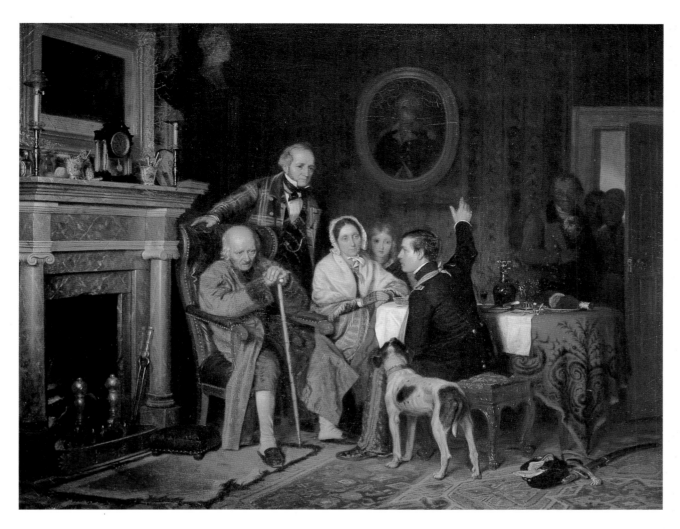

4.3 Richard Caton Woodville: *Old '76 and Young '48*, 1849
Oil on canvas, 21 × 26⅞ in. (52.3 × 68.2 cm.)
Walters Art Gallery, Baltimore, Maryland

4.4 Richard Caton Woodville: *War News from Mexico*, 1848
Oil on canvas, 27 × 24¾ in. (67.5 × 61.9 cm.)
Private collection. On loan to the National Gallery of Art, Washington, D.C.

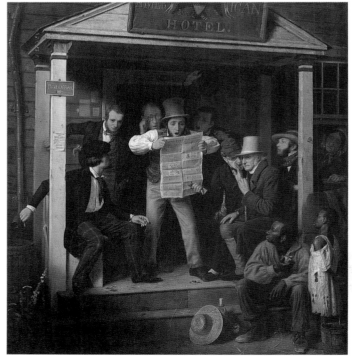

War News from Mexico of 1848 [**4.4**], exhibited at the American Art-Union in 1849. Here he focuses not on the ambiguity felt by many toward this campaign, but on how most Americans came to understand what it was all about—through reading the penny press, or inexpensive mass-produced newspapers. The war with Mexico was the first foreign war to be covered extensively by U.S. correspondents, and it soon became clear that private news-gathering institutions were more efficient than the military itself (President Polk often relied on newspapers rather than official dispatches for his information). The "eye-witness" accounts of the penny press were distributed across the country, competing with stories in local publications

and creating in the process a national audience hungry for its news.

The mass-production of newspapers grew out of advances in technology that took place in the 1830s and 1840s, most notably the development of the steam engine. James Gordon Bennett, editor of one of the first penny-press newspapers, the New York *Herald*, made use of ocean steamers to gather news from around the world and of steam-driven rotary presses to print his newspaper. He also introduced crude woodcuts based on drawings of battles. In addition, the spread of literacy in the U.S. and the constitutionally protected freedom of the press ensured a growing role for newspapers in American life. News was now becoming big business and was marketed with an eye to providing readers with accounts that could be relied upon to tell the "truth" in an objective fashion, unlike party publications whose articles were filled with political bias. Illustrations added to the sense of truthfulness of the accompanying article. Through effective marketing, which involved presenting itself as the "voice of the people" and the "defender of the public good" against growing business monopolies, the penny press defined the parameters of the war with Mexico and other events of national importance, while at the same time growing in size itself. Of course, newspaper accounts were not completely objective; rather, they were filtered through the sensibilities of those who owned the presses and circulation networks. The news reporter and editor, like the artist, became interpreters of the news.

Woodville places in the center of his painting not a soldier or a politician but a newspaper. All eyes are focused on this paper, the source of information/truth that is then relayed to those not close enough to read its print. The group of men gathered around the central figure is framed by the portico of the "American Hotel," a not so subtle indication of the symbolic dimension of the painting. The business of news and politics in the United States is also clearly represented as a white man's world, an accurate depiction of democratic practices in the United States at mid-century: at the right edge is a woman leaning out of a window, and on the steps are a black man and young black girl—all outside of the portico. All gaze at the group of white men, making us aware that, while marginal to the main action, their lives will be transformed by the events recorded in the newspaper. Slavery would become a flashpoint in the politics of territorial expansion, while the political rights of women in the country as a whole would find a voice in the Seneca Falls convention of 1848 (see p. 272).

Woodville also repeats the connection between the past and the present found in his *Old '76 and Young '48* [4.3]. The knee breeches worn by the seated old man identify him with the Founding Fathers and the American Revolution. Notices posted on the porch post and front of the hotel announce calls for volunteers to fight in Mexico and a horse sale. This reference to business dealings calls attention to what this war was all about—the acquisition of land and the expansion of business opportunities (most newspapers promoted the government's expansionist policies). Thus, Woodville's painting is a celebration not of the glories of battle, but of the business of war and of the patriotism of U.S. entrepreneurism.

Life on the Front Lines

Newspapers were not the only media making information about the war widely available. With the invention of lithography in the late 18th century in Europe, and its subsequent spread throughout the United States in the 19th century, hundreds of prints could be made with relative speed and little expense from a single stone, a drastic departure from the time-consuming processes of engraving and etching (see p. 275). Most of the important events of the war with Mexico were recorded in oversize colored lithographs. While many were patterned after stock European prints of battles or earlier published images of Mexico, several were based on eye-witness accounts, for artist-soldiers were among the first troops sent into Mexican territory.

Major Joseph Horace Eaton, General Zachary Taylor's aide-de-camp, was one of these artist-soldiers. Several of his sketches were published, most notably his *Battle of Buena Vista* of 1847, which was turned into a hand-colored lithograph by Frances Bond Palmer (1812–76) [4.5]. Eaton has carefully arranged the troops and recorded the distinctive characteristics of the terrain, indicating that his picture was as much a topographical military record as a work of art. In addition, he has positioned the viewer well above the battle, thus suggesting a full understanding, if not control, of the situation. Yet the orderliness and lack of casualties give little indication that Eaton portrayed the prelude to one of the bloodiest days of the conflict (February 23, 1847). While the United States ultimately won the battle, victory seemed far from inevitable.

W. M. Albin, a reporter in Saltillo, Mexico, south of Laredo, Texas, wrote to a friend in 1846 of his frustration with the license taken by those who created illustrations for U.S. newspapers:

> One image represents Gen. Taylor mounted on a fierce, prancing steed, in full military suit, with towering plume, huge epaulettes Those who for the last five or more years have seen Gen. T. every day, and never mounted on any other but "that same old white horse," with that same old long coat on, and glazed cap, and common soldier's light blue overalls, will be forcibly struck with the faithfulness of this picture.

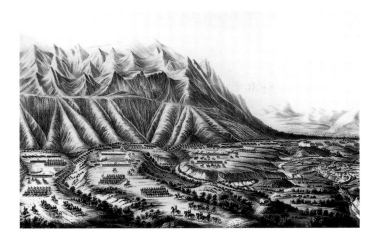

4.5 Frances Bond Palmer after Major Joseph Horace Eaton: *Battle of Buena Vista. View of the Battle-Ground of the "Angostura" Fought Near Buena Vista, Mexico February 23rd. 1847 (Looking S. West)*, 1847
Hand-colored lithograph, 19 ¼ × 29 ½ in. (48.9 × 74.9 cm.)
Amon Carter Museum, Fort Worth, Texas

That readers of the penny press expected greater accuracy or truthfulness in printed images than in painted scenes is not surprising, since those who promoted the press promised such accuracy. It is also not surprising that this promise often was not fulfilled, for those who founded the early mass newspapers soon became aware of the power they wielded in constructing a national understanding of events in keeping with their own interests. While Albin was able to detect the inaccuracy of General Taylor's representation, few had the advantage of his inside information. Those far from the battlefield relied primarily on the lithographs and news stories (supplemented

for some by letters from the front) for their understanding of the war between Mexico and the United States.

The heroic image of General Taylor that Albin found so questionable was just part of an outpouring of visual, oral, and written praise for the victorious general that buoyed his reputation and led, in 1848, the year of the signing of the Treaty of Guadalupe Hidalgo ending the war, to his election as president of the United States. That the man who conquered Mexico would now lead the country into the second half of the 19th century was a sure sign that Manifest Destiny and territorial expansion were the order of the day.

Mexican Culture as American Culture

The "Santeros" of New Mexico

The war with Mexico resulted in the addition of a vast new territory to the still-fledgling nation—present-day California, Nevada, Utah, the majority of Arizona, and parts of Colorado and New Mexico (the current states of Washington, Oregon, and Idaho were acquired by treaty with Great Britain in 1846) [4.6]. This territory was already populated by individuals who, prior to 1848, had been Mexican citizens. Most chose to remain in their homes, hoping they would be treated fairly as part of the American democratic experiment. While their hopes were often dashed by corrupt and intolerant U.S. government officials and settlers (by 1858 almost 90 percent of New Mexicans had

4.6 Territorial growth of the United States from 1776 to 1912

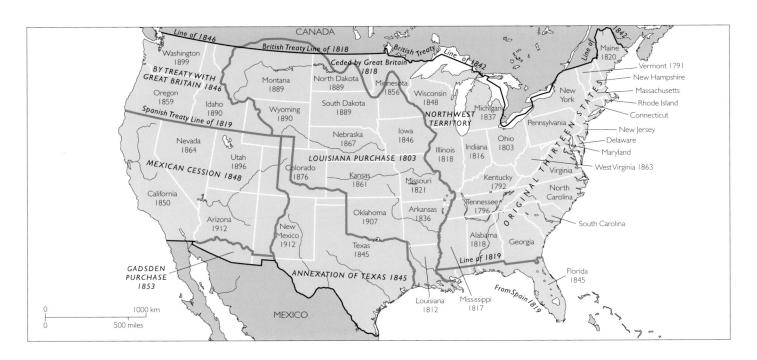

lost their land), they managed to keep a presence in the region, working what was left of their farms, ranches, and businesses and maintaining their cultural and religious practices.

As indicated earlier, religion played a central role in the lives of those who colonized the northern frontier of New Spain. Roman Catholicism, unlike Protestantism, thrived on lavish visual displays, and sparsely populated communities were often brought together through the numerous celebrations honoring Christ, the Virgin Mary, and various saints. Family life was also organized around daily religious rituals, with images of saints and Jesus adorning family altars. While the paintings and sculptures created for these ceremonies and altars were modest compared to their counterparts in Mexico City, they embodied the region's attempt to continue both the religious traditions of Spain and Mexico and the unique visual tradition that had begun to take shape in the region in the 17th century.

While it had been part of Mexico, the territory ceded to the United States was so distant from the cultural and political center that it developed and maintained a strong sense of separate identity. This isolation, according to the art historian Keith McElroy, led to the emergence of a local art tradition that was more than simply the awkward copying of the art of Mexico City by untutored craftspeople. Paintings, prints, and sculpture from Mexico and Spain provided the models for much of what was produced locally. Yet *santeros*, the artists who produced the numerous images of saints, also, McElroy believes, made conscious choices to reject or add elements to their work. In particular, they maintained a certain lack of finish and abstraction of the human body that is in marked contrast to the highly naturalistic religious art of Mexico's urban centers.

The subject-matter chosen by the *santeros* reflected the tastes of both Mexico City and regional communities. Most popular were single figures of saints in landscape or interior settings. In accordance with the mandate of the Council of Trent, convened by the Roman Catholic Church in the mid-16th century in response to the Protestant Reformation, depictions of the Holy Family and the humanity of Christ were emphasized, with numerous images of the Virgin, the Crucifixion, the Christ Child, and St Joseph. John Nepomuk [1.22], canonized in 1729, was also popular because he was the patron saint of confession and secrecy (he was martyred for refusing to reveal the secrets of the confessional) and was favored by the numerous lay confraternities who were major patrons of the *santeros*, commissioning many works for their *moradas* or chapels (more will be said about these confraternities later).

Two early 19th-century *santeros* who have attracted the attention of scholars and collectors are Pedro Antonio Fresquís

(1749–1831) and Rafael Aragón (*c.* 1795–1862). Much of Fresquís's work is marked by a light, delicate patterning and shallow space, attributable to the influence of popular prints from Mexico which, in turn, were influenced by textile patterns from India and Southeast Asia. Mexican trade with the East had increased throughout the 18th century and was visible not only in religious paintings but also in textile and tableware designs. This patterning is clearly apparent, particularly in the elaborate borders, in Fresquís's *Crucifixion with the Virgin of Sorrows* [4.7] and *St Inez* [4.8], both painted in the late 18th–early 19th century. Also apparent are an asymmetrical arrangement of figures and a somewhat fantastic rendition of towering plant forms. The prominent role of plant forms, often indigenous, in depictions of saints by Fresquís and others suggests another manner in which Native and Christian spiritual traditions are combined: the power of the saint is supplemented by the healing powers attributed to particular plants in indigenous rituals.

These whimsical, highly detailed, and ethereal compositions stand in stark contrast to the bolder, abbreviated forms and symmetrical compositions of Rafael Aragón, as seen in his

4.7 Pedro Antonio Fresquís: *Crucifixion with the Virgin of Sorrows*, late 18th–early 19th century
Wood, gesso, and water-based paint
Spanish Colonial Arts Society Collection, Santa Fe, New Mexico

4.8 Pedro Antonio Fresquís: *St Inez*, late 18th–early 19th century
Wood, gesso, and water-based paint
Spanish Colonial Arts Society Collection, Santa Fe, New Mexico

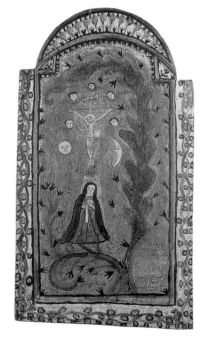

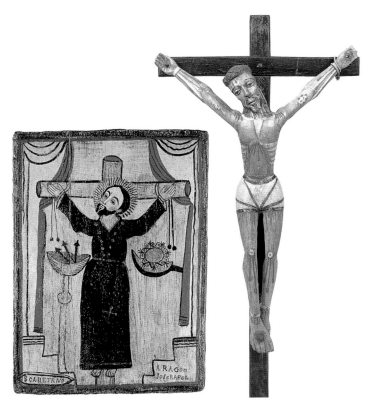

4.9 Rafael Aragón: *St Cajetan, c.* 1830–50
Wood, gesso, and water-based paint, 11 × 8 in. (27.9 × 20.3 cm.)
Spanish Colonial Arts Society Collection, Santa Fe, New Mexico

4.10 Rafael Aragón: *Crucifix,* early–mid-19th century
Wood, gesso, and water-based paint
Spanish Colonial Arts Society Collection, Santa Fe, New Mexico

works can be seen as regional commentaries on the more sumptuous triumphal chariots of Death that appeared in images of the elaborate religious ceremonies of Renaissance and Baroque Europe.

The festivities of Holy Week, the most important of the religious calendar, were often organized and led by local lay confraternities. Associations of this type had a long history within the church. In the 13th century, after the foundation of the Franciscan order, men and women who wanted to follow a rule like that of the friars, yet who were married and had families or other secular obligations, became organized into a "Third Order" (friars constituted the First Order, nuns the Second). Gradually the other mendicant orders also founded organizations of Tertiaries. Regulations for conduct included simplicity of dress, daily prayers, confession and communion, fasting, and charitable work. Lay confraternities that were not formally associated with orders also arose. Often they had quite specific purposes, such as devotion to a particular aspect of Christ or the Virgin Mary or to the accomplishment of certain charitable activities.

Franciscan Tertiaries, as well as several lay confraternities, existed in New Mexico by the middle of the 18th century. Their most important tasks included caring for local churches or

4.11 José Benito Ortega: *Death Cart, c.* 1875–1907
Cottonwood, pine, willow, gesso, water-based paint, glass, fabrics, buckskin, and iron
Spanish Colonial Arts Society Collection, Santa Fe, New Mexico

St Cajetan of the early 19th century [**4.9**]. His otherwise static works are enlivened by the delicately tilted heads of the figures and the highly animated, snake-like lines of the halos. Aragón also created wooden sculptures, or *bultos.* The elongated legs and arms, enlarged head, highly schematized or abstracted facial features, and brightly painted streams of blood give his early–mid-19th-century *Crucifix* [**4.10**] an expressive quality often missing in works whose makers were concerned more with exact naturalistic rendering. It may well have been this emotional immediacy, so clearly conveyed in both color and form, that made these works so popular with their audiences.

Dramatic religious sculptures such as Aragón's *Crucifix* were common in the American Southwest in the 19th century. They played prominent roles, along with skeletal figures of Death, in Holy Week reenactments of the Descent from the Cross and Burial of Christ. Death figures often appeared seated in simple wooden carts and dressed in women's clothing, as in José Benito Ortega's *Death Cart* of *c.* 1875–1907 [**4.11**]. Such

chapels, sponsoring religious ceremonies and festivities, and providing for the spiritual and physical needs of their members and those of the larger community. They came under attack, however, after 1821, when a new and decidedly anticlerical republican government came to power in Mexico City. Its classical liberalism, which placed primary emphasis on the rights of the individual and the creation of a modern nation state, was inimical to the welfare of the Catholic Church: laws were soon enacted to remove much of the non-religious power of the clergy, and to divest the church of its vast land-holdings. The new government also went after the communal lands of local towns and villages. The confraternities came under particular attack, for in addition to organizing many of the public religious festivals they also administered the communal landholdings.

The remoteness of New Mexico and other northern territories protected the church to a certain extent from these laws. New Mexican authorities resisted orders from Mexico City to divest the Franciscans of their control over the missions, which would have removed the Pueblo lands surrounding the missions from protection under Spanish law and thus opened them up to confiscation by local landholders. Similarly, attempts to destroy the lay confraternities met with little success. While they could no longer sponsor public religious ceremonies, which had been banned by the Mexican govern-ment, and while their Franciscan mentors had been expelled from New Mexico and replaced by secular clergy (priests who do not live under the rule of a religious order), confraternities went underground, maintaining religious practices and com-missioning images from local *santeros*.

Confraternities also provided local resistance to changes brought to New Mexico from the United States. The settlers who came to the region from 1846 on brought with them an even stronger commitment to classical liberalism and the primacy of individual initiative. They set up competing Protestant religious institutions, whose leaders condemned and ridiculed the practices of Catholicism, with their display of "crude" and "vulgar" images. In addition, in 1851 the French-American Catholic priest Jean-Baptiste Lamy arrived as the first Bishop of Santa Fe. Pro-American and anti-Hispanic, he held local religious imagery in contempt, imported prints and plaster statuary to replace it, and built a new cathedral of stone—common in his native France—rather than adobe. Such was the strength of local religious practices, however, and their integration into the lives of Spanish New Mexicans, that no amount of condemnation and ridicule could destroy their power. While the *santero* school declined after Lamy's arrival, it did not disappear, thanks in large part to the confraternities.

The Local and the International: New Mexican Furniture and Textiles

The Mexicans who inhabited the Southwest also had a rich and fully developed secular culture, marked by imaginative furniture design and textiles. As with the religious imagery, the furniture remained relatively unaltered in form over several centuries, relying on 16th-century Spanish prototypes. Change is found primarily in the carved decoration. The pieces were simple in design and highly portable, consisting primarily of boxes, chests, chairs, benches, tables, cupboards, and shelves. Chests were by far the most common item: families often owned several, using them for storage, as supports for boards for dining or sleeping, or as surfaces on which to write or sit. In New Mexico the only wood readily available for furniture-making was local pine, which imposed certain restrictions. Pine tends to split in straight lines along the grain, so pieces are typically rectilinear, with simple carved decoration.

Three main types of chest were constructed in the 18th and early 19th centuries: board chests, made of six boards fitted together with dovetail joints and pegs; more complicated framed chests, consisting of panels set into a framework of rails and stiles with pegged mortise-and-tenon joints; and false-framed chests—the first type disguised as the second by applied strips of molding. One late 18th- or early 19th-century board chest [4.12] is covered by painted geometric designs, which include the stepped-fret motif, a reference to either the Pueblo Indian cloud-terrace motif or the Moorish stepped and bracketed designs found on Mexican and Spanish furniture from the 16th through 19th centuries. Families also imported furniture from Mexico, in particular from the area of Michoacán. Many examples of the latter were brightly painted with elaborate floral designs [4.13].

Visitors, particularly those arriving from the eastern United States in 1846 and after, frequently remarked upon the lack of

4.12 Anonymous, from New Mexico: board chest, late 18th–early 19th century
Pine, gesso, water-based paint, iron hardware, W 29 in. (73.7 cm.)
Spanish Colonial Arts Society Collection, Santa Fe, New Mexico

furniture in people's homes. Yet often what was lacking was furniture of a familiar type. In *El Gringo, or New Mexico and Her People* (1856) W. W. H. Advise writes of New Mexican interiors:

> Few chairs or wooden seats of any kind are used, but in their stead mattresses are folded up and placed around the room, next to the wall, which, being covered with blankets, make a pleasant seat and serve the place of sofas. This is an Eastern custom, and was undoubtedly borrowed from the Moor The females in particular, prefer the easy *colchón*—folded mattress—to the straight and stiff-backed chairs and settees; and frequently they spread a single blanket in the middle of the floor, upon which they sit at work and receive visitors.

The mattresses often functioned as couches by day and beds by night. Another Anglo-American, Susan Magoffin, described the Santa Fe home of the wealthy Gaspar Ortiz family in 1846,

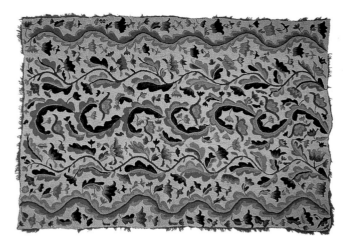

4.14 Anonymous, from New Mexico: *colcha*, late 18th–early 19th century Hand-spun, handwoven *sabanilla* cloth with undyed and vegetal-dyed wool yarn and possibly Manchester yarn
Spanish Colonial Arts Society Collection, Santa Fe, New Mexico

"one of the best in the city The long salon to the front is the sitting room. This is furnished with cushions, no chairs, two steamboat sofas, tables, a bed, and other little fixtures."

A wide array of textiles, made locally or imported from Mexico or Asia, provided a wealth of color in New Mexican homes. Blankets and shawls were found in abundance, draped over cushions and mattresses; sometimes even the floors, particularly in the *salón de recibo* or parlor, were covered wall-to-wall with a cloth known as *jerga*, roughly woven most often in a checkerboard pattern using natural white and brown combinations or vegetal dyes. During the 1860s commercial dyes were introduced, resulting in *jergas* containing brighter colors.

When the first Spanish settlers arrived in New Mexico, they found the Pueblo peoples weaving fine cloth of cotton and vegetable fibers on vertical looms. The Spanish brought with them their own textiles and, more importantly, herds of *churro* sheep, which adapted well to the high desert terrain. By the early 19th century, hundreds of thousands of these sheep existed throughout the Southwest and wool replaced cotton among the Pueblo peoples and the Navajo, except for certain ceremonial attire.

While Native peoples had their own weaving traditions, the friars who came into the area also trained those who lived near the missions to use European treadle looms. The friars then set up several workshops using a mixture of forced Native labor and Spanish workers to produce textiles for trade not only within the territory of New Mexico but also with neighboring Mexican states to the south. Many of the woven and embroidered *colchas* or bed coverings produced in the region came from these workshops. Some show the influence of textiles imported from India, with their elaborate floral patterns [4.14].

4.13 Anonymous, from Mexico, probably Michoacán: writing chest, 18th century Hardwood, gesso, paint, gold leaf, iron hardware, W 31 in. (78.7 cm.)
Spanish Colonial Arts Society Collection, Santa Fe, New Mexico

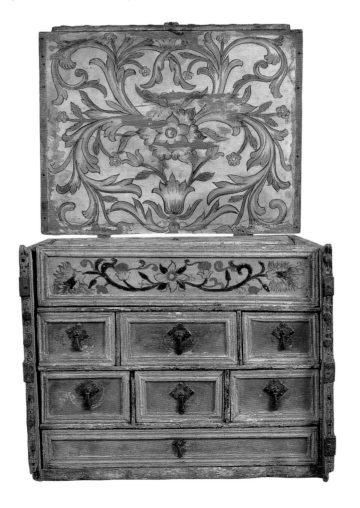

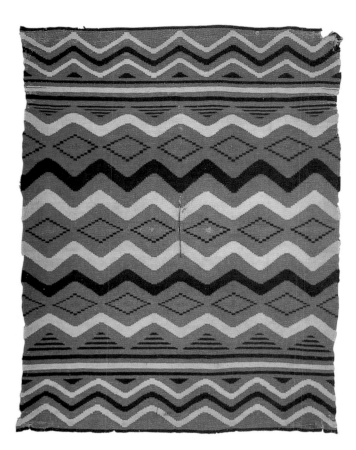

4.15 Anonymous, Navajo: *sarape*, c. 1825–60
Hand-spun undyed and vegetal-dyed wool, 69⅜ × 52½ in. (176 × 133.4 cm.)
National Museum of the American Indian, Smithsonian Institution,
Washington, D.C.

herds of sheep destroyed, they were forced to adapt to a new economy of factory-processed yarns and chemical dyes.

Sarapes from the town of Saltillo in northern Mexico were also in great demand in New Mexico and prized for their beauty and high quality. Woven in two matching vertical panels, then sewn together, they were most commonly marked by a central diamond shape, often composed of several smaller diamonds surrounded by serrated concentric bands, with a decorative border echoing the colors and motifs of the central diamond [4.16]. Many of those who produced 19th-century Saltillo *sarapes* were descendants of the

4.16 Anonymous, from Saltillo, Coahuila, Mexico: *sarape*, late 18th–early 19th century
Hand-spun undyed and vegetal-dyed wool
Spanish Colonial Arts Society Collection, Santa Fe, New Mexico

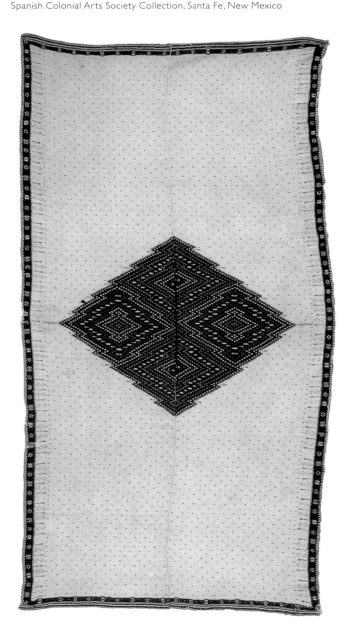

The blankets and *sarapes* or ponchos in New Mexican homes were often marked by a series of zigzag stripes and diamonds, a pattern popular with Navajo weavers [4.15]. This design had appeared earlier in Navajo basketry patterns and was then adapted to woven blankets. The Navajo are thought to have taken up weaving in the latter half of the 17th century, adopting the wide upright loom of their Pueblo neighbors. Yet in Navajo culture the women did the weaving, while in Pueblo culture it was the men. Navajo weavings soon became part of a vast trade network that stretched south into Mexico and east into the Great Plains. The period between the 1820s and the 1860s is often described as the Classic period in Navajo weaving, which was brought to an end in 1863 by what became known as "The Long Walk." In order to counter indigenous attacks on settlers moving onto Native lands, the U.S. government forced thousands of Navajo to march to Bosque Redondo in eastern New Mexico. Five years later they were allowed to return to a much smaller territory within their original homelands in northeastern Arizona and northwestern New Mexico. Their

Tlaxcalans, allies of the Spaniards in their war against the Aztecs (see p. 24). They had been sent into the region as colonists in 1591 to help subdue hostile indigenous peoples and thus enable the establishment of silver mines by the colonial government. They settled in the town of Saltillo and were granted a special *barrio* or neighborhood, San Esteban de Nuevo Tlaxcala. Tlaxcalan men had already gained a reputation as skilled weavers among the Spanish in central Mexico (they had been taught the craft by the Otomí, with whom they had intermarried) and continued this activity in their new northern home, combining their old practices with new Spanish designs, materials, and technology.

The form of the *sarape*—a rectangular blanket with a vertical slit for the head and open at the sides—may have originated in the indigenous *manta*, for such garments did not exist in Spain. After Mexico gained independence from Spain in 1821, the *sarape* became a prominent nationalist symbol, a requisite part of the costume of the *vaquero*, the Mexican counterpart of the American cowboy.

In addition to textiles from the friars' workshops, Navajo blankets, and Saltillo *sarapes*, New Mexican homes might contain embroidered silk shawls from China and the Philippines, evidence of a cosmopolitan taste that would soon expand to include the new textiles and furniture brought into the area from the United States by tourists and businessmen. New dyes and tools would also aid in the transformation of local traditions of textile production, while the designs of Navajo and Mexican weavers and embroiderers would find their place in drawing rooms throughout the nation in the following century.

Prelude to the Civil War: Representing African Americans and Slavery

When Leutze's *Westward the Course of Empire Takes Its Way* appeared in the Capitol in Washington in December 1862 [4.17], there were certain significant changes from the oil study of 1861 [3.33]. One was the addition of symbols of mining, hunting, and agriculture. Another, and perhaps the most important, was the inclusion of a black man in the center foreground leading a white woman and child on a mule.

Leutze had received his Capitol commission in June 1861, shortly after the opening salvo of the Civil War. One hotly debated issue at the time was whether or not slavery should be extended into the new territories. Secretary of War Simon Cameron, who approved Leutze's initial study, was an expansionist opposed to the emigration of blacks into the western territories. By including a black man in such a prominent position, Leutze (whose pro-abolitionist sentiments were well known) suggests that blacks, as well as whites, might experience a new freedom in the West. The presence of the woman and child on a mule creates a parallel between the flight of the Holy Family from persecution at the hands of Herod and the opening up of the West. Leutze thus provides

4.17 Emanuel Leutze: *Westward the Course of Empire Takes Its Way*
(*Westward Ho!*), 1861–62
Mural, 20 × 30 ft. (6 × 9 m.)
United States Capitol, Washington, D.C., House wing, west stairway

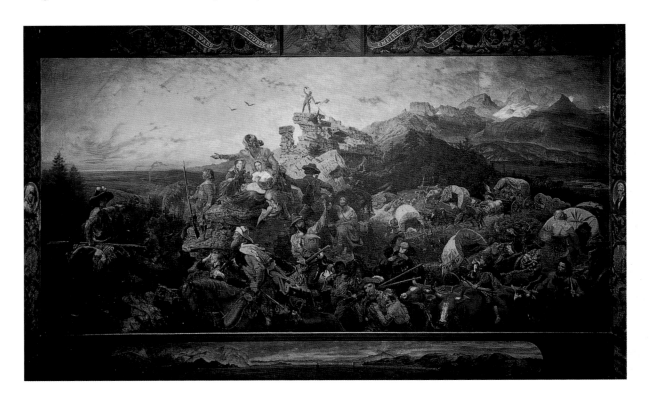

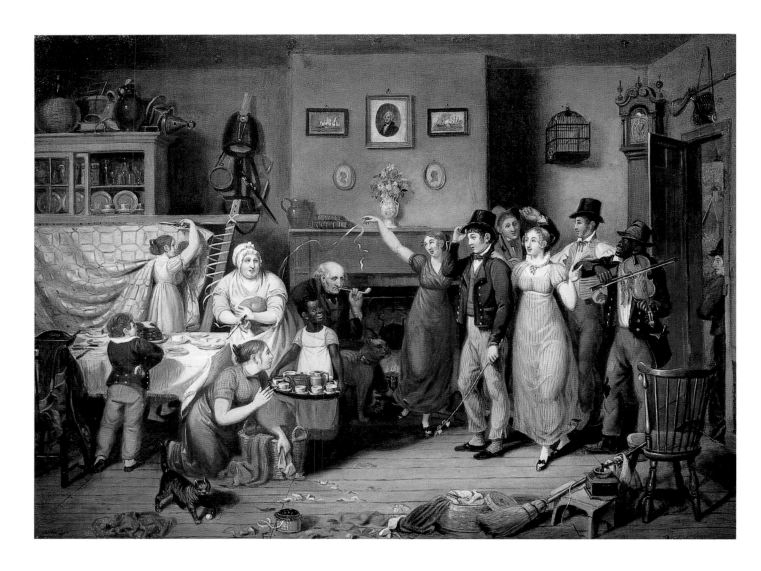

4.18 John Lewis Krimmel: *Quilting Frolic*, 1813
Oil on canvas, 16 ⅞ × 22 ⅜ in. (42.8 × 56.8 cm.)
Henry Francis du Pont Winterthur Museum, Winterthur, Delaware

another gloss on the theme of Manifest Destiny, one marked by the morally charged arguments of the abolitionist movement.

As the historian Lerone Bennett, Jr, has noted, "America, contrary to the generally accepted view, is an African as well as a European invention." African slave labor made possible the growth of a plantation economy in the South in the 17th and 18th centuries, while African American wage labor contributed to the expansion of industrialization in the second half of the 19th century. Some European Americans attempted to justify the enslavement and exploitation of Africans and African Americans through visual and written representations of them as either childlike and in need of care, or savage and in need of disciplining (they were not, however, like Native Americans, "doomed to perish," for their labor was central to the country's economy).

Yet the Civil War forced a re-evaluation of the image of black men and women in American culture. Prior to the 1860s the dominant 19th-century stereotypes of black men were silent servants, situated on the margins of the composition [e.g. **4.3**], or high-stepping, banjo-playing "darkies," happy and childlike, who, when not working contentedly in the fields, performed either for their families or for their white owners. Black women were "mammies," protective of their white charges and proud of their place as servant, maid, and nanny within the white household. Enslavement was seen as "good" for Africans, for it domesticated inherently "savage" people: to free them would actually do them a disservice, for they would lose their childlike innocence (whether acquired or innate) and revert to savagery.

Such stereotypes appear in John Lewis Krimmel's *Quilting Frolic* of 1813 [**4.18**]. Krimmel (1786–1821) was born in Germany and studied with the genre painter Johann Baptist Seele before coming to the United States in 1810. He was also an admirer of

the works of the British artists William Hogarth and David Wilkie and, like them, recorded the looks and foibles of the peasant, merchant, and artisanal classes. *Quilting Frolic* contains a detailed inventory of the belongings of a middle-income household. The paintings on the wall—a portrait of Washington flanked by two maritime scenes, one of which involves a battle—attest to the cultured and the patriotic character of the inhabitants. Other objects hanging on the walls or resting on the tops of cupboards indicate the social status and lineage of the family. The black servant girl and the black fiddler underline this family's social status, the girl through her role as a servant and the fiddler through his shabby clothing, which contrasts so markedly with the finery of the white figures next to him. According to the art historian Guy McElroy, Krimmel was among the first "to utilize physiognomical distortions [toothy grins, oversized lips] as a basic element in the depiction of African-Americans; his comic portrayal was probably meant to establish a good-natured humorous scenario, but it profoundly reinforced developing ideas regarding the humorous, even 'debased' appearance of African-Americans."

The Abolitionist Movement and the Challenging of Stereotypes

While the stereotypical depictions of African Americans produced by Krimmel and others dominated the art world in the first half of the 19th century, they did not go totally unchallenged, particularly after the establishment of the American Anti-Slavery Society in 1833. Led by both African Americans and European Americans, it joined African American anti-slavery organizations such as the Free African Society, founded in 1787, and the General Coloured Association, founded in 1826. It became one of the key organizations in the American abolitionist movement, flooding the southern slave-holding states with literature and lobbying throughout the country for an end to slavery. The abolitionist movement was fueled by the rise of evangelical religion in the 1820s, which called for an end to sinful practices and allowed African Americans to enter its ranks. Abolitionists also used the charges of political hypocrisy that had been leveled at the rebel revolutionaries by the British at the end of the 18th century: how could revolutionaries claim independence in the name of freedom and liberty when they themselves were enslaving a whole race of people? Many artists and writers belonged to the movement or were inspired by its efforts, and translated its messages into painted or written form.

One of these artists was Nathaniel Jocelyn (1796–1881). Initially trained as an engraver, he turned to painting in 1820 and became well known as a portraitist in the New Haven area of Connecticut, although he returned to engraving at the end

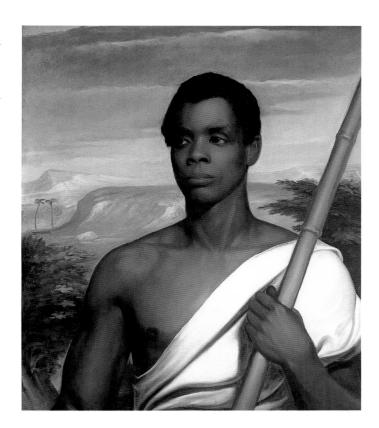

4.19 Nathaniel Jocelyn: *Cinque*, 1839
Oil on canvas, 30¼ × 25½ in. (76.8 × 64.8 cm.)
New Haven Colony Historical Society, New Haven, Connecticut

of his career after a disastrous studio fire. In 1839, he was commissioned by the black abolitionist Robert Purvis to produce a large oil portrait entitled *Cinque* [4.19]. It commemorated an event of that year in which Cinque, one of fifty-three men and women captured by Spanish slavers in the Mendi region of Africa, sold in Havana, and being transported to Puerto Rico, led a rebellion on the ship *La Amistad*. While Cinque and the others demanded that the ship return to Africa, the crew altered its course at night and managed to bring it ashore on Long Island. Local authorities arrested the mutineers and freed the crew, but abolitionists defended the cause of the mutineers, and after two years of legal proceedings, the Supreme Court ruled the Africans had been illegally seized. Cinque and his compatriots toured the Northeast, appearing at numerous anti-slavery meetings, before returning to Africa in 1841.

In place of the physiognomical distortions used by Krimmel in his depiction of the black fiddler [4.18], Jocelyn has produced a highly individualized, noble portrait of an African man. Jocelyn's abolitionist sympathies no doubt played a major role in his decision to depict Cinque in this manner, but he was also undoubtedly influenced by the numerous accounts of Cinque's

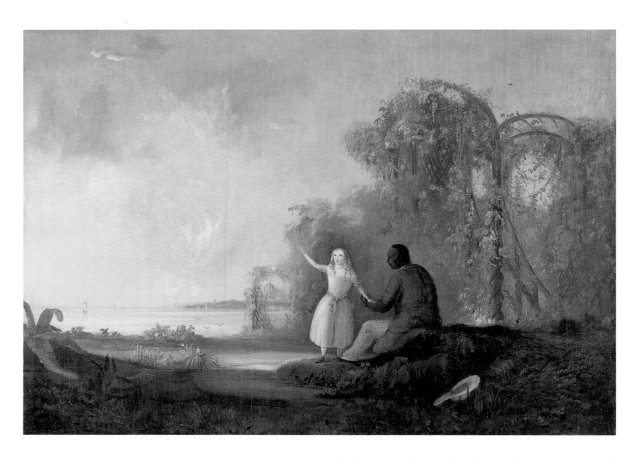

4.20 Robert S. Duncanson: *Uncle Tom and Little Eva*, 1853
Oil on canvas, 27¼ × 38¼ in. (69.2 × 97.2 cm.)
The Detroit Institute of Arts, Detroit, Michigan

activities in the popular press that included descriptions of him as "of magnificent physique [and] commanding presence." Phrenologists had carefully analyzed Cinque's head in an attempt to understand his daring behavior and had reported that its shape indicated "great vigor of body and mind . . . ambition, independence . . . love of liberty." Such curiosity suggests that, despite accounts of numerous rebellions on board slave ships, many European Americans still assumed that "ambition," "independence," and the intelligence necessary to plan a successful revolt were anomalies among Africans. Their obsession with his physical features, recorded in Jocelyn's portrait, also suggests that they thought his intelligence could be due to the fact that he did not "look like an African": in other words, he did not look like the stereotype of Africans that had been created by European American artists in the United States.

Jocelyn has also rejected the ragged clothing of Krimmel's fiddler and has clothed Cinque in the white toga of ancient Greece and Rome. His exotic origin is evoked by the palm trees in the background, and the stalk of cane he holds, a reference to the sugar-cane fields of the Caribbean where he and his fellow

rebels were to have labored. By using conventions from European neoclassical painting—the pose, the toga, the cane held like a staff of office—Jocelyn creates a parallel between the struggles for freedom of Cinque and African slaves in general and the struggles of democratic Greece and republican Rome, with which European Americans traditionally identified.

The abolitionist movement resulted in growing support for the education of African Americans. Several writers and artists received both the financial and moral backing they needed to succeed in their chosen field. Robert Scott Duncanson, whose landscapes were discussed in the last chapter (pp. 152–53, 173–75), produced two paintings dealing directly with African American subjects: *View of Cincinnati, Ohio, from Covington, Kentucky* [3.47], and *Uncle Tom and Little Eva* (1853) [4.20]. In the latter, two central characters in Harriet Beecher Stowe's popular abolitionist novel, *Uncle Tom's Cabin; or, Life Among the Lowly* (1852), are set within a landscape that combines a luminous harbor scene with an overgrown arbor. Duncanson's composition was patterned after a wood engraving by Hammatt Billings (1818–74) that had appeared in the 1852 illustrated edition of the novel as well as on the coversheet of the popular song *Little Eva; Uncle Tom's Guardian Angel* by John Greenleaf Whittier [4.21]. Stowe's book sold over 300,000 copies in a year and was translated into several foreign languages. The 116 engravings

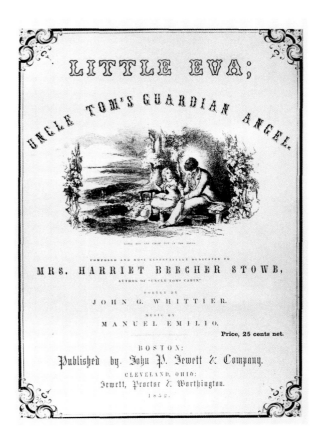

4.21 Baker and Smith after Hammatt Billings: *Uncle Tom and Little Eva*, 1852
Wood engraving, 3½ × 5½ in. (8.9 × 14 cm.), on a song sheet cover

after designs by Billings certainly increased sales of the novel, yet its ability to touch the emotions of a wide range of readers with a powerful abolitionist message was the main cause of its popularity.

Billings's engraving illustrates a scene at the opening of Chapter 22 at the St Clare family's summer home, "on a little mossy seat, in an arbor, at the foot of the garden" on the shores of Lake Pontchartrain, outside of New Orleans. It is sunset on a Sunday evening and Little Eva is reading from the Bible to her humble and faithful servant and friend Uncle Tom, who had earlier saved her from drowning. The scene illustrates her commitment to educating the family's black servants and, ultimately, to using her inheritance to buy a home in one of the free states so they could all be liberated. It also attests to Little Eva's (and thus Stowe's) belief that both spiritual and physical salvation for African Americans would be found through devotion to the Christian God. The little blond Eva thus represents the best of abolitionist sentiment and Christian love, although she dies shortly after the scene by the lake, leaving the task of freeing slaves to those who have been inspired by her example.

The patronizing tone of both the written passage and the engraving are unmistakable: the blond, white child will lead the old black man out of darkness and ignorance into salvation and light. Duncanson's painting [4.20] maintains the tone; he has made the scene more dramatic, however, by placing Little Eva in front of Uncle Tom, standing and gesturing toward the setting sun with eyes turned upward. There is a sense of Christlike prophecy in her pose, suggesting her impending death, and an equal sense of religious devotion on the part of Uncle Tom. This interpretation of the scene draws, once again, upon Stowe's text: "[Uncle Tom] loved her as something frail and earthly, yet almost worshipped her as something heavenly and divine. He gazed on her as the Italian sailor gazes on his image of the child Jesus—with a mixture of reverence and tenderness."

The passivity and devotion of Uncle Tom were seen by white abolitionists as evidence of his humanity and of the rightness of their efforts to free him. While such portrayals may have been necessary in order for the movement to make political headway, they were not wholeheartedly accepted by all African Americans. "Uncle Tom" eventually became a derogatory label, used by some African Americans to criticize those who felt their salvation lay in working with, rather than against, white people and their interests. Stowe reaffirmed her commitment to the "Uncle Tom" approach to liberation in her second anti-slavery novel, *Dred* (1856), in which she condemns the idea of African Americans achieving freedom through retaliation against whites.

The character of the rebel in the book is obviously patterned after Nat Turner, the slave who led a rebellion in 1831 in Virginia that resulted in the killing of fifty-five whites before it was crushed and Turner caught and hanged. His was only the latest in a series of revolts or planned insurrections that had increased the tension between southern plantation owners and their growing slave population. Indeed, the rebelliousness of southern slaves had forced the federal government to confront the possibility that an end to slavery might come about through a massive uprising, which could spread to an attack on the enslavers and the privileged classes in general. While the Civil War is connected in the minds of many to the liberation of African American slaves, it was also about controlling the *way* in which this liberation was to take place.

Rebellious slaves often managed to escape from southern plantations and find freedom in the North or in the new western territories, where the Fugitive Slave Act of 1793 was seldom enforced. The treatment of escaped slaves became a particularly volatile political issue in 1850, when California applied for statehood. There were then fifteen free states and fifteen slave

states, and the addition of California threatened to tip the balance in favor of the former. A compromise worked out between the North and the South included a more stringent Fugitive Slave Act providing for the return of escaped slaves to the South. This Act was further reinforced by the Supreme Court's Dred Scott decision of 1857, which confirmed that a slave's arrival in the free North did not automatically give her or him freedom; the majority opinion also held that an African American descended from slaves had no rights as a citizen and therefore no standing in court. Not until the Civil War and, in particular, the January 1863 Emancipation Proclamation and the repeal of the fugitive slave laws the following year, would arrival in the North signify freedom.

4.22 John Rogers: *Slave Auction*, 1859
Plaster, H 13¼ in. (33.7 cm.)
Courtesy The New-York Historical Society, New York City

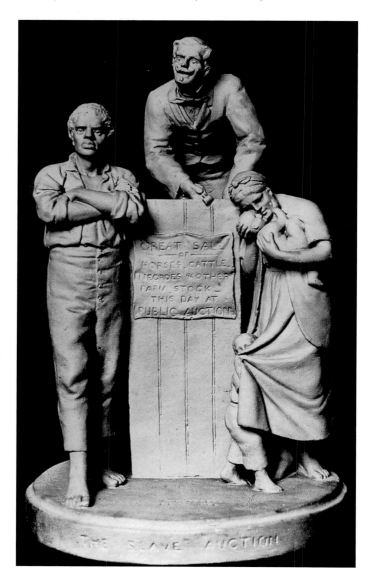

Two years after the Dred Scott decision the possibility of a massive slave revolt was once again brought home to the southern states. That year the sixty-year-old white man John Brown led a group of twenty-two men, five of whom were African American, in an attempt to seize the federal arsenal at Harper's Ferry in West Virginia and then set off a revolt of slaves throughout the South. His plan failed and he was executed. Many in the South were convinced that northern abolitionists and politicians were behind Brown's actions and that the North was not only committed to depriving them of their property but was prepared to do so, if necessary, through the arming of southern slaves.

The critical reception of two images produced in 1859 gives an indication of the tensions surrounding the issue of slavery at this time. John Rogers (1829–1904), a Yale-trained engineer who turned to sculpture in the late 1850s, created many small genre scenes which were reproduced in plaster and sold in great numbers. The first work he mass-produced and offered for sale on a mail-order basis was *Slave Auction* [4.22], put on the market only a few weeks after the execution of John Brown. The group includes a white auctioneer in the center, calling for bids, and a slave family below the podium. The male slave assumes an angry and aggressive stance, arms crossed, a scowl on his face. The woman cradles one child in her arms while another hides behind her skirt. The message of the piece is twofold: slavery is an affront to the dignity and humanity of African Americans, and African American men are not going to accept this fate passively. The work did not sell as well as Rogers had expected, prompting him to comment at the end of the year: "I find the times have quite headed me off . . . for the Slave Auction tells such a strong story that none of the stores will receive it to sell for fear of offending their southern customers."

The second work produced in 1859, which received a much more positive response, was a painting by Eastman Johnson (1824–1906) entitled *Negro Life in the South* (also referred to as *Kentucky Home*) [4.23]. Shown at the 1859 spring exhibition of the National Academy of Design in New York, it portrays African Americans engaged in a variety of leisure-time activities—playing the banjo, dancing, socializing, playing with children. In style and subject-matter it shows the influence of Johnson's studies in Düsseldorf and Holland from 1849 to 1855. While there he had been impressed by the minutely detailed paintings of peasant and small-town life that had been recorded by Dutch artists, particularly in the 17th century.

The figures are arranged for the most part in discrete groups in front of a ramshackle house. A woman and child look out of the top window at the scene below. But they are not

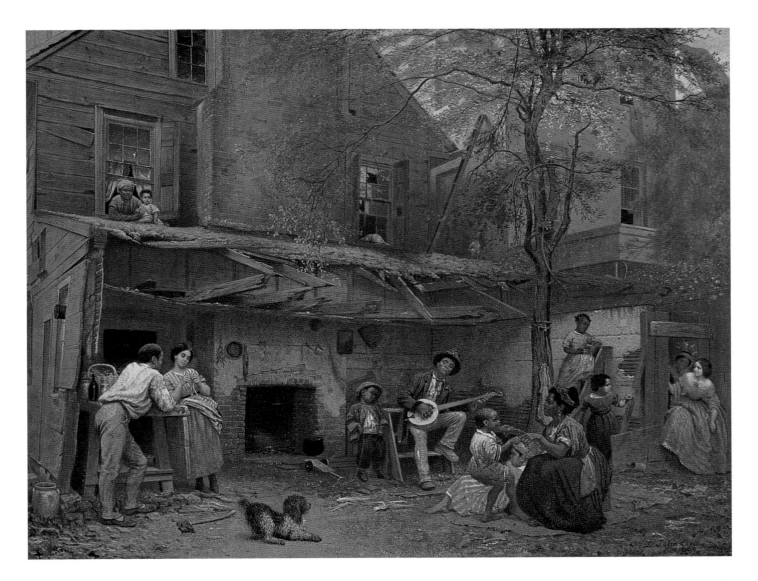

4.23 Eastman Johnson: *Negro Life in the South* (*Kentucky Home*), 1859
Oil on canvas, 36 × 45 in. (91.4 × 114.3 cm.)
Courtesy The New-York Historical Society, New York City

the only ones gazing upon these activities. Stepping through a hole in the fence between the slave quarters and the slave-owner's house is a young white girl, dressed in a finery that, as in the Krimmel painting [4.18], contrasts sharply with the ragged clothing of the slaves. Her presence is acknowledged by two young girls, one of whom has much darker skin than the other. The varying shades of skin color depicted could be accounted for by the varying skin colors of West Africans themselves. Yet it was more probably the result of the rape of black female slaves by their white male owners. The offspring of these violent encounters were always considered African Americans—"one drop" of black blood was all it took, by law, for an individual to be considered black—and thus slaves.

The painting was an instant success, due both to its style and to its content. The scene was painted in painstaking detail, achieved in part through Johnson's use of the backyard and household servants of his father's house in Washington as models. This detail engaged viewers and convinced them of the artist's consummate talents. The painting was also noncommittal on the issue of slavery. Abolitionists in the North interpreted it as a condemnation of the dismal living conditions in the South, while slaveholders were confirmed in their belief that, despite somewhat "uncomfortable" living conditions, southern slaves were basically a happy lot. The contrast between the dilapidated slave quarters and the home of the owners could also be read as evidence of the peaceful coexistence of master and slave.

Several of Johnson's black figures bear a certain resemblance in their arrangement and activities to an 1850 lithograph that defended slavery by comparing it to the lives and working conditions of British factory workers. In *Slavery As It Exists*

Race and the Civil War

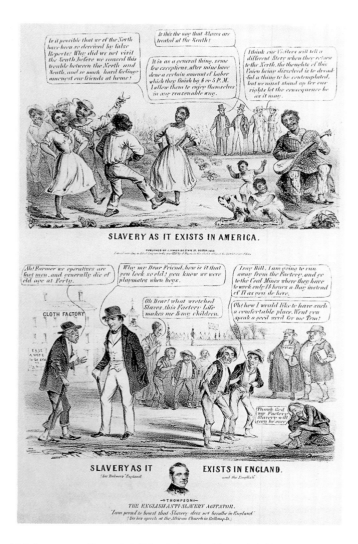

4.24 Anonymous: *Slavery As It Exists in America; Slavery As It Exists in England*, 1850
Lithograph published by J. Haven, Boston
Library of Congress, Washington, D.C.

in America; Slavery As It Exists in England [4.24], black slaves are portrayed as happy and carefree, while white wage laborers long to escape a bondage that turns them into old men before their time. (It would not take much of a stretch of the imagination to connect the British factory system to a similar system emerging in the northeastern United States at the time.) Neither group is shown engaging in work: rather, labor is represented in the text. In the American scene, two southern slave-owners describe for their northern visitors how truly easy are the lives of their slaves, whose work usually ends around four or five o'clock in the afternoon, while in the English scene the factory workers bemoan their seventeen-hour work days. Significantly the slaves, unlike the factory workers, do not speak for themselves, buttressing the argument that they are like children and need the protection of their masters.

What was the relationship between Johnson's image [4.23]—and the many others like it showing happy, dancing slaves—and the material conditions of slave life in the South? John Little, a slave who escaped to Canada, helps us formulate at least a partial answer in a passage from his description of his life prior to his escape as told to the Boston school principal and part-time journalist Benjamin Drew in 1855:

> They say slaves are happy, because they laugh, and are merry. I myself and three or four others, have received two hundred lashes in the day, and had our feet in fetters: yet, at night, we would sing and dance, and make others laugh at the rattling of our chains. Happy men we must have been! We did it to keep down trouble, and to keep our hearts from being completely broken: that is as true as the gospel! Just look at it,—consider upon it,—must not we have been very happy? Yet I have done it myself—I have cut capers in chains!

But the singing and dancing could not keep down trouble in the South. After Abraham Lincoln's election to the presidency in the fall of 1860, six southern states seceded from the Union, with five more joining them later. Their goal was to set up a separate, sovereign nation that would allow them to control their agricultural economy, which relied for its success on slave labor. The northern industrial states wanted economic expansion, wage labor, a free market economy, and high protective tariffs for manufactured goods, all of which the southern states opposed. Lincoln's main aim during the early months of the war, which began in April 1861 with the bombardment of Fort Sumter in South Carolina, was to preserve the Union, even if it meant assuring the southern states that he would not dismantle the institution of slavery. As late as September 1862, when he issued his preliminary Emancipation Proclamation, he promised to leave slavery intact in the states that came over to the North. The Emancipation Proclamation of January 1, 1863, declared slaves free in areas still fighting the North, but said nothing about those behind Union lines. Abolitionist forces pushed for a more all-encompassing declaration and, in April 1864, the Senate adopted the Thirteenth Amendment declaring an end to slavery. The House of Representatives followed with a vote of approval in January 1865.

Paintings of Fugitives, Contraband, and Soldiers

Many of the paintings of African Americans during and immediately after the Civil War focused on the flight of slave families to the North (some, like Duncanson, escaped the war by going

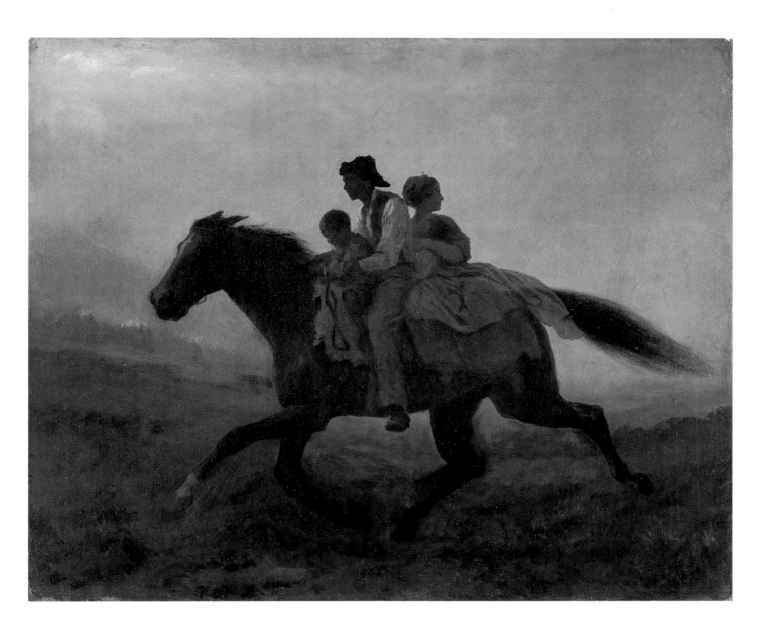

4.25 Eastman Johnson: *A Ride for Liberty: The Fugitive Slaves, c.* 1862–63
Oil on board, 22 × 26 ¼ in. (55.8 × 66.6 cm.)
The Brooklyn Museum of Art, New York

to Canada) and were often based on events artists had witnessed while serving in the army or accompanying Union forces. Two examples are Eastman Johnson's *A Ride for Liberty: The Fugitive Slaves* of *c.* 1862–63 [**4.25**] and Theodor Kaufmann's *On to Liberty* of 1867 [**4.26**]. Johnson's *A Ride for Liberty* is strikingly different from his earlier *Negro Life in the South* [**4.23**]. In place of a meticulously rendered anecdotal scene of slave families contentedly enjoying themselves, one finds a sketchily rendered nighttime scene of flight away from slavery and toward the safety of the Union lines, indicated on the left by the reflections off the barrels of the soldiers' rifles. The faces of the family on the horse, along with the horse itself, are mere dark silhouettes against a gray, smoke-filled sky. The scene counters the southern claim that slave families were happy with their life on southern plantations. This fleeing family, like the group in Leutze's *Westward the*

Course of Empire [**4.17**], also contains Christian connotations, suggesting a parallel with the flight of Mary, Joseph, and the baby Jesus to Egypt. Johnson had accompanied Union troops on several occasions in 1862 and 1863, and on the back of the canvas he identifies the source of the painting: "A veritable incident in the civil war seen by myself at Centerville on the morning of McClellan's advance toward Manassas, March 2, 1862."

Theodor Kaufmann (1814–after 1877) enlisted in the Union Army in 1861 and advocated the Union cause in his writings, lectures, and paintings. German-born, he received his artistic training in Munich and Hamburg before coming to the United

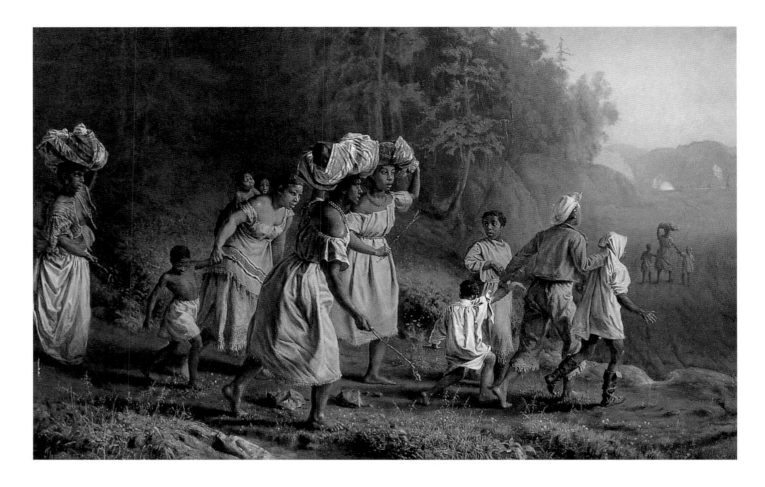

4.26 Theodor Kaufmann: *On to Liberty*, 1867
Oil on canvas, 36 × 56 in. (91.4 × 142.2 cm.)
The Metropolitan Museum of Art, New York

States in the early 1850s. In *On to Liberty* [4.26] he creates a dramatic scene of the flight of African American women and children, although it is much more anecdotal in its detailed rendering of costumes and facial features than Johnson's painting. Emerging out of a dark forest, the group heads toward Union lines visible in the distance. While the scene is filled with tension, Kaufmann provides some comic relief in the group of children to the right, the older boy dragging the younger one along by the back of his shirt. Such comic relief accommodated earlier stereotypes of African Americans found in paintings like Krimmel's *Quilting Frolic* [4.18]. Kaufmann also adds an element of voyeurism, undoing the blouse of the female slave to the far left so that her breasts are partially revealed. The absence of adult men in the group reflects the fact that they were often conscripted by the Confederate Army to work as laborers and thus were less likely to be fleeing with their families.

Many African Americans joined in the war effort on the side of the North. They found their way into the ranks of the Union Army as enlisted soldiers or as "war contraband" (escaped slaves, considered as property by their owners, were viewed as "confiscated" property by Union officers). In both capacities they carried out the more menial tasks of the war effort, including cooking for the troops, building roads, driving mule teams [4.31] and burying the dead, while, at the same time (until 1864), being paid less than white soldiers. Their lives were portrayed in the paintings and graphic work of the artist Winslow Homer (1836–1910). Homer was born in Boston and grew up at a time when the city was filled with abolitionist debates and controversy. He was apprenticed in a lithography shop in the mid-1850s before taking up work as a freelance illustrator and then training as a fine artist in 1859 at the National Academy of Design, where he exhibited his first work the following year. After the outbreak of the Civil War, Homer joined the Union campaign as an artist-reporter for *Harper's Weekly*. He was also commissioned by the publishers Louis Prang and Co. in 1863 and 1864 to design sets of campaign sketches, which were reproduced in lithographic form.

A Bivouac Fire on the Potomac, one of Homer's earliest wartime scenes, appeared as a wood engraving in the December

4.27 Winslow Homer: *A Bivouac Fire on the Potomac*, in *Harper's Weekly*, December 21, 1861
Wood engraving, 13¾ × 20 in. (34.9 × 50.8 cm.)
Sterling and Francine Clark Art Institute, Williamstown, Massachusetts

corkscrew curls, and the grinning, fat-lipped fiddler sitting at the edge of the fire playing for the dancer.

An attempt to move away from such stereotypes—a direction he would increasingly follow—can be found in his small painting *The Bright Side* of 1865 [**4.28**]. It depicts five mule drivers, four of whom are asleep, leaning against the sunny side of a tent. Only the head of the fifth man is visible. Homer claimed to have sketched the scene from life, with the fifth man appearing out of the opening in the tent just as he had finished drawing the first four. When the work was shown in 1865, first at the Brooklyn Art Association's Spring Exhibition in March and then at the National Academy of Design Annual Exhibition in April, it received favorable critical and popular reviews, which were at least in part responsible for Homer's acceptance into the Academy in May of that year.

Critics praised *The Bright Side* both for its "truthfulness" and for its "humor." One wrote: "The lazy sunlight, the lazy, nodding donkeys, the lazy, lolling negroes, make a humorously conceived and truthfully executed picture." For this critic, and for many others, a "truthful" depiction of African Americans

21, 1861, issue of *Harper's Weekly* [**4.27**]. It focuses on camp life, as did most of his war images, rather than the battlefront. It is evening, and an African American dances around the fire for the pleasure of the white Union soldiers. Homer has used two of the stereotypes then in place for the depiction of African Americans: the shabbily clothed high-stepping dancer with

4.28 Winslow Homer: *The Bright Side*, 1865
Oil on canvas, 13¼ × 17½ in. (33.7 × 44.4 cm.)
Fine Arts Museum of San Francisco, San Francisco, California

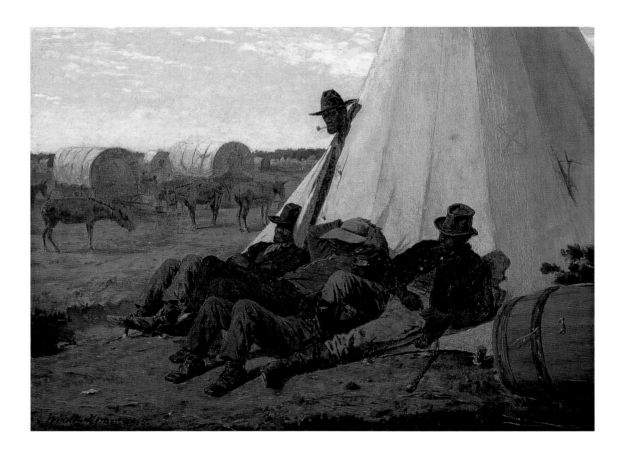

was, inherently, humorous. African Americans were also "inherently" lazy; despite ample record of the often brutal labor that was involved in their work, teamsters were frequently compared with the mules they drove, animals regularly described as unintelligent, stubborn and lazy, despite, again, evidence to the contrary.

The art historian Marc Simpson points out, however, that "if a seemingly racist humor can be found in Homer's painting of the teamsters, complicating elements are also there that require more than a chuckle in response." The direct gaze of the central figure is one such complicating element. The depiction of all five men as closely observed individuals rather than stock characters is another. However, while Homer abandons the physiognomical stereotypes of African Americans, he still places them in a setting and poses that allowed most viewers to ignore their individuality in favor of the generalizing stereotypes.

4.29 Thomas Nast: *Entrance of the 55th Massachusetts (Colored) Regiment into Charleston, South Carolina, February 21, 1865*, 1865
Pencil, neutral wash, and oil, heightened with white, on board,
14 1/4 × 21 1/4 in. (36.2 × 53.9 cm.)
Museum of Fine Arts, Boston, Massachusetts

Another artist who covered the Civil War for *Harper's Weekly* was Thomas Nast (1840–1902), best known for his scathing political cartoons of the late 19th century. Born in Germany, he came to the United States in 1846 and studied with Kaufmann, later entering the National Academy of Design. After working for *Frank Leslie's Illustrated Weekly* and the *New York Illustrated News*, Nast was engaged by *Harper's Weekly* in the summer of 1862. In 1865 he produced an image that was strikingly different from the majority of portrayals of African Americans during the war. *Entrance of the 55th Massachusetts (Colored) Regiment into Charleston, South Carolina, February 21, 1865* [4.29] shows the volunteer all-black regiment triumphantly entering the southern city. It is one of a limited number of pictures that acknowledge the presence of African Americans as active Union soldiers who fought in many of the major battles of the Civil War. It would have had added significance for black soldiers and abolitionists, for less than two years earlier, Colonel Robert Gould Shaw, the white officer who headed the first all-black Union regiment, the 54th Massachusetts, had died along with almost half of his troops in the attempt to capture a fort near Charleston (see pp. 234–35).

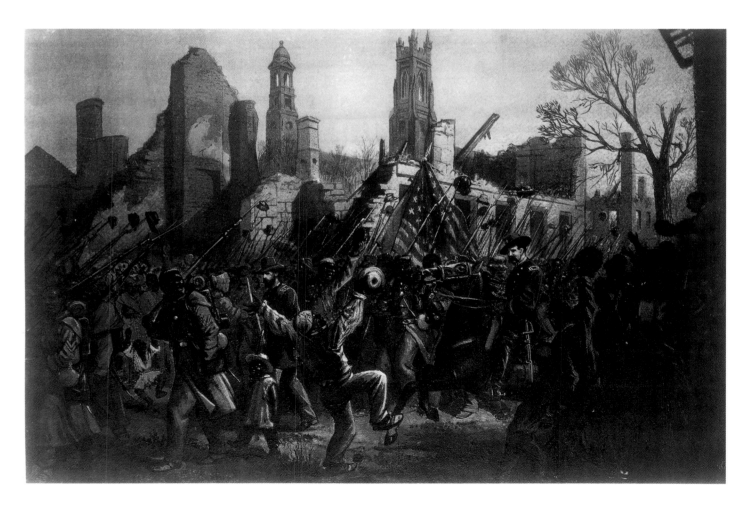

Once Lincoln's initial resistance to the enlistment of African Americans ended, the numbers joining up increased throughout the war. Official records indicate that approximately 185,000 joined the Union Army, and over 200,000 civilians worked in Union camps. Historians now agree that the presence of such large numbers of African Americans in the northern forces turned the tide against the Confederate Army in 1864 and 1865. The African American in the center foreground of Nast's drawing can be seen as dancing not for the pleasure of the white officers but in joy at the arrival of the black regiment and at the coming end of the Civil War.

Photographs of the War

The price of the Union victory at Charleston depicted in Nast's image is graphically told in the ruins towering over the scene, ruins that recall the many burned-out buildings featured in photographs taken at the end of the war. A view of 1866 by George P. Barnard (1819–1902), *Ruins in Charleston, S.C.* [4.30], shows the same city; some think that Nast's work was based, at least in part, on such a photograph. The Civil War was extensively documented by photographers. Among the thousands of images produced were sets of stereoscopic views, in which two identical photographs are looked at through a device containing two lenses, giving the impression of depth to a picture. The results were miniature panoramas, three-dimensional experiences undertaken within the comfort and safety of the home. Photographic technology at the time required the subject to remain still for long periods of time—anywhere from five to thirty seconds—so most of the scenes were of camp life or the aftermath of fighting. Thus,

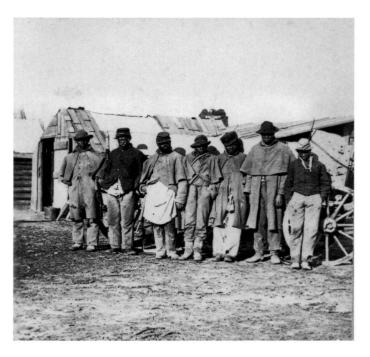

4.31 War Photograph and Exhibition Company: *A Group of "Contrabands,"* c. 1861–65
Stereograph (one image of two)
George Eastman House Collection, Rochester, New York

they presented war not as a grand, heroic activity, in the style of Trumbull or West, but as episodes of daily life or as gruesome scenes of corpse-strewn battlefields. In many cases stereographs were accompanied by written explanations, thus providing a more directed "educational" experience for the viewer.

A Group of "Contrabands" [4.31], produced by the War Photograph and Exhibition Company between 1861 and 1865, shows a group of African American teamsters lined up in front of a wagon and a shack, which is described as their home. Their eclectic clothing indicates their "contraband" status (see p. 218), and their solemnity and placement in the middle ground of the composition suggest both a physical and a psychological distance between them and the viewer. The image is a far cry from the happy, dancing slaves of prewar times and from the sleeping figures of Homer's painting *The Bright Side* [4.28].

A stereoscopic view by Taylor and Huntington Publishers that appeared in 1864, *Execution of a Colored Soldier* [4.32], shows the fate of an African American in the Union Army accused of having "attempted to commit a rape on a white woman" near Petersburg, Virginia. The soldier, whose name was Johnson, was tried by court-martial, found guilty, and hanged. All this information is given on the back of

4.30 George P. Barnard: *Ruins in Charleston, S.C.*, 1866
Photograph, from George P. Barnard, *Photographic Views of Sherman's Campaign*, 1866

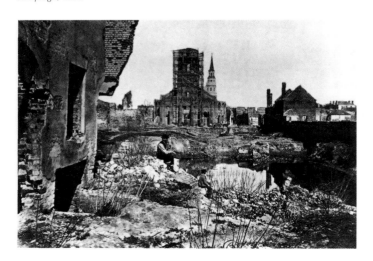

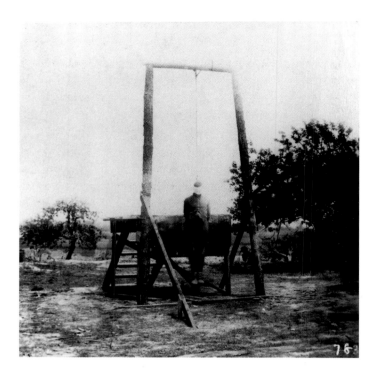

4.32 Taylor and Huntington Publishers: *Execution of a Colored Soldier*, 1864
Stereograph (one image of two)
Courtesy The New-York Historical Society, New York City

(1866). The American Studies scholar Alan Trachtenberg notes that such books constituted attempts "to organize a rapidly accumulating mass of war and war-related images, to present, even as the war progressed and images piled up, the entire mass as a single whole, an emergent totality." Like the narratives accompanying stereographs, these books presented the war "as if from the grand perspective of Providence."

But there were fissures, at times, in these narratives, claims Trachtenberg. One appears in the commentary accompanying a photograph by John Reekie, *A Burial Party, Cold Harbor, Virginia, April 1865* [4.33], in *Gardner's Photographic Sketch Book*:

> This sad scene represents the soldiers in the act of collecting the remains of their comrades, killed at the battles of Gaines' Mill and Cold Harbor. It speaks ill of the residents of that part of Virginia, that they allowed even the remains of those they considered enemies, to decay unnoticed where they fell. The soldiers, to whom commonly falls the task of burying the dead, may possibly have been called away before the task was completed. At such times the native dwellers of the neighborhood would usually come forward and provide sepulture for such as had been left uncovered.

This text speaks of soldiers, who then turn out to be missing, of native dwellers, who both bury and do not bury the remains of their enemies. Yet the fact that African American soldiers are doing the actual burying is never mentioned. "In a gesture so simple that it eludes the author of the text," writes Trachtenberg,

4.33 John Reekie: *A Burial Party, Cold Harbor, Virginia, April 1865*
Photograph, from Alexander Gardner, *Gardner's Photographic Sketch Book of the War*, 1866
Library of Congress, Washington, D.C.

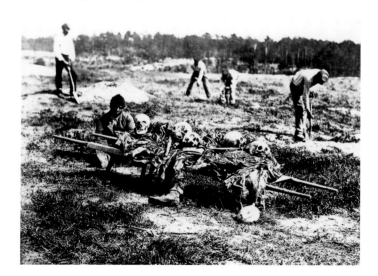

the image. In the photograph he is shown hanging from the scaffold, his face covered by a white cloth [4.32]. Union soldiers rest in the shade of a tree to the right, and the text on the back tells us: "A request was made of the Rebels, under a flag of truce, that we might be permitted to hang Johnson in plain sight of both armies, between the lines. The request was granted, and this is a photograph of him hanging where both armies can plainly see him." The educational value of the stereograph lay in its assurance that freedom for African Americans would not be achieved at the expense of "white womanhood." While the description suggests that Johnson was fairly tried, few, if any, black men were ever acquitted when charged with a crime against a white woman. As the art historian Ellwood Parry has noted in a discussion of this image, the public display of his hanging also suggests that white men on both sides of the war saw this as an occasion for a shared racist entertainment.

Photographs also appeared in books about the war. Mathew Brady (see p. 136) and Alexander Gardner (1821–82) were actively involved in the production and distribution of war imagery in the form of stereographs, album cards and large mounted photographic prints. They also published a number of books of prints, including *Brady's Photographic Views of the War* (1862) and *Gardner's Photographic Sketch Book of the War*

"the two grand invisibilities of the war become palpable here: the dead in their state of utter decomposition and dissolution; blacks in the posture of field laborers whose performance of the task of sweeping the battlefield clean of its grim refuse prefigures a history we still inhabit."

During the Civil War over half a million slaves fled the South. Four million remained, yet it was only a matter of time before many of them would also escape to the North. The African American activist and scholar W. E. B. Du Bois later wrote of these events in *Black Reconstruction* (1935):

Either the south must make terms with its slaves, free them, use them to fight the North and thereafter no longer treat them as bondsmen; or they could surrender to the North with the assumption that the North after the war must help them to defend slavery as it had before.

General Robert E. Lee chose the latter route, surrendering to General Ulysses S. Grant at Appomattox on April 9, 1865. The war was at an end. Five days later, President Lincoln was assassinated. While slavery was never officially restored in the South, white politicians in the North did, in fact, collude with their counterparts in the South to reinforce in new ways the subservience of African Americans.

Images of Reconstruction

Winslow Homer's "Prisoners from the Front" and "A Visit from the Old Mistress"

In the decade after the end of the Civil War, known as the Reconstruction Period, education was opened to African Americans in the South, and African American men were given the vote and allowed to run for political office. Many were elected to local, state, and federal positions. Discrimination in the use of public facilities was outlawed by the Civil Rights Act of 1875. Southern whites did not accept these new laws, however, and organized groups such as the Ku Klux Klan (founded in 1866) to terrorize African Americans and prevent them from exercising their new freedoms. As long as the Union Army remained in the South, they were protected to a certain degree from these attacks. But in 1877 troops were withdrawn as part of a larger political deal. Republicans agreed not to interfere with the re-establishment of white control of the South if southern Democrats would give the Republican presidential candidate Rutherford B. Hayes enough electoral college votes to become president. In 1883 the Civil Rights Act was nullified by the Supreme Court, which found it unconstitutional. It was replaced in 1896 with a Supreme Court decision allowing

railroads, and thus, by precedent, all other public services, to segregate black and white if the segregated facilities were "equal." By 1900 all southern states had written into law the disenfranchisement and segregation of blacks.

Homer produced several paintings addressing the tensions and accommodations produced by the end of the war and by the attempt to "reconstruct" the South. One such painting is *Prisoners from the Front*, completed in 1866 [4.34]. This work draws upon the well-established compositional conventions of confrontation scenes between the vanquished and the victor after a battle. The identification of the two groups is usually clearly marked. The vanquished kneel or dramatically bow down on the left, guarded by members of the victorious army. The victor stands to the right surveying the vanquished, often surrounded by his military retinue.

The general outlines of this compositional scheme have been maintained by Homer, but with certain significant alterations. To the left of center stand three Confederate soldiers who have just surrendered. Two Union soldiers stand to the right and just behind this group. Facing the Confederate soldiers is a Union officer. He is alone, although behind him at a distance are more Union soldiers with their horses and a Division flag. They are all located in a barren landscape, the young trees and bushes having been cleared by the advancing armies for firewood and to facilitate the movement of troops. The Confederate soldiers have indicated their surrender by placing their rifles on the ground. They do not, however, bow down in submission. The prisoner closest to the Union officer assumes a defiant pose, hand on hip, staring directly at his Union counterpart, his flowing locks contrasting with the other man's short hair. Both appear to be in their twenties or thirties. The remaining prisoners are of markedly different ages. The old man in the middle sports a full white beard and white hair and is the most submissive of the three, standing with his hands clasped in front of him. To the left of the old man is a very young man, probably in his teens, with his hands in his pockets, the slightly worried expression on his face belying his attempt at nonchalance. It is the defiant Confederate soldier who dominates, however. He occupies the center of the painting. Yet none of the figures—the prisoners, their two guards, and the Union officer—is positioned above the others. They are all arranged on the same level in a horizontal band across the front of the picture plane, the high horizon line cutting through the head of each figure, locking them in place.

The picture was well received when it was shown at the National Academy of Design Annual Exhibition in 1866 and, along with *The Bright Side* [4.28], at the Paris World Exposition

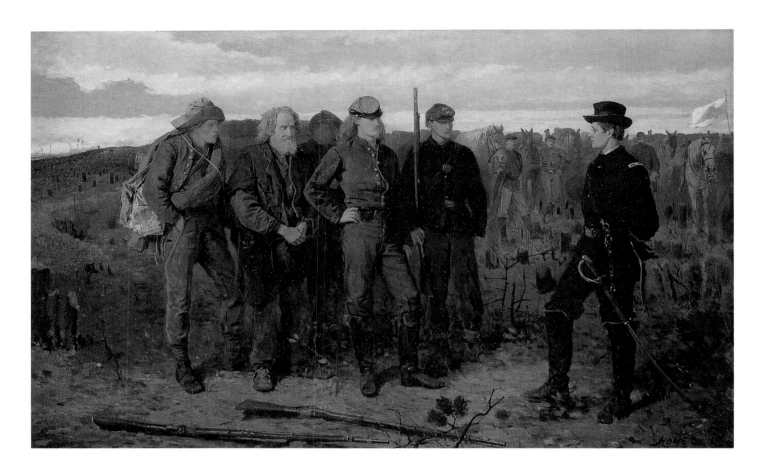

4.34 Winslow Homer: *Prisoners from the Front*, 1866
Oil on canvas, 24 × 38 in. (61 × 96.5 cm.)
The Metropolitan Museum of Art, New York

of 1867. As the art historian Patricia Hills has noted, the American section of the Paris Exposition that year included at least fifteen (out of eighty-two) works referring to the war or to African Americans, indicating a strong interest on the part of artists and the section's organizers in addressing the significance of this conflict, particularly for African Americans (this interest declined sharply by the end of the 1860s as political support for the reforms of Reconstruction waned).

While Homer's works received a positive reception in New York and Paris, critics had some difficulty categorizing *Prisoners from the Front* [**4.34**]. Was it a figure painting, a genre painting, or a history painting? The latter usually contained symbolic representations of lofty ideals or permanent truths or, at the very least, commemorations of particular victories or heroes. *Prisoners from the Front* does none of these things. The taking of prisoners was usually only accorded the privilege of being commemorated in paint if the prisoners were high-ranking and well-known figures. The Union officer is recognizable as General Francis Channing Barlow, a distant

cousin of Homer whom he had visited at the front early in the war, but the identity of the Confederate soldiers is unknown.

Some critics, however, did see *Prisoners from the Front* as a symbolic commentary on the Civil War as a whole rather than simply a factual recording of one event that took place during the war. In this sense it was a history painting rather than an anecdotal genre painting. It was seen as a history painting for other reasons as well. In an 1869 article entitled "Historical Art in the United States," the art critic Eugene Benson argued that history painting should not be about events before the painter's lifetime but should deal with events that are contemporaneous. History painting should "give us art that shall become historical; not art that is intended to be so." He saw *Prisoners from the Front* as a perfect example of such history painting.

What, then, is the nature of Homer's commentary on the Civil War in this painting? In an earlier article in the April 1866 issue of the New York *Evening Post* Benson (using the pseudonym Sordello) wrote:

On the one side the hard, firm-faced New England man, without bluster, and with the dignity of a life animated by principle, confronting the audacious, reckless, impudent

young Virginian, capable of heroism, because capable of impulse, but incapable of endurance because too ardent to be patient; next to him the poor, bewildered old man, perhaps a spy, with his furtive look . . . ; back of him "the poor white," stupid, stolid, helpless, yielding to the magnetism of superior natures and incapable of resisting authority. Mr. Homer shows us the North and South confronting each other, and looking at *his* facts, it is very easy to know why the South gave way. The basis of its resistance was ignorance, typified in the "poor white," its front was audacity and bluster, represented by the young Virginian—two very poor things to confront the quiet, reserved, intelligent, slow, sure North, represented by the prosaic face and firm figure and unmoved look of the Union officer.

The main characters were thus read more as types than as individuals and, as types, they were "keys" to the meaning and causes and, ultimately, the outcome of the Civil War. The defiant Confederate soldier in the center of the painting represented the defiance of the South in the face of defeat by the North. The Union officer's contemplative gaze, in turn, represented the North's evaluation of how best to deal with this implacable southern defiance. According to one critic, "the men are both young; they both understand each other." In 1888 another wrote that "the influence of his picture was strong on the side of brotherly feeling." It was this "understanding" and "brotherly feeling" that ultimately led to the deal struck between the North and the South that allowed Hayes to become president. A new Union would be created that allowed southern whites to maintain political and economic control through concessions to northern industrialists and politicians. Those who lost out in this deal were those in whose name the Civil War was supposedly fought—black slaves. As early as 1865 and 1866, the years in which Homer was creating *Prisoners from the Front*, vagrancy and apprenticeship laws were being passed by southern legislatures (the Black Codes), which restricted the rights of freedmen.

Does Homer represent this aspect of the Civil War—the betrayal of African Americans—in his painting? The one element that could possibly carry this message is the shadowy dark-skinned figure of a Union soldier standing behind the three prisoners. Unlike the rest of the foreground figures, his facial features are only faintly suggested (those of the figures in the distant right background are more clearly discernable). His boots are not completely sketched in and the bottom half of his left leg is missing. So unfinished is the presentation that it is possible, at first glance, to read this figure as a white soldier in

shadow. But the bodies of the Confederate prisoners are the only possible source of shadow, and their positioning makes the necessary blocking out of the sun impossible. Is this soldier, therefore, African American?

Recent x-radiographs have revealed that the soldier was absent from Homer's original composition. He was added after the Confederate prisoners had been laid in and the brown ground filled in around them. Then, rather than being worked up in the same detail as the rest, his face was left marked by the color of the brown ground. An infrared photograph further revealed that Homer painted the face in and scraped it off at least once, if not several times; but rather than restoring it, he simply smoothed over the traces of the scrape marks and added the brim of the cap. Perhaps Homer had intended to create an obviously white counterpart of the other Union guard. Yet in the painting he submitted as "finished" to the National Academy of Design in 1866, the soldier behind the prisoners remained dark-skinned and only faintly articulated.

None of the critics who commented on *Prisoners from the Front* mentioned this dark-skinned soldier. Yet Homer's support for the abolitionist cause and his increased awareness of the contributions of African Americans to the war effort both as soldiers and as support personnel may well have prompted him to include a reference to black soldiers, and thus to slavery, in his symbolic commentary on the Civil War. Having laid in the devastated landscape and included the figures of the Confederate soldiers and General Barlow, he may have turned to his earlier depictions of contrabands and banjo-playing African Americans [4.27, 4.28]. Should he include one of these figures, or was there a better way to represent the presence of African Americans in the war? But how does one represent an African American as an active subject, not a sleeping teamster or a banjo-playing entertainer but an alert soldier? How would the critics respond to the inclusion of a black soldier in his painting? While black and white soldiers may have fought side by side in the heat of battle, they were organized in segregated units and would not have been found together in the kind of post-battle scene recorded in *Prisoners from the Front*.

Perhaps Homer's awareness of the potential resistance of critics, and the public in general, to the inclusion of a black soldier may have caused him to back away from presenting a fully realized figure. Yet he did not omit the soldier altogether, nor did he make him recognizably white. In the end, he may have decided simply to leave intact the ghostly presence of an African American soldier behind the Confederate prisoners as another, more subtle, "key" to understanding the nature of the Civil War and its aftermath: that African Americans functioned as both soldiers and slaves, the former helping win the war for

the North on the battlefield, the latter providing the war's moral justification. The latter also represented those who had the most to lose as a result of the "brotherly" postwar negotiations between the North and the South that had begun even as the paint dried on Homer's canvas.

A second painting by Homer that addresses the aftermath of the Civil War is also a confrontation scene. Here, however, the confrontation is located indoors and takes place between a white woman and three African American women who were once her slaves. In *A Visit from the Old Mistress* (1876) [**4.35**] the white woman is dressed, like the Union officer in *Prisoners from the Front* [**4.34**], in dark clothes. Like him, she confronts three adult figures. The former slaves, like at least two of the Confederate prisoners, are dressed in ragged clothing. Homer's

manner of execution is even more "unfinished" in this painting than in *Prisoners from the Front*, although the greatest finish appears in the face and upper costume of the white woman. This is particularly evident if we compare her to the African American woman closest to her, whom she confronts directly and whose features, like those of the Union guard in the earlier painting, are only barely articulated. Indeed, this woman echoes the guard not only in the schematic manner in which she is rendered but also in the shape and positioning of her head. If the African American has emerged from the shadows of the Confederacy, therefore, it is as a woman in the home rather than a man on the battlefield.

What is the nature of the confrontation being depicted here? Who is the victor and who the vanquished? The title of the painting might suggest that the women on the left are the victors. The white woman is, after all, the "old" or former mistress. Yet, in compositional terms, she is located in the position of the victor. She has a slight smile on her face and looks

4.35 Winslow Homer: *A Visit from the Old Mistress*, 1876
Oil on canvas, 18 × 24⅛ in. (45.7 × 61.3 cm.)
Smithsonian American Art Museum, Washington, D.C.

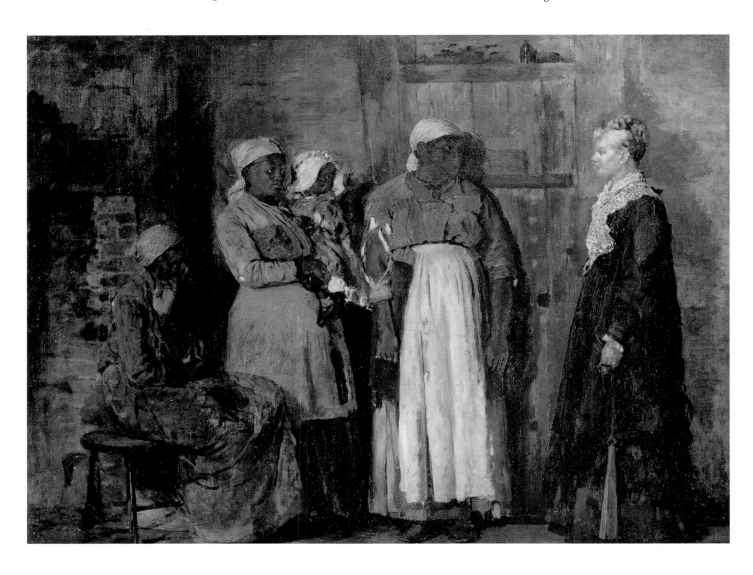

directly at the women in front of her. However, as in *Prisoners from the Front*, there is no show of obeisance on the part of the others. Rather, there is a distinct sense of suspicion and mistrust, particularly visible in the gesture and facial expression of the seated woman on the far left. In historical terms, they are the victors. This was 1876, over a decade since the end of the Civil War and of the institution of slavery. That the woman on the left remains seated rather than rising at the entrance of the white woman signals the changed relations between "mistresses" and their former slaves. Yet the following year northern and southern politicians struck their deal to put Hayes in the White House, effectively ending Reconstruction. From this point on, the gains made by African Americans over the previous ten years would be systematically dismantled.

As in *Prisoners from the Front*, therefore, there is no clear-cut victory or defeat. Even the visit of a white woman to her former slaves' quarters cannot be read as an act of capitulation. Such visits were common in the earlier slave-holding period and were often depicted in engravings in the popular press in the 1870s as examples of "the good old days" when slaves knew their place and appreciated the benevolent gestures of their masters and mistresses. In creating an enclosed, almost claustrophobic, space for them (the painting is almost exactly half the size of *Prisoners from the Front*), Homer acknowledges the intimate nature of the contact between white women and the African American slaves who worked for them in the plantation mansions. While white men also had personal servants, most of their contact with black slaves occurred in the fields or potteries or other places of work separate from the home. White women maintained control in the domestic sphere—over their children and over their African American servants. These servants engaged in tasks that directly involved the health and well-being of the family—cooking, cleaning, and raising the children. As is suggested in *Uncle Tom's Cabin*, household servants often became the friends of their young white charges, if not of the older members of the household. Such friendships created the basis for an understanding of the inequities of slavery and a willingness to end slavery as a whole. The potential for understanding between the two races appeared to be greater in the female sphere of the home, therefore, than in the male spheres of business, politics, and war.

Yet the potential for violence was also great in the home, as indicated by the numerous beatings of household slaves and by the attempts made by these same slaves, sometimes successful, to murder their masters and mistresses. While the work of household slaves was generally lighter than that of field slaves, it was accompanied by a constant surveillance by whites that forced the continuous wearing of a public mask. Yet, according to Lerone Bennett, Jr, court records of the mid-19th century "yield ample evidence that a large number of slaves refused to play the game of slavery: they would neither smile nor bow. Other slaves bowed but would not smile." Others bowed and smiled but, at the same time, deliberately sabotaged the system from within, breaking utensils or staging slowdowns. The close proximity of the female figures in Homer's painting and their demeanors suggest both the potential for understanding and the potential for harm. The physical and psychological distance between the white and black women, while filled with tension and mistrust, is also bridgeable by a single gesture.

Thomas Nast's "Grand Historical Paintings"

Thomas Nast also recorded the limits of Reconstruction, using the sharp tongue of political caricature. "It is necessary," writes Morton Keller in his book on the artist, "to see Nast against the background of a transatlantic art of social commentary, for he could draw on no rich tradition of American graphic satire or caricature." The most compelling of these European sources iconographically were French, notably the artist Honoré Daumier, whose commitment to the causes of liberty and justice were echoed in Nast's works. Stylistically, he was more indebted to British caricaturists, such as Sir John Tenniel, whose work appeared in the British publication *Punch*. *Harper's Weekly* would be the major venue for Nast's graphic commentaries.

In 1867, Nast produced his "Grand Caricaturama," thirty-three pictures approximately 8 x 11 feet (2.4 x 3.4 meters) each that he described as "Grand Historical Paintings." While Homer created a subtle commentary on the conventions of history painting in *Prisoners from the Front*, Nast challenges these conventions through open ridicule. Nast also plays with the conventions of the panorama, where images on a vast scale were meant to transport the viewer to another world for a vicarious experience of the drama of exotic scenery or epic battles. Nast transports his viewers to a place from which they would want quickly to escape, all the while directing their viewing through a lecture by a hired speaker accompanied by music.

The "Grand Caricaturama" was meant as a scathing criticism of President Andrew Johnson's response to Southern resistance to reconstruction efforts. When he assumed office in 1865, Johnson did not continue Lincoln's hard-line policy toward the defeated South: i.e., unregenerate white southern politicians would not be allowed to resume power and the federal government would protect the rights of freed slaves. Instead, Johnson argued for states' rights and white supremacy,

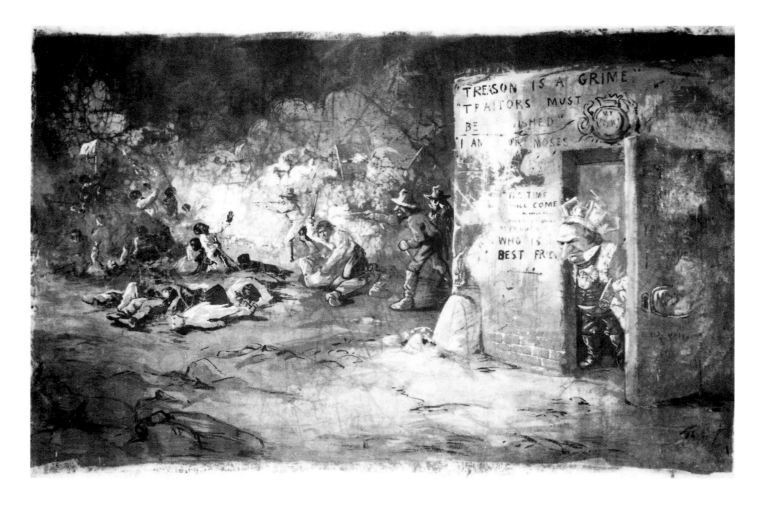

4.36 Thomas Nast: *The Massacre at New Orleans*, from Nast's "Grand Caricaturama," 1867
Monochrome painting, H 94¾ in. (240.7 cm.)
Library of Congress, Washington, D.C.

and indicated he was ready to abandon freed slaves to their former masters. Only the strong presence of Radical Republicans in Congress prevented him from fully realizing his pro-South policies. As a Radical Republican and popular illustrator, Nast was influential in helping to bring about Johnson's demise as a force within the Republican Party (Ulysses S. Grant was the Republican candidate in the 1868 presidential election).

Only five of the works that made up the "Grand Caricaturama" still exist today. One of these, *The Massacre at New Orleans* [4.36], number 24 in the series, depicts President Johnson on the right, wearing a crown and looking out the door of a building at the scene taking place on the left. His crown and the coat of arms above the door are references to what Radical Republicans claimed were Johnson's royal aspirations. The scene at the left shows the massacre by the city's white

police of Radical Republicans, most of whom were black, who had gathered together for a constitutional convention in New Orleans on July 30, 1866. It is patterned after the painting *The Third of May, 1808* (1814) by the Spanish artist Francisco Goya, where a group of men is about to be shot at close range, with one in the middle ground holding up his arm in a pleading gesture. In front of this group are the bodies of those who have already been killed. This reference to Goya reinforces the suggestion of royalist aspirations on the part of Johnson, for Napoleon's invasion of Spain, which led to the massacre of May 3, 1808, took place after he had declared himself emperor.

"King" Johnson is a mean-spirited man, with a run-down brick building for a castle. His lackeys are murdering unarmed people (thirty-seven black delegates and three white sympathizers were killed), one of whom holds up a white flag of truce. Thus, Nast uses history painting to convey a moral message. This massacre, and other racially motivated massacres that followed, could have been stopped, suggests Nast, had Johnson been less allied with racist Southerners and more willing to prosecute those responsible for such lawless actions.

Monuments to Freedom

The Freed Slave

In 1867, the same year Nast produced his "Grand Caricaturama" and a year after Homer completed *Prisoners from the Front*, Edmonia Lewis (*c.* 1845–after 1909) presented another testimony to the end of slavery. Like Robert Duncanson, she had benefited from the encouragement and support of white abolitionists. Born in upstate New York of a Chippewa mother and an African American father, Lewis—originally named Wildfire—was orphaned at four and raised by her mother's people until she was twelve. At thirteen, with the help of her brothers and of various abolitionists, she entered the Young Ladies Preparatory Department at Oberlin College in Ohio, adopting the Christian name of Mary Edmonia Lewis. While at Oberlin, Lewis was accused of attempting to poison two of her white schoolmates and of stealing. Brought to trial, she was defended by the well-known African American lawyer John Mercer Langston, and acquitted of all charges, yet was not allowed to graduate. With the help of the abolitionist William Lloyd Garrison, she settled in Boston where she came into contact with the sculptor Edward Brackett. He lent her sculpture fragments to copy and, along with the sculptor Anne Whitney, helped her develop her skills as an artist.

Lewis's first works were busts and medallions of various abolitionist leaders and heroes, including Garrison, Charles Sumner, Maria Weston Chapman, and Colonel Robert Gould Shaw (see pp. 234–35). Lewis's posthumous portrait of Shaw, done in 1865, impressed his family, who organized a group of friends to buy a hundred copies at fifteen dollars each.

This money, and the help of her benefactors the Story family, allowed Lewis to finance a trip to Italy in 1865, where she joined the group of women gathered in Rome around the American sculptor Harriet Hosmer. These women went to Europe in search of good marble, collections of classical Greek and Roman sculpture, and trained carvers who would teach them. They were encouraged by liberal parents or, as was the case with Lewis, friends who could wholly or partly support them financially. Almost all remained single and devoted their lives to their artistic endeavors. The success of those like Hosmer and Lewis was notable for two reasons: the difficulty for women of becoming a recognized artist in any medium in the 19th century; and the special physical challenges produced by sculpture, which resulted in even stronger prejudices against women taking it up.

Harriet Hosmer (1830–1908) provided Lewis with both a supportive environment within which to work in Rome, and examples of images that addressed the issues of slavery and rebellion. Born in Massachusetts, Hosmer traveled to St Louis to study anatomy and to explore the far West before proceeding on to Rome in 1852, where she remained for the rest of her professional career. Success came quickly. By the end of the decade she was selling her work directly from her studio (a common practice in Rome and Florence) and receiving regular visits from artists and collectors including, in the latter category, the Prince of Wales and the Russian Czar.

In 1857 Hosmer carved the reclining *Beatrice Cenci* [4.37], a late 16th-century Roman noblewoman who, with her mother Lucretia, killed her abusive and tyrannical father Francesco. Both women were condemned to death and beheaded, despite many pleas for clemency. Hosmer shows Beatrice asleep the

4.37 Harriet Hosmer: *Beatrice Cenci*, 1857
Marble, 17⅛ × 41⅛ × 17 in. (43.8 × 104.7 × 43.1 cm.)
St Louis Mercantile Library, St Louis, Missouri

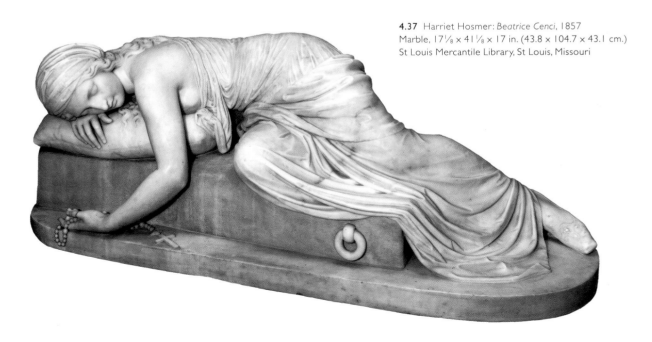

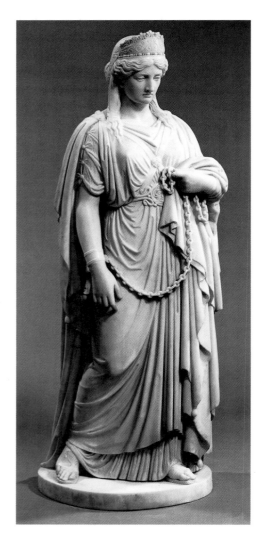

4.38 Harriet Hosmer: *Zenobia in Chains*, 1859
Marble, H 84¾ in. (215.3 cm.)
Wadsworth Atheneum Museum of Art, Hartford, Connecticut

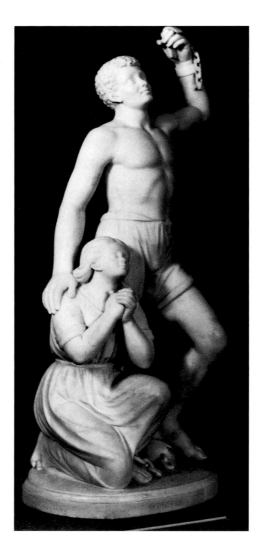

4.39 Edmonia Lewis: *Forever Free*, 1867
Marble, 41¼ × 11 × 7 in. (104.8 × 27.9 × 17.8 cm.)
James A. Porter Gallery of Afro-American Art, Howard University,
Washington D.C.

night before her execution, having come to terms with her actions and fate through prayer. Two years later she produced *Zenobia in Chains* [4.38]. Zenobia, a 3rd-century queen of Palmyra in Syria, was defeated and captured by the Romans. Hosmer has modeled Zenobia on antique prototypes, present-ing her as noble and resolute in her defeat; she gathers up her chains along with her robe, grasping them firmly in her hand as she contemplates her future. When the statue was exhibited in the U.S. in 1863, it was received with great enthusiasm as an example of moral rectitude and resistance to defeat, a fitting symbol for a country in the throes of a civil war.

While Hosmer focused on the political and personal strug-gles of women against men and male-defined institutions, Lewis turned her attention to the struggles of African Americans against the institution of slavery. She created two

works on this subject while in Rome, *The Freed Woman and Her Child* (now lost), and *Forever Free*, of 1867 [4.39]. The latter, originally titled *The Morning of Liberty*, attempts to capture the emotional impact on African American slaves of Lincoln's proclamation, on the morning of January 1, 1863, that all persons held as slaves (in those areas still fighting the North) "are, and henceforward shall be, free." A woman, the manacle still around her ankle, kneels and clasps her hands in thanksgiving while a man stands above her, one hand on her shoulder, the other raised and holding the manacle and chains that had been previously attached to his ankle. Another manacle remains attached to his wrist, however, indicating that freedom has yet to be fully achieved. Both gaze upward, acknowledging the existence and help of a higher power (it was around this time that Lewis converted to Catholicism).

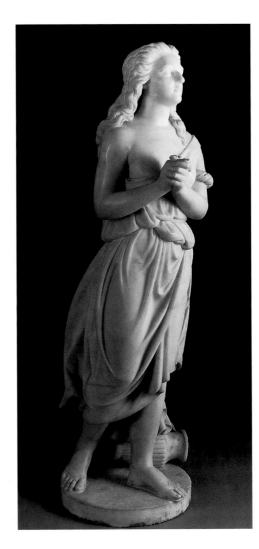

4.40 Edmonia Lewis: *Hagar in the Wilderness*, 1868
Marble, 52⅝ × 15¼ × 17 in. (133.6 × 38.8 × 43.4 cm.)
Smithsonian American Art Museum, Washington, D.C.

While Lewis fully intended the figures to be read as African American slaves, there is little in their appearance, save the curly hair and the slightly broader features of the man, that identifies them as such. One might argue that, as in Johnson's *Negro Life in the South* [4.23], Lewis acknowledges the varying physical features of African American slaves, who were often, like Lewis herself, a mix of African and European or African and Native American descent. The art historian Kirsten Buick also suggests that Lewis's decision to Europeanize the features of the black woman in *Forever Free* was an attempt to prevent the work from being read as autobiographical, as a "self-portrait" rather than a statement about black women as a whole. Unlike Johnson, however, Lewis could not use her chosen material—marble—to render the subtle variations in skin color of African American slaves. A tension is thus created between the (absent) dark skin and the whiteness (of the marble) against which darkness is always measured and found wanting. Marble, the famed material of Greek and Roman artists, gave aesthetic and historical legitimacy to the two freed slaves, while at the same time erasing the visual signifier of race and thus of servitude.

A year after completing *Forever Free*, Lewis created *Hagar in the Wilderness* (1868) [4.40], a tribute to the Old Testament Egyptian maidservant of Abraham's wife, Sarah, who was cast into the desert to escape the rage of Sarah after having borne Abraham a child. The parallel to the situation of African American female slaves in the U.S. is clear (according to Buick, "Egypt was coded as black Africa among abolitionists and colonizationists in the 19th century"). Lewis wrote, in reference to another work representing Hagar, "I have a strong sympathy for all women who have struggled and suffered."

Lewis remained in Rome throughout the late 1860s and early 1870s, making only brief visits to the United States to promote her work. In October 1869 she visited Boston to present *Forever Free* to the Reverend L. A. Grimes at Tremont Temple. In 1873 she traveled to California where five of her works were exhibited at the San Francisco Art Association. She was in Boston in 1876 around the time of the Philadelphia Centennial Exposition, which included her *Death of Cleopatra* of the same year.

Lewis's financial success attested to her skill at producing the type and quality of work expected by the American art-buying public in the later 19th century. Yet, even in Rome, she was continually confronted by the prejudices of an art world accustomed to acknowledging only male members of the white race. Like Hosmer, she was often viewed as a novelty, as "exotic" because of her gender and her dress, which was often described as "mannish" (the novelist Nathaniel Hawthorne visited Hosmer in 1858 and described the upper half of her clothing as "precisely that of a young man"). Lewis was also subject to comments about her race. Henry James described her as "a negress, whose colour, picturesquely contrasted with that of her plastic material, was the pleading agent of her fame." In other words, her success was the result not of her artistic talent, but of her novelty, which James sees in terms of a contrast—between her dark skin and the white marble in which she worked. The critic Laura Curtis Bullard wrote in 1871:

> Edmonia Lewis is below the medium height, her complexion and features betray her African origin; her hair is more of the Indian type, black, straight and abundant Her manners are child-like, simple and most winning and pleasing. She has the proud spirit of her Indian ancestor, and if she has more of the African in her personal appearance, she has more of the Indian in her character.

Thus, despite the fact that Lewis was in her mid-twenties and an accomplished artist at the time this description was written, she was still seen as childlike, winning and pleasing, attributes which made her success and independence as an artist and single woman less threatening to men and to those women who believed in the need to maintain their "femininity" even as they entered professions previously closed to them. Bullard also combines two stereotypes—the "proud" Native American and the "childlike" African American—in her description of the artist. Little is known of Lewis's career after the mid-1880s. She disappeared from exhibition records and art journals and the last printed reference to her appears to be in the Catholic *Rosary* magazine, which noted in 1909 that she was aging but "still with us."

The Victorious Soldier

Edmonia Lewis was one of the first American artists to commemorate black Americans in sculpture. However, her work had a limited audience. And while John Rogers' *Slave Auction* [4.22] reached many more people, its diminutive size and multiple copies deprived it of the moral legitimacy of "fine" art. The art historian Kirk Savage notes that several artists did attempt to create monumental public sculptural works commemorating the emancipation of slaves. Few succeeded, however, and those who did created commemorations that reinforced, as much as undermined, the traditional relationship between master and slave.

The task these artists faced was similar to the one Homer may well have faced as he worked on *Prisoners from the Front*: how to create an image of a black person as a free agent, as a heroic individual representative of the new united nation that Northern politicians claimed had emerged from the bloodshed and devastation of the Civil War. Prior to the Civil War, calls for an end to slavery were often accompanied by an image of a kneeling, chained slave surrounded by the words "Am I Not a Man and a Brother." This image was derived from a small low-relief Wedgwood ceramic medallion designed in England in 1786, which functioned as an emblem of the British abolitionist movement. It appeared in the U.S. in the early 19th century in popular prints [4.41] and on a variety of household objects. Once slavery ended, one would assume the kneeling slave would stand, as in Lewis's work, celebrating his newly found freedom. Yet it appears sculptors and their audiences found it difficult to envision a freed slave in a public place in anything but a kneeling position.

Savage suggests that sculptors were faced with a challenge not faced by painters: how to create a heroic representation of a free black person in a medium that had come to be "embedded

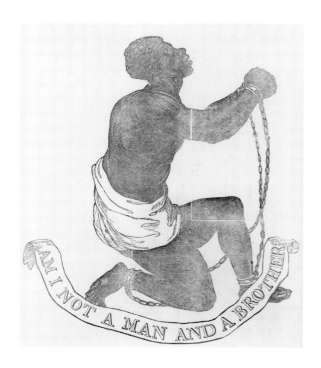

4.41 Anonymous: *Am I Not a Man and a Brother*, 1837
Woodcut, 10½ × 9 in. (26.7 × 22.8 cm.)
Library of Congress, Washington, D.C.

in the theoretical foundations of racism that supported American slavery and survived long after its demise." Racism, in Savage's words, "centered on the analysis and representation of the human body." And in the central 19th-century texts articulating racist theory, such as *Types of Mankind* (1854) by J. C. Nott and George R. Gliddon, the ideal body type was often represented by classical Greek or Roman sculpture. Thus, classical sculpture came to signify not simply antiquity, but whiteness. "Natural philosophers used classical sculpture," writes Savage, "to visualize and articulate a new racial construct, but the resulting theory transformed the understanding of classical sculpture by racializing it." The body of the black person signified the antithesis of both whiteness *and* sculpture, for "classical sculpture still served as the benchmark of the sculptural and thereby defined what was not sculpture." This helps explain the tension that exists in Lewis's work, as she tries to reconcile the classical and the black body.

One of the few monuments to the emancipation of black slaves that materialized in the decade immediately following the Civil War was the bronze and stone *Freedmen's Memorial to Abraham Lincoln* or *Emancipation Monument* in Washington, D.C., of 1876 [4.42] by Thomas Ball (1819–1911). As a public monument located in the nation's capital, it had to be both conservative and progressive; it had to commemorate an event—emancipation

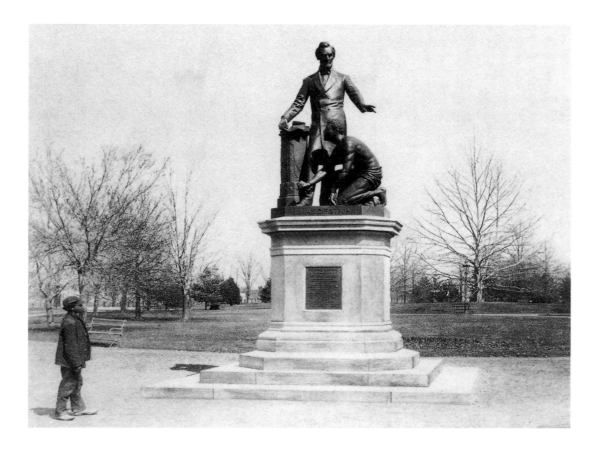

4.42 Thomas Ball: *Freedmen's Memorial to Abraham Lincoln*
(*Emancipation Monument*), 1876
Lincoln Park, Washington, D.C.

—that had not yet been fully realized in a manner acceptable to both abolitionist and former slave-owner. The solution arrived at by Ball and other sculptors was to commemorate emancipation not through the bodies of independently acting freedmen, but through the body of Abraham Lincoln.

Ball's monument is dominated by the relationship between the standing Lincoln, who holds a scroll representing the Emancipation Proclamation, and the kneeling black man (modeled after a former slave named Archer Alexander who had escaped the South in 1863), who gazes at the scroll in recognition of its significance for him. This configuration speaks to the limits of emancipation and to the continuance of the link between master/benefactor and slave/freedman. The presence of a white man and a black man together on a public monument was thus made acceptable through the visual hierarchy of standing and kneeling and its coding of the master/slave (servant) relationship. The semi-nude body of the black man, which by itself would have referred to the heroic realm of classical sculpture, here comes to represent the less civilized, less human contrast to the fully clothed Lincoln. It is a far cry from Homer's *Visit from the*

Old Mistress [4.35], where the black women hold their ground in the presence of their former mistress. Yet a small painting did not have to carry the ideological load of a public sculpture.

Ball's monument was paid for by African Americans through a public subscription. Yet it was a group of white men, members of the Western Sanitary Commission of St Louis, a war relief agency, who collected the money and decided on its design and character. (They rejected a design by Harriet Hosmer that included four standing African Americans, along with four allegorical figures and a portrait of Lincoln.) The resulting work inserted the sculpted black body into a national monument for the first time, yet negated the freedom it claimed to celebrate. Its ultimate failure to celebrate emancipation made it an apt commemoration of Reconstruction, for Reconstruction also failed to emancipate blacks from the political and social structures underlying slavery. And even this compromised reference to emancipation disappeared after 1876. Subsequent portraits of Lincoln were devoid of kneeling (or standing) freedmen or even of scrolls that had earlier symbolized the Emancipation Proclamation. Instead, Lincoln came to be depicted on his own, celebrated as the Savior of the Union rather than the Liberator of Slaves.

Not surprisingly, emancipation also failed to materialize in public monuments in the South. There the Civil War ended up

being commemorated in the body of another famous man, General Robert E. Lee. Just as Lincoln monuments came to focus on "union" rather than "emancipation," Lee monuments commemorated the battle to protect states' rights rather than to preserve slavery. The most famous of these monuments is the equestrian statue by the French sculptor Antonin Mercié (1845–1916), with a pedestal designed by the architect Paul Pujol, erected in Richmond, Virginia, in 1890 [4.43]. The need to dissociate the southern cause from slavery after the war in order to situate the region as a full partner within the new Union precluded the appearance of any black figure, kneeling or standing,

4.43 Antonin Mercié and Paul Pujol: *Lee Memorial*, 1890, seen at its unveiling Monument Avenue, Richmond, Virginia

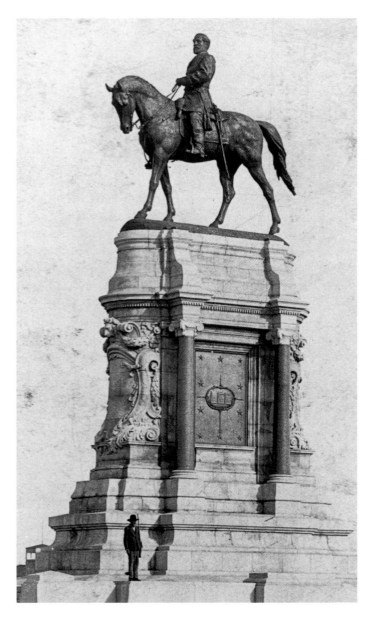

soldier or slave, on the monument. The very absence of blacks in public monuments in the South, however, combined with their very real presence on the streets of southern cities, was a constant reminder of the racial domination that had formed the basis of slavery and that continued to determine interracial relationships once the institution of slavery was abolished.

The standing black soldier in full military garb would not appear in a public monument in the North until the end of the century. The *Shaw Memorial* of 1897 on Boston Common [4.44] by Augustus Saint-Gaudens (1848–1907) celebrates Colonel Robert Gould Shaw and the all-black 54th Massachusetts, nearly half of whom had been killed, with their leader, in 1863 attempting to take Fort Wagner near Charleston. Saint-Gaudens had established a national reputation as a sculptor with several public monuments, including two of Lincoln in Chicago. He was also closely connected to those responsible for the *Shaw Memorial*.

The idea for the commemoration was originally proposed in 1865 by Joshua B. Smith, a former slave living in Boston, who donated $500 of his own money. The project was eventually taken over by a group of individuals from the white cultural elite of Boston, one that included many active participants in the abolitionist movement and supporters of the political and economic rights of freed slaves. This group was aware of the injustice of excluding black soldiers from Civil War monuments and hoped to rectify this situation with the *Shaw Memorial*. As Savage points out, they were also motivated by a strong antipathy toward the proliferation of standardized, made-to-order, "common soldier" monuments. These endless individual white soldiers ("common" could never be represented by a black soldier) standing at parade rest on top of pedestals in public squares throughout the country were effective in promoting the nationalist ideology of the citizen-soldier and in restoring a sense of individual initiative and personal agency to the many survivors of the Civil War. Yet, for the organizers of the Shaw commission, they were a "cultural disaster." They degraded what was viewed as the "noblest" of art forms. True art was unique; its value resided not in its repetition, but in its difference. What could be more "different," then, than a monument commemorating the role of black soldiers in the Civil War?

Saint-Gaudens's high-relief bronze monument, set into a stone frame designed by the architect Charles Follen McKim (1847–1909), combines the traditional equestrian portrait of the military leader/hero with the more recent form of the standing "common soldier." Shaw and his horse are placed beside the foot soldiers, suggesting a certain level of camaraderie. Shaw is also located between the black soldiers under his command and the Angel of Death, who hovers above them all bearing the symbols of Victory (laurel) and Sleep (poppies). In his depiction

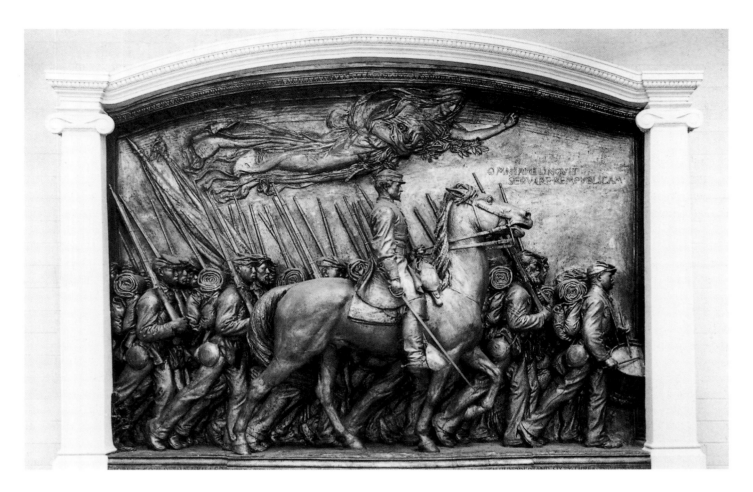

4.44 Augustus Saint-Gaudens: panel of the *Memorial to Robert Gould Shaw and the 54th Massachusetts Regiment*, 1897
Boston Common, Boston, Massachusetts

of the members of the 54th Regiment, Saint-Gaudens departs from the "common soldier" monuments in at least two ways: the soldiers are moving rather than standing at parade rest, marking them more clearly as historical agents; and each soldier has been portrayed with distinct, individual features, rather than as a generic stereotype.

Yet some see Shaw's monument as containing certain elements that worked against the celebration of African American soldiers. Albert Boime argues, for example, that the clear association between the black troops and the horse—the legs of the troops echo those of the horse, the troops are on the same level as the horse and many are obscured by its body, both follow the direction of Shaw—downplays the individuality and humanity of the troops by reaffirming the common racist equation between African Americans and animals. Boime supports this reading, in part, by citing Saint-Gaudens's correspondence surrounding the Shaw monument, which reveals a view of African Americans as childlike, ignorant, "difficult," and lacking in initiative. This

view was certainly not that of Shaw and his family, who were leaders of the abolitionist movement in Boston. When Saint-Gaudens initially proposed a conventional equestrian statue, family members encouraged him to consider, instead, a plan that would allow for the prominent inclusion of Shaw's troops, for it was his role as leader of an *African American* regiment that was of greatest significance for them. When General Gilmore proposed exhuming Shaw's body from the common grave on the battlefield where he had been buried along with his African American troops, the family rejected the idea, preferring, instead, the unity of black and white symbolized by this common grave.

While Savage agrees that Saint-Gaudens "shared the common racial prejudices of the white elite," he also argues that these prejudices were overcome in the monument by artistic imperatives, in particular by the artist's desire to create a work marked by individuality rather than repetition, an individuality that set the work apart from common soldier monuments.

Saint-Gaudens's sympathetic portrait studies of black men do not imply a special sympathy for black men in the mind of the artist, nor does the lack of sympathy he showed in his memoirs invalidate the visual evidence of the sculpture. It

was the self-imposed demands of art, not racial ideology, that compelled the sculptor to portray these men as he did. The artistic imperative of difference over repetition was so powerful that it drove Saint-Gaudens to humanize his models in ways he had never originally intended.

The impact of these artistic imperatives is suggested in a passage from Saint-Gaudens's memoirs, where he states that "through my extreme interest in it [the project] and its opportunity, [I] increased the conception until the rider grew almost to a statue in the round and the Negroes assumed far more importance than I had originally intended."

This tension between African Americans as individuals and African Americans as stereotypes, between the white commander and his black troops, led to differing responses to the monument. Many white critics ignored the individuality of the troops, referring to them as an undifferentiated "mass" and seeing the work, instead, as a celebration of the heroism of Shaw. Yet others remarked upon the significance of these troops to the monument's larger meaning—the participation of black soldiers in the eradication of the institution of slavery.

Much of the emotional power of the monument came from the fact that those who viewed it were fully aware of the symbolic and pragmatic significance of the entrance of African American soldiers into the Civil War and of the tragic fate of the regiment and its leader. The location of the monument reinforced this awareness, for John A. Andrew, governor of Massachusetts, had presented the colors to the regiment on Boston Common on May 28, 1863, before it set off to join the Union forces in South Carolina. Saint-Gaudens depicts the soldiers as they moved forward across the Common and on toward Boston Harbor. In his 1916 publication *Emancipation and the Freed in American Sculpture*, the black writer Freeman Henry Morris Murray commented on this movement and on the destination of the troops:

The scene is evidently the departure of the colored troops; the leader a young man of noble mien who recognizes the significance of the fateful day. With head square set upon the broad shoulders and sad eyes unflinching, he rides steadily to his fate. The fiery horse is a splendid sculptural achievement, clean cut and magnificently wrought, but, conspicuous as he is, easily dominated by the presence of the silent rider. Then, behind and across the entire background, march with swinging tread the black men, their muskets over shoulders which bend under the burdensome knapsacks. They are equipped for a long journey from which not many will return. The movement

of this great composition is extraordinary. We almost hear the roll of the drums and the shuffle of the heavy shoes. It makes the day of that brave departure very real again.

Murray celebrates the strength and commitment of the soldiers at the same time as he mourns their impending deaths. The monument held special personal significance for him, for his father had served under Shaw at Fort Wagner and had survived. In the early 20th century, such visual recognition of their accomplishments would increase as African Americans like Murray came together in major urban centers of the North to form their own distinct cultural movement.

Native Americans in the Popular Press: *Harper's Weekly* and the Washita River Massacre

During the 1870s Edmonia Lewis often participated in western fairs, setting up booths in the form of wigwams to emphasize the links between the West and her Native American heritage. She also created several small marble works directly addressing this heritage, such as *Old Indian Arrowmaker and His Daughter* (1872) [4.45], based on Henry Wadsworth Longfellow's

4.45 Edmonia Lewis: *Old Indian Arrowmaker and His Daughter*, 1872
Marble, H 27 in. (68.6 cm.)
Carver Museum, Tuskegee Institute, Alabama

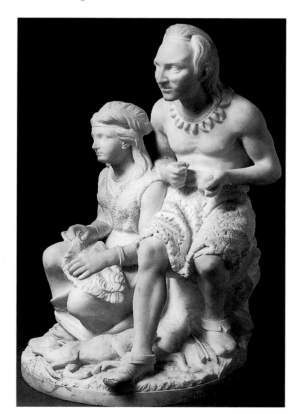

1855 poem "The Song of Hiawatha." Although, as in *Forever Free* [4.39], the daughter's facial features are decidedly Europeanized, here Lewis conveys a sense of the interrelationship between the activities of Native American men and women. The older man creates the arrows to kill the forest animals, whose hides the young woman will prepare for clothing and whose meat she will cook. It is a tranquil scene, yet it is not self-contained, for the two figures both gaze outward, perhaps at Hiawatha, who offered Minnehaha a deer as part of his marriage proposal.

The last quarter of the 19th century was far from tranquil for Native peoples. Once the Civil War was over, the army turned its attention to the final eradication of Native resistance to westward expansion and to the continued confiscation of the land granted Native Americans under earlier treaties. And artists continued to play a role in representing these developments through paintings, drawings, and photographs. Many of the photographs taken by individuals such as Thomas Easterly [3.44] appeared in sets of stereoscopic views similar to those produced of the Civil War. Photographs were also added to official government records of transactions between Native Americans and government representatives and were translated into illustrations that appeared in popular magazines and novels. Sometimes they provided only general inspiration for the illustrations; other times they were literally copied. This was also the case with certain paintings and drawings. Sometimes the magazine illustrator utilized general painterly conventions in creating his or her image; other times he or she copied specific paintings or drawings in detail.

Page 41 of the January 16, 1869 issue of *Harper's Weekly* [4.46] contains a series of images from the worlds of both drawing and photography. It is part of a larger article recounting the latest success for the U.S. Army in "The Indian War," General George Armstrong Custer's surprise attack and victory over the Cheyenne Chief Black Kettle at Washita River, Oklahoma, on November 27, 1868. After killing the chief and 102 of his warriors, Custer and his troops proceeded to the undefended village where all males over eight years old and many of the women and younger children were also killed. The lodges, winter stores of food, and ammunition were then destroyed, leaving the survivors to die a slow death from starvation or exposure to the cold. Custer also destroyed 875 Indian ponies.

The three wood engravings that take up most of the page are meant both to illustrate and to justify what came to be known as the Washita River Massacre. The top and bottom images are engraved versions of drawings produced by Theodore R. Davis, a well-known illustrator-reporter on the staff of *Harper's*. While Davis had spent six months with Custer

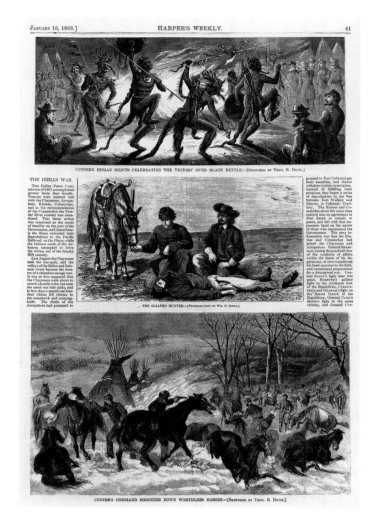

4.46 Theodore R. Davis and William S. Soule: illustrations in *Harper's Weekly*, January 16, 1869

out West in 1867, he had been back East for at least a year when the massacre occurred. His experience with Custer undoubtedly contributed to the decision to assign him the task of illustrating the article.

Davis's drawings give the impression that he had been present at Washita River, an impression reinforced by the very fact that they are "sketches," quickly executed, and by the phrase "Sketched by Theo. R. Davis" included in parentheses after the caption for each image. Davis did not portray the actual battle, but instead showed two events that happened immediately afterwards. The top engraving is captioned "Custer's Indian Scouts Celebrating the Victory Over Black Kettle." The opposition between the civilized white soldiers and the savage Indian scouts is spelled out in the wild gestures, face paint, and costumes of the group of Osage and Kaw scouts, who perform by firelight, and the impassive faces and poses of the white

soldiers who watch. The demonic aspect of the scouts is further reinforced by the tails that form part of their costume. This sketch also suggests that Native Americans, as much as European Americans, were responsible for the massacre at Washita River. The U.S. Army took advantage of existing rivalries between Native peoples and played one group off against another, promising them land or weapons in exchange for cooperation.

The bottom image shows Custer's soldiers engaged in an activity that the caption describes as "shooting down worthless horses." Again there is an opposition between the wild horses and the calm soldiers who shoot the horses in the head at close range. Thus, the horses—only partially tamed nature—and Native Americans are visually equated. This would not be the first time that the destruction of animals was seen as parallel to the destruction of Native Americans. The animal in question, however, was usually the buffalo. Just as the destruction of the Cheyenne horses (certainly not "worthless" to them) was part of the military strategy of the 1868–69 campaign, so too was the destruction of buffalo part of a larger military strategy. "Kill every buffalo you can," advised one army officer. "Every buffalo dead is an Indian gone."

The frantic activity contained in the upper and lower sketches contrasts sharply with the stasis of the central image. The words in parentheses after its caption, "The Scalped Hunter," explain this contrast—"Photographed by Wm. S. Soule." As we have seen, photographic technology was not yet able to depict objects in motion clearly. While the sketch could capture the action of war, even if only as conceived of in the imagination of the artist, the photograph could capture only its mundane preliminaries or its more deadly aftermath.

This wood engraving after a photograph by William Soule contains the one dead person on the magazine page. But this white man did not die before or during the Washita River battle referred to in the caption to the image directly above. The source of the photograph is included in the *Harper's* article. The hunter Ralph Morrison was murdered and scalped by Cheyenne warriors less than a mile from Fort Dodge, Iowa, on December 7, 1868. William Soule, stationed at the Fort, "availed himself of the opportunity to benefit science and gratify the curiosity of your readers by taking a counterfeit presentment of the body, literally on the spot." This was, according to the author of the article, "the only picture ever taken on the Plains of the body of a scalped man, photographed from the corpse itself, and within an hour after the deed was done." The author continues: "The pose of the remains is delineated exactly as left by the savages, the horrible contortion of the ghastly features, the apertures left by the deadly bullet, the reeking scalp, the

wounds, the despoiled pockets of the victim, all are true to life anomalous as the presentment of death may seem." The gruesome detail of this description serves not only to titillate the reader but also to reinforce the veracity of the visual account. This aspect of truthfulness is further guaranteed by the scientific method used to capture the scene—photography—despite the fact that the written description includes elements not readily visible, or not visible at all ("horrible contortion"), in the engraving. Of course, even if the dead body had been photographed exactly as it had been found, the two figures behind it were obviously posed to create a connection between the dead man and the actions of the soldiers who would avenge his death. The death of one white hunter thus functions visually as a justification for the actions at Washita River as captured in the images at the top and bottom of the page, despite the fact that the hunter was killed ten days after the massacre had occurred.

Encyclopedias of Experience: Native American Ledger Art

The Art of Incarceration: The Fort Marion Ledger Drawings

The battles between Native Americans and the U.S. Army continued throughout the late 1860s and early 1870s. In the spring of 1875, at the end of the Red River War, seventy-two Southern Plains chiefs and warriors were imprisoned at Fort Marion (the renamed Castillo de San Marcos [1.13]) in St Augustine, Florida. These Cheyenne, Kiowa, Arapaho, Comanche, and Caddo were deemed "dangerous criminals" by the U.S. government for their wartime aggressions and were held to ensure that their people would adjust more peacefully to the reservation life that had been imposed upon them in the aftermath of the recent battles.

During their three years of incarceration, from 1875 to 1878, many of these men filled drawing books with brightly colored images of Plains Indian life and of the world of white men and women within which they were forced to live. Such drawings had appeared earlier in the century, after the introduction of the necessary materials to the Plains Indians by white traders and soldiers. Indeed, the Mandan Mah-To-Toh-Pa [3.35, 3.39] was given such materials by Karl Bodmer during the artist's visit in 1833–34. By the last third of the century this "ledger art," so-called because the paper often came from accountants' ledgers and was thus lined, was a significant presence alongside the traditional painted buffalo hides within tribal culture. (Often the ledgers already contained entries by their previous white owners, over which the Native artists drew their images.) Because it evolved during a time of radical transition within

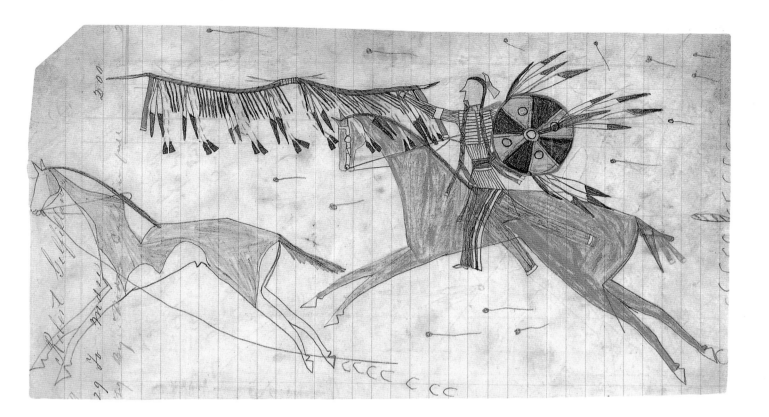

4.47 Anonymous, Cheyenne: *Last Bull Captures a Horse*, 1871–76
Pencil and colored pencil on paper, 6⅞ × 10½ in. (17.7 × 26.7 cm.)
United States Military Academy Library, West Point, New York

southern Plains culture, ledger art also functioned as a testimony to the changes and adjustments being made by Plains peoples.

One example of a Cheyenne ledger drawing from the early 1870s was discovered in the papers of Captain John Gregory Bourke, an aide-de-camp to General George Crook of the 3rd U.S. Cavalry in Wyoming Territory [4.47]. The work, datable to 1871–76, shows Last Bull, Head Chief of the Kit Fox Society (he is identified by his shield and his Kit Fox Society bow lance), capturing a horse. This capture occurs during a battle, indicated by the bullets that fly past Last Bull but do not stop him. As is typical of ledger art, and of its antecedents found on the animal hides examined in earlier chapters [1.35, 3.36], the figures are two-dimensional, with clear, dark outlines that are carefully filled in with flat areas of color. Human figures and animals are shown in profile and the action proceeds from right to left, an arrangement common in most ledger art depicting battles or hunting scenes (when two individuals face each other, the victor is almost always positioned on the right).

The exploits of warriors and hunters, along with scenes of courting, were the most common subject-matter of ledger art. Books of drawings produced by men were powerful autobiographical statements and were often taken along into battle. In all three categories of images the horse played a key role, whether as a warrior's mount or as war booty or as an indication of a man's status. Horses transformed the lives of

Plains Indians when they were introduced by the Spanish in the 17th century, affecting their ability both to hunt buffalo and to wage war. Horses connoted power, both military and personal, and were key to a male warrior's identity. It is little wonder, then, that horses played such a dominant role in the pictorial art of Plains Indians throughout the 19th century. In the last quarter of the 19th century, however, as Native peoples were increasingly confined to reservations, the horse came to symbolize not only the personal exploits of individuals, but also the ethnic identity of Plains Indians as a whole. As the art historian David Penney has pointed out, reservation life offered little opportunity for men to distinguish themselves in battle, or in the hunting of buffalo, whose herds had been depleted by the 1880s. Yet men and women continued to produce images of mounted warriors and hunters in their paintings and beadwork. These figures "gave testimony to the great accomplishments of that earlier generation whose memory was thus kept alive" and became symbols of "solidarity and difference in relation to others."

Captain Bourke, like many U.S. soldiers, acquired his books of drawings either by ransacking Indian camps and battlefields

or by purchasing them from their makers or other military men or traders (his collection contained over a thousand drawings). Bourke presented a large display of these drawings in Omaha in 1881, catering to a growing public interest in works by Native Americans. Another military officer, Colonel Garrick Mallery, had contributed to this interest with an 1877 article on the Lakota (Sioux) Lone Dog's Winter Count, a calendrical history covering 1800–1876 (each year is represented by one or two pictographs recording a notable event of that year), which had caught the attention of the federal government. Mallery was then hired by the U.S. Geological and Geographical Survey to conduct research on the Native peoples of North America. Five years later the Bureau of American Ethnology devoted its entire annual report to his 822-page *Picture-Writing of the American Indians*. In this work Mallery noted that "when Indians now make pictographs it is with intention and care—seldom for mere amusement. Even when the labor is undertaken merely to supply the trade demand for painted robes or engraved pipes or bark records, it is a serious manufacture."

This was certainly true of the works produced at Fort Marion. Captain Richard H. Pratt encouraged the artistic efforts of his prisoners by providing them with drawing materials and allowing them to sell their books of drawings for two dollars each to the tourists who often visited the fort (they also sold bows, arrows, fans, and pottery). The books were part of Pratt's larger attempt to reform his Native charges through education, religious instruction, and hard work, an effort that had obvious connections to the broader penal reforms that were under discussion throughout the nation. The material produced was soon in great demand, and one might argue, in fact, that the popularity of the Fort Marion work helped spur the vogue for ledger drawings and other objects decorated with indigenous designs among European Americans in the last decades of the 19th century. Janet Berlo notes that in the 1890s in particular a "brisk commerce in beadwork, basketry, pottery, and many other goods swept across the nation. Of special interest were small items and miniatures that could be displayed in a Victorian parlor or in an 'Indian corner.'"

There was thus a new audience for the products of these Native American artists—white tourists rather than fellow warriors or tribal members or the occasional soldier or trapper. This new audience, along with the fact of the artists' imprisonment, had a decided effect on the subject-matter of the drawings: scenes from the train journey to Fort Marion and from daily life at the fort now appeared, leading to new representations of encounters between whites and Native Americans. At least one of the artists, the Cheyenne Howling Wolf, also had extensive contact with European artistic traditions during a trip to Boston for medical treatment, which resulted in certain stylistic changes in his work, notably an increased use of landscape elements and a painterliness that countered the two-dimensionality of his earlier ledger art.

In *Fort Marion Prisoners Dancing for Tourists* (1875–77) [4.48] the Cheyenne warrior Cohoe presents his own interpretation of the theme of the "savage" Indian entertaining "civilized" European Americans that had been represented by Davis approximately six years earlier in his *Harper's* sketch [4.46]. There are striking differences between the two images. While Davis places the viewer at eye level, within the circle of army officers, Cohoe presents a double perspective. The viewer is simultaneously on the same level as the group and above it. The overall feeling is of distance or removal, as opposed to the inclusiveness of Davis's piece. While Davis creates a sense of three-dimensionality through the use of shading and perspectival conventions (e.g. the overlapping of figures or their decreasing size as they recede into the background), Cohoe creates a two-dimensional image through the use of flat areas of color and clearly outlined figures of equal size placed in a space devoid of ground lines or other orientational markers.

Davis pays great attention to the costumes of the dancing scouts, while Cohoe pays equal attention to the costumes of the white tourists, particularly those of the women. The identities of his figures appear, indeed, to lie in their clothing rather than their facial features, for their faces are left completely blank. One of the effects of the adoption of paper and pencil or watercolor on Native art was an increase in detail, a detail more readily produced with pencils or pens or manufactured brushes than with the stick and bone brushes used earlier to paint on hide. The only man dressed in a soldier's outfit, standing to the right of the dancers, may well have been Captain Pratt, while the circle of Native figures behind the two standing men could represent drummers or chanters.

Both Davis and Cohoe were creating for white audiences, but from strikingly different positions. The white artist Davis was creating within the conventions of Western art for an employer committed to the sensationalization of information and for an audience eager to experience—vicariously, of course—some of the drama of the frontier, an audience that, for the most part, had accepted the distinction between "savage" and "civilized" that is embedded in Davis's image. The Cheyenne prisoner Cohoe, on the other hand, was drawing upon the conventions of Plains Indian hide painting to create images for white tourists who wanted to take with them a souvenir of their trip to what Berlo describes as an "idealized penal colony, where a miniature but representative society of Plains warriors enacts scaled-down and sanitized simulacra

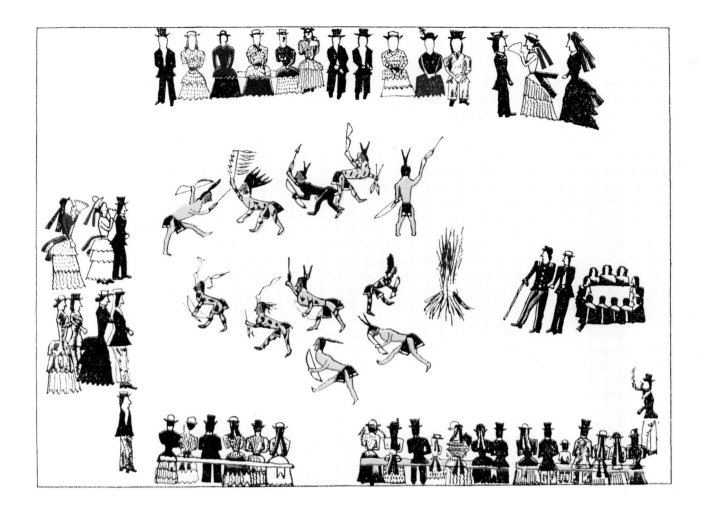

4.48 Cohoe, Cheyenne: *Fort Marion Prisoners Dancing for Tourists*, 1875–77
Pencil and colored pencil on paper
Private collection

of warfare for their captors' pleasure." The three-dimensionality and mimetic nature of Davis's work read as "real" to the white viewer; the two-dimensionality of Cohoe's work read as childlike, naive. The tourists who left Fort Marion thus took with them, again in Berlo's words, "a memento of their voyeuristic experience, secure in their privileged insight into 'the Indian Problem' and its solutions."

Cohoe's fellow prisoners would have read his image differently. Having experienced, themselves, the indignity of having to don "traditional dress" to perform for tourists, or having watched others do so, they may well have read the scene as one of humiliation rather than pleasurable entertainment. The two-dimensional style would have signified not "childlikeness" but their own art traditions, while the tourist audience arranged in rigid order around the dancers would have conveyed a sense of the dancers' own entrapment, both literally at Fort Marion and

figuratively within a foreign culture. In fact, the rectilinear arrangement of the tourists around the circular arrangements of Native Americans suggests the importance of the free-flowing circle in Native American life as opposed to the box-like architectural forms and the penchant for order, symmetry and conformity so ever-present at Fort Marion.

Yet the continuation of their ceremonies and their visual arts traditions, in however compromised a form, undoubtedly functioned as a means of resistance to the imposed white order. Through their drawings the imprisoned chiefs and warriors represented their experiences at Fort Marion not only for themselves and for white tourists but also for other members of their tribes: they often sent drawings to their families as "letters" and received similar pictographic responses in return.

The Kiowa prisoner Wo-Haw (1855–1924) also created an image that spoke to the entrapment of Native Americans within white culture. In *Classroom at Fort Marion* (1875–77) [4.49] he depicts, again in the flat, two-dimensional Plains style, a schoolroom scene where nine warriors, in Western suits with hair shorn, attentively watch the female teacher in the

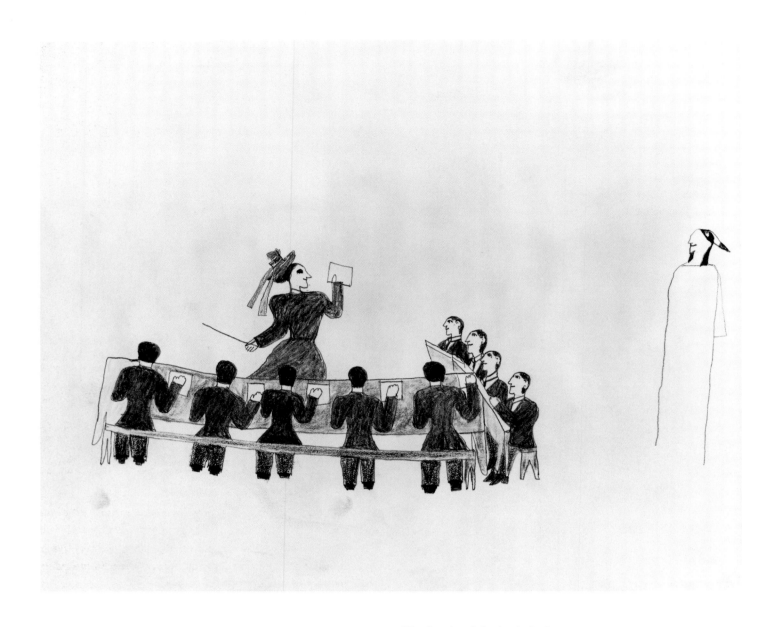

4.49 Wo-Haw, Kiowa: *Classroom at Fort Marion*, 1875–77
Pencil and crayon on paper, 8¾ × 11¼ in. (22.2 × 28.5 cm.)
Missouri Historical Society, St Louis, Missouri

center. Wo-Haw has also absorbed certain Western artistic conventions, positioning the teacher behind the long table and placing a shorter table at right angles to suggest a three-dimensional space. While the students turn their attention to the teacher in front of them, they are, at the same time, being watched, not by another white teacher or soldier but by the spectral form of a Native American with a feather in his long hair. Here is the ghostly presence of that culture from which these warriors had been forcibly removed, a culture that their white captors wanted them to forget or to replicate only for the amusement of tourists.

The Battle of the Little Bighorn

Throughout the 19th century two solutions had been proposed to the "Indian problem": extermination and assimilation. The need for a "solution" became even greater after the defeat of General Custer and his men on June 25–26, 1876, at the battle of the Little Bighorn in southeast Montana, a battle recorded five years later in a series of forty-two large drawings by one of the participants, the Minneconjou Lakota Red Horse. Coming upon an encampment of over 7,000 Lakota, Cheyenne, and Arapaho on the Little Bighorn River, Custer underestimated its size and thought he and his 500 men of the 7th Cavalry could destroy it as easily as they had the village of Native Americans camped along the Washita River eight years earlier. In a poignant testimony to the aftermath of the battle, Red Horse depicts a field of dead horses [4.50]. Given the high regard in

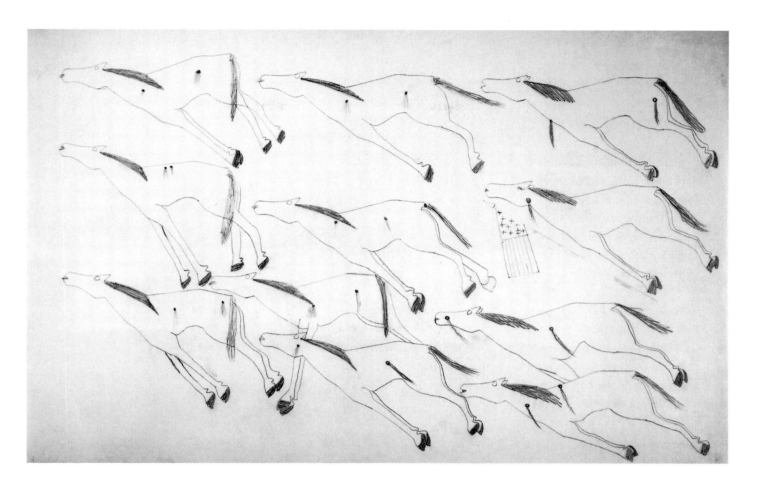

4.50 Red Horse, Minneconjou Lakota: *Dead Cavalry Horses*, 1881
Pencil and colored pencil on paper, 8¾ × 11¼ in. (22.2 × 28.5 cm.)
National Anthropological Archives, National Museum of Natural History,
Smithsonian Institution, Washington, D.C.

which horses were held by Native peoples, it is not surprising that Red Horse resists the sensationalizing engaged in by Davis, who showed the frantic horses in the act of being slaughtered at Washita River [4.46]. Instead, through an economy of means, he presents us with horses whose physical weight has dissolved, whose bodies appear to float in a timeless space, anchored to the historical moment only by the small American flag, positioned in front of the only horse whose eyes have not yet closed, whose last breath has yet to be taken.

A more dramatic rendition of the actual encounter at the Little Bighorn is given by the Cheyenne Hehúwésse or Yellow Nose (c. 1852–after 1914) in four drawings, produced around 1885. In one [4.1] he shows himself riding into the enemy camp and performing his most famous exploit of the battle, the capture of a U.S. flag and his subsequent use of it to "count coup," i.e. touch the enemy, on several soldiers. The drawing shows him counting coup on a soldier whose mount has collapsed beneath him. Yellow Nose's drawing is a far cry from

the pictographs of riders found on hides in the first part of the 19th century [1.35]. While the figures are still formed of clear outlines and filled in with flat areas of color, Yellow Nose's horse, almost doubled in half as it charges, is without precedent in its presentation of energy and movement.

Custer's defeat provided ammunition for those assimilationists who argued against the policy of creating reservations for Native Americans, not because the policy deprived them of land that was rightfully theirs, but because Native peoples forced onto reservations still remained a threat to surrounding white communities and to the belief in the superiority of European Christian ways. An article in the September 1876 issue of *Frank Leslie's Popular Monthly* suggested that not only reservations but the entire Indian way of life should be abolished, and Indians given trousers and shirts instead of blankets. This blueprint for survival was also promoted a decade later by the Friends of the Indians, which included many wealthy philanthropists and Protestant clergymen, who felt Native Americans should be given membership in American society in exchange for a repudiation of their culture. The Friends lobbied in support of the Dawes Act, passed by Congress in 1887, which offered an allotment of land and eligibility for full citizenship to every

Native American male who willingly cut his ties with his tribe and adopted the habits of European American life.

Yet the author of the article in *Frank Leslie's Popular Monthly* also acknowledged that there had been greater success in assimilating Africans and Chinese than Indians, primarily because the former had been removed from their homelands and cultures, making their immediate survival in this new country more dependent upon assimilation. It was not a "new" country for Native Americans, and their sense of entitlement to their ancestral lands and ways of life was strong. Assimilation was successful only after a large percentage of them had been killed, and then only partially successful. The land on which they lived, and continue to live, functioned as a reminder of their culture and their history, as did their ledger drawings. Berlo fittingly describes the ledger books as "encyclopedias of experience," records of both spiritual and individual history that "depict the comprehensiveness of the Plains Indian worldview in the second half of the 19th century." The art historian Anna Blume adds:

> In the turbulent years at the end of the nineteenth century, there was an interconnected web of killing and writing, drawing and photographing on the Great Plains. Ledger books, with their drawings by Native Americans, exist in the interstices between writing, drawing, and violence; their production is a metaphor for history in the Great Plains itself.

While the production of ledger art declined after the early 1890s, its stylistic influence remained and played a strong role in a revival of Plains painting in the 1920s and 1930s.

The End of the Ghost Dance

Symbols of the Ghost Dance in Ceremony and Dress

Despite being heavily outnumbered, Native peoples continued to engage in armed resistance against the U.S. Army until 1890, when this resistance was finally broken in a battle between the Lakota and the army at Wounded Knee Creek, South Dakota, on December 29. Over two hundred Lakota men, women, and children died. Their burial in a mass grave was delayed two days by a blizzard. On January 1, 1891, George E. Trager (1861–after 1895) recorded the scene in a photograph entitled *The End of the Ghost Dance* [4.51]. U.S. soldiers stand, weapons in hand, by the large hole in the ground, stacked high with the frozen bodies of the dead. They assume the position of proud hunters, the Native bodies equated with the Indian ponies and buffalo that met a similar fate at the hands of these same soldiers or their counterparts.

The title of Trager's photograph refers to the Ghost Dance movement, begun around 1889 in the Nevada region by a Paiute visionary, Wovoka. Wovoka prophesied that a time would come when white people would be no more, the land would be returned to Native peoples, and peace would reign. The beginning of this new era would be marked by the appearance of a "messiah" or savior figure, and the transformation would be non-violent: whites would simply disappear, along with persecution, hunger and disease. All generations, both living and dead, would then coexist together in a perfect world. The similarity to the Christian Last Judgment narrative is not surprising, for many such combinations of Western European and indigenous cultural and religious traditions existed in the United States by the end of the 19th century. Despite the non-violent aspect of Wovoka's prophecy, it instilled fear in many European American settlers and prompted the army to step up its attacks on the final pockets of Native resistance.

The Ghost Dance movement is among the best-known of several such millenarian movements, which evolved out of the extreme hardships endured by Native peoples in the early years of the reservation period. It represented a form of resistance to the social, political, and economic orders being imposed upon these peoples and spawned its own ceremonies and ritual objects. The movement extended throughout the Plains region, and while regional variations existed in the ceremonies and the decoration of ritual objects, all who adopted the Ghost Dance performed a distinctive circle dance, which was meant to hasten the arrival of the new era. In many Plains areas, men and women took part together, a practice unprecedented in earlier dance ceremonies. Individuals would often go into a trance and collapse, while the dancing continued around them.

In 1891 Yellow Nose was commissioned by the anthropologist James Mooney to depict a Ghost Dance ceremony on a deer hide [4.52]. Here the circle of men and women follows the edges of the hide. Arapaho women are distinguished from Cheyenne women by their hairstyles (the former have loose hair, while the latter's is braided). At least two people have fallen to the ground in a trance. One woman on the lower edge holds a stuffed crow, a bird associated with the Ghost Dance; other objects held include handkerchiefs and a hoop or baqati wheel.

While Yellow Nose indicates several aspects of the costume designs, such as stripes, dots, and belts containing disks of German silver, he doesn't show the detailed imagery that characterized Ghost Dance shirts and dresses. Fortunately, several of these items of clothing still exist. Two Arapaho dresses from *c.* 1890 provide a glossary of Ghost Dance

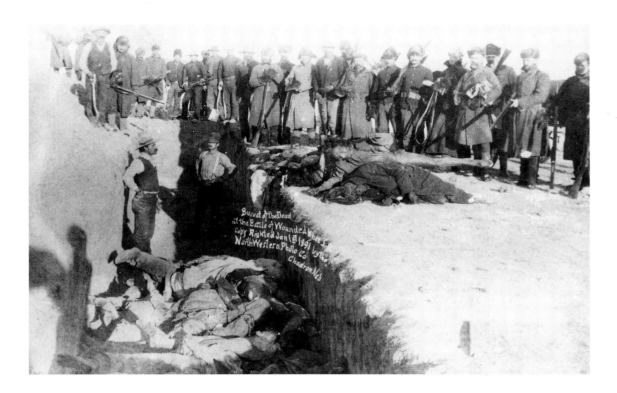

4.51 G. E. Trager: *The End of the Ghost Dance*, 1891
Photograph
Nebraska State Historical Society, Lincoln

4.52 Yellow Nose (Hehúwésse), Cheyenne: robe depicting
the Ghost Dance, 1891
Colored ink on deerskin, 39 × 49 ⅝ in. (99.1 × 125.7 cm.)
National Museum of Natural History, Smithsonian Institution,
Washington, D.C.

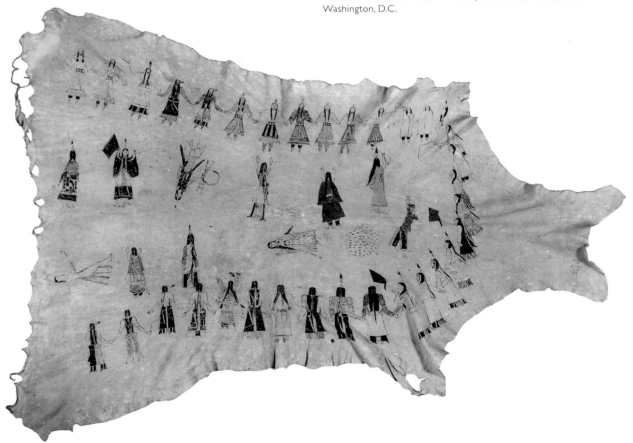

symbols. Those on the first dress [4.53] are primarily astral. The yoke contains two forms representing stars—the two rows of circles at the top and the two rows of Maltese crosses (all four arms of the cross are of equal length) at the bottom. The latter represent the morning star, which may allude to the coming of a new era. In the center of the yoke is a crescent moon. The eagle feathers may refer to the belief that eagles carried Ghost Dancers to the other world, where they met their ancestors and tasted the world of peace and prosperity that was to come. Thus the symbolism on this dress firmly locates its wearer within the cosmic universe of a spiritual and cultural revival. The second dress [4.54] also includes astral symbols, this time in the form of five-pointed stars, suggesting a source in American flags and military paraphernalia. The

yoke, however, contains the figure of a woman flanked by two eagles. In her left hand she holds a pipe, symbolic of peace, and in her right hand a branch, perhaps a sage bundle. Above her are two Maltese crosses, as well as a crescent moon, and in her hair is a feather. The dress is fully painted and also contains bands of beadwork at the hem and metal tinklers, which were used by southern Plains Ghost Dancers.

Many Plains Indians believed that Ghost Dance clothing performed a protective function, like a shield, preventing the wearer from being harmed by bullets or other weapons. Some dancers even referred to the painted bib area or yoke of dresses and shirts as the "shield." This protective function was also associated with another group of Ghost Dance symbols, several of which are found on an Oglala Lakota Ghost Dance shirt from

4.53 Anonymous, Arapaho (Inuna-ina): Ghost Dance dress, *c.* 1890
Hide with pigment and eagle feathers, 57½ × 35 in. (146.1 × 89 cm.)
Logan Museum of Anthropology, Beloit College, Beloit, Wisconsin

4.54 Anonymous, Arapaho (Inuna-ina): Ghost Dance dress with painted design of birds, turtle, and stars
Buckskin, 21½ in. (55 cm.) long
Museum of the North American Indian, New York

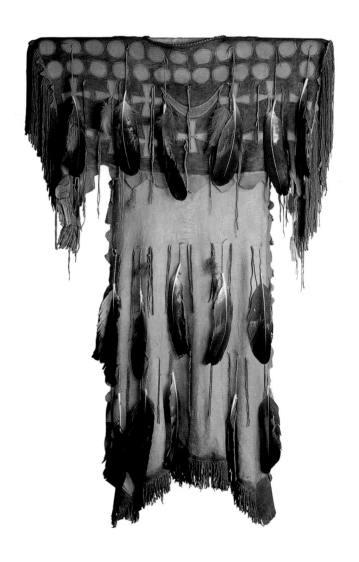

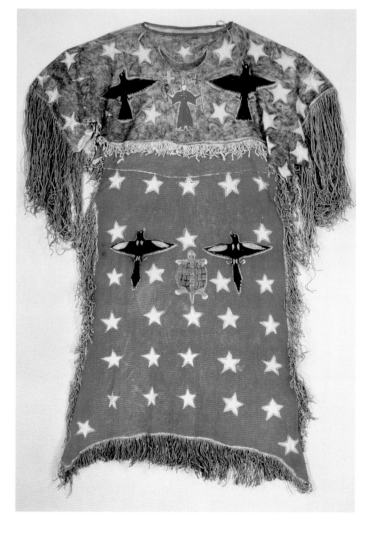

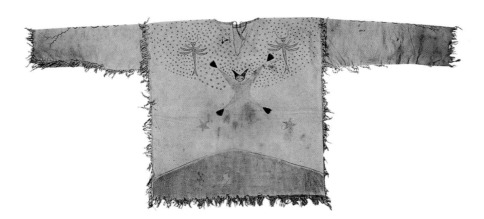

4.55 Attributed to Little Wound, Oglala Lakota: Ghost Dance shirt, 1890–91
Cotton muslin, pigment, and commercial leather, 34¼ × 32½ in.
(87 × 82.6 cm.)
University Museum, University of Pennsylvania, Philadelphia

1890–91 that has been attributed to Little Wound [4.55]. The yoke is marked by a dot pattern representing a hail of bullets. Among the dots are two dragonflies, known for their quick, darting movements, thus allowing them to dodge the hail of bullets. To the large four-pointed star in the center of the shirt has been added a head, thus anthropomorphizing it and turning it into a five-pointed star. The back of the shirt also contains a hail of bullets around the neck and a splayed eagle with jagged lines of power or lightning coming from its claws.

Imagery, however, was not able to protect the wearers against the hail of bullets that descended on Native peoples at Wounded Knee or at other battles of the last decade of the 19th century. With little hope now of the arrival of a new era, the Ghost Dance movement slowly disappeared, although the notion of a return to an earlier time survived and prompted additional revivals of older cultural forms that had fallen into disuse. Such revivals would take on a new dimension in the early 20th century under the guiding hand of European American entrepreneurs.

Several European American artists also produced images of the Ghost Dance. One of the most powerful of these representations is a life-size bronze statue by Paul Wayland Bartlett (1865–1925) entitled *The Indian Ghost Dancer* (1888–89) [4.56]. Bartlett produced the work while he was in Paris, and the plaster model from which the bronze statue was cast was exhibited at the 1889 Paris Salon. Through a highly textured surface, intense facial expression, and exaggerated pose, he conveys the trance-like state of exhaustion experienced by the dancer. Of course, Ghost Dancers wore elaborate costumes rather than performing in the nude. As a young sculptor attempting to establish himself in the art worlds of France and the United States, however, Bartlett needed to prove his ability to model the

human form. That he does so with such expressiveness, an expressiveness evident if one compares this work with Hosmer's *Zenobia* [4.38] or Lewis's *Forever Free* [4.39], is testimony to his apprenticeship with the leader of innovation in the realm of sculpture in Paris, Auguste Rodin. He was an assistant in Rodin's studio in the late 1880s and early 1890s.

Yet Bartlett did not support many of the artistic movements flourishing in Paris under the general rubric "Modernism" in

4.56 Paul Wayland Bartlett: *The Indian Ghost Dancer*, 1888–89
Bronze, H 67⅛ in. (170.7 cm.)
Smithsonian Museum of American Art, Washington, D.C.

the late 19th century. Rather, he saw the self-absorption, sensuality, and lack of rigorous training evident in the life-styles and work of these artists as "subversive." In 1913 he spoke of Modernist artists as having "the mentality of epileptics" and as gathering in studios "where painting is only a vicious daubing, and where deformities, holes and humps pass for sculpture." The art historian Thomas Somma argues, in fact, that *The Indian Ghost Dancer* is not only a statement about the practice of Ghost Dancing and, by association, the barbaric nature of Native Americans, but also a reference to the irrational, undisciplined, and irresponsible world of the Modernist artist, a world where self-absorption and trance-like, epileptic states prevent artists from acquiring the qualities of industriousness, rationalism, and competition that were the hallmarks of true artistic genius. Such attacks on Modernist art would multiply in the early 20th century as the formal innovations of European Modernism made their way across the Atlantic.

The Hampton Institute and Lessons in American History

Debates over the character of European artistic vision and practice were certainly far from the minds of Native Americans in the 1880s and 1890s. This did not mean, however, that they did not take part in discussions about the nature of education in general and the continuation of their own cultural practices in particular. Many who survived the battles and deprivations of the time ended up in educational institutions established specifically for Native Americans and/or freed African Americans. One of these was the Hampton Institute, a co-educational normal school set up in 1868 for freed blacks, with a program

4.57 Frances Benjamin Johnston: *Class in American History*, 1899–1900
Photograph
Library of Congress, Washington, D.C.

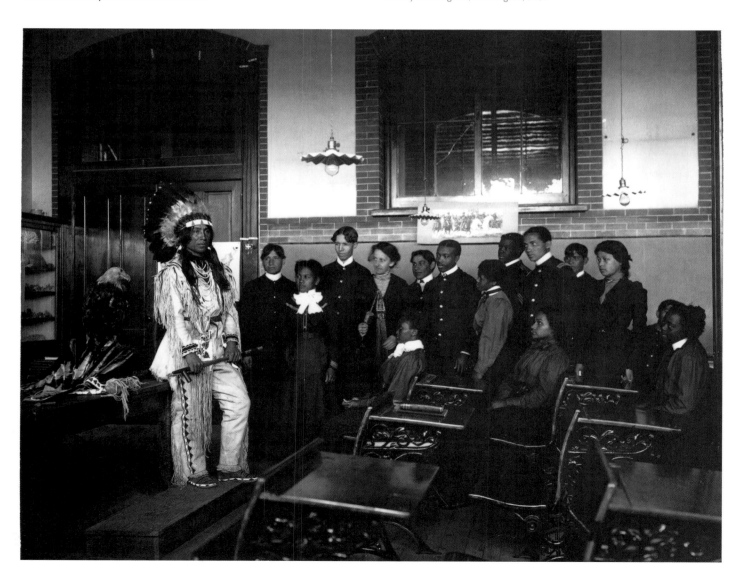

for Native Americans added in 1877. Its founder, Samuel Chapman Armstrong, was born in Hawaii, the son of missionaries. His father, as Minister of Public Instruction at Honolulu, viewed indigenous Hawaiians as "lazy people" and believed that their education must include physical labor if they were truly going to become civilized. Samuel Armstrong maintained this commitment to physical labor and practical skills at the Hampton Institute. He also inherited some of his father's mistrust of dark-skinned people, writing in 1862, after having joined the Union Army, that "I am sort of an abolitionist, but I have not learned to love the Negro." Even after having led a regiment of black soldiers for the final two years of the war, he noted in 1865 that he felt "the colored soldier had not done enough" to have proved himself the equal of the white soldier.

Upon leaving the army Chapman was granted a position with the Freedmen's Bureau as superintendent of the Ninth Subdistrict of Virginia. In this capacity, he gathered around him a group of individuals committed to his cause of educating future African American teachers and leaders, helping them to adapt to existing social and political norms. The same goal was later set for Native Americans. They were to receive vocational and religious training at his Institute and then return to their reservations to pass on the knowledge they had gained.

In the late 1890s the Washington photographer Frances Benjamin Johnston (1864–1952) was commissioned by the Hampton Institute to create a series of photographs marking its success. This series was shown at the Universal Exposition in Paris in 1900 as part of an exhibit tracing the rapid progress of African Americans since the end of the Civil War. One of the photographs was *Class in American History* [4.57]. As in Wo-Haw's drawing [4.49], Native Americans in European garb with cropped hair (here joined by African Americans) are pictured with a Native American in "traditional" dress. He is not a ghostly presence, however; nor is he evidence of a living culture. Rather, he is present in flesh and blood as "history" and as artifact, a symbol of a noble yet savage culture destroyed by the inevitable march of progress, embodied in the print of gunslinging cowboys or cavalry above the heads of the children and in the very clothes and hairstyles of the children themselves.

The print on the wall refers to a contrast that was central to the imagery of the West in the late 19th century, that between the cowboy and the Indian. An artist who became famous for his depictions of these two figures was Frederic Remington (1861–1909), whose *A Dash for the Timber* (1889) [4.58] could well have been the model for the print in Johnston's photograph. Remington had begun his artistic career in the early 1880s as an

4.58 Frederic Remington: *A Dash for the Timber*, 1889
Oil on canvas, 48¾ × 84⅜ in. (123.8 × 214.6 cm.)
Amon Carter Museum, Fort Worth, Texas

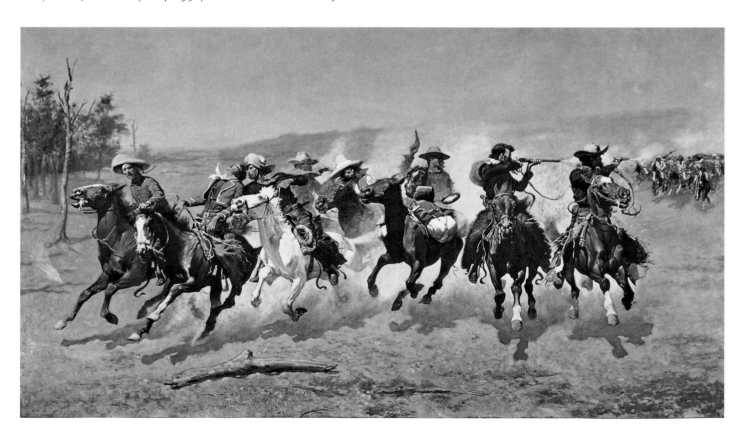

illustrator for *Harper's Weekly*, providing images of the West to accompany the magazine's articles (later he also wrote and illustrated his own articles). By 1888 he was submitting paintings to the annual exhibition of the National Academy of Design, which received favorable reviews. Soon prints after several of these paintings began circulating throughout the country, available for anywhere from ten cents to two dollars. Remington was one of several artists depicting the West in the last decades of the 19th century. Yet his appearance in a popular and widely circulated magazine, and in a promotional campaign begun by *Harper's Weekly* in 1890 which presented him as both a true Westerner and one who "draws what he knows and knows what he draws," ensured him a place in the public imagination.

Yet what Remington knew about the West, and how that knowledge affected his paintings and drawings, has come under scrutiny in recent years. The art historian Alex Nemerov quotes Remington: "I sometimes feel that I am trying to do the impossible in my pictures in not having a chance to work direct but as there are no people such as I paint it's 'studio' or nothing." While Remington made several trips to the West, sketching, photographing, and collecting clothing, guns, and other artifacts for his paintings, the works themselves were created primarily in his studio in the East. The accuracy of costume and setting ensured that many would read his images as truthful accounts. Yet what gave his works even greater power was the belief that this place and time of charging horses and brave men and threatening Indians was over, that the civilized life of the East, with its factories and cities and increasing numbers of immigrants, had pushed the West off the map. Civilization had won out, yet what was lost was the adventure and excitement and proving ground for men like Remington.

Several of the Native prisoners at Fort Marion went to the Hampton Institute after their release. One of them, the Cheyenne Bear's Heart, captured the collision of cultures embodied in Wo-Haw's drawing and Johnson's photograph in a May 1880 speech he made in English in Virginia in front of an audience that included President Rutherford B. Hayes and Governor John D. Long:

Before Indians went to school, Capt. Pratt he gave Indians clothes just like white men, but Indians not want hair cut. Sunday Indians go to church St. Augustine: down from head, Indians same as white men; but heads, long hair just like Indians. By and by after Indians go to church, they say I want my hair cut; my teachers very good. Two years I stay at St. Augustine, then come Hampton. At Hampton I go to school and work.

Donal Lindsey writes in his study of Native Americans at the Hampton Institute that most evidence "shows not only whites but many Indians and blacks verbalizing Eurocentric themes. At a school whose educational philosophy was among the nation's most accommodationist, independent thinking by blacks and Indians was usually unwanted and thus its expression rarely preserved." Lindsey also notes that such independent thinking did occur at times, and forced changes in the Institute's policies. Bear's Heart does not openly criticize the policies of either Fort Marion or the Hampton Institute. Yet he may well have found that what was most valuable in the education that he and his fellow prisoners and classmates received were lessons in the advantages of accommodation as a mechanism of survival.

All three individuals—Bear's Heart, Wo-Haw and Johnston—present, in their words and images, the coming together of two worlds that was so crucial a part of the development of visual culture and of a sense of national identity in the United States in the 19th century. Bear's Heart conveys, in halting words, the gradual process of Native Americans' accommodation to the ways of their captors, although he leaves much unsaid about what motivated this accommodation. Wo-Haw [4.49] presents Native culture as a living presence (albeit a ghostly one) in the daily lives of his people at Fort Marion. Johnston [4.57] presents this same culture exhibited as a curiosity, an example of what needs to be left behind as a lived experience, yet, at the same time, kept alive as a memory and a symbol of the United States, like the stuffed eagle on the table, through endless pictorial representations. This living memory was, and still is, necessary, according to the historian Richard Slotkin, in order to assuage a national conscience trying to reconcile the near-destruction of a people with the establishment of a democratic nation. Wo-Haw's image, and others like it, however, also need to be brought to the fore in order to remind us that Native American culture did not die in the 19th century, but remained a resilient and dynamic force in Native life. Recognizing this allows us to read the many images of this life and of the American frontier critically, not as records of unchallengeable facts or truths, but as the products of individuals perpetuating or resisting the material and ideological processes of conquest and colonization.

5

Work and Art Redefined

5.1 Robert Koehler: *The Strike*, 1886 (see pp. 262–63)
Oil on canvas, 71⅝ × 108⅝ in. (182 × 276 cm.)
Deutsches Historisches Museum, Berlin, Germany

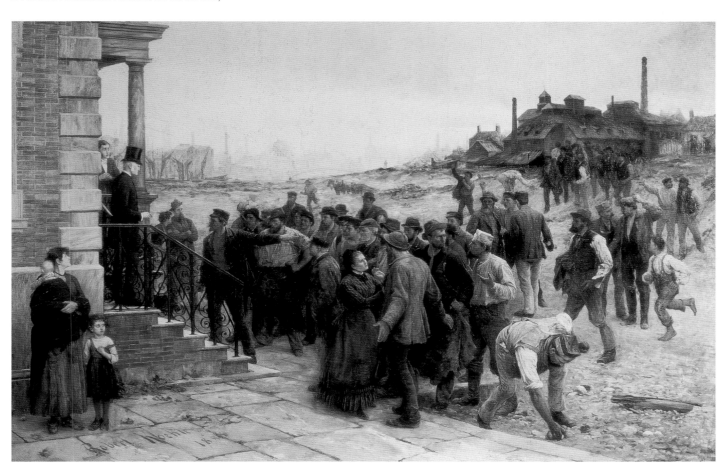

Timeline 1834–1898

5.16 (see p. 273)

1834 Nathaniel Currier begins producing lithographs (joined by James Merritt Ives in 1852)

1844 Founding of Philadelphia School of Design for Women

1847 Hiram Powers's *Greek Slave* (1843) [5.16] tours the U.S.

1848 Seneca Falls Convention and "Declaration of Sentiments"

1854 Treaty of Kanagawa opens Japanese ports to trade with U.S.

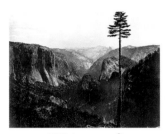

5.52 (see p. 298)

1857 Beginning of the construction of Central Park, New York, designed by Frederick Law Olmsted, with the assistance of Calvert Vaux

1864 Yosemite Valley, California, becomes a state park (becomes a national park 1890) [5.52]

1869 Publication of *American Woman's Home* by Catherine Beecher and Harriet Beecher Stowe; founding of the American Women's Suffrage Association

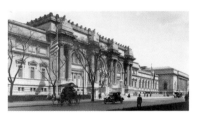

5.55 (see p. 301)

1870 Founding of the Metropolitan Museum of Art, New York [5.55], and the Museum of Fine Arts, Boston; John D. Rockefeller forms the Standard Oil Company of Ohio; the first train travels from Boston to San Francisco

1871 Great Chicago Fire

1873 December 13: Winslow Homer's *The Old Mill* (*The Morning Bell*) (1871) [5.6] appears in *Harper's Weekly*; publication of *The Gilded Age* by Mark Twain and Charles Dudley Warner

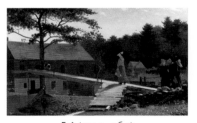

5.6 (see p. 260)

1874 James Parton publishes *The Triumph of Enterprise, Ingenuity and Public Spirit*, hailing chromo-lithography as "oil painting by machinery"; Charles Eliot Norton appointed at Harvard to the first chair in fine arts at an American university

1875 Thomas Eakins's *The Gross Clinic* [5.13] rejected by the Philadelphia Centennial art jury (it appears in the medical section)

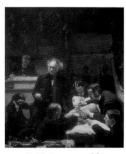

5.13 (see p. 268)

1876 Centennial Exhibition, Philadelphia; founding of the Philadelphia Museum of Art; invention of the telephone by Alexander Graham Bell

1879 Founding of the Art Institute of Chicago; Thomas Alva Edison invents the incandescent light bulb

1880 Rookwood Pottery in Cincinnati, Ohio founded by Maria Longworth Nichols Storrer

1882 Chinese Exclusion Act

1883 Thomas Eakins collaborates with Eadweard Muybridge on a project documenting locomotion for the University of Pennsylvania

1884–92 Monadnock Building, Chicago [5.59], by Daniel Burnham and John Wellborn Root

1886 Robert Koehler paints *The Strike* [5.1]; founding of the American Federation of Labor; national strike for eight-hour work day; Haymarket Riot in Chicago; installation of Auguste Bartholdi's Statue of Liberty in New York harbor

1887 Eadweard Muybridge publishes *Animal Locomotion* [5.11]

1888 Exhibition of John Singer Sargent's *Isabella Stewart Gardner* at Boston's St Botolph Club

1889 Completion of Frederic Edwin Church's home, Olana

1890 Publication of *How the Other Half Lives* by Jacob Riis [5.54]; publication of *The Gentle Art of Making Enemies* by James Abbott McNeill Whistler

1893 Hawaii becomes a U.S. Protectorate; World's Columbian Exposition, Chicago [5.56]; Frederick Douglass and Ida B. Wells denounce segregated admission policies at Exposition

1898 U.S. annexes Hawaii; Puerto Rico becomes a U.S. Territory and Guam and the Philippines ceded to the U.S. by Spain after Spanish-American War

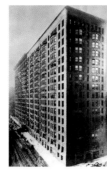

5.59 (see p. 304)

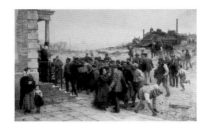

5.1 (see p. 251)

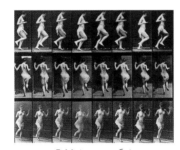

5.11 (see p. 267)

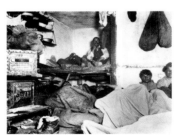

5.54 (see p. 300)

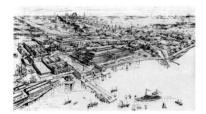

5.56 (see p. 303)

With the end of the Civil War, the United States turned its attention to rebuilding its political and economic infrastructure, asserting a new national unity as well as a growing international presence. The last quarter of the 19th century came to be known as the "Gilded Age," after a popular 1873 book by Mark Twain and Charles Dudley Warner that cast a critical eye on post-Civil War America as a time when "the air [was] full of money, nothing but money, money floating through the air." American industrialists and financiers, unfettered by anti-trust, health, labor, and income tax legislation, were able to amass vast fortunes, gaining control over large segments of the U.S. economy and exploiting the labor of the successive waves of immigrants who continued to enter the country. Artists and architects were often the beneficiaries of these wealthy individuals, who constructed and decorated elaborate mansions, as well as cultural institutions such as libraries and museums.

But the amassing of wealth by these "Robber Barons" did not go unchallenged, as workers organized and fought back against oppressive working conditions and low wages. Richard Slotkin writes that the motif of "the last stand" so common in artistic depictions of the western frontier came to function in a new way in the late 19th century as a powerful allegory of the plight of capitalism in an era of increasing labor unrest. Workers and immigrants were shown pitted against factory owners or their armed guards, paralleling the stand-offs between Native Americans and the U.S. Cavalry or rowdy roughriders. In newspaper descriptions of these confrontations, protesting workers were often described as "savages" or "redskins." The art historian Alex Nemerov notes that Frederic Remington was sent to Chicago by *Harper's Weekly* in 1894 to cover the Pullman strike. Just as he portrayed Native Americans and the cavalry engaged in close combat, so too did he show the coming together of strikers and soldiers in images such as *Giving the Butt* (1894) [5.2], where the latter attack the former with the butts of their rifles. Remington describes the strikers for *Harper's* readers as "vicious wretch[es] with no blood circulating above [the] ears," a description buttressed by his visual image of them as scruffy and ill-dressed. Considering himself of pure Anglo-Saxon stock, Remington blamed the country's increasing labor unrest on "the malodorous crowd of anarchistic foreign trash."

Remington was right in one respect. The strikes and labor protests that rocked the country in the last quarter of the 19th century were grounded in the ever-swelling ranks of manual laborers arriving from countries throughout the world. The population of the United States more than doubled between 1860 and 1900 (from 31 million to 76 million), with the fast pace of industrial development that resulted from the material

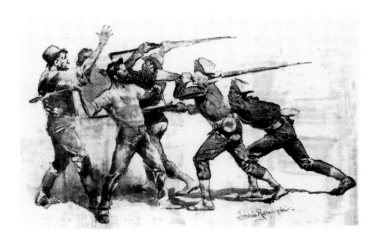

5.2 Frederic Remington: *Giving the Butt* (published in "Chicago under the Mob" in *Harper's Weekly*, July 21, 1894)
Pen and ink on paper
Frederic Remington Art Museum, Ogdensburg, New York

needs of the Civil War continuing apace in the postwar decades. But Remington was wrong in thinking that this unrest would have disappeared had the workers all been Anglo-Saxon immigrants. The very nature of the work and the conditions within which it took place—long hours of either repetitious or heavy labor in buildings that were often unbearably hot in the summer and freezing cold in the winter—denied the laborer the dignity that had been a crucial part of the myth of the United States as a nation of independent farmers and entrepreneurs. This myth had been embodied in John Neagle's 1826–27 painting *Pat Lyon at the Forge* [5.3]. Lyon, a successful blacksmith, asked Neagle (1796–1865) to portray him in his work clothes at his forge, rather than lounging in his study in his Sunday best. He was proud of having been able to rise to his position of wealth and prominence through hard work rather than inherited privilege, a rise that occurred despite having been falsely accused and imprisoned in his youth for bank robbery (the tower seen through the window is that of Philadelphia's Walnut Street Jail in which he was incarcerated). The positioning of the young man behind Lyon suggests that he, too, will have the opportunity to make his own fortune through hard work. The majority of working men and women at the end of the 19th century, however, were more likely to sell their labor for a wage than to own and run their own small farm or business.

Factories were not the only places where the nature of work was changing. Artistic labor was also undergoing a transformation, as mass production techniques cut the cost of prints and sculptures while mass distribution systems facilitated the appearance of these objects in thousands of homes across the nation. The sculptor John Rogers had his plaster models [e.g. **4.22**] mass-produced in bronze in a large factory in New York

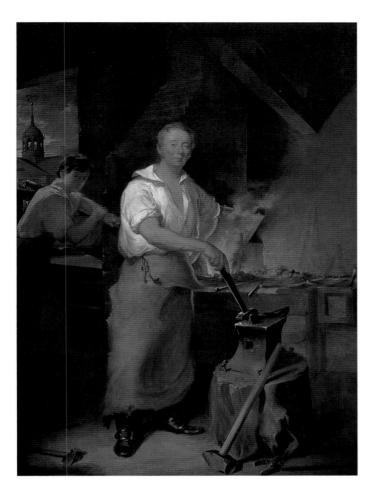

5.3 John Neagle: *Pat Lyon at the Forge*, 1826–27
Oil on canvas, 93 × 68 in. (236.1 × 172.6 cm.)
Museum of Fine Arts, Boston, Massachusetts

City. He also published illustrated catalogues of his work, allowing individuals who had never seen one of his small pieces to order their very own copy for around ten or fifteen dollars.

The growing popularity of photography also resulted in the establishment of mini-factories staffed by groups of individuals who were assigned one of several tasks that went into the production of a photograph. The literal creation of the photograph, therefore, was increasingly taken out of the hands of the photographer him- or herself. Oliver Wendell Holmes described the inside of the photography studios of Messrs E. and H. T. Anthony of New York City in his 1863 *Atlantic Monthly* essay "The Doings of the Sunbeam." Here Holmes focuses on the making of decorative portrait albums:

A young person who mounts photographs on cards all day long confessed to having never, or almost never, seen a negative developed, though standing at the time within a few feet of the dark closet where the process was going on

all day long. One forlorn individual will perhaps pass his days in the single work of cleaning the glass plates for negatives. Almost at his elbow is a toning bath, but he would think it a good joke, if you asked him whether a picture has lain long enough in the solution of gold or hyposulphite.

"As an account of fragmented and alienated labor," writes Alan Trachtenberg, "this could hardly be improved upon."

Photographs were not only marketed as objects in their own right or as illustrations in books: they were also, as the painter Samuel Morse predicted (see p. 136), increasingly used by artists as preliminary "sketches" (e.g. Remington was known to have used photographs extensively in the creation of his paintings). Photography changed, in certain ways, the "work," or labor, of art just as it changed, at times, the appearance of the resulting "work of art," leading to more accurate rendering of humans or animals in movement (the sequential photographs of Eadweard Muybridge were particularly important in this respect [see p. 267]) or a "snapshot-like" quality in genre scenes. New products and technologies also affected the ways in which artists worked. For example, collapsible tubes for paint were invented in 1841 by the American artist John G. Rand, freeing painters from hours of preparation and allowing them much greater mobility.

The changing world of work inside studios, photography shops, and factories was also marked by another crucial factor—gender. Gendered divisions of labor were not, of course, new. But as the nation shifted from a household economy, where the needs of the family were met primarily by labor within the home, to a market economy, where these same needs were met through the purchase of manufactured products made outside the home, many women were forced to enter the wage-labor force. Their jobs often echoed the types of labor they had performed in the home—domestic service, teaching, textile production. At the same time, middle-class women were increasingly subjected to what came to be known as "the cult of domesticity," which anchored women's identity in their ability to manage their homes and raise their children. This management included a minimum of physical labor, for their forced idleness became an indication of the husband's financial success. Many paintings appeared at the end of the century in which well-dressed women lounge about in lavish interiors or have tea in overgrown gardens, while waited on by domestic servants.

Women also became identified with culture, as its preservers rather than its creators. They were given the task of decorating their homes in a manner that would encourage the moral and cultural development of their offspring. Some of

those with enough money also turned their attention to creating a national culture by providing patronage to artists or acquiring important collections of art using their own or their husbands' wealth. And many also disproved the myth that women could not be producers of culture. In addition to painting and sculpting, women also played an important role in the creation of fine ceramics, metalwork, and needlework. Many became emboldened by a growing women's movement and assumed active roles in the re-examination of political, social, and artistic norms that marked the end of the 19th and the beginning of the 20th century.

The increasing association of women with culture also facilitated the development of a new critical art language and a new style. John Ruskin's emphasis on "truth" and "nature" was replaced by James McNeill Whistler's focus on "beauty" and "art." Detailed realism and smooth surfaces were abandoned by many artists for hazy landscapes and paint-laden brushstrokes, the clearly drawn narratives of the former now nudged aside by the moods and vague sentiments of the latter. The decorative was celebrated in painting and the subject-matter best suited for such a decorative emphasis was women, whether naked or clothed, whether residing in comfortable interiors or misty landscapes. Men occupied the recognizable world of economics, women the ideal world of aesthetics. This move away from the narrative and toward the decorative or abstract would continue in the first part of the 20th century and would spawn increasingly heated debates over which styles of art were truly representative of the United States in a new, "modern" era.

One Hundred Years of Independence: Taking Stock of America at the 1876 Philadelphia Centennial Exhibition

The one hundredth anniversary of national independence from England in 1876 was, for many, a major landmark, proof of the country's coming of age. A civil war had been weathered, ensuring the unity of the nation. Technological advances had taken place that drastically altered the lives of Americans, sometimes for the better, sometimes for the worse. In 1870 the first train traveled from Boston all the way to San Francisco. Brokers could exchange news in seconds via Samuel Morse's telegraph. Middle- and upper-class families could read their daily magazines and newspapers by gaslight. Many farmers now had automatic reapers, and women were aided in their daily needlework tasks by the sewing machine. At the same time the continually deteriorating conditions in factories and the lack of safety devices on much of the new machinery took the lives and limbs of increasing numbers of men and women. This same new machinery also created unemployment for many skilled laborers. Slums expanded to accommodate the waves of people pouring into cities in search of work, setting up stark contrasts between the homes of the wealthy and the poor.

The Philadelphia Centennial Exhibition of 1876 focused, however, on the glories rather than the tragedies of progress. The nature of this celebration, and the framework of historical progress within which it was encased, were eloquently captured in an illustrated engraved stock certificate issued in 1875 to shareholders in the Centennial Corporation [5.4], established to facilitate the funding and organization of the Fair. Its overall iconography was probably established by a committee of the Centennial Board of Finance, with the project then given to Felix O. C. Darley (1811–88) and Stephen J. Ferris (1835–81) of Philadelphia, who created the final engraving.

The stock certificate is divided into three registers, each containing groupings of figures that, together, frame the text in the center. The main characters in the top register are women—not historical characters, however, but allegorical representations of continents and concepts. America, dressed in the classical garb of Liberty and wearing a liberty cap, stands in the center, her arms extended in a welcoming gesture to either side. At her feet sit personifications of Fame, with her laurel wreaths, and Art, with her palette and brush. To the right of Art stand women bearing gifts. They are recognizable, through their physical features, gifts, and clothing, as representations of the lands of India, Africa, and the Far East. To the left of Fame stand Europe, Central America, and South America, similarly identifiable by their features and what they wear. In front of this group of women are busts of George Washington on the left and Ulysses S. Grant on the right. (Their two seats of office, the Philadelphia State House and the Capitol in Washington, float faintly above them in the background.) The two presidents, whose terms of office mark the two ends of the country's hundred years of independence, are connected by a bald eagle carrying a U.S. flag, the pointed staff of which is directed somewhat ominously at the head of Grant.

Thus America as hostess welcomes nations from around the world to the Centennial International Exhibition. Her hand-maidens, Fame and Art, sit ready to judge and commemorate the best that this world has to offer, represented by the agricultural gifts carried by the women to either side. Yet agricultural products were not the primary focus of the Centennial Exhibition. Instead, center stage was occupied by the kinds of objects carried by the pairs of men faintly sketched in the background on either side—inventions relating to trade and commerce. National progress was to be measured not by agricultural wealth, but by advances in industry and technology.

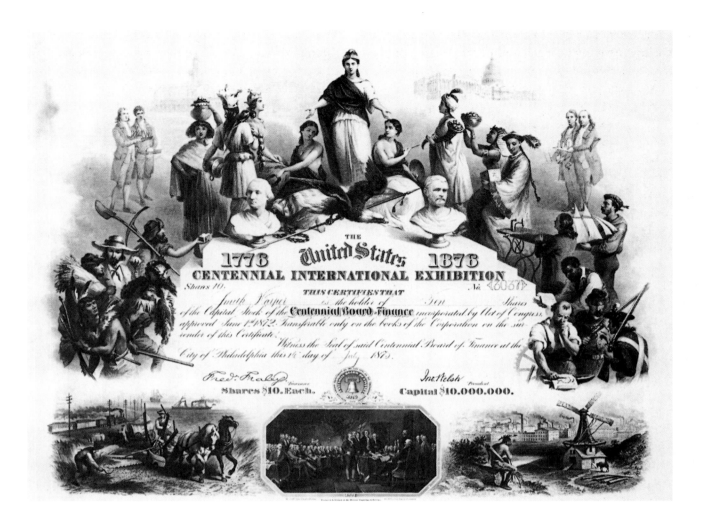

5.4 F. O. C. Darley and S. J. Ferris: *Centennial Stock Certificate*, 1874–75
Engraving, 18½ × 22½ in. (47 × 57 cm.)
Courtesy of Professor and Mrs Ellwood Parry III

In the central register, to the right, appear two men presenting a sewing machine and a schooner—real, not symbolic, images of trade and commerce. Below them are four men—a black man engrossed in a book, a Yankee mechanic, a Union soldier, and a Continental soldier. While the book represents the educational opportunities opened to African Americans after the end of slavery, and their assimilation into European American culture, the man's isolation heralds the "separate but equal" legislation that was soon to take away much that had been gained in the decade after the end of the Civil War.

The group of men on the left side of the central register represent the various geographical sections of the West and South. A California miner offers a piece of gold to America, while behind him a Southern plantation owner holds a boll of cotton and talks to a Midwestern farmer with his sheaf of wheat. A mountain man who carries furs from the Rocky Mountains

ignores a Native American behind him, who turns away from the central group as he glances at them over his shoulder. There is no place for him, with his indigenous clothing and weapons, in this celebration of Western expansion. In addition, the representation of the South and West as suppliers of natural resources—food, minerals, furs—is a subtle reminder of the political and commercial primacy of the Northeast, for no one character represents this region of the country. Rather, the industry and commerce and political rule represented throughout the stock certificate are presumed to reside there.

The three vignettes at the bottom repeat the themes above. In the center is a reproduction of John Trumbull's painting *The Declaration of Independence*. Beneath the farmers, miner, trapper, and Native American are images of what made westward expansion possible. Settlers came first by Conestoga wagon, then by train. They harvested the land, once home to massive herds of buffalo, first with a sickle, then with a reaping machine. They kept in touch with eastern relatives first by mail rider, then by telegraph. The ships that transported people and goods were powered first by wind, then by steam engines. Such

5.5 Thomas Crawford: *The Progress of Civilization*, 1851–63
United States Capitol, Washington, D.C., Senate pediment

was the nature of progress over the past hundred years. The vignette on the lower right reiterates this theme of past and present, with the farm and windmill in the foreground contrasted to the factories and smokestacks in the background. The Native American reappears here not in the act of turning away, but in the act of pondering what lies ahead, having resigned himself to the inevitable advance of "progress."

The pensive pose of this figure is similar to a marble statue of *The Dying Indian Chief* (1856) by Thomas Crawford (1813–57), which appeared on the right side of his sculptural program for the pediment of the Senate wing of the Capitol [5.5] (before his death he also completed a model for a bronze statue of Freedom for the pinnacle of the Capitol). Crawford had learned his lessons well as a student in the Roman studio of the Danish neoclassical sculptor Bertel Thorvaldsen. His heavily muscled, perfectly proportioned figure is Indian only in his headdress. The pediment, like the stock certificate, contains a celebration of western expansion, industry, and commerce—a settler chopping down a tree, a soldier, a merchant sitting on bales of goods, a mechanic leaning on a cogwheel—all presided over by a female figure of America accompanied by an eagle. The dying chief is included, along with a Native American woman and child, as a reminder of what had to disappear in order for this particular version of progress to be achieved.

The Centennial Stock Certificate thus encapsulates the advance of civilization over the past hundred years through the exploitation of natural resources on the one side, with the inevitable exclusion of Native Americans, and the development of industry and commerce on the other, with the necessary assimilation of African Americans after the end of slavery. Here, then, are the material elements of progress—the minerals, the wheat, the machines. Only in the lower left-hand corner do we see the actual processes of labor involved in the development of agriculture, industry or commerce, and nowhere are there any indications of the inevitable conflict that accompanied this development—no massacres of Native Americans, no striking workers, no slaves. Instead, what occupies the center of the composition is a description of the particular type of economic organization into which these resources and developments were increasingly channeled: the corporation.

As Alan Trachtenberg points out in his book *The Incorporation of America*, corporations prior to the middle of the 19th century were usually of a religious or communal nature, guilds, monasteries or boroughs established through an act of sovereign authority. The general assumption was that the incorporated body would act in the interest of the public good. By the middle of the 19th century, however, incorporation in the United States had become increasingly a private enterprise. This development was fueled by the rapid economic growth that took place during the second quarter of the century, a growth accompanied by the extension of the railroads westward, the rise of the factory system, and the development of a national market. Selling shares directly to a general public allowed for the quick and efficient raising of capital necessary for the corporation's expansion. Thus, corporations pushed more and more small individual or family-owned enterprises out of business. The increase in capital enabled the integration of industries, bringing the total process, from the extraction of raw materials to the making and sale of the final product, under the umbrella of a single corporation. John D. Rockefeller incorporated the Standard Oil Company of Ohio in 1870; by

1880 he controlled approximately 90 percent of the oil trade, from extraction to transportation and sale. Stockholders benefited from the company's success (or suffered from its failure) without having to take responsibility for its operations, which 2would be the purview of its board of directors, or be liable for actions taken by or against the corporation.

Of course, the Centennial Corporation was more akin to the earlier incorporated bodies. It sold stock not to make a profit, but to fund a patriotic venture that was to benefit the nation as a whole, hence the elaborate imagery on the stock certificate. Yet investment in the Centennial Corporation would, ultimately, serve American businessmen well, for the Centennial Exhibition was primarily a trade fair, a place for nations to exhibit their commercial and technological might. Such a reassuring display of economic prosperity was sorely needed in the United States, for three years earlier, in 1873, the country had been hit by a severe economic downturn, with bankruptcies and business failures affecting all sections of the economy. This crisis, which would persist to varying degrees for over twenty years, created widespread market uncertainties and increasing competition both at home and abroad. Many businesses were unable to move their inventory, while prices declined worldwide. Credit for farmers tightened, wages were cut, layoffs increased, and many families were forced to the brink of starvation.

Thus, a sense of economic gloom hung over the Machinery Hall at the fair, with its profusion of power looms, presses, lathes, sewing machines, toolmaking machines, wire cables, locomotives, telegraphs, and the first version of Alexander Graham Bell's telephone. Yet even the most economically deprived visitors to the Hall may have forgotten their cares and been overcome by awe and wonder in the face of the two most impressive machines on display, the 30-foot (9-meter) high Corliss double walking-beam steam engine and a 7,000-pound (3,175-kilogram) electrical pendulum clock, with twenty-six lesser "slave" clocks dispersed around the building. "Unstinted but channeled power, and precisely regulated time: that combination," writes Trachtenberg, "seemed to hold the secret of progress." Yet, as he also notes, the image of the machine in the latter half of the 19th century was "increasingly charged with contradictory meanings and implications." The other side of the awe and wonder expressed in the face of mechanical prowess appeared within a year of the closing of the Exhibition, when railroad workers on the Baltimore and Ohio line, hit with a 10 per cent pay cut in July 1877, went on strike. The strike quickly spread to other lines across the country. It also quickly escalated into violent confrontations between local police and militia on the one hand, and strikers on the other. The latter took over railroad yards and smashed equipment. More than a hundred were killed, and millions of dollars of property destroyed. The United States embarked on its second hundred years of independence, therefore, with a fierce battle over who would reap the economic benefits of this thriving democracy.

Images of Workers

Factory and Foundry: Winslow Homer and Thomas Anshutz

In 1608 Captain John Smith commented to the Virginia Company Stockholders that "nothing is to be expected thence but by labour." The wealth of the British colonies was not in already mined gold and silver that could be traded or stolen from indigenous peoples, but in the potential for agricultural and commercial goods. In the face of intransigent resistance by Native peoples to enslavement, the founders of colonies in the New World had to acquire workers by whatever means possible. Indentured servants and convicts were followed by African slaves. In addition, many skilled craftspeople struck out for the New World with hopes of making their fortunes.

Organized resistance to exploitation also accompanied the arrival of indentured servants and slaves. While strikes were not numerous, they did occur in both the northern and southern colonies in the 18th century. Slave rebellions before the Civil War also took place. But these strikes and rebellions tended to be localized and small in scale. It wasn't until the second half of the 19th century, with the expansion of industrialization and the development of large corporations, that strikes assumed a national scale.

The new forms of industrial labor emerging in the second half of the 19th century and their social ramifications did not attract the interest of many artists, but an abundance of imagery appeared in the popular press. Before moving to Prout's Neck, Maine, in 1883, where he spent the rest of his life and produced a series of dramatic seascapes, Winslow Homer created some of the earliest visual commentaries on industrial labor in the fields of both fine and popular art. For example, a variant on his painting *The Old Mill* or *The Morning Bell* (1871) [5.6] appeared as an engraving in *Harper's Weekly* in 1873 [5.7]. It is interesting to compare the two images. In the painting, the factory, probably a textile mill, is located in the middle distance and is surrounded by trees, the one in front of it dwarfing the building. The young woman advancing on the bridge walks upright, although her gaze is cast downward. She is more fashionably dressed than the three women behind her, who stop in conversation, just as the dog in front of her stops to sniff the trunk of the tree. The women's hats catch the glint of the morning sun. There is little, except perhaps their lunch pails and a slight reluctance on their part to continue across the bridge, to suggest that they are off to

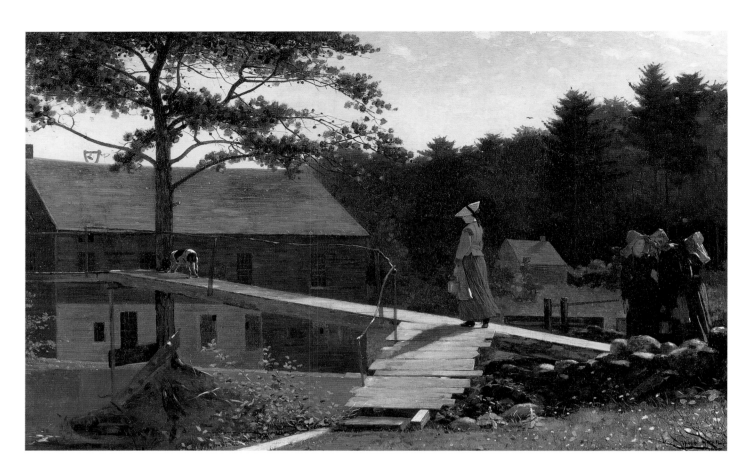

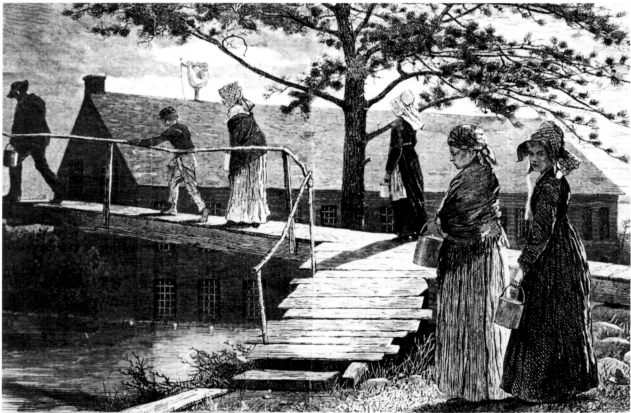

5.6 Winslow Homer: *The Old Mill (The Morning Bell)*, 1871
Oil on canvas, 24 × 38¼ in. (61 × 97.2 cm.)
Yale University Art Gallery, New Haven, Connecticut

5.7 Winslow Homer: *The Morning Bell*, in *Harper's Weekly*,
December 13, 1873
Wood engraving, 9⅛ × 13½ in. (23.4 × 34.3 cm.)

a long day's labor. Indeed, a writer for the April 20, 1872, issue of the *New York Evening Telegram* read the painting as "an old school house, with a group of country girls, dinner buckets in hand going over the lonely wooden path." Even the bell calling them to work is not a major presence in the painting, located as it is beneath one of the lower branches of the tree.

In the engraving, however, which appeared in *Harper's Weekly* in the issue of December 13, 1873, the factory has grown considerably in size and the lone tree functions not as a pastoral setting but as the last vestige of a forest quickly being replaced by industrial architecture. The four women have been rearranged, with two placed in the foreground close enough for us to discern their unhappy expressions. Two women now occupy the bridge, with the one closest to the factory bent over as if already anticipating the long day ahead. In front of her is a young boy and between the two of them a much-enlarged bell. A man with bent head precedes them all across the bridge. The

bell and the factory clearly indicate the changes in both the location and rhythm of work that were taking place, while the women, man, and child provide a catalogue of the generations and genders of late 19th-century factory workers. Thus Homer, like many artists, reserved his pointed commentaries on the effects of industrialization for his commercial work, maintaining a more palatable, pastoral narrative in his paintings.

Several artists working in the last quarter of the 19th century, however, did feel compelled to comment in their paintings on changes in the nature and organization of work and the distribution of wealth. Thomas Anshutz (1851–1912) grew up in Wheeling, West Virginia, in a family that owned and operated iron mills. In 1880–81 he produced a small painting entitled *The Ironworkers' Noontime* [5.8] in which he pays close attention to the anatomy of the male workers he has chosen as his subject-matter. The figures are arranged across the full width of the canvas and also recede into space. All occupy different poses, with their various gestures working off of one another. Anshutz made numerous drawings (in 1880 he began sketching Wheeling's ironworkers) in his attempts to discover the exact

5.8 Thomas Anshutz: *The Ironworkers' Noontime*, 1880–81
Oil on canvas, 17⅛ × 24 in. (43.5 × 61 cm.)
The Fine Arts Museums of San Francisco, San Francisco, California

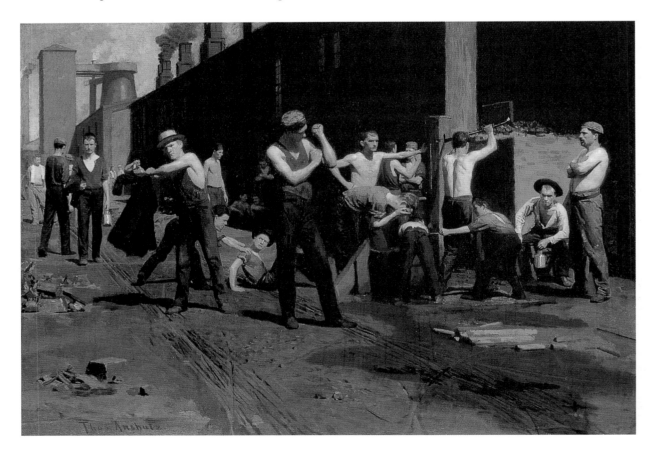

combination of figures and poses that would produce, for him, a perfect compositional balance.

Like Homer, Anshutz has located his figures in front of the factory in which they work. Yet there are no trees intervening between the workers and the factory, no picturesque river to cross. Instead, the carefully arranged interlocking figures, who convey a sense both of group identity and of individual isolation, are set against a massive angled building in a landscape devoid of vegetation. Only the two pairs of children engage in anything that could be described as communication. Two men to the right of center may be talking to one another, but the arm of the man in front of them stretches across their faces, preventing the viewer from knowing for sure if a conversation is taking place. The majority of the figures look off into the distance or are absorbed in a particular task or self-reflection. The short, staccato movements marked by the bare arms of the men create a sense of dislocation. This is not an image of the work that these men do, but of the effects of that work on their bodies and their minds. The blank stares create a sense of exhaustion; the contrast between the bright sun and the dark windows reminds the viewer that this is but a momentary break in a long day of heavy labor. A contemporary critic described Anshutz's painting as follows:

> At the stroke of noon the toilers at forges and furnaces emerge into the cinderous outer precincts of the foundry for a brief respite from labor, and refreshment against labor yet to come. Utter weariness and the robust strength of abundant manhood are seen in contrast. One young giant stretches his powerful limbs, as if shaking off his chains. Some seek refreshment in drenching their hot, grimy bodies with water, while others sink listlessly into supine repose.

The painting was also seen as a marked departure from previous depictions of work, which tended to be much more idealized versions of individual craftspeople, such as Neagle's *Pat Lyon at the Forge* [5.3], or family farms. Unlike Neagle's painting, *The Ironworkers' Noontime* contains no tools to mark the various tasks performed by ironworkers. They are connected to their work through the architecture of the mill behind them and through the brown used to delineate both the building and the men's clothes. In addition, the hours of the men are not regulated by the needs of the body—independent artisans ate when hungry or rested when tired—or by the rising and setting of the sun or the passage of the seasons. Instead, work routines were set by factory owners and organized around the clock or the bell to achieve optimal productivity from both workers and machines. The imposition of standard time across the nation by the early 1880s aided the efforts of industry and commerce to regulate both the production and the sale of commodities. Paintings like Neagle's were ultimately more popular in the late 19th century than those depicting factory workers, for few art patrons wanted to be reminded of the current or potential labor unrest that had spread throughout the country. Instead, they wanted to be reminded of Jefferson's dream of an ideal nation of citizen-farmers and small businessmen who would labor with the best interests of the country, as well as the individual, at heart.

Anshutz received little encouragement to continue his immortalization of industrial workers in paint, despite the reproduction of the painting in *Harper's Weekly* on August 30, 1884 (which prompted Procter & Gamble to use it as the basis for an ad to sell Ivory Soap), so he turned to the production of portraits and genre scenes. *The Ironworkers' Noontime* was bought in 1883 by Thomas B. Clarke, a merchant collector and later an art dealer. Clarke was interested in encouraging the development of figure painting in the United States as a marketable item to place in competition with European imports. The same year that he bought Anshutz's work he also instituted a cash prize to be awarded at the annual exhibition of the National Academy of Design for the best figure painting by an American artist who was not a member of the Academy.

Labor Unrest: Robert Koehler's "Strike" and Monuments to Justice and Liberty

The inclusion of children in Anshutz's painting refers to the large numbers employed in factories and mines nationwide. In 1880 there were over one million between the ages of ten and fifteen in the wage-labor force; by 1900 there were over two million. Another painting that makes reference to child labor is *The Strike* (1886) [5.1] by Robert Koehler (1850–1917). Koehler was born in Germany but grew up in a working-class family in Milwaukee, studying art in the United States, Paris, and Munich before traveling to Minnesota in 1886 to become the director of the Minneapolis School of Fine Arts. *The Strike* was the first major work exhibited in the United States in which the struggle between workers and employers was openly addressed. Men and boys cross a barren landscape, reminiscent of the landscape in Homer's *Prisoners from the Front* [4.34] (no bountiful nature here), separating the factory and the home of its owner. The men are angry; one addresses the employer, gesturing at his companions behind him. The worried look of the owner's assistant is echoed in the worried gaze of the small girl below him in the left-hand corner. The factory owner shows no such emotion.

There are three adult women in the painting. One stands in the lower left-hand corner, holding a baby and accompanied by the young girl. She and her children can be seen as the justification for the men's actions: they need a living wage in order to support themselves and their families. The second woman stands just below the factory owner, next to one of the strikers, to whom she appears to be talking, her hand resting on his arm (her white apron suggests she might be a servant in the owner's house). The third woman stands in the foreground in the middle. She is literally on the edge of the paving that signifies the ordered space of the city, with its classical porticos, as opposed to the devastated landscape occupied by the men and the factories. She engages in a heated discussion with one of the men, who holds his arms out as if saying, "But, what else can we do?" She could be a relative of one of the men, or perhaps a middle-class reformer (about whom more will be said later). At any rate, she appears to be trying to interject a voice of reason into the emotionally charged scene. Her central position suggests the importance Koehler gave to women in their role as peace-makers. Koehler described the evolution of the painting in the March 23, 1901, issue of the *Minneapolis Journal*:

The Strike was in my thoughts for years. It was suggested by the Pittsburgh strike (of 1877). Its actual inception was in Munich and there the first sketches were made. I had always known the working man and with some I had been intimate. My father was a machinist and I was very much at home in the works where he was employed. Well, when the time was good and ready I went from Munich over to England and in London and Birmingham I made studies and sketches of the working man—his gestures, his clothes. The atmosphere and setting of the picture were done in England, as I wanted the smoke. The figures were studies from life, but were painted in Germany. Yes, I consider *The Strike* the best, that is the strongest and most individual work I have yet done.

In contrast to *The Ironworkers' Noontime* [5.8], the response was enthusiastic when *The Strike* was shown at the National Academy of Design in 1886. A *New York Times* critic wrote on April 4:

Mr. Koehler has done well to show the earnest group of sweating workmen, quite possibly with justice on their side, but ready, some of them, to take the law into their own hands. He has contrasted with them fairly well the prim capitalist. But in trying to rouse our sympathies with a beggar woman his moral gets heavy All the same, *The Strike* is the most significant work of this spring exhibition.

This review provides some clues as to why Koehler's work was so well received and Anshutz's not. First, in Anshutz's work, the laborers are at rest. There is no moral or narrative at play with which the viewer can engage. Second, Koehler's work is large—approximately 6 x 9 feet (1.8 x 2.7 meters)—which allows for a highly dramatic presentation of the moral message concerning failed justice. Art viewers were used to large dramatic paintings, and while most depicted historical scenes or military exploits, at least two large strike scenes had been painted by French artists in the early 1880s in Europe. Alfred-Philippe Roll's *Coal Miners' Strike* had been exhibited at the Paris Salon of 1880, while Paul Soyer's *The Iron Workers' Strike* appeared in 1882. Koehler was in Europe during the early 1880s and may well have seen one or both of these works, as did possibly several other American artists, for many studied with Paul Soyer.

A third reason for the positive reception of Koehler's work can be found in the way in which the artist acknowledges the reality of the strike, yet presents it as a personal confrontation between the capitalist and the workers, with the suggestion that a solution can be reached through personal negotiation or the efforts of the woman in the center foreground. In reality, such personal meetings seldom occurred. Strikers were met, instead, by the military or private police forces, not by those who owned the factories. In fact, the absence of a boss in Anshutz's *The Ironworkers' Noontime* more effectively represents, according to the historian John Gladstone, "the corporate 'they,' absent but omnipresent." Koehler, on the other hand, ignores the fact "that the age of the trust, the corporate monopoly, is already upon us, that the boss will no longer be a clearly identifiable character, a paternalistic individual, but will metamorphose into an anonymous corporate octopus, that he will become a faceless 'they,' and, as in *Ironworkers*, will be remote from the shop floor."

By the 1880s the public was familiar with striking workers and with the reasonableness of much of what they were demanding. Many began to feel that they might well have "justice on their side." Out of this feeling grew the social reform movement of the last quarter of the 19th century, with reformers, both men and women, arguing for shorter hours, improved working conditions, and a minimum wage to diffuse the potential for violence. The fear of violence was strengthened by events in 1886. Labor leaders across the country had designated May 1 as the target date for achieving the eight-hour workday, calling for a nationwide strike wherever the eight-hour day was refused. Chicago, with its anarchist/socialist Central Labor Union and its large population of radical German labor activists, became a major center of activity. Koehler's

work was reproduced as the center spread in the May 1, 1886, issue of *Harper's Weekly*, and on the same day over 300,000 workers went out on strike, with 40,000 in Chicago alone. The city's railroads ground to a halt and most of its industries were paralyzed. On May 4 a rally was called near Haymarket Square to support striking workers at the McCormick Reaper Works. At the end of a day of peaceful assembly, the police moved in and demanded the crowd disperse. As they advanced, a bomb was thrown into their midst. Seven policemen and several civilians were killed and many others injured. One individual, a policeman, could be shown to be a victim of the bomb; the others were killed when the police opened fire on the unarmed crowd after the bomb was thrown. No official count of the civilian dead was ever made. The bomb thrower was never found, but eight labor leaders, the backbone of the anarchist labor movement, were arrested and charged with inciting the act. They were found guilty and seven were condemned to death, the eighth receiving fifteen years in the penitentiary. Four were hanged, and one was killed in jail under suspicious circumstances. Three were later pardoned by Illinois Governor John Peter Altgeld. Thus, after May 4, it would have been impossible to look at Koehler's work and not confront the reality of the national strike and the violence that followed.

Two monuments appeared in the Chicago landscape to commemorate the Haymarket incident, one dedicated to the police who tried to disperse the demonstration, the other to the condemned labor leaders. The first was commissioned in 1888 by a committee of twenty-five businessmen and civic leaders and completed in 1889 by the Danish sculptor Johannes Gelert (1852–1923) [5.9]. The bronze life-size figure was erected in Haymarket Square on May 31, Memorial Day. Gelert had arrived in the United States in 1887 after studying art in Copenhagen and Paris, and the *Police Monument* was his first major commission. Intended to represent Captain William Ward, who had called out for the crowd to disperse, it was modeled after another police officer, Thomas Birmingham, whom Gelert had spotted directing traffic in Chicago. The static, erect figure, with legs spread and arm raised, his costume and features portrayed with detailed realism, embodied male institutional authority in contemporary Chicago.

Interestingly, Gelert's initial design for the monument showed an allegorical female figure of Law holding an open book over her head. The selection committee favored, instead, a decidedly male and down-to-earth commemoration of the event and of the authority which was to preserve order in the city. However, a female allegorical figure was chosen by anarchist sympathizers who organized and raised funds for a

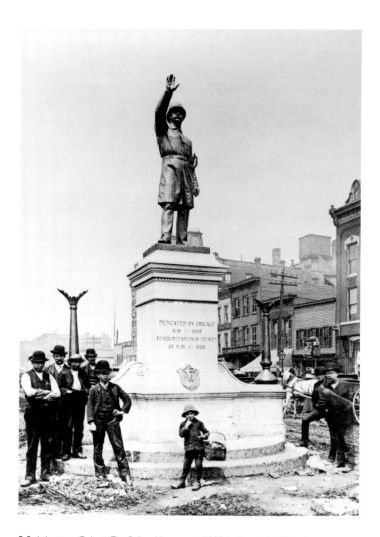

5.9 Johannes Gelert: *The Police Monument*, 1889, in its original location in Haymarket Square, Chicago
Chicago Historical Society, Chicago, Illinois

monument to the "Haymarket Martyrs." Again, this large bronze and stone sculpture was the first major commission of a recent immigrant (this time from Germany), Albert Weinert (1863–1947). The *Haymarket Monument* [ill. p. 2] was erected in Waldheim Cemetery (now Forest Home) outside of Chicago, where the executed labor leaders were buried.

The art historian Melissa Dabakis points out the contrast between these two monuments and the manner in which they "display a gendered coding that both reinscribed and subverted power hierarchies." Unlike the decidedly static and male figure on the *Police Monument*, the female who dominates the *Haymarket Monument* strides forward, one foot extending off her stone base. With one knee bent, she twists her torso to one side as she stares resolutely forward, her drapery billowing behind her and her hood casting deep shadows across her face. With one bare arm she pulls up her cape and with the other she

holds a laurel wreath over the head of the dead martyr stretched out behind her.

While her classicizing features and aquiline nose mark her as allegorical, she is very different from the allegorical female figures at the top of the Centennial Stock Certificate [5.4]. She not only assumes an active pose but wears a recognizable peasant smock and apron. Just as this clothing brings her out of the realm of the ideal and into the material world of fields and factories, the bare arms, resolute gaze, and pose mark her as "masculine," and thus dangerous. While the curls of hair and noticeably swelling breasts add a traditional feminine touch to the work, they cannot completely erase the marks of masculinity. Weinert was undoubtedly aware of the use of such earthy and aggressive Liberty and Justice figures both to mock and to celebrate revolutionary struggle and resistance, particularly in France in the years surrounding the Paris Commune of 1871. Women acting in a revolutionary way, even if in allegorical guise, were, for supporters of traditional structures of power, non-women. They were everything that women were not supposed to be. For many revolutionaries, however, such women were admirable figures who symbolized the overthrow of the existing social order.

Weinert also reworks another well-known figural group, that of Mary cradling the dead body of Christ. The reclining pose of the martyr suggests the many painted and sculpted representations of Christ taken down from the cross. Yet the female figure in Weinert's work does not cradle the dead man in her lap; instead, she sets out to continue the work begun by him and to live out the challenge issued by August Spies just before he was hanged that is carved into the base of the monument: "The day will come when our silence will be more powerful than the voices you are throttling today." Here, the usual gender roles are reversed: the motionless dead man is contrasted to the active, living woman.

As Dabakis points out, the "complex relationship between universal and political meaning" in the *Haymarket Monument* —the allegorical versus the historical—informed its production and reception. The mainstream Chicago press viewed the work with apprehension if not outright disgust. The woman was described as expressing "contempt," "fearlessness," "defiance," and "resolution." Identified variously as Justice, Anarchy, or Revolution, she was seen as "a female figure in an attitude of defiance," and thus as a figure to be feared and condemned. Yet for anarchist sympathizers she was a "warrior woman," a symbol of revolutionary struggle to be emulated. "At Waldheim Cemetery over the graves of the martyred anarchists," writes Dabakis, "the *Haymarket Monument* has functioned as a site where anarchists, socialists, and their sympathizers interacted with the image of an unruly woman and envisioned a world where power relations were not fixed. To this community, woman served as the sign of that liberatory space."

The *Haymarket Monument* has fared much better over the years than the *Police Monument*, becoming a gathering place for groups and individuals attempting to keep alive the struggle for justice for working people. The *Police Monument* has suffered both relocation and mutilation. In 1900 it was moved to Union Park, where it was knocked off its base on May 4, 1927, by a streetcar that jumped its tracks (that this occurred on the anniversary of the riot led to speculation that it was not an accident). In 1958 the statue was moved back to Haymarket Square and in 1968 (again on the anniversary of the riot) it was partially painted black by Vietnam War protesters. The following year, its legs were blown off. The statue was repaired, bombed again a year later, repaired once again, and placed under twenty-four-hour surveillance. In 1972 it was moved to the lobby of the central police headquarters, and finally, in 1976, to the courtyard of the Chicago Police Training Center, where it can be viewed only by special appointment. "Commemorating an historical event in Chicago police history," writes Dabakis, "the monument constructs a social memory at once sacred to those upholding political order and reviled by those seeking to change it."

Another highly symbolic public monument was put in place in 1886, the year of the Haymarket riot: the Statue of Liberty (1875–84) by the French sculptor Auguste Bartholdi (1834–1904) [5.10]. A gift from France to the United States in commemoration of the countries' alliance during the Revolution of 1776, as well as in anticipation of future economic ties, the statue was an engineering wonder. Approximately 151 feet (46 meters) in height, it was composed of beaten copper sheets riveted together and suspended by steel and iron struts from an inner pylon, a design begun by the architect Eugène-Emmanuel Viollet-le-Duc (1814–79) and completed after his death by the engineer Gustave Eiffel (1832–1923). This design allowed the statue to be assembled in France, then taken apart to be shipped to the United States and reassembled. Located on Bedloe Island in New York harbor, the Statue of Liberty stands on an elaborate multi-tiered neoclassical pedestal designed by the American architect Richard Morris Hunt (1827–95).

Not surprisingly, much of the public discussion evoked by this sculptural project in the year of its dedication focused on the nature and meaning of the concept of liberty. For the conservative French republican intellectuals and politicians who initiated and promoted this artistic gift to the United States (it was funded by public subscription), "liberty" was a stabilizing force, a guarantee against the excesses of both monarchy and anarchy. For French socialists and communists, however,

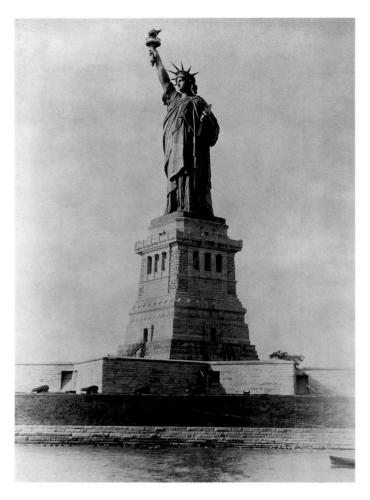

5.10 Auguste Bartholdi: The Statue of Liberty (*Liberty Enlightening the World*),
1875–84, set up in 1886 on the pedestal by Richard Morris Hunt
Copper sheeting over iron armature, H of statue 151 ft. 6 in. (46.2 m.)
New York harbor

The last phrase in Depew's comment can only be read as a reference to the recent trial of the Haymarket Eight. Indeed, Lucy Parsons, the wife of one of the condemned anarchists and an ex-slave, was in New York two weeks prior to the dedication of the Statue of Liberty raising money for an appeal against the guilty verdict. In her presentation she called into question the talk of liberty circulating within the nation at that time: "Is it American liberty when poor working men cannot talk for their rights; when seven men are doomed to die because they are socialists and a number of children are about to become fatherless and women made widows to die of broken hearts?" The talk that filled the mainstream newspapers and political speeches was of liberty "for the rich and not for the poor."

Bartholdi embodied, in the design of his statue, the conservative republican notions of liberty espoused by his American and French backers, which he himself shared. Unlike the *Haymarket Monument* [ill. **p. 2**], which depicts a determined woman with sleeves rolled up and robes billowing behind her, Bartholdi's liberty assumes a more subdued contrapposto stance, at rest yet ready to move. Her heavy gown anchors her in place and her raised arm with torch continues the static, vertical pose. The original title of the work was *Liberty Enlightening the World*, a theme reinforced by the crown of rays on her head and the torch in her hand. In selecting this crown Bartholdi rejected the more politically charged Phrygian bonnet, or liberty cap, which, since 1792, had increasingly become a symbolic reference to popular uprisings (Darley and Ferris used it on the figure of America in their stock certificate design [**5.4**] to refer to the American Revolution). Yet many of the millions of immigrants arriving in the latter half of the 19th century would engage in repeated protests, if not uprisings, as they struggled to achieve the liberty and enlightenment promised them by Bartholdi's statue.

Celebrating the New Male Professionals: Portraits by Thomas Eakins

The last half of the 19th century saw not only a drastic increase in the number of industrial and factory workers, but also the development of new professions. Medical doctors, professors, engineers, scientists, architects, and lawyers trained in Europe or in the fledgling educational institutions of the United States were now replacing their earlier largely self-taught counterparts. These men (women were seldom allowed in) celebrated reason, order, and self-discipline as the hallmarks of the modern professional and of progress in general in their fields, a progress closely connected with technological advances. They also engaged with what the art historian Martin A. Berger describes as "the complex and contradictory dictates of masculinity," as work in

"liberty" was more of a revolutionary force that brought disruption in the name of freedom. A similar split occurred in the United States. The wealthy businessmen and politicians courted by Bartholdi who facilitated the acceptance of the French gift and the raising of funds for the pedestal (a public subscription also played a role in this endeavor) preferred to view Liberty as a beneficent rather than revolutionary figure. At the dedication, President Grover Cleveland commented: "Instead of grasping in her hand the thunderbolts of terror and death, she holds aloft the light that illumines the way to man's enfranchisement." The railroad magnate Chauncey M. Depew added that the struggles for universal suffrage, equality under the law, freedom of religion and speech, "the problems of labor and capital, of social regeneration and moral growth, of property and poverty, will work themselves out under the benign influences of enlightened lawmaking and law-abiding liberty, without the aid of kings and armies, or of anarchists and bombs."

offices or laboratories replaced the physical labor often seen at the time as the hallmark of male identity. Strenuous physical exercise or sport was often promoted by contemporary critics as an antidote to the emasculating effects of too much mental labor.

An artist who excelled in the representation of members of this new class, and whose often heroic images may have helped reassert their masculinity, was the painter Thomas Eakins (1844–1916). Eakins studied first at the Pennsylvania Academy of the Fine Arts and later in France with Jean-Léon Gérome. He was particularly interested in the human body, how it functioned, how it moved through space, which led him to the dissection room on the one hand and the photography studio on the other (it also led to his resignation in 1886 from his teaching position at the Pennsylvania Academy, where he had been criticized for his use of a nude male model in a class containing both men and women).

In 1883 Eakins collaborated with the photographer Eadweard Muybridge (1830–1904), who had come to the United States from England in the 1850s, on a project documenting locomotion for the University of Pennsylvania (the results of the project were published in 1887 in a book by Muybridge entitled *Animal Locomotion*). In his own motion studies, Eakins relied not on Muybridge's methods, but on those of the Frenchman Étienne-Jules Marey. While Muybridge captured movement in a series of separate frames using several cameras [5.11], Eakins combined several positions of the same figure in a single frame, using a single camera in front of whose open

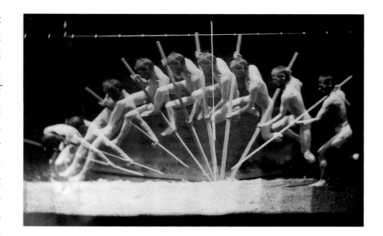

5.12 Thomas Eakins: *Motion study: George Reynolds, nude, pole-vaulting to left*, 1885
Copy from a dry-plate negative
The Pennsylvania Academy of the Fine Arts, Philadelphia

lens spun a disc containing a small hole, which allowed for successive exposures on a single plate [5.12]. Muybridge's images had the advantage of being able to be projected serially onto a screen using a device he invented called a zoopraxiscope. His shows for both scientists and general audiences provided a taste of what was to come in the field of "motion pictures."

Eakins devoted most of his career, however, to painting portraits, producing over two hundred (only approximately twenty were commissioned). Eakins was particularly interested in depicting middle-class professional men engaged in either work or leisure time pursuits, creating images of surgeons in the midst of operations and men rowing or sculling on the Schuylkill River in Philadelphia (his women appeared primarily in domestic interiors).

One of Eakins's earliest portraits of a professional man, and certainly his best-known, is *The Gross Clinic* or *Portrait of Professor Gross* of 1875 [5.13]. In this painting he portrays the Philadelphia surgeon Dr Samuel D. Gross pausing in the midst of performing an operation in an amphitheater filled with medical students. He is assisted by an anesthesiologist and four surgeons (one is hidden behind him) and holds in his hand a bloody scalpel. The patient lies on the operating table, the incision in his left leg clearly visible, while a female relative, probably his mother, recoils in horror, her hand covering her face at the sight of the scalpel, providing an emotional counterpart to the surgeon's calm. Dr Gross, located at the apex of the pyramidal composition, towers over the group of figures in the foreground, his high forehead bathed in light as he gathers his thoughts before speaking. Light also bathes the hand holding the scalpel and the thigh of the patient, highlighting the three major elements of Eakins's narrative: the intellectual power and

5.11 Eadweard Muybridge: *Female Figure Hopping*, 1887
Sequence photography, from *Animal Locomotion*, Philadelphia, 1887
Library of Congress, Washington, D.C.

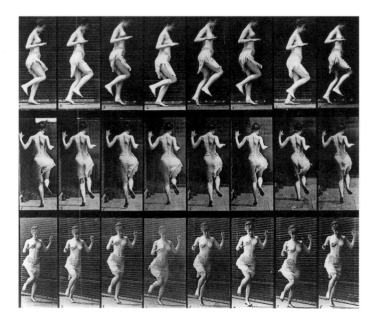

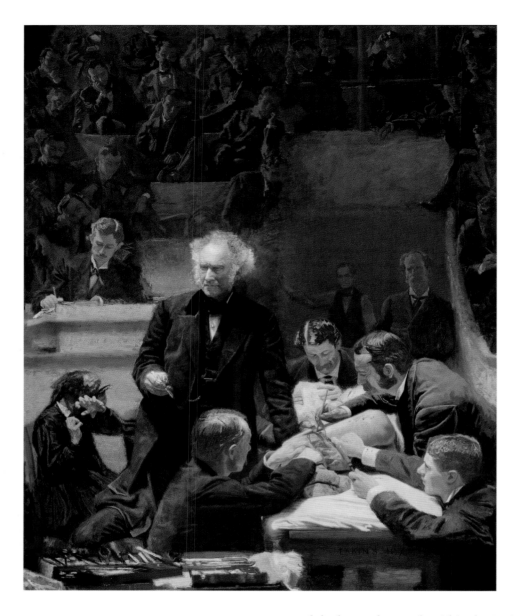

5.13 Thomas Eakins: *The Gross Clinic (Portrait of Professor Gross)*, 1875
Oil on canvas, 96 × 78 in. (244 × 198 cm.)
Philadelphia Museum of Art, Philadelphia, Pennsylvania

technical skill of Dr Gross, which come together in the thigh of the man to produce a successful operation.

Among the figures seated in the amphitheater is Eakins himself, at the far right, holding a pad of paper and pencil. Eakins had studied anatomy at Jefferson Medical College where Dr Gross taught, as well as in Paris at the Ecole de Médicine, going on to teach anatomy and dissection himself. He was thus familiar with the life of the medical clinic and with the skills of Dr Gross. He was prompted to undertake this ambitious portrait by the upcoming Centennial celebration in Philadelphia, a city whose reputation as the center of advanced medical

research had spread not only within the United States but also in Europe.

The art historian Elizabeth Johns argues that the portrait in fact represents a community of individuals:

> In choosing Dr. Gross as his sitter, Eakins selected a surgeon who was ideal not just in Philadelphia eyes but also by international standards: a man of humble origins, trained in the French clinical—the scientific—tradition, an untiring worker, and a brilliant researcher and writer. Dr. Gross was at the center of a community—a community of people, of values, of techniques, of history.

Surgical training was dominated by two schools in the United States. The first was based in British practice, which often

focused on assigning students to work individually with a surgeon, while the second drew on French practice, which depended largely on instruction via clinics like the one shown in Eakins's painting. British surgery was seen as more elitist, with entrance into medical schools thought to depend more on personal connections than individual talent, while French surgery had about it a democratic aura. Clinics and lectures in early 19th-century Paris were free and open to anyone with a passport. Jefferson Medical College, founded in 1825 by the surgeon George McClellan, also offered equal access to a medical education and adopted the clinical method of teaching. By the 1860s it produced over one-quarter of the medical graduates in the country. Thus, *The Gross Clinic* celebrated the clinical method of teaching and the democratic character that was attached to it.

The painting also emphasized Dr Gross's role as a teacher, one he valued highly. Eakins respected Gross's insistence on a dignified and solemn atmosphere in the clinic as opposed to the more dramatic and flamboyant demonstrations adopted by many of his colleagues, which may have aggravated the still common belief that the medical profession was in large part "quackery." "The operation is proceeded with, slowly, deliberately, and in the most orderly, quiet, and dignified manner," wrote Gross in his *System of Surgery* (1882). Certainly he is the epitome of quiet dignity in Eakins's portrait. Eakins also alluded to another aspect of Gross's medical philosophy in his choice of the particular operation being performed, the removal of a piece of dead bone, the final stage in the treatment of osteomyelitis. This infection of the long bones of the body was found primarily in individuals between the ages of five and twenty-two. Until the 19th century, amputation of the limb above the infection was the usual treatment. Gross was a strong believer in "conservative" surgery; to remove a limb or part of a limb was seen as failure. He performed many operations for osteomyelitis, and took great satisfaction in restoring young bodies to health.

Eakins's painting was rejected by the Centennial art jury, whose members were offended by the presence of so much blood. Nevertheless, it appeared at the Centennial Exhibition, in the medical section, under the sponsorship of Dr Gross, along with medical texts and the latest developments in medical care. It was admired by many of the approximately seven hundred physicians and surgeons who attended an international congress held in conjunction with the exhibition.

Fourteen years later Eakins created another work in which a surgeon pauses in the midst of an operation, *The Agnew Clinic* (1889) [5.14]. This painting was commissioned by Dr D. Hayes Agnew's students in honor of his retirement in 1889 from the University of Pennsylvania. The students paid $750 for a single portrait, and Eakins added all of the other figures at no extra charge. Here one can see the changes that had taken place in the field of surgery. The dark street clothes of 1875 have been replaced by white gowns (while not evident by looking at the picture, Dr Agnew and his assistants would have been operating with sterile instruments, the practice of asepsis having been adopted by then to control the spread of germs). The lighting is different, reflecting the shift from natural daylight as it entered the clinic through skylights to a much brighter and more evenly dispersed artificial light. In addition, as Johns points out, "the pyramidal structure of the Gross clinic scene is transformed into a horizontal format that shows the teamwork more characteristic of recent surgery, which had to some extent replaced the individual heroism of Gross." Finally, a solemn uniformed nurse replaces the emotional relative, an indication of the emergence of the new profession of nursing. While earlier in the century women had functioned as doctors in their roles as midwives and healers, they now were largely denied the option of practicing medicine as full-fledged professionals (few medical schools accepted them) and channeled into the position of assistants to male doctors. Dr Agnew himself strongly opposed the education of women in regular medical classes and thought that teaching them anything more than "housekeeping, hygiene and *belle-lettres*" was a waste of time.

Just as we know the names of Dr Agnew and his male assistants, so too do we know the name of the nurse. She is Mary V. Clymer, who was the top woman in her nursing class. What makes her presence particularly significant is the shift in the sex of the patient in the Agnew painting from male to female, and of the operation from the removal of a piece of bone to the removal of a cancerous breast. In an essay on the painting, Judith Fryer writes that Nurse Clymer assumes a problematic position:

> she is part of the medical team, not a spectator, but also not a doctor, hierarchically inferior even to the medical students whom she might one day assist. With whom does she identify—the doctors or the unconscious and mutilated woman?

Unlike the relative in *The Gross Clinic*, however, and unlike the unconscious woman with breasts bared on the operating table, Nurse Clymer is actively looking on, and thus functions as a surrogate for the female viewer of the painting, a means of entry into the male medical work of Agnew's clinic. She also functions as a chaperone, making "proper" the actions of the three doctors who physically press upon the body of the patient, and the gazes of the male students who focus in rapt attention on the spectacle of a woman's breast being cut open.

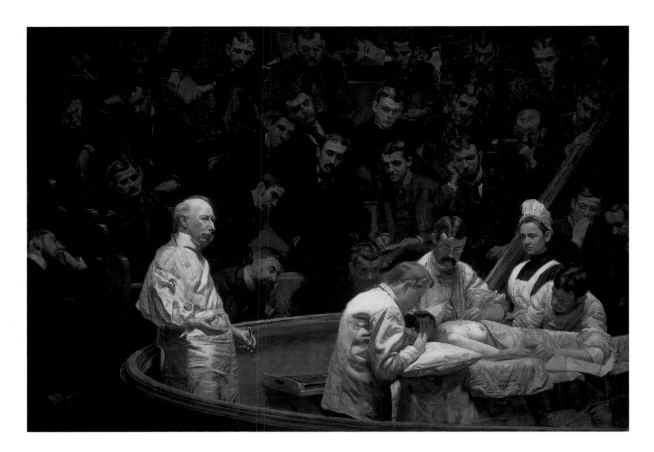

5.14 Thomas Eakins: *The Agnew Clinic*, 1889
Oil on canvas, 74½ × 130½ in. (189.2 × 331.5 cm.)
University of Pennsylvania Art Collection, Philadelphia

Eakins again includes himself, at the right edge of the canvas, directly behind Clymer. She blocks his view of the patient's body, making it necessary for the action to be described to him by his neighbor, Dr Fred Milliken. Eakins is thus included in the medical community through words rather than sight. But, of course, the real Eakins had full access to the patient's naked body in the act of painting her, something viewers of the painting would certainly understand. The same is true of Nurse Clymer. While she blocks Eakins's view of the patient, she is also, writes Fryer, "subject to the doctors who employ her, and to the artist who paints her, and who views her—in the painting—from behind *and*—before his easel—from the front." Thus, Eakins, like Drs Agnew and Gross, has "mastered" the female body, has come to know it through both scientific study and artistic representation.

Fryer also addresses the way in which socioeconomic class enters into Eakins's paintings of both clinics. Not only are the doctors part of a newly emerging professional middle class, but the patients on whom they operate are surely from the lower classes. Poor men and women from almshouses were regularly offered medical care in exchange for allowing their bodies to be used in medical instruction. No self-respecting middle- or upper-class woman would have her body displayed in the manner of the patient in *The Agnew Clinic*. Also, the use of chloroform as an anesthetic and the surgical procedure of breast removal (mastectomy) were still in an experimental phase, and who better to experiment on than the poor? Thus, while Eakins's painting is certainly a portrait of Dr Agnew in his role as surgeon and teacher, it is also a statement about how gender and class operated within the medical profession at the end of the 19th century.

In 1891 the directors of the Pennsylvania Academy of the Fine Arts refused to include the painting in an exhibition because, suggests Fryer, "it violated museum standards of decorum." For a society that celebrated feminine beauty and refinement within a well-appointed home, the representation of the cancerous, mutilated body of a poor woman would have been unacceptable. Yet this mutilated body is only intimated, not revealed, in Eakins's painting, for, unlike in *The Gross Clinic* [5.13], the viewer is not given access to the actual incision. Rather, he or she is presented with a complete healthy breast, which, combined with the large number of men looking on, gives the painting a sexual charge that may well have been more of a reason for the academy's rejection of the painting.

Also largely absent from the painting is the blood that covers the hands of Dr Gross and his assistants in Eakins's earlier work. Instead, blood is limited to some spatters on the gowns of Dr Agnew and Dr White, who completes the operation, and a few drops on their hands, despite the fact that breast cancer surgery was marked by an inordinate loss of blood. The art historian Bridget Goodbody notes that Dr Agnew actually insisted that there not be a lot of blood in the painting, and she posits that this insistence may have been a response to "the public's equation of surgery with butchery." She also suggests that the absence of blood was an attempt to hide the medical profession's inability to cure breast cancer patients or even to prolong their lives. Dr Agnew estimated that 1 in 10 patients died during surgery due to loss of blood, while others estimated 1 in 6; shortly before his death he stated in a lecture that he performed breast cancer surgery solely for the "moral effect" on the patients and that the operation shortened rather than prolonged their lives. Dr White referred to this operation as "the present opprobrium" or shame of surgery; another of Agnew's colleagues, Dr S. Weir Mitchell, wrote in 1893 that, despite advances in medical science, doctors were doomed to be "defeated by a woman's breast." This defeat is erased in the painting, however, not only by the absence of blood and of the mutilated breast, but also by the clear presentation of the healthy breast which, in Goodbody's words, "generates the feeling that the patient is whole" and creates a corresponding sense of confidence in the doctors' powers to cure her.

Eakins received a much more positive response to his depictions of healthy middle-class women at rest or of men at play. Even when at play, however, Eakins's men exhibit the qualities of reason, order, and self-discipline that often marked their working lives. This is certainly true of his rowing paintings. *Max Schmitt in a Single Scull* of 1871 [5.15] was his first major rowing painting (he created nineteen in all). In it he depicts his friend Max Schmitt, champion rower, having just won a major race in Philadelphia on the Schuylkill River on October 5, 1870. As with *The Gross Clinic* and *The Agnew Clinic*, Eakins includes himself in the painting, to the right of center in the middle distance rowing away from the viewer. The scene is one of healthful outdoor activity, engaged in on a clear fall day, with the rust colors of the leaves and the boat reflected in the calm water.

From the 1860s to the 1880s rowing enjoyed heightened popularity among middle-class professionals. Eakins himself was an avid rower, as were his parents and sisters. Many viewed the sport as improving both one's mental and physical capabilities, for it required concentration as well as strength. Some even argued that it helped people meet the challenge of modern life. As more and more men were confined indoors during the workday, sports such as rowing allowed them to develop mental, physical and moral discipline in a setting reminiscent of an

5.15 Thomas Eakins: *Max Schmitt in a Single Scull*, 1871
Oil on canvas, 32¼ × 46¼ in. (81.9 × 117.5 cm.)
The Metropolitan Museum of Art, New York

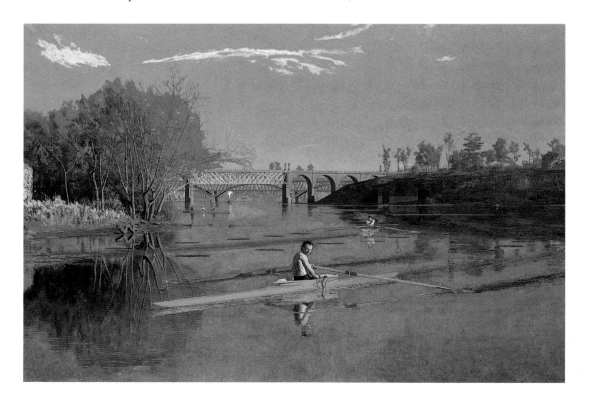

earlier, more robust working environment (fewer women took up rowing). This, theoretically, applied to those who worked in factories as well as those who worked in offices, for rowing was celebrated as a "democratic" sport, available to all for the cost of a boat rental.

The Female Body and the Rights of Women: The "Declaration of Sentiments" and Hiram Powers's *The Greek Slave*

Middle-class women would not enjoy the same benefits as men from the rapid changes taking place at the end of the century. They would have to fight doggedly to share in the "liberty" that was so openly touted as the hallmark of American democracy. At the 1876 Centennial Exhibition women were not only denied a space in the Main Exposition Hall for a display of work (after a committee of women had raised $125,000 for the Exhibition), but were also excluded from the platform of dignitaries at the Fourth of July ceremonies. And at the dedication of the Statue of Liberty in 1886, the New York State Woman Suffrage Association was refused a place in the naval parade to Bedloe's Island. In response, the women moored their boat in a prominent position near the island and invited the public on board to hear the president of the Association, Lillie Devereux Blake, assert "that in erecting a Statue of Liberty embodied as a woman in a land where no woman has political liberty men have shown a delightful inconsistency which excites the wonder and admiration of the opposite sex."

The New York Woman Suffrage Association had its roots in an event that took place almost forty years prior to the dedication of the Statue of Liberty. On July 19, 1848, shortly after the public proclamation of the Treaty of Guadalupe Hidalgo, approximately three hundred men and women gathered in Seneca Falls, New York, under the leadership of Elizabeth Cady Stanton and Lucretia Mott, two prominent advocates of women's rights, to initiate another battle, this time for the political, social, civil, and religious rights of women. At the end of two days, 100 people (68 women and 32 men) signed the "Declaration of Sentiments," a document written largely by Stanton and modeled upon the Declaration of Independence. It proclaimed, among other things, that all men *and women* are created equal. Thus began a women's rights movement that would mobilize both sexes across the nation and that would culminate in the passage of the Equal Suffrage (Nineteenth) Amendment to the Constitution in 1920 granting women the right to vote. It was also closely aligned with the abolitionist movement. The African American author and activist Frederick Douglass, then editor of the *North Star* in Rochester, New York, was one of the signers of the Declaration of Sentiments.

The presence of women as actors in, rather than allegorical representations of, history created widespread and heated debates regarding their proper place in society. Should they have the vote and own property? Should they be allowed to attend institutions of higher education? Should they be allowed equal access to all professions and trades? Many opposed the extension of the rights of women by arguing that while morally superior to men, they were too delicate to enter the public sphere. The Declaration of Sentiments challenged this assumption, asserting that if women were, indeed, morally superior, then they needed to exercise that moral superiority in religious and other public assemblies, as well as in the home. The Declaration also criticized the double standard often adopted by men in their criticisms of women who dared to assume a public life: "Resolved, That the objection of indelicacy and impropriety, which is so often brought against woman when she addresses a public audience, comes with a very ill-grace from those who encourage, by their attendance, her appearance on the stage, in the concert, or in feats of the circus." This resolution addressed another aspect of the debates regarding women's proper place in society, one that was particularly relevant in the art world: what was the relationship between women's moral and sexual natures? How was the female body to be displayed and viewed?

These questions can best be addressed by looking at a work of art created five years before the Seneca Falls convention that gained national notoriety in subsequent years for its display of the naked female body: *The Greek Slave* (1843) [5.16] by the Vermont-born artist Hiram Powers (1805–73). The statue was exhibited not only in the United States, but also in Powers's studio in Florence (where, like Harriet Hosmer [pp. 229–30], he spent most of his professional career) and at London's Crystal Palace exhibition in 1851. The artist made six full-size replicas of the work as well as several smaller versions and busts. The art historian Joy Kasson has thoroughly documented the extent of and reasons for *The Greek Slave*'s widespread popularity, particularly in a country still resistant to the public display of nudity. While there is, indeed, a prurient side to the statue, Powers was able to make the nudity acceptable by emphasizing the woman's powerlessness, and thus her lack of responsibility for her own downfall. The image therefore becomes one of pathos and violence, given a contemporary meaning by the recently ended Greek and Turkish war (1821–32). Powers described the figure as the only surviving member of a Greek family from an island invaded by the Turks. (According to Kasson, few in the United States publicly connected *The Greek Slave* with slavery in the United States, although many may well have done so in private.)

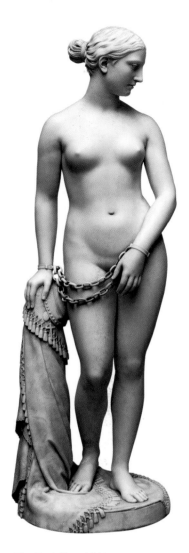

5.16 Hiram Powers: *The Greek Slave*, 1846
Marble, after the original plaster of 1843, H 66 in. (168 cm.)
The Corcoran Gallery of Art, Washington, D.C.

artist was able, writes Kasson, "to make the spiritual reign over the corporeal; to sink form in ideality; in this particular case, to make the appeal to the soul entirely control the appeal to the senses."

The numerous love poems inspired by the statue revealed, however, that not all viewers chose the spiritual route in their response to the work. Many of these poems, and some of the commentaries by both male and female viewers, revealed a play between purity and eroticism that spoke to an ambivalence regarding the naked body and female sexuality in particular. The 1840s saw an increased concern about the dangers of sexuality and the threat that modern life posed to the delicate constitutions of women, a concern fueled in part by the rise of dance halls and other places of popular entertainment where partially clothed female bodies, and thus female sexuality, were on display. *The Greek Slave* epitomized this endangered female body, while providing it safe haven in an idealized moral narrative. Yet viewers often saw the statue as representative of the disruption of domestic harmony, a disruption that could only partially be compensated for by the woman's spiritual purity and resignation to her fate.

Others saw a revolutionary potential in *The Greek Slave*. While a slave herself, she had the power to inspire resistance to enslavement. She was able to subdue the gallery audience, to create a respectful silence as her condition was contemplated. Women were empowered to view her openly and to take away lessons specific to their own situation. The popularity of *The Greek Slave* can thus be found in the many narratives embedded within it. Such narratives, writes Kasson,

> told the story of the female body as their authors understood it—vulnerable, dangerous, and endangered, representing beauty and shame, attractive in its self-absorption but threatening to overwhelm the viewer. By extension, they told the story of the body politic, which was undergoing transition to a commercial culture amid contemplation of unsettling changes in gender roles and family life. The contradictory meanings embodied in *The Greek Slave*—eroticism indulged and denied, passion and passionlessness, power and powerlessness—were the meanings with which its viewers themselves struggled in a rapidly transforming culture.

Here was a pious Christian woman, her cross visible on her abandoned clothing, the accompanying locket suggesting a lost husband, her head averted and her chained hand covering her genital area in an attempt at modesty.

When *The Greek Slave* went on tour to several U.S. cities in 1847, it was accompanied by a pamphlet containing numerous texts—press notices, poems—that instructed audiences on how to view the work properly, i.e. how to perceive the moral rather than sensual elements. Perhaps the most influential of these texts was a review by a Unitarian minister, the Rev. Orville Dewey, who compared *The Greek Slave* favorably with the famous ancient Venus de' Medici (the obvious model for Powers's statue), and affirmed that "there is *no* sentiment in the Venus, but modesty." Thus, the meaning of Powers's work lay not in the sensuality of the female body but in the higher moral purpose it inspired. The

Women were thus expected to fill a complex role. They were to be both pure and seductive, powerful and powerless, moral guardians of the home yet ruled by their emotions. Their influence was allowed to extend outside the home primarily in the carefully reared bodies of their sons and daughters, the former as active citizens and wage earners and the latter as future

caretakers of their own homes. The movement that coalesced in Seneca Falls in July 1848 would systematically challenge this ideology of domesticity, creating new opportunities for women as political and cultural actors on the stage of history.

Domestic Culture and Cultural Production

"Cheap and Popular Pictures" for the Home

In their roles as mother and keeper of the home, women were expected to provide their children with a sense of "culture." Not only were they to imbue their offspring with the general values, habits, and structures of thinking, feeling, and acting shared by a particular community—one definition of culture—but they were also to provide exposure to culture as defined in terms of an elite realm of refinement, aesthetic sensibility and higher learning, a realm that could also operate as a social and political force. The more "cultured" an individual in the latter sense, the more likely this person was to succeed as a businessman or politician or professional if male, and as a wife if female. Working-class women could provide their children with the first sense of culture—the values of a working-class, and often immigrant, community—but seldom the second. This was often used by social commentators as evidence of the unsuitability of members of this class for political leadership, although, as will be seen below, some felt mass production would provide many working-class families with access to some of the benefits of "high" culture.

In the latter half of the 19th century much was written about the importance of environment on character development. The home was presented not only as the breeding ground for future citizens but also as an escape from the harsh workaday world for those who had already graduated to citizenship, providing a dose of civilized culture as an antidote to the cut-throat norms of the marketplace. Thus, the decoration of the home took on particular importance. Popular guides were published to help instruct women in this endeavor. One of the better-known of these was *American Woman's Home* by Catherine Beecher and Harriet Beecher Stowe, published in 1869. The authors encouraged wives and mothers to "renovate degraded man and clothe all clime with beauty." They recommended setting aside $80 for the purchase of such "tasteful" and "beautiful" objects as wallpaper, tablecloths, curtains, pictures, and plaster groups. Of this sum, $20 was designated for the latter two categories of objects. If one could not afford original paintings, one could always buy chromolithographs, which, "when well selected and of the best class, give the charm of color which belongs to expensive paintings." The authors suggested *The Little Scrapbook Maker* by Miss Oakley ($7.50) or

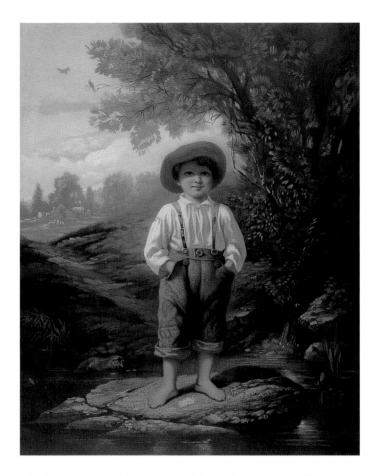

5.17 Louis Prang and Co. after Eastman Johnson: *The Barefoot Boy*, 1867 Chromolithograph, 12¾ × 9¾ in. (32.7 × 25.1 cm.) Boston Public Library, Boston, Massachusetts

The Barefoot Boy by Eastman Johnson ($5.00), reproduced by Louis Prang and Co. [5.17]. And if one couldn't afford store-bought picture frames, then one could make them out of twigs, demonstrating not only one's frugality but also one's creativity.

In setting out to purchase their color lithographs, many women would have turned to the firm of Currier and Ives, the best-known and most successful lithography firm in the United States in the last quarter of the 19th century. Nathaniel Currier began producing lithographs in 1834 and was joined by his brother-in-law James Merritt Ives in 1852. At their height in the 1860s, 1870s, and 1880s, their name was almost synonymous with the category of popular lithography itself.

The success of Currier and Ives was due in large part to effective marketing rather than superior quality, although the two men prided themselves on producing as high a quality print as was possible through the lithographic process. They did not, however, have any "artistic" pretensions: they presented themselves as "publishers of cheap and popular pictures," not of "fine" art. The smaller 3 x 5-inch (7.6 x 12.7-centimeter) prints

sold for from 15 to 25 cents retail, while the larger folio images [5.18, 5.19] cost several dollars. The primary outlet was the Currier and Ives store on Nassau Street in New York City, where the wares were stacked on long tables in the center or in bins around the walls. Framed and unframed prints and a few original paintings hung on the walls. Outside were additional tables offering items at bargain prices. If people did not want to come down to the store, they could purchase prints from the numerous peddlers who wheeled their carts through the streets of the city. Currier and Ives also had agents across the country and a London office to facilitate distribution throughout Europe.

The main factory for the production of Currier and Ives lithographs was on Spruce Street in New York. Here the stones were prepared, images transferred, and printing done. A drawing was made in reverse with a grease pencil on a slab of limestone. The grease in the ink penetrated the stone, allowing the surface drawing to be washed off. The stone was then kept moist and subsequently inked with a roller (the ink adheres only to the area saturated by the grease pencil) and passed through a press, thus transferring the ink from the stone to the paper and creating a positive image. Lithographs were much easier to produce than engravings or etchings and were more economical, for several hundred prints could be taken from a single stone.

As with photography, the production of lithographs involved a complex division of labor, also marked by gender. Artists were hired under a variety of contractual arrangements, but three categories were particularly important. In the first were the individuals commissioned to create the works to be copied. Some well-known artists appear in this group, but most were lesser-known ones, who often became associated with particular types of scenes, and most were men. Frances Bond Palmer, one of the few women, was in demand not only for still lifes but also for rural views and scenes of westward expansion, such as *Across the Continent: "Westward the Course of Empire Takes Its Way"* (1868) [5.18], a less lofty take on Leutze's piece for the Capitol Rotunda [4.17]. In the second category were shop hands and printers, responsible for copying the designs onto the stones and printing them. These individuals were mostly, if not all, men. The third category included the countless women hired to color the prints by hand in assembly-line fashion. Rather than producing true chromolithographs by using separate stones for each color, Currier and Ives printed only the black-and-white drawing, which was then colored by hand on

5.18 Frances Bond Palmer and James Merritt Ives: *Across the Continent: "Westward the Course of Empire Takes Its Way,"* 1868
Hand-colored lithograph, 17⅝ × 27⅛ in. (43.8 × 68.7 cm.)
Private collection

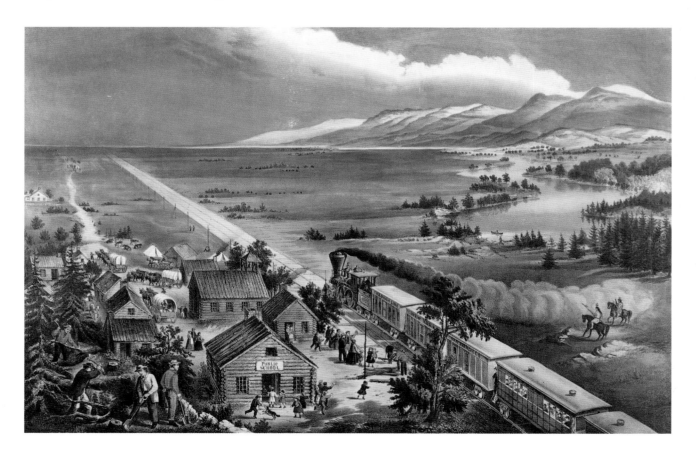

the fifth floor of the Spruce Street factory. The women, mostly of German descent, sat around a table, in the center of which was propped a fully colored print to serve as a model. Each would apply one color, then pass the new image on to her neighbor. When the print had made a complete round, another woman, known as the "finisher," would add the final touches. Currier and Ives used only the finest Austrian colors in an attempt to prevent fading from exposure to light. The names of the colorists, and of the shop hands and printers, are mostly unknown, subsumed under the name of the artist who produced the painting that was copied, and the company itself.

The women who colored lithographs were trained either at Currier and Ives or at the numerous art schools that were springing up around the country. One of the best-known of these schools was the Cooper Union in New York City. Founded in 1859 by the wealthy iron master Peter Cooper, it provided free instruction for working-class men and women. This training including the coloring of lithographs and photographs, and seven rooms were devoted to the female school of design.

The cultural historian Russell Lynes argues that Currier and Ives were successful because they understood public taste and provided people with what they wanted, which included snow-covered parks, idyllic country scenes, and seascapes. But Currier and Ives prints also contributed to the formation of public taste, including the reinforcement of contemporary prejudices. Middle-class homes acquired images of Native Americans as noble savages, African Americans as childlike or comic figures [5.19], and the urban landscape devoid of the harsh reality of slums and factories. The function of such prints in constructing particular social norms and values was

5.19 Otto Knirsch after Arthur Fitzwilliam Tait: *Catching a Trout.*
"We hab you now, sar," 1854
Lithograph, published by Nathaniel Currier, 18¼ × 25¾ in. (46.4 × 65.4 cm.)
Museum of the City of New York, New York

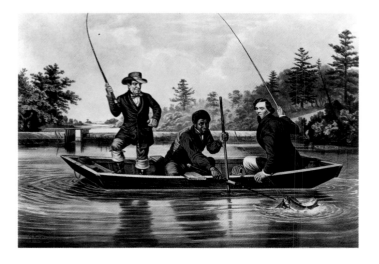

remarked upon by the popular essayist James Parton in his 1874 book *The Triumphs of Enterprise, Ingenuity and Public Spirit.* Lithographs and chromolithographs, which he hailed as "oil paintings by machinery," were able to do the "special work of America at present," in that they were able to help in the conversion of the influx of immigrants from Europe's underclasses, "as well as the emancipated slaves from the South," into "thinking, knowing, skillful, tastefull [*sic*] American citizens." Even those who could not afford their own prints (in 1890 the annual wages for railroad laborers totaled $124, with brakemen making $212) could view them in the shop windows of Currier and Ives or other printsellers.

Parton's linkage of machinery and culture, as well as his linkage of both to social change, was significant. The mass production and dissemination of culture were made possible by mechanization and the development of a market economy. This same mechanization, and the division of labor that accompanied it, were responsible for the erosion of older cultures of work and shared pleasure, which were then replaced by the mechanically produced new cultures. Thus, the same processes that created insecurities in people's daily lives, both at work and at home, also created new images of security for the home environment in the form of cultural goods.

This connection between security, consumption, and culture was articulated perhaps most eloquently by the economist Simon Patten in his 1889 essay "The Consumption of Wealth." Patten's solution to the gap between the standards of living of the laboring classes and employing classes lay not in any reordering of social relations or redistribution of wealth, but in providing the laboring classes with more opportunities to consume a greater variety of goods. Patten argued that people worked not simply to satisfy material needs but also to satisfy desires. As existing desires are satisfied, new ones will take their place, thus creating the need for a wider variety of goods to satisfy these new desires. Unfortunately, the satisfying of desires through consumption had yet to raise the poor from their state of poverty because the goods that they could afford appealed to their more "primitive" desires (drinking, smoking) and thus did not challenge them to strive for higher personal and professional goals. What was needed, therefore, was to make goods that appealed to a person's more "refined" senses— fine music, painting—cheaper, and those that appealed to their "primitive" senses more expensive. With a higher level of refined taste would come a greater consumption of goods (both facilitated by a shorter work day and inexpensive education) and a greater social harmony. The ultimate gain for society would be the widespread coexistence of both peace and production. High culture would thus guide consumption and promote a society

of equals. Who would have thought that so much would result from the cheap reproductive processes that made "the beautiful within reach of all"? Even advertisements, remarked Patten, would allow beauty into the homes of the very poorest. Beauty is thus transformed into a commodity, and the walls of the domestic sphere into billboards.

Helpful Women: The Evolving Image of the Domestic Servant

As middle-class women participated in this new commodification of culture and inculcation of new social norms and values, they were also struggling with the material transformation of labor within the home, particularly as manifested in the presence of household servants. The employment of servants was nothing new in the 19th century. As the art historian Elizabeth O'Leary points out, approximately half of the immigrants who came to the American colonies from Europe in the 17th and 18th centuries arrived as bound servants. "In every colony," she writes, "white servitude preceded black slavery." Yet while it was possible for white servants to work their way out of servitude, this was not an option for the majority of blacks who, by the end of the 17th century, had become slaves, not servants (the first Africans arrived in Jamestown in 1619 as indentured servants).

The lives of servants, both white and black, during the colonial period were very hard, with many dying of overwork and illness before they were able to pay off the debts they owed those who financed their trip to the New World. The rhetoric of liberation from the tyranny of bondage that accompanied the American Revolution thus struck a chord with those who had experienced bondage in their early years in the colonies and who feared that their hard-won freedom might be taken away from them should the rebellion against England be crushed. Following the Revolution, indentured servitude among whites quickly disappeared and the portrayal of white servants in paintings and prints, rare during colonial times [1.75], became even rarer in the new republic. Even the term "servant" fell out of use as a term for white household workers (it remained in effect for blacks, along with "slave") and was replaced by the less offensive term "help." Much of the "help" employed in early 19th-century homes was composed of the sons and daughters of neighbors or relatives, thus blurring the authoritarian boundaries between employer and employee. Also, at this time the home was still an important site of economic production, so that the members of the household often worked side by side with their "help."

These social and economic relations of production within the home changed in the middle of the 19th century. As factories multiplied and increasingly took over the task of producing many of the necessities of life, many women were forced out of the home and into these factories to provide the currency necessary to purchase manufactured goods. Women also entered domestic service, especially those arriving in large numbers from Europe. Ireland was a major source of immigrants, particularly after the potato blight of 1846–49. Some ten years later, Irish men and women constituted almost half of the country's foreign-born population. By 1850, 15–30 per cent of urban households employed live-in domestics, and nearly all of these were female. Paid domestic labor had come to be regarded by native-born women as one of the least desirable forms of employment, in part because it was associated with low morals (though the suspect morals of young female servants were often the result of the unwanted sexual attentions of the men of the house) and in part because it involved heavy, backbreaking labor. Factory labor also allowed women greater independence, for domestic workers often lived with their employers and were on call twenty-four hours a day.

As more and more foreigners took over the duties of domestic help, a greater distinction was made between them and family members, and the word "servant" came back into popular usage. In addition, many middle- and upper-class women, who employed the majority of domestic workers, began complaining increasingly of the "servant problem." Even Lilly Martin Spencer, who had produced sympathetic images of household workers such as *Shake Hands?* (1854) [5.20], began to

5.20 Lilly Martin Spencer: *Shake Hands?*, 1854
Oil on canvas, 30⅛ × 25⅛ in. (76.5 × 63.8 cm.)
Ohio Historical Society, Columbus

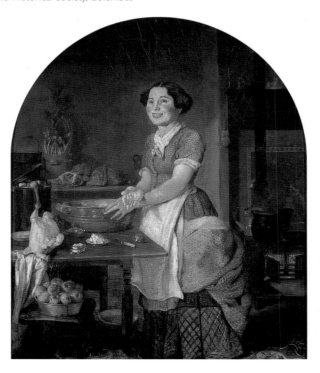

5.21 Jean-Baptiste-Adolphe Lafosse after Lilly Martin Spencer: *The Fruit of Temptation*, c. 1857
Lithograph, published by Goupil, New York, 24½ x 20⅛ in. (62.2 x 51 cm.)
Ohio Historical Society, Columbus

working-class men and women saw them as a threat to their jobs, while middle- and upper-class men and women saw them as swelling the ranks of the working class and spreading revolutionary ideas about socialism and workers' rights.

African American women were also found in large numbers among the ranks of household servants. In fact, the animosity between African American and Irish workers intensified in the last half of the 19th century as both groups competed for the lowest-paying jobs in urban centers. Like their white counterparts, African American female servants were most often included at the margins of compositions (e.g. Woodville's *Old '76 and Young '48* [4.3]), or, when foregrounded, were shown as comic or irresponsible figures. An example of the latter can be found in *Her Mistress's Clothes* (1848) [5.22] by Harriet Cany Peale (1800–1869), the second wife of Rembrandt Peale. O'Leary points out how the painting alludes to the pseudosciences of phrenology and physiognomy, which promoted racial comparisons and hierarchies, with the "Anglo-Saxon" form always presented as occupying the highest rung on the evolutionary ladder: by juxtaposing the heads of the young white girl and her even younger African American servant, Cany Peale sets up an obvious contrast, in which the oval face, aquiline nose, light skin and small lips of the white girl are inevitably seen as superior. Further, a difference is made between the dresses worn by the two young women, about which the painter, who was employed in a fancy-goods business in Philadelphia before her marriage, would have been very knowledgeable: the African American girl may be wearing "her mistress's clothes," but the neoclassical Empire-style gown and cameo necklace, earrings and belt, while valuable, were long out of fashion, as opposed to the latest style of simple, off-the-shoulder dress and plaid scarf worn by the white girl. The viewer is invited to smile at the servant's naiveté, as she is obviously pleased by her reflection in the mirror.

Perhaps the oddest aspect of the painting, however, is the position of the white girl's hand on the black girl's neck. It appears to be meant to be read as directing her gaze toward the mirror, but it ends up looking as if the white girl is strangling her young servant. Cany Peale created this painting at a time of heightened racial tension in Philadelphia, a city that contained the largest population of free African Americans of any northern city. Three years earlier a Jamaican Emancipation Day parade had been followed by riots, where white mobs attacked the black paraders and then went on to destroy black homes and churches. These events led not to the punishing of members of the white mob, who were primarily Irish, but to the passage of ordinances limiting African American assembly. "A local audience having grown uneasy with its large black community,"

complain at the end of the 1850s of the difficulty of finding good servants, of their laziness and dishonesty. This less sympathetic attitude can be found in her painting *The Fruit of Temptation* (c. 1857), known from a lithograph by Jean-Baptiste-Adolphe Lafosse for Goupil [5.21]. Here, instead of an industrious woman pausing in her work to offer her hand playfully to the viewer, we have an irresponsible servant, concerned more with her own appearance than with the household labor and childcare tasks assigned to her. Her feckless nature was often attributed to her foreignness. She was "Bridget," the Irish Catholic immigrant whose laziness was matched only by her surliness.

Household disarray had a broader symbolic meaning as well. A prosperous home was seen as indicative not only of a well-ordered and stable family but also of a prosperous and stable nation. The waves of new immigrants were pinpointed by many as the cause of disruption within both the home and the nation, despite the fact that their labor enabled the massive expansion of industry, which led to the increasing accumulation of wealth within the United States. Many native-born

5.22 Harriet Cany Peale: *Her Mistress's Clothes*, 1848
Oil on panel, 10⅛ × 8¼ in. (25.7 × 21 cm.)
The Charleston Renaissance Gallery, Robert M. Hicklin Jr, Inc., Charleston,
South Carolina

5.23 Anonymous: trade-card advertisement for Edward Chamberlin & Co.'s
"Concentrated Leaven," 1860
Lithograph, published by John H. Bufford, Boston, Massachusetts
Courtesy The New-York Historical Society, New York City

writes O'Leary, "might have found Peale's portrayal of a domesticated African American reassuring." They also might have been further reassured by the white girl's firm grip on the black girl's throat, a suggestion that any dissatisfaction with this domesticated status would be met with swift punishment.

Older African American female servants appeared in paintings and popular media primarily in the roles of cooks or nursemaids. These figures, commonly referred to as "Mammy" or "Dinah," were most often represented as fat and sexless, with heads covered by kerchiefs. They were fiercely independent, but ultimately kind and loyal and devoted to their white charges. This Mammy/Dinah character can be found in an 1860 trade card advertisement for Edward Chamberlin & Co.'s "Concentrated Leaven" [5.23], a precursor of the ubiquitous Aunt Jemima pancake advertisement [8.84] that made its debut in 1893 at the World's Columbian Exposition in Chicago. What is most striking is not the magical effect of the leaven, but the contrast between the slender, well-dressed, small-featured white woman and the large-featured, buxom, plainly dressed African American woman. The latter is a powerful character

physically and she appears fully at home in her kitchen. She nurtures all the members of the household, and because of this nurturing commands a certain degree of respect. But no-one would mistake her physical presence and control of the kitchen for any real social or economic power.

As the economy continued to grow in the last quarter of the 19th century, with an ensuing expansion of an urban-based middle class, the demand for household servants grew. O'Leary notes that "by the end of the 1870s, one-fourth of all urban and suburban households employed at least one servant." The wealthier households now looked to European-trained help, and began insisting on a more rigid formal relationship. "Servants were increasingly set apart by special uniforms, titles, duties, and stations," writes O'Leary. "As never before in the nineteenth century, an American servant class became clearly visible."

This visibility was particularly manifest in the numerous paintings of the domestic interiors of the upper class. Here servants were portrayed not as surly and/or homely Irish "Bridgets" primping in front of a mirror or elbow-deep in flour, but as beautiful women who functioned, along with their

5.24 William Henry Lippincott: *Infantry in Arms*, 1887
Oil on canvas, 32 × 53¼ in. (81.3 × 135.3 cm.)
The Pennsylvania Academy of the Fine Arts, Philadelphia

mistresses, as decorative objects testifying to the wealth of the man of the house. And in the Gilded Age, an era of conspicuous consumption and growing number of millionaires (there were only three millionaires in the United States in 1861, while by 1900 there were more than four thousand), decorative objects abounded.

William Henry Lippincott (1849–1920) produced several paintings of upper-class households, including *Infantry in Arms* (1887) [5.24]. Lippincott had studied in Paris in the studio of Léon Bonnat and upon his return went to New York and became an instructor at the National Academy of Design. The lavish dining room in the painting includes not only leather chairs, an Oriental carpet, and various silver, brass, and gold-leaf objects but also a liveried nursemaid, attired in the traditional dark dress and white apron and hat. She stands with a child both "in her arms" and "in arms" (dressed in military costume), while the child's mother sits opposite her. The latter's seated pose and the former's uniform make it perfectly clear who is the servant and who the mistress. Despite the nurse-

maid's smile, the young blond girl clings to her mother's dress, unwilling to leave her side, in fear of her "armed" sibling.

Liveried nursemaids also changed the look of major urban parks, as is shown in *A Spring Morning in the Park* (1892) [5.25] by Alice Barber Stephens (1858–1932), with its numerous women in dark dresses and white hats and aprons. Stephens

5.25 Alice Barber Stephens: *A Spring Morning in the Park*, 1892
Oil on canvas, 18 × 26 in. (45.7 × 66 cm.)
Private collection

was a well-known professional illustrator who studied painting in the late 1870s at the Pennsylvania Academy of the Fine Arts under Thomas Eakins and later at the Académie Julian and the Académie Colarossi in Paris. The effects of French Impressionism, with its loose brushwork and dappled sunlight, can be seen in this rendition of Rittenhouse Square in Philadelphia in the spring. While at first glance a scene of upper-class leisure, it is also a scene of work, as the several uniforms testify. Indeed, the figures at work function to heighten the leisured status of the woman in the flowered hat in the left foreground who is being shown the young child by a nanny while another child hovers behind her and plays with a dog.

Revivalism in Architecture and Interior Design

While uniforms made servants more visible in parks and paintings of upper-class parlors, architects worked to ensure that they were seen within the home only when necessary. Just as Thomas Jefferson utilized dumbwaiters and subterranean kitchens to keep his servants out of view (see p. 103), so too did late 19th-century architects construct elaborate mansions that, like many of the homes of the wealthy in Europe, included separate service wings, entrances, and stairways. A design by George B. Post (1837–1912) for a New York mansion (1878–82) for Cornelius Vanderbilt II shows a service staircase and servants engaged in various tasks [5.26].

Post's drawing suggests not only the palatial size of many of the houses of late 19th-century "Robber Barons" but also the intricate nature of the items found within these homes. The second half of the century saw the supplanting of classicism by a series of revivalist styles in both exterior and interior design—highly elaborate and naturalistic Rococo, elegant and uplifting Gothic, stately Renaissance, or an imaginative combination of several period styles. The architectural historian Spiro Kostof describes the decades after the Civil War as ones of "exuberant eclecticism and a lawless, energetic, architectural laissez-faire. Unmindful of even the pretense of archaeological accuracy, buildings were composed as if to prove that all human culture was fair quarry for this triumphant nation." Calvert Vaux (1824–95) and the painter Frederic Edwin Church (see pp. 156–60) designed one of the most eclectic residences of this period, Olana (Arabic for "our place on high"), Church's home overlooking the Hudson River near Hudson, New York (1870–72, 1888–89) [5.27]. Church was inspired by the architecture of Egypt and the Near East, having traveled in those regions in the late 1860s. As a veteran showman and entrepreneur, he was undoubtedly pleased with this unique architectural statement, with its multicolored tiles, glazed brick, and carnivalesque roofline.

5.26 George B. Post: presentation drawing for the house of Cornelius Vanderbilt II, New York (detail), 1878–82
Ink and watercolor on paper, 30 × 50 in. (76.2 × 127 cm.)
Courtesy The New-York Historical Society, New York City

5.27 Calvert Vaux and Frederic Edwin Church: Olana, Hudson, New York, 1870–72 and 1888–89

5.28 Samuel Newsom and Joseph Cather Newsom: William Carson House, Eureka, California, 1884–86

displayed. The structure was designed in the High Victorian style by Samuel Newsom (1854–1908) and Joseph Cather Newsom (1858–1930), brothers who traveled to California from Ontario, Canada, and who soon established a flourishing business. Kostof describes this mansion as one of those "gaily painted houses with irregular silhouettes, jutting elements and projections, crests, brackets, scrolls, and finials; oversized public monuments of stone and aggregates of curdled ornament, building up to tall mansarded roofs and contumacious towers." Conspicuous consumption was the rule of the day, and homes like Carson's would appear with regularity in the urban centers of California throughout the late 19th century.

An obsession with decoration also marked the interiors of these elaborate homes, beginning in the mid-century. Sometimes one house would contain rooms in different period styles, or rooms that combined elements from many different periods. In a reconstruction of a Rococo Revival parlor of around 1852 [5.29] one can see the characteristic elements that mark the Rococo style in the delicately carved fruit and vegetal ornament of the rosewood furniture by the well-known New York cabinetmaker and manufacturer John Henry Belter. Naturalistic designs also mark the tapestry velvet rug, mirrors,

The economic boom that followed the Civil War brought new wealth and new homes to entrepreneurs on the West Coast as well. The lumber magnate William M. Carson constructed an elaborate home in Eureka, California, in 1884–86 [5.28] in which the source of his wealth—wood—was excessively

5.29 A Rococo Revival parlor, with architectural elements from a house at Astoria, New York, of c. 1852, and rosewood furniture by John Henry Belter
The Metropolitan Museum of Art, New York

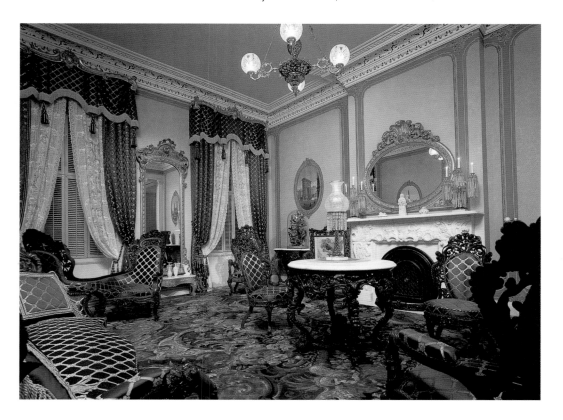

window coverings, and chandelier. The overall opulence of the room, with its myriad patterns and gilded mirrors and chandeliers, suggests the wealth of its inhabitants. One can also well imagine what faced the servants who were required to maintain it in pristine order. The sweeping, dusting, and polishing of the furnishings of even a modest urban mansion, along with the washing of household linens and clothing, would keep several women busy from dawn to dusk.

The Feminine Ideal and the Rise of Aestheticism

As the interiors of the homes of the nation's wealthy became more profusely decorated, many of the paintings that hung within them became more decidedly decorative. The late 1870s and 1880s saw the return of a generation of young artists who had gone to Europe to take advantage of the more extensive art training offered there, in particular in the cities of Paris and Munich. They included Kenyon Cox, William Merritt Chase, Thomas Dewing, and Abbott H. Thayer. A shift in emphasis had taken place in the European art world, particularly in the academies and ateliers of Paris, from the heroic male ideals and masculine virtues celebrated in the early part of the century in paintings by artists such as Jacques-Louis David and Baron Jean-Antoine Gros to the feminine ideals of beauty expressed in the female nude, as found in the paintings of William-Adolphe Bouguereau, Alexandre Cabanel and Jean-Léon Gérôme, three artists with whom many American painters studied. Thus, the focus of much of their training was the female figure.

When these artists returned to the United States they continued this emphasis, which marked a notable shift from the earlier focus on men in American painting. The new female figures were not, however, historical women taking part in a nationalist narrative of westward expansion or economic transformation. They were, on the contrary, often in groups but seldom conversing; never engaged in any apparently meaning-ful activity, not even domestic; sometimes dressed in classical garb, more often in contemporary dress, sometimes naked, but almost always situated in interior spaces or vaguely defined landscapes; and most often, if not always, white. When the interior spaces were recognizably 19th-century, these spaces were also recognizably middle- or upper-class.

Just as "culture" had been elevated to a position above and separate from the materialism of everyday life, so too were women, as an ideal force, allotted a role outside of this materialistic world, even as they were simultaneously charged with countering its effects within the home (see p. 274). Culture and women were both portrayed in lengthy commentaries by learned men—and several learned women—as refining and civilizing forces. In order to perform these functions, women—and culture—needed to be protected and isolated, ensconced in a world of ideal truth and beauty. This world, not surprisingly, was full of references to middle- and upper-class lifestyles, thus conflating women, art, and the economic elite. The art historian Bailey Van Hook writes,

> Idealized images of women could fulfill the artists' prescriptions for art, as no other subject could, because their flesh-and-blood female counterparts were perceived as occupying a position analogous to art itself. In other words, the definition of art (and more widely of culture) coincided with the construction of the feminine gender in the Gilded Age, making the resulting imaging of women inevitable.

Accompanying this movement from male-dominated history and genre scenes to female-dominated interiors and landscapes was a shift in artistic discourse. The British critic John Ruskin was particularly popular in the third quarter of the 19th century in the United States, with his emphasis on moral narrative and truth to nature. He was a strong supporter of a group of artists in England whose narrative paintings were based on historical or contemporary literary texts (Shakespeare, Keats, Tennyson) and who called themselves the Pre-Raphaelite Brotherhood. Among the most notable of these artists were Dante Gabriel Rossetti and Edward Burne-Jones. While many American painters were familiar with the work of the Pre-Raphaelites, and admired its decorative qualities, they tended to reject its anecdotal, sometimes moralizing, narratives (also found in many American genre paintings of the mid-19th century) in favor of more generalized scenes that could be categorized in terms of formal or aesthetic considerations rather than content. Many artists, according to Van Hook, "had consciously shifted the language of their written and pictorial discourses to substitute beauty for Ruskin's emphasis on truth, art for nature, and aesthetics for morality."

One of the leading proponents of the attack on Ruskin, and on narrative realism in general, was the American expatriate artist James Abbott McNeill Whistler (1834–1903). Whistler's work was well known in the United States by the end of the 19th century, particularly after the exhibition of his *Symphony in White No. 1: The White Girl* (1862) [5.30] in New York City at the Metropolitan Museum of Art and the Union League Club in 1881. While Whistler may have been bankrupted by his libel suit against Ruskin in the mid-1870s (in referring to Whistler's painting *Nocturne in Black and Gold: The Falling*

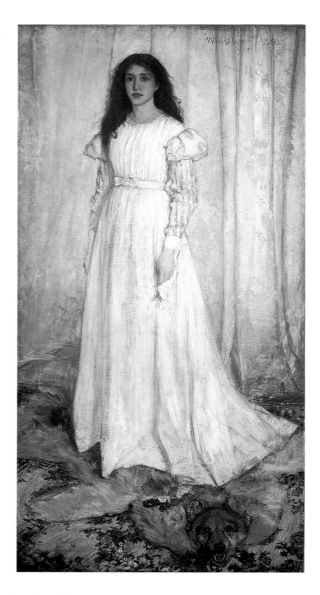

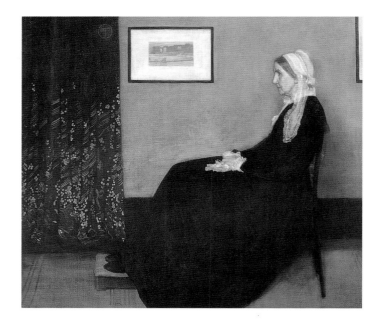

5.30 (left) James Abbott McNeill Whistler: *Symphony in White No. 1: The White Girl*, 1862
Oil on canvas, 84½ × 42½ in. (214.7 × 108 cm.)
National Gallery of Art, Washington, D.C.

5.31 (above) James Abbott McNeill Whistler: *Arrangement in Grey and Black No. 1: The Artist's Mother*, 1871–72
Oil on canvas, 57 × 64½ in. (144.6 × 163.8 cm.)
Musée d'Orsay, Paris

Rocket of *c.* 1874, Ruskin had commented that the artist had flung "a pot of paint in the public's face"—Whistler won, but was awarded only a farthing), his legal victory undoubtedly aided in the spread of his opinions, which quickly supplanted those of Ruskin in the United States.

In a collection of essays entitled *The Gentle Art of Making Enemies*, published in 1890, Whistler wrote that art "should be independent of all clap-trap—should stand alone and appeal to the artistic sense of ear or eye, without confounding this with emotions entirely foreign to it, as devotion, pity, love, patriotism and the like. All these have no kind of concern with it, and that is why I insist on calling my works 'arrangements' and 'harmonies.'" The best-known of the former is a painting exhibited in 1872 at London's Royal Academy under the title *Arrangement in Grey and Black No. 1: The Artist's Mother* [5.31]. While it is a portrait of his mother, the identity of the

woman, according to Whistler, should be of no interest to the viewer, only the formal arrangement of grays and blacks. Art was not about moral instruction or story-telling but, instead, about formal perfection—the flat areas of gray and black, the echoing of the picture frame in the framed print on the wall, the contrast between the delicate patterning of the curtain and the stark black of the woman's dress. To use art as a morally uplifting device in the service of social reform would only result in it succumbing to the materialistic concerns of an industrial, consumer society. Artists should produce not what they see in nature but their emotional response to it. Their work should be filled with sentiment, not sentimentality. Art should be about art, not the world around it. These ideas formed the basis of the Aesthetic Movement of the 1870s and 1880s in Europe and influenced several American artists then studying there.

While many returning from Europe turned their attention to the female nude, their nudes were much less voluptuous than those of the academic painters with whom they had studied, for the subject in general still met with a cool reception. As late as 1906 Anthony Comstock, secretary of the New York Society for the Suppression of Vice, ordered a raid on the offices

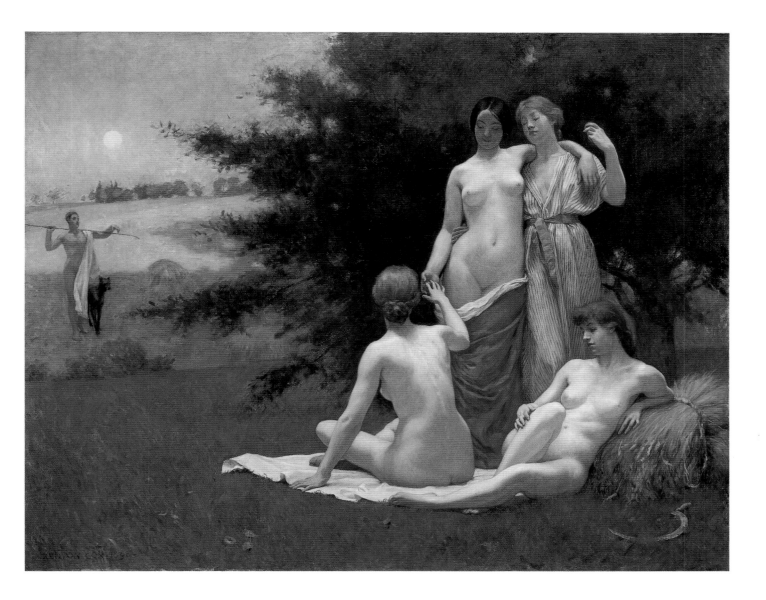

5.32 Kenyon Cox: *Eclogue*, 1890
Oil on canvas, 48 × 60½ in. (121.9 × 153.7 cm.)
Smithsonian American Art Museum, Washington, D.C.

of the *American Student of Art* because the publication included illustrations of nudes. When Americans did paint nudes, they attempted to downplay the sexual implications by making the women more youthful and thus more "innocent," as well as more idealized, as can be seen in *Eclogue* (1890) [5.32] by Kenyon Cox (1856–1919). Cox had studied with Cabanel and Gérôme in Paris in the late 1870s and early 1880s, before returning home in 1882. An eclogue is an idyllic pastoral poem, and he has arranged his figures in poses reminiscent of classical prototypes, although this does not totally remove the erotic charge of the painting. He also adds a male figure and his dog in the background, both looking in the women's direction, confirming the purpose of this display of female flesh.

Despite his attempt at idealization through the adoption of classical poses, Cox's inclusion of the individual features of his live models inserts a touch of naturalism, as does the striped dressing gown of the standing woman on the right. This combination of the ideal and the real also appears in works of Abbot H. Thayer (1849–1921) such as his *Angel* (c. 1889) [5.33], for which his daughter Mary posed. Thayer studied under Gérome, and chose not the classical world for his feminine ideals but the world of Christianity. His figures were often described as exuding a divine or spiritual beauty, in addition to or as opposed to a mere physical beauty. He himself insisted that he was searching for a transcendent beauty, one that would impart to the physical body a moral quality. For the art historian Ross Anderson, Thayer perceived "woman as a being whose purity was constantly menaced, who if not

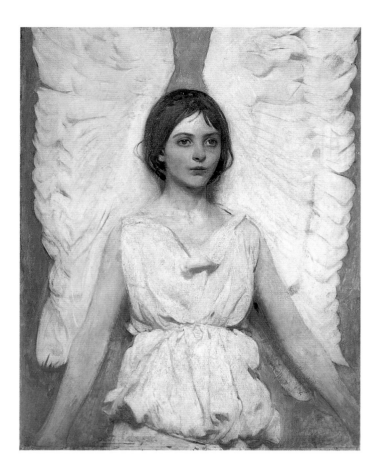

5.33 Abbot H. Thayer: *Angel*, c. 1889
Oil on canvas, 36¼ × 28⅛ in. (92 × 71.5 cm.)
Smithsonian American Art Museum, Washington, D.C.

enshrined by art might easily fall into an abyss of materialistic degradations." Thayer saw himself as a transformative agent, taking the real female body in front of him and, through the processes of artistic creation—the addition of wings or white gowns—turning her into a purer, higher creature.

Critics sometimes interpreted the youth and innocence of the female figures of Cox and Thayer as particularly "American" qualities, and contrasted them not only with the more voluptuous, and thus more lascivious, nudes and semi-clothed women in paintings by Europeans but also with the very real female immigrants entering the United States at this time, whose poverty and foreignness marked them as less than "ideal." By the end of the century an image of the "American Girl" emerged that functioned, in the words of Van Hook, both at home and abroad as a symbol of "national innocence, independence, and naiveté . . . a child compared to her European forebears, uncorrupted by jaded European decadence." The American Girl was decidedly white, if not necessarily Anglo-Saxon, and decidedly pure, despite her increased visibility in the

public sphere. Her ascendancy would be short-lived, however, for at the beginning of the 20th century culture and femaleness would part company and new, more masculine ideals would displace the feminine qualities of purity and beauty.

While women in clothing or settings evoking the worlds of ancient Greece or Rome appeared in the works of several of these European-trained artists, their paintings more often contained women in contemporary garb, located in interiors or gardens. One example is *In the Studio* (1880) [5.34] by William Merritt Chase (1849–1916). Chase studied in Munich, and his heavier impasto and darker tones reflect the influence of this training (the female nude was also not as prominent a force in Munich as it was in Paris). The elegantly dressed woman sitting on the bench looking at the portfolio at her feet is painted as simply another of the richly textured objects that adorn this artist's studio—the Japanese fabrics, brass plant-holder, ornately carved Renaissance-Baroque credenza, and gilded frames. The woman both looks at art and is presented as art by the painter.

The art historian Sarah Burns suggests, however, that the women depicted in the lavish studios of Chase and his male contemporaries play a more complex role. The emergent consumer culture of the late 19th century created a focus on self-gratification, largely through the acquisition of material goods, rather than on the Victorian moralities of work, thrift, and self-denial. In this context, the elaborately decorated studio "became in essence a salesroom: an aesthetic boutique where the carefully compounded art atmosphere functioned very specifically both to set off the painter's own wares and to create desire among potential clientele by seducing their senses through the romantic associations of the aesthetic commodities on show." This enticing arrangement of objects was replicated in the new palaces of consumption that were being developed at this time—department stores. The emphasis of Chase and others on the surface quality of paintings, on the experiencing of emotion or sentiment, increased the association between the object being viewed and immediate visual pleasure that was so effectively used to sell commercial products in these stores.

This merging of the displays of art and commerce (department stores also often included art galleries) created an ambivalence and anxiety among artists and critics, writes Burns, as the "older discourses shoring up art's elevating moral and ideological functions" came up against new, market-driven discourses that directly addressed "the commercial dimensions of artworks produced as luxury consumer goods promising individual self-gratification, both sensual and spiritual." In both realms—the department store and the studio—the feminine

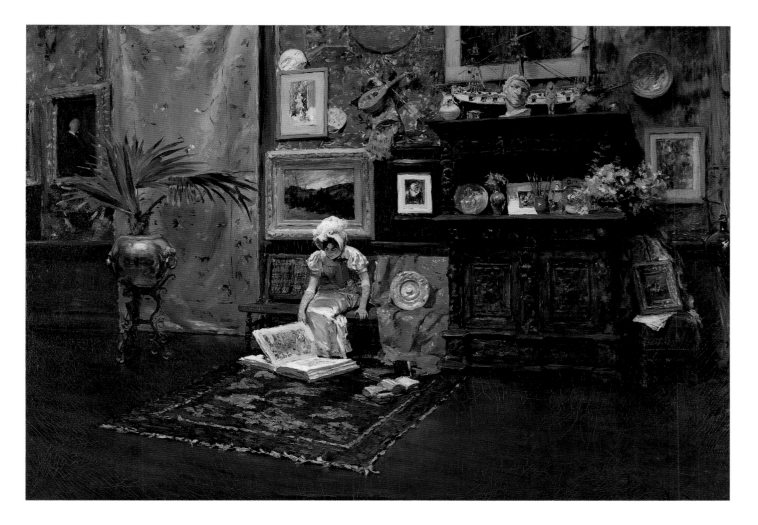

5.34 William Merritt Chase: *In the Studio*, 1880
Oil on canvas, 28⅛ × 40¹⁄₁₆ in. (71.4 × 101.8 cm.)
The Brooklyn Museum of Art, New York

played a crucial role. Women had been identified early on in the development of the department store as the major customers; they were the ones who perused the goods on display and made the family purchases. According to contemporary accounts, women also constituted the majority of visitors to the open houses held by artists like Chase in their studios. Thus, Burns suggests that the women in paintings of studio interiors may be read as "cultural shoppers" "engaged in a drama of cultural consumption." At the same time, women were seldom the nominal purchasers of major artworks (their fathers or husbands would assume this role). Rather, they functioned as "stand-ins: mediators between raw money from the arenas of commerce and capital and the pure, transcendent spheres of art." Their presence aided in the feminizing of the studio, its appearance as a passive, yet sensual, world dependent on industrial or commercial wealth, which was coded inevitably

as male. By the early 20th century many male artists were stripping their studios of opulent clutter in an attempt both to reassert their masculinity and to distance themselves from the excesses of material consumption.

The prominence of objects from Japan in Chase's painting [**5.34**] reflects not only a well-established association between the Far East and the exotic or sensual, but also an increased interest in the region in both the United States and Europe after a U.S. Navy expedition led by Commodore Matthew C. Perry resulted in the opening of Japan to trade. In 1856 Perry published a report on his journey, which contained facsimiles of Japanese prints; by 1860 prints by Hokusai were circulating in Boston and New York, just as Japan was setting up its first embassy in New York. Painters began featuring objects from Japan (*Japonaiserie*) and adopting the formal qualities of the prints, with their shallow spaces and large areas of unmodulated color (*Japonisme*) (Whistler did both). Wealthy individuals also began acquiring art objects. William H. Vanderbilt had a Japanese Room constructed in which to display his collection [**5.35**]. It was marked by red-lacquered

suggesting the act of fishing, or perhaps butterfly-catching. But their actions and identities are not important to Dewing: what he wants to convey is a mood, one suggested by the title *Summer*. Indeed, artists often gave their paintings emblematic or evocative titles—Morning, Spring, Summer, Lilies—that denied the specificity of the setting and the figures, thus encouraging the viewer to focus on the aesthetic aspect of the work.

The art historian Kathleen Pyne also argues that the women in Dewing's paintings "encapsulated the late 19th-century definition of America as an Anglo-Saxon nation that promised to be the culmination of world civilization." Dewing was one of many in the United States who subscribed to the theories of the British philosopher Herbert Spencer, who offered a more palatable alternative to Charles Darwin's seemingly grim survival-of-the-fittest theory of evolution. In Pyne's words, Spencer "held that nature advanced harmoniously in an inherently moral universe toward higher forms of life. In his scheme, evolution impelled human life toward a peaceful, utopian state." This theory was particularly popular with those of Anglo-Saxon descent, who were feeling embattled and threatened by the latest waves of immigration, and could envision themselves as the most advanced state of life. Spencer also believed that environment played a key role in evolution. Hence, "cultured" environments would civilize "darker" immigrants, and advance those of lighter complexion even further in their progression toward utopia. In addition, Spencer's emphasis on "unity," "harmony," and "repose" fit well with the new aesthetic theories espoused by Whistler and his supporters.

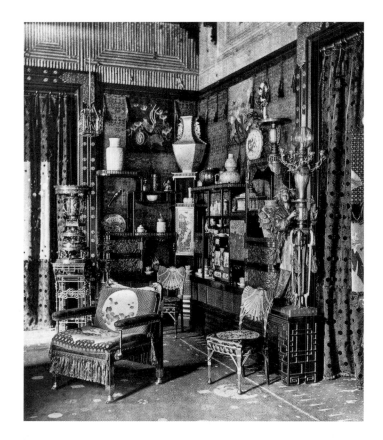

5.35 The Japanese Room in the house of Cornelius Vanderbilt II, New York
From Edward Strahan (Earl Shinn), *Mr. Vanderbilt's House and Collection*,
New York, 1883–84
Morris Library, University of Delaware, Newark

beams, ebonized wood cabinets, gold brocade wall-hangings, and a woven bamboo ceiling. In addition, Japanese motifs were taken up in the decorative arts [5.65, 5.66]. This interest in the artistic products of Asia was accompanied by an interest in the region's potential for economic investment. Soon the United States would become a neighboring colonial power, with the expulsion of Spain and the U.S. occupation of the Philippines in 1898 as a result of the Spanish-American War.

Several artists, including Thomas Wilmer Dewing (1851–1938), combined women and landscape in their paintings. Dewing studied in Paris with Jules-Joseph Lefebvre and Gustave Boulanger and became known in the 1880s, like Cox, for female figures draped in classical garb. In the 1890s, however, he began creating works marked by subtle tonalities and mists or hazes, with figures more decidedly contemporary while still anonymous and idealized (he would later be categorized as one of a group of landscape artists known as Tonalists). *Summer* of *c.* 1890 [5.36] reflects this new style. Here two elegantly dressed women move through a vaguely defined landscape; one extends a long, slim pole in front of her,

5.36 Thomas Wilmer Dewing: *Summer*, c. 1890
Oil on canvas, 42 1/8 × 54 1/4 in. (107 × 138 cm.)
Smithsonian American Art Museum, Washington, D.C.

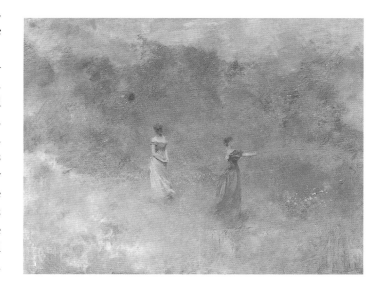

5.37 William B. Post: *Summer Days*, 1895
Photograph
George Eastman House, Rochester, New York

disdain for mass culture and mass audiences would continue into the 20th century.

Images of the Particular: Portraiture and *Trompe l'Oeil* Painting

Portraiture in the Late 19th Century

While artists who adhered to the theories of the Aesthetic Movement argued for the importance of form over content, it was difficult to focus on formal qualities alone when the content of a painting was a recognizable individual as in Whistler's portrait of his mother [5.31] or in Chase's *Portrait of Miss Dora Wheeler* (1883) [5.38]. Despite the strong design, shallow composition, and careful placement of yellows and blues, which enhance the decorative quality of Chase's painting, the viewer's eye is continually drawn to the least decorative element—the self-confident gaze and strong features of Dora Wheeler, an artist who had studied at the Académie Julian and with Chase in New York.

The same is true of Ellen Day Hale's *Self-Portrait* of 1885 [5.39]. Hale (1855–1940) came from a prominent Boston family whose lineage included Nathan Hale the patriot, Lyman Beecher the preacher, Harriet Beecher Stowe the author, and Catherine Beecher the educator. Many of her living relatives were also authors and painters, and her art instruction began early in Boston, culminating in several trips to Europe in the early 1880s to study with various artists and at the Académie

5.38 William Merritt Chase: *Portrait of Miss Dora Wheeler*, 1883
Oil on canvas, 62½ × 65¼ in. (158.7 × 165.8 cm.)
The Cleveland Museum of Art, Cleveland, Ohio

Dewing's paintings, according to Pyne, "evoked two essential metaphors for the idea of evolutionary self-refinement. One centered on the turning inward of the self to the nurturing world of the psyche and the imagination; the other involved the release of the self into the sustenance and boundlessness of nature." Thus the women in his paintings who dissolve into nature and/or into self-reflection are furthering the progress of civilization. "As Dewing's women read a poem, listen to music, or contemplate the rarefied art object, they are distillations of intellect and aesthetic sensibility; their physical bodies have been devalued and sloughed away." Yet these bodies are of a decidedly Anglo-Saxon cast, with their elongated limbs, pale skin, and aquiline facial features: they are simultaneously not of this world in their aesthetic contemplation, and very much of it in their upper-class physical and cultural characteristics.

This utopian world of long-necked women in elegant attire baffled most art viewers, who still wanted "the facts." The more their works were criticized as unintelligible, the more the artists pointed to the need to maintain a distance between their art and the undiscerning public, be it conservative art critics or the person in the street. Having to compete with a proliferation of image-makers, from producers of popular prints to portrait photographers, many felt compelled to distinguish themselves clearly from this mass-produced culture. They created paintings marked by formal effects that mechanical reproduction had yet to master—heavy impasto, subtle gradations of color, fog-shrouded hills. Photographers like William B. Post (1857–1925), though, easily replicated their subject-matter and mood, if not their color [5.37]. While the idealized women would soon disappear, the emphasis on formal innovation and the

5.39 Ellen Day Hale: *Self-Portrait*, 1885
Oil on canvas, 28½ × 38¾ in. (72.4 × 98.4 cm.)
Museum of Fine Arts, Boston, Massachusetts

Colarossi and the Académie Julian. In her self-portrait [**5.39**] she adopts the floral patterned backdrop and shallow space that mark so many of the decorative paintings produced at this time. But we are, again, struck by the self-confident gaze and strong personality of the artist. She has increased the emphasis on her face and hand by portraying herself in dark clothing; even her ostrich-feather fan is dark. Her prominence in the painting—she takes up almost half of the canvas—ensures that her presence and her identity will take precedence over any formal effects.

Two artists well-known for their portraits of elegant middle- and upper-class women were John Singer Sargent and Cecilia Beaux. Sargent (1856–1925) was born in Florence of American parents and spent most of his life in Europe, particularly in Paris and in London. He was closely associated with the Aesthetic Movement in England in the 1880s and 1890s. Unlike Whistler, he believed that rendering the "appearance" of things was an honorable goal for an artist, but he also believed that appearances needed to be refined and intensified for the viewer. His friend Edmund Gosse wrote that Sargent thought "the artist ought to know nothing whatever about the nature of the object before him . . . but should concentrate all his powers on a representation of its appearance." Thus, the less one knew about the subject, the freer one was to concentrate on its formal qualities.

Sargent was most concerned with creating form through the manipulation of light and shadow, and produced brilliant paintings marked by luscious skin tones, accents of rich color, and subtle plays of light across surfaces. His paint-laden brush-strokes provided texture to the surface of the canvas and often implied an effortlessness of execution. He had learned his lessons well in the Paris studio of Emile-Auguste Carolus-Duran, an artist who encouraged his students to strive for virtuosity and flair in their work. These qualities—feathery brushwork, subtle plays of light—are clearly apparent in one of his more decorative works, *Nonchaloir* (*Repose*) of 1911 [**5.40**]. Sargent's niece Rose-Marie Ormond modeled for it, yet the painting does not necessarily read as a portrait. Instead, it conveys to the viewer, above all, the mood of repose or relaxation. The woman is integrated into the interior through the green and gold tones that permeate everything, from table to sofa to dress to skin.

While Sargent's portraits speak to his concerns with the decorative, they also contain a tension between his commitment to form and his need to capture the features and personality of a subject about whom he must, of necessity, know something. This tension can be seen in his 1888 portrait of the wealthy Bostonian art patron Isabella Stewart Gardner [**5.41**]. Sargent has emphasized the decorative through the placement of the figure in front of a 16th-century Italian cut-velvet brocade owned by the sitter. By placing her head in the center of one of the pomegranate motifs he adds a subtle religious connotation, the concentric rings radiating outward like a pulsating aura or halo. In fact, the author Henry James described the painting as a "Byzantine Madonna with a halo." The curved lines of the design are also echoed in the pearls around Gardner's neck and waist, and in her arms. Yet, unlike the woman in *Nonchaloir*, Gardner does not dissolve into her interior. She stands proudly in the center of the image, as if waiting to accept the offerings of her admirers.

The painting produced a considerable stir when it was exhibited in 1888 at Boston's St Botolph Club. Many thought

5.40 John Singer Sargent: *Nonchaloir* (*Repose*), 1911
Oil on canvas, 25⅛ × 30 in. (63.8 × 76.2 cm.)
National Gallery of Art, Washington, D.C.

Gardner had been depicted as a goddess, while others debated the significance of her pose, wondering whether it was meant as a flattering likeness or as a more generic representation of woman as enigma, much as Rose-Marie Ormond becomes representative of woman as repose. Perhaps the most complex response came several years later, in the French writer Paul Bourget's 1895 publication *Outre-mer (Notes sur l'Amérique)*. Bourget calls Sargent's portrait the "American Idol" and goes on:

> Rubies, like drops of blood, sparkle on her shoes . . .
> The head, intellectual and daring, with a countenance
> as of one who had understood everything The rounded
> arms . . . are joined by the clasped hands—firm hands . . .
> which might guide four horses with the precision of an
> English coachman. It is the picture of an energy at once
> delicate and invincible, momentarily in repose, and there
> is something of the Byzantine Madonna in that face, with
> its wide-open eyes. Yes, this woman is an idol, for whose
> service man labors, whom he has decked with the jewels
> of a queen, behind each of whose whims lie days and
> days spent in the ardent battle of Wall Street. Frenzy
> of speculation in land, cities undertaken and constructed
> by strokes of millions of dollars, trains launched at full
> speed over bridges built on a Babel-like sweep of arch,
> the creaking of cable cars, the quivering of electric cars,
> sliding along their wires with a crackle and a spark, the
> dizzy ascent of elevators in buildings twenty stories high . . .
> these are what have made possible this woman, this living
> orchid, unexpected masterpiece of this civilization.

The art historian Albert Boime sees this passage as indicative of male anxieties surrounding the emergence of the "new woman" on the cultural and political scene at the turn of the century. Here was the "femme fatale" that populated the work of British and French followers of Aestheticism, the counterpart to the more passive and sexually available female nudes. While she is made possible by men's accomplishments—Gardner's father was a wealthy New York merchant and her husband a prominent Boston banker—she also makes them possible. She exerts power over men, urges them on in their acquisition of wealth, and directs the spending of their fortunes. She will banish the pure and innocent American Girl from her position as national icon, and take her place as the more aggressive New Woman, more apt to be criticized than celebrated in painting.

Cecilia Beaux (1855–1942) created another version of the New Woman in her portraits. Beaux began her art training in the Philadelphia home of her maternal grandparents and aunts (her mother died shortly after giving birth to her, and her

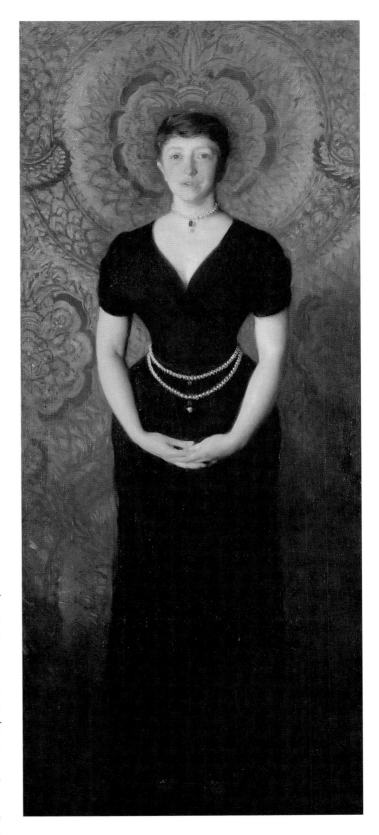

5.41 John Singer Sargent: *Isabella Stewart Gardner*, 1888
Oil on canvas, 74¾ × 31½ in. (189.9 × 80 cm.)
Isabella Stewart Gardner Museum, Boston, Massachusetts

grief-stricken father returned to his native France). While recently having suffered financial setbacks, they instilled in her the attitudes of the well-to-do, in particular an appreciation of the various arts. She started by copying lithographs and later studied with a relative, the history painter Catharine Anne Drinker. She also supplemented her income by painting nearly life-size heads of children on porcelain plates. According to her biographer Tara Tappert, these were so successful that "parents nearly wept over them," and by the early 1880s her reputation as a china painter had spread to "mothers in the Far West." Fortunately, a few of these early portraits survive, such as *Clara Hoopes* (1882) [5.42]. The image of Clara, the daughter of a neighbor of Beaux's in West Philadelphia, was based on a daguerreotype taken in about 1853, when she was eight years old, and the unnaturally stiff pose reflects this origin. Beaux has updated the portrait by including brown-flowered wallpaper and geometrically patterned wainscoting in the background, marks of the Aesthetic-style interior decoration of the 1870s and 1880s. Tappert notes that Beaux proudly sent her china portraits to the annual exhibitions at the Pennsylvania Academy, but later denounced them as the "lowest depth I ever reached in commercial art."

After several years of further study in Philadelphia, Beaux traveled to Paris in the late 1880s and attended the Académie Julian, returning to the United States in 1889. While in Paris she met Sargent, with whom she remained close friends. The stylistic similarities between them, and their common focus on portraiture, caused many critics to compare their work. For example, one reviewer wrote of *Sita and Sarita* (1893–94) [5.43] when it was shown in 1895 at the Society of American Artists in

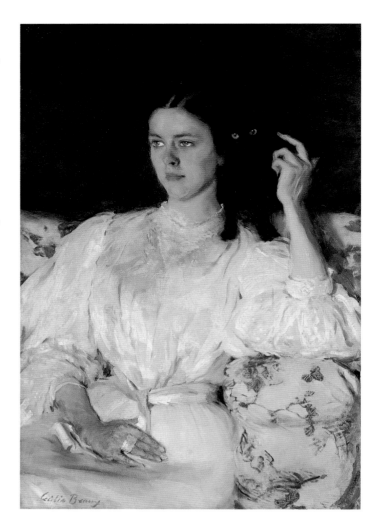

5.43 Cecilia Beaux: *Sita and Sarita*, 1893–94
Oil on canvas, 37 × 25 in. (94 × 63.5 cm.)
Musée d'Orsay, Paris

5.42 Cecilia Beaux: *Clara Hoopes*, 1882
Oil on porcelain, D 12½ in. (31.8 cm.)
Elizabeth Arthur

New York: "I am going to say that I don't see how even Mr. Sargent could paint a portrait with more distinction than that of the woman with a black cat by Miss Beaux in the present exhibition." Beaux quickly became a much-sought-out portrait painter after her return from Paris, building on the reputation she had already made for herself. By the turn of the century her clientele came not only from Philadelphia, but also from Boston, New York, Washington, and many towns in between, causing her to move to New York to be more centrally located. Beaux was interested in the same problems as many of her male contemporaries—how to create a sense of quick execution through heavily laden brushstrokes while still maintaining the structural integrity of the figure; how to give an overall decorative unity to the composition. She also focused on similar subject-matter—women and girls in interior settings or generalized landscapes. Most of her sitters were known to her, and

she is as successful at capturing their personality as she is at devising a composition deserving of the adjective "decorative." In *Sita and Sarita*, a portrait of her cousin, Sara Allibone Leavitt, with a black cat, the young woman's body dissolves into a series of white slashes and folds (this is one of a series of "white" paintings from the 1890s), further reinforcing the shallowness of the space that is initially suggested by the dark background. The billowing lines of the sleeves are echoed in the curved forms of the upholstery and its vegetal designs.

The most compelling aspect of the painting, however, an aspect that works against the decorative denial of content, is the pairs of eyes which echo each other and which continually draw the viewer's own gaze. While the woman stares off into the distance, the cat stares directly out. It is so close to her head that it blends into her black hair, suggesting that it is somehow a manifestation of her, her "familiar." Beaux had met Edouard Manet in Paris and was undoubtedly aware of his painting *Olympia* (1863) [5.44] and the furore it caused when it was exhibited at the Paris Salon of 1865. The frankness of Olympia's nudity and her confrontational pose caused many to see her not as an inviting nude but as an urban prostitute, whose nakedness was an affront to respectable society. The black woman with flowers behind her and the black cat at the end of the bed also functioned as signs of Olympia's sexual availability.

Beaux's cat, which assumes the same arched pose and direct stare as the cat in *Olympia*, is associated with a fully clothed woman, one whose respectability and "purity" are symbolized by her white dress. Yet the sheer material in the top of the bodice gives a glimpse of the skin beneath, just as a slight blue shadow suggests the cleavage between her breasts. These details, plus the cat, foreground a sexual energy behind the

5.44 Edouard Manet: *Olympia*, 1863
Oil on canvas, 51¾ × 74¾ in. (130.5 × 190 cm.)
Musée d'Orsay, Paris

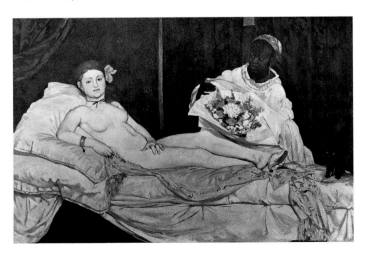

5.45 Cecilia Beaux: *Henry Sturgis Drinker (Man with a Cat)*, 1898
Oil on canvas, 48 × 34 in. (121.9 × 86.4 cm.)
Smithsonian American Art Museum, Washington, D.C.

reserved exterior, as does the figure's hand, which, as in *Olympia*, is placed firmly over her pubic area. Just as the cat in *Olympia* darkens the light-colored shawl beneath it with its shadow, so too does Beaux's cat darken the white shoulder upon which it is perched. Beaux's painting subtly works against the denial of sexual feelings in "respectable" women that was so much a part of gender discourse at the end of the 19th century and that was undoubtedly drilled into her by her grandmother and aunts, who were of good Puritan New England stock. And it does so with humor, playfully commenting on the connections so often made between "uncontrolled" female sexuality, evil, witches (with their animal "familiars"), and darkness.

An interesting comparison can be made between *Sita and Sarita* and another portrait in which a figure is paired with a cat, that of Beaux's brother-in-law *Henry Sturgis Drinker* (1898) [5.45]. Normally her portraits of professional men show figures in dark suits seated in simple wooden chairs with little else to

identify the location. Drinker, a corporate railroad lawyer, is indeed seated in a Windsor chair and located in a shallow space, but it is a space that is decidedly domestic, with shutters and curtains clearly visible in the background. The use of an overall color scheme of white, green, and gold adds a decorative quality, most often associated with images of women. Drinker wears a white, not black, suit, which catches the light coming in through the window. Again, white clothing is usually worn by women, not men, although contemporary viewers would undoubtedly have interpreted the white here as an indication of the casualness of the moment, rather than the "purity" of the sitter.

The attitudes of cat and human are reversed from those in *Sita and Sarita*, where the cat confronts us and the woman looks away. The man gazes out at us directly, while the orange tabby cat rests with eyes half-closed in his lap. The open and unselfconscious manner in which Drinker presents himself to his artist sister-in-law suggests not only his comfort in her presence but also his own sense of self-confidence. Yet the self-confidence is not total, for the slightly knitted brow and darkened left eye suggest a possibly troubled soul. Tappert describes Drinker as a man who loved his wife, Beaux's sister Etta, "in a distracted and somewhat distant manner . . . a strong-willed patriarch who occupied a distinctly male world and firmly believed that only men shaped destiny." Beaux has, in Tappert's words, "domesticated" and "tamed" this distant patriarch, bringing him out of the world of law and high finance and into the more subdued female-controlled world of the home.

Beaux also created several portraits of women using the conventions commonly adopted for male portraiture—sombre palettes, dark and nondescript backgrounds. Such conventions were appropriate, for these women occupied important positions in that male world outside of the home. The subject of *M. Adelaide Nutting* (1906) [5.46] was superintendent of nurses and principal of the training school for nurses at Johns Hopkins University Hospital in Baltimore. Just as Dr Agnew's students commissioned Eakins to create a portrait of their teacher, so, too, did Nutting's students, along with the alumnae association, commission Beaux to commemorate the retirement of their beloved teacher in paint. The mottled green background lightens somewhat the dark foreground marked by Nutting's black dress. The white hat, collar, and cuffs draw attention to the sources of her success—her sharp mind and skilled hands. In these hands she holds the red notebook that she constantly carried with her on her rounds. She gazes past the viewer with assurance, reflecting on her many years of work and on what lay ahead for women in the field of medicine.

5.46 Cecilia Beaux: *M. Adelaide Nutting*, 1906
Oil on canvas, 37 × 24 in. (94 × 61 cm.)
Johns Hopkins Hospital, Baltimore, Maryland

"Trompe l'Oeil" Painting in the Late 19th Century

Just as art historians have analyzed the portraits of Beaux, Sargent, and Eakins in light of the shifts in gender roles at the end of the 19th century, so too have some applied this same interpretive lens to another group of images, *trompe l'oeil*—eye-deceiving—still lifes, whose detailed realism "tricked" the viewer into thinking that he or she was viewing the "real" thing rather than a painted image, even if this perception was only momentary. The objects in these late 19th-century *trompe l'oeil* still lifes are different in almost every way from those depicted in the works of Dewing or Chase [5.34] or Thayer. They are not precious aesthetic creations, often from distant lands, but well-worn, much-handled items from everyday life—books, pipes, guns, hats, newspaper clippings, money. They are cracked and

5.47 William Michael Harnett: *Faithful Colt*, 1890
Oil on canvas, 22½ x 18½ in. (57 x 47 cm.)
Wadsworth Atheneum Museum of Art, Hartford, Connecticut

includes the fruit, dishes, and silverware of traditional still life paintings [**3.60**]. What marks the genre in the late 19th century is both the well-worn quality of its subject-matter and its widespread popularity. Peale could not make a living selling his still lifes, but Harnett and others led quite comfortable lives.

The art historian David Lubin has looked closely at the work of Harnett and attempted to explain his popularity and that of his fellow *trompe l'oeil* painters. Lubin describes the typical patron as "the self-made, geographically mobile, urban middle-class bureaucrat, businessman, or career professional." Such men played a crucial role in the dissemination of art beyond museums and galleries and private mansions and into men's clubs and hotel lobbies and department stores. Works that refused to follow the hierarchies of academies and critics were often welcomed. While the academician might place still life at the lower end of the hierarchy of genres (with history painting still assuming a prominent place at the top), and might also dismiss *trompe l'oeil* illusionism as lacking in that crucial element of great art—imagination—the department store shopper and middle-class traveler followed his or her own tastes. And these tastes were increasingly being guided by the same men who marketed other objects with persistence in their stores and saloons. The art market was, indeed, becoming more "democratic," much to the chagrin of artists like Whistler and Dewing.

That the subject-matter of most late 19th-century *trompe l'oeil* paintings was seen as masculine by both male and female viewers is not surprising. Harnett's *Faithful Colt* celebrates the trusty gun with which a man defended himself and his family. *A Bachelor's Drawer* (1890–94) [**5.48**] by John Haberle

rusted and chipped or torn. One of the best-known painters in the genre was William Michael Harnett (1848–92), and his *Faithful Colt* (1890) [**5.47**] is characteristic both in the detailed illusionism and in the aged objects featured. *Trompe l'oeil* artists often arranged their material on or in front of a wall, thus increasing the illusionism of the work, as the painted wall blended easily into the wall upon which the painting was hung. In an earlier chapter we saw a *trompe l'oeil* painting by Raphaelle Peale, which

5.48 John Haberle: *A Bachelor's Drawer*, 1890–94
Oil on canvas, 20 x 36 in. (50.8 x 91.4 cm.)
The Metropolitan Museum of Art, New York

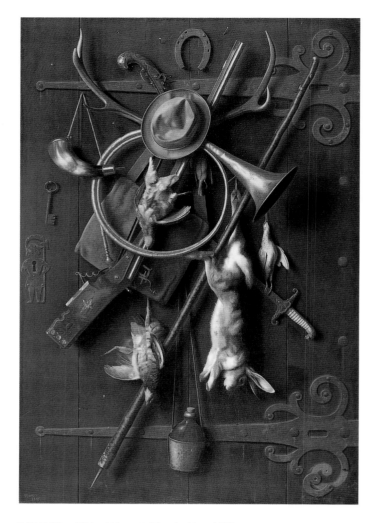

5.49 William Michael Harnett: *After the Hunt*, 1885
Oil on canvas, 71½ × 48½ in. (181.6 × 123.2 cm.)
The Fine Arts Museums of San Francisco, San Francisco, California

value. They certainly differed greatly from the shiny objects that filled the ever-increasing numbers of advertisements and shop windows. They also differed in that manufacturers and department store owners clearly targeted women as their audience, for women had become, among their other various roles, the ultimate consumers. This implied dissimilarity "must have made the viewers who admired these paintings feel, by contrast, more manly—or, this is to say, less like a woman."

In at least one important respect, however, *trompe l'oeil* pictures were like mass-produced commodities. Their visual style, their precision, and the erasure of the hand of the artist—one seldom sees the trace of a brushstroke on the surface—imitated the erasure of the hand of the laborer in the very processes of mass production. While critics may have been impressed by the skill of artists like Harnett, they often criticized their work as impersonal or imitative, qualities easily attached to mass-produced items. Yet these qualities also allowed the paintings to counter their associations with a past realist tradition by partaking of a distinctly "modern" machine aesthetic. "Old and worn objects provided appealing subject matter," writes Lubin, "but just so long as the portrayal of them, the painting itself, had the look of an object good as new." In the end, Harnett's paintings softened these associations with mass production through a tender and referential treatment of old and worn objects, suggesting that traditional ways of life could coexist with the new machine age. This was a message welcomed by many caught up in the psychological and material dislocations of an urbanizing and industrializing era.

The Battle over Public Space

Sites of Moral Instruction:
Urban Parks and Wilderness Preserves

Psychological and material dislocations were readily apparent on urban streets at the end of the 19th century. The harmonious interaction between servant, young charge, and wealthy mistress displayed in Stephens's *A Spring Morning in the Park* [5.25] contrasts with the battles that were taking place around urban parks not only over wages and working conditions but also over access. New York's Central Park is a case in point [5.50]. An early example of the "city beautiful" movement that swept the country in the last quarter of the century, it was designed for the most part by Frederick Law Olmsted (1822–1903), with the assistance of the architect Calvert Vaux, in the late 1850s and drew more heavily upon the British pastoral and picturesque traditions than the formal garden designs common in France. Thus, rather than broad avenues and elegant fountains (the formal Bethesda Fountain and area to the south being the main exception), one

(1856–1933) evokes the world of single men, marked by playing cards and female nudes and an understandable discomfort with such tasks as naming babies. Harnett's *After the Hunt* (1885) [5.49] hung in Theodore Stewart's Warren Street saloon in New York; for the businessman or professional who was now married and seldom trod the backwoods, gun in hand, in search of game, it carried a reassuring reminder of the markers of masculinity. Lubin argues that these images served "a psychologically affirmative function" for many men, as well as women, by aesthetically demarcating gender identities at a time when they were being challenged.

Lubin also notes that virtually all of the objects "seemed distinctly different from modern, urban, factory-made consumer goods." While they had obviously once been new commodities, they are shown in their worn states, suggesting that their economic value has been replaced by use value and sentimental

finds winding paths, open fields, groves of trees, lakes and streams, and carefully placed buildings which appear unexpectedly as one rounds a corner. Like many landscape painters, Olmsted ordered the natural environment through the application of artificial conventions. He took great pains to make sure that his constructed landscape looked "natural."

While wealthy New Yorkers wanted the park primarily as their own cultural preserve dotted with museums and other educational institutions, working-class men and women wanted a place for sport and amusement. Olmsted managed to steer a course between these two competing camps. The eldest son of a wealthy New England merchant, he shared with many late 19th-century intellectuals a concern for the creation of a unifying national culture. One way in which it could be created, he thought, was through environmental planning or "ecological engineering." Olmsted believed that the American democracy that had developed in a rural environment now had to be adapted to an urban environment. What needed to be maintained was the sense of community of the village. Since the home and

the workplace had become increasingly separated, this required a new physical locale, and that locale could be the city park. Olmsted's concern with order, despite the look of randomness, was closely connected to this vision of the park as a social experiment. Central Park, a vast natural space in the midst of a rapidly growing city, was to be an educational environment, a place where poor immigrants could mingle with members of the middle and upper classes, many of whom occupied the townhouses and mansions then bordering its southern end, and therefore learn the "proper" way to comport themselves. Thus, the park became both a release valve of sorts, a place to go to escape the cramped and unhealthy quarters at work and at home, and a "schoolroom." To ensure it retained its educational character, strict regulations regarding behavior within the grounds, ranging from the types of vehicles allowed to the types and numbers of commercial vendors granted licenses, were established, and enforced by the police. In addition, four sunken "parkway" roads helped prevent cross-town traffic from impinging on the peaceful strolls of the park visitors.

Olmsted also applied his ordering skills to a more unruly landscape, Yosemite Valley, a large expanse of relatively untouched wilderness on the eastern edge of California. He had traveled to California in 1863 to take up the job of director of the Mariposa Mining Estates, a gold mining enterprise on the edge

5.50 Frederick Law Olmsted and Calvert Vaux: Central Park, New York, begun 1857
This bird's-eye view by John Bachman of *c.* 1870 shows about one-third of the park, looking south toward the formal Bethesda Fountain in the center of the much more extensive informal landscape, with the crowded city beyond.
Courtesy The New-York Historical Society, New York City

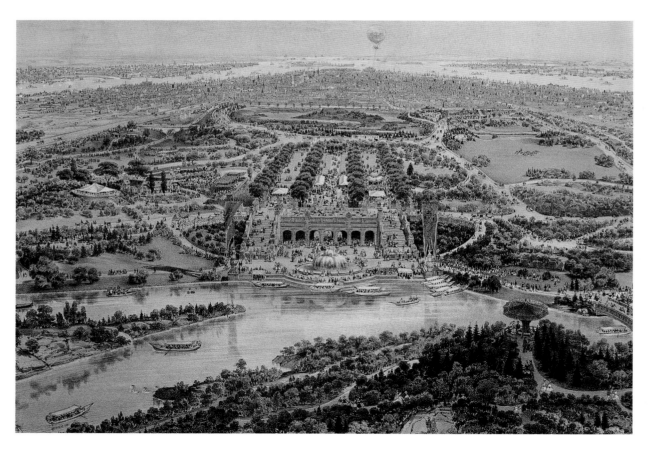

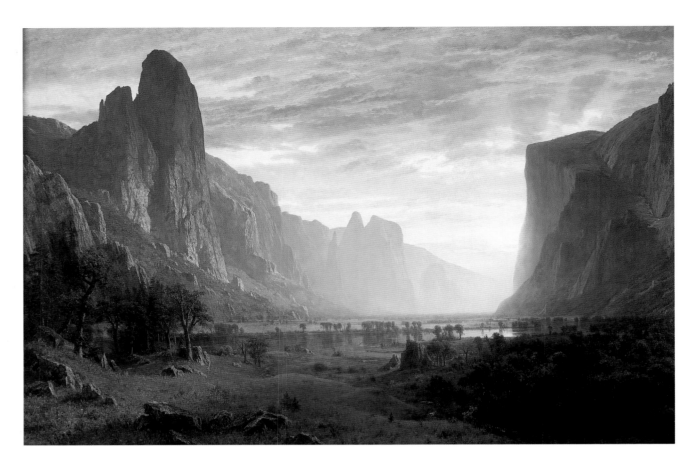

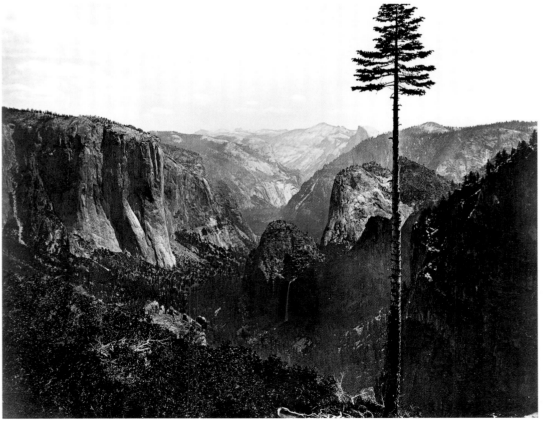

5.51 Albert Bierstadt: *Looking Down Yosemite Valley, California*, 1865
Oil on canvas, 64 × 96¼ in. (162.6 × 244.5 cm.)
Birmingham Museum of Art, Birmingham, Alabama

5.52 Carleton E. Watkins: *Best General View, Mariposa Trail*, 1863
Photograph
Library of Congress, Washington, D.C.

of Yosemite controlled by eastern interests. His concerns were with not only the physical plant of the mining operations, but also the homes and public facilities being built for the miners and their families. The following year the lobbying efforts of those concerned with preserving sections of the nation's pristine wilderness paid off, and Yosemite Valley became a state park in 1864 (it became a national park in 1890).

5.53 George Fiske: *Kitty Tatch and a friend at Yosemite National Park, c.* 1895
Photograph
National Park Service

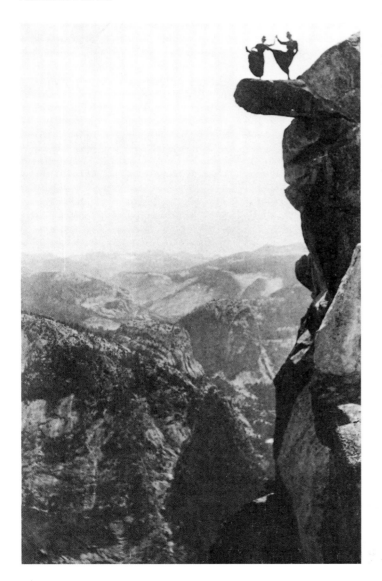

A commission was established, and Olmsted was appointed its first president. Upon visiting the valley, Olmsted was immediately struck by its potential as a place for recreation and scientific study. He oversaw the mapping and surveying of the site and drafted a report outlining management policy for its maintenance and preservation. Visitors were met by a series of carefully laid-out roads and trails which, while determined in large part by geological formations, were also conditioned by Olmsted's vision of the sublime. In due course, many arrived with a preconceived image acquired through commercial brochures or through paintings such as Albert Bierstadt's *Looking Down Yosemite Valley, California* (1865) [5.51].

Photographers also joined painters in preparing the visitor for his or her wilderness experience. Often their work relied on the same artistic conventions used by painters like Bierstadt. For example, in 1863, the same year Bierstadt painted *The Rocky Mountains, Lander's Peak* [3.32], the San Francisco photographer Carleton E. Watkins captured a view of Yosemite in his *Best General View, Mariposa Trail* [5.52]. As in the painting, the landscape recedes into the distance in overlapping layers of hills and rock. In both works mountains and hills take up three-quarters of the picture plane, with a thin band of sky at the top. Watkins's Yosemite views were widely distributed as prints and stereographs and helped create for the park a reputation as one of America's most stunning pristine landscapes. Twenty-four of his photographs were also included in Josiah Dwight Whitney's 1868 publication *The Yosemite Book*, which was intended to help those who could not visit the valley themselves, as well as those who could. Like Olmsted's trails, it guided the viewer from place to place, ensuring a common experience of the site. Of course, one could never ensure that visitors would not stray from the paths, or take photographs at unmarked sites. One such photograph by George Fiske [5.53] shows two "New Women," Kitty Tatch and a friend, who, having left the well-trodden path, defy conventions of propriety in a landscape that called out for such daring acts.

Carleton Watkins would later accompany a government team headed by Clarence King charged with making a geological and topographical survey of the territory between the Rocky Mountains and the Sierra Nevada in the area of the 40th parallel, following the transcontinental railway. King's was one of four surveys of the western territories initiated in the late 1860s as part of an ambitious post-Civil-War collaboration between politicians and businessmen to promote private enterprise. As urban parks were constructed to relieve the pressures of urban life, and sections of wilderness set aside for national parks, vast tracts of land and money were appropriated by Congress to help create a privately owned national railroad system.

Urban Poverty and Public Art Museums

Photography served to record less panoramic scenes as well. Jacob A. Riis (1849–1914) provides a glimpse of the homes and neighborhoods of those urban poor who traveled to Central Park on their days off. Riis was born in Denmark in 1849 and came to the United States in 1870. He worked primarily as a writer and a reporter for various newspapers and magazines. In the late 1880s and early 1890s, however, he used his camera to take photographs of a New York tenement district [6.14], which were included in several books, the most famous of which is *How the Other Half Lives* (1890). *Five Cents a Spot* (1889) [5.54] shows a small room in a house on Bayard Street; Riis described the scene: "In a room not thirteen feet [4 meters] either way slept twelve men and women, two or three in bunks set in a sort of alcove, the rest on the floor. A kerosene lamp burnt dimly in the fearful atmosphere, probably to guide other and later arrivals to their 'beds,' for it was only just past midnight." Those passing the night here paid five cents for their spot.

5.54 Jacob A. Riis: *Five Cents a Spot*, 1889
Photograph
Museum of the City of New York, New York

At the time of his death Riis was celebrated as a social reformer and no mention was made of his photographs. Today he is celebrated, instead, as one of the first photographers to direct his attention to the urban poor, and his images are seen as a historical record of a particular moment in time. One must remember, however, that these photographs, like those taken in studios, were often posed in order to achieve the desired effect. Sometimes the posing created a nobler image of the sitters, as they pulled out what few prized possessions they owned for display. Other times a more sinister or destitute atmosphere was created. Yet despite these alterations, Riis's photographs do provide as close an image as we are ever likely to have of the living conditions of that "other half."

Riis's photographs were meant to aid in the clearing of New York's worst slums and in the construction of more sanitary housing for the city's working class. Sometimes, however, the slums were replaced by housing for the city's wealthier residents, thus compromising the efforts of well-meaning reformers. These reformers came primarily from the educated middle class, with women among the most visible. In their attempts to better the lives of the country's urban poor, they lobbied for laws requiring sanitary and safe working and living

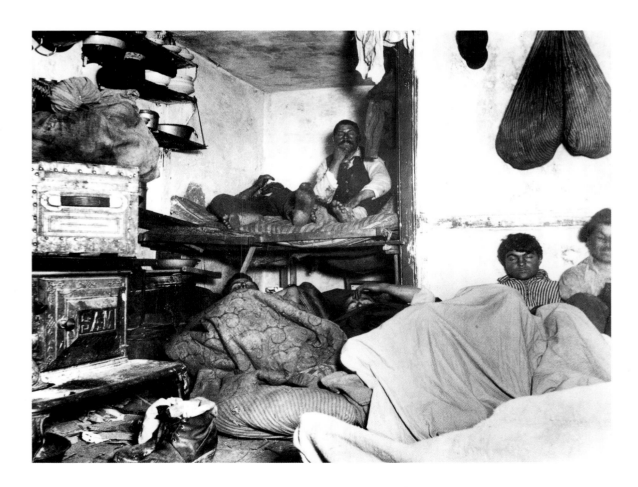

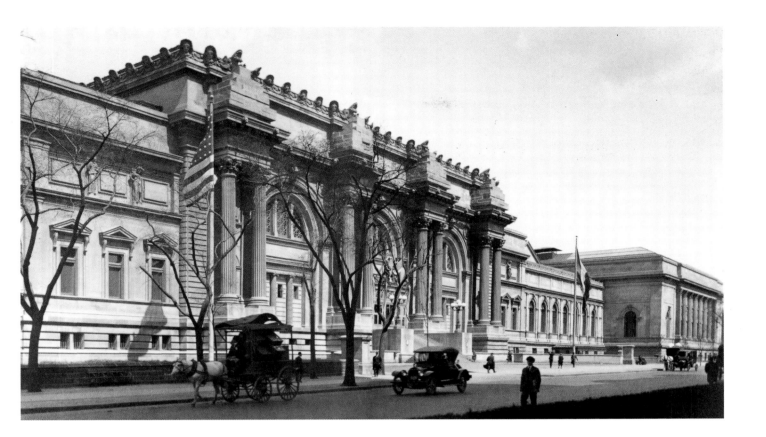

5.55 Richard Morris Hunt: Fifth Avenue facade of the Metropolitan Museum of Art, New York, 1902

conditions and limits on the use of child labor. They also set up community centers or settlement houses where people could come for physical and cultural nourishment. Culture, as mentioned earlier, was drawn into the battle against poverty and political unrest. While helping immigrant communities retain a sense of cohesiveness, social reformers also worked to assimilate the members of such communities into a broader "American" culture, whose parameters were still being formed.

"High" culture came to play a particularly prominent role in the education, assimilation, and pacification of urban immigrant populations. It was seen as a key element in combating social and political unrest, and was often rhetorically coupled with social reform legislation. Its promotion created some strange bedfellows, as middle-class reformers (bent on improving the lives of working people) and wealthy philanthropists (who effectively benefited from the low wages and poverty of these same people) came together in the last quarter of the 19th century to establish major cultural institutions—libraries, museums, concert halls, universities. The Metropolitan Museum of Art in New York and the Museum of Fine Arts in Boston were founded in 1870, the Philadelphia Museum of Art in 1876, and the Art Institute of Chicago in 1879.

The buildings constructed to house these early museums often drew on Gothic and Renaissance architecture, which served to associate this most recent phase in the development of American culture with either the spiritual cohesiveness and idealism of Gothic England or the artistic and scientific revolutions of the Italian Renaissance. For Charles Eliot Norton, the first professor to teach art history at Harvard University (he was appointed to the first chair of fine arts in any American university in 1874), medieval England was the high point, when all social classes were (he imagined) unified by Christianity, and that unity was manifested in the architecture of churches and cathedrals. The Renaissance, on the other hand, celebrated a mix of secular and sacred forces, and marked the beginning of the rise to prominence of the former over the latter. Market economies were soon to replace those based on feudal allegiances. So extensive was the use of Renaissance forms in all areas of the visual arts that the last decades of the 19th century and the first decade of the 20th came to be referred to as the American Renaissance.

One of the best-known of the new museums by the end of the century was the Metropolitan Museum of Art in New York [5.55], which utilized both architectural styles. Its original building of 1870 by Calvert Vaux drew on the pointed arches of

Gothic cathedrals, while its later Fifth Avenue facade by Richard Morris Hunt turned to the Italian Renaissance, with Corinthian columns and massive Roman arches. Like its many sister institutions, its interior was marked by monumental staircases and hallways, and its rooms were filled with casts and originals of ancient Greek and Roman statues and European paintings from more recent eras, all donated by wealthy patrons. Thus, while the museum was meant to function as a democratic enterprise, diffusing knowledge, taste, and refinement, it also reminded those of modest means who entered into its halls that high culture was not a part of their daily lives but resided, rather, in objects from foreign lands and distant times. It was something to be admired, but at a distance.

The founding of the Metropolitan Museum was also meant as a statement of American prestige on an international level, intended, in part, to put the lie to the country's reputation in Europe as a materialistic, uncultured nation, and to proclaim its readiness to assume a prominent position in the development of Western civilization. The idea for the museum was first broached by the lawyer John Jay in Paris in 1866, at a gathering of men filled with pride in the triumph of Northern industrialists in the Civil War. Three years later three hundred wealthy New Yorkers gathered to hear William Cullen Bryant, the president of the organizing committee, summarize why a major museum of art was needed:

> Our city is the third greatest city in the civilized world. Our Republic has already taken its place among the great powers of the earth; it is great in extent, great in population, great in activity and enterprise of her people. It is the richest nation in the world. [With a museum of art] we might have, reposited in spacious and stately buildings, collections formed of works left by the world's greatest artists which would be the pride of our country.

Thus, national pride was a central issue. By proposing to bring into existence a museum to rival the Louvre in Paris, Bryant and those for whom he spoke—the Rockefellers, the Carnegies, the Morgans—asserted their cultural, as well as economic, power. They also asserted their concern with the public good through their association with a public institution. Yet the relationship between public and private with regards to the museum was a complicated one, embedded in the manner in which it was to be owned and administered. The building would be located on city land and owned by the city, with taxpayer money used to cover maintenance costs. The collection would be owned and controlled by those wealthy individuals who made up the museum's Board of Trustees. Thus private

individuals would determine which art would best serve the educational needs of the nation and how that art would function as a reinforcement of already established economic and social, as well as cultural, hierarchies.

The End of a Century: Art, Architecture, and the World's Columbian Exposition

The Chicago School of Architecture and the White City

The biggest cultural event of the 19th century in the United States was also the biggest economic event of the century: the World's Columbian Exposition of 1893 in Chicago [5.56]. This exposition marked the four hundredth anniversary of the arrival of Christopher Columbus in the New World and was intended to provide proof to both the nation and the world of the quality of U.S. achievements in the realms of industry, technology, agriculture, and the fine arts. The grounds were laid out by Frederick Law Olmsted, in what was his last major urban design project. The Fair's primary architectural statement was its central Court of Honor, which featured an elaborate display of white neoclassical facades [5.62]. Nicknamed the "White City," it captured the visitor's imagination through its unity, its overwhelming size, and its festive atmosphere. Yet the strength of these classical forms was illusory, for the plaster exteriors, with their references to the authority of ancient Greece and Rome, hid steel frames that provided the structural support for the buildings. And the festive atmosphere was, if not illusory, then certainly temporary, for, like the Centennial celebration of 1876, Chicago's Exposition took place in the midst of a severe economic depression. It functioned, in part, as an attempt to restore faith in national institutions at a time when such faith was being seriously eroded by labor unrest and economic crisis.

In choosing a neoclassical style for the main court, the Fair's organizers turned their backs on a revolutionary development in building design taking place in the city of Chicago itself. Ironically, the man given the task of overseeing the architectural elements of the Fair, Daniel H. Burnham (1846–1912), was a key player in this new development, which led to the rise of the modern skyscraper.

Several factors prompted the appearance of radical architectural change in Chicago. As a major railroad hub and gateway to the Far West, the city had grown rapidly throughout the third quarter of the century. In 1871 fire destroyed a large portion of the downtown area. Speculation was intense; the price of land rose by 700 per cent between 1880 and 1890. In order to make the most efficient use of this limited and expensive space, buildings began to rise upwards, a movement facilitated

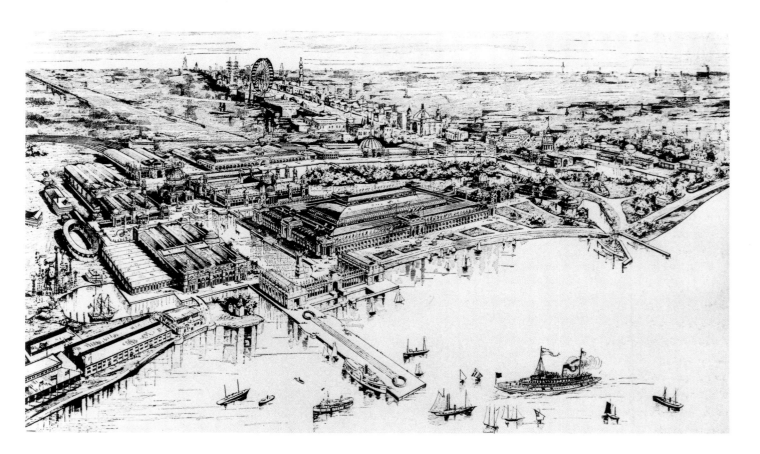

by new technological developments, including Bessemer steel, the passenger elevator, and the telephone.

As architects designed taller buildings and utilized new technologies, several also considered abandoning the elaborate historical decoration that had adorned earlier commercial exteriors. They began to develop an aesthetic that celebrated "truth to materials," taking its cue from engineers, who claimed a greater concern with forms that expressed the present function of a building. This move away from historical decoration can be seen in the eleven-story Home Insurance Building (1884–85) [5.57] by William Le Baron Jenney (1832–1907). The first six stories made use of cast- and wrought-iron columns and cast-iron girders; the remainder were supported by girders of steel, the first use of that material in a building. While the internal structural systems spoke to the new technologies available to architects, Jenney clad them in a conventional stone veneer and included familiar decorative elements such as columns, capitals, and cornices. Yet he used these elements sparingly and in a way that emphasized both the height of the building (the corner piers and central pilasters) and the grid structure of its internal framework (the window patterns).

William Holabird (1854–1923) and Martin Roche (1855–1927) worked in Jenney's office. They left separately in the early 1880s and, in 1883, set up their own partnership. Three years

5.56 World's Columbian Exposition, Chicago, 1893. The Court of Honor or "White City" is in the left foreground; the Midway Plaisance runs back from upper center to beyond the ferris wheel

5.57 William Le Baron Jenney: Home Insurance Building, Chicago, 1884–85 (destroyed)

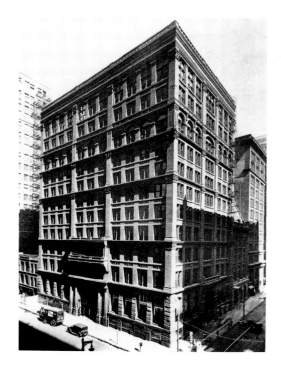

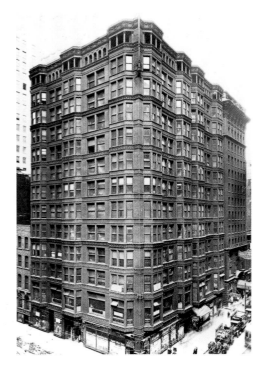

5.58 Holabird and Roche: Tacoma Building, Chicago, 1887–89 (destroyed)

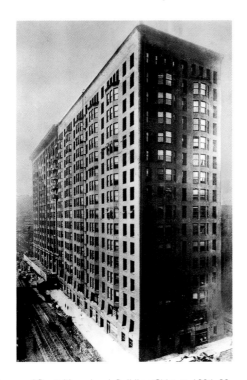

5.59 Burnham and Root: Monadnock Building, Chicago, 1884–92

later they began the design of the twelve-story Tacoma Building [5.58], making use of improved riveted metal frame construction. Here the exterior exploited the enclosing wall's new-found freedom from its supporting function. The continuous succession of bays runs the full height, thus maximizing exposure to light and air. While the metal frame is still hidden, Holabird and Roche used a brick and terracotta sheathing, creating a much lighter effect than in the Home Insurance Building. In addition, traditional exterior ornamentation is eliminated and the large plate-glass windows are exposed with a greater frankness. Thus, lightness rather than monumentality is the dominant impression conveyed by the building.

A further simplification of the exterior of the Chicago office building can be found in the Monadnock Building (1884–92) [5.59] by Daniel Burnham and John Wellborn Root (1850–91), completed after Root's death and shortly before the opening of the World's Columbian Exposition. The emphasis here is not on lightness but on weight and monumentality. This is due in large part to the fact that the Monadnock is not a steel-frame building; rather, the brick walls still serve as supporting elements for the sixteen stories and are 17 feet (5 meters) thick at the base (they flare out slightly to facilitate their load-bearing function). Soon, however, load-bearing walls would become a thing of the past, and the steel frame combined with the absence of exterior decoration would become the distinctive features of Modernist architecture.

Residing somewhere between the architecture of the tall, undecorated office building and the neoclassical architecture of the World's Columbian Exposition is the work of Louis Sullivan (1856–1924). Another student of William Le Baron Jenney, Sullivan left in 1874 to study at the Ecole des Beaux-Arts in Paris before returning to Chicago and entering the practice of Dankmar Adler (1844–1900), later becoming a partner in the firm of Adler and Sullivan.

Sullivan was a proponent of the new tall building with all its technological advances, yet did not eschew ornamentation outright. What he rejected was historicist ornamentation, that which selfconsciously harked back to an earlier time in order to lend legitimacy to the building, or at the very least to create an aura of nostalgia. Sullivan's preferred decorative motifs were drawn from geometry and nature. In the Wainwright Building in St Louis, Missouri [5.60], of 1890–91, verticality is emphasized by the corner piers that run, unobstructed, almost the full height from ground level to the elaborate projecting cornice. While the building is faced with stone, the exterior articulation of piers and windows echoes the metal frame within. The most striking decoration can be found on the cornice, which establishes the Wainright's presence on the St Louis skyline. Minor decorative elements can also be found in the horizontal areas (or spandrels) separating the vertical banks of windows; the bases and capitals of the intermediate piers in the central section of the building; the face of the belt course that marks the

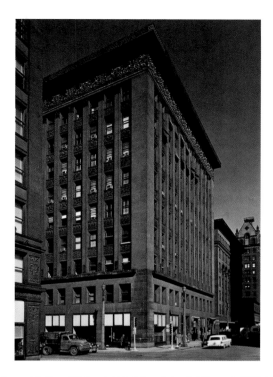

5.60 Adler and Sullivan: Wainwright Building, St Louis, Missouri, 1890–91

division between the lower and central sections; and a narrow frame around the main entrances on the ground floor. In all cases the designs are drawn from nature and are composed of repetitive and intricate foliate motifs.

Sullivan was present at the World's Fair, having been given the task of designing the Transportation Building. Its location outside the central court allowed him to depart from the dominant neoclassicism and produce, instead, an imaginative facade composed of geometric forms—the rectangle, the semicircle—with elaborate foliate decoration that framed, and thus highlighted, these forms. The entrance [5.61] was marked by a series of receding rounded arches and the foliate ornamentation was covered with bright gold leaf. In fact, the exterior combined red, orange, blue, yellow, and green.

Sullivan criticized the neoclassical architecture of the Fair [5.62] as "snobbish and alien to the land." Instead, as early as 1885 he had called for an architecture that spoke to the aspirations and desires of the many, not the few. Yet one could argue that the Court of Honor was more familiar, more accessible, to the general public than Sullivan's imaginative Transportation Building with its elaborate, gilded facade, for hundreds, if not thousands, of neoclassical public buildings had been built in cities and towns across the country. While Sullivan still gives a nod to classical forms in his use of the Roman arch and broken colonnades, his building more readily conjures up associations with the Middle East rather than Middle America.

In the process of creating a national architecture that spoke to the general population, Sullivan also wanted to create buildings that celebrated American business enterprise as a heroic, individual effort. Yet his golden doorway can also be seen as a celebration in part of the corruption and excess that marked the

5.61 Adler and Sullivan: entrance to the Transportation Building, World's Columbian Exposition, Chicago, 1893 (destroyed)

business ventures of the Gilded Age. Immediately inside it was a miniature replica of the town of Pullman, outside of Chicago, which had been created for the employees of the Palace Car Company. It was a model workers' town, with clean, tree-lined streets, green lawns, varied architecture, and elegantly furnished library. But this beautiful environment was also accompanied by close control over workers' lives and by low wages, and only a year after the Fair the nation witnessed a bloody strike between the American Railroad Union and the Pullman Palace Car Company over successive wage cuts.

Sullivan's inclusion of non-classical elements in his facade was part of a larger architectural variety found outside of the Fair's Court of Honor. In fact, the further one moved away, the more varied the styles became, until one found oneself on the Midway Plaisance, a mile-long strip of land that extended out from the main body of the Fair. The content of the Court of Honor and of the Midway Plaisance, and their relationship to each other [5.56], shed interesting light on contemporary notions of progress and racial and ethnic hierarchies. In celebrating Columbus's landing, the exhibition was celebrating the bringing of European civilization to the New World. In the court, housed in massive, white, neoclassical buildings, were the achievements of that civilization, chiefly its American representatives, tacitly accepted as the standard by which the achievements of all peoples were to be measured. The Midway, on the other hand, officially classified under the Department of Ethnology, contained various replica villages, restaurants, marketplaces, etc., of non-white, non-Western, and a few marginal European groups. The exhibits were organized culturally and racially, from the far end, as follows: Africa/Native American; Mohammedan world; West and East Asia; Teutonic and Celtic races. The literary critic Denton J. Snider observed at the time that the best way of viewing these groups and their exhibits was "to behold them in the ascending scale, in the progressive movement; thus we can march forward with them starting with the lowest specimens of humanity, reaching continually upward to the highest stage."

By emphasizing the superiority of the white race not only in the Midway, but also throughout the Fair, its organizers provided white Americans with a sense of shared racial identity and national pride, one buttressed by scientific concepts of progress and evolution. While Africans and African Americans were on display in the Midway Plaisance and elsewhere during the entire run of the Fair (including a woman dressed up as Aunt Jemima), African American visitors were allowed admittance only on select days. In a publication entitled "The Reason Why the Colored American Is Not in the World's Columbian Exposition," Frederick Douglass and Ida B. Wells denounced the segregated admission policies and the exhibition of "the Negro as a repulsive savage." They also connected such displays to the growing imperialist ambitions of the United States— ambitions that would lead to the Spanish-American War and U.S. intervention in the Caribbean and the Philippines in 1898.

Women at the Fair: Allegories, Architects, and Artists

In celebrations of the white race at the World's Columbian Exposition, men appeared as actors on the stage of history, while women functioned as they had at the earlier 1876 Centennial Exhibition—as allegorical representations of continents or concepts. The Court of Honor embodied this division. At either end of the great lagoon stood two large sculptural works, a figure of the *Republic* by Daniel Chester French (1850–1931) [5.62], and *The Triumph of Columbia* or *The Barge of State* by Frederick William MacMonnies (1863–1937) [5.63]. While Augustus Saint-Gaudens had been charged with overseeing the program of the court and gave both French and MacMonnies an indication of the types of works he would like to have in the lagoon, the commissioned artists were responsible for the final designs. French produced a stiff, classically garbed female figure with both arms raised, the right holding a globe surmounted by an American eagle, the left a pike topped by a liberty cap. The static pose—both feet are planted firmly on the ground—and classical drapery suggested the solid basis upon which the American Republic was founded. Standing on a 35-foot (10.7-meter) high pedestal in the middle of the basin, the 65-foot (20-meter) tall statue reached well above the cornice line of the buildings and was further set off by its extensive gilding and by a crown of electric lights that glowed in the evening. The Republic may be based on traditions from the past, but not to the exclusion of the technological achievements of the present.

MacMonnies, on the other hand, produced an elaborate work full of movement and drama. Twenty-eight figures either occupy or surround the central barge. Seated atop a high pedestal is Columbia, bare-breasted, with drapery billowing behind her. An additional eight bare-breasted female figures, representing the Arts, Sciences, and Industries, work the gigantic oars. A female Victory, wreath in hand, stands at the ship's stern while a scantily clad older male figure, representing Time, controls the rudder (even in the allegorical world, women need men to steer the boat).

The art historian Judy Sund comments on the reciprocal relation between the sculptures of French and MacMonnies: "Columbia and the Republic might be seen as two aspects of a feminized United States: the one emblematic of its physicality (the land, the continent, Columbia), the other of its ideals and/ or institutions (i.e. the Republic)." The two personifications could

also relate generationally, with the youthful Columbia propelled inevitably forward by Art, Science, and Industry toward the establishment of the Republic. Ultimately, however, these figures were not historical actors. That role was reserved for Columbus himself, who was commemorated in two statues, one on the pavement directly behind MacMonnies' sculptural group, and the other atop a monumental peristyle located behind French's *Republic*.

The Fair was filled with similar scantily clothed female allegorical figures, despite the increased presence of women in all aspects of American life and in the organization of the Fair itself. They even topped the Woman's Building (1893) [5.64], designed by Sophia Hayden (1868–?). Hayden was the first woman graduate of the Massachusetts Institute of Technology. She drew on her architectural training to create a simple, two-story Renaissance building with end pavilions, an open arcade in the central section, and a pediment over the main entrance, with steps leading down to the lagoon. Unfortunately, this was to be her only building, for the stress of working with too little money, constantly changing requirements, and interference from the all-male Board of Architects led to a nervous breakdown and a retreat from the architectural profession.

5.62 Court of Honor, World's Columbian Exposition, Chicago, looking west to the Administration Building, 1893 (destroyed)
Seen from the back is Daniel Chester French's *Republic*; in the distance is MacMonnies's *The Triumph of Columbia*

5.63 Frederick William MacMonnies: *The Triumph of Columbia* (*The Barge of State*), World's Columbian Exposition, Chicago, 1893 (destroyed)

5.64 Sophia Hayden: the Woman's Building, World's Columbian Exposition, Chicago, 1893 (destroyed)

The Woman's Building was located at a crucial transition point between the Fair proper and the Midway Plaisance. The nature of this transition is described by a character in a contemporary novel by Clara Louisa Burnham:

> In the Midway it's some dirty and all barbaric. It deafens you with noise; the worst folks in there are avaricious and bad; and the best are just children in their ignorance . . . and when you've come out o' that mile-long babel where you've been elbowed and cheated, and you pass under a bridge—and all of a sudden you are in a great, beautiful silence. The angels on the Woman's Buildin' smile down and bless you and you know that in what seemed like one step you've passed out o' darkness into light.

The building was thus a step above barbarism, yet below the buildings in the Court of Honor, designed by leading male architects.

The Woman's Building was organized and operated by a Board of Lady Managers appointed by the all-male World's Columbian Commission. These one hundred and fifteen white middle- and upper-class women were led by the Chicago socialite Bertha Honoré Palmer. Their goal was to create a building which would function as a meeting-place for women at the Fair and not primarily as an exhibition site, but the difficulty faced by women in getting their work displayed in the main part of the Fair led to it taking on the role of showplace for a wide variety of objects, from paintings and sculptures to needlework and industrial goods and inventions.

The Board of Lady Managers had high aspirations: they wanted to represent the concerns and accomplishments of all women from all races and classes. Their own inherent race and class biases, however, prevented them from fully achieving their goal. For example, they refused to allow African American women to sit on the Board to judge the submissions by African American women. They were also at odds with those who refused to take part in the creation of a separate building and who argued, instead, that women should appear on an equal footing throughout the Fair.

Whatever its shortcomings, the building provided an unprecedented opportunity to view a wide range of accomplishments by women [5.69]. A visitor could see the advances that had been made not only in painting and sculpture but also in needlework, ceramics [5.65, 5.66], metalwork, and other media. The last half of the 19th century saw a drastic increase in the number of women entering what have come to be known as the "craft" professions. One reason for this development, according to the art historian Anthea Callen, was a reduction in the number of men, caused by both the Civil War and emigration to the West. Many "respectable" middle-class women were left without the prospect of marriage and a family. Another reason was an increasing sense of independence, which led to a conscious choice not to marry. The question then arose: what were these women to do to make a living? How could individuals socialized and trained in the roles of domesticity function in a productive manner in the world outside of the home? Teaching and the craft professions were seen by many as a fitting extension of the "natural" roles of women. Craft production, or the applied arts, did not require the kind of "genius" seen as necessary in the fine arts. Through schools such as the Philadelphia School of Design for Women—the first school of design in the nation, founded in 1844—and the coeducational Cooper Union in New York, many middle-class women were prepared for entrance into the fields of art education, decorative embroidery or needlework, and pottery.

5.65 Maria Longworth Nichols Storer: Rookwood Pottery basket, 1882
Painted underglaze decoration and gilt overglaze on clay, H 8¼ in. (20.6 cm.)
Cincinnati Art Museum, Cincinnati, Ohio

5.66 Clara Chipman Newton: horn pitcher, 1882
Painted underglaze decoration and gilt overglaze on clay, H 6½ in. (16.5 cm.)
The Brooklyn Museum of Art, New York

Women were also central in the growth and promotion of art pottery, setting up societies and schools and planning exhibitions. One of the most important organizations was Rookwood Pottery in Cincinnati, Ohio, which was founded by Maria Longworth Nichols Storer (1849–1932) in 1880. Nichols Storer came from a wealthy Cincinnati family. Her father was a well-known patron of the arts and encouraged his daughter's interest in ceramics, eventually providing her with the money to found Rookwood. In its early years it offered classes in pottery decoration for amateur women, but as it became more of a business the classes were abandoned and an increasing number of men were hired as decorators. Several women remained, however, and produced works that achieved both national and international recognition.

The work of Maria Longworth Nichols Storer was included in the Cincinnati Room of the Woman's Building in 1893. Her ceramic basket of 1882 [5.65] shows evidence of her early interest in Japanese art, which was sparked first by some books of designs given to her in 1875, and then by a display of Japanese ceramics included at the Philadelphia Centennial Exhibition the following year. The basket makes use of motifs often found in Japanese art—spiders, dragonflies, dragons—but its shape, and the gilt lion-head feet, show the eclecticism that marked much of her work and that of other women ceramists of the period, among them Clara Chipman Newton (1848–1936). Newton was Nichols Storer's personal assistant but also a pottery decorator in her own right. Her horn pitcher of 1882 [5.66] uses dragonflies on one side, with bamboo branches on the other.

Of course, fine craft or applied-art production was not limited to women. The focus on elaborate home decoration at the end of the century grew out of both the Aesthetic Movement, which promoted interior design and the creation of artistically distinctive functional objects for the home, and the Arts and Crafts Movement. The latter originated in England in the mid-19th century under the leadership of the poet, artist, designer, and social reformer William Morris (1834–96). Morris celebrated the virtues of handmade objects and the importance of excellence of design and execution as an alternative to the low quality of mass-produced goods. His design principles, as well as his socialist politics, found a sympathetic audience among many American artists, although the expensive, handcrafted objects produced in Arts and Crafts workshops had little impact on the spread of cheap, mass-produced goods.

A demand did arise, however, among more prosperous Americans not only for fine ceramics but also for stained glass, mosaics, and silverware. Perhaps the best-known individual who moved to meet this demand was Louis Comfort Tiffany (1848–1933). His father had a flourishing business importing decorative objects from China, Japan, India, North Africa, and Europe, but Louis preferred to study painting, and traveled to Paris in 1868. After a limited success as a painter, Tiffany turned his attention to interior decoration. While his studio also produced objects in metal, ceramics, and wood, he is best remembered for his art glass productions. By the 1880s he had set up a factory in New York. Favrile glass, marked by brilliant, iridescent colors, was his own invention; in 1890–91 he used it to create an elaborate mosaic of stylized peacocks for the entrance hall of Henry O. Havemeyer's New York mansion [5.67], showing his debt to Whistler and the Aesthetic Movement in general. Thomas Alva Edison's invention in 1879 of the

5.67 Louis Comfort Tiffany: Peacock mosaic, for the entrance hall of the Henry O. Havemeyer House, New York, 1890–91
Iridescent cabochon glass, pottery, and plaster, 52 × 64 × 4 in. (132.1 × 162.6 × 10.2 cm.)
University of Michigan School of Art and College of Architecture and Urban Planning, on extended loan to the University of Michigan Museum of Art, Ann Arbor

5.68 Tiffany Studios: lamp, c. 1910
Bronze and leaded glass, H 14⅝ in. (37.2 cm.)
The Metropolitan Museum of Art, New York

incandescent light bulb, with its unprecedented brilliance, forced designers to rethink the lamp form, and Tiffany capitalized on that brilliance to illuminate the extraordinary colors of his glass. As with much of his other glasswork, the lamps are commonly marked by vegetal motifs, the sinuous forms serving to unify the compositions on shade and base [5.68].

While the fine ceramics, glassware, metalwork, needlework, and various commercial products and inventions in the Woman's Building certainly drew much interest, the main focus of attention was the Hall of Honor, with its several paintings and sculptures and, most importantly, its two large murals high up in the tympana at either end [5.69]. At the south end was *Primitive Woman* by Mary Fairchild MacMonnies (1858–1946) [5.70], who was married to Frederick MacMonnies, showing women dressed in diaphanous, wind-blown robes arranged across the front of the picture plane. They plow fields, carry water, take care of children, and attend to a man who has just returned from the hunt. Here is not the "primitiveness" of the Midway Plaisance, "some dirty and all barbaric," but the ideal primitive found in the works of Dewing and Cox and Thayer [5.32, 5.36]. These women are ideal not only because they refer to an ancient Greek past, but also because they engage in activities still deemed most appropriate for women.

Modern Woman by Mary Cassatt (1844–1926) [5.71], however, which occupied the north tympanum, rejected the ordered, subdued neoclassicism of the fair and adopted, instead, bright colors and contemporary middle-class dress. On the left, a group of young girls are shown pursuing a winged figure of Fame while themselves being pursued by geese, while in the center women pluck the fruits of knowledge, a revision of the theme of Eve in the Garden of Eden. On the right women appear not as allegorical figures representing the arts, but actually engaged in creating art, music, and dance. Men are omitted, as well as women as caretakers of children or men. When one of Cassatt's male friends asked if this was not the portrayal of women apart from their relations with men, she wrote:

> I told him it was. Men, I have no doubt, are painted in all their vigor on the walls of the other buildings; to us the sweetness of childhood, the charm of womanhood, if I have not conveyed some sense of that charm, in one word, if I have not been absolutely feminine, then I have failed.

Cassatt thus tried to calm his anxiety by assuring him that her actions, while they might seem to be radical, were really thoroughly "feminine."

The critical response to the two murals was mixed, although most preferred that of MacMonnies. One critic praised it for

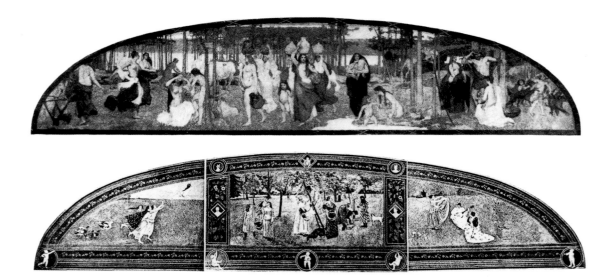

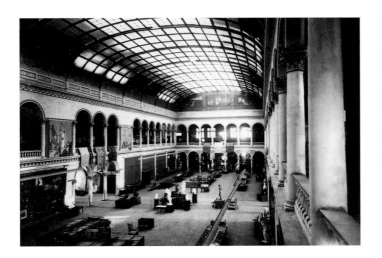

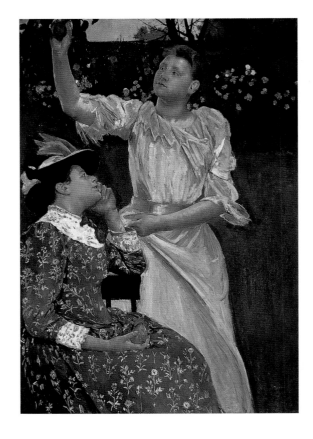

portraying women in the "more suitable role of domesticity." It was also liked because it conformed to the neoclassicism of the Fair, which placed women in the ideal world of myth and allegory. Cassatt's work was most commonly described as cynical and primitive, with a discordant and garish color scheme—all reflections on the "modern" aspects of her style. *Young Women Picking Fruit* of 1891 [**5.72**], a study for the mural, gives a sense of its color. Perhaps the most telling review of the two murals was a piece by Henry B. Fuller for the *Chicago Record*, which complained:

> Mrs. MacMonnies addresses the eye in a gentle and insinuating fashion; Miss Cassatt does not address the eye at all—she assaults it. Mrs. MacMonnies' tone is light and silvery, while the impudent greens and brutal blues of Miss Cassatt seem to indicate an aggressive personality with which compromise and cooperation would be impossible. Indeed, Miss Cassatt has a reputation for being strong and daring; she works with men in Paris on their own ground.

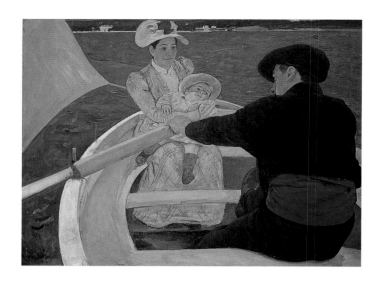

Thus, Cassatt refused to conform, rejecting the role of gentle wife and assuming, instead, the position of equal to men in the art world of Paris. At a time when the nation was turning to Art and Woman to help control confusion and unrest, it is understandable why so many preferred the work of MacMonnies.

While Cassatt omitted references to domesticity in her mural, she did not do so in her easel paintings or prints. Like

5.73 Mary Cassatt: *The Boating Party*, 1893–94
Oil on canvas, 35½ × 46⅛ in. (90.2 × 117.1 cm.)
National Gallery of Art, Washington, D.C.

5.74 Mary Cassatt: *Mother and Child*, c. 1905
Oil on canvas, 36¼ × 29 in. (92 × 73.7 cm.)
National Gallery of Art, Washington, D.C.

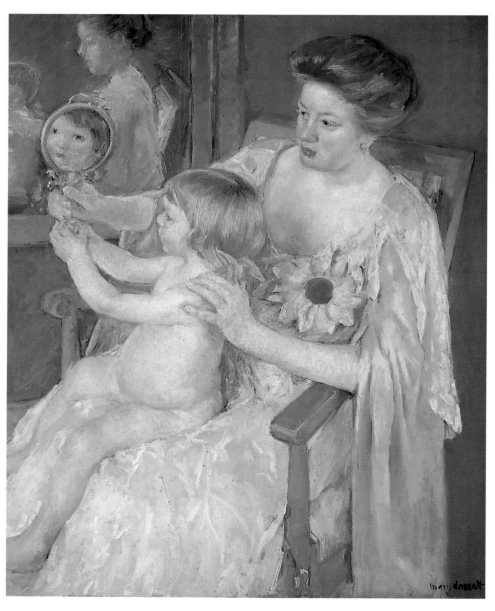

Whistler, Cassatt spent most of her life in Europe, leaving her home town of Philadelphia in the mid-1860s and settling in Paris in 1866. Like Dewing, Cox, and Thayer, she focused on women in her paintings. Unlike them, however, her women are often engaged in a particular domestic activity, caring for children. Her subjects are also, as in the work of Beaux and Sargent, recognizable people, for she often used her friends and relatives, as well as servants and other working-class women, as models. As she came from a prosperous Philadelphia family, the settings, like those of Beaux and Sargent, are ones of comfort and wealth. Unlike those artists, however, Cassatt took up the more radical stylistic innovations of French Impressionism and Post-Impressionism. She also took her women out-of-doors, into the streets and parks of Paris and onto the Seine, as in *The Boating Party* (1893–94) [**5.73**]. While certainly the woman and child so carefully depicted in the center of the composition draw the viewer's attention, with their colorful dress and sweet expressions, so too do the broad expanses of blue and yellow that sweep across the painting and anchor the figures into place. The space is a shallow, Modernist space, with the interior of the boat tipped up to cut off the recession into the distance. Broad areas of flat color—blue, yellow, green—create patterns that, again, emphasize the flatness of the canvas rather than any illusion of three-dimensionality. Cassatt's painting was strikingly different stylistically from the work of many of her American contemporaries who depicted similar subject-matter, such as Thomas Eakins's *Max Schmitt in a Single Scull* of 1871 [**5.15**].

Cassatt's paintings of mothers and children are not sentimental depictions, but rather serious, and often monumental, renditions of the processes of nurturing that were women's socially prescribed tasks. It is interesting to compare her *Mother and Child* (c. 1905) [**5.74**] with two earlier treatments of the subject, an engraving from the January 1867 issue of *Godey's Lady's Book* [**5.75**] and Lilly Martin Spencer's *Beauty and Barberism* (c. 1890) [**5.76**]. All three images address the socialization of young girls, their introduction into the world of "appropriate" female behavior. In the engraving *The First Party*, the child decked out in her fancy dress with curled hair enters willingly into the game of "womanhood," as she

5.75 Anonymous: *The First Party*, engraving from *Godey's Lady's Book*, January 1867
Library of Congress, Washington, D.C.

5.76 Lilly Martin Spencer: *Beauty and Barberism*, c. 1890
Oil on canvas, 25 × 30 in. (63.5 × 76.2 cm.)
Whereabouts unknown

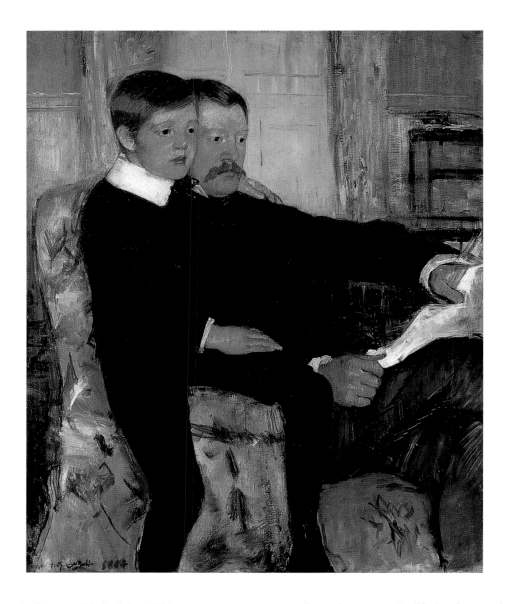

5.77 Mary Cassatt: *Alexander Cassatt and His Son Robert*, 1884
Oil on canvas, 39 × 32 in. (99 × 81.2 cm.)
The Philadelphia Museum of Art, Philadelphia, Pennsylvania

gazes approvingly at herself in the mirror while her mother gazes approvingly at her. There is no doubt that she will follow cheerfully in the footsteps of the older woman and become, herself, a wife and mother. Spencer portrays a less willing subject, a child who suffers at the hands of her mother as she is forced to take on the persona of a "respectable" young girl. Spencer reveals her own criticism of this process of socialization, as well as her sense of humor, by titling the painting *Beauty and Barberism*.

As in *The Boating Party*, Cassatt rejects the detailed three-dimensional space of Spencer and the *Godey's Lady's Book* artist and creates a shallow space marked by a series of rectangles—the canvas itself, the frame of the chair, and the frame of the mirror—whose repetitive shapes emphasize the constructed nature of the composition. Cassatt's painting lies, psychologically, somewhere between what David Lubin calls the "narcissistic self-satisfaction and mother-daughter bonding" of *The First Party* and "the emotional pain and psychic destruction" of *Beauty and Barberism*. As in *The First Party*, Cassatt's mother watches as her young daughter gazes into the mirror. She is also dressed in elegant, although less formal, attire. Her gaze is more thoughtful, however, as she contemplates her child's future. Cassatt's child, on the other hand, is quite different from those in the other two images. She is younger, and is naked. The moment is one of self-awareness rather than of "narcissistic self-satisfaction" or "emotional pain." Cassatt recasts the mirror, as she recast the Garden of Eden, as the site not of women's vanity but

of women's selfconsciousness. She presents the child as aware of her separateness from her mother and yet clearly connected to her both compositionally—through the dominant yellows—and psychologically. What is emphasized now is her face, her personality, as well as the role of her mother in initiating her into the realm of femaleness. Her nakedness, set against the elaborate dressing gown and coifed hair of her mother, suggests a blank palette, one that will be filled with both her own thoughts and the expectations of the society in which she will grow up. She will become highly conscious of her appearance, of how people see her, a fact emphasized by the second mirror in the painting, which reflects both figures, and the very painting itself, which is the product of the artist's gaze.

The mirrors also function as destabilizing elements, for Cassatt has built mistakes into the perspective of her painting such that it would be impossible for a viewer actually to see the figures and mirror images as portrayed. In writing of this painting, Harriet Scott Chessman speculates "that the inaccuracy of her own mirroring invites us to see and understand the inaccuracy of the cultural mirrorings charted with such soberness in this image." Cassatt also uses the mirrors to implicate the viewer as both object and subject of vision. "She shows us the girl's face in the mirror," notes Chessman, "as if this were the face the girl herself sees; yet we realize that, if we can see an image of the girl's face, the image she can see must, uncannily, be our own." We, as viewers, exist in a world that "impinges on the world of mother and child and determines how the child will be dressed, how her meanings will become figured."

Cassatt also produced at least one image of the relationship between male members of a family, *Alexander Cassatt and His Son Robert* (1884) [5.77]. This painting is strikingly different from her images of mothers and children, in which the focus is a shared emotional and physical intimacy. Alexander and his son gaze in the same direction rather than at each other. Their physical proximity—they melt into one another in their black suits—heightens the emotional distance between the two. Their connection is at the level of intellect; their eyes are parallel as they both gaze in the direction of the newspaper held by the father. Thus, just as Cassatt's mother prepares her daughter for a world of fashion and selfconsciousness, Alexander prepares his son for the competitive, isolating world of business and commerce, where emotional sensitivity and introspection are liabilities. Their dark suits also suggest a level of social conformity against which many artists in both Europe and the United States were already rebelling.

Race and Religion at the Turn of the Century: Henry Ossawa Tanner

While Frederick Douglass and Ida B. Wells were condemning the segregated admission policies of the World's Columbian Exposition and the racist stereotypes contained in its exhibits, another African American was arguing for the significance of the work of African American artists. In a presentation at the Congress on Africa of the World's Columbian Exposition, the artist Henry Ossawa Tanner (1859–1937) pointed out that the actual achievements of African American artists "proved negroes to possess ability and talent for successful competition with white artists." His own career clearly provided an example of such success.

Tanner was born in Pittsburgh and moved to Philadelphia as a child. His father, a minister and later a bishop in the African Methodist Episcopal Church, instilled in him a stern belief in the Christian God and in the power of religion as a unifying force in the African American community, one which could help achieve the dignity of all human beings, whatever the color of their skin. The household was a gathering place for many of the country's leading African American intellectuals and politicians. In 1880 Tanner entered the Pennsylvania Academy of the Fine Arts, where he studied with Thomas Eakins. While he benefited artistically, he could not escape the racism that forced so many artists of color either to abandon their pursuits or to leave the United States. In his autobiographical *Adventures of an Illustrator* (1925), Joseph Pennell, who attended the Academy at the same time, described a scene where a young "octoroon, very well dressed . . . quiet and modest," with short cropped "wool" and a moustache, was tied to his easel in the middle of Broad Street one night by a group of white students "when he began to assert himself." Pennell does not name the victim, but the description matches photographs of Tanner at the time.

In 1891 Tanner traveled to Paris, where he entered the Académie Julian and joined the American Art Students' Club. He also made trips to Pont-Aven on the Brittany coast and enjoyed the company of fellow artists in an environment that was substantially less racist than that of Philadelphia. His early paintings were primarily seascapes, landscapes, and animal paintings. It was not until the mid-1890s that he began to take up the theme that would become the major focus of his work in the early 20th century—religion. In the interim, he created a small number of genre paintings that addressed the life of African Americans.

Tanner's return to Philadelphia in the summer of 1893, his participation in the Congress on Africa, and his inevitable re-encounter with racism may have prompted him to turn

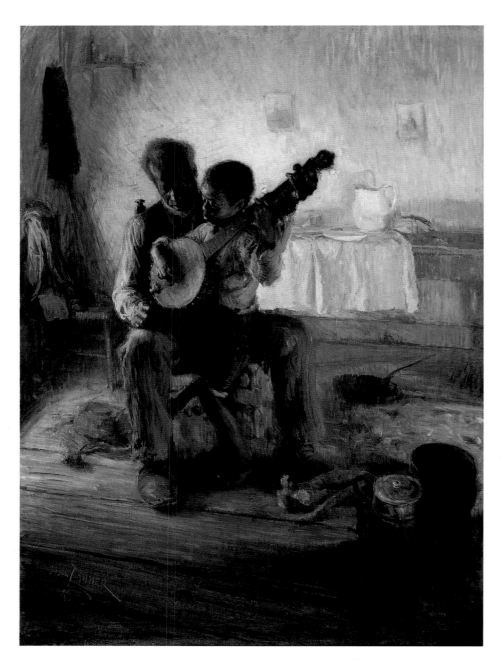

5.78 Henry Ossawa Tanner: *The Banjo Lesson*, 1893
Oil on canvas, 48 × 35½ in. (121.9 × 90.2 cm.)
Hampton University Museum, Hampton, Virginia

his attention to African Americans as subject-matter. He gave a further indication of the reasons for his choice in a statement the following year, in which he referred to himself in the third person:

> Since his return from Europe he has painted many Negro subjects, he feels drawn to such subjects on account of the newness of the field and because of a desire to represent the serious and pathetic side of life among them, and it is his thought that other things being equal, he who has most sympathy with his subject will obtain the best results. To his mind, many of the artists who have represented Negro life have only seen the comic, the ludicrous side of it and have lacked sympathy with and affection for the warm big heart within such a rough exterior.

In writing the last sentence he may well have been thinking of people like Krimmel [4.18] and the early Johnson [4.23].

In 1893 Tanner created his first major painting of African American life, *The Banjo Lesson* [5.78]. This work openly

addresses, and subverts, the stereotype of the banjo-playing, high-stepping figure that had become so common over the previous decades in both commercial imagery and fine art, as well as the increasingly popular commercial images of "Uncle Tom" or "Uncle Ned." The banjo here, far from being a prop, is central to a scene of the passing on of cultural knowledge from one generation to the next, and the pride and sense of hope and self-fulfillment attached to the acquisition and maintenance of this knowledge.

How does Tanner's painting differ from the work of artists who saw only the "comic" side of African American life? While Johnson drew on the scenes of peasant life painted by 17th-century Dutch artists, Tanner looked to another 17th-century Dutch artist for inspiration—Rembrandt van Rijn. In adopting Rembrandt's looser brushwork and in paring down the objects in the painting, Tanner forces the viewer to focus on the central figures and on their activity. In addition, his use of a golden light entering from the side, which marks so many of Rembrandt's paintings and which highlights the faces and sharpens the outlines of the figures against the background, adds a sense of solemnity and a religious feeling. Tanner would develop this brushwork and use of light even further in his biblical paintings of the subsequent decades.

Tanner portrays the two figures in *The Banjo Lesson* as distinct individuals intensely absorbed in the task at hand. The banjo becomes a conduit, a connection from one generation to the next. It also represents a bridge between Africa and America, for the banjo was developed from a stringed instrument brought over from Africa. In her study of the banjo in American popular culture, Karen S. Linn has traced the changing and conflicting meanings attached to it as a result of its integration into national commercial culture after the Civil War. Before the Civil War the banjo was seen as primarily an African American instrument. In the later 19th century, however, urban entrepreneurs attempted to introduce it into elite white culture and, in the process, to downplay its connections with the lives and culture of African Americans. One way of doing this was to promote a new style of playing. Instead of continuing the downward strokes and chording of minstrel performers whose songs grew out of African American culture, the "new" banjo players plucked the strings separately and upward, like a guitar, in order to play the new parlor music of the day. But African Americans soon mastered this style of playing, and the boy in Tanner's painting has his right hand positioned for that new upward motion. The image could thus have been read as an affirmation both of the banjo as a distinctly African and African American instrument and of the ability of African Americans in this field, as in many others, to adapt to changing techniques and acquire new knowledge.

The Banjo Lesson was exhibited in October 1893 in Philadelphia and the following year in the annual Paris Salon. It was purchased by Robert C. Ogden, a partner in John Wanamaker's dry-goods business and a promoter of African American public education, who donated it to the Hampton Institute (see pp. 248–49). It was appropriate that a school committed to educating African Americans should possess a painting that presented in such a compelling and dignified way the role of education in African American life. Tanner's work is very different from the display of cowboys and Indians in Frances Benjamin Johnston's photograph of a Hampton "class in American history" [4.57]: rather than an image of assimilation relegating cultural traditions to the past, it is a testimony to the changing and vital nature of those traditions.

Ogden, while a religious man himself, was not fully in favor of Tanner's turn to religious subject-matter. He thought Tanner would have more influence on African Americans through genre scenes than through more "abstract" religious paintings that were less readily identifiable as the work of an African American artist. Like the African American educator and political figure Booker T. Washington, Ogden believed that African Americans would improve their lives not through political agitation but through education, and that the progress of the "race" would be well served by those who became public examples of success. Washington wrote after an encounter with the artist in 1899 in Paris:

My acquaintance with Mr. Tanner reinforced in my mind the truth which I am constantly trying to impress upon our students at Tuskegee—and on our people throughout the country, as far as I can reach them with my voice—that any man, regardless of color, will be recognized and rewarded just in proportion as he learns to do something well—learns to do it better than some one else—however humble the thing may be.

Tanner was well aware of the part that his race played in public perceptions of his work, and was seriously committed to taking apart negative stereotypes of African Americans, but he did not want to be judged by the color of his skin. Ogden wrote of a showing of *The Annunciation* (1898) in his home:

I have had a notion that a few people interested in Tanner because of his race might be made useful to him by an opportunity to inspect the picture; I am afraid, however, that this would be offensive to his fine and somewhat

sensitive nature, as he has no desire whatever to pose as a professional colored man, preferring to risk his entire success upon his merits as an artist—just as any other man would.

Tanner's light skin opened many doors that were closed to dark-skinned blacks. Yet the greater ease with which he was able to move through the white world also created a constant reminder of what was always beyond his grasp—the privileges of those whose physical appearance read "white."

Tanner's move to religious subjects may have been motivated by recognition of the fact that they sold better to white audiences than scenes of African American life (little economic support came from the African American community itself); but the paintings also encapsulated much of the radical teachings of his father—the belief that all people were created equal in the eyes of God and that the struggles of the Jews could be seen as parallel to the struggles of blacks to free themselves from bondage.

His religious pictures are much more somber, less sentimentalized, than many of the time. His *Daniel in the Lions' Den* (1907–18) [5.79] plays with strong contrasts between light and shadow to evoke the deep contemplation and impending liberation of the prophet from persecution; Daniel's ability to calm the lions is subtly suggested by the highlighting that links the lower half of his body and the face of the lion next to him. In 1924 Tanner wrote that he had attempted "to not only put the Biblical incident in the original setting . . . but

5.79 Henry Ossawa Tanner: *Daniel in the Lions' Den*, 1907–18
Oil on paper mounted on canvas, 41 1/8 × 49 7/8 in. (104.4 × 126.9 cm.)
Los Angeles County Museum of Art, Los Angeles, California

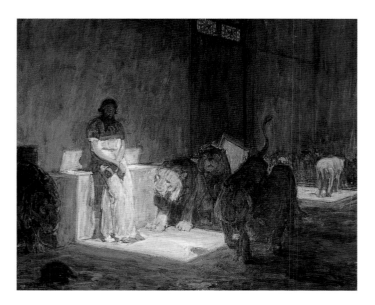

at the same time give the human touch 'which makes the whole world kin' and which ever remains the same." One could argue that he was able to embody this notion of the universal in the particular in both his religious paintings and his scenes of African American life, for both are marked by solemn figures engaged in simple acts that speak to noble causes, be they freedom from physical bondage or the maintenance of cultural traditions.

Men at Sea: Albert Pinkham Ryder and Winslow Homer

The connection between the human and the spiritual was expressed in a different way in the paintings of one of Tanner's contemporaries, Albert Pinkham Ryder (1847–1917). In *The Flying Dutchman* (c. 1887) [5.80], Ryder takes up the iconography of the storm-tossed boat and its symbolic associations with the struggles between humans and nature, and, in a country where nature is equated with the divine, between humans and God.

Ryder grew up in New Bedford, Massachusetts, at that time the greatest whaling port in the world. While art historians often comment on the imaginative or dreamlike quality of Ryder's small seascapes, he was also very familiar with the physical reality of the sea, and the emotional and spiritual turmoil it caused those whose lives depended upon it. This familiarity informed the marine scenes Ryder painted following his move to New York City at the end of the 1860s.

The art historian Elizabeth Broun notes that *The Flying Dutchman* has often been connected to Richard Wagner's well-known opera of the same name. Yet she argues that a more likely source is *The Phantom Ship*, a novel by Captain Frederick Marryat published in 1839 and frequently reprinted. Marryat writes of a Dutch ship captain who, while sailing round the Cape of Good Hope during bad weather, swears on a relic of the true cross in issuing a challenge that no storm should defeat him, although he sail until Judgment Day. This challenge is taken up by the devil, who condemns him to sail forever in gale-force winds in the cape seas until presented with the relic on which he blasphemed. The captain's son spends the rest of his life trying to track down the phantom ship and present his father with the fragment of the true cross that will set him free. Redemption is available to both father and son only through forgiveness of their enemies, which must be done before the son can succeed in presenting his father with the relic.

Ryder's painting shows the son reaching out to the phantom ship, his old age suggesting that his quest will soon be at an end. The two vessels—those of the father and the son—occupy the center of the canvas, and are rocked by a turbulent sea. The massive cloud that blends with the sails of the father's boat creates an ominous feeling, yet the golden glow of the sun

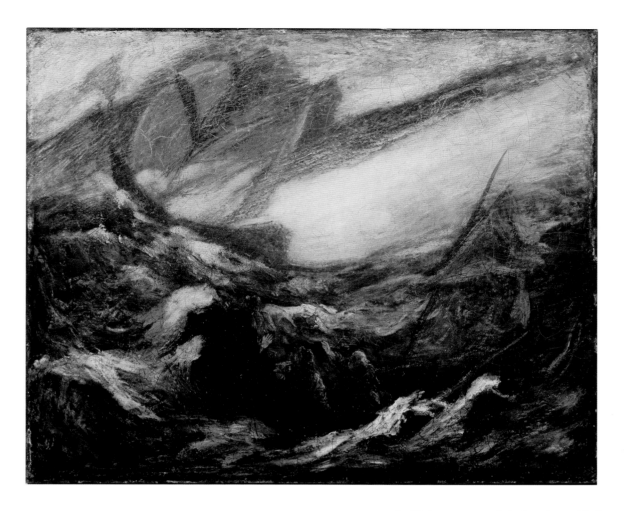

5.80 Albert Pinkham Ryder: *The Flying Dutchman*, c. 1887.
Oil on canvas mounted on fiberboard, 14¼ × 17¼ in. (36.1 × 43.8 cm.)
Smithsonian American Art Museum, Washington, D.C.

on both boat and cloud points to a sense of optimism. By reducing the level of detail in his painting and by applying the paint in thick, swirling fashion throughout the composition, Ryder enhances the power of the rhythmic forms echoed in both the ships and the sea, making these two aspects of the painting into a single unit. Humans and nature are entwined in one churning mass that has yet to be calmed by the kiss of forgiveness.

Broun rejects the notion that Wagner's opera was the source for Ryder's painting in large part because it omits any mention of the son and the true cross and replaces him, instead, with a man who hopes to benefit financially from introducing the Dutchman to his daughter, for it is the love of a faithful woman, rather than the forgiveness of one's enemies, that is the source of the Dutchman's salvation. Broun argues that Ryder's focus in this painting, as well as in many other seascapes, was on religious salvation and on virtuous characters, rather than

mercenary gain. This argument is in keeping with the common assessment of Ryder as a man unconcerned with the material world, who lived the last decades of his life as a recluse in tattered clothes and a rundown apartment and whose energies were directed only toward his art.

Yet, as Albert Boime points out, while Ryder did not engage in the kinds of material pursuits that marked the lives of many of his well-off patrons, he "demonstrated his economic awareness in his sensitivity to the prices of his pictures and stated that he would never sell below their current market value and even sell higher in anticipation of their steady increase." He also invested much of his earnings in the stock market, including buying stock in the Pullman Palace Car Company in 1895, a year after the American Railroad Union strike against this company over wage cuts had been so violently put down. Thus, while Ryder may have shared with the Dutchman a sense of isolation and loneliness, he was also a participant in a Gilded Age culture and economy marked by excess and inequity.

Winslow Homer also produced a seascape similar in theme to Ryder's *Flying Dutchman*. Homer made several trips through

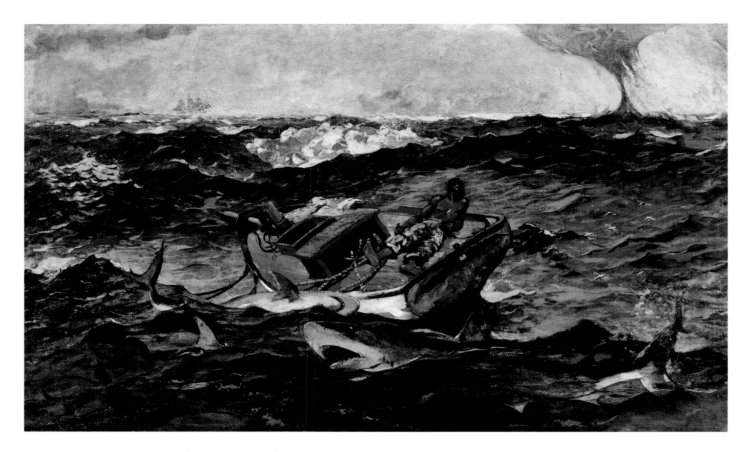

the Gulf Stream in the last three decades of his life, one of which occurred in late 1898 and early 1899, when he sailed to the Bahamas and Florida. Several preliminary sketches indicate that the painting *The Gulf Stream* (1899) [5.81] was based, at least in part, on what Homer saw during these trips. But, as with Ryder's seascapes, *The Gulf Stream* was imbued with broader symbolic value. In fact, the message of *The Gulf Stream* is more in keeping with another painting of a black man in a boat surrounded by sharks, John Singleton Copley's *Watson and the Shark* (1778) [2.5]. Just as Copley's painting alluded to the topics of slavery and revolution in the American colonies (see pp. 84–6), Homer's later painting, according to the art historian Peter Wood, "deals in subtle and extended ways with slavery, U.S. imperialism in the Caribbean, southern race wars, and Jim Crow segregation." *The Gulf Stream*'s association with American imperialism is clear in the combination of its title, which points to the major military arena in the Spanish-American War of 1898, and the storm setting. Slavery appears in the figure of the black man and the bamboo that writhes, snake-like, out of the hold of the boat, representing the plantations and sugar industry that fueled the slave trade. The black man's isolation suggests the segregation of the Jim Crow south.

5.81 Winslow Homer: *The Gulf Stream*, 1899
Oil on canvas, 28⅛ × 49⅛ in. (71.4 × 124.8 cm.)
Metropolitan Museum of Art, New York

Wood also points to the presence and importance of one particular black man in Homer's life, Lewis Wright, who was the personal servant of, first, Homer's father, and, second—after the latter's death in August 1898—of Homer himself. Wright was an ex-slave who moved from Virginia to Maine in 1896 to work for the painter's father, Charles Savage Homer. He was approximately the same age as Winslow and their relationship may well have prompted the artist to reflect more deeply on race relations in both the North and the South. Wright's association with the death of Homer's father may also have contributed to the melancholy nature of the painting, the sense of resignation and isolation in the face of powers beyond one's control. These intimations of mortality are further reinforced by the black cross near the base of the broken mast (in actual fact a cleat, but symbolically funerary), the tomb-like entrance to the hold, and the shroud-like sail across the upper deck. *The Gulf Stream* is thus a complicated painting about personal and national turmoil, one that casts an anxious eye on the coming century.

The Machine, the Primitive, and the Modern

6.1 Max Weber: *Rush Hour, New York*, 1915 (see p. 341)
Oil on canvas, 36¼ × 30¼ in. (92 × 76.9 cm.)
National Gallery of Art, Washington, D.C.

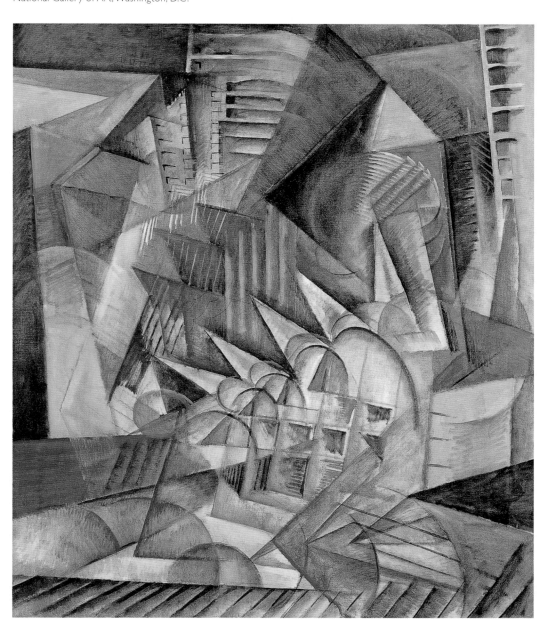

Timeline 1900–1929

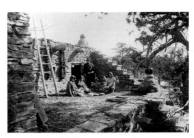

6.73 (see p. 370)

1900 Robert Henri moves from Philadelphia to New York

1901 Founding of the Socialist Party

1903 Publication of *The Souls of Black Folk* by
W. E. B. Du Bois

1905 Founding of the Industrial Workers of the World
(IWW); Alfred Stieglitz opens the Little Galleries of the
Photo-Secession; Nampeyo and family are the first
Pueblo Indians to occupy Fred Harvey's Hopi House,
designed by Mary Coulter [6.73]

6.9 (see p. 330)

1906 Publication of Upton Sinclair's novel *The Jungle*

1907 The Santa Fe Railway introduces its annual illustrated
calendar

1908 First exhibition of "The Eight" (also known as the
Ashcan School) at the Macbeth Galleries in New
York; *Chez Mouquin (At Mouquin's)* [6.9] by William
Glackens included in first exhibition of "the Eight"
(also known as the Ashcan School) at the Macbeth
Galleries in New York City

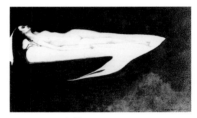

6.49 (see p. 354)

1909 Founding of the National Association for the
Advancement of Colored People (NAACP); Ida
Rubinstein appears in Russian Ballet production
of *Cleopatra*, Romaine Brooks uses her as model
for *The Crossing* [6.49]

1910 Founding of the Urban League to help African
Americans from rural areas adapt to city life;
beginning of Mexican Revolution (lasts until 1917);
African American boxer Jack Johnson defeats white
ex-champion James J. Jeffries, white on black violence
ensues across U.S.; British art critic Roger Fry
organizes exhibition of Post-Impressionist art

6.32 (see p. 342)

1913 The Armory Show in New York introduces Modernism
to the American public [6.32]; Paterson Strike Pageant

1914 John Sloan commemorates the Ludlow Massacre on
the cover of *The Masses* [6.18]; publication of *Art* by
Clive Bell

6.18 (see p. 335)

1914–18 World War I

1915 Founding of the People's Art Guild in New York

1916 Founding of the Society of Independent Artists in New York

1917 U.S. enters World War I (April 6); Division of Pictorial Publicity of federal Committee on Public Information produces over 700 posters in support of war [**6.37**]; the mailing license of *The Masses* is revoked under the Espionage Act of June 15; rejection of Marcel Duchamp's *Fountain* by the jury of the Society of Independent Artists; Russian Revolution

1918 Art Young and other staff members of *The Masses* are tried for "conspiring to obstruct enlistment"

1919 Louisa Keyser appears at the St Louis Exposition of Industrial Arts and Crafts [**6.76**]

1920 Nineteenth Amendment to the U.S. Constitution grants women the vote; Alvaro Obregón elected president of Mexico; formation of National Socialist Party in Germany

1921 José Vasconcelos, Secretary of Education, initiates public mural program in Mexico

1922 William E. Harmon establishes a foundation to provide financial support and exhibition opportunities for African American artists (ends 1933)

1923 Edward Weston and Tina Modotti travel to Mexico

1924 Passage of the National Origins Act (Immigration Restriction Act) excluding Asian immigration and limiting European immigration by nationality; Motley, *Mending Socks* [**6.84**]

mid-1920s Fred Harvey begins his "Indian Detour," capitalizing on growing interest in Pueblo ceremonies and architecture [**6.68**]

1929 Malvina Hoffman commissioned by the Field Museum of Natural History, Chicago, to create life-size sculptures documenting the races of the world [**6.90**]; publication of Anita Brenner's *Idols Behind Altars*

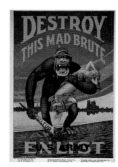

6.37 (see p. 345)

6.76 (see p. 372)

6.84 (see p. 378)

6.68 (see p. 367)

6.90 (see p. 381)

The rapid pace of technological and social change that had marked the second half of the 19th century continued into the 20th. Muybridge's photographic motion studies were soon followed by motion pictures. Henry Ford transformed his 1892 invention of a "horseless carriage" into a flourishing automobile industry that changed people's lives and the shape of American cities. In 1903, the same year Ford opened his Ford Motor Company, Orville and Wilbur Wright made the first sustained flights in a power-driven airplane. Two years later, Albert Einstein transformed scientific thinking with his theory of relativity, discarding the concept of absolute motion and instead treating only relative motion between two systems of reference. Space and time were no longer viewed as separate, independent entities but rather as forming a four-dimensional continuum called Space-Time.

As these scientific and technological changes occurred, the population of the country surged forward. Fifteen million new immigrants arrived in the United States between 1890 and 1915 alone. The majority settled in the nation's cities, prompting massive crowding as well as unprecedented building campaigns. Poverty increased at the same time as the millionaires of the late 19th century—the J. P. Morgans and John D. Rockefellers—amassed even greater fortunes, largely as a result of the continuing availability of cheap immigrant labor and absence of federal legislation limiting their actions. This would change somewhat in the early decades of the 20th century, with anti-trust and labor and health legislation enacted during the presidencies of Theodore Roosevelt, William H. Taft, and Woodrow Wilson and the expansion of the efforts of organized labor. In 1902 striking coal miners succeeded in shutting down production nationwide and winning a nine-hour workday.

Internal migrations also contributed to the country's rapid shift from an agrarian to an industrial power (by 1920 the urban population had surpassed the rural population). Large numbers of African Americans, as well as whites, left the rural south for the industrial north in search of jobs. The concentration of African Americans in major cities, in particular Chicago and New York, created the potential for greater political power as well as for cultural movements, and facilitated the founding of the National Association for the Advancement of Colored People (NAACP) in 1909.

The political fabric of the nation was changing in other ways as well. The Spanish-American War of 1898, which resulted in the acquisition of Puerto Rico, Guam, and the Philippines, made the United States a colonial power, with a growing political and economic interest in Central America. The Mexican Revolution of 1910–17 drew troops into another military conflict on foreign soil in an attempt to protect American economic interests.

The majority of the nation's artists, who also gathered in urban centers, witnessed the changes in the physical and social fabric of the country. Like scientists and engineers, many questioned the received knowledge of the past and searched for artistic strategies that would create essential connections between their work and this new, fast-paced modern world. Others clung more tenaciously to the past in an effort to resist social and political change.

Some supported the Mexican revolutionaries and traveled to Mexico to learn from the experiments in public art that had flowered with the installation of the presidency of Alvaro Obregón in 1920. Others took up the ideas of socialism and tried to enact political reform at home, joining the staff of the socialist journal The Masses to spread their beliefs to a larger audience through cartoons and illustrations. The journal's opposition to the country's entry into World War I in 1917 resulted in its demise, and the persecution of leftists after the successful Russian Revolution of that same year made the promotion of socialist ideals difficult. The Left survived, however, to constitute, once again, a significant political force in the 1930s.

Many who attempted to record the political and social turmoil of the early 20th century favored attention to the "real" as opposed to "ideal" in their work. Whereas art had been defined as the realm of beauty and perfection in the salons and academies of the late 19th century, it was now championed as able to capture both the beautiful and the ugly as they coexisted in a rapidly changing world. Critics in New York, the center of the art market and art production, began to speak of the best art as that which captured the raw power of the new century, a quality with a decidedly masculine tenor. As Bailey Van Hook has noted, "will, energy, drive, strength, force, and ambition were exalted In an age marked by colonization, industrialization, and urbanization, a more forceful symbol was needed—not a virgin but perhaps a dynamo." The first group of artists to capture this more dynamic image of America came to be known as the Ashcan School.

While the Ashcan artists were creating new images of urban America [6.2], their styles remained relatively conventional. Stylistic innovation was, however, being taken up by many as the formal experiments begun in Europe in the middle of the 19th century spread to the U.S. This "Modernist" art encapsulated a relatively wide range of styles and subject-matter, all of which challenged traditional conventions of visual representation and often created new images in response to contemporary developments such as the expansion of commercial imagery and industrial technology. Some, following in the footsteps of Whistler, condemned the materialism of a commercialized

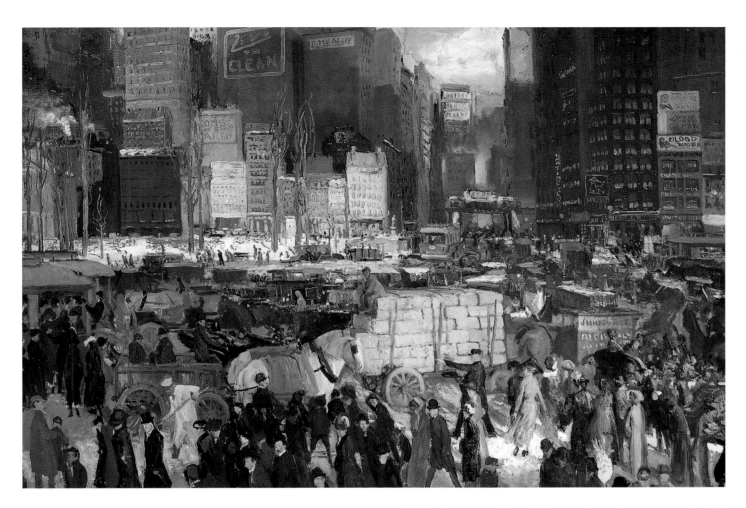

6.2 George Bellows: *New York*, 1911
Oil on canvas, 42 × 60 in. (106.7 × 152.4 cm.)
National Gallery of Art, Washington, D.C.

world and focused on the formal qualities of a decorative art that existed in isolation from this world and from an often hostile public. Others celebrated technological innovations and the streamlined machine forms that emerged from these innovations and claimed that such forms were best able to represent a new, distinctly American, art. Both groups conceived of themselves as an 'avant-garde' within the art world (a term first used by artists in the second half of the 19th century), challenging the status quo and improving society at large through the creation of both new objects and new ways of seeing.

Many Modernist artists challenged gender categories, blurring accepted lines between male and female and rethinking the representation of the body in art. Supporters of Modernism created new educational opportunities for aspiring artists and new venues for the production and display of their work. Works defined as Modernist were but a small percentage of the large output of artists in the United States in the first half of the 20th century. But even those who continued to labor within,

and defend, more traditional forms of visual representation did so in the context of, and with varying degrees of knowledge of, the Modernist experiments surrounding them. Choosing not to explore new forms or subject-matter increasingly required justification.

For many, Modernism captured the rapid shrinking of the world as a result of new technologies of communication and transportation, and the excitement and wonder created by the coming together of different cultures and of the old and the new. In 1941 the French anthropologist Claude Lévi-Strauss described an encounter he experienced in the American Room of the New York Public Library: "There, under its neo-classical arcades and between walls paneled with old oak, I sat near an Indian in a feather headdress and a beaded buckskin jacket—who was taking notes with a Parker pen." Earlier in the century, the photographer Edward Curtis responded to similar juxtapositions in a different manner: he retouched his images of Native peoples in order to remove such "impurities" as suspenders, parasols, and alarm clocks.

The juxtapositions relished by Lévi-Strauss and brushed away by Curtis were not new. As indicated in earlier chapters,

they had been an integral part of the daily experiences and cultural representations of Native Americans for centuries, as the objects central to their ritual and daily lives were—and still are—marked by continuous borrowings from other peoples encountered through war and trade. But these juxtapositions multiplied tenfold in the 20th century. They also played a key role in the development of Modernist art. Many European and American artists and scholars looked to Native American, as well as African, works for formal innovation. At the same time, they celebrated the cultures from which those works emerged as simpler and less corrupt than their own and more in touch with "primitive" instincts, qualities now given a positive spin. In the continuing attempts to define a modern American aesthetics, artists looked to the particularities of a non-technological Native American or African slave past, which would be reframed and incorporated into the rhetoric of cultural nationalism. Lévi-Strauss's Parker pen and feather headdress represented a momentary coming together of two nationalist aesthetics— one based on the machine and the other on the primitive—as well as the failure of the assimilationist policies of the federal government and the resiliency of Native American culture.

Realism and the Ashcan School

Painting New York City

In writing of the early 20th century, the art historian Virginia Mecklenburg notes that a form of realism emerged in New York that signified "a willingness to examine selectively the motivations, psychology, and appearances of a world in which beauty and ugliness coexisted in order to arrive at a more fundamental understanding of the human condition." Beauty and ugliness, as well as conflict and confrontation, were present in abundance in the city at the turn of the century. The struggles between wage laborers and their employers that had spread throughout the country in the 19th century continued. By 1904 there were approximately four thousand strikes a year, the majority centered in urban areas—Chicago, Detroit, San Francisco, New York. They were called to protest low wages and unsafe working conditions, as well as long hours and the absence of job security.

Many politicians made the plight of the working class a central issue in their election campaigns, and sponsored acts to stop the most egregious trammeling of workers' rights. The decades either side of 1900—known as the Progressive Era— saw the passage at the federal level of the Meat Inspection Act and Pure Food and Drug Act, and further legislation regulating, among other things, railroads and pipelines, the growth of monopolies, and the money and banking system. Several states passed laws regulating wages, hours, safety, and compensation. Unfortunately, such laws were not always strictly enforced.

The passage of reform laws was the result, in part, of pressures brought to bear on both the Democrats and the Republicans by the Socialist Party, founded in 1901 and led by Eugene Debs. While the Socialist Party was not a significant presence at the federal level, its candidates won a series of state and municipal elections, forcing the two main parties to broaden their platforms. Reform was also promoted by several writers, known collectively as "muckrakers." Upton Sinclair's novel *The Jungle* (1906), about the Chicago meatpacking industry, is said to have played a significant role in the passage of the Meat Inspection Act. Jack London, with *The Iron Heel* (1907), and Ida Tarbell, with *History of the Standard Oil Company* (1904), also exposed the darker side of capitalism, as did Theodore Dreiser in *The Financier* (1912) and *The Titan* (1914).

In the art world, several individuals gathered around the painter Robert Henri in New York City—George Bellows, William Glackens, George Luks, Everett Shinn, and John Sloan. These artists, who formed the nucleus of the Ashcan School, attempted to present an urban life usually ignored by the Academy, i.e. the life of the lower classes. As the art historians Rebecca Zurier and Robert Snyder put it, they "forged a contemporary form of realism that conveyed partial but real truths about New York City, its mosaic of communities, and the complexities of life and art in a diverse city where most people were strangers to one another." They captured the changes made by immigration, mass media, shifting gender roles, and the increasingly lavish public display of wealth. From 1897 to 1917 they recorded the city not as a distant panorama but "from the ground up." They focused on the crowded public spaces, where strangers rubbed elbows and vied with miscellaneous traffic as they negotiated the streets and avenues. Perhaps nowhere was this more effectively conveyed than in George Bellows's painting *New York* (1911) [6.2]. The art historian Marianne Doezema points out that it is not an image of an actual location in the city but rather a composite of many locations. Yet it manages to convey the "throbbing density, the magnificent heterogeneity" of urban life. In it we see the social, economic, and political activities that allowed the city to function—embodied in the pushcarts, the trolleys, the skyscrapers, and the policeman.

These artists also revealed, in the words of Zurier and Snyder, "the subtle and densely layered systems of order and accommodation that [made the city] navigable and knowable. A recognition of the microneighborhoods and internal structures that define the city was one of the distinguishing features of Ashcan art." They often relied on popular stereotypes of ethnic groups. Most of those they painted were strangers, captured

quickly in passing or sketched from the studio window, with little intimate knowledge of the details of their lives. Yet they also broke through the stereotypes in sympathetic depictions of groups or individuals. At the very least, they created images of people who were most often overlooked.

Robert Henri (1865–1921) studied at the Pennsylvania Academy of the Fine Arts in Philadelphia before spending a period in Paris in the studio of the academic painter William-Adolphe Bouguereau. Henri was more impressed, however, by the work of Edouard Manet, the Dutch painter Frans Hals, and the Spanish painters Diego Velázquez and Francisco de Goya. One can certainly see the influence of Hals in Henri's *Laughing Child* of 1907 [**6.3**]. Both Hals and Henri were interested in the spectacle of common life, in the individuals who walked the streets of their respective towns and cities. Theirs is primarily a sympathetic rather than comic portrayal of these people, with the dark background bringing out the features of their sitters and the golden light giving an added warmth. The works of both are also marked by a heavy impasto, suggesting the materiality of both the painting and the sitter.

In the mid-1890s a number of young artists working as illustrators for the *Philadelphia Press* and other city newspapers

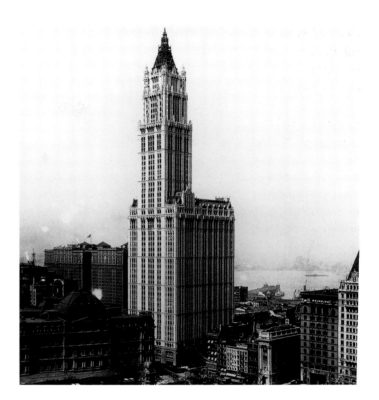

6.4 Cass Gilbert: Woolworth Building, New York, 1911–13

6.3 Robert Henri: *Laughing Child*, 1907
Oil on canvas, 24 × 20 in. (61 × 50.8 cm.)
Whitney Museum of American Art, New York

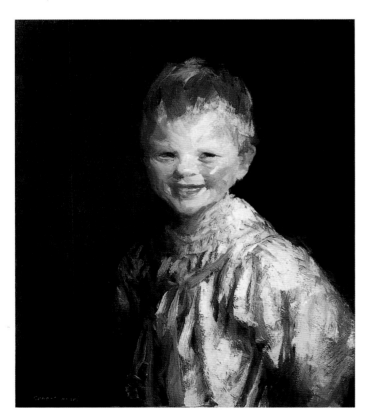

began gathering in Henri's studio. They included Glackens, Luks, Shinn, and Sloan. Their journalistic training made them adept at both noticing the world around them and capturing it in quick, impressionistic sketches, which were later worked up in the newspaper office into finished illustrations. The experience also made them receptive to Henri's admonitions to paint the life around them, and to do it quickly—"Do it all in one sitting if you can," he advised them. "In one minute if you can."

Henri moved to New York in 1900. Luks and Glackens had arrived in 1896, Shinn in 1897; Sloan and Bellows followed in 1904. They went there for the same reasons: the city was the center of the publishing and entertainment industries, as well as the art world. It had the largest concentration of dealers, and its National Academy of Design and Society of American Artists set the standards for schools and associations across the country. New York was also the center of finance and commerce, with its Wall Street stock market and corporate headquarters. Architectural and technological wonders were appearing at every turn, such as the neogothic Woolworth Building by Cass Gilbert (1859–1934), the tallest building of its time when completed in 1913 [**6.4**], and the elaborate transportation networks composed of subways and bridges that connected the city's five boroughs, officially incorporated into one urban unit in 1898. At the same time, the city's Lower East Side became the crowded home to a wide range of immigrant communities that

provided an array of activities, costumes, architectural forms, and advertising that fascinated artists attuned to the everyday activities of an urban environment.

The Ashcan artists found employment on New York's newspapers and magazines and gained fame as skilled illustrators. For example, soon after arriving Luks took over the Sunday comic *Hogan's Alley*, featuring Mickey Dugan (known as the "Yellow Kid" because of the smock he wore) and his gang of friends. This commercial work did more than promote their reputations as illustrators. It also provided them the opportunity to make friends with journalists who were, or later became, art critics and who were able to promote their work once they moved into the realm of fine art. These critics participated in the event that brought the group into prominence as serious artists, an exhibition at New York's Macbeth Galleries in 1908.

Henri had been voted a member of the Academy in 1906 and served on its jury in 1907, but resigned in protest when several canvases by his fellow Ashcan artists were rejected, even though others had been accepted. Rather than keep his resignation a matter of internal politics, Henri went to the press, whose power as an arbiter of taste and a promoter of scandal he fully understood. Critics sympathetic to Henri and his friends came to their defense. The Macbeth Galleries exhibition was organized by the artists themselves, and when it opened several reviews appeared that championed them as rebels protesting the stuffiness and exclusivity of the Academy. Two critics were particularly important in this respect, Charles FitzGerald of the *New York Sun* and *New York Evening Sun*, who was Glackens's brother-in-law, and Frederick James Gregg of the *New York Evening Sun*. Both, according to Mecklenburg, "believed that art should be responsive to the issues of modern life and employed the language of progressivism—words such as aggressiveness, masculinity, and vitality—that denoted new approaches to social and political issues as well as art." FitzGerald and Gregg also focused on the painters' connections to the world of illustration as proof of their radicalism, "for to be progressive in that field meant employing a realistic rather than sentimental or melodramatic approach." The Ashcan artists' opposition to the "feminine sentimentality" of the Academy was emphasized—despite the fact that they had exhibited regularly at the Academy in the first years of the century.

In the Macbeth exhibition Henri and his four associates—Sloan, Glackens, Luks and Shinn—were joined by Ernest Lawson, Arthur B. Davies and Maurice Prendergast, giving the group its first name, The Eight. Lawson and Prendergast also painted city scenes, but without the sense of grittiness and immediacy present in the work of the Ashcan artists. Lawson

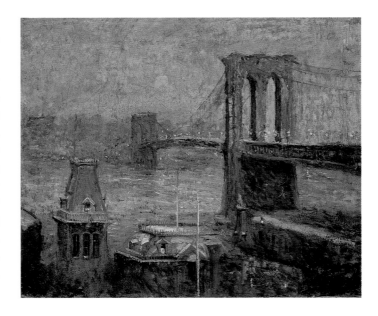

6.5 Ernest Lawson: *Brooklyn Bridge*, 1917–20
Oil on canvas, 20⅜ × 24 in. (52 × 61 cm.)
Terra Foundation for the Arts, Chicago, Illinois

(1873–1939) studied with the American Impressionists J. Alden Weir and John Twachtman and was further attracted to the style upon a trip to Paris in 1873. In his painting of one of the most celebrated of New York's technological wonders, *Brooklyn Bridge* [6.5], he shows the scene suffused in mist, viewed from a distance rather than "from the ground up." In his cityscapes,

6.6 Maurice Prendergast: *Promenade*, 1913
Oil on canvas, 30 × 34 in. (76.2 × 86.4 cm.)
Whitney Museum of American Art, New York

6.7 Arthur B. Davies: *Unicorns*, 1906
Oil on canvas, 18¼ × 40¼ in. (46.4 × 102.2 cm.)
The Metropolitan Museum of Art, New York

the noise and bustle are inaudible. Prendergast (1859–1924) situates himself at street level but transforms his animals and humans into brilliant, decorative arrangements of color. In *Promenade* (1913) [6.6] both horses and women appear to occupy a timeless realm rather than the recognizable landscape of one of New York City's numerous parks. This sense of timelessness is taken to an extreme in the work of Arthur B. Davies (1862–1928), whose visionary landscapes were filled not with horse-drawn carriages and society matrons but with imaginary creatures and nameless nymphs, as in *Unicorns* (1906) [6.7].

Henri had stopped painting urban landscapes of New York after an exhibition in 1902, and concentrated primarily on portraits. At the Macbeth Galleries most of his works were portraits and landscapes painted in Maine and Spain. While some might think he was abandoning the urban life he had so clearly championed as appropriate subject-matter for contemporary painting, he argued otherwise. Portraits, particularly of younger people, could evoke progress, independence, and democracy. Through the qualities of movement and spontaneity, one could capture "humanity in the making, in the living." After 1908 Henri became increasingly involved in campaigns organized by intellectual groups in New York, including the promotion of Irish theater, the Walt Whitman Fellowship, and the campaign for birth control led by Emma Goldman. Along with Bellows, he accepted Goldman's invitation to teach art classes at the anarchist Ferrer School, filled with young immigrants and a few notables, such as Leon Trotsky.

For the Macbeth exhibition Shinn decided on theater scenes from London, Paris, and New York. He was interested in the spectacle of urban life, equating what occurred in the theaters with what occurred in the crowded streets. While a work like

Footlight Flirtation (1912) [6.8] might appear to be simply an imitation of late 19th-century French theater scenes by Edgar Degas and others, Snyder argues that it conveys a distinctively vigorous interaction between audience and performer that derived from American vaudeville. Vaudeville audiences were often vocal in their reaction, shouting enthusiastically to indicate their approval and booing equally loudly when the show did not satisfy their expectations. Performers had to work extra hard to engage them. In *Footlight Flirtation* the woman onstage attempts to catch the eye of someone in the audience, whose members appear to be either just arriving or about to leave. Vaudeville suffered a serious decline with the introduction of movies as a new form of popular entertainment.

Glackens chose to highlight two large works in his section of the Macbeth exhibition, *Chez Mouquin* and *The Shoppers*. While

6.8 Everett Shinn: *Footlight Flirtation*, 1912
Oil on canvas, 29½ × 36½ in. (75 × 92.7 cm.)
Collection of Mr Arthur G. Altschul

6.9 William Glackens: *Chez Mouquin (At Mouquin's)*, 1905
Oil on canvas, 48³/₁₆ × 36¹/₄ in. (122.4 × 92.1 cm.)
The Art Institute of Chicago, Chicago, Illinois

Glackens created numerous scenes of life on the Lower East Side for magazine illustrations, he never depicted this part of New York in his paintings. Instead, he painted the neighborhood around his studio on Washington Square, and had his friends pose in their finest as shoppers and café-goers. *Chez Mouquin* (1905) [**6.9**], while it shows a popular New York establishment frequented by members of the Ashcan group, certainly owes a debt to Manet. Both artists convey the glitter, fashion, spectacle, and isolation of urban nightlife. Glackens's two figures are together, yet don't look at each other. The man's face is flushed with drink while the woman hides behind her white make-up and dazed expression. As in Manet's *A Bar at the Folies Bergère* (1882), the reflections in the mirror do not make sense, for if all those people were seated next to and in front of the man and woman facing the viewer, we would not be able to see this couple so clearly. The mirror thus represents a larger social dislocation resulting from the rapid pace of change taking place in the urban spaces of Paris and New York.

Glackens's other painting, *The Shoppers* (1907) [6.10], captures the ritual of consumerism that was becoming a central activity in the lives of urban women. Department stores were filling their many floors with a bewildering variety of goods, most of which were now not stored behind counters in glass cases but openly displayed and clearly priced and arranged along long, broad aisles so that shopping became something other than filling a predetermined list. Shoppers were encouraged to browse, to buy things they hadn't anticipated they would want or need. "By the turn of the century," write Snyder and Zurier, "New York department stores were known as 'Adamless Edens' equipped with amenities—restaurants, reading rooms, and ladies' lounges—designed to turn shopping into a day-long activity especially appropriate for respectable women." The central woman in Glackens's composition (the model was his wife Edith) is engaged in evaluating a piece of merchandise, her own elegant dress attesting to her skill in the "art" of shopping.

Of course, all-day shopping sprees were available only to those women who were not wage-laborers attempting to make ends meet. Certainly poor and lower-class women also had to shop for food and clothing, but much of their shopping took place in the streets. Glackens captures this type of scene in his drawing *Far from the Fresh Air Farm* (1911) [6.11]. Here is the crowded Lower East Side with its streets filled with vendors and children and horse-drawn carriages and its buildings overflowing with tenants and laundry and commercial signage.

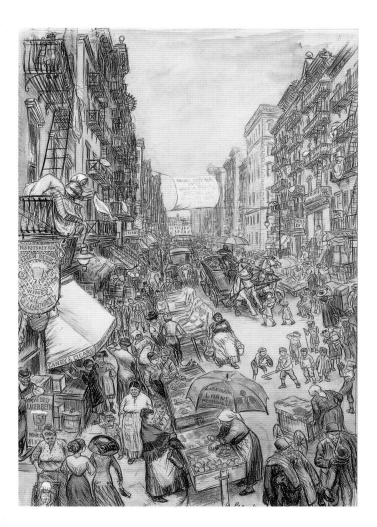

6.11 William Glackens: *Far from the Fresh Air Farm*, 1911
Carbon pencil and watercolor on paper, 25 1/2 × 17 in. (64.8 × 43.2 cm.)
Museum of Art, Fort Lauderdale, Florida

6.10 William Glackens: *The Shoppers*, 1907
Oil on canvas, 60 × 60 in. (152.4 × 152.4 cm.)
The Chrysler Museum, Norfolk, Virginia

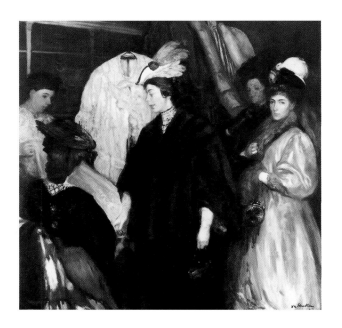

This drawing appeared as a full-page illustration in *Collier's* magazine with the caption: "The crowded city street, with its dangers and temptations, is a pitiful makeshift playground for the children." Social welfare reformers had attempted to alleviate this problem with vacations for children from inner city slums. But Glackens's drawing does more than simply illustrate a social "problem." While the scene initially suggests chaos and disorder, upon closer examination it reveals the complex system of commerce and social interaction—the push-cart vendors supplement the offerings of the small stores, the older children care for the younger children—that allowed such neighborhoods to survive.

Luks (1867–1933), unlike Glackens, made the street life of the Lower East Side a central theme of his paintings, as well as his drawings. One of the works he included in the Macbeth Galleries exhibition was *Hester Street* (1905) [6.12], a much

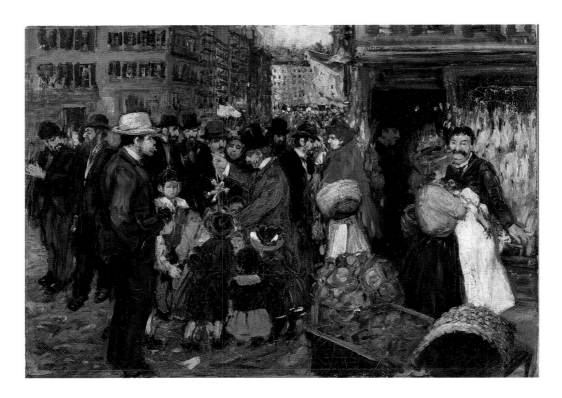

6.12 George Luks: *Hester Street*, 1905
Oil on canvas, 28⅛ × 36⅛ in. (71.4 × 91.8 cm.)
The Brooklyn Museum of Art, New York

6.13 George Luks: *The Spielers*, 1905
Oil on canvas, 36⅛ × 26¼ in. (91.8 × 66.7 cm.)
Addison Gallery of American Art, Phillips Academy, Andover, Massachusetts

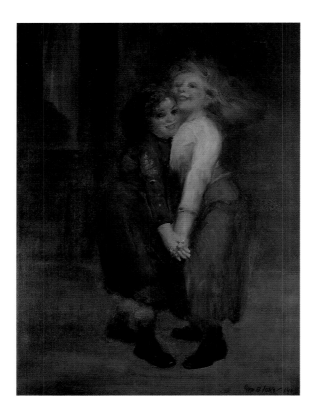

more sympathetic scene of lower-class urban life. While people interact in Glackens's drawing, we have little sense of their personalities and few are smiling as they go about their business. In Luks's painting, a group of children are entertained by a man with a toy, while a woman converses with a shopkeeper and men gesture as they engage in conversation. The viewer is down among the crowd rather than above it, able to appreciate the camaraderie apparent throughout the scene. This is a neighborhood where people know each other and feel comfortable exchanging a few words. Luks has chosen to omit any direct references to the hardships of life in the Jewish community surrounding Hester Street, with its garment sweatshops and homeless people, hardships captured by Jacob Riis in *How the Other Half Lives* (see p. 300). Instead, he conveys a sense of community as it presents itself through the rituals of commerce and social interaction.

Luks puts this same positive spin on Lower East Side life in his painting of two young dancing girls entitled *The Spielers* (1905) [6.13]. (Spieling was a popular type of German dancing among working-class immigrants at the time.) His reliance on Hals is evident in his handling of the paint and in the warm tones that suffuse the work. Children did dance in the streets of New York, despite their poverty. Luks is looking for the joy and beauty in the life of the poor, rather than the tragedy and the despair. He is painting for members of an art world still unwilling to display works deemed "too depressing" in their galleries and homes. Riis, on the other hand, in photographs

such as *Two Ragamuffins, "Didn't Live Nowhere"* (c. 1898) [6.14] had a mission—to expose the reality of homeless children in order to promote change. His photograph focuses, therefore, on what most would find a tragic scene—young children forced to fend for themselves outside of the sanctity and comfort of the home. Each in its own way is posed, each conveys a message meant for a particular audience, each records an aspect of urban reality.

George Bellows (1882–1925) did not exhibit at the Macbeth Galleries, but he had already caught the eye of critics receptive to the painting of city life and was seen as one of the most promising of the young followers of Henri. In 1907 he had shown *Pennsylvania Excavation* [6.16] at the National Academy of Design, and at the Academy's spring exhibition in 1908 *Forty-two Kids* (also of 1907) attracted enough attention to earn him election to the Academy the following year. The critic J. Nilsen Laurvik described him in 1908 as a painter "of passing phases of the town in a manly, uncompromising fashion."

The term "manly" was repeated often in subsequent years, due to both the artist's choice of subject-matter and his style of painting. As Zurier notes, Bellows's paintings "show an expressionistic boldness and a willingness to take risks . . . [and] a fascination with violence that makes Sloan and Luks seem warmhearted, Shinn refined, Glackens reticent." And while Bellows did produce picturesque scenes of Lower East Side street life and gatherings in Central Park, the most popular of his works focused on pursuits clearly defined as masculine—

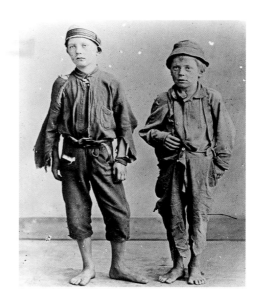

6.14 Jacob A. Riis: *Two Ragamuffins, "Didn't Live Nowhere,"* c. 1898
Photograph
The Museum of the City of New York, New York

boys swimming naked in the Hudson River, the excavation for Pennsylvania Station, boxing. *Both Members of This Club* (1909) [6.15] captures the clash of two powerful male bodies amidst a sea of demonic male viewers who appear to be calling for blood.

6.15 George Bellows: *Both Members of This Club*, 1909
Oil on canvas, 45¼ × 63⅛ in. (115 × 160.5 cm.)
National Gallery of Art, Washington, D.C.

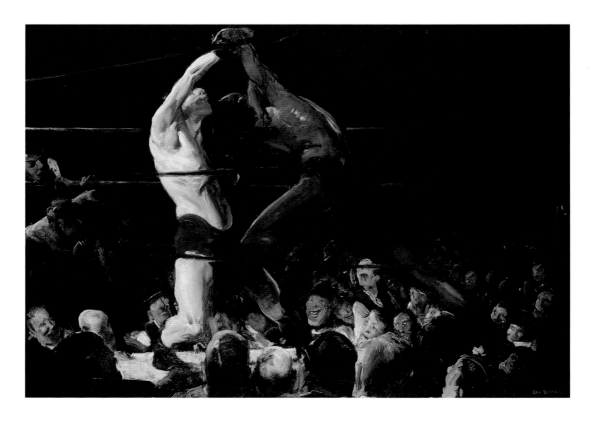

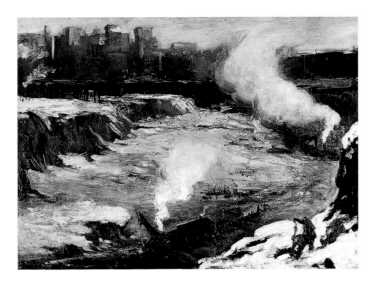

6.16 George Bellows: *Pennsylvania Excavation*, 1907
Oil on canvas, 34 × 44 in. (86.4 × 111.8 cm.)
Private collection

The work was painted at a time when the legality of boxing was still in flux, with fights permitted in clubs but not in public. In painting a fight between a white man and a black man, Bellows also addressed a key development in the world of professional boxing, the rise of the black boxer, embodied in the figure of Jack Johnson, who won the heavyweight title from Tommy Burns in Australia in 1908. His defeat of James J. Jeffries, the ex-champion, in 1910 sparked race riots across the United States. Bellows's painting represented many white fans' worst fears—the defeat of a white boxer by a black boxer, symbolizing the defeat of white manhood by black.

Pennsylvania Excavation (1907) [6.16], one of a series of works focusing on the construction of McKim, Mead and White's Pennsylvania Station, completed in 1910, captures the power of modern technology and the sheer scale of the architectural projects that came to represent the height of progress in the early 20th century. Bellows does not show us the final product, based on an ancient Roman baths building, that occupied a full city block [6.17]. Instead, he paints the empty space that had to be created in order to lay the foundations. While conveying the isolation and smallness of the men who worked at the site, the painting also suggests the displacement of people that this construction project entailed. The viewer understands that this gaping hole was once covered with structures similar to those that now ring its perimeter, structures inhabited by individuals forced to move elsewhere. Thus, the artist's dark palette suggests both gloom and power. This was a scene with which Bellows was very familiar, for he lived nearby and walked past it almost every day.

Socialism and Art: The Painting and Graphic Art of John Sloan

Both Bellows and Sloan (1871–1951) contributed drawings to the socialist journal *The Masses*, and both engaged in heated debates over whether or not the journal had a place for non-political art, as well as propaganda. Sloan and several others were particularly concerned about editorial policies that required images to appear with captions. Art Young, another contributor to *The Masses* [6.36], condemned the group as more

6.17 McKim, Mead and White: Pennsylvania Station, New York, 1906–10

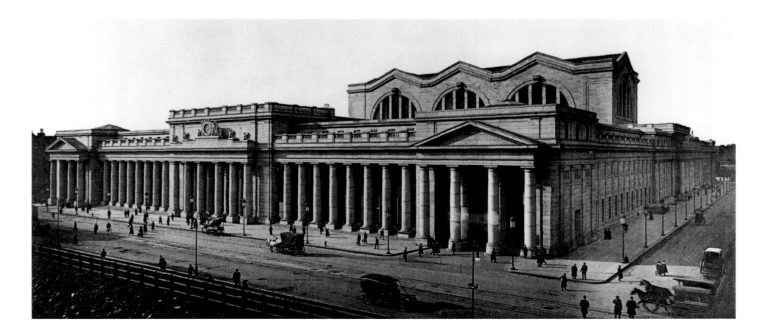

interested in painting "art" than critical political commentaries. He wrote:

> The dissenting five artists were opposed to "a policy." They want to run pictures of ash cans and girls hitching up their skirts in Horatio Street—regardless of ideas—and without title. On the other hand, a group of us believe that such pictures belong better in exclusive art magazines. Therefore we put an emphasis on the value of constructive cartoons for a publication like *The Masses*.

Thus the name "Ashcan School" was born. Sloan and four others subsequently split with the journal in 1916.

Sloan had certainly produced "constructive cartoons" prior to his departure, as is evident in his cover for the June 1914 issue, commemorating the "Ludlow Massacre" [6.18]. That event was the outcome of one of the most bitter and violent struggles between workers and corporate capitalists and their supporters in the early 20th century. In late 1913 a strike was called at the Rockefeller family's Colorado Fuel and Iron Corporation, prompted by the murder of a union organizer, low pay, and dangerous working conditions. A number of tent cities were set up after the workers were expelled from the company shacks. First a detective agency was brought in to attack the tent colonies, then the National Guard. Still the strike held. On April 20, 1914, the National Guard initiated an armed attack at Ludlow. Miners returned the fire, and the Guard then set fire to the city. Thirteen were killed by gunfire, and eleven children

6.18 John Sloan: *Ludlow Massacre*, cover of *The Masses*, June 1914

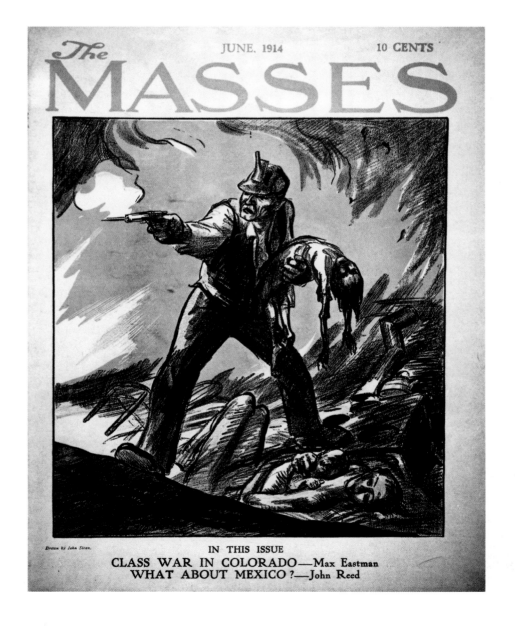

and two women were burned to death in a pit they had dug for shelter. When the news spread, three hundred armed strikers set out from other tent cities, and three hundred miners at Colorado Springs walked off the job, armed themselves, and headed for Ludlow. Mines were destroyed and more people killed. President Wilson sent in federal troops to suppress the strike and unrest. Despite the national outrage that ensued in favor of the strikers, no militiamen or mine guards were punished. Sloan's cover shows a miner holding the corpse of a burned child in one hand and firing at the National Guard with a gun held in the other hand. It is a highly emotional and partisan image, meant to elicit outrage at the Rockefellers and the Colorado governor, and support for the strikers.

While Sloan had no reservations about using his artistic talents to produce biting indictments of social and political injustice in his work for *The Masses* (although he believed that not all his drawings needed to contain such indictments), he refused to include this subject-matter in his painting: "serious" art, he believed, must be ideologically neutral. For example, in his 1912 painting *A Woman's Work* [6.19] he ignored

6.19 John Sloan: *A Woman's Work*, 1912
Oil on canvas, 31⅝ × 25¾ in. (80.3 × 65.4 cm.)
The Cleveland Museum of Art, Cleveland, Ohio

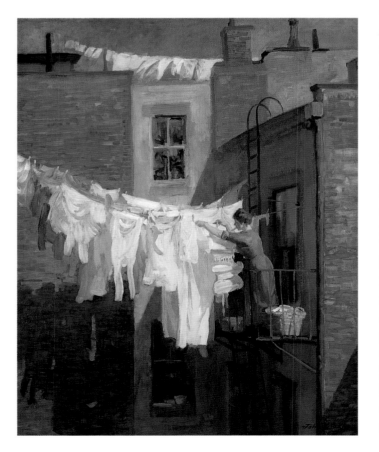

the political unrest that was directly affecting his own wife Dolly, who, along with Sloan, was a member of the Socialist Party. That year Dolly was involved in organizing support for the female mill workers of Lawrence, Massachusetts, who went out on strike; their children were sent to New York to be taken care of by supporters for the duration of the strike. Instead of painting women organizing or striking, Sloan shows the peace and calm of a sunny day, with the fresh wash blowing in the breeze and a woman engaged in what the title defines as "woman's work": doing the laundry. This is one of many paintings by Sloan where the female protagonists are in the process of cleaning—themselves, clothes, floors, etc. Indeed, just as Bellows garnered a reputation for painting men and masculine pursuits, Sloan came to be known for his paintings of women and feminine pursuits.

Sloan may have intended this domestic female imagery to distance his fine art from activist politics, yet the art historian Patricia Hills sees a political meaning in these paintings of women. Sloan's "desire for purification, redemption and regeneration in a world here and now" echoed a desire promoted by many idealistic socialists. While women were part of the working class, they were also viewed by many working-class and middle-class men as removed from the class struggle. They were the cleaners and nurturers within the home. They would bring about salvation and order through their domestic example. Women themselves used their assigned role as nurturers and peacekeepers to argue for the extension of their political rights outside of the home. Thus, the presentation of women in the act of hanging out clothes or drying their hair or washing the floor could be interpreted as a partisan statement, a reaffirmation of a political position that saw women as both within and outside of the world of activist politics.

In 1917, the year after Sloan broke with *The Masses*, he left the Socialist Party, greatly disillusioned by the inability of socialism to check the nationalism that led to World War I. The year 1917 also marked a turning point for the Ashcan artists. They abandoned the life of New York as subject-matter, some leaving altogether (Shinn went to Hollywood, Glackens to France), while others, like Sloan, Bellows and Henri, spent only a part of each year in the city. This shift may have been the result of at least two factors: the decline in the market for illustrations, as the reproduction of photographs became more feasible; and the replacement of the reform mentality of the Progressive Era with the free-spending capitalism of the 1920s. Urban lower-class life was no longer at the forefront of popular discussion, and after the war the mood was one of celebration rather than social concern.

Sculpting Everyday Life

Many sculptors were also following the call to represent the material lives of real people as opposed to the ideal worlds of gods and goddesses. To a large extent, as the art historian Ilene Fort has noted, early 20th-century genre sculpture tended to be created by "a new breed of artists from outside the mainstream." They came from the Midwest and the West, rather than from the eastern seaboard. Many were also women, immigrants and/or children of immigrants. Often they did not have the financial resources of their middle- and upper-class predecessors. This "outsider" status allowed them to break more easily with established tradition, focusing on their own cultural heritage or the tumultuous lives of working-class Americans. They took up the themes found in the paintings of the first decades of the century—labor, urban life, and popular entertainment.

Abastenia St Leger Eberle (1878–1942) moved to New York from Ohio in 1899 and began studying at the Art Students League. By 1906 her work was being accepted for exhibition at the National Academy of Design. That same year she joined the National Sculpture Society. Like Henri, she believed that artists had a social mission and could use their talents to reveal the life around them and, at times, prompt a change for the better. Eberle was a follower of the social reformer Jane Addams, who founded Hull House in Chicago as a place where immigrants could learn the skills necessary to survive in the United States, while still retaining pride in their own distinct histories and cultures. Eberle lived in a settlement house when she moved to the Lower East Side and is best known for small-scale bronze figures of street urchins and women engaged in domestic or maternal duties. Her *Girls Dancing* (1907) [6.20] is the sculptural counterpart to Luks's *Spielers* [6.13], displaying the same energy and playfulness.

Eberle also produced more solemn works, such as *White Slave* (1913) [6.21], a condemnation of the practice of the abduction of young white girls and their sale into prostitution. The work was exhibited at the Armory Show of 1913 (see below) and condemned by some for its gruesome realism. Eberle undoubtedly knew of the famous *Greek Slave* by Hiram Powers [5.16], and refused to allow her viewers the disengagement Powers allowed his through his idealization of the figure and her isolation from any specific narrative. She probably was also familiar with works like John Rogers's *Slave Auction* [4.22]. *White Slave* in effect combines the nakedness of the Powers work and the historical specificity of the Rogers narrative. The auctioneer wears contemporary dress, locating the scene in the present. His grotesque facial features and the rough surface treatment given to his clothing emphasize by contrast the

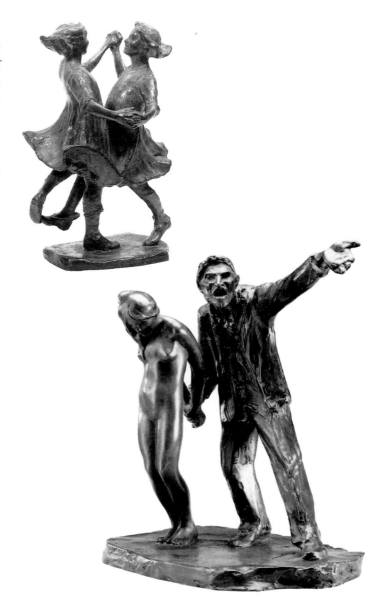

6.20 Abastenia St Leger Eberle: *Girls Dancing*, 1907
Bronze, 11¼ × 7 × 7½ in. (28.6 × 17.8 × 19.1 cm.)
The Corcoran Gallery of Art, Washington, D.C.

6.21 Abastenia St Leger Eberle: *White Slave*, 1913
Bronze, 19¾ × 17 × 10¼ in. (50.2 × 43.2 × 26 cm.)
Collection of Gloria and Larry Silver

vulnerability of the young girl with her smooth skin and small size. Eberle actively campaigned for women's rights and organized an exhibition of women artists in 1915 to raise money for the suffrage movement.

Several sculptors were inspired by the struggles of unskilled workers engaged in manual labor, the most notable of whom was Mahonri Young (1877–1957). Young was born in Salt Lake City, Utah, the grandson of the Mormon leader Brigham Young. Like Eberle, he traveled to New York in 1899 and enrolled in the

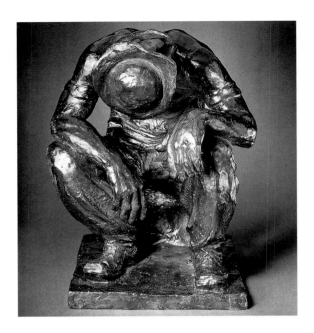

6.22 Mahonri Young: *Tired Out* (*Fatigue*), 1903
Bronze, 9 × 5¾ × 7 in. (22.9 × 14.6 × 17.8 cm.)
Los Angeles County Museum of Art, Los Angeles, California

Art Students League; in addition, like so many of the Ashcan artists, he initially supported himself as a newspaper illustrator. He left for study in Paris, then went home to Salt Lake City in 1905, and settled in New York in 1910. Six of his works were included in the Armory Show. In Paris in 1903 he showed two new works: a plaster model of *Tired Out* [6.22] and its companion piece *Laborer*. These were central elements in his ambitious plans for a monument to labor [6.23]. In his initial drawings for

the monument he combined the idealized nude with the clothed and semi-clothed worker, and borrowed from earlier works such as Michelangelo's ceiling for the Vatican's Sistine Chapel. Young wanted to convey both the strength of the male body and the suffering it endured. One cannot help but compare the figure in the center of the top register with Rodin's *Thinker* [6.27] in the *Gates of Hell* (1880–c. 1900). Young's worker is too exhausted even to contemplate the nature of his condition.

Another sculptor who turned his attention to the lives of working people was Saul Baizerman (1889–1957). Instead of adhering to the realism of Young or Eberle, however, he turned to the ideas of Cubism, and began reducing his forms to a series of planes and angles, or paring them down to organic, curvilinear shapes. In the early 1920s he began a series of small bronze works entitled *The City and the People*, in which he depicted people both at work and at play—*Two Men Lifting* (1922) [6.24], *Roller Skater* (c. 1924–31) [6.25]. There are no specific details of clothing or physique that allow the viewer to place these figures in a particular time or locale. What places them is their style, for this type of abstraction of form could only have occurred at the turn of the 19th and 20th centuries.

6.24 Saul Baizerman: *Two Men Lifting*, 1922
Bronze, 3¾ × 6½ × 2½ in. (9.5 × 16.5 × 6.4 cm.)
Hirschhorn Museum and Sculpture Garden, Smithsonian Institution, Washington, D.C.

6.25 Saul Baizerman: *Roller Skater*, c. 1924–31
Bronze, 4¹⁵⁄₁₆ × 2⅞ × 2 in. (12.5 × 12.4 × 5.1 cm.)
Gary and Brenda Ruttenberg

6.23 Mahonri Young: *Monument to Labor*, c. 1902–3
Graphite on paper, 7⅜ × 8¼ in. (18.7 × 21 cm.)
Harold B. Lee Library, Brigham Young University, Provo, Utah

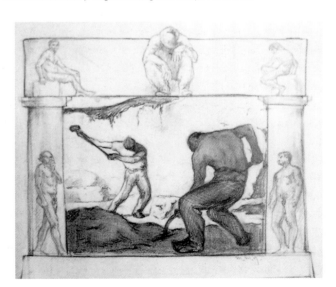

Modernism and the Avant-Garde

Alfred Stieglitz and 291

Sloan, Henri, and those who thought like them were challenging the Academy's definition of appropriate subject-matter for art by arguing for the grittier aspects of the everyday world of New York City. At the same time, other artists and critics were challenging the Academy's dictates regarding style, as well as subject-matter. Some, like Whistler, argued that artists should paint not literally what they see, but their emotional response to it. This meant abstracting the shapes and colors of objects, emphasizing their decorative qualities.

Modernist theorists like the British critics Roger Fry and Clive Bell distinguished between "fidelity to experience" and "pure aesthetics." The ideal and the universal now appeared as a focus on formal problems—color, line—as opposed to content, which occupied the secondary realm of the ephemeral. Bell summed up his position in a small book published in 1914 entitled *Art*, which drew heavily on the work of Fry and on developments in the Parisian art world. Fry had organized two important exhibitions, one in 1910 on Manet and Post-Impressionism (the first time the term Post-Impressionism was used), and another in 1912 on Post-Impressionism. Fry felt that Post-Impressionist art—e.g., the work of Vincent van Gogh, Paul Gauguin, Georges Seurat, and Paul Cézanne—relied for its effect on formal strength rather than associated ideas. This formal strength allowed the work to achieve a "classic concentration of feeling." The term "classic" here referred to those things that were "common" and "universal," rather than romantic and particular. Such classic elements were best represented by a style that was more abstract than naturalistic. Fry also presented his argument in populist terms. The understanding of form would allow art to be appreciated by the many rather than the few, who might not recognize the story or the symbols being used in figurative painting or sculpture. He did admit, however, that this form had to be allied with some kind of representational elements in order to be most effective.

Bell developed Fry's thoughts further along the line of autonomous form. For him, Post-Impressionism was marked by a return to first principles in art, which focused on form. Social or historical referents were secondary. His book was illustrated with a wide range of objects—a 5th-century Chinese statue, a 6th-century Byzantine mosaic, a late 19th-century French landscape. This diversity was justified, according to Bell, because the central problem of aesthetics was to discover the quality that was common to all works of art, a quality that distinguished art as art. He termed this quality "significant form." Effective arrangements of form, color, and line create

6.26 Gertrude Käsebier: *Portrait of Alfred Stieglitz,* 1902
Gum bichromate platinum print on tissue, 11¾ × 9⅛ in. (29.8 × 23.1 cm.)
The Museum of Modern Art, New York

strong emotions in the viewer. The representative element is secondary, and often gets in the way of the full appreciation of significant form.

Bell also maintained an almost messianic belief in the power of art. Echoing the elitist theories of Herbert Spencer (see p. 288), Bell argued that art could prove to be the salvation of the world through its ability to promote aesthetic emotion. Those few who had access to aesthetic ecstasy could lead the rest of humanity. At the same time, Bell was trying to break down the snobbery of the British art world by looking for "objective" bases for aesthetic judgments through attention to the object itself, rather than through impressionistic storytelling. He also rejected the art hierarchy that separated Western art forms from those of non-Western cultures, available to Europeans through centuries of colonialism. For Bell, all art works contained the potential for significant form. Still, according to Bell, only an elite group would be able to distinguish this form.

One of the major proponents of the theories of Fry and Bell in the United States in the first part of the 20th century was Alfred Stieglitz (1864–1946) [6.26]. Stieglitz had first studied photography in Germany in the 1880s, returning to New York in 1890 to embark on a career as a photographer with impressionistic city views. As editor of *Camera Notes*, he played a key role in promoting photography as an art form and in the founding of the group known as the Photo-Secession in 1902. In 1905 he opened his Little Galleries of the Photo-Secession, better known as 291 (from its address, 291 Fifth Avenue), in New York

City. The Little Galleries was set up as headquarters for the group and as a home for Stieglitz's new journal *Camera Work* [6.27], which began publication in 1903 (it remained in print until 1917).

Most members of the group, including Edward Steichen (1879–1973) and Gertrude Käsebier (1852–1934), initially attempted to replicate the effects of painting in their photographs, a practice that gained them the label Pictorialists (the group's first show was titled "An Exhibition of American Pictorial Photography Arranged by the Photo-Secession"). This is evident in Käsebier's *Portrait of Alfred Stieglitz* (1902) [6.26] and Steichen's *Rodin with His Sculptures "Victor Hugo" and "The Thinker"* (1902) [6.27]. Both Steichen and Käsebier had been trained as painters and thought that making photographs that looked like paintings, largely through manipulation of the photographic negative, would raise the status of the medium within the art world. While Stieglitz shared this tactic in his early work, he soon shifted to what he termed "straight" photography, eschewing any alteration of the negative. One of his first efforts in this regard was *The Steerage* (1907) [6.28], taken on a transatlantic voyage in 1907. According to Stieglitz, what appealed to him in this image was the juxtaposition of several different shapes: "a round hat; the funnel leaning left, the stairway leaning right, the white drawbridge with its railings made of circular chains—white suspenders crossing on the back of a man in the steerage below, round shapes of iron machinery, a mast cutting into the sky, making a triangular shape." He developed the negative in full, with no cropping or surface manipulation.

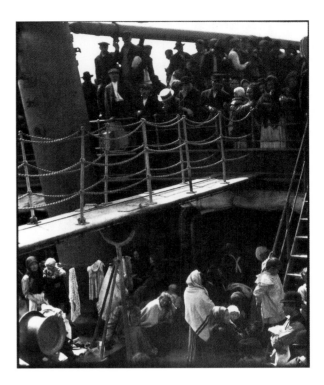

6.28 Alfred Stieglitz: *The Steerage*, 1907
Photograph
Library of Congress, Washington, D.C.

While photography was important to Stieglitz, he was also committed to promoting the work of Modernist painters and sculptors. In January of 1908 he showed a series of drawings by Rodin and in April of that same year staged an exhibition of the drawings of the French artist Henri Matisse. The critical reception of this work was mixed, with the most favorable comments directed at the Rodin drawings, for, as mentioned earlier, by 1908 Rodin was already recognized as an important European sculptor. A more negative reception met a 1909 exhibition of the work of the Americans Arthur B. Carles, Edward Steichen, Arthur Dove, John Marin, Max Weber, Marsden Hartley, and Alfred H. Mauer.

In keeping with Fry and Bell, Stieglitz argued that there was a great and unbridgeable gap between true art and society, and that the fault lay with society, which was unappreciative of the best of art. Stieglitz's solution was not to try to close the gap between art and society, but to foster individual artistic creativity in isolation (fortunately, he was able to provide artists with some financial support). He saw art, and in particular the Modernist art being produced by those like Rodin and Matisse, as the only true expression of the individual in an increasingly mechanized society. Of course, even with the support of wealthy patrons, Modernist artists still needed and wanted recognition from the public, if only a small portion of that public. The fact that exhibitions of their work were often met with

6.27 Edward Steichen: *Rodin with His Sculptures "Victor Hugo" and "The Thinker,"* 1902
Photogravure, from *Camera Work*, 1905
Morris Library, University of Delaware, Newark, Delaware
Reprinted with the permission of Joanna T. Steichen

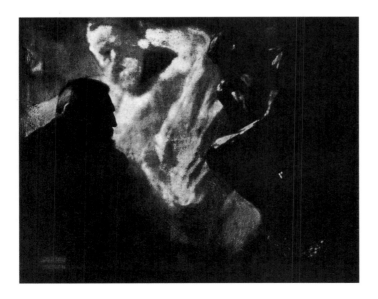

outrage was seen as proof of the philistine nature of the public, rather than of any problem with the works themselves.

In 1914, the same year Bell published his book *Art*, Stieglitz hosted an exhibition of African art at 291. The development of a generalized theory of significant form allowed objects from different countries to be included under one overarching aesthetic system. This facilitated the presentation of African and Native American works in art galleries and not just in museums of natural history. Native American objects in the Smithsonian Institution in Washington and the Museum of Natural History in New York reflected the efforts of anthropologists and politicians to record and categorize cultures that were under threat. African objects in European museums reflected early exploration and later colonial empires. Artists in Europe and the United States now saw in these objects an elegance of form, an exoticism that answered their search for an alternative to the tradition of naturalistic representation that had so dominated Western art. This focus on highly abstracted and, to many, exotic forms was further enhanced by the growing popularity of the theories of the unconscious promoted by the psychiatrists Sigmund Freud and Carl Jung. Jung, in particular, in such works as *Psychology of the Unconscious* (1912), spoke of a collective unconscious shared by all human beings, thus sparking a search for common symbols. As non-industrialized nations were seen as closer to nature, artists turned to the rituals and visual cultures of these nations to find their collective symbols.

In the early years of 291, the gallery functioned as a gathering place for a small group of American painters, including Max Weber and Arthur Dove. These artists had begun their careers in the United States and traveled to Europe for a brief period of study. Max Weber (1881–1961) studied with Jean-Paul Laurens and Henri Matisse in Paris from 1905 to 1908 and experimented with the latter's brilliant colors and with the Cubist fragmenting of space found in the work of Pablo Picasso. In *Rush Hour, New York* (1915) [6.1] he conveys the agitated movement of downtown New York through jagged, repeated forms that contain only vague references to architectural structures. Such experiments with movement were being carried out in Europe by several artists, most importantly the Italian Futurists, whose celebration of dynamism and speed was captured in Filippo Tommaso Marinetti's "Futurist Manifesto," published in Paris in 1909.

Weber's use of color in this work also suggests a familiarity with the paintings of two Americans living in Paris at the time, Morgan Russell (1886–1963) [6.29] and Stanton Macdonald-Wright (1890–1973) [6.30]. In their experiments, which came to be known as Synchromism, Macdonald-Wright and Russell engaged with the ideas of many artists and theorists—the

6.29 Morgan Russell: *Synchromy in Orange: To Form*, 1913–14
Oil on canvas, 135 × 123 in. (343 × 312 cm.)
The Albright-Knox Art Gallery, Buffalo, New York

painter Robert Delaunay, the scientists Eugène Chevreul and Herman von Helmholtz—who were searching for a way in which to present pure color, detached from any representative form yet able to convey particular emotions or sensations. With paintings devoid of recognizable imagery—examples are

6.30 Stanton Macdonald-Wright: *Abstraction on Spectrum (Organization, 5)*, 1914–17
Oil on canvas, 30⅛ × 24³⁄₁₆ in. (76.5 × 61.4 cm.)
Des Moines Art Center, Des Moines, Iowa

6.31 Arthur Dove: *Nature Symbolized No. 2*, 1911–14
Pastel on paper, 18 × 21 ⅜ in. (45.8 × 55 cm.)
The Art Institute of Chicago, Chicago, Illinois

Russell's *Synchromy in Orange: To Form* (1913–14) [6.29] and Macdonald-Wright's *Abstraction on Spectrum (Organization, 5)* (1914–17) [6.30]—they joined the early ranks of those who created pure abstractions. Their first joint exhibition was held in Munich in 1913, when they issued their Synchromist manifesto. They showed their work in New York the following year, when Weber may well have seen it.

Arthur Dove (1880–1946) also took up the language of abstraction, although he maintained clearer references to the natural world than Weber, Macdonald-Wright, and Russell. After his return to New York in 1910 from a trip to Paris, he created paintings such as *Nature Symbolized No. 2* (1911–14) [6.31] that were filled with organic shapes that evoked nature without transcribing it. Dove described the manner in which he worked as follows:

> one day I made a drawing of a hillside I chose three
> forms from the planes on the sides of trees, and three
> colors, and black and white. From these was made a
> rhythmic painting which expressed the spirit of the whole
> thing. The colors were chosen to express the substances
> of those objects and the sky. There was the earth color,
> the green of the trees, and the cyan blue of the sky.

Thus he drew the colors and lines from objects in nature, but then transformed them into abstract shapes that he felt conveyed the sentiment or mood of a particular fragment of the natural world.

The Armory Show and the Paterson Strike Pageant

In 1913, the year of Macdonald-Wright's and Russell's Munich show, another groundbreaking exhibition was held: the International Exhibition of Modern Art, staged in New York at the 69th Regiment Armory from February 17 to March 15 [6.32]. Many historians and critics at the time, and since, have pointed to what became known as the Armory Show as a turning point in American art. It was organized by the Association of American Painters and Sculptors, founded in 1911, and was intended as an opportunity to present to the public the most recent developments in America. As a challenge to the traditionalism of the National Academy of Design, it included the work of both Ashcan School artists and artists in the Stieglitz circle. Ultimately, however, it took on an international flavor due to the desire of the president of the association, Arthur B. Davies, to include contemporary European work. While Davies himself produced dreamlike classical landscapes [6.7], he was well aware of the work of Modernist artists on both sides of the Atlantic and interested in promoting it. The painter Walt Kuhn was another key player in the organization of the show. He traveled with Davies throughout Europe and, with the aid of the critic Walter Pach and the painter Alfred Mauer, selected the European works to be included.

Despite the fact that over three-quarters of the approximately 1,300 works in the exhibition were by artists from the United States, the paintings and sculpture of the Europeans took center stage in the popular press. These included what has

6.32 Walter Pach: *Interior View of the International Exhibition of Modern Art, 69th Regiment Armory, New York*, 1913
Photograph
The Museum of Modern Art, New York

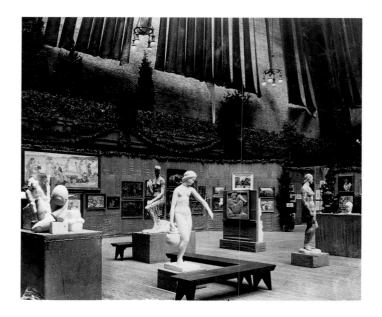

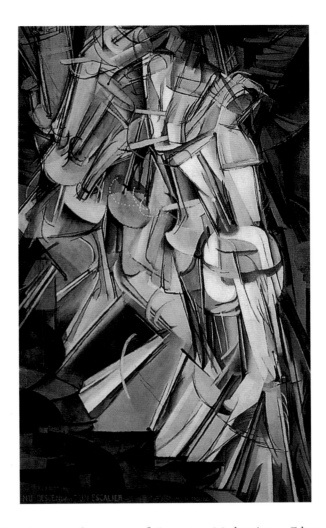

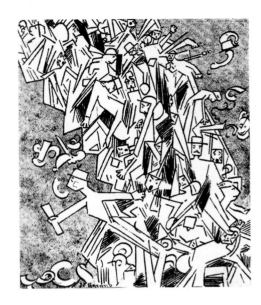

6.33 (left) Marcel Duchamp: *Nude Descending a Staircase, No. 2*, 1912
Oil on canvas, 57½ × 35⅛ in. (146 × 89.4 cm.)
The Philadelphia Museum of Art, Philadelphia, Pennsylvania

6.34 (above) *The Rude Descending the Staircase (Rush Hour at the Subway)*,
illustrating "Seeing New York with a Cubist" in the *New York Evening Sun*,
March 20, 1913

since become the canon of European Modernism—Edouard
Manet, Claude Monet, Edgar Degas, Georges Seurat, Henri de
Toulouse-Lautrec, Odilon Redon, Auguste Renoir, Auguste Rodin,
Paul Cézanne, Vincent van Gogh, Paul Gauguin, Pablo Picasso,
Henri Matisse, André Derain, Georges Braque, Marcel Duchamp,
Ferdinand Léger, Vassily Kandinsky, Constantin Brancusi, and
many others. The critical response was primarily one of outrage
at the distortion of form, intensity of color, and looseness of
execution. Duchamp came in for particularly vitriolic treatment
with his *Nude Descending a Staircase, No. 2* (1912) [6.33]. One of
the many cartoons lampooning the painting was *The Rude
Descending the Staircase (Rush Hour at the Subway)*, which
appeared in the *New York Evening Sun* [6.34]. Yet in spite of, or
perhaps because of, the controversy, over 250,000 people paid
to see the exhibition in its three venues—New York, Chicago, and
Boston. Many collectors purchased several of the European
works, including practically all of the 30 Cubist paintings, and
over 300 pictures in all, both American and European, were
sold. Over the next few years increasing numbers of galleries
and museums opened their doors to both European and

American Modernism. As the art historian Milton Brown has
noted, "Modernism had been shown and it was to have its effect
on America, in spite of the ridicule heaped upon it."

In reviewing the Armory Show for the *New York Herald*, the
art critic Royal Cortissoz proclaimed: "The United States is
invaded by aliens, thousands of whom constitute so many
perils to the health of the body politic. Modernism is of precisely
the same heterogeneous alien origin and is imperiling the
republic of art in the same way." This association between Mod-
ernism and foreigners, as well as political radicals, would
continue throughout the first half of the 20th century, just as
"aliens" would be accused of causing whatever economic or
social catastrophe happened to befall the nation. Certainly the
massive immigration from southern and eastern Europe in the
last decades of the 19th century and the first decades of the 20th
century, and the growth of the Socialist Party and labor unions,
increased the concerns of Americans whose roots lay in the
northern countries of Europe that they were losing cultural,
political, and economic control of the country.

Shortly after the close of the Armory Show another cultural
event opened at Madison Square Garden that would have rein-
forced those concerns. In January 1913 textile workers in
Paterson, New Jersey, went on strike, with the organizational
help of the radical Industrial Workers of the World (IWW), a
labor federation founded in 1905 in Chicago. On June 7, twelve

hundred strikers staged a performance in Madison Square Garden in front of a crowd of fifteen to sixteen thousand people in which they acted out their current struggles and the demands they were making of the textile company owners. Robert Edmond Jones (1887–1954) produced a powerful poster for the event [6.35], which recalls the Ludlow Massacre drawing by John Sloan [6.18], and emerges out of the same tradition of political graphics.

The Paterson Pageant was organized not by the workers themselves but by a group of Greenwich Village intellectuals and artists that included the wealthy socialite Mabel Dodge, the writers Walter Lippman and John Reed, and John Sloan (Dodge was also involved in the organization of the Armory Show). Reed directed the pageant, while Sloan painted the backdrop. The strike leader, Elizabeth Gurley Flynn, called the pageant "a unique form of proletarian art." Yet she also thought that it

6.35 Robert Edmond Jones: *The Pageant of the Paterson Strike*, 1913
Poster
The Tamiment Institute Library, New York University, New York

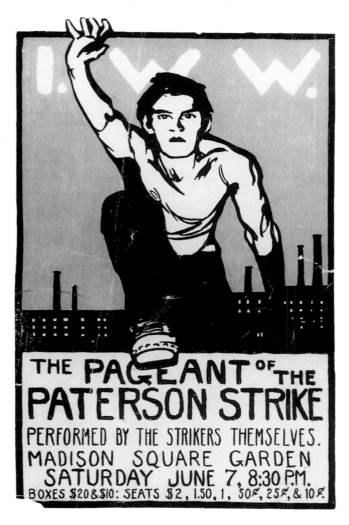

might actually have harmed the struggle of the textile workers, first by creating jealousy among them as to who would take part, and second by distracting attention from the strike itself. In the end the pageant lost rather than made money for the union, and although it certainly increased public sympathy, the strike ended badly for the workers a month later.

World War I and the Art of Reproduction

Selling and Protesting the War: World War I Posters and "The Masses"

The year following the Armory show and the Paterson Pageant, war broke out in Europe. By the time it was over, four years later, ten million people had died and the lives of countless others had been altered forever. The material costs of this war, estimated at over a third of a trillion dollars, devastated the economies of nations throughout the world and played a decisive role in the emergence of the Great Depression of the 1930s. Political boundaries and international power relations were transformed and internal political revolutions fostered—the Soviet Revolution in Russia, the Fascist movement in Italy, and the National Socialist movement in Germany. The latter contributed directly to the outbreak of a second global conflict two decades later.

The United States did not enter World War I until April 6, 1917. The war not only advanced the rise of American military power and the arms industry but also strengthened efforts to homogenize an ethnically diverse population. It also gave the government an additional rationale for persecuting those who dared question its actions. *The Masses* had its mailing license revoked under the Espionage Act of June 15, passed to prevent foreign subversion but quickly used to suppress left-wing periodicals, and ceased publication in December. Its crime had been to criticize those who stood to benefit from the war. Art Young's *Having Their Fling* [6.36], published in the September issue, summarized this criticism. It was brought into court as evidence in the April 1918 trial of Young and several other *Masses* staff members for "conspiring to obstruct enlistment." When asked to justify the drawing, Young stated that he was simply illustrating General Sherman's comment: "war is hell."

The censorship of the left-wing press attests to the importance and power of imagery in the formation of public opinion. In order to encourage domestic support for the war, President Wilson created the Committee on Public Information. Within this committee was the Division of Pictorial Publicity, which was responsible for the production of over 700 posters, 400 cards and designs for newspaper publicity, and almost 300 cartoons. The Division focused on two themes, enlistment and

Posters were particularly well suited to the economic and political competition that emerged with the development of industrialized nation states, and were used to sell both products and patriotism, as well as to attack one's enemies. Designers expressed this praise and patriotism through a variety of styles, ranging from academic realism to a decorative Art Nouveau to a simplified modernism. As the 20th century progressed, market research proved the simpler styles to be the most effective, as they were easily readable at a glance, a quality increasingly necessary in a fast-paced world.

All of the major players in World War I used posters heavily as propaganda both during and after the war. In order to inspire people to enlist or buy bonds, these posters showed the enemy as a monster and often played upon sexual anxieties. H. R. Hopps drew the two themes together in his *Destroy This Mad Brute* (*c.* 1917) [**6.37**]. This work resembles a circus poster and shows

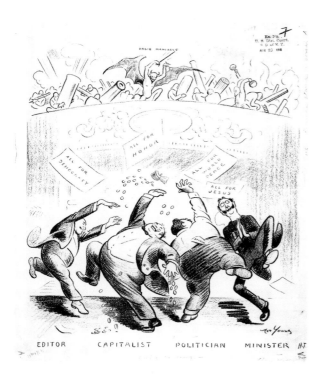

6.36 Art Young: *Having Their Fling* (published in *The Masses*, September 1917)
Crayon and graphite on board, 17⅞ × 14¹³⁄₁₆ in. (45.7 × 38.1 cm.)
Argosy Gallery, New York

bond buying. The first was needed in order to provide the human bodies to wage the war, the second the materiel—guns, food, clothing—that would enable these bodies to fight. Broadsheets, posters, and billboards publicized appeals for four Liberty Loans and one Victory Loan.

The posters drew on relatively new developments in public images. Broadsheets or handbills had existed in the United States since at least the 18th century (see p. 83) and had been used by the military to recruit and by local governments to inform its citizenry of various events. During the 19th century, however, certain technological, social, economic, and political developments influenced the look and the pervasiveness of public images. In a study of war and revolution posters, Peter Paret, Beth Irwin Lewis, and Paul Paret note that "the introduction of inexpensive, multi-copy processes of color printing and the development of bright printer's inks made posters technically feasible; the change from a traditional, largely rural way of life to the mobile mass societies of the industrial age made them economically desirable and at times even necessary." While handbills had been a relatively minor aspect of everyday life at the end of the 18th century, a hundred years later "the poster had grown into a permanent visual and psychological presence for the tens, and eventually hundreds, of millions of potential viewers that constitute modern society."

6.37 H. R. Hopps: *Destroy This Mad Brute*, c. 1917
Poster
Hoover Institution on War, Revolution and Peace, Stanford University, California

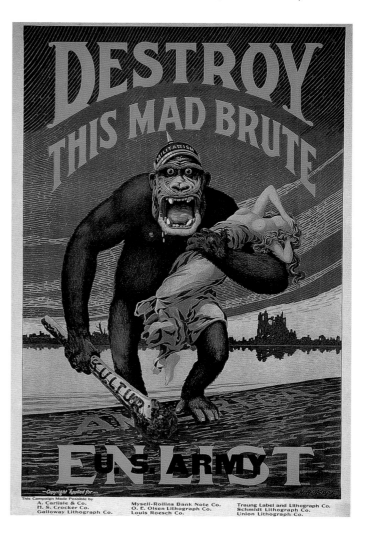

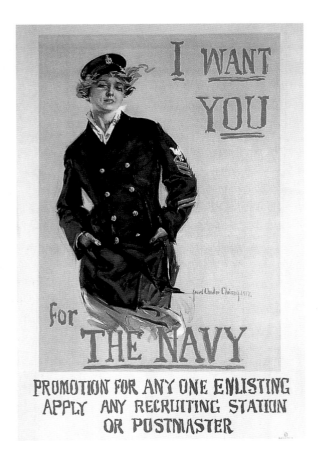

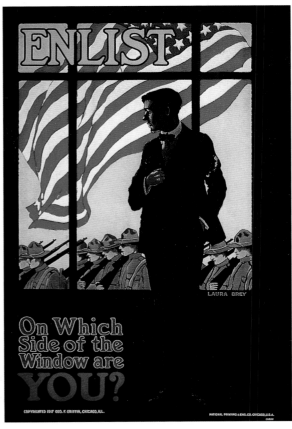

the German, recognizable by his spiked helmet, as the monster of militarism, out to rape America's women and destroy its cities after having wreaked havoc in Europe. Civilization is represented by the blond maiden in classical garb; savagery by the hairy brute carrying the blood-stained club of German "Kultur." While Art Young also condemned militarism as a major cause of war, he recognized the connections between militarism and capitalism and did not limit his condemnation to Germany alone.

Howard Chandler Christy (1873–1952) produced a series of provocative "Christy girl" recruiting posters, such as *I Want You for the Navy* (1917) [6.38], which linked the thrill of war and the terror of carnage and death with sex. Laura Brey also called up male anxieties, but in a different way, with her *Enlist. On Which Side of the Window Are You?* (1917) [6.39]: as the Paret and Lewis study points out, private space is depicted as feminine and public space as masculine, thus suggesting the effeminacy of the man who does not enlist.

The images found in *The Masses* are strikingly different from these official posters, and the contrast makes it easier to understand why government officials would want them removed

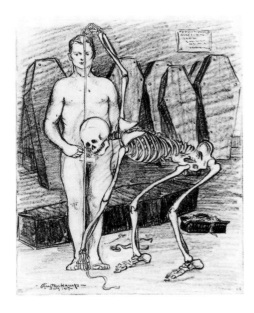

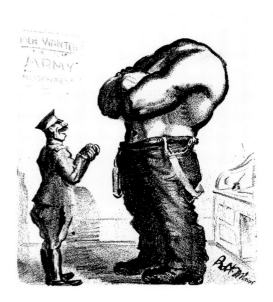

6.41 Robert Minor: *Army Medical Examiner: "At last, a perfect soldier!,"* back cover of *The Masses*, July 1916

from public view. *Physically Fit* [6.40] by Henry Glintenkamp (1887–1946), which appeared in October 1917, shows an innocent-looking naked man being measured for a coffin by Death. The drawing was provoked by a story that the army was placing bulk orders for coffins. An earlier issue parodied the heroism portrayed in official recruiting posters with *Army Medical Examiner: "At last, a perfect soldier!"* [6.41] by Robert Minor (1884–1952). The works of Young, Glintenkamp, Minor, and many other artists on the staff raised crucial questions about the nature of the war and the interests of those who insisted on fighting it.

Rethinking Reproduction: Marcel Duchamp

World War I also had another effect on the art world in the United States. It brought to this country several European artists who were unwilling to take up the roles of soldier or support personnel, and who voiced their critiques of war through a critique of rationalism and Enlightenment thinking in general. The artist who would have the most long-lasting effect was Marcel Duchamp (1887–1968). While Duchamp was exempted from the draft in France due to a minor heart condition, he still found the escalation of war fever and the taunts of those who questioned his patriotism unsettling, and he sailed for New York in June 1915. Duchamp had already established his notoriety with his *Nude Descending a Staircase, No. 2* [6.33], which was purchased after the Armory Show closed by the San Francisco antique and print dealer Frederick C. Torrey. Assailed by reporters as he descended the gangplank, he was guided through the

crowd by Walter Pach to the home of Louise and Walter Arensberg, wealthy collectors who had themselves only recently settled in the city. Their home soon became the center of a group of artists and intellectuals that included the French émigrés Albert Gleizes and Francis Picabia, and the American painters Marsden Hartley and Charles Sheeler. In 1919 Walter Arensberg purchased *Nude Descending a Staircase, No. 2* from Torrey.

Duchamp and Picabia, who also exhibited at the Armory Show, launched the New York branch of the Dada movement. Historians have identified Dada as an art of protest against World War I. Those who joined the movement and who gathered in New York, Zurich, Paris, and Berlin claimed that art as a significant ongoing form of social action was dead. With the rise to power of individuals bent on national suicide, it could no longer serve to understand and organize the world. Dada poetry and visual art focused on the irrational and nonsensical. The movement's name meant "yes, yes" in Romanian and Russian and "hobbyhorse" in French, and suggested the babbling of a young child.

Duchamp did more, however, than simply engage in the production of the nonsensical. Rather, in the words of the literary scholar Dalia Judovitz, he questioned "the traditional categories that have defined the notion of the art object, the creative act, and the position of the artist." In particular, Duchamp reexamined artistic production "as a function of reproduction," be it of specific previous works or of the artistic conventions that define such works. He also revealed how art works are embedded in institutional frameworks—galleries, auction houses, etc.—that determine the works' meaning as art. For Duchamp, writes Judovitz, "mechanical reproduction becomes the paradigm for a new way of thinking about artistic production, one that recognizes that creativity operates in a field of givens, of ready-made rules."

Duchamp's interest in the process of reproduction was historically grounded. All around him in France and, later, in New York, were reproductions—war posters, theater posters, advertisements—, the result of a burgeoning consumer society. This interest was also grounded in his own past. Like members of the Ashcan School, Duchamp began his artistic career within the realm of commercial art. After a year at the Académie Julian in 1904–5, he was apprenticed to a printer in lieu of military service. Then, from 1905 to 1910, he produced cartoons for two newspapers, *Courrier Français* and *Le Rire*. Like the Ashcan artists, he continued to paint while executing his commercial art, a combination of activities that heightened his understanding of the various frames of reference—newspapers, galleries— within which pictorial images could be viewed and the varying responses of the public based on these frames of reference.

From experiments with the bright colors of Fauvism and the spatial reorganization of Cézanne, Duchamp moved to the discoveries of Cubism, with its further spatial fragmentation. *Nude Descending a Staircase, No. 2* [6.33] marked his entrance into the Parisian art world as a painter, no doubt in part because the work was rejected by the Salon des Indépendants in 1912 and then chosen for the Armory Show of the following year, where it garnered considerable media attention. At this point, however, at what one might consider the beginning of an illustrious career as a painter, Duchamp abandoned conventional painting. He began, instead, experimenting with chance and with its seeming opposite, precise mechanical drawings. Both call into question the well-established notion of the artist as autonomous producer and of the art work as an intentional result of creative activity. Thus, while the Ashcan artists turned from the realm of the ideal to the world around them as a result of their work as illustrators for newspapers, Duchamp's immersion in the realm of commercial reproduction led him to question, as Judovitz puts it, "the creative function of the artist and the meaning of art as a form of making."

Duchamp was interested increasingly in the conceptual, as opposed to manual and visual, aspects of the creative act. To this end, he created *Nude Descending a Staircase, No. 3* in 1916, a full-sized hand-colored photographic facsimile of *Nude Descending a Staircase, No. 2*. Here the nude as an artistic convention completes its descent from the pedestal of artistic tradition. It appears not only as a standing, active figure (nudes are more often shown reclining or passive) and as a denaturalized, fragmented body (thus resisting the voyeurism embedded in the tradition of the nude), but also as a reproduction, clearly referencing the earlier works by its numerical designation while claiming, at the same time, to be different. Artistic creativity has become an intellectual, as well as visual, experience, "a form of production based on reproduction."

Duchamp is probably best known for his introduction into the world of art of the ready-made, a term he first used during his initial visit to New York and which he defined in 1968 as "a work of art without an artist to make it." The work is "already" made as a physical object, but remains to be "made" into art through a process outside of the current artistic conventions. A urinal—titled *Fountain* (1917) [6.42]—, a bottle rack, and a bicycle wheel enter into the world of art through their physical displacement from the public toilet and restaurant and street to the artist's studio and, eventually, to the art gallery. They are not simply placed as is, however. Instead, Duchamp denies their functionality by altering not only their physical location but their positioning. The bicycle fork is screwed into the top of a kitchen stool, allowing the wheel to rotate freely; the bottle rack

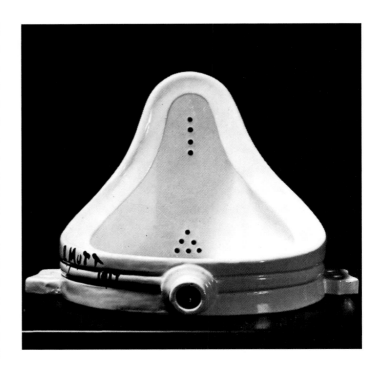

6.42 Marcel Duchamp: *Fountain*, 1917 (version of 1964)
Ceramic, H 24⅝ in. (62.2 cm.)
The Philadelphia Museum of Art, Philadelphia, Pennsylvania

is hung from the ceiling; the urinal is laid on its back. By signing *Fountain* "R. Mutt", Duchamp raised further questions about authorship and individuality as hallmarks of the accepted definition of art.

Duchamp's claim of artistic status for the urinal was denied in 1917 by the Society of Independent Artists, of which he was a founding member, when he submitted the work for inclusion in the group's inaugural exhibition. As the art historian David Reed points out, the absence of a jury and the hanging of all works in alphabetical order was supposed to guarantee the democratic nature of the show. It is not clear if other members of the hanging committee besides Duchamp, who was its chair, knew he had submitted *Fountain*, and he didn't tell them, but it is clear that they did not know what to make of it, and simply placed it out of view behind a partition for the duration of the exhibition. Duchamp parted with the organization soon after.

The art historian Wanda Corn points to another series of meanings invested in Duchamp's *Fountain*, ones dependent upon the artist's position as a vocal advocate of *américanisme*, a fascination with America that was beginning to take hold in intellectual circles in Europe during the war. The United States was admired not for its "fine" artists but for its engineers and purveyors of popular culture. The accomplishments of American engineers were most often celebrated in two areas, bridges

and plumbing, while producers of popular culture were lauded for their comic books and advertising imagery.

Fountain is literally a representation of the wonders of American plumbing. Duchamp probably bought the "fountain" at Mott Works, a plumbing manufacturer in New York City. Yet rather than sign it "R. Mott," he changed the last name to "Mutt," a reference to the popular cartoon strip "Mutt and Jeff." The "R" stood for Richard, which, in French, means "fat cat" or "moneybags." Thus, Duchamp encoded his *Fountain* with multiple references to the America of which many Europeans were enamored: a world of fine plumbing, imaginative popular culture, and vast wealth. The title also creates a contrast between the historical public fountains of Europe and the modern, private "fountains" of America.

This set of references within *Fountain* was especially significant because of a competing claim regarding the sources of American Modernism being issued at the same time by Stieglitz and the small group of artists that constituted what Corn calls his "second circle." During World War I, Stieglitz turned away from exhibiting the work of European Modernists and focused, instead, on five native-born American artists— John Marin, Paul Strand, Arthur Dove, Marsden Hartley, and Georgia O'Keeffe—as well as his own work (Charles Demuth was occasionally included in this circle). As a group, these artists espoused a form of cultural nationalism that rejected industrial and popular culture and advocated, instead, an "organic aesthetic" as the basis for a true, American Modernist art (Stieglitz named his last gallery, founded in 1929, An American Place). They thought that through representations of natural forms, art could help heal the emotional wounds caused by society's enslavement to material goods. Their campaign took on, at times, the tenor of a religious crusade.

While they continued to claim that modern artists must work in isolation from the larger, commercialized society, they were also intensely critical of the status quo. They stood opposed to the celebration of American cities, technology, and popular culture promoted by European artists like Duchamp and Picabia and American artists like Charles Sheeler and Stuart Davis, as well as the Ashcan School. When Duchamp submitted *Fountain* to the Society of Independent Artists in 1917, therefore, he, in Corn's words, "threw down the glove to any New York Modernist who envisioned a spiritualized American art of light, landscape, and inner feelings." Stieglitz certainly was aware of this challenge. The photograph of *Fountain* that appeared in the May 1917 issue of Duchamp's magazine *Blind Man* was taken by Stieglitz at his studio in front of a painting by Marsden Hartley. Stieglitz, O'Keeffe, Marin, and Strand would also turn their attention, at times, to the

depiction of the urban landscape, yet even here they showed not what they would have described as the "vulgar" aspects of city life, but the beautiful and sometimes organic quality of urban forms [7.16, 7.17].

Duchamp thus helped galvanize a debate during the late 1910s and 1920s about the direction Modernist art was to take in America in the 20th century. While he pointed to American technology and popular culture as sources for art, he also proposed a radical approach to the very definition of art itself. His primary interest appeared to be not the transformation of an ordinary, mass-produced object into a work of art through the touch of the artist, but, in his own words, the creation of "a new thought for that object." He was interested in discovering what allowed one object to be called art and another similar object not. He did not want to deny art-making as an activity, but to rethink the conditions of artistic production. Looking back on his career, Duchamp stated that he was "against this attitude of reverence the world has [for art]. Art, etymologically speaking, means to 'make.' Everybody is making, not only artists, and maybe in coming centuries there will be a making without the noticing."

Despite his best intentions, however, Duchamp could not "make" without being noticed, at least by a small group of critics and collectors in New York City and Los Angeles in the 1910s and 1920s and, at mid-century, by growing numbers of art historians and critics who saw his early gestures as precursors of a broader questioning of artistic activity that took hold in the second half of the century. Duchamp himself fueled this interest by authorizing reproductions of *Fountain* and other works, which were sold for large sums of money. Soon people were seeing him as the Midas of the art world, turning whatever he touched into a valuable art commodity. This was, according to Reed, the ultimate irony.

> The man who wished to "make works which are not works of 'art,'" to deflate the pretensions of the artist, became the man who inflated the domain of the artist by, apparently, revealing that this magic individual could name anything as a charismatic receptacle of his notions without fear of common sense or contradiction.

Modernism, Gender, and Sexuality

The (Homo)Sexual Male Body

Critics and art historians today have also credited Duchamp with initiating a particularly sophisticated and playful critique of gender. In *L.H.O.O.Q.* (1919) [6.43], by putting a moustache and goatee on the face of the *Mona Lisa*, with her low-cut dress and cleavage, he played with signifiers of male and female while

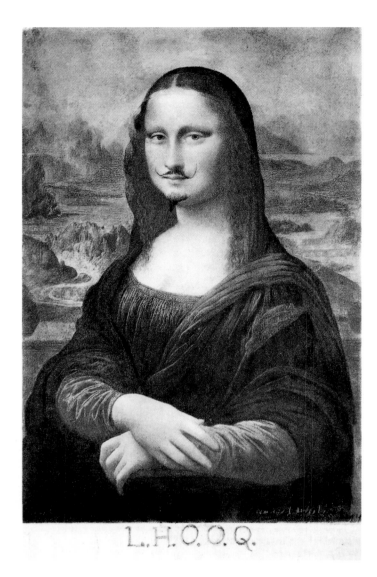

6.44 Man Ray: *Marcel Duchamp as Rrose Sélavy*, 1920–22
Photograph
The Philadelphia Museum of Art, Philadelphia, Pennsylvania

This donning of women's clothing made explicit reference to the most public form of expression of contemporary gay subculture: cross-dressing. Drag balls were common in the 1920s, attended primarily by homosexual men who, behind the protection of a costume, and sometimes a mask, could dance with other men. The art historian Jonathan Weinberg notes that such balls were tolerated in New York because they confirmed the stereotype of the homosexual as effeminate, making heterosexual men feel securely different. Duchamp, however, had affairs with women, and wore women's clothing "not on the way to a masquerade but on the cover of an art magazine, *New York Dada*." His challenge to the boundaries of gender was thus also a challenge to the heterosexual stereotypes of homosexuality.

Weinberg also looks closely at two American artists, Charles Demuth (1883–1935) and Marsden Hartley (1877–1943), at how their sexual orientation affected their work and their lives within the art world of New York City. He argues that they were doubly marginalized, as both homosexuals and avant-garde artists, and struggled to reconcile the representation of these particular forms of marginalization with the production of an art that was distinctly "American."

By the beginning of the 20th century "homosexuality" was a term used to indicate not only one's sexual partner, but also one's identity. The concern to define homosexuality came from both a desire by heterosexuals to control those they deemed "different" and a desire by homosexuals to liberate themselves, to create a sense of self. Crucial to the discussion of homosexuality were the works of a number of medical professionals, who

6.43 Marcel Duchamp: *L.H.O.O.Q.*, 1919
Pencil on a reproduction, 7¾ × 4⅞ in. (19.7 × 12.4 cm.)
Private collection

at the same time calling into question the cult of originality and the veneration of cultural icons. Here his interest in punning and word play is also evident. In pronouncing the letters of the title, one finds oneself voicing a sentence in French that suggests "she has a hot ass" ("elle a chaud au cul"). The following year Duchamp again complicated gender identity by transforming himself into his female alter ego Rrose Sélavy, captured in the early 1920s by the American photographer Man Ray (Emmanuel Radnitzky) (1890–1976) [**6.44**]. As with *L.H.O.O.Q.*, the choice of name added to the sexual tension of the image—"Rrose Sélavy" translates as "Eros, c'est la vie," or "Eros, that's life." Thus, Duchamp's play with the mutability of gender coincided with his questioning of a stable artistic identity.

began writing more systematically on the topic at the turn of the century. The German psychiatrist Richard von Krafft-Ebing and others defined those who engaged in same-sex acts as "inverts," the result of biological or psychological aberration. The English psychologist Havelock Ellis believed that human beings were basically bisexual and that they became heterosexual or homosexual as a result of social conditioning. Sigmund Freud shared this view, but also argued that homosexual desires were often repressed and appeared in the form of neuroses, an opinion that allowed for a more open discussion yet also increased fears of "contagion." While the proliferation of texts about homosexuality "contained the potential for group identification and protest," writes Weinberg, it "also allowed society to point to particular persons with the certainty that they were other." The trial and imprisonment of Oscar Wilde in London in 1895 placed homosexuality in the public eye in Europe and the United States as both a sexual practice and a crime. Lesbianism, however, was ignored. It appeared that those who formulated the law could not, or did not want to, acknowledge its existence even in order to criminalize it.

Demuth's work falls into three general categories, distinguished by style, subject-matter, and audience: in the first category are figure paintings, in the second semi-abstract portraits and architectural subjects, and in the third still lifes. The figure paintings, most often in watercolor, depict acrobats, vaudeville scenes and nightclubs—and also sailors, domestic interiors and bathhouses, subjects that allowed for more explicit references to homosexuality and that were produced primarily for a like-minded audience. *Turkish Baths with Self-Portrait* (1916) [**6.45**] is a thinly veiled image of male eroticism in a site increasingly associated with homosexual activity. Demuth's interest in bathhouses may have been the result of his travels in Europe from 1912 to 1914, where he would have encountered a more open attitude toward, although not total acceptance of, homosexuality. He frequented the Paris home of the lesbian couple Gertrude Stein and Alice B. Toklas and visited friends of Marsden Hartley in Berlin. In Demuth's *Eight O'Clock* series, and in most of the Turkish bath works, the men are presented, in Weinberg's words, "in danger of stepping over the line of what is permissible." The images emphasize the anonymous encounters, the illicit sexual meetings in public places that were so much a part of gay life. Demuth makes visible what was normally meant to be invisible, and in doing so he took certain risks. Homosexuals were constantly subject to threats of blackmail, and exposure could both ruin their reputations and land them in jail.

The second category of work by Demuth includes semi-abstract poster portraits—combinations of objects and words indicative of a particular individual's life—and compositions

6.45 Charles Demuth: *Turkish Baths with Self-Portrait*, 1916
Watercolor and pencil on paper
Private collection

6.46 Charles Demuth: *My Egypt*, 1927
Oil on composition board, 35¾ × 30 in. (90.8 × 76.2 cm.)
Whitney Museum of American Art, New York

based on architecture or machinery executed in oil and tempera. These paintings were Demuth's most "Modernist" in terms of style. His depictions of machines and buildings were included with works by other artists, such as Charles Sheeler, under the rubric "Precisionist" because of the sharply focused objects and smooth surface of the paintings. In *My Egypt* (1927) [**6.46**] Demuth celebrates both modern agriculture and his own home town, where he lived with his mother. The grain elevators of Lancaster, Pennsylvania (specifically, the John W. E. Shelman Feed Company), are seen as the equivalent of the pyramids of Egypt, structures that combine both physical grandeur and spirituality. He draws on Cubism to convey this double meaning through fragmented planes that construct and at the same time veil the towering edifice. Much Precisionist art also echoed Duchamp's celebrations of technology as the symbol of a distinctly American form of Modernism. The hard-edged, streamlined forms of contemporary machinery were adopted for all manner of products, from household goods and fashion designs to painting and sculpture (see p. 382).

The third category of works by Demuth is composed of watercolor still lifes, primarily of fruits, vegetables and flowers, which were his most successful paintings within the art world and which provided him with most of his income. More conservative stylistically than his poster portraits and architectural paintings, they reflect his fascination with the natural world, with the state of plants before their processing by modern industry. These works, as Corn points out, gained him the most favor within the second Stieglitz circle, of which he was only an occasional member (Stieglitz sold several of Demuth's still lifes). This acceptance had much to do with the circle's celebration of the natural world as the source of inspiration for American Modernist art, although as both Corn and Weinberg point out, his still lifes, as well as his person, were often described as a little too "pretty," "delicate," or "feminine," words that resonated with homophobic sentiment. In 1921 the critic Paul Rosenfeld, a key supporter of members of the Stieglitz group, noted that Demuth's talent was "limited" because "there is always the suspicion of an almost feminine refinement in his wash." Demuth's poster portraits were not as well received because they contained too many references to everyday street life and advertising images. *My Egypt* may have been more acceptable because of the spiritual veil he has managed to cast over the grain elevators.

Marsden Hartley and Demuth were frequent companions from 1913 to 1917 in New York, Paris, and Provincetown, Rhode Island, and traveled together to Bermuda. While they had much in common in terms of their personal and professional interests, the two artists were different in many ways. Hartley was also drawn to the natural world, but this attraction manifested itself primarily in landscape paintings. His early life was also very different. The youngest of nine children (Demuth was an only child), he was born in a mill town in Maine, where his father was a cotton spinner (Demuth's family ran a tobacco shop). His mother died when he was eight years old, and he was raised alternately by his father and sister. A habitual theme in Hartley's painting, according to Weinberg, is the "presentation of desire in a context that included death." Even a large portion of his writing is about death. He turned to landscapes as a source of spiritual healing, investing his mountains and valleys with a vibrant energy. While Demuth lived most of his life with his mother, Hartley rarely stayed in one place for any length of time, severing relationships by his constant restlessness, or having them severed by death. In general, he had difficulty maintaining an emotional commitment, and turned this difficulty into a positive aesthetic value, claiming that great art comes about when one is able to divorce oneself from emotion. Desire and distance, two qualities that marked Hartley's personal life, also marked many of his paintings.

In 1909 Hartley became a part of Stieglitz's circle, then traveled to Paris in 1912, finding the city more conducive to his lifestyle, with a much more open display of homosexuality and cross-dressing. He was a frequent visitor, like Demuth, at the residence of Stein and Toklas. Yet he found Germany more appealing. Also in 1912 he went to Berlin, home of a homosexual liberation movement led by Magnus Hirschfeld and of an extensive network of clubs and bathhouses and relatively tolerant police. He stayed with a friend, Arnold Ronnebeck, and fell in love with Ronnebeck's cousin Karl von Freyburg. He also met members of the well-known avant-garde artists' group the *Blaue Reiter* (Blue Rider), including Vassily Kandinsky, who praised his work, and he was subsequently invited to exhibit with the group.

Hartley stayed in Germany from 1913 to 1915, becoming fascinated not only with German Expressionism but also with the German military, mixing sexuality with militarism in some of his writing. There he found a culture that was strongly male-oriented, possessing what one could call a cult of male beauty. He wrote to his friend the artist Rockwell Kent that it was masculinity that made the country so appealing to him, particularly in relation to the feminine French.

In 1914 and 1915 Hartley produced several war-related paintings, including *Portrait of a German Officer* [6.47], a memorial to von Freyburg, who was killed in October 1914. As Demuth did in his poster portraits, Hartley includes letters and symbols that create an emblematic portrait of the young officer. The letters "K v. F" refer to his name, "24" to his age, "4" to his regiment, the military insignia and flags to the German army and the war in general. Hartley called this work "Cosmic Cubism" or "Spiritual Cubism," an amalgamation of Modernist experimentation and spiritual investigation. He was fascinated by Kandinsky's work on the spiritual in art and also by the concepts of cosmic transcendence and regeneration.

Hartley exhibited his war series at Stieglitz's 291 in 1916. Some accused him of being pro-German; all saw the military content; but few, if any, noted the personal references. The portraits are like masks, both suggesting and hiding the erotic content. Hartley was able to speak more boldly of von Freyburg after his death because of a long tradition of celebrating close friendships fostered by war when mourning the death of a male friend. He was also able to speak through symbols rather than a body, and through death, rather than a live commitment. Hartley, notes Weinberg, "represents homosexual desire only to diffuse it through the multiple masks of literary obfuscation, abstract style, encoding, and death."

In the 1930s Hartley decided he would become the painter of Maine, his home state, a title Winslow Homer had captured

6.47 Marsden Hartley: *Portrait of a German Officer*, 1914
Oil on canvas, 68¼ × 41⅜ in. (173 × 105.1 cm.)
The Metropolitan Museum of Art, New York

at the end of his career with his powerful paintings of the Maine coastline. But it would be Nova Scotia, and not Maine, that gave Hartley his last significant opportunity to distinguish himself as an artist, and with paintings in which homosexuality is clearly depicted. Hartley spent two summers in the mid-1930s in a fishing community outside of Lunenburg, staying with the Mason family. The relationship ended when the two sons were drowned, but three years later he wrote a poem and completed a series of paintings on the event. In Hartley's poem one of the sons becomes "Adelard," who is described as both masculine and feminine, with a man's body and a young girl's heart, and as loving men as much as, and maybe even more than, women. This mixing of genders comes through

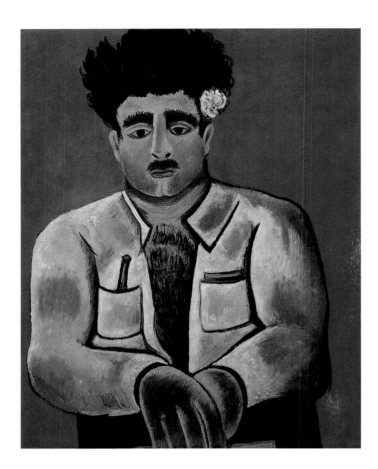

6.48 Marsden Hartley: *Adelard the Drowned, Master of the "Phantom,"*
c. 1938–39
Oil on academy board, 28 × 22 in. (71.1 × 55.9 cm.)
Frederick R. Weisman Museum of Art, University of Minnesota, Minneapolis

in the portrait of *Adelard the Drowned, Master of the "Phantom"*
(*c.* 1938–39) [**6.48**]. The broad shoulders, large hands, hairy
chest, and mustache are countered by the pensive gaze,
upswept hair, and pink flower. The deep red background adds a
sense of intense emotion, both desire and mourning. Hartley
has abandoned the obfuscation and encoding of much of his
earlier work addressing homosexuality, but not the context of
loss and death.

Figuration, Abstraction, and the Female Body

The painter Romaine Brooks (1874–1970) also devoted her
career to the depiction of the lives and looks of those engaged
in same-sex relationships. An American born in Rome into an
extremely wealthy family, Brooks inherited the family fortune
in 1902, and subsequently moved to Paris where she spent
most of the rest of her life. She met the American poet Natalie
Barney in 1915 and became part of a community of women
devoted to the production of art. (Many, like Brooks and
Barney, were able to carry on their work because they were

independently wealthy.) Brooks addresses homosexuality in
her paintings in a manner different from that of either
Demuth or Hartley. As opposed to focusing on naked, sexually
charged bodies, Brooks devotes her attention to the theme of
cross-dressing, a practice engaged in by lesbians as well as by
gay men to mark their identities. Masculinized attire also came
into vogue in the early 20th century as a statement of female
liberation and a marker of the "New Woman," but it had a very
particular meaning within the lesbian community.

This is not to say that Brooks never depicted naked women.
Early in her career she painted a series of reclining nudes, one
of the most striking of which is *The Crossing* (*c.* 1911) [**6.49**]. The
work is a haunting portrait of the dancer Ida Rubinstein, who
first appeared in Paris in 1909 in the Russian Ballet production
of *Cleopatra*, directed by Sergei Diaghilev. There she was
carried on stage wrapped in cloth like a mummy and was slowly
uncovered, emerging in a dazzling costume as the Egyptian
queen. Brooks's painting creates the impression of movement
across space, with the white sheet taking the shape of a wing.
The body is thin and pale, and the hair dissolves into the black
background. Above all there is a sense of transition, of moving
from one state to another, be it female to male, or life to
death. The decorative lines and shallow space reveal Brooks's
knowledge of the Art Nouveau styles evolving in Europe in the
early 20th century. This decorative aspect and her limited
palette also suggest an association with the work of Whistler,
of which she was certainly aware, having lived in England in
the first decade of the century. Brooks has brought together
these various lessons from contemporary European art
movements to create a commentary on her own experiences, on
the community of women in which she lived and their tastes
and desires.

6.49 Romaine Brooks: *The Crossing (Le Trajet), c.* 1911
Oil on canvas, 45⅜ × 75⅜ in. (115.2 × 191.4 cm.)
Smithsonian American Art Museum, Washington, D.C.

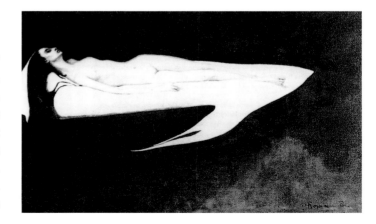

For her self-portrait of 1923 [6.50] Brooks adopts the costume of the female cross-dresser, the black jacket and white shirt of a standard male suit. Her hair is short and her body slim. While male cross-dressers were usually marked by an exaggerated femininity—heavy make-up, colorful and revealing clothes—Brooks's female cross-dressers are androgynous rather than exaggeratedly masculine. They suggest a time when male and female had yet to be separated out. Of course, by the 20th century feminine roles and costumes were so clearly defined that any reduction in the markers of femininity, any adoption of streamlined, unadorned dress would be read as masculine. The

6.50 Romaine Brooks: *Self-Portrait*, 1923
Oil on canvas, 46¼ × 26⅞ (117.5 × 68.3 cm.)
National Gallery of Art, Washington, D.C.

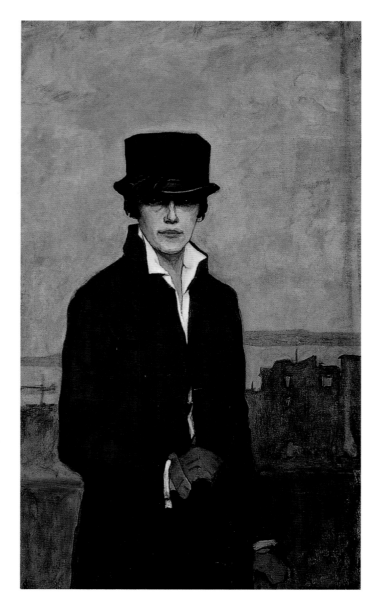

eroticism in Brooks's portraits and self-portrait is found in the very transgressing of gender boundaries, in the unknown pleasures that such transgressions suggest.

Situated outside, in front of a gray skeletal cityscape, Brooks confronts the viewer with a direct, yet hooded, gaze. The brim of her modified top hat shades her eyes, allowing us to see their shape, but not their expression. As the art historian Whitney Chadwick has pointed out, this dapper attire, aloof pose, and urban location also raise associations with the figure of the "dandy" or "*flâneur*," a figure celebrated by many late 19th-century Modernist painters and writers, who, "like the lesbian, stands outside bourgeois culture, flouting conventions of dress and social roles." Brooks's chin and neck are framed by the collar of her open white shirt, whose top button is undone. The thumb of her gloved left hand is inserted in her unbuttoned coat, suggesting a future moment of revelation. There is a playful self-consciousness in this self-portrait that belies the initial impression of distance and rigidity. Brooks records her lesbian performance, her playful teasing of the viewer as she both conceals and reveals.

Another artist who adopted the androgynous look of Brooks's circle was Georgia O'Keeffe (1887–1986). It appears in many of the photographic portraits produced by her lover and, after 1924, husband Alfred Stieglitz [6.51]. O'Keeffe first encountered Stieglitz in 1916, when he exhibited a series of her abstract charcoal drawings. Like Hartley, she was drawn to Kandinsky's book *On the Spiritual in Art* (1914), with its celebration of the expressive elements of color and shape freed from

6.51 Alfred Stieglitz: *Georgia O'Keeffe: A Portrait-Head*, 1918
Gelatin silver print
National Gallery of Art, Washington, D.C.

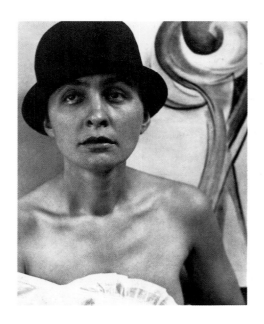

associations with any particular objects. Stieglitz recognized the expressive quality of her work and also read it in a particular way, as inherently feminine: his first comment upon seeing the drawings is said to have been "Finally! A woman on paper." The designation became, from that moment on, the primary theme of critical writing about her work. "Once Stieglitz's enthusiastic formula had made the initial connection," observes the art historian Anne Wagner, "O'Keeffe's art emerged as the unmediated translation of a woman's self into representation and onto paper." This combined eroticizing and feminizing was "the most decisive condition under which O'Keeffe worked, the one that had the most serious consequences, both for her reputation and for the direction her painting was to take."

Wagner sees O'Keeffe's early abstractions as, indeed, dealing with concepts of the body, attempting to image it in abstract form. In fact, "O'Keeffe staked her claim as a modernist painter on her effort to rewrite the terms in which the body could be experienced in representation." Stieglitz's contribution was to define that body as decidedly feminine, and then to reimage it in starkly figurative terms in his photographs. Yet the bodies in both paintings and photographs are complex, full of tensions between male and female, presence and absence, the figurative and the abstract.

O'Keeffe recognized that figuration and abstraction were structurally related and endlessly opposed, as key areas of investigation for Modernist artists. Her shift from abstraction to figuration with her flower paintings was, in Wagner's view, an attempt to bring together these two areas to create an alternate, Modernist notion of embodiment. *Red Canna* of 1925–28 [6.52] contains both a recognizable rendition of a red canna, writ large, and also a series of shapes and colors that defy the literal reading. The edges of the image are particularly ambiguous, undulating forms dissolving into unknown spaces. Like her earlier abstractions, they suggest bodily forms, with their voids and folds and crevices. Unlike the creators of more traditional floral still lifes, she chooses fragments of nature, those which can be transformed into images both figurative and abstract.

One might wonder why O'Keeffe chose flowers as the subject-matter through which to explore this relationship between figuration and abstraction. She was certainly aware that flower-painting had been categorized as a form of art "suitable for women" for centuries. Thus there is a hint of a challenge in her adoption of this subject-matter, an acknowledgment of the dominant critical reading of her work as that "of a woman" and, at the same time, a rejection of the simplistic association between women and nature. Her flowers are large, garish, sensual. While O'Keeffe expressed frustration with the insistent feminizing of her work—"The things they write

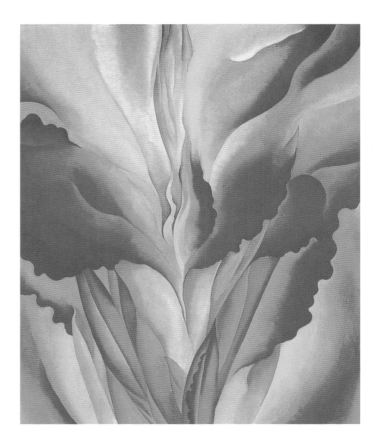

6.52 Georgia O'Keeffe: *Red Canna*, 1925–28
Oil on canvas, 36 × 30 in. (91.4 × 76.2 cm.)
Collection of the University of Arizona Museum of Art, Tucson

sound so strange and far removed from what I feel of myself"— she was not ready to abandon her flower paintings (her renditions of the more "masculine" subject-matter of skyscrapers in the 1920s [7.16] received less attention). If critics were going to insist on both celebrating and dismissing her as a "woman painter," then she would seemingly go along with them and, perhaps in the process, silence them, although she did not succeed in the latter.

Wagner suggests that this insistent feminizing of O'Keeffe's works was the result, in part, of attempts to counter the anxieties "provoked at just this moment in America by the specter of a woman become 'masculine' or 'unsexed.'" O'Keeffe wanted to change the way bodies, in particular female bodies, were represented in both Modernist and more traditional works of art, just as many women wanted to change the way in which they were defined as political and social beings. She, like Brooks, crossed gender boundaries in her work. By referencing the body through exaggerated phallic and labial forms that often appeared simultaneously in her flowers, she created tensions and ambiguities and resisted easy readings. Her paintings

pointed to new possibilities, argues the art historian Anna Chave, for the sexual positioning of men as well as women, which explains, in part, why many male critics were so often angered by her work when it was first exhibited, describing it as "shameless" and "sensationalist."

The role that Stieglitz played in O'Keeffe's artistic explorations is the focus of much debate among critics and art historians. All who write about her work acknowledge the fact that the careers of the two artists were intimately intertwined. Stieglitz's recognition of O'Keeffe assured her a place in the Modernist art world taking shape in New York in the 1910s. He gave her a solo exhibition at 291 in 1917, the last before the gallery closed, and then continued to promote her work in group exhibitions until her large one-person show at the Anderson Galleries in New York in 1923. He also included many of his photographic portraits of her in his major exhibition in 1921.

Some see Stieglitz as the exploiter, claiming O'Keeffe as his own creation, and O'Keeffe as the victim, with little power to change the way in which her work was being presented. Chave argues that Stieglitz promoted O'Keeffe's image as a sexual being to enhance his own virility. Wagner, on the other hand, sees more of a knowing collaboration between the two artists. Their common project, she believes, "was their fascination with the novel complexity—the modern contradictions—of the female subject: O'Keeffe." Just as O'Keeffe's paintings cross gender boundaries, so, too, do Stieglitz's photographs create a varied image of her—naked, clothed in various attire, full body, close-ups of hands or breasts or face—one equal to her own complex renderings of embodiment (Stieglitz makes a self-conscious connection between his photographs and O'Keeffe's work by including many of her charcoal drawings and paintings in the backgrounds of the photographs [6.51]).

O'Keeffe—and, by extension, all women—was presented as multifaceted in personality and physical appearance, ultimately unknowable in any definite way. Such a reading separates Stieglitz's 300-photograph "portrait" of O'Keeffe from the larger corpus of Modernist photographs that reduce women, and in particular well-known and accomplished women, to sexual objects. While O'Keeffe may well have experienced uncertainties and/or qualms about the production and reception of these photographs, they could not have been created without her implicit, if not active, cooperation. While her relationship with Stieglitz was undoubtedly fraught with difficulties, it was also a site of artistic collaboration and exchange.

Stieglitz was also interested in another photographer who engaged in creating multiple representations of the female body, Anne Brigman (1869–1950). Brigman had joined

Stieglitz's Photo-Secession in 1903, a year after its founding, and her work appeared in every members' exhibition at the Little Galleries of the Photo-Secession from 1905 to 1908. It also appeared in the 1909, 1912, and 1913 issues of *Camera Work*. Brigman was, in fact, the only photographer west of the Mississippi to be featured so prominently in the gallery and magazine. She and Stieglitz corresponded between 1906 and 1919 (they met in 1910), with Brigman sending him both photographs and long descriptions of her life in Oakland, California, and Stieglitz responding with encouragement and advice.

Like O'Keeffe, Brigman investigated and dramatized the connections between women's bodies and nature, although in a different way. She saw nature as a source of personal liberation and spiritual renewal. In works such as *The Cleft of the Rock* (1905) [6.53], she embeds the naked female body in the landscape, depicting herself emerging from the folds of a rock. It is possible to see such images as yet another example of the numerous scenes staged by late 19th- and early 20th-century Pictorialist photographers which tend to equate the female body with nature, although, as the art historian Susan Ehrens

6.53 Anne Brigman: *The Cleft of the Rock*, 1905
Gelatin silver print
Oakland Museum of California, Oakland

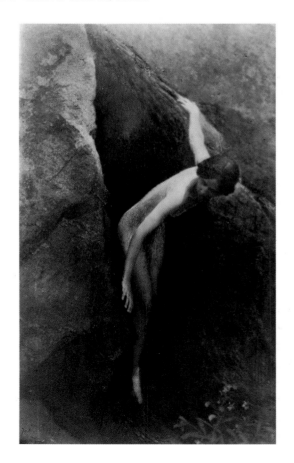

remarks, it was unusual for a female photographer to produce female nudes in the landscape at this time. The cultural historian and literary critic Judith Davidov, however, sees something else in this work. She argues that "what is most striking to a female viewer is the way these images—their very artifice—suggest the tantalizing problem women face when they turn the camera on themselves: how to represent the 'natural' unmasked, undisguised self, disencumbered of the cultural construction they, as social beings, have learned."

Davidov points to Brigman's self-conscious use of the camera and its self-transforming potential. She quotes the photographer's description of a moment when the power of the camera became evident to her:

> One day, during the gathering of a thunder storm when the air was hot and still and a strange yellow light was over everything, something happened almost too deep for me to be able to relate. New dimensions revealed themselves in the visualization of the human form as part of tree and rock rhythms and I turned full force to the medium at hand and the beloved Thing [her camera] gave to me a power and abandon that I could not have had otherwise.

Brigman, according to Davidov, here presents herself as invested, through the camera, with the power to "'visualize' the human form as part of natural rhythms," and thus symbolically to heal her wounded body (she had lost a breast in an accident aboard her sea-captain husband's ship). "In posing naked among the rocks and cliffs and streams, she shows *what the camera sees*, which suggests the extent to which her project is based upon artifice or masquerade." Such artifice prompts us to question the nature of the self that is being presented in the photograph, and suggests, in Davidov's words, "that we might read Brigman's photographs as parody of the Woman = Nature equation." This heightened awareness of the self as culturally constructed would present itself time and again in the work of women artists of the 20th century.

Imogen Cunningham (1883–1976) also called into play in her photographs the association between women and nature. While she had experimented in the 1910s with the same combinations of nude figures and natural landscapes found in Brigman's work, she shifted in the following decade to more intimate images of the details of nature, in particular of the plant life found in her small garden in San Francisco, where she had moved with her family from Washington state. She also joined with other photographers like Stieglitz and Ansel Adams (1902–84) in the 1920s in arguing that photography should not, as the Pictorialists had done, attempt to imitate painting,

that it possessed its own distinct qualities of technique and composition. Cunningham and Adams, along with Edward Weston, would promote this view and their pristine, sharp-edged photographs through the organization f.64, which they helped found in the San Francisco Bay area in 1932 (the name of the group was taken from the smallest aperture setting on a camera, which produced the greatest and sharpest depth of field, so that both the foreground and background of a photograph appeared in focus).

While Adams is best known for his majestic landscape views, such as *Monolith, the Face of Half Dome, Yosemite National Park* (1927) [6.54], which continued the work of Carleton E. Watkins [5.52] in conveying the power and uniqueness of this part of America, Cunningham followed in the footsteps of O'Keeffe in her presentation of nature. Her *Magnolia Blossom* (1925) [6.55], like O'Keeffe's flower paintings [6.52], brings the viewer into the flower, emphasizing the delicacy of its parts and conveying a sense of movement, as the petals seem to unfold before us. Davidov suggests that O'Keeffe and Cunningham

6.54 Ansel Adams: *Monolith, the Face of Half Dome, Yosemite National Park*, 1927
Photograph
Ansel Adams Trust, Carmel, California

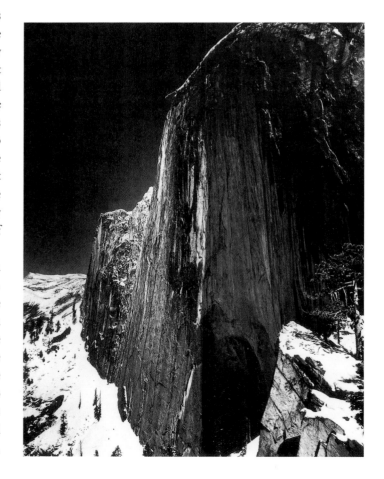

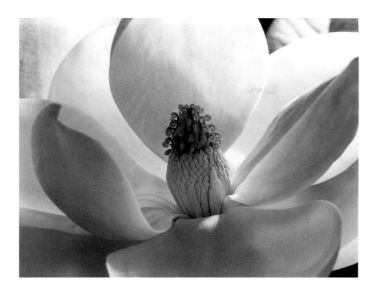

6.55 Imogen Cunningham: *Magnolia Blossom*, 1925
Gelatin silver print
The Imogen Cunningham Trust, Berkeley, California

experienced a similar intimate and sensual relationship with the natural world. She compares Cunningham's statement, "The flowers of your garden blossom in my body. The joy of life that is everywhere burns like incense in my heart," with O'Keeffe's words, "Sometimes I think I'm half mad with love for this place [the Southwest] My center does not come from my mind—it feels in me like a plot of warm moist well-tilled earth with the sun shining hot on it." Both photographer and painter attempted to convey, through their focus on natural forms, the transformative and sensual power of the natural world.

Escape to Mexico

The Mexican Revolution and Mural Movement

As was the case in the 19th century, many artists in the early 20th century felt, for various reasons, that the United States was not a hospitable place for the creation of their particular type of art, be it Modernist abstraction, naturalistic realism, panoramic landscapes, or reclining nudes. Some stayed put and carved out alternative communities within which to live and work, while others traveled to foreign lands in search of a more nurturing environment, or to different parts of the United States that contained what seemed to them a less corrupt and more "exotic" culture.

Much has been written about artists who traveled to Paris or Berlin to find their artistic community. But several also looked south, to Mexico, in the 1920s. The country was appealing for different reasons, some of them political, some cultural, some economic. They came, say the art historians Mary Ellen Miller and James Oles,

> motivated by Mexico's artistic scene, by an inexpensive cost of living and a delightful climate, by a search for unspoiled landscapes and an ancient culture more difficult to find in the States. In a way, Mexico functioned as a site for the discovery of essentially American values, colors, traditions, and histories, as an alternative to the cultural dominance of Europe and especially Paris.

Often limited by preconceived notions of the country gained through tourist literature or representations in popular culture, the images of these artists say much about how the United States viewed Mexico and its culture at this moment in time.

In the first two decades of the century Mexico underwent a radical political transformation. In 1910 Porfirio Diaz, who had presided over the country for most of the previous thirty years, was reelected. His regime had been marked by widespread corruption and by the selling off of natural resources to foreign investors, in particular from the United States, which he saw as the best way to bring Mexico into the 20th century as an international economic, if not political, power. Resistance grew, and shortly after the election Diaz was forced from office. The ensuing Mexican Revolution lasted a decade, with a succession of military factions gaining control of Mexico City. The United States did not remain neutral, sending in troops in 1913 and 1916, while the oil fields owned by American interests, in particular Standard Oil and Edward L. Doheny, continued to operate. The writer Katherine Anne Porter, active in the promotion of Mexican art in the 1920s and 1930s (see below), later observed that "so far as the oil people are concerned, they cheerfully admit it is cheaper to keep a few minor revolutions going than to pay taxes." By 1920, American financial interests owned 20 per cent of Mexican national territory and controlled 57 per cent of the Mexican petroleum industry.

In 1917 military and political leaders managed to come together under the newly elected president Venustiano Carranza to work out a constitution that contained many social reforms. Unfortunately, the fighting continued and Carranza was assassinated, along with the popular military figure Emiliano Zapata. Finally, in 1920, the fighting ended, and Alvaro Obregón was elected president, bringing to a close a decade in which some two million people, or 13 per cent of the population, had died.

Obregón knew that the social and economic reforms outlined in 1917 needed to be put in place. He was particularly committed to educational reform, and in 1921 appointed José

Vasconcelos as his Secretary of Education. Vasconcelos promoted a particular brand of what the art historian Karen Cordero Reiman describes as "spiritual nationalism," a "Mexicanness" embodied in the figure of the indigenous peasant, dressed in regional garb and engaged in "timeless" rural activities. Such an image helped to legitimize the postrevolutionary government by suggesting that the different social sectors that had been at each other's throats in the previous decades were now unified. At the same time, it seemed to celebrate those who suffered most during times of both war and peace—the rural population. Thus, writes Reiman, an image that had appeared often in popular art in the previous decade and that had begun to acquire nationalist connotations now "became one of the most potent national symbols in the years following Obregón's rise to power in 1920 and a key element of a postrevolutionary aesthetic discourse, many aspects of which continue in Mexico today."

With Vasconcelos's resignation in 1924 many of the artists he had commissioned abandoned his spiritual and idealized nationalism and created more politicized images of the indigenous population and populist revolts. This was particularly true of the artists who formed the Syndicate of Technical Workers, Painters and Sculptors in 1923, an organization with close ties to the Mexican Communist Party. Diego Rivera, for example, filled his murals of the mid-1920s in the Ministry of Public Education in Mexico City with revolutionary heroes from the ranks of peasants and industrial workers and caricatures of corrupt politicians and capitalists. Rivera, along with José Clemente Orozco and David Alfaro Siqueiros, would travel to the United States in the 1930s and create works of art that galvanized the mural movement in this country [7.29, 7.32, 7.34, 7.36, 7.39, 7.40, 7.50], although the U.S. government was much less tolerant of revolutionary content.

A less flattering image of the Mexican peasant and revolutionary was circulated throughout the United States in the 1910s in the photographs taken by American journalists sent to cover the Mexican Revolution. For example, Walter Horne (1883–1921), who arrived in El Paso in 1910, stayed on and produced photo postcards that gained a wide circulation. Oles notes that in August 1916, "when thousands of National Guard troops were stationed in El Paso and tensions were especially high, Horne was selling five thousand postcards a day to soldiers as well as retailers." His subject-matter ranged from the boredom of life in the army to the brutality of war. Amongthe most popular were several postcards of the execution, on January 15, 1916, of three men accused of stealing by Carranza's forces [6.56]. The popularity of such images in the United States was fueled, according to Reiman, by "a long tradition of representing the apparently arbitrary violence of Latin America."

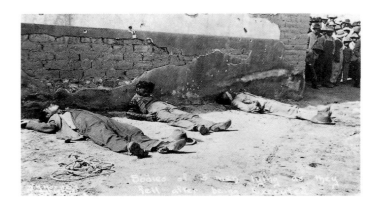

6.56 Walter Horne: *Bodies of 3 men lying as they fell after being executed*, 1916
Photographic postcard
Library of Congress, Washington, D.C.

The Search for the Exotic: American Artists in Mexico

Most of the artists who went to Mexico in the 1920s, however, were attracted to, and portrayed in their own work, the idealized rather than the revolutionary peasant, a choice that reflected, in part, their understanding of the country from tourist literature. As was the case in this literature, the exotic Mexican peasant woman received particular attention, and was conflated with the exotic Mexican landscape.

This preference for, and idealization of, Mexican peasant women appeared in the work of both men and women. In 1925 Lowell Houser (1902–1971), one of the earliest American artists to visit the country after the revolution, produced *Ajijic Maidens Carrying Water Jars* [6.57]. Houser had arrived with Everett Gee Jackson in 1923, the year President Harding officially recognized the Obregón administration, and the two artists settled in Lake Chapala, near Guadalajara. His painting is a study

6.57 Lowell Houser: *Ajijic Maidens Carrying Water Jars*, 1925
Gouache on paper, 23 × 28¾ in. (58.4 × 73 cm.)
Everett Gee Jackson Collection, San Diego, California

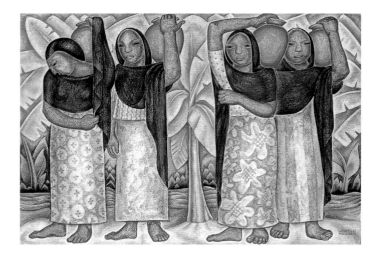

in decorative patterns, with organic forms creating a backdrop for the four women, whose generalized features suggest they are formed from the same mold, like the water jars they carry on their shoulders. The clay jars echo their round faces, and reinforce the association of the women with nature, earth, and fertility.

Henrietta Shore (1880–1963), who arrived in 1927, repeats this frieze-like arrangement in *Women of Oaxaca* (*c.* 1927) [**6.58**]. Dressed in the familiar costume of Tehuantepec and carrying the black jars of San Bartolo Coyotepec, they convey a greater sense of movement, with their swaying bodies and with the painting's undulating groundline, but they are even more anonymous than the figures in Houser's work, for their features are barely sketched in. Of particular interest to both artists, as in the tourist images, are the costumes of the women and their primal association with water and earth. As Oles points out, "the arduous task of bringing water from distant wells to the home is transformed into an elegant promenade."

Not all American artists refused to recognize the hardships or less romantic aspects of Mexican life. George Biddle (1885–1973) arrived in 1928. Having begun his artistic studies in 1911, he had evolved into a skilled printmaker and painter and had traveled extensively in Tahiti, Paris, and the Caribbean studying different artistic traditions. He had come to Mexico specifically to meet Diego Rivera and to see, firsthand, the murals Rivera had created. His enthusiasm would later prompt him to write to his friend Franklin D. Roosevelt, the newly elected president of the United States, and encourage him to support mural art in the United States as the government had done in Mexico (see p. 392).

6.58 Henrietta Shore: *Women of Oaxaca, c.* 1927
Oil on canvas, 16 × 20 in. (40.6 × 50.8 cm.)
The Buck Collection, Laguna Hills, California

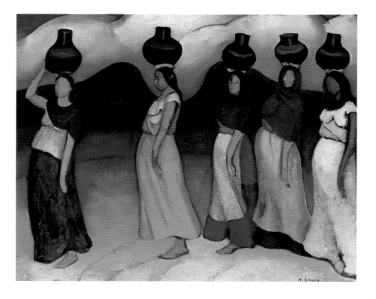

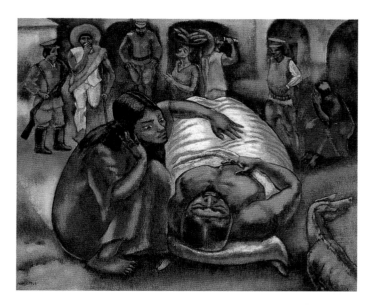

6.59 George Biddle: *Shot by Bandits*, 1929
Oil on canvas, 25 × 30 in. (63.5 × 76.2 cm.)
D. Wigmore Fine Art, Inc., New York

Biddle's *Shot by Bandits* (1929) [**6.59**] moves completely away from the romantic and confronts the reality of renewed hostilities within Mexico at the end of the 1920s. In 1928 Obregón (re-elected that year) was assassinated, and organized labor began a series of strikes throughout the country. *Shot by Bandits* records a scene Biddle came across during his travels in Tehuantepec in the summer of 1928. The sharply foreshortened figure of the dead peasant wrapped in a blood-stained sheet and attended by a distraught woman occupies the center of the composition. Another male peasant in the left background leans on a crutch, having lost the lower half of his left leg. The military figures have arrived too late to prevent the attack. In the lower right corner a dog looks sharply out of the picture, implying the presence of more bandits or more soldiers. The communal life and daily routines of these peasants have been disrupted and they have, once again, become the victims of violent unrest prompted by government action that pits soldiers against peasants, and peasants against one another.

Several American photographers also visited Mexico in the 1920s, including Tina Modotti (1896–1942) and Edward Weston (1886–1958). Modotti was born in Northern Italy and came to the United States at the age of seventeen, settling with her family in San Francisco. In 1917 she met an artist from Oregon and in 1918 moved with him to Los Angeles, where she had a brief career as an actress in the Hollywood film industry, playing gypsies, odalisques, and fallen women. While in Los Angeles she met Edward Weston, who had come to California from Chicago in 1906 and by 1911–12 had set up his own portrait studio. A trip to New York

in 1922, where he met Stieglitz and Paul Strand, aroused in him an interest in the abstract qualities of objects, both natural and industrial, particularly when photographed close up. By the end of the decade his attention would be directed almost solely toward nature—peppers, shells, rolling sand dunes.

In 1923 Weston left his wife and children in Los Angeles and moved with Modotti to Mexico City. He remained there with her until 1926, taking numerous photographs of her, of Mexican architecture, and of local plant life. He was also attracted to Mexican folk or popular art (the two terms were often used interchangeably)—objects produced by hand, primarily by peasants or inhabitants of small towns who had received little if any formal art training [6.61]. This art, using materials and forms seen by purchasers as "traditional" to the area, had long been of interest to tourists, and Mexican ceramics and textiles had occupied curio cabinets in middle-class homes across the United States since the late 19th century.

The vogue for folk art increased during the Obrégon administration, with its celebration of the peasant as the spiritual foundation of "Mexicanness," and in 1921 a large exhibition was organized in conjunction with the centennial celebration of Mexico's independence from Spain. A version of it was sent to Los Angeles the following year, the first major exhibition of Mexican popular art in the United States. There it was accompanied by a monograph by Katherine Anne Porter, who wrote: "The artists are one with a people simple as nature is simple: that is to say, direct and savage, beautiful and terrible, full of harshness and love, divinely gentle, appallingly honest. No folk art is ever satisfactory to those who love smooth surfaces and artificial symmetry."

Porter had gone to Mexico in the 1920s to study art and to write and had become involved in leftist politics. As did so many on the Left in Mexico, she idealized indigenous peoples even as she attempted to promote their interests. In her catalogue essay she reiterates the major themes of the myth of Mexico that had drawn artists southward, seeing its landscape and its people as savage, beautiful, gentle, simple, honest. Yet, as Oles points out, this celebration of what was perceived as a uniquely indigenous art ignored the fact that folk artists in Mexico as elsewhere borrowed from artistic traditions outside their own regions or nation. As shown in earlier chapters, designs from Asia and materials and techniques from Spain and other parts of Europe influenced Mexican lacquerware, textiles, and carvings.

Weston may well have attended the Los Angeles exhibition. He certainly turned his attention to popular art when he arrived in Mexico in 1923. This was due, in part, to the fact that he and Modotti were hired by Anita Brenner to provide the illustrations for her publication *Idols behind Altars* (1929) [6.62], a celebration of both contemporary muralists and folk art. Brenner had been born in Mexico to European immigrants. The family was forced to go to the United States during the Revolution, but she returned in 1923 to study at the National University, and remained until 1928. Back in the United States again, she headed the department of Latin American life and culture for the journal *The Nation*. She would continue to visit Mexico and to study and write about its art and culture for many years.

Weston found that Mexican folk art helped him in achieving his aim of "rendering the very substance and quintessence of the *thing itself*." This appears in his photographs in a close attention to form and to texture, be it the rough finish of certain clay pots or the shiny surface of a lacquered object. In *Pájaro Blanco* (1926) [6.60] Weston emphasizes form and texture by isolating and cropping the object. He cuts off the legs of the bird sculpture from Guerrero (the title means "White Bird") in order to emphasize the form of the gourd from which it is made, and places it against a sky-like backdrop to suggest flight. The effects of the cropping are evident when compared with a complete gourd bird [6.61], whose legs, as well as painted feathers, distract the viewer's attention from the elegant shape of the rest of the body.

6.60 Edward Weston: *Pájaro Blanco*, 1926
Gelatin silver print
Center for Creative Photography, Tucson, Arizona

In another photograph, *Hand of Amado Galván* (1926) [**6.62**], which appeared as the frontispiece to Brenner's book, the focus is also on organic shape and texture. Weston eschews the connection with the earth that he had set up in other photographs of ceramics, and presents, instead, a more dramatic image, shot from below with the sky as backdrop. Celebrating as it does the act of creation by the first Mexican folk artist to gain widespread recognition, Amado Galván, it was a fitting image for a book that promoted Mexican folk art as "art," the outcome of creative genius. The melding of the hand and the clay vessel reinforces the elemental aspect of Galván's work that was so much a part of the appeal of the objects as a whole.

These folk objects were presented in the photographs and paintings and literature of the time as the opposite of the mass-produced items that filled homes in the United States. "As the stereotypes would have it," writes Oles, "American living rooms were filled with chrome and glass and angular art deco furniture, while Mexican households cherished pottery vessels and quaintly painted lacquer chests." The reality, however, was much more complex. Rural Mexicans just as often preferred the mass-produced items that were increasingly becoming available, whether made locally or imported. As

6.62 Edward Weston: *Hand of Amado Galván*, 1926
Frontispiece to Anita Brenner, *Idols behind Altars*, New York, 1929

6.61 Anonymous, from Olinalá, Guerrero, Mexico: crane, c. 1930
Lacquered gourd
San Antonio Museum of Art, San Antonio, Texas

American artists celebrated the communal and unchanging nature of Mexican folk art, the objects themselves were being produced increasingly for tourists and collectors rather than for local use. This shift accompanied a decline in the living standards of rural people, many of whom, with the growth of foreign ownership of Mexico's industries and natural resources, were displaced from what little land they had and forced to work for low wages in cities or factories. The market for folk art provided much-needed income for many Mexicans, although it also benefited financially those intermediaries, often foreign, through whom much of the art was sold. Some have argued that this market kept alive forms and media that might otherwise have succumbed to the influx of mass-produced goods. That is true to some extent; but it also dictated, through pressures from outside of Mexico's borders, which particular forms and media would be produced, and it had an effect on the character of the objects themselves. Weston and other artists recognized and lamented this development, although their observations were often couched in terms of the loss of a "pure" tradition in the face of the onslaught of modernity. Soon after his arrival in Mexico, Weston commented: "it is evident that the Indian's work is becoming corrupt, and with another generation of overproduction and commercialization will be quite valueless."

Art in the Service of Revolution: The Photographs of Tina Modotti

Tina Modotti also examined the objects used and produced by Mexicans, but from a perspective different from that of Weston. She took her first lessons in photography from him and adopted his focus on formal concerns in her early photographs, such as *Mexico City Stadium* [6.63]. Her subject-matter soon changed, however, as she became increasingly involved in the political struggles and demonstrations that were taking place in Mexico City. It was in the realm of politics, in fact, that Modotti and Weston experienced their greatest differences. Weston was anti-Communist, while Modotti joined the Communist Party in Mexico and began organizing against imperialism and fascism. While she never abandoned the formal concerns that she learned under Weston, the objects in her photographs resonated with new meaning. *Sickle, Cartridge Belt, and Guitar* [6.64] isolates three objects and highlights their different surface textures against the straw mat. Yet, in choosing to juxtapose these particular objects, she alludes to the concerns of revolutionary activists for agrarian reform, armed revolt, and a people's culture. Photographs like this conveyed a subtle understanding of the power of abstract forms to create emotion or sentiment, while focusing that sentiment on a particular political message.

Modotti also recorded demonstrations and political gatherings in images that show large numbers of peasants and

6.63 Tina Modotti: *Mexico City Stadium, c.* mid-1920s
Photograph
Collection Vittorio Vidali

industrial workers as active rather than passive individuals. In these works formal concerns, while not absent, are downplayed in the interests of capturing the particulars of a specific moment in time.

6.64 Tina Modotti: *Sickle, Cartridge Belt, and Guitar,* late 1920s
Photograph
Collection Vittorio Vidali

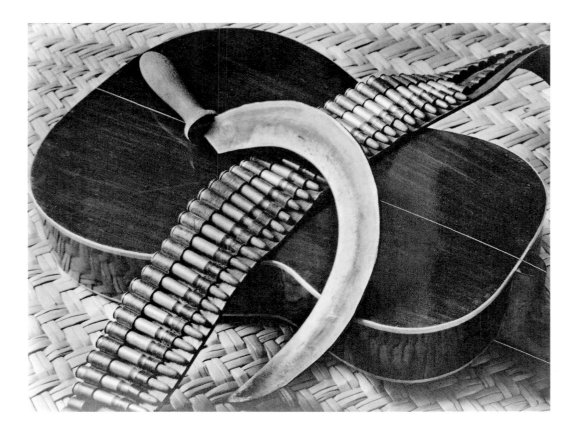

In 1929 Modotti's photographs were exhibited at the National Library in Mexico City, and she wrote the following in her introduction to the catalogue:

> Every time that the words art or artist are used in relation to my photographic works, I get an unpleasant impression that is doubtless due to the bad use made of these terms. I look on myself as a photographer and nothing else, and if my photographs stand out from those generally produced, it is because I am seeking to create not art, but good photographs, without tricks and manipulation.

Thus, Modotti saw her task in artisanal terms—she was a photographer, not an artist—and resisted the attempts of Weston and Stieglitz and other early 20th-century photographers to turn the medium into an art form, as opposed to a form of documentation. What she valued above all was this documentary quality. She continued:

> Photography, for the very reason that it can only be produced in the present and that it is grounded in the objective existence of whatever is in front of the camera, stands out as the most satisfying means for recording objective life in all its manifestations. Hence its documentary value, and if one adds to this sensitivity and an understanding of the subject and above all a clear idea of the position it should occupy in the unfolding of history, I believe that the result is worthy of a place in the social revolution to which we must all contribute.

Modotti's are the words of a political activist, of an image-maker who values the message over aesthetic concerns, but who also realizes that a powerful message requires a powerful form. Her photographs indicate that she possessed a sensitivity to and understanding of the subjects she recorded and of their place in the history of Mexico.

On January 10, 1929, she was with the Cuban revolutionary Julio Antonia Mella when he was assassinated, and in 1930 she was expelled from Mexico for allegedly conspiring to kill the president of the country, Pascual Ortis Rubio, and for being a Communist. She went first to Germany, then to the Soviet Union, and then to Spain to fight in the Civil War (1936–39) (see pp. 442–43) on the side of the Republican government. During these years she gave up photography in order to devote herself fully to other political activities. In 1939 she returned to Mexico after the election of the more liberal president Lázaro Cardenas, who opened the country to Republican exiles from Spain. She remained there until her death in 1942.

Mexico in America: Imaging the American Southwest

The Santa Fe Railway and the Selling of the Southwest

The romanticized images of Mexico and Mexican folk art were easily adapted to the peoples and cultural products of the American Southwest. Here, too, the tourist industry made its mark on the physical and cultural landscape. As with Mexico, the railroad was a key factor in enabling large numbers of people to travel to areas that, until the end of the 19th century, had been difficult to reach. Of particular importance for the Southwest was the Atchison, Topeka and Santa Fe Railway which, by 1918, had lines stretching from Chicago across Missouri, Kansas, Colorado, New Mexico, and Arizona to California. What distinguished the Santa Fe Railway, as it came to be known, was its highly successful advertising campaign. In attempting to draw passengers westward, it played on two popular rhetorics, that of technology and that of nature, in order to create a third, that of belonging. As noted earlier (see pp. 173–76), trains were seen as representing the incursion of technology into the wilderness, which was both a sign of progress and a threat to the pristine nature so clearly associated with the country's self-image. What the Santa Fe Railway did, suggests the anthropologist T. C. McLuhan, was create a nationalist rhetoric of belonging, "one that made assertions about soil, roots, and country. The effect was to reduce the inevitable estrangement between man and nature that began with the birth of the railroad."

The Santa Fe created this rhetoric of belonging through photographs, lantern slides, illustrations, and calendar art. The company discovered, in McLuhan's words, "the powerful and poetic uses of the wilderness and Indian life and market[ed] them to establish for the railroad a rich national identity." Its advertising forces, led by William Haskell Simpson, created images and slogans that took heretofore fascinating but often intimidating national natural wonders and made them seem accessible, while still leaving them imbued with an enticing mystery.

> In an outpouring of patriotic spirit and image-building, they appealed to nationalistic pride to "re-capture the first fine careless rapture" in a journey of discovery With patriotic drama and allure, the railroad's advertising became a sustained hymn to *natural* America.

The Santa Fe's efforts began in the 1890s, when they commissioned the famous artist Thomas Moran to paint the Grand Canyon in exchange for transportation, food, and lodging. The painting was subsequently reproduced as a color lithograph and distributed throughout the country. In 1907 the Railway

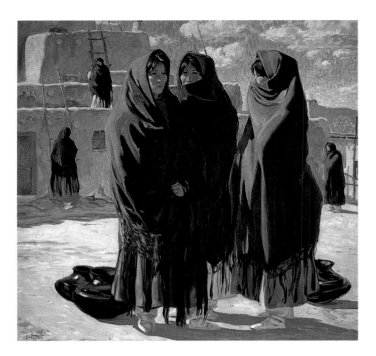

6.65 Walter Ufer: *Taos Girls*, 1916
Oil on canvas, 30 × 30 in. (76.2 × 76.2 cm.)
Santa Fe Collection of Southwestern Art, Santa Fe, New Mexico

introduced its annual calendar, which was again distributed nationwide, free, in what McLuhan describes as "one of the largest general mailings in advertising history." The images were primarily of Native peoples, or what came to be known as "the Santa Fe Indian." They were produced by members of the new artists' colonies growing up around Santa Fe and Taos in

New Mexico, including Walter Ufer (1876–1936) and Bert Greer Phillips (1868–1956). Ufer's *Taos Girls* (1916) [**6.65**] and Phillips's *The Secret Olla* (1918) [**6.66**] are typical of the romanticized, light-filled images that adorned the Railway's calendars. The figures are dignified, yet passive and withdrawn, living in a world of handmade objects and pre-industrial buildings. Or they are shown crouching within nature, as in *Taos Turkey Hunters* (1916) [**6.67**] by a third Santa Fe Railway artist, E. Irving Couse (1866–1936). The original paintings appeared in waiting rooms or branch offices, and were often seen in national and international exhibitions.

The artists who began gathering in Santa Fe and Taos around 1900 saw the region as filled with fresh, new, unsullied landscapes. They were among the many who, dissatisfied with city life, looked for some place to renew their creative juices. New Mexico, while still being within the United States, provided a suitably exotic setting. McLuhan quotes a photographer, who, in 1897, after witnessing a Pueblo Indian ceremony, wrote: "Then one by one they retired to their homes and we began to realize that we were still in America. One becomes so interested, so anxious to see it all, that he almost forgets, and it seems like a dream." Of course, the painters and photographers who arrived in the Southwest brought with them preconceptions about the wilderness and Native peoples, influenced in part by the Railway's advertising. They also brought with them a trained eye, one that immediately began to reconfigure what they saw in artistic terms. Ernest L. Blumenschein (1874–1960), one of the founders of the Taos colony, recalled his arrival in the region in 1898: "When I came into this valley—for the first time in my

6.66 Bert Greer Phillips: *The Secret Olla*, 1918
Oil on canvas
Santa Fe Collection of Southwestern Art, Santa Fe, New Mexico

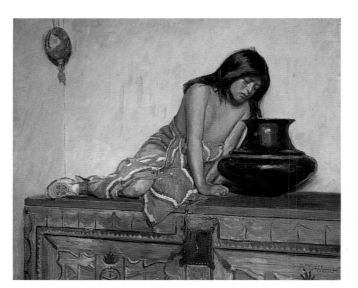

6.67 E. Irving Couse: *Taos Turkey Hunters*, 1916
Oil on canvas
Santa Fe Collection of Southwestern Art, Santa Fe, New Mexico

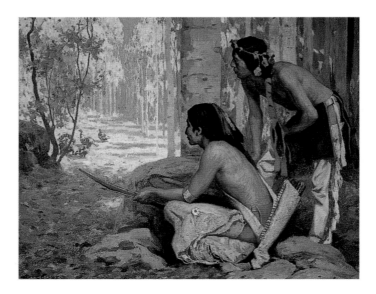

life, I saw whole paintings right before my eyes. Everywhere I looked I saw paintings perfectly organized, ready for paint." Phillips settled in Taos with Blumenschein in 1898, with Couse arriving in 1902. (O'Keeffe began visiting New Mexico in the summer of 1929 and moved there permanently in 1949.)

Couse was one of the most popular of the Taos artists with the Santa Fe Railway (he appeared without interruption in the Railway's calendars from 1916 to 1938), perhaps because he was so amenable to the suggestions of Simpson, who often had very explicit ideas about what he wanted. As McLuhan points out, Simpson's comments to the artist present a clear indication of his particular conception of the "Santa Fe Indian," and thus provide a rare glimpse into corporate image-making. On one occasion, Simpson wrote to Couse: "The figure of the Chief doesn't look quite tall enough for one entitled to that name. Perhaps the 'squattiness' may be due to the war bonnet being so wide, or possibly to the way the blanket hangs. No doubt you can overcome this when working from the model." The "Santa Fe Indian" would be tall and noble to the very end.

The Santa Fe Railway also commissioned photographers to take pictures of both the natural wonders of the West, in particular Yosemite and the Grand Canyon, and its Native peoples. These images were distributed primarily as postcards or as lantern slides, which accompanied lectures given by Railway representatives throughout the country. One of the best-known of the photographers was William Henry Jackson (1843–1942), who accompanied Ferdinand V. Hayden's geological survey of the Yellowstone region in 1870–71 and worked for almost every major railroad in the United States in the later 19th and early 20th centuries. His Detroit Publishing Company successfully marketed his images (many of them hand-colored by his wife) in millions of reproductions as photographs or postcards. Jackson also delivered lectures on his travels illustrated with his own hand-colored lantern slides. In *Hopi Harvest Dance* [6.68] he captures two key elements of the Southwest that drew tourists: the distinctive architecture and the elaborately costumed ceremonies.

More popular than the Harvest Dance was the Hopi Snake Dance, which was painted, photographed, and filmed repeatedly in the first decades of the century. The photographer A. C. Vromans, viewing it at the village of Walpi in 1895, noted: "We found some forty white people camped, all to see the dance. Was not a little surprised to learn these were artists of note. Authors, sculptors, newspaper correspondents from a half dozen papers and some dozen or more ladies." With its elaborately costumed dancers and writhing reptiles, the Snake Dance truly functioned as a symbol of the "natural" or "primitive" or "exotic" aspect of Hopi life. The increasing numbers of visitors, however, had a disruptive effect on the dance, which was intended

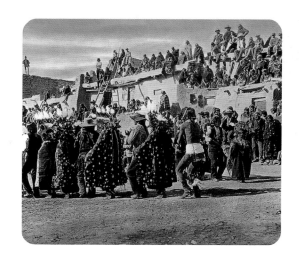

6.68 William Henry Jackson: *Hopi Harvest Dance*, n.d.
Hand-colored photograph
William E. Koplin collection

to bring much-needed rains to the fields. As early as 1901 the ethnologist Jesse Walter Fewkes noticed that "when gazed upon by so many strangers, some of the Snake men appeared to be more nervous and did not handle the reptiles in the fearless manner which marked earlier performances." By the early 1920s the Hopi had banned sketching and photographing of the Snake Dance, and later closed the ceremony to all outsiders.

The effect of the crowds on the rituals of the Native peoples of the Southwest is suggested by John Sloan in his *Indian Detour* (1927) [6.69], which shows the Corn Dance at Santo Domingo Pueblo going on amidst a ring of tour buses and largely oblivious tourists. Sloan also contrasts Native spirituality, in the form

6.69 John Sloan: *Indian Detour*, 1927
Etching, 6 × 7¼ in. (15.2 × 18.4 cm.)
Kraushaar Galleries, New York

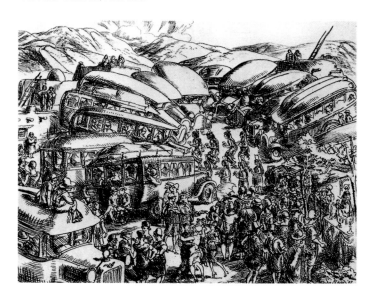

of the dance, with Christian spirituality, in the form of the altar on the right, at which several tourists stare. The artist, who first visited Santa Fe in 1919 and returned there almost every summer until 1950, described this print as a "satire on the Harvey Indian Tour." Fred Harvey was an entrepreneur who made his fortune providing food, hotel rooms, souvenirs, and sightseeing. His "Indian Detour," begun in the mid-1920s, was a particularly successful joint venture with the Santa Fe Railway, for it allowed tourists to venture away from the tracks while at the same time maintaining the comfort of a well-appointed train. The luxury buses gave easy access, for the first time, to the northern and central areas of New Mexico and Arizona and all of the major Hopi villages.

From Artifact to Souvenir to Work of Art:
The Promotion of Hopi Pottery and Washoe Basketry

Through the Indian Detour and the souvenir shops in his hotels, Harvey, along with the Santa Fe Railway, created a highly successful market for Native American goods. Tourists were encouraged not only to experience the "real" thing in coming to the Grand Canyon and the Hopi villages but also to buy "authentic" Indian souvenirs. The skills of Native potters, jewelry makers, carvers and weavers were now devoted to the creation of saleable goods. As in Mexico, while the demand provided income to their makers, it and the interventions of middlemen such as Harvey often led to alterations in the look and materials of the goods themselves. Sometimes new "authentic Indian objects" were mass-produced for the tourist market: McLuhan notes, for instance, that the Tesuque Rain God made by the Tewa at the pueblo of Tesuque played no actual role in Tewa culture.

One of the sites where "Indian objects" were sold was Harvey's Indian Building in Albuquerque, with a 200-foot-long arcade under which numerous Native Americans displayed their wares. The interior, which was completed in 1902 [6.70], was designed by the architect Mary Colter (1869–1958); it was her first project for the Fred Harvey Company (she would work for Harvey until 1948). American Studies scholar Leah Dilworth describes it as follows:

> The room's arrangement combined the abundance and eclecticism of the Victorian interior with the ethnographic exhibit, like a curiosity cabinet writ large. It was also a rather masculine interior; there was a Rooseveltian moose head on the wall, a canoe suspended from the ceiling, Navajo rugs on the floor, baskets hanging on the wall, and Indian pots and baskets lining the shelves. Textiles of primitive manufacture were draped tastefully about, and there were various animal skins, potted cacti, and what

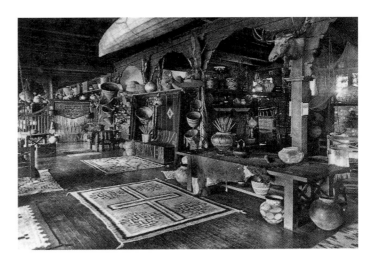

6.70 Mary Colter: the main room in the Indian Building, Albuquerque, New Mexico, 1902

appears to be locally crafted furniture. The room was a textbook lesson in a Southwest rendering of an arts and crafts interior.

Colter was one of the founders of what came to be known as the Santa Fe style in architecture and interior design. This style incorporated a celebration of the handcrafted object of the Arts and Crafts movement of the late 19th and early 20th centuries with the distinct forms of Hopi, Zuñi, and Navajo artistic production and the cluttered arrangements of middle-class Victorian parlors.

While Hispanic architectural and decorative traditions were heavily utilized in Colter's interior and exterior designs for Fred Harvey, there was virtually no sign of Hispanic life. The Albuquerque building was originally called the Indian and Mexican Building, but the latter adjective was soon dropped. Native Americans were "pure" primitives, whereas Hispanos, according to Dilworth, "were perceived as combining the savagery of the Indian with the bad traits of the Spanish." In addition, after 1910 Mexico meant the revolution going on just across the nearby border. Thus, Hispanic farmers and laborers in the Southwest could not be so easily romanticized. "Unlike Indians," writes Dilworth, "Hispanos did not qualify as a primitive folk worth preserving; they were not about to disappear, and anthropologists did not study them."

Some of the Native Americans who created works for Harvey and other souvenir entrepreneurs gained widespread reputations for their skill, and their work was soon promoted as art rather than artifact, allowing sale at higher prices. One potter who gained such a reputation was the Hopi-Tewa Nampeyo (c. 1860–1942). Nampeyo was born in Hano Pueblo on First

Mesa. Her mother was a potter, and the young girl would have learned the art by watching her mother work, from the gathering and working of the clay to the making and applying of colors to the firing of the pots. While Hopi culture was matrilineal, it was Hopi men who became the mediators between the traditional world of the Hopi and the world of outsiders, and the spread of Nampeyo's reputation was facilitated by her brother Polaccaca: after changing his name to Tom Polacca and converting to Christianity, he became a key spokesperson in dealing with the increasing numbers of white traders, tourists, and government officials who entered the region. He was the first to establish a close relationship with Thomas Keam, who in 1875 opened a trading post close to First Mesa. Keam would become one of the major middlemen in the marketing of Hopi ceramics. In turn, he supplied the Hopi with manufactured cloth, metal utensils, flour, sugar, coffee, and other processed goods.

The same year Keam opened his trading post, William Henry Jackson visited Hano and took the first known pictures of Nampeyo, who was then merely the young sister of his interpreter and guide, Tom Polacca. Soon after, the Smithsonian Institution and private collectors initiated a period of insatiable collecting of Hopi artifacts that resulted in the export of thousands of *katcina* dolls (see p. 30), ceramics, domestic implements, clothes, basketry, religious objects, dance masks, and much more. This collecting was at its height between 1879 and the late 1880s, and was driven in part by the belief, examined in previous chapters, that Native peoples were "doomed to perish," and that their cultures must be preserved in museums as part of America's past.

The passion for "ancient" Hopi ceramics had a twofold effect. Many more women turned to pottery as a way to make money; and the more skilled among them, like Nampeyo, began to copy the older shapes and decorations, which they found in the shards scattered among the ancient ruins close to the mesas. The anthropologist Alexander Stephen, who lived in the villages atop First Mesa in the early 1890s, comments on this practice in a diary entry of 1893 in which he refers to another Hopi potter and compares her to Nampeyo: "She does not approach Nümpe´yo, the distinguished Tewa potter, in artistic skill Like Nümpe´yo she tells me she makes her designs after some she has seen on ancient ware, but knows nothing of their significance." While a later anthropologist, Jesse Walter Fewkes, would claim credit for introducing Nampeyo to ancient Hopi ceramics during his excavation of Sikyatki in 1895, Stephen makes clear that she was already responding to the demand for ancient ceramics before that date.

The earliest pieces attributable to Nampeyo were purchased in 1896 by Walter Hough, the curator of anthropology for the Smithsonian Institution. While Nampeyo made many large bowls, she is best known for her large-diameter jars. On one such jar of 1912 [6.71] she tilts two *katcinas* toward each other, creating a triangular shape, which she alternates with a circle motif. She may have studied the designs on shards from Sikyatki and other ancient sites, but she took great artistic license in her interpretations of them. By the first decade of the 20th century Nampeyo's reputation was secure. The anthropologists, tourists, artists, and government officials who came to First Mesa invariably left with one of her jars or bowls. She was a prolific potter and a smart businesswoman, and soon had the help of her daughter Annie, who has garnered a reputation of her own in recent years.

6.71 Nampeyo, Hopi-Tewa: jar, 1912
Painted clay, 9 × 12 in. (22.9 × 30.5 cm.)
Gilcrease Museum, Tulsa, Oklahoma

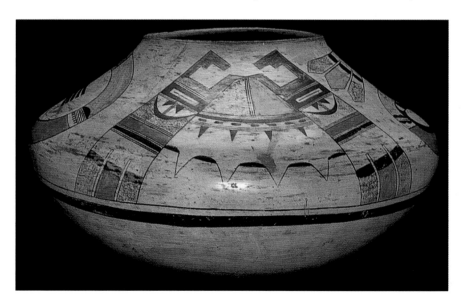

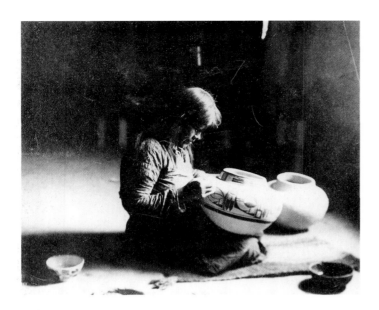

6.72 Edward S. Curtis: *Nampeyo decorating pottery*, 1900
Photograph
Smithsonian Institution, Washington, D.C.

Nampeyo was also probably the most photographed Hopi in the early 20th century. Edward S. Curtis (1868–1952), who spent much of his life recording the Native peoples of the United States and Canada, took several pictures of her, including *Nampeyo decorating pottery*, of 1900 [**6.72**]. Her biographer, Barbara Kramer, notes that this may have been the first photograph to identify the potter by name and her work, but warns that there is reason to question the ethnographical accuracy of the image, "for it is apparent that he combed out her characteristic Tewa hairstyle to make her look younger and prettier by Anglo standards" (married women like Nampeyo wore their hair parted in the middle and gathered in two rolls wound with dark cotton string that hung down on their shoulders; unmarried women had their hair arranged in two elaborate whorls on either side of their head above their ears).

In 1905 Nampeyo and her husband Lesso and other members of her family were the first group to occupy Fred Harvey's Hopi House, a three-story terraced structure designed by Mary Colter and meant to replicate a Hopi dwelling. It was located opposite one of Harvey's hotels on the rim of the Grand Canyon. A photograph of them taken at the time was used to publicize the building [**6.73**]. In exchange for being on display as a tourist attraction, the residents were given housing, food, and satisfactory prices for any items they produced. Nampeyo and her family made a second trip to Hopi House in 1907. In 1909 they agreed to participate in one final tourist display, at the Land Show in Chicago, organized by the *Chicago Tribune* to encourage agricultural development in the South and the West. There Nampeyo shaped her clay and Lesso performed various Hopi dances. The event spread Nampeyo's reputation even further, and ensured a nationwide demand for her work among

6.73 Anonymous: *Native Roof Garden Party, the Hopi House*, 1905
The adults, seen from left to right, are Nampeyo, her daughter Annie and son William, and her husband Lesso.
Photograph
Special Collections Department, University of Arizona Library, Tucson, Arizona

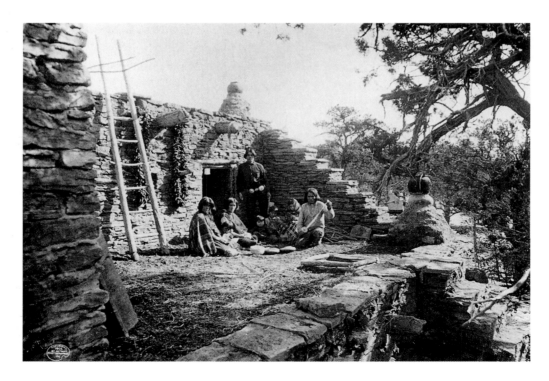

collectors. By 1920, however, her eyesight began to fail, and while she still shaped bowls and pots until a few years before her death, her daughters Annie and Fannie were increasingly responsible for painting the designs.

Another example of the creation and marketing of "authentic Indian objects" centers on a group of Washoe women in the region around Lake Tahoe, bordering the states of Nevada and California. The work of these women has been studied by the art historian Marvin Cohodas, who observes that "Washoe fancy basketry is a twentieth-century 'art of acculturation' . . . owing little to traditional techniques, forms, or designs as they appear to have existed in the nineteenth century. Promoted by collectors and dealers of Indian curios, it evolved rapidly to meet the demands of the marketplace." This evolution was facilitated by the widespread imitation of a small group of innovative and commercially successful artists. Just as Nampeyo was reliant on entrepreneurs like Thomas Keam and Frank Harvey for the marketing of her wares, Louisa Keyser, or Dat So La Lee (d. 1925), the best-known Washoe basket maker, was tied financially and personally from 1895 until her death to Abe and Amy Cohn, the proprietors of the Emporium Company in Carson City, Nevada (Amy's interest in basketry was responsible for the Emporium's entrance into the native "curios" market). In exchange for support for herself and her husband, Keyser handed over to the Cohns all the baskets she was able to make, and gave demonstrations in order to attract customers (she also made an appearance at the 1919 St Louis Exposition of Industrial Arts and Crafts).

This focus on Native artisans at work functioned not only as proof of the authenticity of the objects produced but also as a commentary on the transformation of labor in general at the time. Dilworth argues that "The immediacy of Indian craftwork—its relatively unmediated methods of production—seemed to provide an antidote to the alienated labor of industrial production." Of course, few could return to such artisanal work in their own lives as a source of income. But they could escape into this world momentarily—by visiting the Southwest, or by viewing Native Americans and their work at national or international expositions, or by taking part in a growing number of classes in basket-weaving or ceramics or silversmithing offered in schools throughout the country. These classes often had a remedial flavor, for engaging in craft production was promoted as a "healing" activity, one that could counter the effects of a world increasingly alienated from both nature and manual labor.

Louisa Keyser's baskets were seen as of a particularly high quality by the Cohns, and were recorded in a special ledger. A photograph of the Emporium around 1900 shows the display of native basketry, with Keyser's work arranged in the center of the

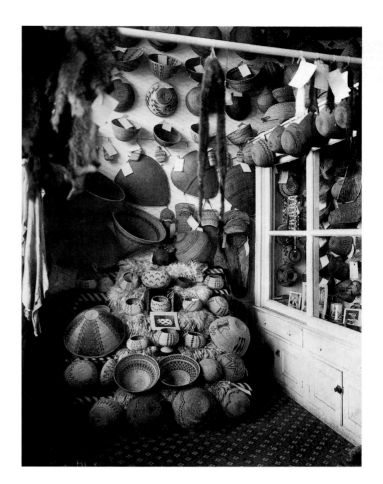

6.74 The Cohn Emporium, Lake Tahoe, c. 1900

lower grouping [**6.74**]. Traditional Washoe baskets, used for the storage, cooking, and serving of food, were deep inverted cones, rising from a narrow base to a wide mouth, and were decorated with simple geometric designs ringing the upper edges [**6.75**].

6.75 Washoe woman with a traditional storage basket, n.d.

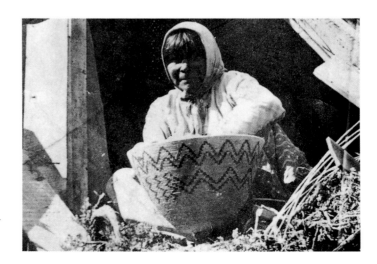

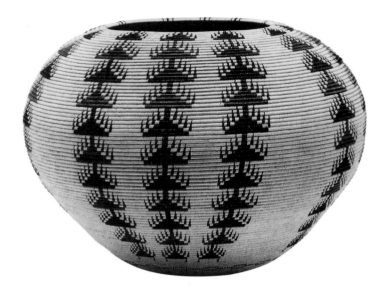

6.76 Louisa Keyser (Dat So La Lee), Washoe: *degikup* basket, *c.* 1917–18
Willow, redbud, and bracken, 12 × 16¼ in. (30.5 × 41.3 cm.)
Philbrook Museum of Art, Tulsa, Oklahoma

Keyser experimented with various shapes and designs, a process made easier by her isolation from her Washoe community and her exposure to other basketry traditions in the Emporium. She ultimately developed her own unique shape, the *degikup*—which swelled out from a narrow base, then curved inward to an open neck slightly wider than the base—and decorated it with vertical bands of abstract forms. The art historian Evan M. Maurer has analyzed how Keyser achieved an effective harmony between the form of the object and its two-dimensional decoration in a basket from *c.* 1917–18 [**6.76**]:

> This design is known as the scatter pattern, and consists of a series of stepped triangles arranged vertically on a narrow black band The stepped triangles grow in size as the form of the basket widens, and diminish as the form curves inward at both top and bottom. These motifs are arranged in four groups of three The central element of each group is aligned on a vertical axis, but the two flanking elements gently bow outward, to compensate visually for the perspective changes that result from the curving surface.

Maurer compares this subtlety to the ancient Greek use of swelling, or *entasis*, in a column.

The relationship between the Keysers and the Cohns was complex. Louisa Keyser gained a level of material security that allowed her to experiment and to perfect her basketry. The Cohns gained an artist whose abilities they clearly respected.

Yet Amy Cohn felt it necessary to invent a history for both the artist and her works: Keyser was a Washoe princess born in precontact times, the *degikup* a traditional Washoe mortuary basket, and the abstract designs a narrative of Washoe legends and history. Keyser preferred to use her English name, Louisa; but the Cohns insisted on publicizing her under an invented Washoe name, Dat So La Lee, or "big hips," referring to her large size. By exerting total control over her public image, which came across as childlike and irresponsible, they perpetuated white stereotypes of Native Americans at the same time as they transformed Keyser from a maker of "curios" into a maker of "art," selling one of her baskets in 1914 for $1,400. Members of the next generation of Native American artists would attempt to take control of their image, and to redefine the relationship between their indigenous communities and the expanding art world and art market.

The Harlem Renaissance

Harlem and the "New Negro"

The struggle to control their self-image and the marketing of their work also occurred within communities of African American artists. The exclusion of African Americans from mainstream cultural, economic, and political institutions that had marked the 19th century continued into the 20th, resulting in the development of new black institutions and support networks. Artists were aided in their efforts by the emergence of new political and intellectual leaders, notably the Harvard-educated historian and activist W. E. B. Du Bois. According to the art historian Richard Powell, by celebrating the cultural and spiritual lives of African Americans in publications such as *The Souls of Black Folk* (1903), Du Bois allowed them "a metaphysical reality and an inner being which refuted the absurdities of everything which was then commonly touted as 'Negro,' from popular culture's 'coon' imagery to Booker T. Washington's widely sanctioned message of black acquiescence."

Du Bois's writings contributed to the evolution of the "New Negro," a term used to describe a new generation of educated and politically astute men and women who argued eloquently and organized effectively for the rights of black men and women. This new elite sponsored literary societies and art and industrial exhibitions to combat racist stereotypes, showcasing the range of talents within African American communities. From these efforts grew what came to be known as the "New Negro Arts Movement" or the "Harlem Renaissance" of the 1920s and early 1930s. The latter term has dominated the writing on this movement in recent years, though several of the artists did not live and work in Harlem, or did so only after the

early 1930s (e.g. Archibald J. Motley, Jr, of Chicago, Hale Woodruff of Indianapolis, and Sargent Johnson of San Francisco). The centrality of Harlem in the public imagination is due in large part to its location in New York City, where it benefited from a general flourishing of the arts and entertainment industries. It also reflects the presence in African American communities throughout the United States of the works of two major Harlem artists, the painter and graphic artist Aaron Douglas and the photographer James VanDerZee, whose images were diffused through journal and book illustrations, murals, and commercially distributed photographs. The term "Harlem Renaissance" is used here in the spirit suggested by Powell, "removed from its regional connotations and . . . placed within the more inclusive concept of a metaphoric racial landscape, where this born-again black culture is realized in a range of art works, visual artists, and artistic meccas." Many of the artists included may not have worked in Harlem during the height of the Harlem Renaissance, but they benefited from the attention and support given to African American artists by the small group of black and white intellectuals and patrons who defined the movement.

Harlem was also the destination point of tens of thousands of African Americans who left the South in the first decades of the 20th century. World War I hastened this exodus, with its need for soldiers on the battle front and workers in the factories of the North. When they returned from Europe, the art historian Mary Schmidt Campbell notes, black soldiers brought with them an awareness of

> the burgeoning popularity of negritude, a philosophy created by African and Caribbean poets that promoted the unity and beauty of peoples of African descent. In London, Paris, and Berlin, they could also witness the extraordinary appeal of jazz—the new Black American music—and an international appreciation of the depth and complexity of Black culture that was unimaginable in the provinces of their hometowns.

Some could also have learned that the evolution of European contemporary art in the first two decades of the 20th century was at least partially informed by the cultures of Africa and the African diaspora.

This new awareness led to a renewed sense of national pride and cultural identity, and a renewed determination to battle the racism and violence against African Americans that had increased rather than decreased in the years immediately following the war. Painters, sculptors, writers, and musicians joined in the exploration of what the art historian David Driskell

calls "the spirit of negritude." They turned their attention to two related tasks: (1) an exploration of the civilizations of Black Africa; and (2) a redefining of the meaning of black experience in the United States.

Among the best-known of the writers of the Harlem Renaissance was the Harvard-educated philosopher and Howard University professor Alain Locke. Locke urged black Americans to re-establish the position of art at the core of life, as, he argued, it had been in Africa, and to make art a liberating force. He also saw the exploration and celebration of African art and culture as a way to foreground the contributions of African artists to Modernist art. Locke shared the belief of Stieglitz and many critics that Modernist art at its best was separate from the world of machines, that it embodied an uncontaminated form of creativity. He saw African art, rooted as it was in the crafts and the creation of beautiful objects for use, as epitomizing pre-industrial purity. Such art could act as a liberating force for contemporary African American artists. It would, in fact, be more liberating for them than for European American artists, because of their historical and racial bond. While white artists might use African art as a source of formal innovation, black artists would find inspiration for either independent originality or a new expression of a half-submerged "race soul."

While Locke has been celebrated over the years as the spokesperson for a vital cultural renaissance among African American artists, the literary scholar Henry Louis Gates, Jr, sees in Locke's arguments, and in the Harlem Renaissance in general, the transformation of a much more politicized New Negro movement of the first two decades of the 20th century into a more apolitical movement focused primarily on the arts. Blacks were to lobby for equality through the arts, not through direct political action, and white Americans could now embrace blacks through art that conformed to the Modernist conventions of Western Europe, tinged with the exotic overtones of Africa, rather than through inclusion in the political processes of the country. Certainly not all African Americans subscribed to the philosophy of liberation through the arts. The most notable alternative was offered by Marcus Garvey and his Universal Negro Improvement Association (UNIA) [6.80], which insisted not only on "race pride" but on autonomous development and a return to Africa, for the divide between white and black was seen as too great to overcome. As unlikely as liberation through art might have seemed in the 1920s, a return to Africa was equally unlikely for the majority of African Americans, and Garvey's UNIA collapsed in 1924.

The relationship between the world of the white avant-garde and the emerging African American subculture of Harlem was highly problematic. African American artists worked in a

separate community, yet tended to look to the white art world, as well as their own community, for recognition through exhibitions and sales that would prove their equality. Yet when recognition came, it was often through black-only exhibitions, such as those organized by the William E. Harmon Foundation, a white New York-based philanthropic organization. Locke had persuaded the real-estate magnate William Harmon to set up this foundation in 1922 to sponsor annual national competitions, exhibitions, and awards. The awards were first bestowed in 1926; almost every major writer and artist associated with the Harlem Renaissance was an award winner. So important was the support of the Harmon Foundation that the end of its juried exhibitions and awards in 1933 has been seen as an important factor in the demise of the Harlem Renaissance.

White recognition of black artists was often marked by racist assumptions. While the Harmon Foundation provided crucial financial support, its publications promoted the notion of the artists and their work as "inherently" humorous, simple, and filled with "natural rhythm." The historian Nathan Huggins writes that the black people of Harlem had little chance to define their own identities: Harlem was seen by dissatisfied white artists and intellectuals as a place that had "magically survived the psychic fetters of Puritanism," and black culture became an antidote to the sterile, machine-driven material existence of white culture, particularly a white culture that had spawned the technological nightmare of World War I. This white fantasy of the exotic, sexualized, and primitive affected the reading of works by African American artists, writers, and entertainers who were trying to express their African heritage or to explore the reality of black identity in the United States. Yet many were optimistic that continued interaction between white and black intellectuals and artists would result in a greater understanding of the complex nature of black life and a willingness by whites to grant blacks respect as equals.

Africa and America: The Imaging of African American Life
Many African American artists in the early 20th century followed the example of Henry Ossawa Tanner (see pp. 315–18) in taking up the call to create depictions of the material and spiritual lives of African Americans. Aaron Douglas (1899–1979) was one such artist. Douglas arrived in Harlem in 1924, having finished his bachelor's degree at the University of Nebraska in Lincoln and taught art in a Kansas City high school for a year. He soon began studying with the German immigrant Winold Reiss (1887–1953), who was well known within the African American community for his support of the New Negro Arts Movement and for his portraits and scenes of Harlem life (both Reiss and Douglas provided illustrations for Locke's 1925 anthology

of Harlem Renaissance writers, *The New Negro*). Reiss worked in two different styles, a flat, sharp-edged, decorative manner which drew on his work as a graphic artist and interior designer, and a highly naturalistic, fully rounded and carefully modeled manner which he used to capture the features and personalities of those who sat for their portraits. His *Portrait of Langston Hughes* (c. 1925) [6.77] combines these two styles, the former in the background and the latter in the face and hand of the young poet, who would become a central figure within the Harlem Renaissance.

Richard Powell sees this portrait of Hughes as representative of another aspect of the New Negro Arts Movement, its location within a general celebration of the "new" in the United States in the 1920s, which found its most visible form in the proliferation of ever more varied commodities and a worship of technology and its streamlined machine forms. Whatever was "new" was evaluated through the lens of commercial promotion as well as

6.77 Winold Reiss: *Portrait of Langston Hughes*, c. 1925
Pastel on artist board, 30 1/16 × 21 5/8 in. (76.3 × 54.9 cm.)
National Portrait Gallery, Smithsonian Institution, Washington, D.C.

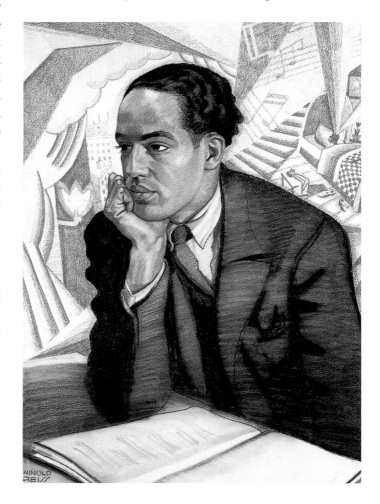

of nationalism, for the United States was flexing its muscles as a "new" world power after World War I and sought to make its mark as distinctly different from the "old" European world powers. This would be achieved often through a presentation of folk or indigenous motifs in an updated, streamlined style. Reiss, for example, not only visited the homes and nightclubs of African Americans but studied African and Precolumbian art in New York museums and traveled to Mexico. In his *Portrait of Langston Hughes*, Reiss moves, in Powell's words, from a "painstaking delineation of Hughes's face" to a "cubistic background of Art Deco marginalia, musical notes, and whimsical 'Negro' decorations," thus situating the "New Negro" "in the world of product and display, where the commodity (Hughes) was clearly placed between modernity and a persistent, pliable folk temperament."

When Douglas was studying with Reiss he met the Philadelphia collector Albert Barnes, one of several wealthy white patrons of black artists, who allowed him to examine his extensive collection of West African sculpture and his Modernist European paintings. Douglas proceeded to combine the stylized forms of the two worlds to create a series of illustrations and murals that spoke to Locke's call for a new Negro art informed by Africa and celebrating the lives and history of African Americans. In 1925 Douglas wrote to Hughes:

> our problem is to conceive, develop, establish an art era
> Let's bare our arms and plunge them deep deep through
> the laughter, through pain, through sorrow, through hope,
> through disappointment, into the very depths of the souls
> of our people and drag forth material crude, rough,
> neglected. Then let's sing it, dance it, write it, paint it
> Let's create something transcendentally material,
> mystically objective. Earthy. Spiritually earthy. Dynamic.

Douglas conveys this range of emotions in his work. For example, he combines hope and determination in *Ma Bad Luck Card* (1926) [**6.78**], an illustration for "Hard Luck" by Hughes in the October 1926 issue of *Opportunity*, the publication of the Harlem-based Urban League, an African American organization founded in 1910 to help black migrants from rural areas adjust to urban life. This image shows a debt to the graphic work of Reiss, with its flat, sharply outlined silhouettes, geometric forms, and contrast between light and dark. Douglas has given dignity to his figure, omitting the mundane details of everyday life and conveying, instead, a sense of monumentality and timelessness. The man represents the struggles of Africa and of Africans in America. Even when dealing with a historical figure, as he does in his 1931 mural devoted to the escaped slave Harriet Tubman, who

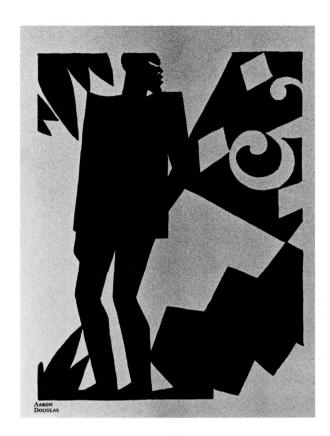

6.78 Aaron Douglas: *Ma Bad Luck Card*, 1926
Illustration for "Hard Luck" by Langston Hughes, in *Opportunity*, October 1926
Schomburg Center for Research in Black Culture, The New York Public Library, New York

repeatedly returned to the South to help others escape [**6.79**], he generalizes her form to represent all black women who broke the shackles of slavery to flee north. At the same time, his powerful profiles suggest the profile figures of Egyptian

6.79 Aaron Douglas: *Harriet Tubman*, 1931
Mural, 54 × 72 in. (137.2 × 183 cm.)
Bennett College, Greensboro, North Carolina

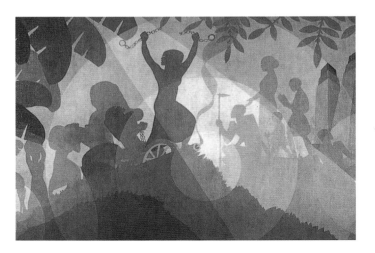

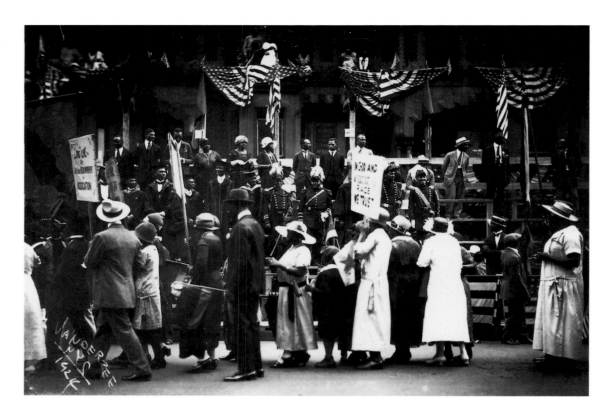

6.80 James VanDerZee: *UNIA Parade with Marcus Garvey and Members on Bandstand*, 1924
Silver print
© Donna Mussenden VanDerZee

wall-paintings. There are also similarities in this mural to the Precisionist paintings of Demuth [6.46], notably the limited palette and the shafts of light that function as veils across the surface of the work, creating an otherworldly atmosphere.

6.81 James VanDerZee: *Couple in Raccoon Coats*, 1932
Silver print
© Donna Mussenden VanDerZee

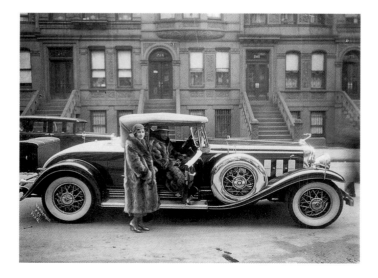

Douglas celebrates and memorializes a history that too often had been misinterpreted or forgotten altogether.

The photographs of James VanDerZee (1886–1983), who operated a portrait studio in Harlem, differed considerably from Douglas's prints and paintings. Whereas Douglas celebrated the iconic and eternal through pared-down forms, VanDerZee focused on the particular and the contemporary, recording the minute details of life in Harlem, be it a gathering of Marcus Garvey's Universal Negro Improvement Association [6.80], a funeral, or a couple proudly displaying their expensive clothes and car [6.81]. He also photographed the physical decay of many tenement buildings, although few of these photographs were widely distributed. Despite such disrepair, and despite the fact that disease rates were far higher than in white Manhattan, most Harlem residents did not see their neighborhood as a slum, and were optimistic about the future. It is this optimism and self-esteem that VanDerZee captured in many of his photographs. Most of those who commissioned portraits arrived at his studio in their finest clothes. Like the majority of portrait photographers, he offered advice on how to pose and utilized the wonders of photographic manipulation. He touched up imperfections of costume, skin, or hair and added props to help his clients look their best, in the process contributing to the creation of a collective image of the New Negro.

Palmer Hayden (1890–1973), a pseudonym for Peyton Cole Hedgeman, followed the lead of Douglas in combining

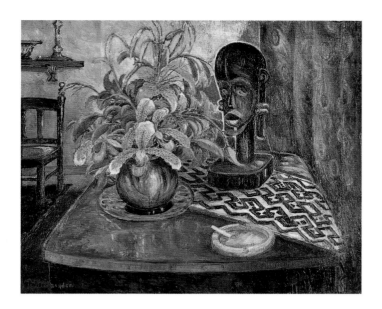

6.82 Palmer Hayden: *Fetiche et Fleurs*, 1926
Oil on canvas, 23 × 28 in. (58.4 × 73.7 cm.)
Museum of African American Art, Los Angeles, California

6.83 Palmer Hayden: *Midsummer Night in Harlem*, 1936
Oil on canvas, 25 × 30 in. (63.5 × 76.2 cm.)
Museum of African American Art, Los Angeles, California

references to Africa and America in his paintings, as can be seen in *Fetiche et Fleurs* (1926, first exhibited in 1933) [**6.82**]. His inclusion of African elements could be read by viewers at the time as a reference to two worlds—the Modernist art world of Paris and New York, and the world of historical and contemporary African culture. The tablecloth is made of Bakuba raffia cloth from the Congo and the sculpture is reminiscent of a Fang mask from Gabon. The style of the painting, the general arrangement of the objects, and the medium all refer to European artistic traditions of still life and Modernism, although a Modernism of the late 19th, rather than early 20th, century.

Hayden's career was made possible through the support of a wealthy philanthropist, Alice Dike, and through the Harmon Foundation. Dike gave Hayden $3,000 to go to Paris in 1927 after he won first prize in the painting division of a Harmon Foundation competition, and he lived there until 1932. During this time he turned away from European still lifes and African art and began recording the daily lives of African Americans in a style informed by untutored or folk traditions. The results of this shift can be seen in *Midsummer Night in Harlem* (1936) [**6.83**]. While several critics praised his focus on black life, many others were insulted by what they saw as his borrowings from

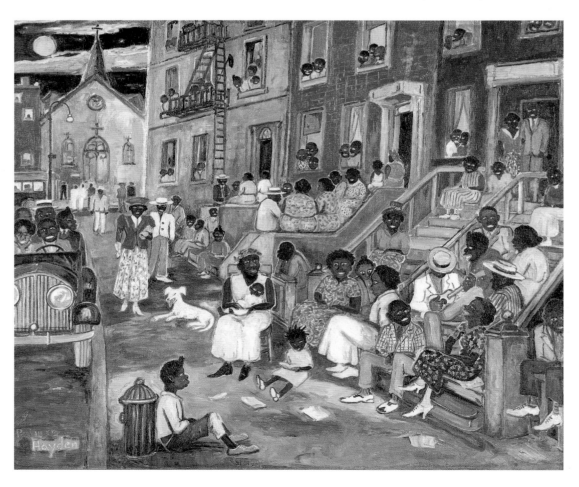

white stereotypes of African Americans, most notably the exaggeration of facial features. Hayden argued that he was not making fun of black people, but was painting a time in which he lived and a people for whom he had a great deal of affection. As Powell notes, many of the major figures of the Harlem Renaissance—the writer Zora Neale Hurston, the musician Louis Armstrong—created humorous or expressionistic images of black culture in an attempt "to infuse their art with the totemic allure of 'the folk.'" That this "folk" was, itself, often infused with borrowings from white racist stereotypes was a reminder of the complex process of identity formation for blacks in a world still clearly dominated by whites.

Archibald J. Motley, Jr (1891–1981) also depicted the everyday lives of African Americans, although he chose a style less informed by folk traditions and represented his figures in a manner less open—although not completely resistant—to charges of racial stereotyping. One of his best-known early paintings is *Mending Socks* (1924) [6.84]. Here the references to African American identity are contained primarily within the figure of the woman, rather than the objects on the table or wall. The viewer is ultimately forced to ask: "Whose interior is this?" The most likely answer in 1924 would have been: "That of the white family represented by the portrait on the wall." The elderly woman, wearing a telltale apron, would have been read as a household servant. The transition between the African American woman and the white woman is marked by a crucifix. Christianity mediates between the worlds of black and white. For the former it is both a source of oppression, having been

6.84 Archibald J. Motley, Jr: *Mending Socks*, 1924
Oil on canvas, 43¾ × 40 in. (111.1 × 101.6 cm.)
North Carolina Museum of Art, Raleigh

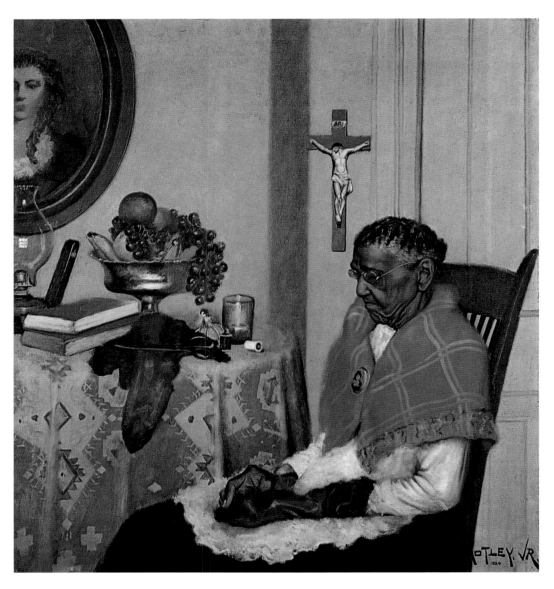

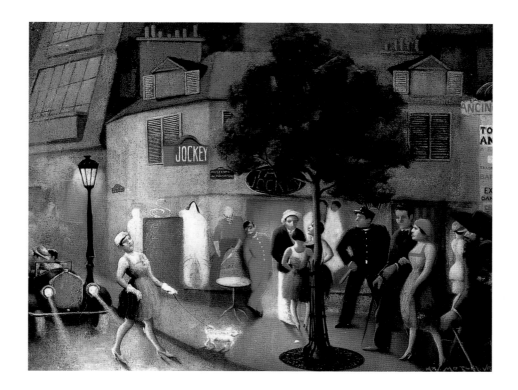

6.85 Archibald J. Motley, Jr: *Jockey Club*, 1929
Oil on canvas, 25¾ × 32 in. (65.4 × 81.3 cm.)
Schomburg Center for Research in Black Culture, The New York
Public Library, New York

forced upon African slaves with their arrival on the North American continent, and a source of strength and liberation: the lessons of Christ could apply to all human beings, not just whites. This crucifix embodies the highly charged debate over the values of assimilation versus those of separation, a debate that would be carried out within courts of law as well as sites of worship.

In his painting of the late 1920s and 1930s Motley focused more explicitly on the urban scene, with its nightclubs and crowded streets. He, like VanDerZee, contributed to the creation of what Powell describes as "a citified image of African-Americans," one that "reflected the phenomenon of a growing black urbanism and the marketing of a black urban identity to public policy advocates and the common people alike." This citified image appears clearly in *Jockey Club* (1929) [6.85], which highlights the markers of contemporary urban life of the 1920s, from fashions and cars to commercial signage. The Jockey Club was an American-owned nightclub in Paris. Motley gives us a glimpse of the club's white patrons before they enter the premises. These patrons, and the policeman who carefully surveys them, are contrasted to the black figure of the doorman, whose face appears to express a certain apprehension, and the

painted figures of cowboys and Indians that adorn the facade of the building. Thus the rough-and-tumble and energy-charged worlds of the Wild West and African America had been brought into the Parisian world of high fashion and urbanism as signs of U.S. cultural distinctiveness. Yet, as the art historian Mary Ann Calo has pointed out, while black creativity was "consistently framed in terms of a dynamic interaction of race and nationality" in the 1920s, black artistic production, like Native American artistic production, was just as consistently isolated from mainstream cultural practices. While critics used the terms "primitive" and "exotic" to celebrate the work of Modernist European American artists, they used these same terms to relegate the work of African American and Native American artists to the margins.

African American sculptors also turned to the lives of African Americans as subject-matter for their work. Just as Tanner had provided inspiration for painters, Meta Warrick Fuller (1877–1968) provided a role model for sculptors. Fuller had studied in Paris with Rodin in 1902 and had been strongly influenced by the emotional charge of his work, which was enhanced by his refusal to smooth away the roughness of his plaster models before they were cast in bronze, or entirely to hide the marks of the chisel in his marble sculptures [6.27]. In addition, his bodies were often stretched or distorted or incomplete.

Fuller, like Rodin, was interested in the macabre and in the psychological dimensions of human experience; but she was

also motivated by an evolving racial consciousness, which manifested itself upon her return to the United States in 1903 in a number of works, including a fourteen-part tableau on the theme of "Negro's progress" from Africa to America for the Jamestown Tercentennial Exposition of 1907, and *The Awakening of Ethiopia* of *c.* 1914 [6.86]. The lessons she learned from Rodin are clear in this latter work—the roughness of the surface suggesting the process of creation, the unfolding of the drapery and turn of the head suggesting movement. She may have been inspired by the utopian Pan-Africanist novel *Ethiopia Unbound* (1911), written by the Gold Coast activist and newspaper publisher J. E. Casely Hayford. Both sculptor and writer envisioned Ethiopia as awakening from a long sleep and shedding the garments that had both preserved her and immobilized her. Such an awakening functioned as a symbol for both Africans and African Americans of liberation from the oppressive restraints of racism. The sculpture also embodied, for African Americans, their shared past with Africans and with those who made up the larger African diaspora.

While Fuller's sculptures pointed to the struggles of contemporary African Americans, they did so primarily in a symbolic language. The sculptor Richmond Barthé (1901–89) focused less on contemporary African American life than on more generalized representations of Africa. He created several bronze dancing figures, including *African Dancer* (1933) [6.87], in which he celebrated the beauty of the black body and the rhythms of African dance that contributed to African American dance forms. Some might argue that he reaffirmed the dominant conception of Africa at the time as a "dark" continent of mystery, sensuality, and savagery. Yet he gives his figures an elegance and self-involvement that counter the more highly sexualized presentations of black men and women that appeared on the stages of nightclubs throughout the United States and Europe.

Certainly rhythm and sensuality are key elements in both the celebration and denigration of African Americans and their cultural expressions. African American artists struggled to reclaim these qualities and to re-present them as positive aspects of their

6.86 Meta Warrick Fuller: *The Awakening of Ethiopia, c.* 1914
Bronze, 67 × 16 × 20 in. (170.2 × 40.6 × 50.8 cm.)
Schomburg Center for Research in Black Culture, The New York Public Library, New York

6.87 Richmond Barthé: *African Dancer*, 1933
Plaster, 43 1/2 × 17 1/16 × 14 1/16 in. (110.5 × 43.3 × 37.3 cm.)
Whitney Museum of American Art, New York

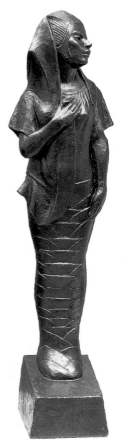

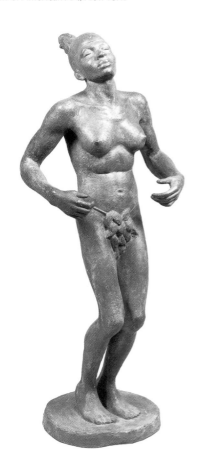

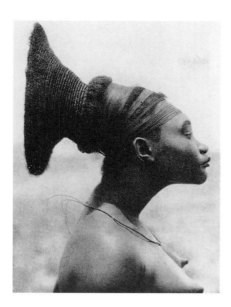

6.88 George Specht: *Nobosodru, Femme Mangbetu*, 1925
From Georges-Marie Haardt, *La Croisière noire*, Paris, 1927

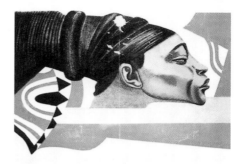

6.89 Aaron Douglas: cover of *Opportunity*, May 1927

6.90 Malvina Hoffman: *Mangbetu Woman*, 1930
Bronze, 33 × 19 × 19 in. (84 × 48 × 48 cm.)
The Field Museum of Natural History, Chicago, Illinois

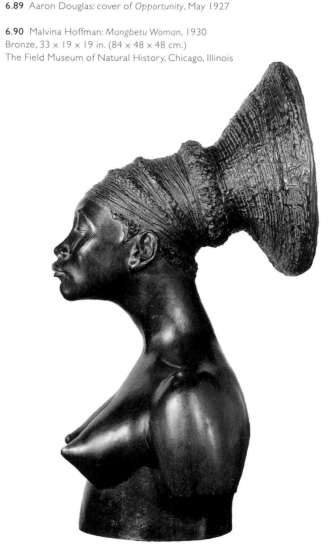

history and their lives. Several white artists joined them in their efforts, such as the sculptor Malvina Hoffman (1885–1966). Hoffman, who had also studied with Rodin in the early decades of the century, moved from the creation of a series of dancing figures to the rendering of the physical features of different racial types. In 1929 the Field Museum of Natural History in Chicago commissioned her to do a series of life-size sculptures documenting the races of the world. In all she completed 102 bronzes, which were exhibited at the Musée d'Ethnographie in Paris in 1932 and installed in the Field Museum in 1933.

While such projects could not help but call up earlier attempts by colonial powers to categorize the colonized in order better to control them, Hoffman's sculptures convey a respect for the people she portrayed, which comes through in a heightened sense of individuality rather than stereotype, combined with elegance and dignity, as in *Mangbetu Woman* (1930) [**6.90**]. The source for this sculpture was not a person Hoffman met on her travels, but a photograph of a woman named Nobosodru by George Specht [**6.88**], who accompanied a French expedition across Central Africa in 1925. Aaron Douglas also used Specht's photograph as a source for his cover of the May 1927 issue of *Opportunity* [**6.89**], isolating her head and elongating it in order to emphasize the forward motion and assertive quality of the image as a symbol of uplift and progress. Many artists, both black and white, would continue throughout the course of the 20th century to complicate the one-dimensional representations of African Americans that dominated the worlds of both fine art and mass media.

Gender, Consumption, and Domestic Spaces

Modernism and Fashion Design

While the female body appeared in posters promoting World War I and in paintings, sculptures, and graphic art that both celebrated and challenged gender and racial norms, it also functioned as a signifier of changes within a rapidly growing consumer culture. This development is captured by industrial designer Raymond Loewy (1893–1986) in a segment of his "Evolutionary Chart of Design" of 1930 [6.91]. Here domestic design is placed alongside fashionably dressed women's bodies; both move in tandem across the centuries, sheltering the body to varying degrees as they shed their frills and accoutrements. Loewy's penchant for the "streamlined moderne" style, marked by sleek, curving lines suggestive of speed and efficiency (like Douglas's *Opportunity* cover [6.89]), is evident in the last two house and dress designs.

Loewy was a key player in the expanding ranks of industrial designers in the 1920s. As American businesses multiplied and competition for sales increased, industrial designers were called upon to give a new look to an old product, or to provide innovative packaging for a new one. Loewy was one of the most successful of these designers. Having come to the United States

6.91 Raymond Loewy: "Evolutionary Chart of Design" (detail), 1930

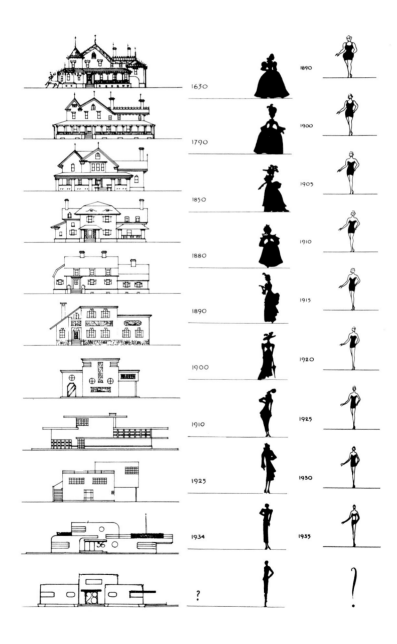

from France in 1919, he worked as a fashion illustrator and window designer until 1927, when he founded his own industrial design company. The centrality of Loewy as an industrial designer is indicated by his company's clientele, which included many of the icons of American industry: Studebaker, Pennsylvania Railroad, Greyhound, Frigidaire, Coca-Cola, Nabisco, Lucky Strike, and Shell Oil.

Loewy was clearly aware of the central role that women's fashion played within a consumer culture increasingly focused on the female shopper. While his chart traces parallel developments in fashion and architectural design, it also alludes to the increasing use of female bodies to sell products other than women's clothes. And it suggests a shift in the perception of the function of clothes: from an indication of class and occupation to a statement of individual identity, an identity increasingly swayed by the blandishments of advertising images. Indeed, the dresses themselves seem to be reshaping the very bodies of the women, a process suggested by the progression of the more visible bodies of the figures wearing bathing costumes on the right.

Loewy was also probably aware of the role fashion design played within women's reform movements of the late 19th and early 20th centuries. Corsets, bustles, and voluminous petticoats were all attacked as obstructing women's movements, if not their breathing. As Whitney Chadwick notes, "esthetic, medical, social, and anthropological discourses finally converged in a fundamental redesign of the ideal female figure that replaced the corset's exaggerated and constricting curves with the more flexible serpentine curvature of the modern body."

Chadwick also argues that fashion design played an integral role in defining Modernist design principles within the art world in the early 20th century. She notes, for example, that by 1913 "the Italian Futurists were exploiting the idea of clothing as a signifier for revolutionary modernism," while Russian artists were developing their understanding of Modernist artistic practice within the context of a political revolution that called for the comprehensive redesign of all aspects of society, including fashion. The connection between industrial design, Modernism and fashion was made explicit in the 1925 Exhibition of Decorative and Industrial Arts in Paris, which included clothing designs by Russian and French artists. This exhibition was also a key moment in the defining of a broader architectural and design movement known as Art Deco (see pp. 423–24).

Yet the liberatory and revolutionary rhetoric of many avant-garde fashion designers was undercut by the high prices of the clothes they designed and by their incorporation into a fashion industry that stressed the youthful and beautiful female body in its targeting of women as consumers. The "New Woman" was increasingly defined by her ability to purchase the "newest" fashions of the day. And while Loewy's chart suggests the fashions of the 1920s may well have offered women greater freedom of movement, it also contains a disturbing diminution of the very presence of the female body on the page, whose future can only be captured in the attenuated curve of a question mark. The freedoms gained by women in the United States were, indeed, limited, despite the achievement of the right to vote in 1920. As Chadwick notes,

> In the end, the image that promised a new world for the modern woman in twentieth-century industrial society would exist as a reality only for wealthy and privileged women. As it filtered to masses of working women, it functioned more and more as a fantasy, remote from the realities of most women's lives but strenuously asserted through media campaigns as a means to promote consumption—selling youth, beauty, and leisure along with the latest fashions.

Designing the Home: Women as Architects and Patrons

Wealthy and privileged women were also the ones who were able to benefit most from advances in architectural design in the early 20th century, be it as architect or as patron. It was very difficult for women to succeed in the field of architecture, even when it came to designing the homes with which they were still so insistently associated. Architects, like sculptors, were assumed to need a kind of assertiveness and physical presence, as well as physical strength, which women, in the minds of most, did not possess. Thus, women were strongly discouraged from entering the profession.

A few women did manage, however, to make their mark. Mary Colter, for example, gained a name for herself within the field, although primarily through her work for a single patron, Fred Harvey (see pp. 368–70). The San Francisco Bay architect Julia Morgan (1872–1958) also succeeded in establishing a career as a practicing architect. Morgan was the first woman graduate of the College of Civil Engineering at the University of California and went on to study at the École des Beaux Arts in Paris. The architectural historian Dell Upton points out that Morgan's success lay largely in the time and place in which she worked and in her family connections. She set up her practice in 1905, a year before the devastating 1906 earthquake; there was plenty of work for architects during the subsequent rebuilding of San Francisco and the East Bay. She had grown up in the East Bay city of Oakland in an upper-middle-class family and most of her early commissions came

from family and friends. Upton also notes that her career had a "gendered twist, for most of her work was domestic and most of her non-domestic work was obtained from woman-associated institutions, such as churches, women's colleges and women's subdivisions of coeducational colleges, and the Young Women's Christian Association."

Morgan is best known for the home she designed for the newspaper magnate William Randolph Hearst at San Simeon, a commission that spanned most of her professional career (she retired in 1940). The complex was originally named "La Cuesta Encantada" (The Enchanted Hill), but is now more popularly known as Hearst Castle (1919–mid-1940s). Located on a 250,000-acre (100,000-hectare) ranch on the California coast midway between Los Angeles and San Francisco, it was a testament to the massive wealth of Hearst. It was also a testament to the conspicuous consumption that marked the

6.92 Julia Morgan: Casa Grande, Hearst Castle, San Simeon, California, begun mid-1920s

homes of his predecessors, the late-19th century Robber Barons, both in its size and its penchant for revivalist architecture (see pp. 281–83). The Castle and guesthouses together contained 56 bedrooms and 61 bathrooms, as well as 19 sitting rooms, a movie theater, and indoor and outdoor swimming pools (the main house alone had 115 rooms). It was surrounded by 127 acres (50 hectares) of gardens and the world's largest private zoo. The main house, Casa Grande, filled with Hearst's collections of art and antiques, was modeled after a 16th-century Spanish cathedral [6.92], while the pools drew on the architectural features of ancient Roman baths. Morgan was the architect, yet she clearly, in Upton's words, "subordinated her aesthetic identity and her declared aversion to ostentatious design to Hearst's demands, both from a sense of professional obligation and from respect for her client as a powerful man."

The relationship between architect and patron was often a contentious one, and while Upton suggests that Morgan "gladly" acquiesced to Hearst's demands, the same cannot be said of Frank Lloyd Wright (1867–1959) and several of his female patrons. Wright is one of the best known designers of domestic architecture in the United States in the first half of the 20th century. He began his career in the Chicago office of Adler and Sullivan (see pp. 304–6), establishing his own practice in 1893. That same year he visited the World's Columbian Exposition (see pp. 302–12), where the Japanese pavilion, a half-scale reproduction of a Japanese temple, left a strong impression on him, with its fine craftsmanship, open modular planning, and broad roof floating above non-structural walls (he made his first trip to Japan in 1905 and returned several times thereafter).

These architectural qualities appeared in his designs for private homes at the turn of the century, such as the one he built for the businessman Ward W. Willits in Highland Park, Illinois, in 1902–3 [6.93], with its marked horizontal lines, simple rectilinear massing, deep overhanging eaves, and open interior design structured around a central fireplace. Wright also believed strongly in locating a building within its natural landscape and allowing for an optimal experience of this landscape from within the home, and he therefore linked the interior and exterior with a terrace and a covered driveway. These "Prairie Houses" were suggestive of the broad, open plains of the Midwest and were imbued with Jefferson's rural vision of America.

In 1915 Wright embarked on a very different project for theater producer and oil heiress Aline Barnsdall. The original idea was for a theater alone, but by 1919 it had evolved into a set of buildings that would accommodate a theater, living

6.93 Frank Lloyd Wright: Ward W. Willits House, Highland Park, Illinois, 1902–3 Detail of a plate in Wright's *Ausgeführte Bauten und Entwürfe*, Berlin, 1911

quarters for directors, actors and staff, a community space, and a home for Barnsdall atop Olive Hill in Los Angeles [6.94]. Wright and Barnsdall worked on this project from 1915 to 1923; in the end, her residence, which came to be known as Hollyhock House, built between 1919 and 1921, and two other smaller residences were the only structures completed. In the process they argued about and rethought not only building types, but also house design, family life, and domesticity.

In explaining the contentious relationship between Wright and Barnsdall, the architectural historian Alice T. Friedman writes that male architects often faced serious challenges in "designing houses for unconventional women clients whose programs were hybrids of traditional and unusual domestic activities." Domestic design often engaged with, and portrayed, attitudes regarding family life, the nature of appropriate social behavior, privacy, and the education of children. Women who resisted, in various ways, the pressures to conform to traditional roles as wives and mothers often sought out "new architectural solutions to accommodate unconventional ways of living." In his autobiography, written in the late 1920s, Wright recounted the battles he engaged in with Barnsdall over the design and construction of her home (he accused her of, among other things, being too easily swayed by the ideas of her theater friends), describing her as wanting "no ordinary home, for she was no ordinary woman."

Barnsdall was certainly no ordinary woman. For one thing, she was extremely wealthy, particularly after the death of her father in 1917. Yet even for a wealthy woman she was unusual. She was one of a small number within her class who, like Mabel Dodge (see p. 344), participated in the worlds of avant-garde art and left-wing politics. Having moved to Chicago in 1913, she was introduced to the world of radical politics,

feminism and avant-garde art theater by the writings of the American anarchist Emma Goldman (she met Goldman in 1914 or 1915). Goldman argued that theater could be a vehicle of social change by confronting the most important issues of the day: love, sexuality, marriage, the education of children, poverty, class struggle, and national identity. Theater, in Barnsdall's words, was "destined to help form the taste and ideals of the world." She was inspired by Goldman not only to support, as a theater producer, plays that addressed social issues, but also to engage in political activism. She contributed to the defense fund of the labor leader Tom Mooney, who had been jailed in 1916 in connection with a bombing on Preparedness Day in San Francisco (on 22 July 1916 a parade was held in honor of U.S. preparedness to enter World War I); backed Upton Sinclair's campaign for governor; opposed the War; and contributed money to help Goldman fight her order of deportation to Russia. The latter resulted in Barnsdall's passport being suspended by the State Department. Shortly after she arrived in Los Angeles in 1916 she became pregnant but refused to marry. Thus, according to Friedman, "Barnsdall's progressive feminist politics, her beliefs about art, and her uninhibited way of life constituted a challenge to convention that ultimately gave the Olive Hill project its distinctive character, informing Wright's design for Hollyhock House with brilliance and creative energy, while surrounding architect, client, and everyone else involved in an atmosphere of context and conflict."

In his autobiography Wright described his design for Aline Barnsdall's home on Olive Hill in Los Angeles as "a California Romanza" and wrote that its "poetry of form" was like a piece of music that allowed the musician "free form or freedom to make one's own form." Hollyhock House focused on theatricality and on the experience of monumental form, which framed the surrounding landscape. The house is a literal embodiment of Barnsdall's passionate commitment to theater, with its roof terraces and semicircular garden forming a flexible outdoor

6.94 Frank Lloyd Wright, Hollyhock House, Los Angeles, California, 1919–21

auditorium. For Wright, Hollyhock House was his response to the distinctive qualities both of his client—he found her "as domestic as a shooting star"—and of the site.

> Hollyhock House was to be a natural house, naturally built; native to the region of California as the house in the Middle West had been native to the Middle West. Suited to Miss Barnsdall and her purpose, such a house would be sure to be all that "poetry of form" could imply, because any house should be beautiful in California in the way California herself is beautiful.

The living spaces of Hollyhock House enclose an open courtyard, rather than the central or "noble" room of Wright's earlier domestic designs. The rooms are large and airy, filled with soft light, and large French doors lead out to the interior courtyard and to the surrounding grounds. While no plays were produced in the small outdoor amphitheater, it stood as a symbolic reminder of the origins of the Barnsdall project, even more poignant as the theater itself was never built. Wright's domestic design uses the typology of the ancient amphitheater as a parallel to the theatrical "family" that Barnsdall had created in place of a more traditional family.

In order to give Hollyhock House an "American" feel, Wright drew on both Precolumbian Mayan architecture, most evident in the frieze of stylized hollyhocks, and the Pueblo architecture of the American Southwest, with its irregular profile of stepped and stacked cubes, plaster walls, small window openings, and central courtyards surrounded by flat roofs, from which people could watch various ceremonies [6.68]. In addition, many New Mexican pueblos were, like Hollyhock House, located atop high hills or flat-topped mesas [1.17].

Barnsdall's theater company began to fall apart in the early 1920s and she soon lost interest in the Olive Hill project, commissioning Wright to design for her a house in Beverly Hills and turning her energies to supporting the building of a new theatrical and concert venue, the Hollywood Bowl. In 1927 she transferred ownership of Olive Hill to the city of Los Angeles, to be used as the headquarters of the California Art Club. The house is now part of a public park and art gallery, in keeping with her initial intention to create a public theater complex infused with the ideas of feminism, socialism, and Modernist architecture and "destined to help form the taste and ideals of the world."

Art for the People, Art Against Fascism

7.1 Harry Sternberg: *Fascism*, 1942 (see p. 443)
Screenprint, 15¼ × 20½ in. (38.7 × 52.1 cm.)
Philip and Suzanne Schiller Collection, Columbus Museum of Art, Columbus, Ohio

Timeline 1927–1945

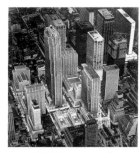

7.46 (see p. 422)

1927 Beginning of construction of Rockefeller Center, New York [7.46]

1929 Stock Market Crash, beginning the Great Depression (October 23); founding of the Museum of Modern Art, New York

1930 Founding of the Whitney Museum of American Art; José Clemente Orozco completes the first Mexican mural in the U.S., at Claremont, California; first television broadcast

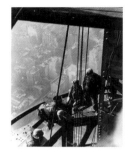

7.18 (see p. 401)

1932 Franklin Delano Roosevelt elected president of the United States; Dorothy Dunn founds the Santa Fe Indian School ("The Studio School"); unveiling of *Tropical America* mural by David Alfaro Siqueiros in Los Angeles (painted over a few years later); publication of Rexford Tugwell's *Men at Work: Photographic Studies of Modern Men and Machines*, illustrated with photographs by Lewis Hine [7.18]

1933 Launching of Roosevelt's New Deal; organization of Artists Group of Emergency Work Bureau (later Artists' Union); creation and destruction of Diego Rivera mural in Rockefeller Center; Adolf Hitler becomes Chancellor of Germany

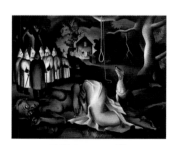

7.36 (see p. 413)

1934 Coit Tower murals [7.36]; Big Strike (longshoremen) in San Francisco

1935 Organization of American Artists' Congress; NAACP and John Reed Club exhibitions on the theme of lynching [7.72]; beginning of the Index of American Design; Farm Security Administration's photography project, led by Roy Stryker, and Federal Art Project of the Works Progress Administration (WPA/FAP); Soviet leader Josef Stalin calls for Popular Front against fascism

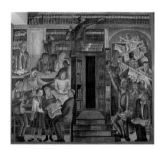

7.72 (see p. 438)

1936 First meeting of the American Artists' Congress; first issue of *Life* magazine, with photograph by Margaret Bourke-White on cover [7.52]

1936–39 Spanish Civil War

7.52 (see p. 426)

New Deal 1933–45

Section of Painting & Sculpture, Treasury Dept

WPA/FAP 1935–43

FSA Photography Project 1935–43

Treasury Relief Art Project 1935–38

1937 "Degenerate Art" exhibition of Modernist art, Munich, Germany; formation of American Abstract Artists; formation of Congress of Industrial Organizations (CIO); Memorial Day Massacre of workers at Republic Steel, Chicago [**7.37**]; Museum of Non-Objective Art opens (forerunner of Guggenheim Museum)

late 1930s Modernist artists begin to leave Europe for U.S.

1938 Publication of "Manifesto: Towards a Free and Revolutionary Art" in the *Partisan Review* (signed by André Breton and Diego Rivera but written by Breton and Leon Trotsky)

1939 Adolf Hitler and Joseph Stalin sign non-aggression pact; Soviet Union invades Finland; American Artists' Congress helps bring Pablo Picasso's painting *Guernica* to New York City to raise money for the Spanish Refugee Relief Campaign; publication of Clement Greenberg's "Avant-Garde and Kitsch" in the *Partisan Review*

1939–45 World War II [**7.80**]

1941 Bombing of Pearl Harbor by Japanese (December 7); U.S. enters World War II

1942 Executive Order 9066 of February 19 authorizes internment of Japanese Americans living on the West Coast [**7.85**]; Organization of Artists for Victory; founding of Peggy Guggenheim's Art of This Century Gallery [**7.96**] and of the Office of War Information (OWI) [**7.28**]; "Artists in Exile" exhibition at Pierre Matisse Gallery, New York City

1943 Artists for Victory organize "America in the War" exhibition displaying 100 prints simultaneously in twenty-six museums across the country; Jackson Pollock's first one-man show at Art of This Century

1945 Death of President Franklin Delano Roosevelt; U.S. drops atomic bombs on Hiroshima and Nagasaki, ending World War II; United Nations founded

7.37 (see p. 414)

7.80 (see p. 444)

7.85 (see p. 446)

7.96 (see p. 454)

7.28 (see p. 407)

The 1930s occupy a particularly powerful symbolic position within public discourse in the United States. Whenever the economy takes a turn for the worse, commentators immediately express fears of another depression like the Great Depression of the 1930s. There have been other long-term economic crises in the history of this country, but none has seized the public imagination as firmly as the one that began with the stock market crash in New York City in 1929. This is due, in no small part, to the fact that the Great Depression prompted an unprecedented rethinking of political and economic institutions by the federal government. This rethinking involved, among other things, the creation of jobs for thousands of people in the visual and performing arts, who recorded both the dreams and the realities of a shaken nation. The federal art projects of President Franklin D. Roosevelt's administration allowed paintings, prints, sculptures, and photographs to reach a wide and varied audience throughout the country. Post offices [7.2], elementary schools, community centers, state capitols, and popular magazines were filled with federally sponsored art.

Make-work programs were part of a larger effort by Roosevelt to address the economic crisis confronting the nation by having the federal government step in where private industry could, or would, not. These programs resulted in the construction of whole towns for displaced wage-laborers and farmers, as well as such massive engineering projects as the dam-building of the Tennessee Valley Authority (TVA), which aimed to control flooding and drought and to bring electricity to those who had yet to benefit from it. The arts were used in part to raise public confidence through images of an America of technological wonders and productive farms peopled by healthy male workers who received the support and adulation of their wives and children. Much was left out of the majority of these official images—strikes, labor organizing, political and economic alternatives to capitalism, female wage-laborers. These topics did, however, appear in paintings and prints by artists not employed by the federal government, and even occasionally in the work of those on the government payroll. The latter generated considerable controversy, especially among those who opposed Roosevelt's social welfare policies in general and his arts programs in particular, and who saw images of strikes or condemnations of capitalism as subversive and un-American.

Many artists during the 1930s documented the lives of common people. Public murals now contained not the winged personifications of various Western virtues but farmers and industrial laborers [7.6, 7.13]. Many had learned the formal lessons of Modernist abstraction in New York or Paris or Berlin, but decided that a more literal, narrative rendering of the world around them was necessary in order to make their work meaningful to a larger segment of the population. This turn to American subject-matter was part of a broader re-examination

7.2 James Michael Newell: *Underground Railroad*, 1940
Fresco
Post office, Dolgeville, New York

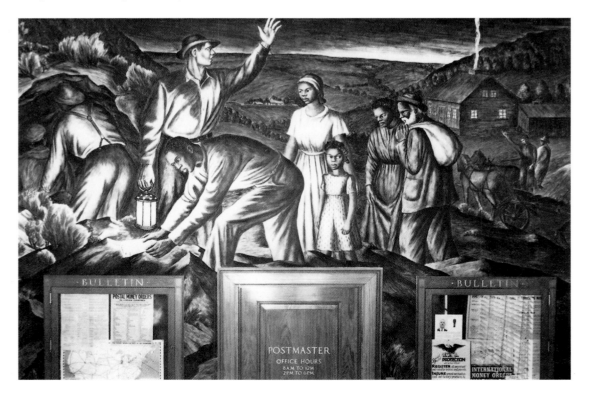

of individual and national values and a patriotic, and at times xenophobic, reassertion of what was special or distinctive about the United States of America. Some persisted with a more abstract style and iconography, while at the same time arguing for the significance of their work in nationalistic terms. Abstraction was, in their minds, both modern and American.

The federal government was not the only organization enlisting artists to promote its programs nationwide. Several corporations also turned to artists, not only to sell products but also to invent a new image of the American businessman as an individual with the welfare of the nation as a whole at heart. This image appeared with particular force in a magazine directed at corporate America, Time, Inc.'s *Fortune*, which began publication in February 1930. The editors called on several prominent progressive artists and writers to present its message of corporate responsibility, creating a connection between corporations and progressive politics, as well as between corporations and Modernist art. The Museum of Modern Art in New York (MoMA), founded in 1929, helped identify Modernist works to include as illustrations. MoMA soon became a major player in the creation of a market for American Modernism through its ambitious exhibition program and through the advice its curators and directors gave to the heads of rising corporations like Time, Inc.

As the 1930s progressed, the attention of many artists turned to Europe, where hostilities had escalated after Adolf Hitler rose to power in Germany in 1933. The Spanish Civil War (1936–39) and World War II were recorded by artists of all political persuasions, yet those on the Left carried their condemnations of fascism further, implicating capitalism in their critiques and claiming that fascist forces in Europe and Asia were aided by political, racial, and religious intolerance in the United States. The war also engendered a moral crisis in many artists, as they struggled to comprehend the extent of the destruction made possible by new military technology and by the obsessions of Hitler. Alongside literal and allegorical depictions of suffering and devastation appeared abstract works whose creators claimed to be representing the very chaos and uncertainty that marked the contemporary world.

A New Deal for Art

A New Boss: Federal Programs for the Arts

Many who experienced the stock market crash of October 29, 1929, saw it as punishment for the high living and smug self-confidence of the 1920s. Credit had been extended too freely and financial speculation had run rampant in an economy still recovering from the costs of World War I. The result was the collapse of what had been thought to be an unshakable banking system. The Republican President Herbert Hoover was both unable and unwilling to undertake the vast relief measures necessary to cope with an unemployed population which, by 1932, reached 15 million. On July 28, 1932, approximately 200,000 war veterans marched on Washington and camped on the lawn of the Capitol to reinforce their demand that they be allowed to collect their veteran benefits. Hoover ordered federal troops to disperse the crowd. Photographs and film footage of burning tents and clouds of tear gas helped ensure the defeat of Hoover in the elections that fall and the victory of Franklin Delano Roosevelt.

Roosevelt became the hero of the poor and the unemployed, enacting a series of relief measures, particularly make-work projects, and passing regulatory laws meant to restore faith in the nation's political and economic institutions. Sorely shaken by the stock market crash and closing of many of the nation's factories and banks, and by the drought in the Midwest and downward spiral of farm prices that had begun in the 1920s, many began to question whether a capitalist economy could produce a true democracy. They looked to socialism and the Soviet Union as a possible alternative. Roosevelt's election and the reforms he enacted helped deflect many of these political challenges from the Left. The funding of art in post offices and schools in small towns across the country was part of a broader celebration of the average American intended to make the government appear more accessible and responsible to the ordinary person and less tied to the interests of the corporate and political elite.

Many American artists working in the 1930s examined the policies of the Soviet Union and their own government in their search for solutions to the country's problems. Some joined existing left-wing cultural organizations such as the Communist Party's John Reed Clubs or formed their own, most notably the Artists' Union. The precursor of the Artists' Union, the Artists Group of Emergency Work Bureau, was established in the summer of 1933 in New York City to agitate for state-sponsored art projects. It sent numerous letters to Harry Hopkins, the head of the newly created Civil Works Administration (and later head of the Works Progress Administration or WPA), arguing its case, and issued a manifesto declaring that "the State can eliminate once and for all the unfortunate dependence of American artists upon the caprice of private patronage." In 1934 the group changed its name to Unemployed Artists Group (UAG) and finally, that same year, to the Artists' Union. From November 1934 through December 1937 it published its own highly influential journal, *Art Front*.

Members of the organization voiced an affinity with the working class and began to see their fates as part of a larger

movement, a class struggle against global capitalism. In an essay for the July/August 1936 issue of *Art Front*, the artist Louis Lozowick wrote:

In all parts of the world there are signs of incipient and open revolt against the system. The organized working class, joined by growing numbers of intellectuals, farmers and other elements, and guided by the philosophy of Karl Marx, is the only force that can abolish it. Artists like others, whether they want it or not, whether they know it or not, cannot remain outside of the situation described.

Not all politically progressive artists were so committed to Marxism. Many were strong supporters of national campaigns by American workers to unionize, but saw Roosevelt's reform efforts, not Soviet-style socialism, as the surest way to achieve workers' rights and to bring about change. In fact, artists were able to form a union in large part because they now had an employer with whom to bargain over wages and working conditions—the federal government. The forcefulness of their arguments for federal art programs may well have helped convince Harry Hopkins to found the Public Works of Art Project (PWAP) in 1933 with a grant from his agency, with the first funding made available in December. The painter George Biddle [6.59] had written that year to his friend President Roosevelt:

The Mexican artists have produced the greatest national school of mural painting since the Renaissance. Diego Rivera tells me that it was only possible because [President] Obregón allowed Mexican artists to work at plumber's wages in order to express on the walls of the government buildings the social ideals of the Mexican Revolution. The younger artists of America are conscious as they have never been of the social revolution that our country and civilization are going through; and they would be very eager to express these ideals in permanent art form if they were given the government's co-operation.

The PWAP was replaced in 1934 by the Section of Painting and Sculpture of the Treasury Department (later the Section of Fine Arts), which was joined in 1935 by the Treasury Relief Art Project (TRAP) and the Federal Art Project of the Works Progress Administration (FAP/WPA). The Treasury Section programs produced paintings and sculpture for federal buildings and chose artists primarily through open competitions and commissions, while the FAP/WPA and TRAP provided support for artists based on financial need.

Holger Cahill, Director of the FAP/WPA, was strongly influenced by the writings of the American philosopher and educator John Dewey, who considered art individual expression arising out of societal experience. Like Vasconcelos in Mexico (see p. 360), Cahill felt that art should belong to everybody, not just a privileged few. In order to achieve accessibility artists were encouraged to utilize readily recognizable imagery in their work, and art classes were set up in schools and community centers across the country. Cahill also believed that the art produced under the auspices of the federal government had to be "distinctly American," which, for him, meant not only American in content but also devoid of any hint, stylistically, of European Modernism. However, Cahill was not able to prevent Modernist works from being produced by at least a small segment of those on the federal payroll. From 1935 to 1943, both the Treasury and FAP programs employed thousands of artists who created hundreds of thousands of works of art—murals, sculptures, paintings and prints—and taught equally large numbers of individuals how to make or understand art.

With the establishment of the Federal Art Project of the WPA in 1935, the Artists' Union became the *de facto* bargaining agent for many of the visual artists employed by the government (its slogan was "Every artist an organized artist"). Its members distinguished themselves from members of the craft unions representing musicians, actors and directors, and writers on the WPA rolls by their aggressive and imaginative demonstrations. Such protests were effective in postponing, for a few years at least, the cutbacks in WPA funding that occurred at the end of the decade. During the first few years of the Union's existence, the weekly Wednesday night meetings in New York, usually attended by two to three hundred members, were an opportunity for artists to socialize as well as discuss business.

Government sponsorship affected the day-to-day lives of the artists who enrolled in the various federal programs in several ways. Importantly, it provided many with their first experience of independence from the commercial art market. Looking back on this era, Robert Gwathmey noted in an interview with the historian Studs Terkel in 1968: "Artists have to live, right? Eat, sleep, breathe, build. The great difference is when you have a government as a patron or anyone else as a patron, who made no demands on you at all, there were no enlarged notions of making that extra buck. That was a very free and happy period." This was, indeed, a decade remembered by artists who lived through it as a time when people pulled together, shared limited resources, and gained the respect of the federal government for their endeavors. Art was seen as another form of work, not as an expendable leisure-time activity.

A Prosperous America: Federally Sponsored Murals

Artists on the FAP/WPA payroll received a weekly wage, in return for which they were required either to submit a certain number of art works, which were then distributed to state and municipal institutions, or to execute murals or sculptures in specific locations. As mentioned above, the preference of FAP administrators was for recognizable, narrative imagery, but Cahill was chiefly concerned with supplying artists with much-needed material support, and there was tolerance in at least some local offices for more abstract works. The FAP also sponsored art classes and exhibitions and publicized its efforts widely in order to ensure the renewal of its annual congressional appropriation.

Most artists employed by the Section of Painting and Sculpture of the Treasury Department competed for the opportunity to produce work for a particular federal building. The content was approved ahead of time and monitored throughout the creation process. While FAP artists also produced public murals, those of the Treasury Section were more numerous and more widely distributed geographically. They were funded through a percentage of the construction costs of federal buildings and were subject to greater restrictions on style and content, although like the majority of FAP murals, they most often depicted people at work and at play. The artists were given a list approved by Section officials from which to select their subject-matter: "the Post; Local History, Past or Present; Local Industries; Local Flora and Fauna; Local Pursuits, Hunting [**7.3**], Fishing, Recreational Activities; Themes of Agriculture or pure landscapes." Depictions of suffering were rare and, when they did appear, were often presented as part of a past that had been, or was in the process of being, changed by the policies of the New Deal administration. Those in charge had a particular vision of what they wanted Treasury Section art to look like and to accomplish. Edward Bruce, the head of the Section, explained its purpose:

> Our objective should be to enrich the lives of all our people by making things of the spirit, the creation of beauty part of their daily lives, by giving them new hopes and sources of interest to fill their leisure, by eradicating the ugliness of their surroundings, by building with a sense of beauty as well as mere utility, and by fostering all the simple pleasures of life which are not important in terms of dollars spent but are immensely important in terms of a higher standard of living.

In a detailed study of post office murals, Marlene Park and Gerald Markowitz acknowledge certain aesthetic limitations in many of the works, while at the same time arguing for their significance as a record of artistic production in the 1930s and of the most ambitious program of federal art patronage ever undertaken. The Treasury Section was an example of the Roosevelt administration's attempt to bring art into every corner of the country, to work against the notion of art as an elite enterprise. While this meant that figurative compositions using conventions of realism were favored, no single type of realism was mandated, so that there is a certain variety and range of abstraction in the figures and landscapes. The art historian Barbara Melosh describes Treasury Section art as "representational . . . updated with modernist gestures."

Roosevelt's art programs were also part of a larger effort to balance a centralization of power, which had been achieved in part through a myriad of regulatory agencies, with a respect for regional needs in order to create a national culture that preserved regional differences. Roosevelt thus funded projects like the Tennessee Valley Authority that met the material needs of certain parts of the country and supported the recording of local cultural traditions through endeavors like the Index of American Design. The Index began under Cahill's direction in 1935 and enlisted several hundred artists located throughout the various states who, from 1935 to 1941, produced some 22,000 watercolor illustrations. In 1950 Cahill described the Index as a record of "the practical, popular and folk arts of the peoples of European origin who created the material culture of this country as we know it today." He noted that the work of Native Americans was to be left to the ethnologists who had already been making pictorial records in that field, but makes no mention of Americans of African or Asian descent. The Index would thus create a very particular image, at both the regional and national level, of America's material culture.

7.3 Gerald Nailor, Navajo: *Hunting Ground* (detail), 1940
Medium unknown
Department of the Interior, Washington, D.C.

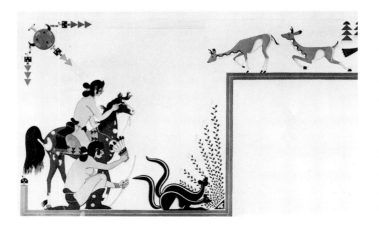

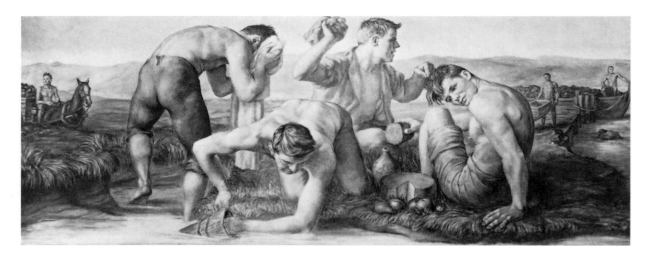

7.4 Jared French: *Meal Time with the Early Coal Miners*, 1938
Oil on canvas
Post office, Plymouth, Pennsylvania

According to Park and Markowitz, the Treasury Section murals and sculpture make "clear the tension between regionalism and nationalism implicit in the New Deal's programs. On the one hand, the Section was a national program consciously promulgating national ideals. On the other hand, this national ideal included within it regional pride, local concerns, and grass roots participation." The term "regionalism" was also used during the 1930s to describe a type of art that focused on scenes of Midwestern farms and small towns. Regionalist artists treated their subject-matter with reverence, extolling the virtues of agrarian and small-town life, of the independent farmer and small-scale entrepreneur. Similar ideals had fueled the Populist movement of the late 19th century, which attacked Wall Street and big business. Regionalist artists were often contrasted to Social Realist artists, who tended to view the country's past and present as a series of struggles for power between the rich and the poor, and whose images focused largely on factory or industrial wage-laborers and urban life. Social Realists promoted class consciousness and the fight of working people against the injustices visited upon them by the property-owning and ruling classes. While both Regionalists and Social Realists (who were sometimes one and the same, or who moved from one group to the other over the course of their careers) were employed by the federal government, most of the works commissioned by the Treasury Department and the FAP were Regionalist in tone. What critical content managed to seep into federal art works did so at the hands of Social Realists like Philip Evergood and Ben Shahn. Social Realism can also be discerned in the celebration of the heroic industrial worker as key to the stability of the nation.

Treasury Section murals and sculptures (only 300 of the 1,400 commissions were for sculpture) were created by local artists whenever possible, who were either commissioned directly or selected through local competitions and charged with producing images of local significance. By far the most common site for the display of their work was the post office, for every town of any size had one, and several new ones were built during the 1930s and early 1940s. Most murals were located in a relatively small space over the postmaster's door, which necessitated simple, often tripartite, compositions (the door was often flanked by matching bulletin boards [7.2]). Criticisms by locals of works as they progressed were taken into consideration by Section administrators and passed on to the artists. These most often concerned content—the crops were not common in the area, the manes of horses were too thick, the method of harvesting tobacco was inaccurate. Artists often, although not always, complied with the requested changes.

Criticisms also came from Treasury Section bureaucrats. For example, nudity and poverty were strongly discouraged. When Jared French (1905–88) submitted a sketch of naked men representing Stuart's Raiders for the Parcel Post Building in Richmond, Virginia, Edward Rowan wrote to him: "You have painted enough nudes in your life so that the painting of several more or less should not matter in your artistic career. It is too obviously flying in the face of the public." French responded to Rowan's criticisms in his *Meal Time with the Early Coal Miners* (1938) [7.4] in Plymouth, Pennsylvania, by at least partially clothing his handsome, muscular youths in the foreground, although he left a fully naked young man standing facing the viewer in a boat in the top right background. By the end of the decade artists often anticipated, and thus avoided, potential criticisms from local residents and bureaucrats. In 1939, Rowan wrote to Lucile Blanch (1895–1981) of her Appalachia, Virginia, mural (1940) [7.5]: "I . . . concur with you one hundred percent in your attitude

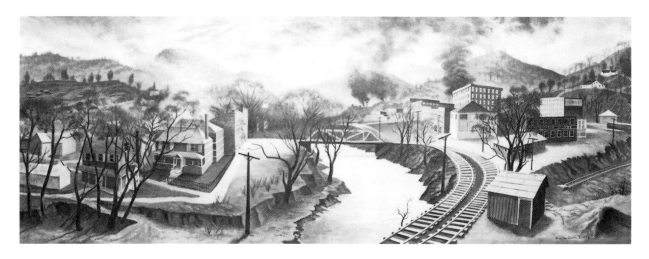

7.5 Lucile Blanch: *Appalachia*, 1940
Oil on canvas
Post office, Appalachia, Virginia

about not using the miners and their sufferings and deprivations as the subject matter for this mural By all means give them a gay and charming landscape and the simple things that surround them." Officials were not always concerned about the personal politics of the artists, but they were concerned about the politics of the art that was produced.

While Treasury Section art focused on local imagery, Park and Markowitz point out that it also included several symbolic figures—"the family, the pioneer, the 'common man,' the farmer, the worker—to tie people from scattered and often isolated communities together as a nation and to promote a common heritage and purpose." Harry Sternberg (1904–2001) included the three most important of these symbols in his mural *The Family—Industry and Agriculture* (1939) [**7.6**] in

Ambler, Pennsylvania. Here the worker with his wife and child are positioned between the factories on the left and the farm on the right. The worker's overalls could function as clothing for the farm or the factory, thus suggesting the connection between the two sites of labor that many on the Left saw as crucial to the success of a socialist revolution. The family represents social cohesion and clearly defined gender roles. The wife rests her right hand on her husband's shoulder in a supportive gesture, while he uses his right hand to prevent the baby from crawling off the blanket. Sternberg wrote of his mural: "The emphasis . . . is on the beauty of the forms to symbolize the joy and beauty a worker finds in his work—when working conditions are good. This is a picture of promise—a picture of life as it should be—and as it will be under our

7.6 Harry Sternberg: *The Family—Industry and Agriculture*, 1939
Oil on canvas
Post office, Ambler, Pennsylvania

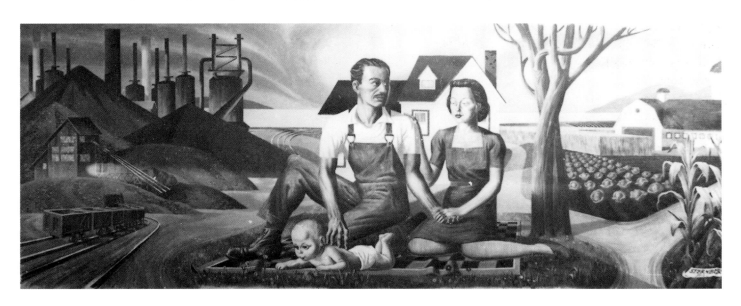

developing and progressive democracy." The nuclear family here, and in multiple images throughout New Deal art, also functions as a metaphor for responsible citizenship within this "developing and progressive democracy." The virtues of hard work and commitment to community, as represented in the activities of the family, were celebrated as integral to the success of the nation in its early years, and were subsequently called upon to provide inspiration for those in the 1930s and 1940s.

The story of the nation's past that appeared in Treasury Section murals, however, was carefully edited. References to the hardships of slavery were absent in the South and suggested in only a few murals in other parts of the country, such as James Michael Newell's *Underground Railroad* (1940) [7.2] in the post office at Dolgeville, New York. Treasury Section officials wanted to emphasize commonalities rather than differences, despite their acknowledgment of the significance of regional characteristics. Thus, ethnic, racial, or class divisions were downplayed. The one major exception to the erasure of racial divisions can be found in the depictions of Native Americans. Over 10 per cent of the small Treasury Section commissions were devoted to themes of Native American life, with examples found in almost every state in the nation. This indicates, according to Park and Markowitz, "that Indians were not seen simply as a part of the past but that their history, character, and fate were somehow central to the meaning of America for which people were searching in the 1930s." Perhaps this meaning lay in the numerous romanticized images of a Native past in harmony with nature, as in Margaret Martin's *Indian Hunters and Rice Gatherers* (1940) [7.7] in St James, Minnesota. Or perhaps it lay in the less numerous images of battles where distinctions between good and evil, savage and civilized, were so clearly

defined, unlike in contemporary times. Melosh also suggests that "the displaced Indian" present in several murals embodied the fear of downward mobility that was so clearly of concern to many Americans in the 1930s.

While most of these images of Native life were produced by European Americans, several Native Americans also received commissions to create a record of their past. Section administrators went out of their way to encourage their participation, as part of the Roosevelt administration's commitment to promoting Native American cultural production. The competition for a series of sixteen panels for the post office in Anadarko, Oklahoma—in the center of a large Native population—was open only to Native American artists and an exception was made to the usual insistence on three-dimensional figures in a recognizable setting in order to accommodate what many viewed as a distinctly indigenous stylistic tradition. Five Kiowa artists (known as the "Kiowa Five") were asked to prepare sketches. Several had taken art classes at St Patrick's Mission School in Anadarko before studying with Professor Oscar Jacobson at the University of Oklahoma in 1927 and 1928. Stephen Mopope (1898–1974), nephew of the Kiowa artist Silverhorn, was selected to execute the work; he then hired the other four as assistants. The series, completed in 1937, recorded the history and contemporary life of the Kiowa. Its overall style, represented in *Indian Family Moving Camp* [7.8], continued certain aspects of Plains art found in the hide paintings and ledger drawings of such 19th-century artists as Silverhorn and Yellow Nose [4.1, 4.52]: flat, two-dimensional figures, broad areas of unmodulated color and absence of background.

This two-dimensional style was also promoted by Dorothy Dunn, a European American who founded the Santa Fe Indian School, or "The Studio School" as it came to be known, in 1932. Dunn had come to New Mexico in the 1920s as an Indian Service teacher at a school near Santa Fe and had used art to help her students learn English. In the late 1920s a move

7.7 Margaret Martin: *Indian Hunters and Rice Gatherers*, 1940
Oil on canvas
Post office, St James, Minnesota

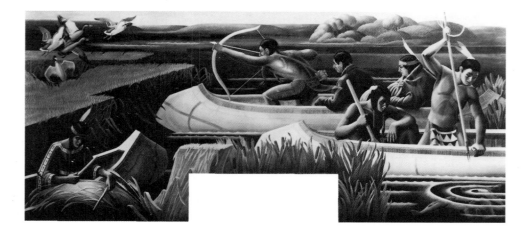

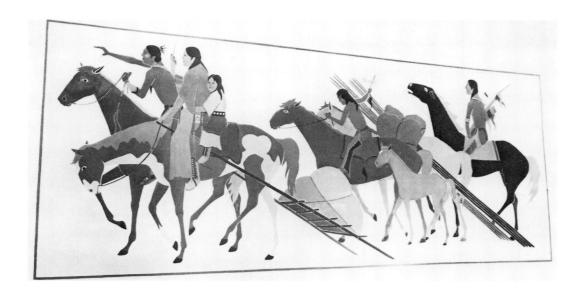

7.8 Stephen Mopope, Kiowa: *Indian Family Moving Camp*, 1937
Medium unknown
Post office, Anadarko, Oklahoma

occurred within government policy to use the arts and crafts as a way to improve the education of Native American children, and Dunn traveled to Chicago in 1928 to train as an art teacher. She returned to Santa Fe in 1932 and opened her school; she remained there until 1937.

Dunn encouraged her young students, mostly high-school age, to replicate the content and style of local artistic traditions, both figurative and abstract, found in rock art, *kiva* murals, pottery, and basketry. The recovery of seventeen layers of murals at the prehistoric site of Kuaua in the mid-1930s was particularly influential. The art of her students was to display disciplined brush work, firm and even contour lines, flat application of color, lack of shadowing or other three-dimensional effects, and non-specific backgrounds. Dunn did not offer the standard courses in color theory or perspective found in art schools, preferring to allow her students to develop what she saw as their own natural abilities through exposure to, or remembrance of, traditional forms.

Dunn has been criticized by many scholars and some of her own pupils for her romanticized interpretation of indigenous artistic practices and her insistence that her students adhere to these practices. Yet others, like the art historians Ruth Phillips and Janet Berlo, see her attitude as "remarkably non-authoritarian" at a "time when the overriding impulse in the dominant culture was towards assimilation and obliteration of Indian traditions." The Navajo artist Gerald Nailor (1917–52) enrolled in the Albuquerque Indian School from 1930 to 1934 and attended Dunn's Studio School in 1936–37, before studying

with two Oklahoma artists, Kenneth Chapman and Olaf Nordmark. Among his many mural commissions were two works, *Initiation Ceremony* (1940) and *Hunting Ground* (1940) [7.3], painted in the Department of the Interior building in Washington. Here the decorative quality of *kiva* murals [1.18] and the use of abstract symbols reveal the influence of Dunn's philosophy.

While Treasury Section murals contained images of both rural and industrial life, the former far outnumbered the latter. Rural life, represented by small towns or farms, was much more reassuring in a time of uncertainty. The farmer was able to control his work environment, at least the farmers in Treasury Section murals. Little reference is made to sharecropping or to the emergence of large-scale mechanized farming, and when these practices appear they are presented free from any conflict or dissatisfaction on the part of those working the land. The overall picture is one of self-reliance, comradeship, and hard work. Communities are small, and the family more easily integrated into the life of the farm, thus suggesting a continuity between work and home that had been so clearly interrupted by urban life.

In scenes of contemporary farm life, as in historical scenes of the frontier, women appear in abundance, picking fruit or helping to gather the crops, or taking care of children. While they are regularly depicted as physically strong, they rarely appear alone or engage in the kind of camaraderie with women that often marks scenes of men working together. Their identity is located in their association with their husbands as comrades and co-workers (what Melosh calls the "comradely ideal") and with their children as nurturers and caretakers. The major exception is found in the depiction of black women, who are shown working side-by-side in the fields. When whites and blacks appear together, as in Lee R. Warthen's *Cotton Scene*

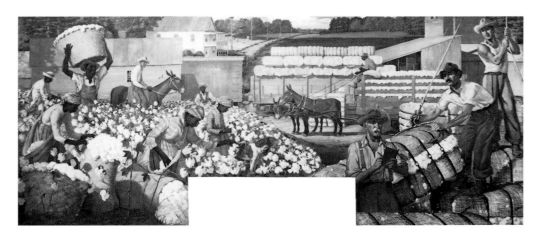

7.9 Lee R. Warthen: *Cotton Scene*, 1941
Oil on canvas
Post office (now Chamber of Commerce), Hartselle, Alabama

(1941) [7.9] in Hartselle, Alabama, their duties are clearly distinguished, with blacks bent over in the fields and whites either overseeing the picking on horseback or weighing the cotton. There is no sense of the celebration of independence and enterprise that is present in so many of the images of farming in other parts of the country, where the farmer is both boss and laborer. Black men and women were most often shown working their rented fields in groups rather than laboring on a family-owned farm. Heroic images of rural men and women were, notes Melosh, "reserved for whites in most Section art."

7.10 H. Amiard Oberteuffer: *Vicksburg—Its Character and Industries*, 1939
Oil on canvas
Post office and courthouse, Vicksburg, Mississippi

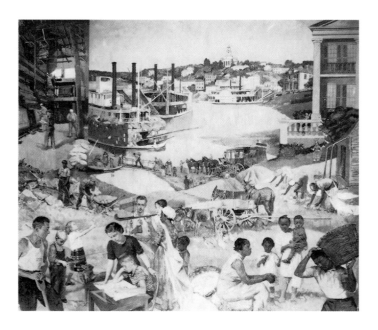

The political minefield that had to be traversed by artists who wanted to depict African American life in Southern murals (and most of the artists were from the North or Midwest) is suggested by the response to a work by H. Amiard Oberteuffer, *Vicksburg—Its Character and Industries* (1939) [7.10] in the Vicksburg, Mississippi, post office and courthouse. The mural includes a panoramic view of the town, with scenes from the past in the background and from the present in the foreground. The involvement of blacks in the cotton industry appears in both areas. The two races are clearly divided, with whites on the left and blacks on the right. While the numbers in the foreground are equal—four children and three adults each—at least a few people complained, according to the chairwoman of the local jury, that there were "an excessive number of Negroes in the picture, especially in the foreground." She went on to add in her letter to Rowan that "though there may be more of the Negro race in our vicinity the whites *do* rule."

Female and male figures were also presented at times in Treasury Section art as symbols separate from any historical narrative. William Zorach (1889–1966) provides an example in his pair of low-relief carvings of 1940 for Greenville, Tennessee, *Natural Resources* [7.11] and *Man Power* [7.12]. In the former, a woman represents nature; in the latter, a man represents culture, and in particular industry. Industry was the preserve of men, a claim made repeatedly throughout New Deal murals. Women, despite their presence in the wage-labor force, were seldom depicted outside the home or farm. This absence suggests a larger development in the 1930s: while the New Deal helped many disadvantaged groups, it did not improve the lot of working women. Instead, observes Melosh, it "stands as the single example of a liberal American reform movement not accompanied by a resurgence of feminism." In fact, the gains made by women in the 1920s were rolled back. As unemployment increased, women in offices and factories were fired in order to give jobs to men. Employers, both business and government,

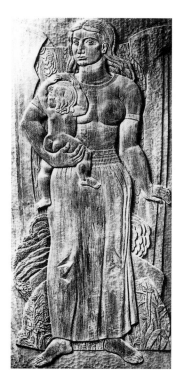

7.11, 7.12 William Zorach: *Natural Resources* and *Man Power*, 1940
Wood reliefs
Federal courthouse, Greenville, Tennessee

The images of male industrial workers or wage-laborers, like the scenes of rural life, tended to adhere to a common pattern. Most were interior scenes, depicting muscular men working together. Even when the scenes were set outdoors, the figures, along with the machinery, often filled a shallow foreground space, as in Xavier Gonzalez's *Drilling for Oil* (1941) [7.13] in Kilgore, Texas. This compositional format held true on the whole with low-relief sculpture as well. Figures carved in the round were also heavily muscled and often assumed dramatic poses, as in the pair of sculptures *Man Controlling Trade* (1942) [7.14] by Michael Lantz located in front of the Federal Trade Commission building in Washington, D.C. And, as with scenes of the heroic farmer, most of these manly industrial workers were white.

The heroic and powerful nature of these depictions can be attributed, in part, to the strength of the labor movement in the

justified their actions by citing concerns for "family stability," which in their minds meant a father engaged in paid commercial, agricultural, or industrial labor and a mother engaged in unpaid domestic labor. Hence the endless images of rural women as wives and mothers, helpers to their men in the home and in the nearby fields.

7.13 (below) Xavier Gonzalez: *Drilling for Oil*, 1941
Oil on canvas
Post office, Kilgore, Texas

7.14 (right) Michael Lantz: *Man Controlling Trade* (one of a pair), 1942
Limestone
Federal Trade Commission building, Washington, D.C.

1930s, although, as mentioned earlier, references to the battles between workers and employers over the right to unionize were mostly absent from New Deal murals. When Richard F. Gates submitted a sketch of a worker in chains for a mural in Harlan, Iowa, Rowan responded: "It is our opinion that the workman would be just as eloquent to your theme if he were not shackled. I must ask you to remove all chains in your treatment of this figure." In addition, because images of industrial labor consistently excluded women or references to the family, they spoke more clearly to issues of masculinity, male camaraderie, and the nation's industrial might. The permanence and power of these male workers were meant to encourage viewers to believe that the Depression was merely a temporary lull in a national history of abundance and progress, an abundance made possible by the labors of average working men. The Roosevelt administration had, in fact, found a most effective symbol for its political and economic ambitions in the manly worker.

Documents of Despair and Renewal: Photography and the Farm Security Administration

One federal agency did produce—in fact, encouraged—images of the devastation of the Depression—the Farm Security Administration (FSA). These images were created and distributed by the FSA's photography project, organized by Roy Stryker in 1935. Stryker had become aware of the impact of photographs in the early 1920s when he was selecting images to illustrate Rexford Tugwell's textbook *American Economic Life* (1924), a work that later functioned as a guide for much New Deal economic policy. He used the photographs of Lewis W. Hine (1874–1940), one of the few photographers producing images of industrial workers in the early decades of the 20th century.

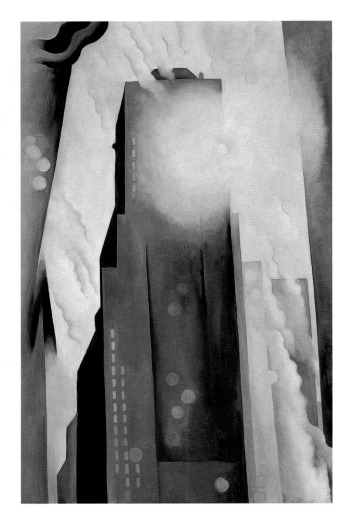

7.15 Lewis W. Hine: *Young Girls Knitting Stockings in Southern Hosiery Mill*, 1910
Photograph
George Eastman House, Rochester, New York

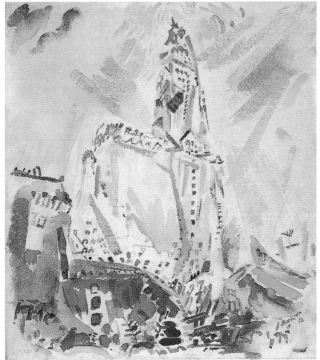

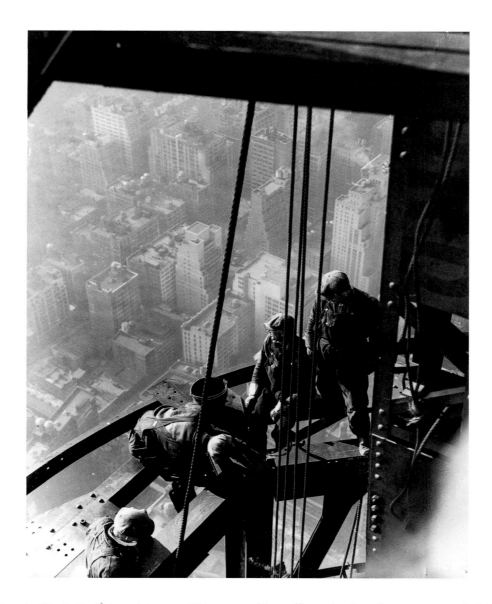

7.16 (opposite, above) Georgia O'Keeffe: *The Shelton with Sunspots*, 1926
Oil on canvas, 49 × 31 in. (123.2 × 76.8 cm.)
The Art Institute of Chicago, Chicago, Illinois

7.17 (opposite, below right) John Marin: *Woolworth Building, No. 31*, 1912
Watercolor over graphite on paper, 18½ × 15¹⁵⁄₁₆ in. (46.9 × 39.9 cm.)
National Gallery of Art, Washington, D.C.

7.18 (above) Lewis W. Hine: *Rivetting on the dome, a quarter mile up,*
during construction of the Empire State Building in New York City, 1931
Photograph
George Eastman House, Rochester, New York

The art historian Terry Smith notes that Hine's scathing critiques of industrial brutality, particularly with regard to the use of child labor [7.15], softened after World War I. He began focusing more on a celebration of the growing power of American industry and of the working men who were central to its success. One sees this in the smiling faces of his photographs for Tugwell's textbook and even more so in his images of the construction of the Empire State Building in his book *Men at Work: Photographic Studies of Modern Men and Machines* (1932). Hine's workers perch on girders high above New York [7.18], an urban perspective very different from that of the Ashcan artists or of modernists like Georgia O'Keeffe [7.16] or John Marin [7.17], whose views from the base of skyscrapers emphasize the power of the buildings themselves rather than those who built them.

Stryker's task within the FSA was to record the conditions of those who inhabited rural or small-town environments, in particular those who had been displaced by drought or foreclosure. By the mid-1930s, up to 25,000 square miles of farm land in the Midwest had succumbed to drought and unsound agricultural practices, which allowed the strong prairie winds to blow away the unprotected topsoil, creating the dust storms that gave the region its famous name, the "Dust Bowl." Farmers left their

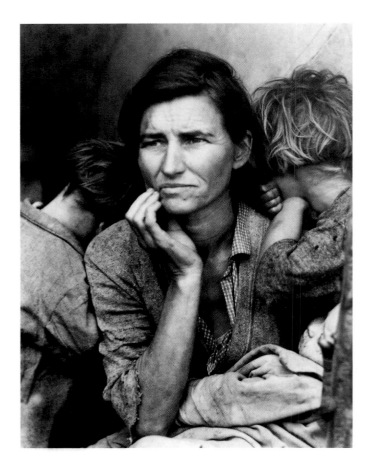

7.19 Dorothea Lange: *Migrant Mother, Nipomo, California*, 1936
Photograph
Library of Congress, Washington, D.C.

7.20 Walker Evans: *Washroom and Dining Area of Floyd Burroughs's Home, Hale County, Alabama*, 1936
Photograph
Library of Congress, Washington, D.C.

parched fields [**7.65, 7.66**], and many headed west to find work as migrant laborers and to survive as best they could in makeshift camps or by the side of the road.

Stryker hired several photographers, including Dorothea Lange, Walker Evans, Ben Shahn, Russell Lee, Marion Post Wolcott, Carl Mydens and Arthur Rothstein, to record the lives of these migrant workers and others hit hard by the Depression. Like Tina Modotti (see pp. 361–65), most of the FSA photographers did not see themselves as producing "art"; rather, they felt they were simply documenting what they saw in straightforward photographs with no artistic "frills." Ben Shahn (1898–1969) summarized this attitude in 1944: they had, he wrote,

> only one purpose—a moral one I suppose. So we decided: no angle shots, no filters, no mats, nothing glossy but paper We tried to present the ordinary in an extraordinary manner. But that's a paradox because the only thing extraordinary about it was that it was so ordinary. Nobody had ever done it before, deliberately.

Now it's called documentary . . . We just took pictures that cried out to be taken.

The facts presented in these FSA photographs, however, were not left totally to the discretion of the photographers. They were provided with "shooting scripts" by Stryker, which included scenes such as families listening to the radio and gatherings on street corners. The end result was a group of images marked by a sense of compassion rather than collective struggle. Few showed striking workers or lynchings or farmers protesting low prices, or, at least, few that were printed and distributed, for Stryker also punched holes in negatives he deemed inappropriate or not useful. Instead, one finds run-down farm houses and small-town gas stations or tenant farmers who confront the photographer with blank or worried stares. There was also little indication of the increasing mechanization of farm life or of the fact that many displaced farmers ended up moving to urban centers and working in city-based industries. Rather than focusing on this new source of employment, FSA photographers

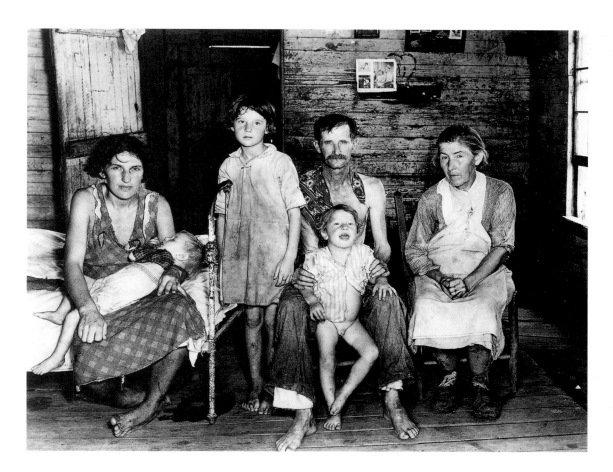

7.21 Walker Evans: *Bud Fields and His Family, Hale County, Alabama*, 1936
Photograph
Library of Congress, Washington, D.C.

created what Smith terms "an imagery of subjection, figured mainly through pictures of rural poverty." And this "imagery of subjection" gained much of its meaning and force through its juxtaposition to the imagery of "growth and power, figures of industry and the city" found in government-sponsored murals. The photographs signified a tragic past soon to be done away with by New Deal largess, the murals a prosperous future, although we know in retrospect that both rural and urban poverty would continue throughout the 1930s.

Stryker's photographers were later sent out to record the successes of Roosevelt's new programs, but what we remember are the images of poverty and destitution, for those were the ones that carried the greater emotional charge. Dorothea Lange (1895–1965) presented the ravages of a hard life on the faces of mothers and their children in works like *Migrant Mother, Nipomo, California* (1936) [7.19], a portrait of the Cherokee woman Florence Owens (later Thompson) and her daughters. Images of mothers and children were common among FSA photographs, for they were perfect symbols of endurance in the face of disaster. It is clear from negatives in the FSA archives that Lange, and other photographers, often posed their subjects in order to create the exact sentiment they desired, and then selected and cropped images to heighten that sentiment.

Walker Evans (1903–75) chose to use a large, cumbersome, 8 x 10-inch (20.3 x 25.4-centimeter) plate camera rather than the hand-held cameras employed by most of his colleagues. As a result, many of his photographs appear more "artistic" or carefully composed. His *Washroom and Dining Area of Floyd Burroughs's Home, Hale County, Alabama* (1936) [7.20] reads like a 17th-century Dutch interior scene, with the inner space framed by a doorway and the careful attention to lighting and the different textures of the various objects. His *Bud Fields and His Family, Hale County, Alabama* (1936) [7.21] is the opposite of Lange's *Migrant Mother*. Instead of a woman and her children caught unawares (we know that Lange posed her subjects, yet the posing is not self-evident), we have a family that is as consciously arranged in their home as in a photographer's studio. These two photographs also represent what Smith calls the "two angles of glance" that were most common in FSA photography: "the frightened look out and away, signifying despair in need of sympathetic comfort [Lange]; and the direct look at the viewer, signifying independence, valor, the right to recovery [Evans]."

Modernist Architecture, Domestic Design, and Planned Communities

By 1938, the emphasis of FSA photographs shifted from the devastation of rural America to the successes of Roosevelt's social welfare programs. In 1938 Shahn was commissioned to record not the poverty of the rural South but the prosperity and community life of the small towns of the Midwest, as he did in *Linworth Methodist Episcopal Church, Central Ohio* (1938) [**7.22**]. And instead of the poverty of Bud Fields and his family, we find the modernized interior of *Kitchen, Hidalgo County, Texas* (1939) [**7.23**] by Russell Lee (1903–86), its geometric cabinetry suggestive of the functional, often prefabricated, architecture of many federal planned communities.

An example of that architecture can be found in *The Medical Center, Greenbelt, Maryland*, photographed by Marion Post Wolcott (1910–90) in 1939 [**7.24**]. Greenbelt was perhaps the best known of the planned communities created by the Roosevelt administration under the direction of Rexford Tugwell. Tugwell believed that rather than building new towns in rural areas and trying to attract industry to provide jobs, the government should encourage people to move to where the jobs were—the cities—and build communities close to these urban centers. He was inspired by the "Ville Contemporaine" by the Swiss architect Le Corbusier (1887–1965), a model city for three million people displayed at the Paris Exhibition of 1922. Le Corbusier emphasized functionality in his design, combining housing, stores and offices. While Tugwell ultimately abandoned the skyscrapers and reduced the size of Le Corbusier's city, he retained a central feature of its plan, a "green belt" of undeveloped land that surrounded the

7.23 Russell Lee: *Kitchen, Hidalgo County, Texas*, 1939
Photograph
Library of Congress, Washington, D.C.

city and protected it from encroachment by other communities or building projects. He also promoted Le Corbusier's functionality. The 1935 plan for Greenbelt by Hale Walker [**7.25**] shows the housing units (single-family dwellings and row houses) arranged in a curving "J" shape, with interior walkways and peripheral roads connecting housing to shops, schools, and community buildings. The intent was to provide both a functional and a pleasant place to live, with plenty of green, open spaces and opportunities for socializing. Republican opposition to government incursions into private real estate meant that only three of Tugwell's projects were built. In 1955 the three towns—Greenbelt, Maryland; Greendale, Wisconsin; and Greenhills, Ohio—were sold to private developers.

Such designs for planned communities, with their pared down forms, were inspired not only by the work of Le Corbusier, but also by the experiments of another group of architects in Europe, who were grappling with many of the same questions as painters and sculptors. How was one to construct an edifice that was truly "modern"? What was the relationship between a building and those who would view or inhabit it? How was one to deal with both the past and the political and technological developments of the era? After World War I, architects debated how to reconstruct devastated countries and economies. One of the major centers of such debate was a school of art, architecture, and design in Weimar, Germany, renamed the Bauhaus in 1919 when Walter Gropius (1883–1969) arrived as its new head.

The Bauhaus was organized around three major principles: (1) the unity of all creative arts under the primacy of architecture;

7.22 Ben Shahn: *Linworth Methodist Episcopal Church, Central Ohio*, 1938
Photograph
Library of Congress, Washington, D.C.

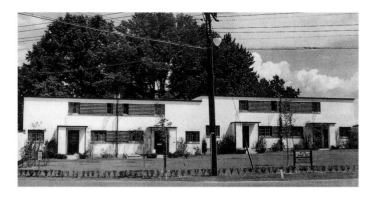

7.24 Marion Post Wolcott: *The Medical Center, Greenbelt, Maryland*, 1939
Photograph (detail)
Library of Congress, Washington, D.C.

7.25 (right) Hale Walker: plan for Greenbelt, Maryland, 1935

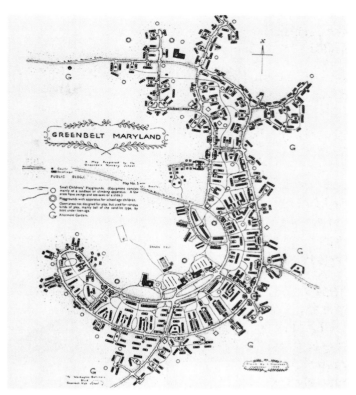

(2) a reconsideration of crafts; and (3) the unity of art and technology. Architects, painters, designers, and sculptors were to help recreate a new Germany that would look to the future, not the past, and that would utilize new technology for humane and socially minded purposes rather than for war. Many of the faculty argued that use value should take precedence over formal innovation for its own sake, and that new industrial materials and methods of production were to guide the ultimate form that the object or building would take, although, as in many educational institutions, there was no unanimity. Many, like the painters Paul Klee and Kandinsky, encouraged students to develop a more intuitive approach to their work and not to tie the creative process solely to practical pursuits.

The architecture promoted by the Bauhaus was one of clean lines and simple geometric massing, with an absence of historicizing detail [cf. **7.24**, **7.26**], a significant departure from much current architectural design. A shift to the right in German politics in the mid-1920s resulted in the withdrawal of federal support and the subsequent move of the school to Dessau in 1925. The architect Ludwig Mies van der Rohe (1886–1969) took over as head in 1930, but was to enjoy this position for only two years. With the rise to power of Hitler and the National Socialist Party, the school was ultimately closed in 1933. Modernist architecture, with its celebration of the future rather than the past and its association with socialist utopian ideals, was not what Hitler wanted as part of his Third Reich. Many of the faculty left Germany for the United States, including Gropius and Mies (Gropius was appointed Professor of Architecture at Harvard in 1937, while Mies became head of the School of Architecture at the Armour

Institute in Chicago, later the Illinois Institute of Technology, in 1938).

The principles promoted by the Bauhaus were not unknown in the United States in the early 20th century. Architects in Chicago had created their own form of Modernist architecture in the 1880s and 1890s (see pp. 302–06). Some architects in Europe knew of these developments. Many also knew of the work of Frank Lloyd Wright (see pp. 384–86). Gropius and Mies, as well as Austrian architect Rudolph Schindler (1887–1953), studied Wright's designs, which were available through the publication in Germany in 1910 of a portfolio of his work. Schindler subsequently left Austria for Chicago in 1917, hoping to find employment with Wright, which he did in that same year. He followed Wright to Los Angeles, where he often ended up overseeing the actual building of Wright's projects in the architect's absence (he played this role, along with Wright's son Lloyd, in the construction of Hollyhock House [**6.94**]).

Another Austrian architect inspired by Wright's designs was Richard J. Neutra (1892–1970). He remained in Europe until 1923, thus becoming more aware of the Bauhaus experiments in architecture and design. He brought this knowledge with him from Berlin to Chicago, where he worked briefly for Wright. He moved to Los Angeles in 1925 and set up a successful practice designing both public and private buildings. Among the best-known of his private commissions is the

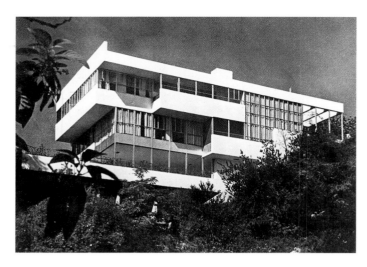

7.26 Richard J. Neutra: Philip Lovell House, Los Angeles, California, 1928

Philip Lovell House (1928) [**7.26**]. Here Neutra reveals his clear understanding of Bauhaus design principles in his choice of materials and general massing. The building is composed of a series of clean, rectilinear shapes stacked one on top of the other, with irregularly spaced projecting elements and window patterns that break up the otherwise undecorated exterior surface. It is supported by a steel skeleton, with fully integrated steel casement windows. The Lovell House is also significant for its manner of construction: it was prefabricated in a factory in sections, brought to the site on a truck, and built in forty hours, thus providing a model for the mass-production processes that would become so popular in the coming decades.

Neutra was not the only architect designing easily constructed houses in California at the time. The brothers Charles Sumner Greene (1868–1957) and Henry Mather Greene (1870–1954), from Ohio, after training at MIT moved to Pasadena in 1893. On the way they visited the World's Columbian Exhibition in Chicago (see pp. 302–11), and there they discovered Japanese architecture—a love they had in common with Wright. They created inexpensive one-floor bungalows with low-pitched roofs and jutting eaves and porches that were praised as models of aesthetic integrity, efficient use of space, and healthful living. They also designed more elaborate multi-story bungalow-type houses such as the David B. Gamble House in Pasadena (1909) [**7.27**], which reaches out into the surrounding environment with screened porches and terraces and patios that lead down into the nearby gardens. The Gamble House is also marked, like Wright's early houses, with intricate Arts and Crafts detailing in the predominantly wood-paneled interior.

It was the minimalist Bauhaus aesthetic, however, that marked the majority of the federal government's planned communities, in large part for financial reasons; Bauhaus homes were less expensive to build and more adaptable to prefabrication than other domestic designs, even those of Greene and Greene. Yet this aesthetic didn't always meet with the approval of the houses' residents. While these planned communities were intended to embody the power of government to create order and prosperity amid chaos, many criticized the rigidity and regularity of their planning and the starkness of their architecture, much of which was eventually altered with idiosyncratic additions.

Critics of the government's planned communities often compared them with the "real" communities of America, the older, small towns like Linworth, Ohio, recorded by Shahn [**7.22**], that had sprung up to service farmers and adventurers who had moved westward from the early settlements of New England. Such towns, writes Terry Smith, were "invested with positive value during the mid- and later 1930s, in the FSA photographs and elsewhere within the visual culture." Some were attracted to their evocation of a past that was slipping away. Others celebrated the small town as the moral center of the nation, the place where values of community and restraint were preserved in the face of a seemingly amoral and opportunistic celebration of industry and commerce in the city.

The work of the painter and commercial artist Norman Rockwell (1894–1978) served to reinforce the centrality of small-town life during the 1930s and early 1940s in such images as *Freedom from Want* (1943) [**7.28**], one of four designs for posters he produced for the Office of War Information

7.27 Greene and Greene: David B. Gamble House, Pasadena, California, 1909

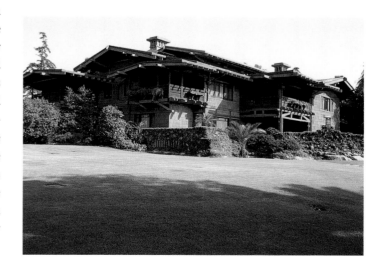

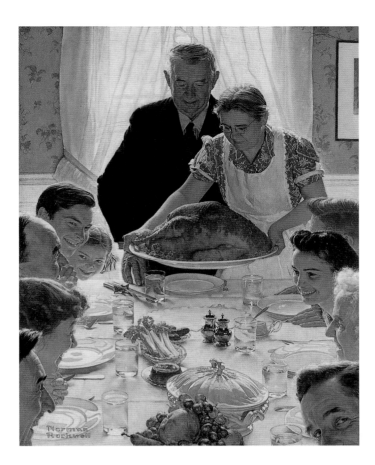

7.28 Norman Rockwell: *Freedom from Want*, 1943
Oil on canvas, 45¾ × 35½ in. (116.2 × 90.2 cm.)
Norman Rockwell Museum, Stockbridge, Massachusetts

(OWI). Both Rockwell's images and FSA photographs were distributed to, and printed in, *Life*, *The Saturday Evening Post*, and other widely read magazines (Rockwell produced hundreds of covers for the *Post*). In fact, FSA photographs of small-town America and those taken by many of the magazine's photographers were so similar in style and content that, in Smith's words, "an extraordinary continuity of image and outlook seems to occur," suggesting a common project on the part of media corporations and the federal government to affirm the existence of a healthy, democratic nation of largely self-sustaining communities. The massive number of photographs produced by the FSA and other agencies and circulated by the federal government throughout the country contributed to the naturalization of this message of well-being, making it difficult for other artists to mobilize alternative visions of what it meant to prosper in a democracy. During World War II, small-town America was often presented in both federal propaganda, such as Rockwell's *Four Freedom* posters, and commercial imagery as "what we are fighting for."

Alternative Visions: Urban Life and the Industrial Worker

The heads of Roosevelt's art projects saw public art as a way to build support for the New Deal while, at the same time, building patriotic sentiment in the midst of economic crisis. They also saw images as a powerful way to construct a national consensus about current lives and future hopes. There is, in retrospect, an overwhelming sameness, a normalizing, that takes place in federally sponsored public art. To be "American" meant to desire, if not actually achieve, the dream of material prosperity and the productive nuclear family presented so insistently in New Deal imagery. There were a few exceptions, however, to the bucolic image of a productive, cooperative America in federal murals, works that acknowledged the injustices that had occurred with regularity throughout American history and the conflicts that marked the 1930s.

The Mexican Muralists in America

The presence of critical perspectives in a handful of New Deal murals had much to do with the work of three foreign artists, the Mexican muralists José Clemente Orozco, David Alfaro Siqueiros, and Diego Rivera. Their images impressed American artists like George Biddle, who used the example of Mexico's federal mural projects to help persuade Roosevelt to initiate his own arts programs. These three also painted large, dramatic murals in cities and small towns throughout the United States. This work, according to the art historian Laurance Hurlburt, "directly addressed the central concerns of North American intellectuals and artists during the early and mid-1930s," concerns that focused, in particular, on the concepts of community and collectivism. Orozco, Siqueiros, and Rivera had survived a period of political and economic upheaval and had taken up the cause of social transformation in their many public murals of the 1920s in Mexico. Thus they provided an example of how artists could promote broad social and political change rather than remain isolated in the studio, concerned only with individual well-being. The artist Mitchell Siporin declared, "Through the lessons of our Mexican teachers, we have been made aware of the scope and fullness of the 'soul' of our environment."

Orozco (1883–1949) was the first to arrive, in 1927. His work focused, as Hurlburt points out, on "the call for the destruction of old or existing human orders—through the sacrificial acts of mythological or actual personages—and the creation of new and superior social systems." In 1930 he completed *Prometheus*, a large fresco in the student dining

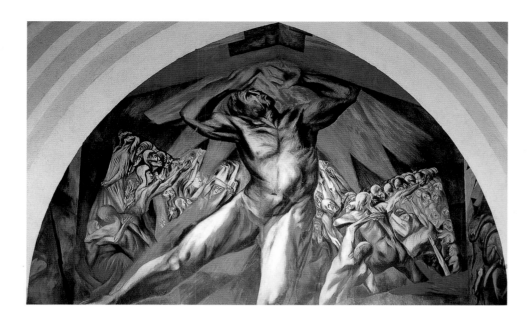

7.29 José Clemente Orozco: *Prometheus*, 1930
Fresco, 25 × 30 ft. (7.6 × 9.1 m.)
Pomona College, Claremont, California

hall of Pomona College, in Claremont, California [**7.29**]. The mythical hero epitomized not only the human struggle for knowledge—he stole fire from the gods and thus brought knowledge of the arts and sciences to humankind—but also the price paid for acquiring such knowledge: he is chained to a rock and has his flesh torn and liver eaten daily by an eagle. Orozco saw himself as a Promethean figure, spreading knowledge through his art; and like Prometheus, punished for his efforts, receiving little critical recognition from the American art establishment. This theme of the hero/victim was further developed in a series of murals he executed for the Baker Library Reserve Room at Dartmouth College in Hanover, New Hampshire, from 1932 to 1934. In apocalyptic and expressionistic images of war and conquest, Orozco condemned corrupt political and religious institutions of both pre- and post-conquest America (meaning Mexico as well as the United States) and embraced, instead, an all-encompassing political and spiritual conflagration and transformation led by heroic individuals—e.g. Quetzalcoatl—whose self-sacrifice enables the emergence of a new civilization from the ruins of the old.

Orozco's most politically partisan murals appeared in New York City's New School for Social Research and were painted the same year as his *Prometheus*. They recorded in broad, expressionist forms the oppression of workers throughout the world and the revolutionary action necessary to overcome this oppression. The New School had been founded in 1918 as an alternative to the conventional post-secondary education offered in both public and private schools. Its founding faculty members were associated with the liberal journal *New Republic* and included the historians Charles Beard and James Harvey Robinson, who had resigned from Columbia University to protest the firing of several faculty opposed to U.S. involvement in World War I. The New School was governed by its faculty and students and stressed intellectual growth rather than vocational training. The philosophies of John Dewey and Thorstein Veblen were celebrated in the promotion of a society where science and technology were directed toward the spread of equality and social justice. Originally focused on the social sciences, the school expanded its offerings in the arts and the humanities in the mid-1920s and contemporary art was increasingly enlisted as an essential agent in the creation of a new society structured on the principles of artistic creativity, social research, and democratic reform. The school's commitment to Modernist principles manifested itself in its new building by Joseph Urban (1872–1933), which opened in 1930 [**7.30**]. The clean, uncluttered lines of the exterior were matched by open interiors, where the walls displayed murals devoted to contemporary themes [**7.53**]. In 1933 the school became a "university in exile" for German scholars fleeing Hitler.

Siqueiros and Rivera also directly addressed the role of work and workers in contemporary society. Siqueiros (1896–1974) abandoned his mural painting in the late 1920s, spending most of his time organizing workers in western Mexico, where he was arrested in 1930 and jailed for two years. In May of 1932 he traveled at the invitation of Mrs Nelbert M. Chouinard to Los Angeles, where he taught mural classes at the Chouinard Art School and completed three mural commissions, one for the school, one for the Plaza Art Center,

7.30 Joseph Urban: New School for Social Research, New York, 1930

and one for the private garden of the film director Dudley Murphy. In these works Siqueiros experimented with new technologies (e.g. waterproof cement and spray guns) and created explicit condemnations of racism, U.S. imperialism, and contemporary Mexican politics.

Siqueiros's most controversial work was *Tropical America* (1932) [7.31], painted on the exterior wall of a building on Olvera Street in downtown Los Angeles. Hurlburt quotes Siqueiros: "In this new work we are integrally applying our new technique: fresco on cement instead of painting on lime and sand, airbrush exclusively, photographic sketches, air compressors, etc. Moreover, the fresco can be seen from three different streets." Siqueiros had been asked by the director of the Plaza Art Center, F. K. Ferenz, to paint a scene of tropical America. In a

7.31 David Alfaro Siqueiros: *Tropical America*, 1932
Fresco on white cement, 16 × 80 ft. (4.9 × 24.4 m.)
Italian Hall, El Pueblo de Los Angeles Historical Monument, Olvera Street, Los Angeles, California

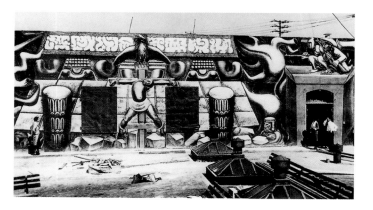

letter of August 1932 the artist declared: "It has been asked that I paint something related to tropical America, possibly thinking that this new theme would give no margin to create a work of revolutionary character. On the contrary, it seems to be that there couldn't be a better theme to use. I am pleased and hope to demonstrate this." The resulting mural included a crucified indigenous person in the center in front of a crumbling Precolumbian temple, with armed Peruvian and Mexican revolutionaries to the right and a wild, undulating jungle to the left. Siqueiros made plain the mural's meaning:

> It is a violent symbol of the Indian *peon* of feudal America doubly crucified by the oppressors, in turn, native exploitive classes and imperialism. It is the living symbol of the destruction of past national American cultures by the invaders of yesterday and today. It is the preparatory action of the revolution that enters the scene and readies its cartridges to effectively launch the life-restoring battle for a new social order.

The eagle atop the crucifix was a clear reference to U.S. economic imperialism in Latin America, the overgrown jungle and crumbling temple testimony to U.S. commitment to maintaining the feudal conditions that allowed for the exploitation of natural and human resources. While the mural received much favorable coverage when it was unveiled in October 1932, its critics managed to have the sections visible from the street whitewashed within a few years, with the rest covered over several years later (it is currently being restored). Siqueiros was deported in November 1932.

While Siqueiros may have been the most politically radical and politically persecuted of "Los Tres Grandes," the most notorious of the three in the United States, who produced the largest number of murals in this country, was Diego Rivera (1886–1957). Rivera was brought to San Francisco in November 1930 by William Gerstle, Timothy Plueger, and Albert Bender. The art historian Anthony W. Lee describes these three men—the owner of a shipping line, a major city architect, and the head of a successful insurance company—as representing "a new kind of cultural player," different from the city's more conservative art patrons such as William Randolph Hearst and Michael de Young. These new cultural patrons exhibited a "mix of university learning, political savvy, industrious entrepreneurship, and liquid capital." Unlike Hearst and de Young, they supported the city's local artists.

Bender had corresponded with Rivera as early as 1926, having been introduced by the San Francisco painter Ray Boynton, who had gone to Mexico to work with Rivera. Gerstle

knew of him through another San Francisco artist, the sculptor Ralph Stackpole, who had also gone to Mexico to work with him. Bender, Gerstle, and Plueger arranged for Rivera to paint a large fresco mural on a stairwell wall at the Lunch Club of the Pacific Stock Exchange. What appears as somewhat of a contradiction—a Communist painting a mural in a bastion of capitalism—is explained by Lee as the result, in part, of diplomatic maneuvering between the United States and Mexico at the end of the 1920s.

One of the ways the American Ambassador to Mexico, Dwight Morrow, worked to counter resistance to U.S. dominance of Mexico's mining and oil industries was to enlist Rivera as his cultural spokesperson. Rivera was an influential figure for the Left in Mexico, yet he had had a stormy relationship with the Mexican Communist Party, having being expelled in 1924 and readmitted in 1926. Morrow knew that if he could gain Rivera's favor he could increase his own credibility with the local population, and he succeeded by appealing to the artist's ego. In 1928 Morrow arranged for the staging of an exhibition of Mexican art in New York through his friend John D. Rockefeller (in 1930 he used his connections to the Carnegie Corporation to organize a large exhibition of Mexican art at the Metropolitan Museum), and while Rivera was only one of several artists included, his work received considerable attention. In 1929 Morrow commissioned Rivera to paint a large mural for the Palace of Cortez in Cuernavaca. The same month Rivera accepted the commission, he was again expelled from the Communist Party. That split, combined with Rivera's promotion by Morrow, provided an opening for American businessmen to look to him as an artist who could create "socially conscious" murals—which would hopefully improve the reputations of his patrons with the average American worker—without ultimately biting the hand that fed him. Bender arranged a series of exhibitions of Rivera's work on the West Coast in 1929, working with Morrow who helped obtain the visa necessary to allow Rivera to travel to San Francisco.

Rivera's Pacific Stock Exchange mural, *Allegory of California* (1931) [**7.32**], was greeted with guarded praise. San Francisco critics focused on the details—the "suave color scheme," the symbols of California's wealth, the recognizable portraits. But few were able to offer full-scale readings of the mural. The reasons, for Lee, are apparent: *Allegory of California* does not "cohere in an overarching description or allegorical structure." Instead of a summary of the limitless natural resources of the state and the boundless power of local industry overseen by a benevolent goddess, "Rivera presents elements of the natural world severed, isolated, or shoved aside." The body of the woman, rather than clearly displayed as in most allegories of

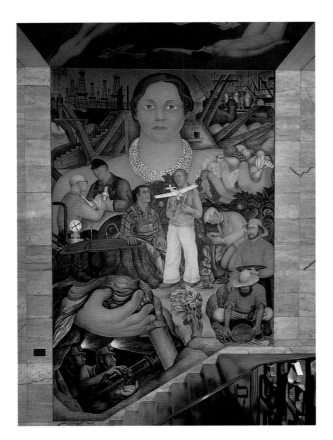

7.32 Diego Rivera: *Allegory of California*, 1931
Fresco
Pacific Stock Exchange, San Francisco, California

natural abundance, is almost totally hidden by a fragmented landscape peopled by men who extract its/her resources in various ways (chopping, panning, drilling). Lee notes,

> She seems to be slipped in, between foreground figures and background industry, as if somehow trying to bring them into relation. But in this middle ground the awkwardness of her body is a sign of the awkwardness of her allegorizing task, and her very presence figures an inability to wrest thematic unity from the mural's congested surface.

Rivera had done extensive research before executing his mural. He traveled throughout the state, visiting farms, factories, oil fields, and mines. He would have been aware, therefore, of the massive restructuring of agriculture and industry that had taken place in the 1910s and 1920s, with natural resources and industrial power consolidated increasingly in the hands of California's wealthiest citizens. The attorney, sociologist, and writer Carey McWilliams described this California landscape in 1939:

Travelers along the highways pass through orchards that seem literally measureless and gaze upon vast tracts of farm land stretching away on either side of the road to distant foothills, yet, curiously enough, there seem to be no farms in the accepted sense. One looks in vain for incidents of rural life: the schoolhouse on the hilltop, the comfortable homes, the compact and easy indolence of the countryside. Where are the farmers? Where are the farmhouses? . . . The impression gained is one of vast agricultural domains, huge orchards, and garden estates, without permanent occupants.

Critics writing about Rivera's *Allegory of California* ignored signs of these developments in his mural—the cranes and conveyer belts behind the fruit and vegetables, the tiny eucalyptus tree (imported from Australia) and the stump of a once vast tree, the fact that the land, itself, is overwhelmed by machines and people. The mural made explicit, in Lee's words, "the blunt fact that the land was fully cultivated. The riches of California were not some fantasy of an Edenic, unspoiled paradise but had already been subjected to the machinery of capital."

The Coit Tower Murals and the Big Strike

Two San Francisco artists who were inspired by Rivera's work and who played central roles in the city's radical art community were Victor Arnautoff (1896–1979) and Bernard Zakheim (1898–1985). The former was from the southern Ukraine, the latter from Warsaw. Both had fought in World War I before emigrating to the United States and settling in San Francisco. Arnautoff became a leading spokesperson for the pro-Bolshevik Russian community, while Zakheim organized the Yiddish Folkschule, where young Jewish artists and radicals were able to come together to mix politics and art. They had assisted Rivera in Mexico before his arrival in San Francisco, and functioned as his link to the Left in the city.

Arnautoff and Zakheim were also involved in the most controversial government-sponsored art project on the West Coast during the 1930s, the Coit Tower murals, one of the first projects commissioned by the Public Works of Art Project (PWAP) committee in San Francisco. The San Francisco PWAP was established in 1933, and was controlled by politically conservative art patrons who wanted to prevent leftist artists from dominating the images that would appear in federally funded public murals. Their concerns were prompted, in large part, by Rivera's influence in the city, for while more liberal patrons and art critics may have liked, if not wholly approved of, Rivera's work, the conservative art establishment would have none of it. The founding of an Artists' and Writers'

Union, led by Zakheim, the poet Kenneth Rexroth, and the anarchist Frank Triest, in the very same year was undoubtedly seen as further reason to maintain tight control over public mural commissions.

The PWAP was charged with overseeing the decoration of the interior walls of Coit Tower, a 288-foot (275-meter) structure designed by Henry Howard and completed in October 1933 as a monument to the firemen of San Francisco [7.33–7.36]. Lillie Hitchcock Coit, whose bequest funded its construction, had had a close association with the Knickerbocker Engine Company Number Five of the Volunteer Fire Department during her life. The Coit Tower mural project was, according to Lee, "the largest collective project funded as part of the federal programs, not just in San Francisco but in the country The walls covered by the finished murals would constitute three-quarters of all the wall space given to murals in the state." The conservative PWAP committee, along with the influential San Francisco banker Herbert Fleishhacker, who had played a central role in the funding and construction of the tower, selected the artists to create the murals. Among them were Arnautoff, Zakheim, John Langley Howard, Ray Boynton, Ralph Stackpole, José Moya del Pino, Otis Oldfield,

7.33 Henry Howard: Coit Tower, San Francisco, California, 1933 (Beyond is Alcatraz Island, with the former prison.)

Jane Berlandina, and William Hesthal. The committee also oversaw the general program. However, they could not control the events that galvanized the city of San Francisco in 1934 and affected the ultimate form taken by several of the murals.

The most significant of these events was the Big Strike of 1934, the culmination of increasingly tense relations between longshoremen and those who ran the shipyards. Striking workers immobilized the city and much of the commercial shipping along the Pacific coast from May 9 to July 31, when the walls of Coit Tower were being painted. Some of the artists felt compelled not only to march in the various demonstrations but also to include allusions to labor issues in their murals.

Zakheim, one of the lead artists in the conceptualization of the Coit Tower murals, wanted to focus on contemporary issues such as the economic crises facing local workers. The heads of the PWAP insisted, instead, on the familiar themes of agriculture, genre scenes, landscapes, and seascapes. Each artist was given a theme and a wall on which to express it. While the PWAP attempted to present the project as a collaborative effort by like-minded artists, differences soon emerged prompted largely by politics. The painters given space on the second floor were not members of leftist organizations, and their frescos tended to be generic scenes of leisure and entertainment. The paintings in the small interior lobby, in oil on canvas, by Oldfield, Moya del Pino and others, were primarily landscapes and seascapes.

The most politically radical works were the frescos on the main floor by Zakheim, Arnautoff, Howard, and Clifford Wight. Arnautoff's *City Life* (1934) [**7.34**] shows the chaos of the streets of San Francisco. While striking workers are absent—to have included them would surely have resulted in strong objections from committee members—there is at least one reference to the city's radical, pro-Communist cadres. Arnautoff has placed the leftist journals *Masses* and *The Daily Worker* on the right side of a newsstand in the center (not visible in the detail below). In addition, the presence of a traffic accident in the background and an armed robbery in the foreground runs counter to the atmosphere of community and harmony that usually characterized government-sponsored murals.

7.34 Victor Arnautoff: *City Life* (left section), 1934
Fresco
Coit Tower, San Francisco, California

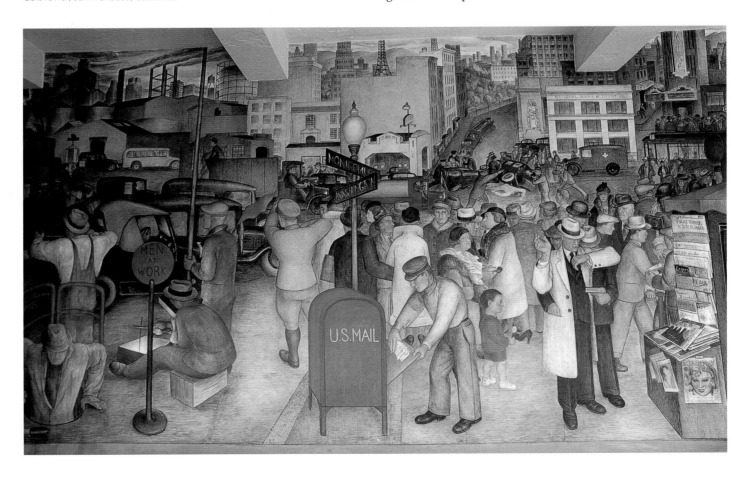

California Industrial Scenes (1934) by John Langley Howard (1902–99) [7.35] alludes to the successes of the California Agricultural Workers Industrial Union (CAWIU), with a multi-racial crowd of workers gathered in front of a combined industrial and agricultural landscape on the left. The CAWIU, led by Sam Darcy, rejected the split between agricultural and industrial laborers that had marked most union organizing and that often resulted in racial segregation. In the center, Howard contrasts the newly built Shasta hydroelectric dam in northern California, a sign of the state's economic progress, with a poor miner's family forced to live in a tent and pan for gold to make ends meet (their poverty is emphasized by the affluent tourists in front of the tent who have come to view the new dam).

Zakheim's *Library* (1934) [7.36] was described in the San Francisco *Chronicle* as a "Red Plot" because of its inclusion of the names "Rexroth" and "*Das Kapital*" on the spines of two books and a reference to the Australian labor organizer Harry Bridges in a newspaper headline reading "Slaughter in Australia" (Bridges was a central figure in the current strike activities in the city). Finally, objections were voiced about a hammer and sickle with the legend "United Workers of the World," one of three motifs painted above windows by Clifford Wight (the other two were a circle containing the Blue Eagle of the National Recovery Act, a key piece of New Deal legislation, and another circle containing the legend "In God We Trust").

The critics of the murals closed Coit Tower in June, a month before it was to open to the public, and threatened to paint over the offending works. Artists responded by organizing a picket line, echoing the demonstrations below them on the docks. The connection between the murals and the longshoremen's strike is described by Lee:

> On July 5, a sketch of Wight's offending panel appeared in the *Examiner*, along with a detail of Zakheim's *Library*. All that morning and afternoon, phalanxes of police and strikers clashed The National Guard set up barricades on the Embarcadero, erected machine gun posts, established field kitchens, and prepared for protracted combat. During the daylong skirmishes, two demonstrators were killed and hundreds wounded. On July 7, the day Coit Tower was supposed to have opened, the Bridges-Darcy coalition called for a general strike On July 9 the Fleishhacker group considered destroying the murals. Fleishhacker himself made a last appeal to Zakheim; much later Zakheim recalled his words: "You know we are on the threshold of a war and we cannot tolerate what you have painted in the Coit Tower. Therefore if you want to play ball with us, you'll change it."

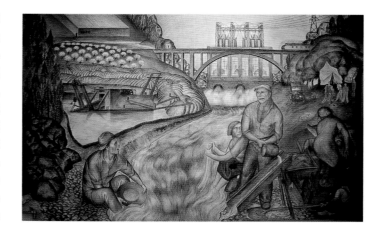

7.35 John Langley Howard: *California Industrial Scenes* (detail), 1934
Fresco
Coit Tower, San Francisco, California

Ultimately, the strike and the broader labor action broke down under unified opposition from a combination of industry and government forces. While many of the demands of the workers were met, the general calls for more radical social and political transformations were stifled. Coit Tower remained closed until October, and when it opened, Wight's hammer and sickle were gone. Fleishhacker and the PWAP committee had managed to prevent the tower's more radical images from contributing to public discourse during the height of the strike. Only when life returned to normal were the city's

7.36 Bernard Zakheim: *Library*, 1934
Fresco
Coit Tower, San Francisco, California

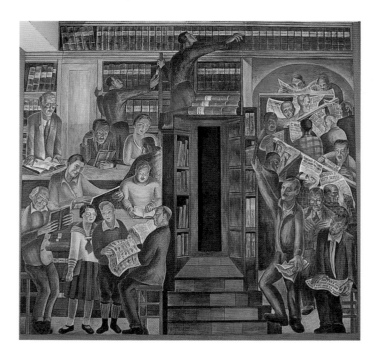

residents allowed to form their own opinions about these most controversial of murals.

Painting Injustice:
Philip Evergood, Ben Shahn, and Thomas Hart Benton

Another artist active in both the Artists' Union and the federal arts projects who strove to make art a part of the labor struggle was Philip Evergood (1901–73). Evergood was employed by both the PWAP and the FAP/WPA, acting at one point as Managing Supervisor of the FAP's Easel Division. He also became president of the Artists' Union in 1937, having proved his mettle in the "291" strike organized by the Union in New York in December 1936 to protest the proposed layoffs of WPA artists (291 individuals were arrested, including Evergood). During his tenure as president, the Artists' Union affiliated

with the newly formed Congress of Industrial Organizations (CIO), becoming the United American Artists, Local 60 of the United Office and Professional Workers of America.

Evergood's involvement in the PWAP and Artists' Union shifted his attention away from the biblical subjects, still lifes, and nudes of his earlier paintings to workers, employed and unemployed, in the streets of New York. His past had not prepared him for such subject-matter. His mother's family was well-off, and funded his extensive education abroad. His father was a painter who seldom sold a picture. During the 1930s he was fortunate enough to obtain employment through the connections of his wife's family and ultimately through the federal art programs. Evergood later wrote:

> When I thought of my background in Eton and Cambridge and that kind of nonsense, which had taken up so much of my life (but which had its value, I think), I felt very moved to shake it off and to be a part of what I was painting, the way Daumier and Courbet and Goya were. It was a feeling

7.37 Philip Evergood: *American Tragedy*, 1937
Oil on canvas, 29½ × 39½ in. (74.9 × 100.3 cm.)
Private collection

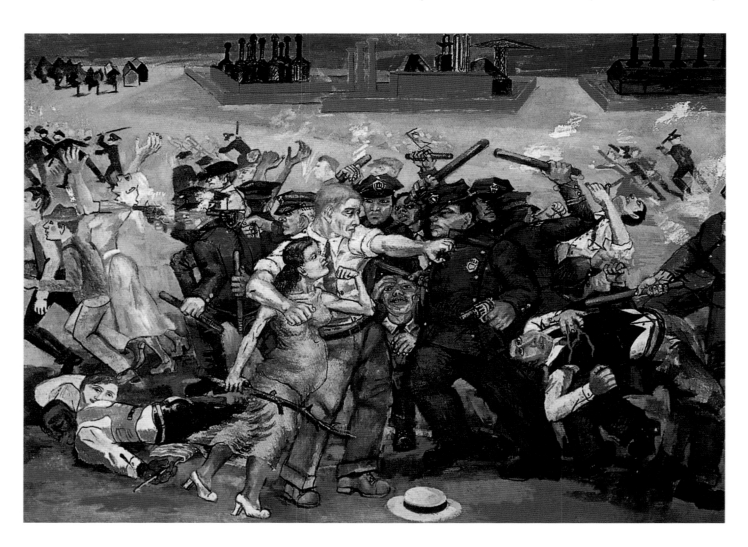

that you have to know humanity at the time you live. You can't just sit down at a desk and write a *Nana* unless you've lived it, by God, unless you've damn well sat in a cold basement half the night with down-and-outers and felt their suffering. And to me it meant even more. It meant fighting for them politically, besides putting it down on canvas. It meant sacrificing your good comfortable safety to fight for some of these guys and stick my neck out too.

Evergood's most powerful depiction of the struggles between workers and industrialists is captured in his painting *American Tragedy* (1937) [**7.37**]. The passage in 1935 of the Wagner Act, with the subsequent establishment of the National Labor Relations Board, gave American workers the right to organize unions to bargain for better wages and working conditions. The workers at Republic Steel in Chicago had decided to exercise this right, and in 1937 struck for higher wages. During a Memorial Day picnic/demonstration outside the factory, the police opened fire on the unarmed crowd. Ten people were killed and over one hundred injured. Evergood studied newspaper photographs and written accounts of the event before producing his painting, into which he incorporated elements from the photographs, such as the prone black man holding an American flag. He conveys the chaos of the scene through the number of figures crowded into the foreground and their proximity, resulting in police firing at point-blank range and hand-to-hand combat.

The focus of the painting is the heavily muscled red-haired male worker and his pregnant Hispanic wife, who also flexes her muscles. Here is an ironic reference to the couples in the New Deal post office murals, ironic in that the man and woman in Evergood's painting are not plowing or harvesting a field, but are, instead, engaged in a battle with the establishment forces of law and order on blood-splattered and barren ground (the branch in the woman's right hand functions not as a sign of nature but as a potential weapon). And unlike the New Deal murals of industry, where machinery and workers are intertwined in the foreground, the factories here occupy the distant background, and sit idle while the workers and their families are shot and clubbed by the police. Patricia Hills suggests that the crouching man with the bloodied face beneath the outstretched arm of the central worker in the white shirt is Evergood himself, whose face had been similarly bloodied by police in the 291 strike, and that the central worker was modeled after another artist who participated in the 291 strike, the sculptor Paul Block. If so, here were artists on the front lines of the labor struggle. Hope appears in the form of the pregnant woman. Hills suggests that the branch in

her hand, along with her pregnancy, could refer to the "stem of Jesse," father of King David, from whose branch the Messiah would come according to the Old Testament. In this context, the savior will be the next generation of laborers who will continue to fight for workers' rights.

Ben Shahn was also concerned with the struggles of workers and instances of institutionalized injustice. Shahn arrived in New York from Eastern Europe in 1906, at the age of eight, one of many Eastern European Jews fleeing persecution. Trained as a lithographer, he studied at City College, the National Academy of Design, and the Art Students League, before embarking on two trips to Europe in the 1920s. Like many artists of the 1920s, he moved through a series of Modernist styles before settling on a less abstract, more figurative art. He expressed the reasons for this shift in his choice of style and subject-matter in familiar terms: he wanted to tell stories, and Modernist art was not suitable for storytelling. Above all, he wanted his stories to be about his own experiences of America.

Shahn first gained attention in the art world with his 1931–32 series of twenty-three gouache paintings on the trial of the anarchists Nicola Sacco (a shoemaker) and Bartolomeo Vanzetti (a fish peddler), two Italian immigrants. Sacco and Vanzetti were arrested in 1920 and charged with the robbery and murder of a paymaster and guard in Braintree, Massachusetts. They were executed in 1927, after seven years of appeals and two trials. Their situation gained international attention, for their arrest and the verdict were seen as the result of their politics and ethnicity, not conclusive evidence of their guilt. Like Evergood, Shahn studied newspaper accounts of the trial and based several of his works on photographs that accompanied these accounts. His flat, linear style derived both from mass-media images and from the experiments of Modernist artists. In his series he presents Sacco and Vanzetti not as heroic men marching or battling police but as humble individuals whose personalities come through in the cut of their suits and the expressions on their faces.

Shahn also produced a large tempera panel painting on the case, entitled *The Passion of Sacco and Vanzetti* (1932) [**7.38**], for a mural competition sponsored by the recently founded Museum of Modern Art. Here Shahn indicts the members of the committee established to determine whether there had been bias in the first trial—Judge Robert Grant, President A. Lawrence Lowell of Harvard University, and President Samuel W. Stratton of the Massachusetts Institute of Technology. The three men stand as insincere mourners above the coffins containing the figures of Sacco and Vanzetti, while Judge Webster Thayer, who presided over both trials, is

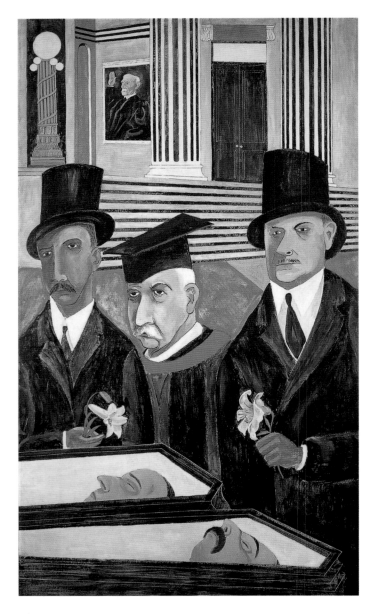

7.38 Ben Shahn: *The Passion of Sacco and Vanzetti*, 1932
Tempera on canvas, 84½ × 48 in. (214.6 × 121.9 cm.)
Whitney Museum of American Art, New York

imprisoned in the neoclassical architecture in the background. The Lowell Committee found there had been no bias, and refused to recommend clemency. Matthew Josephson, critic for *The New Republic*, wrote of this painting in 1932:

> Here is fishy, green-eyed, bony-faced, lantern-jawed Thayer, painted for all posterity in his hollow robes of justice. Here are the three silk-hatted, degenerate-looking Yankees of the Lowell Committee, against a classical, paper-maché courthouse. Judge Thayer, the Lowell Committee, won out in 1927. But what of 1937 and 2027? One senses, at this

point, the enormous latent power of artists and poets over human events—if they would but use it. The statesmen propose; the artists, poets, dispose, in the long run.

Thus, Shahn's painting was seen as holding meaning not only for those who viewed it in 1932, but also for those who would view it in the future. Indeed, the debate over the guilt or innocence of Sacco and Vanzetti continues to this day.

One artist who painted both urban and rural life and who voiced a trenchant critique of the excesses of industrial capitalism before ultimately signing on as a supporter of the New Deal was Thomas Hart Benton (1889–1975). Benton was the son of a populist Missouri congressman. His great-uncle was a U.S. Senator who promoted an economic and political order based upon independent American producers or workers. Benton inherited this belief in a worker-determined economy and a politically active community of citizens. He voted for the Socialist ticket in the early 1920s and was friendly with many members of the newly formed American Communist Party (CPUSA), executing the illustrations for Leo Huberman's *We the People*, a Marxist history of the United States published in 1932. By the early 1930s, however, Benton was cutting his ties with organized leftist politics, seeing the leaders of the CPUSA and large labor unions as interested more in their own political or economic power than in the needs of individual workers. Like many others, Benton blamed the "corrupting self-interest" of corporate capitalism for the economic crisis of 1929, but hoped that Roosevelt's New Deal would usher in a new industrial democracy where skilled labor and worker autonomy would flourish.

Throughout the 1920s and 1930s Benton devoted his energies to the production of a national art that focused on Americans as workers and that was intelligible and meaningful to a wide range of people. At the same time, however, he did not reject as inherently "foreign" the stylistic innovations of Modernism. The art historian Erika Doss suggests that the expressive figural distortions and tortured, twisted compositions that mark Benton's murals of the 1920s and 1930s were his attempts to bring together the lessons he learned in Europe with his political aspirations.

While Benton studied in Paris between 1908 and 1911 and continued to experiment with Modernist forms when he returned to New York, he also joined the group of artists gathered at New York's People's Art Guild, founded in 1915 by the Polish émigré John Weischel. Weischel wanted to bring artists and common people together and believed that the best art for this task was Modernist art, with its richness and dynamism. The Guild organized classes and lectures and

mounted exhibitions in many of the city's neighborhood centers. Weischel believed that art and workers could come together to change society, a message that helped bring about, for Benton, a resolution of his republican family past, with its emphasis on civic participation, and his Modernist visual language.

The Depression gave new immediacy to Benton's attempts to envision a democracy guided by an alliance between agricultural and industrial workers on the one hand and the government on the other, and of a nation that simultaneously preserved and linked localized cultures to form a collective American identity. As millions were laid off and factories closed, Benton, like so many artists, continued to create images of robust workers, both urban and rural, engaged in meaningful labor in recognizable settings. His first major mural commission of the 1930s, ten panels on the theme of *America Today* (1930–31) for the New School for Social Research, contained such imagery. Most of the panels are filled with male workers engaged in industrial and agricultural labor as independent individuals with the tools of their trade. Yet while faceless masses of factory workers or organized ranks of strikers are absent, there are some signs that all is not well on the industrial front. Shown with the muscular city builders are the tenement houses in which they live, and the mining panel [7.39] includes exhausted miners at the end of a long day of work. The flames from the smelter appear

also to be coming from the mine portal, suggesting the many disasters caused by inadequate safety precautions. Thus, there were limits to Benton's dream of an industrial and agricultural democracy.

Alternative Visions: The Corporate View of Industrial America

Images of Ford: Diego Rivera, Frida Kahlo, and Charles Sheeler

At the same time the federal government entered the public realm to promote its new vision of social reform, industry executives endeavored to present a public image of themselves as "enlightened" capitalists with the interests of workers at heart. Several corporate leaders commissioned major works of art in public places in order to help achieve this goal. For example, in 1931 Rivera accepted a commission from Edsel Ford for a series of murals in the Detroit Institute of Arts documenting the automotive industry [7.40]. Like Dwight Morrow, both Edsel and Henry Ford wanted to promote good relations with Mexico, where they had extensive financial interests, and they too realized that commissioning a Mexican artist could improve those relations, particularly at a time when the Mexican government was threatening to end U.S. oil and mining concessions. And with this mural they could also present their respect for their workforce, by including images of workers in an art museum— of which they were major funders—while at the same time resisting all their workers' efforts to unionize. As Terry Smith has pointed out, such visual propaganda was particularly necessary in 1932, when Rivera was painting his murals: this was the nadir of the Depression, with three-quarters of a million Michigan workers unemployed and with armed Ford servicemen and Dearborn police putting down workers' demonstrations.

Rivera accepted the commission for various reasons. As with the Pacific Stock Exchange, he saw it as an opportunity to promote his reputation in the United States, to spread his ideas to an international audience, and to make some money. In his Detroit murals he could advocate the rights of workers while celebrating a technology that was going to improve their lives, as long as its benefits were shared equitably. Rivera is quoted as saying: "Marx made theory. Lenin applied it with his sense of large-scale social organization And Henry Ford made the work of the socialist state possible." According to Smith, there is little evidence that the artist joined in any of the workers' demonstrations that took place while he was painting his murals. Instead, he contributed to the cause of the working class "by seeking a visual language which would speak not only to the immediate crisis but beyond it, through time, through future struggles, to a different, as yet unimaginable future."

7.39 Thomas Hart Benton: *Coal*, mural from the series *America Today* for the New School for Social Research, New York, 1930
Distemper and egg tempera with oil glaze on gessoed linen, 92 × 117 in. (233.7 × 297.2 cm.)
Collection, AXA Financial, Inc. through its subsidiary The Equitable Life Assurance Society of the U.S. © AXA Financial, Inc.

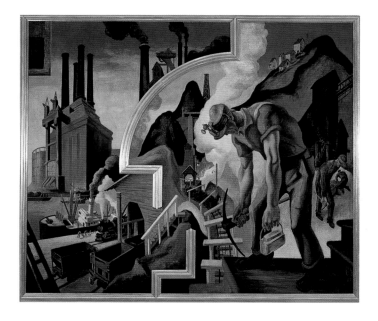

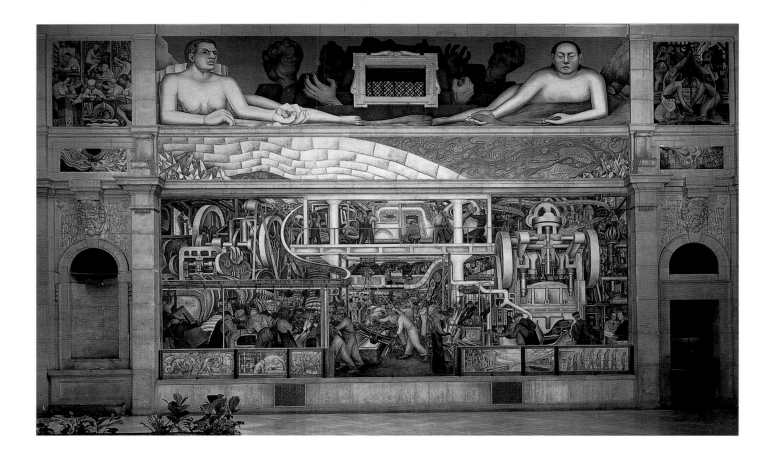

7.40 Diego Rivera: *Detroit Industry* (south wall), 1932–33
Fresco
The Detroit Institute of Arts, Detroit, Michigan

The resulting images, created between July 1932 and March 1933, celebrate workers and technology within the framework of the natural world, while at the same time raising questions about the potential for technology to enslave as well as liberate. On the south wall of the interior court [7.40] Rivera creates the impression of a crowded workshop below ground. The long, thin central panel depicts sediment and rock formations, while in the panel above, clenched fists, a symbol of revolution, break through the surface of the earth and are framed, as in the north wall, by reclining female figures representing the different races of the world and minerals used in automobile production (white race/limestone and yellow race/sand on the south wall, red race/iron ore and black race/coal on the north wall). A large stamping press appears on the right, reminiscent of the massive stone statue of Coatlicue [1.8], thus connecting the power of the natural world with the power of technology, as well as the Mexican spiritual past with the American industrial future (in his 1940 mural *Pan American Unity* at the City College of San Francisco, the press/statue is presented as half machine, half carved stone). The workers appear to be both controlling and controlled by the massive machines surrounding them. William R. Valentiner, the Director of the Museum (in profile), and Edsel Ford (facing out) are included in the lower right-hand corner. Rivera exaggerates both the density of the machines and the gestures of the workers, enlivening the image with the straining, diagonal forms of the men and undulating curves of the machines.

Mechanization had, in fact, reduced the amount of physical exertion necessary to construct a Ford motor car while increasing the repetitive nature of a worker's task. Rivera does not present the viewer with heroic workers dominating the workplace or engaging in revolution. He was aware that the contemporary reality was much more complex. But his workers pull and push in unison, and while they occupy themselves with the various assembly line tasks, they are not isolated from one another. Through their combined efforts, they have the potential to transform both modern industry and modern society. As Smith points out, Rivera's murals are not about the making of commodities—the only complete car is a tiny image in the far distance on the south wall—or about a future utopia, but "about human growth through work and struggle."

Frida Kahlo (1907–54) accompanied her husband Diego Rivera to Detroit and created her own image of the Ford complex in a small oil painting on metal, *Self-Portrait on the*

Borderline Between Mexico and the United States (1932) [7.41]. Here we see the exterior rather than the interior of the Ford operations, and the references to pre-conquest Mesoamerica are much more evident. The smokestacks and industrial and corporate architecture of Detroit are matched by the pre-conquest temple pyramid of central Mexico; the environmental violence of the North, where the natural world has been displaced by the industrial, contrasts with the ritual violence of the South as embodied in the bloody-mouthed sun (Huitzilopochtli) and crescent moon (Coyolxauqui) (see pp. 22–23). The roots of the plants on the left are echoed in the electrical wiring of the loudspeaker, searchlight and generator on the right. In its fantastical imagery, the painting draws on both Surrealism [7.41] and a type of small Catholic devotional painting on metal and wood [4.7, 4.8].

7.41 Frida Kahlo: *Self-Portrait on the Borderline between Mexico and the United States*, 1932
Oil on metal, 12¼ × 13¾ in. (31 × 35 cm.).
Manuel and Maria Reyero, New York

The art historian Margaret Lindauer has argued that the focus of *Self-Portrait on the Borderline* is neither Ford nor the Aztec deities, but the border itself, and the ways in which it functions as "an ideological site" where the primitive/indigenous/Mexican and modern/European/U.S. opposition is maintained. Kahlo was a member of the Mexican Communist Party and a cultural nationalist, critical of capitalism and supportive of a distinct Mexican national identity, one free from U.S. intervention and influence. Yet she did not idealize the Mexican past as Rivera did. She challenges the touristic visions of the tropical South, as well as the corporate celebrations of the industrial North. Neither landscape is populated, suggesting the barrenness of these stereotypes as foundations for living cultures, although the suggestion of a more dynamic cycle of life and death in the South (the sacrifices that ensure the rising and setting of the sun, the temple and ceramics that emerge from and return to the earth) implies that Mexico stands as a more hopeful model for the future.

Kahlo's use of the female body also differs significantly from that of Rivera. Rather than presenting heroic allegorical females

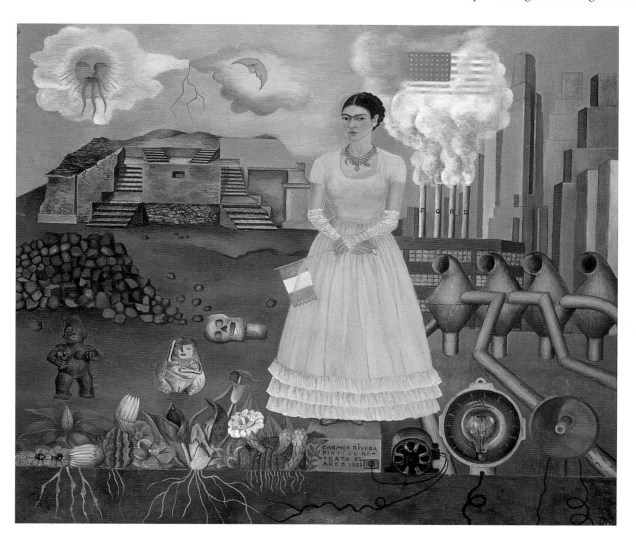

as stand-ins for geographical, geological, or racial divisions, Kahlo uses her own body in order to ground her broader political commentary in personal experience. In *Self-Portrait on the Borderline*, the composition is anchored, both literally and metaphorically, in her body. She wears a 19th-century European-style dress, along with a pre-colonial indigenous bone necklace. As someone with both indigenous and European heritage (a *mestiza*), she took pleasure in performing her *mestizaje* through costumes and through the collection and display of indigenous objects. She understood the political power of this concept as articulated by José Vasconcelos (see pp. 359–60), who argued that Mexico's future lay in its combination of the spiritual and aesthetically sensitive indigenous on the one hand, and the rational and scientific European on the other, which would create a more perfect "cosmic" race. Yet Kahlo also understood that this ideology did not ameliorate the desperate material conditions experienced by the majority of Mexico's indigenous population.

While Kahlo uses her own body in her painting, she also records her first name on the border marker/pedestal as Carmen, one of her lesser-known given names, and not Frida; and she uses her married, not maiden, last name. These choices, along with the transparent, ephemeral nature of the two flags she holds in her hands, highlight the indeterminacy of both personal and national identity.

Rivera and Kahlo were not the only artists who produced images of Ford's production facilities, and it is interesting to compare their work with that of Charles Sheeler (1883–1965). Sheeler had trained in the studio of William Merritt Chase before moving into the circle of avant-garde artists around the Arensbergs in New York (see p. 347). Like Duchamp and Picabia, he was interested in machine forms, though without the Dada artists' wry irony or playfulness, and these forms filled both his paintings and his photographs. Throughout the 1920s Sheeler produced not only paintings and "art" photography but also commercial photography for advertising, and studio portraiture for Condé Nast publications including *Vogue* and *Vanity Fair*. Smith believes that Sheeler's

> work was valued because he photographed spark plugs, cars, and society ladies as if they were works of art. He applied, in a measured way, many of the modernist techniques of isolating, cropping, bold lighting, contrasting sharply different with even surfaces, thereby transforming the advertised subjects into things in themselves, possessing the look of objects of a valuing gaze.

Sheeler brought these qualities to Ford when he was commissioned in 1927 to photograph the River Rouge plant

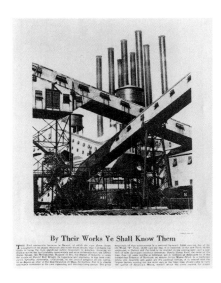

7.42 Charles Sheeler: *Criss-Crossed Conveyers*, 1927, photograph reproduced in *Vanity Fair*, February 1928
Lane Collection, Museum of Fine Arts, Boston

in Dearborn, Michigan, for a publicity campaign undertaken by the advertising agency N. W. Ayer of Philadelphia. The agency's art director, Vaughn Flannery, wanted to upgrade the company's image by associating it with a Modernist aesthetic and a famous artist. Sheeler produced a portfolio of images that were reproduced in commercial publications such as *Vanity Fair* [**7.42**], as well as in *Creative Art* and other photography magazines, and were shown in photographic exhibitions. Workers play a minimal role in these photographs. Of greatest interest to Sheeler are the machines themselves, and the architectural forms that house them.

The absence of workers also marks two paintings by Sheeler of the River Rouge plant, *American Landscape* (1930) [**7.43**] and *Classic Landscape* (1931) [**7.44**]. Like Kahlo [**7.41**], Sheeler focuses on the exterior of the River Rouge facilities and embeds a contrast between nature and industry in his composition. In place of the rolling hills and bodies of water and vegetation suggested by the word "landscape" in each of the titles, Sheeler has inserted the hard edges and rectilinear shapes of industry (Sheeler's work has also been included under the rubric Precisionist). Here are the new, modern, landscapes, the American landscapes, the industrial forms that echo the shapes and monumentality of the temples of Greece and the pyramids of Egypt (Demuth's *My Egypt* [**6.46**] also comes to mind). While the Ford logos on the side of several railway cars in *American Landscape* suggest the specific locale of the painting, the absence of the product—cars—makes it possible to read the two paintings as generic celebrations of American industry. In addition, while the absence of workers and clear, white light create a static feel, in each image the viewer is located at a point

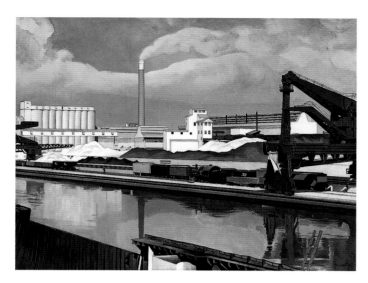

7.43 Charles Sheeler: *American Landscape*, 1930
Oil on canvas, 24 × 31 in. (61 × 78.8 cm.)
The Museum of Modern Art, New York

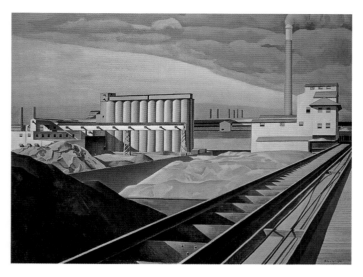

7.44 Charles Sheeler: *Classic Landscape*, 1931
Oil on canvas, 25 × 32¼ in. (63.5 × 81.9 cm.)
Collection of Barney A. Ebsworth

of movement and transition—on a barge approaching the dock in *American Landscape*, and on a railway track in *Classic Landscape*.

Smith argues that positioning the viewer in this way speaks to another aspect of modern industry embodied in the Ford motor company: "a local/global system of centralization, singularity, and dominance." Ford created an efficient and cost-effective industrial complex where raw materials were brought to the plant via train and barge and processed to make the parts

necessary to produce his automobiles, which were then shipped to other Ford-owned outlets for sale.

One of the materials necessary in Ford's cars was glass, and the building in which it was made at Dearborn was designed by the Detroit architect Albert Kahn (1867–1942) in 1922 [**7.45**]. Just as Julia Morgan benefited from setting up her office in San

7.45 Albert Kahn: Ford Glass Plant, Dearborn, Michigan, 1922

Francisco just before the city's big earthquake of 1906 (see pp. 383–84), so, too, did Kahn benefit from starting his career in a city then emerging as the center of the automobile industry. His clients included Packard Motor Company and General Motors, as well as Ford. The architectural historian David Handlin writes of Kahn's work: "At a time when the assembly line was becoming the basis of industrial production, Kahn almost single-handedly transformed the American industrial plant from a multistory, small-span building to a single-story, large-span structure that spread out over many acres and was lit though a saw-tooth roof." With its tall smokestacks, massive size, and clean, undecorated surfaces, Kahn's Glass Plant was the prototype for the buildings included in Sheeler's photographs and paintings.

In 1931 Sheeler commented on the intersection of industrial efficiency and aesthetics in buildings like Kahn's in a caption for a full-page color plate of *American Landscape* [7.43] in the March issue of the new business magazine *Fortune*:

> The plant is perhaps as good an illustration as could be found of the belief, which prevails amongst some artists, that forms created with the idea of functioning in the most efficient manner carry an abstract beauty that could not be achieved as convincingly were they to be conceived with the primary intention of making beautiful shapes Here is to be seen the machine working with an infallibility which precludes human competition. Noticeable is the absence of debris. Everything in the path of the activity is in the process of being utilized It becomes evident that one is witnessing the workings of an absolute monarchy. It confirms a preference for that type of government with the proviso that the monarch be of the caliber of Henry Ford.

Thus, Sheeler produced a celebration of industry, and of Ford in particular, different from the one produced by Rivera in the Detroit Institute of Arts [7.40]. Rivera used the age-old technique of fresco to create a fine art statement in a neo-Renaissance museum, which celebrates both industry and industrial workers. Sheeler used a Modernist aesthetic to produce photographs and paintings that were part of, or grew out of, a commercial marketing campaign where the goal was to promote the purchase of Ford automobiles, as well as to advocate an efficient, industrial "monarchy" as a solution to the country's political and economic woes.

Rockefeller and the Limits of Corporate Patronage

After completing his Detroit murals, Rivera traveled to New York where he began a commission from Nelson Rockefeller for a large mural and side panels for the lobby of Radio City

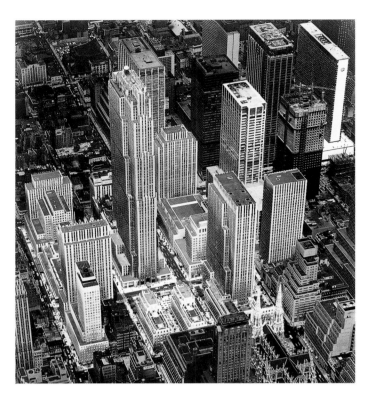

7.46 Reinhard & Hofmeister, with Raymond Hood and Harvey Wiley Corbett: Rockefeller Center, New York, 1927–39

Music Hall, located in Rockefeller Center (1927–39) [7.46]. Designed for John D. Rockefeller, Jr, by the firm of Reinhard and Hofmeister, with the assistance of the architects Raymond Hood and Harvey W. Corbett and a large team of managers and designers, this massive architectural complex of fourteen buildings covering three long city blocks between Fifth and Sixth Avenues was begun at the onset of the Depression and constructed right through the economic crisis. It represented, therefore, a symbol of hope in a time of despair, a sign that the economy was not irreparably damaged.

The look of Rockefeller Center was due, in part, to New York's Zoning Ordinance of 1916 requiring that a building could rise sheer from the pavement for only a certain height, depending on the size of the lot; it then had to be pulled back in a series of setbacks to allow light to reach street level. The architectural historian Spiro Kostof comments on the overall effect of this ordinance on the design of New York skyscrapers:

> In predetermining the overall shape as a system of setbacks, the ordinance made it easy to abandon the habit of thinking of the skyscraper as affinitive to the classical column—with a distinctive ground-storey treatment for the base, the uniform office floors for the shaft, and the attic topped by a projecting cornice for the capital [cf. 5.60]. The

cornice might be given up altogether, or replaced by all manner of fanciful crowning features. Stepped elevations now recalled the ziggurat of old or the craggy, tasseled silhouettes of Gothic cathedrals. The shelflike recessions could be made over as roof terraces or penthouses.

Many architects in the late 1920s rejected the Gothic trappings of Cass Gilbert's Woolworth Building [6.4] and turned to different design traditions. In the Chrysler Building in New York (1928–30) [7.47], William van Alen (1883–1954) looked to a Southeast Asian temple tower for the crowning spire, clad in gleaming metal. The building made bold use of Art Deco forms (see below), playing with references to cars—radiator cap ornaments, wheels, etc.—to keep Chrysler's product in the viewers' minds.

The architects of Rockefeller Center, instead, adopted the plain surfaces of Chicago School architecture, with its reliance for decoration on the vertical frame and the repetitive window patterns. Like Louis Sullivan, however, they allowed for decorative schemes at the entrances. Rather than his intricate Art Nouveau foliage designs, there appeared scenes in what came to be known as Art Deco (after a 1925 industrial and decorative arts exhibition in Paris), a style summed up by the art historian Susan Rather as marked by "attention to surface, the use of exotic materials, textural variety, strong color contrasts, and a preference for simplified geometric or stylized forms." The best example at Rockefeller Center can be found in the main doorway to the RCA Building, in Lee Lawrie's multicolored stone and glass relief *Genius, Which Interprets to the Human Race the Laws and Cycles of the Cosmic Forces of the Universe* (*c.* 1930) [7.48]. Lawrie (1877–1963) was German-born but grew up in Chicago and studied with the American sculptor Augustus Saint-Gaudens. He worked with several architects, among them Bertram Goodhue, who realized the adaptability of Art Deco, with its broad, often repetitive forms and sweeping lines, to architectural settings.

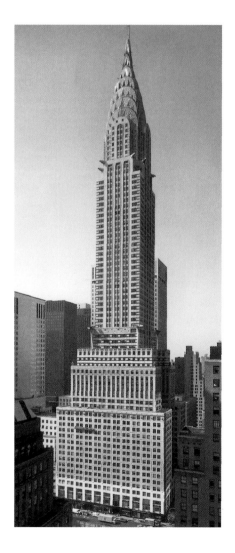

7.47 (left) William van Alen: Chrysler Building, New York, 1928–30

7.48 Lee Lawrie: *Genius, Which Interprets to the Human Race the Laws and Cycles of the Cosmic Forces of the Universe,* c. 1930
RCA Building, Rockefeller Center, New York

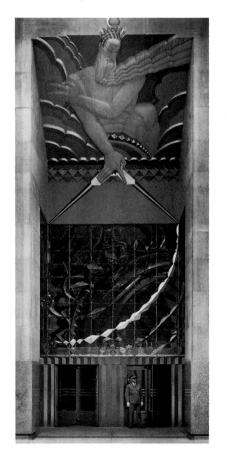

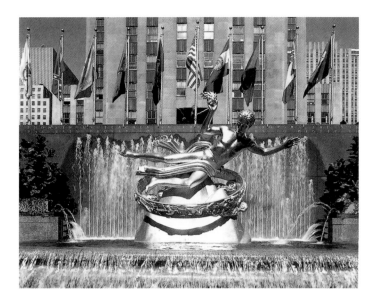

7.49 Paul Manship: *Prometheus*, 1934
Gilded bronze, H 18 ft. (5.49 m.)
Rockefeller Center, New York

Another example of the Art Deco style can be found in a sculpture in the main plaza in front of the RCA Building, on an axis with Lawrie's doorway—the large gilded bronze statue of *Prometheus* (1934) by Paul Manship (1885–1966) [**7.49**]. Manship was one of the most successful American sculptors between the wars, a success due, according to Rather, to the way his work "negotiated the distance between tradition and modernity." While his figures "were anatomically more naturalistic" than those of many contemporary European and Russian Modernist sculptors, their naturalism was countered by "stylized, linear incisions marking hair, drapery, and other details," reminiscent of the archaic period in Greek sculpture, and by the highly polished surface and regular rhythmic

contours of much of his work. Manship's *Prometheus* also appears much less "troubled" than Orozco's [**7.29**] as he floats lightly, although somewhat awkwardly, over the waters of the fountain rather than straining desperately to protect himself from the impending wrath of the gods from whom he has stolen the fire of knowledge.

Rivera's RCA paintings were to occupy the lobby entered through the doorway designed by Lawrie. And like Lawrie, Rivera chose a grandiose, although less Olympian, title—*Man at the Crossroads Looking With Hope and High Vision to the Choosing of a New and Better Future* (1933). The study, approved by Nelson Rockefeller, contained a critique of militarism and intolerance, representing the corrupt past, on the left side of the composition, and a celebration of a populace united and empowered by science and technology, representative of the new and better future, on the right side. The study did not, however, show Lenin, whom Rivera later inserted on the right side as an indication of the type of leadership that was necessary to move society into the ideal future, obviously modeled on the Soviet Union. Rockefeller cited the inclusion of Lenin as his reason for stopping the production of the mural, and then later having it jackhammered off the wall when the artist refused to remove the figure. Rivera, flush from his success in Detroit, had overestimated the tolerance of his latest corporate benefactor. Rockefeller nevertheless paid him in full, and he re-created the mural, with certain alterations, the following year in the Palace of Fine Arts in Mexico City [**7.50**].

7.50 Diego Rivera: *Man, Controller of the Universe*, 1934
Fresco
Museo del Palacio de Bellas Artes, Mexico City

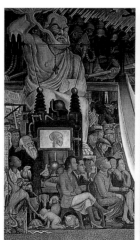
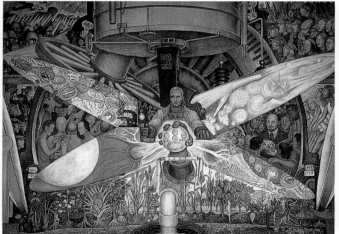
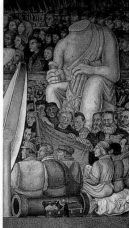

Industry and Labor in "Fortune" and "Life"

It was not unreasonable for Rivera to have believed that his patrons would accept the head of Lenin. After all, *Fortune* magazine had commissioned him to design the front cover of the March 1932 issue devoted to the Soviet Union. In addition, the May Day series of paintings, from which the cover was drawn, was purchased soon after its completion by Abigail Aldrich Rockefeller, the wife of John D. Rockefeller, Jr, and one of the founders of the Museum of Modern Art. Perhaps Henry Luce's magazine could afford to be a little more tolerant in the less permanent medium of ink and paper. But, more to the point, tolerance was, in fact, one of the key themes of this new magazine, which, like the murals commissioned by Ford and Rockefeller, was intended to promote a new image of the American businessman. Luce, co-founder of Time, Inc., the publisher of *Fortune*, outlined his proposal to the directors of the corporation in 1929:

> It will be as beautiful a magazine as exists in the United States
> It will be authoritative to the last letter.
> It will be brilliantly written
> It will attempt, subtly, to "take a position," particularly as regards what may be called the ethics of business . . . in a general way, the line can be drawn between the gentleman and the money-grubber, between the responsible and the irresponsible citizen. *Fortune* is written for those who have a sizable stake in the country and who ought, therefore, to yield to no other class in either the degree or the intelligence of their patriotism.

Thus, Luce's new magazine presented the American business world with a new image of itself. For Luce, business was, "essentially, our civilization." As such, it needed to express its importance, and ethical responsibilities, in a form both "beautiful" and "modern." It would prove its fitness as guardian of the country's future through self-criticism and self-regulation as opposed to government regulation. *Fortune* would hire the best artists, photographers, and writers to convince its audience of businessmen that this new self-representation was vital to the health of the nation, politically and economically. There were limits, however, to the criticism allowed in the magazine. While the exposés of certain industries by writers such as Dwight Mac-Donald and Archibald MacLeish lent credence to Luce's claims to be providing a watchdog publication for American business, they were qualified by the broader promotion in the magazine of the inevitability of private enterprise as a controlling force in the life of the nation.

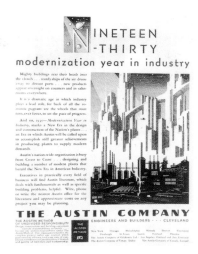

7.51 Austin Company advertisement in *Fortune*, March 1930

This theme of business as the nation's future was presented in part through the use in many advertisements of a decidedly futuristic style, one developed by Modernist artists who included Georgia O'Keeffe and Charles Demuth—clean, hard lines, geometric shapes, broad areas of sharply contrasting colors or stark oppositions of black and white. The business world was also imaged increasingly as massive architectural forms and machines, devoid of human presence. An example appeared in the March 1930 issue in an ad for the Austin Company of Cleveland [7.51]. In case the visual message was missed, the text spelled out the connections between this hard-edged, pared-down style, modernity, and industry—"Nineteen-thirty. Modernization year in industry." Artistic Modernism also appeared in *Fortune* in the reproduction of art works as illustrations for articles on corporate culture. Such reproductions updated the aesthetic tastes of the businessmen reading the magazine, even providing suggestions for future purchases for those interested in patronizing contemporary artists (Thomas Hart Benton, Edward Hopper, and Charles Sheeler were but a few of the artists included in *Fortune*'s pages).

Fortune also presented its image of the new corporate America through a distinctive series of documentary photo essays, which accompanied written essays on particular corporations. These photo essays often combine the stark Modernism of photographers like Stieglitz, Weston, and Sheeler with the documentary directness of Jacob Riis and Lewis Hine. One photographer in particular who distinguished herself in this area was Margaret Bourke-White (1904–71). While she photographed both workers and machines, the more powerful images are the latter, for her own sympathies and excitement in the early 1930s lay in the rendering of the technological aspects of modern industry.

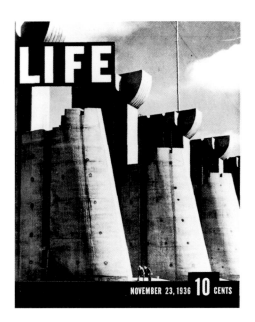

7.52 Margaret Bourke-White: *Fort Peck Dam, Montana*, photograph on the cover of *Life*, November 23, 1936

Bourke-White went on to work for another Time, Inc. magazine, *Life*, producing the image for the cover of their first issue, *Fort Peck Dam, Montana* (November 23, 1936) [7.52]. Like the dams of the Tennessee Valley Authority, Fort Peck was a Bureau of Reclamation project. It was the largest earthen dam at the time of its construction, and the architects adopted the bold forms of a medieval fortress for its facade. Bourke-White, photographing it from close up and below, isolates these dramatic forms and conveys a sense of the power of the federal government, at the same time reducing the human presence to two tiny figures in the foreground.

The essay inside, however, tells another story, one of human activity in the town of New Deal, Montana, that grew up to house the large number of men and their families who came to work on the dam. Only one of the sixteen photographs actually shows men at work, and half depict bars and brothels, despite an attempt to regulate such activities in the workers' camps (construction of the dam was overseen by the army). One of the photographs at the end, of the interior of a bar [7.53], is, in fact, at least partly a work scene, for the woman with the young child is identified in the text below as a waitress or "hasher," who takes her child to work because she can't leave her at home. The woman in the separate photograph on the lower right, Mrs Nelson, is flanked by two children and is also described in terms of the work she does—she "washes New Deal without running water." Here we find a hint of the existence of that large segment of the paid workforce mostly missing from both government and corporate imagery in the 1930s—the female wage-laborer.

7.53 Margaret Bourke-White: *Montana Saturday Nights*, photograph in *Life*, November 23, 1936

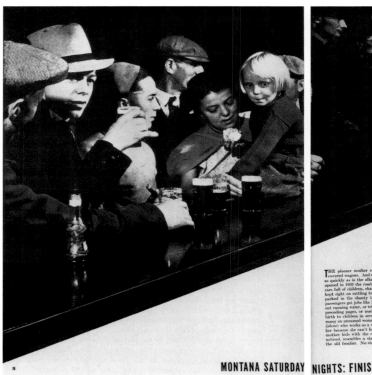

MONTANA SATURDAY NIGHTS: FINIS

Alternative Visions: Women at Work in the City

Thomas Hart Benton devoted two of his murals for the New School for Social Research (see p. 408) to recreational life, with its combination of sex, sports, and religion. In one of these, *City Activities with Dance Hall* (1930) [**7.54**], the artist shows himself in the lower right-hand corner conversing with the director of the School, Alvin Johnson. While one might be tempted to see them as depictions of people at play, they are also, like Bourke-White's photograph in *Life*, scenes of people at work. They differ from Benton's other New School murals in that many of the workers are women—burlesque dancers, acrobats, and movie actors. In fact, these panels are the only ones to feature women in prominent positions. And they are portrayed primarily in a highly sexualized manner, whether as burlesque dancers or passengers on the subway, a manner that would ultimately have raised questions about their moral character. Benton thus contrasts morally questionable urban pursuits in which women play a prominent role—drinking, dancing, acting—to the robust activities of the countryside and to the manly pursuits of industry. The city, despite its construction by muscular male workers, is therefore given a decidedly feminine cast.

Women often appeared in urban settings as highly sexualized entertainers or clerks in the relatively small number of images that dealt with female wage-earners in the 1930s. Depictions of independent working women were thus closely aligned with the development of cities and the spaces of modernity, and also with changes in sexual mores commonly associated with the "New Woman." Often "New Women" were cast as sexual workers, which meant not just prostitutes, but those who made their fortunes through their sexual wiles. Benton's *City Activities with Dance Hall* includes a reference to a wily female type widely celebrated in the 1930s: the blond in the center of the dance hall dancing with the older man with glasses suggests the "siren" or "gold digger," the woman who relies on her looks and fancy clothes (bought at bargain prices, for the gold digger is assumed to be poor or working-class) to snag an older, well-heeled man who will take care of her. The art historian Ellen Wiley Todd argues that this "figure of hyper-glamorized working-class femininity" is "a figure of sexual danger, a threat to masculinity already compromised by unemployment." She is also the vehicle and victim of a consumer culture where female bodies are for sale and looks all that matter. A stereotyped icon of female beauty and a sexual commodity constructed for a male viewer's gaze, the siren appeared in lithographs, paintings, films, and advertisements throughout the 1930s.

7.54 Thomas Hart Benton: *City Activities with Dance Hall*, mural from the series *America Today* for the New School for Social Research, New York, 1930 Distemper and egg tempera with oil glaze on gessoed linen, 92 × 117 in. (233.7 × 297.2 cm.)
Collection, AXA Financial, Inc. through its subsidiary The Equitable Life Assurance Society of the U.S. © AXA Financial, Inc.

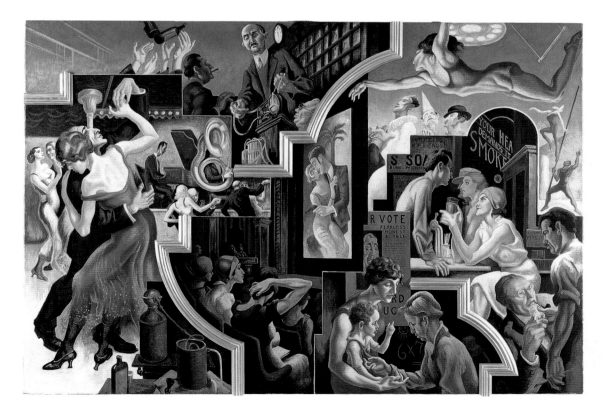

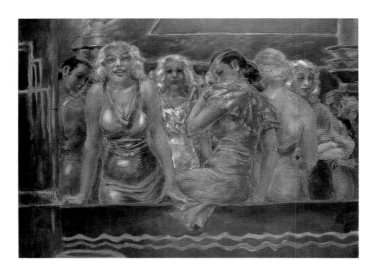

7.55 Reginald Marsh: *Ten Cents a Dance*, 1933
Tempera on panel, 36 × 48 in. (91.4 × 121.9 cm.)
Whitney Museum of American Art, New York

The artist most closely associated with the siren image is Reginald Marsh (1898–1954). In *Ten Cents a Dance* (1933) [**7.55**] he shows several versions of this female icon, with her plunging neckline and full figure. The title also locates these women in a particular place and identifies their occupation: they are taxi dancers, women who hire themselves out for dancing, a practice particularly prevalent in the 1930s in urban centers. As greater numbers of people moved into the city, leaving behind families and other social networks, they gravitated toward commercial centers of entertainment, paying for what they probably would have found for free or a small entrance fee in their small-town Saturday night dance hall. In Marsh's painting the women are positioned behind a low wall, arranged for the viewing pleasure of the male customers, one of whom is visible in the background on the right. While some look demurely out at the viewer, the blond second from the left smiles with open mouth, as if she is about to call out to someone that she recognizes, suggesting that certain men came to these dance halls on a regular basis. *Ten Cents a Dance* is, therefore, another scene of women working, in which their sexuality played a major role.

Another place where women were on public display was the burlesque hall. There were several of these in the Union Square/14th Street district, as well as in other parts of New York. Here the pretense of civility and respectability that could be maintained in the dance halls was dropped. The woman in *Houston Street Burlesque* (1928) [**7.56**] by Mabel Dwight (1876–1955) was hired to display her body for men. They leer at her from below and from above, the lighting from the ramp casting macabre shadows across their faces and making them appear devilish. The performer seems at ease as she gestures gracefully

with her arms. A powerful figure, she dominates both the composition and the men around her. Yet the leg emerging from the right edge of the picture frame reminds the viewer that it is not the woman herself that matters, but her body parts—her legs, her breasts, her buttocks. The social commentary is clear: the burlesque dancer may well enjoy her work and experience a sense of power over the men in the audience, but her economic well-being is dependent upon their sexual desires.

One artist who devoted her attention to a different kind of working woman—the office worker—was Isabel Bishop (1902–88). In the late 1920s Bishop had a studio on 14th Street near Union Square and became part of a group of painters known as the Fourteenth Street School, which included Kenneth Hayes Miller (her teacher), Marsh, and Raphael and Moses Soyer. These artists took their subject-matter from Union Square and the neighboring streets and often depicted those who were out of work, both male and female.

After her marriage to a neurologist, Bishop moved to Riverdale, just north of Manhattan, but maintained a studio in Union Square, where she worked almost every day. The area employed approximately 10,000 office workers during the 1930s, most of whom were women. While clerical work had been a male occupation in the 19th century, it now quickly became a female

7.56 Mabel Dwight: *Houston Street Burlesque*, 1928
Lithograph, 9½ × 8 in. (24.1 × 20.3 cm.)
Philip and Suzanne Schiller Collection, Columbus Museum of Art, Columbus, Ohio

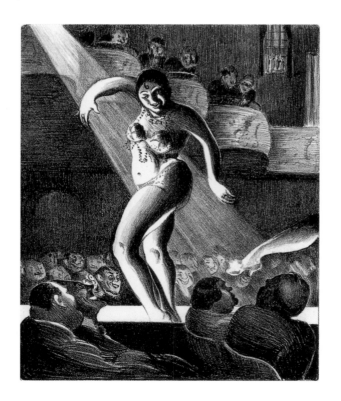

preserve. Office work was seen as more respectable than other forms of labor open to women, most notably factory and domestic work. It was also seen as a place where a woman could improve both her employment and her personal status, the former by rising through the ranks of clerical workers and secretaries, the latter through marriage to a boss or other male employee. By 1930, one out of every three women in New York held an office job. Most were white, unmarried, native-born, with a high-school education.

Todd argues that Bishop's paintings capture this attempt to better one's life, both in their subject-matter and in their style. That Bishop should turn her attention to this subject-matter is explained in part by her own rise in social standing from the daughter of a school teacher to the wife of a doctor. Bishop was aware of the complex factors that determined a woman's success in the office world. For example, she knew that female employees had to walk a delicate line, looking stylish but at the same time "proper." As unemployment grew in the 1930s, competition for office work became more intense, with hiring decisions often made on the basis of a woman's appearance. Mass-production had made it possible for women on modest incomes to outfit themselves with inexpensive versions of the latest fashions. Many books now appeared offering them advice on just how to maintain the balance between attractiveness and modesty in their apparel and in their behavior.

Bishop presents her office workers as respectable women, modestly but fashionably dressed, as in *Lunch Hour* (1939) [7.57]. She also presents them as self-consciously "presenting" themselves, aware that they are constantly being surveyed, both as women and as workers. Interestingly, she never shows them actually at work. They are at lunch or walking in the streets. They might exhibit the effects of work—wrinkled clothes, make-up that needs freshening—but they are not at work. They are shown as self-possessed individuals but not productive workers.

Todd also notes that Bishop's style suggests movement, either through physical space or up the social ladder. To achieve this, she borrowed a technique from European painters of the Baroque era, in particular Peter Paul Rubens, passed on to her through the teachings of Hayes Miller. She used a white ground and on it applied uneven, transparent washes of underpainting, creating a shimmering effect, then applied color glazes, allowing the underpainting and white ground to show through in places. The results are unfixed surfaces which Bishop herself describes as not limiting the individuals in any one position.

Bishop's depictions of women outdoors, on the city streets, differ considerably from similar scenes by Marsh. In *Hat Display* (1939) [7.58] Marsh presents a highly sexualized figure, with breasts and buttocks emphasized. Certainly she is engaged in a similar confrontation with the demands of fashion in the form of

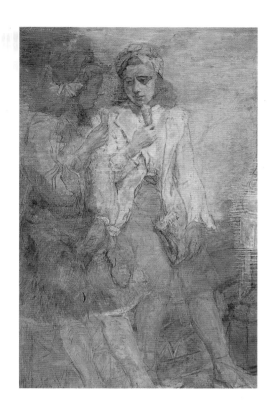

7.57 Isabel Bishop: *Lunch Hour*, 1939
Oil and tempera on panel, 27 × 17½ in. (68.6 × 44.5 cm.)
Collection of Mr and Mrs John Whitney Payson

7.58 Reginald Marsh: *Hat Display*, 1939
Watercolor on paper, 40 × 26⅜ in. (101.6 × 67.3 cm.)
Whereabouts unknown

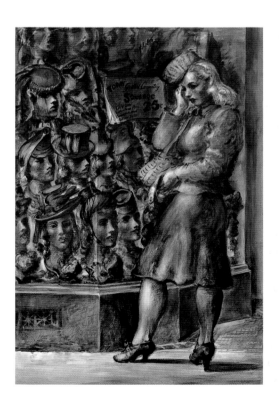

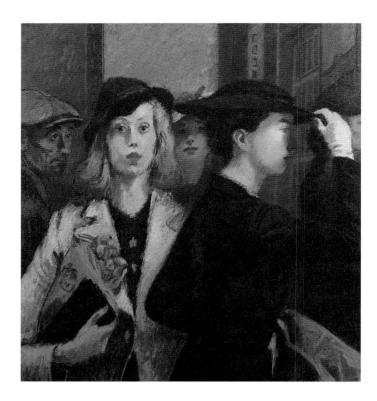

7.59 Raphael Soyer: *Office Girls*, 1936
Oil on canvas, 26 × 24 in. (66 × 61 cm.)
Whitney Museum of American Art, New York

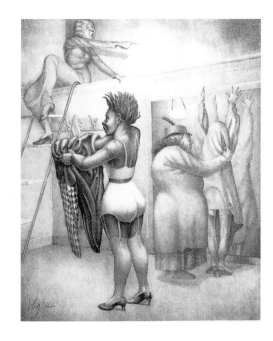

7.60 Kyra Markham: *The Fit Yourself Shop*, 1935
Lithograph, 13 × 10 in. (33 × 25.4 cm.)
Philip and Suzanne Schiller Collection, Columbus Museum of Art, Columbus, Ohio

the hat mannequins in the window, but she is less a subject engaged in self-reflection than an object being observed. Indeed, even the mannequins in the window seem to be watching her. A more sympathetic depiction of office workers, and one more in keeping with Bishop's presentations, is Raphael Soyer's *Office Girls* (1936) [**7.59**]. Here modestly but stylishly dressed women hurry through the streets to their jobs. Soyer adds the old man at left as a reminder that all is not youth and energy in New York City, that the unemployed were often older men, who looked with envy and longing at the women because they were both beautiful and employed.

Those experts who filled books and advice columns in the 1920s and 1930s with commentaries on social change, the family, and women's roles also identified an unsettling shift that was taking place in America from a rural, production-oriented economy to an urban, consumption-oriented economy. Much of the work previously carried out within the home—food preparation, care of the sick, production of clothing—was now being performed by workers in restaurants, hospitals, and factories. Consuming also acquired a political dimension in the 1930s. Business and government pundits declared that economic recovery could only be achieved if consumption increased. Shopping became women's patriotic duty. This patriotism was

tempered, however, by the hard facts of life, which included low wages and/or a sporadic income. The bargain shopper, and bargain department stores, became a familiar sight in urban centers across the United States.

Probably the most famous locale for bargain shopping for women's clothing, and certainly the most fully recorded by artists, was the area around Union Square and 14th Street: it is

7.61 Kenneth Hayes Miller: *The Fitting Room*, 1931
Oil on canvas, 28 × 34 in. (71.1 × 86.3 cm.)
The Metropolitan Museum of Art, New York

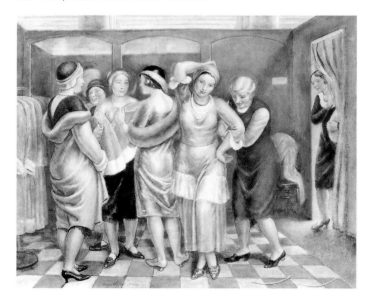

said that more women's apparel was sold in Union Square on one day than in any other place in the country. Dressing rooms were communal, with little or no help from store clerks. These rooms appear in the work of several artists in the 1930s, including *The Fit Yourself Shop* (1935) [**7.60**] by Kyra Markham (1891–1967). The woman closest to us, who is African American, seems from the disheveled appearance of her hair to have just pulled off a dress over her head. Another woman perches on a ledge at the top of a ladder and points, with her mouth open, at something outside of the picture to the right; perhaps she is a store employee yelling at a customer in the dressing room. In the right half of the print, an elderly woman, fully dressed in hat and coat, helps another, possibly her daughter, try on a dress. The communal dressing room contained women of all races and ethnicities, all sharing the same lower-class status and the same desire to improve their appearance and, by extension, their lot in life.

The Fitting Room (1931) [**7.61**] by Kenneth Hayes Miller (1876–1952) presents a striking contrast to the Markham print. This is not a bargain basement, but an upscale department store, replete with saleswomen to help the customers try on their dresses. The women are all white and assume poses reminiscent of classical Greek statues. Their ample bodies are accentuated by the sweeping folds of drapery that frame their buttocks or abdomens. Miller painted the bountiful female, the woman who shopped but who also tended to hearth and home and who brought prosperity with her wherever she went, a reassuring message at the beginning of the Depression. And he also painted the growing numbers of women who earned their living by attending to the shoppers and who would, themselves, contribute to the growing consumer economy through their purchases.

Edward Hopper (1882–1967) also turned his attention to the working woman. Hopper studied with Robert Henri and took up Henri's interest in city life, extending that interest to life in small-town America. His paintings are neither energetic celebrations of city life, like the works of Marsh, nor obvious critiques, but are, instead, commentaries on the isolation and alienation many city dwellers or travelers between urban and rural America experienced. Female figures are often not literally alone, yet they are emotionally alone. In his depiction of an office worker in *Office at Night* (1940) [**7.62**], the woman is on the job, yet lost in thought. Additional tension is created by the late hour and the woman's tight clothing—not the modest dress of Bishop's office girls—which suggest that a sexual encounter, whether willing or coerced, may well be in the offing.

7.62 Edward Hopper: *Office at Night*, 1940
Oil on canvas, 22³⁄₁₆ × 25³⁄₁₆ in. (56.5 × 64.1 cm.)
Walker Art Center, Minneapolis, Minnesota

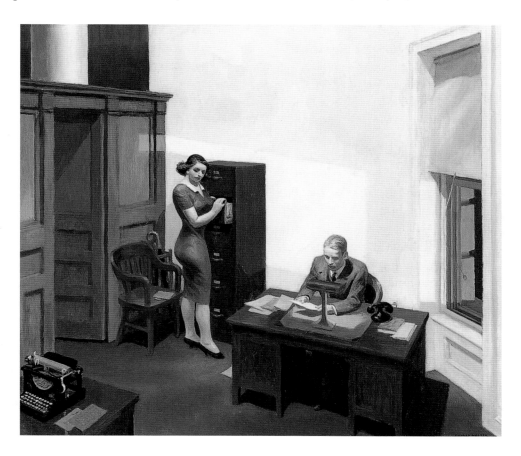

Alternative Visions: Rural America

Drought and Foreclosure: The Other Side of New Deal Murals

Hopper's images of small-town America are often as unsettling as his *Office at Night* [7.62], and counter the celebratory mood found in New Deal murals. As the art historian Milton Brown points out, in the 1920s Hopper and his literary contemporaries Sinclair Lewis and Sherwood Anderson "sought a native tradition, a center of life typical of America and innocent of sophistication." Yet while they looked to the small town as "an anchor in a world of shattered illusion," they were often critical of the poverty and narrow-mindedness found there. Around 1930 the artist Charles Burchfield wrote of Hopper:

> Some have read an ironic bias in some of his paintings; but I believe this is caused by the coincidence of his coming to the fore at a time when, in our literature, the American small towns and cities were being lampooned so viciously; so that almost any straightforward and honest presentation of the American scene was thought of necessity to be satirical.

Hopper's *Early Sunday Morning* (1930) [7.63] shows not the usual bustle of human activity but an empty street and empty buildings. His choice of a hard, white light, which creates striking contrasts between light and dark, emphasizes the emptiness of the scene—you cannot see into the darkened windows.

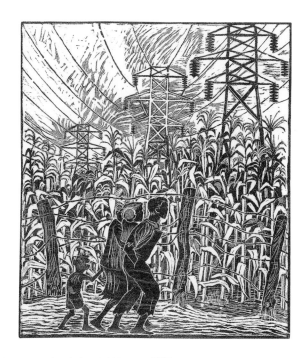

7.64 Lucienne Bloch: *Land of Plenty, c.* 1935
Woodcut, 10⅝ × 8¾ in. (26.6 × 22.2 cm.)
Philip and Suzanne Schiller Collection, Columbus Museum of Art, Columbus, Ohio

The attention to detail in the moldings, window frames, and window coverings and the starkness of the buildings gives the painting a sense of isolation and loneliness.

Several artists concerned themselves with presenting in more unambiguous terms the effects of the Depression and drought in rural America. Lucienne Bloch (1909–99) recorded her understanding of the plight of farm families in her woodcut *Land of Plenty* (*c.* 1935) [7.64]. Having been introduced to the

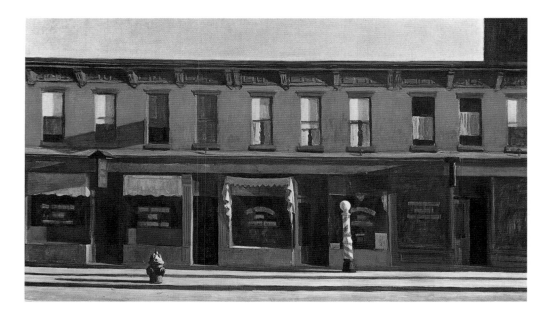

7.63 Edward Hopper: *Early Sunday Morning*, 1930
Oil on canvas, 35 × 60 in. (88.9 × 152.4 cm.)
Whitney Museum of American Art, New York

political power of images as assistant to Diego Rivera from 1932 to 1933, she joined the FAP in 1935. Bloch's nuclear family—mother, father, and two children—confronts a part of rural America seldom, if ever, presented in New Deal murals. The lush fields of corn and new sources of electrical power from government projects like the Tennessee Valley Authority were not to benefit them; they are separated from these riches by a barbed wire fence. As the drought worsened in the 1930s and produce prices dropped, many farmers were unable to make their loan payments and lost their farms. The democratic dream of rural America was only for those who could afford it. As the artist Philip Reisman commented:

> The maddening thing about the Depression was that hardships and suffering stemmed, not from a shortage of goods, as most people imagined, but from an abundance of them. Something was drastically wrong and the very framework of the republic itself appeared to be imperiled. "It remained for us to invent bread-lines knee-deep in wheat," said Socialist Norman Thomas, as tragedy began to stalk the land. "We got more wheat, more corn, more food, more money in banks, more everything in the world than any other nation that ever lived ever had," said humorist Will Rogers, "yet we are starving to death. We are the first nation in the history of the world to go to the poorhouse in an automobile . . ."

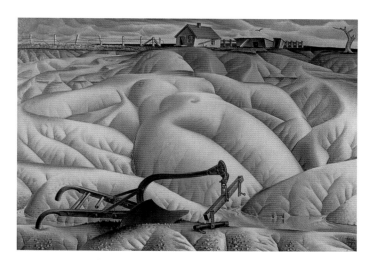

7.66 Alexandre Hogue: *Erosions No. 2: Mother Earth Laid Bare*, 1938
Oil on canvas, 40 × 56 in. (101.6 × 142.2 cm.)
Philbrook Museum of Art, Tulsa, Oklahoma

While Bloch points to the unequal distribution of the products of land that remained rich throughout the Depression, Alexandre Hogue (1898–1944) looks at that part of the country devastated by drought and over-cultivation. In *Drought Stricken Area* (1934) [**7.65**] once productive land has turned into a vast desert, reflective of the vast spaces of Hogue's Texas homeland. In *Erosions No. 2: Mother Earth Laid Bare* (1938) [**7.66**], the artist foregrounds the connection between women and nature, shaping the dry hills and gullies into the body of a woman.

Each of Hogue's works appears to contain direct references to two earlier works by two artists who, by the mid-1930s, had come to represent key proponents of Regionalism—John Steuart Curry (1897–1946) and Grant Wood (1892–1941). Curry

7.65 Alexandre Hogue: *Drought Stricken Area*, 1934
Oil on canvas, 30 × 42¼ in. (76.2 × 107.3 cm.)
Dallas Museum of Art, Dallas, Texas

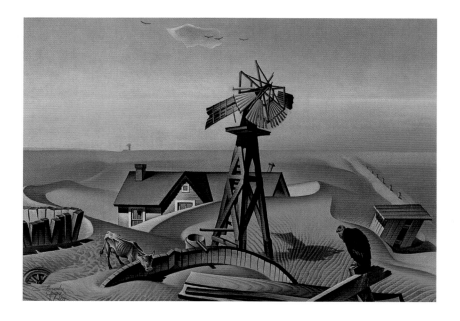

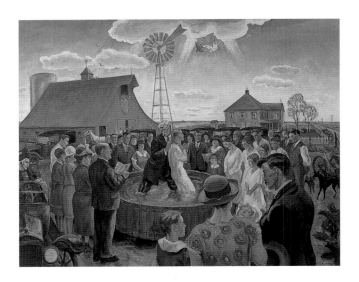

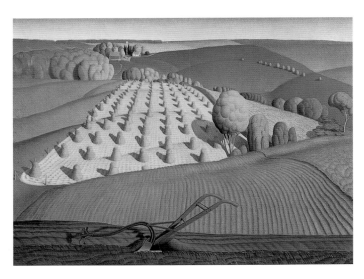

7.67 John Steuart Curry: *Baptism in Kansas*, 1928
Oil on canvas, 40 × 50 in. (101.6 × 127 cm.)
Whitney Museum of American Art, New York

7.68 Grant Wood: *Fall Plowing*, 1931
Oil on canvas, 29¼ × 39¼ in. (74.3 × 99.7 cm.)
Deere & Company Art Collection, Moline, Illinois

and Wood, along with Benton, were the focus of a December 1934 *Time* magazine article on Regionalism in which their work was praised as a distinctly homegrown replacement for foreign-based "incomprehensible" art. As mentioned earlier, Regionalist works were seen primarily as sympathetic records of the fertility and abundance of the land and the strengths of those who worked it. The only conflict was that between the farmer and nature, as it manifested itself in tornadoes or floods. These works often celebrated the piety of rural Americans, as in Curry's *Baptism in Kansas* (1928) [**7.67**]. Hogue's *Drought Stricken Area* [**7.65**] subsequently appears as a parody of this piety. The wooden tub, once the site of a religious ceremony, is now filled with sand. The windmill has ceased to function and the baptismal water has trickled away. Hogue's *Erosions No. 2* similarly parodies the display of abundance that appears in Wood's *Fall Plowing* (1931) [**7.68**]. In Wood's painting the viewer stands atop a hill, behind the plow lodged firmly in the rich soil, looking out over fields dotted with stacks of freshly harvested grain. The farmhouse and barn nestle in the distance among a grove of trees. In Hogue's work, as in Wood's, the plow rests in the foreground, yet the soil has lost its richness. The viewer is placed not above the scene, but below, about to be overwhelmed by its devastation, and it is only a matter of time before the small strip of green fields and the farm buildings succumb to the advancing desert.

While Wood certainly voiced strong regionalist and nationalist sentiments and argued for an art that was distinctly American, certain of his works have come to be read as containing at least subtle critiques of contemporary society and its historical traditions. In her study of Wood, the art historian Wanda Corn notes that he has most often been viewed in one of two ways, with adulation or disdain. The former view is held primarily by Midwesterners, who see in his work a celebration of their lifestyles, while the latter is expressed most often by Easterners, who see his paintings as throwbacks to an earlier realist genre or landscape tradition. Corn looks closely at the vested interests of each interpretive tradition and at the nature of Wood's training and understanding of contemporary art practices.

Wood spent his first ten years on a farm northeast of Cedar Rapids, Iowa, a locale that provided him with much of the subject-matter for his later paintings. In 1901 he moved with his family to Cedar Rapids and from there spent the 1910s and 1920s traveling and studying art in both the United States and Europe. He adopted a loose, impressionist style but, at the same time, was impressed by the paintings of the Northern and Italian Renaissance, which he saw in abundance during a 1928 trip to Munich. Wood's work from the late 1920s on focused almost solely on country or small-town life, and on the positive aspects of such a life. As Corn has written,

> By the 1930s Wood had come to view farmers as a distinctive midwestern folk type endowed with a unique, but unsung, folklore. Indeed, he saw his youth on an Iowa farm as an archetypal rural American experience which, if probed, would reveal a strain of the national culture that was as rich and colorful as that of any other region or period in history.

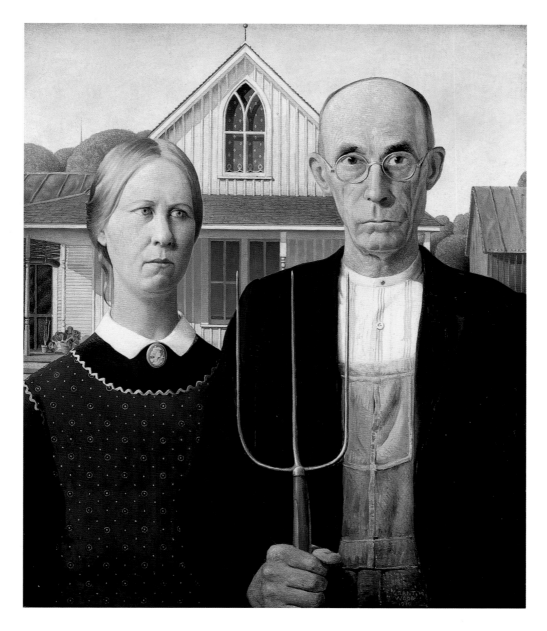

7.69 Grant Wood: *American Gothic*, 1930
Oil on beaverboard, 29⅞ × 24⁹⁄₁₆ in. (74.3 × 62.4 cm.)
The Art Institute of Chicago, Chicago, Illinois

As was the case with so many artists at the beginning of the 1930s, Wood describes having gone through a revelation of sorts upon returning from Europe in the late 1920s: he wanted to paint America, its people and landscapes, rather than simply experiment with line and color.

Wood's best-known painting is *American Gothic* (1930) [7.69]. In this work he produces an image of two recognizable individuals—his sister Nan and his dentist Dr B. H. McKeeby—and two prototypes—the Midwestern man and woman. The meticulous detail, hard light, and elongated faces recall Northern Renaissance portraiture. The stiff poses also recall another portrait tradition, that of 19th-century photography. Wood commented that the figures resembled "tintypes from my old family album." There is a third prototype as well in the painting—the house in the background, an example of the style known as Carpenter Gothic, which symbolized a kind of makeshift, self-taught frontier architecture built by individuals not totally unaware of earlier architectural traditions, as indicated by the prominent Gothic window. Like the figures, it too had an actual model: a house of 1881–82 attributed to the local carpenters Messrs Busey and Herald, that Wood had come across on a trip to Eldon, Iowa.

The painting was awarded the Norman Wait Harris medal at the Annual Exhibition of Painting and Sculpture at the Art

Institute of Chicago in 1930, and subsequently purchased by the Institute. It was also a success with the public. Much controversy ensued over the relationship between the two characters—are they father and daughter or husband and wife?—and over whether this was a positive or negative representation of Midwestern rural life. (Wood conceived of the couple as father and spinster daughter.) As Corn points out, those who lived in the Midwest tended to view the work more favorably than those who did not, or who lived in Midwestern cities rather than small towns or farms. "These people had bad points," commented Wood, "and I did not paint them under, but to me they were basically good and solid people."

Many of the reasons for the popularity of *American Gothic* at the time, notes Corn, are the same as those that account for its constant reappearance, often with comic alterations, in popular culture from the late 1950s until today. The painting is seen as somehow distinctly American, at least by many white Americans. It evokes mythic strains of what many saw as a generic national experience—the country's Puritan beginnings, its frontier life, its promotion of free enterprise and self-reliance, its celebration of common people and the family. It also contains a subtle humor—the pitchfork as symbol of masculinity echoed in the decidedly limp stitching on the front of the man's overalls, the woman's averted gaze suggesting both modesty and nosiness. There is also an aggressive defensiveness to the work, with its barricade of bodies between the viewer and the home in the background and the pitchfork held so firmly in the man's right hand. This claim to, and defense of, territory would certainly have resonated with many in the 1930s, who were on the verge of losing their homes.

Black Poverty and Lynching in Rural America

More serious challenges to the myth of an idyllic rural America came from the brush of Jacob Lawrence (1917–2000). Lawrence moved to Harlem from Philadelphia with his mother, sister, and brother in 1930. His first encounter with art making took place at Utopia House, a local settlement house that offered hot lunches for children and a chance to gain some training in arts and crafts. The African American artist Charles Alston, who was teaching there at the time, encouraged Lawrence in his endeavors and later allowed him to rent a corner of his studio. There the young artist was privy to the heated debates of African American artists and intellectuals: Claude McKay, Langston Hughes [6.77], Richard Wright, Aaron Douglas [6.78, 6.79], and many others. Lawrence also won the attention and support of the sculptor Augusta Savage (1892–1962) and gained further training from

1932 to 1934 in the WPA Harlem Art Workshop, signing on with the WPA/FAP in 1938 as an easel artist.

Early in his career Lawrence identified the subject-matter that would absorb his time and energies as a painter: the life of Harlem and the history of African Americans. Patricia Hills describes him as "the pictorial *griot*—the 'professional . . . praise singer and teller of accounts'—of his own African-American community." He fulfilled this role not only through the stories he had to tell, but also through the way he spun them out in sequences or series of images. Early in his career, Lawrence also fixed on the style he would use to convey these stories. At Utopia House he was already painting brightly colored street scenes inside corrugated boxes with a sense of patterning derived from the rugs and other decorative furnishings of his own home.

Where the ideal of rural America depended in large part on the absence of conflict, Lawrence determined to draw attention to the past realities of slavery. In the late 1930s he began several historical series devoted to Africans who had escaped from slavery and fought to free their people, notably Toussaint L'Ouverture (forty-one paintings), Frederick Douglass (thirty-two paintings), and Harriet Tubman (thirty-one paintings). L'Ouverture was a Haitian slave who fought against the French in the late 18th and early 19th centuries and ultimately led his country to freedom and founded the first black Western republic on the island of Haiti. Douglass escaped from slavery in the American South in 1838 and published *Narrative of the Life of Frederick Douglass* in 1845. In 1847, after English friends had purchased his freedom, he established the paper *The North Star* in Rochester, New York, and edited it for seventeen years, advocating abolition through political activism. He held several government posts during and after Reconstruction. Harriet Tubman was also born a slave in the South and escaped around 1849, committing the rest of her life to liberating other slaves. Between 1850 and 1860 she returned to the South at least nineteen times, leading over three hundred slaves to freedom via the Underground Railroad.

Lawrence's desire was to create painted narratives of the lives of famous African Americans that would be accessible to African American communities. Thus he kept his forms recognizable and included explanatory captions with the images. His historical series were about struggle, pride, determination, and education. He did not turn away from the depiction of the brutalities of slavery. In *She felt the first sting of slavery* (1939–40) [7.70], Lawrence shows Tubman as a young girl having been struck on the head with an iron bar by an angry overseer. In *The cruelty of the planters led the slaves to revolt, 1776* (1937–38) [7.71], he depicts the beating of a slave by a planter

who hypocritically wears a Christian cross around his neck. In each of these small pictures Lawrence utilizes what became recognizable characteristics throughout much of his work— the dramatic diagonal which, in combination with the positioning of the viewer above the scene, functions to destabilize the composition and thus create tension; the rough application of paint that gives each image a rawness and immediacy; the drastically simplified, flat, decorative forms that draw, simultaneously, on folk, Modernist, and African art. This latter combination of references embodied Locke's call to African

American artists to draw on Modernist forms while looking to both Africa and the everyday lives of African Americans for subject-matter.

Lawrence's simple shapes and rejection of mimetic detail also give the characters in individual scenes equal importance, an effect enhanced by the overall perspective from which we view the scene—as if we were above the figures. Hills, in describing the *Harriet Tubman* series, comments that his style, "with its flat shapes, controlled outlines, and limited range of color, kept the emotion restrained [and] the conceptual goals clear." A passage from Lawrence's own writing evokes the formal power of his work, although he had African art in mind when he wrote it: "For here was an art both simple and complex—an art that possessed all of the qualities of the

7.70 Jacob Lawrence: *She felt the first sting of slavery*, from the *Harriet Tubman* series, 1939–40
Casein tempera on hardboard, 17⅞ × 12 in. (45.7 × 30.5 cm.)
Hampton University Museum, Hampton, Virginia

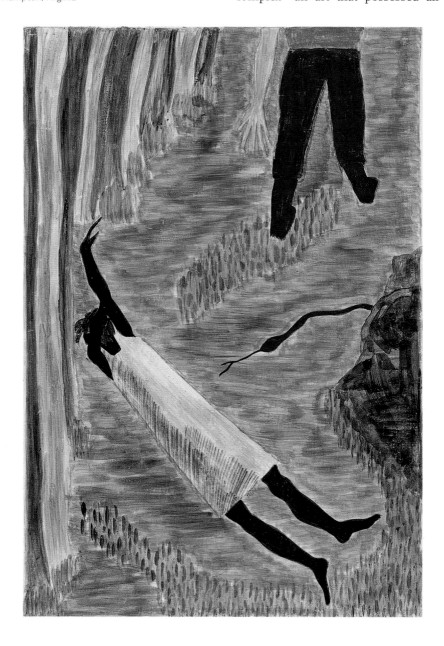

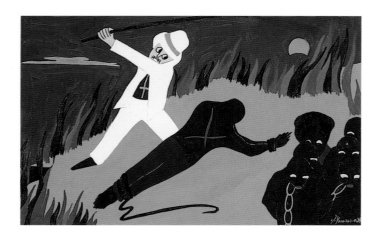

7.71 Jacob Lawrence: *The cruelty of the planters led the slaves to revolt, 1776,* from the *Toussaint L'Ouverture* series, 1937–38
Tempera on paper, 11 × 19 in. (27.9 × 48.3 cm.)
The Amistad Research Center's Aaron Douglas Collection, New Orleans, Louisiana

sophisticated community. It had strength without being brutal, sentiment without being sentimental, magic but not camouflage, and precision but not tightness" [7.71].

Many artists at the time turned their attention to one of the most horrifying results of racism—lynching. The art historian Marlene Park, in her detailed article on images of lynching in the 1930s, observes that "though there were mob murders in colonial America, lynching became a major form of deliberate, lawless violence after the Civil War." While victims included women and children, most were men. And while Native

7.72 Joe Jones: *American Justice* (*White Justice*), 1933
Oil on canvas, 30 × 36 in. (76.2 × 91.4 cm.)
Philip and Suzanne Schiller Collection, Columbus Museum of Art, Columbus, Ohio

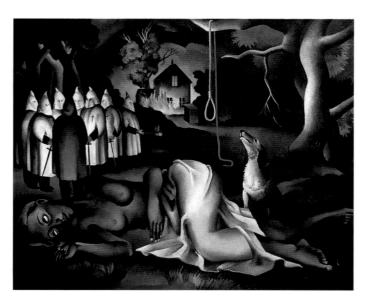

Americans and Italian, Mexican, and Chinese nationals were among those lynched, of the nearly 5,000 recorded victims, 72.7 per cent were African American.

American Justice (also titled *White Justice*) [7.72] by Joe Jones (1909–63) first appeared in the 1933–34 "American Painting of Today" exhibition in Worcester, Massachusetts. It bluntly portrays the aftermath of the murder of an African American woman by members of the white vigilante organization the Ku Klux Klan. That she has also been raped is suggested by her half-naked body, the draped phallic forms of the Klansmen, and the Klan member's torch at the right edge of the crowd, held as if an extension of his penis. Jones also integrates the theme of light and dark into his work in formal terms. Stark white highlights draw the viewer's gaze from the Klansmen's robes to the woman's upturned eyes, to the sheet that covers the lower half of her body, the noose hanging from the tree, the chest of the dog, the tree itself, and back around to the burning house and the trees behind the Klansmen. These white highlights are everywhere countered by rich browns—the woman's torso and legs, the dog's back, the bottom of the lynching tree, the earth in the center of the canvas. Most strikingly, the white central tree in the group of trees behind the Klansmen is flanked—one might even say overpowered—by two brown trees. While the foreground figure may comment pointedly on Western artistic traditions—the reclining nude in the landscape, the partly draped classical figure that often symbolizes abstract notions like peace and justice—the woman is, above all, dead, a victim of white vigilante mob violence. Her only crime (besides being black) may have been to have achieved some degree of financial success—we assume it is her home that is burning in the background—in a racist rural South.

In 1935 Jones moved from St Louis to New York. The very year he arrived, two exhibitions opened that focused on lynching. One was sponsored by the National Association for the Advancement of Colored People (NAACP), the other by the local Communist John Reed Club. They were part of larger efforts by both groups to pass federal legislation outlawing lynching (unfortunately, the two were not able to work together, and thus sponsored separate bills). The NAACP exhibition included *To the Lynching!* (1935) [7.74] by Paul Cadmus (1904–83). Cadmus had gained notoriety a year earlier when his painting *The Fleet's In!* (1934) [7.73] was removed from a PWAP exhibition at Washington's Corcoran Gallery on the grounds that it defamed the American sailor. Secretary of the Navy Swanson described it in *Time* magazine as depicting "a most disgraceful, sordid, disreputable, drunken brawl, wherein apparently a number of enlisted men are consorting with a party of street-walkers and denizens of the red-light district." (He failed to mention the homosexual encounter taking place in the left-hand section of

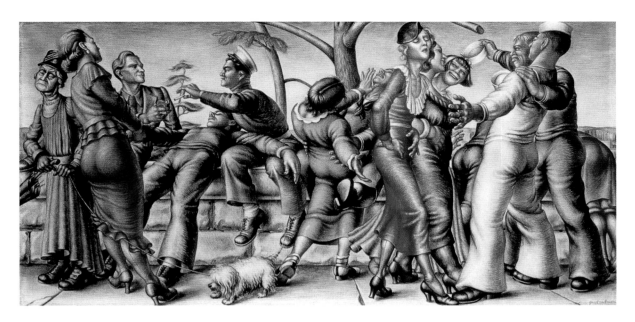

7.73 Paul Cadmus: *The Fleet's In!*, 1934
Oil on canvas, 30 × 60 in. (76.2 × 152.4 cm.)
U.S. Naval Historical Center, Washington, D.C.

the painting, a subject Cadmus would return to many times over the course of his career.) Other newspapers across the country picked up the story and reproduced the painting, bringing much more attention to Cadmus and the work than if it had simply been ignored. *To the Lynching!* [7.74] shows once again "disreputable, drunken" men out of control, only here their goal is murder, not sex. Cadmus focuses on the crazed expressions on their faces and on the terror on the face of the black man about to be lynched. The chaos and hysteria are emphasized by the mass of swirling torsos and the body of the horse, across whose back lies the victim. For Cadmus, lynching is madness and mob violence.

While Cadmus relied on a naturalistic rendering of the figures of the lynching mob and the man about to be lynched, Boris Gorelick (1909–84) chose to present his condemnation of lynching—*Strange Fruit* (1939) [7.75]—in a surrealistic,

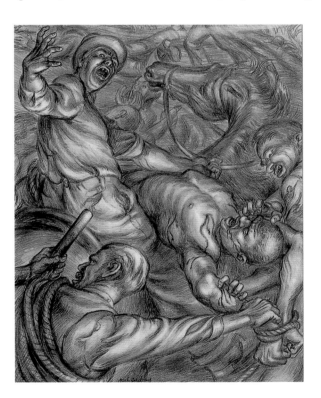

7.74 Paul Cadmus: *To the Lynching!*, 1935
Graphite and watercolor on paper, 20½ × 15¾ in. (52.1 × 40 cm.)
Whitney Museum of American Art, New York

7.75 Boris Gorelick: *Strange Fruit*, 1939
Lithograph, 10⅜ × 13⅞ in. (26.6 × 35.5 cm.)
Philip and Suzanne Schiller Collection, Columbus Museum of Art, Columbus, Ohio

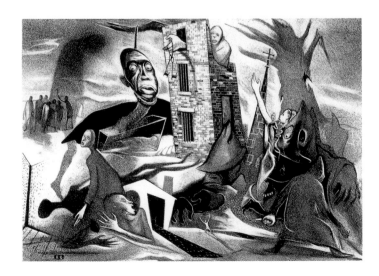

dreamlike, or, one should say, nightmarish manner. The title of Gorelick's work comes from a poem written by Abel Meeropol (aka Lewis Allen) in 1936, which was turned into a song first performed by the African American singer Billie Holiday. The first verse reads:

> Southern trees bear a strange fruit,
> Blood on the leaves and blood at the root,
> Black body swinging in the Southern breeze,
> Strange fruit hanging from the poplar trees.

The origin of the print was not, however, the text of this song. It was, instead, a newspaper story of a lynching Gorelick came across in the 1930s. In a letter he states:

> I tried to incorporate and juxtapose all of the known facts of the event as reported. However, I meant it to be more than "Graphic Reportage." It was a personal statement of outrage and protest. The story shown, is of a young Negro, in the dark of night in Mississippi, snatched from his bed and family by the local sheriff and his posse, and dragged to the jail-house where the keys are thrown to a waiting mob of klansmen who lynch him by hanging him from the nearest tree. His body is later found by his wife and buried by his family and friends. It is a cry from the grave.

Through distortions of scale, macabre shadows, and exaggerated gestures Gorelick achieves his "personal statement of outrage and protest." The body of the lynched man in the center of the composition is both present and absent: it dissolves into dust before our eyes, the dust falling into a waiting coffin; it casts two shadows, one to the left and one below on the ground. The right side of the composition is filled with grotesque hooded figures and threatening trees. On the left the lynched man's family and friends lay him to rest. In the center of the image are the keys being tossed out of the jail, symbolic of the betrayal of justice that lynching embodies.

Several sculptors also turned their attention to the subject of lynching, notably Isamu Noguchi (1904–88) and Seymour Lipton (1903–86). In 1933 Noguchi produced *Death* (also known as *Lynched Figure*) [7.76], which was included in the 1935 NAACP exhibition. The work was based on an event that occurred in 1930, when a white crowd in Sherman, Texas, burned the body of George Hughes, along with the local courthouse and black businesses. A photograph appeared in the *Labor Defender*, published by the International Labor

Defense. Noguchi was attempting, he said, "to find a way of sculpture that was humanly meaningful without being realistic, at once abstract and socially relevant." In *Death* he adopts the abstracted and distorted forms of Modernism to convey the tortured body of the burned man. Lipton's *Lynched*

7.76 Isamu Noguchi: *Death (Lynched Figure)*, 1933
Monel metal, wood, rope, and steel armature, figure H 36 in. (91.4 cm.)
Isamu Noguchi Foundation, Inc., New York

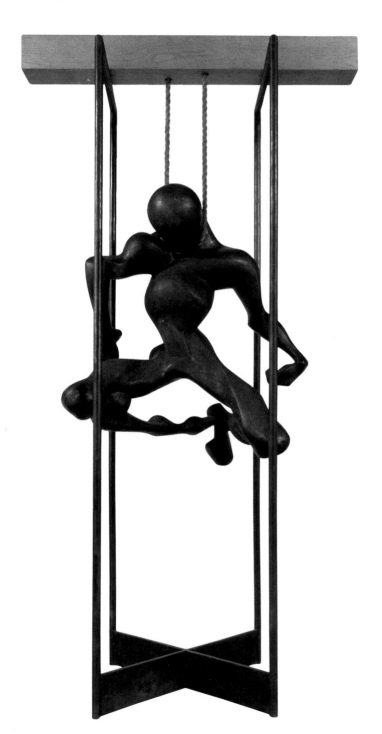

7.77 Seymour Lipton: *Lynched*, 1933
Mahogany, L 24 in. (61 cm.)
Collection of James and Barbara Palmer

(1933) [7.77], which was exhibited at the John Reed Club, uses not the abstracted forms of Modernism but a form of expressionism that refers to naturalistic African carving traditions. The contorted position conveys the pain and brutality of lynching. *Lynched* joined a growing body of works created by artists committed to ending this practice in the United States, through both the persuasive power of images and federal legislation.

Art Against Fascism: The Popular Front and the American Artists' Congress

The mid-1930s witnessed a series of troubling political events in Europe. Adolf Hitler's assumption of the position of chancellor of Germany in 1933 was the culmination of the steady rise of the National Socialist, or Nazi, Party, which he had helped found in 1920. Hitler's consolidation of power led, ultimately, to his invasion of Poland in 1939 and the beginning of World War II. Hitler won over much of the population of the German-speaking lands, which suffered (as did the population of the United States) from a severe economic depression, through virulent anti-Semitism and anti-Communism. By the middle of the decade he had established concentration camps to house those he designated "enemies of the state"—Jews, blacks, Communists, homosexuals, and Modernist artists. The persecution of the latter culminated in the government-organized exhibition "Degenerate Art" of 1937. Hitler and his cultural ministers denounced Modernist art as repugnant, barbarous, and degenerate. It was the very opposite of the

ordered, classical, and easily readable art of the National Socialist Third Reich.

From the very beginning of his political reign, Hitler was aware of the power of art in all of its manifestations—architecture, painting, photography, film, music, pageantry. An unsuccessful artist and architect himself, he used every aesthetic means at his disposal to project his own image of the Third Reich, of the greatness and superiority of German culture. All of his major military and civil projects were justified in terms of their aesthetic or cultural significance. In 1936, at a rally in Nuremberg, Hitler stated: "Art is the only truly enduring investment of human labor." Architects built, painters painted, workers labored, and soldiers fought in the name of German culture. Hitler's aestheticization of politics helps explain why he was so set on destroying Modernist art in Germany. The art of the Third Reich was to be based on the classical past, on Greek and Roman architecture and sculpture. It was to be solemn, narrative, and idealistic. It was to celebrate the "Aryan race" in all its perfection. Modernist art was anathema to the Nazi aesthetic.

Many artists in the United States addressed in their work Hitler's rise to power and the simultaneous spread of fascism in Italy under the leadership of Benito Mussolini. In her book *Antifascism in American Art*, Cécile Whiting examines a variety of paintings, prints, and drawings produced in the United States from 1933 to 1945 in the context of the anti-fascist campaigns of that era. She notes that the debate during the 1930s and 1940s over the function of images in the fight against fascism was complex. Should artists stop painting altogether and take up a rifle? If they continued to paint, should they produce graphic depictions of the brutality of war, nationalistic pro-democratic canvases, or abstract, Modernist paintings? The questions—and the proposed answers—changed as the anti-fascist struggle broadened from a fight by the Left to preserve the Soviet Union against a German onslaught to a defense of the democratic world as a whole. The American anti-fascist movement was also tempered by the country's strong isolationism and unwillingness to be drawn into a global conflict. It was only after the bombing of Pearl Harbor, Hawaii, on December 7, 1941, by Japan, whose emperor Hirohito had formed an alliance with Germany and Italy, that the United States entered the war.

Anti-fascist imagery first appeared in the early 1930s in the political cartoons of such Communist or left-wing journals and newspapers as *The Daily Worker*, *New Masses* and *Leftward*. The role of Communist literature and art at the time, as defined by top Soviet officials, was to serve as a weapon in the promotion of the rights of workers and their fight against

capitalism and fascism. The exact form this art should take in the United States, however, was not stipulated, except that it should not be "Modernist" (by 1933 Socialist Realism, a narrative, celebratory art, was the official style of the Soviet Union). Those organizations, therefore, that pledged to adhere to the cultural goals of the Soviet Union, like the John Reed Clubs, were left with a relatively wide range of styles within the general category "realism" from which to choose. Much of the anti-fascist art at this time appeared in graphic form, for the graphic arts were seen by many as more "democratic" than painting or sculpture, and thus more "proletarian." This may be one reason for the paucity of anti-fascist paintings during this early period.

A common set of visual strategies did emerge, however, from the anti-fascist imagery produced from 1933 to 1935. The style is spare and representational. The images are often crudely drawn or "artless," echoing the crudeness or straightforwardness of the heroes portrayed in the various cartoons or magazine covers. The manner can be traced back to the bold lithographic crayon drawing popularized in the 19th century by Honoré Daumier and other political cartoonists, who established a connection between this style and social and political concern. The main themes of anti-fascist imagery are also clearly represented, with the united proletariat consistently triumphing both over fascism and capitalism. This set of characteristics can be found in an untitled work by William Gropper (1897–1977) [7.78], reproduced in the July 1934 issue of *New Masses*. Here the roughly drawn figures of Hitler and his capitalist crony are clearly about to be dislodged from their makeshift raft into a sea of skulls by a giant clenched fist representing the proletariat.

Hitler's growing power quickly altered the cultural policies of the Communist Party of the United States (CPUSA), and thus of the John Reed Clubs. Worried about Hitler's increasing influence in Europe and his anti-Communism, the Soviet leader Joseph Stalin toned down his criticisms of capitalism and, in 1935, called upon Western democracies to band together with the Soviet Union in a "Popular Front" to resist the spread of fascism. Part of this political shift involved the disbanding of the John Reed Clubs and the establishment of the American Artists' Congress. The easily recognizable narrative imagery dealing with the lives and struggles of workers favored by the Clubs was now replaced by the Congress's openness to a wider range of styles and subject-matter. What was most important was that the artists who joined the Congress be openly committed to the fight against fascism. Professional artists "of recognized standing" in all styles and media were welcomed into the group and aesthetic differences downplayed in the interests of political solidarity. It was no longer necessary to reject bourgeois, Modernist, or abstract art forms if they could be useful in conveying an anti-fascist message. The Congress lasted from 1935 to 1942. At its peak in 1939 it boasted a membership of approximately nine hundred artists.

Thus anti-fascist imagery underwent some notable changes. It became more diverse, with a broader range of stylistic strategies. And, in addition to the militant graphics portraying certain victory, there now appeared poignant oil paintings suggesting probable loss, particularly after the defeat of the Spanish Loyalists in the Spanish Civil War. From 1936 to 1939 the elected Republican government of Spain battled the troops of General Francisco Franco, leader of the Nationalist rebels and, from 1937 on, head of the fascist Falange Party. Franco had the military support of both Hitler and Mussolini, while the Republicans received official support only from the Soviet

7.78 William Gropper: drawing in *New Masses*, July 1934

7.79 Rockwell Kent: *Bombs Away*, 1942
Oil on canvas, 34 × 44 in. (86.4 × 111.8 cm.)
Philip and Suzanne Schiller Collection, Columbus Museum of Art, Columbus, Ohio

Union. Other Western European nations and the United States chose to remain neutral. Leftists, however, organized unofficial support in the form of both supplies and troops, the Abraham Lincoln Brigade being the American contribution in the latter realm.

The American Artists' Congress made support of Republican Spain one of its top priorities and encouraged artists to address this military conflict in their work. Rockwell Kent (1882–1971) commemorated the Spanish Civil War in *Bombs Away* (1942) [**7.79**]. Though this work was painted after the war had ended, the barren, mountainous landscape and planes flying low over a bombed-out town are a clear reference to Guernica, the northern Spanish town attacked by German warplanes in 1937 and memorialized that same year in the powerful painting *Guernica* by the Spanish artist Pablo Picasso. (The American Artists' Congress helped bring Picasso's picture to New York in 1939 to raise money for the Spanish Refugee Relief Campaign.) The clear, harsh light and sharply defined shadows create a surreal atmosphere, one reinforced by the statuesque form of the seated female figure. Kent conveys the extent of the woman's loss not by the display of dead or maimed bodies, but by her dazed expression and immobility. That the danger has not yet passed is clear in the concerned expression on the child's face as she grabs the woman's arm and attempts to rouse her from her state of shock. The shadows on the road could signal the approach of friends or of enemies. An ardent socialist

and member of the American Artists' Congress, Kent was particularly committed to the Spanish Republican cause, executing poster designs, donating money, and giving speeches in support of the Republic.

Parodies of the three major fascist leaders—Hitler, Mussolini, and Hirohito—were particularly popular among artists on the Left. In 1942 Harry Sternberg produced a print entitled *Fascism* [**7.1**]. Sternberg was the son of poor Jewish immigrants and an active member of the American Artists' Congress, so it is no surprise that his print contains such a biting indictment. A three-headed monster (Mussolini, Hitler, and Hirohito) wreaks havoc across the land, trampling on the symbols of Judaism and Christianity, as well as on the instruments of science and the arts. Rats scurry about the figure's feet and corpses litter the landscape. The colors work to heighten the horror of the scene: the sky is blood red, the skin of the monster a sickly green, and the corpses a decaying yellow or cold blue. Sternberg's print was included in 1943 in an exhibition organized by Artists for Victory, which had been established in 1942 to coordinate the war efforts of artists and to function as a liaison between artists, government agencies, and private industry. "America in the War" displayed one hundred prints simultaneously in twenty-six museums across the country (each artist was asked to submit twenty-six impressions of individual works).

Another condemnation of the fascist trio appears in a ceramic work by Viktor Schreckengost (1906–2008). Born in Sebring, Ohio, Schreckengost had spent the years 1929 to 1932 in Vienna studying with the ceramic sculptor Michael Powolny (1871–1954), and thus experienced firsthand the rise of fascism

7.80 Viktor Schreckengost: *The Dictator*, 1939
Glazed earthenware, 13 × 12½ × 10½ in. (33 × 31.8 × 26.7 cm.)
Everson Museum of Art, Syracuse, New York

in Europe. In *The Dictator* (1939) [7.80] he presents a corpulent Emperor Nero seated on a throne from which protrude cherubs with the heads of Hitler, Mussolini, and Hirohito, with the addition here of Stalin as well (the last two are not visible in the illustration). In 1939 Stalin had signed a non-aggression pact with Hitler which allowed the German leader to invade Poland. This, in combination with increasing reports of his purges of intellectuals who opposed his policies, created a growing image of Stalin as a totalitarian, if not fascist, dictator. Only with the invasion of the Soviet Union by Hitler in 1941, and the resultant addition of the Soviet Union to the Allied forces, did Stalin regain favor within the United States. But his betrayal of the anti-fascist cause led to serious rifts among artists on the Left. One of the victims was the American Artists' Congress, which dissolved in 1942. Schreckengost's association of fascist leaders with Nero was a satiric commentary on the attempts of Mussolini and Hitler to represent themselves as the leaders of a new empire patterned on that of ancient Rome.

The War at Home: Japanese American Internment and American Patriotism

Japan's attack on Pearl Harbor resulted not only in the entry of the United States into World War II, but also in the internment of over 110,000 Japanese Americans living on the West Coast. On February 19, 1942, President Roosevelt issued Executive Order 9066, which allowed for the establishment of ten relocation centers in the western part of the country to house Japanese Americans, two-thirds of whom were native-born.

The internment of Japanese Americans was the result of fear the Japanese would attack the mainland and of longstanding anti-Asian sentiment on the West Coast that began when Chinese labor was imported in the 1850s and that was reflected in a 1924 immigration act specifically excluding Japanese. Japanese Americans, it was argued, could not be trusted (many German Americans and Italian Americans were also seen as suspect, but not subjected to relocation and internment). Support for internment also came from local white farmers and businessmen, who assumed possession of most of the internees' property. A member of the Grower-Shipper Vegetable Association of Central California was quoted in the May 9, 1942, issue of *The Saturday Evening Post*: "We're charged with wanting to get rid of the Japs for selfish reasons. We might as well be honest. We do. It's a question of whether the white man lives on the Pacific Coast or the brown men. They came into this valley to work, and they stayed to take over." The War Relocation Authority (WRA) ran the relocation camps in California, Arizona, Utah, Idaho, Colorado, Wyoming, and Arkansas from 1942 to 1945. Once released, the internees were discouraged from returning to their homes and forced, instead, to settle in the Midwest and East in the face of increasing public hostility.

The WRA hired photographers—including Dorothea Lange and Ansel Adams—and filmmakers to make a public record of camp life. While some gave a reassuringly bland impression, others, most notably Lange, produced images of the more tragic

7.81 Dorothea Lange: *WRA, Hayward, California*, May 8, 1942
Photograph
War Relocation Authority Archives, Washington, D.C.

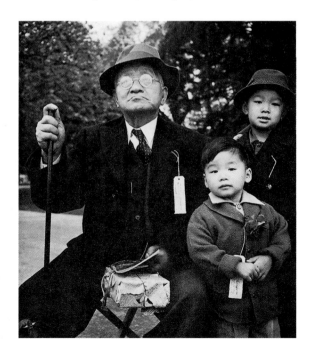

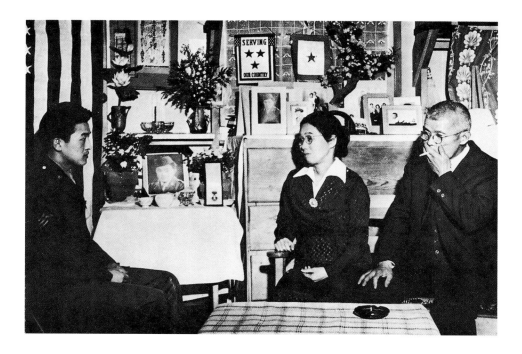

7.82 Anonymous: *WRA, Hunt, Idaho,* c. 1942–45
Photograph
War Relocation Authority Archives, Washington, D.C.

aspects of the relocation process, such as a photograph of a dignified grandfather, with his package wrapped in torn newspaper and his relocation tag, waiting with his grandchildren, all still uncertain as to their fate [**7.81**]. Another WRA photographer captured a moment of intense irony, as a serviceman visits his parents in the Minidoka, Idaho, Relocation Center [**7.82**]. Many within the camps felt that the best way to deal with their situation was to continue to proclaim their patriotism, which for some of the young men meant enlisting. The son is fighting for the freedom of citizens of his own and other countries, while his own parents remain imprisoned. A few internees were able to take pictures with equipment smuggled in that revealed the desolation of most camp sites, as in Toyo Miyatake's *Manzanar Relocation Center* [**7.83**] (he was eventually given

7.83 Toyo Miyatake: *Manzanar Relocation Center,* c. 1942–45
Photograph
Courtesy Archie Miyatake

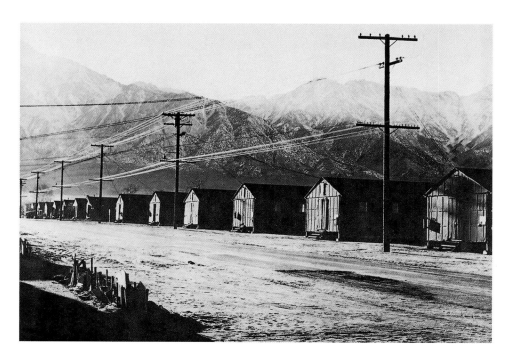

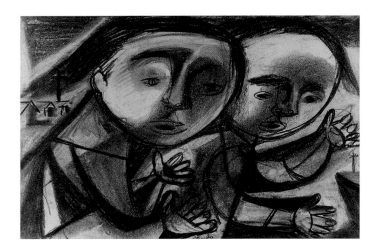

7.84 Mine Okubo: *Evacuee Children, Many Were Born in the Camps*, 1943
Charcoal on paper, 14 × 20 in. (35.6 × 50.8 cm.)
Japanese American National Museum, Los Angeles, California

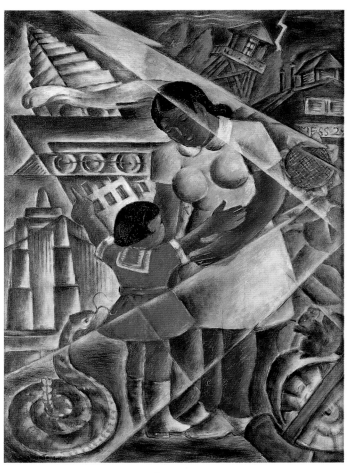

7.85 Henry Sugimoto: *When Can We Go Home?*, 1943
Oil on canvas, 35½ × 23¼ in. (82.6 × 58.4 cm.)
Japanese American National Museum, Los Angeles, California

permission to photograph as long as a white person released the shutter, then only if a white person was present, and finally on his own).

Artists inside the camps also made records in the form of paintings and drawings. Mine Okubo (1912–2001) had studied art in both California and Europe; she was on the payroll of the WPA and executing fresco and mosaic murals for the U.S. Army's Servicemen's Hospitality House in Oakland when Executive Order 9066 was issued. She later recalled an FBI visit after the bombing of Pearl Harbor: "the whole house had been ransacked—everything we had, all the old Japanese suitcases filled with parents' old kimonos, my parents' past life. Everything had been stolen. Everything." Okubo was interned at two camps, Tanforan, California, and Topaz, Utah, and created several charcoal drawings of a wide range of activities and emotions. The art historian Kristine Kuramitsu notes that charcoal was "well suited to portraying the tactile realities of the dusty relocation centers." In *Evacuee Children, Many Were Born in the Camps* (1943) [**7.84**], Okubo expresses the concern of many Japanese American adults about how the camps would affect the children (over half of the internees were children). "I am an American," stated one evacuee. "I have never known anything else. This evacuation can't change me because I am old enough and will always be the same. But what about the children in their formative years? What will it do to them?" Okubo's children crowd to the front of the picture plane, arms raised to ward off the dust that constantly blows through the camp. Their faces express not joy but concern and confusion. They appear to be fleeing the barracks and crucifix-shaped electrical poles in the back-

ground [cf. **7.83**]. Many of Okubo's works were intended for public exhibition and, like the ledger drawings of Fort Marion's Native American prisoners (see pp. 238–42), were sent to friends outside the camps.

Henry Sugimoto (1900–1990) had studied in California and Europe, like Okubo, before being interned in the camp at Jerome, Arkansas. His oil paintings also focus on camp life, although his style is much more self-consciously Modernist. In *When Can We Go Home?* (1943) [**7.85**] he draws on Cubism and Futurism to fragment the image, locating the mother and child in the center of a kaleidoscope of architectural and natural forms. The child gestures to the left, to images of the world outside the camp (the Modernist architecture and stylized train), while behind the mother, to the right, are the markers of life inside the camp (the storage barn and guard tower). The lightning bolt emphasizes the rift that has occurred in this family's life, while the sunflower at its base suggests

the resiliency of the internees and their continued hope that life in the camp would soon be over.

As Japanese American artists struggled to maintain their sense of dignity and identity within the camps, artists outside continued their efforts to keep the realities of war ever-present in the minds of those on the home front. Some created images that could be described as direct propaganda (caricatures of political leaders, scenes of the dead and the dying), others produced allegories about the grim nature of war in general. Still others turned to American folk life, using it to produce images that were intended to fortify American patriotism. Grant Wood took this latter route in his painting *Parson Weems' Fable* (1939) [**7.86**], a representation of the story of George Washington and the cherry tree found in Mason Locke Weems' 1806 publication *The Life of Washington the Great*, a text part fact, part fiction (there is no evidence that Washington ever confessed to his father that he had chopped down a cherry tree). Wood wrote of this work in 1940:

> I sincerely hope this painting will help reawaken interest in the cherry tree and other bits of American folklore that are

too good to lose. In our present and unsettled times, when democracy is threatened on all sides, the preservation of our folklore is more important than is generally realized While our own patriotic mythology has been increasingly discredited and abandoned, the dictator nations have been building up their respective mythologies and have succeeded in making patriotism glamorous.

Thus, Wood wanted to reinvigorate not only the fable of George Washington and the cherry tree, but also fable-making itself. He achieves the latter by including the storyteller, Weems, prominently in the foreground pointing to the action taking place in a theater-like setting in front of him.

In creating this image, Wood entered into a broader debate surrounding nationalistic myth-making enterprises engaged in by both American and Nazi artists. Wood, while wanting to save the cherry tree story from what he called "the debunking biographers," also, in Whiting's words,

7.86 Grant Wood: *Parson Weems' Fable*, 1939
Oil on canvas, 38⅜ × 50⅛ in. (97.7 × 127.5 cm.)
Amon Carter Museum, Fort Worth, Texas

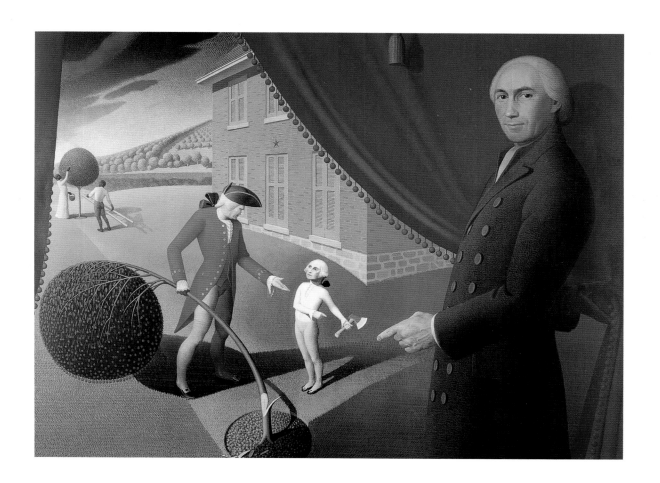

"acknowledged that artifice was involved in the production of national myths." Many in both countries presented their own re-imagings of the past as "true" and condemned those of the other as "false," so any calling into question of the veracity of American legends "undercut the liberal-traditionaist dichotomy between American history-as-truth and Nazi history-as-fiction since . . . it defined American national character by the artifice of storytelling." The fact that Wood revealed this artifice with humor (the young Washington's head is a replica of the well-known likeness of the president by Gilbert Stuart [2.11]) rather than with "the deadly earnest chauvinism of fascist nationalist mythology" did not prevent some critics from questioning the painting's patriotic sentiment.

Social Surrealism, Abstraction, and Democracy

Social Surrealism and Critiques of Fascism

While most Social Realists and Regionalists exaggerated and distorted human figures and settings in order to imbue their narratives with a sense of heightened drama, they did not move fully away from the recognizable or even the possible (in war, the seemingly impossible often became tragically possible). Other artists, such as Peter Blume (1906–92), turned more self-consciously to a recent art movement, Surrealism, to convey the horrors and irrationalities of fascism. In his painting *The Eternal City* (1934–37) [7.87], the acid green head of Mussolini hovers like a Jack-in-the-box on a bright yellow

paper accordion neck ornamented with a scowling dragon, over a pile of classical fragments in front of a somewhat fantastical view of the Roman Forum. Blume wrote: "I made the red lips clash with the green of the head, the color of the head strident and like nothing else in the picture: antithesis, dissonance. It hurt me to paint the head, but no compromise was possible." While the strident green emphasizes the monstrosity of Mussolini, the paper neck reduces him to a toy, a plaything whose power has been drained away through humor and ridicule. The ruins of the Forum are also the site of a contemporary revolt against the Italian army. This background scene is modeled, according to Blume, on a description of an event in Russia outlined by Leon Trotsky in his *History of the Russian Revolution* (1932). Each object is rendered in exacting detail, recalling the works of 15th-century Flemish artists like Jan van Eyck. Whiting notes that "writers in the leftist press particularly appreciated the painting's complicated iconography as an improvement over the simple visual clichés of the early thirties," such as muscular workers with clenched fists.

Blume's head of Mussolini mocks not just the man, but the public celebration of him throughout Italy. Blume had been in Italy on a Guggenheim fellowship in 1932, the year

7.87 Peter Blume: *The Eternal City*, 1934–37
Oil on composition board, 34 × 47⅞ in. (86.4 × 121.6 cm.)
The Museum of Modern Art, New York

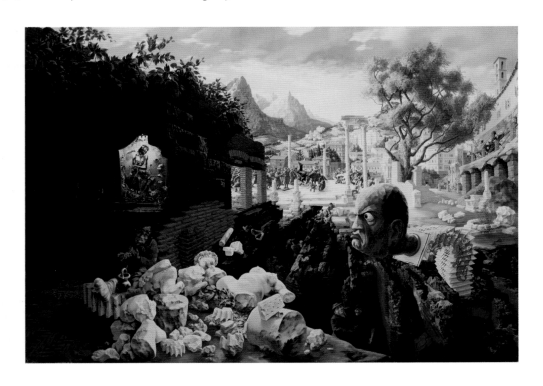

marking the tenth anniversary of the fascists' march on Rome. Busts of the dictator were everywhere, presenting him in the guise of Roman emperor, saint, soldier, and modern leader. One of these was the model for the head in the painting, a papier-maché version in the Decennial Exposition in Rome, which also appeared on the cover of the exhibition catalogue. Blume recalled:

> The Mussolini figure—with his jaws jutting out, and his bravado, and his macho image, chest beating, and all that sort of stuff—was something he was cultivating. And wherever you went you would . . . see these pompous quotations of Mussolini scrawled on the walls. You would see that thing with jutting jaws all over the place. But the culmination of it, of course, was the large papier-maché head at that exposition in 1932.

By locating the caricature within Roman ruins, Blume also mocked Mussolini's campaign to promote fascist Italy, through the construction of classical edifices and the excavation of ancient sites, as the new Roman Empire. This ridiculing of the Italian leader was well received in the United States, where, after his declaration of war on Ethiopia in 1935, public opinion turned against a man who had previously been admired by many for his reorganization of the Italian economy.

Blume was not the only artist who turned to Surrealism as a style for the political critiques of the Popular Front. So, too, did James Guy (1910–83). Guy was a member of the John Reed Club in the early 1930s and of the American Artists' Congress. Like the European artists who founded the movement in the mid-1920s—the painter André Masson, the writer André Breton—, he believed that Surrealism could function as a radical political force, that its bizarre, unsettling, and seemingly irrational imagery could help produce an overt disruption of the dominant values, attitudes, and ideas of the bourgeois status quo. Inspiration was to come from an investigation of the unconscious, through such techniques as "psychic automatism" or free association.

Guy came across Surrealism early in his career in Hartford, Connecticut, where in 1931 the Wadsworth Atheneum sponsored one of the first exhibitions, under the title "Newer Super Realism." This show contained paintings by the Spaniards Salvador Dalí, Joan Miró and Picasso, and by Masson. After Guy moved to New York, he was able to pursue his interest at the Museum of Modern Art (MoMA), the Whitney Museum, A. E. Gallatin's Museum of Living Art, and the Julien Levy Gallery. Throughout the 1930s the Julien Levy Gallery held one-man shows of Dalí, Max Ernst, Blume, Walter Quirt,

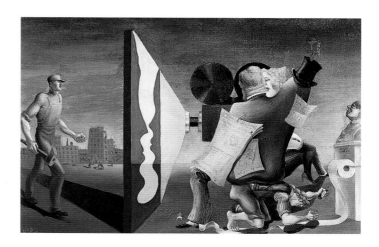

7.88 James Guy: *Public Education, No. 1*, 1936
Oil on canvas, 13 x 20 in. (33 x 50.8 cm.)
Collection of John P. Axelrod, Boston, Massachusetts

and other European and American Surrealists. Levy published his book *Surrealism* in 1936, the same year an ambitious show entitled "Fantastic Art, Dada and Surrealism" opened at MoMA.

Guy, like Blume, insisted not only on disrupting dominant bourgeois ways of thinking through bizarre and irrational images but also on including specific references to current political struggles. Because of these political references, the art historian Ilene Fort has suggested we label his work "Social Surrealism." She cites as an example Guy's *Public Education, No. 1* (1936) [**7.88**]. The newspaper magnate William Randolph Hearst (see p. 384) sits on the back of a journalist, who writes his articles on toilet paper, while Hearst's girlfriend, the movie star Marion Davies, sits on his lap. Hearst's opposition to labor unions earned him the designation "Public Enemy Number One." Guy's title, in conjunction with the newspapers pinned to Hearst's back and the movie screen, suggests that the public, in the form of the worker on the left, needs to approach newspapers and movies with caution as sources of information. This was particularly necessary in light of the fact that by the early 1930s Hearst owned twenty-eight daily papers, eight magazines, twelve radio stations, an international wire service, and half interest in a motion picture company that produced newsreels. The painting also highlights the alliance between political reactionaries in the United States and Europe through a bust of Hitler, which carries the inscription "TO W. H. FROM A. H." Hearst had visited Germany in 1934 and negotiated a deal with Hitler whereby Hearst's International News Service would provide Nazi papers with their foreign news coverage.

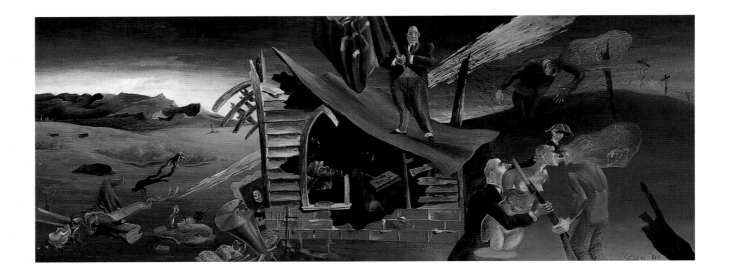

7.89 James Guy: *Black Flag*, c. 1940
Oil on masonite, 10 × 26 in. (25.4 × 66 cm.)
Philip and Suzanne Schiller Collection, Columbus Museum of Art, Columbus, Ohio

Some four years later Guy created a direct condemnation of war in Europe. In *Black Flag* (c. 1940) [7.89], he presents a nightmarish landscape presided over by a diplomat holding aloft a black flag on which is painted a death's head and a Nazi swastika. Below him to the right another member of the German ruling elite lures a young man into the army with promises of sex and glamor, embodied in a classical statue of a woman, legs and arms missing, which the potential soldier kisses. Guy used this kissing motif a number of times—Hitler kissing a blond woman in *Carnivorous Landscape* (c. 1938), Mussolini embracing a woman who represents Spain in *Harvest of Fascism* (1937)—and always with negative connotations. In *Black Flag*, writes Fort, "the kiss is a political ploy to hide the true intent of the diplomat, who speaks of peace and friendship but actually intends destruction." The figure of the man entangled in the barbed wire fence suggests the fate of this new recruit.

Yet the particular iconography of this kiss scene is also suggestive of the carefully crafted cultural policy of the National Socialists. Guy's limbless statue with the blond hair of an Aryan woman embodies Hitler's spurious aesthetic program. She is not a real woman, but an image of a woman, manipulated by men. Framed between the Nazi flag and the shadow of a soldier engaged in a Nazi salute, she is the German cultural greatness for which the soldier is about to fight, a greatness attained through the destruction of other cultures and traditions of both the present and the past. As Fort notes, "the bombed church supports the diplomat of peace who waves a flag of death, while the remains of civilization—books, masterpiece paintings—lie in rubble nearby.... All of tradition, culture, and refinement are destroyed as the real world takes on the surreal dimension of a battlefield."

Style as Subject, Abstraction as Freedom

While several artists were looking to certain Surrealist forms to disrupt "business as usual" in the art world, others were investigating the power of a different form of abstraction, more geometric and two-dimensional, to promote the causes of freedom and democracy. Stuart Davis (1894–1964) was one of the first to promote the political relevance of this form of art. Davis was born in Philadelphia, where his father was art director of the Philadelphia Press (see p. 327). He studied with Robert Henri in 1910 and associated with various members of the Ashcan School in New York. He also joined the staff of *The Masses*, and was one of several artists who stopped contributing work in 1916, when the editors tried to insist that all of the drawings be explicitly political (see pp. 334–35).

Davis slowly began moving away from narrative realism after the Armory Show of 1913 (in which he exhibited five watercolors) and, by the 1920s, was experimenting with collage-like paintings that incorporated name-brand consumer products, as in his *Sweet Caporal* (1922) [7.90]. He simplified the elements even further in the late 1920s, but most often maintained recognizable shapes that allowed viewers to identify the location or subject-matter. His subject-matter in the 1930s was often the workplace—the waterfront, factory, store—or the city itself, although there were seldom workers in sight. Instead, his images are filled with flat, colorful, playful shapes, like paper cutouts. He also became increasingly

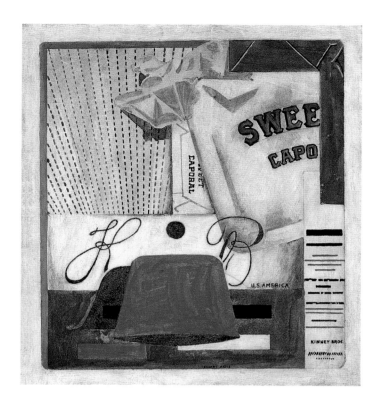

7.90 Stuart Davis: *Sweet Caporal*, 1922
Oil and watercolor on canvas board, 20 × 18½ in. (51 × 47 cm.)
Museo Thyssen-Bornemisza, Madrid

interested in jazz and its syncopated rhythms, and attempted to capture these rhythms in his later paintings.

Davis did not become seriously involved in leftist causes until the Popular Front, when liberals, socialists, and communists worked side by side in the fight against fascism. He served for a time as president of the Artists' Union and, in 1935, as editor of the union's journal *Art Front*, and became the first national secretary of the American Artists' Congress. He also produced several paintings dedicated to the anti-fascist cause in which his Modernist style played a crucial role. In *Artists Against War and Fascism* (1936) [**7.91**], Davis takes his flat, cut-out images and darkens their color, depicting two soldiers leading away a figure covered by a bloody white hood, while a cannon and interrogation light hover overhead and barbed wire fills the background to the right.

Whiting describes Davis at this time as "an independent socialist thinker, committed to the overall theoretical goals of Marxism and the broadest policies of the Popular Front." After the Hitler-Stalin Pact and the Soviet invasion of Finland in 1939, however, he repudiated Marxism and continued his anti-fascist artistic endeavors as an anti-Communist liberal, seeing the fight now as one between democracy and totalitarianism (both Soviet and Nazi) rather than between democracy and fascism. Throughout this period he argued that abstract painting could play an effective political part in the fight against fascism (or totalitarianism) by celebrating the most progressive aspects of American democracy—freedom, dynamism, and individualism. For him, an art of social content that did not remain individual and dynamic in form became a static, fascist (or, after 1939, totalitarian) art. Abstract art was an active social force; it expressed the spirit of universality and democracy; it was in and of itself a democratic art. This democratic abstraction as practiced by Davis was also seen by some critics as distinctly American. This presentation of Modernism as an art of democracy, freedom, and individualism of a kind found particularly in the United States also provides early evidence of an ideological position that was to gain ascendancy at the end of the war.

Davis was joined in his promotion of abstract Modernism as politically progressive by the critic Clement Greenberg, whose article "Avant-Garde and Kitsch" appeared in 1939 in the leftist journal *Partisan Review*. The ground had been prepared by another piece in the *Partisan Review* the previous year, entitled "Manifesto: Towards a Free and Revolutionary Art." Signed by Breton and Rivera, it was written by Breton and Trotsky, who argued that a truly independent and free art was inherently critical, and therefore politically subversive.

Early on in "Avant-Garde and Kitsch" Greenberg argued that there needed to be an elite cadre of artists whose duty it would be to preserve the best of bourgeois culture from the confusion and violence of the times. Without such an avant-

7.91 Stuart Davis: *Artists Against War and Fascism*, 1936
Gouache on paper, 12 × 16 in. (30.5 × 40.6 cm.)
Collection Louisa and Fayez Sarofim

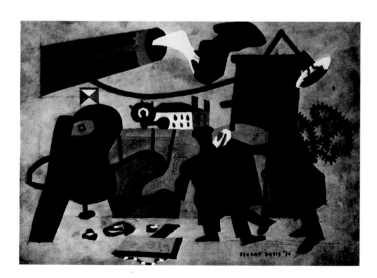

garde, all of culture would fall prey to kitsch, an imitative and commercialized art which developed in industrialized capitalist and totalitarian societies to amuse a mass proletariat who could not appreciate true culture. Hitler, Stalin, and Mussolini used kitsch as their official culture to ingratiate themselves with the masses, who preferred kitsch because it was easily recognizable and required little effort to enjoy. These political leaders, themselves, preferred kitsch because it was suitable as a vehicle for propaganda. Avant-garde art was not. "As a matter of fact," writes Greenberg, "the main trouble with avant-garde art and literature, from the point of view of fascists and Stalinists, is not that they are too critical, but that they are too 'innocent,' that it is too difficult to inject effective propaganda into them, that kitsch is more pliable to this end."

To provide the masses with a high order of art would require providing them with the leisure time necessary to appreciate this art, which would mean a restructuring of the means and relations of production. Obviously, this was not what fascist governments wanted, nor, according to Greenberg, what the liberal, reform government of the United States wanted, no matter how much social welfare legislation it might enact. It was much easier to create the illusion that the masses had more power than they actually had by proclaiming that the art and literature they enjoyed was the only true art and literature. The avant-garde had refused the prevailing standards of a capitalist bourgeois society and had rejected Communist as well as bourgeois politics. At this point their "true and most important function," according to Greenberg, was "to find a path along which it would be possible to keep culture moving in the midst of ideological confusion and violence."

For Greenberg, the art of kitsch was static, while the art of the avant-garde moved—here one thinks of Davis's arguments regarding the freedom and dynamism of abstract art. Avant-garde artists maintained this motion, in part, through their search for the absolute, a search that led them to "abstract" or "nonobjective" art. Their subject-matter thus became "the disciplines and processes of art and literature themselves." The following year Greenberg elaborated further on this development in an essay entitled "Towards a Newer Laocoon." Each of the arts, defined by its medium, must dissociate itself from other media and turn to an examination of its intrinsic properties. For painting, this meant an examination of two-dimensionality; for sculpture, it meant investigating three-dimensionality.

Greenberg observes in a footnote in "Avant-Garde and Kitsch" that his proposition that avant-garde artists of the late 19th and early 20th centuries—Picasso, Mondrian, Cézanne, Matisse—"derive their chief inspiration from the medium they work in"

came from a remark made by the painter Hans Hofmann (1880–1966) in a lecture on Surrealism. Hofmann claimed Surrealism was a reactionary tendency that was attempting to restore "outside" subject-matter rather than examining the processes of the medium. He felt that painters should express the essence of painting—two-dimensionality—by depicting a tension between the two-dimensional and the three-dimensional, as he attempted to do in his *Effervescence* (1944) [7.92]. Here pictorial depth or the suggestion of three-dimensionality was achieved through the use of color to create the sense of the advance or recession of elements within the painting as a whole.

Several artists whose work moved in the direction outlined by Greenberg and Hofmann had gathered together in New York in 1935 to explore a geometric, nonobjective art; two years later, they formed the American Abstract Artists (AAA).

7.92 Hans Hofmann: *Effervescence*, 1944
Oil, india ink, casein, and enamel on panel, 54⅛ × 35½ in. (137.6 × 90.2 cm.)
University of California Art Museum, Berkeley

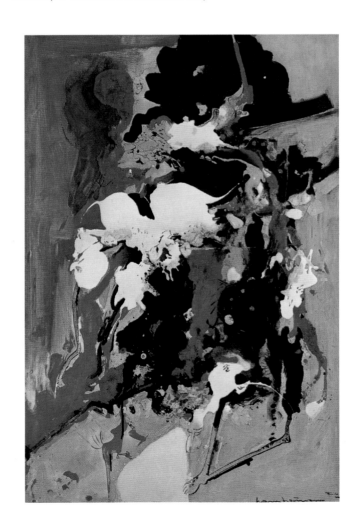

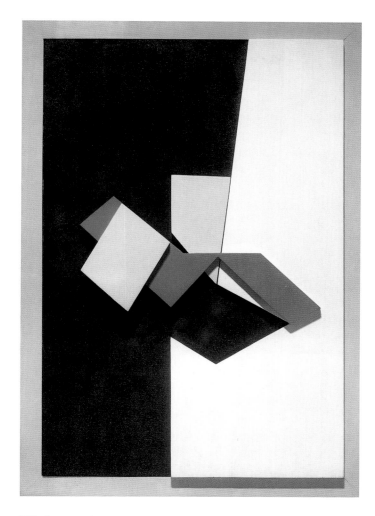

7.93 Gertrude Greene: *Space Construction, 1942*, 1942
Painted board and wood, 36 × 24 in. (91.4 × 61 cm.)
Whitney Museum of American Art, New York

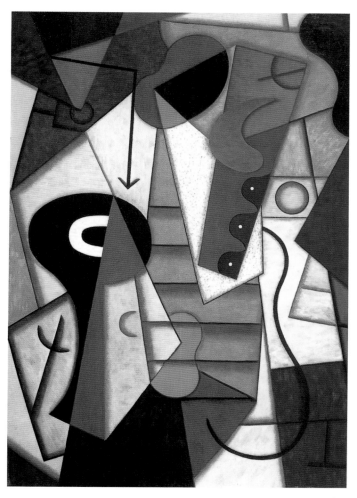

7.94 George L. K. Morris: *Nautical Composition*, 1937–42
Oil on canvas, 51 × 35 in. (129.5 × 88.9 cm.)
Whitney Museum of American Art, New York
Courtesy of Frelinghuysen Morris House & Studio, Lenox, Massachusetts

The art historian Barbara Haskell describes the group as imbued with "a utopian vision of universal harmony. Against the chaos of the present, they posited a geometric, nonobjective art of order and stability based on reason and devoid of references to the real world." One member of the group, Rosalind Bengelsdorf, wrote of the relationship between it and society at large: "It is the era of science and the machine So-called abstract painting is the expression in art of this age. The abstract painter coordinates his emotional temptations with his reason: the reason of this age." The AAA sponsored exhibitions of its members' work accompanied by yearbooks with essays and illustrations. In addition, one artist and theorist associated with the group, John Graham, published a book in 1937 entitled *Systems and Dialectics of Art*, in which he argued that nonillusionistic painting was the most advanced form of Modernist painting.

While some AAA artists worked in painterly and expressionist styles, the group came to be associated more with those, like Gertrude Greene (1904–56) [**7.93**] and George L. K. Morris (1905–75) [**7.94**], who worked with hard-edged geometric and biomorphic forms. One artist whose work certainly fit this rubric but who declined to join the group was Alexander Calder (1898–1976). Calder had first gained prominence in the late 1920s with his small, playful wire circus sculptures, in which he addressed the tension between the two-dimensional and three-dimensional through the thin, expressive line of the wire. In the 1930s, however, having been exposed to the experiments of the Dutch artist Piet Mondrian with primary colors, and the work of Joan Miró with biomorphic forms, Calder developed a different formal vocabulary. This can be found in his *Calderberry Bush* of 1932 [**7.95**]: flat, cut-out shapes of metal painted in primary colors plus

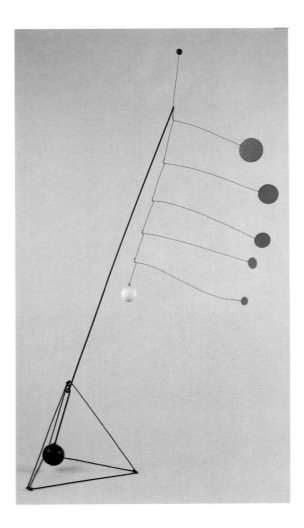

7.95 Alexander Calder: *Calderberry Bush*, 1932
Painted steel rod, wire, wood, and sheet aluminum, dimensions variable,
with base 88½ × 33 × 47½ (224.8 × 83.8 × 120.7 cm.)
Whitney Museum of American Art, New York

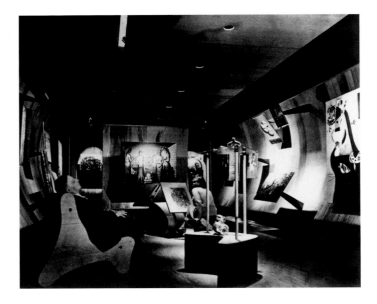

7.96 Frederick Kiesler: the Surrealist room in the Art of This Century Gallery,
New York, 1942

7.97 Mark Rothko: *Sacrifice of Iphigenia*, 1942
Oil on canvas, 50 × 36⅞ in. (127 × 93.7 cm.)
Collection of Christopher Rothko

white and black, wire, and thin metal supports. The mechanical movement of many of the circus "performers," facilitated by hand cranks and motors, is now achieved through balance and air currents. Duchamp coined the term "mobiles" to describe these works. In the late 1930s Calder began to suspend his mobiles from the ceiling. In subsequent decades he would ground many of his now much-enlarged metal forms, creating "stabiles."

In the late 1930s and early 1940s several Surrealists, including Masson, Breton, and Max Ernst, arrived in the United States, having fled the spread of war in Europe. Their arrival gave new impetus to those artists who were investigating the more painterly and expressionist forms of abstraction. Newcomers and locals met chiefly at Peggy Guggenheim's Art of This Century Gallery in New York [**7.96**]. Several, like

7.98 Adolph Gottlieb: *Eyes of Oedipus*, 1945
Oil and casein on canvas, 35⅞ × 27⅞ in. (89.8 × 69.45 cm.)
© Adolph and Esther Gottlieb Foundation, New York

the American artists Mark Rothko (1903–70) and Adolph Gottlieb (1903–74), turned to ancient myths for inspiration. While neither Rothko nor Gottlieb conceived of this work as anti-fascist, Whiting reads it as such by situating it within the wartime dialogue about the use of myth for nationalist and fascist political purposes. Indeed, she argues, it derived specifically from that very dialogue.

During the early 1940s Rothko and Gottlieb often drew on Greek myths involving tragedy and violence—the sacrifice of Iphigenia [7.97], the blinding of Oedipus [7.98]. Their images were not "illustrations"; rather, suggests Whiting, the titles invited the viewer "to interpret the impression of irrationality communicated by the style in terms of the violent and tragic events of the Greek myth." The viewer was also invited to connect the tragedies of World War II with the tragedies of the ancient past. During both eras, the individual experienced a sense of helplessness in the face of national or world events. Rothko's and Gottlieb's myth paintings became more "irrational" in style and less reliant on iconographic references after 1943. This development was prompted by their growing interest in the Surrealist technique of automatism and in the movement's concern with the primal unconscious, archaic myths, and the irrational.

In line with Carl Jung's theory of the collective unconscious as the bridge between antiquity and the modern age, the two artists envisioned their myth paintings as timeless and universal; the violence in them was a reenactment of ancient struggles caused by the same human passions that united and divided all of humanity. Thus, they were as meaningful in contemporary America as in ancient Greece. In the early 1940s Gottlieb wrote: "Today, when our aspirations have

been reduced to a desperate attempt to escape from evil, and times are out of joint, our obsessive, subterranean and pictographic images are the expression of the neurosis which is our reality. To my mind, certain so-called abstraction is not abstraction at all. On the contrary, it is the realism of our time." Rothko's and Gottlieb's interpretations of Greek myths through images of universal irrational emotions certainly differed from Nazi celebrations of, and identification with, the classical past. They also differed from the work of other American artists who attempted to use both ancient and American myths to fight fascism by promoting patriotism (see pp. 443–44). Rothko and Gottlieb rejected the idea that any political position—fascist or anti-fascist—should be taken in art, echoing Greenberg's claim that art was to be free from partisan politics altogether.

Roosevelt's New Deal social welfare policies, necessitated by the country's severe economic crisis, were never, or only grudgingly, accepted by many conservative Republicans and Democrats. In the early 1940s, with business back on its feet supplying materiel for the war and with unemployment down, the pressures on Roosevelt to end or amend his social welfare programs, particularly those that limited the actions of American corporations, increased. Federal programs employing artists were among the first to be drastically reduced or ended altogether. Gone, now, was the federal support that had resulted in meaningful work for unemployed artists and visual celebrations of American life throughout the United States.

At the same time, the art world was experiencing the beginnings of a radical shift in the debates surrounding the connections between art and politics. Hitler's persecution of Modernist art, and the Soviet suppression of Modernism in the mid-1930s in favor of Socialist Realism, led many critics and artists to associate realism with fascism and totalitarianism, and Modernism with democracy. Only in democracies, the argument went, did artists have the freedom to paint in whatever style they chose, and only in democracies, therefore, could Modernism flourish. Those artists who had been experimenting with Surrealism and geometric abstraction now found a new rationale for their work. The only way to be politically as well as artistically avant-garde was to resist the political manipulation of one's art by resisting transparent narrative realism altogether. Abstract art, they professed, could not be used as nationalist propaganda by a Hitler or a Stalin— or even a Roosevelt. Thus, it was better able to represent the true freedom inherent in a democracy. This argument continued to gain force in the immediate postwar years, when it was given new meaning by the rise of the Cold War.

8

From Cold War to Culture Wars

8.1 Judith Baca: "Division of the Barrios & Chavez Ravine" and "The Birth of
Rock & Roll," detail of *The Great Wall of Los Angeles*, 1976–83 (see p. 531)
Mural, H c. 13 ft. (4 m.), total L almost ½ mile (2,500 ft. / 762 m.)
Tujunga Flood Control Channel, Van Nuys, California

Timeline 1946–2012

8.70 (see p. 504)

1946 Publication of Otto Kalir's *Grandma Moses, American Primitive* [8.70]; Winston Churchill delivers his Iron Curtain speech, now seen as marking the beginning of the Cold War

late 1940s Emergence of a group of abstract Modernist artists known as the Abstract Expressionist or New York School

8.52 (see p. 492)

1950–53 Korean War

1954 Brown vs. Board of Education Supreme Court decision bans racial segregation in the nation's schools

1954–58 Seagram Building in New York by Ludwig Mies van der Rohe [8.52] becomes prototype for Modernist office buildings

1958 Alan Kaprow initiates "Happenings"

1959 Publication of Robert Frank's *The Americans* [8.35]

8.35 (see p. 482)

1961 Building of the Berlin Wall

1963 Publication of Betty Friedan's *The Feminine Mystique*; assassination of President John F. Kennedy; founding of the Spiral Group

1964 Passage of the Civil Rights Act; President Johnson commits U.S. troops to Vietnam; "Supermarket" exhibition opens at the Bianchini Gallery, New York [8.72]

8.72 (see p. 507)

1965 Founding of National Endowments for the Arts and Humanities; passage of Voting Rights Act; assassination of Malcolm X

1966 Founding of the National Organization of Women (NOW); construction of the Peace Tower by the Artists' Protest Committee, Los Angeles

1967 Organization of Angry Art Week in New York by Artists and Writers Protest; other protests against Vietnam War [8.88]

8.88 (see p. 520)

▼ Abstract Expressionism / NY School late 1940s–50s

Cold War 1946–91

Minimalism late 1950s–early 1980s

Pop Art early 1960s–70s

Vietnam War 1964–75

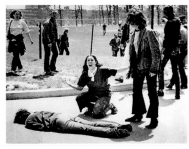

8.90 (see p. 521)

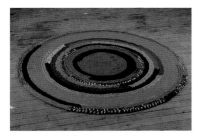

8.93 (see p. 524)

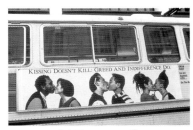

8.117 (see p. 548)

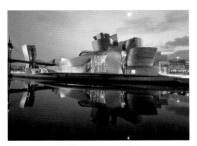

8.134 (see p. 564)

8.136 (see p. 568)

Cold War 1946–91

Minimalism late 1950s–early 1980s

Pop Art early 1960s–70s

Vietnam War 1964–75

Postmodernism early 1970s–?

1968 Earthworks exhibition at Dwan Gallery, New York; assassinations of Martin Luther King and Senator Robert Kennedy

1970 Killing of four students at Kent State University by National Guard (May 4) [8.90]; founding of first feminist art program at California State University, Fresno

1972 Demolition of Pruitt-Igoe housing complex, St Louis; publication of *Learning from Las Vegas* by Robert Venturi, Denise Scott Brown, and Steven Izenour

1973 Founding of the Woman's Building, Los Angeles, as space for creation and display of feminist art [8.93]; U.S. troops withdrawn from Vietnam

1976 Founding of the Social and Public Art Resource Center (SPARC)

1981 Acquired Immune Deficiency Syndrome (AIDS) is identified; destruction of Richard Serra's *Tilted Arc*

1987 Aids Coalition to Unleash Power (ACT-UP) founded [8.117]

1989 Cancellation of Robert Mapplethorpe retrospective at the Corcoran Gallery, Washington; fall of the Berlin Wall

1990–91 Persian Gulf War

1991 Fall of the Soviet Union, end of the Cold War

1997 Guggenheim Museum opens a branch in Bilbao, designed by Frank Gehry [8.134]; failed attempt by U.S. House of Representatives to abolish the National Endowment for the Arts

2001 Opening of Las Vegas Guggenheim (closes 2003); destruction of the World Trade Center, New York

2003 Beginning of the Iraq War

2004 Publication of photographs of abuse of Iraqi prisoners in Abu Ghraib prison, Baghdad [8.136]

2007 United Nations Intergovernmental Panel on Climate Change concludes global warming is very likely caused by human activities and cannot be stopped

The peace negotiated in 1945 that brought an end to World War II did not bring an end to international hostilities. Instead, the United States became mired in another type of war, a Cold War, in which the enemy was not simply a political demagogue like Adolf Hitler or Joseph Stalin, but a subversive ideology—communism. The search for communists or "suspected communists" affected all areas of life. Union leaders were pressured to purge political radicals. Actors, directors and screenwriters were called before the House Committee on Un-American Activities (commonly referred to as HUAC) to prove their patriotism. Artists committed to commenting on political struggles or social issues, as well as those committed to nonobjective or radically abstract work, found themselves attacked as "communistic" and "un-American" by conservative politicians and artists. The optimism of the New Deal era was gone, replaced by domestic paranoia and fear of an atomic third world war.

In histories of American art written since the 1960s, the late 1940s and early 1950s are most commonly described as the heyday of Abstract Expressionism, a time when the formal innovations of Modernist art, begun in the middle of the 19th century in Paris, came to a head in an explosion of paint in the studios of New York City. While this stylistic development was explained by the art critic Clement Greenberg as the result of the inevitable progression of Modernist art away from three-dimensional renderings of the world towards two-dimensionality or flatness, the artist Ben Shahn offered a different explanation in 1951:

I shall now unabashedly align the change in the art landscape with the change in the political atmosphere . . . Repudiation was indeed in the air [in the late 1940s]. The Congress was busily vanquishing the ghost of the New Deal, the Reign of Committees had begun. Relations between the recent allies, the United States and Russia, chilled, provoked by mutual intransigence. Liberalism was in bad odor, both for its New Deal leanings, and for its indulgence of Communism. Suspicion, accusation and renunciation grew.

For Shahn, the artistic implications of these political developments were clear: "At first what was called 'social content,' and more recently just content at all, have come under curiously bitter attack, as having some subversive connotation." Such attacks compelled many artists, Shahn believed, to retreat into their studios and concern themselves with aesthetic rather than political revolutions.

Since the 1970s art historians have reaffirmed this connection between stylistic and political developments in the postwar era, although they have been more nuanced in their readings of this connection and more sympathetic toward the aesthetic value of Abstract Expressionism than Shahn. Some have also argued that artists like Jackson Pollock [8.2, 8.13] and

8.2 Jackson Pollock: *Autumn Rhythm No. 30*, 1950
Oil on canvas, 105 × 207 in. (267 × 526 cm.)
The Metropolitan Museum of Art, New York

Robert Motherwell did not retreat from politics so much as engage in a new political battle centered around style and content, a battle whose general terms originated in the actions of Hitler in the 1930s. As was shown in the previous chapter, Hitler's censorship of Modernist art and celebration of classical realism facilitated the claim that Modernist works of art, particularly in their most abstract forms, were truly the aesthetic hallmark of democracy.

Supporters of Abstract Expressionism ultimately won out over its critics, and the main figures within this movement gained acceptance nationally and internationally by the end of the 1950s. This did not mean, however, that theirs was the only art being produced and promoted within the American art world at the time. Artists like Shahn, Isabel Bishop, and Paul Cadmus were still popular with important dealers and collectors, although they were no longer seen as part of the avant-garde. In addition, many young artists rejected the pronouncements of Greenberg, whose influence within the art world was considerable, regarding the direction contemporary art should take. They rejected the claim that a concern with the formal qualities of line, shape and color, devoid of any reference to the external world, was necessarily the most aesthetically radical act. Instead, they continued to explore various forms of realism, although a realism often informed by the Cold War, the cynicism and iconoclasm of the Beat counterculture, and the material successes of consumer culture.

Consumer purchases, from homes to home appliances, soared after World War II, as did advertising and the fortunes of U.S. corporations. This combination of material success and a repressive Cold War climate led to conformism on the one hand, documented in books like David Riesman's *The Lonely Crowd* (1950) and William H. Whyte, Jr's *The Organization Man* (1956), and dropping out on the other, symbolized by works like Allen Ginsberg's *Howl* (1955) and Jack Kerouac's *On the Road* (1957), manifestos of the Beat world. Several artists joined the Beat movement, producing images of the grittier, less affluent side of American society. Robert Rauschenberg followed in the footsteps of the composer John Cage who, inspired by Duchamp, challenged the exclusion of the sights and sounds of everyday life from the realm of fine art. Others, like Andy Warhol, began in the ranks of commercial artists before moving into fine art galleries with advertising-inspired imagery.

The commercial and critical success of such artists as Warhol and Rauschenberg in the 1960s ushered in a complex and fragmented art world in which increasing numbers of players competed for center stage with a broad variety of subject-matter—often scandalous—and styles. This art world fragmentation was also fuelled by national and international crises. The civil rights and anti-Vietnam War movements of the 1960s tore the country apart, creating a crisis of conscience that led to an increasing cynicism about the effectiveness of the United States as a protector of democracy both at home and abroad. The murders of Martin Luther King, Jr, and Robert F. Kennedy in 1968 both saddened and enraged a nation already shaken by the assassination of President John F. Kennedy in 1963, the urban uprisings of African Americans, and the student demonstrations against the Vietnam War. Artists organized anti-war protests, designed posters, and called for political change. Many women who worked within these political movements became politicized in another way, recognizing the limits placed on them by the sexist assumptions of their male colleagues. They gathered together to form their own organizations, energizing a new women's movement.

Artists were also challenging institutional definitions of art and of the appropriate sites for its display. Many moved outside of the museum/gallery system and into old warehouses or store fronts or open fields, producing what has been variously termed installation art, earthworks, and environmental art. Others brought dirt or old tires or other objects previously seen as garbage into museum spaces. Technological developments led to new forms, such as video art and, later, computer and digital art, and the public protest demonstrations of the 1960s sparked a new era of performance art both inside and outside of traditional institutions. The 1970s saw a rash of demonstrations against the exclusion of women and artists of color—African American, Native American, Asian American, Chicano/a— from the annual exhibitions and collections of major American museums, and alternative exhibition spaces and artists' organizations multiplied.

Many institutions, particularly those specializing in contemporary art, welcomed these developments, providing both space and financial support. The outrageousness of the work often created media sensations, which attracted attention to the institutions themselves. Since the end of World War II the art market had steadily expanded, particularly in the area of contemporary art; in the 1980s this expansion escalated into a veritable boom, with collectors eager to speculate on the profitability of the latest work and hoping to get in on the ground floor by buying up the creations of such newcomers as the painters Julian Schnabel and Keith Haring. Culture was seen as a new area of great market potential, and blockbuster exhibitions of old masters, as well as outrageous acts by young upstarts, became the order of the day. At the same time, attacks were launched against public funding, in particular the National Endowment for the Arts (NEA). Art was to be evaluated according to the dictates of the market, not the

learned opinions of artists and critics doling out taxpayers' dollars.

The proliferation of styles, exhibiting spaces, and journals created heated debates at the end of the 20th century about key issues in art making and art criticism: What is the role of authenticity in the creation and evaluation of works of art? How has new technology transformed art production? How is meaning generated in and around a work of art? The ease with which politically radical art had been incorporated into mainstream institutions led many artists to focus on the mechanisms of incorporation, in particular the way in which public discourse, both words and images, had been increasingly brought under the control of powerful international corporations. The many voices that emerged out of the social movements of the 1960s and 1970s—those of women, artists of color, gays, lesbians, and other previously marginalized groups—also contributed to broad questions surrounding the concept of identity: How is one's identity constituted? How is it expressed in art? Who, exactly, is an "American"?

These questions and debates coalesced in the 1980s and 1990s into what became known as the "culture wars," with defenders of the traditional canons of Western culture challenging those newcomers who were attempting to redefine the canon. These newcomers forced debate not only about the complexity and diversity of American culture but also about America's political and economic relationships with other countries throughout the world, relationships that, at the beginning of the 21st century, are increasingly informed by the "war on terror" and by the growing recognition of the reality and ramifications of global warming.

Gestures of Liberation:
Abstract Art as the New American Art

The Blinding Light of the Blast:
Representing Atomic Destruction

World War II had a profound effect on many artists. Some had friends or family who were killed in battle. Some were soldiers or war correspondents. Most followed the war through newsreels and newspaper reports. All struggled to express visually their experiences and understanding of a radically transformed world. Several artists turned their attention to the new weapons of war, notably the atomic bomb. On August 6, 1945, the United States dropped the first atomic bomb on the Japanese city of Hiroshima. Three days later, it dropped a second bomb on Nagasaki, effectively ending the war. Testing continued in the late 1940s. Philip Evergood depicted the test of July 1, 1946, on Bikini Atoll in the South Pacific, in his painting *Renunciation*

8.3 Philip Evergood: *Renunciation*, 1946
Oil on canvas, 49¼ × 35½ in. (125 × 90 cm.)
Collection of Mr and Mrs Harris J. Klein, New York

(1946) [**8.3**], where he uses the tradition of political caricature and expressionist distortion to show the resulting devastation. His roughly applied paint and crude draftsmanship suggest the barbarity of the event, as does the presence of the apes.

Another rendition of this atomic test, *Bikini, Tour of Inspection* (1946) [**8.4**], was created by Ralston Crawford (1906–78). Here there are no ships tossed by the giant waves created by the blast and no symbolic apes. Instead, the tone is cool and unemotional with broad areas of flat color, and the only suggestion of rupture or explosion appearing in the jagged edges of some of the forms. Crawford worked for the visual presentation unit of the Air Force during the war, applying his artistic knowledge to the development of meteorological maps and charts. One of Crawford's Bikini paintings appeared in the December 1946 issue of *Fortune* magazine in an article on the test. Crawford, who had been present, is quoted as follows: "My forms and colors are not direct transcription;

they refer in paint symbols to the blinding light of the blast, to its colors, and to its devastating character as I experienced them in Bikini lagoon."

The monstrous world of persecution and anxiety and distorted bodies produced by the Second World War is also strikingly conveyed in an additional painting from 1946, *Charred Beloved II* [**8.5**] by Arshile Gorky (1904–48). The taut lines, barbed shapes, dark caverns and biomorphic forms appear both to threaten and to cry out in anguish. An Armenian who had escaped the massacre of Armenians by the Turks in 1915, Gorky arrived in the United States in 1920. Passing himself off as a Russian, he worked systematically through various Modernist styles, ending with Surrealism. *Charred Beloved II* can be interpreted as a Surrealist commentary on a fire that destroyed his studio in January 1946 and on the larger fires of the atomic blast.

As the art historian Amy Lyford has noted, Isamu Noguchi experienced the war differently from his European American counterparts. As a Nisei, or second-generation Japanese American (he was born in New York of a Japanese father and a Scottish/Native American mother), he was treated with suspicion after the Japanese attack on Pearl Harbor in December 1941. While residing on the East Coast helped save him from being rounded up in 1942 with West Coast Japanese Americans, he did not feel he could stand by and do nothing. He later wrote of this period: "With a flash I realized I was no longer the sculptor alone. I was not just American but Nisei. A Japanese-American. I felt I must do something." In January 1942 Noguchi helped organize the Nisei Writers and Artists Mobilization for Defense to counter the increasing anti-Asian sentiment fueled

8.4 Ralston Crawford: *Bikini, Tour of Inspection*, 1946
Oil on canvas, 24 × 34 in. (61 × 86.4 cm.)
Estate of Ralston Crawford

8.5 Arshile Gorky: *Charred Beloved II*, 1946
Oil on canvas, 54 × 40 in. (137 × 101.6 cm.)
National Gallery of Canada, Ottawa

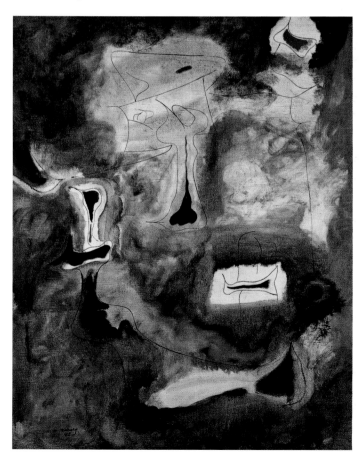

by the press, particularly on the West Coast. He then volunteered to enter the Colorado River War Relocation Center in Arizona in April 1942 in order to use his talents as an artist and designer to help ameliorate the conditions endured by the evacuees. Unfortunately, his plans failed, for neither the supplies nor the irrigation necessary to realize them made it to the camp. In fact, Noguchi himself had difficulty getting the necessary papers to secure his release.

When Noguchi left the camp in November 1942, what little faith he had left in the fairness of the U.S. political system had been destroyed. Like many artists, he turned to an abstract visual language in order to convey the chaos and despair of war

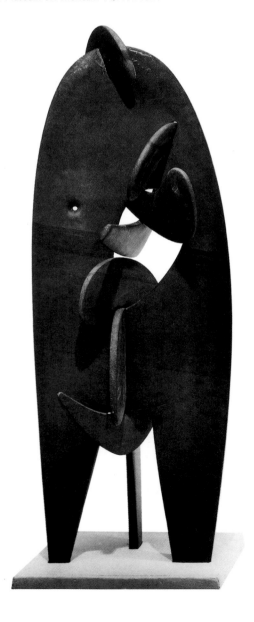

8.6 Isamu Noguchi: *Humpty Dumpty*, 1946
Ribbon slate, H 58¾ in. (149.2 cm.)
Whitney Museum of American Art, New York

and internment. In 1946, the year he created *Humpty Dumpty* [8.6], he wrote about investigating the "adjustment of the human psyche to chaos" and the "transfusion of human meaning into the encroaching void." By naming his five-foot-tall fragile, pierced and precariously balanced abstract stone work after a nursery rhyme character, he adds a poignancy to the otherwise nihilistic theme of the sculpture, for who, indeed, was going to put the nations and communities shattered by World War II "back together again"?

Abstract Expressionism and the Cold War

As artists grappled with questions of subject-matter and style in the late 1940s, critics worked to construct a new image of Modernist art in the postwar era, one firmly located in the United States as opposed to Europe, and in New York City in particular. As the art historian Serge Guilbaut points out, they worked not only within the aesthetic parameters established by the works of art themselves but also within the Cold War rhetoric promoted so insistently by those like President Harry Truman, Senator Joseph McCarthy, and Congressman George Dondero. The search for communist traitors led to the institution of a loyalty oath in 1947 for all government employees and the beginning of a series of public hearings by HUAC investigating individuals accused of being spies or having been associated with the Communist Party. Such questioning of the patriotism of those who were different or in some way challenging the status quo encouraged supporters of Modernist artists to insist on the Americanness of these artists and the work they produced.

Patriotic assertions were particularly meaningful in light of Secretary of State George C. Marshall's cancellation, in April 1947, of "Advancing American Art," a traveling exhibition of contemporary art put together the previous year by the State Department. Conservative politicians and artists had attacked the exhibition as "communistic" for its inclusion of "modern" art and politically suspect artists. "Modern" art was any that strayed from the presentation of the external world in easily recognizable form; it was condemned as "incomprehensible, ugly and absurd," and thus a threat to the moral and aesthetic integrity of American culture. The administration of President Truman, extremely sensitive to accusations of communist infiltration within its ranks, was quick to react. On May 6, 1947, Secretary of State Marshall announced that there would be "no more taxpayers' money for modern art."

Thus, a struggle developed among competing groups of politicians, critics, dealers, and museum professionals over what type of art best represented the United States of America. Was it the work of Norman Rockwell [7.28] and Andrew Wyeth

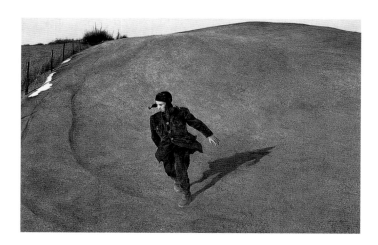

8.7 Andrew Wyeth: *Winter 1946*, 1946
Tempera on board, 31⅜ × 48 in. (79.7 × 121.9 cm.)
North Carolina Museum of Art, Raleigh

(b. 1917) [8.7], or that of Jackson Pollock (1912–56) [8.2] and Willem de Kooning (1904–97) [8.12]? Those who supported Pollock and de Kooning might have included Wyeth and Rockwell in their list of American artists, but not in their list of "major" contemporary artists of the late 1940s. The United States was a changed nation after the war, they argued, and needed a new art to reflect that change.

While individual artists and critics exchanged words over who was truly American, a broader shift in discussions about nationality in the art world was also taking place. In the 1930s overwhelming support was expressed for scenes of American life and for the right of the American people to have an art that was comprehensible to them. In the late 1940s and early 1950s, however, a competing rhetoric within the art world gained power; the general public, whose tastes and opinions could be so easily manipulated by political demagogues and commercial ad agencies, was now suspect. At the same time, the notion of social responsibility that underpinned much New Deal policy— that people had to work together in groups and with the government in order to overcome adversity—was replaced by a renewed emphasis on the individual, whose opportunities for success were to remain unfettered by government regulation. Individual freedom, free enterprise, and a new internationalism were to be the hallmarks of American democracy as the United States became a major world political and economic power. These qualities were given added meaning by being continually opposed to conditions in the Soviet Union, a country of collective farms and industry, pervasive government oversight, and a reliance on realist traditions in art and literature. Only the art of abstraction, according to its supporters, could truly capture the essence of this new individualistic

and enterprising America. In the absence of government sponsorship of Modernist art abroad, the Museum of Modern Art (MoMA) in New York stepped in, organizing major international exhibitions and taking responsibility for the American pavilion at the prestigious Venice Biennial, one of the major international venues for the display of contemporary art. Thus, the connection between free enterprise and artistic freedom in the United States was further reinforced.

Among artists who engaged with the formal experiments of Cubism, Expressionism, and Surrealism a further division occurred. Those, like Shahn and Evergood, who maintained a narrative element in their work through recognizable figures and settings, found themselves increasingly opposed to those who were arguing for an abandoning of recognizable imagery altogether. The resulting struggle was characterized by the art historian Milton Brown in 1947 as one "between the modernist and the realist tradition, expressed in other terms as an opposition between the 'pure' and the social artist." Robert Motherwell (1915–91) and the critic Harold Rosenberg, members of the Modernist group, argued in 1947 that "political commitment in our times means logically no art, no literature." In order to create works of contemporary relevance free of the limitations imposed by a repressive political climate, artists had to find a way to inhabit "the space between art and political action." That space would function as the arena in which artists could act out their search for personal liberation through art, utilizing a new, thoroughly abstract, visual language. Five years later Rosenberg wrote that the painterly gestures of these new abstract artists were gestures "of liberation, from Value— political, aesthetic, moral."

The new abstract visual language that emerged over the next several years was not, however, monolithic. It took a variety of forms, from Pollock's frantic slashes and skeins of paint flung across the canvas to the broad, dark brushstrokes of Franz Kline (1910–62), the hovering fields of color of Rothko, and the attenuated, biomorphic forms of Gorky. While these artists did not form a "school" per se (although they have often been labeled Abstract Expressionists), they did constitute a social network. In 1948 Clyfford Still, Rothko, Motherwell, William Baziotes, and David Hare founded the Subjects of the Artists school in New York City, with weekly meetings, often followed by drinks at the Cedar Tavern. In the early 1950s the Artists' Club in Greenwich Village functioned in a similar manner. Artists gathered to hear lectures and engage in discussions about art world issues.

One can certainly find earlier Modernist artists who had produced radically abstract work of both the gestural and color field variety, such as the Russians Wassily Kandinsky and

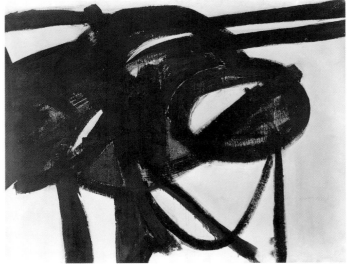

8.8 (left) Barnett Newman: *Day One*, 1951–52
Oil on canvas, 132 × 50¼ in. (335.3 × 127.6 cm.)
Whitney Museum of American Art, New York

8.9 (above) Franz Kline: *Chief*, 1950
Oil on canvas, 58⅜ × 73½ in. (148.3 × 186.7 cm.)
The Museum of Modern Art, New York

Kazimir Malevich. The new American work was different, how-
ever, in its sheer size and lack of "finish." Walking through the
galleries of MoMA in New York or the Smithsonian American
Art Museum in Washington, D.C., at the turn of the 21st century,
one cannot help but be struck by the scale of the works and by
their apparent spontaneity, particularly after having moved
through the galleries holding the paintings and sculpture of the
1930s and early 1940s. While artists who have been grouped
loosely under the label of Abstract Expressionism painted
relatively small canvases as well, it was their large works, like
Autumn Rhythm: No. 30 (1950) [**8.2**] by Pollock, *Day One*
(1951–52) [**8.8**] by Barnett Newman (1905–70), *Chief* (1950) [**8.9**]
by Kline, *No. 7 (Green and Maroon)* (1953) [**8.10**] by Rothko,
Western Air (1946–47) [**8.11**] by Motherwell, and *Woman and
Bicycle* (1952–53) [**8.12**] by de Kooning, that garnered the most
attention when they were produced, and that have been most
consistently reproduced ever since.

Critics at the time focused on the size and rawness of the
paintings. Here was a bold, adventurous art lacking in the
studied refinement of European art—Rosenberg called it
"action painting." It was marked by the frontier, the wide-open
spaces of the West. It was informed by the experiments of
European Modernism—Cubism, Surrealism, Expressionism,
Futurism—yet took these experiments one step further,
pushing the envelope of abstraction and two-dimensionality

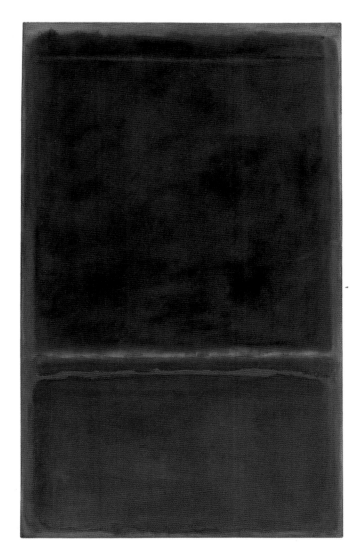

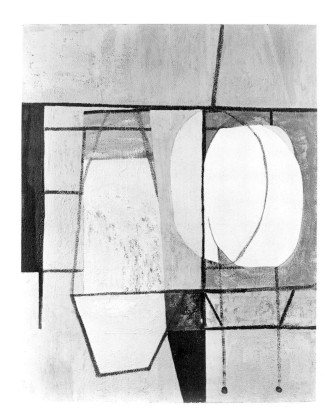

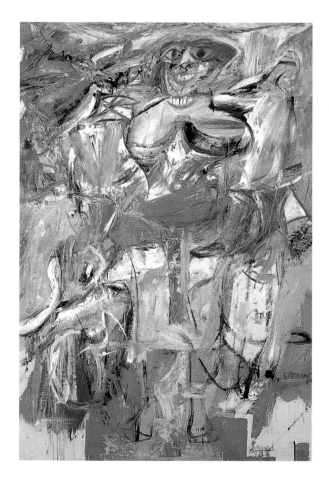

8.10 Mark Rothko: *No. 7 (Green and Maroon)*, 1953
Oil on canvas, 91⅛ × 54⅞ in. (231 × 139.4 cm.)
Phillips Collection, Washington, D.C.

8.11 Robert Motherwell: *Western Air*, 1946–47
Oil on canvas, 72 × 54 in. (182.9 × 137.1 cm.)
The Museum of Modern Art, New York

8.12 Willem de Kooning: *Woman and Bicycle*, 1952–53
Oil on canvas, 76½ × 49 in. (194.3 × 124.5 cm.)
Whitney Museum of American Art, New York

with an unprecedented aggressiveness and freedom. These massive canvases were also consistently described as transcendent, forward-looking, and autonomous. As Barnett Newman wrote in 1948: "We are freeing ourselves of the impediments of memory, association, nostalgia, legend, myth, or what have you, that have been the devices of Western European painting. Instead of making cathedrals out of Christ, man, or 'life,' we are making them out of ourselves, out of our own feelings."

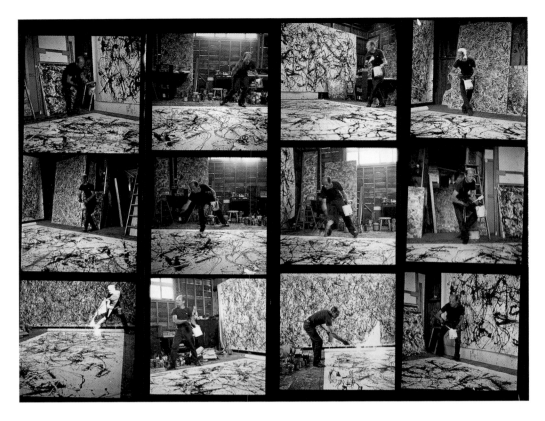

8.13 Hans Namuth: Jackson Pollock painting in his studio, 1950
Sheet of photographic contact prints (detail)

8.14 David Smith: *Helmholtzian Landscape*, 1946
Painted steel with wood base, 15⅞ × 19 × 7¾ in. (40.3 × 48.3 × 19.7 cm.)
Kreeger Museum, Washington, D.C.

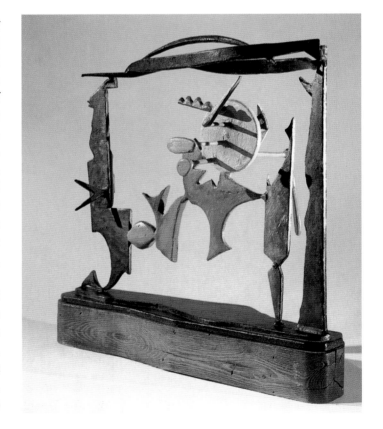

These artists relied not on events in the world outside of the studio but, rather, on the inner turmoil of the individual acted out on the canvas. Artists and critics alike borrowed from the language of postwar Existentialists like the French philosopher Jean-Paul Sartre in speaking of the process of self-creation as a solitary struggle fraught with anxiety. In 1951 Clyfford Still (1904–80) wrote: "When I expose a painting, I would have it say 'Here I am: this is my presence, my feeling, myself. Here I stand implacable, proud, alive, naked, unafraid.'" Yet the images and writings of several artists derived their meanings at least in part from the historical moment in which they found themselves. They chose to focus on certain themes with direct references to political events or institutions: chaos and death, atomic power and the Holocaust, freedom and anxiety.

In addition, the self that was embodied in Abstract Expressionist paintings was seen by those who promoted them as decidedly masculine. In 1956 the art critic Rudi Blesh described Abstract Expressionists as "a remarkably rugged lot, with minds as well muscled as their bodies They are built like athletes, and some of them, like Pollock and De Kooning, paint like athletes. If pictures could explode, theirs would, so

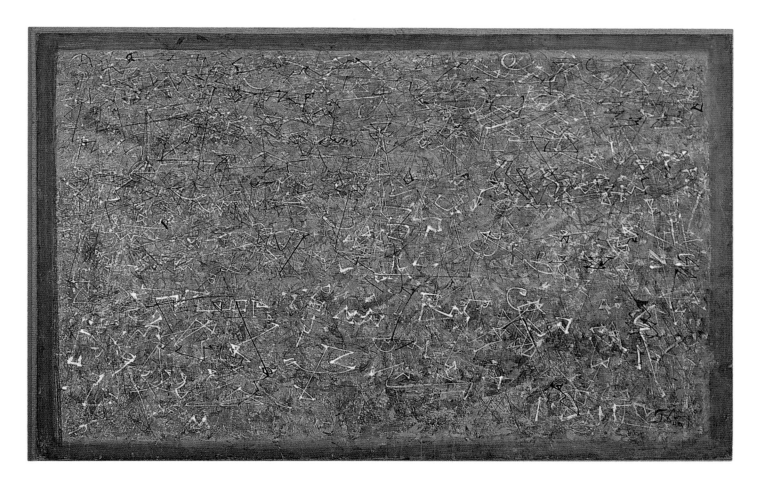

8.15 Mark Tobey: *Universal Field*, 1949
Tempera and pastel on cardboard, 28 × 44 in. (73.9 × 116.2 cm.)
Whitney Museum of American Art, New York

grimly by the force of their wills have they compressed their dual muscularity onto the canvas." Pollock, in particular, was celebrated as an anti-intellectual man of action, born in the "Wild West" of Cody, Wyoming, a violent man who acted out his incoherent rage, which was often fueled by alcohol. This violence was seen as literally present in his early work, of 1946–51 [8.2], in the process of the elimination of the figure, and in his very manner of painting, which was captured and reproduced in a series of photographs by Hans Namuth (1917–90) in 1950 [8.13].

This same focus on masculinity appeared in the writings of Greenberg, who commented in 1947 that Pollock and the sculptor David Smith (1906–65) were the only major American artists at that time. Pollock's paintings were, in Greenberg's words, marked by "violence, exasperation and stridency," while Smith's sculptures [8.14] had "a virile elegance that is without example in a country where elegance is otherwise obtained by only femininity or by [a] wistful, playful,

derivative kind of decorativeness." The latter part of Greenberg's comment may have been a subtle reference to the paintings of Mark Tobey (1890–1976) [8.15], whom Greenberg did not consider a major artist. These paintings had a delicacy and tightness that worked against the image of aggressive individualism constructed for the key figures of Abstract Expressionism. Tobey was inspired by the art and religions of Persia, China, and Japan, having spent time in a Zen Buddhist monastery in the 1930s. His overall compositions suggested one particular aspect of the religious traditions of Bahaism and Zen Buddhism he so admired: the unity and interrelatedness of all things.

Abstract Expressionism's Others: Race, Gender, and the Politics of Exclusion

Tobey's paintings may also have been too easily associated with the decorative art traditions of Asian cultures. Decorativeness was, according to the art historian Ann Gibson, "the nightmare of abstraction, its mindless doppelganger." The all-overness of many Abstract Expressionist canvases had to be distinguished from mere decorative patterning. This was done by claiming

that the content of Abstract Expressionist art was universal and its execution spontaneous, the exact opposite of the carefully executed decorative object. Newman even argued that the abstract designs on the woven baskets of Kwakwaka'wakw (or Kwakiutl) women were decorative, with all the disdain the word entailed, while the abstract designs carved and painted by Native American men had a metaphysical meaning, and were thus more aesthetically significant.

Gibson has also pointed out the exclusive and exclusionary character of the group identified in the late 1940s and early 1950s and since as the core of Abstract Expressionism—Pollock, de Kooning, Motherwell, Rothko, Still, Kline, Gottlieb, Gorky, Newman. This character is strikingly evident when one looks at the photograph by Nina Leen accompanying an article on the new school of abstract art in the January 15, 1951, issue of *Life* [8.16]. Among "The Irascibles," so-called because of their protests against the Metropolitan Museum of Art's exclusion of Modernist art, the lone white female, Hedda Sterne, stands, purse in hand, above a sea of white male faces.

While women, and artists of color, were actively engaging in many of the same explorations of form and content as the canonical Abstract Expressionists, their work was often dismissed as too grounded in the personal. Pollock, Newman, and Still may have spoken of their painting as arising out of their inner selves, but, as indicated above, they saw the resulting forms as universal rather than autobiographical. These forms were manifestations of the collective unconscious, which Carl Jung claimed was shared by all peoples throughout the world. Only when one rose above the particulars of history and biography could one connect with these forms. Peoples who engaged primarily in hunting and agriculture and who preceded or avoided the effects of the industrial revolution were seen as having greater access to this collective unconscious, in large part because of their greater connection with nature and distance from the rationalism that had accompanied industrialization—hence the interest of Modernist artists in their creative expressions. Only the most talented and inspired artists of the industrialized world could reconnect with this unconscious, a reconnection that required both recognition of the limits placed by the world of industry and capital on creative freedom, and the will and talent to transcend that world.

In fact, Greenberg saw the best 20th-century Western artists as now surpassing many contemporary "primitive" peoples in their ability to create universal forms. In his 1939 article "Avant-Garde and Kitsch" he both celebrated the move of avant-garde artists toward the primitive, which he defined in terms of purity and universality, and criticized the art of the "primitives" from

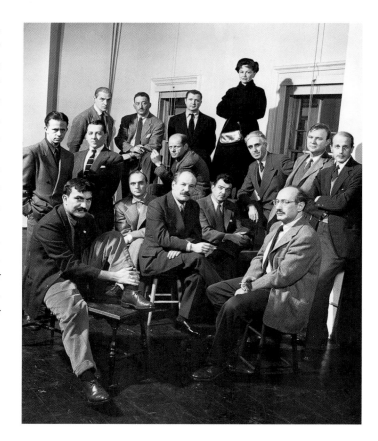

8.16 Nina Leen: *The Irascibles*, photograph reproduced in *Life*, January 15, 1951 From left to right, top row: Willem de Kooning, Adolph Gottlieb, Ad Reinhardt, Hedda Sterne; middle row: Richard Pousette-Dart, William Baziotes, Jackson Pollock, Clyfford Still, Robert Motherwell, Bradley Tomlin; bottom row: Theodoros Stamos, Jimmy Ernst, Barnett Newman, James Brooks, Mark Rothko

whom Modernist artists were drawing inspiration, for the art of these peoples—"the natives of China," "the South American Indian"—was being corrupted by Western kitsch. Thus, only the civilized white Western artist, existing in a self-imposed isolation from the everyday Western world and from the world of "primitive" peoples, could produce a pure, universal art.

Critics used a similar argument to dismiss African American and Native American abstract artists. Their references to non-Western aesthetic traditions were often seen as evidence of the extent to which these artists were rooted in their own past. When Adolph Gottlieb utilized African forms, his work was read as universal; when the African American artist Hale Woodruff (1900–80) drew on such forms, as in *Afro Emblems* of 1950 [8.17], his work was seen as biographical. By the end of the 1940s, the canonical Abstract Expressionists were increasingly removing direct references to African or Native American motifs, along with other content, in the interest of creating an even "purer" painting. Now, in place of "primitive" content, was a "primitive" process, defined by a lack of finish,

8.17 Hale Woodruff: *Afro Emblems*, 1950
Oil on canvas, 18 × 22 in. (45.7 × 55.9 cm.)
Smithsonian American Art Museum, Washington, D.C.

earthy colors, and an "intuitive" approach (Pollock mentions being inspired by the technique used by the Navajo to create their ceremonial sand paintings, where the artist similarly hovers above the picture surface).

Several artists of color followed this line of aesthetic investigation, although it did not necessarily bring them greater recognition than that received by those who continued to mine the iconography of African and Native American art. Leon Polk

8.18 Leon Polk Smith: *New York City*, 1945
Oil on canvas, 47 × 33 in. (119.4 × 83.8 cm.)
Whitney Museum of American Art, New York

Smith (1906–96) resisted borrowing the forms of his own Cherokee culture while attempting to produce an art that was distinctly Modernist. He moved away from his figural paintings of the 1930s to a completely abstract all-over geometricism by the mid-1940s, as can be seen in his *New York City* (1945) [**8.18**]. Like other abstract artists, he spoke of his work in terms of freedom, yet he refused to celebrate "primitivism" as a source of inspiration or of universal forms. He later noted of the art world of the 1940s: "I said 'there is no such thing as primitive art—Africa, Precolumbia—these were highly developed aesthetics, not intuitive superstitions.'"

The African American artist Norman Lewis (1909–79) also moved from a figurative art in the 1930s to increasing abstraction in the 1940s and 1950s, as is evident in his *Every Atom Glows: Electrons in Luminous Vibration* of 1951 [**8.19**]. He actively associated with the key Abstract Expressionist artists and drank with them at their favorite hangout, the Cedar Tavern. Of Caribbean parentage, he had studied art in Europe before coming to New York. Articulate and sharp-witted, he could not be categorized as "primitive" himself. He espoused many of the

8.19 Norman Lewis: *Every Atom Glows: Electrons in Luminous Vibration*, 1951
Oil on canvas, 54 × 35 in. (137.2 × 88.9 cm.)
John P. Axelrod Collection

same painterly concerns as other Abstract Expressionists and, in 1946, argued that black artists did not always have to reflect "Africanness" or social relevance in their work. "I have been concerned," he wrote, "not only with my own creative and technical development but with the limitations which come under the names, 'African Idiom,' 'Negro Idiom,' or 'Social Painting.'" Yet, despite these disclaimers and despite his attempt to distance himself from the calls of earlier black scholars and artists to draw inspiration from both African art and African American life, he was still seen as personally connected to a "primitive" world and unable to attain the distance required to improve upon or transcend it.

Women also faced a persistent attitude within the male-dominated art world that they were generally incapable of creative genius, of transcending the natural world. Their use of non-Western forms was often seen as evidence of their biological connection to that world. Women, and the art they produced, were seen as lacking intellectual rigor and originality. And one of the worst things an artist could be called in the mid-20th century was "derivative." The critic Thomas Hess wrote in 1951: "The American myth of sacrosanct originality (probably initiated by patent lawyers but today perpetuated by all retailers, especially art dealers) has made the possibility of derivation more unmentionable than venereal disease." Critics celebrated not only originality but also consistency. Hedda Sterne (b. 1916) shifted styles regularly during her career, simultaneously painting both realistic portraits and more abstract canvases, such as *Cross* (1946–47) [8.20]. In recalling the late 1940s and early 1950s in an interview with Gibson she stated: "All my friends said, 'stick to one image, stick to one image.' But I wouldn't. Rothko said this to me when we went to a Noguchi show: 'Too many images, too many images.'" Fortunately, her dealer Betty Parsons "never pressured me to stick to anything," and allowed Sterne the aesthetic diversity upon which she obviously thrived.

Lee Krasner (1908–84) faced a particularly complex task in carving out for herself a reputation as a significant abstract artist because of her marriage to a key male Abstract Expressionist—Jackson Pollock. Krasner began working in an abstract vein in the late 1930s, under the tutelage of Hans Hofmann, whose teaching focused on discerning the abstract forms within the natural world and on controlling, in his words, "the emotional accumulations in the process of creation." For Hofmann, art was not unlimited self-expression. Rather, the artist was to exercise control and detachment. In 1945 Krasner married Pollock and, four years later, both were included in an exhibition entitled *Artists: Man and Wife*. The reviewer for *Art News*, undoubtedly with a work like Krasner's *Composition*

8.20 Hedda Sterne: *Cross*, 1946–47
Oil on canvas, 40 × 26 in. (101.6 × 66 cm.)
Collection of the artist

(1949) [8.21] in mind, wrote: "There is also a tendency among some of these wives to 'tidy up' their husbands' styles. Lee Krasner (Mrs. Jackson Pollock) takes her husband's paints and enamels and changes his unrestrained, sweeping lines into neat little squares and triangles."

Krasner did, in fact, create a series of small abstract canvases that imposed an order on the abstract energy of Pollock's large works. She even titled a series that she created from 1946 to 1949 *Little Images*. Krasner admitted that Pollock had an effect on her as an artist. She found his painting "a living force" that "hit hard," and listed him along with Matisse and Picasso as sources of artistic influence. But this does not lead inevitably to the conclusion that Krasner's works were "lesser" Pollocks, "neat and tidy" versions of the great master. Krasner played off of Pollock's paintings in finding her own artistic voice. While Pollock celebrated risk and the presence of the artist, Krasner denied this presence and risk and opted, instead, for the self-control advocated by Hofmann. It was no accident, argues Anne Wagner, that Krasner's rejection of an expressive self occurred in the years immediately following her marriage to Pollock: "The *Little Images*," she writes, "offer a painted answer—hard-won, intellectually rigorous—to

8.21 Lee Krasner: *Composition*, 1949
Oil on canvas, 38¹/₁₆ × 27¹³/₁₆ in. (96.6 × 70.5 cm.)
The Philadelphia Museum of Art, Philadelphia, Pennsylvania

the most difficult problem Krasner faced: establishing an otherness to Pollock that would not be seen as the otherness of Woman. Its urgency was only heightened by social circumstance—by being a wife."

In the early 1950s Krasner's style shifted. She created a series of canvases filled with squares and rectangles that clearly did not allude to Pollock. The reviews of her first one-person show in 1951, which contained these geometric paintings, did not mention him. After his death in 1956 Krasner returned to a gestural mode of painting and increased the size of her canvases, moves that allowed critics once again to comment on the influence of Pollock. Ultimately, Krasner could not shake off her association with Pollock—as his wife, as someone influenced by him as an artist, as his widow, and as the caretaker of his estate and his reputation.

Women fared better in what Irving Sandler has termed the "second generation" of abstract artists, although non-white artists did not. (Sandler includes Leon Polk Smith as a second- rather than first-generation abstractionist but in terms of his age and the length of his career, Smith belongs in the first group.) In his book on this second generation, *The New York School: The Painters and Sculptors of the Fifties*, Sandler documents the success of a small group of artists who took up the "gestural" mode of abstraction of Willem de Kooning (as opposed to the color field alternative of Newman and Rothko) in both painting and sculpture. They included Helen Frankenthaler (b. 1928), Joan Mitchell (1925–92), Grace Hartigan (b. 1922), and Elaine de Kooning (1918–89). While Frankenthaler stained her large abstract canvases with paint rather than brushing it on, as in *Mountains and Sea* (1952) [8.22], Mitchell maintained the slashing brushstrokes

8.22 Helen Frankenthaler: *Mountains and Sea*, 1952
Oil on canvas, 86⅞ × 117¼ in. (220.6 × 297.8 cm.)
Collection of the artist, on loan to the National Gallery of Art, Washington, D.C.

8.23 Joan Mitchell: *Hemlock*, 1956
Oil on canvas, 91 × 80 in. (231.1 × 203.2 cm.)
Whitney Museum of American Art, New York

of Willem de Kooning (Elaine de Kooning's husband), combining them with the all-overness of Pollock's canvases, as in *Hemlock* (1956) [**8.23**]. Hartigan and Elaine de Kooning also worked with paint-laden brushes in creating large canvases

8.24 Grace Hartigan: *River Bathers*, 1953
Oil on canvas, 69⅜ × 88¾ in. (176.2 × 225.5 cm.)
The Museum of Modern Art, New York

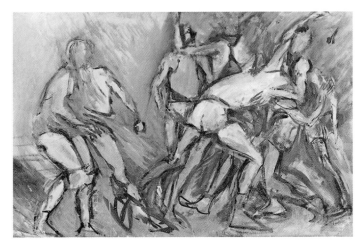

8.25 Elaine de Kooning: *Scrimmage*, 1953
Oil on canvas, 25 × 36 in. (63.5 × 91.4 cm.)
Albright-Knox Art Gallery, Buffalo, New York

that included recognizable subject-matter, as in the former's *River Bathers* [**8.24**] and the latter's *Scrimmage* [**8.25**], both of 1953.

In looking back on the 1950s, Frankenthaler wrote that Greenberg, a friend at the time, saw her first stained painting, *Mountains and Sea* [**8.22**], the day she created it. He "agreed it was 'finished' and shouldn't be touched; that is, complete and shouldn't be added to . . . Clem encouraged me to go ahead and make more. I did." This exchange reveals an important factor in the success of Frankenthaler and the other three artists: their membership in a very influential art world network. In his book, Sandler describes in detail the group of dealers, artists, curators, and critics that was so crucial to a contemporary artist's success in the 1950s in New York and in the United States as a whole. It included the first generation of Abstract Expressionist artists, in particular Willem de Kooning and Hofmann, who remained part of the New York downtown art scene (Pollock, Newman, Rothko and Still were more difficult to gain access to after 1951) and whose reputations, by the mid-1950s, had been solidified within the art world. Also included were the critics Dore Ashton, Clement Greenberg, Thomas Hess, Harold Rosenberg, Meyer Schapiro, and Sandler himself (and the publications for which they wrote, notably *Partisan Review, Nation, The New York Times, Art Digest*, and *Art News*); the art dealers John B. Myers (of the Tibor de Nagy Gallery), Eleanor Ward (of the Stable Gallery), Martha Jackson, Eleanor Poindexter, and Leo Castelli; and the museum professionals Alfred H. Barr, Jr, and Dorothy Miller of MoMA. They arranged exhibitions in the U.S. and abroad, and wrote essays and books consistently promoting a select group of artists. Elaine de Kooning and several other

artists also published criticism in major art journals like *Art News*, praising the work of their colleagues. Sandler's portrait of this intricate world makes it difficult to imagine how any young artist outside of it could have succeeded in New York at the time.

Such an integrated support network was particularly important by the end of the 1950s, for the number of individuals pursuing careers as artists had increased dramatically with the expansion of art schools and art programs within universities, facilitated by the G.I. Bill's funding of postsecondary education for veterans. In addition, as art became part of a booming post-war consumer economy, new institutions were set up both to train artists, whether commercial or fine, and to market their products. This proliferation of artists created a challenge for critics, dealers, and collectors, for how was one to determine "quality" in the increasing numbers of works produced? How was one to identify the "latest" or "newest" style? Artists and critics alike would be compelled to take on many of the same challenges as the manufacturers and advertisers of other commodities, who struggled to maintain their market share with new content or, increasingly, new packaging.

In 1955 *Fortune* reported that the art market, which was beginning to include modern and contemporary art, was "boiling with an activity never known before." Among its "speculative or 'growth' painters," *Fortune* listed Willem de Kooning, Pollock, Baziotes, Motherwell, Still, Kline, Ad Reinhardt, and Larry Rivers. Rivers (1923–2002), like de Kooning, felt no need to ban the figure from his paintings. While Greenberg and others may have sung the praises of nonrepresentational art, there was still much interest in figurative abstraction. In a 1955 article in *Art News*, Elaine de Kooning challenged the notion that banning all recognizable references to the figure, or subject-matter in general, was revolutionary in itself. "Docile art students," she wrote, "can take up Non-Objective art in as conventional a spirit as their predecessors turned to Realism." The absence or presence of subject-matter or the suggestion of three-dimensionality were irrelevant. "In art, flatness is just as much an illusion as three-dimensional space. Anyone who says 'the painting is flat' is saying the least interesting and least true thing about it." In fact, subject-matter was one of the most interesting things about painting. A "living subject" could bring to life a "dead style."

In addition to exploring figuration, Rivers also realized the need to create work sufficiently shocking to draw the attention of both artists and critics. Of his 1953 painting *Washington Crossing the Delaware* [8.26], a contemporary take-off on the famous 19th-century painting of the same name by Emanuel Leutze, Rivers wrote:

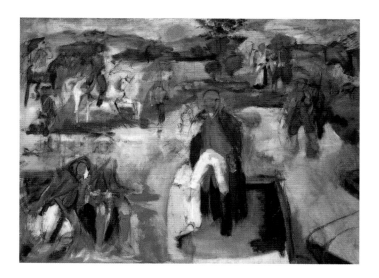

8.26 Larry Rivers: *Washington Crossing the Delaware*, 1953
Oil, graphite, and charcoal on linen, 83⅝ × 111⅝ in. (212.4 × 283.5 cm.)
The Museum of Modern Art, New York

I was energetic and ego-maniacal and, what is even more important, cocky and angry enough at the time to want to do something no one in the New York art world doubted was disgusting, dead and absurd, rearrange the elements, and throw it at them with great confusion. Nothing could be dopier than a painting dedicated to a national cliché.

As we will see later in this chapter, others would carry this desire to shock and confuse even further, spurred by both personal ambition and the increasing demands of an expanding art market for something outrageous and new.

Pastiche and Parody: Another Take on the Real

The Blurring of Boundaries:
Painting into Sculpture, Junk Into Art

It is not surprising that Marcel Duchamp thought little of Abstract Expressionism, concerned as it was with painting as an end in itself and as a primarily visual or "retinal" experience, with the artist as anguished creator. Duchamp was much more concerned with the intellectual aspects of image-making, with the processes by which a particular object is designated "art" (see pp. 347–49). The composer John Cage (1912–92), who was strongly influenced by Duchamp, also rejected the celebration of the artist as existential hero and the artwork as "masterpiece." He took up Duchamp's focus on the everyday, as represented in the artist's *Fountain* [6.42] and his other ready-mades. For Cage, aesthetic inspiration was to be found in the world outside the studio, not in the inner recesses of

an artist's psyche. As he stated in an interview with Sandler in 1966: "I want to change my way of seeing, not my way of feeling."

One of the first artists to exploit the ideas of Cage and Duchamp in challenging the virile and existential assumptions of Abstract Expressionism was Robert Rauschenberg (1925–2008). Rauschenberg began the decade as a member of the inner circle of Abstract Expressionists. He was a friend of Kline and hung out at the Cedar Tavern. He had also exhibited with several of the major figures in group shows. This early work included paintings that were all one color,—white, black, red—some of which were devoid of any surface texture or recognizable imagery, others of which included newsprint dipped in paint and stuck to the canvas. Rauschenberg met Cage in 1951 at Black Mountain College in North Carolina, where much avant-garde experimentation took place across the fine arts. The encounter encouraged him to investigate more fully the relationship between "art and life," between objects considered art and objects considered junk or non-art. It also encouraged him to evaluate his relationship to the current paintings and artistic identities of the canonical Abstract Expressionists. This critical assessment manifested itself in 1953–54 with his abandonment of painting and the construction of multi-media works that he would refer to as "combines." Rauschenberg's relationship with Willem de Kooning in particular at the time is captured in his 1953 *Erased De Kooning*, in which he erased a drawing given to him by de Kooning for this very purpose.

The art historian Jonathan Katz adds another figure to the list of significant influences on Rauschenberg in the 1950s—Jasper Johns (b. 1930). Johns and Rauschenberg are constantly presented as a pair of artists who constituted their own movement, labeled variously as junk art or proto-Pop. They often exhibited together and were discovered by their dealer, Leo Castelli, at the same time in 1957. While they have thus been identified as an artistic pair, they have seldom been written about as a couple which, in fact, they were from 1954 to 1961. Katz argues that their emotional and physical relationship was just as significant for their work as their public artistic relationship. It provided a "community" denied to them by the insistent heterosexuality of Abstract Expressionism and the intense homophobia of Cold War society in general (Katz points out that more homosexuals than communists lost jobs in the federal government during the Red Scare purges of the 1950s).

Much of the work of Johns and Rauschenberg can be read as a dialogue between them, one that often includes coded references to gay culture, if not literal references to their relationship (e.g. fragments of letters). At the same time, one of the greatest

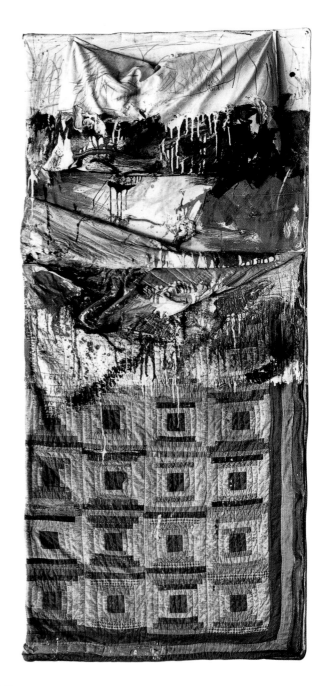

8.27 Robert Rauschenberg: *Bed*, 1955
Combine painting, oil and pencil on pillow, quilt and sheet on wood supports, 65¾ × 31½ × 8 in. (191.1 × 80 × 20.3 cm.)
The Museum of Modern Art, New York

presences in their art is their joint opposition to, or at least ironic critique of, Abstract Expressionism. In *Bed* of 1955 [8.27] Rauschenberg locates the rationale for Modernist painting in male sexuality: a quilt and pillow are partially covered with the expressive explosions of paint of Abstract Expressionists like Pollock and de Kooning, so clearly celebrated as "virile" and "masculine" by contemporary critics. *Bed* has a violent element

as well, with the paint suggesting blood and urine and vomit. Some critics observed that it invoked the site of a rape or a murder. One could not rise to the level of the universal in responding to Rauschenberg's piece. Instead, it insistently forced the viewer to address the material reality of the world both inside and outside of the artist's studio.

Rauschenberg's multi-media collage *Bantam* (1954) [8.28] contains a more subtle and coded commentary on masculinity, femininity, gay subculture, and the art of the avant-garde. The fabric swatches suggest the all-over patterning of certain abstract canvases, pointing to a factor which certain critics and Abstract Expressionist artists ignored or denied—the connection between their work and textiles or decorative art, art forms associated with the feminine rather than the masculine. The bold strokes of paint covering the fabric swatches can be seen as Rauschenberg's commentary on this denial, this attempt to obliterate the tightness and order of the feminine with the

looseness and messiness of the masculine. Katz also suggests that masculine anxiety is present in the title: according to Webster's Dictionary, "bantam" means "1 . . . a small but aggressive or pugnacious person; 2. any of several breeds of small fowl in which the male is often a good fighter; 3. a boxer or wrestler weighing between 113 and 118 pounds." "In short," writes Katz,

bantam refers to an over-wrought, overacted masculinity— a kind of nervous overcompensation of a perceived lack. Here the gestural paint splashed over the Yankees photo, coupled with a curious title, seems to deliver a highly coded, campy indictment of Abstract Expressionism and its self-conscious and exaggerated masculinity.

8.28 Robert Rauschenberg: *Bantam*, 1954
Mixed media
Private collection

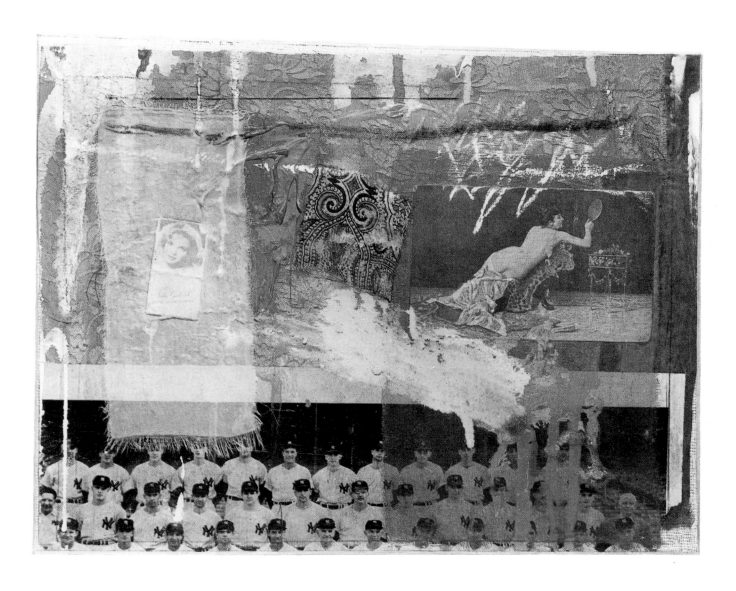

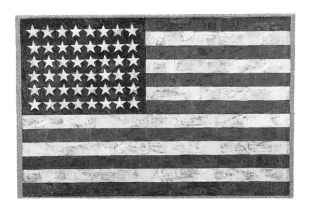

8.29 Jasper Johns: *Flag*, 1954–55
Encaustic, oil and collage on fabric mounted on plywood,
42¼ × 60⅝ in. (107.3 × 153.8 cm.)
The Museum of Modern Art, New York

8.30 Jasper Johns: *Target with Plaster Casts*, 1955
Encaustic and collage on canvas with objects,
51 × 44 × 3½ in. (129.5 × 111.8 × 8.8 cm.)
Collection David Geffen

The autographed photograph of Judy Garland, the "high priestess" of gay culture in the 1950s, and the sensuously posed odalisque provide a female counterpart to this exaggerated masculinity, and thus highlight the performative aspects of both masculinity and femininity. In multi-media works like this Rauschenberg also appeared to be taking on Clement Greenberg, who wrote in 1954: "In fact, it seems as though, today, the image and object can be put back into art only by pastiche or parody—as though anything the artist attempts in the way of such a restoration results inevitably in the second-hand." Rauschenberg literally takes the second-hand or used object to construct his parodies of the Abstract Expressionist avant-garde.

Johns first gained attention with his paintings of American flags and targets, for example *Flag* (1954–55) [**8.29**] and *Target with Plaster Casts* (1955) [**8.30**]. They were smaller than most of Rauschenberg's works, more controlled, and less openly ironic. (Johns's first flag was included in an assemblage of

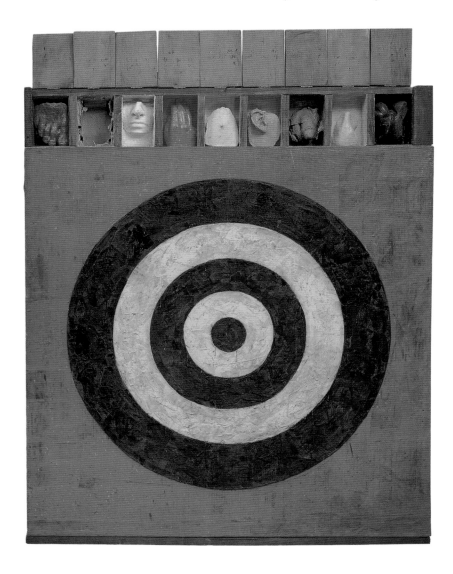

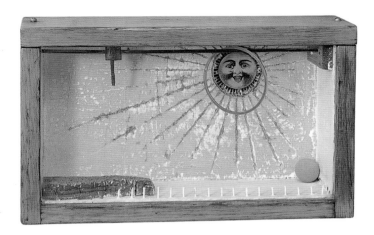

8.31 Joseph Cornell: *Sun Box, c.* 1955
Painted wood, metals, and cork, 7¾ × 12⅞ in. (19.7 × 33 cm.)
Collection Mr and Mrs B. H. Friedman, New York

1955 by Rauschenberg entitled *Short Circuit.*) *Target with Plaster Casts* recalls another multi-media or collage artist, Joseph Cornell (1903–72). Cornell had been constructing boxes filled with personal, highly enigmatic objects since the 1930s, drawing on the random accumulations of various Surrealist works. His *Sun Box* of *c.* 1955 [**8.31**] continues this gathering of objects which, on their own, are seemingly mundane but which, when placed together, suggest a wealth of associative meanings. Here a smiling sun is framed by a metal ring hanging from a rod stretching the width of the box. Beneath are a ball, a piece of cork, and a row of nails painted white.

The associations prompted by Johns's works are less playful or romantic. Rather, there is a coolness in his creations, a resistance to the poetic or mythological. Like Rauschenberg's combines, they also lack the high drama of Abstract Expressionist canvases, a drama used by critics as evidence of the artist's manliness or Americanness. Yet what is present—the American flag and a target—engages with questions of nationality and with current political controversies, for the American flag and a target constituted two highly charged images in the 1950s. In the midst of hysterical patriotism and the targeting of supposed communists, homosexuals, and others deemed "subversive" by members of HUAC and other right-wing politicians, Johns calmly asks the art world to consider these two images as works of art, to address, for example, the issue of two-dimensionality so central to Modernist theory—is the painting a painting or a flag? He also creates a rich, textured surface, using encaustic (pigment mixed with wax and applied while hot) over crumpled pieces of newspaper. Greenberg addressed this tension between the surface texture, the flatness

of the canvas, and the content in 1962, when he wrote of paintings like Johns's *Flag*:

> The original flatness of the canvas, with a few outlines stenciled on it, . . . [represents] all that a picture by Johns really does represent. The paint surface itself, with its de Kooning-esque play of lights and darks, is . . . completely superfluous to this end. Everything that usually serves representation and illusion is left to serve nothing but itself, that is, abstraction; while everything that usually served the abstract or decorative—flatness, bare outlines, all-over or symmetrical design—is put to the service of representation.

Thus, one can read Johns's paintings as complex aesthetic statements, as representations of the stifling of dissent and persecution of difference in the name of national security—or as both.

Johns and Rauschenberg continued to exchange ideas throughout the 1950s and to create mixed-media works and paintings that called attention to art world discourses about sexuality and about style and content, in particular the dictum that painters must focus on the "essence" of painting—two-dimensionality—and sculptors the essence of sculpture—three-dimensionality. In his 1961 essay "Modernist Painting," Greenberg wrote that three-dimensional space was "the province of sculpture, and for the sake of its own autonomy painting has had above all to divest itself of everything it might share with sculpture. And it is in the course of its effort to do this, and not so much . . . to exclude the representational or the 'literary,' that painting has made itself abstract." The art of Johns and Rauschenberg was a clear denial of the need for such a separation. They helped open the way for the return of a particular kind of content in the contemporary art scene in New York, a content that focused on the changing lives of Americans and the material evidence of those lives.

Two additional artists working in New York who carried forward this breaking down of the division between painting and sculpture and between avant-garde art and everyday life were Louise Nevelson and Marisol Escobar. Nevelson (1900–1988) was one of many artists who, in the 1950s, began searching city streets and junk yards for source material, incorporating the detritus of consumer culture into their art. Like John Chamberlain (b. 1927), Nevelson played with the tension between the original function of the recycled objects and the new aesthetic meaning given to them by their reworking by an artist and relocation into the spaces of the art world. While Chamberlain focused in his early work on

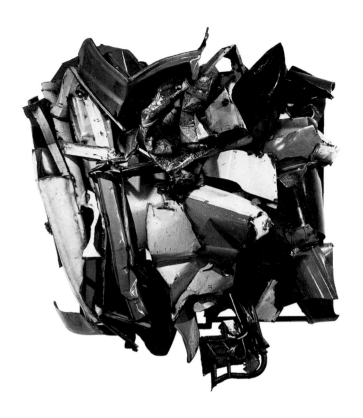

8.32 John Chamberlain: *Essex*, 1960
Automobile body parts and other metal, relief, 108 × 80 × 43 in.
(274.3 × 203.2 × 109.2 cm.)
The Museum of Modern Art, New York

8.33 Louise Nevelson: *Dawn's Wedding Chapel II*, 1959
Wood, 115⅞ × 83½ × 10½ in. (294.3 × 212.1 × 26.7 cm.)
Whitney Museum of American Art, New York

crushed metal parts evoking the ubiquitous automobile, as in *Essex* (1960) [**8.32**], Nevelson preferred wooden forms taken from furniture or the interior woodwork of domestic spaces. Her *Dawn's Wedding Chapel II* (1959) [**8.33**] is composed of several wooden boxes or crates, arranged to mimic the facade of a church with its two towers, and filled with spindles from banisters, the legs of chairs, and other bits of odd-shaped wood that appear to be left-overs from a construction site. A coat of ivory paint unites the disparate objects, while the piece's title suggests the color is that of a wedding dress. Nevelson has thus taken cast-off materials and imbued them with a sense of sacredness and ritual.

Marisol Escobar (b. 1930)—she used Marisol as her professional name—was born in Paris of Venezuelan parents and came to the United States in 1950. In the early 1960s she began creating carved and painted wooden figures often described as hovering between the urbane and the naive, between fine art and folk art. As can be seen in *Women and Dog* (1964) [**8.34**], her human figures are often only partially carved out of the wooden blocks, with arms or legs outlined in paint or carved separately and attached. Sometimes the head is too small or too large, suggesting a lack of understanding of human proportions. The paint is often applied in flat areas of color, outlining a dress or a handbag in the simplest of forms.

Marisol's work has been described as narcissistic by some critics, for the majority of the carved human forms she created contain her own face, as is the case with *Women and Dog*. The fact that she was attractive increased the perception that, like so many women, she was obsessed with her own physical appearance. Yet the multi-media sculptures that bear Marisol's features are varied in their identities and the roles they assume—child, adolescent, mother, clothed, partially clothed, etc. They also contain references, like the works of Rauschenberg and Johns, to various artistic styles—the multiple faces suggesting the multiple perspectives of Cubism, the patterning on the skirt and blouse referencing geometric abstraction, the cowhide handbag a miniature Clyfford Still. One can interpret Marisol's art, therefore, as a self-conscious and ironic commentary on both the roles assigned to women

8.34 Marisol (Escobar): *Women and Dog*, 1964
Wood, plaster, synthetic polymer paint, taxidermed dog head, and mixed media,
72¼ × 73 × 30⁵⁄₁₆ in. (183.5 × 185.4 × 77 cm.)
Whitney Museum of American Art, New York

in contemporary American society and stylistic developments within the art world.

Opting Out and Raging On: Art of the Beat Generation

Artists on the West Coast were also engaged in the creation of assemblages during the late 1950s and early 1960s, often with a more explicitly political content. With little in the way of a well-established art market or gallery system, artists in Los Angeles and San Francisco relied on their own avant-garde communities for ideas and support. In San Francisco this community included Jess (Burgess Collins, 1923–2002) [8.37] and Bruce Conner (1933–2008), poets Robert Duncan and Allen Ginsberg, and writer Jack Kerouac. Ginsberg and Kerouac were key figures in what was known as the Beat generation (a term coined by Kerouac in 1948)—poets, writers, musicians, filmmakers and artists who, beginning in the early 1950s, preached rebellion as the only answer to the prevalent political repression and conformity of the time. They rejected the lure of the suburban home and two-car garage, and opted instead for opting out. Their creative work drew on American literary giants like Walt Whitman, and on Zen Buddhism, drugs, Hollywood, and the down and out. They ferreted out the seamier side of American life and celebrated it. They wrote sexually graphic and often autobiographical poems and books and were sometimes successful in defending them against obscenity charges, as was the case with Ginsberg's *Howl and Other Poems* (1956) and William Burroughs's *Naked Lunch* (1959).

Several photographers of the 1950s replicated the Beat sensibility. In 1959 Robert Frank (b. 1924), who came to the

8.35 Robert Frank: *Charleston, South Carolina*, from the series *The Americans*, 1953–57
Gelatin silver print
Addison Gallery of American Art, Phillips Academy, Andover, Massachusetts

organized by Edward Steichen, 503 images by photographers from 68 countries were selected to show the commonalities of peoples throughout the world, commonalities based in emotions such as joy, sorrow, and anger. Absent are references to the political turmoil experienced throughout Africa and Southeast Asia, where European colonial regimes were crumbling as a result of another common feeling—the desire for self-governance. Rather than focus on an imagined sense of kinship, Frank looked for the odd and the troubling, the divisions that could be found throughout America [**8.35**].

Frank was joined in his depictions of the odd and the troubling by Diane Arbus (1923–71). Arbus began her career working with her husband as a fashion photographer, first for her father's store, then for magazines like *Harper's Bazaar*. In the late 1950s she turned her attention not to the nation's most beautiful, as defined by the fashion industry, but to those omitted from fashion magazines and other mass media publications. The figure in *A Young Man in Curlers at Home on West Twentieth Street, New York City* (1966) [**8.36**] is both the opposite and the same as the fashion model. The sameness lies in the concern of both with artifice—the curlers, the make-up, the nail polish. Yet *Young Man*

United States from Switzerland in 1947, published a mammoth book of photographs, *The Americans* (Jack Kerouac wrote the introduction). The many scenes were captured on a trip across the country funded by a Guggenheim Fellowship. Their mood is very different from that of a collection of photographs displayed in 1955 at MoMA in New York, and later internationally, under the title "The Family of Man." For that exhibition,

8.36 Diane Arbus: *A Young Man in Curlers at Home on West Twentieth Street, New York City*, 1966
Gelatin silver print
The Museum of Modern Art, New York

8.37 Jess (Burgess Collins): *The Mouse's Tale*, 1951–54
Collage and gouache on paper, 47 × 32 in. (119 × 81.2 cm.)
San Francisco Museum of Modern Art, San Francisco, California

orgy of male flesh. Certainly Jess had a role model in his partner Robert Duncan, who, as early as 1944, had written an article in the New York journal *Politics* arguing that gay writers needed to reveal their sexuality. He also undoubtedly knew about the many paintings by Paul Cadmus containing homoerotically charged male bodies [**7.73**].

Ed Kienholz (1927–94), a key figure in the founding of the Ferus Gallery in Los Angeles, confronted viewers with direct and often gruesome commentaries on political and social injustices, taking on issues such as health care, abortion, and the Vietnam War. His *The Illegal Operation* (1962) [**8.38**] contains a dirty sack resting on an old shopping cart, ripped open with its insides spilling out, a stark symbol of the cruelty and pain suffered by the women forced to resort to illegal back-alley

8.38 Ed Kienholz: *The Illegal Operation*, 1962
Mixed media, dimensions variable
Collection of Betty and Monte Factor

unmasks the artifice. Here is the scene behind stage, before the transvestite enters the public realm, where his disguise may well fool the undiscerning passer-by. This man is "odd" only in the sense that he exists outside of socially defined standards of normality. Arbus makes him visible as a fitting subject for art, rather than for police or tabloid photography, while at the same time replicating the harsh look of police photographs. To criticisms that Arbus exploits the circus "freaks" and transvestites and other social outcasts in the very process of photographing them, the photography historian Robert Hirsch responds:

> Arbus's pictures are not about types of freaks but a cataloging of that communal secret of wanting to be "normal" and wanting to be accepted for who we are. The pain that makes viewers avert their eyes is due to the internal violence Arbus pictures between the void of our inner self-perception and that of outer public reality.

The works of Beat poets and artists, like Arbus's photographs, also contained a sexual outspokenness that raised the anxieties of Cold Warriors intent on suppressing any kind of nonconformity or difference. One of Jess's earliest collages, *The Mouse's Tale* of 1951–54 [**8.37**] (based on a concrete poem by Lewis Carroll), is much more obvious in its references to homosexuality than the work of Johns and Rauschenberg. The large human figure is made up largely of scores of male pinups, a veritable

abortions. The whole installation, including a filthy bedpan and bucket of rags, is harshly lit by the bare bulb of the lamp. It would be another decade before women in the United States would have access to safe and legal abortions.

Passionate Obsessives: Sabato Rodia and James Hampton

While Kienholtz, Rauschenberg, Chamberlain, Nevelson and many other artists were self-consciously rejecting the traditional materials of the art world and the formal dictates of Greenbergian Modernism, others were mining the aesthetic

8.39 Sabato (Sam) Rodia: Watts Towers, Los Angeles, California, 1921–54

potential of cast-off materials or junk for different reasons. These individuals have been categorized as self-taught or folk artists, and have only in more recent years been viewed by critics, curators, and art historians as a significant part of the artistic legacy of the United States. The two best-known of those who created sculptural works out of recycled material in the mid-20th century are Sabato (Sam) Rodia (1875–1965) and James Hampton (1909–64).

Rodia came to the United States from Italy in 1893, finding employment as a laborer on construction jobs and eventually settling in California. Between 1921 and 1954 he created a series of elegant, open towers and garden ornaments in the yard of his home in Watts, a low-income community of Los Angeles [8.39]. The highest of the towers rose to approximately 90 feet (27 meters). They were made up of broken plates, bottles, tiles, and shells fixed to a foundation of steel bars covered with concrete reinforced with wire. Rodia constructed them without the aid of scaffolding and drew only upon the knowledge of structural design he had accumulated during his years in the building trades. The soundness of that knowledge was revealed when, in 1957, the city of Los Angeles attempted to have the towers dismantled, claiming they were dangerous. A group of artists and others within the Los Angeles cultural community rallied to save them and had them subjected to several stress tests, which they passed. The work subsequently became a monument to the creative potential of individuals outside of the art world, who may have lacked training or resources but not skills, initiative, or imagination.

Hampton was a contemporary of Rodia on the East Coast. An African American who worked as a night janitor in various federal buildings in Washington, Hampton was also deeply religious, having grown up the son of a Baptist preacher in Elloree, South Carolina. He said he had received regular visits from angels since 1931, shortly after his arrival in the capital, and it was upon their instruction that, in 1950, he began the construction of *The Throne of the Third Heaven of the Nations Millennium General Assembly* [8.40], a work that occupied him until his death in 1964. Composed of almost 180 separate pieces made up of old furniture, light bulbs (representing the light of Christ), bottles, cardboard, and other discarded objects covered with silver and gold foil, the *Throne* was intended as a liturgical display in his church, although it ultimately ended up in the Smithsonian Institution after his death (during his life it was in the garage he had rented to build it).

Like Rodia's Towers, Hampton's Throne is overwhelming in its detail and imaginativeness. The art historian Lynda Roscoe Hartigan posits that Hampton may well have drawn inspiration for this work from the interiors of urban storefront churches, which were adaptations of rural churches to city life. Their

8.40 James Hampton: *The Throne of the Third Heaven of the Nations Millennium General Assembly*, c. 1950–64
Gold and silver tinfoil, Kraft paper, plastic over furniture, and paperboard, 177 pieces, 10 ft. 6 in. × 27 ft. × 14 ft. 6 in. (3.2 × 8.23 × 4.42 m.)
Smithsonian American Art Museum, Washington, D.C.

altars were often made up of inexpensive furniture and included prominently placed text on the walls (Hampton includes text throughout his installation). The monumentality and richness of his *Throne*, however, come not from these modest places of worship, suggests Hartigan, but from the institutions set up by contemporary charismatic, theatrical preachers like Charles M. "Sweet Daddy" Grace. In addition to overseeing his United House of Prayer for All People of the Church of the Rock of the Apostolic Faith in Washington, and numerous branches throughout the country, Grace staged mass baptisms, faith-healings, and other public spectacles. He is said to have preached from a white satin throne in his District United House of Prayer.

The evolutionary biologist Stephen Jay Gould, in writing about Hampton's Throne, wonders at the way in which people like Hampton are so often dismissed as crazy:

The passionate obsessives of our culture, whether they memorize pi to one thousand places or spend their lives building an image of their dreams, must always bear this cross of our cruel assumption that no sane person could approach anything that makes no money with such single-minded dedication.

These individuals had somehow resisted the profit-driven logic of capitalism and drawn upon a love of craft or a commitment to a higher spiritual power. Gould warns, however, against dismissing the *Throne* as "the idiosyncratic vision of one peculiar man, a work fueled from within and entirely outside the traditions of art and society." Instead, it is, among other things, an intricate and complex representation of "the traditional biblical concept of time and its meaning for human history." In its bilateral symmetry around the central throne of Christ, and in its tracing of the Old and New Testaments through inscriptions on the viewer's right (Old) and left (New) sides, Hampton captures the dual aspect of time articulated within the Bible, what Gould has termed "time's cycle" and

"time's arrow." The bilateral imagery, with its repeated forms on either side of the throne, represents the cyclical nature of time, the events that are paralleled in the Old and New Testament and that provide order, rules, and laws. The linear tale of biblical history, "time's arrow," provides meaning to individual lives, for if all events simply repeated themselves, none would be distinctive or unique. Hampton may have been directed to construct his Throne by angels, but the resulting work was informed by his detailed and life-long study of the Bible.

A Commitment to Social Justice: Milton Rogovin and Elizabeth Catlett

Religion, and the storefront churches in which it was often practiced, also informed the work of the photographer Milton Rogovin (1909–2011). Rogovin, born in New York City, was the son of Russian-Jewish immigrants. Trained as an optometrist in the late 1920s, he worked within this profession during the 1930s, at the same time joining in the political radicalism sparked by the Great Depression (see Chapter 7). Upon his move to Buffalo, New York in 1938, he became a member of the United Optical Workers Local Industrial Union 951 (CIO), and the following year set up a private practice devoted primarily to the city's union members. After serving in the U.S. armed forces during World War II, he returned to Buffalo to resume his optometry practice. Because of the Cold War hysteria of postwar America, however, Rogovin lost many of his customers. In addition, after being called before the House Committee on Un-American Activities in 1957 and labeled "Buffalo's No. 1 Communist" in the *Buffalo Evening News*, he found it increasingly difficult to act directly upon his political beliefs.

Rogovin had started taking photographs in 1942, and it was to this medium that he turned in the 1950s as a way, in the words of the art historian Melanie Herzog, to "make people conscious of social and economic inequities . . . [B]y visually documenting the problems of the poor he could make people think about these issues of social justice."

In 1958 Rogovin began photographing a series of storefront churches in some of the poorest African American communities in Buffalo. One of these photographs, taken in a church housed in a former barber shop [8.41], shows the secondhand furniture and the handmade signs that marked many such storefront church interiors and echo Hampton's *Throne of the Third Heaven* [8.40]. Rogovin writes:

> The mirrors were still on the walls. The coat and hat hangers were above the mirrors. The minister did not consider it important to repaint the walls, which hadn't had a paint job in many years. One of the parishioners

had created a little picture on a wall—instead of using crayon or marker, he created the image by removing some of the dirt on the wall.

Thus, like Hampton, the parishioners drew upon what was available to adorn their spaces of worship, making of their lack of resources an opportunity for creative expression. Rogovin has captured the multiple ways in which the word, work, and light of God are conveyed to the congregation—the hand-painted sign, the preacher below the bright fluorescent bulbs, and the simple drawing of the crucifix with its rays of radiating light. Text, voice, and picture come together in the frame of the photograph, which is repeated in the frame of the mirror, the focal point of this complex composition.

8.41 Milton Rogovin: *Untitled*, from the series *Storefront Churches*, 1957–61 Photograph

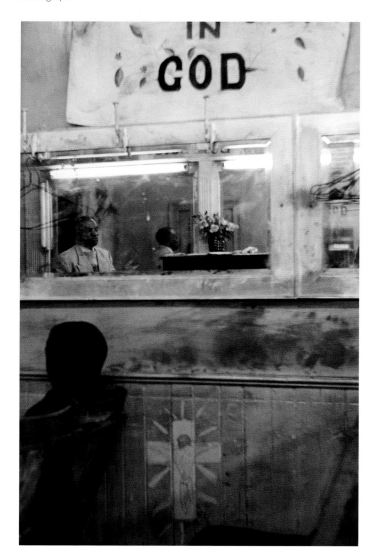

Rogovin worked closely with his photographic subjects, asking for permission to take their pictures and for feedback on the results, providing them with copies of the photographs in which they appeared. Yet he also recognized his position as an outsider, particularly in terms of religion:

> Having been brought up as a child in a Jewish synagogue where the rabbi delivered his sermon in a quiet atmosphere, I was at first disturbed by the music, shouting and seeming lack of coherence of the sermon. I learned to approach the sermon as I would a concerto. The preacher was the soloist accompanied by the musicians and audience.

His understanding of the significance of this musical aspect of church services was drawn, in large part, from African American sociologist and civil rights activist W. E. B. DuBois's book *The Souls of Black Folk* (1903). DuBois relates the importance of the preacher, the music and the trance, and connects them to the experiences of African Americans in slavery. Rogovin contacted DuBois, who subsequently wrote the introduction to the first publication of the photographer's work in 1962 in the magazine *Aperture*.

Rogovin's experience photographing Buffalo's African American storefront churches was, in his own words, "a critical factor in turning me away from being a casual photographer to becoming a thoroughly committed social documentary photographer. Before starting any new series I would have to be convinced that it had the possibilities of dealing with the problems of people; especially the poor, the disadvantaged, the 'forgotten ones.'" Rogovin thus joined a long line of photographers, from Jacob Riis [5.54, 6.14] and Lewis Hine [7.18] to Dorothea Lange [7.19] and Robert Frank [8.35] who attempted to engage with the material realities of their subjects through a photographic approach that merged the aesthetic and the social. He would go on to record the lives of working-class people in Buffalo and throughout the world, providing insight into the way they lived, both at work and at home.

Before turning to the storefront churches of Buffalo, Rogovin took a series of photographs of the people of Mexico during several trips to this country with his wife Anne in the early 1950s. These images were informed by both his vision of social justice and the work of a group of printmakers at the *Taller de Gráfica Popular* (TGP, the People's Graphic Art Workshop), located in Mexico City. Founded in 1937, the TGP was committed to the production of inexpensive black-and-white linocuts (with some woodcuts and lithographs) celebrating the lives and achievements of the Mexican people and criticizing the social injustices to which they were often subjected. The printmakers put themselves at the services of various working-class or activist organizations that needed graphic images. The Rogovins returned to the U.S. with copies of their work, which they sold to raise money for the workshop.

During their time in Mexico, the Rogovins met another American artist greatly influenced by the TGP, the sculptor and printmaker Elizabeth Catlett (b. 1915), who was a member of the workshop at the time of their visit. A native of Washington, D.C., she first studied art at Howard University with the painter Lois Mailou Jones (1905–98) and the art historian James Porter (1905–70), then at the University of Iowa with Grant Wood [7.68, 7.69] and subsequently in New York City with the Russian-French abstract sculptor Ossip Zadkine (1890–1967), emerging at the beginning of the 1940s as an up-and-coming young sculptor. She also studied printmaking at the Art Students League in New York City with the activist printmaker Harry Sternberg [7.1].

Spurred by an earlier interest in the revolutionary work of Mexican muralists (see pp. 359–60, 407–11, 417–18) and printmakers, Catlett traveled to Mexico in 1946 on a Julius Rosenwald Fund fellowship to produce a series of prints, paintings, and sculptures on the struggles and achievements of African American women. After a brief return to the U.S., she went back to Mexico in 1947 and remained there permanently, becoming a full member of the TGP and marrying one of its artists, Francisco Mora (1922–2002).

Herzog describes Catlett's Mexican prints of both Mexicans and African Americans as "a politically charged expression of cross-cultural convergence, a meaningful representation of her Mexican experience in relation to the African American identity she brought to Mexico." In this work Catlett constructed "a visual, historical narrative of individual and collective identity," one "inevitably affected by the changing social and political conditions in Mexico and the United States which she experienced as a socially engaged African American woman living in Mexico in the mid-twentieth century." One of these changes was the Cold War, and while living in Mexico saved Catlett from much of the persecution experienced by Rogovin, the arm of the U.S. government was long; she was briefly imprisoned as a "foreign agitator" in 1959 at the urging of the U.S. embassy, which was intent on deporting U.S. citizens living in Mexico who were "suspected communists" (Catlett subsequently became a Mexican citizen).

Catlett had met several of the TGP artists—José Chávez Morado (1909–2002), Luis Arenal (1908/9–85), and Ignacio Aguirre (1900–90)—before traveling to Mexico. Inspired by

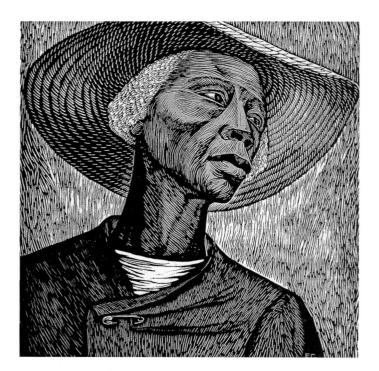

8.42 Elizabeth Catlett: *Sharecropper*, 1950s (before 1952)
Linocut, 17⅜ × 16¾ in. (44.1 × 42.5 cm.)
Collection of Elizabeth Catlett

Minimal Forms and Art as Idea

The Hard Edge: Painting and Sculpture

In her 1955 article defending recognizable subject-matter in painting (see p. 475), Elaine de Kooning was clearly taking on the pronouncements of Clement Greenberg and of artists like Ad Reinhardt. Just as Greenberg had proclaimed that representation could never lead to major art, but was bound to result in "second-hand, second-rate painting," so Reinhardt (1913–67), who had studied with Hofmann and who created large canvases containing subtly rendered geometric forms, argued that the presence of representational imagery and illusionistic space only diminished a painting's significance. Instead, artists had to search for the "artness" of art, which, in the case of painting, could be found in its flatness.

In the mid-1950s Greenberg threw his critical weight behind young artists who were banning illusionistic space from their canvases, who were turning away from Willem and Elaine de Kooning and following up, instead, on the color field paintings of Newman, Still, and Rothko. For example, in *Charter* (1959) by Ellsworth Kelly (b. 1923) [**8.43**] both geometric and organic forms are isolated, enlarged, and reduced to their basic outlines,

8.43 Ellsworth Kelly: *Charter* (EK 226), 1959
Oil on canvas, two joined panels, 95 × 60 in. (241.3 × 152.4 cm.)
Yale University Art Gallery, New Haven, Connecticut

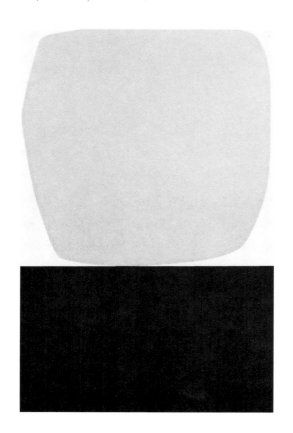

their powerful visual narratives of the struggles of Mexicans in the past and the present, Catlett produced a series of fifteen small linocuts entitled *The Negro Woman* (1946–47), which included both anonymous women working in the home and the fields, and such historical figures as Harriet Tubman.

Around this time Catlett also produced *Sharecropper* (c. 1950–52) [**8.42**], one of her best-known linocuts. Herzog describes this print as a "superb example of the fusion of artistic languages." To the "expressionistic angularity" of this image of an African American woman, a stylistic trait common in Catlett's pre-Mexico prints, she adds the "careful, closely spaced hatchings" used "to delineate contour, pattern, material, and texture" that were common in the work of the TGP. Combined, these stylistic devices result in an image that both foregrounds the power and centrality of the female figure and anchors her in the natural environment of fields and gardens (the grass-like background hatching, the carefully delineated straw of the hat) that sustains her very existence. The success of this stylistic fusion is echoed in the print's welcome reception in both the U.S. and Mexico: it won a graphic art prize in the Atlanta University Annual Exhibition in 1952 and appeared in the Mexican journal *Artes de México* in 1957. A color version became particularly well known in the U.S. in the 1970s, when Catlett's work formed an important part of a new African American arts movement (see pp. 512–17).

delimited by hard edges and bright colors or contrasts of black and white. Kelly rejected the spontaneity and ambiguity of the gestural abstractionists for an art of clarity, simplicity, and control. So too did Frank Stella (b. 1936) in a series of large black paintings, first exhibited in 1959 at MoMA. In these works, such as *Die Fahne Hoch!* ("The flag on high!") (1959) [8.44], Stella produces a regularly spaced black grid, resembling the pattern of a black pinstripe suit, in which the thin lines of unprimed canvas articulate the edges of each black stripe. These evenly spaced stripes radiate out from a center that is sometimes within the frame of the canvas, sometimes outside of it. Stella's paintings are marked, overall, by a strong sense of anonymity and regimentation. Yet, at the same time, this anonymity is given a historical location in the title, which refers to a Nazi anthem (the "Horst Wessel Song"), and thus to the death and destruction created during Hitler's regime.

Several of the artists Greenberg championed also followed in the path of Frankenthaler [8.22] by staining their canvases with paint rather than applying it with brushes, notably Morris Louis (1912–62) and Kenneth Noland (1924–2010). Gone now was even the suggestion of illusionism in the texture of the paint on the surface of the canvas, although one could still, if one was so inclined, find associations with nature in works like Louis's *Beta Kappa* (1961) [8.45] or Noland's

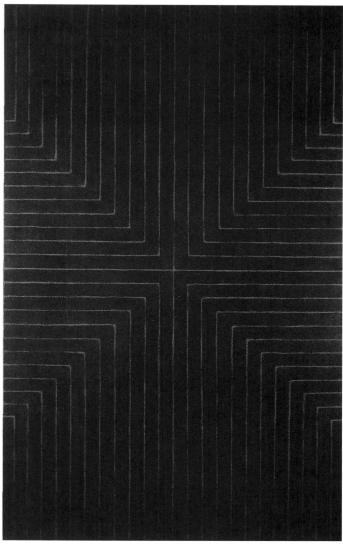

8.44 Frank Stella: *Die Fahne Hoch!* ("The flag on high!"), 1959
Enamel on canvas, 121½ × 73 in. (308.6 × 185.4 cm.)
Whitney Museum of American Art, New York

8.45 Morris Louis: *Beta Kappa*, 1961
Acrylic resin on canvas, 103¼ × 173 in. (262.3 × 439.4 cm.)
National Gallery of Art, Washington, D.C.

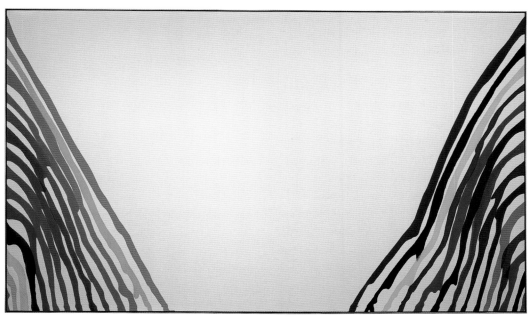

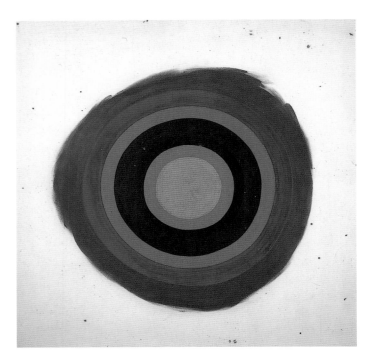

8.46 Kenneth Noland: *Song*, 1958
Synthetic polymer on canvas, 65 × 65 in. (165.1 × 165.1 cm.)
Whitney Museum of American Art, New York

Song (1958) [**8.46**]. The attraction for Greenberg lay in the inexorable march toward flatness and in an originality he was able to celebrate in patriotic terms. In his 1955 article "'American-Type' Painting," Greenberg once again made a nationalistic claim for color field painting's significance (as he had with Pollock and David Smith at the end of the 1940s): it was, he declared, "the most radical of all developments in the painting of the last two decades, and has no counterpart in Paris . . . as so many other things in American abstract expressionism have had since 1944." For Greenberg, Kelly, Louis, and Noland had moved on; Hartigan, Rivers, Willem de Kooning, and others in the gestural and illusionistic camp had not.

Sculptors were also taking up the themes of simplicity, clarity, and control advocated by painters like Kelly and Noland. They found inspiration in the later works of David Smith, particularly his *Cubi* series [**8.47**]. While Smith turned to stainless steel and basic geometric shapes, he maintained an "artfulness" in his sculptures through their burnished surfaces and through his use of a pedestal to set off the piece from the surrounding space (only occasionally does he abandon this pedestal). And while one can walk around them, Smith constructed his pieces with one optimal viewing position in mind. Artists like Donald Judd (1928–94), Carl Andre (b. 1935), Robert Morris (b. 1931), and Dan Flavin (1933–96) took Smith's simplifications one step further, creating a series of pared-down forms that

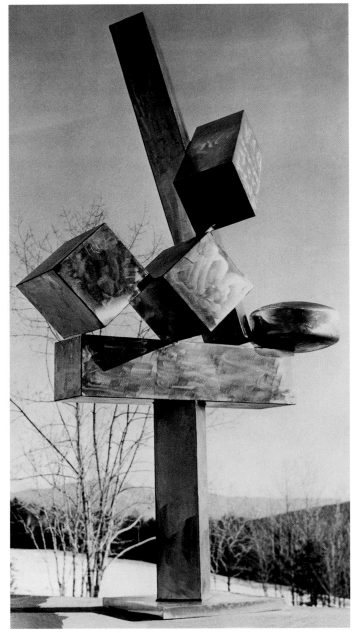

8.47 David Smith: *Cubi XIX*, 1964
Stainless steel, H 113⅛ in. (287.3 cm.)
Tate Gallery, London

initiated a new movement known as Minimalism. They rejected "artfulness" and a privileged viewing position. They took the industrial materials used by Smith and Chamberlain [**8.32**] and removed any vestiges of prior use or evidence of the hand of the artist. They created objects that could be walked around and viewed equally satisfactorily from any angle. The end results can be seen in the identical stainless steel rectangles of Judd [**8.48**], the zinc plates of Andre [**8.49**], the fluorescent tubes of Flavin [**8.50**], and the stainless steel L-shapes of Morris [**8.51**].

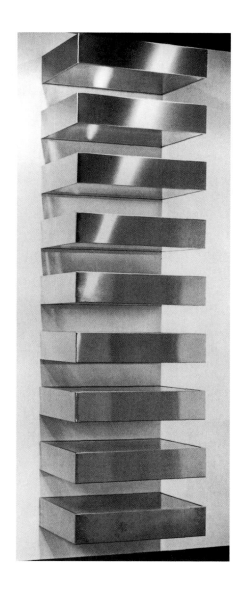

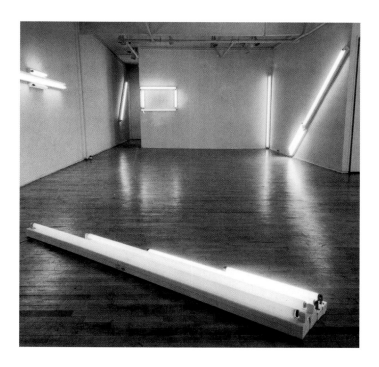

8.48 (left above) Donald Judd: *Untitled*, 1967
Stainless steel and plexiglass, each unit 9¹⁄₁₆ × 40¹⁄₁₆ × 31¹⁵⁄₁₆ in.
(23 × 101.8 × 10 cm.)
Modern Art Museum of Fort Worth, Texas

8.49 (left below) Carl Andre: *144 Zinc Square*, 1967
Zinc, 144 × 144 in. (365.8 × 365.8 cm.)
Milwaukee Art Museum, Milwaukee, Wisconsin

8.50 (above) Dan Flavin: Installation view of "Dan Flavin" at the Green Gallery,
New York, 1964

8.51 (below) Robert Morris: *Untitled* (*L-Beams*), 1965
Stainless steel, three parts, 96 × 96 × 24 in. (243.8 × 243.8 × 61 cm.)
Whitney Museum of American Art, New York

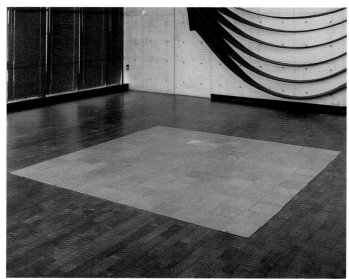

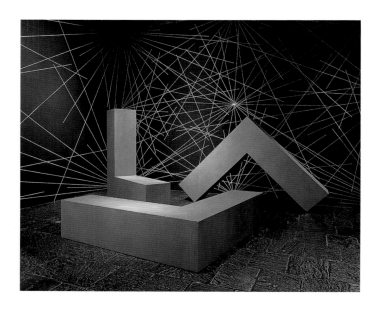

Here anonymity and repetition dominate. Aesthetic choices are obviously involved in the selection of the objects' shape, size, color, and material. Yet the "work" of art was often relegated to skilled craftsmen in industrial shops, who welded and painted according to the artist's specifications or to the standard specifications of building contractors and architects.

If the goal of Modernist art was the defeat of illusionism, then Minimalism was successful. Yet, for Greenberg, it also went beyond the dictates of Modernism in denying the transcendent experience, or what he called "aesthetic surprise," that significant art, no matter how nonillusionistic, created in the viewer. In the late 1960s Greenberg wrote:

> Minimal Art remains too much a feat of ideation [the mental formation of ideas], and not enough anything else. Its idea remains an idea, something deduced instead of felt and discovered. The geometric and modular simplicity may announce and signify the artistically furthest-out, but the fact that the signals are understood for what they want to mean betrays them artistically. There is hardly any aesthetic surprise in Minimal Art . . . Aesthetic surprise hangs on forever—it is there in Raphael as it is in Pollock—and ideas alone cannot achieve it.

The art critic Michael Fried, a student of Greenberg, also had problems with Minimalist sculpture. He dismissed Morris's work as not art but, rather, material suitable for the realm of theater (Morris had, in fact, designed his abstract shapes first as props for dance productions). In being theatrical, in gaining its meaning in part through the movement of the viewer around the object, which prompted recognition of its setting or location, Morris's work was neither theater nor sculpture, but occupied a space in between. This space, in Fried's opinion, lacked aesthetic integrity.

Many Minimalist artists agreed with Greenberg's and Fried's descriptions of the characteristics of their work, but not with their evaluations of the aesthetic significance of those characteristics. Their creations were meant to contain no meaning other than the expressiveness, or the idea, of the object itself. Minimalist sculpture was not intended to create in the viewer a contemplative state that allowed for an escape from the everyday world into a rarified, aesthetic world of line and color. Rather, it was about the materials and colors of that everyday, industrial world, if it was about anything.

The art historian Anna Chave sees another meaning inherent in Minimalist sculpture. She argues that it was popular with corporations, who were increasingly becoming involved in the amassing of art collections, because it participated in a certain "rhetoric of power," one informed by markers of industry and technology—the clean, hard cubic forms, the shiny metals, and, in the case of Frank Stella's pinstripe paintings, the power business suit. The artists—again, all male—also described their work in aggressive, confrontational language. They wanted to control space and, at times, to alarm, if not endanger, the spectator with their enormous, often precariously balanced, forms. (A massive timber piece by Carl Andre submitted for an exhibition at the Tibor de Nagy Gallery in 1965 almost caused the gallery's floor to collapse.) Thus, Chave sees the seemingly blank face of Minimalism as "the face of capital, the face of authority, the face of the father," in an era where corporate authority was being exerted more forcefully both on the home front and abroad.

The Hard Edge: Architecture

The characteristics that, according to Chave, made Minimalist sculpture popular among corporate collectors—clean, cubic

8.52 Mies van der Rohe and Philip Johnson: Seagram Building, New York, 1954–58

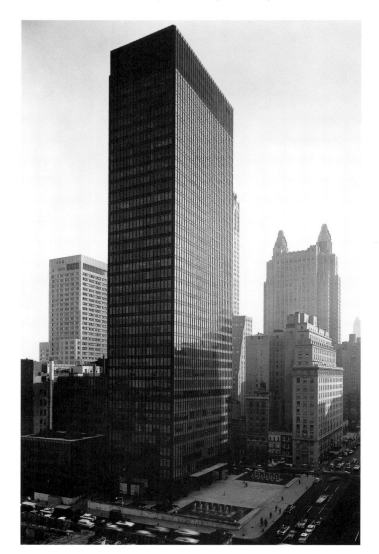

forms, shiny surfaces—can also be found in the architecture of corporate offices. Just as painters and sculptors were taking up the tenets of Modernist aesthetics in the early 20th century, so, too, were architects. By the middle of the century, their austere, geometric forms dominated the urban landscape, symbolic now not of the socialist and collectivist ideals of the Left in Europe and the Soviet Union in the 1920s or the social welfare state of Roosevelt's 1930s (see pp. 404–6), but of a free market economy and the power of American corporations. As with painting and sculpture, Hitler's persecution of Modernist architects and his promotion, instead, of a historicizing neoclassical architecture to celebrate his fascist reign imbued Modernist architecture with anti-fascist significance.

In postwar America, as elsewhere, Modernist architecture represented a break with the past. It was forward-looking, rational, confident, and democratic. It celebrated technology and spoke, with its towering mass, to the power of American business and American democracy. Ludwig Mies van der Rohe's Seagram Building in New York of 1954–58 [8.52], designed with Philip Johnson (1906–2005), became the prototype for urban skyscrapers whose structural steel framework was revealed in the geometric patterning of the windows and the reduction of the walls to mere curtains of glass. Mies can, in fact, be seen as the counterpart to the critic Clement Greenberg in his emphasis on the purity of forms. The architect boiled his philosophy down to the phrase "less is more," which represented his search for the essence of architecture, which he found in the rational structure of the building itself.

The rational and forward-looking also appeared in buildings made of a much more traditional and weighty material, concrete. One of the American architects who most fully explored the possibilities of concrete as a medium for the expression of modernity was Louis I. Kahn (1901–74). Having studied at the Beaux-Arts-oriented University of Pennsylvania in the 1920s, Kahn maintained a commitment to the mass, solidity, and geometry of classical architecture, while fully aware that contemporary aesthetic and technological developments—e.g. routing the conduits for heating, plumbing, electricity, air conditioning—provided new design possibilities. He explored these possibilities in his Salk Institute (1959–65) in La Jolla, California [8.53]. The concrete structure contains open lab spaces that alternate with spaces through which full-story-high utility ducts can be moved around according to need. A central court is positioned between the two main buildings, marked only by a small, narrow rill or channel in the concrete that carries a stream of water from east to west, appearing to drop off into the Pacific Ocean below. The architect

8.53 Louis I. Kahn: The Salk Institute, La Jolla, California, 1959–65

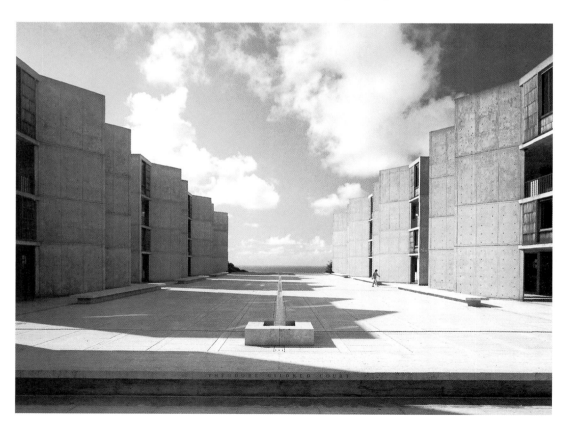

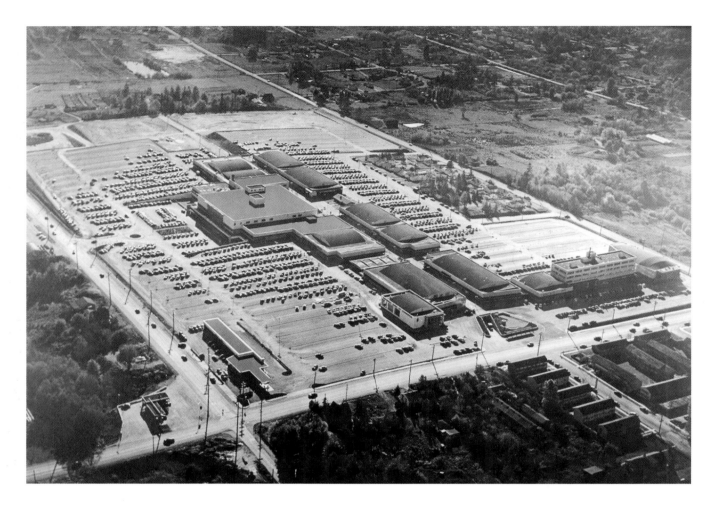

8.54 John Graham and Company: Northgate Regional Shopping Center, Seattle, Washington, 1950

Robert Stern describes the Salk Institute as "one of the most perfectly constructed works in concrete ever. The normally obdurate mix of cement, sand, and water has been coaxed into a marble-like density and meticulously poured to suggest industrial age masonry, which gives the building the dignity and chthonic majesty of an ancient ruin."

Domestic architecture was also affected by the principles promoted by Mies. The designers of suburban housing tracts learned from the experiments of Modernist architects with prefabrication and simple modular units, which lowered the cost of a building and decreased the construction time. This allowed builders to keep up with the explosion in the housing market after the end of World War II, fueled by a dramatic increase in the population and a simultaneous increase in prosperity. The federal government also provided veterans with low-interest housing loans, with no down payment required, while at the same time building extensive highway networks that allowed people to move out of inner-city apartments and into suburban single-family dwellings.

While many homeowners still wanted some references to the cottages and farmhouses of the past in their new suburban homes, these references were pared down to the deep overhang of a low sloping roof or the application of shutters to what was ultimately a simple box form. As single-story buildings were less expensive and land abundant, many homes took on the horizontal look of Wright's Prairie Houses [6.93].

Accompanying these suburban developments were shopping malls, which, again, often for economic rather than aesthetic reasons, echoed the stark boxes of Gropius and Mies, now surrounded by massive parking lots to accommodate the new postwar automobile culture. One of the earliest of such shopping malls was the Northgate Regional Shopping Center in Seattle, Washington, designed by John Graham (1908–91) and Company in 1950 [8.54]. Catering to the needs of their suburban customers, Graham and Company arranged the stores along a central pedestrian "main street," with two large department stores in the middle to draw shoppers from either end of the complex, past the smaller shops along

the way. A third department store was added at one end to further encourage shoppers to move the full length of the mall. The architectural historian Marc Gelernter notes that such malls, even in the 1950s and 1960s, were so successful "that they began to threaten the continuing viability of the traditional downtowns," causing serious economic difficulties in urban centers already suffering from the move of people to the suburbs.

Later in the century shopping malls would more fully diversify their offerings, including theaters, dentists, hairdressers and doctors, among other services. Some would even include whole theme parks for the entertainment of adults and children alike. Many would also enclose the "main street," allowing for a weather-controlled space that, in combination with expanded services, would make malls a more attractive destination year-round.

While the inhabitants of housing tracts ultimately stamped their own personalities onto their cookie-cutter houses through the addition of second stories or bay windows or the like, wealthier individuals commissioned architects to design a wide array of imaginative dwelling spaces that often defy simple categorization, although the most radical of these designs can be traced to the Bauhaus or to the work of Wright. Often the homes of architects themselves expressed most fully the principles they were promoting in their public and private commissions.

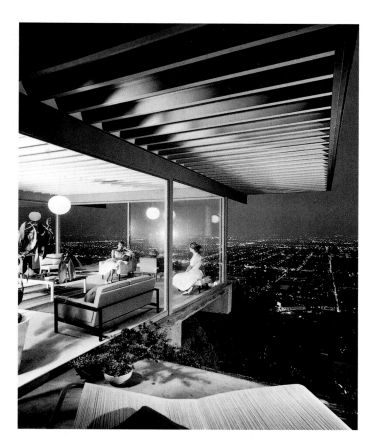

8.55 (below) Philip Johnson: Philip Johnson House (The Glass House), New Canaan, Connecticut, 1949

8.56 (above right) Pierre Koenig: Case Study House No. 22, Los Angeles, 1959–60

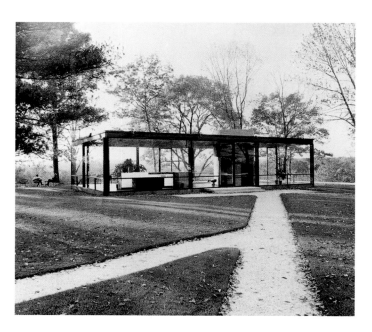

The residence of Philip Johnson in New Canaan, Connecticut (1949) [8.55], shows the degree to which architectural forms could be reduced to their basic cubic shapes and then opened up to the surrounding environment.

Such designs were not limited, however, to the residences of architects. Just as *Life*, *The Ladies' Home Journal* and *Better Homes and Gardens* commissioned famous architects in the 1930s to design affordable homes for their readers, in 1945 John Entenza, editor of *Arts and Architecture*, initiated the Case Study House Program. Between 1945 and 1966 the journal sponsored the design and construction of thirty-six homes meant to serve as prototypes for future mass-produced housing. All had open plans which were intended, in part, to facilitate the integration of family life, just as their large windows and patios were intended to dismantle barriers between inside and outside, as can be seen in Case Study House No. 22 in Los Angeles of 1959–60 [8.56] by Pierre Koenig (1925–2004).

The Case Study House designs were very popular and were adapted to a broad range of clients of varying incomes. With their clean lines and streamlined interiors, they spoke to an understated prosperity, to a modernity that was democratic in its increased access to material comforts, and that looked to the future not the past, although that future may not have

stretched much beyond the life of the current owner. The architectural historian Sylvia Lavin notes:

> Instead of being conceived of as permanent and monumental, houses of the 1950s were expected to last only as long as the mortgage amortization period; instead of containing attics in which to store family treasures, flat-roofed and often basementless postwar houses encouraged the acquisition of increasingly disposable goods; and through the invasion of picture windows, television, and other media, the privacy of the postwar house entered a new and more public arena.

Thus, the logic of consumer culture was conflated with the utopian ideals of Modernist architects.

The Soft Edge: Cultural and Commercial Spaces

The pared-down, rational structure of much Modernist architecture, while dominating major domestic and commercial commissions in the middle decades of the 20th century, was not without its challengers. A second strain of Modernist architecture drew from the later career of Frank Lloyd Wright, who had become increasingly interested in more organic forms, and thus in the circle rather than the rectangle or square as the underlying geometry of a building. His most famous work in this vein, and one of his most highly visible buildings, is the Guggenheim Museum in New York (1956–59) [8.57]. Wright was interested in the expressive potential of the shape, only later adapting the spiral ramp in the center of the building to the functions of a gallery space. Even with the addition of recessed areas replicating the more stable rectilinear spaces of traditional galleries, the experience of the viewer is dominated by the fluid, downward movement of their bodies along the ramp.

This more organic architectural approach also characterized the work of Eero Saarinen (1910–61). According to Gelernter, Saarinen "[i]n looking for a rationale for his invented forms . . . revived the eighteenth-century French idea of *architecture*

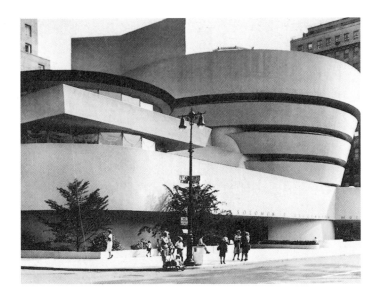

8.57 Frank Lloyd Wright: Guggenheim Museum, New York, 1956–59

parlante, in which a building is expected metaphorically to express its function and character." Thus, in his design for the Trans World Airlines Terminal at Kennedy Airport in New York (1956–62) [8.58], he hoped to capture the quality of flight with his sweeping, wing-like forms.

Saarinen's airport design, while drawing on organic forms, was also a celebration of the rapid developments within aviation technology, developments that would lead to the landing of a man on the moon in 1969. An architect, inventor, and author who devoted much of his career to the investigation of new technologies for the construction of often futuristic projects was Richard Buckminster Fuller (1895–1983). Committed to, in his own words, "applying the principles of science to solving the problems of humanity," he first drew attention to himself with his designs in the late 1920s for what he called his Dymaxion car (with two wheels in front and one in

8.58 Eero Saarinen: Trans World Airlines Terminal, Kennedy Airport, New York, 1956–62

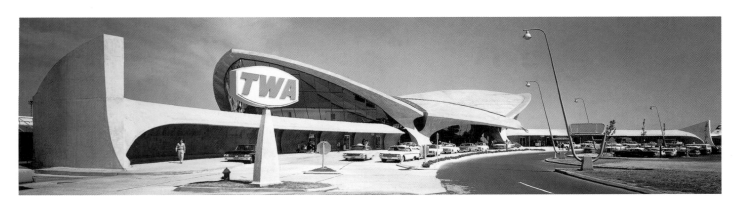

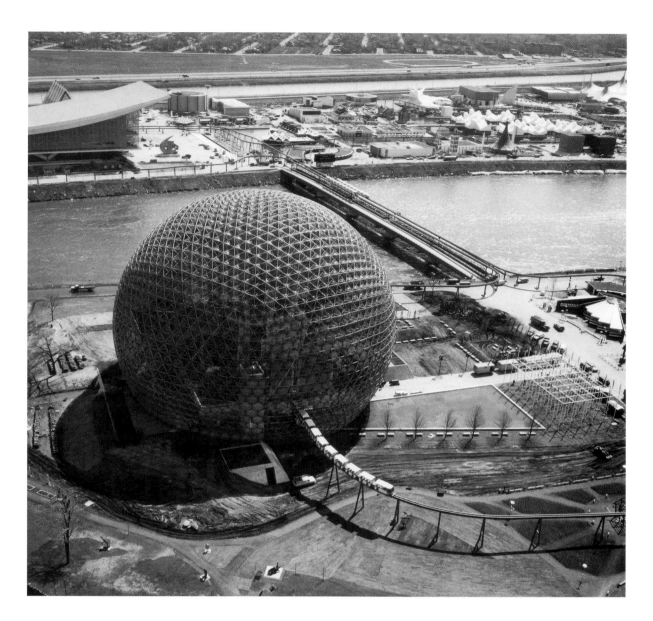

8.59 R. Buckminster Fuller: U.S. Pavilion, Montreal Exposition, Montreal, Canada, 1967

back to minimize the turning radius) and his mass-produced 4D or Dymaxion House (Dymaxion is drawn from the words DYnamic MAXimum tenSION). The house hung from a central pillar containing essential utilities, and included such labor- and resource-saving devices as a ten-minute atomizer bath that used only a quart of water, compressed air and vacuum systems for cleaning, and spaces divided by storage units with movable shelves and hangers.

After World War II, Fuller focused on the development of his geodesic dome, a structure formed of segments of light-weight plastics in the form of a tetrahedron (a triangular pyramid), which he patented in 1954. The structural significance

of such a dome was that it was both lightweight and stable. Smaller versions were soon in use for both temporary and permanent housing around the world (one of the first to recognize the value of the design was the U.S. Army). His proposal to cover a whole city with a geodesic dome to control its climate, however, was not tested until several decades later, albeit on a much smaller scale (Biosphere 2, an artificial closed ecological system in Oracle, Arizona, designed by John Polk Allen of Space Biosphere Ventures and others, was completed in 1989 and was used to test if and how people could live and work in such an enclosed space). Fuller was given the opportunity, however, to construct a prototype of a large dome when he was commissioned to design the U.S. Pavilion at the 1967 Montreal Exposition marking the 100th anniversary of Canadian confederation [8.59]. Seen as a celebration of U.S. technological

ingenuity, it provided Fuller a platform from which to remind people that the world's resources were limited, and that the technological might of the nation should be devoted to developing sources of renewable energy and ways to live both comfortably and lightly on the earth.

The Soft Edge: Sculpture

Just as organic architectural forms existed alongside hard-edged Modernist architecture in the 1950s and 1960s, so too was Minimalist sculpture joined by a series of works that rejected, if not parodied, its basic principles. Not unexpectedly,

8.60 (left) Louise Bourgeois: *Little Girl (Fillette)*, 1968
Latex over plaster, 23½ × 11 × 7½ in. (59.7 × 28 × 19.1 cm.)
The Museum of Modern Art, New York

8.61 (above) Bruce Nauman: *Neon Templates of the Left Half of My Body Taken at Ten-Inch Intervals*, 1966
Neon tubing with clear glass tubing suspension frame, 70 × 9 × 6 in. (177.8 × 22.9 × 15.2 cm.)
Collection of Philip Johnson

these works were marked by the use of soft materials rather than hard, and the artists included several women, as well as members of the original Minimalist group (Carl Andre, Robert Morris). This art appeared en masse in a 1966 exhibition at the Fischbach Gallery in New York organized by the art critic Lucy Lippard and titled "Eccentric Abstraction." Here were pieces that oozed and flowed, that were scattered across the floor, that spoke to the organic rather than the industrial, to process rather than finish, that were packed with associative meanings that were often erotic, engaging with the calls of the 1960s for a sexual revolution that involved a freer, less sublimated sexuality. Galleries now began exhibiting artworks that contained clear references to the human body, like *Little Girl (Fillette)* (1968) [**8.60**] by Louise Bourgeois (1911–2010), which one critic described as "a big, suspended decaying phallus, definitely on the rough side," and *Neon Templates of the Left Half of My Body Taken at Ten-Inch Intervals*

8.62 (above) Lynda Benglis: *For Carl Andre*, 1970
Acrylic foam, 56¼ × 53½ × 46³⁄₁₆ in. (142.9 × 135.9 × 117.3 cm.)
Modern Art Museum of Fort Worth, Texas

(1966) [8.61] by Bruce Nauman (b. 1941), in which the artist takes the fluorescent tubes of Flavin [8.50] and playfully bends them to conform to his own body. *For Carl Andre* (1970) [8.62] by Lynda Benglis (b. 1941) and *Eight Part Piece (Cayuga Salt Mine Project)* (1969) [8.63] by Robert Smithson

(1938–73) imitate the Minimalist use of repeated forms, yet here the forms go limp or are partially devoured by mounds of soft earth. What draws one's attention is the texture of the acrylic foam or the shiny reflective surface of the mirrors as they slice into the dull, gritty earth.

8.63 Robert Smithson: *Eight Part Piece (Cayuga Salt Mine Project)*, 1969
Rock salt and mirrors, 11 × 360 × 30 in. (27.9 × 914.4 × 76.2 cm.)
Estate of the artist

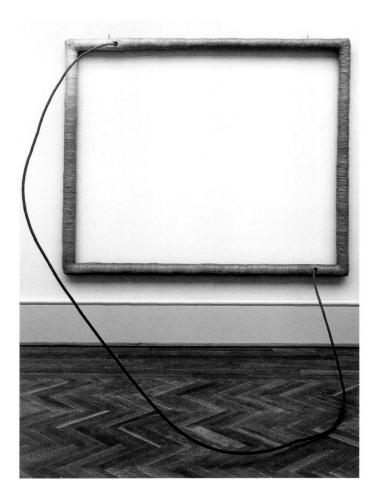

8.64 Eva Hesse: *Hang Up*, 1966
Acrylic on cord and cloth, wood and steel, 72 × 84 × 78 in.
(182.9 × 213.4 × 198.1 cm.)
The Art Institute of Chicago, Chicago, Illinois

The relationship between painting and sculpture was once again taken up by this group of artists, as in *Hang Up* [8.64] by Eva Hesse (1936–70). Here the frame has been carefully wrapped in cloth and the wire that is usually hidden behind, performing its function of keeping the picture on the wall, is now enlarged and projects out into the viewer's space. We are conceptually behind the painting, looking through the frame at what is both nothing and everything. Here the notion of the painting as a window on the world has been denied; we see only the blank wall of the gallery. The work engages the viewer as does a sculpture—he or she walks around the wire, perhaps steps over and through it. Yet the cloth wrapping the frame has also been painted—a nod to the original function of a frame as a support for a painting. The result is engaging, humorous, and intellectually challenging.

Earth as Art

Smithson's *Eight Part Piece (Cayuga Salt Mine Project)* [8.63] indicates another direction in which several artists in both the Minimalist and the anti-Minimalist or Postminimalist (Robert Morris called it "Anti-Form") group moved. Smithson gave a name to this move in a 1968 exhibition he organized at the Dwan Gallery in New York entitled *Earthworks*. The show included both earth brought into the gallery by various artists and photographic documentation of projects, both proposed and completed, located outside of the gallery. That same year Christo (Christo Vladimirov Javacheff, b. 1935) and Jeanne-Claude (b. 1935) wrapped one mile (about 1.6 kilometers) of the Australian coastline near Sydney in erosion control fabric. Two years later, in the Great Salt Lake in Utah, Smithson produced his best-known work, *Spiral Jetty* [8.65], whose shape was derived, in part, from his discovery while researching the project that the molecular structure of the salt crystals along the lake's shore was spiral in form. Many earthworks have changed over time or have completely disappeared (*Spiral Jetty* appears and disappears as the Great Salt Lake rises and recedes), with only photographs or videos documenting their original state.

This interest in moving out into, and working with, the land has been connected by many critics and historians to the environmental movement, an outgrowth of the protests against the practices of major corporations, including the indiscriminate use of toxic chemicals and other pollutants. The marine biologist Rachel Carson was among the first to expose this practice in her 1962 book *Silent Spring*, a study of the dangers of insecticides. As a result of the efforts of Carson and other scientists and environmental activists, the National Environmental Policy Act was passed in 1969, and the federal Environmental Protection Agency was created. In working with the land on a grand scale—lines in the desert, acres planted in differently colored plants, hillsides divided by miles of cloth curtains—artists drew attention to nature, forcing the public to see it in a new way, although few of the early Earthwork artists made direct commentaries on the crises facing the environment.

The women involved in the Earthwork movement tended to create smaller, less grandiose works—due, suggests Whitney Chadwick, to their inability to gain access to the same levels of funding as the major male Earthwork artists, rather than to any inherent propensity to think small. Many women addressed seasonal changes or astronomical movements, as is the case with *Sun Tunnels* of 1973–76 [8.66] by Nancy Holt (b. 1938), located in the Great Basin Desert in northern Utah. The positions of the concrete tunnels mark the seasonal extreme positions of the sun on the horizon, while the holes in them are aligned with stars in four different constellations.

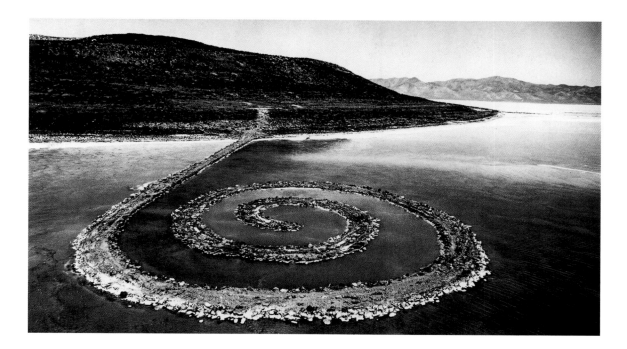

8.65 Robert Smithson: *Spiral Jetty*, 1970
Black rock, salt crystals, earth, and water red with algae, L 1,500 ft. (457.2 m.),
W 15 ft. (4.6 m.)
Great Salt Lake, Utah

Earthworks have also been interpreted as a critique of the art market and gallery system. Theoretically, they could not be bought and sold and certainly could not be displayed in one's home. Yet the inaccessibility of many of them, or their temporary nature, forced those interested in seeing them to come to a gallery and look at photographs, thus compromising their critique to a certain extent. In addition, many earthworks were, in fact, bought and sold and could only have been made in the first place with the financial help of individuals or foundations. Virginia Dwan of Dwan Gallery provided $9,000 for the

8.66 Nancy Holt: *Sun Tunnels*, 1973–76
Concrete, four tunnels, total L 86 ft. (26.2 m.)
Great Basin Desert, Utah

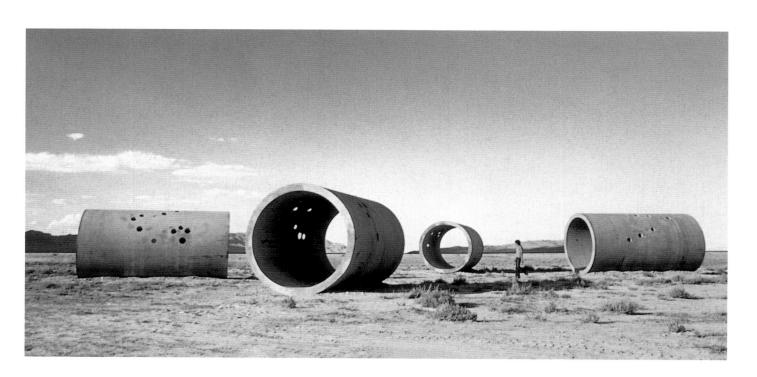

construction of *Spiral Jetty*, with Douglas Christmas of Ace Gallery (Vancouver, Canada, and Venice, California) providing another $9,000 to fund a film of it. Smithson bought back *Spiral Jetty* and the film from Dwan and Christmas with several of his early works. Thus, the commodity aspect of art production could not be so easily undercut.

The Framed Proposition

Another kind of art emerged alongside this exploration of minimal forms and planning of grandiose and often unrealizable environmental projects—Conceptual art. The separation of conceptualization from execution that marked much Minimalist art led, for some, to the conclusion that the art object itself was superfluous. In 1967 Sol LeWitt (1928–2007), best known for his repetitive grid constructions, wrote that "the idea itself, even if not made visual, is as much a work of art as any finished product." And these ideas are manifested in linguistic form, so that words become the very materials of the practice of art. "The art I call conceptual," wrote one of the major proponents of the genre, Joseph Kosuth (b. 1945), "is . . . based on . . . *the understanding of the linguistic nature of all art propositions*" (his italics). Kosuth manifested this understanding by placing in galleries enlarged text panels that included dictionary definitions of words often used in discussions of art, be they abstract words, such as "universal," or the mundane colors of the artist's palette [8.67].

8.67 Joseph Kosuth: *"Titled (Art as Idea as Idea)"*, 1967
Photographic enlargement on board, 48 × 48 in. (121.9 × 121.9 cm.)
Whitney Museum of American Art, New York

THIS IS NOT TO BE LOOKED AT.

8.68 John Baldessari: *This Is Not to Be Looked At*, 1966–68
Acrylic and photoemulsion on canvas, 59 × 45 in. (149.9 × 114.3 cm.)
Collection of Joel Wachs

Often Conceptual art combined text with photographs as either a record of the site where a work was intended to be located but had yet to be—or would never be—realized, or as a means of creating a disjunction between image and words that would prompt further speculation on the nature of the material world, the role of art within that world, or the relationship between words and objects. Kosuth created a series of works that juxtaposed a dictionary definition with a photograph of an object and the object itself, while John Baldessari (b. 1931) produced photo-text compositions, such as *This Is Not to Be Looked At* (1966–68) [8.68]. Several artists would take up this focus on language and linguistic theory in the coming decades, developing extensive bodies of critical writing that would rival the writings of professional art critics and test yet another art world relationship, that between artist and critic.

Conceptual art, like Minimalist art, also drew attention to the very act of viewing a work of art. While Minimalism, in denying illusionism, forced the viewer to become aware of his or her own body as it moved between or around objects, Conceptual art, in the words of the art historian John B.

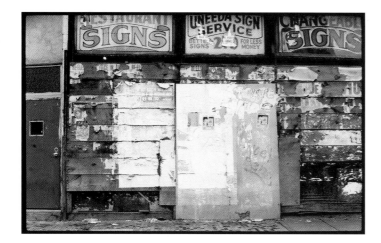

```
muddled

fuddled

flustered

lushy

sottish

maudlin
```

8.69 Martha Rosler: *The Bowery in two inadequate descriptive systems*, 1974–75: detail of a pair of images. The series consists of 45 gelatin silver prints of text and images and 3 black panels, each measuring 20.3 × 25.4 in. (8 × 10 cm.)

Ravenal, "embraced viewers as active participants in 'making' the work, often presenting scenarios, instructions, or methodologies that engaged them as mental collaborators." As such, it took part in the broader rethinking of institutional and aesthetic values that marked the 1960s, re-examining the nature of the art object and the art viewing experience.

Conceptual art also foregrounded the role of information or information systems in establishing cultural and social norms, in particular those systems produced by an ever-expanding and diversifying media industry. Some artists focused on exposing the misinformation that permeated such media information systems, be it the absence of certain facts necessary to understand an event or the more subtle use of image and text to promote a particular set of conclusions. While later artists would confront the techniques and iconography of the mass media more directly (see pp. 543–45), the work of Conceptual artists was often more understated, such as the series by Martha Rosler (b. 1943) entitled *The Bowery in two inadequate descriptive systems* (1974–75) [**8.69**]. The two "inadequate descriptive systems" in Rosler's work are photographic and textual, neither of which can fully capture the 'truth' of any particular moment or situation. In writing about this work, the art historian David Joselit notes that Rosler, "[k]eenly aware that pictures of urban vagrants are among the clichés of documentary photography . . . set herself the task of representing the Bowery—that neighborhood of downtown New York mythically tied to the 'bum'—without falling into the bathos of victim photography." She achieved this by refusing to people her photographic representations of urban landscapes and, instead, alternating them with columns of text composed of synonyms for drunkenness. She thus points not only to the inadequacy and arbitrariness of photographic and textual 'truths', but also to the moral questions raised by the practices of documentary photography.

Popular Art, Pop Art, and Consumer Culture

Grandma Makes Art: Anna Mary Robertson Moses

Greenberg and other supporters of Abstract Expressionism and its color field successors had argued that a major defining aspect of Modernist art was its distance from commercially produced and distributed popular art, or "kitsch." And while Rauschenberg and Johns included references to kitsch in their paintings and combines, their work was ultimately designated "high art" and circulated within the institutions of the art world. It is instructive, therefore, to consider at least one example from the mid-20th century of an artist who bridged the worlds of art (in this case folk art) and kitsch or popular art, and who achieved, in the process, both wealth and fame. Anna Mary Robertson Moses (1860–1961)—better known as Grandma Moses—spent the latter part of the 19th century and early part of the 20th century engaged in the various kinds of art activities open to homemakers —the occasional drawing or painting, wallpapering, interior design, and needlework. In 1927, after her husband died, she turned to easel painting. In 1938 Louis J. Caldor, an engineer and art collector in New York City, saw Moses's paintings in the window of Thomas's Drug Store in Hoosick Falls, New York. He bought them all, and became her official patron and agent.

Caldor's interest in American folk art was not unusual, considering the promotion of Americana by the art world and the federal government throughout the 1930s. Artists and

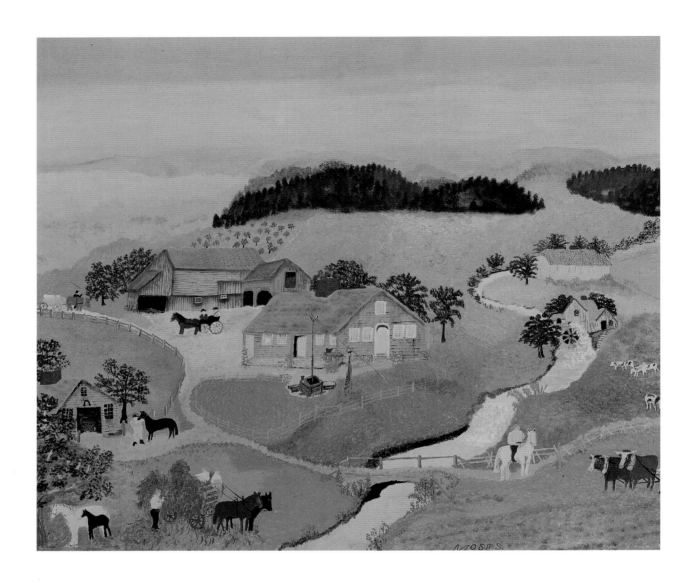

8.70 Grandma Moses (Anna Mary Robertson Moses): *The Home of Hezekiah King, 1776*, 1943
Casein on masonite, 19 × 23½ in. (48.3 × 59.7 cm.)
Phoenix Art Museum, Phoenix, Arizona

critics were looking for the roots of Modernism in the work of untutored artists and those from non-Western cultures, while the Roosevelt administration wanted to present itself as a government of the people, which meant, in part, supporting what the people wanted and produced (see Chapter 7). One result was a 1938 exhibition at MoMA entitled "Masters of Popular Painting," which was part of a series on the sources of modern art and included both European and American self-taught artists.

The career of Grandma Moses took off in the 1940s, with several one-woman and group shows of her scenes of rural and small-town life [8.70] and the publication in 1946 of Otto Kallir's *Grandma Moses, American Primitive.* In 1947 she signed a contract with Hallmark for greeting card designs and became probably the best-known artist in the United States. In 1949 she received an "Outstanding Achievement in Art" award from the Women's National Press Club—one of four women, including Eleanor Roosevelt, honored in a ceremony in Washington presided over by President Truman. From then on Truman, and his successors Presidents Eisenhower and Kennedy, recognized the political expediency of sending the nation's Grandma a card every year on her birthday—a gesture, the art historian John Michael Vlach notes, that was always reported in the press.

During the 1950s Moses's paintings were included in exhibitions abroad organized by the United States Information Agency (USIA). In 1952 her autobiography, *My Life's History*, edited by Otto Kallir, was published. That same year Lillian Gish played her in a television drama, and three years

later Moses appeared on CBS television on Ed Murrow's well-known and respected program "See It Now." Kallir also helped set up Grandma Moses Properties, Inc., which dealt with licensing her pictures for commercial production in any medium, including prints, plates, drapes, and at least one mural of a rural scene. In 1956 *Look* magazine commented on this commercial venture: "What for little Anna Robertson was a work of handicraft in 1867 has become a booming business in 1956. Modern factories produce her home mural ... in brilliant oil colors on washable canvas. Pre-trimmed to size, they can be easily hung by any paste-pot amateur." By the time of her death, Moses had produced over 1,500 paintings and her designs had permeated all areas of American life, from the galleries of museums of fine art to the bedrooms and kitchens of rural farmhouses.

The art world, according to Vlach, did not think much of Moses's art, but critics realized that it would be bad form to criticize a national institution, so they praised her personal virtues: she was "brave, vigorous, beautiful, etc." Few looked at the origins, growth, or impact of her work, preferring to believe that she created in "blissful ignorance," free, like Modernist artists, of outside influence. Yet Vlach points out that Moses was not so unaware of the world around her, particularly the world of commercial art of the 19th and 20th centuries. Her father had been a painter, and she often copied his pictures. She was, therefore, familiar with certain academic conventions regarding subject-matter and composition. She also copied many Currier and Ives prints, which were often reproductions after well-known artists (see pp. 274–77). When she began creating her own designs she often clipped pictures from magazines and traced figures and houses. Thus, her art was not solely self-generated, just as that of Abstract Expressionist artists did not emerge solely from some internal primal center.

Realigning High Art: Pop Art and the Consumer Revolution

Grandma Moses was a foil to the predominantly male artistic avant-garde. While many saw her as one of the sources of Modernism, she was not sufficiently removed from her "folk" world to invest her paintings with a higher aesthetic significance. She did not have the crucial intellectual distance. She was also extremely popular with the general public, definitely a disadvantage in an art world that argued that accessibility was in inverse proportion to artistic significance. As it happens, however, Grandma Moses may well have functioned not only as the Grandmother to the nation and an inspiration to the millions of women who engaged in some form of artistic activity in the privacy of their own homes. She may also

have inspired a new generation of fine artists, one that did not eschew the recognizable or the popular, that parodied the virility and pomposity of many of the key Abstract Expressionists, and that exploited the mechanisms of production, promotion and distribution of a consumer economy.

This generation was at home in the consumer culture of the 1950s and 1960s, when the dream of owning a home and one, if not two, cars was becoming a reality for more and more working- and middle-class Americans. European nations needed American goods to help rebuild their cities and industries, producing increased demand, and thus increased prosperity for American workers and business owners. Domestic purchases were further encouraged by a burgeoning advertising industry, out of which emerged a new group of artists schooled in the attention-grabbing image and skilled at operating within the supermarket aisle and department store window, where viewing was combined with mobility and rapid assessment of quality and value. While scholars of this phenomenon have all agreed on its name—Pop art— debates still rage over its artistic significance or political meaning. Was it a celebration of consumer culture or a critique? Who was its intended audience? Were these artists serious or simply mining the gullibility of the art world and a new generation of wealthy collectors?

Pop art, argues the art historian Christin Mamiya, was dependent on a fully matured consumer culture not just for its iconography—packaged food, appliances, cars, Hollywood celebrities—but also for its methods of production and promotion. The absence of such a fully developed consumer culture in the United States in the 1920s and in Britain in the 1950s helps explain why the experiments of Stuart Davis with cigarette packages [7.90] and the British artist Richard Hamilton with advertisements for vacuum cleaners and canned goods failed to evolve into a full-scale artistic movement. (The phrase "Pop art" was first used by Hamilton and the British critic Lawrence Alloway in the 1950s to describe the work of a group of British artists who were mining American popular culture for their imagery.)

This fully developed consumer culture was grounded in the dramatic expansion of American corporations in size and geographic diversity in the late 1950s and early 1960s, which resulted in an unprecedented control of the American economy by large, multinational corporations, who were able to promote, through ever more insistent advertising, their own particular market philosophy. They continued, on a scale unimagined by Henry Luce, a celebration of the motto: "What's good for business is good for America." Thus, when Pop art emerged in the early 1960s, it was imbued, both visually and conceptually, with

an immediacy that facilitated its acceptance. It was no coincidence, for example, that the food brands featured with greatest regularity by Pop artists—Del Monte, Coca-Cola, Pepsi-Cola, and Campbell's—were produced by companies whose extensive ad campaigns dominated the mass media. More importantly, however, according to Mamiya,

> the Pop movement appropriated the mentality that was fundamental to mass production and utilized the strategies that had brought about corporate dominance. In this manner, Pop art did more than reflect consumer culture— it brought about a realignment of the cultural community so that it was more consistent with corporate models, and in so doing, it contributed to a validation of that very system. The making and selling of art was now going to follow more closely the dictates of a market system in which novelty, packaging (of both the artist and the art), and mass production were the order of the day.

Pop art was also heavily inflected, like earlier movements, by gender. The major artists within the movement were men. Women appeared as subject-matter within a consumer culture that was consistently gendered female. Thus, Pop was an art created by men which allowed the traditional realm of women—consumption—to be taken seriously and, at the same time, elevated above the banality of the grocery or department store through aesthetic distancing. Lucy Lippard wrote in 1976:

> In the early 1960s, the male artists moved into woman's domain and pillaged with impunity. The result was Pop Art, the most popular American art movement ever If the first major Pop artists had been women, the movement might never have gotten out of the kitchen. Then it would have struck those same critics who welcomed and eulogized Pop Art as just women making more genre art. But since it was primarily men who were painting and sculpting the ironing boards, dishwashers, appliances, food and soap ads, or soup cans, the choice of imagery was considered a breakthrough.

The relationship between Pop art and the culture from which it drew its iconography, style, and, at times, method of manufacture was complex. In the first half of the 1960s critics debated the nature of this relationship at length, trying to position Pop art either inside or outside of the fine art world and ultimately failing to do so definitively. The art historian Cécile Whiting finds that this heated debate in both art journals and the popular press "attests to Pop's ability to ride the line between high art and consumer culture," and hence to the permeability and instability of the boundaries defining these two areas of activity during this period.

This permeability and instability can be found in two early displays of the work of Andy Warhol (1928–87). Warhol is certainly the best-known of the Pop artists and the one whose fame came to rival that of Grandma Moses. He began his career in the 1950s as a commercial artist, and when he became a fine artist he adopted the production techniques of consumer culture, creating endless silk-screened images of Campbell's soup cans, Coca-Cola bottles, and celebrity portraits in his large New York studio, dubbed The Factory. In 1961, the year before he broke into the fine art world with an exhibition at the Ferus Gallery in Los Angeles, the New York department store Bonwit Teller hired him to create a window display that combined female mannequins dressed in the latest fashions with Pop art paintings. Bonwit Teller's use of art in its windows was not unusual. But the purpose was most often to raise the status of the product for sale by associating it with "high" art, which everyone recognized as qualitatively different. Warhol's paintings were clearly art, yet they were also clearly about contemporary mass media culture rather than traditional high art—or even high fashion—subject-matter, with their replicas of Coca-Cola signs, Superman cartoons, and ads for plastic surgery. Thus, those unfamiliar with the latest developments in the art world would have had a difficult time separating the art from advertising.

This melding of the worlds of fine art and consumerism appeared in another form in a 1964 exhibition at the Bianchini Gallery in New York, which transformed itself into a small-scale supermarket filled with real merchandise, the images of commercial artists, and the work of Warhol and other Pop artists [8.72]. As businesses competed for customers, advertising focused on creating brand names or "personalities" to distinguish one business's products from the next, a tacit acknowledgment that the actual products themselves were indistinguishable in their basic physical make-up. The exhibition reinforced this focus on image-making. It contained three levels of representation and reality—the actual merchandise, with its packaging; the work of commercial artists; and Pop art—and both the unsuspecting grocery shopper and the connoisseur ended up assessing the value of the representation rather than the value of the object itself.

In 1961, the same year Warhol designed his Bonwit Teller window, another Pop artist, Claes Oldenburg (b. 1929), had created his own commercial site for the display of his work, turning his studio on the Lower East Side of Manhattan into

a discount store filled with roughly made sculptures imitating a wide range of products, from food to women's clothing [8.71]. Oldenburg's *Store* was the bargain shopper counterpart to the elite Bonwit Teller. Just as Warhol's paintings were hung with adequate space in between in a manner similar to the tasteful arrangement of the dresses in front of them, Oldenburg's objects were spread everywhere in crowded disarray, like the items in so many of the shops around his studio. While the bargain hunters who frequented those shops may well have come into his studio during the exhibition, they are unlikely to have bought the non-utilitarian objects on display. Instead, the buying audience came primarily from the art world, able to evaluate the objects as "art" and not "merchandise" and to note the ironic commentary on Abstract Expressionism in the messiness of the paint application. Thus Oldenburg's *Store*, like the Bonwit Teller window and the Bianchini Gallery exhibition, combined two viewing practices, one associated with looking at art and one associated with looking at commercial products. Some

8.71 (right) Claes Oldenburg: *The Store, Ray Gun Mfg. Co., 107 East 2nd Street*, 1961. Mixed media environment

8.72 (below) Henri Dauman: *Supermarket Exhibition at the Bianchini Gallery*, from "You Think This is a Supermarket?," *Life*, November 20, 1964.
© Henri Dauman/Dauman Pictures, NYC

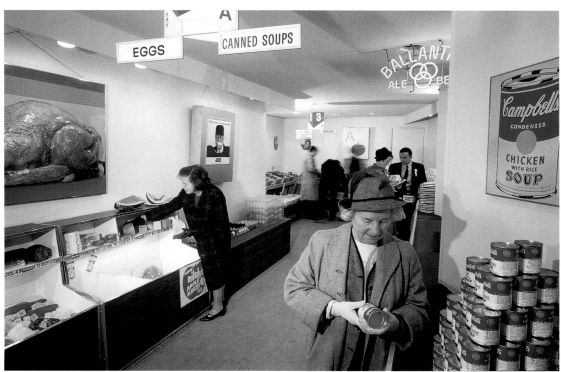

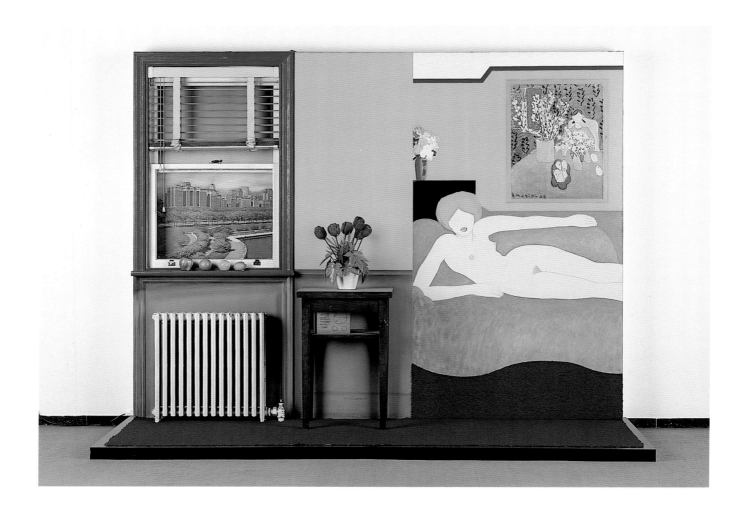

8.73 Tom Wesselmann: *Great American Nude No. 48*, 1963
Mixed media, 84 × 108 × 34 in. (213.4 × 274.3 × 86.4 cm.)
Kaiser Wilhelm Museum, Krefeld, Germany

viewers were able to reconcile these practices and, in the process, to discern the commentaries on both modernist art and consumer culture in the objects on display. Others went away confused.

The Pop artist who represented the domestic interior with the greatest frequency was Tom Wesselmann (1931–2004) [**8.73**]. Here was the postwar American home, with brand-name still lifes and modern appliances and the female nude thrown in occasionally for good aesthetic measure. Here was that continually reiterated economic "health of the nation" writ large (his mixed-media interiors were often life-size). The home was the center of the consumer revolution, where women played their patriotic role, ensuring the continued prosperity of the nation not only by purchasing the necessary household goods but also by continually updating them. Wesselmann's American-made appliances are the latest models, those mass-

produced for a middle-class market and celebrated in 1959 by Vice-President Richard Nixon in his famous "kitchen debate" with Soviet Premier Nikita Khrushchev at the American National Exhibition in Moscow. Capitalism, Nixon declared, had bested communism by improving the standard of living of American workers and providing them with a wealth of material goods.

Capitalism also provided easy access to pornography, a source Wesselmann drew upon for the poses of several of his faceless female nudes (men are rare in Wesselmann's paintings of domestic interiors). These nudes become yet one more reference to the circulation of images in mass media and consumer culture (as do the reproductions of famous works of art he includes in his collages). They also suggest a sexualized space as a counter to the more common image of endlessly repetitive rows of houses filled with conservative, conformist families. By parodying the domestic interior through the often incongruous placement of his nudes or of Modernist art in bathrooms or kitchens, Wesselmann provided critics with a way to read his works as self-conscious commentaries on domestic

"good taste" rather than literal transcriptions of a female-dominated sphere.

Roy Lichtenstein (1923–97) also adopted the conventions of parody in his large reproductions of action and true romance comics. Through his testosterone-filled fighter pilots [8.74] and tearful drowning damsels [8.75], he drew attention to the constructed nature of gender roles, to their grounding in the performance of certain scripted parts. His Korean War airmen are the epitome of aggressive masculinity, his damsels in distress of passive femininity. Lichtenstein's exaggeration of the gender stereotypes of comic book characters allowed some critics to see his work as significantly different from the comics he copied, and therefore to attribute to it a higher aesthetic purpose. Others simply dismissed it as creating the same visual impact as his sources.

In comparing his paintings to his sources, one can certainly discern the ways in which Lichtenstein altered the originals. The most obvious change is his isolation of one frame from a series, stopping the action usually at the tensest moment in the narrative. He also eliminated minor details at times in order to maintain the focus on the central emotion in the image—anger, fear, despair. Men appear much more assured of their actions, women much more debilitated by their emotions. And, finally, he enlarged the images, so that one additionally confronts the process by which comic books are produced, where tone and color are created mechanically and cheaply by the use of varying sizes of dots on photographic film; in the paintings, the dots have been

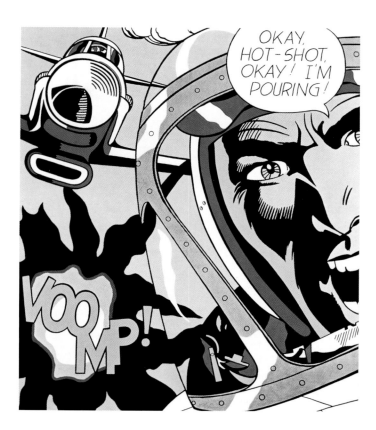

8.74 Roy Lichtenstein: *Okay, Hot-Shot*, 1963
Oil and magna on canvas, 80 × 68 in. (203.2 × 172.7 cm.)
Collection Remo Morone, Turin, Italy

8.75 Roy Lichtenstein: *Drowning Girl*, 1963
Oil and synthetic polymer paint on canvas, 67⅝ × 66¾ in. (171.6 × 169.5 cm.)
The Museum of Modern Art, New York

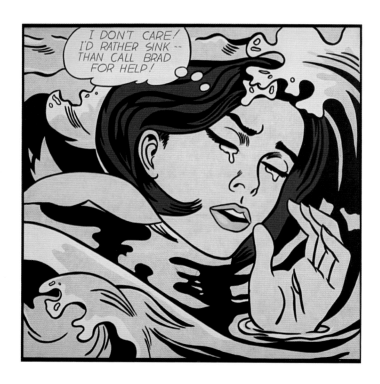

painstakingly recreated by hand on the canvas. Lichtenstein himself wrote:

> I think my work is different from comic strips—but I wouldn't call it transformation What I do is form, whereas the comic strip is not formed in the sense I am using the word; the comics have shapes, but there has been no effort to make them intensely unified. The purpose is different, one intends to depict and I intend to unify. And my work is actually different from comic strips in that every mark is really in a different place, however slight the difference seems to some.

Several Pop artists took a more openly humorous approach in their display of consumer products, as did Ed Ruscha (b. 1937) in his *Actual Size* of 1962 [**8.76**], where the tiny meticulously painted Spam can rushes across the canvas in a blaze of glory. Two artists took up where Duchamp left off with his *Fountain* [**6.42**], presenting their own versions of this household necessity. Oldenburg's vinyl *Soft Toilet* of 1966 [**8.77**] sags where the original would have stood firm, while *John with Art* of 1964 [**8.78**] by Robert Arneson (1930–92) gives us an all too real glazed ceramic rendition of the bathroom fixture, expressionistically splashed with paint (a playful reference, suggests the art historian Jonathan Fineberg, "to the abstract expressionist aspiration of letting everything within the artist

8.76 Ed Ruscha: *Actual Size*, 1962
Oil on canvas, 72 × 67 in. (182.9 × 170.2 cm.)
Los Angeles County Museum of Art, Los Angeles, California

8.77 Claes Oldenburg: *Soft Toilet*, 1966
Vinyl, plexiglass, and kapok on painted wood base,
57 1/16 × 27 5/8 × 28 1/16 in. (144.9 × 70.2 × 71.3 cm.)
Whitney Museum of American Art, New York

spill out freely in the work"), and complete with ceramic feces in the bowl that spell "art." Oldenburg went on to produce, along with his wife Coosje Van Bruggen (b. 1942), massive outdoor sculptures in the shapes of clothespins, cue balls, and other common objects.

Other artists added a more somber note to their commentaries on consumer culture. George Segal (1924–2000) used human figures cast in white plaster from a living model in his sculptural installations, creating the suggestion of absence, of lack of personality or volition. This lack is heightened by the detailed, full-color backgrounds of contemporary life against which they perform their various mundane actions, as in *The Gas Station* (1963–64) [**8.79**]. Here Coca-Cola has failed to bring life to the slumping figure, who holds a bottle in his right hand as he is instructed to do by the advertisement on the drink machine beside him. Warhol himself created silk-screened images during the early 1960s that more clearly engaged with some of the darker sides of American culture as they were captured in the mass media—race riots, car accidents, electrocutions, and other "disasters."

8.78 Robert Arneson: *John with Art*, 1964
Glazed ceramic with polychrome epoxy,
34½ × 18 × 25½ in. (87.6 × 45.7 × 64.8 cm.)
Seattle Art Museum, Seattle, Washington

8.79 George Segal: *The Gas Station*, 1963–64
Assemblage, 8 ft. 6 in. × 24 ft. 2 in. × 4 ft. (2.62 × 7.48 × 1.23 m.)
The National Gallery of Canada, Ottawa

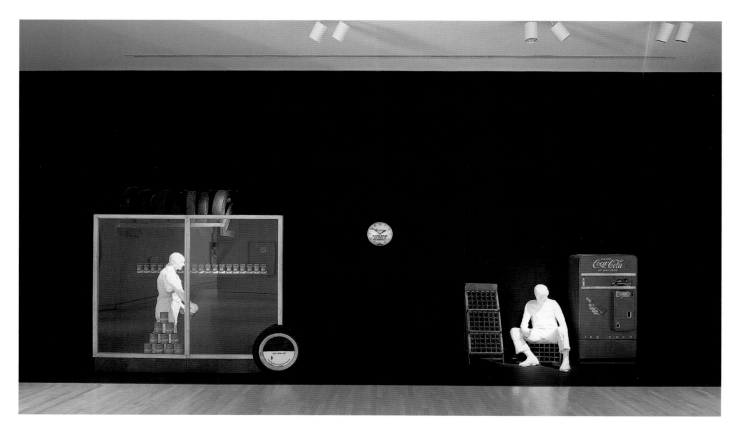

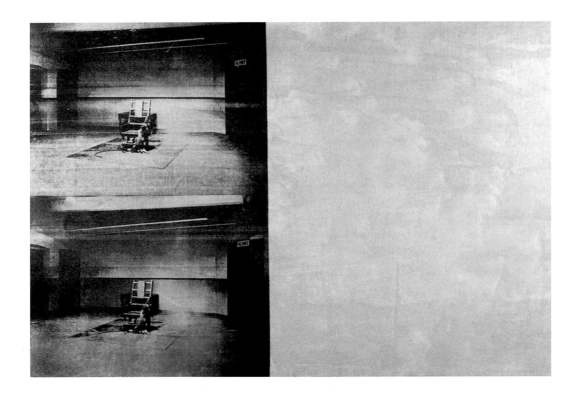

8.80 Andy Warhol: *Silver Disaster: Electric Chair*, 1963
Acrylic and silkscreen on canvas, 42 × 60 in. (106.7 × 152.4 cm.)
Sonnabend Collection, New York

In *Silver Disaster: Electric Chair* (1963) [8.80] there are no bright colors or brand names or celebrity portraits; instead, the painting, with its doubled electric chairs and empty expanse of canvas, evokes the theme of absence or void.

The success of Pop art was due not only to its alliance with a burgeoning consumer culture but also to the efforts of key art world figures. Just as the first and second generations of Abstract Expressionists benefited from the support of dealers, critics and curators in the 1950s, Pop had its champions in the 1960s in the dealers Leo Castelli (who first showed Jasper Johns in 1958) and Irving Blum of the Ferus Gallery, and the collectors Robert and Ethel Scull, who had their own gallery (the Green Gallery) run by the dealer Richard Bellamy. Castelli's ex-wife Ileanna Sonnabend also promoted Castelli's Pop artists in her Paris gallery, initiating a boom with European collectors (Segal was first shown by her in 1963). The art historian Thomas Crow argues that this commercial success in the United States and Europe prompted Warhol to abandon his more abrasive work of the early 1960s for friendlier images. Instead of race riots and electric chairs (which sold well in Europe but not at home), he now produced multiple silk-screens of flowers and of Ethel Scull, although he redirected much of the money from the sale of his "friendly" art to the production of experimental films and music whose images of sexuality and violence surpassed the abrasiveness of his earlier work.

An Art of Protest:
The Civil Rights Movement and the Vietnam War

Disquieting Images: Civil Rights and Civil Wrongs

In the September 1970 issue of *Artforum* a series of artists' statements appeared under the heading "The Artist and Politics: a Symposium." They were answers to the following question posed by the magazine:

> A growing number of artists have begun to feel the need to respond to the deepening political crisis in America. Among these artists, however, there are serious differences concerning their relations to direct political actions. Many feel that the political implications of their work constitute the most profound political action they can take. Others, not denying this, continue to feel the need for an immediate, direct political commitment. Still others feel that their work is devoid of political meaning and that their political lives are unrelated to their art. What is your position regarding the kinds of political action that should be taken by artists?

As they anticipated, the editors received a range of replies. There were those who wanted to keep their art separate from their political activity, those who felt it must engage directly with political events, and those who saw political action as inevitable, but not necessarily within one's control. Representing the latter position was Robert Smithson:

> The artist does not have to will a response to the "deepening political crisis in America." Sooner or later the artist is implicated or devoured by politics without even trying. My "position" is one of sinking into an awareness of global squalor and futility. The rat of politics always gnaws at the cheese of art. The trap is set. If there's an original curse, then politics has something to do with it.

Smithson's pessimism is not surprising considering the events of the 1960s. The fight for civil rights for African Americans gained important legal victories in the 1950s, in particular the defeat of "separate but equal" laws in the 1954 Brown v. Board of Education Supreme Court ruling. Nevertheless, many southern states resisted integrating their schools and public facilities, leading to boycotts, demonstrations, and, beginning in 1960, lunch counter sit-ins throughout the South by both black and white students. In 1963, the Justice Department reported that three hundred cities had desegregated their lunch counters. Newspapers and televisions brought these struggles into homes throughout the country, recording police dogs attacking unarmed African American demonstrators. In August 1963 the Reverend Martin Luther King led a march on Washington, where he called for equality, integration, and constitutional rights for African Americans. The euphoria created by the march and King's speech was shattered less than a month later by the deaths of four black girls in the bombing of a church in Birmingham, Alabama, by white supremacists.

Recognizing the need for increased federal action, President Kennedy and, after his assassination in November 1963, President Lyndon B. Johnson pushed through a series of social reforms meant to alleviate the nation's poverty, experienced disproportionately by African Americans, and to solidify the protection of civil rights. In 1962, Michael Harrington had published *The Other America: Poverty in the United States*, pointing out an American reality that contradicted the image of wealth and prosperity promoted so insistently by both business and government throughout the 1950s—40 million individuals living below the poverty level. Government statistics attested to their existence, but the poor had become invisible in a country whose image-makers maintained the illusion of prosperity and whose employed were moving into the suburbs, away from city centers. Unlike earlier in the century, when political machines operated out of immigrant or working-class neighborhoods, the poor now had no political clout. Harrington's book helped make them visible. President Kennedy claimed he was inspired in part by the book to initiate an "unconditional war" on poverty, a war enacted by President Johnson.

According to Harrington, in spite of technological innovations, farm subsidies, and bigger profits for large corporate farms, the harshest and most bitter poverty in the United States was still to be found in the fields, where many remained to eke out an existence on small family holdings. The hardest hit of these areas were located in the South. Harrington also noted that "the Negro poor farmer is not simply impoverished; he is terrorized as well." On isolated farms outside of towns or cities, African American families were particularly vulnerable to violence or intimidation by the Ku Klux Klan or other white vigilante groups. Thus they were in particular need of legislative, if not police, protection.

The Civil Rights Act was passed in 1964 reaffirming the Brown v. Board of Education decision and banning discrimination in housing and employment. The Voting Rights Act of 1965 provided greater protections against racial discrimination in voter registration. Yet racism would not so easily go away, and violence against blacks continued, prompting several black leaders to break with King over the viability of non-violent resistance. In the summer of 1964 a white policeman shot and killed a fifteen-year-old black boy in Harlem; two nights later the streets were engulfed in violent protests, which spread to Brooklyn and several cities in New Jersey. Further uprisings subsequently shook the cities of Los Angeles, Chicago, Cleveland, Detroit, Baltimore, and Birmingham. In 1965 the black nationalist leader Malcolm X was gunned down by an assassin; in 1968 King met with the same fate.

In 1963, the year of King's March on Washington, a number of African American artists, including Norman Lewis, Hale Woodruff, Charles Alston (1907–77), and Emma Amos (b. 1938), met at the New York studio of Romare Bearden (1914–88). The meeting led to the founding of the Spiral Group, which concerned itself with civil rights campaigning and with a renewed discussion of African American identity in relation to both Africa and the United States. Bearden, who had already gained a reputation as an abstract painter, proposed that the group produce a collaborative collage that would express some kind of consensus or unity. He already had begun working with a series of collages of photographs taken from commercial sources, combining fragments of human anatomy in a seemingly haphazard manner. The collaborative work was never realized, but Bearden continued with his own photomontages, enlarging

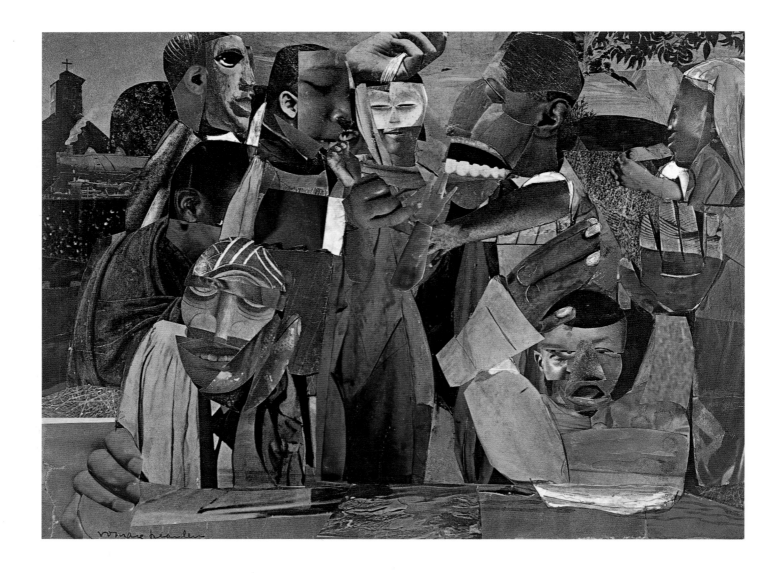

8.81 Romare Bearden: *Prevalence of Ritual: Baptism*, 1964
Photomechanical reproduction, synthetic polymer and pencil on paperboard,
9⅛ × 12 in. (23.2 × 30.5 cm.)
Hirschhorn Museum and Sculpture Garden, Smithsonian Institution,
Washington, D.C.

some photographically. Both the original collages and the enlargements were shown in an exhibition titled *Projections* at the Cordier and Ekstrom Gallery in New York in October 1964 and a year later at the Corcoran Gallery in Washington.

In one of these 1964 collages, *Prevalence of Ritual: Baptism* [**8.81**], the fragmented figures are made up, the artist tells us, "from parts of African masks, animal eyes, marbles, mossy vegetation." They contain disturbing contrasts in scale, with teeth sometimes larger than hands and hands sometimes larger than heads. The faces include young and old, male and female, representing the different generations within African American communities. Bearden's collage technique also calls

to mind the pieced and appliquéd quilts used in so many African American homes, while the sharp-edged, shifting compositional rhythms echo the syncopated rhythms of jazz. Thus, the artist draws his style, as well as his subject-matter, from African American culture. "I work out of a response and need," he stated, "to redefine the image of man in the terms of the Negro experience I know best." Yet he also wanted his collages to speak to issues larger than the particularities of black life. Of *Prevalence of Ritual* he wrote:

> In my work, if anything I seek connections so that my paintings can't be only what they appear to represent. People in a Baptism in a Virginia stream are linked to John the Baptist, to ancient purification rites, and to their African heritage. I feel this continuation of ritual gives a dimension to the works so that the works are something other than mere designs.

Prevalence of Ritual also includes a train in the upper left corner, which resonates with multiple meanings. It signals the ride north to freedom, yet its tracks, often laid by African American chain gangs, mark the dividing line between white and black neighborhoods. "I use the train as a symbol of the other civilization," wrote Bearden, "the white civilization and its encroachment upon the lives of blacks. The train was always something that could take you away and could also bring you where you were. And in the little towns it's the black people who live near the trains." In many of the songs of blues and jazz musicians, too, the train represented a sense of possibility, of movement through time and space; and at the same time, the sound of its whistle seemed to capture the despair of ever being able to achieve that freedom of which Martin Luther King so eloquently spoke in 1963.

In her catalogue essay for the *Projections* exhibition, Dore Ashton wrote that the expressions on the faces in Bearden's collages were often "accusing" or "disquieting," and other critics saw references to the current political unrest in the utilization of African sculpture, a key element in the promotion of black pride in the 1960s. Bearden claimed that while he wasn't backing away from the pain and tragedy of the time, his collages weren't intended to be protest images. They were engaging in an investigation of the lives of African Americans, from southern farm communities to the urban centers of the North. Bearden mined the imagery and themes of black life and culture and reconfigured photographs into often disturbing and thought-provoking statements. In 1969 the novelist Ralph Ellison wrote of the collages: "His combination of technique is in itself eloquent of the sharp breaks, leaps in consciousness, distortions, paradoxes, reversals, telescoping of time and surreal blending of styles, values, hopes and dreams which characterize much of Negro American history."

Many African American artists chose to present in their work more direct commentaries on contemporary civil unrest. Among the first to do so was Faith Ringgold (b. 1930). A resident of Harlem, Ringgold began a group of paintings in the early 1960s called the *American People* series where she addressed, head on, the failures of integration and the violent resistance to any attempts to make integration a reality. In one painting from the series, *Die* (1967) [8.82], black and white men and women shoot and stab each other while a black girl and white boy huddle together in terror. In other paintings the American flag is foregrounded, a stark reminder of the emptiness of the rhetoric of freedom and democracy in the Declaration of Independence and Constitution when applied to African Americans. Many other African American artists—for example, Charles White (1918–79) and David Hammons (b. 1943)—would incorporate the American flag in their condemnations of racial injustice.

Ringgold also took to the streets with her politics, joining other artists in 1970 in picketing the Whitney Museum of American Art for the total absence of black artists in a current major exhibition, and adding her voice to demands that MoMA

8.82 Faith Ringgold: *Die*, 1967, from the *American People* series
Oil on canvas, 72 × 96 in. (182.9 × 243.8 cm.)
Private collection. Faith Ringgold © 1967

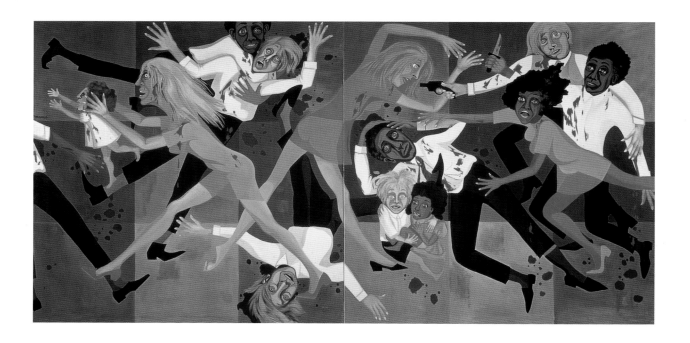

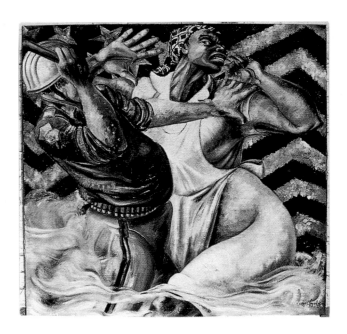

8.83 Jeff Donaldson: *Aunt Jemima and the Pillsbury Doughboy*, 1963
Oil on canvas, 48 × 48 in. (121.9 × 121.9 cm.)
Collection of the artist

American culture's roots in black Africa. To the African past celebrated by black intellectuals and artists since the Harlem Renaissance were now added the contemporary struggles of African colonies for independence, which were seen as parallel to the struggles for civil rights. Black Americans took to heart the words of the African revolutionary Frantz Fanon, who declared at the Second Congress of Black Artists and Writers in Rome in 1959: "The struggle for freedom does not give back to the national culture its former value and shapes; this struggle which aims at the fundamentally different set of relations between men cannot leave intact either the form or the content of the people's culture."

Betye Saar's small mixed-media work, *The Liberation of Aunt Jemima* (1972) [8.84], gives the black female figure weapons with which to fight back against discrimination. The vintage plastic "mammy" figure is placed in front of rows of Aunt Jemima faces taken from the well-known pancake packaging, a not-so-

8.84 Betye Saar: *The Liberation of Aunt Jemima*, 1972
Mixed media, 11¼ × 8 × 2¾ in. (29.8 × 20.3 × 7 cm.)
University of California Art Museum, Berkeley

create a Martin Luther King, Jr, Wing for black and Puerto Rican art. In the 1970s, Ringgold moved to creating textile works in the form of soft sculptures and hanging panels that further investigated the experiences of black women and men.

Several artists also focused on media stereotypes of African Americans. Both Jeff Donaldson (1932–2004) and Betye Saar (b. 1929) took on one of the most pervasive, the smiling "mammy" Aunt Jemima. Advertisements showing this female figure, happy in her role as cook and maid for white America, helped sell Pillsbury products to those who were unaware of, or unwilling to come to terms with, the extent to which American prosperity depended on the oppression of black people. In *Aunt Jemima and the Pillsbury Doughboy* (1963) [8.83], Donaldson radicalizes Pop art's engagement with popular culture, turning the Aunt Jemima figure into a representation of all African Americans who struggle against racism and police brutality. The identification of the policeman as another figure from advertising, the "Pillsbury Doughboy," suggests a connection between corporate interests and a racist police state. The complicity of the government in this racist project is indicated by the distorted American flag behind the two struggling figures.

Donaldson went on to help found the Coalition of Black Revolutionary Artists—COBRA—in Chicago, which later became the African Commune of Bad Relevant Artists, or AFRI-COBRA. The group promoted a representational style accompanied by text to clarify the work's message, with the content focusing on family, black heroes, and pride in African

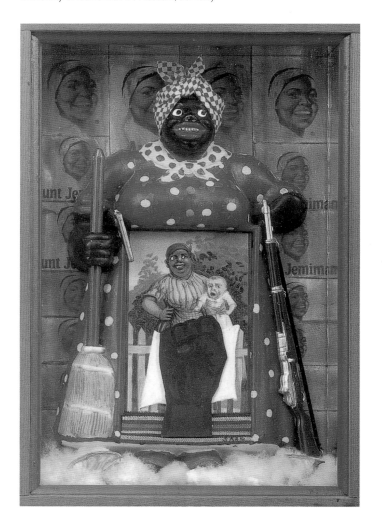

subtle reference to the repeated images of Campbell's soup cans and Coca-Cola bottles in the work of Warhol. In addition to the broom that came with the original figure, the plastic Aunt Jemima holds a pistol and a rifle. Embedded in the figure's stomach is a small print of Aunt Jemima with, according to the artist, a mulatto baby, as an indication of the sexual enslavement of black women. Silhouetted against them is a clenched black fist, symbol of the Black Power movement. This is no docile black servant; she is ready and willing to join her black sisters in liberating herself. Saar also created mixed-media objects and larger installations that, like the collages of Bearden, explored the spiritual sides of African American life, drawing symbols from various world religious traditions, particularly from Africa, and combining them with objects from everyday life.

Black artists also created images of contemporary African American heroes. *Monument to Malcolm X, II* (1969) [**8.85**], a large sculpture by Barbara Chase-Riboud (b. 1936), combines a crown of crushed metal with masses of long black cords suggestive of knotted hair. The photographer Gordon Parks (1912–2006) captures Muhammad Ali after his fight against Henry Cooper in London in 1966 [**8.86**], and emphasizes not the boxer's powerful body but his forward-looking gaze. By the mid-1960s Ali—who was an articulate spokesperson for black nationalism

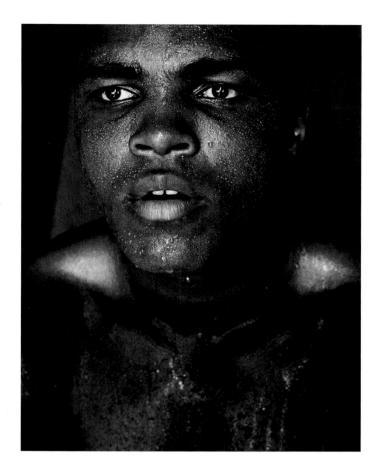

8.86 Gordon Parks: *Muhammad Ali after the Henry Cooper Fight in London, England*, 1966
Silver print
© Gordon Parks 1970

8.85 Barbara Chase-Riboud: *Monument to Malcolm X, II*, 1969
Bronze and wool, 78 × 43 × 32 in. (198.1 × 109.2 × 81.3 cm.)
The Newark Museum, Newark, New Jersey

and had joined the Nation of Islam, changing his name from Cassius Clay—had become a symbol of pride for African Americans as he rose to the position of world heavyweight champion. In 1967 he refused induction into the armed forces on the basis of his religious beliefs, and was subsequently stripped of his title by the World Boxing Association and sentenced to five years in prison (the sentence was reversed on appeal).

Angry Art: Protesting the Vietnam War

Had Ali agreed to his induction, he would have been sent to take part in a war that many in the United States opposed—the Vietnam War. This military conflict had its origins in the withdrawal of the French from their former colony in 1954. Vietnam was divided into two parts, a communist North allied with the Soviet Union, and a South allied with the United States and Western Europe. The government under President Eisenhower began sending military advisors to the South in the late 1950s to help that country in its attempt to defeat the Northern forces and create a unified Vietnam. American participation escalated

throughout the early 1960s, accompanied by a rise in civil unrest at home. In August 1964, two U.S. spy ships exchanged fire with North Vietnamese boats in the Gulf of Tonkin. President Johnson took this incident as an act of open aggression by the North and ordered a series of retaliatory air raids. Congress, responding to his request, passed the Gulf of Tonkin Resolution, giving Johnson the power to "take all necessary measures to repel any armed attack against the forces of the United States and to prevent further aggression." Now, instead of military advisors, troops were sent to support the South Vietnamese army. By the end of 1966 almost 400,000 American soldiers were stationed in Vietnam (these figures would peak at 543,000 in 1968).

Johnson's decision to commit U.S. troops divided Americans, many of whom saw no reason for hundreds of thousands of their fellow countrymen to be fighting in Vietnam, or who suspected the reasons had more to do with corporate profits than national security, which, in the Cold War era, meant stopping the spread of communism. Others, including Muhammad Ali, protested the high percentage of African Americans in the army, seeing this as the government's solution to the rise in black militancy at home. King also began voicing his opposition to the war, raising the specter, in the minds of those in favor of U.S. military involvement, of a merging of the civil rights and anti-war movements. Anti-war demonstrations broke out on campuses and in major cities across the country. Television coverage filled living rooms with images of napalm-scarred bodies,

defoliated landscapes and wounded American soldiers. Senator J. William Fulbright remarked that the Vietnamese carnage was "poisoning and brutalizing our domestic life The 'Great Society' has become the sick society." In February 1968 Senator Robert F. Kennedy wrote: "We seem to fulfill the vision of Yeats: 'Things fall apart, the center cannot hold; / Mere anarchy is loosed upon the world.'" Little hope was left for a peaceful or legislative end to either domestic or international conflict after the assassinations of Martin Luther King on April 4, 1968, and, less than three months later, of Robert Kennedy, and the election of Richard Nixon to the presidency in November.

Some artists continued to believe, along with Greenberg, that their most radical response to the political chaos generated by the civil rights and anti-war movements was simply to continue to make "pure" art, to protect the preserve of creativity from outside forces. Some incorporated subtle references to this chaos in their art. Others addressed it head on. Warhol created a series of silk-screens of race riots based on newspaper photographs. Another Pop artist, James Rosenquist (b. 1933), made connections between American consumer culture, corporations, and the military in several works from the mid-1960s, most significantly in *F-111* of 1964–65 [8.87].

F-111 is made up of fifty-one separate panels, which when combined reach a length of 86 feet and a height of 10 feet

8.87 James Rosenquist: *F-111*, 1964–65
Oil on canvas with aluminum, 10 × 86 ft. (3.04 × 26.21 m.)
The Museum of Modern Art, New York

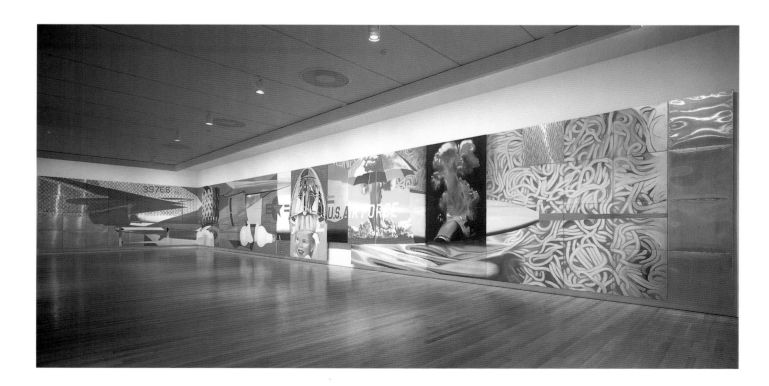

(26 by 3 meters). The painting is dominated by the image of the new supersonic missile-carrying fighter-bomber, the F-III. The prototype was tested in 1964, with the Defense Department making a formal commitment to its production in 1965. Across the surface of the plane Rosenquist has superimposed consumer products—a cake, car tire, light bulbs, hairdryer, umbrella, canned spaghetti. Over its nose is the image of an atomic cloud, which the umbrella vainly attempts to contain—perhaps a reference to the old "duck and cover" campaign of the 1950s that suggested to school children that all one had to do was duck under one's desk and cover one's head during an atomic attack to minimize chances of injury. A blond girl with a helmet-like hairdryer represents the family, in the name of which all this consumption and fighting is undertaken. She is the future, and a somewhat disturbing one at that, with her lipstick and curlers, seemingly oblivious to the massive military hardware behind her and more interested in the angel food cake to her right, under the tire.

Rosenquist is clearly making a connection in his painting between the domestic economy, as determined by large corporations and their advertising machines, and national defense. In response to the question "What is the F-III?" he explained,

> It is the newest, latest fighter-bomber at this time, 1965 People are planning their lives through work on this bomber, in Texas or Long Island. A man has a contract from the company making the bomber, and he plans his third automobile and his fifth child because he is a technician and has work for the next couple of years. Then the original idea is expanded, another thing is invented; and the plane already seems obsolete. The prime force of this thing has been to keep people working, an economic tool; but behind it, this is a war machine.

President Kennedy and his economic advisors were very clear in their thinking that domestic consumption was essential to the economic health of the nation. When this consumption began to flag, other ways had to be found to keep factories operating at capacity. World War II had pulled the United States out of a depression, and there was no reason to believe that another war would not do the same. The $7 billion cost of the F-III program was certainly welcomed by the military and its industrial partners as yet another way to keep the nation well defended and the economy strong. In addition, the Soviet Union's successful launching of the spacecraft Sputnik in 1957 had spurred increased government funding for space exploration. Military spending was also given a boost after the Cuban missile crisis of 1962, when the newly elected President John F. Kennedy faced down Soviet Premier Khrushchev over the installation of nuclear warheads in Cuba.

At the same time as it was increasing its share of the federal budget, the military was also solidifying alliances with industrial giants, including General Electric and Westinghouse—hence the significance of the light bulbs in Rosenquist's painting positioned over the jet fighter. This relationship had been of great concern to President Eisenhower: in his farewell address in 1961 he warned Americans of the dangers of an uncontrolled "military-industrial complex."

Rosenquist's painting isolates and foregrounds readily recognizable advertising and government images that the average viewer might well see side-by-side in magazines such as *Look* or *Life*—an ad for a light bulb sandwiched in between ads for canned spaghetti and for an angel food cake mix, followed by an article on the military. He makes clear the relationship between industry, government, and the military in their promotion of individual and government spending on cars, cakes, and rockets as the key to the country's prosperity. Rosenquist was also aware that the F-III would undoubtedly be used in Vietnam. In discussing the scuba diver positioned over the plane's nose and next to the atomic explosion he commented:

> His "gulp!" of breath is like the "gulp!" of the explosion. It's an unnatural force, man-made. I heard a story that when a huge number of bombers hit in Vietnam, and burned up many square miles of forest, then the exhaust of the heat and the air pressure of the fire created an artificial storm and it started raining and helped put the fire out. The natives thought that something must be on their side; they thought it was a natural rain that put the fire out but it was actually a man-made change in the atmosphere.

By the mid-1960s many artists were openly protesting the war in Vietnam. In 1966 the Artists' Protest Committee in Los Angeles organized the construction of the *Peace Tower*, a structure some 60 feet (over 18 meters) high surrounded by 400 panels of identical size by artists from all over the world, including Evergood, Motherwell, Judd, Nevelson, and Hesse. The tower was designed by the sculptor Mark di Suvero (b. 1933) and was intended to remain in place until the end of the war, but was dismantled after the land's owner succumbed to pressure from pro-war factions and cancelled the rental agreement.

The following year Artists and Writers Protest organized Angry Art Week in New York, which included the creation of *The Collage of Indignation* at the Loeb Student Center of New York University over a period of five days by some 150 artists.

8.88 Nancy Spero: *Helicopters and Victims*, from *War Series*, 1967
Ink and gouache on paper, 35¾ × 24 in. (91 × 61 cm.)
Collection of the artist

One of these was the painter Leon Golub (1922–2004), a key figure in the Chicago group of artists known from their graphic images of misshapen and mutilated bodies as the Monster Roster. He expressed the sentiment of Artists and Writers Protest in the April 1967 issue of *Arts Magazine*:

> Today art is largely autonomous and concerned with perfectibility. Anger cannot easily burst through such channels. Disaffection explodes as caricature, ugliness, or insult and defamation . . . essentially the work is angry—against the war, against the bombing, against President Johnson, etc. The Collage is gross, vulgar, clumsy, ugly.

Many of the artists who were involved in the creation of the Collage went on to produce further condemnations of the war in Vietnam, including *Helicopters and Victims* of 1967 [**8.88**] by Nancy Spero (1926–2009) and *Vietnam II* of 1973 [**8.89**] by Golub.

Two photographers outside of the art world contributed two of the most powerful images of the human cost of the war both at home and abroad. John Filo captured the agony of a young college student, Mary Ann Vecchio, as she knelt beside Jeff Miller, one of the four students shot to death by National Guardsmen at an anti-Vietnam War demonstration on May 4, 1970, at Kent State University in Ohio [**8.90**]. Ronald Haeberle recorded the aftermath of the massacre of 347 unarmed women, elderly men, and children by American soldiers in the South Vietnamese village of My Lai on March 16, 1968. The incident became public knowledge in 1969, and in 1970 Haeberle's photograph was turned into a poster by the Art Workers Coalition (AWC) [**8.91**]. Superimposed on it are a question and answer that became notorious, taken from an interview conducted by the television newsman Mike Wallace with one of the My Lai participants, Paul Meadlo: "Q. And babies? A. And babies." While MoMA had originally agreed to allow the poster to be distributed under its auspices, the agreement was cancelled by the board of trustees. A New York City lithographers' union subsequently printed 50,000 copies, which were distributed worldwide by informal artists' networks and carried in anti-war demonstrations.

The passive endorsement of the war by art museums because of the interests of their board members was coming under increasing scrutiny by artists at the end of the 1960s. In 1970, in an interview with Jeanne Siegel in *Studio International*, Carl Andre declared:

8.89 Leon Golub: *Vietnam II*, 1973
Acrylic on linen, 10 × 40 ft. (3.05 × 12.19 m.)
Rhona Hoffman Gallery, Chicago, Illinois

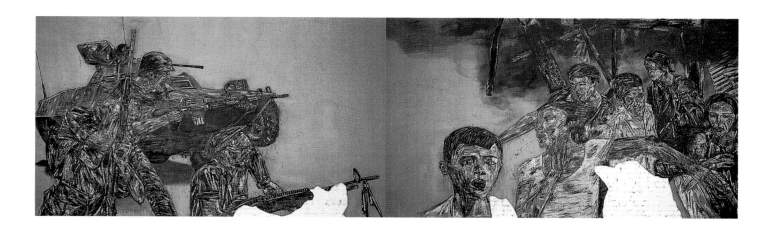

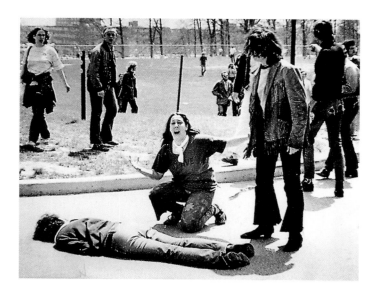

8.90 John Filo: *Anti-Vietnam War Demonstrator Shot by National Guardsmen at Kent State University*, 1970
Photograph

it is the pretence of the museum that they are an apolitical organization. And yet . . . the board of trustees are exactly the same people who devised the American foreign policy over the last twenty-five years . . . [they] favour the war, they devised the war in the first place and wish to see the war continued, indefinitely. The war in Vietnam is not a war for resources, it is a demonstration to the people of the world that they had better not wish to change things radically because if they do the United States will send an occupying, punishing force.

The artist Hans Haacke (b. 1936) continued this critique with an installation entitled *MOMA-Poll* (1970) at MoMA. He had been invited to participate in an international exhibition entitled *Information*. Two months before the opening the United States bombed and invaded Cambodia, despite that country's claims to neutrality, sparking another wave of protests nationwide and a call by artists for a temporary closure of museums as a sign of solidarity against the war. Haacke's installation centered on a question posted on the wall: "Would the fact that Governor Rockefeller has not denounced President Nixon's Indochina policy be a reason for you not to vote for him in November?" Below were two plexiglass containers, one for "yes" votes and one for "no." All visitors were given ballots with their entrance tickets. Nelson Rockefeller had been a MoMA board member since 1932. The Rockefellers also had financial interests in companies such as Standard Oil and Chase Manhattan Bank that were accused of being linked to the production of napalm and other chemical and biological weapons research. Of the 37,129 people who responded to Haacke's question (12.4 per cent of the total attendance at the museum during the exhibition), 68.7 per cent answered "yes" and 31.3 per cent "no." Artists' protests would continue until U.S. troops were finally withdrawn from Vietnam in 1973; the war ended two years later with victory for the North.

8.91 Art Workers Coalition, with photograph by Ronald Haeberle, paper supplied by Peter Brandt: *Q. And Babies? A. And Babies.*, 1970
Offset lithograph printed in color, 25 × 38 in. (63.5 × 96.5 cm.)
The Museum of Modern Art, New York

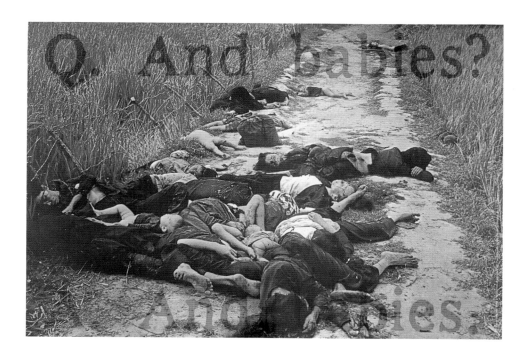

The Personal is Political: Feminist Art of the 1970s

Dispelling the Feminine Mystique: Old Media, New Messages

Many women who participated in the civil rights and anti-war movements of the 1960s developed the theoretical and practical skills needed to understand and to confront discrimination and exploitation as experienced by women and to organize their own movement. The National Organization of Women (NOW) was founded in 1966 to promote the political, social, and economic interests of all women. Its first president was Betty Friedan, author of the bestseller *The Feminine Mystique* (1963). Friedan took on the romanticization of domesticity promulgated by women's magazines, psychologists, social scientists, and other purveyors of social norms, naming it "the feminine mystique." Middle- and working-class homes throughout America were permeated not by domestic bliss, she argued, but by widespread dissatisfaction with limited personal and professional options.

The women's liberation movement was given added impetus by women's entrance into the labor force in unprecedented numbers. The rapid expansion of the service sector of the American economy in the 1960s drew large numbers of both single and married women, particularly white women (women of color were already well represented in the labor force) out of the home and into low-paying, often part-time jobs. Ironically, many of Friedan's dissatisfied women were given partial relief by this service sector expansion. While NOW used its organizational clout to lobby for legislation guaranteeing equal pay for equal work and reform of the welfare system to allow women equal access to benefits and job training, wage disparities based on gender persisted (in 1970 women made approximately fifty cents for every dollar earned by men).

This jump in the number of female wage-earners was accompanied by a new category of advertising and magazine writing. The focus was on women not as homemakers and mothers but as "independent" workers, whose purchases would be directed toward their own pleasure rather than the needs of their families. For example, *Cosmopolitan*, with Helen Gurley Brown, author of the bestsellers *Sex and the Single Girl* (1962) and *Sex and the Office* (1964), at its helm, addressed the desires of growing numbers of white working women for a more "liberated" role in society. Women are shown succeeding in the world outside the home, yet their decreased economic dependence on men is offset by an increased emotional and sexual dependence and by an assumption that their economic independence is temporary, and that their ultimate goal, aided by purchases of clothes, make-up, and other items advertised in the pages of the magazine, is to "catch and keep a man."

Cosmopolitan targeted young adult women with increasingly sexualized representations of female bodies. This focus on the "sexually liberated woman" was partly a response to the calls for greater sexual freedom issued by young men and women throughout the 1960s. Sexual liberation was a form of revolt against a repressive social and political system; it was to be part of a larger political and social transformation. The availability of the birth control pill and, after 1973, legal abortions facilitated a more open exploration of sexuality.

Cosmopolitan's commodity-oriented, sexualized depiction of the new liberated woman was countered by *Ms* magazine, founded in 1972 with the feminist journalist and activist Gloria Steinem as editor. *Ms* was the mass media organ for the women's movement, where bold statements of sisterhood and challenges to patriarchy were the order of the day. It offered in-depth coverage of political, economic, and cultural struggles and successes throughout the country. Reports appeared of the results of "consciousness-raising" sessions, where women gathered to share stories, discovering, in the process, that they were not alone in experiencing in their personal lives the effects of gender discrimination, that the personal was political. *Ms* also covered the efforts of scholars to unearth the histories of women, to provide inspiration and direction for women facing many of the same challenges as their foremothers.

Artists were highly visible in the critiques and celebrations of the women's movement. Women Artists in Revolution (WAR), a splinter group of the Art Workers Coalition, pursued the specific concerns of women, demonstrating in front of the Whitney Museum and at the Metropolitan Museum of Art for the increased representation of women in their collections and exhibitions. Faith Ringgold turned her attention to fighting gender discrimination within the black art community, founding, with her daughter Michele Wallace, Women Students and Artists for Black Art Liberation (WSABAL) in 1970. The following year she joined several other black women artists in forming Where We At Black Women. Artists and scholars founded journals—*The Feminist Art Journal, Heresies, Chrysalis*—and organized exhibitions of women's art in both mainstream and alternative spaces. In 1971 the art historian Linda Nochlin published "Why Have There Been No Great Women Artists?," in which she identified the patriarchal biases of society rather than a lack of talent as the cause of this absence. In 1976 she followed up on this article with a major exhibition at the Los Angeles County Museum of Art, organized with the art historian Ann Sutherland Harris, entitled *Women Artists, 1550–1950*.

Women artists also worked to transform art education. In 1970 Judy Chicago (born Judy Cohen in 1939) founded the first feminist art program in the U.S. at the California State University, Fresno. Chicago had been taught primarily by male artists, saw only the work of men in her art history classes, and never received the encouragement given to her male counterparts to continue as an artist. She wanted to provide young female art students with a different, more supportive educational experience. In 1971 she moved the program to the California Institute for the Arts in Valencia, outside of Los Angeles, where she co-taught it with Miriam Schapiro (b. 1923). Both emphasized the development of community rather than competition among artists. They also focused on the experiences of women, defined by women, as the content of art.

8.92 Alice Neel: *Margaret Evans Pregnant*, 1978
Oil on canvas, 57¾ × 38 in. (146.7 × 96.5 cm.)
© The Estate of Alice Neel, courtesy Robert Miller Gallery, New York

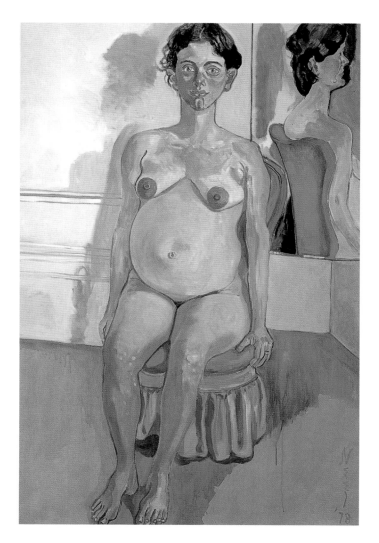

The lessons learned by the students in Chicago's and Schapiro's classes were realized in the program's most ambitious project, *Womanhouse* (1972). Taking an old abandoned Hollywood house, Chicago, Schapiro and their students renovated the building and turned each of the rooms into an art environment that critically engaged with women's roles as homemaker and nurturer, wife and mother. The kitchen was painted pink—appliances, floor, ceiling, counters—with eggs transitioning into breasts covering the ceiling and walls. A female mannequin was embedded in the shelves of the linen closet. The bathrooms were transformed into spaces of nightmarish self-reflection or inventories of the paraphernalia of women's personal hygiene. The artists used traditional materials—paint, wood, canvas—for their work as well as ceramics and various forms of needlework, materials most often relegated to the realm of craft and of women's lives. In addition, a series of performances were staged during the month the building was open (it was demolished shortly after) which reenacted, either literally or symbolically, the various activities that marked the life of a homemaker—ironing sheets, scrubbing floors, waiting, giving birth.

Feminist artists of the 1970s continued to examine many of the same issues raised in *Womanhouse*. Alice Neel (1900–1984) created paintings of naked pregnant women, including *Margaret Evans Pregnant* (1978) [8.92], as commentaries on the ever-varied and ever-changing female body. Harmony Hammond (b. 1944) addressed the relationships between the worlds of art, craft, and the home in her *Floor Piece VI (Sculpture)* of 1973 [8.93]. The title is a playful commentary on the names given to Minimalist sculpture and the claims of Minimalists to be doing something radical by rejecting the pedestal and placing their works directly on the floor. Just as Minimalist works often challenged viewers to rethink the nature and use of industrial materials, so, too, did Hammond's humble hooked rug prompt thoughts about the categorization of materials and objects as either art or not art. Schapiro, along with Joyce Kozloff (b. 1942) and Kim MacConnel (b. 1946), among others, helped initiate a new trend in painting and mixed media called Pattern and Decoration, or P + D, in which designs drawn from such domestic sources as textiles and wallpaper were self-consciously celebrated in large works [8.94]. Schapiro also referred to her pieces as "femmages," collages composed of materials and designs traditionally seen as female.

Audrey Flack (b. 1931) was a member of another new movement in painting in the 1970s, Photorealism, sometimes called Superrealism. Other members were the painters Chuck Close (b. 1940), Richard Estes (b. 1936), and Ralph Goings

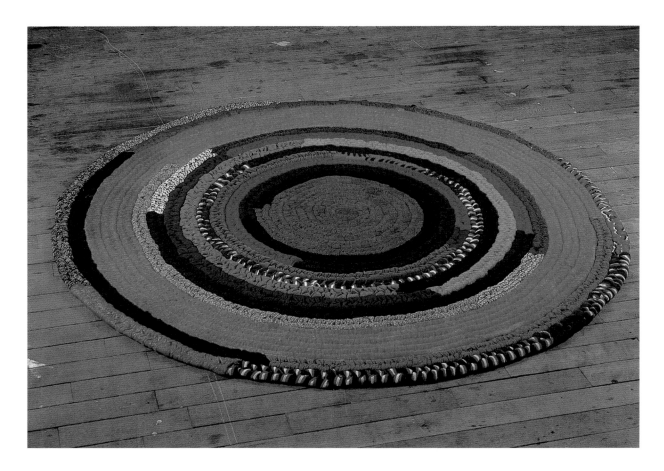

8.93 Harmony Hammond: *Floor Piece VI (Sculpture)*, 1973
Cloth and acrylic paint, D c. 60 in. (152.4 cm.)
Collection of the artist

(b. 1928), and the sculptor Duane Hanson (1925–96). Photo-realism drew its name from the heavy reliance of artists on photographs, which were often projected onto canvas so that their duplication could be as exact as possible. This exactitude was made easier still by the use of the air brush, originally designed for retouching photographs. Photorealist paintings distinguished themselves from their sources primarily through their large size. (Hanson's painted and costumed cast polyvinyl human figures, on the other hand, were life-size, and were often initially mistaken for real people.)

8.94 Miriam Schapiro: *Anatomy of a Kimono* (detail), 1976
Fabric collage and acrylic, whole work 6 ft. 8 in. x 56 ft. 10 in. (2.1 x 17.2 m.)
Collection Bruno Bischofberger, Zurich, Switzerland

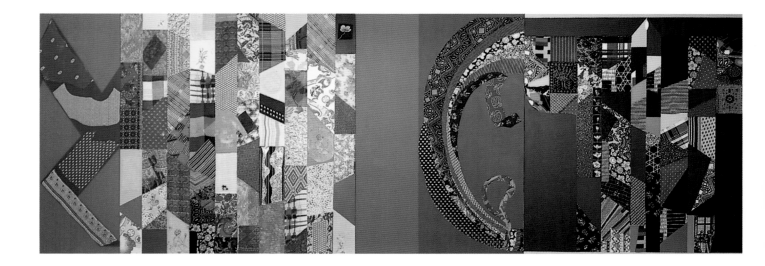

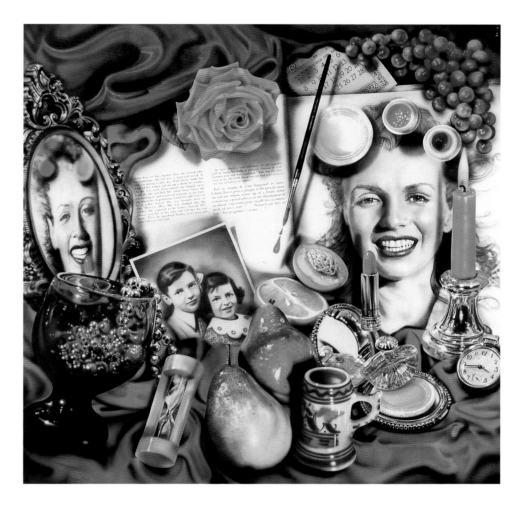

8.95 Audrey Flack: *Marilyn: Vanitas*, 1977
Oil over acrylic on canvas, 96 × 96 in. (243.8 × 243.8 cm.)
Collection of the University of Arizona Museum of Art, Tucson

In *Marilyn: Vanitas* (1977) [**8.95**] Flack utilized her expert skills at rendering the rich surface textures of commercial products to reexamine the tools of artifice directed toward women by advertising and Hollywood. The work suggests a *vanitas* painting, a form of still life in which various elements prompt a reflection on the passage of time and on one's ultimate death. Marilyn Monroe had epitomized female beauty and sexualized innocence in the world of Hollywood before her suicide in August 1962. The main image of a young Monroe—taken from a photograph by André Dienes which appeared in Norman Mailer's biography, *Marilyn*—is surrounded by make-up and jewels, and also by half-eaten fruit, a burning candle, a pocket watch, a small hourglass, and a calendar page that refers to the month of her death. In addition, the large photograph is reflected in the mirror to the left in a way that makes it seem Marilyn is alive and applying her lipstick. Thus Flack reveals the multiple levels of representations to which Marilyn Monroe was subjected

during her life and after her death, adding a final one in the form of her own painting.

Judy Chicago left the California Art Institute and its feminist art program in 1973, moving on to found, with the graphic designer Sheila de Bretteville and the art historian and critic Arlene Raven, the Feminist Studio Workshop, a school for women artists. The Workshop was housed in the Woman's Building, founded in 1973 and named after the Woman's Building at the 1893 exhibition in Chicago (see p. 308). After its move to a new location in downtown Los Angeles, the Woman's Building included studio and workshop space, galleries, a book store, and the office for the Los Angeles chapter of NOW. For over a decade it served as a center for feminist art and political activity, where women artists were able to find a supportive space in which to explore often difficult topics—incest, rape, abortion, domestic violence, racism, homophobia (it closed in 1991).

Much of the work of feminist artists in the 1970s focused on the female body—how it had been represented in fine art and the mass media, how it could be reconfigured in the present. The female nude, defined and portrayed almost exclusively by men, had been a mainstay of Western painting and sculpture

since at least the 16th century. In the 1960s the increased sexual freedoms enjoyed by women, coupled with the increasingly sexualized portrayals of them in advertising as well as in the productions of such male Pop artists as Wesselmann [8.73], prompted a heated debate among feminist artists. They began to view the nude in art as embodying (literally) not just an innocent aesthetic arrangement of shapes and colors but a set of power relationships: between women as naked, powerless, and presented for the sexual delectation of men, and men, who took their "rightful" possession of the naked female through the act of viewing, an act that is aestheticized—i.e. made something other than pornographic viewing—by the location of the images in an art museum.

The question then arose: Could women artists produce non-exploitative images of female sexuality, and particularly of the naked female body? Some argued that until women had achieved full equality, which meant, among other things, full control over their own bodies and full respect as individuals with sexual needs and desires of their own, few images of female sexuality were going to be able to resist being drawn into a way of viewing that ultimately sees women as passive, sexual objects to be possessed—or evil sexual demons to be feared or conquered—rather than active agents of their own desires. Others argued that it was more dangerous to remain silent, to continue to leave the defining of female sexuality to men. However problematic it might be, women needed to explore the

imaging of this sexuality. Women also needed to acknowledge the existence of the female as an active viewer capable of finding pleasure, sexual or otherwise, in the viewing of female bodies.

Some artists decided to investigate a symbolic rather than literal depiction of female sexuality. One of the first to do so was Chicago. In the early 1970s she began working intensively with circular motifs—what she called her "central core" imagery—which, she argued, marked much of the work of women artists. Her observations were taken by some as a claim that there was a distinctly "feminine" aesthetic, i.e. a way of arranging shapes and colors that was inherently female. This claim sparked intense discussion within the feminist art world, with many vehemently denying what they saw as an essentialist proposition, i.e. that biology was aesthetic destiny. Women's experiences certainly influenced their art in several ways, particularly in choice of subject-matter, but being a woman did not ultimately mean that one adopted a particular style or iconography.

Chicago's best-known exploration of this central core imagery is *The Dinner Party* (1974–79) [8.96], which she conceived of as "a symbolic history of women in Western Civilization." Its focus is a large, three-sided table containing thirty-nine place settings dedicated to women from the mythical and historical

8.96 Judy Chicago: *The Dinner Party*, 1974–79
Painted porcelain and needlework, 576 × 576 × 36 in. (14.63 × 14.63 × 0.91 m.)
Collection of the artist

past up to the present, including the Egyptian pharaoh Hatshepsut, the Native American guide Sacagewea, and the American painter Georgia O'Keeffe. The triangular shape of the table here refers to the ancient symbol for both woman and goddess, while the thirteen place settings on each side of the table recall Judy Chicago's initial conceptualization of the piece as a female Last Supper. Each setting is composed of a ceramic plate, a gold-edged napkin, porcelain flatware, and a gold-lined chalice, and rests on an elaborately ornamented needlework runner matched in theme, style, and historical needlework technique to the woman being honored. The plates contain different versions of a composite vagina/butterfly image, an ancient symbol of rebirth and Chicago's trademark since 1972. This image, which begins as a flat design on the first plate, becomes increasingly three-dimensional as one moves around the table and forward in history. The table rests on a triangular platform, where the names of an additional 999 women are inscribed in gold on the ceramic floor.

The response to *The Dinner Party* when it was shown in San Francisco in 1979 was overwhelmingly positive. The exhibition also included a series of tapestry banners leading into the main gallery, a display of traditional china painting, and documentation of the making of *The Dinner Party*, which had taken some five years and the efforts and talents of approximately two hundred women to complete. Many of these women participated in a performance event on the opening night, organized by the artist Suzanne Lacy (b. 1945), that involved the staging of a series of dinner parties around the world. Lucy Lippard spoke for many when she praised the work as a celebration of "the rightful creative heritage of all the women to whom *The Dinner Party* is dedicated" and as an indication of the strength and energy of the women's art community.

Yet there were also dissenting voices. Lolette Kuby, a feminist scholar and active member of NOW, found what she termed "39 pudenda on 39 plates" highly offensive and even more reprehensible than *Playboy* magazine photographs. At least *Playboy*'s editors were up front about what they were doing. In claiming that her work was serious and elegant, Chicago had created a joke at the expense of women. She had played into the hands of a male-dominated society that continually insists on reducing women to sexual symbolism. "Traveling under the guise of an exaltation of the female principle," wrote Kuby, Chicago's *Dinner Party* "is a reduction, once again, of women to vulvas and wombs, seedpods and plants, earth and netherearth." She asked what the critical reception would have been if the work had been created by a man, or if an artist, male or female, had created a similar piece celebrating famous men with male genitals rising up off of plates. Thus, a symbolic

approach to the representation of the female body was not without its problems.

Stepping Out: Feminist Performance Art

Many artists, like Chicago, drew on the spiritual, in particular ancient goddess worship, for their subject-matter. Sometimes it was used with comic and political effect, as in the performance *The Great Goddess Diana*, staged numerous times beginning in 1978 in Venice, California, by a group of artists called the Waitresses. They appeared unexpectedly in restaurants wearing uniforms with multiple breasts (associated with a particular manifestation of Diana, goddess of the hunt) and proceeded to tell customers of the sexual exploitation and low pay of contemporary waitresses, our modern-day Dianas. Others created their goddess imagery within the natural landscape, simulating ancient rituals, as in some two hundred performances by Cuban-born Ana Mendieta (1948–85) from 1973 to 1980 in which she marked various sites with the silhouette of her body [8.97]. She conceived of these works as "a dialogue between the

8.97 Ana Mendieta: *Untitled*, from the *Silueta* series, 1976
Photograph of performance on beach with red pigment
Courtesy Galerie Lelong

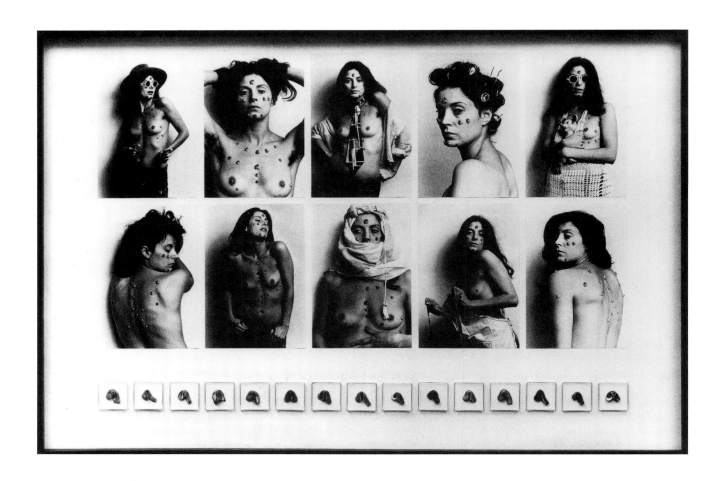

8.98 Hannah Wilke: *S.O.S. Starification Object Series*, 1974–82
Ten black-and-white photographs with fifteen chewing-gum sculptures,
40½ × 58 in. (102.9 × 147.3 cm.)
Private collection

landscape and the female body" based also on her relationship to Cuba. Of her connection to nature she noted:

> I believe this has been a direct result of my having been torn from my homeland during my adolescence. I am overwhelmed by the feeling of having been cast from the womb (nature). My art is the way I re-establish the bonds that unite me to the universe. It is a return to the maternal source. Through my earth/body sculptures I become one with the earth.

Several performance artists decided that, rather than address the female body through symbolism, they would attack it head on and present women not as idealized nudes or central core imagery or silhouettes marking the ground, but as recognizable, naked women. Some turned to their own bodies, creating photographic or painted self-portraits that challenged commonly accepted standards of beauty, or, as in

the paintings of Neel [**8.92**], made visible aspects of women's bodies—e.g. pregnancy—that were often hidden from view. Hannah Wilke (1940–93) used her own naked body, posed to imitate the sexualized poses of pornography and high art, yet covered with pieces of chewing gum folded to resemble female genitalia [**8.98**]. In doing so, she highlighted the fact that while much is made of the beauty of the female body, depictions of actual female genitals, the locus of female sexuality and sexual power, seldom saw the light of day, except in x-rated pornographic magazines. Carolee Schneeman (b. 1939) also used her body, and in particular her genitals, in a 1975 performance entitled *Interior Scroll*. With her naked body marked by broad strokes of paint around the face and torso, Schneeman slowly removed from her vagina a long, thin paper scroll, while narrating the words written on it, which included, among other things, a commentary on her attempts to be an artist in a male-dominated art world. In this perform-ance, Schneeman confronts the dominant understanding of the artist as male and artistic subject-matter as female, exterior-izing her subjectivity through the usually hidden female genitalia and performing the female body as both subject and object.

Performance art of the 1970s functioned as a powerful medium, its immediacy particularly well suited to the confrontational politics of much early feminist work. It had multiple roots, going back to the early 20th-century spectacles of Futurist, Dadaist, and Surrealist artists and forward to the Happenings of Alan Kaprow (1927–2006) and the events staged by the international performance/Conceptual art group Fluxus. In 1958 Kaprow, who had studied with John Cage, published an essay in *Art News* arguing that the innovations of Jackson Pollock—his expansive canvases and energetic involvement in the very act of painting—were forcing artists to move beyond painting itself: "We must become preoccupied with and even dazzled by the space and objects of our everyday life . . . [by] entirely unheard of happenings and events, found in garbage cans, police files, hotel lobbies; seen in store windows and on the streets, and sensed in dreams and horrible accidents." Kaprow subsequently organized a series of Happenings within and outside of galleries in which non-art material—used tires, garbage from the streets—and chance occurrences marked the experience of the viewer/participant, although these experiences were not always totally unscripted. Other artists, including Jim Dine (b. 1935) and Claes Oldenburg, staged similar events.

Carolee Schneeman, a member of Fluxus, entered the scene in 1963 with a piece called *Eye Body*. She subsequently introduced into these events the type of performance art for which she would later become well known, one that focused explicitly on the sexualized, naked body of the artist. During the 1970s several male artists also used their own bodies as "visual territory" (Schneeman's phrase) in performances, most notably Vito Acconci (b. 1940) and Chris Burden (b. 1946). In a 1972 work entitled *Seedbed*, Acconci had a slanted false floor constructed in the Sonnabend Gallery in New York under which he positioned himself with a microphone. He then proceeded to narrate sexual fantasies while masturbating, all of which was audible to those who entered the gallery. In 1971 Burden staged a performance in which a friend shot him in the arm; he later subjected his body to further tests of endurance.

Performing Politics

The political demonstrations of the 1960s were also important precursors of feminist performance art, for they revealed the power of public action to draw attention to significant issues. The theatrical events of the anti-war and civil rights activist Abbie Hoffman (1936–89) were particularly relevant. Hoffman wrote that "a modern revolutionary heads for the television station, not the factory," thus acknowledging the power of the media in the 1960s and the possibility of using this power toward radical ends. Hoffman also acknowledged, with these words, what many activists on the Left saw as the demise of the working class as a revolutionary force for change. In his 1964 book *One Dimensional Man*, the New Left philosopher Herbert Marcuse argued that "the containment of social change is perhaps the most singular achievement of advanced industrial society." Twentieth-century capitalism, through a slight redistribution of the increasing profits realized through new technological developments, had created in the working class "an overriding interest in the preservation and improvement of the institutional status quo." Scholars on the Left subsequently devoted much attention to the mechanisms by which this investment in the status quo was maintained. They paid particular attention to the mass media and institutions of education.

One of Hoffman's most famous actions occurred in April 1967, when he and several friends invaded the New York Stock Exchange and threw dollar bills from the visitors' balcony, causing chaos below as traders scrambled to pick up the money. In January 1968 he, Jerry Rubin, and other like-minded souls proclaimed themselves "Yippies," then founded the Youth International Party, which staged several street demonstrations and media events. Later that year he was arrested after the demonstrations that engulfed the Democratic Convention in Chicago. He used his guerrilla theater talents to turn the ensuing trial into a judicial circus, claiming, among other things, to be judge Julius Hoffman's illegitimate son.

Abbie Hoffman believed that "creativity is needed to reach people snowed under by ruling-class images, and only artists can manage the breakthrough." Yet too often artists produced art that was elitist, if not boring. Happenings, as far as Hoffman was concerned, "were an extension of abstract art and as such were designed for the ruling class . . . That the Museum of Modern (sic) Art honored 'happenings' and 'pop art' while ignoring our brand of political theater just proves the connection between successful artists and the rich." For Hoffman, art was to be both serious and fun. "Even in Mississippi where we were truly frightened most of the time with people shooting at us, living with the constant thought that we might lose our lives, it seemed like people enjoyed their 'work.' . . . There's no incongruity to conducting serious business and having fun." Hoffman's "museum of the streets" included an Army recruiting center in Times Square plastered with stickers saying "See Canada Now" (many fled to Canada to avoid being drafted to Vietnam), stop signs on street corners reading "Stop War," and plastic bags of cow's blood and tape recordings of battle sounds greeting guests at an official dinner for Secretary of State Dean Rusk. Hoffman's interventions were outrageous and often comic. They were meant to destroy any pretense to objectivity or neutrality, to wake people up to the horrors and absurdities of the current political crises.

Hoffman's tactics were taken up in 1969 by the Guerrilla Art Action Group (GAAG), whose members staged several noisy demonstrations/performances at major New York museums, and by the Los Angeles feminist performance artists Suzanne Lacy and Leslie Labowitz (b. 1946). Lacy and Labowitz took to heart Hoffman's advice to "head for the television station." In 1977 they orchestrated several performances protesting sexual violence against women, declaring, "It was violence—in the media and in society—that gave birth to feminist media art." The first, *Three Weeks in May*, was composed of a series of thirty events staged throughout Los Angeles by several artists. In one, a huge bright yellow map of the city received one bright red "rape" stamp for every rape reported to the police, and nine fainter red stamps representing unreported sexual assaults. As the focus was education, another map of equal size listed where victims of sexual assault and their families could go for help. The work, noted Lacy and Labowitz, "brought together normally disparate groups—including artists, self-defense instructors, activists and city officials—in a temporary community that suggested future collaborative possibilities." It also brought the media, who had been contacted by the artists ahead of time so that their actions would extend to a much larger audience.

The same media invitations went out for another performance at the end of the same year, *In Mourning and In Rage*, in which nine tall women dressed in black and one in red appeared in front of Los Angeles City Hall to commemorate the ten victims of the serial murderer known as the Hillside Strangler [8.99]. The participants mourned the deaths and also made statements, one by one, linking these particular murders with sexual violence in general, a connection often absent from media coverage, and calling for concrete solutions. Through a powerfully staged tableau and moving testimony, this performance helped generate a much-needed discussion between city officials, the police, and the public in general about sexual violence against women.

Public Art and the Public Interest

The performances of Lacy and Labowitz can also be seen as a new form of public art and a contribution to the debates engaged in by many artists since the 1960s over the nature of public space and the art that is to be placed within this space. In the past in the United States public art works often functioned as representations of civic virtues meant to instill valuable moral lessons. They were also intended to mark the common values of a diverse community and nation: heroic military efforts in defense of one's country or one's freedoms, respect for the laws of the land. The 1960s changed all that. As people began to march for civil rights and against the involvement of the United States in the war in Vietnam, many began to look at public art and ask: "Whose values are being represented? Whose traditions and beliefs? To whom are these works supposed to speak?" Certainly artists in the 1930s had created images of working-class Americans in government buildings throughout the country, but those murals omitted much— the racism directed at African Americans, Native Americans, Latinos and Asian Americans, the struggles to unionize, the labor of women outside the home (see Chapter 7). Calls were issued for a new kind of public art, one that was truly, in the words of the art historian Arlene Raven, "in the public interest."

Walls of Pride: Chicano/a Murals

These calls were met most effectively by a new generation of muralists, who began covering walls throughout the country with images of local history or of the less celebratory side of national history. These artists argued that a public art could only be truly public if those who shared space with it were consulted about its ultimate form and use. In California in particular, a new and dynamic movement evolved that took inspiration from both the murals of Mexico and the struggles of farm workers in the United States, led by Cesar Chavez and Luisa Moreno, to unionize under the United Farm Workers of America (UFW).

The growing political activism of individuals of Mexican descent around this unionization drive, which ultimately grew into a full-blown civil rights movement, led to the adoption by many of the name Chicano, derived from Mexicano. While it had circulated as an informal term for several decades within communities whose members described themselves as

8.99 Suzanne Lacy and Leslie Labowitz: *In Mourning and In Rage*, 1977
Performance in Los Angeles, California

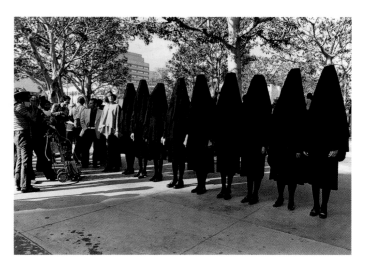

Mexican Americans, it was now used publicly as a form of positive self-identification, indicative of a new political consciousness and a commitment to social change. One of the first Chicano murals was produced in 1968 by Antonio Bernal on the side of the UFW Center in Del Ray, California. The piece celebrates modern revolutionary leaders, included La Adelita, Pancho Villa and Emiliano Zapata (key figures in the Mexican Revolution of 1910–20), Joachim Murieta (outlaw/hero in gold rush time), Cesar Chavez, Reies Tijerina (leader of the land grant movement in New Mexico), Malcolm X, and Martin Luther King. A companion piece depicted Pre-Columbian leaders.

While some Chicano and Chicana artists joined forces with the UFW in creating murals and posters, others turned to local neighborhoods or barrios to create images they hoped would empower their communities, creating civic pride and activism through both celebration and critique. Judith Baca (b. 1946) was born and raised in Los Angeles in a community whose roots ran deep into the Mexican past, yet throughout high school and university she was not exposed to the works of Mexican muralists or of other politically committed artists or artists of color, or to the history of Mexico in general. This convinced her that it was crucial for ethnic cultures to be represented within the country's educational system.

After completing her undergraduate degree, Baca returned to her high school, where she organized her first mural project in an attempt to bring together students from different neighborhoods. The following summer, while working for the Los Angeles Recreation and Parks Department she organized a team of twenty youths from four different neighborhoods. In the process of teaching them how to make art, she also taught them how to uncover the histories of the ethnic communities of Los Angeles and how to make connections between the present and the past. In 1974 she submitted a successful proposal to the City Council for a citywide mural program. During its ten-year existence, 250 paintings were created that involved the participation of more than 1,000 crew members, many of whom were young people with an interest in art as a career. The artists worked with members of the communities where their murals were to be located, establishing a dialogue about local histories and the images to be included. Baca became director of a second citywide mural program in 1988.

These murals were joined by others created by groups such as the San Francisco-based Chicana artist collective Las Mujeres Muralistas, and individuals under their own initiative, like Los Angeles artist Willie Herrón (b. 1951). They brought into the public domain an astonishing variety of images to challenge the stereotypes and the absences in art galleries, educational institutions, and the mass media. They commemorated Chicano community life, religious traditions, agricultural labor, and history. These themes are all brought together, and combined with images of the contributions of other minority communities in the Los Angeles area, in *The Great Wall of Los Angeles* [8.1], which was commissioned from Baca in 1976 by the Army Corps of Engineers for the Tujunga Flood Control Channel in the San Fernando Valley, one of the many "concrete arteries" (Baca's words) constructed to control the rivers and run-off in the Los Angeles basin.

The 2,500-foot (762-meter) long work, painted over five summers between 1976 and 1983, involved several professional artists and hundreds of young assistants. Baca envisioned it as a tattoo over a scarred landscape, one that depicted an alternative history of California. This history acknowledged ethnic peoples, racism, class conflict, sexism and homophobia, and gave a public voice to those who had been silenced. Its images range from depictions of the indigenous inhabitants of California and the arrival of the Spanish to the Depression and labor organizing of the 1930s, the internment of Japanese Americans in World War II, the white flight to the suburbs in the 1950s, with the accompanying displacement of peoples of color by the construction of freeways, and the civil rights and gay liberation movements.

In organizing the production of the mural, Baca enlisted the help of scientists, historians, politicians, and members of local community groups. Her young assistants were black, white, Chicano/a, Jewish, and Asian American and brought with them their experiences of racial and religious conflict. Through their work, they began to understand the roots of racial conflict and to break down some of the barriers that existed between them. To facilitate this project, Baca, the filmmaker Donna Deitch, and the artist Christina Schlesinger founded the Social and Public Art Resource Center (SPARC) in Venice, California. Over the years since 1976 SPARC has served as a nonprofit multicultural arts center devoted to the production, exhibition, distribution, and preservation of public art works.

Modernist Art and Public Controversy: Richard Serra's "Tilted Arc" and Maya Lin's Vietnam Veterans Memorial

The 1960s also saw the revitalization of government funding for art with the establishment of the National Endowment for the Arts (NEA). The programs of the 1930s had ended with the entry of the United States into World War II; now the NEA's "Art in Public Places," set up in 1967, opened the way for large-scale abstract, as well as figurative, sculpture to appear in downtown plazas throughout the country. The first piece installed under this program was Alexander Calder's *La Grande Vitesse* (1969), located in Grand Rapids, Michigan. Those who headed the NEA during its early years were arts professionals

who believed in the importance of Modernist art. They were concerned less with the opinions of the public about the sculpture that was to occupy their public spaces than with the freedom of individual artists to express themselves there.

The issues raised by the public siting of abstract art can best be elucidated by looking at the controversies surrounding two works created in the early 1980s, Richard Serra's *Tilted Arc* (1981) [8.100] and Maya Ying Lin's Vietnam Veterans Memorial (1982) [8.101]. Serra (b. 1939) was nominated by a committee of art critics and curators. He received the commission in 1979,

under the administration of President Jimmy Carter, and was even thanked personally by the President in a ceremony at the White House. Funded through the Art in Architecture program of the General Services Administration (GSA), which received 0.5 per cent of the cost of federal buildings to finance works of art, *Tilted Arc* stood in the plaza in front of the Jacob K. Javits

8.100 Richard Serra: *Tilted Arc*, 1981, in situ in Federal Plaza, Foley Square, New York (now removed)
Cor-ten steel, 12 ft. × 120 ft. × 2½ in. (3.65 × 36 × 0.06 m.)

Federal Building and the United States Court of International Trade in Foley Square in New York. Thomas Crow explains the significance of the setting:

> The location was one of conspicuous visibility and symbolic importance; not only was it the principal site of federal authority in the city, it was hard by the nerve centers of downtown artistic culture in SoHo and Tribeca and therefore a local monument to artists and other opinion leaders in that community. The work would thus be guaranteed to come under extraordinary scrutiny in both its civic and aesthetic manifestations.

In constructing the piece, Serra took into consideration the foundation of the plaza, waterproofing and drainage, pavement maintenance, the effects of wind on pedestrian traffic, security, and lighting. He described his intentions as follows:

> I plan to build a piece that's 120' [36 meters] long in a semi-circular plaza. It will cross the entire space, blocking the view from the street to the courthouse and vice versa. It will be 12' [3.65 meters] high and will tilt one foot [30 centimeters] toward the Federal Building and the courthouse. It will be a very slow arc that will encompass the people who walk on the plaza in its volume . . . After the piece is created, the space will be understood primarily as a function of the sculpture.

Soon after the dedication of *Tilted Arc* in 1981, a petition was signed by some 1,300 office workers asking for its removal (10,000 people worked in the buildings facing the plaza); 300 more signatures were collected from the Environmental Protection Agency. The campaign for the sculpture's removal was spearheaded by Judge Edward D. Re and took place during the first years of President Ronald Reagan's Republican administration, at a time when the GSA was being overhauled and the government's art policies reviewed.

Critics claimed the piece of rusting metal (the Cor-ten steel used by Serra develops a patina of rust) was an eyesore, that it attracted the homeless who used it as a urinal, that it blocked the view and access to the courthouse and Federal Building, that it prevented the use of the plaza for concerts, and that it posed a security threat (a bomb explosion would be vented inward). Some labeled it oppressive, like the Berlin Wall. Defenders of the *Arc* often used the same words as its detractors, admitting that it was confrontational and controversial, but asserting that all "good" art possessed such qualities. Serra argued that his sculpture was not, in fact, done with the public in mind, that he

was operating within the conventions of Modernism, which were understood by a relatively small audience. He also felt it was successful because it had forced people to think about a space they normally took for granted.

The GSA suggested that *Tilted Arc* be relocated, which was opposed by Serra. The piece was site-specific, and removal would mean its destruction. Public hearings were held in March 1985, where the major issue became artistic freedom versus censorship. What also arose, however, was a discussion of the process by which public art was commissioned or acquired. What is the obligation of the artist to the public, particularly when public funds pay for the piece and public space is used? What are the rights of the artist, as outlined in a contract with the federal government? Does the owner of a work of art have the right to dispose of it in whatever way she/he deems appropriate?

The case was decided against Serra, who appealed and once again lost. He then sued the government for breach of contract and freedom of speech, but eventually lost that suit as well. *Tilted Arc* was removed from Foley Square on March 15, 1989, ten years after it was commissioned, and stored in a Brooklyn warehouse (ironically, the Berlin Wall came down later that same year). William Diamond, the GSA regional administrator, heralded the piece's removal as a democratic triumph over "a group of elitists in Washington." "This is a day for the people to rejoice because now the plaza returns rightfully to the people."

Yet, according to the art historian Casey Blake, it was the "people" who had, in fact, been left out of the debate almost entirely. Rather, they became a pawn in the battle between two elites—art world professionals and conservative political bureaucrats. The defenders of *Tilted Arc*, including Serra, insisted that the "public" was ignorant of the significance of Modernist art, and that to pander to public taste was detrimental to aesthetic quality. Only those who had managed, through education in critical thinking, to rise above the enticements of consumer culture could legitimately pass judgment on art. As Blake points out, Serra's defenders were unable to "imagine a public for public art."

Conservative critics of *Tilted Arc* claimed to speak for the public, whose interests would be best represented by a plaza free of controversy and available for either the pursuit of individual pleasure or celebrations of civic authority. They spoke of a time when, in the words of one critic, "everyone understood the purpose of public art. In stone, marble, and bronze were glorified the ideals and triumphs of the nation and community." Public spaces, therefore, were not to be the sites of energetic democratic debate about politics or aesthetics, but, rather, "properly policed and depoliticized" oases in the midst of concrete urban deserts.

8.101 Maya Ying Lin: Vietnam Veterans Memorial, 1982
Black granite
Constitution Gardens, Washington, D.C.

Comments in petitions signed by people who worked in the offices facing Foley Square, however, indicate that what frustrated them most was not necessarily the look of Serra's piece, but that no one had consulted them about the decision to put it there in the first place, and that they were being manipulated by two groups fighting over the symbolic dimensions of the plaza. Their critiques of the sculpture were positioned within broader statements about their own powerlessness, about the rundown plaza itself, and about the sorry conditions inside the office buildings. They wanted the plaza set aside as a place for people to occupy, not as a constant reminder of the inhumanity of the conditions in which they were forced to work. Some even suggested that the sculpture could stay, but that it should be cleaned up—polished or painted a bright yellow—or have holes cut in it so people could see the other side of the plaza. Such opinions were welcomed neither by the supporters of Serra, who were suspicious of any critical

public opinion concerning Modernist art, nor by conservative bureaucrats, who did not want to address complaints about workplace conditions or the lack of political power experienced by office workers. Both groups denied, therefore, the possibility of "democratic debate on a functional aesthetic for public spaces." Only the removal of Serra's *Tilted Arc*, argues Crow, allowed "the relations between public symbols and private ambitions, between political freedom, legal obligation and aesthetic choice" to be fully aired.

The Vietnam Veterans Memorial by Maya Ying Lin (b. 1960) is also a Modernist work of art [8.101]. Located in Constitution Gardens in Washington, it consists of two polished black granite walls 246 feet (75 meters) long arranged in a V shape, 10 feet (3 meters) high at their intersection and steadily decreasing in height toward each end. The area in front is excavated, so that the wall forms an embankment, with a walkway along which people can move and survey the work. The polished surface captures the reflections of the viewers, integrating them into the monument. The names of the dead are carved into the granite slabs. One of the walls points to the Lincoln Memorial, the other to the Washington Monument.

The idea for the memorial to the almost 58,000 U.S. soldiers killed or missing in action was initiated by Jan Scruggs, a veteran of the war, who helped form the Vietnam Veterans Memorial Committee to lobby for funding and for a site. The committee gained the support of Senator Charles Mathias, who helped secure the site. A national competition for the design was announced in 1980 and was open to all who wished to apply. The eight-person selection committee reviewed the submissions without the names of the artists attached. There were three main criteria for the work: (1) it had to contain all of the names of the dead; (2) it had to be reflective and contemplative; and (3) it could not make a political statement.

The committee received over 1,400 entries and in May 1981 selected the winner, Lin, a twenty-one-year-old Chinese American Yale University architecture student. The Vietnam Veterans Memorial Committee was divided over the choice. There were three main objections. First, a political statement was being made through the selection of the color black, which some argued was the color of shame and sorrow rather than glory (other war monuments in the city were of light-colored marble or granite). Second, the names were arranged in the order that the soldiers died, not alphabetically, and first names preceded surnames, suggesting too much emphasis on the individual rather than the cause for which he had died. Third, the V shape suggested the peace symbol of anti-war protesters.

Lin and her supporters responded to each objection. Black is a color traditionally used for funeral monuments, so it was not an unusual choice for a war memorial. General George Price, an African American, commented: "I remind all of you of Martin Luther King, who fought for justice for all Americans. Black is not a color of shame. I am tired of hearing it called such by you. Color meant nothing on the battlefields of Korea and Vietnam. Color should mean nothing now." The names were arranged in the order of death for reasons of historical accuracy, not to deny the larger purpose of the war. And the V sign is a symbol of victory as well as peace. Yet, of course, Vietnam was not a victory for the United States. And no matter what Lin and others might argue, her work was, in fact, a political statement, just as any work about the war in Vietnam would unavoidably have been.

Some opponents wanted the competition reopened. Others wanted to place an American flag at the intersection of the two walls, or a figurative statue. Ultimately a compromise was reached. Lin's monument was built as designed, and a second, over-life-size bronze monument of three soldiers was created by Frederick Hart (1943–99) and placed at a distance away from Lin's work. A second bronze memorial to the women who served in Vietnam, designed by Glenna Goodacre (b. 1939) and depicting three female figures and a wounded soldier, was unveiled in 1993 further to the south.

The juxtaposition of Lin's monument and these figurative pieces served to highlight the aesthetically radical nature of her work. Where most war memorials rise above the ground in the form of heroic figures or architectural elements like arches or columns, Lin's sinks into the earth, creating a space that embraces visitors. It captures the ambiguity that will always mark America's response to the Vietnam War. This ambiguity is present in a comment Lin made in 1985: "I had an impulse to cut open the earth . . . an initial violence that in time would heal. The grass would grow back, but the cut would remain . . ."

The Vietnam Veterans Memorial acknowledges the loss of life with a quiet respect and provides a space to grieve. It does not celebrate with pomp and circumstance a war that left little for people to celebrate, yet it does not deny that war's place within the nation's history. The work opened to the public on Veterans' Day in 1982 and, within six months, was the third most heavily visited site in Washington. People took rubbings of the names on the wall and left offerings in front of it, attesting to its success in engaging viewers and in commemorating and honoring the individuals who had died.

Is Less More? Re-evaluating Modernism in Architecture

Playfulness and Postmodernist Architecture

Clearly not all Americans approved of Modernist sculptural designs. The same was true of Modernist architecture. The flight of white working- and middle-class Americans to the suburbs and the slicing up of urban neighborhoods by new freeways led to the decay of many inner cities. The federal government responded by promoting urban renewal projects that resulted in the demolition of large sections of existing neighborhoods and the construction of massive housing projects composed of identical multi-story apartment blocks. An early example is Stuyvesant Town and Peter Cooper Village in New York City, designed by Irwin Chanin and Gilmore Clarke for Metropolitan Life and built in 1947 to house returning servicemen [8.102]. Not all such housing projects were as successful as this one, however (the buildings and grounds have been consistently maintained over the years). The symbolic end of Modernist architecture, in fact, has been identified by the architectural critic Charles Jencks with the demolition of one public housing project, the Pruitt-Igoe in St Louis, designed by the Japanese American architect Minoru Yamasaki (1912–86) in 1951 and built in the mid-1950s. A monument to rational, utopian Bauhaus planning, with thirty-three concrete slab buildings of

8.102 Irwin Chanin and Gilmore Clarke: Stuyvesant Town and Peter Cooper Village, New York, 1947

eleven stories each, this multi-million-dollar complex won an American Institute of Architects Award. By the time the dynamite charges were set off in 1972, it had turned into a social and economic horror, riddled with crime and vandalism. Missing had been, among other things, the personal privacy and sense of place that are so integral to the creation of community.

Just as famous as the destruction of the Pruitt-Igoe project in marking an end to the dominance of Modernist architecture were the publications and buildings of Robert Venturi (b. 1925). In 1966 Venturi consolidated his architectural philosophy in his book *Complexity and Contradiction in Architecture*, in which he responded to Mies van der Rohe's "less is more" with "less is a bore." Great architecture of the past was not just classically simple; it could also be, like the Mannerist and Baroque architecture of the 16th and 17th centuries in Europe, ambiguous and complex. While in Rome in 1954, Venturi had been impressed by the human scale of the city, by its sociable piazzas and mixture of the grand and the common.

Venturi's architectural principles become clear in the house he designed for his mother, Vanna Venturi, in Chestnut Hill,

Pennsylvania (1962–65) [8.103], where Modernist tenets of architectural purity are thrown to the wind. The shape of the gable roof is exaggerated, now defining the majority of the house's mass. It is also split in two, with a large vertical gap separating the two parts, a postmodern version of a broken pediment. Symmetry is rejected in the window grouping, as is the prohibition against applied decoration. Two thin horizontal

8.103 Robert Venturi: Vanna Venturi House, Chestnut Hill, Philadelphia, Pennsylvania, 1962–65

moldings run around the lower portion of the building, and a broken arch stretches above the doorway and across a horizontal beam, thus juxtaposing two different structural principles for spanning a space—an arch and a post-and-lintel construction. Once inside the house the visitor is confronted with a final surprise: it is only one room deep behind the facade.

In 1972 Venturi, Denise Scott Brown, and Steven Izenour published *Learning from Las Vegas*, a book that took seriously the architectural vernacular of commercial buildings like those that lined the city's Strip. They looked at how this architecture worked, both symbolically and literally, seeing in it a source for new, more human-centered structures (this was the Las Vegas of the 1960s, before the theme-oriented megahotels had taken over).

Proponents of this new architecture—labeled "postmodern" in the 1970s—described it as a playful and eclectic mix of styles, as opposed to the monolithic sameness of Modernist forms. In place of rational functionalism and claims of universality were the irrational, the vernacular, and the metaphoric. Postmodern architecture was radial rather than linear, synchronic rather than diachronic. It took into consideration the surrounding environment and the specific needs of those who were to inhabit it, meeting these needs with wit and a sense of adventure.

Postmodernism was quickly taken up by both private and corporate patrons. It was particularly suited to the creation of corporate signatures amidst the anonymous towers of urban centers. For example, one can easily pick out the A.T. & T. Building (1978–83) [8.104] by Philip Johnson and John Burgee (b. 1933) from among the hundreds of skyscrapers in New York. Crowned by a massive broken pediment and marked by strong vertical arrangements of windows, the building reminds one of an enormous highboy dresser. It is wrapped in granite rather than glass, and the street level is marked by an open loggia with a large central Romanesque arch, while the lobby contains a gilded Art Deco angel from the old A.T. & T. Building mounted on a large black pedestal. Here is truly an architectural pastiche, with references to both the grandeur of the Baroque and the Pop mentality of the late 20th century.

The Piazza d'Italia in New Orleans of 1978–79 [8.105] by Charles Moore (1925–93) takes pastiche to an even greater

8.104 Philip Johnson and John Burgee: A. T. & T. Building, New York, 1978–83 (model)

8.105 Charles Moore: Piazza d'Italia, New Orleans, Louisiana, 1978–79

extreme, giving the local Italian American community a playful array of classical forms—Corinthian columns, Roman arches—made out of neon, cement, stainless steel, and water. The pavement is inlaid with a map of Italy, with Sicily, the area from which most of New Orleans's Italians had come, in the center. The setting for the annual St Joseph's festival, Moore's Piazza combines archaeology, modernism, commerce, and theater.

Paranoia and Postmodernist Architecture

Postmodernism in domestic architecture on the West Coast is represented by the home in Santa Monica, California of the architect Frank Gehry (b. 1929), completed in 1978 [8.106]. Scholars have described Gehry's work as deconstructivist, as composed of recognizable forms that have been dismantled or cut up and then rearranged in new and surprising configurations. For his own residence he took a small pink bungalow, typical of the many constructed between the 1930s and the 1950s, and wrapped it in a seemingly haphazard array of corrugated metal, chain-link fence and rough plywood, materials most often found in industrial areas or shanty towns. Gehry also took apart the interior of the house, revealing the wooden beams and other marks of construction usually concealed by finishing touches. Thus

8.106 Frank Gehry: Gehry House, Santa Monica, California, 1978

he has created three layers—the "incomplete" interior, the finished exterior of the original house, and the industrial enclosure of the whole. "The heart and soul of the house are laid bare, so to speak," writes the architectural historian Rosemarie Haag Bletter, "while the exterior is armored against a somewhat hostile neighborhood."

It is not clear whether the hostility referred to by Bletter was simply the criticisms of his neighbors, many of whom did not find the odd juxtapositions of materials aesthetically pleasing, or some larger neighborhood tension; she mentions as an aside that the house was shot at by a sniper, but that this should not be taken as architectural criticism. She does go on to remark that many of Gehry's Los Angeles works are inward-looking, with barriers "thrown up between the buildings and their settings" and no "inviting, generous gestures toward the local context." This introversion she attributes to an absence of social consensus and the devastation of the public environment of Los Angeles by the automobile. The often fragmented character of the designs can similarly be attributed to the fragmentation of the family, the constant tearing down and rebuilding that marks the city, and the numerous earthquakes that regularly shake the region. "Gehry's type of fractured assemblages," writes Bletter, "constitutes an appropriately disquieting response to fragmentation of the extended family, community and urban space."

While Bletter speaks in generalities about the hostilities and tensions that mark the public spaces of Los Angeles, the

8.107 José Rafael Moneo: Cathedral of Our Lady of the Angels, Los Angeles, California, 2002, seen from the south. Above the bronze entrance doors is a statue of the Virgin Mary by Robert Graham

urban historian and architect Mike Davis provides the specifics. In *City of Quartz* (1990) he notes that the architectural response to the decay of urban environments and the increase in poverty and unemployment is symbolized by the proliferation of "Armed Response" signs on both public and private buildings throughout the city. Architectural design has been drawn into the policing of social boundaries, a policing that has supplanted earlier hopes for urban reform and social integration. Public space has been destroyed in order to "secure" the city, with security cameras regularly surveying alleys and lobbies. In addition, the homeless have been discouraged from finding a comfortable spot to sleep, day or night, by sprinklers that turn on at night in public parks and by convex bus benches.

This policing of public space is particularly evident in the massive redevelopment project in the Bunker Hill area of downtown Los Angeles, where a sea of concrete and glass contains little to welcome the pedestrian at street level, but much to entertain once he or she has penetrated the perimeter—bubbling fountains, art galleries, and amphitheaters for public performances. Police and private security officers ensure that "undesirables"—the homeless or panhandlers—do not take refuge in these idyllic spaces. The fortress-like ambience is further emphasized by the radical change that occurs a few blocks away, where one encounters crowds of working-class people, primarily Latino, and the open markets of Broadway. A few blocks further and one discovers where the homeless have been sequestered—a ten-block area known as "The Nickel" or "Skid Row." It is in light of this Los Angeles that Davis reads Gehry's work—his "stealth houses" with blank gray exterior walls to camouflage the wealthy interiors, his public library in Hollywood with security functions as design motifs—as clarifying "the underlying relations of repression, surveillance and exclusion that characterize the fragmented, paranoid spatiality" of postmodern Los Angeles.

These mechanisms of exclusion also mark the exterior of one of the latest additions to Bunker Hill, the massive Cathedral of Our Lady of the Angels (2002) [**8.107**] by the

Spanish architect José Rafael Moneo (b. 1937): an impressive edifice with its 150-foot (46-meter) bell tower and large windows of thinly veined Spanish alabaster, it towers over the Hollywood Freeway. The Freeway follows the old *Camino Real*, the roadway used by the Spanish in the 18th century, and the Cathedral speaks to the history of Spanish mission architecture in the region, with its adobe-colored concrete and its "carillon wall" with three rows of bells facing Spring Street. It also utilizes the latest in earthquake construction (the earlier Cathedral was seriously damaged in a 1994 earthquake). The entire structure sits on base isolators, allowing the building to move about 24 inches (60 centimeters) in any direction during an earthquake.

Access to the complex—which consists of the Cathedral itself, the interior courtyards, the restaurant, gift shop, conference center, offices and rectory—is limited to one small gated entrance and the adjacent underground parking, both on Spring Street. Moneo commented that he did not want people to enter the Cathedral directly from the street but, instead, to engage in a spiritual journey from sidewalk to lower plaza to upper plaza to the church entrance, marked by the 25-ton bronze doors and statue of the Virgin Mary designed by sculptor Robert Graham (1938–2008). Yet such a journey did not necessitate the complete walling-off of the Cathedral grounds. The impression from outside the walls is of both a spiritual and a physical sanctuary, a fortified retreat from the real and imagined dangers of an urban environment.

Postmodernism and Art

While the term "postmodernism" was used to describe developments in the field of architecture in the 1970s, by the 1980s it had become widespread in all the arts, architecture, and literature. Under the influence of certain French theorists—Jean Baudrillard, Jean-François Lyotard, Roland Barthes, Michel Foucault, Jacques Derrida—postmodernism "deconstructed" what was perceived as the narrowness and arbitrariness of Modernism (the latter's socially disengaged formalist aesthetic, emphasis on originality and individual expression, and view that art inevitably evolved, through a process of self-criticism, toward purely formal abstraction). Postmodernism challenged privileged art styles, media, and subject-matter, emphasizing, instead, a plurality that overturned inherited hierarchies and criteria of judgment. Many have located its beginnings in the work of Marcel Duchamp and the Pop art of the 1960s, which rejected Modernism's abandoning of recognizable content and focus on a search for the "essence" of individual media. Pop art presented itself, instead, as

surface appearance or packaging. It not only reintroduced content, but often drew directly from the world of consumer culture, thus challenging the Modernist dictum that art needed to be segregated from the mundane in order to maintain, in the words of Greenberg, its "purity . . . [which was its] guarantee of quality and independence."

Postmodernism's rejection of the dominant, linear narrative of Modernism and emphasis, instead, on relativity and difference was also associated by many with political and economic turmoil. In addition to the civil rights and anti-war movements of the 1960s, the economic expansion that had taken place since the end of World War II had slowed considerably by the early 1970s. American dominance of world trade was being challenged by the rebuilt economies of Europe and Asia. In 1973 a stagnating economy was worsened by two events: an embargo on shipments of oil by Arab countries in retaliation for U.S. support of Israel and Israel's subsequent victory in the Yom Kippur War, and the withdrawal of American forces from Vietnam. That same year, history seemed to repeat itself as members of the American Indian Movement (AIM), founded in 1968, squared off against federal forces at Wounded Knee, South Dakota, on the Pine Ridge Reservation, over the same issues that had brought the ancestors of these two groups together at the end of 1890 (see p. 244)—treaty rights and self-governance. In 1974, President Richard Nixon resigned from office, facing impeachment as a result of an attempt to wiretap the Democratic National Committee headquarters in Washington's Watergate Hotel during the 1972 presidential election.

This evidence of economic and military vulnerability, internal divisions, and political corruption was projected throughout the nation and the world through newspapers and television, contributing to increased feelings of alienation from electoral politics and anxiety about the country's future. The seizure of the American embassy in Tehran in 1979 after the fall of the United States-supported Shah, and the taking of over sixty hostages, increased this anxiety. All of these events informed much postmodern art, with its sense of loss, exhaustion, arbitrariness and irony, its play with the surfaces and fragments of an old order and suspicion of passion and politics.

Others agreed with the characteristics ascribed to postmodern art by those who saw it as a break with Modernism, but argued that, ultimately, it continued to promote several concepts central to the art world within which Modernism flourished. The obsession with novelty and with rejecting established art forms still existed in the 1980s and 1990s,

only now the duration of an artist or style was significantly shorter. And the celebration of the artist as individual genius also continued, although the nature of this genius shifted from lonely, misunderstood creator to shrewd, entrepreneurial image-maker negotiating his way through the booming art market of the 1980s. And those who commanded top prices continued to be predominantly male, particularly in the worlds of painting and sculpture, the difference being that success was now coming earlier in an artist's life in a culture that valued not only novelty but also youth and good looks.

A third group saw postmodernism as a rethinking of the formal developments of Modernism, both stylistic and theoretical. For example, the 1980s saw a proliferation of "neo" art movements—e.g. Neo-Expressionism, Neo-Minimalism. Many artists also took up the critical self-reflection that marked much Modernist work, only now they looked more closely at the place of the artist within the historical continuum of art and at the very production of art itself. They explored more closely how meaning was constructed and deconstructed through visual representation. They appropriated previous styles or images, resituating these in the late 20th century, thus investing them with new meaning. For example, Sherrie Levine (b. 1947) literally reproduced the photographs and paintings of earlier artists (e.g. Walker Evans, Ralston Crawford), in the process calling into question the concept of originality, although at the same time making her own claim to originality by being the first artist to engage in such imitation. Her replicas also prompted a feeling of nostalgia for a time when originality seemed possible, when artists and audiences still believed in the higher purpose of art.

8.108 Robert Longo: *National Trust*, 1981
Two charcoal and graphite drawings on paper, one cast fiberglass and aluminum bonded sculpture, three panels, overall 5 ft. 3 in. × 19 ft. 6 in. (1.6 × 5.94 m.)
Walker Art Center, Minneapolis, Minnesota

Art Stars

Artists' relationships to the institutions of the art world and consumer culture also underwent a transformation that can be interpreted as either an abandoning or a rethinking of art world practices. Artists depended primarily on galleries, museums, and critics to promote their work beyond their own limited circles of friends and colleagues. In the 1980s and 1990s many postmodernists took matters into their own hands, aggressively courting the mass media and art market using the tactics refined by Warhol to promote themselves and their productions. They recognized that art was a commodity and celebrated this fact rather than bemoaning it as a limitation on artistic creativity. In addition, their willing engagement in the production of painting and sculpture that "looked like" painting and sculpture, with all its tactile appeal and recognizable subject-matter, was welcomed by collectors, many of whom had grown weary of the rarified theoretical statements of Conceptual art and the photographic records of earthworks.

Robert Longo (b. 1953) was a self-promoter of this type. He became well known in the 1980s for large charcoal drawings of young men and women in business or evening attire placed in enigmatic poses [**8.108**]. The drawings, which were designed by Longo but executed by a commercial artist, were interpreted by many as depictions of the new generation of entrepreneurial fortune-seekers known as Yuppies, or Young Urban Professionals. In 1986 Longo commented: "I'm a good salesman, and I transfer my enthusiasm about my work to other people. I convince them that I'm going to be an artist forever and an important one." He expanded his notoriety through the production of MTV music videos, the popular culture counterpart to Warhol's radical and far from popular experimental films of the late 1960s.

Another artist who promoted himself effectively was Keith Haring (1958–90). Haring began his career creating simply

8.109 Keith Haring: *Subway Drawing, 51st Street, c. 1980–83*
White chalk on black panel
© The Estate of Keith Haring

outlined figures in an easily recognizable signature style, which were initially drawn on empty advertising spaces in New York subway stations [8.109]. After Haring's discovery by dealers and collectors, his work appeared not only on canvas in galleries and museums but also on watches, T-shirts, toys, and other products for sale in his very own store.

While the location of Haring's early work immediately suggests parallels with the graffiti that was increasingly covering the walls of New York's public spaces and subway cars in the 1980s, his images were tame in comparison and much more limited in scope and iconographic range. Instead, the complexity of graffiti iconography was brought into the art world in the 1980s by the African American painter Jean-Michel Basquiat (1960–88), whose quick rise to fame, achieved through his own concerted self-promotion, was cut short by a drug overdose in 1988. Like Rauschenberg, Basquiat created ironic combinations of popular culture—in this case graffiti—and art world styles like Abstract Expressionism that often offered biting commentary on both racial stereotyping and the intersections of white and black cultures (he was later mythologized as tragic art hero in Julian Schnabel's 1996 film *Basquiat*).

Jeff Koons (b. 1955) utilized his understanding of the business world as a commodities broker to parlay his artistic efforts into a highly successful career within five years, carefully placing his sculptures—based, not surprisingly, on mass market commodities [8.110]—in important collections. "It's like a company choosing a franchise," he declared: "You want one on a busy corner, not in the middle of nowhere." Koons's self-promotion

also included placing ads depicting himself, at times in the company of attractive, scantily clad women, in art journals. In addition, he created a series of works of himself and his wife, Italian porn-star-turned-politician Ilona Staller, better known as

8.110 Jeff Koons: *New Shelton Wet/Dry Triple Decker*, 1981/86
Acrylic, fluorescent light, plexiglass, and three vacuum cleaners,
120¼ × 24¼ × 24¼ in. (316 × 71 × 71 cm.)
Des Moines Art Center, Des Moines, Iowa

8.111 Julian Schnabel: *Exile*, 1980
Oil and antlers on wood, 90 × 120 in. (228.6 × 304.8 cm.)
Collection of Mrs Barbara Schwartz

Cicciolina, in erotic poses. Finally, Koons also experienced one of the dangers of the practice of appropriating images produced by others—lawsuits over copyright infringement.

This articulate self-promotion by artists was accompanied by the use of increasingly aggressive tactics by art dealers and collectors. The New York dealer Mary Boone gained attention in the early 1980s through her swift and successful promotion of the young Neo-Expressionist artist Julian Schnabel (b. 1951), who juxtaposed references to past and present art styles and iconography (e.g. Old Masters, the "junk" and fine art of Rauschenberg, the paint-laden brushstrokes of Abstract Expressionism) in large, richly textured paintings such as *Exile* (1980) [8.111]. At the same time, Charles Saatchi, founder of what was, by the 1980s, the largest advertising agency in the world, revolutionized collecting by purchasing art in large blocks, then using his advertising know-how and art world connections (he was on the Board of Trustees of the Tate Gallery in London) to promote the careers of the artists just purchased, thus driving up the prices after having cornered the market. Schnabel was one of those snapped up by Saatchi in the early 1980s. Collectors like Saatchi and the oil baron Armand Hammer also set up their own private museums to display

their holdings. The presence of astute artists, dealers, and collectors, whose words and actions influenced a highly volatile market, led to a diminished role for critics and public museums as the central arbiters of aesthetic taste and artistic value.

Mass Media Manipulations

Many artists in the 1980s and 1990s focused critical attention on the pervasiveness of images in American society, in particular those produced by the mass media, and their role in defining social structures, personal and group identities, and political possibilities. As photographic and computer technologies became increasingly sophisticated in manipulating images to create what appeared to be "real" events and places (witness the convincing re-creation of the Roman Colosseum in Ridley Scott's 2000 film *Gladiator*), and as control of the media was consolidated in fewer and fewer hands, the "truth" value of photographic representation diminished. The art historian Lisa Phillips has written of the 1990s: "The confusion of the real and the imaginary qualifies almost every cultural art form . . . In a total reversal of standards, anything that looks real must now be doubted, while anything announcing its artificiality is more trustworthy."

Artists wanted to problematize representations in the media as well as in fine art, to interrupt the incessant flow of images and to unveil the mechanisms through which they were produced and circulated. By highlighting the processes through which information is manipulated and transformed into highly

8.112 Cindy Sherman: *Untitled Film Still No. 6*, 1979
Gelatin silver print
Collection of Alvin and Marilyn Rush

appealing images, and by revealing what had been omitted from public representations, artists hoped to decrease the ability of media images to control people's material, intellectual, and emotional lives. They gained much of their insight into the power of visual representations through Marxist writers such as Walter Benjamin, John Berger and Louis Althusser, and the recent French poststructuralist theorists Foucault, Derrida and Baudrillard, along with their more psychoanalytic counterparts Jacques Lacan and the French feminists Luce Irigaray and Hélène Cixous.

Photography played a major role in these works, being able to reproduce the look of mass-media images so effectively. Cindy Sherman (b. 1954) began creating a series of black-and-white photographs in the late 1970s that replicated movie stills. In all of these she used herself as the model [8.112], thus exposing the artificiality and constructed nature of femininity in Hollywood. Later she focused on the grotesque and the fantastic in large and richly colored Cibachrome prints, conjuring up scenes of decay and violence rather than glamor. As with so much art that attempts to critique through replication, however, the critical edge is often lost in the pleasurable viewing of images that look so much like those seen on movie and television screens or in magazines. Some have argued that Sherman's success was due in large part to the palatability of her early imagery, or to the ability of her later works to feed an increasing appetite in American society at large for the macabre, the violent and the grotesque, evident in the movies coming out of Hollywood studios.

Another photographer, Barbara Kruger (b. 1945), spent much of the 1960s as an art director for *Mademoiselle* and other Condé Nast women's magazines. Like Warhol, she brought her graphic design skills to her fine art work. Unlike Warhol, her commercial art experience manifested itself not in the use of recognizable subject-matter drawn from the mass media but in eye-catching juxtapositions. "I learned to deal with an economy of image and text which beckoned and fixed the spectator," commented Kruger. "I learned to think about a kind of quickened effectivity, an accelerated seeing and reading which reaches a near apotheosis in television." Yet in the world of advertising, the image and text are meant to convey an easily recognizable message—this perfume will make you attractive to men, so buy it. Kruger subverts such comfortable recognition, producing, in her own words, "a doubled address, a coupling of the ingratiation of wishful thinking with the criticality of knowing better."

Kruger gathers photographic material from various kinds of publication—photography journals, popular magazines, instruction manuals—and overlays it with blocs of bold-face type in various sizes. The juxtapositions are jolting: "Your manias become science" superimposed over an image of an atomic blast, "We have received orders not to move" over the image of a seated woman, bent over and pinned down by

8.113 Barbara Kruger: *Your Body is a Battleground*, 1989
Poster, 34 × 29 in. (86.4 × 73.7 cm.)
Private collection

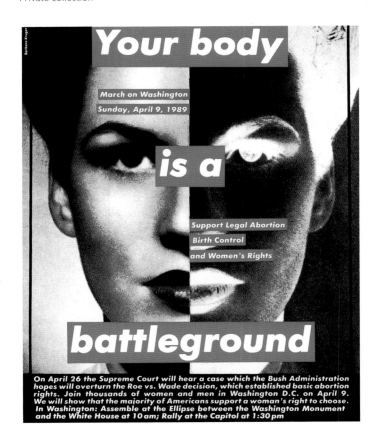

a series of ropes, "You invest in the divinity of the master-piece" over the segment of Michelangelo's Sistine Chapel ceiling showing God reaching out to give Adam life. Kruger's work deals with power, and how it operates through various dispersed sites—television, movies, advertising, schools, religious institutions, art museums—to create consensus among the populace at large concerning issues such as gender relations, sexuality, morality, the family, the role of government, and the marketplace. The circulation of alternative discourses thus becomes a matter of guerrilla warfare, inserting oppositional statements to break into the repetitive descriptions of what has come to constitute the "normal" or the "natural."

In *Your Body is a Battleground* (1989) [8.113] Kruger combines the face of a beautiful woman, found throughout commercial advertising, with a political slogan from the women's movement, foregrounding the manipulation of women's bodies, at both the material and symbolic level—in law, advertising, medicine, politics, etc. Her use of personal pronouns—you, we—prompts the active engagement of the viewer. You are either the body as battleground, or the forces battling over this body. The face is divided vertically, one half a negative version of the other, suggesting racial as well as gender divisions.

Your Body is a Battleground was produced both as a framed image for display in a gallery and as a poster, with additional text, for a rally in Washington to defend a woman's right to choose an abortion. Kruger's works also appear on billboards, bus kiosks and T-shirts. Thus they circulate in many of the same venues as the media and fine art images they address. Because of this, they are in danger of losing their critical edge, becoming somewhat ironic but ultimately harmless statements in a media world that has increasingly incorporated the irony of much postmodern work into ad campaigns for items such as clothing or perfume and in an art world where opposition is a saleable commodity (Kruger was one of the first women to be represented by Mary Boone, and in 1992 was the only visual artist included in *Newsweek*'s list of one hundred individuals who constituted the country's "cultural elite"). Kruger is aware of the ability of both spheres to incorporate dissent. Yet her work posits the existence of a public that still retains the power to read against media and aesthetic stereotypes. While it does not prescribe a particular kind of critical action, it allows for an increasing self-consciousness about the position of the spectator in a world that is permeated by representations.

Another artist who created text-based art that prompted a similar self-consciousness about the power of words is

8.114 Jenny Holzer: *Truisms* (*Your Oldest Fears Are the Worst Ones*), 1982 Spectacolor signboard in Times Square, New York, 20 × 40 ft. (5.62 × 12.19 m.)

Jenny Holzer (b. 1950). Holzer's *Truisms* (1982) and *Inflammatory Essays* (1979–82) consist of short statements with the ring of slogans or popular sayings but with a critical twist—"Private property created crime," "Only dire circumstance can precipitate the overthrow of the oppressors." These statements appeared on posters, T-shirts, stone benches and public billboards, and were also made into electronic signs, in particular those using light-emitting diode (LED) technology, in which the message or messages scroll continuously, creating a seemingly endless ribbon of text. The meanings suggested by her works depend, in part, on their locations. For example, one of her *Truisms*, *Your Oldest Fears Are the Worst Ones*, appeared in 1982 on a large spectacolor signboard high above Times Square, New York [8.114], an area experiencing high rates of crime at the time that was also home to numerous pornography shops and night clubs featuring topless dancers.

Art Activism

Crossing Borders

Artists like Koons, Longo, Schnabel and the Neo-Expressionists Eric Fischl (b. 1948) and David Salle (b. 1952)—along with a few women like Kruger and Sherman—were the focus of attention in the popular press, if not the art world press, in the 1980s. Yet many others continued to produce art that was more explicitly critical in its engagement with political and economic developments at home and abroad. Several new organizations appeared in the late 1970s and 1980s, including Collaborative Projects or Colab (late 1970s), Fashion Moda (1978), Group Material (1979), Epoxy Art Group (1982), the Border Art Workshop (*Taller de Arte Fronterizo*) (1984), and the Guerrilla

THE ADVANTAGES OF BEING A WOMAN ARTIST:

Working without the pressure of success.
Not having to be in shows with men.
Having an escape from the art world in your 4 free-lance jobs.
Knowing your career might pick up after you're eighty.
Being reassured that whatever kind of art you make it will be labeled feminine.
Not being stuck in a tenured teaching position.
Seeing your ideas live on in the work of others.
Having the opportunity to choose between career and motherhood.
Not having to choke on those big cigars or paint in Italian suits.
Having more time to work after your mate dumps you for someone younger.
Being included in revised versions of art history.
Not having to undergo the embarrassment of being called a genius.
Getting your picture in the art magazines wearing a gorilla suit.

Please send $ and comments to: **GUERRILLA GIRLS** CONSCIENCE OF THE ART WORLD
Box 1056 Cooper Sta. NY, NY 10276

WHEN RACISM & SEXISM ARE NO LONGER FASHIONABLE, WHAT WILL YOUR ART COLLECTION BE WORTH?

The art market won't bestow mega-buck prices on the work of a few white males forever. For the 17.7 million you just spent on a single Jasper Johns painting, you could have bought at least one work by all of these women and artists of color:

Bernice Abbott	Elaine de Kooning	Dorothea Lange	Sarah Peale
Anni Albers	Lavinia Fontana	Marie Laurencin	Ljubova Popova
Sofonisba Anguisolla	Meta Warwick Fuller	Edmonia Lewis	Olga Rosanova
Diane Arbus	Artemisia Gentileschi	Judith Leyster	Nellie Mae Rowe
Vanessa Bell	Marguérite Gérard	Barbara Longhi	Rachel Ruysch
Isabel Bishop	Natalia Goncharova	Dora Maar	Kay Sage
Rosa Bonheur	Kate Greenaway	Lee Miller	Augusta Savage
Elizabeth Bougereau	Barbara Hepworth	Lisette Model	Vavara Stepanova
Margaret Bourke-White	Eva Hesse	Paula Modersohn-Becker	Florine Stettheimer
Romaine Brooks	Hannah Hoch	Tina Modotti	Sophie Taeuber-Arp
Julia Margaret Cameron	Anna Huntingdon	Berthe Morisot	Alma Thomas
Emily Carr	May Howard Jackson	Grandma Moses	Marietta Robusti Tintoretto
Rosalba Carriera	Frida Kahlo	Gabriele Münter	Suzanne Valadon
Mary Cassatt	Angelica Kauffmann	Alice Neel	Remedios Varo
Constance Marie Charpentier	Hilma af Klimt	Louise Nevelson	Elizabeth Vigée Le Brun
Imogen Cunningham	Kathe Kollwitz	Georgia O'Keeffe	Laura Wheeling Waring
Sonia Delaunay	Lee Krasner	Meret Oppenheim	

Information courtesy of Christie's, Sotheby's, Mayer's International Auction Records and Leonard's Annual Price Index of Auctions.

Please send $ and comments to: **GUERRILLA GIRLS** CONSCIENCE OF THE ART WORLD
Box 1056 Cooper Sta. NY, NY 10276

Girls (1985) [8.115]. Like earlier political organizations, they provided alternative exhibition and distribution systems for artists, particularly those taking unpopular political positions. They often produced installations both within and outside of galleries and museums which addressed American involvement in the civil wars raging in Nicaragua and El Salvador, the growing gap between rich and poor in the U.S., racism, immigration, gentrification and its accompanying homelessness, and the continued threat of nuclear disaster.

In 1980 Colab took over a former massage parlor near Times Square and installed the *Times Square Show*, a month-long celebration of art, film, and performance infused with playful irreverence, radical politics, street culture, and challenges to the commodity-orientation of the mainstream art world. In the second half of the 1980s posters by the Guerrilla Girls, a group of individuals who remain anonymous and who wear gorilla masks when they appear in public, were plastered throughout the streets of Manhattan pointing out the sexism and racism of the art world [8.115]. At the same time, the Border Arts Workshop, composed of Chicanos/as, Mexicans, and European Americans, staged performances at the Mexican border south of San Diego criticizing U.S. immigration policy and highlighting issues related to life in the border area.

The northern border came under the scrutiny of the photographer Allan Sekula (b. 1951) in his photographic series *Geography Lesson: Canadian Notes* (1985–86). Sekula recognized that "For citizens of the United States, Canada is typically neither here nor there. 'Canada' occupies a zone of conceptual indifference: unthought, insignificant, simultaneously the same and different, but in ways that do not seem to matter much in an 'American' scheme of things." Yet, through a series of photographs and written text that center on two cities in Ontario—Ottawa, the federal capital, and Sudbury, the site of the largest nickel mining and smelting complex in the world at the time—Sekula shows that Canada does, in fact, matter in the "American scheme of things."

In Ottawa, Sekula looks at the Bank of Canada, designed by Arthur Erickson (1924–2009) and completed in 1979 [8.116].

8.116 Allan Sekula: "Bank of Canada, August, 1985," from *Geography Lesson: Canadian Notes*, 1985–86
Silver dye-bleach print (Cibachrome), 11 × 14 in. (28 × 35.6 cm.)
Collection Vancouver Art Gallery

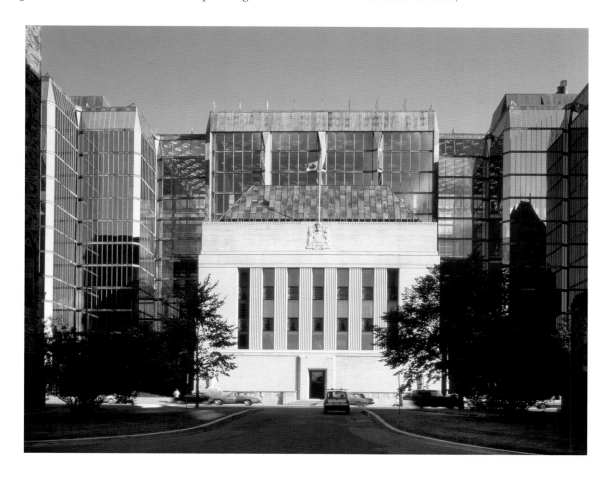

The Bank of Canada is an independent federal agency, yet, like all Canadian federal agencies, is enmeshed in a global financial network. The original building, completed in 1938, has been embedded in the new structure, as if, writes Sekula, "a brick had been frozen halfway into a block of ice." The result embodies the playfulness and historical pastiche that marked so much postmodern architecture. Located across the street from the parliament buildings, the Bank's reflective glass surface literally and figuratively "reflects" the relationship between capital and government. The building is both open and closed to the public. People are free to enter the lobby, which is filled with tropical plants and a large stone from the island of Yap in the South Pacific, while the wealth of the nation is safely tucked away in underground vaults. Thus, the connection between present and past and wealth and nature, and the reality of the international circulation of currency, are reinforced.

In Sudbury Sekula photographs the operations of the Canadian multinational firm Inco, formerly the International Nickel Company of Canada, which has subsidiaries in Indonesia, Guatemala, and the U.S. Sekula reveals three 'secrets' about Sudbury. First, it is not a landscape. Years of roasting nickel ore over open fires has destroyed the region's agricultural economy and defoliated the surrounding territory. Second, Inco is not really a Canadian company. Originally incorporated in New Jersey, International Nickel only became a 'Canadian' company in 1928, in order to avoid anti-trust action in the United States. By 1977, the measure of Canadian ownership of Inco stock was running at 30 per cent, with over 50 per cent of stock ownership residing in the United States. Third, Canadian unions are not Canadian. Most Sudbury workers belonged in the early 1980s to the United Steelworkers of America.

At the same time, Sekula notes that Canadian workers in the early 1980s were twice as likely as Americans to belong to unions, which still holds true today. And those workers were also becoming increasingly militant and independent from their union head offices in the U.S., providing dissident American unionists with an example to follow in their own struggles with undemocratic unions. Sekula's "geography lesson" is thus a lesson in the interconnections between labor and capital across the northern border of the U.S. In his presentation of the natural wealth of Canada through an extensive recording of the locales and architectural features of industry and high finance, Sekula also counters the more generalized and romanticized image of Canada in the U.S. as a nature playground and summer tourist destination.

Art and AIDS

In the mid-1980s a new cause gained prominence among activist artists—the fight against AIDS (Acquired Immune Deficiency Syndrome). The disease was first identified in 1981 and spread rapidly among gay communities throughout the country. Because gay men were among its first and most obvious victims, the response by federal and state authorities was slow. The Christian Right, empowered by their influence in the administration of President Reagan, publicly argued that AIDS was God's vengeance on homosexuals for their sinful lifestyle. Education about how to prevent the disease from spreading (e.g. the use of condoms) was seen as promoting homosexuality and therefore not a legitimate activity for the government. AIDS education and research had to rely on the private sector, in particular members of gay and lesbian communities.

The artists in these communities were quick to take up the challenge. In 1986 a small group of gay men produced one of the two most powerful emblems of the AIDS crisis, the phrase "Silence = Death" below a pink triangle. The latter was a symbol used by Nazis to identify homosexuals, only now inverted, with the apex at the top, suggesting its reclamation. The other well-known emblem, the looped red ribbon, was created by the Artists' Caucus of Visual AIDS, which initiated December 1 as A Day Without Art in 1989, when arts institutions were asked to close their doors, veil a work, or otherwise mark the crisis, which had taken a particularly heavy toll on the arts communities.

The men involved in the creation of "Silence = Death" subsequently joined with others in 1987 to form AIDS Coalition To Unleash Power (ACT-UP), with its own graphics arm, called Gran Fury. Through public demonstrations and posters, such as *Kissing Doesn't Kill: Greed and Indifference Do* (1989) [8.117], ACT-UP called attention to the crisis while, at the same time, providing education about who was at risk (one poster read "Women Don't Get AIDS, They Just Die From It") and safe sex practices ("Use Condoms or Beat It").

8.117 Gran Fury: *Kissing Doesn't Kill: Greed and Indifference Do*, 1989
Silkscreen on three panels, 30 × 144 in. (76.2 × 365.8 cm.)
Art Against AIDS/On the Road (a project of AmFAR) and Creative Time, Inc., New York

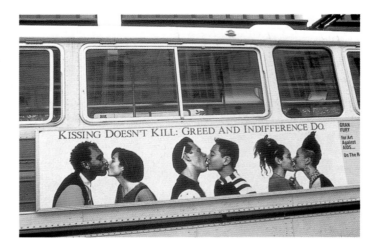

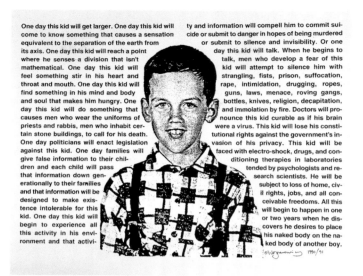

One day this kid will get larger. One day this kid will come to know something that causes a sensation equivalent to the separation of the earth from its axis. One day this kid will reach a point where he senses a division that isn't mathematical. One day this kid will feel something stir in his heart and throat and mouth. One day this kid will find something in his mind and body and soul that makes him hungry. One day this kid will do something that causes men who wear the uniforms of priests and rabbis, men who inhabit certain stone buildings, to call for his death. One day politicians will enact legislation against this kid. One day families will give false information to their children and each child will pass that information down generationally to their families and that information will be designed to make existence intolerable for this kid. One day this kid will begin to experience all this activity in his environment and that activi-ty and information will compel him to commit suicide or submit to danger in hopes of being murdered or submit to silence and invisibility. Or one day this kid will talk. When he begins to talk, men who develop a fear of this kid will attempt to silence him with strangling, fists, prison, suffocation, rape, intimidation, drugging, ropes, guns, laws, menace, roving gangs, bottles, knives, religion, decapitation, and immolation by fire. Doctors will pronounce this kid curable as if his brain were a virus. This kid will lose his constitutional rights against the government's invasion of his privacy. This kid will be faced with electro-shock, drugs, and conditioning therapies in laboratories tended by psychologists and research scientists. He will be subject to loss of home, civil rights, jobs, and all conceivable freedoms. All this will begin to happen in one or two years when he discovers he desires to place his naked body on the naked body of another boy.

8.118 David Wojnarowicz: *Untitled*, 1990
Photostat, 30¾ × 41 in. (78.1 × 104.1 cm.)

Several other artists addressed the issues of AIDS and homophobia. David Wojnarowicz (1954–92) created a series of works in which he foregrounded the homophobia embedded in U.S. society [8.118] and his own struggle with AIDS. Keith Haring created safe-sex and anti-drug images (drug users who share needles are particularly vulnerable to AIDS) before succumbing to the disease in 1990. And Felix Gonzalez-Torres (1957–96), in a billboard of 1991 [8.119], entered into the controversy over

8.119 Felix Gonzalez-Torres, "Untitled," 1991
Billboard installation at 2511 3rd Avenue and East 137th Street, Bronx, for "Projects 34: Felix Gonzalez-Torres" at the Museum of Modern Art, New York, 1992
Dimensions vary with installation

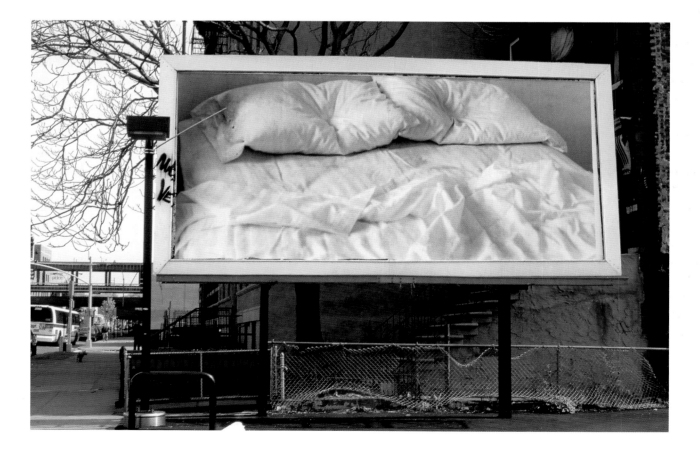

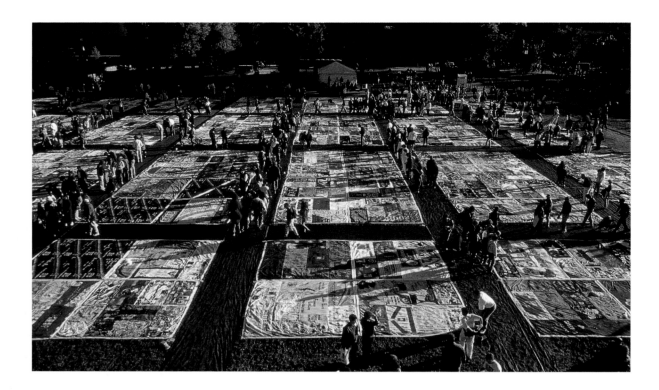

8.120 NAMES Project: *AIDS Quilt*, begun in 1987, on display in the Mall, Washington, D.C., in 1988

the federal government's attempts to pass legislation criminalizing sexual acts between consenting adults of the same sex in private by bringing the private space of the bedroom out into the public sphere.

Another artistic effort that addressed the AIDS crisis is the *Aids Quilt* [8.120], begun in 1987 by the NAMES Project, founded by Cleve Jones and Mike Smith, and still evolving. Unlike the confrontational art of ACT-UP, this work creates a cathartic place for individual mourning. Composed of separate panels made by the friends and family of those who had died from AIDS, it recalls 19th-century mourning quilts that were made from the clothing of the deceased. Jones wanted to create a memorial that would prevent the dead from becoming just another body of statistics in reports of the epidemic. It was displayed as a whole in Washington in 1987, 1988, 1992 and 1993, but has since become too large to be seen all at once. Instead, sections are shown at smaller locations throughout the country. Demonstrating the effects of the disease on thousands of individuals—gay, straight, young, old, rich, poor, white people and people of color—it helped maintain support for AIDS education and research in the private sector until the more liberal administration of President Bill Clinton finally provided much-needed recognition in the 1990s of the seriousness of the epidemic and the need for federal action.

Zoe Leonard (b. 1961) also took up the personal losses and national crisis created by AIDS. In a work entitled *Strange Fruit (for David)* (1992–97) [8.121], she took oranges, bananas, grapefruits, lemons, and avocados and hollowed out their insides, stitching their skins back together in, as the art historian Marie Shurkus writes, "a rather desperate attempt to re-create wholeness." Shurkus argues that the power of Leonard's sculptural installation—the stitched skins are scattered across the floor of the gallery—lies in its affective quality, its ability to create an "embodied transaction" that "elicits grief from viewers by activating their bodies qualitatively." This is done, in part, through the visceral nature of the objects and the viewer's ability to associate his or her response to the decaying forms, and to Leonard's failed attempts to save the fruit, with other images and experiences that elicited a similar response. Through this process Leonard's work recalls other bodies, the bodies of loved ones succumbing to AIDS. (In recognition of the centrality of the concept of decay in this work, the artist and the Philadelphia Museum of Art have agreed to forgo conservation efforts and allow the piece to be exhibited until it disintegrates.)

In writing about Leonard's work, Shurkus draws on the concept of *duration* developed by the French philosopher Henri Bergson. For Bergson, "one moment does not merely replace another, rather the present prolongs the past, but not as it was; instead the past is in a constant state of transition." Works like Leonard's evoke a heightened consciousness of this state

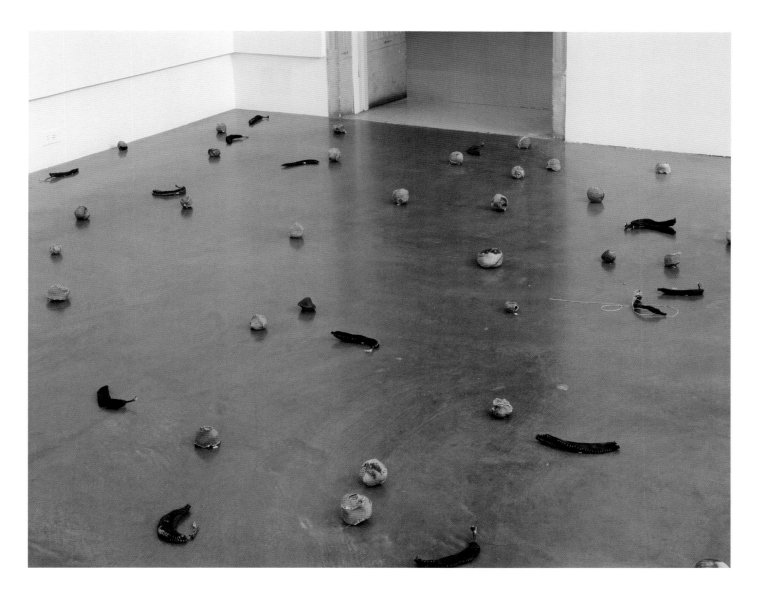

8.121 Zoe Leonard: *Strange Fruit (for David)*, 1992–97
Installation view
Philadelphia Museum of Art

of transition, creating an embodied memory that both expands our understanding of the present and alters our recollection of the past.

While Leonard's work speaks effectively—and affectively—to individual experiences and memories it also, as Shurkus points out, "speaks to a cultural history that a group of individuals might recognize." It does so specifically through the title: *Strange Fruit* refers to both the Billie Holiday song about lynching (see p. 440) and a derogatory phrase for homosexuals; *(for David)* singles out her friend David Wojnarowicz [8.118], who, as part of his AIDS activism, created a photographic portrait entitled *Stitched* with his mouth stitched shut.

Shurkus writes: "For viewers, the recollected image of a mouth sewn shut intersects with Leonard's sewn fruit and vegetable skins to produce a symbolic understanding of Leonard's work in terms of another era when treatment for AIDS was essentially non-existent and attending the funerals of young friends became common."

Video Art

The use of video among artists committed to aesthetic and/or political radicalism also increased during the 1980s and 1990s, facilitated by the development of inexpensive portable cameras. Video was used both to record performance pieces or installations and as an artistic medium in itself. It had first appeared as an art form in the 1960s, most notably in the work of the Korean-born and New York-based artist Nam June Paik (1932–2006), a member of Fluxus. Paik's

8.122 Nam June Paik: *Zen for TV*, 1963–75
The Gilbert and Lila Silverman Fluxus Collection, Detroit

Paik also collaborated with the Japanese engineer-inventor Shuya Abe in developing a synthesizer that allowed for the manipulation of electronic video information, so that images could be distorted or the colors changed. In his later work he often included multiple television monitors stacked in various configurations with different images on each screen coordinated to create dizzying and ever-changing effects [8.123]. Here the disruption of the viewing experience comes not from the solitary contemplation or manipulation of an abstract pattern on a single television set, but from the incessant and overwhelming bombardment of images, which both distress and mesmerize the viewer, as does the saturated media environment of the late 20th century. The cultural critic Frederic Jameson sees these later works as emblematic of a "new mode of thinking relationships." Rather than engaging the old viewing practice of concentrating on a single screen as a way to counter bewilderment in front of Paik's televisions, the postmodern viewer "is called upon to do the impossible, namely, to see all the screens at once in their radical and random difference . . . and to rise somehow to a level at which the vivid perception of radical difference is in and of itself a new mode of grasping what used to be called relationship."

Other video artists continued to use a single monitor and to engage the viewer in a more intimate experience. For example, in *Cornered* (1988) [8.124] the African American artist Adrian Piper (b. 1948) placed a monitor in the corner of

early works focused on disrupting the normal flow of information from television to viewer, which he did by placing magnets on top of television sets or rewiring them in order to produce "feedback" or abstract designs that could, in some cases, be manipulated by the viewers through the turn of a dial [8.122]. He also attempted to disrupt the physical nature of the viewing process itself by placing television sets in various arrangements on the floor, like Minimalist sculptures.

8.123 Nam June Paik: *Fin de Siècle II*, 1989
201 television sets and 4 laser discs, overall 40 × 14 × 5 ft.
(12.19 × 4.26 × 1.52 m.)
Whitney Museum of American Art, New York

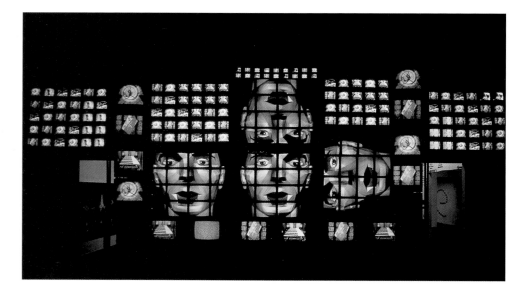

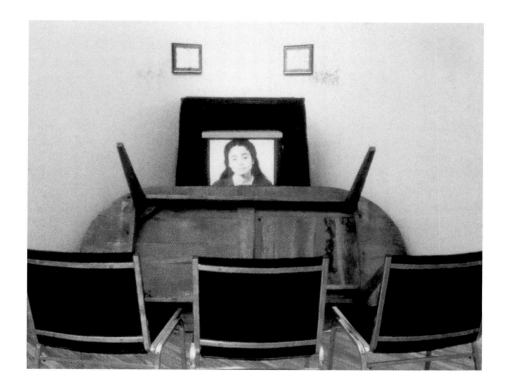

8.124 Adrian Piper: *Cornered*, 1988
Mixed media installation with video monitor, table, and birth
certificates, variable size
Museum of Contemporary Art, Chicago, Illinois

a room, with an upended table in front of it like a barricade. Piper appears on the screen, conservatively dressed and located, like the television itself, in the corner of a room. She begins with the statement "I'm black," which gains meaning from the fact that she does not appear to be black, i.e. she does not have the dark skin and facial features of someone of obvious African descent. The rest of the 16-minute monologue addresses what Piper lists as possible responses to her initial statement—annoyance, anger, embarrassment—and how they help reveal some of the less overt forms of racism. Her tone is that of a schoolteacher lecturing young pupils, and her argument is offered as a series of logical propositions. Her intent is to educate the viewer through calm, rational argument rather than through passionate diatribe. The same intent was present in a business card she had printed up two years earlier, and handed out as necessary, that began "Dear Friend, I am black. I am sure you did not realize this when you made/laughed at/agreed with that racist remark."

Piper, who has a PhD in philosophy from Harvard and is active as a professor and scholar, conceives of her work—drawings, installations, performance—as "meta-art," a term that reveals her roots in the Conceptual art of the 1960s.

Her purpose is not to provide an opportunity for aesthetic contemplation or entertainment, but to heighten the viewer's awareness of political, ethical, and economic realities. One of these realities is that while blatant acts of racism have significantly diminished in number in the United States at the end of the 20th century, more subtle, often unconscious ones have not.

In more recent years, with advances in technology, artists have created more visually complex videos and video installations. In 1994 the African American video artist Phillip Mallory Jones (b. 1947) produced *First World Order*, in which he combined documentary footage about the creative and spiritual lives of people in "Third World" countries with African and Pre-Columbian sculptures transformed into human beings by means of computer-assisted image morphing. He thus makes connections across political boundaries between different peoples and their cultural traditions.

The Crossing of 1996 by Bill Viola (b. 1951) is composed of two color video channels projected on 16-foot (4.9-meter) high screens. Sometimes the images are projected on both sides of one screen, sometimes on two different screens. In either case the videos are shown simultaneously, with a man appearing out of the darkness in each, moving forward until he occupies the whole screen. In one video, water begins to fall on his head, in the other a fire begins at his feet. Accompanied by soundtracks of falling water and a raging fire, water and fire increase in force until they have fully consumed the man

[8.125]. The images then fade into darkness while the sound-tracks subside. The size of the screens, the darkened gallery, and the volume of the soundtracks produce an intense sensory experience for the viewer and prompt reflection on the long-standing human fascination with fire and water, both their nurturing and destructive aspects, whether found in nature or the built environment.

The sensory experiences of the human body are addressed in a different way by Diane Gromala, a former art director at Apple Computer, in her *Dancing with the Virtual Dervish: Virtual Bodies* (1996) [8.126], created with choreographer Yacov Sharir. In this work, Gromala comments on the body's continual decay and reformation. The technology of Virtual Reality intro-duces a whole new level of commentary on the relationship between the viewer and the work of art and on the nature of "reality." By donning head-mounted displays, body suits or data gloves, the viewer experiences and interacts with a computer-generated, simulated world created beforehand by the artist. "In

Virtual Reality (VR)," writes Michael Rush, "the still passive aspect of watching a screen is replaced by total immersion into a world whose reality exists contemporaneously with one's own. In a sense, everything one sees on a computer is part of the 'vir-tual' universe." In other words, the art work or "virtual" world disappears at the flick of a switch. If Minimalism forced the viewer to become aware of his or her body moving around works of art (see pp. 488–92) and Conceptual art engaged the viewer as an active participant in the literal or intellectual "making" of the work (see pp. 502–03), Virtual Reality does away altogether with the distinction between the art object and the viewer, as well as the materiality of the work itself. Here the "frame" or the delivery system is all that remains once the computer is turned off.

Using computer-generated images of her own body and a head-mounted stereoscopic video display, Gromala creates a world in which, she writes, "the virtual body is overwritten with texts, meditations on pain, Eros [love] and Thanatos [death]." In maneuvering through this world, viewers "feel immersed within the body and interact with it. Such interactions include 'touching' text, which then changes, or 'flying' into an organ—say, a heart—to find another surreal world. Three dimensional sound helps users locate themselves in surreal virtual spaces."

8.125 Bill Viola: *The Crossing* (detail), 1996
Video/sound installation with two channels of color video projection
onto screens

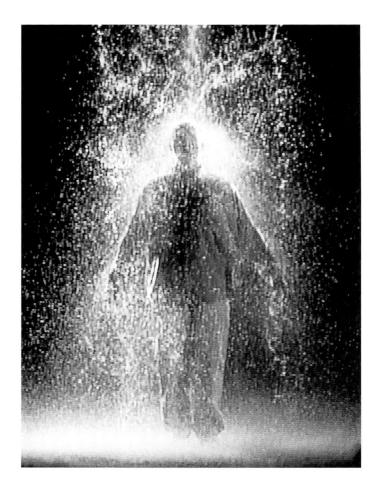

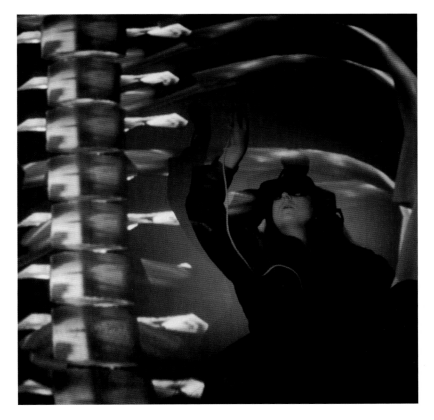

8.126 Diane Gromala and Yacov Sharir: *Dancing with the Virtual Dervish: Virtual Bodies*, 1996
Performance with head-mounted virtual reality device and projected computer-generated images

Viewers thus experience the body in a whole new way—or, at least, they are led to believe this by the extent to which they are completely immersed in this Virtual Universe.

Cultural critics like Paul Virilio predict that advances in technology will result in a world increasingly defined by two realities, the actual and the virtual, with each becoming more and more indistinguishable from the other.

The Culture Wars

Sexual Subversion: Attacks on Public Funding for the Arts

Artistic representations of, or investigations into, bodily experiences, more often material than virtual, caught the attention of a powerful legislative "body" in the late 1980s and resulted in a heated battle over the rights of individuals and the obligations of governments.

The controversy over Serra's *Tilted Arc* [8.100] was an indication that all was not well in the realm of government patronage of the arts. The election of Ronald Reagan as President in 1980 marked the beginning of a concerted attack, part of a broader war on government funding for public services in general—welfare, health care, education—and the push to privatize what little had managed to escape the capitalist marketplace. Reagan had come to power advocating smaller government, heightened patriotism, militarism, faith in God, and support for private enterprise.

In the arts, the main focus of attack was the National Endowment for the Arts (NEA). Conservatives rejected the basic tenet of the 1965 National Foundation on the Arts and Humanities Act that had led to the founding of the NEA and the National Endowment for the Humanities (NEH), which stated in part:

> The practice of art and the study of the humanities require constant dedication and devotion. While no government can call a great artist or scholar into existence, it is necessary and appropriate for the Federal Government to help create and sustain not only a climate encouraging freedom of thought, imagination, and inquiry but also the material conditions facilitating the release of creative talent.

Critics argued that funding the arts was a waste of taxpayers' dollars and that in an era of rising federal deficits and cutbacks the money could be better used elsewhere. In fact, arts funding was minuscule compared to federal expenditure in other areas and to spending in other countries. In 1983, the annual figure for expenditure on arts and museums in the United States was

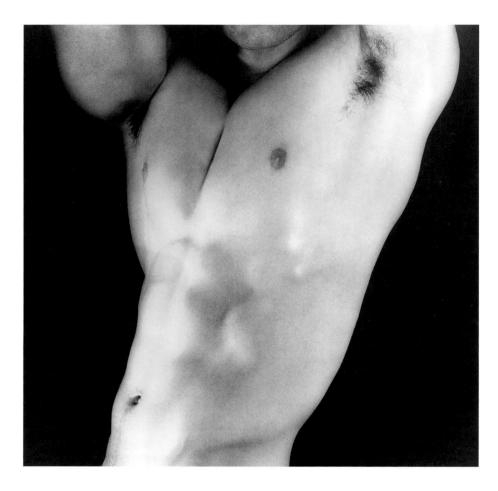

8.127 Robert Mapplethorpe: *Torso*, 1979
Platinum print, edition 3, 25½ × 22 in. (64.8 × 55.9 cm.)
© Copyright The Estate of Robert Mapplethorpe / A+C Anthology

$3.00 per person, as opposed to $45.60 per person in Sweden, $28.50 in Canada, and $16.10 in Great Britain. The annual budget of the NEA was smaller than the annual Pentagon budget for military music.

In 1989, however, a new weapon was added to the arsenal of NEA critics—sexuality, and in particular homosexuality. In June 1989 Republican Representative Dick Armey protested the NEA's financial support for a retrospective of the works of the photographer Robert Mapplethorpe (1946–89) [8.127], organized by the University of Pennsylvania's Institute of Contemporary Art. Of a total of 120 photographs, 7 were singled out as pornographic (5 with homoerotic content and 2 with child nudity). The exhibition had already appeared in Philadelphia and Chicago and was to open in Washington on July 1, but was cancelled by the Corcoran Museum's director due to the hostile atmosphere in the city (it was moved to the Washington Project for the Arts). It then traveled to Cincinnati. When it opened at the Contemporary Arts Center, the director, Dennis Barrie,

was arrested and indicted on obscenity charges. He was subsequently acquitted after a jury decided that Mapplethorpe's photographs were art, not pornography.

Armey and others, including Republican Senators Jesse Helms and Alfonse D'Amato, were able to use the sexually explicit, homoerotic work of Mapplethorpe to push through a clause in the 1989 NEA appropriations legislation that prohibited the funding of "obscene" art. "Obscene" was defined as that which appealed to "prurient interest" or was "patently offensive" and lacked "serious artistic" or other value. The legislation also singled out several specific subjects to be prohibited, including "sadomasochism" and "homoeroticism." An additional requirement, that all grant recipients certify in advance that they would not produce "obscene" art, was challenged in court in 1991 and ultimately rescinded. The 1990 NEA appropriation legislation, however, directed the chair of the Endowment to ensure that "artistic excellence and artistic merit are the criteria by which applications are judged, taking into consideration general standards of decency and respect for the diverse beliefs and values of the American public." That same year, the chair, John Frohnmeyer, overturned the recommendations of NEA peer panels for grants to performance artists Karen Finley (b. 1956),

John Fleck (b. 1951), Tim Miller (b. 1958) and Holly Hughes (b. 1955). All four dealt explicitly with sexuality in their performances, the last three with homosexuality and lesbianism.

Such legislation put artists and arts organizations on the defensive, while conservative politicians continued to hammer away at the NEA. In 1996 almost all grants to individual artists and for seasonal or general operating support for arts institutions were eliminated. In 1997 the House of Representatives voted to abolish the NEA, but the House-Senate conference committee managed to gain the organization a reprieve. By 1998 the annual budget had been cut to $98 million, only just over half of the 1992 level (funding in 2004 rose to $121 million).

As the art market flourished, the NEA's power dwindled. These parallel developments did not occur by chance. In the 1980s art was consistently represented in the mass media as yet another financial investment, along with junk bonds, that could bring quick profits, and artists were portrayed as young entrepreneurs eager to cash in on this investment potential. Thus, Congressional critics were strengthened in their attempts to "get the government out of culture" and leave art to make its way in the marketplace. A sluggish stock market in the early 1990s, which brought down the prices of art as well as other commodities, did not hamper the campaign to destroy the NEA through calls for privatization and condemnations of homosexuality. Art continued to be presented as a commodity, and artists as potential threats to America's moral value system.

The attack on art dealing with gay and lesbian subject-matter occurred in the midst of a larger attack on "objectionable" materials in the public realm—in school textbooks, film, and television. In 1988, for example, the American Family Association, a fundamentalist Christian organization, demonstrated against Martin Scorsese's film *The Last Temptation of Christ* because it showed Christ as an imperfect and sexual human being. Sexuality in general became demonized, and was reframed by conservatives as promiscuity in order to go after abortion rights, Aid for Families with Dependent Children (AFDC), and funding for AIDS research. The Christian Right's declaration that AIDS was God's punishment of homosexuals was folded into the attacks on gay and lesbian art (Mapplethorpe died of AIDS the year his retrospective opened).

Another factor that fed into the success of the attacks against the NEA was the end of the Cold War. Again, it was no coincidence that the initial assaults by Armey occurred the same year as the fall of the Berlin Wall. The founding of the NEA in the 1960s was facilitated by the emphasis of Cold Warriors on the freedom of expression to be found in the United States, as opposed to government repression in communist countries. There had always been opponents to federal arts funding, but as long as there was a Cold War, their opposition could be countered by pointing out that a thriving art world that included the experimental as well as the saleable was a sign of a healthy democracy. After the demise of the Soviet Union in 1991, and amidst pronouncements of the death of communism and the victory of capitalism, the focus of Congressional debate shifted from "freedom of expression" to "practicality" and "profitability." If the arts were to survive they had to prove that they were practical or profitable or, preferably, both. Supporters of public arts funding soon began to rephrase their arguments in more pragmatic terms. In a 1997 NEA report on the state of the arts, Gary O. Larson wrote:

No longer restricted solely to the sanctioned arenas of culture, the arts would be literally suffused throughout the civic structure, finding a home in a variety of community service and economic development activities—from youth programs and crime prevention to job training and race relations—far afield from the traditional aesthetic functions of the arts This extended role for culture can also be seen in the many new partners that arts organizations have taken on in recent years, with school districts, parks and recreation departments, convention and visitor bureaus, chambers of commerce, and a host of social welfare agencies all serving to highlight the utilitarian aspects of the arts in contemporary society.

Bringing the arts out of museums and private galleries and into broader circulation was certainly the goal of many contemporary artists at the time. Yet this emphasis on "practicality" and outcome—lower crime rates, an increase in tourism—was used to exclude from public funding art forms that were not obviously "useful." The rhetoric of pragmatism was a far cry from the language of the NEA's founding legislation, where it was enough for the government simply "to help create and sustain . . . a climate encouraging freedom of thought, imagination, and inquiry."

With the decline of public funding, artists and arts organizations were forced to rely increasingly on private funding from corporations and foundations, which were interested in supporting only certain kinds of work. The fastest growing sector of arts funding in the 1990s was, in fact, the corporate sector. Many executives, like their predecessors Henry Luce (see p. 425) and Edsel Ford (see pp. 417–18), openly acknowledged the public relations value of supporting the arts, particularly by sponsoring blockbuster exhibitions (the tobacco giant Philip Morris was especially active in this area during the 1980s and early 1990s). Such sponsorship was even more important in an

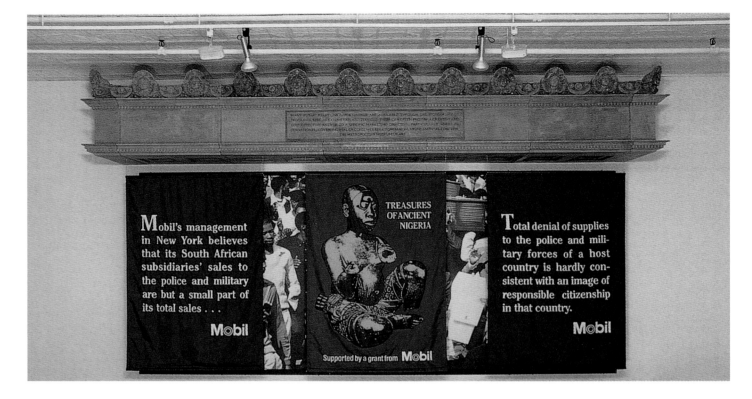

8.128 Hans Haacke: *MetroMobiltan*, 1985
Fiberglass construction, three banners, and photomural, 11 ft. 8 in. × 20 ft. × 5 ft. (3.6 × 6 × 1.5 m.)
Centre Georges Pompidou, Paris

era of rising art prices, which made not only purchasing but also the organizing of exhibitions more difficult, for few museums could afford to insure works whose price tags were often in the millions of dollars (in 1989 Willem de Kooning's 1955 painting *Interchange* sold at auction for $20.7 million).

In 1985 Hans Haacke explored the political implications of this new corporate sponsorship in *MetroMobiltan* [8.128]. Here, as in much of his work in the 1970s and early 1980s, he excerpts text from the literature produced by museums and corporations and juxtaposes it with images that make its political meaning more transparent. *MetroMobiltan* refers to an exhibition of Nigerian art at the Metropolitan Museum sponsored by the Mobil Corporation, which had major oil interests in Nigeria. In the center is a brown banner advertising the show. Flanking this are dark blue banners with texts and the Mobil logo. Behind the banners is an enlargement of a photograph by Alan Tannenbaum of a funeral of black South Africans. In 1981 Mobil provided the police and military of the apartheid regime in South Africa with some 20 per cent of their fuel needs, and a shareholder resolution had been presented by a coalition of church groups asking for this to stop. The texts on the blue banners are taken from the Corporation's response. Across the top is a fiberglass replica of the ornate entablature of the Metropolitan [5.55], in the center of which is text from a leaflet published by the museum titled "The Business Behind Art Knows the Art of Good

Business—Your Company and the Metropolitan Museum of Art." It reads:

> Many public relations opportunities are available through the sponsorship of programs, special exhibitions and services. These can often provide a creative and cost effective answer to a specific marketing objective, particularly where international, governmental or consumer relations may be a fundamental concern.

Haacke thus asks viewers, as he had in 1970 with *MOMA-Poll* (see p. 521), to recognize the connections between culture, corporations, and political repression.

Art and the Politics of Identity

The attacks on the NEA and the discussion of what was "appropriate" subject-matter for government funding, as well as for inclusion in curricula throughout all levels of public education, were soon gathered under the label "culture wars." The issues raised, however, were not always of equal concern to all contemporary artists. The African American writer Michele Wallace

argues that while black artists depended on federal arts funding, the NEA culture wars were primarily battles between liberal and conservative whites, between "bourgeois bohemians" and members of the "conservative nouveau-riche." What white artists and their supporters were defending—the freedom to present sexually explicit subject-matter, of whatever form they chose, in their art—was problematic for many black people both within and outside of the arts community, for clear historical reasons. Black men and women had been, and continued to be, stereotyped as highly sexualized, providing an excuse and justification for the rape and lynching of blacks by whites. Black artists and arts professionals, therefore, could not so easily line up on the side of the defenders of the NEA around the issue of sexual expression, where "appeals to the aesthetic" were used to defend "all kinds of otherwise reprehensible or visionary behavior without judgment or censure" and with little consideration given to questions of race.

Debates over representations of people of color—Chicanos/as, African Americans, Asian Americans, Native Americans—and their exclusion from mainstream arts institutions had grown in force since the 1960s. Artists of color also protested their exclusion from alternative movements; the women's art movement, for instance, was criticized for focusing primarily on the concerns of white middle-class women. These artists began to gain critical attention in the 1980s with their redefinitions of the term "American" and investigations into the multiple identities within which they lived and worked.

Artists of color found opportunities to create dialogues between ethnic groups about these questions of identity within projects like Baca's *Great Wall* [8.1] and through the activities of Group Material, the Epoxy Art Group, Border Arts Workshop, and other artist collectives. Opportunities also arose in the form of group exhibitions. *The Decade Show: Frameworks of Identity in the 1980s*, organized in 1990 by three New York museums—the Museum of Contemporary Hispanic Art, the New Museum of Contemporary Art, and the Studio Museum in Harlem—helped to focus attention on the work and concerns of artists of color and to spark discussions throughout the art world about both exclusion and stereotyping.

In her large multi-media work *Trade (Gifts for Trading Land with White People)* of 1992 [8.129], the Shoshone/Salish/Cree artist Jaune Quick-To-See Smith (b. 1940) draws her imagery

8.129 Jaune Quick-To-See Smith: *Trade (Gifts for Trading Land with White People)*, 1992
Oil and mixed media on canvas, 60 × 170 in. (150 × 430 cm.)
Chrysler Museum of Art, Norfolk, Virginia

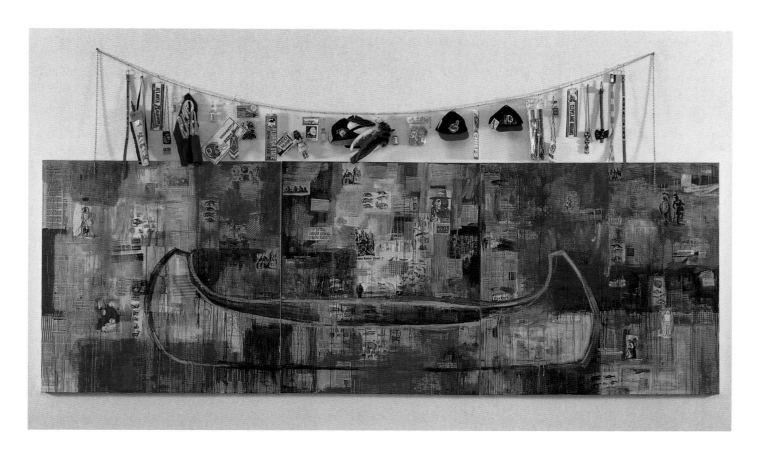

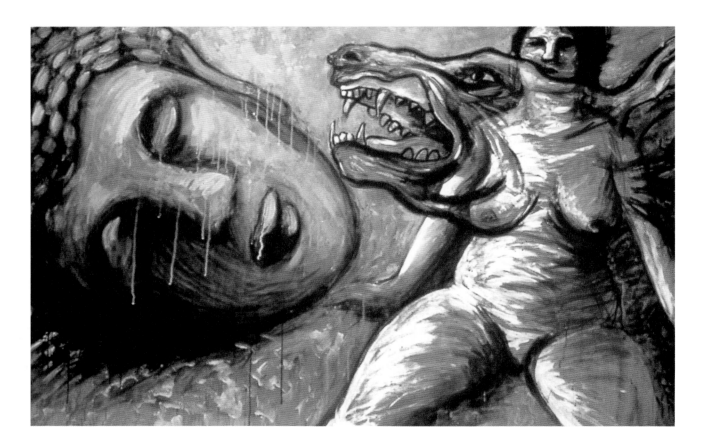

8.130 Margo Machida: *The Buddha's Asleep*, 1985
Acrylic on canvas, 50 × 78 in. (127 × 198.1 cm.)
Private collection

from popular culture and fine art to provide visual testimony to the long history of misrepresentations of Native Americans in American culture and their attempts to counter such misrepresentations. The painting, reminiscent stylistically of the work of Rauschenberg [8.28], contains a ghost-like image of a large canoe floating through a sea of clippings from Native American newspapers and reproductions of paintings and photographs of Native Americans by European Americans. These clippings and reproductions are partially obscured by dripping layers of paint, the dominant red suggesting blood and physical violence. Above the painting hang objects popularly associated with Native American culture—beaded necklaces and belts, tomahawks, plastic "Indian" dolls and moccasins, caps with the insignia and names of various sports teams (the Cleveland Indians, the Washington Redskins, the Atlanta Braves). The canoe suggests the journey through both time and space undertaken by Quick-To-See Smith and other Native American artists in the campaign for recognition of their place in American society.

Margo Machida took a more autobiographical approach in her examination of the position of Asian Americans. In the 1980s she created a series of paintings in which she depicted herself in the guise of powerful male Japanese figures, such as the author Yukio Mishima who committed ritual suicide, or accompanied by icons of Japanese culture, as in *The*

Buddha's Asleep (1985) [8.130]. Machida adopted the style of Neo-Expressionism, applying paint in broad, heavy strokes to build up her overlapping layers of emotionally charged symbols. The subject of *The Buddha's Asleep*, she explained in 1989 in a letter to Lucy Lippard,

> is my sense of divided identity, torn between a desire to find centeredness and repose in a distant, idealized Asian heritage (Buddha) and the pained, angry and defensive present reality (the snarling dog). The dog is a recurrent image in my paintings as a guardian figure and alter ego, representing strength, survival, and aggression. The Buddha's head, severed from its body, is a cultural artifact incapable of offering any help. The nude image of my upper body is vulnerable and literally unable to move (cut off at the legs), caught between these conflicting desires.

Multiple visual traditions are also present in the work of Zarina Hashmi (b. 1937), who uses only her first name professionally. Working as both a printmaker and a sculptor, Zarina

draws on the visual conventions of, among other things, Indian textiles, Modernist abstractions, minimalist sculpture, and architectural drawings. Born in Aligarh, India, she lived in other parts of Asia, Europe, and Latin America before making New York City her home base. Her small bronze-and-wood *Books for the Road* (1998) [8.131] encapsulates this nomadic existence, one that is familiar to many contemporary artists. The bronze frames or wheels contain wooden discs or pages that are etched with lines that imply the spaces for writing as well as the grain of wood, and recall the abstract markings of many modernist works. Sharon Mizota writes: "As in the archetypal book, the pages suggest a narrative, in this case perhaps a travel diary or an attempt to capture and record the passage of all-too-fleeting moments. Together with the wheels they emphasize an understanding of movement not only as a process of spatial dislocation, but [also] one of temporal displacement." Yet this suggestion of motion is countered by the heavy, misshapen wheels, hinged together in order to form the cover that contains the wooden pages. The narrative implied by the pages is also undermined by the absence of words.

In an information age dominated by the virtual and the ephemeral, where data circles the globe in seconds, Zarina's small, awkward wood-and-bronze books anchor the viewer firmly in the material world and partake of the organic playfulness and material contrasts found in the sculptures of such "Eccentric Abstractionists" as Louise Bourgeois [8.60] and Eva Hesse [8.64]. These books prompt contemplation of the multiple ways in which stasis and motion affect the lives of artists and non-artists alike, from the wooden and metal carts of the pre-industrial trade routes that spread from China across India to Europe, to the freighters, jets, and internet that facilitate the workings of an increasingly global art world and economy.

The performance artist Coco Fusco (b. 1960) also addresses global developments and their impact on the movement of peoples and the struggles of artists of color to define their identities and gain a voice in the art world. The crumbling of the Soviet Union and political turmoil in Africa had led to an increase in ethnic conflict in the 1990s, particularly in the Balkans, and a corresponding increase in the numbers of people displaced from their homes in the name of ethnic nationalism. Debates within the United States about ethnic identity and the manner in which this identity was to manifest itself in both art and politics were informed by these global conflicts. In the culture

8.131 Zarina Hashmi: *Books for the Road*, 1998
Bronze, etching, and wood, each unit 4 × 4 × 4 in. (10.1 × 10.1 × 10.1 cm.)

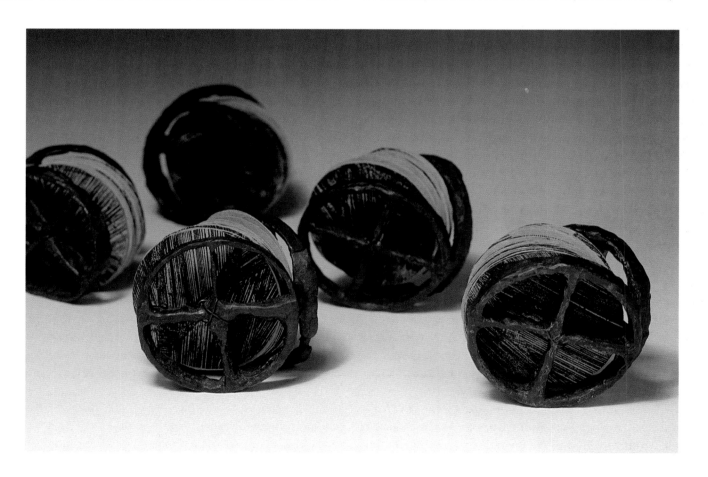

wars, the defenders of more traditional forms of artistic expression often evoked images of Balkanization and ethnic conflict in deploring what they saw as the erosion of American culture in the face of the increasing demands of marginalized groups—people of color, gays and lesbians—for representation.

Yet, at the same time that countries were fragmenting along ethnic lines, larger economic and political alliances were being formed across national boundaries—the World Trade Organization (WTO), the European Union (EU), the North American Free Trade Agreement (NAFTA). These organizations facilitated the flow of goods and, to a lesser extent, labor across borders, funneling free-market messages and standardized products throughout the world while also making the cultural products of other countries more available in the United States. Some celebrated these developments as the beginnings of a truly global culture, where ideas and products could move about the world with speed and efficiency either through traditional means of transportation and communication or via computers and the Internet. Many artists created their own websites as a way to distribute their work, coming up with new computer-based forms in the process. Artists of color took advantage of this expansion of information and communication, drawing on an ever-wider array of sources that ranged across religious, ethnic, gender and economic categories. Surely, many argued, a "global culture" was preferable to the ethnic battles undertaken in the name of particular cultural traditions.

Yet these visions of a global culture were also problematic. Fusco believes that a "postmodern fascination with the exchange of cultural property and with completely deracinated identity can seem for many people of color less like emancipation and more like intensified alienation." She continues:

Within the realm of culture two interrelated but seemingly contradictory struggles are in the foreground. One, waged in the realm of political representation, is an interracial, intercultural battle in the public sphere over appropriation, in which people of color are demanding the right to determine the meaning of their culture and delimit its identity—or, rather, to point to borders that still exist. This is a battle that seeks to resolve a legacy of inequity by addressing the power relations involved in symbolic representation. On the other hand, the artistic outpourings from these same communities in recent years have stressed hybridity as a cultural experience and as a formal strategy.

This struggle to combine the preservation of one's cultural traditions with an openness to other cultures as sources of artistic inspiration was not new for artists of color. Yet it became more intense as the political and aesthetic stakes were raised by demographic shifts, often the result of the increase in the flow of refugees from impoverished and/or war-torn countries (at the end of the 20th century whites constituted only 40 per cent of the population of Los Angeles) and by the voracious appetite of the art market for things new and exotic, which has resulted in both the raiding and the stereotyping of cultural traditions from throughout the world.

Fusco addressed this stereotyping in a piece with the Mexican performance artist Guillermo Gómez-Peña (b. 1955) in 1992, the quincentenary of Columbus's arrival in the New World. The work was performed in several public venues (Madrid, London, Minneapolis, Washington, Sydney). In each location, the two artists spent three days in a cage, wearing stereotypical Afro-Indian garb—feathers, face paint, grass skirt—posing as "Two Undiscovered Amerindians" [8.132]. They pretended to speak no English or Spanish and had "guards" translate if viewers wanted to communicate with them; they also wore sunglasses and watched television, suggesting that the "civilizing" process had already begun.

Fusco's and Gómez-Peña's performance created many questions for the primarily white viewers. All of the material surrounding the event—maps, guides—suggested they were "authentic" Amerindians from the island of Guatinau in the Gulf of Mexico. How then was one to react to their public display? With amusement? With outrage? The performance alluded to the historical practice of exhibiting indigenous peoples from Asia, Africa and America in museums, circuses, parks and other public places, a practice Fusco suggests is the true origin of performance art. It also highlighted the artificiality of these early displays, which were meant to educate, as well as titillate, the audience about the existence of "Others" around the world. Viewers of Fusco's and Gómez-Peña's piece were reminded of their position as global consumers of exotic cultures and of the "colonial unconscious of American society" that still required displays of "uncivilized Others" to justify their enslavement or displacement (Fusco notes that in 1992 a black woman midget was displayed at the Minnesota State Fair as "Tiny Teesha, the Island Princess").

The performances of Fusco and Gómez-Peña helped sensitize museums to the racial politics of museum display, as did the work of Fred Wilson (b. 1954). Wilson was one of the first artists to be invited by a cultural institution to reconfigure its permanent collection in an exhibition that would bring to light the "hidden stories" in the institution's storage rooms (this practice has since become common within the museum world). In 1992, the same year Fusco and Gómez-Peña appeared as Amerindians from Guatinau, the Maryland

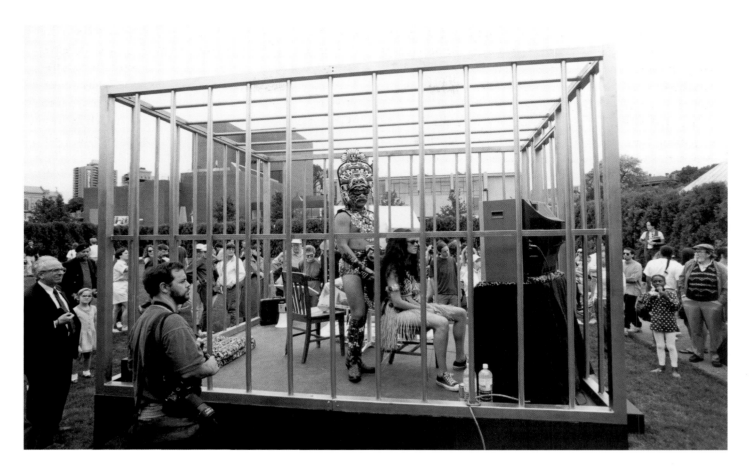

8.132 Coco Fusco and Guillermo Gómez-Peña: *Two Undiscovered Amerindians Visit . . .*, 1992
As performed at the Walker Art Center, Minneapolis, Minnesota

Historical Society in Baltimore gave Wilson access to their collection and galleries; the result was *Mining the Museum* (1992–93), an exhibition which included, among other things, manacles used to chain together black slaves positioned alongside carefully worked silver vessels [8.133]. This jarring combination gives the lie to the seemingly noncommittal

8.133 Fred Wilson: *Mining the Museum*, at the Maryland Historical Society, Baltimore, 1992–93: detail showing silver vessels and slave shackles exhibited together

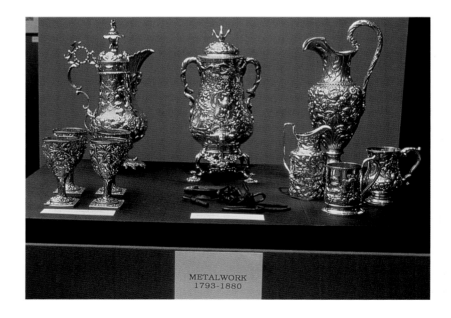

8.134 Frank Gehry: Guggenheim Museum, Bilbao, Spain, 1997

museum label: "Metalwork 1793–1880." Wilson's exhibition title suggests the excavation process necessary in order to unearth the materials that lie waiting to form the basis of a new understanding of the past.

The art world also underwent further transformations in the 1990s. Art prices continued to rise while the auction houses of Sotheby's and Christie's were forced to respond to charges of fixing fees and preferential treatment for certain customers. At the same time, American museums were increasing their national and global presence with websites and domestic and foreign branches. For example, the Guggenheim opened buildings in Venice, Berlin, Bilbao, and Las Vegas. The Bilbao museum is housed in a striking limestone- and titanium-clad building by Frank Gehry [8.134] that has made the city a new tourist attraction. Las Vegas was already a tourist attraction when the Guggenheim opened in 2001 in the Venetian Resort on the Strip. This was its first joint venture with the Russian Hermitage Museum in St Petersburg. The Hermitage collection was located in the casino itself and the larger space for rotating exhibitions in an adjacent building designed by the Dutch architect Rem Koolhaas.

The director of the Guggenheim, Thomas Krens, saw no problem with combining a casino and an art museum. With 30 million visitors to Las Vegas every year, what better place to locate an institution dedicated to educating people about art? Krens also compared art museums to theme parks, arguing that a successful museum needs the equivalent of "five rides": great permanent collections, great special exhibits, great architecture, eating opportunities, and shopping opportunities. To make the second ride—special exhibitions—more thrilling for the general public, he supplemented displays of fine art with those of motorcycles and the clothing of the Italian fashion designer Giorgio Armani. Unfortunately, the Guggenheim's "rides" could not complete with those of the surrounding casinos, and the doors to Koolhaas's building closed permanently in May of 2003.

Some artists have welcomed these national and global moves by museums, seeing more opportunities for the display and sale of their work, while others condemn them as yet more evidence of the art world's acquiescence to the forces of the marketplace, with its insatiable appetite for spectacle and drama. Certainly art has become more available to the average American than at any previous time in history, with cultural institutions of all sorts opening up in cities and towns large and small throughout the country. And while people of color are often included as exotic "Others," they, along with white women, are also increasingly being positioned in exhibitions and texts as active participants in the development of contemporary American art, as in the Whitney Museum's *The American Century: Art and Culture, 1950–2000*. This exhibition was the

second of a two-part survey of 20th-century American art that revealed the overwhelming wealth of creativity that marked the last half of the century. Statements about "ultimate truths" or "universals" were replaced by multiple narratives recounting the experiences and claims of the diverse peoples that inhabit this country. Many are optimistic that these multiple visions and stories are finally gaining the visibility they deserve, although how they are told and by whom still remains an issue.

Envisioning the 21st Century

9/11 and the War on Terror

The "decentering" of postmodernism and the postmodern world, with its global networks and market economy, has created riches for some and poverty for many. Within this world new forms of political activism have arisen, with environmental and indigenous rights groups and others committed to social justice using the Internet to coordinate their efforts across continents. Yet global communication networks have also been used by extremist political groups, enabling them to pursue their goals with even greater success. Increasingly the target of these groups has been the United States.

The optimism that many Americans felt at the end of the 20th century was shattered by the events of September 11, 2001. Thousands of New Yorkers on the streets and in nearby buildings and millions of television viewers around the country and the world watched as the 110-story twin towers of the World Trade Center (1966–74), designed by Minoru Yamasaki, burned and then collapsed, killing almost three thousand people, after terrorists flew two hijacked commercial airliners into the buildings (another jet hit the Pentagon in Washington, D.C., while a fourth crashed in a field in Pennsylvania). These events created a political and emotional crisis, leading to both military and legislative responses, including the U.S.-led invasions of Afghanistan and Iraq and the passage of the Patriot Act. They also led to anti-war and civil rights movements protesting these government actions. Few Americans could avoid the debates over the reasons for, and significance of, the attacks by the militant Islamic fundamentalist organization al Qaeda, or over the nature of the U.S. government's "war on terror," just as few could avoid the endlessly repeated media images of the planes flying into the buildings, or the buildings themselves burning and collapsing.

The artistic responses to 9/11 (as it has come to be known) were numerous. Within days the streets and subway stations surrounding the remains of the World Trade Center were filled with photographs of individuals who had worked in the two towers, placed there by friends and relatives hoping to find them alive. These calls for information were soon joined by makeshift shrines to those whose fate had become known. While transitory in nature, such spontaneous visual pleas and commemorations were often captured by photographers, who then shared the images with a broader audience through publications and exhibitions. Jeffrey Lohn photographed the same pictures and shrines several times over several days as they were obscured and ultimately dissolved by the rain and wind. Leslie King-Hammond created her own shrine, *Prayer for the New Ancestors: Altar for the Warrior Spirits of 9/11* (2001), out of newspaper clippings, cory shells, beads, candles, African statuary, and other objects. In March 2002 a temporary installation composed of 88 searchlights appeared next to the site. Designed by the architect Richard Nash Gould and titled *Tribute in Light*, it created two vertical columns of light that cut through the night sky (the installation was repeated in subsequent years on September 11).

Others, like Art Spiegelman, protested the ways in which the World Trade Center site, or "Ground Zero," had become hyperpoliticized or, in the words of Devin Zuber, had become "one of the most contested sites of public memory in recent history, a staging ground for both war campaigns and protest suicides." In his graphic novel *In the Shadow of No Towers* (2004), Spiegelman attempts, in his words, to "sort out the fragments of what I'd experienced from the media images that threatened to engulf what I actually saw." He does so through large, full-color scenes that expand beyond their frames and that warn against the incorporation of the buildings' destruction into the escalating rhetoric of war.

The magnitude of the tragedy ultimately resulted in calls for a more permanent memorial to the victims of 9/11. This memorial project was inevitably part of the larger design competition for the rebuilding of the World Trade Center complex itself. The winner of this competition was the Berlin-based American architect Daniel Libeskind (b. 1946), chosen by the Lower Manhattan Development Corporation in 2003. Libeskind's task was daunting—to re-create millions of square feet of prime commercial office space while also commemorating the thousands of lives lost. The centerpiece of his multi-story complex was the "Freedom Tower," a patriotic 1776 feet (541 meters) in height, connecting the destruction of 9/11 to the Declaration of Independence and thus the site of the World Trade Center to the battlefields of the Revolutionary War. Controversy surrounding the overall design, coupled with the vagaries of New York cultural and real estate politics, ultimately led to changes, among them the moving of the spire on top of the building, originally off-center to mimic the Statue

of Liberty's raised arm, to the center, and the covering of the plain concrete base of the building in glass prisms. Libeskind was also demoted to site planner, while Daniel Child of Skidmore, Owings and Merrill became project architect. The controversies that dogged the early years of the design competition, the result of both its financial and symbolic significance, will undoubtedly continue through its projected 2011 completion date.

In April 2003 another competition was launched for a World Trade Center Site Memorial, with the winner, New York architect Michael Arad, chosen the following year by a jury that included the designer of the Vietnam Veterans Memorial, Maya Lin (see pp. 534–35). Berkeley landscape architect Peter Walker was brought in after the selection to create the landscaping. Arad's and Walker's design, titled *Reflecting Absence* [8.135], encompassed the footprint of the two towers and was marked by two large recessed pools and rows of deciduous trees. Ramps led down to the memorial spaces, 30 feet (9 meters) below, which included an enormous pool, seen through a wall of water and surrounded by a ribbon of names. The western edge of the site contained a deep gash that exposed the original foundations, with a staircase that led down to an interpretive center. The intention of Arad and Walker was to create a "mediating space" that integrated the city and the memorial (one entered the site at street level) and at the same time provided a place for reflection.

While initially well received, Arad's and Walker's design for the World Trade Center Site Memorial, like Libeskind's site plan, became mired in controversy, as individuals representing the various groups personally or politically invested in the project began to study the design. Some argued the exposed retaining wall would be a constant reminder of the collapse of the buildings, as would the sound of the falling water. Others questioned the expense of maintaining this waterfall during the winter. Still others challenged the sacralizing of the footprint of the towers, arguing that their presentation as "sacred space" that needed to be preserved anchored the site too firmly in the politicized rhetoric of sacrifice, freedom and progress, rather than the more personal, open-ended language of grief and reconciliation. The complaints inevitably resulted in several changes, the most significant of which was the elimination of the underground rooms in order to save money (the total budget projections at one point neared $1 billion).

It would, indeed, have been surprising had there not been a mixed response to the Memorial design, given the complexity of the event and its continuing lack of resolution, both political and personal (the remains of many of those who died that day will never be recovered). According to journalist Christopher Hawthorne, the Minimalist approach that marks Arad's and Walker's design, and that has been used overwhelmingly for memorials since Lin's Vietnam Veterans Memorial of 1982, works best "in a vacuum, when the designer has at least a measure of autonomy." It operates less well when it is charged with commemorating an event that the country is still struggling to define. While Minimalism, with its sober and

restrained characteristics, "avoids kitsch and sentimentality and . . . provides a powerfully intimate framework for visitors to reflect and mourn, . . . any unwise change or attempt at value engineering—even a seemingly minor one—can threaten [Minimalist memorials'] overall integrity." In addition, their lack of obvious narratives opens them up to the claim that they are unpatriotic. And cutbacks in government funding for all forms of public art have led to the need for extensive fundraising, which results in an increase in the number of individuals who expect to have input into the design process.

The Memorial, and the World Trade Center site in general, are reminders not only of the events of 9/11, but also of the "war on terror" in general, which began shortly after September 11, 2001 with the assault on Afghanistan. The U.S. invasion of Iraq less than two years later, in March 2003, was presented by President George W. Bush as part of this larger war on terror, one that defied the strategies of conventional warfare and, thus, the protections of conventional treaties like the Geneva Conventions, which regulate the treatment of prisoners of war. In April of 2004 the American public was given access, via the worldwide web and television, to graphic images of Iraqi prisoners at the U.S.-run Abu Ghraib prison in Baghdad being subjected to various forms of physical and emotional abuse. The photographs were taken by those committing the abuse, who included members of the 372nd Military Police Company, CIA officers, and private contractors.

Those in charge of U.S. military operations in Iraq argued that the soldiers involved in this abuse were "bad apples" and that the majority of American soldiers did not engage in torture (although revelations over the following years indicated that torture was carried out much more widely than military leaders acknowledged at the time). Yet few addressed the question why those who committed the abuse felt compelled to photograph their actions, and then to distribute the photographs among their friends. What role did these images play in the abuse itself? Were they simply a record after the fact, or were they an integral component of the actions of these men and women?

Literary critic Susanne Kappeler provides one way to understand such images. In her book *The Pornography of Representation*, she sees images of torture produced by torturers as pornographic. For her, pornography is not a given entity or special case of sexuality—although sexuality certainly played a role in the Abu Ghraib images. Instead, she sees it as a set of representational practices. Pornographic representations are both images and objects of exchange; they have a material reality of their own, separate from what they image, while, at the same time, being intimately connected to that which they depict.

In one chapter of her book Kappeler discusses two photographs documenting the 1984 torture and murder of a black man by a white man in Namibia. They include both the torturer and the tortured (one includes just the arm of the torturer holding up the black man's mutilated body, the other shows the murderer holding up the victim by a chain). Kappeler found the images in an issue of *Guardian Weekly*, which contained the following narrative account:

Sunday afternoon—two white guests arrive at the farm. Thomas has now stood, bound, for two days without food or water. Van Rooyen suggests to his friends that they should have some drinks and soon they begin celebrating the capture of a young "terrorist." The victim is fetched and forced to pose whilst one of the guests borrows van Rooyen's Instamatic camera. A short time after the pictures are taken there is an almost inaudible sob from Thomas Kasire. After a faint shudder he falls backwards—lifeless.

Kappeler argues that these pictures are in every sense pornographic. They had nothing to do with fighting terrorists. Neither did the torture. Both were engaged in for sheer pleasure; both were a form of the white man's "free expression of himself, an assertion of his subjectivity," and, as such, an expression of his power over the black victim. The torturer/pornographer then invites his friends to join him in the enjoyment of this power. Thus, the taking of the pictures forms an integral part of the torture and of the enjoyment of the act of torture. The United States has its own history of such images in the numerous photographs taken at the lynchings of black men by members of lynching mobs and the men, women and children who came to watch (see pp. 436–41).

Kappeler notes that enjoyment, "according to [the Marquis de] Sade, requires a sophisticated intellectual structure, beyond sheer gratification. It requires an audience. With an audience, torture becomes an art, the torturer an author, the onlookers an audience of connoisseurs." Some artists, recognizing the pornographic power of such images of tortured bodies, have attempted to undermine this power, while at the same time creating a new audience whose response is transformed from pleasure to protest. Among the Abu Ghraib photographs was one of an Iraqi man in a loose cape with a hood over his head, standing on a box. With arms outstretched and wires connected to his body, he eerily calls up images of the Crucified Christ. Two Los Angeles artists working anonymously under the name Forkscrew Graphics positioned this man's dark

8.136 Forkscrew Graphics: *iRaq*, 2004
Silkscreen on paper, 36 × 24 in. (76 × 70 cm.)

silhouette against a bright colored background in *iRaq* (2004) [8.136], their political protest against the U.S. war in Iraq.

The image initially appeared as a poster plastered throughout Los Angeles and the subways and streets of New York City, particularly Lower Manhattan. It quickly moved to cities in Europe, onto the Internet and into gallery exhibitions. Forkscrew Graphics adopted the format of a popular advertising campaign for Apple Computer's new pocket-size iPod music player, where the wires coming from the ears of the silhouetted figure in the ad are those of the iPod's headphones. At the bottom of the poster, instead of Apple's "10,000 songs in your pocket," is the sentence "10,000 Iraqis killed. 773 US soldiers dead." (At the same time, an almost identical poster was produced by an artist known only by the name Copper Greene, the Pentagon code word for detainee operations in Iraq, with the text at the bottom reading "10,000 volts in your

pocket, guilty or innocent.") *iRaq* also appeared later in 2004 on the cover of the election issue of *The Nation*. Inside, the Forkscrew Graphics artists describe to journalist Alisa Solomon their reasons for creating this poster:

> We want to show that no matter how manipulated the media sphere becomes, and no matter how many tons of messages the marketing world dumps on the public, there are ways to take the symbols of marketing and use them to disrupt the barrage of commercial communication.

Thus, like James Rosenquist (see pp. 518–19), Forkscrew Graphics brought together the worlds of war and consumer culture. The artists are not, however, indicting Apple Computer directly for its involvement in the prosecution of the war in Iraq, as Rosenquist did with General Electric and the war in Vietnam. Instead, as the graphic designer Milton Glaser points out, the *iRaq* poster calls into question the political justifications for the war and its physical and moral ramifications. "In the original advertisement," writes Glaser, "the iPod headphone wire represents freedom and euphoria, while in the parody it represents ideas of imprisonment and torture."

In many ways, Apple Computer and its iPod are the 21st-century equivalent of General Electric and its light bulb. The discoveries and expansion of computer technology, like the development and expansion of electrical technology, have helped transform the lives of individuals and the economies of countries throughout the world. The advertising campaigns of these two commercial giants have also both captured and capitalized upon broader public sentiments. Ads for the iPod of 2004 celebrated freedom in a year when the word was used repeatedly as the ultimate cause and result of military interventions (the invasion of Afghanistan was dubbed "Operation Enduring Freedom") and when the war in Iraq, if not the war on terror in general, was still seen by many as winnable. The 2006 campaign for the miniscule iPod shuffle, with its random mix of pre-selected songs, called on buyers to "embrace uncertainty," just as the public was called upon to accept the reality of a war with no clear end in sight.

Altered States and the Connectivity of the Whole

This book began with an examination of the Aztec capital of Tenochtitlan, with its monumental temple platforms, gardens and markets, and the modest portraits of Puritan New Englanders. Each helped define a daily world marked by spiritual practices, political uncertainties and economic endeavors; each utilized the technological and visual conventions of its time. The artists of the 21st century are no different. Some have taken up the most

advanced tools of the contemporary world to create images unimaginable in either 16th-century Tenochtitlan or 17th-century Boston. Others have created works that, while enabled by modern technology, remain recognizable to those of distant eras, in form if not in concept. And, like their 16th- and 17th-century counterparts, 21st-century artists create works that negotiate various tensions—between the past and the present, the individual and the community, the urban and the rural, the national and the global.

Lilla LoCurto and William Outcault have re-imagined the genre of portraiture, and in particular the self-portrait, in their *thinskinned* series of 2004. Using three-dimensional whole-body laser-scanning technology, they have literally exploded the physical body that has formed the heart of the genre of portraiture. Beginning their careers as sculptors, LoCurto and Outcault turned to video installation in 1992 as a response to the AIDS pandemic, engaging with the issue of the body in crisis through images of their own fragmented bodies in a work entitled *Self-Portrait*. Later in the decade they turned to the age-old problem faced by many artists—representing three-dimensional objects in two dimensions. They began experimenting with full-body scanners and cartography soft-

ware, producing eighteen color images titled *selfportrait.map* (2000) that range, in the words of curator Helaine Posner, "from the recognizably figurative to the abstract, from the grotesque to the sublime" and that are "seemingly adrift in an indeterminate sea." These images provided the source material for three subsequent series of works, including *thinskinned*.

In the *thinskinned* series, LoCurto and Outcault initially animated images of themselves in various positions—standing, sitting, crouching—captured simultaneously from various perspectives. Posner describes the effect: "their bodies, or fragments thereof, spin in a digital void, suddenly bursting into horizontal bands of flesh that gradually reassemble into a figure or simply disappear. Initially, the effect is violent, but it becomes unexpectedly serene to watch these abstracted forms slowly and gracefully drift through space." The artists then created a series of pigment prints of a sequence of moments from the animated piece, such as *thinskinned [b7]* (2004) [8.137].

8.137 Lilla LoCurto and William Outcault: *thinskinned [b7]*, from the *thinskinned* series, 2004
Pigment print on paper, 24 × 36 in. (61 × 91.4 cm.)

While *thinskinned [b7]* addresses the tradition of portraiture, and the sub-category of the self-portrait, it also engages with the practices of medical imaging and of technologies that are literally remapping and reconstructing the human body. As LoCurto and Outcault capture the shredding of the body into elegant ribbons of flesh (as a moment frozen in time: the body does not reassemble), surgeons throughout the country are stitching together the torn bodies of soldiers or reconstructing those disfigured by disease or made seemingly less desirable by the passage of time. Decorating or otherwise altering the surface of the body has a venerable past. Yet the reconstructions of the 21st-century body are much more radical, and part of a different set of physical and symbolic rituals involving struggles over personal and national identities. Just as in the 19th century Thomas Eakins hides the wound of the breast cancer patient in order to maintain the illusion of the female body's perfection (see p. 270), so too do the U.S. mass media of the 20th and 21st centuries circulate endless images of perfect bodies. The violence enacted upon these bodies in order to achieve perfection is normally not shown—or, rather, not until the recent emergence of television programs such as *Nip/Tuck* (about plastic surgery), *CSI* (about crime scene investigations), and *Six Feet Under* (about funeral homes). Perhaps *thinskinned* can be seen as a metaphor for our viewing of the mass-mediated body: we recognize the violence that has taken place, but are lulled into a feeling of serenity through the rhythms and gyrations of increasingly disembodied televisual or digital forms, which miraculously reassemble themselves, or disappear altogether.

How we perceive and inhabit the world around us has also been the focus of the work of Helen Mayer Harrison (b. 1929) and Newton Harrison (b. 1932). In 2003, the British artist David Haley wrote:

From space, looking back at earth, we may see three key issues: the accelerating increase of the human species, the accelerating decrease of other species, and the accelerating effects of climate change. We might ask, how are we to cope with these changes *creatively*?

The Harrisons have attempted to answer this question. For almost four decades, they have been working collaboratively to initiate conversations within and beyond the art world about environmental degradation and conservation, about how, in the words of Buckminster Fuller, to live "lightly on the earth" (see p. 496–98).

With their move to San Diego in 1970, they began a series of projects that addressed the ecological problems of southern California. Like another southern California artist, Judith Baca (see p. 531), they conceived of their art as both process and product. The dialogues they engaged in with engineers, biologists, historians, businesspeople, politicians and others were as much a part of their art as the final physical manifestation of their ideas. Describing these projects as "survival pieces," they addressed, for example, the impact of smog and urban sprawl on the orchards of California with a small portable orchard that modeled a healthy environment for the cultivation of fruit trees. They also created a series of "fish events" composed of ponds in which various shrimp or fish were grown, with algae in the water changing color depending on the water's salinity. Installed in various cities around the world (Los Angeles, London, Brussels), the works were accompanied by conversations and performances and, in the end, a feast whose centerpiece was the fish from the ponds, expertly fried and ready to eat. Some of the invited guests, writes the art historian Peter Selz, "were dismayed by an artwork so poignantly replicating normal life experience."

The Harrisons also situated their engagement with the present state of the environment within the longer history of land use in the region. In a 1976 work entitled *Meditation on the Gabrielino Whose Name for Themselves Is No Longer Remembered Although We Know That They Farmed with Fire and Fought Wars by Singing*, they created a large (5 feet 8 inches x 12 feet / 1.7 x 3.7 meters) multi-media canvas (photographs, paper, graphite, colored pencil and ink) presenting the landscape within which this early southern California Native people lived, along with the mission after which they were named (see p. 44). As Lucy Lippard has observed, the work "compares the ecocide and accompanying genocide of the 'Gabrielino' to what we are doing today to our portion of the earth."

Integral to many of the installations produced by the Harrisons are maps. In their *Meditations on the Condition of the Sacramento River, the Delta, and the Bays at San Francisco* (1977) they use large maps of California—political, geographical, topographical, satellite—to reveal not only the afflicted state of this watershed, but also possible solutions. As Selz points out, while these maps called to mind the abstractly delineated spaces of earlier cartographers, used to navigate the globe or conduct warfare, they differed in that they "were accompanied by explicatory texts, which pointed out the problems caused by damming, agribusiness, and other ventures that place profit ahead of sustainability." In addition, the Harrisons took their message out of the San Francisco Art Institute and the San Francisco Museum of Modern Art and onto the streets of the city with posters, billboards, and television programming.

So who's attending to the connectivity of the whole?

8.138 Helen Mayer Harrison and Newton Harrison: *So Who's Attending to the Connectivity of the Whole?*, 2001
Modified GIS maps on canvas-backed paper; the two images, here shown together, are framed separately and displayed as a diptych measuring 9 × 5 ft. (2.75 × 1.5 m.)

The Harrisons also increasingly took their art outside of the borders of the United States. Recognizing that environmental concerns are global concerns, they created projects in the Czech Republic, England, Israel, and the Netherlands, among other places. In 2001 they also created a series of large maps reproduced in a book entitled *Peninsula Europe*, which posed the question, "So who's attending to the connectivity of the whole?" [**8.138**]. By ignoring the political boundaries that divide this region, and foregrounding, instead, its geological features (mountain ranges, rivers, watersheds), they initiated, in Selz's words, "a new discourse on the continent's future, embracing its cultural and biological diversity."

The Harrisons' approach to the interconnectedness of the European peninsula can be applied globally as well. At the beginning of 2007 the United Nations Intergovernmental Panel on Climate Change issued a report that concluded that global warming was a reality that could not be ignored, and that human activities were very probably its cause. Human activities are also very probably the only means through which such global warming can be slowed down and its ramifications understood and addressed, and these activities must cross political boundaries to be effective. The Harrisons offer us a model for such human negotiations, one that foregrounds the "connectivity of the whole" and that promotes and respects the needs of culturally and biologically diverse communities across the globe.

Building Green: Workshop/apd and Jeanne Gang

Many have pointed to the disruption of weather patterns or their intensification—extreme drought, flooding, hurricanes, or winter storms—as one effect of global warming. The negative impact of these weather events is often exacerbated by lack of foresight, benign neglect, or hubris, whether in the design of an individual building or of a community or region as a whole. This combination of extreme weather and human failings came together on Monday, April 29, 2005, when Hurricane Katrina made landfall near New Orleans. With winds of 125 miles per hour, the storm breached dozens of levees built to contain the

Mississippi River, which flows through the city, and flooded wide swaths of several neighborhoods, leading to the deaths of more than 1500 people and massive destruction of property. "Considered both the worst natural and manmade disaster in U.S. history," writes the urban and regional planning scholar Clyde Woods, "Katrina fundamentally transformed the New Orleans region, Louisiana, and the Gulf Coast."

This disaster was not unexpected. The city was laid out in 1718 (see pp. 105–6), only months before a major flood. As the author and journalist John McPhee observes, "Even as New Orleans was rising, its foundations filled with water. The message in the landscape could not have been more clear: like the aboriginal people, you could fish and forage and move on, but you could not build there—you could not create a city, or even a cluster of modest steadings—without declaring war on nature." The damage from Hurricane Katrina was exacerbated by the destruction of large areas of marshland at the mouth of the Mississippi River in order to facilitate the ship traffic that had

increased exponentially with the development of industry—oil, chemical, metals—along the banks of the Mississippi between Baton Rouge and New Orleans.

The rebuilding of the devastated sections of New Orleans, particularly the primarily low-income African American neighborhoods, has been slow, with little coordinated help from local, state, and federal governments. The Federal Emergency Management Agency (FEMA) closed its long-term recovery office approximately six months after the flooding because of a disagreement with the city over who was to pay for the planning process. *Atlantic* correspondent Wayne Curtis, writing in 2009, noted that since the FEMA closing, "depending on whom you talk to, government at all levels has been passive and slow-moving at best, or belligerent and actively harmful at worst."

8.139 Workshop/apd: Holy Cross Project House, Global Green, New Orleans, 2009. Prototype house is green; the other houses shown here were built later as part of the same project.

This passivity created a vacuum that was filled by a series of private initiatives, both for-profit and non-profit. Curtis describes the result:

> In the absence of strong central leadership, the rebuilding has atomized into a series of independent neighborhood projects. And this has turned New Orleans—moist, hot, with a fecund substrate that seems to allow almost anything to propagate—into something of a petri dish for ideas about housing and urban life. An assortment of foundations, church groups, academics, corporate titans, Hollywood celebrities, young people with big ideas, and architects on a mission have been working independently to rebuild the city's neighborhoods, all wholly unconcerned about the missing master plan. It's at once exhilarating and frightening to behold.

Curtis posits that this "exhilarating petri dish" is fueled by a combination of contemporary design principles, green technology, and the push towards sustainability, which have all converged to make possible "a great leap in urban architecture."

Several of these housing initiatives have focused on the construction of low-cost, environmentally friendly homes that combine contemporary stylistic innovations with local building types, in particular the popular plain, narrow (usually no more than 12-feet-wide) wooden shotgun house (so called because if you fired a shotgun at an open front door, the pellets would pass straight through the doors connecting the series of rooms arranged one behind the other and out the back door). Some have organized design competitions reminiscent of the Case Study Houses of the late 1940s through mid-1960s (see pp. 495–96), which were intended to function as prototypes for future inexpensive mass-produced housing.

One such New Orleans housing initiative was sponsored by Global Green USA, founded in 1994 by activist and philanthropist Diane Meyer Simon as the U.S. arm of Green Cross International (GCI). The latter was created by former Soviet President Mikhail S. Gorbachev, who believed that people needed to learn to be more responsible caretakers of the environment. Global Green USA also had the backing of the actor Brad Pitt, who was actively involved in the rebuilding of New Orleans and who served as the jury chair for Global Green's 2006 competition to design and build a sustainable neighborhood in the Holy Cross section of the Lower Ninth Ward. The winning design was submitted by the New York architectural firm Workshop/apd, founded by Andrew Kotchen (b. 1972) and Matthew Berman (b. 1972); their model green house was completed three years later [8.139]. To the pristine

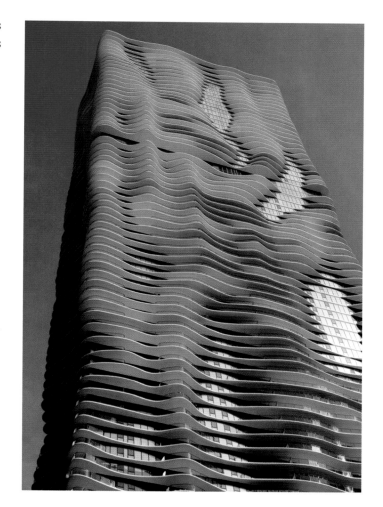

8.140 Jeanne Gang: The Aqua Tower, Chicago, 2009

lines and geometric shapes of much mid-20th-century Modernist domestic architecture [7.26, 8.56] is added the green technology of the 21st century, some of it high-tech (the "Lucid Building Dashboard" touchscreen panel that helps ensure the house remains "net-zero" energy-wise; the solar panels), some of it old-school (a thousand-gallon cistern to capture rainwater for toilet-flushing and plant care; the use of reclaimed wood and raised foundations). The long, narrow shape of the building and the covered front porch are also nods to the shotgun houses of the city's low-income communities.

Environmental factors also informed the design of another example of innovative urban domestic architecture. With Chicago's nickname "the windy city" in mind, Jeanne Gang (b. 1964) wrapped Aqua, her eighty-two-story apartment tower of metal, concrete, and glass, in thin, curving concrete balconies that change in shape from floor to floor [8.140]. The architectural critic Paul Goldberger writes: "Gang turned the

facade into an undulating landscape of bending, flowing concrete, as if the wind were blowing ripples across the surface of the building. You know this tower is huge and solid, but it feels malleable, its exterior pulsing with a gentle rhythm." In fact, the wind is literally broken up into smaller ripples by these balconies, enabling Gang to forgo the installation of a "tuned mass damper," a weight of hundreds of tons placed atop tall buildings to stabilize them against the sway caused by the wind. Breaking up the winds in this way also allows balconies to be installed on every floor (usually balconies do not appear above sixty or seventy floors because it is too windy), and the overhangs provide welcome shade in the summer months.

Gang's building can also be seen as a continuation of the technological and design innovations that grew out of the rebuilding of Chicago after the Great Fire of 1871 (see pp. 302–6). As Goldberger observes:

> Chicago is where architects like Louis Sullivan, John Wellborn Root, Mies van der Rohe, and Skidmore, Owings & Merrill elevated pragmatic solutions to structural problems to the level of art. And that is precisely what Gang has done, albeit with a different aesthetic. . . . [Aqua] reclaims the notion that thrilling and beautiful form can still emerge out of the realm of the practical.

Worlds in Flux: Nick Cave and Alan Michelson

The beautiful, the practical and the ecological come together in another way in the work of Chicago artist Nick Cave (b. 1959). Described variously as a fabric sculptor, body artist, dancer (he trained with the Alvin Ailey American Dance Theater) and performance artist, he is best known for his *Soundsuits*, mixed-media wearable constructions that create a series of sounds when "performed" [8.141]. Like Robert Rauschenberg [8.27, 8.28], Louise Nevelson [8.33], Sabato Rodia [8.39], James Hampton [8.40], and many other artists of the second half of the 20th century (see pp. 475–85), Cave takes the castaways of today's consumer culture and reconfigures them into works full of wonder and delight. Cave turns to secondhand stores or thrift shops for many of his materials, often seeking out handmade objects—crocheted doilies, knitted socks and hats, sequinned tops, wooden toys. As a result, we sometimes marvel as much at the technical skills and imagination of the needleworker or woodcarver as we do at the talents of Cave himself.

Cave's *Soundsuits* call to mind the ceremonial costumes used in many African, African American, Caribbean, and indigenous North American ceremonies. They resemble in their brilliance and detail, for example, the ensembles created for New Orleans Mardi Gras parades by the African American

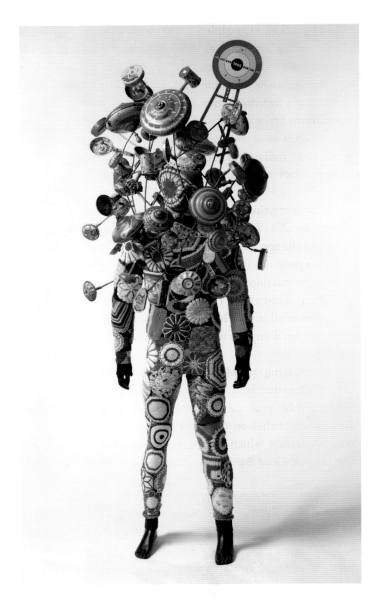

8.141 Nick Cave: *Soundsuit*, 2008
Mixed media

"Mardi Gras Indians," whose name speaks to the historical alliances between the two groups in the early years of colonization (escaped African slaves often sought refuge in Native American communities). The fabrication of these costumes and the public group performances of which they are a part constitute key elements of an alternative community in New Orleans, one that creates counter-myths and symbols for working-class black males in a city still marked by its slave-plantation origins.

Cave's *Soundsuits* cross cultural borders, creating new symbols from the traditions, myths, and rituals of multiple communities. They also completely envelop the wearer,

obscuring his identity while simultaneously enhancing his size. "Thus," writes Stacey Ravel Abarbanel, "the Soundsuits can be understood as coats of armor, shielding Cave from the day-to-day prejudice he encounters as an African American man and facilitating a transformation into an invented realm of vibrant associations and meanings." Such an invented realm, however, is not meant to be escapist but, like the performances of the Mardi Gras Indians, to provide a symbolic foundation for the creation of new communities. Of his *Soundsuits*, Cave comments:

To me, everything outside of myself is community. I don't see myself as an artist but as a humanitarian using art to create change. My hope is that these new Soundsuits will cause people to find ways to live with each other, extend our compassion to other communities and take care of our natural resources. If I can create an opportunity to bring people of all creeds, identities and interests together, then I am doing my work.

Yet bringing people of different creeds, identities and interests together is becoming increasingly difficult in a world of fortified borders and heightened national security. Mohawk artist Alan Michelson (b. 1953) captures the complexities of border crossings, which both separate and connect communities, in his work *Third Bank of the River* (2009) [8.142], an integral part of the new building designed by the architectural firm of Smith-Miller + Hawkinson for the U.S. port of entry in Massena, New York. This border crossing is one of three dozen or so high-tech land ports built or expanded by the Department of Homeland Security in the decade since September 2001.

Michelson's work is nearly 6 feet tall and over 40 feet long. It is composed of hundreds of photographs—including trees, rocks, bridges, and factories—of several miles of the banks of the St Lawrence River, the international border between the U.S. and Canada. Taken from a moving boat, these separate photographs were then digitally joined and organized into four parallel views of the river, which were sandblasted through a dot-matrix screen onto ten sheets of glass. In 2005 Michelson commented that he made such sweeping, panoramic works "because you can't just take them all in and think you know what you're seeing. It forces you to look at things from more than one direction and one angle, and to look at life as flux rather than something that you can fix and control."

Michelson's work is installed high on the west wall of the main passenger lobby; those below waiting in line to go through customs have a clear view of it. At the same time, it

8.142 Alan Michelson: *Third Bank of the River*, 2009
Floatglass painting and engraving, 69 × 489 in. (175.3 × 1,242.1 cm.)

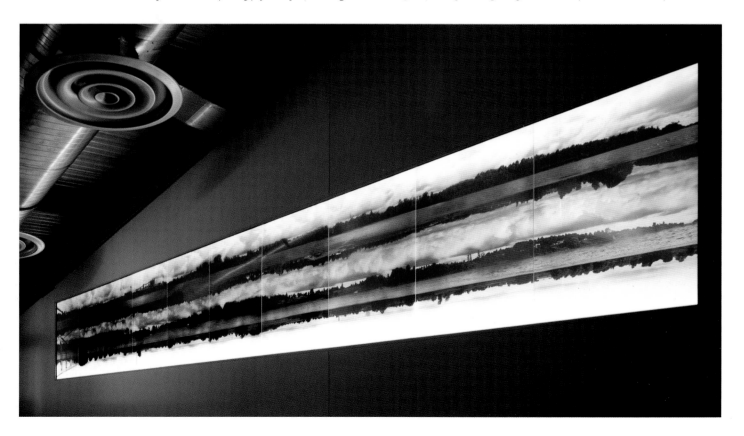

functions as a security window for those in the second-floor offices, whose occupants can view the lobby below through transparent sections of the glass without being seen.

The title of this glass panorama, notes the art historian Kate Morris, refers specifically to the unique geography of this international border crossing:

> In the middle of the St Lawrence, between the United States and the Canadian mainland, lies Cornwall Island. It is within the international boundaries of Canada, yet it is also the sovereign territory of the Akwesasne Mohawk Nation. All travelers crossing the border [at Massena] must traverse Cornwall Island and are for a short time the "guests" of the Akwesasne.

Michelson himself embodies the complexity of this border crossing. An enrolled member of the Six Nations of the Grand River in Canada, he was born in Buffalo, New York, and subsequently raised in Massachusetts and educated in Boston and New York City.

By including in *Third Bank* the shores of Cornwall Island, as well as New York State and the province of Ontario (the top bank in the image is New York State, the middle two the south and north banks of Cornwall Island, the bottom one Ontario), Michelson reminds the viewer of the significance of the Mohawk Nation for both countries, in the present and past. This past is embodied not only in the physical territory depicted in the photographs, but also in the overall formal qualities of the work. In composing his panorama of alternating light and dark parallel lines, Michelson intentionally references the historic Two Row wampum belt [1.44], which ratified a 1613 reciprocal pact of non-interference between the Dutch and the Haudenosaunee or League of the Iroquois, of which the Mohawk were a part (see pp. 48–49). Morris writes: "In the metaphoric language of the 'Guswhenta' Treaty, the two cultures—Native and European—were described as two vessels traveling down a river on a parallel course. These vessels, a birchbark canoe and a European ship, represented the laws and customs of each people; the agreement stated that neither would impede the other's progress." In the wampum belt, the two vessels are represented by parallel horizontal purple stripes, the river by the white background. Similarly, *Third Bank* contains two parallel horizontal areas of purple hues (the river and its banks) framed by three areas of white (the cloudy sky).

Thus, the symbol of the river, which Michelson has also used in several video works, represents the potential for peaceful coexistence; at the same time, it serves as a reminder of conflict and of treaties broken. This conflict was evident even as the new border facility opened in June 2009; disputes between the Akwesasne and the Canadian government over the arming of the Canadian Border Services Agency guards led to the temporary closure of the crossing. In addition, the Jay Treaty of 1794, which guaranteed to Native peoples the right of free passage between the U.S. and Canada, has come under increasing scrutiny.

In his book *The Middle Ground: Indians, Empires, and Republics in the Great Lakes Region, 1650–1815*, historian Richard White argues that in the late 17th and 18th centuries, indigenous–white relations in this area were not simply battles "of primal forces in which only one could survive." Instead, they resulted in the creation of something new, "a common, mutually comprehensible world." In such a world,

> peoples adjust their differences through what amounts to a process of creative, and often expedient, misunderstandings. People try to persuade others who are different from themselves by appealing to what they perceive to be the values and practices of those others. They often misinterpret and distort both the values and the practices of those they deal with, but from these misunderstandings arise new meanings and through them new practices—the shared meanings and practices of the middle ground.

With the emergence of the American Republic, this middle ground of shared meanings and practices was lost, as Americans focused on an image of the Native American as exotic other.

Michelson seeks to recapture this middle ground, or, in his own words, "a possible 'third way' of mutual respect and comity." According to the artist, *Third Bank* "spotlights the river, not only as a border but also as a living environment deserving of respect and protection." In presenting multiple points of view, cultural as well as geographical, Michelson offers new ways of understanding the shifting, dynamic nature of borders and the communities that live both within and across them.

Bibliography

Works are divided into a "General" section, listing titles relevant to more than one chapter, and sections on the individual chapters. Within the latter, sources are given first, in the order in which they are referred to in the text, and then suggestions for further reading. Square brackets indicate the original publication date, in instances where a book was reissued after several years of being out of print.

General works

Amaki, Amalia K., ed. *A Century of African American Art: The Paul R. Jones Collection*. Newark: The University Museum, Univ. of Delaware, and New Brunswick, N.J.: Rutgers Univ. Press, 2004

Anderson, Janet A. *Women in the Fine Arts: A Bibliography and Illustration Guide*. Jefferson, N.C.: McFarland, 1991

Andrews, Wayne *Architecture, Ambition, and Americans: A Social History of American Architecture*. New York: Free Press, 1978

Angus, Ian, and Sut Jhally *Cultural Politics in Contemporary America*. New York and London: Routledge, 1989

Baigell, Matthew *Artist and Identity in Twentieth-Century America*. Cambridge: Cambridge Univ. Press, 2001

—— *A Concise History of American Painting and Sculpture*. Rev. edn, New York: HarperCollins/Icon Editions, 1996

—— *Dictionary of American Art*. New York: Harper and Row/Icon Editions, 1979

—— *Jewish-American Artists and the Holocaust*. New Brunswick, N.J.: Rutgers Univ. Press, 1997

Bank, Mirra *Anonymous Was a Woman*. New York: St Martin's Griffin, 1995 [1979]

Banta, Martha *Imaging American Women: Idea and Ideals in Cultural History*. New York: Columbia Univ. Press, 1987

Barron, Stephanie, Sheri Bernstein and Ilene Susan Fort, eds *Made in California: Art, Image, and Identity, 1900–2000*. Berkeley, Los Angeles and London: Univ. of California Press and Los Angeles County Museum of Art, 2000

—— *Reading California: Art, Image, and Identity, 1900–2000*. Berkeley, Los Angeles and London: Univ. of California Press and Los Angeles County Museum of Art, 2000

Berlo, Janet Catherine, ed. *The Early Years of Native American Art History: The Politics and Scholarship of Collecting*. Seattle, London and Vancouver: Univ. of Washington Press and Univ. of British Columbia Press, 1992

——, and Ruth B. Phillips *Native North American Art*. Oxford and New York: Oxford Univ. Press, 1998

Bird, Jon, et al., eds *Mapping the Future: Local Cultures, Global Change*. London and New York: Routledge, 1993

Bishop, Robert C. *American Folk Sculpture*. New York: E. P. Dutton, 1974

——, and Jacqueline M. Atkins *Folk Art in American Life*. New York: Viking Studio Books/London: Penguin Books, 1995

Bjelajac, David *American Art: A Cultural History*. London: Laurence King Publishing, 2000

Boime, Albert *The Unveiling of the National Icons: A Plea for Patriotic Iconoclasm in a Nationalist Era*. Cambridge and New York: Cambridge Univ. Press, 1998

Brown, Milton W., et al. *American Art: Painting, Sculpture, Architecture, Decorative Arts, Photography*. Englewood Cliffs, N.J., and New York: Prentice-Hall and Harry N. Abrams, 1979

Brown, Steven C. *Native Visions: Evolution in Northwest Coast Art from the Eighteenth Through the Twentieth Century*. Seattle and London: Seattle Art Museum in assoc. with the Univ. of Washington Press, 1998

Burnham, Patricia M., and Lucretia Hoover Giese, eds *Redefining American History Painting*. Cambridge and New York: Cambridge Univ. Press, 1995

Burns, Sarah *Painting the Dark Side: Art and the Gothic Imagination in Nineteenth-Century America*. Berkeley and Los Angeles: Univ. of California Press, 2004

Bustard, Bruce I. *Picturing the Century: One Hundred Years of Photography from the National Archives*. Seattle and London: Univ. of Washington Press, 1999

Calo, Mary Ann, ed. *Critical Issues in American Art*. Boulder, Colo.: Westview Press, 1998

Chadwick, Whitney *Women, Art, and Society*. 4th edn, London and New York: Thames & Hudson, 2007

—— *Mirror Images: Women, Surrealism, and Self-Representation*. Cambridge, Mass., and London: MIT Press, 1998

Chiarmonte, Paula, ed. *Women Artists in the U.S.: A Selective Bibliography and Resource Guide on the Fine and Decorative Arts, 1750–1986*. Boston: G.K. Hall, 1990

Ciucci, Giorgio, et al. *The American City: From the Civil War to the New Deal*. Cambridge, Mass.: MIT Press, 1979

Cohen-Solal, Annie *Painting American: The Rise of American Artists, Paris 1867–New York 1948*. New York: Alfred A. Knopf, 2001

Condit, Carl W. *American Building: Materials and Techniques from the First Colonial Settlements to the Present*. Chicago: Univ. of Chicago Press, 1982

Cooper, Emmanuel *The Sexual Perspective: Homosexuality and Art in the Last 100 Years in the West*. London and New York: Routledge and Kegan Paul, 1986

Craven, Wayne *American Art: History and Culture*. Madison, Wis.: Brown and Benchmark, 1994

—— *Sculpture in America*. New York: Thomas Y. Crowell, 1968

Davidson, Marshall B., and Elizabeth Stillinger *The American Wing at the Metropolitan Museum of Art*. New York: Metropolitan Museum of Art and Alfred A. Knopf, 1985

Davis, Keith F. *An American Century of Photography: From Dry-Plate to Digital, The Hallmark Photographic Collection*. 2nd edn, New York: Harry N. Abrams, 1999

Dewhurst, C. Kurt, Betty MacDowell and Marsha MacDowell *Artists in Aprons: Folk Art by American Women*. New York: E. P. Dutton in assoc. with the Museum of American Folk Art, 1979

Doezema, Marianne, and Elizabeth Milroy, eds *Reading American Art*. New Haven: Yale Univ. Press, 1998

Driskell, David C., with catalog notes by Leonard Simon *Two Centuries of Black American Art*. New York: Alfred A. Knopf/Los Angeles County Museum of Art, 1976

Fagan, Brian M. *Ancient North America, The Archaeology of a Continent*. Rev. edn, London and New York: Thames & Hudson, 1995

Farrington, Lisa E. *Creating Their Own Image: The History Of African-American Women Artists*. Oxford and New York: Oxford Univ. Press, 2005

Foner, Eric *Give Me Liberty! An American History*. New York and London: W.W. Norton, 2005

Foner, Philip S., and Reinhard Schultz, eds *The Other America: Art and the Labour Movement in the United States*. London: Journeyman Press, 1985

Foresta, Merry A. *American Photographs*. Washington, D.C.: Smithsonian Institution Press with the National Museum of American Art, 1997

Fort, Ilene Susan, with contributions by Mary L. Lenihan, Marlene Park, Susan Rather, and Roberta K. Tarbell *The Figure in American Sculpture: A Question of Modernity*. Los Angeles and Seattle: Los Angeles County Museum of Art/Univ. of Washington Press, 1995

Frampton, Kenneth *Modern Architecture. A Critical History*. 4th edn, London and New York: Thames & Hudson, 2007

Fusco, Coco, and Brian Wallis, eds. *Only Skin Deep: Changing Visions of the American Self*. New York: International Center of Photography and Harry N. Abrams, Inc., 2003

Gaehtgens, Thomas W., and Heinz Ickstadt, eds *American Icons: Transatlantic Perspectives on Eighteenth- and Nineteenth-Century American Art*. Los Angeles and Chicago: Getty Center for the History of Art and the Humanities, distrib. Univ. of Chicago Press, 1992

Gelernter, Mark *A History of American Architecture: Buildings in Their Cultural and Technological Context*. Hanover and London: Univ. Press of New England, 1999

Gerdts, William H. *Art Across America: Two Centuries of Regional Painting in America, 1710–1920*. New York: Abbeville Press, 1990

——, and Mark Thistlethwaite *Grand Illusions: History Painting in America*. Fort Worth, Tex.: Amon Carter Museum, 1988

——, and James Yarnall *The National Museum of American Art's Index To American Art Exhibition Catalogues: From the Beginning through the 1876 Centennial Year*. 6 vols. Boston: G. K. Hall, 1986.

Glassie, Henry *The Spirit of Folk Art. The Girard Collection at the Museum of International Folk Art*. New York: Harry N. Abrams in assoc. with the Museum of New Mexico, Santa Fe, 1989

Goldman, Shifra M. *Dimensions of the Americas: Art and Social Change in Latin America and the United States*. Chicago and London: Univ. of Chicago Press, 1994.

Gowans, Alan *Images of American Living: Four Centuries of Architecture and Furniture as Cultural Expression*. New York: Harper and Row/Icon Editions, 1976

Greenough, Sarah, et al. *On the Art of Fixing a Shadow: One Hundred and Fifty Years of Photography*. Washington, D.C.: National Gallery of Art, 1989

Groseclose, Barbara *Nineteenth-Century American Art*. Oxford and New York: Oxford Univ. Press, 2000

Guerrilla Girls *The Guerrilla Girls' Bedside Companion to the History of Western Art*. London: Penguin Books, 1998

Hammond, Harmony *Lesbian Art in America: A Contemporary History*. New York: Rizzoli International Publications, 2000

Handlin, David P. *American Architecture*. Rev. edn, London and New York: Thames & Hudson, 2004

Harris, Neil *The Artist in American Society: The Formative Years, 1790–1860*. New York: Braziller, 1966

—— *Cultural Excursions: Marketing Appetites and Cultural Tastes in Modern America*. Chicago and London: Univ. of Chicago Press, 1990

Haskell, Barbara *The American Century: Art and Culture, 1900–1950*. New York and London: Whitney Museum of American Art in assoc. with W.W. Norton, 1999

Hayden, Dolores *The Power of Place: Urban Landscapes as Public History*. Cambridge, Mass., and London: MIT Press, 1995

Heller, Jules, and Nancy G. Heller, eds *North American Women Artists of the Twentieth Century, A Biographical Dictionary*. New York and London: Garland, 1995

——, ed. *Modern Art in the USA: Issues and Controversies of the 20th Century*. Englewood Cliffs, N.J.: Prentice Hall, 2001

——, and Roberta K. Tarbell *The Figurative Tradition and the Whitney Museum of American Art: Painting and Sculpture from the Permanent Collection*. Newark: Univ. of Delaware Press, 1980

Holmes, Oakley N., Jr *The Complete Annotated Resource Guide to Black American Art*. Spring Valley, N.Y.: Black Artists in America/Macgowan Enterprises, 1978

Hughes, Robert *American Visions: The Epic History of Art in America*. New York: Alfred A. Knopf, 1997

Hunter, Sam, and John Jacobus *American Art of the 20th Century*. Englewood Cliffs, N.J., and New York: Prentice-Hall and Harry N. Abrams, 1973

Johns, Elizabeth "Scholarship in American Art: Its History and Recent Developments," *American Studies International* 22 (1984): 3–40

Johnston, Patricia, ed. *Seeing High and Low: Representing Social Conflict in American Visual Culture*. Berkeley and Los Angeles: Univ. of California Press, 2006

Karpel, Bernard, ed. *Arts in America: A Bibliography*. 4 vols. Washington, D.C.: Smithsonian Institution Press for the Archives of American Art, 1979

Kasson, Joy *Marble Queens and Captives: Women in Nineteenth-Century American Sculpture*. New Haven: Yale Univ. Press, 1990

Kirkham, Pat, ed. *Women Designers in the USA, 1900–2000: Diversity and Difference*. New Haven and London: Yale Univ. Press, 2000

Kostof, Spiro *A History of Architecture: Settings and Rituals*. Oxford and New York: Oxford Univ. Press, 1985

Kruger, Barbara, and Phil Mariani, eds *Remaking History*. Seattle: Bay Press, 1989

Larkin, Oliver W. *Art and Life in America*. Rev. and enlarged edn, New York: Holt, Rinehart and Winston, 1960

Leja, Michael *Looking Askance: Skepticism and American Art from Eakins to Duchamp*. Berkeley and Los Angeles: Univ. of California Press, 2004

Lewis, Michael J. *American Art and Architecture*. London and New York: Thames & Hudson, 2006

Lewis, Samella *African American Art and Artists*. Berkeley, Los Angeles and London: Univ. of California Press, 1990

Ling, Amy, ed. *Yellow Light: The Flowering of Asian American Arts*. Philadelphia: Temple Univ. Press, 1999

Lipman, Jean, and Tom Armstrong, eds *American Folk Painters of Three Centuries*. New York: Hudson Hills Press, 1980

Loewen, James W. *Lies My Teacher Told Me: Everything Your American History Text Got Wrong*. New York: Touchstone/Simon and Schuster, 1995

Lubin, David M. *Picturing a Nation: Art and Social Change in Nineteenth-Century America*. New Haven and London: Yale Univ. Press, 1994

Lucie-Smith, Edward *Latin American Art of the 20th Century*. London and New York: Thames & Hudson, 1993

McCoubrey, John W., ed. *American Art, 1700–1960: Sources and Documents*. Englewood Cliffs, N.J.: Prentice-Hall, 1965

McElroy, Guy C. *Facing History: The Black Image in American Art, 1710–1940*. San Francisco and Washington, D.C.: Bedford Arts and the Corcoran Gallery of Art, 1990

Meyer, Richard *Outlaw Representation: Censorship and Homosexuality in Twentieth-Century American Art*. Oxford and New York: Oxford Univ. Press, 2002

Miles, Ellen G., et al. *American Paintings of the Eighteenth Century*. Washington, D.C., New York and Oxford: National Gallery of Art, Washington, D.C., distrib. Oxford Univ. Press, 1995

Miller, Angela et. al *American Encounters*. Englewood Cliffs, N.J.: Prentice Hall, 2007

Miller, David C., ed. *American Iconology: New Approaches to Nineteenth-Century Art and Literature*. New Haven and London: Yale Univ. Press, 1993

Morgan, David, and Sally M. Promey *The Visual Culture of American Religions*. Berkeley and Los Angeles: Univ. of California Press, 2001

Nabokov, Peter, and Robert Easton *Native American Architecture*. Oxford and New York: Oxford Univ. Press, 1989

Nochlin, Linda, and Henry A. Millon, eds *Art and Architecture in the Service of Politics*. Cambridge, Mass.: MIT Press, 1978

O'Brien, Mark, and Craig Little, eds *Reimaging America: The Arts of Social Change*. Philadelphia and Santa Cruz, N.M.: New Society Publishers, 1990

Parry, Ellwood C., III *The Image of the Indian and the Black Man in American Art, 1590–1900*. New York: Braziller, 1974

Patton, Sharon *African American Art*. Oxford and New York: Oxford Univ. Press, 1998

Phillips, Lisa *The American Century: Art and Culture, 1950–2000*. New York and London: Whitney Museum of American Art in assoc. with W.W. Norton, 1999

Pierce, Donna, and Marta Weigle, eds *Spanish New Mexico: The Spanish Colonial Arts Society Collection*. 2 vols. Santa Fe, N.M.: Museum of New Mexico Press, 1996

Poesch, Jessie J. *The Art of the Old South: Painting, Sculpture, Architecture & the Products of Craftsmen, 1560–1860*. New York: Alfred A. Knopf, 1983

Powell, Richard J. *Black Art and Culture in the 20th Century*. London and New York: Thames & Hudson, 1997

——, and Jock Reynolds *To Conserve a Legacy: American Art from Historically Black Universities*. Cambridge, Mass.: MIT Press, 1999

Prendeville, Brendan *Realism in 20th-Century Painting*. London and New York: Thames & Hudson, 2000

Quimby, Ian M. G., and Scott T. Swank, eds *Perspectives on American Folk Art*. New York: W.W. Norton, for the Henry Francis du Pont Winterthur Museum, 1980

Reps, John W. *The Making of Urban America: A History of City Planning in the United States*. Princeton: Princeton Univ. Press, 1997

Roth, Leland M. *A Concise History of American Architecture*. New York: Harper and Row/Icon Editions, 1979

Rubinstein, Charlotte Streifer *American Women Artists from Early Indian Times to the Present*. New York: Avon Books, 1982

—— *American Women Sculptors: A History of Women Working in Three Dimensions*. Boston, Mass.: G.K. Hall, 1990

Rumford, Beatrix, ed. *American Folk Paintings: Paintings and Drawings Other Than Portraits from the Abby Aldrich Rockefeller Folk Art Center*. Boston, Toronto and London: New York Graphic Society Book; Little, Brown in assoc. with the Colonial Williamsburg Foundation, 1988

Rushing, W. Jackson, III, ed. *Native American Art in the Twentieth Century: Makers, Meanings, Histories*. London and New York: Routledge, 1999

Scully, Vincent, Jr *American Architecture and Urbanism*. New York: Henry Holt, 1988

—— *Modern Architecture: The Architecture of Democracy*. New York: Braziller, 1974

Shohat, Ella, and Robert Stam *Unthinking Eurocentrism: Multiculturalism and the Media*. London and New York: Routledge, 1994

Smith, Shawn Michelle *American Archives: Gender, Race, And Class in Visual Culture*. Princeton: Princeton Univ. Press, 1999

Spencer, Harold, ed. *American Art: Readings from the Colonial Era to the Present*. New York: Charles Scribner's Sons, 1980

Stiles, Kristine, and Peter Selz, eds *Theories and Documents of Contemporary Art: A Sourcebook of Artists' Writings*. Berkeley and Los Angeles: Univ. of California Press, 1996

Taylor, Joshua C. *America as Art*. New York: Harper and Row/Icon Editions, 1976

—— *The Fine Arts in America*. Chicago: Univ. of Chicago Press, 1979

Trenton, Patricia, ed. *Independent Spirits: Women Painters of the American West, 1890–1945*. Los Angeles, Berkeley and London: Autry Museum of Western Heritage in assoc. with the Univ. of California Press, 1995

——, and Patrick T. Houlihan *Native Americans: Five Centuries of Changing Images*. New York: Harry N. Abrams, 1989

Tufts, Eleanor *American Women Artists, Past and Present, A Bibliographic Guide*. New York: Garland, 1984

Turner, Jane, ed. *Encyclopedia of American Art before 1914*. New York: Grove's Dictionaries, 1999

Upton, Dell *Architecture in the United States*. Oxford and New York: Oxford Univ. Press, 1998

Wade, Edwin L., ed. *The Arts of the North American Indian: Native Traditions in Evolution.* New York and Tulsa, Okla.: Hudson Hills Press in assoc. with Philbrook Art Center, 1986

Wallace-Sanders, Kimberley, ed. *Skin Deep, Spirit Strong: The Black Female Body in American Culture.* Ann Arbor: Univ. of Michigan Press, 2002

Wallach, Alan *Exhibiting Contradiction: Essays on the Art Museum in the United States.* Amherst, Mass.: Univ. of Massachusetts Press, 1998

Weinberg, H. Barbara and Carrie Rebora Barratt, eds *American Stories: Paintings of Everyday Life 1765–1915.* New York, New Haven, and London: Metropolitan Museum of Art and Yale University Press, 2010

Weinberg, Jonathan *Ambition and Love in Modern American Art.* New Haven and London: Yale Univ. Press, 2001

Whiffen, Marcus, and Frederick Koeper *American Architecture, 1607–1976.* Cambridge, Mass.: MIT Press, 1981

Whitney Museum of American Art, New York *200 Years of American Sculpture.* New York: David R. Godine in assoc. with the Whitney Museum of American Art, 1976

Wilmerding, John *American Views: Essays on American Art.* Princeton: Princeton Univ. Press, 1991

Zinn, Howard *A People's History of the United States, 1492–Present.* Rev. edn, New York: HarperPerennial, 1995

Preface

Sources

Hauser, Arnold *The Social History of Art.* 4 vols. New York: Vintage Books/Random House, 1951

Clark, T. J. *Image of the People, Gustave Courbet and the 1848 Revolution.* Princeton: Princeton Univ. Press, 1982 [1973]

Corn, Wanda "Coming of Age: Historical Scholarship in American Art," *Art Bulletin* 70 (June 1988): 188–207

Wolf, Eric R. *Europe and the People Without History.* Berkeley, Los Angeles and London: Univ. of California Press, 1982

Levander, Carolyn F. and Robert S. Levine *Hemispheric American Studies.* Piscataway, N.J.: Rutgers University Press, 2008

Berlo, Janet Catherine, ed. *The Early Years of Native American Art History: The Politics and Scholarship of Collecting.* Seattle, London and Vancouver: Univ. of Washington Press and UBC Press, 1992

Kubler, George *Esthetic Recognition of Ancient Amerindian Art.* New Haven and London: Yale Univ. Press, 1991

Henry, William A., III "Beyond the Melting Pot," *Time,* April 9, 1990: 28–31

Chapter 1

Sources

Bucher, Bernadette *Icon and Conquest: A Structural Analysis of the Illustrations of de Bry's "Great Voyages."* Transl. Basia Miller Gulati. Chicago and London: Univ. of Chicago Press, 1981

Columbus, Christopher *The Journal of Christopher Columbus.* Transl. Cecil Jane; rev. and annotated by L. A. Vigneras, with an appendix by R. A. Skelton. London: The Hakluyt Society, 1960

The Spanish and the Aztecs

Cortés, Hernán *Letters From Mexico.* Transl. and ed. Anthony Pagden, with an intro. by J. H. Elliot. New Haven and London: Yale Univ. Press, 1986

Tenochtitlan: Pyramids, Codices, and Monumental Sculpture

Díaz del Castillo, Bernal *The Discovery and Conquest of Mexico.* Transl. A. P. Maudslay. New York: Noonday, 1956

Schwartz, Stuart B., ed. *Victors and Vanquished: Spanish and Nahua Views of the Conquest of Mexico.* Boston and New York: Bedford/St Martin's, 2000

Gruzinski, Serge *Painting the Conquest: The Mexican Indians and the European Renaissance.* Transl. Deke Dusinberre. Paris: Unesco/Flammarion, 1992

Dürer, Albrecht *Writings.* Transl. and ed. William Martin Conway, with an intro. by Alfred Werner. New York: Philosophical Library, 1958

—— *Diary of his Journey to the Netherlands, 1520–1521.* Transl. from the French by Philip Troutman, with an intro. by J.-A. Goris and G. Marlier. Greenwich, Conn: New York Graphic Society, 1971

Loewen, James W. *Lies My Teacher Told Me: Everything Your American History Text Got Wrong.* New York: Touchstone/Simon and Schuster, 1995

Fagan, Brian M. *Ancient North America, The Archaeology of a Continent.* Rev. edn, London and New York: Thames & Hudson, 1995

Miller, Mary Ellen *The Art of Mesoamerica from Olmec to Aztec.* London and New York: Thames & Hudson, 1986

Paz, Octavio *Essays on Mexican Art.* Transl. Helen Lane. New York, San Diego and London: Harcourt Brace, 1993

Todorov, Tzvetan *The Conquest of America.* Transl. Richard Howard. New York: Harper and Row/Harper Torchbooks, 1987 [1982]

Churches, Statues, and Altarpieces

Hall, Linda B. *Mary, Mother and Warrior: The Virgin in Spain and the Americas.* Austin: University of Texas Press, 2004

Klein, Cecelia F. "A New Interpretation of Aztec Statue Called Coatlicue, 'Snakes-Her-Skirt'", *Ethnohistory* 55, no. 2 (Spring 2008): 229–50

Weismann, Elizabeth Wilder *Art and Time in Mexico: Architecture and Sculpture in Colonial Mexico.* New York: HarperCollins/Icon Editions, 1995 [1985]

The Northern Territories of New Spain

Fontana, Bernard L. *Entrada: The Legacy of Spain and Mexico in the United States.* Tucson, Ariz.: Southwest Parks and Monuments Association, 1994

The Pueblo Cultures

Scully, Vincent *Pueblo/Mountain, Village, Dance.* 2nd edn, Chicago and London: Univ. of Chicago Press, 1989 [1972]

Gutiérrez, Ramón *When Jesus Came, the Corn Mothers Went Away: Marriage, Sexuality, and Power in New Mexico, 1500–1846.* Stanford, Calif.: Stanford Univ. Press, 1991

Smith, Watson *When Is a Kiva? And Other Questions About Southwestern Archaeology.* Ed. Raymond H. Thompson. Tucson, Ariz.: Univ. of Arizona Press, 1990

The Christianization of the Pueblos

Drain, Thomas A. (text), and David Wakely (photography) *A Sense of Mission: Historic Churches of the Southwest.* San Francisco: Chronicle Books, 1994

Mather, Christine, ed. *Colonial Frontiers: Art and Life in Spanish New Mexico.* Santa Fe, N.M.: Ancient City Press, 1983

Texas and Arizona in the 17th and 18th Centuries

Mullen, Robert J. *Architecture and Its Sculpture in Viceregal Mexico.* Austin: Univ. of Texas Press, 1997

Battle Scenes on Hide: Segesser I and II

Hotz, Gottfried *Indian Skin Paintings from the American Southwest: Two Representations of Border Conflicts Between Mexico and the Missouri in the Early Eighteenth Century.* Transl. Johannes Malthaner. Norman: Univ. of Oklahoma Press, 1970

The California Missions

Monroy, Douglas *Thrown Among Strangers, The Making of Mexican Culture in Frontier California.* Berkeley, Los Angeles and Oxford: Univ. of California Press, 1990

Moser, Christopher L. *Native American Basketry of Southern California.* Riverside, Calif.: Riverside Museum Press, 1993

Young, Stanley (text), and Melba Levick (photographs) *The Missions of California.* San Francisco: Chronicle Books, 1988

France Bringing the Faith: the Northeast

Material Exchange: The Impact of Trade on Native American Life

Richter, Daniel K. *The Ordeal of the Longhouse, The Peoples of the Iroquois League in the Era of European Colonization.* Chapel Hill and London: Univ. of North Carolina Press, 1992

Trenton, Patricia, and Patrick T. Houlihan *Native Americans: Five Centuries of Changing Images.* New York: Harry N. Abrams, 1989

Ritzenthaler, Robert *Iroquois False-face Masks.* Milwaukee: Milwaukee Public Museum, 1969

Religious Instruction and Cultural Exchange: The Jesuits and the Ursulines

Davis, Natalie Zemon *Women on the Margins: Three Seventeenth-Century Lives.* Cambridge, Mass., and London: Harvard Univ. Press,1995

Harper, Russell J. *Painting in Canada: A History.* 2nd edn, Toronto, Buffalo and London: Univ. of Toronto Press, 1977

Barbeau, Marius *Saintes Artisanes: II – Mille Petites Adresses.* Montreal: Éditions Fides, 1943

Phillips, Ruth B. *Trading Identities, The Souvenir in Native North American Art from the Northeast, 1700–1900.* Seattle and London: Univ. of Washington Press; Montreal and Kingston: McGill-Queen's Univ. Press, 1998

The Influence of Fashion: Painted Caribou-Skin Coats

Burnham, Dorothy K. *To Please the Caribou: Painted Caribou-Skin Coats Worn by the Naskapi, Montagnais, and Cree Hunters of the Quebec-Labrador Peninsula.* Seattle: Univ. of Washington Press, 1992

The Exploration of the Mississippi and Mississippian Culture

Monuments to Death: Burial Mounds and Effigy Funeral Vessels

Fagan, Brian M. *Ancient North America, The Archaeology of a Continent.* Rev. edn, London and New York: Thames & Hudson, 1995

Monuments to Life: Cahokia and the Grand Village of the Natchez

Le Page du Pratz, Antoine S. *The History of Louisiana,* translated from the French of M. Le Page. Ed. Joseph G. Tregle, Jr. Baton Rouge: Louisiana State Univ. Press, 1975

Native America in Europe: The Comte d'Artois's Cabinet of Natural History

Vitart, Anne "From Royal Cabinets to Museums: A Composite History," in George P. Horse Capture et al., *Robes of Splendor: Native American Painted Buffalo Robes.* New York: The New Press, 1993

Roscoe, Will *The Zuni Man-Woman.* Albuquerque: Univ. of New Mexico Press, 1991

A Protestant Presence in America

Picturing the "New World": Jacques Le Moyne de Morgues, John White, and Theodore de Bry

Nabokov, Peter, and Robert Easton *Native American Architecture.* Oxford and New York: Oxford Univ. Press, 1989

Lorant, Stefan, ed. *The New World: The First Pictures of America Made by John White and Jacques Le Moyne and Engraved by Theodore de Bry with Contemporary Narratives of the Huguenot Settlement in Florida, 1562–1565, and the Virginia Colony.* New York: Duell, Sloan, and Pearce, 1946

Hulton, Paul *America 1585: The Complete Drawings of John White.* Raleigh and London: Univ. of North Carolina Press/British Museum Publications, 1984

Morison, Samuel Eliot *The Discovery of America.* Vol. 1: *The Northern Voyages.* New York: Oxford Univ. Press, 1971

Milanich, Jerald T., and Susan Milbrath *First Encounters.* Gainesville: Univ. of Florida Presses, 1989

Smith, John *The Generall Historie of Virginia, New-England, and the Summer Isles.* Vol. 4. London: J. Dawson and J. Haviland for Michael Sparks, 1624

Feest, C. F. "Powhatan's Mantle," in Arthur MacGregor, ed. *Tradescant's Rarities.* Oxford: Clarendon Press, 1983

Nash, Gary *Red, White, and Black.* Englewood Cliffs, N.J.: Prentice-Hall, 1974

The Art and Architecture of the British and Dutch Colonies

Art, Religion, and Politics in 17th-Century England

Craven, Wayne *Colonial American Portraiture: The Economic, Religious, Social, Cultural, Philosophical, Scientific, and Aesthetic Foundations.* Cambridge: Cambridge Univ. Press, 1986

Displays of Status: Portraiture and Domestic Spaces in New England

Lewis, Michael J. *American Art and Architecture.* London and New York: Thames & Hudson, 2006

Bishop, Robert, and Jacqueline M. Atkins *Folk Art in American Life.* New York: Viking Studio Books/London: Penguin Books, 1995

Rhodes, Lynette I. *American Folk Art, From the Traditional to the Naive.* Cleveland: Cleveland Museum of Art, 1978

The Dutch Influence in Architecture and Portraits

Stein, Roger "Thomas Smith's Self-Portrait: Image/Text as Artifact," *Art Journal* 44 (Winter 1984): 315–27

Aristocratic Pretensions in the South

Quinn, Arthur *A New World, An Epic of Colonial America from the Founding of Jamestown to the Fall of Quebec.* Boston and London: Faber and Faber, 1994

Roth, Leland M. *A Concise History of American Architecture.* New York: Harper and Row/Icon Editions, 1979

Vlach, John Michael *Back of the Big House: The Architecture of Plantation Slavery.* Chapel Hill and London: Univ. of North Carolina Press, 1993

Rubinstein, Charlotte Streifer *American Women Artists from Early Indian Times to the Present.* New York: Avon Books, 1982

Products of the Needle and the Chisel

Dewhurst, C. Kurt, Betty MacDowell and Marsha MacDowell *Artists in Aprons: Folk Art by American Women.* New York: E. P. Dutton in assoc. with the Museum of American Folk Art, 1979

Harris, Neil "The Making of an American Culture, 1750–1800," in Charles F. Montgomery and Patricia E. Kane, eds, *American Art: 1750–1800, Towards Independence.* Boston: New York Graphic Society, for Yale Univ. Art Gallery and the Victoria and Albert Museum, 1976

Doors to Eternal Peace: Carved Gravestones

Stein, Roger "Thomas Smith's Self-Portrait: Image/Text as Artifact," *Art Journal* 44 (Winter 1984): 315–27

Bishop, Robert, and Jacqueline M. Atkins *Folk Art in American Life.* New York: Viking Studio Books/London: Penguin Books, 1995

Foreign Wars and Domestic Unrest

Benjamin West's "The Death of General Wolfe" and "Penn's Treaty with the Indians"

Lord, Barry *The History of Painting in Canada: Toward a People's History.* Toronto: NC Press, 1974

Rather, Susan "Benjamin West, John Galt, and the Biography of 1816," *Art Bulletin* 86 (June 2004): 324–45

Abrams, Ann Uhry "Benjamin West's Documentation of Colonial History: *William Penn's Treaty with the Indians*," *Art Bulletin* 54 (March 1982): 59–75

Further Reading

Adorno, Rolena "The Negotiation of Fear in Cabeza de Vaca's Naufragios," in Stephen Greenblatt, ed., *New World Encounters.* Berkeley and Los Angeles: Univ. of California Press, 1993

Allen, Paula Gunn *Pocahontas: Medicine Woman, Spy, Entrepreneur, Diplomat.* New York: HarperCollins, 2003

Bedell, Rebecca *The Anatomy of Nature: Geology and American Landscape Painting, 1825–1875.* Princeton and Oxford: Princeton Univ. Press, 2001

Axtell, James *Beyond 1492: Encounters in Colonial North America.* Oxford and New York: Oxford Univ. Press, 1992

Burke, Marcus, "Mexican Painting of the Renaissance and Counter-Reformation," in New York,

Metropolitan Museum of Art, *Mexican Splendors of Thirty Centuries.* New York and Boston: Metropolitan Museum and Little, Brown and Co., 1990: 286–88

Castillo, Susan, and Ivy Schweitzer, eds. *The Literatures of Colonial America: An Anthology.* Malden, Mass., and Oxford: Blackwell Publishers, 2001

Fitzhugh, William W. *Cultures in Contact: The European Impact on Native Cultural Institutions in Eastern North America, A.D. 1000–1800.* Washington, D.C.: Smithsonian Institution Press, 1985

Greer, Allan, ed. *The Jesuit Relations: Natives and Missionaries in Seventeenth-Century North America.* Boston and New York: Bedford/St Martin's, 2000

Gruzinski, Serge *Images at War: Mexico from Columbus to Blade Runner (1492–2019).* Trans. Heather MacLean. Durham, N.C., and London: Duke Univ. Press, 2001

Jackson, Robert H. and Edward Castillo, eds. *Indians, Franciscans, and Spanish Colonization: The Impact of the Mission System on California Indians.* Albuquerque: University of New Mexico Press, 1996

Leibsohn, Dana "Colony and Cartography: Shifting Signs on Indigenous Maps of New Spain," in Claire Farago, ed., *Reframing the Renaissance: Visual Culture in Europe and Latin America, 1450–1650.* New Haven and London: Yale Univ. Press, 1995

López Austin, Alfredo and Leonardo López Lujan *Monte Sagrado: Templo Mayor.* Mexico City: INAH, 2009

Mancall, Peter C., ed. *Envisioning America: English Plans for the Colonization of North America, 1580–1640.* Boston and New York: Bedford/St Martin's, 1995

Mann, Charles C. *1491: New Revelations of the Americas Before Columbus.* New York: Alfred A. Knopf, 2005

Menzies, Gavin *1421: The Year China Discovered America.* New York: HarperCollins, 2003 (2002)

Morisset, Gérard *La Peinture traditionelle au Canada français.* Ottawa: Le Cercle du Livre de France, 1960

Pagden, Anthony "Ius et Factum: Text and Experience in the Writings of Bartolomé de Las Casas," in Stephen Greenblatt, ed., *New World Encounters.* Berkeley and Los Angeles: Univ. of California Press, 1993

Rabasa, José *Inventing A-m-e-r-i-c-a: Spanish Historiography and the Formation of Eurocentrism.* Norman and London: Univ. of Oklahoma Press, 1993

Sands, James A. *Converting California: Indians and Franciscans in the Missions.* New Haven and London: Yale University Press, 2008

Secrest, William B. *When the Great Spirit Died: The Destruction of the California Indians, 1850–1860.* Sanger, Calif.: Word Dancer Press, 2002

Trexler, Richard C. *Sex and Conquest: Gendered Violence, Political Order, and the European Conquest of the Americas.* Ithaca, N.Y.: Cornell Univ. Press, 1995

Tunis, Edwin *Colonial Living.* Cleveland and New York: World Publishing Company, 1957

Vlach, John Michael *The Planter's Prospect: Privilege and Slavery in Plantation Paintings.* Chapel Hill and London: Univ. of North Carolina Press, 2002

Watts, Pauline Moffitt "Languages of Gesture in Sixteenth- Century Mexico: Some Antecedents and Transmutations," in Claire Farago, ed., *Reframing the Renaissance: Visual Culture in Europe and Latin America, 1450–1650.* New Haven and London: Yale Univ. Press, 1995

Chapter 2

Sources

Representing the Revolution and Its Aftermath
Domestic Production and International Intrigue: John Singleton Copley's "Governor and Mrs Thomas Mifflin" and "Watson and the Shark"

Staiti, Paul "Character and Class: The Portraits of John Singleton Copley," in Marianne Doezema and Elizabeth Milroy, eds, *Reading American Art*. New Haven: Yale Univ. Press, 1998: 12–37

Dinnerstein, Lois "The Industrious Housewife: Some Images of Labor in American Art," *Artsmagazine* 55 (April 1981): 109–19

Boime, Albert "Blacks in Shark-Infested Waters, Visual Encodings of Racism in Copley and Homer," *Smithsonian Studies in American Art* 3 (Winter 1989): 18–47

John Trumbull's Canvases of War

Trumbull, John *Autobiography, Reminiscences and Letters of John Trumbull from 1756 to 1841*. New York and London: Wiley and Putnam; New Haven: B.L. Hamlen, 1841

Jaffe, Irma B. *John Trumbull: Patriot-Artist of the American Revolution*. Boston: New York Graphic Society, 1975

Burnham, Patricia M. "John Trumbull, Historian: The Case of the Battle of Bunker's Hill," in Patricia M. Burnham and Lucretia Hoover Giese, eds, *Redefining American History Painting*. Cambridge and New York: Cambridge Univ. Press, 1995: 37–53

Swett, Samuel "Historical and topographical sketch of Bunker Hill battle," in David Humphreys, *An essay on the life of the Honourable Major General Israel Putnam. Addressed to the state Society of the Cincinnati in Connecticut, and first published by their order.* Boston: Samuel Avery, 1818

Kaplan, Sidney *The Black Presence in the Era of the American Revolution, 1770–1800*. New York and Washington, D.C.: New York Graphic Society in assoc. with the Smithsonian Institution Press, 1973

Prown, Jules David "John Trumbull as History Painter," in Helen Cooper et al., *John Trumbull, The Hand and Spirit of a Painter*. New Haven: Yale Univ. Art Gallery, 1982

The Aspirations of Women: Postrevolutionary Samplers

Bank, Mirra *Anonymous Was a Woman*. New York: St Martin's Griffin, 1995 [1979]

Money, Beauty, and Rank: Silver in the New Republic

Fairbanks, Jonathan "Paul Revere and 1768: His Portrait and the Liberty Bowl," in Jeannine Falino and Gerald W.R. Ward, eds, *New England Silver and Silversmithing 1620–1815*. Boston: Colonial Society of Massachusetts, distributed by the Univ. Press of Virginia, 2001

Kane, Patricia "Chasers, the Chase, and Other Scenes on Boston Rococo-Style Silver," in Falino and Ward, eds, *New England Silver and Silversmithing*: 19–43

Falino, Jeannine "'The Pride Which Pervades thro every Class': The Customers of Paul Revere," in Falino and Ward, eds, *New England Silver and Silversmithing*: 152–82

Bushman, Richard Lyman "The Complexity of Silver," in Falino and Ward, eds, *New England Silver and Silversmithing*: 1–15

Presidential Poses: Images of George Washington
Portraits from Life: Painting and Sculpture

Eliot, Alexander *Three Hundred Years of American Painting*. New York: Time Inc., 1957

Lipman, Jean, and Alice Winchester *The Flowering of American Folk Art, 1776–1876*. New York: Viking Press, in cooperation with the Whitney Museum of American Art, 1974

Bishop, Robert, and Jacqueline M. Atkins *Folk Art in American Life*. New York: Viking Studio Books/London: Penguin Books, 1995

Rubinstein, Charlotte Streifer *American Women Artists from Early Indian Times to the Present*. New York: Avon Books, 1982

Posthumous Portraits: The Mourning Picture

Rumford, Beatrix, ed. *American Folk Paintings: Paintings and Drawings Other Than Portraits from the Abby Aldrich Rockefeller Folk Art Center*. Boston, Toronto and London: New York Graphic Society Book; Little, Brown in assoc. with the Colonial Williamsburg Foundation, 1988

From Painting to Print to Embroidery: The History of an Image

Miles, Ellen G., et al. *American Paintings of the Eighteenth Century*. Washington, D.C., New York and Oxford: National Gallery of Art, Washington, D.C., distrib. Oxford Univ. Press, 1995

Benberry, Cuesta *Always There: The African-American Presence in American Quilts*. Louisville, Ky: The Kentucky Quilt Project, Inc., 1992

Fry, Gladys-Marie *Stitched from the Soul: Slave Quilts from the Ante-Bellum South*. New York: Dutton Studio Books in assoc. with the Museum of American Folk Art, 1990

Architectural Symbols of a New Nation
Home for a President: Thomas Jefferson's Monticello

Roth, Leland M. *A Concise History of American Architecture*. New York: Harper and Row/Icon Editions, 1979

Upton, Dell *Architecture in the United States*. Oxford and New York: Oxford Univ. Press, 1998

Constructing a Capitol: Washington, D.C.

Kostof, Spiro *A History of Architecture: Settings and Rituals*. Oxford and New York: Oxford Univ. Press, 1985

The Louisiana Purchase: New Orleans and Plantation Architecture

Taylor, Joel Gray *Louisiana, A History*. New York and London: W.W. Norton, 1984 [1976]

Ryan, Mary P. "'A Laudable Pride in the Whole of Us': City Halls and Civic Materialism," *The American Historical Review* 105, no. 4 (Oct. 2000): 1131–70

Driskell, David C., with catalog notes by Leonard Simon *Two Centuries of Black American Art*. New York: Alfred A. Knopf and Los Angeles County Museum of Art, 1976

An Architecture of Discipline
Religious Discipline: The Designing of Shaker Communities

Nicoletta, Julie, with photography by Bret Morgan *The Architecture of the Shakers*. Woodstock, Vt: Norfleet Press Book/Countryman Press, 1995

Dickens, Charles *American Notes for General Circulation*. New York : Harper and Brothers, 1842

Rhodes, Lynette I. *American Folk Art, From the Traditional to the Naive*. Cleveland: Cleveland Museum of Art, 1978

Secular Discipline: The Designing of Prisons

Johnston, Norman *The Human Cage: A Brief History of Prison Architecture*. New York: Walker, 1973

Rothman, David J. *The Discovery of the Asylum: Social Order and Disorder in the New Republic*. Boston: Little, Brown, 1971

Nationhood and Native Americans
Native Americans and the Decoration of the Capitol Building

Fryd, Vivien Green *Art and Empire: The Politics of Ethnicity in the United States Capitol, 1815–1860*. New Haven and London: Yale Univ. Press, 1992

Mills, Robert *Guide to the Capitol and to the National Executive Offices of the United States*. Washington, D.C., 1834

Slotkin, Richard *The Fatal Environment: The Myth of the Frontier in the Age of Industrialization, 1800–1890*. New York: Atheneum, 1985

From Indian Queen to Greek Goddess

Fleming, E. McClung "From Indian Princess to Greek Goddess: The American Image, 1783–1815," *Winterthur Portfolio* 3 (1967): 37–66

Groseclose, Barbara *Nineteenth-Century American Art*. Oxford and New York: Oxford Univ. Press, 2000

Sommer, Frank H. "The Metamorphoses of Britannia," in Charles F. Montgomery and Patricia E. Kane, eds, *American Art: 1750–1800, Towards Independence*. Boston: New York Graphic Society, for Yale Univ. Art Gallery and the Victoria and Albert Museum, 1976

Narratives of Captivity

Namias, June *White Captives: Gender and Ethnicity on the American Frontier*. Chapel Hill and London: Univ. of North Carolina Press, 1993

Strong, Pauline Turner "Captivity in White and Red: Convergent Practice and Colonial Representation on the British-Amerindian Frontier, 1606–1736," in Dan Segal, ed., *Crossing Cultures: Essays in the Displacement of Western Civilization*. Tucson and London: Univ. of Arizona Press, 1992

Portraits and Treaties

Force, William Q. *Picture of Washington and Its Vicinity, for 1848*. Washington, D.C.: William Q. Force, 1848

Jacobs, Paul, and Saul Landau, with Eve Pell *To Serve the Devil, Volume 1: Natives and Slaves, A Documentary Analysis of America's Racial History and Why It Has Been Kept Hidden*. New York: Random House/Vintage Books, 1971

Schimmel, Julie "Inventing the 'Indian'," in William Truettner, ed., *The West as America: Reinterpreting Images of the Frontier, 1820–1920*. Washington, D.C., and London: Smithsonian Institution Press, 1991

Trenton, Patricia, and Patrick T. Houlihan *Native Americans: Five Centuries of Changing Images*. New York: Harry N. Abrams, 1989

The Schooling of the Nation's Artists: Samuel F. B. Morse and the National Academy of Design

Staiti, Paul J. *Samuel F. B. Morse*. Cambridge and New York: Cambridge Univ. Press, 1989

Kloss, William *Samuel F. B. Morse*. New York: Harry N. Abrams, 1988

The Entrepreneurial Spirit and the Production of American Culture

Rufus Porter and the "Valuable and Curious Arts"

Jaffee, David "'A Correct Likeness': Culture and Commerce in Nineteenth-Century Rural America," in John Michael Vlach and Simon J. Bronner, eds, *Folk Art and Art Worlds*. Ann Arbor, Mich.: UMI Research Press, 1986

A Plain Likeness: Itinerant Portrait Painters

Neal, John "American Painters and Painting," *The Yankee and Boston Literary Gazette* 1 (1829): 45

Bergengren, Charles "'Finished to the Utmost Nicety': Plain Portraits in America, 1760–1860," in John Michael Vlach and Simon J. Bronner, eds, *Folk Art and Art Worlds*. Ann Arbor, Mich.: UMI Research Press, 1986

Patton, Sharon *African American Art*. Oxford and New York: Oxford Univ. Press, 1998

Lewis, Samella *African American Art and Artists*. Berkeley, Los Angeles and London: Univ. of California Press, 1990

A "Scientific" Likeness: The Daguerreotype

Arthur, T. S. *Ten Nights in a Bar-Room*. Philadelphia: H. T. Coates and Co., 1882

Further Reading

Barratt, Carrie Rebora *Queen Victoria and Thomas Sully*. Princeton: Princeton Univ. Press, in assoc. with The Metropolitan Museum of Art, 2000

Brigham, David R. *Public Culture in the Early Republic: Peale's Museum and Its Audience*. Washington, D.C.: Smithsonian Institution Press, 1995

Cosentino, Andrew J. *The Painting of Charles Bird King (1785–1862)*. Washington, D.C.: Smithsonian Institution Press for the National Collection of Fine Arts, 1977

Evans, Dorinda *The Genius of Gilbert Stuart*. Princeton: Princeton Univ. Press, 1999

Hall, Gwendolyn Mido *Africans in Colonial Louisiana: The Development of Afro-Creole Culture in the Eighteenth Century*. Baton Rouge: Louisiana State Univ. Press, 1993

Johnston, Patricia "Samuel F. B. Morse's *Gallery of the Louvre*: Social Tensions in an Ideal World," in *Seeing High And Low: Representing Social Conflict in American Visual Culture*. Berkeley and London: Univ. of California Press, 2006

Lovell, Margaretta *Art in a Season of Revolution: Painters, Artisans, and Patrons in Early America*. Philadelphia: Univ. of Pennsylvania Press, 2005

Miles, Ellen G. *The Portrait in Eighteenth-Century America*. Newark and London: Univ. of Delaware Press and Associated Univ. Presses, 1993

National Collection of Fine Arts, Smithsonian Institution, Lois Marie Fink, and Joshua C. Taylor *Academy: The Academic Tradition in American Art*. Chicago: Univ. of Chicago Press, 1978

Nemerov, Alexander *The Body of Raphaelle Peale: Still Life and Selfhood, 1812–1824*. Berkeley and Los Angeles: Univ. of California Press, 2001

Pleasants, J. Hall *Joshua Johnston, an Early Baltimore Negro Portrait Painter*. The Walpole Society, 1940

Rock, Howard and Diana L. Linden *The City of Promises: The History of the Jewish People in New York*, Vol. 1, ed. Deborah Dash Moore. New York: New York Univ. Press, 2013

Ryan, Mary P. *Civic Wars, Democracy and Public Life in the American City in the Nineteenth Century*. Berkeley and Los Angeles: Univ. of California Press, 1997

Sellars, Charles Colman *Patience Wright: American Artist and Spy in George III's London*. Middletown, Conn.: Wesleyan Univ. Press, 1976

Ward, David C. *Charles Willson Peale: Art and Selfhood in the Early Republic*. Berkeley and Los Angeles: Univ. of California Press, 2004

Chapter 3

Sources

Nature and the Sacred in Native American Art

Imagery of Creation and the Vision Quest

Swentzell, Rita "The Sense of Process," in *All Roads Are Good, Native Voices On Life and Culture*. Washington, D.C., and London: Smithsonian Institution Press in assoc. with the National Museum of the American Indian, 1994

Medicine Crow, Joseph "Mysterious Powers," in *All Roads Are Good, Native Voices On Life and Culture*. Washington, D.C., and London: Smithsonian Institution Press in assoc. with the National Museum of the American Indian, 1994

Ewers, John C. *Entries in Creation's Journey, Native American Identity and Belief*. Ed. Tom Hill and Richard W. Hill, Sr. Washington, D.C., and London: Smithsonian Institution Press in assoc. with the National Museum of the American Indian, 1994

The Box that Speaks: The Integration of Form, Content, and Material

Holm, Bill *Northwest Coast Indian Art: An Analysis of Form*. Vancouver and Toronto: Douglas and McIntyre, 1965

Lévi-Strauss, Claude *The Savage Mind*. Chicago: Univ. of Chicago Press, 1966 [1962]

God, Nature, and the Rise of Landscape Painting

God's Nature as God in Nature

Novak, Barbara *Nature and Culture: American Landscape and Painting, 1825–1875*. London and New York: Thames & Hudson, 1980

Landscape Tourism

Wallach, Alan "Thomas Cole, Landscape and the Course of American Empire," in William H. Truettner and Alan Wallach, eds, *Thomas Cole, Landscape into History*. New Haven, London and Washington, D.C.: Yale Univ. Press and National Museum of American Art, Smithsonian Institution, 1994

Images of Niagara Falls

Wolf, Bryan "Revolution in the Landscape: John Trumbull and Picturesque Painting," in Helen A. Cooper et al., *John Trumbull, The Hand and Spirit of a Painter*. New Haven: Yale Univ. Art Gallery, 1982

Boime, Albert *The Magisterial Gaze: Manifest Destiny and American Landscape Painting c. 1830–1865*. Washington, D.C., and London: Smithsonian Institution Press, 1991

Thomas Cole, Federalism, and The Course of Empire

Miller, Angela "Thomas Cole and Jacksonian America: The Course of Empire as Political Allegory," *Prospects* 14 (1990): 65–92

Wallach, Alan "Thomas Cole and the Aristocracy," *Artsmagazine* 56 (Nov. 1981): 94–106

Successors to Cole

Sweeney, J. Gray "The Advantages of Genius and Virtue, Thomas Cole's Influence, 1848–58," in William H. Truettner and Alan Wallach, eds, *Thomas Cole, Landscape into History*. New Haven, London and Washington, D.C.: Yale Univ. Press and National Museum of American Art, Smithsonian Institution, 1994

Ketner, Joseph D. *The Emergence of the African-American Artist: Robert S. Duncanson 1821–1872*. Columbia and London: Univ. of Missouri Press, 1993

Edward Hicks and The Peaceable Kingdom

Mather, Eleanore Price, and Dorothy Canning Miller *Edward Hicks, His "Peaceable Kingdoms" and Other Paintings*. Newark: Univ. of Delaware Press/New York, London and Toronto: Cornwall Books, 1983

Black, Mary C. "& a Little Child Shall Lead Them," *Arts in Virginia* 1 (Autumn, 1960)

Russell, Elbert *The Separation After a Century*. Philadelphia: The Friends Intelligencer, 1928

Landscape Painting at Mid-Century: Frederic Edwin Church and the Luminists

Frederic Edwin Church: From the Pastoral to the Sublime

Kelly, Franklin *Frederic Edwin Church and the National Landscape*. Washington, D.C., and London: Smithsonian Institution Press, 1988

Christadler, Martin "Romantic Landscape Painting in America: History as Nature, Nature as History," in Thomas W. Gaehtgens and Heinz Ickstadt, eds, *American Icons: Transatlantic Perspectives on Eighteenth- and Nineteenth-Century American Art*. Los Angeles and Chicago: Getty Center for the History of Art and the Humanities, distrib. Univ. of Chicago Press, 1992

Still and Troubled Waters: Luminist Landscapes

Miller, David C. "The Iconology of Wrecked or Stranded Boats in Mid to Late Nineteenth-Century American Culture," in David C. Miller, ed., *American Iconology: New Approaches to Nineteenth-Century Art and Literature*. New Haven: Yale Univ. Press, 1993: 186–208

Native Americans as Nature

Thrilling Spectacles of Westward Expansion: Albert Bierstadt's "The Rocky Mountains"

Anderson, Nancy K., and Linda S. Ferber *Albert Bierstadt, Art and Enterprise*. New York: Hudson Hills Press in assoc. with the Brooklyn Museum of Art, 1991

Native Borders: Emanuel Leutze's "Westward the Course of Empire"

Truettner, William H., ed. *The West as America: Reinterpreting Images of the Frontier, 1820–1920*, Washington, D.C., and London: Smithsonian Institution Press, 1991

Depicting the "Looks and Modes" of Native American Life

George Catlin and His Indian Gallery

Catlin, George *Letters and Notes on the Manners, Customs, and Conditions of North American Indians*.

Intro. Marjorie Halpin. 2 vols. New York: Dover, 1973 [1844]

Rosaldo, Renato *Culture and Truth: The Remaking of Social Analysis*. Boston: Beacon Press, 1989

Hight, Kathryn S. "'Doomed to Perish': George Catlin's Depictions of the Mandan," *Art Journal* 49 (Summer 1990): 119–24

Photographic Portraits: Another Take on the Real

Schoolcraft, Henry R. *Historical and Statistical Information Respecting the History, Condition, and Prospects of the Indian Tribes of the United States*. 6 vols. Philadelphia: Lippincott, 1856

Nature Transformed: Settling the Landscape
The Iconography of Progress: The City and the Train

Lubin, David M. *Picturing a Nation: Art and Social Change in Nineteenth-Century America*. New Haven and London: Yale Univ. Press, 1994

Human Actors in the Landscape: Genre Paintings of the Yeoman Farmer

Johns, Elizabeth *American Genre Painting: The Politics of Everyday Life*. New Haven and London: Yale Univ. Press, 1991

Human Actors in the Landscape: Genre Paintings of the Westerner

Rash, Nancy *The Painting and Politics of George Caleb Bingham*. New Haven and London: Yale Univ. Press, 1991

Wolf, Bryan J. "History as Ideology or 'What You Don't See Can't Hurt You, Mr. Bingham'," in Patricia M. Burnham and Lucretia Hoover Giese, eds, *Redefining American History Painting*. Cambridge and New York: Cambridge Univ. Press, 1995

Woman as Nature: The Nude, the Mother, and the Cook

Lubin, David "Ariadne" and the Indians: Vanderlyn's Neoclassical Princess, Racial Seduction, and the Melodrama of Abandonment," *Smithsonian Studies in American Art* 3 (Spring 1989): 3–21

Nature Morte: Still Life and the Art of Deception
The Fruits of Art: The Peale Family and Still-Life Painting

Bryson, Norman *Looking at the Overlooked, Four Essays on Still Life Painting*. Cambridge, Mass.: Harvard Univ. Press, 1990

Gerdts, William H. *Painters of the Humble Truth, Masterpieces of American Still Life, 1801–1939*. Columbia and London: Philbrook Art Center with the Univ. of Missouri Press, 1981

Tricking the Eye: Raphaelle Peale and the Art of Deception

Ward, David C., and Sidney Hart "Subversion and Illusion in the Life and Art of Raphaelle Peale," *American Art* 8 (Summer/Fall 1994): 97–121

Stein, Roger "Charles Willson Peale's Expressive Design: The Artist in His Museum," *Prospects* 6 (1981)

Lloyd, Phoebe "Philadelphia Story," *Art in America* 76 (Nov. 1988): 154–71, 195–97, 199–201, 203

Gender and the Art of Flower Painting

Hedges, Elaine, Pat Ferrero and Julie Silber *Hearts and Hands, The Influence of Women and Quilts on American Society*. San Francisco: The Quilt Digest Press, 1987

Ornithological Paintings as "Nature Morte": Alexander Wilson and John James Audubon

Irmscher, Christoph *The Poetics of Natural History: From John Bartram to William James*. New Brunswick, N.J., and London: Rutgers Univ. Press, 1999

—— "Violence and Artistic Representation in John James Audubon," *Raritan* 15 (Fall 1995): 1–34

Further Reading

Avery, Kevin J. *Treasures from Olana: Landscapes by Frederic Edwin Church*. Ithaca, N.Y.: Cornell Univ. Press, 2005

Bloemink, Barbara et al. *Frederic Church, Winslow Homer, and Thomas Moran: Tourism and the American Landscape*. New York: Bulfinch/Cooper-Hewitt, National Design Museum, 2006

Bracken, Christopher *The Potlatch Papers: A Colonial Case History*. Chicago and London: Univ. of Chicago Press, 1997

Burns, Sarah *Pastoral Inventions: Rural Life in Nineteenth-Century American Art and Culture*. Philadelphia: Temple Univ. Press 1989

Carr, Gerald L. *Frederic Edwin Church: Catalogue Raisonné of Works of Art at Olana State Historical Site*. Cambridge: Cambridge Univ. Press, 1994

Conron, John *American Picturesque*. University Park: Pennsylvania State Univ. Press, 2000

Dippie, Brian W. *Catlin and His Contemporaries: The Politics of Patronage*. Lincoln: Univ. of Nebraska Press, 1990

Gurney, George, and Therese Thau Heyman, eds. *George Catlin And his Indian Gallery*. Washington, D.C.: Smithsonian American Art Museum/New York: W.W. Norton, 2002

Hills, Patricia *The Painters' America: Rural and Urban Life, 1810–1910*. New York: Praeger in assoc. with the Whitney Museum of American Art, 1974

Howat, John K. *Frederic Church*. New Haven and London: Yale Univ. Press, 2005

Jonaitis, Aldona *From the Land of the Totem Poles: The Northwest Coast Indian Art Collection at the American Museum of Natural History*. New York, Vancouver and London: American Museum of Natural History and Douglas & McIntyre, 1988

LeBlanc, Steven A. *Painted by a Distant Hand: Mimbres Pottery from the American Southwest*. Cambridge, Mass.: Peabody Museum Press, Harvard Univ., 2004

McKinsey, Elizabeth *Niagara Falls: Icon of the American Sublime*. New York and Cambridge: Cambridge Univ. Press, 1985

O'Toole, Judith Hansen *Different Views in Hudson River School Painting*. New York: Columbia Univ. Press, 2006

Ryan, James Anthony, and Franklin Kelly *Frederic Church's Olana: Architecture and Landscape as Art*. Hensonville, N.Y.: Black Dome Press, 2001

Truettner, William H., and Roger Stein, eds *Picturing Old New England: Image and Memory*. New Haven and Washington, D.C.: Yale Univ. Press and National Museum of American Art, Smithsonian Institution, 1999

Weekley, Carolyn J., with the assistance of Laura Pass Barry *The Kingdoms of Edward Hicks*. New York: Harry N. Abrams, 1999

Wilmerding, John, ed. *American Light: The Luminist Movement, 1850–1875*. Washington, D.C.: National Gallery of Art, 1980

Wilton, Andrew, and Tim Barringer *American Sublime: Landscape Painting in the United States, 1820–1880*. London: Tate Publishing/ Princeton: Princeton Univ. Press, 2003

Chapter 4

Sources

The War between the United States and Mexico
Learning from the Past: Emanuel Leutze's "The Storming of the Teocalli"

Tyler, Ron "Historic Reportage and Artistic License, Prints and Paintings of the Mexican War," in William Ayres, ed., *Picturing History: American Paintings, 1770–1930*. New York: Rizzoli in assoc. with the Frances Tavern Museum, 1993

Truettner, William H. "Storming the Teocalli—Again, Or, Further Thoughts on Reading History Paintings," *American Art* 9, no. 3 (Fall 1995): 57–95

Life on the Home Front

Husch, Gail "'Freedom's Holy Cause': History, Religious, and Genre Painting in America, 1840–1860," in William Ayres, ed., *Picturing History: American Paintings, 1770– 1930*. New York: Rizzoli in assoc. with the Frances Tavern Museum, 1993

Wolf, Bryan "All the World's a Code: Art and Ideology in Nineteenth-Century American Painting," *Art Journal* 44 (Winter 1984): 328–37

Life on the Front Lines

Tyler, Ron "Historic Reportage and Artistic License, Prints and Paintings of the Mexican War," in William Ayres, ed., *Picturing History: American Paintings, 1770–1930*. New York: Rizzoli in assoc. with the Frances Tavern Museum, 1993

Mexican Culture as American Culture
The "Santeros" of New Mexico

Mather, Christine, ed. *Colonial Frontiers: Art and Life in Spanish New Mexico, The Fred Harvey Collection*. Santa Fe, N.M.: Ancient City Press, 1983

Wroth, William *Images of Penance, Images of Mercy: Southwestern "Santos" in the Late Nineteenth Century*. Intro. to Pt 2 by Marta Weigle. Norman and London: Univ. of Oklahoma Press, 1991

—— "New Mexican Santos and the Preservation of Religious Traditions," in Mary Ann Calo, ed., *Critical Issues in American Art*. Boulder, Colo.: Westview Press, 1998

Gonzalez, Deena J. *Refusing the Favor: The Spanish-Mexican Women of Santa Fe, 1820–1880*. Oxford and New York: Oxford Univ. Press, 1999

The Local and the International: New Mexican Furniture and Textiles

Davis, W. W. H. *El Gringo, or New Mexico and Her People*. 1856; repr. Santa Fe, N.M.: Rydal Press, 1938

Magoffin, Susan Shelby *Down the Santa Fe Trail and into Mexico: Diary of Susan Shelby Magoffin, 1846–1847*. Ed. Stella M. Drumm. 1926; repr. New Haven and London: Yale Univ. Press, 1962

Hill, Tom, and Richard W. Hill, Sr, eds *Creation's Journey: Native American Identity and Belief*. With contributions by Diane Fraher, Ramiro Matos, John C. Ewers, Dorie Reents-Budet, Mari Lynn Salvador, Duane King, Mary Jane Lenz, Eulalie H. Bonar, Nancy Rosoff, and Cécile R. Ganteaume.

Washington, D.C., and London: Smithsonian Institution Press, 1994

Prelude to the Civil War: Representing African Americans and Slavery
Hills, Patricia "Picturing Progress in the Era of Westward Expansion," in William H. Truettner, ed., *The West As America: Reinterpreting Images of the Frontier, 1820–1920*. Washington, D.C., and London: Smithsonian Institution Press, 1991

Bennett, Lerone, Jr *Before the Mayflower: A History of Black America, The Classic Account of the Struggles and Triumphs of Black Americans*. 5th edn, Harmondsworth, Middx: Penguin Books, 1984

Boime, Albert *The Art of Exclusion: Representing Blacks in the Nineteenth Century*. Washington, D.C., and London: Smithsonian Institution Press, 1990

McElroy, Guy C. *Facing History: The Black Image in American Art, 1710–1940*. San Francisco and Washington, D.C.: Bedford Arts and the Corcoran Gallery of Art, 1990

The Abolitionist Movement and the Challenging of Stereotypes
Powell, Richard J. "Cinque: Antislavery Portraiture and Patronage in Jacksonian America," *American Art* 11 (Fall 1997): 48–73

Driskell, David C., with catalog notes by Leonard Simon *Two Centuries of Black American Art*. New York: Alfred A. Knopf and Los Angeles County Museum of Art, 1976

Parry, Ellwood C., III *The Image of the Indian and the Black Man in American Art, 1590–1900*. New York: Braziller, 1974

Zinn, Howard *A People's History of the United States, 1492–Present*. Rev. and updated. New York: HarperPerennial, 1995

Race and the Civil War
Drew, Benjamin *The Refugee: or the Narratives of Fugitive Slaves in Canada Related by Themselves with an Account of the History and Condition of the Colored Population of Upper Canada*. Boston: John P. Jewett, 1856. In *Four Fugitive Slave Narratives*, intro. Robin W. Winks, Larry Gara, Jane H. and William H. Pease, and Tilden G. Edelstein. Reading, Mass.: Addison-Wesley, 1969

Lucid, Robert F. "Civil War Humor: Anecdotes and Recollection," *Civil War History* 2, no. 3 (Sept. 1956): 44–46

Paintings of Fugitives, Contraband, and Soldiers
Simpson, Marc *Winslow Homer: Paintings of the Civil War*. San Francisco: The Fine Arts Museums of San Francisco/Bedford Publishers, 1988

Photographs of the War
Trachtenberg, Alan "Albums of War, On Reading Civil War Photographs," in Mary Ann Calo, ed., *Critical Issues in American Art*. Boulder, Colo.: Westview Press, 1998: 135–54

Images of Reconstruction
Winslow Homer's "Prisoners from the Front" and "A Visit From the Old Mistress"
Giese, Lucretia H. "Prisoners from the Front: An American History Painting?," in Marc Simpson, *Winslow Homer: Paintings of the Civil War*. San Francisco: The Fine Arts Museums of San Francisco/Bedford Publishers, 1988

Wood, Peter H., and Karen C. C. Dalton *Winslow Homer's Images of Blacks: The Civil War and Reconstruction Years*. Austin: The Menil Collection/Univ. of Texas Press, 1988

Hills, Patricia "Painting Race: Eastman Johnson's Pictures of Slaves, Ex-Slaves, and Freedmen," in Teresa A. Carbone and Patricia Hills, *Eastman Johnson Painting America*. New York: Brooklyn Museum of Art in assoc. with Rizzoli, 1999: 120–65

Pohl, Frances K. "Putting a Face on Difference," *Art Bulletin* 78 (Dec. 1996): 23–28

Cikovsky, Nicolai, Jr "Winslow Homer's Prisoners from the Front," *Metropolitan Museum Journal* 12 (1977): 155–72

——, and Franklin Kelly, with contributions by Judith Walsh and Charles Brock *Winslow Homer*. Washington, D.C., New Haven and London: National Gallery of Art and Yale Univ. Press, 1995

Thomas Nast's "Grand Historical Paintings"
Keller, Morton *The Art and Politics of Thomas Nast*. New York: Oxford Univ. Press, 1968

Monuments to Freedom
The Freed Slave
Chadwick, Whitney *Women, Art, and Society*. 4th edn, London and New York: Thames & Hudson, 2007

Rubinstein, Charlotte Streifer *American Women Artists from Early Indian Times to the Present*. New York: Avon Books, 1982

Buick, Kirsten P. "The Ideal Works of Edmonia Lewis: Invoking and Inverting Autobiography," *American Art* 9, no. 2 (Summer 1995): 4–19

The Victorious Soldier
Savage, Kirk *Standing Soldiers, Kneeling Slaves: Race, War, and Monument in Nineteenth-Century America*. Princeton: Princeton Univ. Press, 1997

Native Americans in the Popular Press: *Harper's Weekly* and the Washita River Massacre
Parry, Ellwood *The Image of the Indian and the Black Man in America Art, 1590–1900*. New York: George Braziller, 1974

Encyclopedias of Experience: Native American Ledger Art
The Art of Incarceration: The Fort Marion Ledger Drawings
Szabo, Joyce M. *Howling Wolf and the History of Ledger Art*. Albuquerque: Univ. of New Mexico Press, 1994

The Battle of the Little Bighorn
Penney, David W. "The Horse as Symbol: Equine Representations in Plains Pictographic Art," in Evan M. Maurer, ed., *Visions of the People, A Pictorial History of Plains Indian Life*. Minneapolis: Minneapolis Institute of Arts, 1992

Berlo, Janet Catherine "Portraits of Dispossession in Plains Indian and Inuit Graphic Arts," *Art Journal* 4 (Summer 1990): 133–41

Szabo, Joyce M. "Howling Wolf: A Plains Artist in Transition," *Art Journal* 44 (Winter 1984): 367–73

Berlo, Janet Catherine, ed. *Plains Indian Drawings 1865–1935, Pages from a Visual History*. New York: Harry N. Abrams with The American Federation of Arts and The Drawing Center, 1996

Blume, Anna "In a Place of Writing," in Berlo, ed. *Plains Indian Drawings* (above)

The End of the Ghost Dance
Symbols of the Ghost Dance Ceremony and Dress
Somma, Thomas P. "The Myth of Bohemia and the Savage Other, Paul Wayland Bartlett's Bear Tamer and Indian Ghost Dancer," *American Art* 6, no. 3 (Summer 1992): 15–35

The Hampton Institute and Lessons in American History
Samuels, Peggy, and Harold Samuels *Remington: The Complete Prints*. New York: Crown, 1990

Shapiro, Michael Edward, and Peter H. Hassrick *Frederic Remington: The Masterworks*. New York: Harry N. Abrams in assoc. with the St Louis Art Museum, 1991 [1988]

Sweeney, J. Gray "Racism, Nationalism, and Nostalgia in Cowboy Art," *Oxford Art Journal* 15, no. 1 (1992): 67–80

Petersen, Karen Daniels *Plains Indian Art from Fort Marion*. Norman: Univ. of Oklahoma Press, 1971

Donal F. Lindsey *Indians at Hampton Institute, 1877–1923*. Urbana and Chicago: Univ. of Illinois Press, 1995

Further Reading

Banner, Stuart *How the Indians Lost Their Land: Law and Power on the Frontier*. Cambridge, Mass. and London: Belknap Press of Harvard Univ. Press, 2005

Burnham, Patricia M. "Custer's Last Stand: High-Low on Old and New Frontiers," in Patricia Johnston, ed., *Seeing High and Low: Representing Social Conflict in American Visual Culture*. Berkeley and Los Angeles: Univ. of California Press, 2006: 124–41

Dabakis, Melissa "Ain't I a Woman?": Anne Whitney, Edmonia Lewis, and the Iconography of Emancipation," in Patricia Johnston, ed., *Seeing High and Low: Representing Social Conflict in American Visual Culture*. Berkeley and Los Angeles: Univ. of California Press, 2006: 84–102

Goetzmann, William N. *The West of the Imagination*. New York: Norton, 1986

Hills, Patricia "Cultural Racism: Resistance and Accommodation in the Civil War Art of Eastman Johnson and Thomas Nast," in Patricia Johnston, ed., *Seeing High and Low: Representing Social Conflict in American Visual Culture*. Berkeley and Los Angeles: Univ. of California Press, 2006: 103–23

Johns, Elizabeth *Winslow Homer: The Nature of Observation*. Berkeley and Los Angeles: Univ. of California Press, 2002.

Limerick, Patricia Nelson *The Legacy of Conquest: the Unbroken Past of the American West*. New York: Norton, 1987

Museum of Fine Arts, Florida State Univ. *Dimensions of Native America: The Contact Zone*. Tallahassee: Museum of Fine Arts, Florida State Univ., 1998

Panzer, Mary *Mathew Brady and the Image of History*. Washington, D.C.: Smithsonian Institution Press, 1997

Prown, Jules, et al. *Discovered Lands, Invented Pasts: Transforming Visions of the American Frontier, 1600–1860*. New Haven: Yale Univ. Press, 1992

Schekel, Susan *The Insistence of the Indian: Race and Nationalism in Nineteenth-Century Culture*. Princeton: Princeton Univ. Press, 1998

Turner, Frederick Jackson *The Frontier in American History*. New York: R. E. Krieger, 1920

Weber, David J. *Myth and the History of the Hispanic Southwest*. Albuquerque: Univ. of New Mexico Press, 1988

Chapter 5

Sources

Slotkin, Richard *The Fatal Environment: The Myth of the Frontier in the Age of Industrialization, 1800–1890*. New York: Atheneum, 1985

Nemerov, Alex "'Doing the "Old America"': The Image of the American West, 1880–1920," in William H. Truettner, ed., *The West as America: Reinterpreting Images of the Frontier, 1820–1920*. Washington, D.C., and London: Smithsonian Institution Press, 1991

Trachtenberg, Alan "Albums of War," in Mary Ann Calo, ed., *Critical Issues in American Art*. Boulder, Colo.: Westview Press, 1998

—— *The Incorporation of America: Culture and Society In the Gilded Age*. New York: Hill and Wang, 1982

One Hundred Years of Independence: Taking Stock of America at the 1876 Philadelphia Centennial Exhibition

Parry, Ellwood C., III *The Image of the Indian and the Black Man in American Art*. New York: Braziller, 1974

Images of Workers
Factory and Foundry: Winslow Homer and Thomas Anshutz

Cikovsky, Nicolai, Jr, and Franklin Kelly, with contributions by Judith Walsh and Charles Brock *Winslow Homer*. Washington, D.C., New Haven and London: National Gallery of Art and Yale Univ. Press, 1995

Labor Unrest: Robert Koehler's "Strike" and Monuments to Justice and Liberty

Gladstone, John "Working-Class Imagery in *Harper's Weekly*," *Labor's Heritage* 5, no. 1 (Spring 1993): 42–61

Hills, Patricia *The Painters' America*. New York: Praeger, for the Whitney Museum of American Art, 1974

Foner, Philip S., and Reinhard Schultz *The Other America: Art and the Labour Movement in the United States*. London: Journeyman Press, 1985

Dabakis, Melissa "Martyrs and Monuments of Chicago: The Haymarket Affair," *Prospects: An Annual of American Cultural Studies* 19 (1994): 99–133

Roediger, David "Haymarket Incident," in Mari Jo Buhle, Paul Buhle, and Dan Georgakas, eds, *Encyclopedia of the American Left*. Urbana and Chicago: Univ. of Illinois Press, 1992: 295–97

Boime, Albert *Hollow Icons: The Politics of Sculpture in 19th-Century France*. Kent, O.: Kent State Univ. Press, 1987

Celebrating the New Male Professionals: Portraits by Thomas Eakins

Berger, Martin A. *Man Made: Thomas Eakins and the Construction of Gilded Age Manhood*. Berkeley, Los Angeles and London: Univ. of California Press, 2000

Johns, Elizabeth "*The Gross Clinic* or *Portrait of Professor Gross*," in Marianne Doezema and Elizabeth Milroy, eds, *Reading American Art*. New Haven and London: Yale Univ. Press, 1998: 232–63

—— *Thomas Eakins: The Heroism of Modern Life*. Princeton: Princeton Univ. Press, 1983

Goodrich, Lloyd *Thomas Eakins*. 2 vols. Cambridge, Mass.: Harvard Univ. Press, 1982

Fryer, Judith "'The Body in Pain' in Thomas Eakins' *Agnew Clinic*," in Laurence Goldstein, ed., *The Female Body: Figures, Styles, Speculations*. Ann Arbor: Univ. of Michigan Press, 1991

Goodbody, Bridget L. "'The Present Opprobrium of Surgery': *The Agnew Clinic* and Nineteenth-Century Representations of Cancerous Female Breasts," *American Art* 8 (Winter 1994): 33–51

The Female Body and the Rights of Women: The "Declaration of Sentiments" and Hiram Powers's *The Greek Slave*

Kasson, Joy *Marble Queens and Captives: Women in Nineteenth-Century American Sculpture*. New Haven: Yale Univ. Press, 1990

Wellman, Judith "The Seneca Falls Rights Convention: A Study of Social Networks," in Linda K. Kerber and Jane Sherron de Hart, eds, *Women's America*. 4th edn, New York and Oxford: Oxford Univ. Press, 1995: 203–15

Domestic Culture and Cultural Production
"Cheap and Popular Pictures" for the Home

Lynes, Russell *The Tastemakers: The Shaping of American Popular Taste*. New York: Dover, 1980 (1949)

Helpful Women: The Evolving Image of the Domestic Servant

O'Leary, Elizabeth *At Beck and Call: The Representation of Domestic Servants in Nineteenth-Century American Painting*. Washington, D.C., and London: Smithsonian Institution Press, 1996

Revivalism in Architecture and Interior Design

Kostof, Spiro *A History of Architecture: Settings and Rituals*. Oxford and New York: Oxford Univ. Press, 1985

The Feminine Ideal and the Rise of Aestheticism

Van Hook, Bailey *Angels of Art, Women and Art in American Society, 1876–1914*. Univ. Park: Pennsylvania State Univ. Press, 1996

Whistler, James Abbott McNeill *The Gentle Art of Making Enemies*. New York, 1890

Anderson, Ross *Abbott Henderson Thayer*. Syracuse, N.Y.: Everson Museum, 1982

Images of the Particular: Portraiture and *Trompe l'Oeil* Painting
Portraiture in the Late 19th Century

Burns, Sarah "The Price of Beauty: Art, Commerce, and the Late Nineteenth-Century American Studio Interior," in David C. Miller, ed., *American Iconology: New Approaches to Nineteenth-Century Art and Literature*. New Haven: Yale Univ. Press, 1993: 209–38

Pyne, Kathleen "Evolutionary Typology and the American Woman in the Work of Thomas Dewing," *American Art* 7 (Fall 1993): 12–29

Burns, Sarah "The 'Earnest, Untiring Worker' and the

Magician of the Brush," in Mary Ann Calo, ed., *Critical Issues in American Art*. Boulder, Colo.: Westview Press, 1998: 177–98

Hills, Patricia *John Singer Sargent*. New York: Whitney Museum of American Art, with Harry N. Abrams, 1986

Boime, Albert "Sargent in Paris and London: A Portrait of the Artist as Dorian Gray," in Hills, *John Singer Sargent* (above)

Kilmurray, Elaine, and Richard Ormond, eds *John Singer Sargent*. Princeton: Princeton Univ. Press, 1998

Tappert, Tara Leigh *Cecilia Beaux and the Art of Portraiture*. Washington, D.C., and London: Smithsonian Institution Press, 1995

"Trompe l'Oeil" Painting in the Late 19th Century

Lubin, David M. *Picturing a Nation: Art and Social Change in Nineteenth-Century America*. New Haven and London: Yale Univ. Press, 1994

Whiting, Cécile "Trompe l'oeil Painting and the Counterfeit Civil War," *Art Bulletin* 79 (June 1997): 251–68

The Battle over Public Space
Sites of Moral Instruction: Urban Parks and Wilderness Preserves

Fein, Albert *Frederick Law Olmsted and the American Environmental Tradition*. New York: Braziller, 1972

Urban Poverty and Public Art Museums

Trachtenberg, Alan *Reading American Photographs: Images as History, Mathew Brady to Walker Evans*. New York: Hill and Wang, 1989

Davis, Allen F. *Spearheads for Reform: The Social Settlements and the Progressive Movement, 1890–1914*. New York, London and Toronto: Oxford Univ. Press, 1967

The End of a Century: Art, Architecture, and the World's Columbian Exposition
The Chicago School of Architecture and the White City

Pohl, Frances K. "Historical Reality or Utopian Ideal? The Woman's Building at the World's Columbian Exposition, Chicago, 1893," *International Journal of Women's Studies* 5 (Sept./Oct. 1982): 89–311

Rydell, Robert *All the World's A Fair: Visions of Empire at American International Expositions, 1876–1916*. Chicago: Univ. of Chicago Press, 1984

Women at the Fair: Allegories, Architects, and Artists

Sund, Judy "Columbus and Columbia, Man of Genius Meets Generic Woman, Chicago, 1893," in Mary Ann Calo, ed., *Critical Issues in American Art*. Boulder, Colo.: Westview Press, 1998

Upton, Dell *Architecture in the United States*. Oxford and New York: Oxford Univ. Press, 1998

Callen, Anthea *Women Artists of the Arts and Crafts Movement*. New York: Pantheon Books, 1979

Boris, Eileen *Art and Labor: Ruskin, Morris, and the Craftsman Ideal in America*. Philadelphia: Temple Univ. Press, 1986

Zinn, Howard *A People's History of the United States, 1492–Present*. Rev. and updated. New York: HarperPerennial, 1995

Pollock, Griselda *Mary Cassatt*. New York: Harper and Row, 1980

—— *Mary Cassatt: Painter of Modern Women*. New York and London: Thames & Hudson, 1998

Chessman, Harriet Scott "Mary Cassatt and the

Maternal Body," in David C. Miller, ed., *American Iconology: New Approaches to Nineteenth-Century Art and Literature*. New Haven: Yale Univ. Press, 1993: 239–58

Race and Religion at the Turn of the Century: Henry Ossawa Tanner

Boime, Albert "Henry Ossawa Tanner's Subversion of Genre," *Art Bulletin* 75, no. 3 (Sept. 1993): 415–42

Linn, Karen S. *That Half-Barbaric Twang: The Banjo in American Popular Culture*. Urbana: Univ. of Illinois Press, 1991

Mosby, Dewey F., and Darrel Sewell *Henry Ossawa Tanner*. Philadelphia: Philadelphia Museum of Art, 1991

Men at Sea: Albert Pinkham Ryder and Winslow Homer

Broun, Elizabeth *Albert Pinkham Ryder*. Washington and London: Smithsonian Institution Press, 1989

Boime, Albert "Newman, Ryder, Couture and Hero-Worship in Art History," *American Art Journal* 3, no. 2 (Autumn 1971): 5–22

Boime, Albert "Ryder on a Gilded Horse," *Zeitschrift für Kunstgeschichte* 56, no. 4 (1993): 564–75

Conrads, Margaret C. *Winslow Homer and the Critics: Forging a National Art in the 1870s*. Princeton: Princeton Univ. Press, in assoc. with the Nelson-Atkins Museum of Art, 2001

Wood, Peter H. *Weathering the Storm: Inside Winslow Homer's "Gulf Stream."* Athens, Georgia: Univ. of Georgia Press, 2004

Further Reading

Berger, Martin A. *Sight Unseen: Whiteness and American Visual Culture*. Berkeley and Los Angeles: Univ. of California Press, 2005

Braddock, Alan C. *Thomas Eakins and the Cultures of Modernity*. Berkeley and Los Angeles: Univ. of California Press, 2009

Brown, Joshua *Beyond the Lines: Pictorial Reporting, Everyday Life, and the Crisis of Gilded Age America*. Berkeley and Los Angeles: Univ. of California Press, 2002

Brown, Julie K. *Contesting Images: Photography and the World's Columbian Exposition*. Tucson: Univ. of Arizona Press, 1994

Burns, Sarah *Inventing the Modern Artist: Art and Culture in Gilded Age America*. New Haven: Yale Univ. Press, 1996

Carr, Carolyn Kinder, and Sally Webster "Mary Cassatt and Mary Fairchild MacMonnies, The Search for their 1893 Murals," *American Art* 8 (Winter 1994): 53–69

Clark, Robert Judson, ed. *The Arts and Crafts Movement in America, 1876–1916*. Princeton: Princeton Univ. Press, 1972

Cooper, Helen A. *Thomas Eakins: The Rowing Pictures*. New Haven and London: Yale Univ. Press, 1996

Dabakis, Melissa *Visualizing Labor in American Sculpture: Monuments, Manliness and the Work Ethic, 1880–1935*. Cambridge: Cambridge Univ. Press, 1999

Domosh, Mona *Invented Cities: The Creation of Landscape in Nineteenth-Century New York and Boston*. New Haven and London: Yale Univ. Press, 1996

—— *Impressions of California: Early Currents in Art, 1850–1930*. Irvine, Calif.: Irvine Museum, 1996

Griffin, Randall *Homer, Eakins and Anshutz: The Search for American Identity in the Gilded Age*. University Park, PA: Pennsylvania State Univ. Press, 2004

Kaplan, Wendy "The Art that is Life": The Arts and Crafts Movement in America, 1875–1920. Boston: Museum of Fine Arts/Bulfinch Press, 1987

Le Beau, Bryan F. *Currier & Ives: America Imagined*. Washington and London: Smithsonian Institution Press, 2001

Nochlin, Linda "Issues of Gender in Cassatt and Eakins," in Stephen F. Eisenman et al., *Nineteenth Century Art, A Critical History*. New York and London: Thames & Hudson, 1994

Prelinger, Elizabeth *The Gilded Age: Treasures from the Smithsonian American Art Museum*. Washington, D.C., and New York: Smithsonian Institution Press and Watson Guptil Publishers, 2000

Promey, Sally M. *Painting Religion in Public: John Singer Sargent's "Triumph of Religion" at the Boston Public Library*. Princeton: Princeton Univ. Press, 1999

Rawls, Walton *The Great Book of Currier & Ives' America*. New York: Abbeville Press, 1979

Samuels, Peggy, and Harold Samuels *Remington: The Complete Prints*. New York: Crown Publishers, 1990

Simpson, Marc, with essays by Richard Ormond and H. Barbara Weinberg *Uncanny Spectacle: The Public Career of the Young John Singer Sargent*. New Haven, London, and Williamstown, Mass.: Yale Univ. Press and the Sterling and Francine Clark Institute, 1997

Swain, Kristin *Signs of Grace: Religion and American Art in the Gilded Age*. Ithaca, N.Y.: Cornell Univ. Press, 2008

Trapp, Kenneth R., ed. *The Arts and Crafts Movement in California: Living the Good Life*. Oakland, New York, London, and Paris: The Oakland Museum and Abbeville Press, 1993

Wood, Peter H. *Weathering the Storm: Inside Winslow Homer's "Gulf Stream."* Athens and London: Univ. of Georgia Press, 2004

Zalesch, Saul E. "Competition and Conflict in the New York Art World, 1874–1879," *Winterthur Portfolio* 2 (nos 2–3): 103–20

Chapter 6

Sources

Realism and the Ashcan School
Painting New York City

Zurier, Rebecca, Robert W. Snyder and Virginia Mecklenburg *Metropolitan Lives: The Ashcan Artists and Their New York*. New York and London: National Museum of American Art in assoc. with W.W. Norton, 1995

Zurier, Rebecca *Art for the Masses: A Radical Magazine and Its Graphics, 1911–1917*. Intro. Leslie Fishbein. Philadelphia: Temple Univ. Press, 1988

Doezema, Marianne *George Bellows and Urban America*. New Haven and London: Yale Univ. Press, 1992

Socialism and Art: The Painting and Graphic Art of John Sloan

Hills, Patricia "John Sloan's Images of Working Class Women," *Prospects* 5 (1981): 157–98

Sculpting Everyday Life

Fort, Ilene Susan, with contributions by Mary L. Lenihan, Marlene Park, Susan Rather, and Roberta K. Tarbell *The Figure in American Sculpture: A Question of Modernity*. Los Angeles and Seattle: Los Angeles County Museum of Art/Univ. of Washington Press, 1995

Modernism and the Avant-Garde
Alfred Stieglitz and 291

Bell, Clive *Art*. New York: Capricorn Books, 1914

The Armory Show and the Paterson Strike Pageant

Nochlin, Linda "The Paterson Strike Pageant of 1913," *Art in America* 62 (May 1974): 64–68

Brown, Milton *American Painting from the Armory Show to the Depression*. Princeton: Princeton Univ. Press, 1970 [1955]

World War I and the Art of Reproduction
Selling and Protesting the War: World War I Posters and "The Masses"

Paret, Peter, Beth Irwin and Paul Paret/Hoover Institution on War, Revolution and Peace *Persuasive Images: Posters of War and Revolution from the Hoover Institution Archives*. Princeton: Princeton Univ. Press, 1992

Zurier, Rebecca *Art for the Masses: A Radical Magazine and Its Graphics, 1911–1917*. Intro. Leslie Fishbein. Philadelphia: Temple Univ. Press, 1988

Rethinking Reproduction: Marcel Duchamp

Corn, Wanda *The Great American Thing: Modern Art and National Identity, 1915–1935*. Berkeley, Los Angeles and London: Univ. of California Press, 1999

Judovitz, Dalia *Unpacking Duchamp: Art in Transit*. Berkeley: Univ. of California Press, 1995

Reed, David "The Developing Language of the Readymades," *Art History* 8, no. 2 (June 1985): 209–27

Modernism, Gender and Sexuality
The (Homo)Sexual Male Body

Weinberg, Jonathan *Speaking for Vice: Homosexuality in the Art of Charles Demuth, Marsden Hartley, and the First American Avant-Garde*. New Haven and London: Yale Univ. Press, 1993

Cooper, Emmanuel *The Sexual Perspective: Homosexuality and Art in the Last 100 Years in the West*. London and New York: Routledge and Kegan Paul, 1986

Figuration, Abstraction, and the Female Body

Wagner, Anne Middleton *Three Artists (Three Women), Modernism and the Art of Hesse, Krasner, and O'Keeffe*. Berkeley, Los Angeles and London: Univ. of California Press, 1996

Chave, Anna C. "O'Keeffe and the Masculine Gaze," in Marianne Doezema and Elizabeth Milroy, eds, *Reading American Art*. New Haven: Yale Univ. Press, 1998: 350–70

Davidov, Judith Fryer *Women's Camera Work: Self/Body/Other in American Visual Culture*. Durham, N.C., and London: Duke Univ. Press, 1998

Ehrens, Susan *A Poetic Vision: The Photographs of Anne Brigman*. Santa Barbara, Calif.: Santa Barbara Museum of Art, 1995

Edwards, J. P. "Group f.64," *Camera Craft* xvii/3 (1935): 107–13

Escape to Mexico
The Mexican Revolution and Mural Movement
Oles, James *South of the Border: Mexico in the American Imagination, 1914–1947.* With an essay by Karen Cordero Reiman. Washington, D.C., and London: Smithsonian Institution Press, 1993

The Search for the Exotic: American Artists in Mexico
Porter, Katherine Anne *Outline of Mexican Popular Arts and Crafts.* Los Angeles: Young and McAllister, 1922
Albers, Patricia *Shadows, Fire, Snow: The Life of Tina Modotti.* Berkeley and Los Angeles: Univ. of California Press, 1999
Weston, Edward *The Daybooks of Edward Weston: I. Mexico.* Ed. Nancy Newhall. Millerton, N.Y.: Aperture, 1973
Canclini, Néstor Garcia *Transforming Modernity: Popular Culture in Mexico.* Transl. Lida Lozano. Austin: Univ. of Texas Press, 1993

Art in the Service of Revolution: The Photographs of Tina Modotti
Caronia, Maria, and Vittorio Vidali *Tina Modotti Photographs.* New York: Belmark, 1981

Mexico in America: Imaging the American Southwest
The Santa Fe Railway and the Selling of the American Southwest
McLuhan, T. C. *Dream Tracks, The Railroad and the American Indian, 1890–1930.* New York: Harry N. Abrams, 1985
Webb, William, and Robert A. Weinstein *Dwellers at the Source: Southwestern Indian Photographs of A. C. Vroman, 1895–1904.* New York: Grossman Publishers, 1973
Fewkes, Jesse Walter *Tusayan Flute and Snake Ceremonies.* Washington, D.C.: 19th Annual Report of the Bureau of American Ethnology, 1901

From Artifact to Souvenir to Work of Art: The Promotion of Hopi Pottery and Washoe Basketry
Dilworth, Leah *Imagining Indians in the Southwest: Persistent Visions of a Primitive Past.* Washington, D.C., and London: Smithsonian Institution Press, 1996
Kramer, Barbara *Nampeyo and Her Pottery.* Albuquerque: Univ. of New Mexico Press, 1996
Stephen, Alexander *Hopi Journal of Alexander Stephen.* Ed. Elsie Clews Parsons. New York: Columbia Univ. Press, 1936
Cohodas, Marvin "Washoe Innovators and Their Patrons," in Edwin L. Wade, ed., *The Arts of the North American Indian: Native Traditions in Evolution.* New York and Tulsa, Okla.: Hudson Hills Press in assoc. with the Philbrook Art Center, 1986: 203–20
Maurer, Evan M. "Determining Quality in Native American Art," in Edwin L. Wade, ed., *The Arts of the North American Indian: Native Traditions in Evolution.* New York and Tulsa, Okla.: Hudson Hills Press in assoc. with Philbrook Art Center, 1986: 143–55

The Harlem Renaissance
Harlem and the "New Negro"
Powell, Richard J., et al. *Rhapsodies in Black: Art of the Harlem Renaissance.* Berkeley, Los Angeles and London: Univ. of California Press, Hayward Gallery, the Institute of International Visual Arts, 1997

Gates, Henry Louis, Jr "The Trope of the New Negro and the Reconstruction of the Image of the Black," *Representations* 24 (Fall 1988): 129–55
Driskell, David C., with catalog notes by Leonard Simon *Two Centuries of Black American Art.* New York: Alfred A. Knopf and Los Angeles County Museum of Art, 1976
Studio Museum in Harlem *Harlem Renaissance Art of Black America.* Intro. by Mary Schmidt Campbell, essays by David Driskell, David Levering Lewis, and Deborah Willis Ryan. New York: Harry N. Abrams, 1987
Locke, Alain *The New Negro.* New York: Atheneum, 1970 [1925]
Huggins, Nathan *Harlem Renaissance.* New York: Oxford Univ. Press, 1971
Powell, Richard J. *Black Art and Culture in the 20th Century.* London and New York: Thames & Hudson, 1997
Calo, Mary Ann "African American Art and Critical Discourse Between World Wars," in *American Quarterly* 51, no. 3 (Sept. 1999): 580–621

Gender, Consumption, and Domestic Spaces
Modernism and Fashion Design
Porter, Glen "Plains, Trains, and Automobiles," *Humanities* 24, no. 5 (Sept/Oct 2003): 16–19
Upton, Dell *Architecture in the United States.* Oxford and New York: Oxford University Press, 1998.

Designing the Home: Women as Patrons and Architects
Friedman, Alice T. *Women and the Making of the Modern House: A Social and Architectural History.* New York: Harry N. Abrams, 1998
Wright, Frank Lloyd *An Autobiography.* New York: Longmans Green, 1932

Further Reading

Antliff, Allan *Anarchist Modernism: Art, Politics, and the First American Avant-Garde.* Chicago: Univ. of Chicago Press, 2001
Bogart, Michele H. *Public Sculpture and the Civic Ideal in New York City, 1890–1930.* Chicago and London: Univ. of Chicago Press, 1989
—— *Artists, Advertising, and the Borders of Art.* Chicago and London: Univ. of Chicago Press, 1995
Brennan, Marcia *Painting Gender, Constructing Theory: The Alfred Stieglitz Circle and American Formalist Aesthetics.* Cambridge, Mass.: MIT Press, 2001
Cassidy, Donna M. *Painting the Musical City: Jazz and Cultural Identity in American Art, 1910–1940.* Washington, D.C., and London: Smithsonian Institution Press, 1997
Chadwick, Whitney, with an essay by Joe Lucchesi *Amazons in the Drawing Room: The Art of Romaine Brooks.* Chesterfield, Mass., Berkeley, Los Angeles, London, and Washington, D.C.: Chameleon Books and Univ. of California Press in assoc. with the National Museum of Women in the Arts, 2000
Conger, Amy *Edward Weston in Mexico, 1923–1926.* Albuquerque: Univ. of New Mexico Press for the San Francisco Museum of Modern Art , 1983
Connor, Celeste *Democratic Visions: Art and Theory of the Stieglitz Circle, 1924–1934.* Berkeley and Los Angeles: Univ. of California Press, 2001
Constantine, Mildred *Tina Modotti: A Fragile Life.* New York: Paddington Press, 1975

Corn, Wanda *The Great American Thing: Modern Art and National Identity, 1915–1935.* Berkeley, Los Angeles and London: Univ. of California Press, 1999
Deloria, Philip J. *Indians in Unexpected Places.* Lawrence: Univ. of Kansas Press, 2004
Diner, Hasia R. *Lower East Side Memories: A Jewish Place in America.* Princeton: Princeton Univ. Press, 2000
Frampton, Kenneth *Modern Architecture. A Critical History.* 4th edn, London and New York: Thames & Hudson, 2007
Hooks, Margaret *Tina Modotti: Photographer and Revolutionary.* London and San Francisco: Pandora, 1993
Hughes, Langston "The Negro Artist and the Racial Mountain," *The Nation,* 23 June 1926: 692–93
Johnston, Patricia *Real Fantasies: Edward Steichen's Advertising Photography.* Berkeley, Los Angeles and London: Univ. of California Press, 1997
Krech, Shepherd, III, and Barbara A. Hail *Collecting Native America, 1870–1960.* Washington, D.C.: Smithsonian Institution Press, 1999
Latimer, Tirza True *Women Together/Women Apart: Portraits of Lesbian Paris.* New Brunswick, N.J.: Rutgers Univ. Press, 2005
Levine, Neil *The Architecture of Frank Lloyd Wright.* Princeton: Princeton Univ. Press, 1996
Marchand, Roland *Advertising the American Dream: Making Way for Modernity, 1920–1940.* Berkeley, Los Angeles and London: Univ. of California Press, 1985
Meléndez, A. Gabriel, et al. *The Multi-Cultural Southwest: A Reader.* Tucson: Univ. of Arizona Press, 2001
Messinger, Lisa Mintz *Georgia O'Keeffe.* London and New York: Thames & Hudson, 2001
Noble, Andrea *Tina Modotti: Image, Texture, Photography.* Albuquerque: Univ. of New Mexico Press, 2000
Porter, Dean A., Teresa Hayes Ebie and Suzan Campbell *Taos Artists and Their Patrons, 1898–1950.* Albuquerque: Univ. of New Mexico Press, 1999
Prendeville, Brendan *Realism in 20th-Century Painting.* London and New York: Thames & Hudson, 2000
Quick, Michael, et al. *The Paintings of George Bellows.* Fort Worth, Los Angeles and New York: Amon Carter Museum, Los Angeles County Museum of Art, and Harry N. Abrams, 1992
Scott, William B., and Peter M. Rutkoff. *New York Modern: The Arts and the City.* Baltimore: Johns Hopkins Univ. Press, 1999
Swinth, Kirsten *Painting Professionals: Women Artists and the Development of Modern American Art, 1870–1930.* Chapel Hill: Univ. of North Carolina Press, 2001
Zurier, Rebecca *Picturing the City: Urban Vision and the Ashcan School.* Berkeley and Los Angeles: Univ. of California Press, 2006

Chapter 7

Sources

A New Deal for Art
A New Boss: Federal Programs for the Arts
Monroe, Gerald "The '30s: Art, Ideology and the WPA," *Art in America* 63 (Nov. 1975): 64–67

—— "The Artists' Union of New York," *Art Journal* 32 (Fall 1972): 17–20

Terkel, Studs *Hard Times: An Oral History of the Great Depression*. New York: Pantheon Books, 1970

A Prosperous America: Federally Sponsored Murals

Cahill, Holger "Introduction," in Erwin O. Christensen, *The Index of American Design*. New York and Washington, D.C.: Macmillan and the National Gallery of Art, 1950: ix–xvii

Park, Marlene, and Gerald Markowitz *Democratic Vistas: Post Offices and Public Art in the New Deal*. Philadelphia: Temple Univ. Press, 1984

Melosh, Barbara *Engendering Culture: Manhood and Womanhood in New Deal Public Art and Theater*. Washington, D.C., and London: Smithsonian Institution Press, 1991

Berlo, Janet Catherine, and Ruth B. Phillips *Native North American Art*. Oxford and New York: Oxford Univ. Press, 1998

Documents of Despair and Renewal: Photography and the Farm Security Administration

Smith, Terry *Making the Modern: Industry, Art, and Design in America*. Chicago and London: Univ. of Chicago Press, 1993

Stein, Sally "Passing Likeness: Dorothea Lange's 'Migrant Mother' and the Paradox of Iconicity," in Coco Fusco and Brian Wallis, eds., *Only Skin Deep: Changing Visions of the American Self*. New York: International Center of Photography/ Harry N. Abrams, Inc., 2003

Modernist Architecture, Domestic Design, and Planned Communities

Kostof, Spiro *A History of Architecture: Settings and Rituals*. Oxford and New York: Oxford Univ. Press, 1985

Roth, Leland M. *A Concise History of American Architecture*. New York: Harper and Row/Icon Editions, 1979

Craig, Lois A., et al. *The Federal Presence: Architecture, Politics, and National Design*. Cambridge, Mass., and London: MIT Press, 1984

Alternative Visions: Urban Life and the Industrial Worker

The Mexican Muralists in America

Hurlburt, Laurance P. *The Mexican Muralists in the United States*. Albuquerque: Univ. of New Mexico Press, 1989

Siporin, Mitchell "Mural Art and the Midwestern Myth," in Francis V. O'Connor, ed., *Art for the Millions*. Greenwich, Conn.: New York Graphic Society, 1973

Lee, Anthony W. *Painting on the Left: Diego Rivera, Radical Politics, and San Francisco's Public Murals*. Berkeley, Los Angeles and London: Univ. of California Press, 1999

McWilliams, Carey *Factories in the Field*. Boston: Little, Brown, 1939

The Coit Tower Murals and the Big Strike

Lee, Anthony W. *Painting on the Left: Diego Rivera, Radical Politics, and San Francisco's Public Murals*. Berkeley, Los Angeles and London: Univ. of California Press, 1999

Painting Injustice: Philip Evergood, Ben Shahn, and Thomas Hart Benton

Baur, John I. H. *Philip Evergood*. New York: Whitney Museum of American Art, 1960

Hills, Patricia "Philip Evergood's 'American Tragedy': The Poetics of Ugliness, the Politics of Anger." *Artsmagazine* 54 (Feb. 1980): 138–42

Pohl, Frances K. *Ben Shahn: New Deal Artist in a Cold War Climate, 1947–1954*. Austin: Univ. of Texas Press, 1989

Doss, Erika *Benton, Pollock, and the Politics of Modernism: From Regionalism to Abstract Expressionism*. Chicago and London: Univ. of Chicago Press, 1991

Alternative Visions: The Corporate View of Industrial America

Images of Ford: Diego Rivera, Frida Kahlo, and Charles Sheeler

Smith, Terry *Making the Modern: Industry, Art, and Design In America*. Chicago and London: Univ. of Chicago Press, 1993

Lindauer, Margaret A. *Devouring Frida: The Art History and Popular Celebrity of Frida Kahlo*. Middletown, CT: Wesleyan Univ. Press, 1999

Handlin, David P. *American Architecture*. 2nd edn, London and New York: Thames & Hudson, 2004

Rockefeller and the Limits of Corporate Patronage

Rand, Harry *Paul Manship*. Washington, D.C., and London: Smithsonian Institution Press, 1989

Rather, Susan "Avant-Garde or Kitsch? Modern and Modernistic in American Sculpture Between the Wars," in Ilene Susan Fort, with contributions by Mary L. Lenihan, Marlene Park, Susan Rather, and Roberta K. Tarbell, *The Figure in American Sculpture: A Question of Modernity*. Los Angeles and Seattle: Los Angeles County Museum of Art/Univ. of Washington Press, 1995

Founders Society Detroit Institute of Arts *Diego Rivera: A Retrospective*. Detroit, New York and London: Founders Society Detroit Institute of Arts in assoc. with W.W. Norton, 1986

Industry and Labor in "Fortune" and "Life"

Elson, Robert *Time, Inc.: The Intimate History of a Publishing Enterprise*. New York: Atheneum, 1968

Alternative Visions: Women at Work in the City

Todd, Ellen Wiley *The "New Woman" Revised: Painting and Gender Politics on Fourteenth Street*. Berkeley: Univ. of California Press, 1993

Alternative Visions: Rural America

Drought and Foreclosure: The Other Side of New Deal Murals

Brown, Milton *American Painting from the Armory Show to the Depression*. Princeton: Princeton Univ. Press, 1970 [1955]

Corn, Wanda *Grant Wood: The Regionalist Vision*. New Haven: Yale Univ. Press for the Minneapolis Institute of Arts, 1983

Black Poverty and Lynching in Rural America

Turner, Elizabeth Hutton, ed. *Jacob Lawrence: The Migration Series*. Washington, D.C.: The Phillips Collection/The Rappahannock Press, 1993

Hills, Patricia "Jacob Lawrence as Pictorial Griot: The Harriet Tubman Series," *American Art* 7 (Winter 1993)

Wheat, Ellen Harkins *Jacob Lawrence: The "Frederick Douglass" and "Harriet Tubman" Series of 1938–1940*. Seattle and London: Univ. of Washington Press, 1991

Park, Marlene "Lynching and Antilynching: Art and Politics in the 1930s," *Prospects* 18 (1993): 311–65

Pohl, Frances K. *In the Eye of the Storm: An Art of Conscience, 1930–1970*. San Francisco: Pomegranate Artbooks, 1995

Tarbell, Roberta K. "Primitivism, Folk Art, and the Exotic," in Ilene Susan Fort, with contributions by Mary L. Lenihan, Marlene Park, Susan Rather, and Roberta K. Tarbell, *The Figure in American Sculpture: A Question of Modernity*. Los Angeles and Seattle: Los Angeles County Museum of Art/Univ. of Washington Press, 1995

Noguchi, Isamu *A Sculptor's World*. New York: Harper and Row, 1968

Art Against Fascism: The Popular Front and the American Artists' Congress

Hinz, Berthold *Art in the Third Reich*. New York: Pantheon Books, 1979

Whiting, Cécile *Antifascism in American Art*. New Haven and London: Yale Univ. Press, 1989

The War at Home: Japanese American Internment and American Patriotism

Conrat, Maisie and Richard *Executive Order 9066: The Internment of 110,000 Japanese Americans*. Los Angeles: Univ. of California/Asian American Studies Center, 1992

Japanese American National Museum, UCLA Wight Art Gallery, UCLA Asian American Studies Center *The View from Within: Japanese American Art from the Internment Camps, 1942–1945*. Los Angeles, 1992

Noriyuki, Duane "Stories in the Dust," *Los Angeles Times*, 31 July 2002: E1,3

Kuramitsu, Kristine C. "Internment and Identity in Japanese American Art," *American Quarterly* 47 (Dec. 1995): 619–58

Social Surrealism, Abstraction, and Democracy

Social Surrealism and Critiques of Fascism

Tashjian, Dickran *A Boatload of Madmen: Surrealism and the American Avant-Garde, 1920–1950*. London and New York: Thames & Hudson, 1995

Fort, Ilene Susan "James Guy: A Surreal Commentator," *Prospects* 12 (1987): 125–48

—— "American Social Surrealism," *Archives of American Art Journal* 22, no. 3 (1982): 8–20

Style as Subject, Abstraction as Freedom

Hills, Patricia *Stuart Davis*. New York: Harry N. Abrams in assoc. with the National Museum of American Art, Smithsonian Institution, 1996

Greenberg, Clement *Art and Culture, Critical Essays*. Boston: Beacon Press, 1961

Haskell, Barbara *The American Century: Art and Culture, 1900–1950*. New York and London: Whitney Museum of American Art in assoc. with W.W. Norton, 1999

Gottlieb, Adolf "The Idea of Art," *Tiger's Eye* 2 (Dec. 1948): 43

Further Reading

Anreus, Alejandro *Orozco in Gringoland: The Years in New York*. Albuquerque: Univ. of New Mexico Press, 2001

Anreus, Alejandro, Diana L. Linden, and Jonathan Weinberg, eds *The Social and the Real: Political Art*

of the 1930s in the Western Hemisphere. University Park: Pennsylvania State Univ. Press, 2006

Apel, Dora Imagery of Lynching: Black Men, White Women, And the Mob. New Brunswick, N.J., and London: Rutgers Univ. Press, 2004

Baskind, Samantha Raphael Soyer and the Search for Modern Jewish Art. Chapel Hill and London: Univ. of North Carolina Press, 2004

Bustard, Bruce I. A New Deal for the Arts. Washington, D.C., Seattle and London: National Archives and Records Administration in assoc. with the Univ. of Washington Press, 1997

Caws, Mary Ann, Rudolf Kuenzli, and Gwen Raaberg, eds Surrealism and Women. Cambridge, Mass., and London: MIT Press, 1991

Ceglio, Clarissa J. "Complicating Simplicity" (review of the exhibition "Norman Rockwell: Pictures for the American People"), American Quarterly 54 (June 2002): 279–306

Coffey, Mary "Promethean Labor: Orozco and the Gendering of American Art," in Marjorie L. Harth, ed., José Clemente Orozco: Prometheus. Claremont, Calif.: Pomona College Museum of Art, 2001

Dickerson, Albert Inskip The Orozco Frescoes at Dartmouth. Hanover, N.H.: Dartmouth Publications, 1962

Downs, Linda Bank Diego Rivera: The Detroit Industry Murals. New York and London: W.W. Norton, 1999

Fleischhauer, Carl, and Beverly W. Brannan, eds, with essays by Lawrence W. Levine and Alan Trachtenberg Documenting America, 1935–1943. Berkeley, Los Angeles and London: Univ. of California Press in assoc. with the Library of Congress, 1988

Frampton, Kenneth Modern Architecture. A Critical History. 4th edn, London and New York: Thames & Hudson, 2007

Fryn, Vivien Green Art and the Crisis of Marriage: Edward Hopper and Georgia O'Keeffe. Chicago and London: Univ. of Chicago Press, 2002

Gambone, Robert L. Art and Popular Religion in Evangelical America, 1915–1940. Knoxville: Univ. of Tennessee Press, 1989

Hambourg, Maria Morris, et al. Walker Evans. Princeton and New York: Princeton Univ. Press in assoc. with the Metropolitan Museum of Art, 2000

Harth, Marjorie L., ed. José Clemente Orozco: Prometheus. Claremont, Calif.: Pomona College Museum of Art, 2001

Henkes, Robert American Women Painters of the 1930s and 1940s: The Lives and Work of Ten Artists. Jefferson, N.C.: McFarland, 1991

Hills, Patricia Painting Harlem Modern: The Art of Jacob Lawrence. Berkeley and Los Angeles: Univ. of California Press, 2010

Karlstrom, Paul J., ed. On the Edge of America: California Modernist Art, 1900–1950. Berkeley, Los Angeles and London: Univ. of California Press, 1996

Lee, Anthony W. Picturing Chinatown: Art and Orientalism in San Francisco. Berkeley and Los Angeles: Univ. of California Press, 2001

—— ed. Yun Gee: Poetry, Writings, Art, Memories. Pasadena: Pasadena Museum of California Art, in assoc. with Univ. of Washington Press, 2003

Levin, Gail Edward Hopper: An Intimate Biography. New York: Alfred A. Knopf, 1997

Marling, Karal Ann Wall-to-Wall America. Minneapolis: Univ. of Minnesota Press, 1982

Mello, Renato González, and Diane Miliotes, eds José Clemente Orozco in the United States, 1927–1934. Hanover, N.H.: Hood Museum of Art, Dartmouth College, in assoc. with W.W. Norton (New York and London), 2002

Nesbett, Peter T., and Michelle DuBois, eds Over the Line: The Art and Life of Jacob Lawrence. Seattle and London: Univ. of Washington Press, in assoc. with Jacob and Gwendolyn Lawrence Foundation, 2001

Hennessey, Maureen Hart, and Judy L. Larson, eds Norman Rockwell: Pictures for the American People. New York: Harry N. Abrams, 1999

O'Connor, Francis Federal Support for the Visual Arts: The New Deal Now. Greenwich, Conn.: New York Graphic Society, 1969

Orozco, José Clemente José Clemente Orozco. New York: Hacker Art Books, 1985

Platt, Susan Art and Politics in the 1930's: Modernism, Marxism, Americanism, A History of Cultural Activism During the Depression Years. New York: Midmarch Press, 1999

Prendeville, Brendan Realism in 20th-Century Painting. London and New York: Thames & Hudson, 2000

Rivera, Diego My Art, My Life: An Autobiography. New York: Dover, 1960

Roussel, Christin The Art of Rockefeller Center. New York and London: W.W. Norton, 2006

Saab, A. Joan For the Millions: American Art and Culture Between the Wars. Philadelphia: Univ. of Pennsylvania Press, 2004

Stein, Philip Siqueiros: His Life and Works. New York: International Publishers, 1994

Venn, Beth, and Adam D. Weinberg, eds Frames of Reference: Looking at American Art, 1900–1950: Works from the Whitney Museum of American Art. Berkeley, Los Angeles and London: Univ. of California Press, 2000

Chapter 8

Sources

Pohl, Frances K. Ben Shahn: New Deal Artist in a Cold War Climate, 1947–1954. Austin: Univ. of Texas Press, 1989

Gestures of Liberation: Abstract Art as the New American Art
The Blinding Light of the Blast: Representing Atomic Destruction

Berman, Greta, and Jeffrey Wechsler Realism and Realities: The Other Side of American Painting, 1940–1960. New Brunswick, N.J.: Rutgers Univ. Art Gallery, 1982

Lyford, Amy "Noguchi, Sculptural Abstraction, and the Politics of Japanese American Internment," Art Bulletin 85 (March 2003): 137–51

Abstract Expressionism and the Cold War

Guilbaut, Serge How New York Stole the Idea of Modern Art, Abstract Expressionism, Freedom, and the Cold War. Transl. Arthur Goldhammer. Chicago and London: Univ. of Chicago Press, 1983

Brown, Milton "The Forces behind Modern U.S. Painting," Art News 46 (Aug. 1947): 35

Sandler, Irving The Triumph of American Painting: A History of Abstract Expressionism. New York: Harper and Row, 1970

Rosenberg, Harold "The American Action Painters," Art News 51 (Dec. 1952): 22–23, 48–50

Newman, Barnett "The Sublime is Now," Tiger's Eye no. 6 (Dec. 1948): 51–53

San Francisco Museum of Modern Art Clyfford Still. San Francisco, Calif.: San Francisco Museum of Modern Art, 1976

Blesh, Rudi Modern Art USA: Men, Rebellion, Conquest, 1900–1956. New York: Alfred A. Knopf, 1956

Greenberg, Clement "The Present Prospects of American Painting and Sculpture," Horizon (Oct. 1947), repr. in John O'Brian, ed. Clement Greenberg: The Collected Essays and Criticism. Chicago: Univ. of Chicago Press, 1986

Abstract Expressionism's Others: Race, Gender, and the Politics of Exclusion

Gibson, Ann Eden Abstract Expressionism: Other Politics. New Haven and London: Yale Univ. Press, 1997

Brooklyn Museum of Art Leon Polk Smith, American Painter. New York: Brooklyn Museum of Art, 1995

Kenkeleba Gallery Norman Lewis: From the Harlem Renaissance to Abstraction. New York: Kenkeleba Gallery, 1989

Leja, Michael Reframing Abstract Expressionism: Subjectivity and Painting in the 1940s. New Haven and London: Yale Univ. Press, 1993

Wood, Paul, Francis Frascina, Jonathan Harris, and Charles Harrison Modernism in Dispute: Art since the Forties. New Haven and London: Yale Univ. Press in assoc. with the Open Univ., 1993

Hess, Thomas Abstract Painting: Background and American Phase. New York: Viking Press, 1951

Wagner, Anne Middleton Three Artists (Three Women), Modernism and the Art of Hesse, Krasner, and O'Keeffe. Berkeley, Los Angeles and London: Univ. of California Press, 1996

Hobbs, Robert Lee Krasner. New York: Independent Curators International in assoc. with Harry N. Abrams, 1999

Sandler, Irving The New York School: The Painters and Sculptors of the Fifties. New York: Harper and Row, 1978

Baro, Gene "The Achievement of Helen Frankenthaler," Art International 20 (Sept. 1967): 34–36

De Kooning, Elaine "Subject: What, How or Who?" Art News, April 1955: 26–29, 61–62

Phillips, Lisa The American Century: Art and Culture, 1950–2000. New York and London: Whitney Museum of American Art in assoc. with W.W. Norton, 1999

Pastiche and Parody: Another Take on the Real
The Blurring of Boundaries: Painting Into Sculpture, Junk Into Art

Katz, Jonathan "The Art of Code, Jasper Johns and Robert Rauschenberg," in Whitney Chadwick and Isabelle de Courtivron, eds, Significant Others: Creativity and Intimate Partnership. London and New York: Thames & Hudson, 1993

Greenberg, Clement Art and Culture, Critical Essays. Boston: Beacon Press, 1961

—— "Recentness of Sculpture," in Gregory Battcock, ed., *Minimal Art: A Critical Anthology*. New York: E. P. Dutton, 1968

Opting Out and Raging On: Art of the Beat Generation

Crow, Thomas *The Rise of the Sixties*. New York: Harry N. Abrams, 1996

Frank, Robert *The Americans*. New York: Grove Press, 1959

Hirsch, Robert *Seizing the Light: A History of Photography*. Boston: McGraw Hill, 2000

Passionate Obsessives: Simon Rodia and James Hampton

Hartigan, Lynda Roscoe "Going Urban: American Folk Art and the Great Migration," *American Art* 14 (Summer 2000): 26–51

Gould, Stephen Jay "James Hampton's Throne and the Dual Nature of Time," *Smithsonian Studies in American Art* 1 (Spring 1987): 47–57

A Commitment to Social Justice: Milton Rogovin and Elizabeth Catlett

Herzog, Melanie Anne *Milton Rogovin: The Making of A Social Documentary Photographer*. Tucson: Center for Creative Photography in association with the Univ. of Washington Press, 2006

Herzog, Melanie Anne *Elizabeth Catlett: An American Artist in the Making*. Seattle and London: Univ. of Washington Press, 2000

Minimal Forms and Art as Idea
The Hard Edge: Painting and Sculpture

Fineberg, Jonathan *Art Since 1940: Strategies of Being*. Englewood Cliffs, N.J.: Prentice Hall, 1995

Chave, Anna C. "Minimalism and the Rhetoric of Power," *Artsmagazine* 64 (Jan. 1990): 44–63

The Hard Edge: Architecture

Kostof, Spiro *A History of Architecture: Settings and Rituals*. Oxford and New York: Oxford Univ. Press, 1985

Ferguson, Russell, ed. *At the End of the Century: One Hundred Years of Architecture*. New York and Los Angeles: Harry N. Abrams and the Museum of Contemporary Art, Los Angeles, 1998

Stern, Robert M. *Pride of Place: Building the American Dream*. Boston and New York: Houghton Mifflin/American Heritage, 1986

Gelernter, Mark *A History of American Architecture: Buildings in Their Cultural and Technological Context*. Hanover, N.H., and London: Univ. Press of New England, 1999

Lavin, Sylvia "New Landscapes of Domesticity: The Private Triumph of Modernity," in Lisa Phillips, *The American Century: Art and Culture, 1950–2000*. New York and London: Whitney Museum of American Art in assoc. with W. W. Norton, 1999: 28–29

The Soft Edge: Cultural and Commercial Spaces

Gelernter, Mark *A History of American Architecture: Buildings in Their Cultural and Technological Context*. Hanover, N.H., and London: Univ. Press of New England, 1999

Levine, Neil *The Architecture of Frank Lloyd Wright*. Princeton: Princeton Univ. Press, 1996

Upton, Dell *Architecture in the United States*. Oxford and New York: Oxford Univ. Press, 1998

The Soft Edge: Sculpture

Lippard, Lucy *Eva Hesse*. New York: New York Univ. Press, 1976

—— *Overlay: Contemporary Art and the Art of Prehistory*. New York: Pantheon Books, 1983

Earth As Art

Wood, Paul, et al., eds *Modernism in Dispute: Art Since the Forties*. New Haven and London: Yale Univ. Press, in assoc. with the Open Univ., 1993

Chadwick, Whitney *Women, Art, and Society*. 4th edn, London and New York: Thames & Hudson, 2007

The Framed Proposition

LeWitt, Sol "Paragraphs on Conceptual Art," *Artforum* 5 (Summer 1967): 79–83

Kosuth, Joseph "Art After Philosophy," *Studio International* (Oct. 1969): 135

Ravenal, John B. "Sirin Neshat: Double Vision," in Norma Broude and Mary Garrard, eds. *Reclaiming Female Agency: Feminist History After Postmodernism*. Berkeley and Los Angeles: Univ. of California Press, 2005: 446–58

Joselit, David *American Art Since 1945*. London and New York: Thames & Hudson, 2003

Popular Art, Pop Art, and Consumer Culture
Grandma Makes Art: Anna Mary Robertson Moses

Vlach, John Michael *Plain Painters: Making Sense of American Folk Art*. Washington, D.C., and London: Smithsonian Institution Press, 1988

Realigning High Art: Pop Art and the Consumer Revolution

Mamiya, Christin J. *Pop Art and Consumer Culture: American Super Market*. Austin: Univ. of Texas Press, 1992

Whiting, Cécile *A Taste for Pop: Pop Art, Gender and Consumer Culture*. Cambridge: Cambridge Univ. Press, 1997

Celant, Germano *Claes Oldenburg: An Anthology*. Exh. cat. New York and Washington, D.C.: Solomon R. Guggenheim Museum and National Gallery of Art, 1995

Lippard, Lucy "Household Images in Art," in *From the Center: Feminist Essays on Women's Art*. New York: E. P. Dutton, 1976

An Art of Protest: The Civil Rights Movement and the Vietnam War
Disquieting Images: Civil Rights and Civil Wrongs

"The Artist and Politics: A Symposium," *Artforum* 9 (Sept. 1970): 35–39

Studio Museum in Harlem *Memory and Metaphor: The Art of Romare Bearden, 1940–1987*. Intro. Kinshasha Holman Conwill, essays by Mary Schmidt Campell and Sharon F. Patton. New York and Oxford: Oxford Univ. Press, 1991

—— *Tradition and Conflict: Images of a Turbulent Decade, 1963–1973*. Essays by Vincent Harding, Mary Schmidt Campbell, Benny Andrews and Lucy R. Lippard. New York: Studio Museum in Harlem, 1985

Fanon, Frantz *The Wretched of the Earth*. New York: Grove Press, 1963

Angry Art: Protesting the Vietnam War

Leuchtenberg, William E. *Troubled Feast: American Society Since 1945*. Rev. edn, Boston and Toronto: Little, Brown, 1979

Swenson, Gene R. "F-III: An Interview with James Rosenquist," *Partisan Review* 32 (Fall 1965): 589–601

Golub, Leon "The Artist as Angry Artist: The Obsession with Napalm," *Arts Magazine* (April 1967): 48–49

Cook, Blanche Wiesen *The Declassified Eisenhower: A Divided Legacy of Peace and Political Warfare*. Garden City, N.Y.: Doubleday, 1981

Siegel, J. "Carl Andre: Artworker, in an Interview with Jeanne Siegel," *Studio International* 180, no. 927 (1970): 175–79

The Personal is Political: Feminist Art of the 1970s
Dispelling the Feminine Mystique: Old Media, New Messages

Broude, Norma, and Mary D. Garrard, eds *The Power of Feminist Art: The American Movement of the 1970s, History and Impact*. New York: Harry N. Abrams, 1994

Nochlin, Linda "Why Have There Been No Great Women Artists?," *Art News* 69 (Jan. 1971): 22–39

Kuby, Lolette "The Hoodwinking of the Women's Movement: Judy Chicago's *Dinner Party*," *Frontiers* 7, no. 3 (1982): 127–30

Stepping Out: Feminist Performance Art

Leval, Susanna Torruella "Recapturing History: The (Un)official Story in Contemporary Latin American Art," *Art Journal* 51 (Winter 1992): 74

Jones, Amelia *Body Art: Performing the Subject*. Minneapolis and London: Univ. of Minnesota Press, 1998

Kaprow, Allan "The Legacy of Jackson Pollock," *Art News* (Oct. 1958): 24–26, 55–57

Kirby, Michael *Happenings, An Illustrated Anthology*. New York: E. P. Dutton, 1965

Performing Politics

Hoffman, Abbie "Museum of the Streets," in Douglas Kahn and Diane Neumaier, eds, *Cultures in Contention*. Seattle: The Real Comet Press, 1985: 134–40

Marcuse, Herbert *One-Dimensional Man*. Boston: Beacon Press, 1964

Lacy, Suzanne, and Leslie Labowitz "Feminist Media Strategies for Political Performance," in Douglas Kahn and Diane Neumaier, eds, *Cultures in Contention*. Seattle: The Real Comet Press, 1985: 122–33

Public Art and the Public Interest

Raven, Arlene, ed. *Art in the Public Interest*. Ann Arbor, Mich., and London: UMI Research Press, 1989

Walls of Pride: Chicano/a Murals

Cockcroft, Eva Sperling, and Holly Barnet-Sánchez *Signs From the Heart: California Chicano Murals*. Venice, Calif.: Social and Public Art Resource Center, 1990

Gaspar de Alba, Alicia *Chicano Art : Inside/Outside the Master's House*. Austin: Univ. of Texas Press, 1998

Modernist Art and Public Controversy: Richard Serra's "Tilted Arc" and Maya Lin's Vietnam Veterans Memorial

Blake, Casey Nelson "An Atmosphere of Effrontery: Richard Serra, Tilted Arc, and the Crisis of Public Art," in Richard Wightman Fox and T. Jackson Lears, *The Power Of Culture: Critical Essays in American History*. Chicago and London: Univ. of Chicago Press, 1993

Crow, Thomas *Modern Art in the Common Culture*. New Haven: Yale Univ. Press, 1996

Serra, Richard "'Tilted Arc' Destroyed," *Art in America* 77 (May 1989): 35–47

Hess, Elizabeth "A Tale of Two Memorials," *Art in America* 71 (April 1983): 121–27

Is Less More? Re-evaluating Modernism in Architecture
Postmodernist Architecture: Play and Paranoia
Jencks, Charles *The Language of Post-Modern Architecture*. New York: Rizzoli, 1984
Bletter, Rosemarie Haag "Frank Gehry's Spatial Constructions," in Walker Art Center, Minneapolis, *The Architecture of Frank Gehry*. New York: Rizzoli, 1986: 24–47
Davis, Mike *City of Quartz: Excavating the Future in Los Angeles*. New York and London: Verso, 1990

Postmodernism and Art
Jameson, Frederic "Postmodernism and Consumer Society," in Hal Foster, ed., *The Anti-Aesthetic: Essays on Postmodern Culture*. Port Townsend, Wash.: Bay Press, 1983
Huyssen, Andreas *After the Great Divide: Modernism, Mass Culture, Postmodernism*. Bloomington: Indiana Univ. Press, 1986
Gitlin, Todd "Postmodernism: Roots and Politics," in Ian Angus and Sut Jhally, *Cultural Politics in Contemporary America*. New York and London: Routledge, 1989
Pollock, Griselda "Feminism and Modernism," in Rozsika Parker and Griselda Pollock, eds, *Framing Feminism: Art and the Women's Movement, 1970–1985*. London and New York: Pandora, 1987
Art Stars
Small, Michael "Already a Big Man on Canvas, Robert Longo Goes Multi-media," *People*, 10 Nov. 1986: 135
—— "For a Few Fleeting Hours Keith Haring Makes a Bright Canvas of the Berlin Wall," *People*, 10 Nov. 1986: 54
McGuigan, Cathleen "New Art, New Money: The Marketing of an American Artist," *New York Times Magazine*, 10 Feb. 1985: 34
[anon.] "Cornering the Contemporary Art Market with an Eye on Profit." *Insight*, 31 March 1986: 13
Mass Media Manipulations
Phillips, Lisa *The American Century: Art and Culture, 1950–2000*. New York and London: Whitney Museum of American Art in assoc. with W.W. Norton, 1999
Williamson, Judith *Consuming Passions: The Dynamics of Popular Culture*. London and New York: Marion Boyars, 1986
Linker, Kate *Love for Sale: The Words and Pictures of Barbara Kruger*. New York: Harry N. Abrams, 1990

Art Activism
Crossing Borders
Sekula, Allan "Geography Lesson: Canadian Notes," *10.8*, no. 29 (1988): 2–25
Art and AIDS
Crimp, Douglas "AIDS: Cultural Analysis/Cultural Activism," in *Modern Art and Society: An Anthology of Social and Multicultural Readings*, ed. Maurice Berger. New York: HarperCollins/IconEditions, 1994
Shurkus, Marie "Appropriated Imagery, Material Affects and Narrative Outcomes," in *Telling Stories: Countering Narrative in Art, Theory and Film*, eds Jane Tormey and Gillian Whiteley. Newcastle-on-Tyne: Cambridge Scholars Press, 2009: 112–24
Ruskin, Cindy *The Quilt: Stories from the NAMES Project*. New York and London: Pocket Books, 1988

Video Art
Hanhardt, John G. *The Worlds of Nam June Paik*. New York: Guggenheim Museum, 2000
Jameson, Frederic *Postmodernism, or the Cultural Logic of Late Capitalism*. Durham, N.C., and London: Duke Univ. Press, 1991
Johnson, Ken "Being and Politics," *Art in America* 78 (Sept. 1990): 154–61
Rush, Michael *New Media in Art*. 2nd edn, London and New York: Thames & Hudson 2005
Virilio, Paul, and Steve Redhead *The Paul Virilio Reader*. New York: Columbia Univ. Press, 2004

The Culture Wars
Sexual Subversion: Attacks on Public Funding for the Arts
Wallis, Brian, Marianne Weems and Philip Yenawine, eds *Art Matters: How the Culture Wars Changed America*. New York and London: New York Univ. Press, 1999
Beal, Graham "But is it 'Art'?: The Mappelthorpe/Serrano controversy," *Apollo* 132 (Nov. 1990): 317–21
Barrie, Dennis "The Scene of the Crime," *Art Journal* 50 (Fall 1991): 29–32
Institute of Contemporary Art, Univ. of Pennsylvania *Andres Serrano, Works 1983–1993*. Philadelphia: Institute of Contemporary Art, Univ. of Pennsylvania, 1994
Larson, Gary O. "American Canvas." Washington, D.C.: National Endowment for the Arts, 1997
Wallis, Brian, ed. *Hans Haacke: Unfinished Business*. New York, Cambridge, Mass., and London: New Museum of Contemporary Art and MIT Press, 1986
Art and the Politics of Identity
Wallace, Michele "The Culture War Within the Culture Wars: Race," in Brian Wallis, Marianne Weems and Philip Yenawine, eds, *Art Matters: How the Culture Wars Changed America*. New York and London: New York Univ. Press, 1999: 166–81
Mizota, Sharon "Gallery," in *Fresh Talk Daring Gazes: Conversations on Asian American Art*, eds Elaine H. Kim, Margo Machida, and Sharon Mizota. Berkeley/Los Angeles/London: Univ. of California Press, 2003
Fusco, Coco "Passionate Irreverence: The Cultural Politics of Identity," in Wallis, Weems and Yenawine, eds, *Art Matters* (above): 62–73
—— *English is Broken Here: Notes on Cultural Fusion in the Americas*. New York: The New Press, 1995
Quick-To-See Smith, Jaune, and Harmony Hammond *Women of Sweetgrass, Cedar and Sage*. New York: American Indian Center, 1984
Lippard, Lucy R. *Mixed Blessings: New Art in a Multicultural America*. New York: Pantheon Books, 1990
Lieberman, Paul "Auction Houses Sold on $512-Million Price-Fixing Settlement," *Los Angeles Times*, Sept. 26, 2000: A12
—— "Museum's Maverick Showman," *Los Angeles Times*, Oct. 20, 2000: A1, 29

Envisioning the 21st Century
9/11 and the War on Terror
Zuber, Devin "Flanerie at Ground Zero: Countermemories in Lower Manhattan," *American Quarterly* 58 (June 2006): 269–99

Hawthorne, Christopher "Unseemly Memorials," *Los Angeles Times*, 9 Sept. 2006: E1, 18
Kappeler, Susanne *The Pornography of Representation*. Minneapolis: Univ. of Minnesota Press, 1986
Ray, Gene "Tactical Media and the End of History," *Afterimage* special issue, 2006: 33–39
Solomon, Alisa "Art Makes a Difference," *Nation*, 8 Nov. 2004: 28
Glaser, Milton "Designing Dissent," *Los Angeles Times*, 22 Oct. 2006: M6
Altered States and the Connectivity of the Whole
Posner, Helaine "Lilla LoCurto and William Outcault: Self-Portraits for a New Millenium," *Art Journal* 65 (Spring 2006): 40–53
Haley, David "*Species Nova* [To See Anew]: Art as Ecology," *Ethics & the Environment* 8.1 (2003): 143–50
Seltz, Peter *Art of Engagement: Visual Politics in California and Beyond*. Berkeley and Los Angeles: Univ. of California Press, 2006
Lippard, Lucy R. *Overlay: Contemporary Art and the Art of Prehistory*. New York: Pantheon Books, 1983
Hardt, Michael, and Antonio Negri *Multitude: War and Democracy in the Age of Empire*. London and New York: Penguin Books, 2004
Building Green: Workshop apd and Jeanne Gang
Woods, Clyde "Katrina's World: Blues, Bourbon and the Return to the Source," *American Quarterly* 61, no. 3 (2009): 427–53
McPhee, John *The Control of Nature*. New York: Farrar, Straus and Giroux, 1989
Curtis, Wayne "Houses of the Future," *The Atlantic* (November 2009), http://www.theatlantic.com/magazine/print/2009/11/houses-of-the-future/7708/
Goldberger, Paul "Wave Effect: Jeanne Gang and Architecture's Anti-divas," *The New Yorker* 85, no. 47 (1 February 2010): 80
Worlds in Flux: Nick Cave and Alan Michelson
Lipsitz, George "Mardi Gras Indians: Carnival and Counter-Narrative in New Orleans," in *Time Passages: Collective Memory and American Popular Culture*. Minneapolis: Univ. of Minnesota Press, 1990: 233–53, 288–91
Abarbanel, Stacey Ravel "Fowler Museum presents 'Nick Cave: Meet Me at The Center of the Earth,' Jan 10—May 30, 2010," UCLA Newsroom (October 23, 2009), http://newsroom.ucla.edu/portal/ucla/fowler-museum-presents-the-traveling- 111442.aspx
Morris, Kate "Art on the River: Alan Michelson Highlights Border-Crossing Issues," *Smithsonian Institution, National Museum of the American Indian Magazine* (Winter 2009): 36–40
White, Richard *The Middle Ground: Indians, Empires, and Republics in the Great Lakes Region, 1650–1815*. Cambridge: Cambridge Univ. Press, 1991
Michelson, Alan "2010 Design Awards Application, Art in Architecture, Narrative," provided by the artist

Further Reading

Anfam, David *Abstract Expressionism*. London and New York: Thames & Hudson, 1990
Anthes, Bill *Native Moderns: American Indian Painting, 1940–1960*. Durham. N.C., and London: Duke

University Press, 2006

Archer, Michael *Art Since 1960*. New edn, London and New York: Thames & Hudson, 2002

Ashton, Dore *The New York School: A Cultural Reckoning*. Harmondsworth, Middx: Penguin Books, 1979

Atkins, Robert, and Svetlana Mintcheva *Censoring Culture: Contemporary Threats to Free Expression*. New York and London: The New Press, 2006

Batchelor, David *Minimalism*. Cambridge: Cambridge Univ. Press, 1998

Berger, Maurice *Modern Art and Society: An Anthology of Social and Multicultural Readings*. New York: HarperCollins, 1994

Blocker, Jane *Where is Ana Mendieta? Identity, Performativity, and Exile*. Durham, N.C., and London: Duke Univ. Press, 1999

Boettger, Suzaan *Earthworks: Art and the Landscape of the Sixties*. Berkeley and Los Angeles: Univ. of California Press, 2002

Brenson, Michael *Visionaries and Outcasts: The NEA, Congress, and the Place of the Visual Artist in America*. New York: The New Press, 2001

Cockcroft, Eva, John Pitman Weber and James Cockcroft *Toward a People's Art: The Contemporary Mural Movement*. Rev. edn, Albuquerque: Univ. of New Mexico Press, 1998

Crane, Diane *The Transformation of the Avant-Garde: The New York Art World, 1940–1985*. Chicago and London: Univ. of Chicago Press, 1987

Craven, David *Abstract Expressionism as Cultural Critique: Dissent During the McCarthy Period*. Cambridge and New York: Cambridge Univ. Press, 1999

Crimp, Douglas *On the Museum's Ruins*. Cambridge, Mass.: MIT Press, 1993

Denning, Michael *Culture in the Age of Three Worlds*. London and New York: Verso, 2004

Doss, Erika *Spirit Poles and Flying Pigs: Public Art and Cultural Democracy in American Communities*. Washington, D.C., and London: Smithsonian Institution Press, 1995

Felshin, Nina, ed. *But is it Art? The Spirit of Activism*. Seattle: Bay Press, 1995

Ferguson, Russell, et al., eds *Out There: Marginalization and Contemporary Cultures*. New York, Cambridge, Mass., and London: The New Museum of Contemporary Art and MIT Press, 1990

Flatley, Jonathan, and José Esteban Muñoz, eds *Pop Out: Queer Warhol*. Durham, N.C., and London: Duke Univ. Press, 1996

Foster, Hal, ed. *The Anti-Aesthetic: Essays on Posmodern Culture*. Seattle: Bay Press, 1983

Frampton, Kenneth *Modern Architecture. A Critical History*. 4th edn, London and New York: Thames & Hudson, 2007

Frascina, Francis *Art, Politics and Dissent: Aspects of the Art Left in Sixties America*. Manchester: Manchester Univ. Press, 2000

Ghirardo, Diane *Architecture after Modernism*. London and New York: Thames & Hudson, 1996

Goldberg, RoseLee *Performance Art*. London and New York: Thames & Hudson, 1998

Golden, Thelma, ed. *Black Male: Representations of Masculinity in Contemporary American Art*. New York: Harry N. Abrams and the Whitney Museum of Art, 1994

Green, David, and Peter Seddon, eds *History Painting Reassessed*. Manchester and New York: Manchester Univ. Press, 2000

Griswold del Castillo, Richard, Teresa McKenna and Yvonne Yarbro-Bejarano, eds *Chicano Art: Resistance and Affirmation, 1965–1985*. Los Angeles: Wight Art Gallery, Univ. of California, 1991

Guggenheim Museum *After "Mountains and Sea": Frankenthaler 1956–1959*. New York: Solomon R. Guggenheim Museum, 1998

Guilbaut, Serge, ed. *Reconstructing Modernism: Art in New York, Paris, and Montreal, 1945–1964*. Cambridge, Mass., and London: MIT Press, 1990

Heins, Marjorie *Sex, Sin, and Blasphemy: A Guide to America's Censorship Wars*. New York: The New Press, 1994

hooks, bell *Art on My Mind: Visual Politics*. New York: The New Press, 1995

Hopkins, David *After Modern Art, 1945–2000*. Oxford and London: Oxford Univ. Press, 2000

Isaak, Jo Anna *Feminism and Contemporary Art: The Revolutionary Power of Women's Laughter*. London and New York: Routledge, 1996

Jones, Amelia, ed. *Sexual Politics: Judy Chicago's "Dinner Party" in Feminist Art History*. Los Angeles, Berkeley and London: UCLA at the Armand Hammer Museum of Art and Cultural Center in assoc. with the Univ. of California Press, 1996

——, and Andrew Stephenson, eds *Performing the Body/Performing the Text*. London and New York: Routledge, 1999

Jones, Caroline A. *Machine in the Studio : Constructing the Postwar American Artist*. Chicago and London: Univ. of Chicago Press, 1996

Joselit, David *American Art Since 1945*. London and New York: Thames & Hudson, 2003

Kammen, Michael *Robert Gwathmey: The Life and Art of a Passionate Observer*. Chapel Hill and London: Univ. of North Carolina Press, 1999

Kim, Elaine, Margo Machida and Sharon Mizota *Fresh Talk, Daring Gazes: Conversations on Asian American Art*. Berkeley and Los Angeles: Univ. of California Press, 2003

Krauss, Rosalind E. *The Originality of the Avant-Garde and Other Modernist Myths*. Cambridge, Mass.: MIT Press, 1985

—— *Bachelors*. Cambridge, Mass.: MIT Press, 1999

Kuspit, Donald *The Rebirth of Painting in the Late Twentieth Century*. Cambridge: Cambridge Univ. Press, 2000

Lacy, Suzanne, ed. *Mapping the Terrain: New Genre Public Art*. Seattle: Bay Press, 1995

LaDuke, Winona *Recovering the Sacred: The Power of Naming and Claiming*. Cambridge, Mass.: South End Press, 2005

Levin, Gail *Becoming Judy Chicago: A Biography of the Artist*. New York: Harmony Books, 2007

Lippard, Lucy *Get the Message? A Decade of Art for Social Change*. New York: E. P. Dutton, 1984

—— *Pop Art*. London and New York: Thames & Hudson, 1966, 1970, 2001

Lubin, David *Shooting Kennedy: JFK and the Culture of Images*. Berkeley and Los Angeles: Univ. of California Press, 2003

Machida, Margo, et al. *Asia/America: Identities in Contemporary Asian American Art*. New York: The New Press, 1994

Madoff, Steven Henry, ed. *Pop Art: A Critical History*. Berkeley, Los Angeles and London: Univ. of California Press, 1998

Manovich, Lev *The Language of New Media*. Cambridge, Mass., and London: MIT Press, 2001

McMaster, Gerald, ed. *Reservation X*. Seattle and Hull: Univ. of Washington Press and the Canadian Museum of Civilization, 1998

Museum of Contemporary Hispanic Art, The New Museum of Contemporary Art, and the Studio Museum in Harlem *The Decade Show: Frameworks of Identity in the 1980s*. New York: Museum of Contemporary Hispanic Art, The New Museum of Contemporary Art, and the Studio Museum in Harlem, 1990

Owens, Craig *Beyond Recognition: Representation, Power, and Culture*. Ed. Scott Bryson. Berkeley, Los Angeles and London: Univ. of California Press, 1992

Piper, Adrian *Out of Order, Out of Sight*, vols I and II: *Selected Writings in Meta-Art and Selected Writings in Art Criticism*. Cambridge, Mass.: MIT Press, 1996

Powell, Richard *Cutting a Figure: Fashioning Black Portraiture*. Chicago: Univ. of Chicago Press, 2009

Prendeville, Brendan *Realism in 20th-Century Painting*. London and New York: Thames & Hudson, 2000

Prigoff, James, and Robin J. Dunitz *Walls of Heritage, Walls of Pride: African American Murals*. San Francisco: Pomegranate, 2000

Raven, Arlene, Cassandra L. Langer and Joanna Frueh, eds *Feminist Art Criticism: An Anthology*. Ann Arbor, Mich., and London: UMI Research Press, 1988

Reiss, Julie H. *From Margin to Center: The Spaces of Installation Art*. Cambridge, Mass.: MIT Press, 2000

Roberts, Jennifer *Mirror Travels: Robert Smithson and History*. New Haven: Yale Univ. Press, 2004

Robins, Corinne *The Pluralist Era: American Art, 1968–1981*. New York: Harper and Row/Icon Editions, 1984

Rush, Michael *New Media in Late 20th Century Art*. 2nd edn, London and New York: Thames & Hudson, 2005

Rushing, Jackson *Native American Art and the New York Avant Garde: A History of Cultural Primitivism*. Austin: Univ. of Texas Press, 1995

Savage, Kirk *Monument Wars: Washington, D.C., the National Mall, and the Transformation of the Memorial Landscape*. Berkeley and Los Angeles: Univ. of California Press, 2009

Selz, Peter *Art of Engagement: Visual Politics in California and Beyond*. Berkeley and Los Angeles: Univ. of California Press and San Jose Museum of Art, 2006

Senie, Harriet F., and Sally Webster, eds *Critical Issues in Public Art: Content, Context, and Controversy*. New York: HarperCollins, 1992

Simon, Richard Keller, "The Formal Garden in the Age of Consumer Culture: A Reading of the Twentieth-Century Shopping Mall," in *Mapping American Culture*, ed. Wayne Franklin and Michael Steiner. Iowa City: Univ. of Iowa Press, 1992: 231–50

Stich, Sidra *Made in U.S.A.: An Americanization in Modern Art, the '50s and '60s*. Berkeley, Los Angeles and London: Univ. of California Press, 1987

Suderburg, Erika, ed. *Space, Site, Intervention: Situation Installation Art*. Minneapolis: Univ. of Minnesota Press, 2000

Tatum, Charles M. *Chicano Popular Culture: Que Hable el Pueblo*. Tucson: Univ. of Arizona Press, 2001

Varnedoe, Kirk, and Pepe Karmel, eds *Jackson Pollock: New Approaches*. New York: The Museum of Modern Art, 1999

Wallis, Brian, ed. *Art After Modernism: Rethinking Representation*. New York and Boston: The New Museum of Contemporary Art in assoc. with David R. Godine, Publishers, 1984

—— *Blasted Allegories: An Anthology of Writings by Contemporary Artists*. New York, Cambridge, Mass., and London: The New Museum of Contemporary Art and MIT Press, 1987

Weintraub, Linda *Art on the Edge and Over: Searching for Art's Meaning in Contemporary Society, 1970s–1990s*. Litchfield, Conn.: Art Insights, 1996

Whiting, Cecile *Pop L.A.: Art and the City in the 1960s*. Berkeley and Los Angeles: Univ. of California Press, 2006

Wojnarowicz, David *Close to the Knives: A Memoir of Disintegration*. New York: Vintage Books, 1991

Websites

The proliferation of websites dealing with American art since 1990 has opened up new opportunities for students to gain access to images and information. The references below are only a small sampling of what is currently available and are drawn primarily from museums with substantial collections of American art.

Addison Gallery of American Art, Andover, Mass.: http://www.andover.edu

African-American Art on the Internet (B. Davis Schwartz Memorial Library): http://www.Brooklyn.liunet.edu/cwis/cwp/library/aavawww.htm

The American West: http://www.americanwest.com

Amon Carter Museum, Fort Worth, Tex.: http://cartermuseum.org

Archives of American Art, Washington, D.C.: http://www.si.edu/artarchives/

Art In Context Center for Communications (Artists Directory): http://www.artincontext.org

Baltimore Museum of Art, Md: http://www.artbma.org

Brooklyn Museum of Art, New York: http://www.brooklynart.org

Butler Institute of American Art, Youngstown, O.: http://www.butlerart.com

Corcoran Gallery of Art, Washington, D.C.: http://www.org/cga/index.ht

Detroit Institute of Arts, Mich.: http://www.dia.org

Dia Center for the Arts, New York http://www.diacenter.org

Electronic Arts Intermix http://www.eai.org

Fine Arts Museums of San Francisco: http://www.thinker.org/

Guggenheim Museum, New York http://www.guggenheim.org

Henry Francis du Pont Winterthur Museum, Del.: http://www.winterthur.org/

International Council of Museums http://www.icom.org/vimp

Los Angeles Country Museum of Art: http://www.lacma.org

Metropolitan Museum of Art, New York: http://www.metmuseum.org/

Museum of American Folk Art, New York: http://www.folkart.museum.org

Museum of Contemporary Art, Los Angeles http://www.moca-la.org

Museum of Fine Arts, Boston, Mass.: http://www.mfa.org/

Museum of Modern Art, New York: http://moma.org/

Museum of the City of New York: http://mcny.org

National Gallery of Art, Washington, D.C.: http://www.nga.gov/

National Portrait Gallery, Washington, D.C.: http://www.npg.si.edu

Native American Indian Art: http://www.kstrom.net/isk/art/art.html

New York State Historical Association, Farmer's Museum and Village Crossroads, Cooperstown, N.Y.: http://nysha.org

Pennsylvania Academy of the Fine Arts, Philadelphia: http://www.pafa.org

Phillips Collection, Washington, D.C.: http://www.phillipscollection.org/html

San Francisco Museum of Modern Art http://www.sfmoma.org

Smithsonian American Art Museum (formerly National Museum of American Art), Washington, D.C.: http://www.nmaa.si.edu

Terra Museum of American Art, Chicago, Ill.: http://www.terramuseum.org/

Virginia Scott Steele Gallery, Los Angeles, Calif.: http://www.huntington.org/ArtDiv/ScottGallery.html

Wadsworth Atheneum, Hartford, Conn.: http://www.wadsworthatheneum.org

Walker Art Center, Minneapolis http://www.walkerart.org

Whitney Museum of American Art, New York: http://www.echonyc.com/whitney/

William Rockhill Nelson Gallery of Art and Mary Atkins Museum of Fine Arts, Kansas City, Mo.: http://nelson-atkins.org

Women Artists http://www.uwrf.edu/history/women

Yale University Art Gallery, New Haven, Conn.: http://www.yale.edu/artgallery

Glossary

Abstract Expressionism: a term commonly applied to non-geometric abstract art by diverse artists based mainly in New York City and highly active and influential through the 1950s and early 1960s; embraces works in a range of styles, emphasizing spontaneity of expression and individuality; see color field painting.

Adobe: a building material of clay mixed with water and such a binder as straw or manure; used in pueblo architecture of the American Southwest.

Aesthetic Movement: an artistic movement originating in Britain in the 1880s in protest against the idea that art must serve some ulterior purpose and also against the "philistine" taste of the period. Aestheticists denied any moral value in art and argued for the suggestive and evocative over the specific, anecdotal, or didactic.

African Commune of Bad Relevant Artists (AFRI-COBRA): a Chicago-based group of African American artists, founded in 1969 by Jeff Donaldson and Wadsworth Jarrell. Promoted a representational style that focused on family, black heroes, and pride in African American culture's roots in black Africa.

Altarpiece: a devotional sculpted and/or painted artwork situated above and behind an altar.

American Abstract Artists (AAA): a group of artists formed in New York in 1936 to promote and foster public understanding of abstract art.

American Scene Painting: a term applied to artists who painted urban or rural life between World Wars I and II in a narrative manner that was accessible to a broad public. Two main groups included within American Scene Painting were the Social Realists and the Regionalists.

Américanisme: a fascination with America, and specifically American popular culture and industry, amongst European intellectual circles beginning during World War I.

Amphitheater: a circular or oval structure with rising tiers of seats around a central space.

Anarchism: an ideology that calls for the abolition of government as the key to social and political liberty.

Antebellum: Latin for "before the war"; the period 1820–60 before the American Civil War (1861–65).

Arcade: a series of arches carried on columns or piers.

Architrave: the lowermost element of a classical entablature.

Armory Show: an international exhibition of modern art held in New York in 1913 at the 69th Regiment Armory, often considered a turning point in American art history for introducing the major French Modernist art movements to the United States.

Art Deco: a decorative style named after the Exposition Internationale des Arts Décoratifs et Industriels Modernes (Paris, 1925) and marked by simplified geometric or stylized forms, strong color contrasts, and textural variety; most popular in architecture and decorative arts during the late 1920s and 1930s.

Art Nouveau: a late 19th- and early 20th-century style of decoration and architecture that made use of undulating forms of all kinds, especially organic or floral forms.

Arts and Crafts Movement: a movement promoting craftsmanship and a reform of industrial design and industrial labor, initiated in England in the late 19th century by William Morris.

Ashcan School: early 20th-century American movement in painting that focused on a realist depiction of everyday urban scenes. Its name derived from a criticism voiced by artist Art Young that the members of the group wanted to paint "pictures of ashcans and girls hitching up their skirts."

Assemblage: a three-dimensional work of art made from everyday materials, often found objects, not usually associated with fine art production.

Atrium: an open-aired interior architectural space; also a large and grandiose room in a hotel or public building through which one enters another and more important room.

Augustinian: a Roman Catholic order that follows the Rule of St Augustine in pursuing a life of poverty, celibacy, and obedience, without withdrawing from the world.

Automatism: the "automatic" use of brush or pencil, without rational control and thus subject to the prompting of subconscious impulses.

Avant-garde: literally "advanced scout" (French). First used by the utopian socialist Henri de Saint-Simon in 1825 to describe the forward-seeing role of artists, and later used to refer to artists who challenge the status quo and stand apart from their peers.

Balustrade: a railing supported by short pillars or ornamental panels.

Baroque: the prevailing style in art commissioned by the European aristocracy and Roman Catholic church from the late 16th to the early 18th century; marked by an interest in dynamic movement and theatrical effect.

Barrio: Spanish word for a district or neighborhood. In the U.S., refers most often to neighborhoods inhabited primarily by Spanish-speaking populations.

Bastion: the projecting portion of the outer wall of a fortification.

Bauhaus: a design school founded in 1919 in Weimar, Germany with the aim of bringing together all the arts under the primacy of architecture, and where teaching methods stressed the need for a rational, practical approach to design problems.

Baxbe: a sacred power in some Native American cultures. It is believed to come from the First Maker or Creator, is granted through an animal emissary, and is obtained by going on a quest.

Beat Movement: a literary movement of the 1950s, characterized by a rejection of materialism, experimentation with drugs and alternate forms of sexuality, and an interest in Eastern religion.

Beaux-Arts: associated with the École des Beaux-Arts in Paris or with the French government's fine art department; in architecture, an academic and eclectic style of the 19th and 20th century practiced by the École des Beaux-Arts and marked by a reuse and recombination of classical Greek and Roman styles.

Belles-lettres: literally "beautiful letters" (French). Refers to literature that is considered light, refined, and purely aesthetic.

Belt Course: a continuous row or layer of stones or another material decorating the face of a wall, such as a molding. Also called a stringcourse or band course.

Berdache: literally "male prostitute" (Arabic); term used by anthropologists to refer to Native American gender-mixing individuals.

Black Power Movement: a political and cultural movement in the United States, most prominent in the 1960s and 1970s, that emphasized racial pride and the creation of black institutions to promote black collective interests.

Blaue Reiter: literally "Blue Rider" (German). Refers to a group of early 20th-century artists in Germany led by Wassily Kandinsky, August Macke, and Franz Marc. They emphasized child art as a source of inspiration, abstract forms, and the symbolic and psychological aspects of line and color.

Boston Tea Party: a raid on three British ships in Boston Harbor in 1773, in which Boston colonists, dressed as Native Americans, threw the contents of several hundred chests of tea into the harbor as a protest against British taxes on tea.

Brocade: a fabric with a raised pattern created during the weaving process.

Brown v. Board of Education: a 1954 decision of the United States Supreme Court which struck down earlier "separate but equal" laws for blacks and whites in public facilities and institutions.

Bulto: a carved wooden statue of a holy figure.

Burlesque: a type of popular theatrical entertainment initially marked by parody and humor in the 19th century but associated most often with female striptease in the 20th century.

Buttress: a support built against a wall of a building, either inside or out.

Cabinet: refers to a display of natural historical or anthropological "wonders" and "curiosities" that is often regarded as a precursor to the modern museum.

Calumet: a pipe whose stem is decorated with feathers.

Camera Obscura: literally "dark chamber" (Latin); a darkened box or room with a hole or lens in one side which, when light passes through it, casts an image of an object outside the box onto a ground glass screen or a sheet of paper on the opposite inside wall, which can then be traced. A precursor of the modern-day camera.

Capital: the sculpted block which crowns a classical column, pier, pilaster, or pillar.

Caricature: a picture that exaggerates the physical features of the person or object depicted.

Carpenter Gothic: North American vernacular wooden architecture of the 19th century, ornamented with fretwork in Gothic revival style.

Causeway: a road elevated on a bank of sand, rock, or other material, usually across a body of water.

Chicago School: a group of architects working in Chicago from the Great Fire of 1871 to the mid-1920s; closely connected with the evolution of the skyscraper.

Chicano/a: derived from "Mexicano"; a person of Mexican descent living in the United States. The name was adopted as a public form of self-identification and pride by Mexican American political activists in the 1960s.

Chromolithograph: a colored lithograph produced through the use of multiple lithographic stones, one for each color.

Cibachrome: a process for producing photographic color prints directly from transparencies onto photographic paper using azo dyes on a polyester base, which allows for greater image clarity and color purity.

"City beautiful" movement: an architectural movement in the 1890s and early 1900s that sought to beautify and give monumental grandeur to cities in order to create a moral and harmonious order among urban populations.

Civil Rights Act: 1964 legislation that outlawed racial discrimination in public schools, at the workplace, and in public facilities.

Clerestory: a row of windows in the upper part of a wall, usually a church, above the adjacent roof, which allows light into the room.

Codex: a folded painting or screenfold usually made of bark paper or deerskin covered with a thin coat of calcium carbonate; produced by the Aztec, Mixtec, and other Mesoamerican peoples prior to arrival of Hernán Cortés in 1519; revived in the late 16th century by Franciscan friars eager to re-create histories of indigenous populations.

Colcha: an embroidered bed covering produced in New Mexico in the 19th century.

Colchón: a folded mattress that functioned as a type of furniture in 19th-century New Mexican homes.

Cold War: an ideological rivalry after World War II between the Soviet Union and its satellites on the one hand, and the United States and other capitalist Western countries on the other.

Collage: a technique involving attaching various materials—cardboard, string, fabric, newspaper clippings, etc.—to a canvas or board, sometimes combined with painting or drawing.

Colonnade: a row of columns carrying either an entablature or a series of arches.

Color Field Painting: a style of painting, marked by large fields of flat colors applied with a brush or stained into the canvas, which emerged in the U.S. in the late 1940s and 1950s.

Combine: a term coined by Robert Rauschenberg which describes an extension of the principle of collage, in that flat or three-dimensional found objects are attached to the surface of the composition, and are either painted over or left in their natural state.

Communism: a theory or system of social organization based on the communal ownership of all property.

Conceptual Art: art of the 1960s to 1980s that was created according to the following principles: art consists of an idea or concept and does not have to be embodied in a physical form; language is the basic material of art; artistic activity becomes an enquiry into the nature of art itself.

Congregationalist: a Protestant sect in which every local church congregation is independent and self-governing.

Contraband: a term used in the American Civil War to describe escaped slaves who enlisted in the Union Army and, as they were considered property by their owners, were viewed as "confiscated" property by Union officers.

Contrapposto: literally "placed opposite" (Italian); a way of representing the various parts of the body so that they are obliquely balanced around a central vertical axis. First developed by classical Greek sculptors as a means of avoiding stiffness and suggesting impending action (often one leg is straight, while the other is bent, with the upper torso and head rotated to the left or right).

Coquina: shell-limestone that was used to construct fortifications in New Spain.

Corinthian: *see* orders of architecture.

Cornice: the top register of the entablature that includes a projected molding.

Counting coup: within Native American Plains warfare, the act of touching an enemy during battle with a special coup pole rather than injuring or killing him.

Craft: also referred to as applied arts; a classification of art production that includes needlework, ceramics, metalwork, etc.

Crenellation: a parapet with alternate solid parts and openings.

Cubism: the first abstract art style of the 20th century. Represents objects, landscapes, and people as many-sided (or many-faceted) solids in an attempt to represent fully and exhaustively on a flat surface all aspects of what the artist saw in three dimensions.

Cult of Domesticity: a 19th-century Western understanding of the role of women that anchored their identity in the ability to manage a home and raise children.

Culture Wars: refers to a cultural struggle between political conservatives and liberals in the 1980s in the United States over the legitimacy of certain cultural practices; manifested in the art world by criticism of artists and arts institutions, particularly the National Endowment of the Arts, by members of the religious right and other conservative groups for work they considered indecent or offensive.

Dada: the intentionally meaningless name of an anti-art movement that started in Zurich in 1916 and spread to other European centers and New York City. Dada used techniques of provocation, abstraction, and nonsense to protest the creations of Western civilization which had led to war.

Daguerreotype: the first practicable method of photography made by using light-sensitized metal plates, developed in France by Louis-Jacques-Mandé Daguerre and announced to the public in 1839.

Dawes Act: legislation passed by Congress in 1887 that offered an allotment of land and eligibility for full citizenship to every Native American male who assimilated into European American culture.

Declaration of Sentiments: a document signed by 100 attendees at the Seneca Falls Convention of 1848. It was modeled after the Declaration of Independence but declared that "all men and women are created equal"; *see* Seneca Falls Convention.

Deconstructivism: a type of architecture that emerged in the mid-1980s and focused on fragmented forms, non-rectilinear shapes, and the manipulation of certain traditional architectural principles—e.g. the relationship between the internal structure of the building and its external envelope—to create unexpected, if not unsettling, structures.

Degikup: Native American artist Louisa Keyser's (Dat So La Lee) original basket shape that swelled out from a narrow base then curved inward to an open neck slightly wider than the base.

Dome: a hemispheric vault that forms the roof of a building or part of a building.

Dominican: a Catholic order founded in 1216.

Doric: *see* orders of architecture.

Dormer: a structure projecting from a sloping roof, usually housing a window or ventilating louver.

Earthwork: term used from the mid-1960s to describe works of art, either in art galleries or in the open, which make use of such natural materials as earth, rocks, turf, and snow.

Eclogue: an idyllic pastoral poem.

Eight, The: a group of eight American artists who came together in 1907 and, though they painted in different styles, shared a common revolt against Academic art and were determined to bring painting back into contact with ordinary life.

Emancipation Proclamation: a proclamation made by U.S. President Abraham Lincoln on January 1, 1863 freeing all slaves in the states that were still fighting against the Union Army.

Encaustic: a painting technique that originated in ancient times, using pigments mixed with hot wax as a binder.

Enlightenment: a philosophical movement of the 18th century, primarily in Western Europe, influencing intellectual, scientific, and cultural life. Characterized by belief in the power of human reason.

Entablature: the elaborated superstructures carried by the columns in classical architecture, horizontally divided into architrave, frieze, and cornice; may connote similar features in other contexts, such as along the upper portions of walls.

Entasis: the convex curvature, usually very slight, of the shaft of a column.

Episcopal: a Protestant church that originated within the Church of England and that teaches that the roots of Christian belief are the Bible, church tradition, and individual reason.

Equestrian: refers to a painting or sculpture in which the main figure is on horseback.

Estípite: a form that stands in for the shaft of a column but is so extensively carved that its role is purely for decoration, not support.

Executive Order 9066: a presidential order signed and issued on February 19, 1942 by U.S. President Franklin D. Roosevelt as a response to the bombing of Pearl Harbor, Hawaii by the Japanese on December 7, 1941. It ordered the relocation of Japanese Americans living on the West Coast to internment camps.

Existentialism: a philosophical movement of the 19th and 20th centuries that stresses the unique position of the individual person as a self-determining agent responsible for their own choices.

Expressionism: an artistic movement that originated in Germany in the early 20th century in which the forms arise, not directly from observed reality, but from subjective reactions to reality.

f.64: a group of photographers founded in 1932 who produced pristine, sharp-edged photographs in contrast to the more atmospheric work of the Pictorialist photographers of the time; named for the smallest aperture setting on a camera, which produces the greatest and sharpest depth of field.

Facade: the main face of a building, or the side that is most emphasized architecturally.

Farm Security Administration (FSA): a U.S. federal agency that existed from 1935 to 1944 as part of President Franklin D. Roosevelt's "New Deal" administration. The FSA encouraged rural rehabilitation efforts and was well known for its photography program depicting the devastation of the Great Depression.

Fasces: a bundle of rods, often containing an ax with the blade projecting outward, created during the ancient Roman Republic to symbolize Roman political office, and since used to indicate either summary power or strength through unity.

Fascism: a system of government led by a single dictator who forcibly suppresses opposition, controls all industry and commerce, and emphasizes an aggressive nationalism.

Fauves: literally "wild beasts" (French); refers to the artists of an early 20th-century French movement characterized by their use of fierce, nonrealistic color and bold, apparently crude draftsmanship.

Favrile Glass: a multicolored iridescent glass invented and manufactured by the American artist Louis Comfort Tiffany in the late 19th century; created by mixing together different colors of glass when hot.

Federal Art Project of the Works Progress Administration (FAP/WPA): the federal program that existed from 1935 to 1943 as part of President Franklin D. Roosevelt's "New Deal" administration. The Project was founded to provide support to artists based on financial need.

Federal Style: a streamlined version of neoclassical architecture that flourished in both the East and Midwest of the U.S. in the late 18th and early 19th centuries, and was characterized by symmetry and minimal ornamentation.

Federalist: an advocate of a system of government in which power is divided between a central authority and constituent political units.

Feminism: a doctrine advocating rights for women equal to those of men in all spheres of life—social, economic, cultural, religious, political, etc.

Femme Fatale: literally "deadly woman" (French); an archetypal female character who is alluring, seductive, and dangerous to men; also known as a siren.

Figurehead: a carved full-length figure or bust built into the bow of a ship.

Fluxus: literally "to flow" (Latin); name of an international art movement founded in 1962 to unite members of the extreme avant-garde in Europe and later in America. The group had no stylistic identity and blended different artistic media. Its activities were, in many respects, a revival of the oppositional spirit of Dada.

Folk Art: a term applied to objects produced by individuals who have little or no formal training in the fine arts and who most often reside in rural communities.

Fourteenth Street School: a group of painters who took their subject-matter, often the unemployed or low-wage workers, from Union Square in New York City and the neighboring streets, including 14th Street.

Franciscan: a Catholic order founded by St Francis of Assisi that seeks to lead a life of poverty and humility.

Fresco: painting made with mineral or earth pigments on wet plaster.

Frieze: the middle horizontal member of a classical entablature, above the architrave and below the cornice, sometimes decorated with relief sculpture; by extension, any relief or painting used decoratively in a long horizontal format.

Futurism: an early 20th-century artistic and literary movement founded by the Italian writer F. T. Marinetti. It celebrated speed, war, and the technological world of the future.

Gable Roof: in its simplest form, a symmetrical two-sided roof with one slope on each side. A gable is the generally triangular portion of a wall between the edges of a sloping roof.

Gambrel Roof: a symmetrical two-sided roof with two slopes on each side, with the upper slope positioned at a shallow angle in order to maximize head space while the lower slope is quite steep.

Geneva Convention: a 1949 agreement that updated the standards in international law for humanitarian treatment of victims of war.

Genre Paintings: scenes of everyday life.

Ghost Dance Movement: a late 19th-century Native American movement founded by the Paiute visionary Wovoka. Followers prophesized the future nonviolent disappearance of white people, and the return of the land to the indigenous peoples.

Gilded Age: term coined by Mark Twain and Charles Dudley Warner in their book *The Gilded Age: A Tale of Today* (1873). Refers to the U.S. in the period *c.* 1870–98, which was characterized by a greatly expanding economy and the increasing concentration of wealth in the hands of a small number of individuals who exerted strong influence in government and society.

Globalization: the integration of regional economies, societies, and cultures through a global network of communication, transportation, and trade.

Gothic: refers to European art of the 12th to 15th century, but especially describes architecture using pointed arches, rib vaults, and flying buttresses.

Gouache: painting in opaque watercolors, in which the pigments have a gum binder, and the filler is invariably some form of opaque white which gives a typical "chalky" look.

Great Depression: the economic crisis in the United States and Europe that began with the stock market crash in October 1929 and continued through the 1930s.

Gulf of Tonkin Resolution: a joint resolution of the United States Congress passed in 1964 that gave President Lyndon B. Johnson the authority to use military force in Vietnam without a formal declaration of war by Congress.

Happening: an art event that synthesizes both planned and improvised theatrical activity with the visual arts and found materials, and often invites audience participation. Happenings began to occur in the late 1950s.

Harlem Renaissance: also known as the New Negro Arts Movement. A literary and artistic movement based mainly in Harlem, New York in the mid-1920s that sought to combat racism and showcase the range of talents within African American communities.

Hicksite: a sect of the Quaker tradition that emerged in the 1820s in the U.S., led by Elias Hicks. Characterized by the resistance to a focus on "correct" interpretation of biblical texts and the

life and death of Christ in favor of an emphasis on individual revelation as one's primary spiritual guide.

Horror Vacui: literally, "fear of empty spaces" (Latin). Refers to the filling of the entire surface of an artwork with details.

House Un-American Activities Committee (HUAC): also referred to as House Committee on Un-American Activities; a committee of the House of Representatives, active from 1938 to 1975, that investigated and persecuted ostensibly pro-Communist individuals and organizations.

Hudson River School: a mid-19th-century school of American landscape painting influenced by the Romantic movement of the late 18th and early 19th century. Focused on scenes of the Hudson River Valley and surrounding area.

Huguenot: French Protestants, followers of the theologian John Calvin, who reject the sacramental rituals of the Roman Catholic Church and focus on the ability of the individual to gain redemption through faith and study of the Bible.

Impasto: the thick texture produced by heavily applied paint.

Impressionism: a 19th-century movement in painting, principally practiced by French artists, that sought to capture a fleeting impression of color and light.

Indian Detour: a joint venture, begun in the 1920s, of the Fred Harvey Company and the Santa Fe Railway that allowed tourists to travel from railroad depots to major Hopi villages to observe the Native American way of life.

Indian Removal Bill: 1830 legislation that forced the removal of Native Americans east of the Mississippi River to the Plains area to the west, despite treaties guaranteeing them the rights to their lands.

Ionic: *see* orders of architecture.

Japonaiserie: European imitations of Japanese arts and crafts; also a term that refers generally to the Japanese products that appealed to Europeans after the opening of Japan to trade in the 19th century.

Japonisme: refers to the influence of the formal qualities of Japanese art on European art.

Jeffersonian: an advocate of the doctrines of Thomas Jefferson, especially those stressing minimum control by central government, the inalienable rights of the individual, and the superiority of an agrarian economy and rural society.

Jerga: a roughly woven cloth found in 19th-century New Mexican homes.

Jesuit: an evangelizing Catholic order founded by St Ignatius of Loyola in 1534, known particularly for its work in the field of education.

Junk Art: also known as proto-Pop. A variety of assemblages from the late 1950s made out of discarded industrial items and the detritus of modern consumer culture.

Katcina: a supernatural spirit representing the forces of nature (including clouds, rain, animals, and plants) invoked in ritual ceremonies of Pueblo cultures.

Kitsch: mass-produced objects that imitate the aesthetic products of elite culture.

Kiva: a large circular or rectangular underground structure that is the spiritual and ceremonial center of Pueblo cultures of the U.S. Southwest.

Ku Klux Klan: a group of white Americans founded in 1866 to terrorize African Americans and prevent

them from exercising the new freedoms they had achieved as a result of the defeat of the South in the American Civil War.

Land Art: *see* earthwork.

Latia: small piece of wood laid between roof beams in Franciscan mission churches.

Ledger Art: drawings made primarily by Native Americans in the Plains regions in the mid- to late 19th century, so called because the paper often came from accountants' ledgers.

Lintel: a horizontal beam carried by two or more posts or vertical supports to form an architectural opening.

Lithograph: a print made by drawing with a fat- or oil-based medium, such as a wax crayon, onto a smooth stone or metal plate that is then wetted.

Loggia: in both churches and secular buildings, a kind of exterior corridor, communicating with the open air through an arcade or colonnade.

Loyalist: a person who supported the British cause in the American Revolution of 1775–83.

Luminism: name given in the 20th century to a 19th-century style of American landscape painting characterized by a focus on the atmospheric qualities of light and on a mood of calm or tranquillity.

Lynching: punishment carried out by a mob, outside any legal framework, most often by hanging and frequently accompanied by various forms of torture, in order to control and intimidate select groups of people. In the U.S., African Americans have been the most common victims of lynchings.

Maltese cross: a cross in which all four arms are of equal length.

Mammy: also Dinah; a pejorative term which refers to a stereotyped female African American servant, most often represented as fat and sexless, with her head covered by a kerchief.

Manifest Destiny: the 19th-century doctrine that it was the destiny and right of the United States to expand westward across the continent.

Mannerism: term coined to describe European art of the 16th century typified by stylistic trickery or the contradiction of classical rules and a liking for bizarre effects.

Manta: a blanket or poncho originally made and worn by indigenous peoples of New Mexico.

Marau Society: an all-female society in the Pueblo cultures of the American Southwest, also known as Mamzrautu; *see also* pueblo.

Marginella: a type of small, polished, marine shell.

Marxism: a system of economic and political thought, developed by Karl Marx, that argues that the capitalist system will be overthrown by a socialist revolution resulting in a future classless or communist society.

Matrilineal: refers to a culture in which property is passed from mother to daughter.

Matrilocal: refers to a culture in which men move to the homes of their wives when they marry.

Memento Mori: any symbol, such as a skull or hourglass, designed to remind the viewer of the transience of human life.

Mestizo: a Spanish term for a person of mixed Native American and European, usually Spanish, racial background.

Methodist: a Protestant sect that stresses both personal and social morality.

Mexican Mural Movement: a movement originating in Mexico City in the 1920s, in which artists created a new kind of public art throughout the country under the patronage of José Vasconcelos, Minister of Education.

Mezzotint: a method of engraving on copper or steel by burnishing or scraping away a uniformly roughened surface, creating pits that can hold ink.

Millennialism: the belief associated with the Second Great Awakening of the late 18th and early 19th century that the thousand years of peace predicted in the Bible were imminent in America.

Minimalism: term coined in the 1960s to describe art that abandons all pretensions either to expressiveness or illusion, and which is generally three-dimensional and often made up of simple geometrical forms.

Modernism: general name given to the succession of avant-garde styles in art and architecture that have dominated Western culture from the mid-19th to the late 20th century.

Modernity: most often used to refer to a period beginning around the 16th century marked by a move from a feudal or agrarian society dominated by religious institutions to a capitalist industrial society where science, reason, and individualism are celebrated and secular institutions have primary importance in the ordering of daily life.

Moldings: decorative strips or edgings, which may be either concave or convex, and plain or patterned.

Morada: Spanish word for a chapel, often decorated with artworks commissioned from santeros (*see* santero). In New Mexico, the structure associated with the Catholic confraternities known as the Penitente.

Moravian: a Protestant movement founded in the United States by immigrants from Moravia in the modern-day Czech Republic.

Mormonism: a religious movement founded by Joseph Smith, Jr. in the 1830s. Its beliefs are based on the Book of Mormon, a sacred text on the history of the Americas believed to have been written by an ancient prophet.

Mosaic: a design made by cementing small pieces of glass, ceramic, stones, marbles, etc. to a base.

Muckraker: a reporter who writes truthful reports on social issues, often associated with the pro-reform attitudes of the Progressive Era in the late 19th and early 20th century.

Mulatto: a person of mixed black and white racial background.

Mural: a painting made directly on a wall, or fastened permanently to a wall.

Nahuatl: the language of the Aztec peoples of central Mesoamerica.

National Endowment for the Arts (NEA): a federal agency founded in 1965 that offers support and funding for artists and art institutions; almost all grants to individual artists ended in 1996.

National Socialism: also Nazism; a German variety of Fascism, espoused by Adolf Hitler's government from 1933 to 1945. Its policies were based on biological racism and anti-Semitism.

Nature Morte: French term for still life painting.

Nave: the long central space of a Christian church.

Négritude: an early 20th-century philosophy that promoted the unity of peoples of African descent, affirmed black culture, and explored the civilizations of black Africa.

Neoclassicism: a late 18th- and early 19th-century revival of classical Greek and Roman iconography, style, and decorative motifs; also called classical revivalism.

Neo-Expressionism: figurative art style, largely a revival of early 20th-century German Expressionist forms, that emerged in the U.S., Italy, and West Germany during the late 1970s.

Neogothic: architectural style reviving the Gothic, prominent in England and the United States in the 18th and 19th centuries.

New Deal: the policies introduced by President Franklin D. Roosevelt in the early 1930s, designed to promote economic recovery from the Great Depression.

New Negro: a term used in the early 20th century to refer to a new generation of educated and politically astute African Americans who argued eloquently and organized effectively for the rights of black men and women.

New Woman: used in the late 19th and early 20th century to describe a woman who pushed against the limits of a male-dominated society and who argued for women's independence and equality with men.

Nineteenth Amendment: an amendment to the U.S. Constitution, ratified in 1920, granting women the right to vote.

Oculus: a small circular opening in a wall or dome.

Odalisque: a female slave in a Middle Eastern harem, adopted as a subject by 19th- and 20th-century artists as a conventional type of the voluptuous female nude or semi-nude, often with the addition of "Oriental" accoutrements.

One-point Perspective: a method of projecting an illusion of the three-dimensional world onto a two-dimensional surface, in which all parallel lines or lines of projection seem to converge on one point, known as the vanishing point, and associated objects are rendered smaller the farther from the viewer they are intended to seem.

Orders of Architecture: a system devised by the Roman architectural historian Vitruvius (first century BCE) to categorize the various types of classical architecture, founded on three standard types of columns, together with their bases, plinths, capitals, and entablature:
The *Doric order* is the oldest, plainest, and sturdiest-looking, with a fluted column and plain circular capital.
The *Ionic order* has a slenderer column and a capital with symmetrical volutes (scroll-shaped ornaments).
The *Corinthian order* has a capital that represents an acanthus (Mediterranean plant) growing in a basket.

Panorama: a wide-angle view of a space that became a popular way to depict landscapes in the 19th century; often displayed in a room where the viewer was surrounded by the canvas or in a theatrical setting where the long canvas was slowly unrolled.

Pantograph: a mechanical copying machine.

Papier-maché: literally "chewed paper" (French). Pulped paper, usually combined with glue, chalk, and sometimes sand, that can be shaped by molding and then baking.

Patrilineal: a culture in which property is passed from father to son.

Patriot Act: 2001 legislation which reduced restrictions on intelligence gathering by the U.S. authorities, including the ability to search private records, and broadened the discretion of law enforcement and immigration authorities in detaining and deporting immigrants suspected of terrorism-related acts.

Pattern and Decoration: also known as P + D. A movement in painting and mixed media in which designs drawn from domestic sources, particularly textiles, were self-consciously appropriated and celebrated in large artworks.

Pediment: triangular gable wall above the horizontal cornice of a classically treated building; also a triangular or roughly triangular element, sometimes curved, or broken at the center, surmounting a portico or opening.

Peristyle: a continuous colonnade around a building; also an open court surrounded by a colonnade within a building.

Photorealism: also Superrealism; art of extreme verisimilitude associated with the United States in the 1970s which, in painting, is usually based on the direct copying of photographs.

Photo-Secession: also known as 291. A 20th-century American photography movement, led by Alfred Stieglitz, that sought to establish photography as an independent and autonomous means of artistic expression.

Phrygian Bonnet: also known as a liberty cap. A soft conical cap with the top pulled forward, used by artists to represent freedom and liberty. It is named for the inhabitants of ancient Phrygia (in modern-day Turkey).

Pictograph: a picture, usually stylized, that represents an idea or conveys a meaning.

Pictorialism: a photographic movement that emerged around 1885 and taught that photography should emulate the techniques found in painting.

Picturesque: a tradition in landscape painting, popular in the 18th and 19th centuries, that was understood as a balance between the aesthetic ideals of the beautiful and the sublime.

Pier: a large, freestanding, and rectangular pillar.

Pilaster: a pier that is attached to a wall and projects from it only slightly.

Pop art: an art movement originating in the 1950s that makes use of the imagery of consumerism and mass culture, treated with a finely balanced mixture of irony and celebration.

Popular Front: a political coalition of European and American leftist parties in the 1930s organized around an opposition to fascism.

Populism: a political philosophy supporting the rights and power of the people in their struggle against privileged elites.

Posa: a small corner chapel in the mission churches of New Spain.

Post-Impressionism: term used by the British art critic Roger Fry in 1910 to describe the work of a broad range of Western European artists (e.g. Paul Cézanne and Vincent Van Gogh) who were moving away from Impressionism's preoccupation with capturing visual appearances.

Postminimalism: also known as Anti Form. A movement originating in the 1970s that retained the formal simplifications of minimalism but sought to imbue works with a broad range of meaning and reference.

Postmodernism: term used to describe attempts to modify or move beyond the traditions of Modernism in the second half of the 20th century.

Po-wa-ha: literally "water-wind-breath" (Pueblo/Mimbres); the creative energy or breath of the world.

Prairie Style: architectural style connected most closely with Frank Lloyd Wright. It emphasized the relation of buildings to their sites and the use of natural materials.

Precisionism: an early 20th-century American movement in painting characterized by a simple, formal, and sometimes abstracted representation of industrial and architectural scenes and that avoided human reference.

Pre-Raphaelite Brotherhood: a group of English artists originating in 1848 that sought to turn painting into a moral and political act, to jettison the rules of the Royal Academy, and to return art to a closer relation with nature. Their name derived from the desire to produce work in the spirit that imbued Italian artists before Raphael's move to Rome.

Presbyterian: a Protestant movement that adheres to Calvinist doctrine and stresses the sovereignty of God and the authority of the Scriptures.

Primitive: in early 20th-century Western art, refers to the art of Africa, Oceania, and Native America, which was often celebrated for its exoticism and innocence or purity and appropriated into Modernist Western art. The term was not applied to art objects from these regions that contained evidence of contact with European cultures.

Progressive Era: the period in the United States from the 1890s to the 1920s that was characterized by sweeping reforms in political and social organizations.

Public Works of Art Project (PWAP): a federal program that existed from 1933 to 1934 and was charged with employing artists to create public works of art.

Pueblo: literally "town" or "village" (Spanish). Refers to the cultures or peoples of the Southwestern United States and Northern Mexico—e.g. the Hopi and Zuñi—who lived in multistory apartment-like structures built of adobe, stone, or other local materials and organized around central plazas.

Pullman Strike: a strike in 1894 by employees of the Pullman Palace Car Company that sparked a nationwide conflict between labor unions and railroad companies and was a pivotal event in the history of labor reform.

Puritanism: a Protestant movement that broke from the Church of England in the 16th century, advocating stricter religious discipline and a simplification of doctrine and worship.

Pylon: a tall structure used as a support, to mark a boundary, or as decoration.

Quaker: also the Religious Society of Friends; a Protestant movement that teaches that all members of the religious community are equals, eliminating the hierarchies common in other Christian groups.

Readymade: term coined by Marcel Duchamp around 1913 to describe an everyday mass-produced object removed from its normal context and treated as a work of art.

Realism: a style that involves a close investigation of particulars and transmits a sense of concreteness, veracity, and the randomness of the world being depicted.

Reconstruction: the period from 1865 to 1877 following the American Civil War, when the victorious North attempted to "reconstruct" the state and society of the former southern Confederacy, in particular through the abolition of the institution of slavery.

Red Scare: refers to a period from approximately 1947 to 1957 of strong anti-communist sentiment in the United States that resulted in widespread persecution by the government and several non-governmental organizations of individuals with radical, or even liberal, political views.

Regionalism: the work of a small group of North American artists of the 1930s and 1940s who concentrated on rural Midwestern subject-matter and claimed to reject most forms of European influence.

Register: in painting, refers to the ground line on which figures stand in a composition.

Relief: a composition or design made so that all or part of it projects from a flat surface. High relief is carved deeply enough to suggest that the main parts of the design are almost detached from their support; low relief is carved so that the figures project less than half their true depth from the background.

Renaissance: a period of cultural and artistic change in Europe, centered in Italy from the 15th to the 17th century. In architecture, a style characterized by the revival of classical elements, with an emphasis on symmetry, proportion, and geometric forms.

Retablo: Spanish word for a painted or carved altarpiece constructed for monasteries in New Spain.

Robber Baron: a powerful capitalist during the Gilded Age who was considered to have become wealthy by exploiting natural resources and workers, corrupting legislators, or other unethical means.

Romanesque: a term used to describe pre-Gothic art and architecture in Europe from the 8th to the 12th century. Typified by the use of round arches and conspicuously heavy construction.

Romanticism: a cultural movement originating in the second half of the 18th century in Europe and influencing American artistic and intellectual life in the early 19th century. It constituted the rejection, in part, of the celebration of scientific rationalization in favor of a belief in emotion, often as inspired by nature, as the authentic source of aesthetic experience.

Rotunda: a circular building or interior space, usually covered by a dome.

Salón de Recibo: Spanish term for the parlor in 19th-century New Mexican homes.

Sampler: a long and narrow strip of cloth containing "samples" of needlework stitches with designs and lettering that vary in complexity; in the mid-18th century in the U.S. they began to include narrative texts, often drawn from the Bible, and pictorial compositions.

Santa Fe Style: a style in architecture and interior design that combines the celebration of the handcrafted object with the distinct forms of Hopi, Zuñi, and Navajo artistic production.

Santero: literally "saint-maker" (Spanish); a creator of altarpieces depicting Catholic saints.

Sarape: a woven poncho found in New Mexican homes.

Second Great Awakening: a period of great religious revival in the late 18th and early 19th century in the United States.

Section of Painting and Sculpture of the Treasury Department: the federal program that existed from 1933 to 1939 to award employment to artists based on open competitions and commissions.

Seneca Falls Convention: the first women's rights convention, held in 1848 and attended by approximately 300 men and women.

Shaker: a member of the Millennial Church that originated in England in the middle of the 18th century and was brought to the U.S. in 1774 by Ann Lee. Shakers were so called for the practice of shaking during religious services. They advocated celibacy, common ownership of property, and a strict and simple way of life.

Silhouette: a profile of a human face cut out of black paper.

Sipapu: among Pueblo peoples, a shallow hollow in the center of a kiva floor that represented the earth's navel or the place through which the people emerged from the underworld and through which they would return; see also kiva, pueblo.

Social Realism: a term used to describe paintings of the life of the lower classes in the 20th century.

Social Reform Movement: a movement in the last quarter of the 19th century in which reformers called for shorter work hours, improved working conditions, and a minimum wage.

Social Surrealism: art created largely during the 1930s and early 1940s that transformed Surrealism by adding explicit references to contemporary political struggles; see Surrealism.

Socialism: an economic and political theory that advocates public ownership and cooperative management of a community's means of production.

Socialist Realism: pronounced as a dogma for all Soviet artists in all fields of art in 1934. Refers to art made comprehensible to the masses using realistic and naturalistic artistic traditions and designed to inspire people with admiration for the dignity of the working man and woman and their efforts to build Communism.

Stamp Act: legislation passed by the British Parliament in 1765 authorizing a direct tax on many printed materials in Britain's American colonies; such materials were to be produced on paper made in London and carrying an embossed revenue stamp.

Stereograph: a card on which two copies of the same image, usually a photograph, are printed to be viewed through a stereoscope.

Stereoscope: a technology invented in the 19th century as a means of looking at two copies of the same image, perceived differently by the right and left eyes so that they appear to be a single three-dimensional image.

Stringcourse: see belt course.

Sublime: in art, the creation of a sense of wonder and sometimes terror in the face of an awesome power, whether natural or technological.

Surrealism: a movement founded by the French writer André Breton in 1924 that claimed to liberate the unconscious through dreaming and the suspension of conscious control. Two main types of painting were produced: fantastic or enigmatic dreamscapes, and more abstract images achieved through automatism.

Synchronism: an early 20th-century American movement that stressed the importance of color, which was believed to be enough in itself to provide the content of an artwork.

Tapestry: hand-woven fabric, usually of silk or wool or a mixture of the two, with a non-repetitive design, usually figurative, which is woven in as it is made.

Tempera: a painting technique in which pigment is mixed with a binder, normally the yolk of an egg or both white and yolk together, thinned with water, and applied to a surface prepared with a gesso (a form of plaster) ground.

Teocalli: a sacred pyramid in Aztec culture.

Tequitqui: literally "one who pays tribute" (Nahuatl). Art produced by Native artists in the service of Christianity that synthesized the imagery and style of their own native practice with newly introduced European forms.

Theorem: a style of painting in which the artist uses several stencils to outline the basic shapes of the composition and then adds details.

Thirteenth Amendment: the 1865 amendment to the U.S. Constitution that abolished slavery.

Tintype: a photograph on a small plate of tinned iron that was cheaper and easier to handle than glass negatives or positives and, if used for portrait photography, the resulting print from which could be handed to the sitter within a few minutes of the exposure being made.

Tlacuilos: literally "painter" or "scribe" (Nahuatl). Refers to an Aztec codex painter, probably from a noble caste and trained in special schools.

Tonalism: an American style of landscape painting that emerged in the 1880s and was marked by an overall tone of colored atmosphere or mist.

Tory: a member of a political party in Great Britain from the late 17th century to about 1832. The Tories sought to preserve the existing social and political order, and believed in royal authority over the power of Parliament.

Totem: an animal that is adopted and identified as the symbol of a clan.

Transcendentalism: a mid-19th-century philosophical and literary movement that believed in contemplation and spirituality as a means of achieving transcendence over the empirical and scientific.

Transept: a part of a building, particularly a church, that lies across or at a right angle to the main axis.

Treasury Relief Art Project (TRAP): a federal program that existed from 1935 to 1938 as part of President Franklin D. Roosevelt's "New Deal" administration. It was founded to replace the Public Works of Art Project (PWAP) and to provide support to artists based on financial need.

Trefoil: a decorative design with three lobes, particularly a three-lobed shape in Gothic architectural design.

Trompe l'oeil: literally "fools the eye" (French). A type of painting, usually a still life, which by means of various illusionistic devices persuades the spectator that he or she is looking at the actual objects represented.

Truncated Pyramid: a pyramid constructed from a series of steplike platforms.

Tympanum: the triangular area enclosed by a classical pediment.

Unitarian: a religious denomination that teaches that God is one being, rejecting the traditional Christian doctrine of the Holy Trinity.

Ursuline: a Roman Catholic order of nuns founded in Italy in 1535 and dedicated to St Ursula. The order emphasizes the importance of teaching young girls and caring for the sick and the poor.

Vanitas: an allegorical still life in which all the objects depicted are meant to be reminders of the transience of human life.

Vaquero: a cowboy, typically in the Southwest of the U.S.

Viga: a wooden beam used to construct roofs in Franciscan mission churches.

Virtual Reality: a computer-generated, three-dimensional environment that simulates real images and experiences.

Volute: a scroll-shaped architectural ornament, such as those found in pairs on Ionic capitals.

Voting Rights Act: 1965 legislation that outlawed racist discrimination in U.S. electoral practice.

Wampum: strings or woven belts made by the Iroquoians and the Algonquians that are composed of white and purple or black shells strung in various designs. They serve most often as reminders of the terms of treaties or trade negotiations.

War Relocation Authority (WRA): the U.S. government agency established to handle the internment of Japanese Americans during World War II.

Whig: a member of a political party in Great Britain from the late 17th century to about 1832. The Whigs held liberal principles and favored reform. Also refers to members of the patriotic party during the Revolutionary period.

Wigwam: an oblong- or dome-shaped hut common among the native peoples of the eastern woodlands of the United States and as far west as the Mississippi River.

Winter Count: an account of a Native American man's life told through one event from each winter.

Women's suffrage movement: the reform movement begun in the middle of the 19th century that sought the right for women to vote, eventually won in 1920.

Works Progress Administration (WPA): a federal agency existing from 1935 to 1943 that was charged with instituting and administering public works during the Great Depression in order to relieve national unemployment.

Ziggurat: a stepped pyramid with a temple built on top.

Zoopraxiscope: an early type of motion-picture projector, invented by Eadweard Muybridge around 1881, which projected images serially onto a screen.

Acknowledgments for Illustrations

The author and publishers are grateful to the individuals and institutions cited in the captions. Additional credits and information are given below.

Page 2 Photo courtesy of Melissa Dabakis Map of North America drawn by Martin Lubikowski 1.1, 1.45 Collection des Ursulines de Québec, Musée des Ursulines, Québec 1.2 Drawn by Philip Winton, with reference to Martin Gilbert, *Atlas of American History* (Dorset Press, 1985) for the peoples, and Janet C. Berlo and Ruth B. Phillips, *Native North American Art* (Oxford and New York: Oxford University Press, 1998) for the regions 1.3 Drawn by Philip Winton 1.10 Courtesy Fred R. Kline Gallery & Kline Art Research Associates, Santa Fe, New Mexico 1.11 Colección Hancock Sandoval, Propriedad del Centro de Estudios de Historia de México 1.12 Photo South American Pictures/Tony Morrison 1.13 Library of Congress, Washington, D.C. 1.14 Drawn by Simon S. S. Driver 1.15 Drawn by Sue Cawood 1.16 Photo O. C. Havens, National Geographic Society 1.17 Photo W. Belknap, Boulder City, Nev. 1.18 Drawn by Robert Easton 1.19 Peabody Museum, Harvard University, Cambridge, Mass. 1.20 Colorado Springs Fine Arts Center 1.21 Photo Wittick 1.22 Photo Ernest Knee, Museum of International Folk Art, Santa Fe, N.M. 1.23, 1.24 Photo David Wakely, San Francisco 1.25 Museum of International Folk Art, Santa Fe. Fred Harvey Collection. Photo Blair Clark 1.27 Photo David Wakely, San Francisco 1.28 Photo Robert H. Martin 1.29, 1.30 Photo David Wakely, San Francisco 1.31 Photo Sandak 1.32, 1.33 Arizona State Museum, University of Arizona, Photographer: Helga Teiwes 1.38, 1.39 Photo David Wakely, San Francisco 1.45 see 1.1 1.46 Collection des Ursulines de Québec, Musée des Ursulines, Québec 1.50 Chicago Historical Society 1.53 Cahokia Mounds State Historic Site, painting by William R. Iseminger 1.58 The New York Public Library; Astor, Lenox and Tilden Foundations. Bequest of James Hazen Hyde 1.59–1.61, 1.65 British Museum, London, Department of Prints and Drawings 1.66 Worcester Art Museum, Museum purchase, Sarah C. Garver Fund 1.67 Worcester Art Museum, Gift of Mr & Mrs Albert W. Rice 1.68 Society for the Preservation of New England Antiquities, Boston, Mass. 1.69 Library of Congress, Washington, D.C. 1.70 Gilbert Ask Photography 1.71 Photo Sotheby's 1.74 Worcester Art Museum, Museum purchase 1.76 Virginia Chamber of Commerce, photo Phil Flournoy 1.77 South Carolina Department of Archives and History 1.81 Museum of American Folk Art, New York, anonymous gift 1.83 Museum of American Folk Art, New York, photo Daniel Farber 1.84 National Gallery of Canada, Ottawa, transfer from the Canadian War Memorials, 1921 (gift of the 2nd Duke of Westminster, Eaton Hall, Cheshire, 1918) 1.85 Courtesy of the Pennsylvania Academy of the Fine Arts, Philadelphia. Gift of Mrs Sarah Harrison (The Joseph Harrison Jr Collection) 2.1 Photo Erik Gould, courtesy the Museum of Art, Rhode Island School of Design, Providence 2.2 Museum of Fine Arts, Boston. Anonymous gift 2.3 The Metropolitan Museum of Art, New York 2.5 Museum of Fine Arts, Boston. Andrew W. Mellon Fund 2.6 Photo courtesy of Mr and Mrs Harry Orton-Jones 2.7, 2.8 Yale University Art Gallery, New Haven, Trumbull Collection 2.9 Minneapolis Institute of Arts. Tablespoon: Gift of James Ford Bell and his family, and gift of Mr and Mrs Byron Wenger; Teapot and ladle: Gift of James F. and Louise H. Bell, Charles H. Bell, and Samuel H. Bell; Teaspoon: Gift of Charlotte Y. Salisbury, wife of Harrison E. Salisbury and great niece of John Templeman Coolidge 2.11 Courtesy of the Pennsylvania Academy of the Fine Arts, Philadelphia. Bequest of William Bingham 2.12 Peabody Museum, Harvard University, Cambridge, Mass. 2.13 The Museum of the City of New York, gift of the Seawanhaka Yacht Club 2.15 Undercroft Museum, Westminster Abbey, London, copyright: Dean and Chapter of Westminster 2.16 Virginia State Library and Archives, negative no. A9-6850 2.20 National Gallery of Art, Washington, D.C., Andrew W. Mellon Collection 2.23 Courtesy of Mount Vernon Ladies' Association 2.25 Virginia State Library and Archives, Richmond 2.26 Photo Rieley & Associates 2.27, 2.28 Library of Congress, Washington, D.C., Prints and Photographs Division 2.29 Private collection 2.30 Newberry Library, Chicago 2.31 Private collection 2.32 Photo Paul R. Thompson, Mobile, Ala. 2.33 Photo David C. Driskell 2.34 Library of Congress, Washington, D.C., Geography and Maps Division 2.35, 2.36 Bret Morgan Photography, Fairfax, Calif. 2.38 Private collection, photograph courtesy Thomas K. Woodward, American Antiques and Quilts, New York City 2.39 J. Bentham, Works, I (Edinburgh, 1843) 2.40 Virginia Department of Corrections, Richmond 2.42 *Pennsylvania Journal of Prison Discipline*, XI, April 1856 2.43–2.46 Courtesy of the Architect of the Capitol, Washington, D.C. 2.49 Wadsworth Atheneum Museum of Art, Hartford. Purchased by the Wadsworth Atheneum, accession no. 1855.4 2.52 Museum of Fine Arts, Boston. Gift of William Sturgis Bigelow 2.54 Terra Foundation for the Arts, Daniel J. Terra Collection, 1992.51; photograph courtesy of Terra Foundation for the Arts, Chicago 2.55 Courtesy of the Pennsylvania Academy of the Fine Arts, Philadelphia. Gift of Mrs Sarah Harrison (The Joseph Harrison Jr Collection) 2.57 Museum of American Folk Art, New York. Gift of William Bernhard and Catherine Cahill 2.59 Owned by the estate of Arthur S. Dewing 2.63 Museum of Fine Arts, Boston. M. and M. Karolik Collection 2.64 Museum of Fine Arts, Boston. Abraham Shulman Fund 2.65 National Gallery of Art, Washington, D.C., Andrew Mellon Fund 2.66 The Metropolitan Museum of Art, New York, gift of Edgar William and Bernice Chrysler Garbisch, 1962 2.69 Library of Congress, Washington, D.C., Prints and Photographs Division 3.2 After G. B. Tindall and D. E. Shi, *America: A Narrative History* (New York and London: W.W. Norton, 1999), Courtesy W.W. Norton & Company, Inc. 3.7 Photograph by Dawson 3.9 Wadsworth Atheneum Museum of Art, Hartford. Bequest of Daniel Wadsworth, accession no. 1848.4 3.10 The Art Institute of Chicago. Friends of American Art Collection, 1946.396. All rights reserved 3.12 The Detroit Institute of Arts. Founders Society Purchase, William H. Murphy Fund 3.13, 3.14 Courtesy The New-York Historical Society, New York City. Gift of New York Gallery of Fine Arts 3.17 Cincinnati Art Museum. Gift of Norbert Heerman and Arthur Helbig 3.18 High Museum of Art, Atlanta. Lent by the West Foundation 3.19 Free Library of Philadelphia, Rare Book Department 3.21 Library of Congress, Washington, D.C., Geography and Maps Division 3.24 Photo Sotheby's Picture Library, London 3.26 The Metropolitan Museum of Art, New York. Bequest of Margaret E. Dows, 1909 3.28 © The Cleveland Museum of Art, 2001, Mr and Mrs William H. Marlatt Fund, 1965.233 3.29 Cape Anne Historical Museum, Gloucester, Mass. 3.30 National Gallery of Art, Washington, D.C., gift of Frederick Sturges Jr 3.31 Amon Carter Museum, Fort Worth, 17.77 3.32 The Metropolitan Museum of Art, New York, Rogers Fund 1907 3.34 Photo Art Resource/Scala 3.40 Drawings by Mary Butler, from John Canfield Ewers, *Plains Indian Painting, A Description of an Aboriginal American Art* (Palo Alto, Calif.: Stanford University Press, 1939) 3.43 The National Museum of Denmark, Copenhagen, Department of Ethnography 3.48 National Gallery of Art, Washington, D.C., gift of Mrs Huttleston Rogers 3.53 Courtesy of the Pennsylvania Academy of the Fine Arts, Philadelphia. Gift of Mrs Sarah Harrison (The Joseph Harrison Jr Collection) 3.54 Brooklyn Museum of Art, A. Augustus Healy Fund, 70.26 3.55 Private collection. Photo National Museum of American Art, Institution, Washington, D.C. 3.59 Smith College Museum of Art. Purchased with funds given anonymously by a member of the class of 1952 3.62 Ackland Art Museum, The University of North Carolina at Chapel Hill, The William A. Whitaker Foundation Art Fund 3.67 Photo © 2001 President and Fellows of Harvard College 4.2 Wadsworth Atheneum Museum of Art, Hartford. The Ella Gallup Sumner and Mary Catlin Sumner Collection Fund, accession no. 1985.7 4.6 Drawn by Philip Winton 4.17 Courtesy of the Architect of the Capitol, Washington, D.C. 4.20 The Detroit Institute of Arts. Gift of Mrs Jefferson Butler and Miss Grace Conover 4.25 Brooklyn Museum of Art, Gift of Miss Gwendolyn O.L. Conkling, 40.59.B 4.26 The

Metropolitan Museum of Art, New York; gift of Erving and Joyce Wolf, 1982 4.28 The Fine Arts Museum of San Francisco. Gift of Mr and Mrs John D. Rockefeller III 4.30 National Archives, Washington, D.C., Audio-Visual Division 4.31 George Eastman House Collection, Rochester, N.Y. 4.33 Library of Congress, Washington, D.C., Prints and Photographs Division 4.34 The Metropolitan Museum of Art, New York. Gift of Mrs Frank B. Porter, 1922 4.35 Smithsonian American Art Museum. Gift of William T. Evans 4.38 Wadsworth Atheneum Museum of Art, Hartford. Gift of Mrs Josephine M. J. Dodge, accession no. 1900.8 4.41, 4.42, 4.44 Library of Congress, Washington, D.C., Prints and Photographs Division 4.54 National Museum of the American Indian, New York/Bridgeman Art Library 4.56 Smithsonian Museum of American Art, Washington, D.C. Gift of Mrs Armistead Peter III 4.57 Library of Congress, Washington, D.C., Prints and Photographs Division 5.1 Photo The Bridgeman Art Library, London 5.3 Museum of Fine Arts, Boston. Henry M. and Zoë Oliver Sherman Fund 5.5 Courtesy of the Architect of the Capitol, Washington, D.C. 5.6 Yale University Art Gallery, New Haven. Bequest of Stephen Carlton Clark, B.A., 1903 5.8 The Fine Arts Museums of San Francisco. Gift of Mr and Mrs John D. Rockefeller III 5.9 Gravure from Select Chicago (New York: A. Witteman) 5.10 Photograph by S. R. Stoddard, 1890. Library of Congress, Washington, D.C., Prints and Photographs Division 5.11 Library of Congress, Washington, D.C., Prints and Photographs Division 5.12 Courtesy of the Pennsylvania Academy of the Fine Arts, Philadelphia. Charles Bregler's Thomas Eakins Collection. Purchased with the partial support of the Pew Memorial Trust 5.13 Philadelphia Museum of Art, Philadelphia. Gift of the Alumni Association to Jefferson Medical College in 1878 and purchased by the Pennsylvania Museum of the Fine Arts and the Philadelphia Museum of Art in 2007 with the generous support of some 3,600 donors. 2007-1-1 © 2012 Photo The Philadelphia Museum of Art/Art Resource/Scala, Florence 5.14 Courtesy of the University of Pennsylvania Art Collection, Philadelphia 5.15 The Metropolitan Museum of Art, New York. Alfred N. Punnett Fund and gift of George D. Pratt 5.17 Boston Public Library, Print Department 5.19 The Museum of the City of New York. The Harry T. Peters Collection 5.24 Courtesy of the Pennsylvania Academy of the Fine Arts, Philadelphia. Gift of Homer F. Emens and Francis C. Jones 5.25 Photo courtesy R. H. Love Galleries, Inc. 5.27 Photo Emily Lane 5.28 Photo Wayne Andrews/Esto 5.29 The Metropolitan Museum of Art, New York, The Richard and Gloria Manney Parlor 5.30 National Gallery of Art, Washington,D.C., the Harris Whittemore Collection 5.32, 5.33 Photo Art Resource/Scala 5.34 Brooklyn Museum of Art, Gift of Mrs Carll H. De Silver in memory of her husband, 13.50 5.37 George Eastman House Collection, Rochester,

N.Y. 5.38 © The Cleveland Museum of Art, 2001, gift of Mrs Boudinot Keith, in memory of Mr and Mrs J.H. Wade, 1921.1239 5.40 National Gallery of Art, Washington, D.C. Gift of Curt H. Reisinger 5.43 Photo RMN-Arnaudet; J. Schormans (photographer) 5.44 Photo Giraudon, Paris 5.45 Smithsonian American Art Museum, Washington, D.C. Bequest of Henry Ward Ranger through the National Academy of Design 5.47 Wadsworth Atheneum Museum of Art, Hartford. The Ella Gallup Sumner and Mary Catlin Sumner Collection Fund, accession no. 1935.236 5.48 The Metropolitan Museum of Art, New York. Purchase, Henry R. Luce Gift, 1970 5.49 The Fine Arts Museums of San Francisco. Mildred Anna Williams Collection 5.51 Collection of the Birmingham Museum of Art. Gift of the Birmingham Public Library 5.52 Library of Congress, Washington, D.C., Prints and Photographs Division 5.53 National Park Service, Yosemite National Park, Calif. 5.54 The Museum of the City of New York. The Jacob A. Riis Collection 5.55 Metropolitan Museum of Art Archives, New York 5.56 From H. H. Bancroft, The Book of the Fair (1893) 5.57–5.59 Photo Chicago Architectural Photographing Co. 5.60 Photo Hedrich-Blessing, Chicago 5.61 Chicago Historical Society 5.62 Photograph by C. D. Arnold. The Art Institute of Chicago 5.63 Private collection 5.64 The Art Institute of Chicago 5.65 Cincinnati Art Museum. Gift of Mrs Roy D. Kercheval 5.66 Brooklyn Museum of Art, Gift of Ethel Brown, 56.32 5.68 The Metropolitan Museum of Art, New York. Gift of Hugh J. Grant, 1974 5.69 Photograph by the Souvenir Photo Co. Library of Congress, Washington, D.C., Prints and Photographs Division 5.70, 5.71 Chicago Historical Society 5.72 The Carnegie Museum of Art, Pittsburgh. Patrons Art Fund 5.73, 5.74 National Gallery of Art, Washington, D.C. Chester Dale Collection 5.75 Library of Congress, Washington, D.C., Prints and Photographs Division 5.76 Photo National Museum of American Art, Smithsonian Institution, Washington, D.C. 5.77 The Philadelphia Museum of Art. The W. P. Wilstach Collection 5.78 Collection of Hampton University Museum 5.80 Photo Smithsonian American Art Museum/Art Resource/Scala, Florence 5.81 Metropolitan Museum of Art, New York. Catherine Lorillard Wolfe Collection, Wolfe Fund, 1906, acc. no. 06.1234 6.1 National Gallery of Art, Washington, D.C. Gift of the Avalon Foundation 6.2 National Gallery of Art, Washington, D.C. Collection of Mr and Mrs Paul Mellon 6.3 Whitney Museum of American Art, New York. Gift of Gertrude Vanderbilt Whitney 6.4 Courtesy The New-York Historical Society, New York City 6.5 Terra Foundation for the Arts, Daniel J. Terra Collection, 1992.43; Photograph courtesy of Terra Foundation for the Arts, Chicago 6.6 Whitney Museum of American Art, New York. Alexander M. Bing Bequest 6.7 The Metropolitan Museum of Art, New York. Bequest of Lillie P. Bliss, 1931

6.9 The Art Institute of Chicago; Friends of American Art Collection, 1925.295. All rights reserved 6.10 The Chrysler Museum, Norfolk, Va.; gift of Walter P. Chrysler Jr 6.11 Museum of Art, Fort Lauderdale, Fla.; Ira Glackens Bequest 6.12 Brooklyn Museum of Art, Dick S. Ramsay Fund, 40.339 6.13 Addison Gallery of American Art, Phillips Academy, Andover, Mass.; gift of an anonymous donor 6.14 The Museum of the City of New York. The Jacob A. Riis Collection 6.15 National Gallery of Art, Washington, D.C. Chester Dale Collection 6.18 Photo David Prifti 6.19 © The Cleveland Museum of Art, 2001, gift of Miss Amelia Elizabeth White, 1964.160 6.20 The Corcoran Gallery of Art, Washington, D.C. Bequest of the artist 6.22 Los Angeles County Museum of Art. Mr and Mrs Allan C. Balch Collection 6.24 Hirschhorn Museum and Sculpture Garden, Smithsonian Institution, Washington, D.C. Gift of Mrs Saul Baizerman, N.Y., 1979 6.26 The Museum of Modern Art, New York. Gift of Miss Mina Turner. Copy print © 2001 The Museum of Modern Art, New York 6.28 Library of Congress, Washington, D.C., Prints and Photographs Division 6.29 The Albright-Knox Art Gallery, Buffalo.Gift of Seymour H. Knox 6.30 Des Moines Art Center. Purchased with funds from the Coffin Fine Arts Trust.Nathan Emory Coffin Collection. Photo Michael Tropea, Chicago 6.31 The Art Institute of Chicago; Gift of Georgia O'Keeffe to the Alfred Stieglitz Collection, 1949.533. All rights reserved 6.33 The Philadelphia Museum of Art. The Louise and Walter Arensberg Collection © Succession Marcel Duchamp/ADAGP, Paris and DACS, London, 2001 6.37–6.39 Hoover Institution on War, Revolution and Peace, Stanford University, Stanford, Calif. 6.41 Courtesy of The Willner family 6.42 © Succession Marcel Duchamp/ADAGP, Paris and DACS, London, 2001 6.43 © Succession Marcel Duchamp/ADAGP, Paris and DACS, London, 2001 6.44 © Man Ray Trust/ADAGP, Paris and DACS, London, 2001 6.45 Photo Sotheby's Picture Library, London 6.47 The Metropolitan Museum of Art, New York, Alfred Stieglitz Collection, 1949 6.51 National Gallery of Art, Washington,D.C., Alfred Stieglitz Collection 6.52 © ARS, New York and DACS, London, 2001 6.53 Oakland Museum of California, Gift of Mr and Mrs Willard M. Nott 6.54 © 1992 by the Trustees of the Ansel Adams Publishing Rights Trust, Carmel, Calif. All rights reserved 6.55 Photograph by Imogen Cunningham, © 1970 The Imogen Cunningham Trust 6.56 Library of Congress, Washington, D.C., Prints and Photographs Division 6.60 © 1981, Center for Creative Photography, Tucson; Gift of the Oakland Museum Association 6.61 San Antonio Museum of Art, Nelson A. Rockefeller Collection 6.70 From John F. Huckel, First Families of the Southwest (Kansas City: Fred Harvey, 1934) 6.74 The Huntingdon Library, San Marino; Grace Nicholson Collection 6.75 Alpine County Historical Society, Alpine, Calif.

6.76 Philbrook Museum of Art, Tulsa, Clark Field Collection 6.79 National Portrait Gallery, Smithsonian Institution, Washington, D.C., gift of W. Tjark Reiss in memory of his father, Winold Reiss. Reproduced with permission of the W. Tjark Reiss Estate 6.84, 6.85 The Museum of African American Art, Los Angeles; gift of Mrs Hayden 6.86 North Carolina Museum of Art Collection. © Archie Motley 6.87 Schomberg Center for Research in Black Culture, The New York Public Library; Astor, Lenox and Tilden Foundations © Archie Motley 6.88 Schomberg Center for Research in Black Culture, The New York Public Library; Astor, Lenox and Tilden Foundations 6.89 Whitney Museum of American Art, New York. Purchase 6.91 From R. Loewy, *Industrial Design*. Woodstock, NY: Overlook Press, 1979, p. 76 6.92 Courtesy Hearst Castle®/California State Parks 6.93 © ARS, New York and DACS, London, 2001 6.94 Photo © Tom Zimmerman 7.2–7.13 National Archives, Washington, D.C., Audio-Visual Division 7.14 Photo Barbara Melosh 7.15 George Eastman House Collection, Rochester, N.Y. 7.16 The Art Institute of Chicago; Gift of Leigh B. Block 1985.206. All rights reserved 7.17 National Gallery of Art, Washington, D.C., gift of Eugene and Agnes E. Meyer © ARS, New York and DACS, London, 2001 7.18 George Eastman House Collection, Rochester, N.Y. 7.19– 7.21 Library of Congress, Washington, D.C., Prints and Photographs Division; Farm Security Administration/Office of War Information Photo Collection 7.22 Library of Congress, Washington, D.C., Prints and Photographs Division © Estate of Ben Shahn/VAGA, New York/DACS, London 2001 7.23, 7.24 Library of Congress, Washington, D.C., Prints and Photographs Division 7.26 Architectural Publishers Artemis 7.27 Photo Emily Lane 7.28 Norman Rockwell Museum, Stockbridge, Mass. Printed by permission of the Norman Rockwell Family Trust, © 1943 the Norman Rockwell Family Trust 7.29 © DACS, 2001 7.30 From Thomas Hart Benton, *The America Today Murals*, New York: Equitable Life Assurance Society, 1985 7.31 Photo courtesy of the University of Southern California 7.32 ©1931 Banco de México Diego Rivera & Frida Kahlo Museums Trust, Av. Cinco de Mayo No. 2, Col. Centro, Del. Cuauhtémoc 06059, México, D.F. 7.33–7.35 Photo Michael Halberstadt, Vallejo, Calif. 7.36 Photo Lito 7.38 Whitney Museum of American Art, New York. Gift of Edith and Milton Lowenthal, in memory of Juliana Force © Estate of Ben Shahn/VAGA, New York/ DACS, London 2001 7.40 ©1933 Banco de México Diego Rivera & Frida Kahlo Museums Trust, Av. Cinco de Mayo No. 2, Col. Centro, Del. Cuauhtémoc 06059, México, D.F. 7.41 © 2012 Banco de México Diego Rivera Frida Kahlo Museums Trust, Mexico, D.F./DACS 7.43 The Museum of Modern Art, New York. Gift of Abby Aldrich Rockefeller, photograph © 2001 The Museum of Modern Art, New York 7.44 Collection of Barney A. Ebsworth Foundation 7.45 Albert Kahn Associates

7.46 Photo Thomas Airviews Photography, Bayside 7.47 Photo Peter Mauss/Esto 7.48, 7.49 © The Rockefeller Group 7.50 ©1934 Banco de México Diego Rivera & Frida Kahlo Museums Trust, Av. Cinco de Mayo No. 2, Col. Centro, Del. Cuauhtémoc 06059, México, D.F. 7.52, 7.53 Margaret Bourke-White/Timepix 7.55 Whitney Museum of American Art, New York. Collection of Mrs Reginald Marsh, N.Y.C. © ARS, New York and DACS, London, 2001 7.57 Private collection, Courtesy D. C. Moore Gallery, New York, N.Y. 7.58 © ARS, New York and DACS, London, 2001 7.59 Whitney Museum of American Art, New York, purchase 7.62 Walker Art Center, Minneapolis. Gift of the T. B. Walker Foundation, Gilbert M. Walker Fund 7.65 Dallas Museum of Art. Dallas Art Association Purchase 7.66 Philbrook Museum of Art, Tulsa, Clark Field Collection 7.67 Whitney Museum of American Art, New York. Gift of Gertrude Vanderbilt Whitney 7.68 © Estate of Grant Wood/VAGA, New York/DACS, London 2001 7.69 Friends of American Art Collection, All rights reserved by The Art Institute of Chicago and VAGA, New York, 1930.934 © The Art Institute of Chicago. All rights reserved 7.70 Copyright Gwendolyn Knight Lawrence, courtesy of the Jacob and Gwendolyn Lawrence Foundation 7.71 Collection of Hampton University Museum. Copyright Gwendolyn Knight Lawrence, courtesy of the Jacob and Gwendolyn Lawrence Foundation 7.73 Courtesy D. C. Moore Gallery, New York, N.Y. 7.74 Whitney Museum of American Art, New York. Purchase. Courtesy D. C. Moore Gallery, New York 7.76 Photo © Shigeo Anzai, courtesy of Isamu Noguchi Foundation 7.78 Courtesy ACA Galleries, New York 7.80 Everson Museum of Art, Syracuse; gift of the artist, P.C. 86.13 7.81, 7.82 War Relocation Authority Archives, Audio-Visual Division, National Archives, Washington, D.C. 7.84 Estate of Mine Okubo 7.85 Gift of Madeleine Sugimoto and Naomi Togawa, Japanese American National Museum, Los Angeles (92.97.3) 7.86 Amon Carter Museum, Fort Worth © Estate of Grant Wood/VAGA, New York/DACS, London 2001 7.87 The Museum of Modern Art, New York. Mrs Simon Guggenheim Fund, photograph © 2001 The Museum of Modern Art, New York. Courtesy ACA Galleries, New York 7.88, 7.89 Courtesy the Estate of James Guy 7.90, 7.91 © Estate of Stuart Davis/VAGA, New York/DACS, London, 2001 7.92 University of California Art Museum, Berkeley. Gift of the artist © Estate of Hans Hofmann/VAGA, New York/DACS, London, 2001 7.93 Whitney Museum of American Art, New York. Gift of Balcomb Greene 62.16. Courtesy Katharina Rich Perlow Gallery 7.94 Whitney Museum of American Art, New York. Purchase. Courtesy of Frelinghuysen Morris House and Studio, Lenox, Mass. 7.95 Whitney Museum of American Art, New York. Purchased with funds from the Mrs Percy Uris Purchase Fund © ARS, New York and DACS, London, 2001 7.96 Courtesy Lillian Kiesler 7.97 © Kate Rothko Prizel and

Christopher Rothko/DACS 1998 7.98 © Adolph and Esther Gottlieb Foundation/ VAGA, New York/DACS, London 2001 8.1 © Judith F. Baca 8.2 The Metropolitan Museum of Art, New York; George A. Hearn Fund, 1957 © ARS, New York and DACS, London 2001 8.4 Courtesy Salander-O'Reilly Galleries, New York 8.5 National Gallery of Canada, Ottawa, Purchased 1971 © ARS, New York and DACS, London 2001, public domain in Canada 8.6 Whitney Museum of American Art, New York. Purchase. Courtesy of Isamu Noguchi Foundation 8.7 North Carolina Museum of Art, Raleigh, purchased with funds from the state of North Carolina. Courtesy, Wyeth Collection 8.8 Whitney Museum of American Art, New York. Gift of the Friends of the Whitney Museum of Art (and purchase) © ARS, New York and DACS, London, 2001 8.9 The Museum of Modern Art, New York. Gift of Mr and Mrs David M. Solinger, photograph © 2001 The Museum of Modern Art, New York © ARS, New York and DACS, London, 2001 8.10 © Kate Rothko Prizel and Christopher Rothko/DACS 1998 8.11 The Museum of Modern Art, New York. Purchase (by exchange), photograph © 2001 The Museum of Modern Art, New York © Dedalus Foundation, Inc./ VAGA, New York/DACS, London 2001 8.12 Whitney Museum of American Art, New York. Purchase © Willem de Kooning Revocable Trust/ARS, New York and DACS, London, 2001 8.13 Photo © Hans Namuth 8.14 © Estate of David Smith/VAGA, New York/DACS, London 2001 8.15 Whitney Museum of American Art, New York. Purchase 8.16 Nina Leen/Timepix 8.17 Smithsonian American Art Museum, Washington, D.C.; gift of Mr and Mrs Alfred T. Morris Jr 8.18 Whitney Museum of American Art, New York © Leon Polk Smith Foundation/ VAGA, New York/DACS, London 2001 8.19 Courtesy the Norman Lewis Estate, Iandor Fine Arts Inc., Newark, N.J. 8.20 Courtesy CDS Gallery, New York 8.21 The Philadelphia Museum of Art; gift of the Aaron E. Norman Fund, Inc. © ARS, New York and DACS, London, 2001 8.23 Whitney Museum of American Art, New York. Purchased with funds from the Friends of the Whitney Museum of Art 8.24 The Museum of Modern Art, New York. Given anonymously, photograph © 2001 The Museum of Modern Art, New York. Courtesy ACA Galleries, New York 8.25 Courtesy Salander-O'Reilly Galleries, New York 8.26 The Museum of Modern Art, New York. Given anonymously, photograph © 2001 The Museum of Modern Art, New York © Larry Rivers/ VAGA, New York/DACS, London, 2001 8.27 The Museum of Modern Art, New York. Gift of Leo Castelli in honor of Alfred H. Barr, Jr, photograph © 2001 The Museum of Modern Art, New York © Robert Rauschenberg/VAGA, New York/DACS, London, 2001 8.28 © Robert Rauschenberg/VAGA, New York/DACS, London, 2001 8.29 The Museum of Modern Art, New York. Gift of Philip Johnson in honor of Alfred H. Barr, Jr, photograph © 2001 The Museum of

Modern Art, New York © Jasper Johns/VAGA, New York/DACS, London, 2001 8.30 Courtesy of the Leo Castelli Gallery, New York © Jasper Johns/VAGA, New York/DACS, London, 2001 8.31 © The Joseph and Robert Cornell Memorial Foundation/VAGA, New York/DACS, London, 2001 8.32 The Museum of Modern Art, New York. Gift of Mr and Mrs Robert C. Scull and purchase, photograph © 2001 The Museum of Modern Art, New York © ARS, New York and DACS, London, 2001 8.33 Whitney Museum of American Art, New York. Purchased with funds from the Howard and Jean Lipman Foundation, Inc. © ARS, New York and DACS, London, 2001 8.34 Whitney Museum of American Art, New York. Purchased with funds from the Friends of the Whitney Museum of Art © Escobar Marisol/VAGA, New York/DACS, London 2001 8.35 © Robert Frank, courtesy Pace/MacGill Gallery, New York 8.36 The Museum of Modern Art, New York. Purchase. Copy print © 2001 The Museum of Modern Art, New York 8.37 San Francisco Museum of Modern Art; gift of Frederic P. Snowden 8.38 Courtesy Nancy Reddin Kienholz 8.39 © Marcus Schubert, courtesy Raw Vision 8.40 Smithsonian American Art Museum, Washington, D.C.; gift of anonymous donors 8.41 Photo © Milton Rogovin 1952-2002. Courtesy Center for Creative Photography, University of Arizona Foundation 8.42 © Elizabeth Catlett. DACS, London/VAGA, New York 2012 8.43 Yale University Art Gallery, New Haven; gift of Helen W. Benjamin in memory of her husband Robert M. Benjamin © Ellsworth Kelly 8.44 Whitney Museum of American Art, New York. Gift of Mr and Mrs Eugene M. Schwartz © ARS, New York and DACS, London 2001 8.45 © 1961 Morris Louis 8.46 Whitney Museum of American Art, New York. Purchased with funds from the Friends of the Whitney Museum of Art, © Kenneth Noland/VAGA, New York/DACS, London 2001 8.47 © Estate of David Smith/VAGA, New York/DACS, London 2001 8.48 Art © Donald Judd/VAGA, New York/DACS, London, 2001 8.49 Milwaukee Art Museum, purchase, National Endowment for the Arts Matching Funds © Carl Andre/VAGA, New York/DACS, London 2001 8.50 Photo Rudolph Burckhardt © ARS, New York and DACS, London 2001 8.51 Whitney Museum of American Art, New York. Gift of Howard and Jean Lipman © ARS, New York and DACS, London, 2001 8.52 United States Information Office 8.53 Courtesy The Salk Institute, San Diego, California 8.54 DLR Group 8.55 Photo Alexander Georges 8.56 © Julius Shulman Photography, Los Angeles 8.57 © ARS, New York and DACS, London, 2001 8.58 © TWA, by Ezra Stoller Associates 8.59 May Cutler Fonds, Collection Centre Canadien d'Architecture/Canadian Centre for Architecture, Montréal 8.60 The Museum of Modern Art, New York. Gift of the artist in memory of Alfred H. Barr, Jr, photograph © 2001 The

Museum of Modern Art, New York © Louise Bourgeois/VAGA, New York/DACS, London, 2001 8.61 © ARS, New York and DACS, London, 2001 8.62 © Lynda Benglis/VAGA, New York/DACS, London, 2001 8.63 © Estate of Robert Smithson/VAGA, New York/DACS, London 2001 8.64 The Art Institute of Chicago; through prior gifts of Arthur Keating and Mr and Mrs Edward Morris, 1988.130. All rights reserved 8.65 Photo John Weber Gallery © Estate of Robert Smithson/VAGA, New York/DACS, London 2001 8.66 Courtesy of the artist © Nancy Holt/VAGA, New York/DACS, London, 2001 8.67 Whitney Museum of American Art, New York. Gift of Peter M. Brant © ARS, New York and DACS, London, 2001 8.68 Courtesy Margo Leavin Gallery, Los Angeles 8.69 Courtesy the artist 8.70 Collection of Phoenix Art Museum, gift of Mrs N. A Bogdan in memory of Mr Louis Cates, 1962.139. Copyright © 1963 (renewed 1991), Grandma Moses Properties Co., New York 8.71 Photo © Robert McElroy/VAGA, New York/DACS, London, 2001 8.73 © Tom Wesselmann/VAGA, New York/DACS, London 2001 8.74 Photo courtesy of Leo Castelli © The Estate of Roy Lichtenstein/DACS 2001 8.75 The Museum of Modern Art, New York. Philip Johnson Fund and gift of Mr and Mrs Bagley Wright, photograph © 2001 The Museum of Modern Art, New York © The Estate of Roy Lichtenstein/DACS 2001 8.76 Los Angeles County Museum of Art; anonymous gift through the Contemporary Art Council. Courtesy of Ed Ruscha 8.77 Whitney Museum of American Art, New York. 50th Anniversary gift of Mr and Mrs Victor W. Ganz 8.78 Seattle Art Museum; gift of Manuel Neri © Estate of Robert Arneson/VAGA, New York/DACS, London 2001 8.79 National Gallery of Canada, Ottawa, Purchased 1968 © The George and Helen Segal Foundation/DACS, London/VAGA New York 2001 8.80 © The Andy Warhol Foundation for the Visual Arts, Inc./ ARS, New York and DACS, London 2001
8.81 © Romare Bearden Foundation/VAGA, New York/DACS, London 2001 8.84 Courtesy of the artist 8.85 The Collection of the Newark Museum, Purchase 1971, Anonymous Gift Fund 8.86 "Muhammad Ali" courtesy of Howard Greenberg Gallery 8.87 The Museum of Modern Art, New York. Purchase, photograph © 2001 The Museum of Modern Art, New York © James Rosenquist/VAGA, New York/DACS, London, 2001 8.88, 8.89 Courtesy of the artist and the Rhona Hoffman Gallery, Chicago
8.90 Photograph © John Filo 8.91 The Museum of Modern Art, New York. Gift for the Benefit of Attica Defense Fund, photograph of artwork © 2001 The Museum of Modern Art, New York. Haeberle photograph Ronald Haeberle/Timepix 8.93 Courtesy of the artist 8.95 Courtesy Louis K. Meisel Gallery, New York 8.96 © ARS, New York and DACS, London, 2001 8.97 Photograph:

Galerie Lelong, New York 8.98 Courtesy Ronald Feldman Fine Arts, New York 8.99 Photo Susan R. Mogul 8.100 Photo Anne Chauvet © ARS, New York and DACS, London, 2001 8.101 Photo Wendy Watriss 8.102 Photo Thomas Airviews 8.103 Photo Rollin R. La France 8.104 Photo Richard Payne 8.105 Copyright © 1978 Norman McGrath 8.106 © Retoria, photo T. Kitajima 8.107 © Art on File/Corbis 8.108 Walker Art Center, Minneapolis. Art Center Acquisition Fund 8.109 © Photo Klaus Wittman 8.110 Des Moines Art Center; ex-Saatchi Collection 8.113 Courtesy of the artist and the Rhona Hoffman Gallery, Chicago 8.114 Public Art Fund Inc., New York © Jenny Holzer, photo Lisa Kahane © ARS, New York and DACS, London, 2001 8.115 © Guerrilla Girls, New York 8.116 Reproduction courtesy the artist and Christopher Grimes Gallery, Santa Monica 8.118 Courtesy of P.P.O.W., New York 8.119 Photo Peter Muscato © Estate of Felix Gonzalez-Torres. Courtesy Andrea Rosen Gallery, New York 8.120 Frank Spooner Pictures/Jaffe /Liaison, London 8.121 Philadelphia Museum of Art, Philadelphia. Purchased with funds contributed by the Dietrich Foundation and with the partial gift of the artist and the Paula Cooper Gallery, 1998. © the artist, courtesy Galerie Gisela Capitain, Cologne 8.122 Photo George Macianus. Courtesy George Macianus/The Gilbert and Lila Silverman Fluxus Collection, Detroit and the artist 8.123 Whitney Museum of American Art, New York. Gift of Laila and Thurston Twigg-Smith. Reproduction permission courtesy Nam June Paik and Holly Solomon Gallery 8.125 Collection: Edition 1, Collection of the Solomon R. Guggenheim Museum, New York, gift of the Bohen Foundation; Edition 2, Collection of Pamela and Richard Kramlich, San Francisco; Edition 3, Dallas Museum of Art. Photo Kira Petrov 8.126 Photo Ted Esser 8.128 © DACS 2001 8.129 Courtesy Jaune Quick-To-See Smith 8.130 Collection of the artist. Photo Glenn Halvorson, courtesy Walker Art Center, Minneapolis, courtesy of Margo Machida 8.131 Photo D. James Dee. Courtesy the artist and Luhring Augustine, New York 8.132 Courtesy Video Data Bank, Chicago 8.133 Photograph Jeff Goldman, The Contemporary Museum and Maryland Historical Society, Baltimore 8.134 © FMGB Guggenheim Bilbao Museoa, Photographer: Erika Barahona Ede. All rights reserved. Partial or total reproduction prohibited 8.135 © dbox for the Lower Manhattan Development Corporation/Corbis 8.136 Forkscrew Graphics 8.137 Courtesy the artists 8.138 Photo D. James Dee. Courtesy Ronald Feldman Fine Arts, New York 8.139 Photo Tom Olcott. Courtesy workshop/apd 8.140 Photo © WilsonsTravels Stock/Alamy 8.141 Photo James Prinz. Courtesy the artist and Jack Shainman Gallery, New York 8.142 Photo Andre Costantini. © Alan Michelson 2009

Index

Illustrations are indicated by page numbers in *italic*.